A CENTURY OF AFRICAN AMERICAN ART

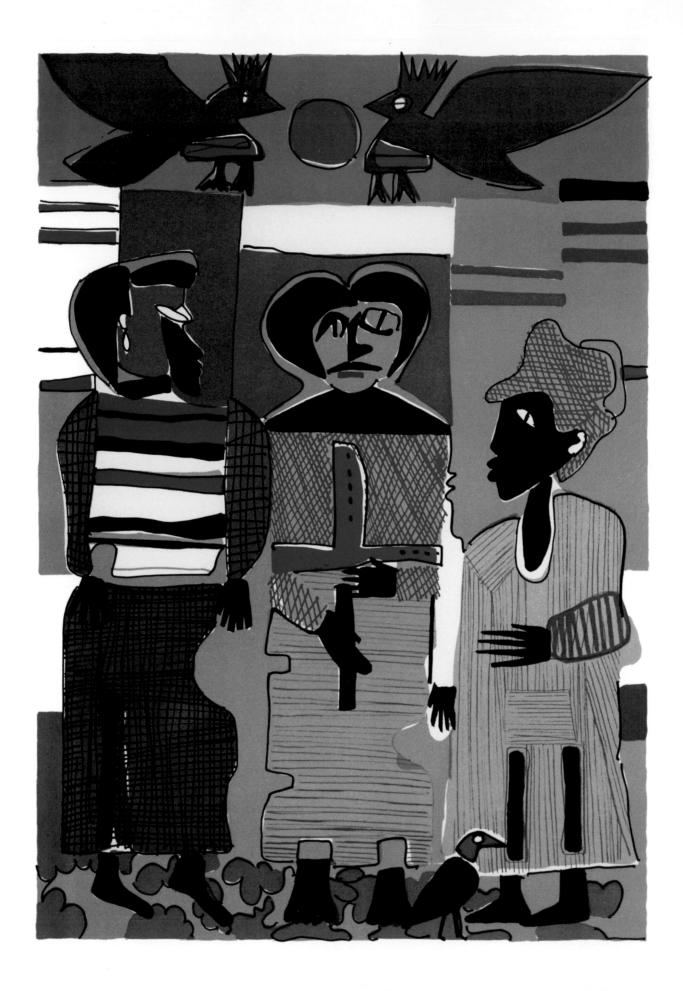

A CENTURY OF

African American Art

THE PAUL R. JONES COLLECTION

Edited by Amalia K. Amaki

THE UNIVERSITY MUSEUM, UNIVERSITY OF DELAWARE

NEWARK, DELAWARE

AND

RUTGERS UNIVERSITY PRESS

NEW BRUNSWICK, NEW JERSEY, AND LONDON

LIBRARY OF CONGRESS CATALOGING-IN-PUBLICATION DATA

A century of African American art: the Paul R. Jones collection / edited by Amalia K. Amaki.

p. cm.

Includes bibliographical references and index.

ISBN 0-8135-3456-9 (hardcover : alk. paper) — ISBN 0-8135-3457-7 (pbk. : alk. paper)

I. African American art—20th century—Exhibitions. 2. African American art—21st century—Exhibitions. 3. Jones, Paul R. (Paul Raymond), 1928 - Art collections - Exhibitions. 4. University of Delaware - Art collections - Exhibitions. 5. Art—Private collections—Delaware—Newark—Exhibitions. I. Amaki, Amalia.

N6538.N5C45 2004

704.03'96073'007474932 dc222004000582

A British Cataloging-in-Publication record for this book is available from the British Library.

This collection copyright © 2004 by The University Museum, The University of Delaware

No part of this book may be reproduced or utilized in any form or by any means, electronic or mechanical, or by any information storage and retrieval system, without written permission from the publisher. Please contact Rutgers University Press, 100 Joyce Kilmer Avenue, Piscataway, NJ 08854-8099. The only exception to this prohibition is "fair use" as defined by U.S. copyright law.

Manufactured in China

FRONTISPIECE:

Romare Bearden, Firebirds, 1979. Lithograph, 28 x 24 in. © Romare Bearden Foundation / Licensed by VAGA, New York, NY. The Paul R. Jones Collection, University of Delaware, Newark.

Contents

List of Illustrations

vii

President's Statement	ix
Director's Foreword	xi
Collector's Foreword	xiii
Introduction	xv
Political Sight:	I
On Collecting Art and Culture	-
AMALIA K. AMAKI	
Collage and Photomontage: Bearden's Spiralist Reflections of America and Africa SHARON PRUITT	17
Nanette Carter's Discursive Modernism: The Collage Aesthetic in Light over Soweto #5	33
Reign(ing) in Color: Toward a Wilder History of American Art IKEM STANLEY OKOYE	45
On the Surface: Color, Skin, and Paint MARCIA R. COHEN AND DIANA McCLINTOCK	55

Collecting Memory:	61
Portraiture, Posing, and Desire	
CARLA WILLIAMS	

- Flash from the Past: 69
 Hidden Messages in the Photographs of Prentice Herman Polk

 AMALIA K. AMAKI
 - African American Printmakers: 79
 Toward a More Democratic Art
 WINSTON KENNEDY
 - Afterword: 89
 A Personal Appreciation—Art, Race, and Biography

 MARGARET ANDERSEN
 - Preservation for Posterity: 95
 The Paul R. Jones Photography Collection

 DEBRA HESS NORRIS

Plates 103

Artists' Biographies 215

Notes on Contributors 249

Index 251

Illustrations

An asterisk (*) indicates work not represented in the exhibition at the University of Delaware.

- * Portrait of Paul R. Jones, 2001
- 1. Jimmie Mosely, Humanity #2, 1968
- 2. John T. Riddle, Professor from Zimbabwe #1, 1979
- *3. Brochure cover, King-Tisdell Cottage Exhibition of Works from the Paul R. Jones Collection
- *4. Sign from exhibition at Charlotte, North Carolina, Savings and Loan
- 5. Bill Hutson, Maiden Voyage, 1987
- *6. Herman "Kofi" Bailey, Woman Grinding Peppers, 1973
- 7. Amos "Ashanti" Johnson, Original Man, 1968
- *8. Leo Twiggs, Old Man with Wide Tie, 1970
- 9. Henry Ossawa Tanner, Return to the Tomb, ca. 1910
- *10. Barrington Watson, Reclining Nude, 1972
- II. Hale Woodruff, Monkey Man #2, 1974
- *12. Jack Whitten, Untitled, 1977
- *13. James VanDerZee, Couple in Raccoon Coats, 1932
- 14. Ming Smith Murray, Katherine Dunham and Her Legacy, 1984
- 15. William Anderson, Man Shaving, 1988
- 16. Romare Bearden, School Bell Time, ca. 1980
- 17. Nanette Carter, Light over Soweto #5, 1989
- 18. Leo Twiggs, Low Country Landscape, 1974
- 19. Margaret T. Burroughs, Three Souls, 1968
- *20. Wadsworth Jarrell, Jazz Giants, 1987
 - 21. Elizabeth Catlett, Girl/Boy/Red Ball, 1992
- 22. Howardena Pindell, Untitled #35, 1974
- 23. James Little, Countdown, 1981
- 24. David C. Driskell, Woman in Interiors, 1973
- 25. Carrie Mae Weems, Kitchen Table Series, 1990
- 26. Clarissa Sligh, Portrait of Paul R. Jones, 1996
- 27. James VanDerZee, The Black Houdini, 1924

- 28. Prentice H. Polk, Margaret Blanche Polk, 1946
- 29. Prentice H. Polk, Alberta Osborn, ca. 1929
- 30. Prentice H. Polk, George Washington Carver, ca. 1930
- 31. Prentice H. Polk, The Boss, 1932
- 32. Prentice H. Polk, George Moore, 1930
- 33. Michael Ellison, The Bar, 1984
- 34. Jacob Lawrence, The Library, 1978
- 35. Elizabeth Catlett, Singing/Praying, 1992
- 36. Samella Lewis, The Masquerade, 1994
- 37. John Wilson, Richard Wright Series: Death of Lulu, 2001
- 38. Margo Humphrey, Pulling Your Own Strings, 1981
- *39. Herman "Kofi" Bailey, Portrait of Paul R. Jones, 1973
- *40. Arthur P. Bedou, *Booker T. Washington* (before restoration), ca. 1915
- *41. Arthur P. Bedou, Booker T. Washington (after restoration), ca. 1915
- 42. Benjamin Britt, We Two, 1968
- 43. Charles White, John Henry, 1975
- 44. Edward Loper, Sr., Portrait of Benoit Cote, 2000
- 45. Ernest Chrichlow, Untitled, 1985
- 46. Benny Andrews, Dianne, 1984
- 47. Selma Burke, Mary McLeod Bethune, 1980
- 48. Reginald Gammon, Sonny Rollins, 2002
- 49. Herman "Kofi" Bailey, African Woman, 1974
- 50. Alvin Smith, Untitled, 1985
- 51. Romare Bearden, Island Scene, 1984
- 52. Imaniah Shinar (James E. Coleman, Jr.), Ebony Queen, 2002
- 53. Larry Walker, Prelude, 2000
- 54. John Feagin, Reflections II, 1973
- 55. Frank Bowling, Untitled, 1980
- 56. Frank Bowling, Untitled, 1980
- 57. Harper T. Phillips, Untitled, 1974

- 58. Jewel Simon, Lick, 1944
- 59. Jack Whitten, Annunciation XVIII, 1989
- 60. Carl Christian, Evening in Summer, 1999
- 61. Aimee Miller, Untitled, 2001
- 62. Ayokunle Odeleye, Caring, 1972
- 63. Rex Gorleigh, Red Barn, 1981
- 64. Edward Loper, Sr., Winter Still Life, 2003
- 65. Cedric Smith, Coca-Cola, 2002
- 66. Romare Bearden, Firebirds, 1979
- 67. Lionel Lofton, Jungle Fever, 2001
- 68. Camille Billops, Fire Fighter, 1990
- 69. Earl J. Hooks, Man of Sorrows, 1950
- 70. John Wilson, Richard Wright Series: Journey of the Mann Family, 2001
- 71. John Wilson, Richard Wright Series: Embarkation, 2001
- 72. John Wilson, Richard Wright Series: Light in the Window, 2001
- 73. John Wilson, Richard Wright Series: Mann Attacked, 2001
- 74. John Wilson, Richard Wright Series: The Death of Mann, 2001
- 75. Charles White, Vision, 1973
- 76. Samuel Guilford, 9 Lives, 1999
- 77. Hayward L. Oubre, Miscegenation, 1963
- 78. Ming Smith Murray, Gregory Hines, 1985
- 79. Ming Smith Murray, Arthur Blythe in Space, 1989
- 80. William Wallace, Sun Ra, 1988
- 81. William Wallace, Miles Davis and Axel McQuerry, 1989
- 82. Jim Alexander, Ellington Orchestra, 1972
- 83. Jim Alexander, Jamming, 1972

- 84. Bert Andrews, Gloria Foster and Morgan Freeman, 1979
- 85. Bert Andrews, Alfre Woodard and Others, 1978
- 86. James VanDerZee, The Barefoot Prophet, 1928
- 87. Prentice H. Polk, Catherine Moton Patterson, 1936
- 88. Prentice H. Polk, Mr. and Mrs. T. M. Campbell and Children, ca. 1932
- 89. Roy DeCarava, Graduation Day, 1949
- 90. Doughba Hamilton Caranda-Martin, Untitled, 2003
- 91. Doughba Hamilton Caranda-Martin, Untitled, 2003
- 92. Doughba Hamilton Caranda-Martin, Untitled, 2003
- 93. Elizabeth Catlett, Couple Kissing, 1992
- 94. Elizabeth Catlett, Boy/Girl Profile, 1992
- 95. Allan R. Crite, The Revelation of St. John the Divine: Procession to Ram Altar, 1994
- 96. Loïs Mailou Jones, Nude, 1996
- 97. Loïs Mailou Jones, Jazz Combo, 1996
- 98. Loïs Mailou Jones, 3 dancers, 1996
- 99. Michael Ellison, Brown Boy, 1985
- 100. Michael Ellison, The Mall, 1985
- 101. Betye Saar, Mother Catherine, 2000
- 102. Betye Saar, Magnolia Flower, 2000
- 103. Betye Saar, The Conscience of the Court, 2000
- 104. Phoebe Beasley, Man/Woman/Child, 1998
- 105. Phoebe Beasley, Yogi, 1998
- 106. John Biggers, Untitled (woman/planks/shell), 1996
- 107. John Biggers, Untitled (figures/two balls), 1996
- 108. Paul Raymond (P. R.) Jones, Jr., Untitled, ca. 1971
- 109. Margo Humphrey, Hometown Blues, 1980
- 110. Richard Hunt, Untitled, 1980
- III. William E. Artis, Michael, ca. 1950

President's Statement

THE OPENING of the first major exhibition of works drawn from the Paul R. Jones Collection is cause for great celebration at the University of Delaware.

The primary mission of the University is education, and we believe you will find this exhibition to be a wonderful learning opportunity. As such, we encourage you to take your time as you move about the recently renovated historic home of the collection, Mechanical Hall, and the other venues on campus where works are on display so that you can both enjoy the art from the Paul R. Jones Collection and truly experience it.

I have a special fondness for the Paul R. Jones Collection, first and foremost because the collection contains wonderful works in a variety of media created by the nation's leading African American artists and also because of the man who built and nurtured it over the course of the last four decades, devoting his life to the art and the artists who for too long had been overlooked and underappreciated.

Paul R. Jones is a most remarkable man—in all ways, a gentleman—a collector and connoisseur of admirable personal and professional qualities, and one of my very best friends.

His achievement in gathering one of the world's largest and most comprehensive collections of works by African American artists is extraordinary, and the story of his success is inspiring.

As you may know, Paul is not independently wealthy. He did not inherit a fortune with which to fund his profound interest in the arts. Rather, he was the grandson of farmers and the son of a mineworker, who later became a mining contractor, Will Jones, and grew up in a work camp near Bessemer, Alabama, where, during

times of labor strife, he remembers the sound of bullets raining on the tin roofs. Paul's mother, Ella, loved to tend garden and thereby introduced her son to the beauty the world can hold.

As a college student, Paul was a victim of the restrictive Jim Crow laws of his native and beloved South, having been denied admission to law school because of his race. He persevered and went into public service, working in the fields of civil rights and housing and urban development, and spending time as a deputy director of the Peace Corps in Thailand.

Early in the 1960s, Paul's interest in the arts began to blossom. He was walking along a street in Atlanta when a sidewalk vendor selling prints of works by the masters caught his eye. Paul went over and picked up three prints, one each by Toulouse-Lautrec, Degas, and Chagall, which he framed himself and hung on the walls of his home. It soon occurred to him that if he were to begin collecting art with any degree of seriousness, he should collect originals. He began visiting museums and galleries and found that conspicuously absent from collections there were works by African American artists.

Paul determined that he would collect such works, and thus became a pioneer in the field. Over the years, he was as much social worker as collector, often providing an artist his or her next meal or month's rent in return for the opportunity to purchase their work. It was not long before the art overran Paul's modest home in Atlanta, causing him to move to a larger home. Even then, the walls were quickly filled and the art spilled over onto beds and chairs and into drawers and closets.

Paul came to realize the need for a considerably larger location for his art, a permanent home capable

of preserving and sharing his collection, and we are grateful that he selected the University of Delaware to be that home.

I am deeply appreciative of the Paul R. Jones Collection because it represents so much more than a prized donation to the University of Delaware.

It is the gift of a lifetime of collecting and an inspiring record of appreciating.

It is the gift of some of the finest examples of work by America's African American artists, artists who have contributed greatly by sharing their unique visions in the wider realm of American art.

It is the gift of collaboration, building bridges between the University of Delaware and the nation's historically black colleges and universities.

It is a gift that keeps on giving, having already been added to through a generous donation from the Brandy-

wine Workshop in Philadelphia, an organization that champions cultural diversity in the visual arts, which honored Paul in 2002 with its James VanDerZee Award for lifetime contributions to the arts.

It is a gift of sharing, and through the University's respected programs in art, art history, art conservation, Black American studies, and museum studies, and through its leading edge technological resources, we plan to preserve, digitize, and display the works in the years ahead so they can be appreciated by as wide an audience as possible.

And, ultimately, it is a gift of great friendship, epitomized by Paul R. Jones, who is a bright light on our campus, particularly inspiring to our students.

The University of Delaware is deeply indebted to Paul and we thank him for his wonderful gift. We are pleased now to open the first major exhibition of the Paul R. Jones Collection to the world. Enjoy!

DAVID P. ROSELLE PRESIDENT, UNIVERSITY OF DELAWARE

Director's Foreword

This inaugural exhibition of the Paul R. Jones collection marks an exhilarating new departure for the University of Delaware. This stunning gift brings to the University artworks of the highest quality, by artists both well and less well known. Many among them, including Romare Bearden, Beye Saar, Jacob Lawrence, Margaret T. Burroughs, Elizabeth Catlett, Allan Rohan Crite, Roy De Carava, James VanDerZee, Benny Andrews, and Charles White, are well recognized, having been given their well-deserved place in texts and exhibitions on African American art and culture. Those who follow contemporary art may best know other artists such as Nanette Carter and Cedric Smith. Given the wide range of this collection, what impresses most about it is the consistent beauty and quality of its components.

This major collection of African American art of the twentieth and twenty-first centuries provides an important resource for study of the works themselves, the artists who created them, as well as the social and historical contexts that engendered them. The University of Delaware is well prepared to take full advantage of this collection, given its excellent resources in Black American studies, art, art conservation, art history, sociology, history, English—to mention only a few.

We are deeply indebted to Paul R. Jones for this generous gift. By choosing to give this art to an institution of higher education, Paul Jones has made a decision that will enhance our understanding of the pivotal role played by African American art within the context of American art for years to come. Students and faculty across this and other institutions will now be able to examine and discuss these works, which will undoubtedly inspire new directions in scholarship. It is, clearly, a win-win situation.

We are also deeply indebted to David P. Roselle, president of the University of Delaware, for his recognition of the importance of bringing this collection to campus. His enthusiastic support and leadership made possible the renovation of a turn-of-the-century building on campus, now fully transformed, which provides state-of-the-art facilities for the exhibition, study, care, and storage of these works of art.

The foundation of every exhibition is the expertise of its curator. For this, we are grateful to Amalia Amaki, curator of the Paul R. Jones Collection. Dr. Amaki defined the scope of the exhibition, developed the ideas presented in the catalogue, edited and contributed to the catalogue, and worked with museum staff to design an exhibition that does justice to its beautiful surroundings. Thanks also goes to the many scholars who contributed to the catalogue, representing a range of fields—from art history to sociology—that reconfirms the interdisciplinary nature of the studies that this collection invites.

I would like finally to thank all of those, too many to name, who contributed to the success of this exhibition and catalogue. These include the staff of many different offices within the University of Delaware, particularly, that of the University Museums and the Office of Public Relations; and the staff of Rutgers University Press. Many students have also already contributed to the development of this project—marking the beginning of what will be a long and mutually beneficial relationship among this unique collection, its collector, the public, and the students, faculty, and staff of the University of Delaware.

JANIS A. TOMLINSON
DIRECTOR, UNIVERSITY MUSEUMS

Collector's Foreword

■HIS EXHIBITION and publication mark the culf L mination of an extensive search for the best home to house an art collection that has taken more than forty years to amass. The artworks have been more to me than precious images created by talented men and women who, in many cases, created them in the face of tremendous personal challenges; they have been true companions—like members of my family—offering daily opportunities to learn about the thoughts, expressions, and ways of living of the makers. They have spoken to me in fresh voices with each encounter, and it was important that these works be deeded to a place where they could continue to inform and enrich the lives of new discoverers. It was also important that the works be properly considered in the context of American art and that they serve as a catalyst for examining other aspects of the nation's cultural dynamics. Further, it was critical to have the artwork available to scholars, students, art lovers, and others in any number of communities via innovative educational, technological, and outreach programs.

I am pleased that the University of Delaware has accepted this challenge, assumed its leadership role, and taken initial steps that all but guarantee a successful implementation of programs utilizing the collection in campus-wide initiatives. The Paul R. Jones Lecture, anniversary celebration of the announcement of the Jones gift, and the initiation of an artist award are pivotal among the numerous annual events designed to engage a broad range of audiences. Over the past three years since the agreement, the collection has taken on a life of its own, with its number of friends steadily increasing, involving people who have truly taken the collection to heart.

I particularly appreciate the courageous leadership of President David P. Roselle. Thanks go out to the offices of the Provost and the Dean of Arts and Science. Finally, special thanks to Dr. Amalia K. Amaki, curator of the collection, whose commitment to the collection, related programs, and the University has been central to the success of projects and this exhibition.

PAUL R. JONES

Introduction

"Every man is a volume if you know how to read him."

These carefully inscribed words are the entrée to the huge scrapbook cradling hundreds of photographs, documents, and other materials from earlier decades of the life of collector Paul R. Jones. The depth of meaning in the words is more astutely realized and more acutely felt after carefully exploring the wealth of data contained on each oversized page, and with the understanding that from his seemingly humble beginning in a small, rural, southern town to his official presence in the nation's capital, an American story is told. It is a notably significant example of the convergence of person and nation in the expressed living of a specific American.

So it is with the lives and work of the artists that are the subject of the essays in this text. While they represent the more than three hundred artists in the complete Jones collection and the sixty-six whose works comprise this exhibition, the selected artists and their corresponding artworks bring cultural currency of national origin and importance within their unique styles and approaches. The essays in this text make intentional efforts toward the de-race-ing of African American artnot stripping the works of the idiomatic cultural constructs from which they germinate, but moving away from readings grounded in strict and unnatural perceptions of previous Euro-American stylistic sources. Here, the writers' discussions are not restricted to the singularity of ethnic cloaking, but rather are legitimate attempts to peel off the many layers of conception, classification, and manifestation that brought the imagery to fruition.

Sharon Pruitt's contextualization of Bearden's photomontage and collage styles in an Archimedean metaphorical group consciousness presses the boundaries of its more typical placement within the confines of cubistderived collage. These bounds are challenged even more by her allusions to Bearden's subjects and themes as salutation to a mythologized past expressed through social activism and facilitated by West African art aestheticism. Ann Gibson's analysis of the mark making in Nanette Carter's collage style in the Light over Soweto series takes into account its differentiating properties as both a protective veil and point of revelation. Gibson practically moderates multiple discussions of modernist principles of interpretation in tracing the range of meanings dispersed in a single work by Carter—its psychological mincing of outrage and proactivity that at the same time is mimetic of the physicality of the South African terrain. The southern landscape of the United States is central to Ikem Okoye's examination of the functionality of muted color in the work of Leo Twiggs. Framing his analog with questions surrounding the validity of ethnic affinity for wild coloration, he places Twiggs's palette (Low Country Landscape) side by side with that of Margaret Burroughs (Three Souls). He culminates with a discussion of color codification and its complex and inevitable association with social and political innuendos, particularly as they relate to race and class within the construct of the rural South. The paradoxical nature of color consumes the investigation of Marcia Cohen and Diana McClintock's discourse on illusion, deception, and appeal. While engaged in a curt academic exercise, they touch on the spectrum of implications of color both as an element and a structural armature supporting an array of formal considerations in art from the Jones collection.

Carla Williams explores the relationship between image, self, and desire—the permeation of a realized ever-changing self through collective poses based upon desired appearance. Her treatment of the collaboration between the sitter and the image-maker and the expectations affecting the final product sets the stage for an examination of the photographs of Prentice Herman Polk, whose portraiture crossed multiple categories and layers of social and artistic meanings. Winston Kennedy's comments on prints as important images to African American oeuvres illuminate the print's place in history and the significance of the medium to this aspect of American art history. At the same time, he introduces creative patterns that are specific to the printmaking methods of some, such as John Wilson's translation of a Richard Wright text in a series of prints, while focusing on the individual style characteristic of others typified in other media, as seen in Jacob Lawrence's The Library.

Margaret Andersen offers insight into her initial work on a biography of collector Paul R. Jones, introducing the special challenges confronting a sociologist rooted in race, class, and gender who undertakes writing a biog-

raphical account. Debra Hess Norris concludes with a discussion of the care and preservation of photographs in the Jones collection in light of the vast number contained therein.

Collectively, the essays serve many functions. Some bring to brighter light the work of mature, yet underexposed artists whose careers have spanned decades. Some offer new insights into the imagery of artists whose names and works are well known. In other cases, the personal creative path of a specific work is charted and examined. And still in others, the significance of a medium evidenced in a large body of work by different artists is emphasized as a way of further investigating the contributions of individuals. The artworks are subjected to an array of cultural, social, political, psychological, and historical contexts in efforts to tap into the spectrum of interests pursued by and implied in the work of the artists in the exhibition.

In the final analysis, each writer contributes to the placement of African American art in the natural order of its existence—the order being in the context of the broader and truer realization that the life of an artwork, like that of its maker, exists within, and was formed out of an American cultural reality.

AMALIA K. AMAKI

A CENTURY OF AFRICAN AMERICAN ART

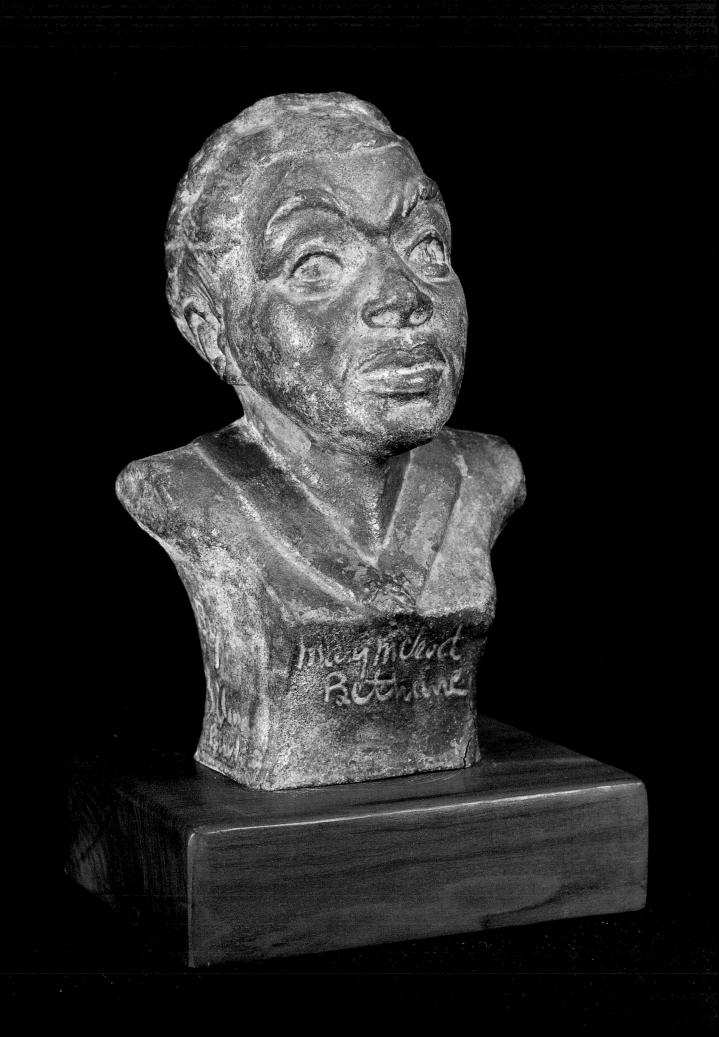

Political Sight:

On Collecting Art and Culture

AMALIA K. AMAKI

THE MAN

But there is a distinct aggressiveness to the acquisitions methodology of Paul R. Jones that suggests just that. From the beginning, he aligned collecting with social and moral responsibility, perceiving it as a necessary, though seldom acknowledged, affirmation of the intrinsic value of African American expression to the totality of American art. He approached collecting as a means to constructing community, recalling how art-related events have historically appealed to African Americans across social and other strata. Moreover, he found art so inviting and alluring that it constituted an effective mechanism for cross-cultural engagement.

Recognized as having one of the top art collections in the country, Paul Jones was motivated to collect largely because of absence—too few works by African American artists on museum walls, in gallery displays, and at auctions. Though not considerably wealthy, he was sustained in his collecting endeavors by a firm belief in the cultural merit of the creativity of the artists and a respect for the inevitability of change, convinced that the time would come when the accomplishments of African American artists would be sufficiently recognized.

Intrigued by art at a young age, his maturation began in the small mining camp on the outskirts of Bessemer, Alabama, where he grew up. There, under the watchful eyes of parents Ella Reed Phillips Jones and William "Will" Norfleet Jones, and four older stepsisters, Sophronia "Sal" Phillips Sims, Maggie "Moch" Phillips Ray, Louella "Pip" Phillips, and Leah Kate Phillips Watts, he was encouraged to actively explore his surroundings—a very loving, secure, and creative environment. He was groomed in his youth to understand the subtle negotiation

FACING PAGE:

Selma Burke, Mary McLeod Bethune, 1980 (Plate 47) and conciliation techniques that established his father as one of the most powerful men in the county. Grounded in a strong work ethic, he was raised to appreciate family, respect friends, and honor the nobility of a humble, simple existence.

Intermittent stays in the north during the school year (where his mother and sisters felt he received a better education) and frequent travel with his father exposed him to different people, situations, and ways of life. Experiences at Alabama State College, Howard University, and Yale University informed his acute awareness of the need to combat social ills based on racial prejudice proactively, strategically, and methodically. Of particular note were his years at Howard, where he encountered leading thinkers across disciplinary lines. He was exposed to such pioneering figures as artist and art historian James A. Porter (1905-1970) who wrote the first history of African American art, Modern Negro Art, in 1943; philosopher Alain Leroy Locke (1886–1954), the leading proponent of the New Negro movement (ca. 1917-1934) who called for "a school of Negro art" in the early 1920s to entail the conscious development of an African American style and aesthetics; and, artists Loïs Mailou Jones (1905-1998), James Lesesne Wells (1902-1993), and Alma Woodsey Thomas (1891–1978). Thomas was Howard University's first fine art graduate (1924) and founding vice president of the Barnett-Aden Gallery in Washington, DC.2 The Barnett-Aden Collection may possibly have played a small yet significant role in the formation of interest or strategies in the collecting of Paul Jones.

Beyond art, Jones had contact with such illustrious Howard professors as political scientist, statesman, and Nobel Peace Prize recipient Ralph J. Bunche (1904–1971), who was Undersecretary General to the United Nations between 1951 and 1971, and played a key role behind the scenes of the 1965 Selma to Montgomery march. Other prominent professors that he encountered were sociologist E. Franklin Frazier, author of the 1939 study, *The Negro Family in the United States*, and John Hope Franklin (b. 1915), one of the nation's most celebrated historians and author of the

literary landmark *From Slavery to Freedom* (1947). Elsewhere, Jones associated with activists Fred L. Shuttlesworth, Charles Evers, Ralph David Abernathy, Martin Luther King, Jr., and other figures on the forefront of the push for equity in America during the civil rights era. Before and after his Howard experiences, Jones profited from rich engagements with extraordinary people in all walks of life and art-related matters. Occasional visits to art venues, interactions with leaders of the art world, and recollections of his mother's award-winning gardens provided additional wealth of diverse experiences that gradually coalesced to prime Paul Jones for the leadership roles he assumed as a nationally recognized conciliation specialist, successful businessman, and pioneer art collector.

For Jones, art became a conduit of the outward expression of a private passion—to bridge distinct communities through a broad-based understanding of the African American cultural tradition as a part of American life and heritage. To this end, he considered it an imperative that visual expressions from the African American constituency assume their proper, inseparable placement within the study and history of American art. "As a young boy, it was instilled in me to respect education, especially higher education, because I was told it was the place where serious quests for truth took place. It is time for a more complete understanding and treatment of American art that properly weaves in the part played by so many omitted African Americans."3 While the art holds a special place for him in its own right, he remains most enamored with the tenacity of the people who create it. Inquire about the collection in general and Jones will deliver a ten-minute overview of its content, his buying strategies, and why he has entrusted so much of it to the University of Delaware. Ask about a specific work in the collection and he will potentially present an hour-long, detailed discussion of the artist's life, work, how he came to know him or her, and his view of that person's relevance to the overall cultural identity of America. As he frequently states: "the sheer essence of art collecting is expression and communication in the company of many nationalities of artists. Its variety of statements,

and its diverse forms and techniques attest to its intended catholicity."4

THE MISSION

Collections, as a rule, are identified with the predominant classification of its inclusive objects, emphasizing a descriptive era, style, media, movement, national culture, or geographical region. When the art makers in a collection are racially defined, the ethnic group heading supersedes other descriptions, even the dominant slant in terms of style, theme, period, or medium, a habit that tends to perpetuate overgeneralized, superficial treatment (if any) of the work of individual artists and the body of images as a whole. The objectives of the collector of these racially tagged holdings are usually minimized similarly. Little to no consideration is afforded the fact that their selection process is likely driven by cultural directives and data that contribute to both a deeper knowledge of the various modes of ethnic expression and a broader understanding of what American art truly encompasses.

The collector of the African American model, like his or her counterpart with other emphases, chooses specific works of art in the presence of a vast range of alternatives. The selected works reflect a particular spectatorship, appropriation, or acknowledgment on the part of the collector formed by any range of preferences, assumed meanings, personal taste, or the art historical/art critical phenomena referred to as a good eye. Collecting patterns are phenomena worthy of examination in their own right. The two fundamental lurking questions at the heart of the collecting act—Why buy? and How high?—assume drastically different connotations in America when the art in question is produced by African Americans. Such collections are seldom taken seriously as exemplars of American art, and are generally pigeonholed into monolithic interpretations of black experience or oversimplified chronologies. As art historian Richard J. Powell writes: "When black people—be they college students, office workers, politicians, or visual artists—come together as a socially cohesive ideologically kindred group, we assume that the reason for the assembly has to do with race. Why? Because race—and specifically racial and cultural 'blackness'—has a peculiar way in Western society of obliterating all existing subtleties, specifics, nuances, and complexities, especially in the cultural and social dominion."

In building his collection, Paul Jones purposely challenged existing canons of art buying and connoisseurship. He was not unaware of the prevalence of what cultural critic Cornel West refers to as "xenophobic America's suspicion that black artists do not measure up to the rigorous standards of high art." He simply dismissed it, confident that he and other collectors possessed indisputable evidence to the contrary; adamant in his belief that, eventually, cracks in the illogic would come, at which time appropriate works would gain warranted, if overdue, acceptance.

In "making the careful selections he was compelled to make," Jones avoided establishing a marginal, panoptical, encyclopedic view of African American art by "basing purchasing decisions on character rather than conduct," namely, seeking purpose in the specific object instead of buying blindly based solely on the reputation of the artist. In deference to the few obvious black favorites of the art establishment, he remained most intrigued by firsthand discoveries of well-trained, highly skilled artists who were underexhibited, underrepresented, and thus, practically hidden from view. He rejected the historical survey as a collecting approach, and rather than looking through catalog listings as a guide, preferred to trust his own judgment and the work of living artists.

Jones believed the climate of the civil rights era charged, enhanced, and spawned creativity within the African American artist community to an extent unmatched by any previous period in the nation's history.

The March on Washington permanently altered America. And with the utmost respect for what [Bayard] Rustin and [A. Phillip] Randolph and [Martin Luther] King and all the other people on the front line and behind the scenes pulled off, it had the tremendous impact that it did because a certain determina-

tion was enlarged in this country. The climate was set. People would not be denied. It was a politically charged momentum that could not be stopped. That climate, that mood and motion—that energy and drive of the era was facilitated and fed to some degree by the creative expressions and energies of talented black artists. I came to really know "Kofi" Bailey and John Riddle [pl. 2] and others well in the smoke of that period. Almost every aspect of the movement engaged artists and used their images to get the word out and to get people out.⁷

In the midst of this activism, Jones, ironically, discerned an indelible inclusion of African American expression within the American construct. He perceived transcultural significances and meanings even in the codified references to racial distinction, affirmation, and documentation. Identifying art as a credible and luring vehicle around which the multicultured American creative spirit could be unified, Jones saw a greater potential in the art he acquired beyond gathering and sharing for the sake of inspiring others to collect. In the process, his personal approach changed, resulting in his essentially looking "to" the art rather than merely looking at it. "There is something invaluable about certain works of art that speaks to the very essence of an experience or feeling or acknowledgment when words fall short . . . it's like an extension of poetry."8

Continuing to operate outside of more typical acquisition modes and avoiding the ritual of trend buying, Jones occasionally purchased work that he "did not understand by artists he did not know [were not well known]" because, in the collector's words: "something in it [the image] drew me in . . . and I trusted it to take me somewhere. . . . I became awfully curious about it and did not have to know everything at that moment . . . there was this mystery." Frequent engagements with these objects in his home did not always produce definitive answers. But he continued to value the experience the exploration provided. He "learned to accept the fact that it [the image] was whatever it was, even if there were no specific words to define it." Submitting to the curious nature of the object, he began making connec-

tions with other visual experiences and events. In so doing, he effectively made a certain disconnect with art history in deference to a more culture-based contextualization of the image.

This practice calls to mind the thinking that Nicholas Mirzoeff espoused in discussions of the visualization of things that are not actually visual and the propensity for modern and postmodern society to place a premium on rendering experience in visual terms." Commenting on the process of visualizing as a collective of sensory experiences, Mirzoeff states: "Visual culture directs our attention away from structured, formal viewing settings like the cinema and art gallery to the centrality of visual experience in everyday life."¹²

It was precisely the daily in-home interaction with acquired objects that initiated the rethinking and subsequently the restructuring of viewing habits on the part of Paul Jones. Drawing associations from a spectrum of sources in order to explore more fully the art he acquired and admired, Jones became aware of the increasing reliance on the visual in the course of any given day. Further, he seemed fascinated by the impact of time on the delicate balances of such powerful concepts as then and now, us and them, in and out—indices constructed and perpetuated by societies whose preference is to gaze rather than to visualize.

So often I have been amazed by lengthy, eloquent, intellectual speculations about a single aspect of a work of art on the part of an art historian or critic when the artist's immediate reaction was that they were not thinking about any of that when they made it. My first thought was—the artist is here . . . why don't you ask? Then I began to realize there was a lot at stake when you take to heart the fact that the subject—what you see—is affected by how you see it. I also began to think about the psychology of art, the politics of art and the business of art. That, in turn, made me even more aware of the need to free up conversations about art—open up the exchange and conduct different discussions around art-bring in different voices and different ways of seeing.13

What Jones suggests has more to do with communicating across a redefined, perhaps arbitrary line than it does with encroaching on the recognized role of the art historian or critic. His comments further touch on an even more complex issue, namely, the need for a different vocabulary to parallel the visual dictionary of media taking center stage in our current lives. As Jones points out: "artists are constantly responding to new visual experiences. As a collector and lover of art, more and more, I want to stay in tune with the kinds of things that capture the artists' imagination and that they think speaks to their time and their experience."

Irit Rogoff in the essay "Studying Visual Culture" examines the role and nature of "vision as critique" through challenging queries about intellectual standards and practices in the field of art history that touch on similar observations to those expressed by Jones. In her comments, she, too, addresses the need for a new language to investigate more purposely and a new dialogue about visual experiences, especially encounters with works of art. Elaborating on her belief that "one cannot ask new questions in an old language," she examines the allegiance of the academy to what may be described as the traditional/historical approach to considering an image. In making a case for the intellectual feasibility of investigations that emerge out of individual inquisitiveness rather than conditioned response, Rogoff concludes that asking old questions will invariably perpetuate old knowledge.

When I was training as an art historian, we were instructed in staring at pictures. The assumption was that the harder we looked, the more would be revealed to us; that a rigorous, precise, and historically informed looking would reveal a wealth of hidden meanings. The belief produced a new anatomical formation called "the good eye." Later, teaching in art history departments, whenever I would complain about some student's lack of intellectual curiosity, about their overly literal perception of the field or of their narrow understanding of culture as a series of radiant objects, someone else on the faculty would always respond by saying "Oh, but they have a good eye." 15

By allowing a variety of visual tools collectively to inform his perception, and ultimately his purchasing habits, Jones essentially amassed a collection that became recognized for its uniqueness as much as its eclecticism. He essentially deconstructed the Eurocentric/Western traditional connoisseurship model and made individual selections based on considerations of multiple issues including more recent currents specific to popular culture.

His frame of reference ultimately extended beyond the shores of the United States to reflect, in particular, a certain awareness of art trends and developments from various parts of Asia, Africa, Central America, and South America as well as North America and Europe. Of note is his acknowledgment of the fact that modernism was a worldwide phenomenon, and not a movement exclusive to the European-centered Western world. He further took into account the questionable relationship existing between certain galleries, museums, art critics, and art historians in the United States, a cooperation that, to his mind, potentially jeopardized the legitimacy of an art community in pursuit of true innovative, informative, compelling, and important expression. 17

Deeply concerned about the minimal representation of imagery by African Americans in the matrix of American art arenas, he focused his attention acutely on their work. An initial affinity for figurative work led to purchases that were, in varying degrees, reminiscent of the styles of late nineteenth-century European painters Edgar Degas, Marc Chagall, and Henri de Toulouse-Lautrec-makers of images that had interested him earlier.18 As his sphere of appreciation quickly expanded and his willingness to take risks grew, he began to include a broad range of subject matter and approaches undertaken by young, mid-career, and mature contemporary African American artists. Almost simultaneously, ideas about the collection's use became more clear. His primary objective became not only to build a broadbased collection of work by contemporary artists but to lend actively to different groups, organizations, and institutions in order to bring as much attention as possible to the work so that others might begin to collect work by African American artists.

Pressing toward this goal, Jones explored every available avenue to gaining sufficient insight, knowledge, and experience to inform wise collecting. He visited artists in their homes, studios, and at art shows, engaging them in discussions of music, sports, food, foreign affairs, and an array of other topics in addition to art. He became a regular attendee of art openings of work by artists of every conceivable background. He frequented exhibition receptions, artist talks, gallery tours, and lectures at venues across the country. He deliberately sought out and interacted with writers and speakers on the subject of African American art, African American culture, American art, and American culture. He familiarized himself with the most independent-thinking educators, curators, and museum directors in the field. He was an ardent reader of exhibition catalogs, artist biographies, reviews, articles, and books. In the process, his passion for art deepened and his intent toward collecting became more determined.

THE MODEL

Having fine-tuned the negotiation skills he inherited from his father during his many years as a governmental employee-including federal work at the White House and as deputy director of Peace Corps in Thailand-Jones developed into a shrewd bargainer who seized every opportunity to make a wise purchase.19 He had an equal regard for all artists, whether they enjoyed a local, regional, or national reputation. By the late 1960s, the word was rapidly spreading throughout the African American art circuit about his willingness to purchase works across the spectrum of development and achievement. Ten years later, artwork had overtaken his home, consuming the existing wall space—including that in his baths and kitchen. Art was stored in closets, dresser drawers, armoires, and bookcases as well as under beds and behind doors. As the collection grew, so did his determination to improve the visibility of the artists' works.

At the same time, Jones was gaining recognition as "a trailblazing collector who bought art based on the merit of the work and the artist's need to make a sell as much as the person's reputation," according to artist

Jenelsie Walden Holloway, who brought a few artists to his attention. Referring to Jones as "a dean of African American collectors," Holloway was amazed by his diligence in both buying art and establishing lifelong relationships with artists. "He single-handedly kept some artists going by encouraging them to continue to do their work and insisting that over time, someone would appreciate what they were doing."

Jones shared the collection with the same conviction with which he acquired it. With so few collectors liberally lending their collections to a comprehensive array of venues—he loaned generously and never charged a fee—he endeared himself over the years to any number of Historically Black Colleges and Universities (HBCUs), small businesses, community groups, churches, and other alternative spaces. W. W. Law, a founder and director of the King-Tisdell Cottage in Savannah, Georgia, stated in 1985, "Paul's generosity to the institute has put us on the map" (pl. 3). Reacting to the amount of media coverage afforded the Jones exhibition when it was on view, Law appreciated the attention it brought to the organization as well.

Since 1968, Jones has loaned work to more than one hundred exhibitions and has allowed in excess of thirty complete shows to be formed from his collection and seen in forty-two states. While he loaned to such venues as the Los Angeles County Museum of Art, the Walker Museum, and the Smithsonian Institution, he did likewise for the Phoenix Art Center, Eastern Illinois University, and Alabama State University. He loaned the first African American art exhibition to the Parthenon in Nashville, Tennessee (1976), emphasizing the inclusion of work by David C. Driskell (b. 1931), Earl Hooks (b. 1927), and Ted Jones, who were Tennessee-based at the time. Years later, the Marietta-Cobb Museum of Art hung art from the collection in all of its galleries, marking the first occasion in the history of the institution that a single exhibition was presented throughout the museum.

Serving as head of the Model Cities program in Charlotte, North Carolina, between 1968 and 1970, Jones hung art throughout the city. He loaned "A Collection of Negro Culture Art" to a local Savings and Loan in 1968

(pl. 4). In 1973 works from the collection were mounted for a month in the auditorium of a Unitarian church located just north of Atlanta, Georgia. Later that same year, a show was mounted in the Alma Simmons Gallery at Frederick Douglass High School in Atlanta. Simultaneous shows occurred at the High Museum of Art and Spelman College in Atlanta. Selections from the collection have been placed on loan in the mansion of one governor (Florida) and the offices of another (Georgia). Although fulfilling his mission has sometimes put the art at some degree of risk, Jones maintains a commitment to "closing the knowledge gaps" pertaining to African American artists.

Some of these shows were reminiscent of the pioneering exhibitions held at churches in Baltimore and Philadelphia in the mid-1800s, and at YMCAs, public libraries, and the national headquarters of the NAACP in New York around the turn of the twentieth century.24 Like Bishop Daniel A. Payne, Reverend John Cornish, Arthur Alfonso Schomburg, and others who spearheaded these early presentations, Jones was determined to facilitate artists in establishing a track record of shows that would in turn aid them in gaining future exhibition opportunities. In making the art accessible to viewers who might not otherwise have an opportunity to see it, he created a potential means of enticing an unlikely group toward the collector pool. In other instances, he felt that exposing young students firsthand to the breadth of artistic expression among African Americans would, perhaps, nurture future interest in their becoming collectors and also assist educators in becoming more knowledgeable of African American art as a part of American culture. He also maintained the desire for the work to be considered for its distinct quality and its content. As historian Henry Louis Gates, Jr., is quoted in Multiculturalism: Roots and Realities (2002): "a rigorous multiculturalism promotes the inclusiveness that is committed to closing conceptual gaps and that also offers fresh images of human excellence."25

Despite the likelihood that many borrowers outside the African American community were motivated by the voyeuristic platform an exhibition provides rather than a genuine interest in the objects as visual emissaries of individual expression, collective creative prowess, or national significance, Jones continued to believe in the potential of the work to impact change.

THE COLLECTION

The Jones collection, rapidly approaching 2,000 works, contains paintings, drawings, photographs, prints, sculpture, batiks, quilts, assemblages, and mixed media works by artists from every region of the country and most of the fifty states. The collection spans the first decade of the twentieth century through the present, the greatest number of works were created after 1960. The art reflects an array of subjects, styles, and materials, and the nature of many pieces, like most successful works of art, lends itself to a range of investigative angles. The large-scale painting Countdown (1981) by James Little (b. 1952) is a quintessential statement of the principles of multiple approaches evenly conveyed in a single image. The work successfully incorporates elements of collage, quilt-making, abstract expressionism, and color field painting while also referencing the textile tradition, coloration, and (oversized) flags of sub-Saharan Africa. Linda Goode-Bryant and Marcy S. Philips, co-writing on the theory of contextures—a concept defining any number of post-1970s abstract, transient approaches employed by African American artists where clarity and definition (reality) are dependent upon the contextual and transitive process used by the artist, and the synthesis through which the context whole of a given reality is presented—considers Little's juxtaposition of colors and styles within one canvas jolting.26 They further point out that the artist "encloses, almost imprisons, his active brushy surface with bordering stripes."27 In addition to framing the work in a general study of abstraction, any one of these linkages could initiate an insightful examination of his work. The same applies to the imagery of painter Bill Hutson (b. 1936). In his 1987 work on raw canvas, entitled Maiden Voyage (pl. 5), Hutson, like Little, brings a definite sense of physicality to the surface of the image. Adding to that quality, he incorporates a system of overlapping and intersecting fields that creates an overall spatial ambiguity that is enhanced by linear overlays and interplays of color and emphasized edges. Ample opportunities exist for such scrutiny in many other works, including art by Howardena Pindell (b. 1943), Alvin Smith (1933–2001), Jack Whitten (b. 1939), Frank Bowling (b. 1936), and others. In fact, one of the collection's most amazing properties is the possibility that, given its scope and despite its eclecticism, many works converge at various points that make varied formal and content examinations possible.

One-on-one interaction with artists became something of a Paul Jones trademark. In addition to becoming seriously engaged with individual artists, he vigorously explored the various aspects of creative processes in attempts to understand more thoroughly how artists worked, what motivated them, where their ideas came from, and how they developed their individual techniques. There were artists that he periodically subsidized, making purchases he otherwise might not have made except that funds were needed by the artists to pay their next month's rent, buy the next meal, or to purchase a ticket home. Herman "Kofi" Bailey (1931–1981) was one of the artists whose work he gladly received under similar such circumstances. They initially met on the recommendation of close friend, Lillian Miles Lewis, who, while working in Special Collections at the Atlanta University Trevor Arnett Library, knew of Jones's interest in art. Born in Chicago, Illinois, but a long-time resident of Los Angeles, Bailey created works that were dramatically influenced by the social climate in America during the 1960s and 1970s. He had strong personal ties with historian, writer, editor (Crisis), and activist William Edward Burghardt (W.E.B.) Du Bois (1868–1963) and President Kwame Nkrumah of Ghana, both of whom informed much of his imagery, particularly his interest in Pan-African models and depiction of well-known African American contemporary and historical subjects. He created a series of lithographs to support the efforts of the Student Nonviolent Coordinating Committee (SNCC) under the leadership of militant student activist and friend Stokely M. Carmichael. Bailey's talent was also utilized for projects supporting the efforts of the Southern Christian Leadership Conference (SCLC) on the invitation of another prominent associate, Martin Luther King, Jr.

Working primarily in charcoal and conte crayon—a compound of graphite and clay—Bailey drew heavily from observations of people in Ghana, operating during his extensive stays there as official artist to the president. He was equally sensitive to the African American leadership at home, which he perceived to be courageous and fearless during a most turbulent time in America. Being something of a periodic fixture around the Atlanta University Center, having served as artist in residence at Spelman College and sold artworks to faculty and administrators across all of the campuses, Bailey was embraced by the city with the level of familiarity and affection usually confined to local talent. His talent and accessibility led Jones to acquire six original works, including his signature work (pl. 6), Woman Grinding Peppers (1973). In this work, Bailey characteristically creates a soft, linear portrayal of a somber, solitary female figure engrossed in daily activity, situated within a lyrical, monochromatic, and atmospheric background.

Jones took a personal interest in everyone he supported, especially younger artists. The premiere example is his long-standing relationship with Amos "Ashanti" Johnson (b. 1950), a prolific draftsman, printmaker, and painter born in Berkley County, South Carolina. Johnson was just beyond his teens when he met Jones. He had studied at Syracuse University and greatly admired the work of Charles White (1919-1979). Taking a lead from White, Johnson hoped to establish his reputation on powerful portrayals of the dignity, pride, and resilience of African Americans. The popularity of White's work peaked around the decade between 1970 and 1980 when Johnson was an art student and thinking seriously about a full-time art career. He became nearly obsessed with White's work, approaching it as if under the tutelage of the renowned artist. Johnson studied his imagery religiously, and, in a manner inspired by the traditional French Academy, he sat almost daily in front of actual works and reproductions of pieces by White, literally copying them in attempts to fine-tune his own drafting skills. In some cases, he created versions of White's images by imitating his technique stroke by stroke. Like

White, as an artist he put a premium on meticulous draftsmanship, and saw realist presentations as an effective means to conveying a sense of cultural identity. Johnson's best technical achievement is *The Original Man* (1968), a reversed-tone pastel drawing addressing notions of the evolution of man, and alluding to the fundamental relatedness of all people (pl. 7). With the background blacked out, the multiethnic head appears to float out of infinity. Jones was drawn to the work because it was purely imagined, and not designed to capture the likeness of a model—the skill for which the artist was best known. At one point, Jones had over sixty works by Johnson in the collection, the number decreasing as the result of donations to museums and purchases by individuals new to the collector ranks.

Leo Twiggs, a batik artist based in Orangeburg, South Carolina, was rethinking his commitment to a practicing artist career when he became acquainted with Jones. Settled in a teaching position at South Carolina State College (currently University) where he was having a strong positive impact, Twiggs was not exactly pleased with the way his art sells were going. Jones owned a piece of his work (pl. 8), Old Man with Wide Tie (1970), purchased at an Atlanta University Annual Art Competition and Exhibition (AU Annual). Responding to an invitation by the artist, Jones attended a 1974 opening of his solo exhibition at a library in Gainesville, Georgia. Unknown to him at the time was the fact that Twiggs was close to making the decision to withdraw from the profession. Jones, in usual fashion, publicly identified the four works he intended to buy. Twiggs, not very familiar with him at that point and being a bit despondent about selling, was skeptical. When he received payment for the works, he feared the check would bounce. Not only did the check turn out to be good, but so was their relationship—and the future of Twiggs as an artist. Ten years later, when he had a oneperson show at the Studio Museum in Harlem, Twiggs surprised Jones with a signed exhibition poster with the notation: "To Paul, who knew when to buy it early . . . My first collector. Best of luck, Leo Twiggs."28

There were countless instances when an ability to act expeditiously paid off for Jones in terms of an important

acquisition. Such was the case when he obtained (pl. 9) the etching Return to the Tomb (ca. 1910) by Henry Ossawa Tanner (1859–1937), the most renowned African American artist of the nineteenth and early twentieth centuries. Jones spotted Tanner's name on a list of artists whose works were advertised in an auction announcement in a Sunday edition of the Atlanta Journal/Constitution. Realizing the auction was in progress as he read, he rushed to the location, eased into an empty seat in the rear of the auction hall, and inquired on the status of Tanner's work from the stranger seated beside him. He learned that there was a single Tanner entry—an etching, which was pulled because no one offered the minimum. Surmising that the pool of bidders probably did not know who Tanner was, he rushed to find a staff person as soon as the auction ended. Making the necessary contacts, Jones agreed to pay the minimum requested and took possession of his wrapped (concealed) purchase sight unseen. It was not until he arrived home and removed the brown paper wrapping that he laid eyes on his acquisition for the first time. The Tanner etching not only gave Jones an example of work by the first African American artist to become internationally known and respected, it added an important historical dimension to a collection that emphasized work produced after 1960.

Two people played noteworthy roles in assisting Jones in building further depth in his collection early on—Norah McNiven, director of public relations at Atlanta University and coordinator of the AU Annual, and Hans Bhalla, chair of the Art Department at Spelman College. The AU Annual, officially initiated as "The Annual Exhibition of Paintings, Prints, and Sculpture by Negro Artists of America," occurred every April between 1942 and 1970. Conceived by artist and educator Hale Aspacio Woodruff (1900-1980), the juried show brought national attention and patronage to more than nine hundred African American artists from around the country29 and included the presentation of acquisition awards. With so few outlets for their work, the Annual attracted work by the most advanced African American artists at the time.

McNiven learned of Jones's affinity for younger, emerging, and underrepresented artists in addition to

those who were established. Committed to ensuring that the work of every participating artist was marketed in such a way that it might sell, she quickly introduced herself to Jones, and began routinely walking him through the entire pool of entries before the shows were mounted. On several occasions, she did so prior to the selection process. This enabled him to make leisurely purchases with discretion and without the competitive pressure of opening night. Via this method, he secured the work of twenty-two entrants, including Philadelphia painter Benjamin Britt (1927–1996), New Orleans-based artist Eddie Jack Jordan (b. 1927), and Maryland painter Jimmie Mosely (1927–1974). Source of some of his earliest acquisitions, the AU Annual was also the event where he saw the work of additional artists for the first time which he would later acquire. A few examples were Chicago artist William Carter (1919-1997), who was the first recipient of the Annual's prestigious John Hope Award,30 Arthur L. Britt (1934–1986), and Freddie Styles (b. 1944), a painter who participated in the last Annual exhibition. Although the historical annual ended in 1972, during its run Jones had made the acquaintance of Bhalla, which would prove beneficial later as they became friends, and Bhalla began to facilitate meetings between Jones and artists.

Bhalla was a photomontage artist and painter from Pakistan whose work Jones purchased. As their relationship developed, Bhalla became increasingly familiar with Jones's particular tastes and interests. Consequently, when Jamaican artist Barrington Watson's work became available at the close of an exhibition at the High Museum of Art in Atlanta, Georgia, Bhalla successfully touted the artist's softly painted watercolor (pl. 10) of a reclining semi-nude female to Jones. In his capacity as host of Spelman's art openings, he extended personal invitations to Jones to attend events. He arranged private dinners and small, informal social gatherings where the collector could better interact with exhibiting artists, and shared information about additional contacts with him on a regular basis. Through Bhalla, Jones met, bought work, and established lifelong friendships with more than a dozen important national artists, two of the most accomplished being Hale Woodruff and Charles White.

Although Jones and Woodruff were neighbors, living in the same apartment building on Carter Street in northwest Atlanta for the better part of a year, they would formally meet in connection with Woodruff's exhibition at Spelman College in 1974. Gathering after a meal at the home of fellow collector William Arnett, who at the time was acquiring African art, they continued the discussion of the work on view at the college. The conversation quickly evolved into a lengthy, intellectual dialogue on African art aesthetics and its significance to modernism and African American art traditions. Woodruff did most of the talking, commenting on its influence on his work, including that on exhibit at Spelman. Jones subsequently purchased Monkey Man #2 (1971), one of the works Woodruff had discussed (pl. 11). Intrigued by the body of work in its own right, and even more enamored with it because of the passion witnessed by the artist, Jones added a painting from the series almost ten years later. This painting was in turn sold to a younger couple after several years who were relatively new collectors and who searched vigorously for Woodruff's work.

Bhalla was also responsible for the collector meeting and befriending Charles White. Within moments of their introduction, Jones and White were almost completely in awe of one another—White in appreciation of an African American collector that he knew well by reputation and Jones for being in the presence of a major artist that he greatly admired. Once again, the occasion for their meeting was an exhibition at Spelman College. Aware that Bhalla brought in leading artists in spite of limited funds, Jones volunteered to host a reception for White at his home following the opening. Having done so, and once the crowd had departed, the two men relaxed for the remainder of the evening with a bottle of scotch—White's drink of choice. According to Jones, they "talked until the wee hours of the morning" touching on any number of topics ranging from the artist's WPA days and his experiences with the Mexican muralists he encountered in that country to "the special challenges confronting the Black artist in America."31 They maintained contact, mostly via late-night telephone conversations initiated by White. Within the first year of contact, as Jones considered which of his works to pursue, White arranged for his dealer in California to give Jones "the family discount" as he did not get involved in the business end of the art enterprise. Jones acted quickly, purchasing four pieces—John Henry (1975), Nude (1970), Wanted Poster Series # L-5 (1970, gifted in the late 1980s to the High Museum of Art in Atlanta), and a second print that he subsequently sold to a close friend, Dr. Calvin McLarin, to facilitate his building a collection. He later added, in separate purchases, a graphite drawing, Prophet (1936), and an etching on a sterling plate entitled Vision (1973). These additions marked a partial shift in emphasis on the part of the collector as he began broadening the base of the kinds of art sought, targeting work by established artists while maintaining an interest in that of emerging and younger practitioners.

Bhalla was also the source of the initial meeting between Jones and a promising young artist named David Driskell. Once again, they met at an art reception for Driskell at Spelman College. Although Jones did not make a purchase from that show, Driskell invited him to another, two-man show at Fisk University of his work and that of sculptor Earl Hooks while they were on the faculty there. Jones purchased five works by each artist from the show. His acquisitions of Driskell's 1973 works were Woman in Interiors, The Worker, Ghetto Girl, Masked Man, and another painting, sold to a younger aspiring collector. His purchases by Hooks included B. B. King, Torso, Bust of Woman, Untitled (Faces), and Man of Sorrows, his signature work. Hooks's pieces were significant in that they boosted the sculpture component of the collection. Jones eventually added to this sector with a bust of Mary McLeod Bethune by Selma Hortense Burke (1900–1995), and *Michael* (ca. 1950), a bronze work by William E. Artis (1914–1977). Both artists were involved, to varying degrees, with presenting noble, positive portrayals that moved away from pointed presentations of suffering and victimization, and were highly representational. Their pieces contrasted the abstract references to human form in the monochromatic works by Hooks.

The person largely responsible for the collection containing a strong African American abstract and non-

objective component is New Jersey-based art consultant Ed Anderson. Formerly in community relations for AT&T, Anderson amassed an impressive private collection of nonrepresentational art by African Americans during the 1970s and 1980s. When he decided to liquidate in 1990, Anderson immediately contacted Paul Jones. The acquisition of ten major works by leading African American abstractionists added considerably to the depth to Jones's overall holdings, bringing to the collection works by Howardena Pindell, Alvin D. Loving, Jr., Alvin Smith, Nanette Carter, Jack Whitten, James Little, Bill Hutson, and Frank Bowling.

Untitled #35 (1974) represented a popular body of work by Pindell that burst onto the national art scene in the early 1970s. Reflecting her personal approach to a minimalist treatment of color, surface, edges, line, and texture, her untitled and numbered dot pieces series also addresses issues related to process-oriented painting and construction/assemblage art. She created the images by painting old cancelled checks, reconfiguring them with a hole-puncher, and meticulously gluing the resulting dots to a support. The act of recycling thus transforms her personal, recorded past into a statement that lacks specificity, and renders her safe from her past, namely, anonymous, although the data defining her former self (past) remains in an abstracted, distorted state.

Among the other paintings enriching the abstract sector was Jack Whitten's Annunciation XVIII (1979) and two untitled mixed media drawings from 1977 (pl. 12). Representing his interest in abstraction that was cemented in the late 1960s, the works incorporate the optical energy characteristic of work from the period within a grid field that evolves out of his related knowledge of architectural drawings. Although he typically works in a very large format, his smaller canvases in the Annunciation series of paintings and the drawings read, technically, as compressed statements on subtle variations of intersecting vertical and horizontal linear, color elements. Like the canvases of De Stijl painter Piet Mondrian (1872-1944), Whitten's insistence on order, clarity of line, cube formats, and allusions to primary colors simplifies an otherwise highly complex image to the point of symbolic significance. At the same time, the works are spatially ambiguous, intriguing, and mysterious. Jones began to see the potential for these artists' work to become as celebrated in the future as that of Jacob Lawrence (1917–2000) and Romare Bearden (1911–1988). Both these artists, over and above their distinguished careers within the context of American art, rose to significant levels of influence in terms of their stylistic affect on generations of African Americans artists and others. Their creative references and responses to photography, fact-derived allusions to universal concepts with the African American face as its model, reporting style utilizing the series format, and their manipulation of spatial contexts that infuse unusual, alternative perspectives have set a stage that will soon be shared with artists from subsequent generations.

LAST, BUT NOT LEAST

Photography as a medium and a conscious component came later to the Jones collection. The collector had obtained a portfolio of slightly more than fifty images of scientist George Washington Carver by Prentice Herman Polk in 1978 when the photographer printed a set for the U.S. Parks Service (which was absorbing the Carver Museum and other spaces on Tuskegee's campus). Polk, who served the University for fifty years, shared in common with Jones the fact of being born in Bessemer, Alabama. Jones's presence on campus—assisting the president with development affairs for one year-led to their meeting and being close friends until Polk passed in 1984. During this time, Jones collected more than one hundred of his photographs. Before Polk's death, Jones encouraged a number of institutions and organizations to develop projects around his work. Most notable among the developments was a project undertaken in 1979-1980 by Nexus Contemporary Art Center (currently The Contemporary) in Atlanta that resulted subsequently in several of his negatives being restored, the creation of a special portfolio containing eleven images, and the publication of a limited edition (1200) photography book, P. H. Polk: Photographs (1980), by Nexus Press. One-man shows followed, including a traveling exhibition—"Alabama Album: The Photographs of Prentice H. Polk"-ad-

ministered by the Southern Arts Federation and mounted in 1985, which toured the southeast for more than twelve years. In 1992, when the Paul R. Jones Collection was brought to the attention of the University of Delaware, William Innis Homer, H. Rodney Sharp Professor and Chair of the Department of Art History, was particularly drawn to the body of work by Polk. Homer expressed interest in Polk's "effort to record the personalities and physical plant at Tuskegee."32 The introduction of Polk's work to the university through the Jones collection inspired one of the institution's art history graduate students to pursue his photography as master's research topic and resulted in Delaware mounting yet another one-person exhibition—"Through These Eyes: The Photographs of P. H. Polk" (1998). Just as loans and collaborations contributed to the broadening of public knowledge of the important work of Polk, the Jones collection would bring other mature and gifted artists in the medium various levels of visibility.

Five years after making the initial Polk purchase, Jones acquired two works of James VanDerZee's (1886–1983) best known images (pl. 13), *Couple in Raccoon Coats* (1932) and *The Barefoot Prophet* (1928), adding a portrait of one of Marcus Garvey's soldiers (1924) three years later. Examples of work by other distinguished photographers were quickly added to the collection, including three works by Roy DeCarava (b. 1919), three by Carrie Mae Weems (b. 1953), eighteen by Bert Andrews (1929–1993), three by Frank Stewart (b. 1949), two by Clarissa Sligh (b. 1939), and two by Adger W. Cowans (b. 1936).

Later, Jones was introduced to an unusual portfolio by photographer Ming Smith Murray, and he immediately began buying. To date, the collection contains more images by Ming Smith Murray than any other photographer other than Polk. The more than fifty prints are a mix of black and white, painted black and white, and color images of roughly forty personalities in the performing and visual arts fields. Spanning the period from the 1970s to the present, her most striking and dramatic work is *Katherine Dunham and Her Legacy* (1984). In speaking to the grace, elegance, and solitude associated with individual performance and personal achievement, the work also addresses the fragility of the

diva state (pl. 14). Its fleeting and haunting nature is conveyed through Murray's decision to focus on a mannequin wearing Dunham's characteristic costume and fans. Portraits of the "real" Dunham in the act of dancing appear tightly cropped in the rear. Her robe (costume) and her role (dancer) are presented in a celebrated fashion on the one hand; however, at the same time, they come across as a somber memorial of her life and career in a potentially shocking way—when the fact of the mannequin as a fake or a dummy is perceived as a metaphor for the unreality of celebrity and the fickleness of stardom. It is this quality in her work—luring the viewer in with pretty, well-designed compositions that gradually reveal points of tension—that drew Jones to Ming's work.

Jim Alexander's visual record of the final decades of the life of legendary jazz great Duke Ellington, stark portrayals of numerous other entertainers, and photo essays of the rural south are among the works of living photographers that serve prominent roles in the context of performance imagery. Others include John H. Cochran, Jerome Miles Wolf, Leonard Mainor, and William Crite.

Certain artists represented in the collection are best known in the southern region although their career paths have granted them considerable exposure in all regions of the country. Gerald Straw (b. 1943), one of the founders of the publication *The Black Photographer's Annual*, enjoys a solid reputation as the recorder of America's rapidly changing urban terrain. Straw is joined in terms of broad exposure with William ("Onikwa Bill") Wallace and Lawrence Huff. William Anderson (b. 1932), who also works in other media, is most recognized for his photography.

The third largest group of photographs by a single artist in the collection is by William Anderson (pl. 15), with almost twenty images included. Having known Anderson for many years, Jones successfully promoted the photographer's work to fellow collectors, museum

curators—for acquisitions and shows—and exhibition organizers.

As with the work in other media, the vast number of photographs in the Jones Collection present diverse subjects, styles, techniques, and points of view on any number of issues. Likewise, they collectively speak to the talents and interests of African American practitioners, and are appropriate models for broader discussions and examinations within the context of American art. The photographic component also exposes the openmindedness of collector Paul R. Jones, reflecting his ability to follow the urges of artists in a variety of material-based modes of expression and his willingness to be inclusive where others have been reluctant.

While the attention may rest momentarily upon the name The Paul R. Jones Collection, what has been imparted to the University of Delaware is a mammoth trust. It is a trust that is, perhaps, best demonstrated metaphorically within the written words of gratitude from an artist yearning to know visibility in an art world that has been conditioned by, or at least has practiced, shortsightedness. The letter reads:

Mr. Paul Jones, you are like Superman when I was 6 years old—my hero! . . . It was a pleasure meeting you on your journey to Chicago in August. Listening to you speak about collecting art was a great inspiration for me. After hearing you speak, I jumped back into my studio and started painting like a madman. Since then I've had three shows and all were a success. Especially the Chicago Jazz Festival, where my piece was selected to be the official logo. . . . Please accept this token of my appreciation . . . a signed Chicago Jazzfest poster. . . . I hope to see you again soon in our travels, and please continue to inspire people to collect art. Without people like you there would be no me. [Jason E. Jones, Evergreen Park, Illinois]³³

- I Bobbie Leigh and Rebecca Dimling Cochran, "Top 100 Collectors in America," Art and Antiques 26 (March 2003): 86
- 2 Alma Thomas became vice president of the Barnett-Aden Gallery in 1943 on the invitation of Howard professor James V. Herring, who founded the art department and was her former teacher and mentor. Herring co-founded the gallery with Alonzo J. Aden (the gallery was named in honor of his mother Naomi Barnett Aden) who served as curator of Howard's gallery for ten years. The Barnett-Aden Gallery was initiated in the northwest Washington, DC, home where Herring and Aden resided. Adolphus Ealey directed the gallery, which presented work by artists regardless of race or creed.
- 3 Paul Jones commenting at the opening reception of the exhibition "Original Acts: Photographs of African American Performers in the Paul R. Jones Collection," at the University of Delaware, February 2002.
- 4 This comment was in the "Collector's Note" in the catalog to the exhibition, *Master Works Selected from the Paul Jones Collection*, Schatten Gallery, Robert W. Woodruff Library, Emory University, in 1984.
- 5 "Immeasurably Unbound" in the exhibition catalog African American Art: Twentieth-Century Masterworks, II, Michael Rosenfeld Gallery, 1995, 5.
- 6 For a more detailed discussion of West on this topic and related issues see the essay "Horace Pippin's Challenge to Art Criticism," in Kymberly N. Pinder, ed., Race-ing Art History: Cultural Readings in Race and Art History (New York: Routledge, 2002).
- 7 Collector Paul R. Jones speaking at the Arts Exchange during the second National Black Arts Festival in Atlanta, Georgia, July 1990, in conjunction with the exhibition "The Paul R. Jones Collection Master Works."
- 8 Comments made to Spelman and Morehouse College students during a guest lecture for the History of African American Art course at Spelman in the fall semester 1997.
- 9 Collector Paul R. Jones speaking to Atlanta University Center students at the Robert Woodruff Fine Arts Building auditorium at Spelman College, February II, 1990, in conjunction with the opening of the exhibition "Photographs: The Paul R. Jones Collection—A Decade of Collecting."
- 10 Ibid.
- 11 For a thorough reading on Nicholas Mirzoeff and visual culture studies consult the following: Nicholas Mirzoeff, Introduction to Visual Culture (New York: Routledge, 1999), (1st and 2d eds., Routledge, 1998 and 2003) and Nicholas Mirzoeff, ed., Diaspora and Visual Culture: Representing Africans and Jews (New York: Routledge, 2000).
- 12 Nicholas Mirzoeff, ed., *The Visual Culture Reader* (London and New York: Routledge, 1998), 6
- Paul Jones has repeated this comment in various terms over many occasions, but did so publicly for the first time during a collector's talk at the King-Tisdell Cottage in Savannah, Georgia, in 1984. It was during the opening reception for the exhibition "Selected

- Works from the Paul R. Jones Collection," marking the first exhibition at the site of borrowed works from a private collection.
- 14 Jones speaking at a conference, "Lens 2003," at North Georgia College and State University in Dahlonega, Georgia, October 10, 2003.
- 15 Irit Rogoff, "Studying Visual Culture," in The Visual Culture Reader, ed. Mirzoeff, 17.
- the Richard Nixon administration Paul Jones traveled extensively throughout Asia (especially Southeast Asia) in the early 1970s, and made trips to Central and South America later in that decade into the 1980s. His excursions were primarily for art viewing and to gain firsthand knowledge of their cultural life. The trips heightened his awareness of art movements and important artists in these regions. During this time, he also became an avid reader of materials on the various regions and art approaches in Africa. Between 1970 and 1980, he collected roughly 150 African art objects, representing almost every region of the continent.
- 17 His desire to minimize the influence of the gallery/museum/critic structure on his acquisition decisions led him practically to dismiss the gallery as a source of buying art in the early decades. He became somewhat known as a collector who bought exclusively from artists out of their studios.
- Among the first objects that Jones placed on the walls of his home were reproductions of paintings by Degas, Chagall, and Lautrec, which he placed in raw frames that he stained himself. He purchased the frames from a local discount store. He holds on to these reproductions as reminders of his humble beginnings as a collector.
- 19 In addition to having held a White House staff position, his governmental experience included serving as Executive Secretary to the Jefferson County (Birmingham, Alabama) Interracial Committee, Probation Officer and Referee in the Juvenile and Domestic Relations Court of Jefferson County, United States District Court Probation Officer in San Francisco, Community Relations and Conciliation Specialist for the Department of Justice in Washington, DC, Citizen's Participation Advisor for Model Cities Program with Housing and Urban Development (HUD), Director of the Office of Civil Rights, National Highway Safety Bureau (Department of Transportation) in Washington, DC, United States Embassy Team as Deputy Director in Thailand, Southeast Regional Director of ACTION, and, Southeast Regional Director of Minority Business Development Enterprise (Department of Commerce).
- 20 Jenelsie Walden Holloway chaired the Spelman College department of art for more than thirty years. She knew Jones during most of that time and made comments about his role as a collector during the reception to the Herman Bailey memorial exhibition in 1981.
- 21 Holloway, commenting at Spelman College art opening in 1990.
- 22 Comments made at the reception to the exhibition February 3, 1985, and repeated in a handwritten letter to Paul Jones in March 1985, the Paul R. Jones Archives, Atlanta, Georgia.
- 23 Both local papers, the Savannah News Press and the Herald, published articles promoting the February opening and a local television station taped a brief segment during the reception.

- 24 See the unpublished dissertation, "The All-Black Exhibition in America, 1963-1976: Its History, Perception, and the Critical Response" (Emory University, 1994) by Amalia K. Amaki for a thorough review of the history of these and other African American art shows.
- 25 Henry Louis Gates, Jr., "The Lives Grown Out of His Life: Frederick Douglass, Multiculturalism, and Diversity," in C. James Trotman, ed., Multiculturalism: Roots and Realities (Bloomington: Indiana University Press, 2002), 5.
- 26 Linda Goode-Bryant and Marcy S. Philips, Contextures (New York: Just Above Midtown, Inc., 1978), 39.
- 27 Ibid., 10
- 28 Paul R. Jones Archives, Atlanta, Georgia.
- 29 Tina Dunkley in "Clark Atlanta University Galleries," in Richard J. Powell and Jock Reynolds, To Conserve a Legacy: American Art from Historically Black Colleges and Universities (Cambridge, MA: MIT Press, 1999), 18.

- 30 The John Hope Award was the Annual's top honor and carried the name of Atlanta University's president. Hope founded the AU Center (Spelman, Morehouse, Morris Brown, Clark Atlanta University, and a theological seminary).
- 31 Paul Jones and Charles White knew each other by reputation before their first face-to-face meeting at the opening of White's work at Spelman College in 1973. As cited in the brochure to the exhibition, *The Paul R. Jones Collection: Art and Everyday Life* (Marietta Cobb Museum of Art, 1999): "Moments after being introduced, Jones and White became almost completely enamored with one another—White was in appreciative awe of an African American who [was not wealthy but] was vigorously buying art by Black artists; Jones was in awe of White's talent and presence as a major artist."
- 32 William I. Homer, "Foreword," in African American Art: The Paul R. Jones Collection (Newark: University of Delaware, 1993).
- 33 September 2003 letter to Paul Jones, the Paul R. Jones Archives, Atlanta, Georgia.

Collage and Photomontage:

Bearden's Spiralist Reflections of America and Africa

SHARON PRUITT

I suggest that Western society, and particularly that of America, is gravely ill and a major symptom is the American treatment of the Negro. The artistic expression of this culture concentrates on themes of "absurdity" and "anti-art" which provide further evidence of its ill health. It is the right of everyone now to re-examine history to see if Western Culture offers the only solutions to man's purpose on this earth. —Romare Bearden

Romare Bearden, america's premiere collagist of the twentieth century, began working in the medium in the early 1960s while affiliated with the Spiral Group, a coalition of African American artists in New York. His initial collages and photomontages were created in efforts to participate artistically in the civil rights movement. The works were narratives inspired by contrasting regions in the United States—the urban north and the rural south—and resonate with a global awareness of art including the Parisian cubist aesthetics and collage technique, the Berlin dada aesthetics and photomontage technique, and the traditional West and Central African aesthetics and motifs. Finally, Bearden's works indicate the complexity of defining a black identity in art during an era when racial tensions were exploding in the United States.

The identity of the African American, not simply confined to a region in America, is also realized by both the disconnect from African culture resulting from European infractions, and a reconnection to the motherland encouraged by American movements and philosophies fostering black pride and black history. Similar to African American artists of the "New Negro Movement," which dates to the earlier part of the twentieth century, Bearden reinforced the philosophy to appropriate African American and African imageries and concepts within a Euro-American art context.

FACING PAGE:

Detail from Romare Bearden's School Bell Time, ca. 1980 (Plate 16) According to Bearden, his oeuvres are not re-creations of social protest events. They do not depict violent mistreatment of African Americans.' Nevertheless, after careful scrutiny of his art and philosophy, it is apparent that Bearden's approach to the creative process and his artistic images reflect reactions to social maladies. However, social maladies cannot be assessed effectively without considering the political and economic status of the individual. There is much evidence that Bearden was a socially and politically conscious artist who created images suitable for didactic lectures on Black History, Black Pride, and Racial Equality.

BEARDEN'S EDUCATION AND EARLY ART CAREER

Born in 1911 in Charlotte, North Carolina, Bearden, an only child, moved with his family to New York City's Harlem when he was around four years old. His family was extremely mobile as he grew up, spending a year in Moose Jaw, Canada, when he was in the third grade, and also spending time with his maternal grandmother in Pittsburgh. Finishing most of his primary education and the first two years of high school in New York City, he graduated in Pittsburgh. When Bearden was in school in New York City, his family spent the summers with his paternal grandparents in Charlotte.²

Bearden spent part of his freshman year in college attending Lincoln University, a historically black male university in Pennsylvania. He attended Boston University for two years, and was graduated from New York University (NYU) in 1935 with a bachelor's degree in mathematics. As early as 1932, Bearden knew about George Grosz, a Berlin dada artist who immigrated to the United States after World War I. A year after graduating from NYU, he entered the Art Students' League in New York in order to study drawing under Grosz. With Grosz's guidance, Bearden improved his cartoon drawings from previous work for Boston University's Beanpot, NYU's The Medley, and the Baltimore Afro-American, a nationally distributed newspaper.

In 1950, Bearden studied philosophy in Paris at the Sorbonne. Not inspired to paint in Paris, he returned to New York and became a writer of jazz music. "Sea-

breeze," recorded with Billy Eckstine, became a hit in the mid-1950s.

The only African American to hold major exhibitions at the Samuel Kootz Gallery, a mainstream gallery in downtown New York, Bearden also exhibited paintings at the Whitney Museum of American Art. Both exhibitions received positive reviews from such acclaimed publications as the *New York Times, Art Digest,* and *Art News.*³ During this period, Bearden supplemented his art income with full-time employment as a welfare caseworker in New York's Department of Social Services, a position he held with few interruptions until 1966.⁴ In the 1960s, while affiliated with the Spiral Group, Bearden's fame increased and he developed a new form of expression—collages and photomontages.

THE FORMATION OF THE SPIRAL GROUP

The civil rights movement of the 1960s spawned the Spiral Group. Under the leadership of Bearden, Norman Lewis, and Hale Woodruff, the members mobilized to establish collective visions, examine their cultural identity, and explore the possibility of defining a black aesthetic. As purveyors of black cultural life, the artists sought to empower themselves through this process of self-examination and self-discovery.

Spiral members also responded to a movement initiated by A. Philip Randolph,⁵ a prominent civil rights labor leader who spent his career working to get better jobs and equal opportunities for African Americans. In 1935, after negotiating for ten years, Randolph successfully unionized the porters in the Pullman Company, the nation's largest employer of African Americans at the time. He was the architect of the cancelled March on Washington, DC, in 1941 by the Brotherhood of Sleeping Car Porters, and was the brain behind the March on Washington in 1963.⁶

Bearden was particularly suited to identify with Randolph's political concerns since his father, Howard, worked as a steward for the Canadian railroads. In addition, when the family settled in New York City Bearden's mother, Bessye, was very active in Democratic party politics and often entertained politicians in their home.⁷

Randolph encouraged Bearden and other New York artists to define their role in the civil rights movement. Bearden met and befriended many artists in the Harlem Artists Guild and the "306 Group," some of whom were formerly members of the Works Progress Administration (WPA) Federal Art Project.

On July 5, 1963, a group of established and younger, relatively unknown artists met at Bearden's downtown studio loft at 357 Canal Street⁹ "for the purpose of discussing the commitment of the Negro artist in the present struggle for civil liberties, and as a discussion group to consider common aesthetic problems."¹⁰

Besides Bearden, Lewis, and Woodruff, other Spiral members included Charles Alston, James Yeargans, Felrath Hines, Richard Mayhew, William Pritchard, Emma Amos, Reginald Gammon, Alvin Hollingsworth, Calvin Douglass, Perry Ferguson, William Majors, Earl Miller, and Merton Simpson." Bearden, Lewis, Woodruff, Alston, and Yeargans were among the older accomplished members who assumed a leadership role.

Initially, members discussed participating in the March on Washington itself, but ultimately abandoned the idea. They focused on defining and discussing aesthetics and philosophical problems unique to African American artists. Defining a black identity in a whitedominated society was not a new discourse, having been discussed by artists in the 1920s during the Harlem Renaissance period and restated in the 1930s discussions of the Harlem Artists Guild. 12 For the Spiral Group, the inquiry about the artistic representation of blackness was met with a variety of solutions. One was the investigation of an African legacy that the Harlem Renaissance artists had explored. Bearden suggested that "identity" be addressed by examining the philosophy of African writers such as Alioune Diop and Léopold Senghor, Senegalese cultural theorists. In 1940, Bearden had already befriended Claude McKay, whose writings inspired Senghor's concepts about the Négritude movement. Another approach was to study African art. Although some Spiralists had previously viewed African art in venues such as the Schomburg Center for Research in Black Culture and the Museum of Modern Art,13 they all were further enlightened by lectures on African art presented by Simpson, a Spiralist who was also an African art dealer.¹⁴

The Spiralists discussed representing black peoples' plight in America in terms of universal construct. Alston suggested Pablo Picasso's post-cubist painting *Guernica* (1937) as an example of an image with a sociopolitical universal theme (man's inhumanity to man) that moved beyond representation of a locale (Spain during the Spanish Civil War). Also, its large scale (II'6" x 25'8"), replete with black, white, and gray images, simulated photojournalism.

The group's concern for universality was not only confined to social politics in art but extended to the social politics of identity in a society that disparaged their achievements. They saw themselves as artists existing in a universal scheme and their philosophical position developed from an identity of self, which was conceived from experiences of cultural hybridizations. Also, they had a worldview about races of people and interracial relationships. These issues were particularly germane to Bearden, who had already met and befriended a diverse array of prominent artists in visual, literary, and performing arts realm of different heritages.15 Bearden stated: "The Negro artist must come to think of himself not primarily as a Negro artist, but as an artist. . . . There is only one art . . . and it belongs to all mankind. . . . Examine the art forms of any culture and one becomes aware of the patterns that link it to other cultures and peoples."16

Lewis advocated the need for excellence whatever form the artwork took. He believed Spiral members would serve as future leaders for other artists and, therefore, were obligated to establish high standards. The members' artworks were critiqued, though some of the younger artists vehemently opposed the harsh criticisms their works received from older members.

Reflecting on the significance of the group discussions years later, Mayhew conceded that each artist was forced to confront two crucial and timeless questions. First, how relevant is the artwork to the struggles of black people? Secondly, how honest is the artist in expressing concepts presented in his or her artwork? The younger artists wanted to portray overt militancy while

the older members rejected these themes. They concluded that images of violence and death were not considered constructive or innovative and were simply an imitation of life lacking artistic creativity, and that scenes of militancy and violence were already well known to the black community. Instead, the older generation felt that real protest or constructive painting should be uplifting and stimulating. While the majority of the members were not inclined to represent a repertoire that was an imitation of life, 77 Reginald Gammon's painting Freedom Now (1964) depicts a civil rights march.18 "He [Mayhew] recalled a young black painter asserting, 'I've got to do protest painting?' To which Mayhew responded, 'Do protest paintings—not to protest but to be innovative and constructive in relationship to art and your relationship with the community. . . . Real protest painting or constructive painting should be involved with an uplifting and stimulating element."19

Bearden expressed a similar attitude about social protest art.²⁰ However, his position on the role of the African American in mainstream society vacillates between the ideas of Dr. Martin Luther King, Jr., and those of Malcolm X: "either the Negro, through such figures as Dr. King, will give this country a transfusion it badly needs, or the Negro must reject the values of this society completely."²¹

In 1966, when fourteen of the sixteen members were interviewed for a review of a group exhibition, each Spiralist expressed different opinions about his/her contribution.²² Years after the group dissolved, members acknowledged this impact by constantly questioning their honesty in the creative process. Bearden realized the significance of periodically returning to "a Spiral discussion moment" to understand the disgust some African Americans had toward the imagery in his work. In May 1985, when Bearden was creating collage paintings, he stated:

One painter wrote from the South that my stuff [artwork] was forced and deliberately painted to cater to what the [white] critics think a Negro should paint like. To many of my own people, I learn, my work

was very disgusting and morbid—and portrayed a type of Negro that they were trying to get away from. One man bought a painting and brought it back in three days later because his wife couldn't stand it in the house. . . . So I ask myself, is what I'm doing good or bad, are my paintings an honest and valid statement. Have you ever felt like this? . . . [a Spiral moment]. I guess to be anything of a painter you need to have the hide of an elephant. There is a lot more to it than just putting the paint on canvas. 33

The Spiralists' focus on abstract forms and distorted figures almost guaranteed opposition from some members of the black community. Considered elitist, the artists' works were viewed as being divorced from their racial and cultural origins. ²⁴ The Spiralists sought an aesthetics that rejected the traditional Eurocentric qualifiers of physical beauty grounded in the Greek art tradition. ²⁵ They wanted to establish a new paradigm for symbols of beauty. Bearden, in particular, opted to create abstract black figures influenced by African figural sculpture to relate to heritage. By doing so, he prescribed a new and African American aesthetics, which proclaimed that "African art and blackness are beautiful."

Older Spiral members, such as Lewis and Woodruff, produced paintings in the mainstream fashion of the New York school of abstract expressionism. They created large paintings filled with gestural brushstrokes, frequently devoid of any recognizable objects.

Previously, Bearden experimented with abstract expressionism but abandoned it for a cubist, abstract style. He studied the structural relationships of planar spaces, similar to Picasso's cubist style. Before Spiral, his abstract paintings were reminiscent of the linear exaggeration of figures expressed in Picasso's synthetic and post-cubist styles. Despite their diverse painting styles, the Spiralists remained unified in their commitment to follow the path of a "spiral."

The name, Spiral Group, was coined by Woodruff. In nature, the spiral is the form found in kinetic energies such as tornados, hurricanes, smoke, etc. However, the name is specifically derived from a principle theo-

rized by Archimedes, who is considered by modern scholars to be the greatest Greek mathematician and whose numerous mathematical principles are so complex that they are still queried today. The choice of a mathematical construct applied to the group appears apropos. The vortex of the spiral suggested for them the freedom to move upward and outward. The relationship between the arts and mathematics dates back to the ancient Egyptian and Greek periods. ²⁶ For the artists, mathematical systems used in art allowed for the existence of order.

Thus, the name Spiral symbolizes the philosophy of the art group who felt a moral obligation to communicate to the community through their art. In spite of the turbulent social climate, their mission entailed uplifting and keeping afloat their own spirits and well as those of their people. As Mayhew notes, "The name 'spiral' embodied this extending concept of evolving and unifying, bonding and constructively supportive relationships with one another, which was an art of Afro-American [and traditional African] sensibility."²⁷

The Spiral Group was short-lived (1963–1965), disbanding in 1965 when the group lost their lease at their meeting place—Christopher Street Gallery. Although criticized by members of the Black Arts Movement, their significance in the 1960s cannot be ignored. As Floyd Coleman stated, the Spiralists "paved the way for those African-American artists who followed, if not in their footsteps, at least in the broad paths they cleared. Thus, the legacy of Spiral will expand and remain secure for generations to come." ²⁸

THE EVOLUTION OF BEARDEN'S COLLAGES: DECONSTRUCTION, FRAGMENTATION, IMPROVISATION

Bearden probably understood the spiral concept better than most members given his degree in mathematics. Perhaps, in an attempt to symbolize the solidarity of his people both as an extension of the spiral and as an example of community or group activity similar to the impending March on Washington, Bearden suggested that the Spiralists create a collaborative work. He had collected a bag full of cut-out photographs from *Life, Look,* and *Ebony* magazines²⁹ and explained to the group his concepts for creating a photomontage. Group members quickly lost interest and resumed working individually on their own projects. Bearden was compelled to complete the photomontage alone. Upon the suggestion of Gammon, he enlarged five or six of his small photomontages by photostating them, increasing their size 8¹/₂ x II¹/₂ inches to three by four feet, or six by eight feet.³⁰

At the time, Bearden was the only African American artist included in the circle of artists exhibiting at the Cordier & Ekstrom Gallery, "a mainstream gallery in downtown New York City originally based in Paris. Arne Ekstrom, one of the dealers of the co-owned gallery, visited Bearden's studio to discuss his next exhibition. Bearden was reluctant to show the photostatic photomontage, but, at the request of Ekstrom, who saw the work wrapped up alongside the studio wall, Bearden discussed the enlarged photomontage. Much to Bearden's surprise, Ekstrom was fascinated by the enlarged photomontage and suggested that, along with twenty more, they would be Bearden's next one-man show. This was a pivotal moment for Bearden, who used collages as his primary medium for the rest of his career.³²

The twenty-one enlarged photostatic photomontages debuted in an exhibition entitled *Projections*, which opened first at Cordier & Ekstrom in October 1964 and a year later at the Corcoran Gallery in Washington, DC. The works were well received by the art community in both locations. In 1971, the series was exhibited at the Museum of Modern Art and the works were described as having "a starkness more akin to *cinéma vérité* than to painting."³³

Technically, the photomontages were collages (French, papier collé), which is a "technique in art consisting of cutting natural or manufactured materials and pasting them to a painted or unpainted surface." Bearden's magazine photographs were not only manufactured, but represented a new medium for him. Whereas, previously, he painted abstractly on canvas, now he employed "found" objects, or ready-mades, for his works. In the late 1950s, Bearden moved from painting in an abstract cubist fashion toward experimenting

with collage technique in a nonrepresentational manner by placing large areas of paint and paper onto the canvas, in doing so adapting an ancient Chinese method he had discussed with Mr. Wu, a bookstore owner whom Bearden regarded as a master teacher of Chinese painting. "Bearden brushed broad areas of color on various thicknesses of rice paper. . . . He glued these to the canvas in as many as nine layers. Then he tore sections of the paper away, always tearing upward and across the picture plane. When he found a pattern or motif he liked, he added more paper and painted additional colored areas to complete the work." 34

Bearden's collages and photomontages did not integrate words, much drawing, nor much painted surface, but did incorporate the angular cubist aesthetics that was derived from Picasso's and Braque's observation of traditional African sculpture. With rare exception, drawing and painting are not dominant in his collages and photomontages, as seen in cubist collages. Occasionally, Bearden pasted cut-out colored magazine paper in the photomontage. However, the majority of the surface of these works is in black and white. Similar to the Chinese painters, 55 Bearden thought that color was deceptive and one could read color better in black and white.

During the early twentieth century, collage elements were the basic medium for European dada and surrealist painters, who sought to create a "new art" that deconstructed European traditions. For Bearden's dada connections one has only to examine its history through the participation of George Grosz, one of Bearden's former teachers.

Dada as a movement initiated officially in Zurich and developed almost simultaneously in other centers—Berlin, Paris, Cologne, Hanover, and New York. Of all the dada centers, Berlin produced as much political material—newspapers and posters—as it did political art.³⁶ The photographic collage was the artistic contribution of the Berlin dadaists and was used to criticize the society. Social and political attacks were vented against the German military and World War I.

The term photomontage was invented by the Berlin dadaists, or Club Dada as they were known, to detach

their work from the cubist collage and to distinguish their efforts with engineers or mechanics. The invention of photomontage in Germany is attributed to two groups of the Berlin dadaists, who combined photographs with typography and cut and pasted papers from newspapers and magazines.³⁷ On the one hand, the new development is claimed by George Grosz in collaboration with John Heartfield (born Helmeut Herzfelde) and on the other hand by Hannah Höch in association with Raoul Hausmann.³⁸

The Berlin dada analyzed society by the means with which it advertised—symbols and emblems of cut photographs, typography, newspaper clippings and advertisements, and magazine advertisements and images. They heightened the inflammatory commentary and presented a scathing indictment of society in their work by employing abrupt shifts in scale and in perspective, dramatic foreshortening, sharp diagonals, and unusual juxtapositions of imagery. In brief, the Berlin dadaists found the perfect medium—collage and photomontage—to portray "a world they thought had gone mad." ³⁹

In his criticism of American mainstream art and its social ills, Bearden used terms such as absurdity and anti-art-terms that are couched in both French and German dada semantics and were voiced as an element of social change in those countries.40 Bearden indicated that dada art philosophy resonated in the United States in 1966 in the destruction of its moral fiber—the mistreatment of African Americans. There are elements of the dada movement that Bearden renounced and others that he retained. Besides the concepts of absurdity and anti-art, Bearden relinquishes the humor, frivolity, and triviality in dada art. Instead, his photomontages capture the graveness of the black survival. While dada artists repudiated Picasso, Paul Cézanne, and the Renaissance artists, Bearden ultimately reveres them.41 Bearden was a voracious reader of history, literature, and philosophy.42 He infused into his art the teachings of world art histories-Asian, African, ancient, medieval, Renaissance, Dutch baroque, impressionism, postimpressionism, and the modern and contemporary movements in both Europe and America. While cubism, dada, and surrealism employ typography, Bearden did not. Also, his photomontages exceed the physical scale of the European collages and photomontages.

Nevertheless, there are components of dada art that are not only apparent in Bearden's art but also occur in both cubist and surrealist art. Close scrutiny of the characteristics of the three art movements—cubism (begun ca. 1910),43 dada (begun ca. 1917), and surrealism (begun ca. 1924)—and Bearden's work reveal similarities. All use mass-produced objects as essential media, often making reference to urban industrialization. Like Bearden, all three movements create oeuvres in which forms and pictorial space are deconstructed then reconstructed in an improvisational manner. The collage deconstructs the illusionistic space that is standard in the tradition of Western art. The artists used art to protest or to deviate from the doctrines of aesthetic realism that sustained the European art academies from the fifteenth through the nineteenth centuries. Almost by definition, collage is a method that deconstructs, fragments, improvises, and reconstructs forms and meaning in the pictorial space. This type of work exemplifies the cerebral arts and constantly challenges the viewer to deconstruct known paradigms regarding art, beauty, and social constructs. By so doing, the art forms empower the viewer to look anew at art, cultural values, and social disorder. Finally, Bearden and members of all three of the art movements created revolutionary art. All were members in a movement associated with political programs. Also, their art displayed, although sometimes subtly, opposition to the modern bourgeois society.44

Like the cubist artists, Bearden's black and white constructions had references to the performing arts. He was an eclectic intellectual who astutely perceived the interrelationships in the arts. However, his interest was not confined to European but included African American arts. Bearden was energized by all the arts of classical music, old and new jazz music, dance, and film. For his visual deconstruction of structures, de-fragmentation of imageries, and improvisations, Bearden did not rely solely on the twentieth-century European art movements but integrated it with the African American expressive art form of jazz. In the 1950s, Bearden was so familiar with jazz that he wrote and published music

for such luminaries as Billy Eckstine and Billie Holiday. 46 Ralph Ellison, a friend of Bearden, correlated jazz and surrealism in Bearden's collages. Ellison saw similarities with "the sharp breaks, leaps in consciousness, distortions, paradoxes, reversals, telescoping of time and *surreal* [italics mine] blending of styles, value, hopes and dreams that characterize much of Negro American History." Thus, because the constructs of jazz as well as cubism are derivative of the traditional sculpture of Λfrica, their similarities are not surprising. It is against this extensive background of artistic knowledge that Bearden was able to change his artwork in reaction to the social ills of the 1960s.

BEARDEN'S COLLAGES AND SOUTHERN MEMORIES

Bearden used the collage "to literally piece together his memories of the past." For the narratives in many of his collages and photomontages, he derived images from his childhood memories of the South and North, which included experiences in Charlotte, Mecklenburg County, North Carolina; Pittsburgh; and New York City. To capture the power of the memories, Bearden had to construct three interrelated mental activities: he reached beyond the photographs to the human qualities they illustrated; he reconstructed the original in his mind's eye; and he re-created images in an unusual, striking manner. By portraying these memories, he recalled images that preserved the history and culture of African Americans.

The major subject matter for Bearden's collages and photomontages were black people, which remained dominant from the beginning of his career in the 1940s until his death in 1988. He produced social realist paintings about black life in the 1940s, abstract paintings of biblical figures and nondescript ethnicity in the 1930s and 1940s, collages and photomontages in the early 1960s, and collage paintings in the late 1960s, 1970s, and 1980s.

In depicting black images and African proportion in his collages and photomontages, Bearden does not deny his African American and African heritage in order to exhibit in mainstream society. This is a particularly honest statement for an artist, whose racial identity was not always discernible because of his fair-skinned and blue-eyed features. In Paris upon his first meeting with Bearden, Albert Murray, the African American novelist and jazz historian, thought Bearden was Russian "or what[ever]" until he laughed. Then, Murray identified Bearden's laughter as that of a black man.⁴⁹

The black images that he employed in his photomontages were more contorted and confrontational with the viewer than those in his earlier paintings. In *Mysteries*, the magnified faces consist of fragments from a variety of cut-out magazine images. Their stark directness possesses the quality of being "in-your-face." These colossal heads seem to reflect the lessons Bearden learned from at least two influential sources: (I) George Grosz and (2) African art.

While a Berlin dadaist, Grosz portrayed provocative visual satires of antimilitaristic and antibourgeois caricatures. ⁵⁰ He encouraged Bearden to concentrate on his drawing style and introduced him to political cartoons and drawings by Europeans that portrayed the pain and sufferings from political wars and opposition movements. ⁵¹ Like other Berlin dadaists, Grosz used photographic collage technique in which heads of people were emphasized for satire and for mocking the concept of nationalism in Germany. ⁵²

Whether or not Bearden adopted this exaggeration from his former teacher is uncertain. However, because Bearden created satirical cartoons earlier in his career and considering the impact of the tense racial climate of the 1960s upon Bearden, it is plausible that the 1964 Projections mocks the concept of nationalism in the United States. Furthermore, Bearden's representation of enlarged heads with direct gazes is described as engaging the viewer in a direct confrontation and presenting "an assertion of presence and a demand for recognition."53 These were the unwelcome, poverty-stricken African Americans who were shunned by the American public and the government. Their destitute economic condition was one with which Bearden was familiar from his observations of living conditions in the South, from his clients as a caseworker in New York City, and from the inflammatory mantra of the war on poverty espoused by civil activists during the 1960s.

Nevertheless, the African sculpture association is indeed plausible. In traditional African sculpture, emphasis on the head occurs in both figural sculpture and masks. The proportion and style in Bearden's photomontage figures are reminiscent of traditional African figural sculpture in which the head is exaggerated, often in relation to the proportions of the rest of the body, in a ratio of 1:3 or 1:4. This enlargement occurs because the head is considered the "seat of power;" it is the body part that identifies a human being, and it is the location where spiritual connections occur.

Bearden was familiar with the use of masked imagery in paintings by Jacob Lawrence, an old artist friend practicing in New York City. Both artists studied African art at the 135th Street Public Library and were escorted by "Professor" Wylie Seyfert, who had lectured to them on the subject, to an African art exhibition at the Museum of Modern Art. 54 Furthermore, while a Spiralist, Bearden heard additional lectures on the subject and saw more art in the private collection of Merton Simpson, an African art dealer and member of the Spiral Group.

In works such as Mysteries and The Prevalence of Ritual: Baptism, specific sculptural heads or masks from West and Central Africa are discernible in the fragmented heads. In Mysteries, the face on the left is composed using part of the face from a photo of a Benin bronze sculptural head. Whereas in The Prevalence of Ritual: Baptism, the Africanized faces include the centrally placed Kwele mask from Gabon, and, in the lower left, a portion of a Kalabari Ijaw mask from Nigeria surmounted by patterns that are reminiscent of the Kifwebe mask from both the Luba and Songye ethnic groups, located in the Eastern Congo Basin (currently, the Democratic Republic of Congo). Bearden was familiar with the multiplicity of art forms and ethnic groups in Africa. When asked his opinion about black art, Bearden replied: "In Africa there are some tribes [ethnic groups] like the Dogon [in Mali] who make funereal [sic] things that are extremely Abyssinian [in Ethiopia]. There may be another tribe across the river who makes very realistic things. There are great stylistic differences in tribal art of Africa."55

In Bearden's photomontage and in the traditional African sculpture, the masked faces suggest a transformative function—the mask conceals human identities and reveals the spirit of beings.

Perhaps better stated, an African ritual performance is a practice in which a performer uses some combination of facial disguise, costume, body decoration, props, movement, vocalization, drumming, and music to create the illusion of the spirit world. A masquerader can become what one in ordinary life cannot—a reversal of roles: men into women, old into young, human into animal, mortals into gods, dead into living, or the reverse of these. In the new persona, the masquerader is a mediator between humans and the spiritual realm. As the embodiment of spiritual powers, the masquerader represents the spirit(s) who restructure social maladies.

SOUTHERN LANDSCAPES WITH NORTHERN EXPOSURES

Despite their experience of physical, mental, and emotional slavery, the South represents a portion of a historic legacy that demonstrates the strength, perseverance, and survival of persons of African descent. It provides a reservoir for both African American and African retentive cultural traditions (pl. 16). As August Wilson, an African American playwright whose plays were greatly influenced by Bearden, stated: "Africa is our [African Americans'] South." ⁵⁶

Bearden's emphasis on memories, particularly of the South, is reminiscent of a statement made by his friend James Baldwin. Baldwin proclaimed: "When blacks migrated from the south to the north, the northern culture did not take. The memories are important because if they are in our souls and spirits, they will sustain man once he leaves home." 57

In such comments, it is apparent that the South represents a wellspring of strength and endurance for Bearden. As his home site, he characterizes the South as a shrine,⁵⁸ and the specific details in the actual land-scape assume a secondary role. Using this approach, Bearden brings together in a cohesive manner both the intellectual and emotional parts of human nature.

Bearden believed that both the visual arts and music generate levity in times of melancholia. While producing his art in New York City, he found solace in the pleasurable experiences of southern life. In his remarks about a blues melody sung by Bessie Smith, Bearden recalled:

Here she's [Bessie Smith] talking about a poignant personal event—her love is gone. But behind her the musicians are "riffing," changing something tragic into something positive and farcical. This is why I've gone back to the South and to jazz. Even though you go through these terrible experiences, you come out feeling good. That's what the blues say and that's what I believe—life will prevail.⁵⁹

People connect with the land, and landscape themes include the relationship of figures to the terrain. ⁶⁰ In *Cotton*, the figures are actively engaged in picking or carrying loads of cotton in the fields. As if in a musical expression, the images' entire bodies are contorted. The figures are placed in landscapes that are generalized and devoid of minute details. Bearden formulates time in space as if seen for the first time, which is very similar to the mechanics of a photographer.

The relationship of the European American planters to the knowledge of the skill of the cotton pickers is well documented. The planters were knowledgeable about the agricultural cultivation practices in various regions of West and Central Africa. They could identify the different African ethnic groups and were often able to relate the various groups to the types of cultivation—rice, cotton, and indigo—found in Africa. 61

Bearden re-creates an aspect of the African Americans' social condition on cotton farms, and he records an element from the historic annals of agriculture in Mecklenburg County. In the South, the end of slavery crippled plantation agriculture. However, even before the Civil War, Mecklenburg County had been one of North Carolina's most productive cotton growing counties. It was comprised, like the rest of the state, of many medium-sized cotton farms rather than a few large cotton plantations. ⁶²

Bearden's opportunities for observing cotton laborers was probably not confined to those on the cotton farms but was expanded to workers who engaged in the activities of transporting the cotton to the processing buildings in and out of Charlotte. One of the processing buildings was on the other side of the railroad bridge near Bearden's great-grandparents' house, where he originally lived and later spent his summer vacations. It was the Magnolia Cotton Mill.⁶³

During this period—the early twentieth century—Charlotte developed into an industrialized urban area specializing in the textile industry. Besides the Magnolia Cotton Mill, there were several mills for spinning and weaving cotton in the Charlotte and the Mecklenburg County area. By 1900, Mecklenburg County boasted sixteen mills, and it was North Carolina's second most important textile manufacturing county. Supporting the slogan "Bring the Mills to Cotton!" North Carolina emerged as the South's leading textile producer by the 1920s. ⁶⁴

In Charlotte, cotton was weighed, put in bales, and shipped to mills where it was processed into cloth. Cotton was transported to Charlotte by trains or wagons from other parts of the country for the train ride north to be manufactured into cloth, or "milled." The opening of railroads in the 1850s made Charlotte a major cotton trading hub for farmers throughout the North Carolina southern Piedmont area. ⁶⁵

In *Cotton*, Bearden's figures and landscape service social or collective motives. Specific imagery in the local and regional landscape highlights a social dilemma of polemics. For example, the cotton fields in southern landscapes supplied an economic means for southern white farmers and plantation owners. However, its imagery evokes contrasting feelings of historical associations: (I) allegiance to the cotton regions, including support of the legalization of slavery of blacks and (2) recognition of and repulsion to the injustices of slavery.

In response to the latter, one must consider the role of the artist both to social issues and to his viewers. Bearden admired Gustave Courbet, a French nineteenth-century social realist painter, for his interest in defining the social responsibility of the artist and his considera-

tion of the viewing audience.⁶⁶ In these photomontages, Bearden's role as an artist appears to be similar to that of a visual illustrator or a recorder of life experiences. He stated: "I create social images within the work so far as the human condition is social, I create racial identities so far as the subjects are Negro, but I have not created protest images because the world within the collage, if it is authentic, retains the right to speak for itself."⁶⁷

In allowing the viewer to develop personal interpretations of his work, Bearden realized that viewers found more social meaning in his artwork than he originally intended. ⁶⁸ Years later, artist Carl Holty and Bearden agreed that: "Not all who look see the same thing; some people, for instance, will be pleased by a particular image, others depressed—each according to his temperament, his imagination, and his spiritual needs. But whatever the image, the only visual reality present is the structure." ⁶⁹

Regardless of one's interpretations of these landscape scenes, the subject matter of the cotton farms is significant in confirming a national destiny. These artworks furnish glimpses of conditions that recall social, economic, and political upheavals as well as progressive changes in American history. These innovative narrative images record the significance of the man-made landscape and respond to a cultural legitimacy.

During Bearden's childhood experiences, trains were continuous sights and sounds. He remembered the long train ride from Moose Jaw back to New York. Like the Magnolia Cotton Mill, a train trestle and railroad bridge were near Bearden's great-grandparents' house. Young Bearden visited the train station with his grandfather "to watch the good trains go by. You He recalled many experiences of watching trains arrive and depart from Charlotte.

His favorite train was the New York and Atlanta Special, which steamed southbound from Charlotte station every morning at 10 o'clock. It came back every evening at 7:30, headed for Washington, New York, and points north. That endless train, with its huge steam engine and coal car, and its Pullman drawing room sleeping cars, dining car, and parlor observation car, was a magical sight for Bearden and his cousins.⁷²

The contrasting slow and fast rhythmic tempos of the trains' movements and the shrill of train whistles are echoed in the manner in which Bearden relates the sounds to jazz. He manipulates line, shape, and color in spaces, creating dissonant and harmonious arrays in his pictorial art. However, trains are not merely a visual or musical art form, but are symbols of the lives of people. Trains denote movement and place for Americans. They transport people and commodities to places far away and form part of the distant vistas. The train symbolized hope for blacks as they migrated from the South to the North for better jobs and education.

Trains structured portions of the landscape that link and divide regions. They connected the South to other parts of the country, particularly to the North. Simultaneously, train tracks were laid in cities, such as Charlotte, in a manner that demarcated the separation between racially divided communities. The train tracks became a dividing line, separating black and white communities and defined the social, political, and economic division of communities. For Bearden, the train is a cultural symbol: "I use the train as a symbol of the other civilization—the white civilization and its encroachment upon the lives of blacks. The train was always something that could take you away and could also bring you to where you were. And in the little town it's the black people who live near the trains."

Finally, other familiarities with trains in Bearden's life include the prestigious jobs with railroads held by African American men close to him. His father was a steward for the Canadian trains, his paternal great-grandfather, H. B. Kennedy, was a mail agent for the CC&A Railroad in Charlotte, and A. Philip Randolph pursued equitable working conditions for Pullman porter.

In his artwork, Bearden unifies figures with the life force of nature and man-made objects in nature. Portrayed as onlookers and detached observers, the lives of rural African Americans are routinely juxtaposed to trains in Bearden's work and are disconnected with the urban, industrial development of Charlotte. In comparison to their bodies and the terrain, the scale of the heads of figures is characteristically magnified in much of his work. In such cases, their large visages, which are remi-

niscent of the enlarged heads in traditional West and Central African figural sculpture, overpower their surroundings. The abstract character derived from African sculpture for Bearden's figures is "made to focus our attention upon the far from abstract reality of a people." The size relationship of the figures to the land, and particularly to the mountains in the distance, elicits a psychological impact and a testament to their steadfastness.

Regardless of their impoverished attire and condition often portrayed, each person represents an important and a collective part of the national character of America. They are all organic components of the lifeline of the nation. The combination of these dissimilar and seemingly disjointed members culminates in a complete product that reflects the essence of the American fabric in general and the African American identity in particular. Similarly, in the African traditional worldview it was accepted that in a cohesive and integrated society each member had a place.77 Viewed from this perspective, it becomes apparent that Bearden must have admired the people that he created and regarded the peopled landscape as a form of profound satisfaction and solace. As a fixation of his memory, these are not imagined figures but are real human beings who walked into his compositions. As he recalled events that occurred, people began to come into his paintings. Bearden remarks: "I just let them come in, like opening a door to guests."78

Similar to the visual journey that a train passenger experiences, in Watching the Good Trains Go By, various visual imageries allow the viewer to participate as an itinerant traveler through time and space. The forms convey the idea of transporting the viewer from and to different locations. For example, the journey takes one from the rural farms and the urbanized industrialization in the South to vistas and the urban North, symbolized by north-bound trains, and possibly ultimately to remembrances of the land of the ancestors-West and Central Africa, comprising ethnically diverse peoples. From this conglomeration of images, Bearden's skill as a narrator of human experiences, as if presented on a stage or in a film, is revealed. Each fragmented figure and image becomes a separate frame of a story or movie. These African American images were counter to the protest and violent treatment that appeared daily in black and white on American television.

SUMMARY AND CONCLUSIONS

Bearden attempted to place his narratives about the social conditions of blacks within a European, African, and African American construct. By Bearden's use of the collage and photomontage technique from Europe, which reflected an African based aesthetics, his works become a full circle back to his ancestral heritage. Moreover, like the oral traditions in Africa, Bearden's narratives assist in passing on African American legacies. He embraced slave ancestry, rituals, and the past because they provided strength for him and his people. The resiliency of these cultural narratives had sustained African Americans in the past and, like an Archimedean spiral, was the buoyancy for sustenance for the Spiral Group during the civil rights movement.

Bearden, a political activist concerned about the vis-

ibility of black artists in major American museums, participated with other demonstrators in a picket line at the Whitney Museum in New York in 1968. The protest was about the exclusion of Negro artists from the Whitney's current exhibition, "The 1930s: Painting and Sculpture in America." In 1997, Bearden's works were shown posthumously at the Whitney in an exhibition entitled "Romare Bearden in Black and White: Photomontage Projections, 1964." His own visuality as a collage artist is emphasized in other venues. Among the three or four African American artists whose artworks appear in current world art history textbooks published in the United States, Bearden is represented as a collage artist.

Bearden photomontages and narratives of black people desegregated mainstream art museums, galleries, and textbooks. Prior to Bearden's photomontages, American art did not realize collage as a viable medium in the context of art. Romare Bearden is the dean of collage art in the United States and as such paved the way for other collage and photomontage artists.

NOTES

- I Myron Schwartzman, *Romare Bearden: His Life Art* (New York: Harry Abrams, Inc., 1990), 131–132.
- 2 Ibid., 15-18, 28.
- 3 For a discussion of these exhibitions, see ibid., 132–152.
- 4 Huston Paschal, *Riffs and Takes: Music in the Art of Romare Bearden* (Raleigh: North Carolina Museum of Art, 1988), n.p.
- 5 Gail Gelburd and Thelma Golden, Romare Bearden in Black and White: Photomontage Projections, 1964 (New York: Harry Abrams, 1997), 18.
- 6 For a discussion of Randolph's philosophy of the civil rights movement, see Paul F. Pfeffer, A. Philip Randolph, Pioneer of the Civil Rights Movement (Baton Rouge: Louisiana State University Press, 1990).
- 7 For information on Bearden's father, see Schwartzman, *Romare Bearden*, 17. For information on Bearden's mother, see ibid., 67.
- 8 Named after the address of the artists' studio loft, 306 West 141st Street, where the first meeting was held. The loft was the art space that was shared jointly by painter Charles "Spinky" Alston, a former WPA artist and cousin of Bearden, and sculptor Henry ("Mike") Bannarn; see Mary Schmidt Campbell and Sharon Patton, *Memory and Metaphor: The Art of Romare Bearden,* 1940–1987 (New York and Oxford: Studio Museum in Harlem; distributed by Oxford University Press, 1991), 20–21.

- 9 By mid-October 1963, meetings were moved to the 147 Christopher Street in the Village, see Romare Bearden and Harry Henderson, *A History of African American Artists: From 1792 to the Present* (New York: Pantheon Books, 1993), 401.
- 10 Ibid., 400.
- II In Jeanne Siegel, "Why Spiral?" *Art News* 65, 5 (September 1966): 48–51, on the Spiral Group's exhibition in 1966, Mayhew and Pritchard are not mentioned. Mayhew joined a year after the group was originally formed. It is uncertain if the same is true of Pritchard.
- 12 Bearden and Henderson, A History of African American Artists, 400.
- 13 Schwartzman, Romare Bearden, 84. The Museum of Modern Art held an exhibition of "African Negro Art" in 1935. Bearden and Lewis attended the exhibit with Wylie Seyfert and Jacob Lawrence.
- 14 Siegel,"Why Spiral?" 50.
- 15 After serving in the U.S. Army from 1942 to 1945, Bearden received a GI Bill to study philosophy at the Sorbonne in Paris. There he befriended eminent European visual artists as Constantin Brancusi and Georges Braque as well as American expatriates: novelists Albert Murray and James Baldwin, poet Samuel Allen, and painters William Rivers and Paul Keene. See Gelburd and Golden, *Romare Bearden in Black and White*, 77.
- 16 Schwartzman, Romare Bearden, 131.

- 17 Bearden and Henderson, A History of African American Artists, 4/4-475.
- 18 This painting was exhibited in the Spiral exhibition in 1964. See Siegel, "Why Spiral?" 50.
- 19 Ibid.
- 20 For a discussion, see Schwartzman, Romare Bearden, 131-132.
- 21 Ibid., 400.
- 22 Siegel, "Why Spiral?" 50.
- 23 Schwartzman, Romare Bearden, 121.
- 24 Floyd Coleman, "The Changing Same: Spiral, the Sixties, and African-American Art," in William E. Taylor and Harriet G. Warkel, eds., A Shared Heritage: Art by Four African Americans (Bloomington: The Indianapolis Museum of Art: distributed by Indiana University Press, 1996), 150–151.
- 25 The Spiralists abandoned the Western ideal of beauty in human forms that originally appeared in Greek sculpture and paintings as the perfect Greek male nude athlete, Greek god, and Greek goddess and was appropriated in later Western art traditions.
- 26 The Greeks are the first Western culture to write theories placing arts and mathematics in separate categories.
- 27 Coleman, "The Changing Same," 149.
- 28 Ibid.,157.
- 29 Richard J. Powell, "What Becomes a Legend Most? Reflections on Romare Bearden," *Transitions: An International Review* 55 (1992): 66, identifies the magazine sources.
- 30 Schwartzman, Romare Bearden, 210.
- 31 Schwartzman, *Romare Bearden*, 206. Cordier & Ekstrom, a colossal and expansive space on 978 Madison Avenue, was the gallery where Bearden exhibited from the early 1960s to his death in 1988. The gallery was run by Daniel Cordier, Arne Ekstrom, and Michel Warren. Besides Bearden, the gallery exhibited works by eminent European artists, such as Dubuffet, Matta, Michaux, Duchamp, Lindner, and Noguchi.
- 32 Ibid., 210-211.
- 33 Charles Allen, "Have the Walls Come Tumbling Down?" New York Times, Sec. 2 (April 11, 1971), 28
- 34 Schwartzman, Romare Bearden, 186.
- 35 Ibid., 187.
- 36 Diane Waldman, Collage, Assemblage, and the Found Object (New York: Harry N. Abrams, Inc., 1992), 102.
- 37 Ibid., 103, 107.
- 38 Ibid., 104.
- 39 Ibid., 112–113.
- 40 Dada art began in Germany and France and was brought to New York City by French artist, Marcel Duchamp, during the early part of the twentieth century. For a brief discussion of dada art in the United States, see Amy Goldwin, "The Dada Legacy," *Arts Magazine* 39 (September/October 1965): 26–28.
- 41 Schwartzman, Romare Bearden, 128. Bearden spent a great deal of time "struggling to understand the structure and composition of Cézanne's work. In the end [in works after the 1960s], Cézanne had as much or more influence on Bearden's handling

- of the picture plane than Picasso."
- 42 Ibid., 207.
- 43 Although Picasso is most known for developing cubist abstraction, the style was technically the joint invention of Picasso and his artist friend Georges Braque. The style was built upon the foundation of Picasso's early work.
- 44 For a discussion of the surrealists' political protest against the French government for the civil rights of African Americans in Paris, particularly the exploitation of Al Brown in a boxing championship, see Bennetta Jules-Rosette, *Black Paris: The African Writers' Landscape* (Urbana and Chicago: University of Illinois Press, 1998), 26–30. Also, for Picasso's association with the surrealist and the impact of surrealism on his painting *Guernica*, see William S. Rubin, *Dada, Surrealism, and Their Heritage* (New York: Museum of Modern Art, 1968), 279–309.
- 45 Schwartzman, Romare Bearden, 128.
- 46 Gelburd and Golden, Romare Bearden in Black and White, 77.
- 47 Aaron Myers, "Bearden, Romare," in Anthony Appiah and Henry Louis Gates, eds., Africana: The Encyclopedia of the African and African American Experience (New York: A Member of the Perseus Group, 1999), 207.
- 48 Mary Schmidt Campbell, "Tradition and Conflict: Images of a Turbulent Decade, 1963–1973," in *Tradition and Conflict: Images of a Turbulent Decade, 1963–1973* (New York: Studio Museum in Harlem, 1985).
- 49 Schwartzman, Romare Bearden, 168.
- 50 For a discussion of the Berlin dada, Grosz's participation in the movement, and Grosz's art, see Rubin, *Dada, Surrealism, and Their Heritage*, 82–93.
- 51 Grosz introduced Bearden to European artists who portrayed the theme of "man's inhumanity to man" in black-and-white prints and drawings. These artists include Honoré Daumier (French), Francisco Goya (Spanish), and Kathë Kollowitz (German). These artists use black-and-white imagery as if mimicrying the photojournalist style as if reporting in print a newsworthy documentary on societal ills.
- 52 Waldman, Collage, Assemblage, and the Found Object, 113.
- 53 Lee Stephens Glazer, "Signifying Identity: Art and Race in Romare Bearden's Projections," The Art Bulletin 76 (September 1994): 423.
- 54 Schwartzman, Romare Bearden, 84.
- 55 Camille Billops and James V. Hatch, "Romare Bearden," in Artist and Influence 17 (New York: Hatch Billops Collection, Inc., 1998): 14.
- 56 See August Wilson and Mateo Belinelli, August Wilson: A Conversation with August Wilson (videorecording), Swiss Television Production, San Francisco, CA: California Newsreel, 1992.
- 57 James Baldwin, quoted in Schwartzman, Romare Bearden, 168.
- 58 For a discussion of homes as shrines, see Peter Howard, Land-scapes: The Artists' Vision (London and New York: Routledge, 1991), 188–189.
- 59 Avis Berman, "Romare Bearden 'I paint out of the blues," ARTnews (December 1980): 66.

- 60 John McCoubrey, American Tradition in Painting (Philadelphia: University of Pennsylvania, 1999), 32.
- 61 Joseph E. Holloway, "The Origins of African-American Culture," in Joseph E. Holloway, ed., Africanisms in American Culture (Bloomington and Indianapolis: Indiana University Press, 1990), 15.
- 62 Thomas W. Hanchett, "Charlotte's Textile Heritage: An Introduction," *Charlotte-Mecklenburg Historic Landmarks Commission* (Charlotte, NC: Historic Landmarks Commission, n.d.), http://www.cmhpf.org/essays/textiles.html.
- 63 Myron Schwartzman, *Celebrating the Victory* (New York, London, Hong Kong, Sydney, Danbury: Franklin Watts, Inc., 1999), 24.
- 64 Hanchett, http://www.cmhpf.org/essays/textiles.html.
- 65 Schwartzman, Celebrating the Victory, 24; Hanchett, http://www.cmhpf.org/essays/textiles.html; and Dan Morrill, "A Survey of Cotton Mills in Charlotte and Mecklenburg County for the Charlotte-Mecklenburg Historic Landmarks Commission," Charlotte-Mecklenburg Historic Landmarks Commission (Charlotte, 1997), http://www.cmhpf.org/essays/cottonmills.html.
- 66 Henri Ghent, an interview with Romare Bearden for the Archives of American Art, June 29, 1968. Microfilm reel 3196, Archives of American Art, Smithsonian Institution, Washington, DC, 217.
- 67 Charles Childs, "Bearden: Identification and Identify," *ARTnews* 63, 6 (October 1964): 25.

- 68 Henri Ghent, interview with Romare Bearden for the Archives of American Art, June 29, 1968, 21.
- 69 Romare Bearden and Carl Holty, The Painter's Mind (New York and London: Garland Publishing, 1981), 20.
- 70 Myron Schwartzman, Celebrating the Victory, 24.
- 71 Sharon F. Patton, African American Art (Oxford and New York: Oxford University Press, 1998), 39.
- 72 Schwartzman, Celebrating the Victory, 25. Also, stated slightly differently in his earlier book (see Schwartzman, Romare Bearden, 20–21).
- 73 Romare Bearden: Visual Jazz (Chappaqua, 1998), videorecording.
- 74 Patton, African American Art, 39.
- 75 Schwartman, Romare Bearden, 14.
- 76 Ralph Ellision statement in the foreword, from Bearden and Holty, The Painter's Mind, xiii.
- 77 Margaret Washington Creel, "Gullah Attitudes toward Life and Death," in Joseph E. Holloway, ed., Africanisms in American Culture (Bloomington and Indianapolis: Indiana University Press, 1990), 71.
- 78 Billops and Hatch, "Romare Bearden," 35.
- 79 Grace Glueck, "1930s Show at Whitney Picketed by Negro Artists Who Call It Incomplete," New York Times (November 18, 1968), Sec. L, 31.

FACING PAGE:

Detail from Romare Bearden's Island Scene, 1984 (Plate 51)

Nanette Carter's Discursive Modernism:

The Collage Aesthetic in Light over Soweto #5

ANN EDEN GIBSON

ANETTE CARTER'S LIGHT OVER SOWETO #5 (1989) IN THE Paul R. Jones Collection at the University of Delaware is one of a series of works in oil pastel on black paper, numbered one to five. Carter has occasionally described her work as "mark-making," a term that fits the appearance of these dynamic drawings, since at first inspection they present the viewer with a display of marks-broad and slender, erratic and directed, crisp and blurred, in sizes from relatively large to small and dot-like. Applied in values ranging from white to dark gray and colors from all along the spectrum, they explode in this collaged drawing from a point of greater density at the lower right to dispersion at the top. Beneath these strokes in the earlier panels in the series hover grays of various tonalities, and in one, a dull red mist of the smallest particles obscures their clarity. But in Light over Soweto #5, as in the other drawings in the series, the bare but toothy ground of the absorbent black of the paper becomes deep space, the color of no color, no light. It turns into a vacuum of infinite distance, unknowable—and becomes the most illusionistic part of the whole picture. Into it, the explosion of violet and red flecks ascends electrically as a large and erratic streak of violet arcs into jagged points. On a horizontal panel of paper collaged to the very bottom of the picture, blue, purple, and brown marks flow horizontally from one border of the drawing to the other. Another piece of paper colored deep red is carefully torn into a deckled edge so that its exposed black core serves as a zig-zag outline at the very top of the drawing, effectively bracketing the storm of darting, jumping strokes of a more intense red, salmon, and

FACING PAGE:

Detail from Nanette Carter's Light over Soweto #5, 1989 (Plate 17) violet. Bleeding off the right hand edge, the narrow edge of an impossibly tall form the color of all human flesh below the skin—an ancestor of Carter's "tree personage," as George Preston Nelson called such a shape when a similar form appeared in a later work—stands, rooted in the collaged band of horizontal marks at the bottom, stretched between the land or water below and the sky above.

Collages gather material from different worlds in a single composition that demands "a geometrically multiplying double reading of each element." They thus call attention to what Thomas Brockelton in his book on collage and the postmodern has called "the irreducible heterogeneity of the 'postmodern'."2 The definition of the use of the collage aesthetic, a term that may be more appropriate to describe the methods used in the physical and conceptual description of Light over Soweto #5 than might at first be evident, is a concept and a practice whose significance for modernity is still undergoing revision. A number of scholars have been at work in the latter decades of the twentieth century and the first years of the twenty-first revising the concept of modernity to include as an important landmark the previously unstressed invention and development of the early twentieth-century practice of cubist collage. They have argued that it influentially changed what we think art is, a change concurrent with developments in philosophy, and one that has more and more frequently informed the making and viewing of art practice until, in the late 1960s, it emerged as a genre that some called the postmodern. Seeing the invention of collage as more than the attempt of analytic cubism to produce a non-naturalistic realism, Yves-Alain Bois has argued that it introduced an entirely different understanding: that all of art's products, from a naturalistic portrait in oils to a piece of newspaper glued to a canvas, are signs—"emblems," as Picasso's scholar-dealer called them, "of the external world, not mirrors."3 As Christine Poggi has observed, that insight founded an increasingly lively alternative to the modernist tradition.4 More recently, Brockleton has noted that such revisions, when factored into developing histories of postmodernism, make it possible to argue that postmodernism was imbricated

in modernism from the very beginning: "right in the heart of cubism."⁵

As suggested by the progression of the description of *Light over Soweto #5* with which this essay starts, Carter's "mark-making"—a term usually associated with a literal and material approach to drawing that sees it as the sum of the literal and material activity that produced it—lends itself as readily to the modernist device of metaphor as it does to the modern materialism of understanding drawing as mark-making. Collage's production of complex pictorial space was noted early on by observers such as Apollinaire. But as the innovations of modernism became more programmatic, critic Clement Greenberg asserted that collage affirms painting's two-dimensional surface, although in fact most viewers tend to see a literally flat piece of paper or canvas as space at the provocation of the smallest dot on its surface.

In an art world context, Carter's work presents an interesting paradox, reuniting as it does what Peter Wollen termed "the two avant-gardes," observable in the contrast between the processes and image juxtapositions of Sergei Eisenstein's mimetic and overtly revolutionary montage in film as compared to the pure and hermetic significations of Clement Greenberg and Michael Fried's "modernist painting." These aspects of the avant-gardes may be seen in the two lines of artistic descent from the contrasting examples of Duchamp, representing more oppositional and conceptual understanding of the avant-garde, and Picasso, seen as the avatar of a modernism more concerned with formal innovation. By the 1970s, these directions had become so divorced that audiences began to distinguish them by identifying the Duchampian strain as postmodern and Picasso's lineage as modernist. In terms of modes of signification, metonym became the rhetorical device of postmodern choice, as metaphor was for modernists.10 Thus, for Duchampian artists such as Jeff Koons, the metonymy of inserting everyday mass-produced objects into a gallery or museum setting gave them the status of "Art"; but for Picasso and Pollock, or so their proponents averred, it was the metaphoric progress toward continually purer formal means that deserved that appellation.

One might claim that Light over Soweto #5 displays the dual or split characteristics of the collage aesthetic of postmodernism, knitting back together Wollen's "two avant-gardes" and in so doing reinvigorating the oppositional of modernity that seemingly died away in the last half of the twentieth century." Recent scholarship on collage hermeneutics suggests that it leads not to a resolution, but instead toward a transformative event, splitting the ideal of universality by recognizing its impossibility, the way Kant recognized the unknowability of the sublime. We are becoming comfortable with the idea that there may be no one right way for everyone. Brockleton thinks the project of late modernity may be the reinterpretation of the reductivist view of the modernist project to find the story of how, in the formative moments of modernity, its split subject emerged.12

Carter is entirely aware that she employs landscapes as metaphors in *Light over Soweto #5* for political and sociological stances, as Karen Wilkin has observed.¹³ The suggestion of running water or a path below and of an electrifying explosion above is reinforced by the energized bravura of lines that compose them. But in addition to metaphor, in the outline of the tree-like form Carter employs mimesis, a traditional figurative device whose effectiveness modernism derided. Her work "blur[s] the line between figuration and abstraction," as one critic succinctly observed.¹⁴

In Carter's work, however, implications of these different systems, multivalent as they are, may be seen as pulling together if one considers the title part of the work. "You can't put down a line about nothing," Carter notes. "My abstractions don't negate reality, or escape it. They are always about it."15 What does she mean? Her marks, put down like hundreds of tiny colored bits of collage, one by one, are certainly abstract by virtue of their size and distance from one another; they do not become visually, that is, mimetically realistic. Yet their organization and the directions in which they appear to be moving read almost like a diagram: "explosion" and "electricity." The mimetically drawn form of a tree, on the other hand, impossibly narrow, straight, and tall, reads more like a cut-out and glued-on collage element, although it is drawn with oil stick right onto the black

paper. The actual collage elements, with the tree, form a *repoussoir* of sorts in the form of an interrupted frame around nearly three quarters of the painting, consisting of a ceiling or lintel from under which one peers at this spectacle, framed by the tree on the right and a field of beaten-down grass or a river at the bottom, across which one anxiously regards but incompletely grasps a powerful and riveting event.

Like windows, whose shapes and functions they echo, frames have symbolically functioned since the Rcnaissance to tell viewers that what is inside is in a different world than the one in which they are now standing. The interrupted or broken frame that Carter provides, composed of collaged pieces of paper, and the fauxcollage tree that is actually drawn, makes an eloquent appeal to spectators, most of whom will be familiar with the function of a frame as something that protects the art inside it. They will also, however, be familiar with a more ambivalent function of frames, one that marks a definitive border between the art and the wall upon which it hangs, but at the same time serves as an element in interior décor, one whose color and style will inevitably have a relationship, whether harmonious or strikingly at odds with its surroundings.

Because of this function as a border between two lands, neither one of which they wholly occupy, but between which they mediate, frames have tended to guarantee the illusionary and representational function of the picture inside. In the twentieth century, however, as paintings became more abstract, more self-sufficient, reluctant to submit to the representational status of standing for something other than themselves, frames, especially elaborate ones, became less necessary, in fact, even disreputable. To frame something is to imply that it represents, or was motivated by something outside itself. It is not autonomous. By the 1950s many artists had dispensed with frames altogether, or replaced them with simple lattice strips to protect the painting in handling. Art historians have deduced from this that a broken frame might serve as the emblem of this movement toward the autonomy to which modern art—or at least modernist art—aspired. The artist's presentation of an incomplete or broken frame as a part of the art was especially modern, since it addressed the liberation of art from representation, and represented as well as exemplified the production of art "that no longer means, but simply 'is'." ¹⁶

But as Carter has remarked, "The title informs you, once you read it." She was speaking about the title of her more recent Point-Counter-Point series, where the theme of negotiated balance of the picture plane (a modernist, self-reflexive subject-matter) developed as she followed the histories of tensions and news of attacks and counterattacks in wars in Europe and Africa where, as she noted, two opposing forces in the same country were eventually going to have to hang together, for better or worse.¹⁷ Titles are crucial in nearly all her work. In the Point-Counter-Point collages, however, one would not necessarily know that the artist was thinking about Bosnia or Rwanda unless one was otherwise informed, since the title describes an interaction whose structure is common to many fields of endeavor, including war and art. Nevertheless, assessment of their delicately calculated asymmetrical balance required viewers to weigh colors, lines, and forms against one another to discover it, thus experiencing the tit-for-tat kind of exchanges that the title names. When a viewer is invited by a title like "Soweto," however, to speculate on the historical and perhaps present meaning of a place name, especially one loaded with current significance, emphasis rests less easily on the act of viewing. The question arises: what meanings did "Soweto" have by 1989?

Unfortunately for those who lived there, but for good reason, "Soweto" became nearly synonymous with another word, "apartheid," after a series of riots that began there spread throughout South Africa in 1976–1977. Apartheid, which literally means "living apart," became law in South Africa in 1948 when the National party came to power. In two decades, the government, run nearly exclusively by a minority of the descendants of European settlers, relocated over 3 million Africans to townships against their will; in the more rural ones workers commuted 3.5 to 7 hours a day to work in the cities, an average of 706 people shared one water tap, and the rate of active tuberculosis for children

by 1987 was 46 percent. Urban townships had a few more amenities, but even there, the lack of post offices. pharmacies, dentists, public libraries, and playgrounds was common. Black opposition movements were banned and driven underground. By the 1960s, white Africans enjoyed a boom matched only by Japan in a country with the most unequal distribution of income data of all economies for which data was available.18 But with OPEC oil prices rising drastically in the early 1970s and a war in the Middle East, South Africa entered a period of crisis and recession, which brought unemployment and inflation. Wages earned by Africans there, half of which were already "below the most generously drawn poverty line," dropped. Since oppositional negotiation regarding apartheid was illegal, this led to the growth of black organizations and militancy.

On June 16, 1976, students in Soweto marched to protest a government directive that Afrikaans be used as a language of instruction in black schools. It turned into a general uprising and spread to other townships. State police responded and between 1976 and 1977 nearly 1,000 people were killed, eighteen organizations were banned, and a black newspaper was closed down. In October of 1977, Steven Biko, the young leader of the black consciousness movement, was murdered while under arrest. World headlines and news programs reported these events. A grass-roots trade union movement grew rapidly and the militant black consciousness movement grew stronger, calling on blacks to be assertive and proud of their heritage, psychologically freeing themselves from dominant Eurocentric values rather than cooperating in their own oppression.¹⁹

If one is familiar with even a few aspects of this sparse discussion of apartheid as it was lived in South Africa, the broken frame in *Light over Soweto #5* can work in precisely the opposite way than one might expect, given its modernist pedigree. Via the title, the broken frame permits whatever information the viewer has, or gets, about the implication of "light over Soweto" to imbue those marks with the narrative of an oppressed people's battle against the forces of their oppression. This is just what Carter has in mind. "I want my pictures to be read like a story," as she has re-

marked.20 At the same time, these meanings leak out into the galleries and museums where viewers stand, and if the work is privately acquired, perhaps into the homes and collections in which it resides. Meaning from outside the world of art gets read into this art, and may be amplified and dramatized there for viewers by the visual devices the artist has used. Such a title predisposes viewers to read these structures in its light, so to speak, directing them to reverse the generally accepted modernist understanding of the broken frame as an emblem of modern art. It suggests that Light over Soweto #5, with its collage-like appearance, participates in what Rosalind Krauss called "the historical logic of modernism itself, in which the newly liberated circulation of the token-sign always carries as its potential reverse an utterly devalued and empty currency." In the case of Picasso's pastiches, with their mass produced and ambiguously located collage images, and of his paintings and drawings done in the styles of other artists, Krauss has characterized this historical logic as "not necessarily destiny of modernism, but . . . its guilty conscience." But Carter, unlike Krauss's Picasso, participates in this history to expose matters of modern conscience rather than to hide them.21 In other words, Carter's incomplete frame signals that her use of collage, despite its current status as the avatar of the counter-cultural version of a modernism whose value lies in its revelation that meaning is never inherent in any sign, uses this understanding to pry open the issue, not of the artist's motivations, but of the viewers'. In this discursive space, the signs Carter has marshaled the collage elements, the ground, the oil-stick marks, and the images they evoke—are metamorphosed by viewers who can construct a story by reading them with the title. As one would expect, the devalued currency that this coin offers on its reverse, perhaps especially for viewers for whom "Soweto" evokes no narrative, as the self-referentiality of modernist formalism, does, often, seem to refer to precisely those aspects of the outside world that its makers found most disturbing.

Paul Gilroy has used the formulation of the politics of fulfillment and the politics of transformation by philosopher Seyla Benhabib to describe such goals and strategies in the arts, but in the field of music. In his discussion of the black Atlantic as a cultural contact zone in which a system of exchanges that formed a counter culture to modernity took place, Gilroy called attention to the efficacy of black music in developing black struggles to communicate. It assisted them at multiple levels of address to organize consciousness, and develop forms of consciousness capable of the selfawareness, confidence, and determination necessary to exercise effectively political agency. He described this aspect of the music as a discursive mode of communication to distinguish its interactive character. In doing so, he demonstrated a grasp of the idea that its modes of exchange with its public, its manner of presentation—its style—carried information as important as that carried by its words. He rightly drew attention to the challenge of transferring the critical edge in such music as the Jamaican "sound system culture" of hip-hop transplanted to the South Bronx in the 1970s to real world politics, emphasizing that it was important to pay attention to the social application of both its lyric and formal innovations. In the latter, Gilroy wrote, the elements of style performed information and points of view metaphorically and even emblematically, at the same time that the mimetic or semi-mimetic form of the lyrics signified in a more traditional way.22

Because of the devices of signification that Carter has chosen to use in Light over Soweto #5, it can, like Gilroy's description of hip-hop in the South Bronx, generate interpretations that work to accomplish what Seyla Benhabib has called "the politics of transfiguration," that is, become part of a "deliberative" discourse by which democratic societies transfigure themselves by establishing understandings that enable the crafting of new desires, social relations, and forms of resistance to its oppressors, as South Africa was doing in 1989.23 Benhabib uses concepts such as these in her efforts to promote a useful form of discourse theory, which is part of the critical social theory that is her field. Discourse theory is situated, like that of the Frankfurt School, between practical philosophy and social science, notes Benhabib, "sharing and radically reformulating the intentions of both." She saw an important part of that

project in 1986 when she published Critique, Norm and Utopia: A Study of the Foundations of Critical Theory in which she urged the development of a "communicative ethics." Communicative ethics is a term that describes more specifically the deliberative ethics that she believes is crucial to the kind of democratic theory she opposes to multicultural theory's more static and essentialist aspects. As I see the operation of Carter's discursive modernism, in Light over Soweto #5, as participating in an interplay between formal structures and social advocacy for political purposes as well as professional advancement, so Benhabib's democratic theory posits "a social constructivism that considers the interplay between structural and cultural imperatives is possible as well as desirable."24 The discourse ethics Carter's work engages also encourages people to think of themselves as belonging to what Benhabib has described as a community of needs and solidarity rather than rights and entitlements. It involves a shift from the latter to the former via an emphasis on consensus rather than on majority rule, which is based on the views of individuals as either participants or observers in public life. Instead, Benhabib emphasizes knowledge and judgments that are reached intersubjectively, that is, in a process of conversation with others rather than a process of discourse in which each individual thinks for him or herself, and then the majority's idea carries. Benhabib's vision of a community of needs and solidarity corresponds respectively to the "norm" and "utopia" of her title, and also, respectively, to the "politics of fulfillment" and the "politics of transformation" mentioned by Gilroy. 25 This entails not only the enablement of a politics of transfiguration but also of a politics of fulfillment, that is, a vision of a society of the future that is able to attain more adequately what the present has not been able to accomplish.²⁶ When read in the terms described in this essay, in Light over Soweto #5, Carter accomplishes something similar. Her understanding of the intellectual, political, and art historical contexts of her work is easier to grasp if you know the basics of her preparation for entrance into the art world.

Carter's own history suggests that her early personal as well as her educational background surely pro-

vided her with the motivation and tools to accomplish such an ambitious turn of modernism's methods to social ends. A long-time activist, as a high school student and a member of the Junior NAACP Carter demonstrated to integrate Hanes department store in Montclair, New Jersey. Like most Americans, Carter's political attention in the late 1960s and early 1970s was focused on the black freedom struggles in the United States. Her activism was bolstered by her father, active in New Jersey politics and a commissioner and then mayor of Montclair, and a mother who taught reading in the public schools and dance in her own studio in Orange, New Jersey, after school, introducing Carter and her sister to black theater and dance on nearly weekly weekend trips into New York City. When politicians and businessmen came to this busy household, Carter and her sister were invited not only to listen, but to voice their views and ask questions, Carter recalls. Both parents were involved with the NAACP and the Urban League. Carter first encountered the fact of apartheid in South Africa while attending Oberlin College (1972–1976) in a book of photographs that contained pictures of the Soweto riots in 1960. Her interest in freedom struggles in Africa and the part played by leaders such as Nelson Mandela, Patrice Lumumba, and the African National Congress in educating its members was further focused by the experience of acting in a play at Oberlin about Lumumba, the first African prime minister of Congo.27

"In the eighties I got involved with the problem of apartheid," reports Carter. "I think you can see that in the work, when you know what I was thinking about." One of the most important elements in Carter's education on South African apartheid was the hard-hitting articles of Randall Robinson, executive director of Transafrica, a lobby that sought to influence positive legislation toward Africa in the United States, and cochairman of the Free South Africa Movement. But perhaps what really brought the struggles of African peoples, and especially those in South Africa, to her attention as topics for art, was her acquaintance with South Africans Hugh and especially Barbara Masakela. She met the Masekelas through artists Al Loving, Ed

Clark, and Bill Hutson, all of whom helped Carter as she strove to get a toehold in the art world in New York. You Hugh was a musician, and Barbara, his sister, was to become minister of cultural affairs and later ambassador to France for South Africa under Nelson Mandela. You But at that point, Barbara, already very active in the ANC and teaching at Rutgers, had decided that she wanted to promote black visual artists, and that the best way to do that was to sell their work.

With her apartment-mate Elaine Simpson, and the help of critic Dorothy White, Barbara Masakela opened her large apartment on West End Avenue as an art gallery—Yolisa House.³² "She was articulate, well-read, and charismatic, a story-teller," recalls Carter of Barbara Masakela.³³ White curated shows there that included Carter, Clark, Hutson, Loving, Madeline Raab (later a cultural commissioner in Chicago), Lula Mae Blockton, Mildred Thompson, and Yvonne Pickering Carter—mostly abstract artists, recalled Nanette Carter. Quincy Troupe lived in the building and came to buy, along with many writers and other musicians. He introduced Masakela's artists to Margaret Porter, who had a gallery in San Francisco.³⁴

So by the early 1980s, Carter was mentored by some of the most important abstractionists of the decade. She was determined to make art that was (a) available to people with average incomes, and (b) spoke to African Americans especially, but also to people around the world about issues of vital importance whose significance was insufficiently recognized. To do this. Carter realized that she needed to develop a visual language that could communicate at various levels to differing sensibilities. Thinking back across her work in the last quarter century she mused, "I've never considered myself as anything but an artist who uses nature as metaphor. It's thematic-wind, sky; this is where the universal comes into play." And about the title Light over Soweto, but also most of her other titles: "Hopefully, if you read the title, it can work that way for you."35

When Carter used the words "Light over Soweto #5" as a title for this drawing, she employed the figural devices of metaphor and mimesis that Gilroy had noticed in music to turn dashes, dots, and jagged lines of red,

violet, and blue oilstick on black paper into a conflagration that reaches deeply into the night skies of South Africa, thereby standing for struggles for independence. Metaphor and mimesis, because of the intense color and dynamic directionality of her strokes, both direct and jagged, are not only visually like Yoruban emblems for Shango, god of thunder and war, one of whose emblems is the zig-zag form of lightning, but given the African retentions in the New World that so impressed Carter in Brazil in 1985 (see below), the jagged forms in Light over Soweto #5 are also emblems for such retentions in general, as well as mimetic references to what most viewers will recognize as the explosive and electric energy unbound in fireworks displays and in futuristic electric devices in science fiction movies and even in cartoons in newspapers, movie theaters, and on television.36

If metaphor uses similarity to connect basically unlike things, metonymy, on the other hand, demands no likeness, and operates merely on the basis of contiguity—of nearness. Carter's use of the word *Soweto*, the well-publicized name of the South African township where, by many estimates, the revolt that led to the true democratization of South Africa began, links the entire freedom struggle of that country, and, by extension, others as well, to this image. Although this essay about her collaged drawing in the Paul Jones collection is about her particular interest in South Africa, it is important to note that in other series she has demonstrated concern for freedom struggles around the world, using references over the years to Brazilian, Native American, and Japanese cultures as well as those of Europe and Africa.

The effectiveness of *Light over Soweto #5* is due in part to the fact that Carter has chosen to apply several layers of figuration: not only the metonymy of a title and the metaphors of strokes whose directions, forms, and rhythms, in the presence of this title, mimic several sorts of fiery events (bomb, electric explosion, chemical fire, etc.). The skill with which she has chosen the size, texture, color, and dimensions of her support, her choice of oilstick, which so accurately records the pressure and speed of the arm and hand that applies it, instead of more elegant paint or gentler pastels, and her

composition of those strokes also, however, make it possible for her in this work, as in most of those she has produced for some time, to offer substantial and subtle insights into complex and specific topics in ways that challenge viewers. This is particularly impressive and amazing, since they operate with such abstract elements. They are organized into shapes that evoke in turn the relatively generalized presentation of basic aspects of nature: earth, air, fire, and water, which are then further metamorphosed by both their visual juxtaposition on the picture plane, and later, the titles.

Carter has made a number of series that thematize other aspects of African struggles. There are too many to detail here, but I will mention a few in order to characterize the fullness of the universal that, as she states. "comes into play" in her work, and to specify its limits as well. The artist's universal consists of sounds and smells, touch and taste, as well as normally visual phenomena, working from the senses. She does not, however, assume that others have the same responses to their sensations that she does to hers.³⁷ Since her imagination encompasses and transfigures sensations from all the senses into vision, when she seeks to present to view what black Africans lost—in the series Savannah Winds (1984), for instance—she means to call up the color, the textures, the smells, she says, of "the grassy plains—of Africa in general; South Africa is said to be so beautiful, the water, the air, and the light; the visual richness of the land in memory and imagination." The Illumination series (1985–86), was sparked by Carter's recognition on a trip to Brazil of the depth and breadth of African retentions in Brazilian life, not only in the rhythms of the Bossa Nova and samba, but in every element of life there.38 In 1986, as she read in the New York Times and magazines such as U.S. News and World Report about the last years of apartheid rule, Carter found the South African government's censorship and seizure of any unapproved copy or photographs by either local or foreign reporters particularly frightening in view of the imposition of a nationwide emergency decree on June 12, in which the police were given the right to hold prisoners incommunicado, and were granted immunity for their acts. A spokesman for Amnesty was

quoted as saying of this latitude in one of the articles Carter read at the time: "this seems to be a license to torture."39 "This was very frightening," Carter recalls. "What could happen to the children?"40 In Burning Apartheid and Burning All Hatred, both of 1986, Carter intended to transform the destructive nature of the fires, literal and figurative, that characterized the killings, bombings, and arson in black African townships, including homes, schools, and eventually churches, as well as the offices of the African National Congress in cities across the country. 4 Maybe the concept of apartheid itself could be burned—completely dismantled—so we could begin anew, she thought. The flames, then, might be seen as not only terrible, but also cleansing—"as destroying the concept of slavery—getting rid of the idea that some people are less than human. That's what makes slavery possible."42

In her desire to memorialize and, in future, restore African savannahs to their condition before the winds of colonial rule and then revolution swept over them, in her vision of African retentions in Brazil—despite their origin in the horrors of the middle passage—as nevertheless comprising a most brilliant and life-affirming aesthetic innovation, in her reading of a positive message of hope and certainty of a better future in the flames themselves, and in transfiguring the electrifying power released in the *Light over Soweto* series into an image of the incineration of apartheid itself, Carter's aims for her work to echo Seyla Benhabib's politics of fulfillment and transfiguration.

Benhabib's critical theory is a concept of social action based on communication. Briefly, Benhabib rejects the most prominent presuppositions of revolutionary critical theory, though not for the same reasons. She rejects the adequacy of Hegel's critique of Kant's moral philosophy, if not Hegel's goal of superseding Kant. Nor is she satisfied with either Karl Marx's model of work as social action (which is the cornerstone of what is now called the "philosophy of the subject") or Theodor Adorno's critique of identity philosophies. Both privilege collective singularity, that is, the satisfaction of one group or organization acting in the name of all, of plurality—the understanding that our embodied identity

and the stories we tell to describe who we are give us a way to see the world that is only revealed in a community of action with others. Group actions in this case would take into account the desires of all of those who wish to be included (i.e., the "consensus of all concerned").

Understanding Carter's vision of *Light over Soweto* #5 prompts such conversation but in different ways. In her understanding of the fiery forms she has limned as not only signifiers of the terrible human costs of apartheid, but also of the potential of South Africa's struggles to cleanse the world of the very concept that supported apartheid, she creates a powerful promise of fulfillment, visible in the simultaneous messages of exaltation and destruction in what one might call the sublime of the billowing clouds of energy that are the central images in this series but heavily dependent on the consensus in the United States coalescing in 1986 that South African apartheid was a crime. In Benhabib's

terms, Carter presents "a view of social transfiguration according to which emancipation carries to its conclusion, in a better and more adequate form, the already attained results of the present." "Emancipation," Benhabib adds, "is realizing the implicit but frustrated potential of the present." Benhabib uses the term transfiguration to suggest that the form that emancipation will take is that of a radical and qualitative break with some aspects of the present. Fundamentally, this means that the society of the future will need to radically negate elements of the present. 43 Carter has named one element of such a negation in her vision of a future in which the attitude that prompted slavery—that some people were less than human—would become unthinkable. In Light over Soweto #5, Carter aims to reverse the damaging conviction that many, not only in South Africa but elsewhere, still hold to be a fact of nature, and whose effects are still at work in the United States.

NOTES

- I See George Preston Nelson's remark in Ruth Bass's review of Carter's exhibition at June Kelly, "Nanette Carter," ARTnews (February 1991): 140.
- 2 Thomas P. Brockleton, *The Frame and the Mirror: On Collage and the Postmodern* (Evanston, IL: Northwestern University Press, 2001), 10–11.
- 3 Yves-Alain Bois, *Painting as Model* (Cambridge, MA: MIT Press, 1993), 74.
- 4 Christine Poggi, In Defiance of Painting: Cubism, Futurism, and the Invention of Collage (New Haven, CT: Yale University Press, 1992), xiii.
- 5 Brockleton, The Frame and the Mirror, 6.
- 6 For metaphor as a privileged figural device in modernism, see Ann Eden Gibson, "The Rhetoric of Abstract Expressionism," in Michael Auping, ed., Abstract Expressionism: The Critical Reception (New York and Buffalo: Abrams and the Albright-Knox Gallery, 1989).
- 7 Rosalind Krauss, *The Picasso Papers* (New York: Farrar, Straus, and Giroux, 1998), 218. As Krauss notes, this realization was Apollinaire's, a phenomenon that inspired what he called the "internal frame," in which something from the outside is projected into a work of art, making art and reality exchange places.
- 8 The essay is retitled "Collage" in Greenberg's Art and Culture: Critical Essays (Boston: Beacon Press, 1961).

- 9 Peter Wollen, "The Two Avant-Gardes," in Readings and Writings: Semiotic Counter-Strategies (London: Verso Editions and NLB, 1982), 92–122.
- 10 Although it can be argued that all metaphor collapses into metonym. See Gibson, "The Rhetoric of Abstract Expressionism."
- II For the waning of the subject, see Peter Bürger, *Theory of the Avant-Garde*, trans. Michael Shaw (Minneapolis: University of Minnesota Press, 1984).
- 12 Brockleton, The Frame and the Mirror, 184-187.
- 13 Karen Wilkin, in Nanette Carter: Slightly Off Keel (New York: June Kelly Gallery, 2002), 3.
- 14 Following this remark, critic George Baumgardner noted that "Nanette Carter's highly abstracted landscapes make effective use of the texture of the supporting canvas [or in the case of *Light over Soweto*, paper] to heighten the nervous, all-over strokes of pastel color. The flickering surface seems to be in constant movement, a sort of landscape that hovers on the horizon of abstraction." "Tibetan Art in the Making and Varieties of Abstraction," *Ithaca Journal* (March 21, 1991).
- 15 Nanette Carter, interview, Sag Harbor, July 26, 2003.
- 16 Brockleton, The Frame and the Mirror, 24–28. Brockelton is discussing Karsten Harries's ideas in The Broken Frame: Three Lectures (Washington, DC: Catholic University Press of America, 1989).
- 17 Nanette Carter, interview, New York City, July 24, 2003.
- 18 Mike Savage, "The Costs of Apartheid," *Third World Quarterly* 9:2 (April 1987): 601–621 and Colin Bundy, "South Africa on

Switchback," New Society (January 3, 1986): 7–12, cited in Andre Odenthal, "Resistance, Reform, and Repression in South Africa in the 1980s," in Beyond the Barricades, Popular Resistance in South Africa (New York: Aperture Foundation, Inc., in association with the Center for Documentary Studies at Duke University and with the cooperation of Afrapix and The Centre for Documentary Photography, Cape Town, 1989), 126.

- 19 Ibid.
- 20 Carter in Wilkin, Slightly Off Keel, 3.
- 21 Krauss, The Picasso Papers, 241.
- Paul Gilroy, "The Black Atlantic," in Jana Evans Braziel and Anita Mannur, eds., *Theorizing Diaspora* (Malden, MA, and Oxford: Blackwell Publishing Ltd., 2003), 69, 72–74.
- 23 See Seyla Benhabib, Critique, Norm, and Utopia: A Study of the Foundations of Critical Theory (New York: Columbia University Press, 1986), 13.
- 24 Seyla Benhabib, The Claims of Culture, Equality, and Diversity in the Global Era (Princeton, NJ, and Oxford: Princeton University Press, 2002), ix, 11.
- 25 Benhabib, *Critique*, *Norm*, *and Utopia*, 10–13, 71–72, 98–99, 111, 336–337.
- 26 Ibid., 2-3, 12-13.
- Nanette Carter, telephone interview with the author, August 20, 2003; interview with the author, Sag Harbor, August 24, 2003.
- 28 Nanette Carter, telephone interview with the author, August 8, 2003.
- 29 Carter has identified articles such as "Foreign Oil, a Lubricant of Apartheid" (New York Times, Thursday, March 20, 1986, A 27) by Robinson and Richard L. Trumka, president of the United Mine Workers of America, as one of those that "got African Americans involved with the ANC" (Carter, interview, August 20, 2003). Robinson's articles differed from those of most reporters to the Times, even those favorably disposed to South African independence, in that he clearly and persuasively described the mechanisms of oppression operating in South Africa, the part that many were unwittingly playing in that oppression, and what everyday Americans and not-so-everyday Americans could do to make a difference.
- 30 Carter in "Nanette Carter, Visual Artist," interviewed by Calvin Reid, November 16, 1997, *Artist and Influence* 17, ed. James V. Hatch, Leo Hamalian, and Judy Blum (New York: Hatch-Billops Collection, Inc., 1998), 62.

- 31 Carter, interview, August 20, 2003.
- 32 Carter in "Nanette Carter, Visual Artist," interviewed by Calvin Reid, 62.
- 33 Carter, interview, August 20, 2003.
- 34 Ibid
- Nanette Carter, interview, Sag Harbor, July 26, 2003.
- 36 For the significance in African art of zig-zag forms, see Robert V. Roselle, Alvia Wardlaw, David C. Driskell, Tom Jenkins, eds., Black Art: Ancestral Legacy: The African Impulse in African-American Art (Dallas: Dallas Museum of Art, 1989).
- 37 Benhabib, The Claims of Culture, 13-14. In this, Carter falls on the side of what Benhabib has called the discourse model of variants of contractarian and universalist models of normative validity. The discourse model of "interactive universalism" is able to take into account in its dialogue the particular life-world dilemmas and experiences of its participants without imposing prescribed moral ideals. It considers individuals' needs as well as their principles, the stories of their lives as well as moral judgments. It does not privilege observers and philosophers, but rather considers that all beings capable of sentience, speech, and action are potential moral conversation partners. Only through entering conversation as far as one is able to do so, can one become aware of the otherness of others, of those aspects of their identity that makes them concrete and specific. Since cultural narrative is crucial to the narrative constitution of individual self-identities, claims Benhabib, these processes of interactive universalisms are crucial in multicultural societies.
- 38 Nanette Carter, interview, Sag Harbor, July 26, 2003.
- 39 James Brooke, "3000 Reported Held by Pretoria in Crackdown," New York Times (June 19, 1986), A 1, 10. This is only one among many sources of news about African struggles for justice and freedom that Carter perused in the 1980s. Another article from the Times she read with interest at this time, from Alexandra, South Africa, entitled "Harsh Restrictions and Hostile Protesters Hamper the Press," was published the day before that by Brooke, in section 1, p. 6.
- 40 Nanette Carter, interview, Sag Harbor, July 26, 2003.
- 41 For the destruction of the years between 1983 and the end of 1987, see Odenthal, "Resistance, Reform, and Repression in South Africa in the 1980s," 127–138.
- 42 Carter, interviews, June 26, August 20, 2003.
- 43 Benhabib, Critique, Norm, and Utopia, 347, 348, 315.

FACING PAGE:

Detail from Nanette Carter's Light over Soweto #5, 1989 (Plate 17)

Reign (ing) in Color:

Toward a Wilder History of American Art

IKEM STANLEY OKOYE

other is a provocative idea that marked early assessments of African American art aesthetics. Stereotyped views of color usage by African American artists contributed to a tendency for the art itself to be differentiated on the part of the broader American public in negative ways. The emblematic notion of color was an idea that African American artists attempted to wrest positively from the minds of critics who insisted on defining such qualities in negative terms. But the systematic use of color serves purposes other than surface appearance, and it is interesting the degree to which this aspect of its application has been ignored. To form an argument about color in such contexts without considering this additional function is equivalent to ignoring the role of overlap, extrusion, and separation in an image where the composition is derived from the juxtaposition of hues. A comparison of work by Margaret Burroughs and Leo F. Twiggs presents the opportunity to examine this juxtaposition.

Margaret Burroughs (b. 1917) is a Chicago-based artist, educator, art administrator, and activist who was initially known for genre paintings but later became established for making black-and-white prints. Born in Saint Rose Parish, Louisiana, she attended the Saturday honors class at the Art Institute of Chicago taught by critic and educator Dudley Craft Wilson and painter George Bueher where Charles White was also a student. She later studied at Teacher's College at Columbia University, Northwestern University, and in Mexico City. She was one of the founders of the South Side Community Art Center in Chicago (1940) under the sponsorship of the Works Progress/Work Projects Administration (WPA) and was director and founder of the DuSable Museum of African American Art

FACING PAGE:

Detail from Leo Twiggs's Low Country Landscape, 1974 (Plate 18) (1961).² Her signature prints and paintings are generally informed by observations from routine trips to continental Africa and from African American life in the inner city. Burroughs lives her avidly Afrocentric politics through extensive travel and arts activism, including founding the National Conference of Artists (NCA), and her advocacy for the connectivity of African Americans to Africa.

Her painting entitled Three Souls (1964) explores the sociopolitical implications of skin color and the racially charged innuendoes associated with tonal difference (pl. 19). Burroughs addresses this touchy issue within the African American community that historically deals with degrees of blackness as it relates to complexion. In this context, the safest range is medium brown—being too light or too dark can trigger an undesirable reaction from members of the African American community. Burroughs places the lighter-skinned figure in the center and portrays her with the most pronounced features. Their faces and torsos overlap in a manner that seems to indicate unification—sisterhood. At the same time, the image alludes to dual existence representing the individual self while also representing the group (race), a common experience for African Americans. By title, however, Burroughs affirms their right to their individual selves, but ironically, at the same time, there is the understanding that the surface difference—skin tone—is insufficient in the face of racial classification which essentially renders all coloration ultimately the same—racially defined as African American.

Leo F. Twiggs (b. 1934) does not appear to be what in common parlance is viewed as political or as an outward proponent of direct associations with Africa. He grew up in St. Stephens, South Carolina, a small town where his family dated back to the antebellum era. After graduating from Claftin College, he received a master's degree in art from New York University (NYU) and became the first African American to receive a doctorate degree in art education and criticism from the University of Georgia (UGA, 1970). He established the first art department in a state-supported historically black college, South Carolina State College, admitting its initial

art students in the fall 1973.³ A batik painter, he is best known in the South Carolina context.⁴

Like Alma W. Thomas (1896–1978), Hale Woodruff (1900–1980), and many other accomplished African American artists, Burroughs and Twiggs were dedicated teachers, devoting their early careers to nurturing sustained interest and leadership within the ranks of young students. Perhaps to the detriment of their personal endeavors as practitioners that may well have brought them fame at an early age, both worked for a deeper survival through a reproductive plenitude, contributing to the continual process of art teaching and art making. On the other hand, each artist mastered media that have not always been considered high art, and their color usage is quite different.

Burroughs's Three Souls is derived from an understanding of European (even primitivist) modernist tradition. Albeit in her work the disjunction of color from nature, as well as its interrogations of contemporary social approbia, is focused on subject matter close to home—domestic and diasporic sisterhood or the nuances of skin color and their paradoxical effect. Twiggs, who produces batik images—a technique historically associated with textile arts-identifies different subject matter as crucial and engages another deployment of color. He is certainly not interested in images of an overt Africanicity. Although his series Silent Crossings evokes, formally, the characteristics of collage, its colors are muted over large areas of batik, bringing a wistful, dreamy quality to the subject matter. In Twiggs's work, the moments of color stand out like beacons in a fog, drawing a viewer's attention toward particular zones of activity, where the issues he chooses to explore, social anxiety and social memory, might easily congregate. There is a difference, more than simply in terms of a generational separation, that might be traced across broader landscapes of African American art.

A DIGRESSION, EUROPE

The tracks were laid in Europe in the 1880s for the ultimate theoretical alliance of color with the primitivism of early modern art in France and Germany. Beginning at

that time, the meaning of color underwent a radical change in European art that involved the detachment of the expressive power of color from its primary connection to reality.⁵ It is therefore not surprising that a certain vividness, density, and dazzling juxtaposition of color became increasingly attached to artistic wildness, as is evident beyond France in the work of German Expressionist artists such as Emile Nolde and Ernst Kirchner. And, given the role Africa was recruited to play in the consolidation of primitivism in such places, it is not surprising that dramatic color would be associated with being African by American-born artists of the diaspora and within the context of Western art history as discipline.

Such things would be of no particular import to the history of African American art were it not for the wellknown fact that African American artists of the first and second public generations invariably traveled to Europe, as did their Euro-American compatriots. 6 The purported aim was always to expand artistic horizons. Though many of these artists already had some notion of what a specifically African American art could be (in its imaginable difference from a white American art), French and German art, in conceptualizing Africa within the primitive, seemed to offer ready-made templates for artistic identification and subjectivity.7 Many years after being initially validated in avant-garde European practices, these patterns were adopted contextually by African American artists in ways that suggest a kind of wish fulfillment with potentially troubling dimensions.8

THOUGHTS ON A HISTORY OF COLOR

From the beginnings of the modernist era to the present, color, as well as its absence, has functioned as a significant political metaphor in African American art. The work of Norman Lewis (1909–1979), Adrian Piper (b. 1943), Robert Colescott (b. 1925), Houston Conwill (b. 1947), Kara Walker (b. 1969), and many others attest to the new and unprecedented ways in which color is manipulated and explored. Nevertheless, the metaphoric usages of color identifiable in the work of these artists and their peers needs to be given a more meaningful scrutiny, particularly within the narrative of African American

art. Specific works by Twiggs and Burroughs are used to briefly introduce discussions of a history of color in African American art, paying careful attention to the artists' locales, an aspect typically omitted from the recent plethora of publications on African American art.

Color in art rarely acquires an indexical value that is consciously related to a race-based subjectivity. That is, a broad survey of Western art history will hardly reveal that artists consistently employ color as a self-racializing language, one, for example, whose syntactic and semantic possibilities trace how the artist positions himself or herself as subject, whether in the capacity of a professional or private autobiography. 10 Yet, this is what the colorfulness of artistic images most typically evokes in the history of African American art precisely in its emergence, and to the extent that it lives a temporarily separated existence from the broader context of American art. Examples include the insistently color-studied work of Alma Thomas and Romare Bearden (1911–1988), and the dazzlingly color defining AfriCobra, both in their development out of the Committee of Bad Relevant Artists (COBRA) and in their separateness from the earlier European group CoBra (pl. 20) with which they share some ideas and concerns.11

Interestingly, in no sense were artists riveted by a concern with the meaning of color-of materials, or of the representational images that arise from them-beyond its perceptual and constructional qualities in the work of the pioneer artists of "that class of Americans called Africans."12 In other words, there were many artists who either fled from the oppressive discomfort of a racialized American polity, or became political activists working toward liberation from racism. Sometimes both tactics coincided in the biographies of the same individual.13 There is little in the oeuvres of black artists that would produce a sustained, convincing argument for the play of color as pigment with the play of color as a euphemism for racialization. For African American artists, apart from the emblematic quality of color in art, neither color itself, nor the structure of its relationships, nor its character as one of many media open to an artist's manipulation, were ever particular arenas of rhetoric through which to explore the racialized politics

of America. Instead, and to the possible advantage of other purposes, colorfulness came to be appropriated in particular ways as a means by which African American artists constructed their own particular subjectivities.

COLOR AND DIFFERENCE

There is an advantage to exploring the issue of color in the work of artists who, though well known in their particular locales, have yet to be acknowledged nationally in the manner of such individuals as Jeff Donaldson, Adrian Piper, or Kara Walker. In the example of Jeff Donaldson (b. 1932), we understand that, working in the context of AfriCobra, it became possible to formulate a manifesto in which several issues, color among them, were articulated with clarity and precision. It would therefore be possible, given this and the very name AfriCobra itself, to understand that Donaldson was probably aware of a European movement predating the one he founded in Chicago. The European group CoBra revived some aspects of primitivism that rhetorically rendered recuperation of an imagined Africa in an appeal, once again, to African Americans in a way that would not have been the case in the years after WWII reading Picasso or Alain Locke.

Given European CoBra's construction of a color theory where art labeled primitive was once again pressed into service, and given the group's interest in jazz, Donaldson's concerns, like European CoBra's, relocated to the particular political culture of post-civil-rights Chicago, and to the naming of AfriCobra in its formation. Whether considering Jeff Donaldson's work or its variation in the 1980s work of fellow members Wadsworth Jarrell (b. 1929) or Michael D. Harris (b. 1948), AfriCobra, like CoBra, revisits the question of connection to the art of African ancestors engaged in New Negro era art, especially the manner of its association with vividness, complexity of color rhythm, and stark color juxtaposition to both Africa and to jazz. In a sense, what was later theorized as a blues aesthetic—an aesthetic sensibility across all kinds of artistic media structured by African originated cultures wherever they reside14—was already a working hypothesis with AfriCobra.

Contra AfriCobra, Africans were no more enamored with color than other groups historically; and the fusing of the identity "African" with a penchant for color is not unlike the common fusion of rhythm with African-ness that reflects a troubling racialized thinking. What is important, however, is the fact that in searching for difference, African American artists imagined an Africa that was relevant to their art making, and therein, responded to color. Color in its wildness—not being fixed, tied down, predictable, or controllable in its effects—came to be granted a crucially important role that produced a style and aesthetic both distinguishable and noteworthy. This historical fact can hardly be in dispute, even if its theoretic of the blues can.

ANOTHER STORY FOR COLOR

How might the concerns and issues previously expressed have played out in the larger community of African American artists, especially to those residing in locations other than major cosmopolitan spaces such as New York and Chicago since 1968? In what ways might such rhetoric have resonated, or not, in South Carolina or Georgia; and how might the contextual nuances read in such suggestions for writing a history of African American art into American art history?¹⁵

The work of Leo Twiggs lends itself to an exploration of this issue. ¹⁶ Although Twiggs spent several years working in New York under the tutelage of Hale Woodruff in the heyday of the New York school and of abstract expressionism, his experiences before and afterward seem squarely rooted in the rural South. Residing in a small town, his father died when he was fourteen, which led to Twiggs caring for his younger siblings—a sister and five brothers—while his mother worked. At that time, it seemed unlikely that he would receive the educational support and training to pursue art—a career path thought to be highbrow and unattainable. Nonetheless, Twiggs managed to earn three academic degrees.

Woodruff, who was a central figure of the New York group Spiral at the time, espoused methods, approaches, and aesthetics of abstract expressionism that increasingly focused on a rhetorical African symbolism. He exposed Twiggs to directions of American modernism,¹⁷ particularly investigations of the alliance between abstract expressionism's democratic American-ness and the idea that the only true American music form was jazz. Twiggs recalled that Woodruff was not enthusiastic about his initial work. According to Twiggs, there was an incident when the likelihood of his successfully completing the program at NYU was assessed and, after a moment's hesitation, Woodruff commented, "He is really coming along." ¹⁸

Twiggs regarded Woodruff's response as merely a general statement on his progress. However, it possibly indicated that the two had different interests. Woodruff, as a central figure of the Spiral group, explored means to achieving an intense absorption of Africa and its art into his work. Considering Africa the source of his creative ancestral models, he created protest paintings that relied on African-derived concepts of representation, rejecting the classic European example. Twiggs, on the other hand, having originated in the South where connections to Africa were more intrinsically paired with nuances of common, everyday life, made no direct references to Africa in his work.

Contrarily, by 1910 and continuing through the New Negro/Harlem Renaissance era and beyond, a distinctive, urban phenomenon evolved in African American art aesthetics rooted in Africa that was inseparable from a certain politics of identity, even without getting into the legitimacy of its particular arguments. During the civil rights movement many artists rallied around a cultural and political sense of blackness and the Alain Locke/W.E.B. Du Bois views of ancestral legacy in art. ²⁰

Woodruff's comment on his student's progress may also suggest that Twiggs was very close to adopting some of the ideologies of the New York school's brand of abstract expressionism. Twiggs, aged twenty-seven when he started his two-year study at NYU, moved toward a greater deployment of color and less reliance on figurative references in his work during his stay in New York.

Unlike Margaret Burroughs, who left Louisiana in the 1930s and settled permanently in the academic and art communities in Chicago, Twiggs returned south upon the completion of his master's study, joining the faculty at Orangeburg and electing to examine definitive aspects of regional culture from the local perspective. Moreover, he conducted the investigation using unconventional materials—painting on batik. Although the production of dyed images on fabric might be associated with modern West African art, particularly the Oshogbo school of Nigeria in the early 1960s, Twiggs linked his work historically with practices of ancient Egypt. His departure from canvas as such in favor of explorations in painting based on methods connectible to Africa is significant. However, it is his choice of subject matter and the negotiation of objectivism/non-objectivism involved that distinguishes Twiggs's imagery from larger trends in American art.

FADING CONFEDERATE COLORS

Most of the work of premiere first-generation African American abstract expressionist artists such as Woodruff, Charles Alston (1907–1977), Romare Bearden (1911-1988), and Norman Lewis (1909-1979)—who was the only African American artist considered a participant in the movement from the start-identified with their racial selves.21 Lewis, perhaps more emphatically than the others, tended to do so through direct links to the activism of the civil rights era, often reiterating this fact with his titles. All successfully explored figurative abstraction in their progression toward this more improvisational style and retained an association with African art in their work. Twiggs's work did not reflect the same interest in African imagery, turning instead to the very pressing matters affecting the daily lives of people of African descent in the 1960s Carolinas. As he engaged in doctoral work at the University of Georgia, making the necessary drive between Orangeburg and Athens, Georgia, for a period of years, and experienced the travails of the civil rights struggle, he formulated the artistic ideas that would surface in the early 1970s in a distinct exploration of Confederate iconography.

Passing through a number of small, conservative southern towns during his routine commute, he observed the nostalgic lure of Confederate symbols throughout, signs and symbols that later emerged recognizably in

his most abstract, nonfigurative work. In so doing, he possibly addressed the impact of returning to his home state and experiencing a new ambivalent sense of estrangement and alienation prevalent in the daily function of African American life. He witnessed racial violence firsthand in 1968 when three students were killed and twenty-seven others were wounded when state troopers fired on demonstrators demanding desegregation of Orangeburg's only bowling alley. Called the Orangeburg Massacre, it was the first in a series of confrontations between students and troopers across America's university campuses; only one other, at Kent State University in Ohio, involved the death of students.²² While the death of white students in the Ohio protest made national headlines, the earlier tragic deaths of African American students in South Carolina received little attention. Later that same year, the incident was overshadowed by the assassinations of Dr. Martin Luther King, Jr., and Robert Kennedy. It is interesting to note that Cleveland Sellers, a Danish professor who was among those wounded during the Orangeburg incident and subsequently imprisoned for inciting the riot, was a fellow countryman to a founding member of the European CoBra group, an organization astutely opposed to all forms of fascism.

In this milieu where actual sociopolitical representation was an issue over which people were murdered, Twiggs was conceivably less interested in the art theoretical explorations of the New York school and the Africanistic color-coded references to which he was exposed in Chicago at the Art Institute and at NYU. Such issues may have seemed overly idealistic, mandating a careful attentiveness to the politics of everyday life, directly and indirectly, to Twiggs as an educator and a witness to turbulent events of national importance. This is not to say that Twiggs's work lacked a political edge. However, his work moved away from a kind of idealism that differentiated it from the previous generation's desire for connectivity to Africa.²³

Twiggs's batik paintings stand out initially as images assembling forms, colors, and textures in particularly thoughtful and engaging ways. His symbolic use of color and its interaction with the signs and symbols ex-

tracted from the southern landscape function as markers of physical and other realities. One of the most commonly applied symbols in his work is the large X. The potential meanings for the sign are numerous and varied. It may refer to the Confederate flag and its role as a pervading remnant of the Civil War South. It may signify Malcolm X, in which case the "X" iterates the namelessness and separation of African Americans from their ancestral lineage due to slave ownership. It may call to mind the use of the "X" as a substitute for the signature of those who could not write, and more poignantly in the context of slavery where African Americans were legally denied the right to learn to read and write. The "X" might reference the railroad—a frequent historical definer of racial boundaries and barriers in countless communities across the country, and also being an important means of relocation for blacks from the South to other regions. The symbol may represent any number of decisions, impasses, crosses we bear, namely, any crossroads in life including death. It may allude to X-files or "X" marks the spot. Many of these and other possible references can be read in his work dating back to a Confederate Flag series from the 1970s. The imagery tends to be deceptively quiet and calm on one hand, yet potentially explosive in its referencing Confederate ideology as subject matter and the tensions it continues to produce and sustain within American society and its cultures.

Although Twiggs accepts the range of symbolic resonance of the cross as crossroads, the driving signification rests with the questions and anxieties still raised by southerners who, well beyond nostalgia, re-energize the meaning of Confederate paraphernalia as they invoke meaning for the Confederate flag's cross. Twiggs's observations and experiences during commutes to Athens apparently brought him to an exploration of this issue. Nostalgia for an old South was palpable, almost as if such valuation could expel the memory of the slavery upon which it was based. Twiggs became increasingly interested in the durability of certain images and the symbolism attached to them.

Of course, being a descendant of those enslaved in the very vicinity of places revisited is significant. Even the physical act of drawing and redrawing, painting and painting over the very forms of these symbols can hardly be benign. Repetition has a way of reinforcing meaning, but it can also diminish its symbolic impact, especially being reproduced by those most aware of this history, namely, its victims. Twiggs is therefore aiming at a kind of subversion, one whose political force cannot, once informed, be easily lost. "Crossings can be impediments that we all come in contact with. Maybe we don't even talk about them . . . we internalize and endure it silently. Life is a series of crossings; Death, being the final crossing."24 Twiggs's work, especially in the context of the more recent controversies surrounding Confederate flags in southern states, is understated, artistically innovative, and politically charged. This work, in its constant dissimulation of the symbols and everyday objects of the Confederacy, effectively subverts the singularity of meaning that is, in the southern context, both the key to its communication and its disturbing power.

As for color, Twiggs's work does not by any stretch of the imagination approach achromatism. Nevertheless, he avoids any assertive use of color to metaphorically relay notions of blackness as theorized in the concept of a blues aesthetic. Teri Tynes surmised that among the issues with which one might surround the narrative of art by African Americans is one centered on the problematics of color, as well as the import from popular culture of positive attitudes toward brightness and even "shine." ²⁵ It is not that Twiggs rejects color; rather he found richness to be more effective than intensity of color.

In Low Country Landscape (1972), an atmospheric portrayal of deep pastels hovers over a simple terrain with a vague form of a tree and tiny smatterings of textures and light toward the right of the image. A thin, slithering light blue line horizontally intersects the picture plane bringing with it any number of possible interpretations. Typical to Twiggs's style of symbolic application, the linear element may signify a body of water such as a lake, river, or creek. It may represent the horizon, refer to a heightened vantage point (looking down into a valley), or be a metaphor for a passageway—a path, trail, road, or train track. Its overall pinkish

coloration with earthy undertones is reminiscent of daylight filtering through a partly clouded dawn or dusk sky. The deep-rose-colored tree is presented almost like a huge bloodstain, emerging in isolation as yet another potential object whose southern role is pointed and paradoxical. While trees were associated within many positive contexts, there was the horrific linkage to lynching. In the vocal lines of singer Billie Holiday, "southern trees bear strange fruit, blood on the leaves and bloody through, Black bodies swinging in the southern breeze, strange fruit hanging from the poplar trees." The most intriguing aspect of Twiggs's batik paintings is its irony. Laced within his soft-hued, gently rendered narratives of the region's landscape, Twiggs's palette constrains the wildness of color,26 an approach confirmed earlier when he painted old, faded, discarded Confederate flags as if to insist on the representation of decayed, forgettable ideas. The final effect is a form of restful harmony, perhaps, in anticipation of the calm of the American democratic ideal advancing as Confederate ideas recede. And unlike those (such as Burroughs and Woodruff) whose work was more overtly political, Twiggs retained the naturalness of color to its related form.

What does Twiggs's trajectory mean within the history of African American art and its relationship to color? How does it relate to other artistic practice? Does it provide a means to clarifying the construction of African American art history and other means to approaching issues of color? Can it enable its inevitable insertions within American art history more singularly and more broadly? A reasonable response is that Twiggs's work does provide such means. His work successfully appropriates the ideological concept of the blues aesthetic in the spatial context of the southern (metaphorical) landscape, affirming that, like the concept of race itself, it is a reality. But are there conceptual boundaries? Do the same possibilities exist purely within the context of other regions? Although any history of color in African American art would explore the evolution and application of a blues aesthetic as it maps its spatial dispersion and reach,27 it would also have to produce historical logics outside of such bounds.28

- I See James J. Winchester, Aesthetics across the Color Line: Why Nietzsche (Sometimes) Can't Sing the Blues (Lanham, MD: Rowman & Littlefield, 2002)
- 2 Margaret Burroughs initially named the Chicago museum the Ebony Museum of Negro History and Art.
- 3 South Carolina State College was known earlier as the Colored Agricultural and Mechanical College. It embraced the philosophy of Booker T. Washington, emphasizing practical training.
- 4 See Frank D. Martin, "Introduction," *Cultural Reflections: Twenty Years of the Visual Arts Tradition at South Carolina State University* (Orangeburg: South Carolina State University, 1998).
- 5 Color, and its manipulation, has, of course, been central to visual representation for as long as have images been projected externally (on to surfaces or objects). There are ways of understanding the history of West European art, and perhaps of all art, in terms of a progressively sophisticated interest in, and ability to theorize color and (in practice) modulate tones, shades and values in the production of a simulacra for reality (or at least of the human perception of it). This is especially so given the historical relationship in the West between visual representation and external reality (very different of course in say African or Pre-Columbian art of the Americas). Although, in West Europe, the new idea of color was most evident in impressionist and neoimpressionist art, it was perhaps taken to its most fluid and poetic conclusion in the work of the Parisian fauves.
- 6 Teresa A. Leininger-Miller, New Negro Artists in Paris: African American Painters and Sculptors in the City of Light, 1922–1934 (New Brunswick, NJ: Rutgers University Press, 2001); and Jody Blake, Le Tumulte noir: Modernist Art and Popular Entertainment in Jazz-Age Paris, 1900–1930 (University Park: Penn State University Press, 2001).
- 7 Richard Powell, "In My Family of Primitiveness and Tradition; William H. Johnson's 'Jesus and the Three Marys'," American Art (Fall 1991).
- 8 In early modern Western thought, as evidenced in the various national Romantic movements, color came to be associated with emotionality where line, regarded in some instances as superior (Quatremère de Quincy), was associated with intellect and reason. It is this logic that later comes to govern, perhaps unknowingly, William H. Johnson's public self-representation and trajectory, much as Henry Tanner may have disapproved of it.
- 9 Ann Gibson, "Black Is a Color: Norman Lewis and Modernism in New York," in Norman Lewis's *Black Paintings*, 1946–1977 (New York, Studio Museum in Harlem, 1998), 21–22; and Ikem Stanley Okoye, "Shamanic Penumbra: Houston Conwill's Art of Color," *New Observations* 97 (September/October 1993).
- There is something remarkable about this in fact, given that the profession of artist has not, until relatively recently, been a particularly status-granting one, and that many artists reputable within art history, from Lissitsky, Picasso, and Picabia backward, operated in contexts of intensified ethnic differencing or in con-

- texts that would have marked them as different—milieu and experiences that today would likely be racialized.
- II It is fortunate in a sense that this reassessment is possible at this moment in time, since CoBra is, as I write, receiving new press in Europe through a traveling exhibition that represents the history of the group. CoBra certainly produced a manifesto of sorts, and among its important focuses is that gathered around making art accessible to a wider, non-elite culture (CoBra was Marxist in its orientation), and which in part involved a less ascetic approach to art making than was the case for abstract expressionism to which their lineage reaches back (CoBra's birth in the aftermath of the trauma wrought by Nazi Germany on Europe's self-identity is comparable to AfriCobra's concern with "relevance" given its birth in the civil rights era response to segregation and its traumas); a return to art's mythical potentiality (contrary, for example, to a certain modernist code); and CoBra's deployment in this regard of a lively color palette reinforced over time by the groups' interest in jazz (Karel Appel, CoBra's most prominent artist, visited New York in 1957, six years after CoBra had been declared defunct by its members. Yet Appel's engagement with the jazz scene [he painted portraits of its musicians] reveals an interest earlier than this moment, and that music historians understand as pervading the cultures of western Europe especially in the aftermath of American culture's influence through the presence of GIs [although in this regard in ways distinctly removed from either its cubist/expressionist and surrealist appropriations]). See for example, Karel Appel: Rétrospective, exh. cat. (Nice: Poinchettes-Art Contemporain, 1987). Also Karel Appel: Recent Paintings and Sculpture, exh. cat., essay D. Kuspit (New York: del Re Gallery, 1987). Alfred Frankenstein (with M. McLuhan and J.-C. Lambert), Karel Appel: Works on Paper (New York: Harry N. Abrams, 1980).
- 12 As Lydia Maria Child put it succinctly in a very different context (I refer to the title of her influential book, *An Appeal in Favor of That Class of Americans Called Africans* [Amherst, MA: University of Massachusetts Press, 1996]).
- 13 Edmonia Lewis, Henry Ossawa Tanner, Augusta Savage, Lois Jones, William H. Johnson, and Elizabeth Catlett might number among the well known.
- 14 E. Elthelbert Miller, "Black and Blue: Toward and African Aesthetic," and Wanda Coleman, "A Second Heart," in High Performance (Winter 1992): 22–26. The idea is theorized with greater sophistication in Barbara A. Baker, The Blues Aesthetic and the Making of American Identity in the Literature of the South (New York: P. Lang, 2003). Richard Powell edits a series of skirmishes with its central notions, some located within black visual art specifically (see Richard J. Powell, The Blues Aesthetic: Black Culture and Modernism [Washington, DC: Washington Project for the Arts, 1989]).
- 15 This was already recognized in a 1990 exhibition and its related catalogue, although the focus was on artists of a generation after Twiggs. Next Generation: Southern Black Aesthetic (Winston-Salem, N.C. Southeastern Center for Contemporary Art, 1990).
- 16 Twiggs's one-person show is mounted at the Georgia Museum of Art in Athens in the winter 2004 and will travel nationally for three years.

- 17 Woodruff, one of the central figures of African American art history, experienced part of his early career in Atlanta where he organized a crucial exhibition in 1942 that engaged African American artists nationwide. From the beginning, Woodruff's paintings pushed the limits of color application and contrast while maintaining a sense of visual harmony. By the time he joined the circle of postwar New York artists exploring the possibility of an American modernist art, he, unlike some of the central figures of abstract expressionism, sustained an interest in an expressionist art that although abstract, remained organized around distinctive symbolism of African origin (see Helen Shannon, ed., Hale Woodruff: Fifty Years of His Art [New York: Studio Museum in Harlem, 1994], 36). Woodruff intended to create a visual anchor that allowed his imagery to be abstract yet remain easily readable and accessible to the African American community. Although he developed a tendency over the years to use contrasting areas of color against unified signature tones (for example, the grey-green in Torso and the earthy reddish brown in Celestial Gate), this approach cannot be plotted as a coded narrative on color (race) nor marked as intentionally African. His work can be narrated as a politics of Africanicity in the sense that its resistance to the extreme forms of fluidity and boundlessness that defines the abstract expressionism of Rothko or Pollock was blocked by symbolic forms derived from African examples in the work of Woodruff, and with a legibility that was guaranteed by color. (Woodruff was undoubtedly interested in African art throughout his career as he was also interested in the concept of modern African American art that might connect Africans in America with continental Africans, as evidenced by his participation in the Dakar FESPACO exhibition and his contributing to the show's catalogue.)
- 18 See Elton C. Fax, Black Artists of the New Generation (New York: Dodd, Mead & Co., 1977), 339.
- 19 For a brief and succinct challenge to this thinking see Elizabeth Mudimbe-Boyi, "Harlem Renaissance and Africa: An Ambiguous Adventure," in V. Y. Mudimbe, ed., The Surreptitious Speech: Présence Africaine and the Politics of Otherness, 1947–1987 (Chicago: University of Chicago Press, 1992).
- 20 Henry Louis Gates, Jr., ed., "The Art of the Ancestor," "Enter the New Negro," and "The American Negro as Artist," in Alain Locke and Jeffery C. Stewart, eds., The Critical Temper of Alain Locke: A Selection of His Essays on Art and Culture (New York: Garland Publishing, 1983).
- 21 Ann Gibson, *Abstract Expressionism: Other Politics* (New Haven, CT: Yale University Press, 1997).
- The protest march was a response to an earlier demonstration where students attempted to integrate a local bowling alley and were refused admittance. For more on this incident, see Jack Bass and Jack Nelson, *The Orangeburg Massacre* (Macon, GA: Mercer, 1984, and New York: World Publishing Co., 1970.)

- 23 In this regard, it might be noted, for example, and by contrast, that as recently as 2002, Margaret Burroughs, many years his senior, still makes such a connection central to the very idea of an artistic subjectivity. She continues to travel to Africa in the capacity of artist, recently (and joyously) leading the Fourth International Conference of the National Conference of Artists (the NCA is an American organization) to a major conference held at Cape Coast and Kumasi (Ghana) last July.
- 24 "Hampton III Galleries" Carolina Arts (December 2001) features work by Leo Twiggs.
- 25 The article summarizes an interview about Twiggs conducted with Edward Spriggs, the Atlanta-based curator who, early on, took an interest in Twigg's work, thus: "African-American artists ... might use a color palette brighter and more various than the more muted tones valued by the dominant art culture. There are issues of composition where African-American artists may use a lot of layering, and, ... there is sometimes the quality of brightness or "shine" that artists may bring to their visual work from popular culture." Teri Tynes, "Leo Twiggs and the Icons of Memory," Free Times, 1997 (archived on http://www.freetimes.com/Reviews/art_reviews/twiggs.html)
- 26 An interview conducted with Twiggs in 1997 makes clear that Twiggs is aware that African American artists as a group do not run shy of an unrestrained use of color, a fact that he uses in part to account for its failure to take its rightful place in the history of American art more broadly. In that discussion there was no sense in which he was indicating that his work was therefore any less restrained.
- 27 It would have to discover who and what were its channels, and where located were those cultural spaces that were "resistant" to it. For example, having described Twiggs's work in the manner I have, it is also the case that a younger southern artist, Tyrone Geter, so many years after AfriCobra, can still produce work which like his own specific claims to Africanness (Geter's being more merely than a birthright, because he spent close to eight years living and teaching as an artist in Nigeria). What accounts, in other words, for its longevity?
- 28 As such, it would also have to explain, remaining within the realm of painting, both Robert Colescott's highly colorful images deployed in the service of an idea not too far from Kara Walker's miserly, almost misanthropic relation to the same medium. There are ways in which Walker's art derives in fact from Colescott's, and what is striking is, nevertheless, that Colescott's subscribes to the wildness of color (even if he does so with a degree of wit), while Walker's wit/irony does without it completely (although there are clearly ways in which her earlier work might be connectible to the monochromatics of Aaron Douglas's oeuvre).

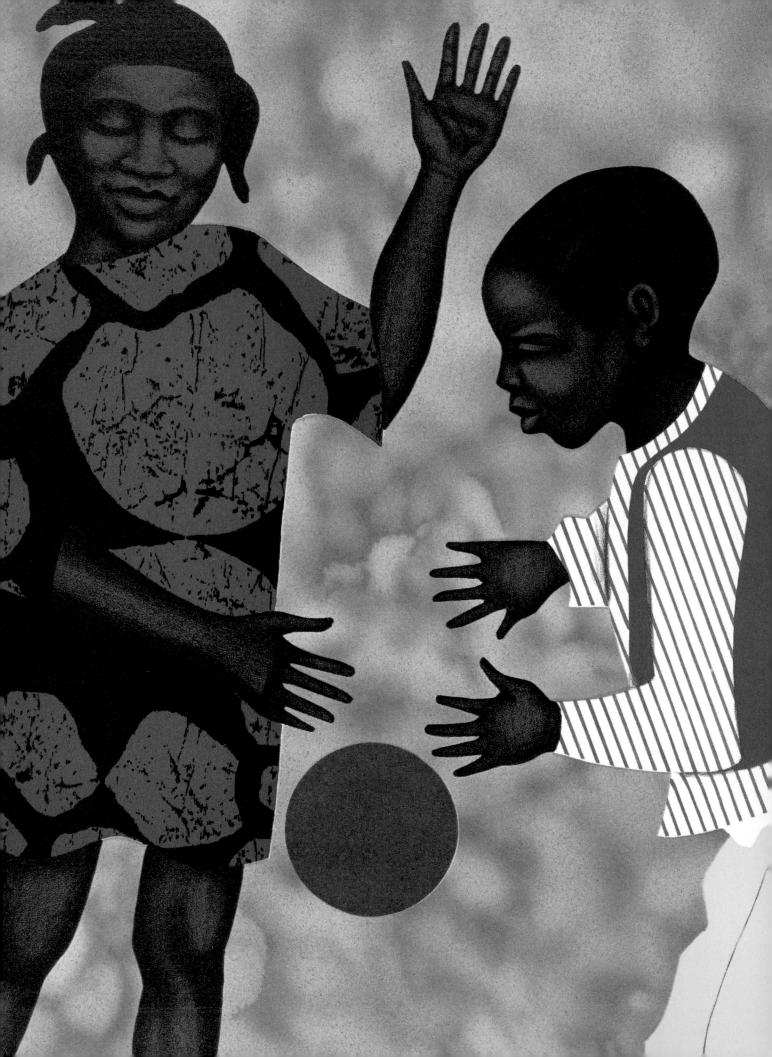

On the Surface:

Color, Skin, and Paint

MARCIA R. COHEN AND DIANA McCLINTOCK

OLOR IS INHERENTLY PARADOXICAL: THE CLARITY OF ITS PRECISE scientific measurement opposes the ambiguity of its elusive associa-I tions. Visible color has been understood as the result of known and measurable wavelengths of light since Isaac Newton's experiments with a prism in the late eighteenth century; however, scientific measurements of color fail to explain its ability to communicate by analogy. Any color is omnidirectional, and can elicit multiple, often contradictory associations. For example, yellow badges marked Jews in Nazi Germany, but "high yellow" identified the desirable pale skin shades of mulatto women in early twentieth-century America. Although blue conjures up favorable thoughts of clear skies and good weather, the ancient Romans denigrated the color blue and associated it with death and the underworld. Blue eyes were considered a sign of bad character, indicating loose morals in women. Everyone knows that the blue base of a flame is hotter than its yellow or red tip, and yet yellow and red are considered warm colors, whereas blue is considered cool. In his comprehensive examination of the use and significance of color throughout history, John Gage notes "colour is within the experience of almost everyone. . . . But, of course, artists have a special way of seeing colour and a special way of presenting what they see." Esteemed painter, teacher, and color theorist Joseph Albers wrote, "If one says 'Red' (the name of a color) and there are fifty people listening, it can be expected that there will be fifty reds in their minds. And one can be sure that all these reds will be very different."3 The architectonic arrangement of color and proportion in Alvin Smith's Untitled (1985) references Albers's systematic explorations of color perception. Smith's use of blue envelops the space. Yet the nature of his oceanic expanse of cool blue is transformed by the splash of warm red in the upper left, which alters the typical spatial reading of advancing warm and receding cool colors.

FACING PAGE:

Detail from Elizabeth Catlett's Girl/Boy/Red Ball, 1992 (Plate 21)

Since the beginnings of recorded history, humans have pondered the nature and meaning of color. In the fourth century BCE, Aristotle identified colors as properties of lightness and darkness, blue and yellow comprising the opposite ends of the spectrum. He elaborated the theory of his contemporary, Plato, who hypothesized that color vision results when processes originating in the eye interact with rays emitted from objects. Accordingly, the perception of color is a property of vision, not an inherent quality of objects, produced by the interaction of certain qualities of the object and the perceiving subject.4 Two thousand years later Isaac Newton discovered that the visible color of an object results from reflected light. Reporting to the Royal Society on his experiments with a prism in 1672, he identified colors as "original and connate properties" of rays of light, not qualities of objects.5 Although Newton sought objectively to quantify his theory of color, and to eliminate the subjective, unpredictable factor of human perception and interpretation as much as possible, his research failed to account for variations in the appearance of identical colors under different circumstances among different individuals—the subjective effect of color phenomena that had been studied by dyers and painters since antiquity. Seizing upon the shortcomings of Newton's theory, a century later the German poet Goethe adopted a vehemently anti-Newtonian stance in his opposing theory of color, Farbenlehre, of 1810. Not surprisingly, many of Goethe's ideas were initially informed by conversations with artists and experiences of art during Goethe's Grand Tour of Europe in the 1780s.6 Unlike Newton, Goethe investigated optical effects at the boundaries between two colors, after-images resulting from the prolonged perception colors, and the apparent changes in colors when viewed through various mediums and lighting conditions. Significantly, he used himself as the perceiving subject in many of his experiments, allowing the subjective dimension of color perception to become a very real factor in his ultimate conclusions. In this way Goethe drew attention to the psychological effects of color. In simplest terms the differences between Newton's and Goethe's respective theories of color represent the objective, scientific approach

versus the more philosophical, subjective orientation—the scientist versus the poet.

Interestingly, in their treatment of color as either a property of light or a perceptual phenomenon, both Newton and Goethe emphasized that color was not an intrinsic quality of objects. Yet most people regularly consider the color we perceive to be a physical property of the object of perception, an assumption that enables the practice of "color coding." Dictionary.com defines a color code as a "system using colors to designate classifications."7 Color coding appears throughout nature. For example, the deadly coral snake is distinguished from the harmless king snake only by the order of the colored stripes on their red bodies: "Black and yellow, dangerous fellow; yellow and black, pat him on the back." Colorful displays of certain orchid varieties that imitate female insects in order to seduce male insects and ensure pollination exemplify deceptive color coding that guarantees survival. Conspicuous color enables animals to communicate. The yellow and black pattern of stripes on a bee or wasp, for example, bodes a poisonous sting or an unpleasant taste. Deftly colored camouflage conceals both prey and predator by mimicry, mimesis, and deception, as demonstrated by the octopus that swiftly assumes a wide range of colors to match its surroundings, or the zebra whose distinctive black and white stripes create confusing patterns that make it difficult to discern when moving within its habitat. Howardena Pindell's points of color in *Untitled #35* (1974) (pl. 22) similarly create chromatic confusion. Bright dots punched from multicolored (hand-painted) paper (canceled checks) mimic the pixel-like flat surface of a pointillist painting. Pindell's space is literally constructed of layers of polychrome particles, creating an elusive push and pull in both two and three dimensions. In another act of mimicry, Pindell camouflages, and thus conceals, the original appearance and surface quality of the material—checks—by altering its color with paint and its form by hole punching that imitates dots and is reassembled as a multihued field.

In human culture, color coding has long been a strategy for identifying and marking groups of people or individuals. Colored flags and pennants identify nations and

athletic teams. Heraldic colors have traditionally established family lineages and legitimized ancestral claims. The bold geometry of James Little's *Countdown* (1981) indexes the symbolic ordering common to emblems and banners (pl. 23). His juxtaposition and placement of color and pattern forms a gestalt, like a flag, that can be read with immediacy.

Color coding can alternatively ostracize and condemn. Hester Prynne is forced to prominently display a scarlet letter A on all of her clothing, forever marking her sin of adultery in Nathaniel Hawthorne's *The Scarlet Letter*. Jewish citizens of pre-Nazi Germany believed themselves to be part of the indigenous culture until the imposition of yellow badges singled out their difference. Color coding also organizes peoples' perceptions of each other: perceived differences in skin color become linked to recognized color codes that denote qualities or characteristics attributed as intrinsic to those people. Local color, indigenous color, is understood in metaphorical terms.

The coding of skin colors historically has involved locating an individual skin color within an imagined range of tones that are organized into a system, like a map of color space. At certain times in certain cultures, skin tones at different ends of the spectrum have been considered desirable. In nineteenth-century Europe, for example, lighter skin was desirable as an indication of social class because the wealthy didn't have to work in the sun. Women went to extremes such as risking death by eating arsenic in desperate attempts to lighten their skin. In 1929, however, the trendsetting fashion magnate Coco Chanel proclaimed that a "girl must be tanned," and by the 1970s teenage girls commonly basted their skin with baby oil in an attempt to accelerate the effects of the sun and achieve a sought-after deep bronze tan. In these and similar examples, skin color is visualized by human society as a palette of gradations of darkness and lightness, organized by desirability.

For the painter, the palette is also a system, like a color atlas, from which everything is generated. The term "palette" describes both the physical object upon which the painter blends paint and the range of color

that characterizes an individual work. In his historical account of the artist's palette as both a tool and a system of organization, John Gage notes that from the eighteenth century, artists' palettes revealed an increasingly personal range of choices of color and color organization, and also reflected prevailing tastes and societal attitudes.9 Charles A. Riley has observed, "The palette holds colors in a natural order that bears a strong relation to the internal order of the work of art."10 It can be argued that social codes embedded within human societies similarly position skin color in an order that bears a strong relation to the internal order of each society. Comparing the color chart, spectrum, and palette as spatial organizations or maps of color, Riley continues: "All three maps are surface arrangements for selection and organization; but the spectrum is a natural order, whereas the palette's main rule of organization depends on usage. Customarily, the most frequently used color is given a bigger, special place on the palette, just as the typesetter's case has a large box of frequently recurring letters close at hand." I Through their prominence on the palette's surface, the colors most favored by the artist are revealed, as is the case within the social hierarchy where the colors most favored by a society are also indicated through their prominence.

Riley has observed: "The first thing to realize about the study of color in our time is its uncanny ability to evade all attempts to codify it systematically. The sheer multiplicity of color codes attests to the profound subjectivity of the color sense and its resistance to categorical thought." On the first page of his famous study *Interaction of Color*, Joseph Albers wrote: "In visual perception a color is almost never seen as it really is—as it physically is. This fact makes color the most relative medium in art. In order to use color effectively it is necessary to recognize that color deceives continually. To this end, the beginning is not a study of color systems. . . . First, it should be learned that one and the same color evokes innumerable readings."

Color is a vitally important property in the biological and cultural realms. Art historian David Hilbert asserts: "The perception of color must have some utility

since the only higher organisms that lack sensitivity to color are those whose nocturnal lifestyles make the perception of color very difficult."14 Color affects every aspect of human life. It is a visual illusion that is perceived, conceived, and interpreted. Color coding enables recognition and identification in nature, classification, naming, and marking in human society. In The Descent of Man (1871), Charles Darwin noted, "We know that the color of the skin is regarded by the men of all races as a highly important element in their beauty."15 Partially as a result of the civil rights movement, Crayola renamed its "flesh" crayon "peach" in 1962, and in 1999 "Indian red" was renamed "chestnut" because children wrongly perceived that it represented the skin of the native North American.16 In the early 1990s, the company introduced its new line of multicultural crayons that featured a wide array of skin tones. As Phillip Ball observes in his comprehensive study The Bright Earth: Art and the Invention of Color, "there are no culture-independent concepts of basic colors."17 As early as 1969, in their seminal study of color and language, Basic Color Terms, Brent Berlin and Paul Kay established that all languages contain terms for black and white, and that if any language contains a third term for color, it contains a word for red. 18 This suggests that there are certain predispositions toward color naming that are common across all human societies.

In the realm of the human body, skin color is a complex socio-biological phenomenon fraught with racist and culturally determined associations. Skin is the boundary between the interior and the exterior, between self and world, and skin color becomes the surface that names and marks the individual. People can be classified and ordered according to schemata of color, symptomatic of a human impulse we can call the tendency to tabular thinking . . . in the case of color, the tabular approach is often hierarchical and prescriptive. In this way a palette of human color emerges, selected according to subjective impulses and cultural perceptions.

In David Driskell's mixed-media image, Woman in Interiors (1973), the figure of a woman sits calmly and, from a patchwork of floral patterns, spectral colors, and disrupted space, gazes resolutely past the viewer. Her solid figure is integrated with the fabric of the collagelike surface, and the fractured space of pattern and color effectively obscures the boundaries of her form (pl. 24). Yet her centrality establishes her as a distinct part of a fragmented whole. Flat, geometric color swatches are seemingly ordered around the woman, ranging from primaries to secondary and tertiary colors, creating an aedicule of color in which the vibrant figure is enshrined. The brilliant colors are reflected in the varied and glowing tones of her brown skin. As with camouflage in nature, she is simultaneously concealed and revealed within her environment. She finds refuge in the rhythmic hues of the palette, a person of color within a chromatic diaspora.

Girl/Boy/Red Ball (1992) by Elizabeth Catlett, a seemingly obvious image of a young boy and girl playing with a ball, opens to multiple readings based on the disposition of color. Wearing a primary blue dress, the girl stands to the left of center, and the boy in his yellow pants, blue vest, and blue-and-white striped shirt bends toward her from the right. Their dark brown skin stands out against the leathery brown membrane of the background. In spite of their appealing clothing, the children's bare feet suggest their vulnerability. The bright red ball hovers between them in an ambiguous space, like a punctuation mark or a stop sign, as if demarcating their separate places. They grasp at the ball, but it is somehow unattainable. Albeit a straightforward and simple arrangement, the disposition of the color and the confinement of the composition impart multiple layers of meaning.

Sensations of color arise from an elaborate series of factors involving the eye, the brain, and the mind, and profoundly affect how we conceptualize the world.

NOTES

- Michel Pastorou, Blue: The History of a Color (Princeton, NJ: Princeton University Press, 2001), 27.
- 2 John Gage, Colour and Culture: Practice and Meaning from Antiquity to Abstraction (Boston: Little, Brown and Co., 1993), 8.
- 3 Joseph Albers, Interaction of Color (New Haven, CT: Yale University Press, 1963), 3.
- 4 David Hilbert, Color and Color Perception: A Study in Anthropocentric Realism (Palo Alto, CA: Stanford University Center for the Study of Language and Information, 1987), 2; Pastorou, Blue, 30.
- 5 Margaret Livingstone, Vision and Art: The Biology of Seeing (New York: Harry N. Abrams, 2002), 19.
- 6 Gage, Colour and Culture, 202.
- 7 http://dictionary.reference.com.
- 8 Joel Swerdlow, "Unmasking Skin," *National Geographic* (November 2002): 54–55.
- 9 Gage, Colour and Culture, 180.

- 10 Charles A. Riley, II Color Codes: Modern Theories of Color in Philosophy, Painting and Architecture, Literature, Music, and Psychology (Hanover and London: University Press of New England, 1995), 8.
- 11 Ibid., 9.
- 12 Ibid., 1.
- 13 Albers, Interaction of Color, 1.
- 14 Hilbert, Color and Color Perception, 121.
- 15 Augustine Hope and Margaret Walch, The Color Compendium (New York: Van Nostrand Reinhold, 1990), 258.
- 16 Bonnie B. Rushlow, A Century of Crayola Collectibles: A Price Guide (Grantsville, MD: Hobby House Inc., 2002), 123.
- 17 Phillip Ball, The Bright Earth: Art and the Invention of Color (New York: Farrar, Strauss and Giroux, 2001), 16.
- 18 Brent Berlin and Paul Kay, Basic Color Terms (Berkeley: University of California Press, 1991), 2.
- 19 Claudia Benthien, Skin: On the Cultural Border Between Self and the World (New York: Columbia University Press, 2002), 2.
- 20 Riley, II Color Codes, 8.

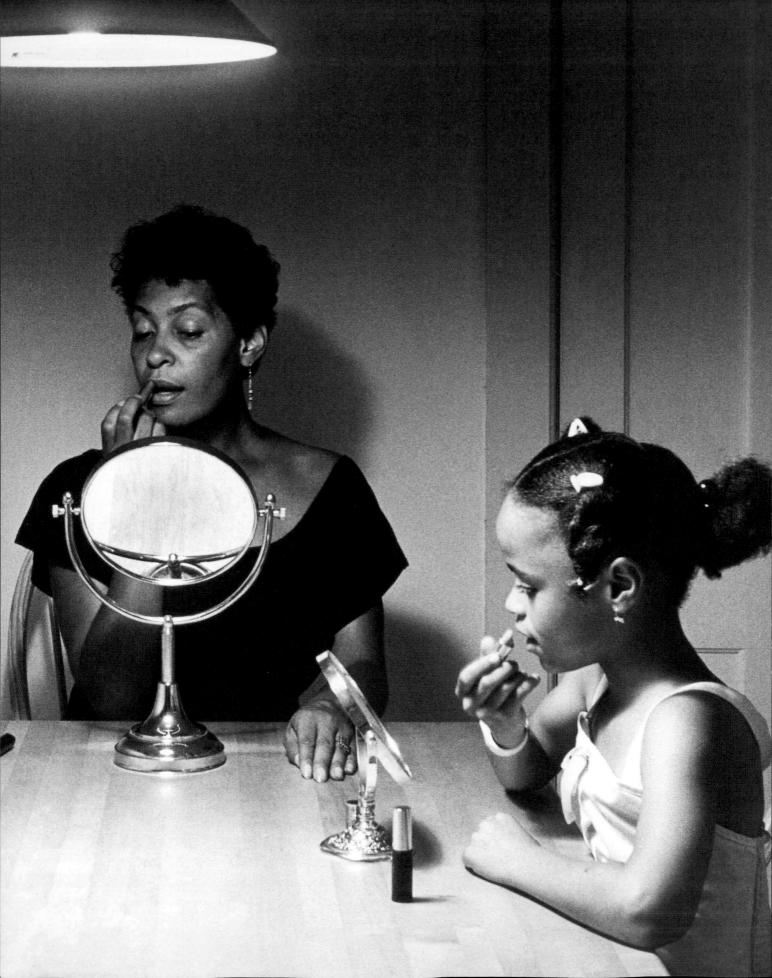

Collecting Memory:

Portraiture, Posing, and Desire

CARLA WILLIAMS

What is often overlooked is that photography is a way of looking at the world. Why does a person stop and take a picture? Why do we pose when someone points a camera? How often do we look at a picture we have taken and see something we did not see at the time? When does a photograph become memory?

the heart of the relationship with camera-based imagery we know as portraiture. In creating a portrait, whether by a professional in a studio or by an amateur taking a snapshot, the maker and the subject have a personal agenda regarding the final product. Why we choose to have portraits made and what we desire by doing so have many answers. We make portraits to record our likeness for identification, to mark time or remember significant events, to flatter, aggrandize, or project a certain image of ourselves. We do so for reasons that are both public and private. "Such is the power of the photograph, of the image, that it can give back and take away, that it can bind," remarks writer bell hooks.²

The underlying reasons for having our portraits made is related to our understanding that photographs are capable of preserving, creating, and communicating our likeness in ways that may delight or embarrass us. How often do we extend a hand to ward off the camera's gaze to prevent a photographer from rendering an image of us for posterity? Likewise, how often have we looked at an image we once hated with new insight, suddenly pleased to have the visual record of that time and place?

The importance of any given photograph among the countless exposures made since the medium's invention more than one hundred sixty years ago cannot be underestimated. The 1994 anthology *Picturing Us: African American Identity in Photography* featured essays by eighteen contributors who were asked to write about a single image that was important to them. Most writers chose a family photograph,

FACING PAGE:

Detail from Carrie Mae Weems's Kitchen Table Series, 1999 (Plate 25) with studio photographs and snapshots represented. Their choices revealed how pivotal one photograph can be to memory and the construction (and reconstruction) of personal and family history.

The studio portrait, though made in a professional setting that is, in effect, a public space, transfers to the private realm when taken home by the sitter. It becomes a family possession in a sense, being thoughtfully framed and hung in a place of prominence in the home or carefully and strategically placed in a scrapbook along with other studio photographs, snapshots, and ephemera. Although the studio portrait is a formal memory code and is created with more deliberation and control than the casual snap, it is also a constructed image—a fictionalized version of reality. Because we see likeness in the image we infer truth regarding what is represented when, in fact, the picture is presented through prisms of desire on the part of the photographer and the sitter.

THE FORMAL PORTRAIT

Clarissa Sligh's 1996 black-and-white photograph of collector Paul R. Jones (pl. 26) reveals much about the expectations associated with the portrait-making process. Photographed in his well-appointed Atlanta home, the Alabama-born Jones is seated on an upholstered white couch, his right leg crossed over the left, his right hand resting assuredly on his knee. The camera is positioned slightly above him as his body sinks into the plush sofa, a slight diminution of power in a portrayal of the collector as worldly gentleman. Atop the white wall-to-wall carpet at his feet lay a zebra-skin rug, an ethnographic allegorical reference to the collector as hunter and conqueror, though in this instance it is art that is the trophy displayed on the wall behind him. The surface of the large artwork reflects the soft tones and texture of lace curtains—allusions to his taste and refinement. The mirror over the mantle to his right echoes this trait as pieces of African sculpture from his collection are captured just within its reflection. Royal staffs—one iron and one wood with leather overlay lean inconspicuously against the right side of the white

fireplace. What does the image reveal about the photographer and sitter?

Sligh, who was born in Virginia in 1939, is the keeper of her family's photographs, preserver of family history and ardent storyteller. She became a photographer after a successful career on Wall Street and is best known for her autobiographical non-silver images that combine family photographs, drawing, and text.

Her portrait of Paul Jones fits squarely within the studio tradition. Its formal structure and the conscious nature of the sitter's pose indicates it is a well-planned image. She made this portrait of Jones, whom she had not met before the sitting, for a photography book on the suburban South.3 Jones's portrait is the very picture of success, material achievement, and cultural pride. The photograph was published as the right panel of a diptych, its companion image being a close-up of Jones's hand holding a double-framed set of much earlier photographs, one of a much younger Jones with his young son, and the other of the son alone. Sligh wrote on the photograph "Mr. Paul R. Jones" in the manner of repetitive writing on a school blackboard.4 Sligh recalled: "He [Jones] looked very different, but his hands were the same."5 In the diptych, the photographer drew a poignant parallel between the expectations of the younger man posed with his future—his son—and the older man who has achieved success yet bears no evidence of the earlier familial bond in the later image. Where is the son now? Why is the father alone? The close-up photograph-within-a-photograph of the father and son's image cradled in the palm of the older father's hand, juxtaposed with the more distant framewithin-a-frame depiction of the collector and his treasures, leads to questions about the very nature of position, possession, memory, and the fulfillment of desire.

Sligh's recollections of her encounter with Jones reveals further insight into his and her expectations of the project:

Before I met him, other people in Atlanta told me Mr. Jones was really interested in art. I didn't know what his expectations were, but he was dressed very casually when I arrived at his house. I spent some time getting to know him. He took me around his house show-

ing me and talking about his art collection so I knew that was really important to him. So I asked him if he would mind changing clothes so I could make a photograph that reflected him as an important art collector. I chose his living room as the place to make the shot. He had also worked in Africa for the government and I wanted to indicate some of that interest too.⁶

Here, initially, there was a stark difference between how the sitter expected to be captured in the image and the way in which the photographer subsequently envisioned the portrayal.

Ultimately, the expectations of both were fulfilled. The photographer's intent on presenting the subject as a prominent collector is achieved through his attire, proximity to his art objects, and pose. The subject's desire for viewers to understand some of his aspirations and accomplishments is revealed in his facial expression, posture, and the setting. Further, this image is a fitting introduction to a broader discussion of portraiture, posing, and desire. It is, in fact, Paul Jones the collector—his taste and his eye—that are the unifying factors in all of the images discussed in this essay.

HOPEFUL MEMENTOS

Photography can play a powerful role in terms of cultural recovery. The camera-based image may contain memories, help us overcome loss and keep history.

When the psycho history of a people is marked by ongoing loss, when entire histories are denied, hidden, erased, documentation may become an obsession. . . . For black folks, the camera provided a means to document a reality that could, if necessary, be packed, stored, moved from place to place. (bell hooks)

Paul Jones's eclectic collection of photographs by African American photographers includes wonderful examples of early portraiture. The nineteenth and early twentieth centuries saw a flourishing of professional photography studios throughout the country that were owned and operated by African Americans. Some examples are: Jules Lion (1810–1866), Augustus Washington (1820–1875), James Presley Ball (1825–1905?), the Goodridge brothers—Glenalvin J. (1829–1867), Wallace L. (1840–1922), and William O. (1846–1890)—Addison N. Scurlock (1883–1964) and sons Robert (1916–1994) and George (b. 1919), Richard Samuel Roberts (1881–1936), Harry Shepherd (1856–date unknown), Arthur P. Bedou (1882–1966), and Elise Forrest Harleston (active 1919–1920), among others.

Arguably most prominent among them was James VanDerZee (1886–1983), proprietor for forty years of the Guarantee Photo Studio, or G.G.G. Photo Studio, in Harlem. Established in 1916, the studio was an immediate success, sparked by a glut of enlisted men going off to fight in World War I who commissioned VanDerZee to make "hopeful mementos to guard against fate." VanDerZee, originally from Lenox, Massachusetts, was self-taught in photography and had worked briefly as a darkroom assistant in a Newark, New Jersey, department store. His success and popularity was also attributed to the manner in which he unapologetically idealized his subjects: "If it wasn't beautiful, why, I took out the unbeautiful-ness, put them in the position that they looked beautiful," he once explained.⁸

Assisted by his second wife, Gaynella, VanDerZee photographed the who's who of Harlem society as well as visiting celebrities and dignitaries. However, the bulk of VanDerZee's clientele was his neighbors, the men and women who lived in Harlem, many of whom were recent arrivals from the South. In the construction of a community's visual history, from which the "cultural recovery" to which bell hooks refers takes place, individuals are recorded collectively to bear witness to the fact of the documented cultural heritage and not for the perpetuation of personal beauty.

The Barefoot Prophet (ca. 1928) is a portrait of Elder Clayhorn Martin, who was a Virginia-born street-corner preacher living in Harlem. According to legend, he received the command from God at an early age to "take off your shoes, for this is Holy Ground. Go Preach My Gospel." A well-known neighborhood fixture standing nearly seven feet tall, The Prophet appears subdued and contemplative in VanDerZee's portrait. He is poised

in a well-tailored double-breasted suit seated in the almost regal splendor of studio furnishings. His spiritual role and presence is further revealed in the unfettered and physical freedom of his long, unruly hair and beard, his bare feet, and revival-style tambourine. His divineness is suggested not only by the open Bible before him but also by the carefully added streaks of light that seem to emanate from the flames of two candles and a shining star through the open window in the backdrop that was added in a similar manner. VanDerZee's skill and thoughtfulness in the construction of cultural history can be seen in his iconographic portrayal of individual subjects.

A photograph of The Black Houdini (1924), an otherwise unidentified master of illusion (pl. 27), is similarly intriguing in its representation of the variety and complexity of experiences of African Americans in the 1920s. Locked in irons and staring directly into the camera, the magician most likely had come to Van-DerZee's studio to have a photograph made to advertise his unusual trade. On the other hand, we are struck by the image of a black man in chains as a cultural artifact and an object of visual encounter. This is deeply felt even though we simultaneously recognize his bondage as a temporary and self-induced state, and thus, part of his illusionary trick rather than as a frightening relic of slavery. The generic landscape in the backdrop helps soften the otherwise jarring impact, yet what inevitably emerges is more than a magician's calling card but a bold visual metaphor of defiance and resistance. Further, this image attests to the degree to which Van-DerZee's African American clientele relied on his ability to capture their likeness as they wished to be seen and as they desired to see themselves.

MEMORY KEEPER

Many portraits by Prentice Herman (P. H.) Polk (1898–1984) taken between 1920 and 1950 act as personal and corporate narratives of the accomplishments, positions, and status of African Americans in and around Tuskegee University. During the New Negro era, African American women frequented photographic

studios to have portraits made that consciously presented positive images of themselves and projected images of progress and success within their communities as a whole. The fulfillment of this desire often included the creation of studio portraits that were initiated by the photographer. The portraits of *Catherine Moton Patterson* (1936) and *Margaret Blanche Polk* (1946) are examples, respectively, by Polk.

The Alabama native was the first student to enroll in the Photography Division at Tuskegee Institute in 1917, studying under Cornelius Marion Battey (1873–1927). Later, following his family to Chicago, he apprenticed for nearly two years in Fred Jenson's photography studio. In 1921, Polk signed up for a correspondence course in photography through which he studied Rembrandt's mastery of shadow. His 1946 portrait study "from the shadow side" of his wife, Margaret Blanche Polk, reveals the photographer's aesthetic and technical concerns.

Polk and Thompson married in January 1926. The striking, sensitive portrait was made twenty years later. Emphasizing her loveliness in middle age, Polk photographed his wife from a camera angle on a diagonal slightly below eye level (pl. 28). Her face and torso emerge from a rich sea of blackness, as her deliberate upward gaze accentuates the soft lean of her body. Polk possibly created the portrait to capture her likeness and to present her as an archetype of New Negro progress. She is poised and seems to look confidently toward the future. Her attire reflects financial comfort—her widebrim hat, white eyelet blouse, finely tailored jacket, and pearl jewelry. Polk understood the importance of photographic portraits in structuring both family and collective history. According to Meredith K. Soles, for Polk "and for countless other African Americans, photographs provided a new visual means to convey emotion, personal pride, and temporality: notions often previously expressed by blacks through musical, verbal, or textual means."12 He often shared his photographs with family members elsewhere. On family photographs sent to relatives, Polk inscribed "Lest you forget," a clear acknowledgment of photography's role as the keeper of memory.13

Called "the Southern VanDerZee"14 for his extensive documentation of the African American life in and around Tuskegee, Polk displayed prints of middleclass clients in his studio window to attract others. He also had a ready clientele within the institution's administration and its professorial elite. In 1936, he photographed Catherine "Kitty" Moton Patterson, the wife of the president and daughter of his predecessor. Patterson is depicted as an upper class, accomplished black woman, seated in her well-appointed home wearing a fine lace dress and heels, playing the harp. Like Sligh's portrait of collector Paul Jones taken some sixty years later, Polk's portrait of Patterson presents the subject in the environment that most intimately defines her status and position. Not only is she someone, the photograph affirms that she plays a role of cultural significance to the history of Tuskegee and broader African American community.

NARRATED FICTION

Contemporary photographer Carrie Mae Weems (b. 1953) is proficient at creating narrative images that explore personal and cultural identity. Taking up photography in her twenties, she received the B.F.A. at the California Institute of the Arts and the M.F.A. from the University of California, San Diego, before pursuing graduate study in folklore at the University of California, Berkeley. Invoking the novelistic, or "the constant narration of the social relations of individuals, the ordering of meanings for the individual in society,"15 Weems produces bodies of work that read sequentially like film. In the 1990 Kitchen Table Series, Weems created twenty black-and-white photographs that make powerful statements both as a group and as single images. Addressing the challenging nature of family relationships, Weems is self-cast in the lead role.

In *Kitchen Table Untitled* (Carrie and girl with mirrors), she focuses on the interaction between a mother and daughter with strong allusions to role-playing as it relates to parental and child responsibility. Weems presents herself and a young girl applying makeup in vanity mirrors—an act that speaks to the mother's role as

teacher and model juxtaposed with the daughter's role as mentee and follower of the mother's example. In a 1993 monograph published by the National Museum of Women in the Arts, the following written narrative accompanied the photograph:¹⁶

Neither knew with certainty what the future held. It could be only a paper moon hanging over a cardboard sea, but they both said, "It wouldn't be makebelieve, if you believed in me."

"He wanted children. She didn't. At the height of their love a child was born. Her sisters thought the world of their children. Noting their little feats as they stumbled teetered and stood. When her kid finally stood and walked, she watched with a distant eye, thinking, 'Thank God! I won't have to carry her much longer!' Oh yeah, she loved the kid, she was responsible, but took no deep pleasure in motherhood, it caused deflection from her own immediate desires, which pissed her off. Ha. A woman's duty! Ha! A punishment for Eve's sin was more like it. Ha."

The impact of the image (and all images in the series) is dependent on viewer familiarity with certain iconographic associations, including the text being derived from popular song lyrics, the photograph being rooted in advertisements, and its location being the home kitchen where private family conversations take place. Her reference to "'language derived from experience'" also refers to the visual language we read into the photograph when considered separate from the text.¹⁸

In this work, Weems projects a view of womanhood that differs from the cultural ideals espoused during the New Negro ideal era, giving us a heroine who is not the desired, established model of motherhood. The tension in the photograph is deepened by the fact of her dual roles as artist and model—using her own likeness and directing her own pose.

It points to the fact that, in a sense, Paul Jones's role as collector mirrors the photographer's role as imagemaker—to preserve a collective history and to ensure that our stories continue to be told. Likewise, using the portrait-making process Sligh has "collected" him, classifying

and categorizing him through costume, gesture, and setting so that, without words, we may know something central about who he is. Sligh, VanDerZee, Polk, and Weems have contributed to shaping the very worlds they photo-

graph even when rendering service to their subjects as clients. They reveal ways in which photographs tell stories, preserve memories, "write" histories, and express the cultural and personal desire of a people.

NOTES

- I E. Ethelbert Miller, "In My Father's House There Were No Images," in Deborah Willis, ed., *Picturing Us: African American Identity in Photography* (New York: The New Press, 1994), 58.
- 2 bell hooks, "In Our Glory: Photography and Black Life," in Deborah Willis, ed., Picturing Us: African American Identity in Photography, 48.
- 3 Alex Harris and Alice Rose George, eds., A New Life: Stories and Photographs from the Suburban South (New York: W. W. Norton & Company, 1996).
- 4 According to Sligh, Jones was given the two photos separately, not as a diptych, and not with any text written on either print.
- 5 Conversation with Clarissa Sligh, August 2003.
- 6 Ibid.
- 7 Dr. Cheryl Finley, "Day or Night, Rain or Shine: The Photographic Legacy of James VanDerZee," in *James VanDerZee: Harlem Guar-anteed* (New York: Michael Rosenfeld Gallery, 2002), 10.
- 8 Quoted in ibid., 10.
- 9 Deborah Willis-Braithwaite and Rodger Birt, *VanDerZee: Photographer*, *1886–1983* (New York: Harry N. Abrams Inc. in association with The National Portrait Gallery, Smithsonian Institution, 1993), 128.
- 10 Amalia K. Amaki, "To Make a Picture," in Through These Eyes: The

- Photographs of P. H. Polk (Newark, DE: The University Gallery, University of Delaware, 1998), 19.
- II Louise Daniel Hutchinson, "P. H. Polk: 'Lest You Forget'," in Through These Eyes: The Photographs of P. H. Polk, 17.
- Meredith K. Soles, "Mementos, Documents, and Signs: The Portrait Photographs of P. H. Polk," in Through These Eyes: The Photographs of P. H. Polk, 24.
- 13 Hutchinson, "P. H. Polk: 'Lest You Forget'," 17.
- 14 Belena S. Chapp, Foreword, Through These Eyes: The Photographs of P. H. Polk, iii.
- 15 Susan Fisher Sterling, quoting Stephen Heath, in "Signifying: Photographs and Texts in the Work of Carrie Mae Weems," in Andrea Kirsh and Susan Fisher Sterling, Carrie Mae Weems (Washington, DC: The National Museum of Women in the Arts, 1993), 26.
- 16 A 1990 installation view of the series on exhibition at P.P.O.W. Gallery in New York shows the text displayed with the photographs. Subsequent reproductions of the image routinely do not include the text passage. Kirsh and Sterling, Carrie Mae Weems, 27.
- 17 Kirsh and Sterling, *Carrie Mae Weems*, 78. As Sterling points out, "the imagery of text and photographs are not synchronized with one another."
- 18 Quoted in Susan Fisher Sterling, "Signifying: Photographs and Texts in the Work of Carrie Mae Weems," in Kirsh and Sterling, Carrie Mae Weems, 28.

FACING PAGE:

Detail from James VanDerZee's The Barefoot Prophet, 1928 (Plate 86)

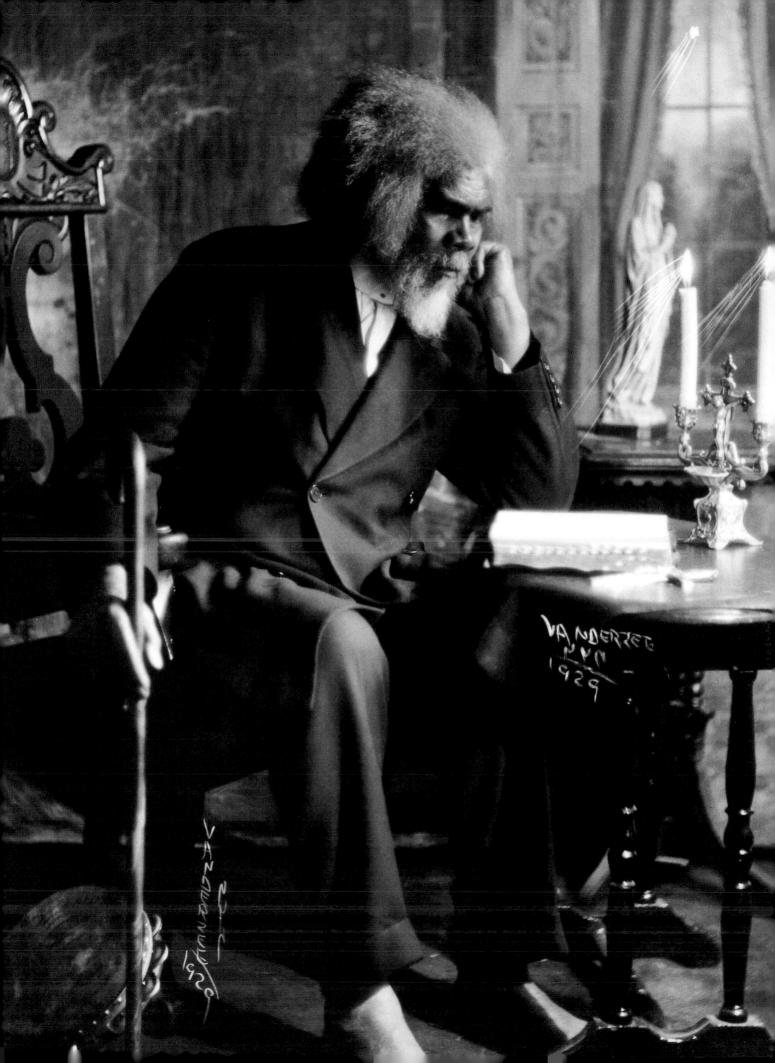

Flash from the Past:

Hidden Messages in the Photographs of Prentice Herman Polk

AMALIA K. AMAKI

"I think the past is all that makes the present coherent, and further, that the past will remain horrible for exactly as long as we refuse to assess it honestly."

- James Baldwin, Notes of a Native Son

N 1936, FILM HISTORIAN WILLIAM PERLMAN WROTE IN THE Movies on Trial that "the influence of the screen for good or for evil cannot be overestimated. As a propaganda medium it is the most powerful of agents. Napoleon said he feared one newspaper more than a thousand bayonets."

Prentice Herman Polk (1898–1984) used simple methods to unveil poignant realities about the complexities of African American life. His vehicle was photography. The truths he revealed were as varied and specific as the many subjects who elected or were cajoled into sitting for him. He created each photograph in pursuit of the complicated task of returning to the subject an honest rendition of what was seen while also handing over to them a bit of creation—a purging of their individual and societal selves into a cultural reverberation of Tuskegee the Alabama town, Tuskegee the institution, and Tuskegee the model of a different South. As quietly as it was kept until the early 1970s, the thousands of negatives made by Polk between 1920 and 1950 categorically denied the monolithic national view of African American life in the South. He, like numerous other African American image-makers from his era, was caught up in what cultural critic Cornel West describes as "the modern black diasporan problematic of invisibility and namelessness."²

Photography came to America's shores centuries after slavery was inflicted on African Americans. Despite the number of photographs made during the 1800s of free African Americans—largely, though not exclusively, in the North—these

FACING PAGE:

Detail from Prentice H. Polk's Alberta Osborn, ca. 1929. (Plate 29) images were virtually hidden from America's visual accounts during the nineteenth century. After the Civil War, overwhelmingly fewer African American photographers in the South maintained studios than their white counterparts. Consequently, documentary works such as Alexander Gardner's anthology *Photographic Sketchbook of the War*, and stereographs of orphans, laborers, people gathered in fields, on stoops, or in front of shacks, shanties, rickety doorways, and windows, and similar perspectives of African American life in the South were more frequently seen. Thus, the evolution of the term "stereotype."

Daguerreotypes, ambrotypes, tintypes, and albumen prints of well-dressed, nicely posed middle-class African Americans increased in number though the identity of the sitter was often unknown. In certain cases, the subject's attire offered clues to his or her profession or social status. To the casual observer, the absence of a name and other relevant data rendered the sitter not only anonymous, but sent the silent message of unimportance and contributed to the systematic devaluation of each subject as an individual and, collectively, to the dismissal of the broader community of African Americans.

Polk took great measures to ensure that the vast majority of his sitters were afforded some form of proper identification. A few exceptions were made where poetically (and selectively) names were given in the spirit of creativity and with the intent to flatter. In cases such as The Boss (1932) and The Pipe Smoker (1932), Polk used descriptive titles to evoke the sense of power, authority, and naturalness of those portrayed. By so doing, he reiterated his role as artist in addition to photographer and that of the sitter as model in addition to subject. This is particularly significant in the aftermath of modernist photographer and dealer Alfred Stieglitz's (1864-1946) radical campaign to convince the Western world that the camera was a sufficient tool for the production of "high" art.3 Polk's art sensibility relative to photography was, in many respects, aligned with Stieglitz's, whose publication Camera Works (1903-1917) was devoted to advancing the work and ideologies of the members of the Photo-Seccession. From the standpoint of practice, Polk

also enjoyed engaging others around discussions of his work, and though the talks fell short of being the critiques that Stieglitz held, they were, nonetheless, indications of Polk's interest in constructive interaction for the sake of making better pictures.

Another clue to Polk's seriousness about photography as art was the liberty he took in identifying his rural subjects, and, perhaps more important, the very act itself of giving them a descriptive name. Much akin to pet names or nicknames, he attached affectionate labels that have a comedic and a cutting edge to them. Out of that dynamic comes specificity and individualism. The undercurrent of the title/label/name "The Boss" is one who controls and has dominion. It is an empowering label placed on an unlikely type. The tension that is evoked by popularizing—placing in the public and popular arena—a name that is fixed on a character type that has been established in association with labels on the opposite end of the spectrum, is evidence of the strategy and care with which the name was applied.

Jacques Lacan, exploring the relationship between the "social symbolic system and individual identity," emphasizes the impact of signs (a name) and symbols in shaping and modeling behavior and identity. He argues: "That a name, however confused it may be, designates a specific person, is exactly what makes up the transition to the human state. If one has to define the moment in which a man becomes human, we can say that it is the moment when, however little it be, he enters into the symbolic relation."4 He extrapolates on reflection in a mirror—being unreal in that it is not you, yet being real in that it is your reflection—as a metaphor for the interaction between the imagined and symbolic self that is processed as identification. Thus, personal identity (perpetuation) feeds off the social (punctuation) that, in turn, reflects codified understandings of the imaged self. The key conduit here is language, visual and linguistic.

The camera is a mirror. Within it is the power of reflection. Depending on whom, what, or how, the reflection is capable of projecting the unreal and the reality of the person who poses in front of it or whose image is taken (stolen). A powerful and damaging consequence

of deliberate manipulation of reflection can be confusion. Confusion can lead to fabrication—conflicting reality with fabrications of reality is the stereotype.

The cumulative weight of media stereotypes of African Americans was enormous by the nineteenth century. Popular culture materials and commercial images in the absence of contradictory visual data became the standard for white America's perception of the African American. Minstrel shows played a critical role in fabricating portrayals of African American life, dating back to Thomas Dartmouth "Daddy" Rice who, between 1828 and 1831, performed a song-and-dance routine in blackface impersonating an old, crippled black slave dubbed Jim Crow. America's first indigenous musical theater and the first national entertainment form, the minstrel show fully developed by 1840, peaked in the post-Civil War era and remained a mainstay of stage performance until the late 1940s.5 Feeding off the popularity of such shows, comic strips in the American press were derived heavily from the minstrel models when they were initiated in the 1890s. As Steven Loring Jones asserted in From "Under Cork" to Overcoming: Black Images in the Comics, "the blackface characterization of African Americans was so successful that it was inevitable it would also have a major impact on early motion pictures, the most powerful and influential industry of them all."6 What had been largely a southern model became essentially the American one, and permeated every mode of public expression between 1890 and 1950.

When photographer P. H. Polk was born, roughly 250 African Americans were listed as professional photographers nationwide in directories, advertisements, society page listings, and articles. By 1930, the number escalated to 545 according to U.S. Census reports. At the same time, the images of southern culture were continually placed within the context of a racial divide that held as part of its premise stereotyped, derogatory views of African American life. From D. W. Griffith's 1915 Civil War epic, *The Birth of a Nation*, to popular culture materials, especially newspapers, periodicals, and commercial media, African Americans on screen and in print were established as types, not individuals,

portrayals that were disseminated throughout American society and supported by literary, historical, and critical writing.

It was a major challenge to the noble efforts of such pioneers as filmmaker Oscar Micheaux, whose productions such as Wages of Sin in 1914 and Harlem After Midnight in 1934 helped to establish an African American strategy to provide more positive representations. However, these and similar "race films" were considerably fewer in number than their denigrating counterparts and catered largely to black audiences. The films were in limited distribution in the South due to censorship bans and the ethnic emphasis. On the other hand, The Birth of a Nation, with its heroic portrayal of the Ku Klux Klan as the protectors of "the purity of southern women and the southern way life," was one of the movie industry's first blockbuster films and enjoyed national circulation. Griffith was lauded as the inventor of a new art form—the feature-length film—and praised for his effective use of close-ups, night shots, and other technological innovations. Though there were well-organized protests in at least a dozen major U.S. cities, riots, and a vigorous campaign mounted by the NAACP that led to the banning of the film in several cities, it still earned Griffith notoriety for artistic direction, and spawned several copycat movies.

Lorenzo Tucker, Micheaux's talented male lead called the Black Valentino, did not enjoy the mass viewership of white, blackface actors Al Jolson and Walter Long. Likewise, the critically acclaimed career of lead actress Anita Bush has been virtually forgotten while the many domestic characterizations of Hattie Mc-Daniel—well-executed, but in support capacities—culminated with her receiving the Academy Award for her 1939 role as Mammy in Gone With the Wind. Though, as the Oscar recipient stated, "it was much better to play a servant than to be one,"7 the fact remained that the collective, repetitive, and exclusive presentation of such images by the industry contributed significantly to the narrow, stereotyped perception of African Americans in general. (It is worth noting that some of her African American contemporary critics felt that Hattie McDaniel's talent as an actress was so superior that it transcended the roles she repeatedly played.)⁸ One of the few places where alternative representations could be consistently publicly seen was the African American photographic studio window. By the 1920s, as Polk embarked upon his professional career, there were increasing numbers of photographs being produced in the South by African American photographers for their African American clientele.

Born in the small town of Bessemer, Alabama, Polk deliberately chose to remain in the South as the wartime (WWI) relocation of thousands of African Americans to the industrial North was actively underway. He entered Tuskegee Normal and Industrial Institute (currently Tuskegee University) in 1916 to pursue painting, unaware that founder Booker T. Washington, who died the previous year, had established a strict policy of providing a "practical" education for students, namely, offering marketable trade skills that did not include the arts. When the dean suggested that Polk study house painting at least to learn how to mix colors, he declined. He did respond when Cornelius Marion Battey (1873-1927) solicited students for a newly formed photography program. Polk was the third student to sign up and learn basic camera and darkroom techniques. Leaving Tuskegee in 1920, he took a correspondence course the following year while working in the shipyards of Chickasaw, Alabama. Polk completed the course and joined his mother and three sisters in Chicago, where they had relocated three years earlier.

In January 1926, he married Margaret Blanche Thompson of Brunswick, Georgia. At about the same time, he met commercial photographer Fred A. Jensen, who instructed him over a period of twenty months on retouching and other printing techniques. Ironically, he financed these lessons working as a painter for the Pullman Company during the day and the telephone company at night. Within a year, Polk was a father and began working as a professional photographer. He quickly became weary of canvassing work door to door for clients, particularly with Chicago's bitter winter rapidly approaching. He and his family returned to Tuskegee, where Polk immediately opened a private portrait studio and photographed the first of his "old characters"—rural figures who arrived on

Tuskegee's campus for agricultural conferences, sales, or other related visits. In 1928, he joined the faculty at Tuskegee Institute as an instructor in the Photography Division. He worked closely with Leonard G. Hyman (b. 1895), the Division Head and Official Photographer for the institute who was active in Washington, DC, for nearly fifteen years prior to working at Tuskegee (1927–1932). Five years later Polk was named head of the photography division. He became Official Photographer in 1939, a post he held virtually until his death on December 29, 1984.

By 1935, Polk was a fixture at Tuskegee and one of its celebrities. The fourth photographer to work in an official capacity for the institution following Arthur P. Bedou (1886–1966), Battey, and Hyman, his popularity stemmed in part from his ubiquitousness and his uncanny ability both to capture the likeness and tap into the uniqueness of his clients. In his official capacity, he was a most effective snatcher of opportune moments, impulsively fading into oblivion to claim a scene that compressed an entire story into a second. At the same time, he had the tenacity to manipulate and maneuver for as long as it took to catch the desired image.

No other photographer has been so readily associated with a Historically Black College or University (HBCU) as has Polk. While continuing the tradition of telling the official story of Tuskegee, he managed to instill (and extract) his own. His prolificacy and longevity aside, Polk produced some of the most provocative, profound, yet characteristic visual records of southern subjects of his time. Beginning in the late 1920s and fully matured by the early 1930s, his photographs reflected the image quality of fashion, advertising, and promotional photography for entertainers. Some possessed the appearance of documentary work, but in those instances, Polk still managed to distinguish the image with his personal stamp achieved through an expression, gesture, or play of light. Of all the images made in his official capacity, none outnumbered the photographs of renowned scientist George Washington Carver (pl. 30).

Polk made more than five hundred photographs of Carver, recording him in the laboratory, classroom, office, hallways, and agricultural fields. If Carver took a walk, or gave impromptu instruction to a student,

Polk's gaze, through the lens of his camera, was there. The trust between the two men was unquestionable, and they had a mutual understanding of the significance of the work each was doing, and the importance of the photographic record to the legacy of Tuskegee, the region, and African Americans nationwide. Carver drew widespread national attention for his inventive uses of the sweet potato, peanut, and numerous other foods in deriving 118 products, including a rubber substitute and over 500 dyes and pigments. The agricultural chemist also developed innovative soil rotation methods for conserving nutrients that greatly enhanced crop production and helped energize America's economy. Further, he created and distributed pamphlets on improved planting and soil preparation techniques to African American farmers in the South during on-site visits. He tutored those he visited so that they might pass the information on to others. Through it all, Polk was there. The results of their collaborations did not go unnoticed. Carver's laboratory and classroom became the destination of many leaders and educators, including white teachers, who brought their students to the campus in defiance of state laws.

Polk's photographs attest to Carver's national status and importance. They include portrayals of him with visitors such as President Franklin Delano Roosevelt and automobile magnate Henry Ford, whose repeated attempts to lure Carver to Michigan failed, but resulted in Ford building the Carver Industrial School in Ways, Georgia, and creating the George Washington Carver Cabin in Greenfield Village in Dearborn, Michigan, in 1942. There are also visual accounts of Carver receiving the honorary degree from Rochester University in 1941 and Stefan Thomas sculpting his portrait to commemorate forty years of service to Tuskegee and many more to the nation. The scientist instructed Polk to take his picture at every opportunity because when he was dead people would want them. Polk complied, probing beyond Carver's day-to-day public persona as Tuskegee's most famous professor and revered agricultural scientist to include aspects of his private life, emphasizing his personal commitment with improving the lives of southern African American farmers.

Polk's photographs of Carver are critical to any discussion that addresses ways that African Americans were portrayed in the South between 1890 and 1950. Carver's position as a nationally recognized and sought after figure made him an ideal subject for contradicting the popularized images by the mainstream media. Carver's combination of traits including that of academic, humanitarian, inventor, community liaison, and world-class scientist was diametrically opposed to the preoccupation of America's popular media with the stereotype of the uneducated, minstrel-derived southern black.

The same applies to Polk's numerous photographs of the Tuskegee Airmen. His images of the first squadron of African American pilots allowed by the U.S. government to fight for their country are reminders of the heroism of numerous black men in uniform. Copies of Polk's 1941 photograph of Eleanor Roosevelt and Charles Alfred Anderson (known as "Chief Anderson") just before an unprecedented flight in his two-seater plane was widely distributed to the press, yet reproduced in only a few newspapers and journals. This was the case despite the fact that the event, supported by the photograph that documented it, played a key role in securing the flight program at the institute and in allowing the participation of the airmen in America's North Africa and European campaigns during World War II.

Curator Edward F. Weeks attributed Polk's "successful and distinctive photographic sense to his human and spiritual responsiveness, the product of instinct and training that resulted in a unique ability to photographically 'touch' the subject and thereby the audience." His keen attention to composition as well as sitter earned him a status rarely afforded a studio photographer. Critic Lee Fleming applauded his use of soft focus to create dream-like qualities in certain works, and the incredible sense of balance employed in others. Weeks attributed Polk's popularity and notoriety to the fact that his "artistry transformed his pictures into images whose impact extended far beyond Tuskegee." 12

At the same time, Polk continued his studio work, characterized by his signature style of making well-constructed images built around deep tones, crisp contrasts and vague, unobtrusive backgrounds. He benefited

from the institution's prestige—it was a must stop on the tour list of most major African American entertainers, writers, and athletes during Polk's initial decades there. Successful business people, leading educators, and political activists regardless of racial background were also frequently on campus. In its own right, the city of Tuskegee had a very prominent and active social elite, as well as the highest per capita level of education and income in the state in the 1940s.13 This facilitated Polk's having a lucrative private studio business. Thus, he achieved as many classic, elegant poses of poised clients as he did in a 1936 portrait of Catherine Moton Patterson, daughter of Robert Russa Moton, Tuskegee's second president, and wife to Frederick Patterson, his successor. He took full advantage of her unusual talent as a harpist, her immaculate grooming, dress, and posture, and her image as a symbolic trilogy of the very concept of a profile—sight (her portrait), sound (her playing the harp), and memory (her personal narrative as daughter/student/wife). Polk habitually suited his clients in personalized portrayals, and while others may be less intimate, he maintained the ability to stimulate a sense of uniqueness. Stunning portraits of student Alberta Osborn (ca. 1926), graduate Mildred Hanson Baker (1937 or 1938), and wife Margaret in 1946 are among the hundreds of examples. Osborn is presented looking slightly over her right shoulder with the lower right cheek gently nestled into the hair of the dark-toned fur she is wearing. The softness of her large eyes and a tiny single pearl on her left ear are the brightest points of emphasis other than sprinklings of highlight pronouncing the sheen of her short, neatly combed black hair. While the appearance of the pose links her to that of a movie actress in a promo shot, her gaze and expression speak to a certain confidence, comfort, and calm of spirit that ensures her distinctness from other portraits. The image is also one that exemplifies Polk's propensity for "working from the dark side," or developing form out of shadow in a Rembrandt-like manner. Less dramatically applied as was the case with other images such as the 1946 portrait of his wife, Osborn's portrait, nonetheless, strongly indicates ways in which he extracted areas of formal detail out of a sea of blackness, while being equally proficient in the

manipulation of lighter tones for the sake of detail and texture. Collectively, the large body of work including photographs of his family, students, and other clients combined with those created in fulfilling his responsibilities as official photographer put forth a radically different image of African Americans in the South than was publicly seen in America. The contradiction in Polk's imagery to the exclusive media portrayal of African American women as domestics and men as field laborers hits even harder with the fact that many were taken in the segregated, Jim Crow South in the midst of the Depression. Equally significant is the point that his photographic treatment of rural subjects from the area broke from the expected and usual portrayals.

Polk felt a kinship with the people who lived in Macon County as well as those making up the Tuskegee farming community. Growing up in Bessemer, a small town adjacent to iron ore mining camps where his father worked, and farms where his mother once picked cotton, he was at ease in the company of rural workers. Over time, they became some of his favorite subjects. Called his "old characters," he portrayed them with the same intimate and personalized care afforded his clients. Unlike those who came to him to have a portrait made, Polk sought out these models, embracing and acknowledging them as legitimate and equal parts of the Tuskegee story. His intermittent departures from duties as official photographer and private studio portraitist to work as a "freelance" artist were rewarded most through the images he created of his rural models.

Not everyone was intrigued or impressed with these images. The opinions of critics were literally split over their significance and their artistry. Deborah J. Johnson considered his "old characters" stereotypes, referring to them further as "examinations of the difficulty inherent in being black and/or poor." Writer Nicholas Natanson dismissed certain of the photographs as "rustic cuteness." Polk saw these subjects as vanishing from the American scene and worthy of vicarious preservation on film and paper. He was also drawn to a "frankness and honesty about them—they were characters," and he considered his photographs candid records of who they really were, in their plainness, simplicity, and rawness. Further, he was

neither ashamed of them nor patronizing to them. As such, he considered them strong individuals, and people who gave the story of Tuskegee proper balance. Most prominent among these images, and clearly the most striking is The Boss (pl. 31). Polk called The Boss his frontrunner, referring to its popularity and status as his most frequently reproduced and requested image. While there are definite parallels that may be drawn between her physicality in the photograph and that of characterizations in motion pictures and other popular media, such comparisons are superficial at best. Film portrayals of African American female subjects rarely convey characteristics of leadership, diligence, and self-sufficiency. The Boss is a visual paradox—seemingly typical to the extent that it portrays in a certain way the expected kind of image of a farm-working woman of the era, yet also breaks away from the tradition and established treatment of the African American laborer that encourages the viewer to lapse into voyeuristic or patronistic patterns. Polk spotted her walking across Tuskegee's campus as she gathered with the other farmers to sell her products. Finding her a striking subject, he persuaded her to come to his studio. Polk patiently explained the procedure to her, assuring her that the camera would not hurt her. The resulting photograph is one that is far from usual. She is portrayed in her own matter-of-factness-confident, hardworking, adventuresome, assertive, and stern. The pose, at an angle, and her expression, authoritative and firm, are not the result of Polk's usual tactics to encourage a response but rather how she presented herself. She wears her own clothes. She is not cloaked in victimization nor placed in pitiful surroundings. She is not helpless and she is not "cute." Instead, she projects notions of independence and is powerful in appearance and, by title, is the boss. Not to be forgotten is the fact that Polk persuaded her to pose for him because she would be paid. While he obtained the photograph he wanted, she was financially compensated. Thus, from the standpoint of the model, the pose and, subsequently, the popular image are both results of a business decision that she made. This places an additional edge on the application and implications of its title, The Boss.

The categorization of this and similar work as disconcerting stereotypes by Johnson and other critics is indica-

tive of a failure to evaluate this body of work on the basis of its own pictorial merit as a group of specific portraits rather than a collection of anthropological or sociological specimens. *The Boss* is not to be studied via the deceptive things on the surface—skin tone, skin texture, size, garments, etc. She warrants examination based on her countenance and contradiction, as an image of an individual rather than a specimen. While the subjects were laborers by vocational classification, Polk did not present them as work-related models stripped of personality. They were rendered with care and as worthy components in the bigger picture of the Tuskegee, Alabama, story.

His portrayals of Henry Baker (1932), Charles Turner (1933), and George Moore (pl. 32) confirm his genuine interest in penetrating beneath the superficial characterization of type, and presenting the faces and normality of unpretentious, simple, hard-working individuals who are comfortable—in deference to their economic circumstance-in their own dark skin. George Moore, whom he photographed on numerous occasions, was one of Polk's favorite subjects. Polk stated that Moore "always wore a hat, even though it was not in good shape, but he was brought up to believe that a gentleman always wore a hat."14 In these and similar subject-based works, Polk created some of his most intense and pensive photographs. While Turner and Moore are presented in a seemingly straightforward, matter-of-fact way, the images contain an austereness and an air of complete selfawareness permeates them. Even though Baker is posed looking up in a manner that calls to mind postures commonly seen on paper fans used in small southern churches, he, too, in an earnest conveyance of acknowledgment and submission to a different level of understanding, also espouses an awareness of "self" from a different human perspective.

In the final analysis, Polk should be seen as a model, being one of several African American photographers in the South whose studio work offered different representations of African Americans in the region. His signature style, extensive body of work, and long association with Tuskegee University established his career as an important one both to the state of Alabama and to the cultural community nationwide.

NOTES

- 1 William Perlman quoted in Gary Null, Black Hollywood (New York: Citadel Press, 1975), 7.
- 2 Cornel West, ""Horace Pippin's Challenge to Art Criticism," in Kymberly N. Pinder, ed., Race-ing Art History (New York and London: Routledge, 2002), 325.
- 3 Stieglitz opened The Little Galleries of the Photo-Secession at 291 Fifth Avenue, New York in 1907 with the assistance of Edward Steichen. He pioneered the cause for photography and modern art from 1903 until his death in 1946.
- 4 Jacques Lacan, *The Seminars of Jacques Lacan*, Book I, *Freud's Papers on Technique*, quoted in Vincent F. Rocchio, *Reel Racism* (Boulder, CO: Westview Press, 2000), 17.
- 5 These shows primarily presented white males wearing burnt cork performing songs and skits that sentimentalized plantation life and portrayed child-like adult slaves with exaggerated features, speech patterns, and body movements.
- 6 Steven Loring Jones, "From 'Under Cork' to Overcoming: Black Images in the Comics," in Charles Hardy and Gail F. Stern, eds.,

- Ethnic Images in the Comics (Philadelphia: Balch Institute for Ethnic Studies, 1986).
- 7 Null, Black Hollywood, 76.
- 8 Ibid.
- 9 According to alumnus Conrad Pope, "Having a portrait made by Mr. Polk was a kind of ritual. It was not a question of if you got him to make your portrait it was when. And you did not just show up at to his place expecting him to take your picture. You made an appointment. It was professional. He schooled you that way."
- Edward F. Weeks, "P. H. Polk and Tuskegee Institute," in P. H. Polk (Birmingham, AL: Birmingham Museum of Art, 1983), 2.
- II Lee Fleming, "P. H. Polk Photographs," Art in America (October 1981), 155.
- 12 Weeks, "P. H. Polk and Tuskegee Institute," 3.
- 13 Tuskegee as a small, rural southern town enjoyed an usual economic and educational position due largely to the number of highly trained professors on the faculty of Tuskegee Institute, the presence of the only Veterans' Administration hospital after World War I for African Americans with the corresponding medical personnel and staff.
- 14 Polk interview by writer at his Tuskegee home in June 1981.

FACING PAGE:

Detail from Prentice H. Polk's

The Boss, 1932.

(Plate 31)

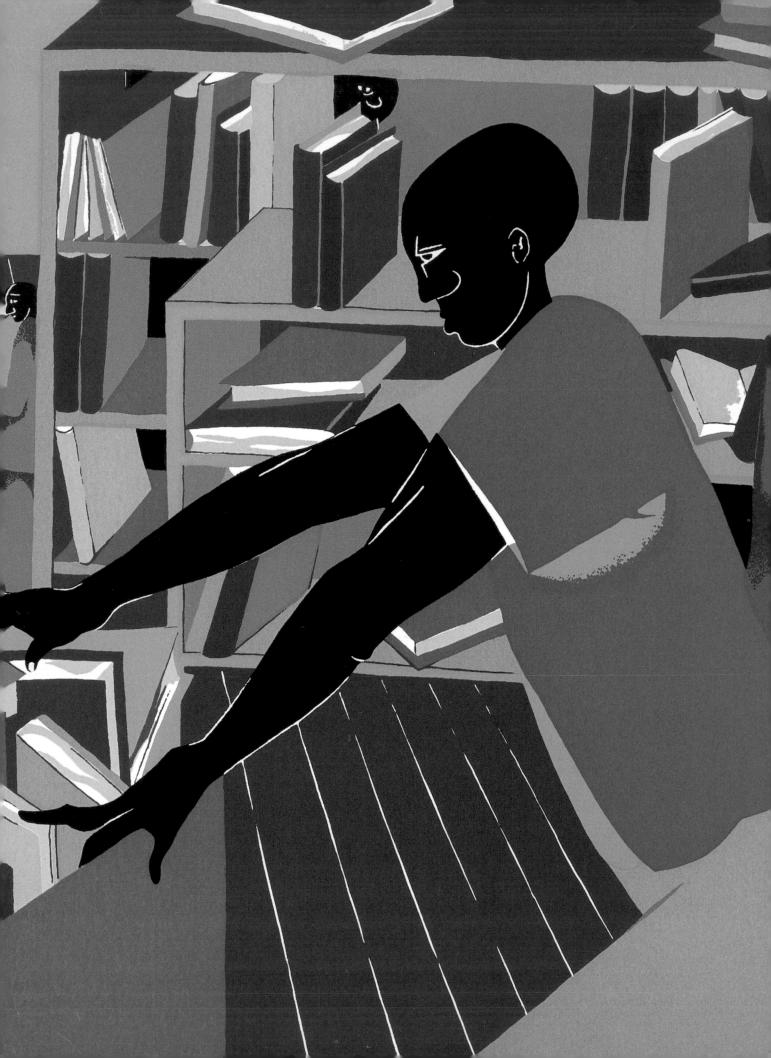

African American Printmakers:

Toward a More Democratic Art

WINSTON KENNEDY

In terms of visual art, the role that black people, their art and their ideas have played in the construction of modernity remains resolutely unrecognized by some.

- Richard Powell in ReBirth of a Nation

number of artists who explore African American agency using the print-making process. Representing a range of styles, subject matter, edition formats, and historical periods ranging primarily from the 1930s era of federal art programs to the present decade, the prints in the collection contribute significantly to the breadth of discussions of African American visual expression. Some of America's best-known artists have work included in this print component, Henry Ossawa Tanner, Jacob Lawrence, Romare Bearden, Elizabeth Catlett, Charles White, and Hale Woodruff among them. Others with regional and national reputations whose first medium is printmaking are also represented.

Until the 1970s it was difficult to find considerable holdings of African American prints in collections beyond historically black colleges and universities such as Howard, Hampton, Fisk, and Atlanta. There were also only a few museums and centers with significant collections of African American prints outside the Schomburg Center for Research in Black Culture, the Museum of Modern Art, and the Metropolitan Museum of Art. With its existing print holdings, which include a major gift to the collection from the Brandywine Workshop in Philadelphia, the Paul R. Jones Collection at the University of Delaware now joins these leading institutions. This chapter introduces a few examples of the printmakers and their works represented in the Paul R. Jones Collection. While numerous methods of study and classification may be applied, this examination focuses on the narratives presented in the work of seven artists from different time periods and representing different points in their artistic development. Some stories are

FACING PAGE:

Detail from Jacob Lawrence's The Library, 1978 (Plate 34) derived from written texts; some are inspired by the artists' actual experiences or by members of their communities; others are imagined.

One of the oldest prints in the collection and one of the earliest acquired by Jones is a 1910 intaglio by Henry Ossawa Tanner (1859–1937) entitled Return to the Tomb. Tanner was the first African American artist to become internationally known, living in Paris for the majority of his career, and being the most influential model for young artists during the New Negro era.¹ Born in Allegheny—now the Northside of Pittsburgh he was the first son of Benjamin Tucker Tanner, a bishop of the African Methodist Episcopal Church (AME) and third generation to live in the area. His family moved to Philadelphia when he was seven. He grew up in an active religious and creative environment where he was free to pursue "things of beauty." After observing a landscape painter in Philadelphia's Fairmont Park during a walk with his father at age thirteen, he decided to become an artist. He was the second African American to study at the Pennsylvania Academy of Fine Arts (c. 1879-1881), preceded by painter, miniaturist, and critic Robert Douglass, Jr., a neighbor with whom his family interacted.2 Tanner studied under realist painter and then academy director Thomas Eakins (1844-1916); under his instruction, Tanner worked from live nude models, studied anatomy and photography, and learned to draw with color.3 This studio pedagogy equipped Tanner with the ability to represent black subjects objectively in his paintings and to do so in a "sober" and realistic manner.

Tanner's progression toward biblical subject matter is traceable to a number of factors, most notably his background, personal faith, and trips to the Holy Land. His parents hoped he would "answer the call" to the ministry, or at least, become a Bible illustrator. Tanner's insistence on a professional art career deeply disappointed his father, who nevertheless provided moral and financial support whenever "worst came to worst." Nonetheless, Tanner was knowledgeable of the allegories of the Old and New Testaments and understood fundamental Christian iconography. He also experienced a gradual growth in his "personal walk of faith,"

and, further inspired by travel to the Holy Land, found religious scenes to be subject matter close to his heart and soul. This was further enhanced by the critical acclaim he received for *Daniel in the Lion's Den* (1895).

Tanner's etching, *Return to the Tomb*, is one of many intaglio prints he completed depicting the life of Christ. Tanner created a modernist version of the tomb visit that echoed his earlier painting *Annunciation XVIII*. Like that earlier work, *Return to the Tomb* was developed compositionally around simplicity, soft textures and tonalities, and angular light as means to achieving optimum, though not overly dramatic impact. He also continued his use of contemporary figures from his personal life as characters in the story. In the case of *Return to the Tomb*, he used his wife, Jessie MacCauley Olssen Tanner, as the model.

The three Marys are shown at the pivotal moment of their arrival at the tomb to anoint the body of Christ with spices and discover that the stone sealing the tomb has been rolled away. Tanner reduced the scene to a close-up of bodily expressions, cropping the image much like a photograph. The poses of the three main figures express their amazement, with soft facial lighting and bodies that are relatively well defined. The loosely rendered surrounding space reinforces the sense of reverence, further enhanced by the use of aquatint to create an overall dusky tone. Thematically, the scene is at the very heart of the resurrection story as well as the redemption message and call to conversion associated with it. In reducing the visual information to its fundamental players, Tanner anticipated viewers would know its full meaning.⁴

More than thirty years after Tanner created the figure-based work for which he became extremely well known, philosopher Alain Locke, in the essay "The Legacy of the Ancestral Arts," seemed to question his effectiveness in relating to the African American experience. Locke, in rephrasing an earlier call for African American artists to embrace a "sober realism" in their creative works (the first occurred in his 1922 publication *The New Negro*), emphasized his preference for racial themes and subjects. Locke praised Tanner's considerable talent, yet apparently considered his style of realism "wanting" in its ability to contribute to his vision of a Negro School of Art. Locke indicated:

If sustained and sustaining interest and support can be relied upon, the immediate future of the Negro artist can be faced with sanguine hope and expectation. From the side of the artist, the best significance of the present obvious achievement is its still greater potential promise. This is obvious both in maturing technique and in deepening significance of content. More and more a sober realism is to be noted which goes beneath the mere superficial picturesqueness of the Negro color, form, and feature and a penetrating social vision which goes deeper than the surface show and jazzy tone and rhythm of Negro folk life.⁵

Locke expressed disappointment in Tanner's lack of interest in black themes—presentations that linked African Americans to their legacy of African art. According to the Reverend W. S. Scarborough, a friend to the Tanner family, prominent African Americans hoped Tanner's work would "counterbalance" the negative treatment of black subjects more commonly seen. Tanner himself saw cultural merit in an African American artist creating alternative portrayals. At the same time, he felt that his work should be considered without racial classification, and that the African American artist could achieve acceptance in the mainstream art society.

Is it possible, at least formally and stylistically, that Scipio Moorhead sufficiently addressed some of the issues of unique imaging to which Locke referred in his eighteenth-century portrait of Phillis Wheatley (1773)—a work that is possibly the first official portrait of an African American by an African American.⁶ Was there further resolution in the work of nineteenth-century artists Patrick Reason (1817–1850), Robert Duncanson (1821–1872), Edward Mitchell Bannister (1826–1901), and Henry Tanner, whose portraiture, antislavery art, landscapes, narratives, and genre paintings were among the most skillfully executed works of their time? And, ironically, Locke essentially answered the question posed in the essay itself when he stated:

[I]n our cultural situation in America, race at best can only be some subtle difference in overtones of the improbable we know and treasure nationally. We must not expect the Negro artist to be different from that of his fellow artist. Product of the same social and cultural soil, our art has an equal right and obligation to be typically American at the same time that it strives to be typical and representative of the Negro; and that, indeed if evidence is rightly read, we believe it already is and promises more to be.⁷

Henry Louis Gates argues, "Renaissances are acts of cultural construction, attempting to satisfy larger social and political needs. And the African-American post-modern renaissance—in its openness, its variety, its playfulness with forms, its refusal to follow preordained ideological lines, its sustained engagement with black artistic past—is no exception." The sustained engagement to which Gates refers is evident in the collecting pattern of Paul Jones and in the innovative creative styles of many of the artists whose work was acquired. One of the most notable among them is Jacob Lawrence.

Considered to be the American artist who "reasserted the legitimacy of narrative painting as modern art," Jacob Lawrence (1917–2000) began creating images of the American scene when he was still in his teens. A native of Atlantic City, New Jersey, he lived briefly in Easton and Philadelphia, Pennsylvania, before settling in Harlem with his mother Rosa Lee and younger siblings Geraldine and William. In his early teens he began studying art with painter Charles Alston (1907-1977) at an after-school program directed by distinguished printmaker James Lesesne Wells (1902–1993). Lawrence capitalized on the vibrant and intense day-to-day Harlem environment, incorporating it into his early work. His strong sense of color and design quickly became evident, and without formal academic instruction, Lawrence rose to national prominence at a fairly young age. The winner of three successive Julius Rosenwald Fund fellowships beginning in 1939, Lawrence was actively mentored and promoted by Alston, who touted him as an unusual talent and as a self-made artist: "Lawrence's development is dictated entirely by his own inner innovations. . . . He is particularly sensitive to the life about him; the joy, the suffering, the weakness, the strength of the people he sees every day. Lawrence symbolizes more than anyone I know the vitality, the seriousness and promise of a new and socially conscious generation of Negro artists."9

In 1941, at the age of twenty-four, while enlisted in the U.S. Navy, he was given a one-person exhibition at the Museum of Modern Art. The first of many major retrospectives of his work was mounted at the Brooklyn Museum in 1960, touring numerous cities under the sponsorship of the American Federation of Arts.

Renowned for his cinematic gouache and tempera series of historical figures and events, Lawrence did not begin making prints until 1963.10 His 1978 serigraph entitled The Library (pl. 34) possesses many of the didactic and formal qualities of works in his earlier Toussaint L'Ouverture Series (1937-38), encompassing forty-one paintings about the Haitian Revolution of 1795, and Migration Series (1940-41), encompassing sixty panels on the migration of African Americans from the South. The unsentimental, unassuming, and yet candid re-creation of scenes from his own childhood, family stories, or historical writings that formed the basis for his critically acclaimed series is also the motivation for this print. The library as subject was a logical evolution for Lawrence since the facility was an important fixture in his personal life and work. "I spent quite a bit of my youth in libraries. I was encouraged by my teachers to go to the library, all of us were . . . and it became a living experience for us. I would hear stories from librarians about various heroes and heroines. The library in my day was a very important part of my life." For Lawrence, the library served as a significant force in furthering his understanding of the history of the African American experience, particularly the economical and political forces that impacted it. To him, it also played an important role in advancing the dreams of African Americans eager for historical and practical knowledge, occupying a natural place in their everyday life.

In *The Library*, there is a simple composition based on a complex integration of art elements and design principles. The print is an unassuming depiction of the space and related activity of its users. Lawrence strengthened the design with his extensive use of bold areas of color. Many of the forms and shadows are ren-

dered in black, giving them a more graphic presence. Creating an interior environment using a modified orthographic perspective, he references linear perspective within the same composition—the converging white lines in the floor guiding viewer attention to the center of the image.

The library, inclusive of all of its social, political, and cultural implications, is truly the subject of the print. At the same time, Lawrence offers an alternative reading of the African American presence in an art portrayal of average individuals pursuing information and knowledge as a common everyday act.

Another important artist to develop images around portrayals of daily life was Elizabeth Mora Catlett (b. 1915). Catlett has been a leader in the visual arts in the push for gender and racial equity since the early 1960s. Born in Washington, DC, she has lived and worked in Mexico since the mid-1950s, making frequent visits to the United States. She studied art at Howard University under Loïs Mailou Jones, James V. Herring, and James A. Porter. She was the first artist to receive the MFA from the University of Iowa (1940), having studied under Grant Wood who advised her to look to her own people for inspiration and "paint" what she knew intimately. Initially established as a sculptor, she turned to printmaking while raising her three sons with her second husband, Mexican artist Francisco Mora. A Rosenwald Fellowship allowed her to complete the well-known print portfolio, The Negro Women Series (1946-47). In this work she demonstrated her increasing use of spot color against the main black-and-white forms in the image.

In a much later print, Singing/Praying (1992) (pl. 35), she used a multicolor grid composition divided into four parts to refer to the interplay of individual spirit and group cohesiveness. By design it speaks to the intrinsic nature of song and acts of faith to the cultural history of African Americans. Dating back to slave-era songs, including call and response techniques, collective singing contributed to a sense of unity—a common cultural bond whether a spiritual, hymn, ballad, or secular song commonly known. Catlett's organization of this piece also calls to mind the effective role of singing in the civil rights movement, where song established the mood

surrounding the marches and demonstrations themselves. It also supplied the rhythm and carried the core message behind the social and political act.

Her isolation of the woman in the upper field of the print is significant. She is presented on her knees with her hands in a prayerful pose and eyes closed. The floral print of her dress draws attention to its simple design. She wears no jewelry and is completely consumed in the reverence of the moment. The left panel shows a close-up of her face in a slight angle, eyes and mouth open as she sings. The two upper panels together emphasize the personal and corporate experience, also, the individual passion and faith that contributes to the group dynamic. In the lower sections, she depicts a male singer on the right, diagonally from the female, while to his right two male heads (a repeat of the same portrayal) appear to be listeners, taking in the sounds or, possibly, singing inwardly. In what may be one of her most powerful statements concerning the string of vocal music that threads the history of African Americans, Catlett may also be making a personal statement of her own affinity for song, given she had desperately wanted to become a blues singer.

Her interest in ordinary portrayals can further be seen in the color serigraph *Girl/Boy/Red Ball* (1992). In this print, she created a seemingly innocent scene of a boy and girl at play with a simple, inexpensive toy. At moments the ball appears as the sun. The neutrality of light and dark earth tones in the ambiguous background is contrasted by the rich blue and other bright colors in the clothing of the two figures. The boy's yellow pants draw attention to him, compensating for his smaller size in relationship to that of the girl with whom he plays. The interplay of color further enhances the animated feel of the piece.

Artist and art historian Samella Sanders Lewis (b. 1924) was a student of Elizabeth Catlett at Dillard University before a transfer to Hampton Institute (now University) placed her under the tutelage of Austrianborn artist Viktor Lowenfeld where she completed study in 1945. Spending her formative years in the South, she later became the first African American woman to earn the Ph.D. in art history (1951) at Ohio State University.

Maintaining a career that included both disciplines, her prolific writing included the text *African American Art and Artists* (revised, 2003).

Lewis created a graphic Passion play in the 1994 color lithograph The Masquerade (pl. 36). Two men and two women stand behind a third man seated at a table to the extreme right of the composition. The seated man wears a symbolic red shirt. Not only does the color draw attention to this figure, but it also identifies his impending role as victim in the unfolding drama. As he clasps a book with both hands, one of the betrayers behind him wears a partially blue jacket. Although his "friendly" right hand rests on the sitter's shoulder, his left hand extends a large knife to a second man (who is almost directly behind the seated man). A third figure looks on from a frozen position while the fifth player huddles beside her, wedged to the right edge of the scene, unable to watch and having covered her face with her hands.

Capitalizing on the universal theme of betrayal, Lewis presents a visual narrative that employs color codes, linear emphasis, and compressed space to support its intended theatrics. Her use of bold black vertical lines and compressed neutral space causes the linear component to read as bars—perhaps a reference to the criminal state of mind of the two standing male characters. The red in the clothing, hat, and hair of the three male subjects ties them together while simultaneously reinforcing the tragic divide in their relationship. Ironically, they each wear a red, white, and blue top—a subtle and ironic metaphor for the U.S. flag and united state of brotherhood. The position of the two women as forced witnesses has its own poignancy and emphasizes the potential impact of visual memory.

John Wilson (b. 1922) is one of America's most distinguished printmakers. Having studied at the School of the Museum of Fine Arts, Boston, Tufts University, and the Ferdinand Leger School in Paris, he was particularly interested in the work of Mexican muralists. He also developed an affinity for the short stories of writer Richard Wright, the highly acclaimed winner of the 1937 book of National Fiction Award for the work under the title *Fire and Cloud*, 12 which coincided with

his own concerns for themes addressing the struggles and conditions of African American people. His print series *Down by the Riverside* (2001) depicts *Uncle Tom's Children* by Richard Wright, telling the compelling story of the dilemma of Mr. Mann and his family in the Deep South.

The river has flooded and his home is surrounded by water. His pregnant wife is in labor and he must get her to a doctor. However, he does not have a boat. He steals a boat from the local postman. During the theft he kills the postman. Though he eventually gets his wife to a doctor she dies because of birth-related complications and the delay of getting medical attention. Ironically, the authorities recruit Mr. Mann to serve on a rescue squad. During the process of that work he is called upon to rescue the family of the man he killed. The deceased postman's son recognizes him. However, Mr. Mann has no desire to kill a second time. Subsequently, the whites attempt to lynch him but he fights back. Mr. Mann is shot by a member of the lynch mob and is left to die down by the riverside.

Homing in on Wright's dealings with the irony and danger associated with racial difference and oppression in America, Wilson created visual portrayals that emulate the sense of sequencing seen in stage productions. With the space operating primarily as theatrical backdrops, he built the images around tones of blue, black, and specks of light for emphasis that enhanced the general sense of emotion and desperation of the main character. As can be seen in the first print in the series, *Embarkation*, the interaction of these elements is accentuated because of his characteristic use of geometricized verticals and horizontals. In Death of Lulu (pl. 37), the tragic death of Mann's wife is conveyed by a detailed drawing of her body with her arm dangling over the side as if a chilling reminder of Jacques Louis David's eighteenth-century portrayal of the death of Marat during the French Revolution. Rich, deep shadows and the color blue are used interchangeably to represent the floodwaters, the river, and the threatening nature of both as well as to signify Mann's situation in general in the story.

It is in contrast with the work of younger printmaker Michael Ellison (1952–2001) who depicted scenes based upon observed events mostly in Atlanta. Living in the city for a good part of his adult life, Ellison was a graduate of the Atlanta College of Art. He created figurebased subtractive block prints in a style that leaned toward abstraction yet contained sufficient realism to permit a reading of forms by the viewer. Brown Boy is a print where the compressed form of a single Black man takes over most of the composition. He has fallen asleep while reading a newspaper and smoking a cigarette. The trail of smoke from the cigarette in a nearby ashtray makes a thin line against the sharp angles of his body. It intersects and echoes the form of a plant at the top of the composition. The use of low-value blues, purples, and black produces a psychologically quiet and restful mood in the image. Through his use of complex forms and subtle colors Ellison created a highly complex rendering of an otherwise simple scene.

Maryland-based printmaker Margo Humphrey (b. 1942) also looks to her surroundings for inspiration and sources of subject matter. Born in Oakland, California, she attended the California College of Arts and Crafts. Drawing from patterns and color relationships seen in African motifs, she applies personally developed coloration to compositions developed around inner city stimuli. Many of her characters are based upon observed people that she incorporates in stories derived from her own experience. Within these stories Humphrey often refers to memory and includes a playful humor. Her 1980 work Home Town Blues is, in one respect, a whimsical composition especially in its execution but, on the other hand, serious in terms of its commentary on homesickness. Laced within the artist's presentation of a commonly felt situation was an expression of personal longing for the nearness of the bay waters, the flora, the sunlight and winds of northern California. In Home Town Blues, she depicts a fantastical city: the translucent body of water in the immediate foreground contains cartoon-like plants and mammals. There is an ambiguous form at the center of the composition with a burst of energy emanating around it. In the larger surroundings are red and yellow buildings as further evidence of energy and vibrancy.

There is a blue-purple sky with yellow rays emanating from behind the buildings filled with a variety of forms. A wonderful flowerlike sunburst occupies the left portion of the sky. Toward the middle of the lithograph there is an angel in a yellow dress and green wings in the sky with an airplane, a bird, a meteor, and other forms. She flies downward, at an angle toward the central energy burst. Her shadow is reflected on the façades of buildings at the center and right of the composition.

Another example of her use of autobiographical data in clever ways can be seen in *Pulling Your Own Strings* (1981) (pl. 38). In this work, she creates an image that is, in actuality, a large-scale picture postcard. Capturing the picturesque quality of an exotic vacation local, her reference to the tropics is also a way of reconnecting visually with her own coastal hometown. Hands of two puppeteers are exposed as they control the suspended figures, a male and female dancing upon a floating stage flanked with palm trees. The backdrop of the stage contains a partially opened door and an airplane flying over a grid map. Under the airplane is the inscription "Name still fly." To the upper right on the

backdrop is a female figure in a striped box with a flower in her hair holding plants. Adjacent to her is the inscription "Everybody's dream box." Although this lithograph is concerning male/female relationships in general, Humphrey also explores the complex gender role playing that people engage in due to external pressures, familial and societal. She leaves a personal mark on the image by inscribing a message in the upper left corner of the postcard: "A postcard from Tunisia. I'll be home soon. Tell everyone I said hello. Love, Margo."

One approach to constructing an African American identity has been through visual autobiography. Telling one's own story within the context of a broader history for artists established a visual pedagogy. Margo Humphrey, in a large body of lithographic work, has contributed to this use of "self" as subject.

The printmakers discussed here illustrate one of the greatest contributions of African American artists to American art: the truthful and honest imaging of African American people and culture. In so doing, they bring a greater balance to the overall portrayal of American culture and art.

NOTES

- I The New Negro era or Movement (ca. 1917–1935), also known as the Harlem Renaissance, flourished most in the 1920s. It was a time of great optimism and hope within the national African American community that sought a respectable place within American society. While it was not restricted to the North, it was facilitated by the migration of thousands of African Americans from the rural South to the urban North, Harlem being the most popular destination for many, especially numerous talented blacks in the arts. Professors Alain Locke (Howard University) and W.E.B. Du Bois (Atlanta University) were the most prominent spokespersons during the time, with Charles Johnson, James Porter, Langston Hughes, and James Weldon Johnson being among others who were at the forefront. Alain Locke coined the phrase New Negro in the 1925 special issue of Survey Graphics, expanding the ideas in subsequent texts that elaborated on his concepts of aesthetics specific to the African American experience based upon the African model. The climate for the movement was set largely due to the Pan-Africanist efforts of W.E.B. Du Bois dating back to the early 1900s. Pan-Africanism basically addresses unifying, promoting, and politically empowering all people of African descent. Including cultural components, Pan-Africanism emphasized overcoming religious, ethnic, language, and geographical differences.
- 2 For information on Robert M. Douglass, Jr., see James Porter, Modern Negro Art (New York: Arno Press, 1969).
- 3 Sharon Patton, African American Art (New York: Oxford, 1998), 98.
- 4 Biblical stories form a central spine of the African American religious experience that has been historically transformed to visual narratives. From an engraving of Nat Turner and his vision of inspired rebellion in Virginia in 1831 to a twentieth-century woodcut of a moment in the life of Dr. Martin Luther King, Jr., African American artists have revealed sensitivity to the role of the Bible and Christian teaching to African American culture. For much of the slavery era Christian stories were the only narratives allowed. At times, hearing them were the only source of comfort on the plantation and during the reconstruction period in the North. Tanner's religious works were important indicators of this cultural connection as well as ministering vehicles for those who understood the iconography and drew inspiration from them.
- 5 Alain Leroy Locke, The Negro in Art (Washington, DC: The Associates in Negro Folk Education, 1940), 10.
- 6 America's first African American poet, Phillis Wheatley's (1754–1784) talent secured her freedom in 1774. She personally selected Moorhead (a slave) to do her portrait for the frontispiece of her book of poetry, *Poems on Various Subjects, Religious and*

- *Moral,* while she was still enslaved to John Wheatley of Boston. The London publisher of her poems required the portrait as an indication of her race.
- 7 Locke, The Negro in Art, 10
- 8 Henry Louis Gates, "Harlem on Our Minds," in Richard J. Powell and David A. Bailey, *Rhapsodies in Black: Art of the Harlem Renaissance* (London/California: Hayward Gallery, Institute International Visual Arts and University of California Press, 1997), 165.
- 9 Milton C. Brown, *Jacob Lawrence* (New York: Whitney Museum of American Art, 1974), 9.
- 10 Deborah Cullen, Creative Space: Fifty Years of Robert Blackburn's Printmaking Workshop (Washington, DC: Library of Congress, 2003), unpaginated.
- 11 Patricia Hill, Jacob Lawrence: Thirty Years of Prints, 1963–1993, A Catalogue Raisonné (Seattle: Francine Seder Gallery, 1994), 41.
- 12 Michel Fabre, The Unfinished Quest of Richard Wright (New York: William Morrow, 1973), 157.
- 13 Ibid., 158.

FACING PAGE:

Detail from Margo Humphrey's Pulling Your Own Strings, 1981 (Plate 38)

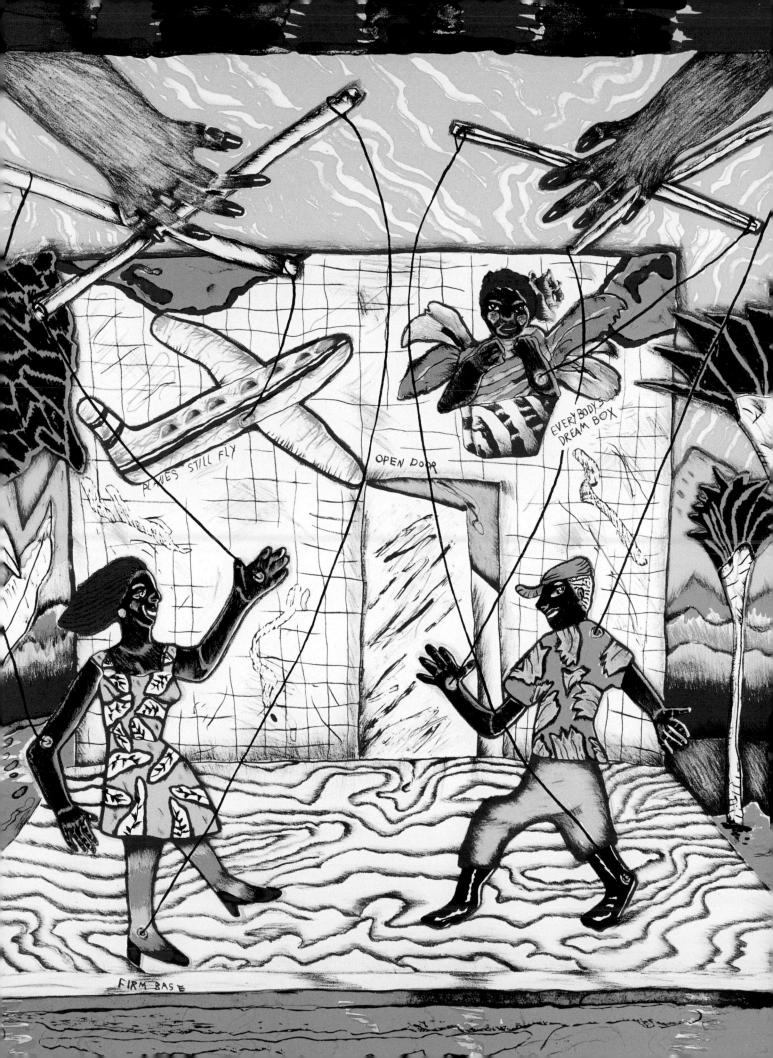

Afterword:

A Personal Appreciation – Art, Race, and Biography

MARGARET ANDERSEN

Although we often forget it, the work of artists reminds us that the transformation of human societies toward their best possibilities is not primarily a job for political technicians, but a task requiring significant creative genius.

— Vincent Harding, Hope and History: Why We Must Share the Story of the Movement, 1990

FIRST MET PAUL R. JONES AT THE UNIVERSITY OF DELAWARE AND quickly learned that his life was extraordinary—not only because of the magnificent collection of art that he has collected, but also because the seven decades of his life span an extraordinary period in American race relations and social history, some of which is revealed in his life story. Paul is not a man of great material wealth. Though now living a comfortable life—mostly because of his own shrewd investments and the current value of the art he owns—for most of his life he was a man of modest means. With a few early business investments—started on a shoestring and, later, a government worker's middle-class salary—he was able to purchase art from African American artists when few others were interested. Despite the talent of the many artists whose work and life he has supported, racism in the world of art devalued their work. Needing rent, sometimes about to be evicted, hungry, out of cash, artists would flock to his door. As Paul puts it, "Sometimes I didn't know if I was an art collector or a social worker." With an eye for interesting work, though academically untrained in art history, he would buy multiple works from the same artist, wanting to create a collection that would show the span and depth of African American artistic creativity. "There's a joke that he bought art by the pound," says Amalia Amaki, curator of the collection and Paul's good friend.

The Paul R. Jones Collection is a treasure and, in keeping with Paul's wishes, is being developed at the University of Delaware as a teaching and research collection.²

FACING PAGE:

Detail from Herman Bailey's Portrait of Paul R. Jones, 1973 (Plate 39) Paul wanted his collection to go to a historically black institution. Although some museums wanted to buy individual pieces, he did not want to break up the whole. He preferred the art be in a place with the resources to preserve it, where it would be showcased and where it would become part of an educational mission. As he states, "I want it to be woven into the fabric of an institution where it will be used for teaching and exhibitions."

I have known Paul since 1997, first meeting him when I was dean of the College of Arts and Science at Delaware. He had established a relationship with our Department of Art History, long known for its scholarship on American art; the college was cultivating a relationship with him. The university had exhibited some of his collection in 1993 as part of a show on African American artists in conjunction with a symposium sponsored by the art history department. When I met him, he was serving as a member of the College Visiting Committee on the Arts.

Not long after I learned about his collection, I traveled to his home to see it firsthand. At the time, he lived in a small, three-bedroom ranch house in southwest Atlanta. I will never forget walking through the front door into a small living room (probably about 12' x 15') that was crammed with stunningly beautiful artworks. A tour of the house revealed there was art everywhereon every conceivable inch of wall space, stacked in the corners, on the floor, in the dresser drawers, stuffed in kitchen cabinets, piled on tables, on top of and under beds-everywhere! And, as we walked around, Paul talked about each and every piece we stopped to view. He knew the artist, he knew when he bought it, he talked about what it represented, and how it moved him. I remember saying to him that day that someone needed to come with a tape recorder and just listen to him talk about the art and his life. He now lives in a larger home—designed in part to showcase what he collected out of sheer dedication to resurrecting and preserving African American culture and making it a part of the national cultural heritage.

Who is the man who has brought this creative legacy together and what does his life tell us about the place of African American art in art history, in society and culture, and in a vision of racial change? C. Wright Mills tells us that you can understand a man's life by understanding the social and historical forces that shape it. But you can also understand the social and historical forces of a time by examining a man's life.

Paul's life spans seven decades. Born (1928) in an age of agricultural and industrial peonage; educated during the peak of Jim Crow segregation; working as a civil rights mediator and as a community relations expert during the civil rights movement and its aftermath; holding a position in the Nixon administration during the Watergate scandal; and developing the nation's largest African American art collection, he has lived through some of the major events that have shaped the course of the twentieth century. His life's course is a part of American social history and is a window opening onto some of the most fascinating parts of that history.

Paul Jones is from relatively modest, though unusual origins. He is the son of Will and Ella Jones. His father worked for the Tennessee Coal, Mine, and Railroad Company (TCI) in Bessemer, Alabama, briefly as a laborer and later in the mining office where he hired workers and mediated conflicts between those in an incipient labor movement and the mine owners (employment broker in today's professional terminology). At other times, he settled conflicts between black and white workers. It was a company town—TCI owned the mines, the housing, the schools, and the commissary.3 Because of his father's position his family enjoyed privileges that were not typical of other black mining families. The Jones family's class standing bridged the black working poor and the middle class—perhaps a juxtaposition that later enabled him to work across various social boundaries. Paul was also born into a family with a strong entrepreneurial spirit—a spirit that lives within him, too.

When he was ten years old, his family sent him north in search of a better education. He lived with older brother, Joe, and his family in New York during the school year, returning home during the summer. Attending high school in Bessemer, he graduated from Paul Lawrence Dunbar High School and later graduated from Howard University in the class of 1948. As an

adult he worked as a probation officer, a community relations specialist, a director in the Model Cities Program, a deputy director in the Peace Corps, and as a White House staff assistant in the Nixon administration. He worked to achieve civil rights and to settle racial conflict. He has forged opportunities for African Americans in political office and has striven to build better communities for those disadvantaged by racism and inequality. And, of course, he has paved a path for artists by not only sponsoring their work, but also by trying to transform the often exclusionary climate in art museums (in their collections, on their boards, and in their exhibits). Through it all, he has kept an eye on the human creative spirit through the collection of African American art.

In getting to know Paul, I quickly learned not only about the value of his remarkable collection, but also of a life that reflects some of the nation's racial history. What was it like growing up as a young boy in a company town with an incipient labor movement? What was his mother's work like? Could true friendships between blacks and whites develop in this racially stratified time? What were the schools like for a young black boy? How could a black man manage to negotiate the conflict between Sheriff Jim Clark and angry black protestors in Selma, Alabama? How did a black man with strong democratic values end up working in the Nixon administration? What was it like during Watergate? How did you get all that art? These and many other questions began my inquiry into the life of Paul R. Jones.

Usually sociologists do research by trying to discover the patterns and processes by which social structures form and evolve; this activity frequently means engaging relatively large bodies of data. Suspicious of the single case because of its inability to allow generalization, sociologists rarely examine the life of one person as a source of insight. But, if we can grasp the relationship between biography and history by studying large-scale social processes, can we not also discover social facts through the study of individual lives?

With no training or background in art history and little knowledge about art other than personal taste, I entered this project (writing about Jones's life) with only

my knowledge about race and society, but with a commitment to transforming race relations through educational change. Like others, I have visited museums, have looked for images that particularly appeal to me, and have illustrated some of my published work with photographs and art that seems to capture certain ideas or events. And, because of my longstanding interest in bringing the work of those who have been ignored to the forefront of education, I have often sought images and work by women and artists of color both to inspire me and to communicate sociological ideas to students. But I never consciously thought about the transformative power of art, nor about the potential for art to become part of a sociological education. Not until I met Paul Jones. Moreover, I never imagined myself writing someone's life history. But I now see this work as both honoring Paul Jones and contributing to the sociological analysis of race in society.

Paul's life tells us much about the social and historical forces shaping race (and the arts) across most of the twentieth century. As Karen Hansen notes, biography can be a prism through which we examine the social aspects of a period of time. Hansen sees that biography accomplishes this by prompting one to ask questions about otherwise taken-for-granted phenomena, illuminating a life as a "point of entry that then connects to larger social and economic processes," and seeing how connections come together in one life.⁴

As Hansen indicates, writing a biography or life history as a sociologist differs from how traditional biographers or historians might write one. Historians use biographies to examine the role of influential people in different arenas of life. Sociology's interest in collectivities, not individuals, is somewhat different. Rather than using a biography to understand an individual life, sociologists expect to focus on the larger social relations in which individual lives are experienced. Biographies can reveal the economic, cultural, and political influences that bear upon a life and that also bear upon a whole society or group. But, more than revealing society and history, biographies also connect us to the emotional and inspirational dimensions of life—dimensions of life often ignored in sociological research.

Paul Jones's life reveals much about society and social change. We see in his life how conflict and cooperation played out in the organization of labor and the early labor movement. We can identify how race is represented in the works of the African American artists that he collects. From his experience we can learn what it is like to work as one of the few black Americans in places like a Republican presidential administration, in the Peace Corps, or on elite art museum boards. We can wonder at the unique class status of an African American family perched between the black laboring class, white management, and the black middle class, and learn firsthand about some aspects of the dismantling of Jim Crow segregation. And in viewing Paul's life history we can study the role of human agency in transforming art institutions. Or, we can simply immerse ourselves in biography, the straightforward listing of dates and facts.

My objective is not to tell Paul's life as pure fact—a feat that could not be accomplished by any life history. Whether narrated by the subject, interpreted by the observer/recorder, or read by the audience, a life is interpreted. As such, subjectivity is a major part of such a research endeavor. Unlike sociological methods that allegedly rely on objective and seemingly detached forms of analysis, developing a life history requires a quite intimate relationship with one's subject. The collection of the life narrative itself is a social process and, as such, subject to the same social influences that shape any social relationship. What are the implications of this fact for this methodology?

Sally McBeth writes, "A life story is more than a recital of events. It is an organization of experience." As such, both the narrator and the observer have a role in how the story is told. A life history engages the memory of the narrator, the relationship between the narrator and the observer, and the observer's hand in how the life is recorded, organized, and presented. In each dimension, social factors weigh in.

Subjectivity clearly plays a clear role in the development of a life history. Life histories are reconstructed accounts of experiences lived over years; these accounts are informed by what people remember and how they experience the significance of events. As historian James Hoopes puts it, a life history from interviews is "spoken memory." Memory is, after all, fallible. Memory can be wrong, incomplete, or fully made up as we continuously reconstruct our concepts of self, our relationship to others and to life events. Our account of our own lives emerges as our life does.

Since sociologists know that the self is a social construction, the point of a sociological life history is not to reveal some fundamental essence of the person, but to instill a sense of the social movement of the life and the social context in which it emerges. When readers engage a life history, they seek not only facts and events, but a sense of time, place, and being. This is created not through presentation of the facts alone, but by how a life story is told, how it is written, how it is placed in context as the author/observer develops it. Thus, no life history can be a completely objective rendering of a person's life.

In attempting to develop Paul Jones's life history, I have collected, reorganized, reordered, and, in some cases (for sake of the written word), rewritten the words that evolved from the interviews with Paul Jones. I have striven for accuracy in the telling of this life history, and hope that it also reveals the sociological context in which it was lived. Moreover, I must confess that I am not at all dispassionate about Paul Jones or the Paul Jones Collection, as claims to more objective social science methods supposedly require. On several levels this project engages some of what I care most deeply about: friendship with a man I truly admire and respect; feelings of mutuality between us as our relationship has grown over the course of this project; greater awareness of the history of race and change in the educational curricula; inspiration from the powerful images that the art invigorates; collaborative work across racial, gender, and class differences, to name but a few. And with biography and life history in mind, I rely on the words of Daniel Bertaux, "If sociology cannot relate to people, . . . it is a failure."9

So, what is a sociologist doing writing in the world of art and about the life of an art collector? Writing about any life engages one in a process of locating an individual in the social-historical times of his or her life. Writing about an art collector, and, in particular, an African American collector of African American art also involves locating art in the context of social institutions that have reflected the racial stratification of society. In the case of Paul R. Jones, we can observe how a person has worked to change those institutions and we can see how the exclusionary practices of those institutions over the years have constructed what we understand to be American art.

Although the task I set for myself in the future and that I have only touched on here, is to understand and

interpret the collector's life, this life history also inspires a sociological appreciation of African American art itself. And because sociological research often rests on the presentation of forms of data that sometimes do not invoke human agency and human expression, writing such a life history also reminds us of the creative capacity of human beings—even under conditions of great oppression. Thus, studying the life of Paul Jones teaches us not only to appreciate his life and the social contexts in which he lived and worked, but it also teaches us to appreciate the work of artists who have been subordinated by the forces of racism.

NOTES

- 1 News Journal, Sunday, February 3, 2002, 10.
- 2 Paul Jones donated the Collection to the University of Delaware in 2001. You can see more about the Paul R. Jones Collection at www.udel.edu/PaulRJonesCollection.
- 3 To learn more about race and the mining industry during the early twentieth century, see Horace Mann Bond, Negro Education in Alabama: A Study in Cotton and Steel (New York: Atheneum, 1939); Brian Kelly, Race, Class, and Power in the Alabama Coalfields, 1908–1921 (Urbana: University of Illinois Press, 2001); Philip Taft, Organizing Dixie: Alabama Workers in the Industrial Era, revised and edited by Gary M. Fink (Westport, CT: Greenwood Press, 1981); Russell D.Parker, "The Black Community in a Company Town: Alcoa, Tennessee, 1919–1939," Tennessee Historical Quarterly 37 (1978): 203–221; Deborah E. McDowell, Leaving Pipe Shop: Memories of Kin (New York: W. W. Norton, 1996); and Nell Irwin Painter, The Narrative of Hosea Hudson: The Life and Times of a Black Radical (New York: W. W. Norton, 1994).
- 4 Karen V. Hansen, "Historical Sociology and the Prism of Biography: Lillian Wineman and the Trade in Dakota Beadwork, 1893–1929," *Quantitative Sociology* 22 (1999): 355.
- 5 Ibid., 353-358.
- 6 For a discussion of the role of subjectivity in sociological biography, as well as in other social science methods, see Daniel Bertaux, ed., *Biography and Society: The Life History Approach in the Social Sciences* (Beverly Hills, CA: Sage Publications, 1981).
- 7 Sally McBeth, "Introduction: Methodological and Cultural Concerns of Collecting and Co-authoring a Life History," in Esther Burnett Horne and Sally McBeth, Essie's Story: The Life and Legacy of a Shoshone Teacher (Lincoln: University of Nebraska Press and Bison Books, 1998), xi-xii.
- 8 James Hoopes, *Oral History: An Introduction for Students* (Chapel Hill: University of North Carolina Press, 1979).
- 9 Daniel Bertaux, ed., Biography and Society: The Life History Approach in the Social Sciences (Beverly Hills, CA: Sage Publications, 1989), 43.

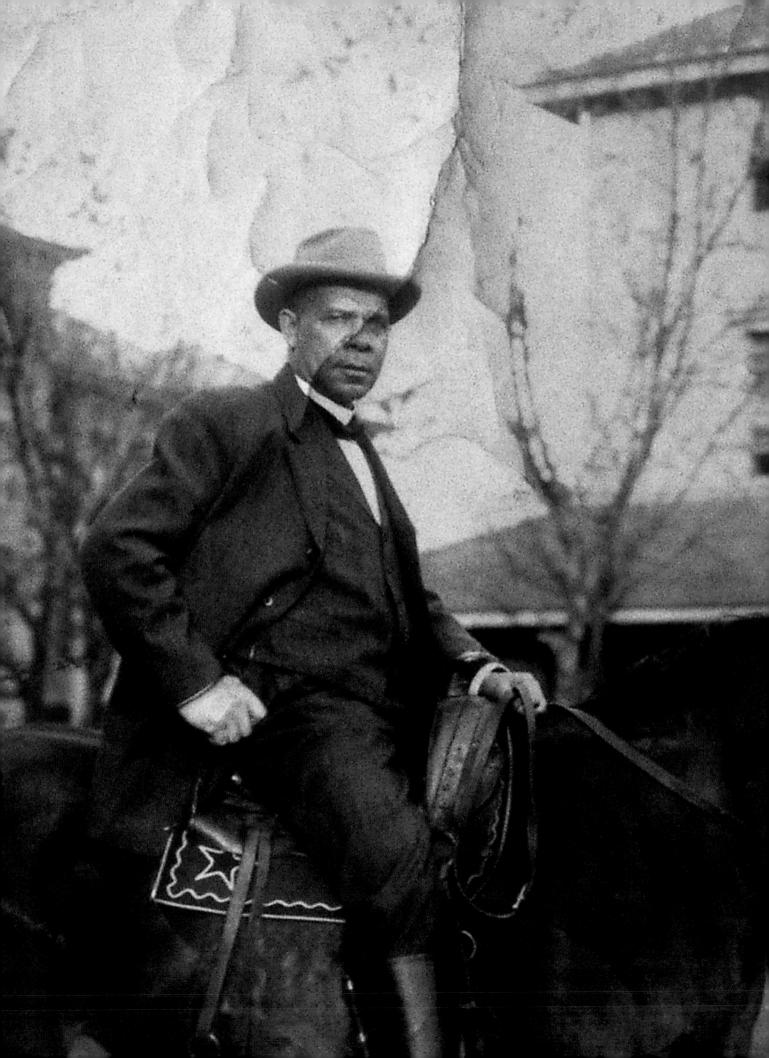

Preservation for Posterity:

The Paul R. Jones Photography Collection

DEBRA HESS NORRIS

housed in the newly renovated Mechanical Hall on the University of Delaware campus, where it will be well protected from rapidly fluctuating environmental levels and atmospheric pollutants. Light levels will be monitored and practical handling policies enforced. This remarkable collection includes photographic images of immense aesthetic, historical, and cultural value. While these images, primarily silver gelatin black-and-white photographs, are generally in stable condition, familiarity with the preservation measures described in this essay will help to ensure their availability for the education and enrichment of future generations.

COMPOSITION AND STRUCTURE OF PHOTOGRAPHIC PRINT MATERIALS

Photographic print materials have complex and vulnerable physical and chemical structures that present the collector with unique preservation challenges. Since the beginning of photography in the late 1830s, many different photographic print processes have been utilized. These include salted paper, albumen, silver gelatin, and contemporary color. The structure of historic and contemporary photographic print materials typically consists of a final image embedded in a transparent binder layer and a primary support. This structure may be further complicated by additional colorants, coatings, and inscriptions, and by the presence of a secondary support such as laminated wood pulp or cotton fiberboards. The chemical composition and physical structure of these photographic print

FACING PAGE:

Detail from Arthur P. Bedou's silver gelatin photograph,
Booker T. Washington, ca. 1915,
after conservation treatment at
the Art Conservation Department,
University of Delaware.
(Plate 41)

materials must be understood to ensure their long-term care and preservation.

Photographic images are created by materials that absorb and scatter light. Final image materials include metallic silver, platinum and palladium metal, pigments, or organic dyes. The final image material in most nineteenth-century photographic prints (including salted paper and albumen) is finely divided silver, commonly referred to as photolytic silver or silver produced by light. In these processes, light-sensitive paper is placed in contact with a negative (typically collodion glass plate) and exposed to light until the image appears. Photolytic silver particles are round; they scatter light to produce the red, purple, or brown image tones associated with nineteenth-century print materials. These small particles (typically 3 to 50 nanometers in diameter) are susceptible to chemical degradation, resulting in fading, discoloration, and a loss in highlight detail—deterioration characteristics we associate with nineteenth-century photographic print materials.

The final image material in most twentieth-century silver gelatin photographic prints is filamentary silver. Produced by chemical development in a photographic darkroom, these silver particles consist of a bundle of irregular, intertwined silver filaments that are much larger in size (typically 1,000 nanometers in diameter) than photolytic silver particles. These large particles are less vulnerable to image oxidation.2 Their irregular structure is ideal for light absorption. Filamentary silver images in stable condition are therefore characterized by a black or near-neutral image color. Degraded silver gelatin images may exhibit a color shift from neutral black to yellow brown as their filamentary structure breaks apart and no longer absorbs light effectively. Mirroring, a reflective silver image layer readily visible in raking light in the dense image areas of a print and caused by oxidation, is a common symptom of deterioration in filamentary silver images.

All silver images are affected by improper processing, specifically inadequate fixing and washing, which may result in severely yellowed or faded final image materials. Although silver image deterioration directly attributable to poor processing is not uncommon (and

often encountered in newspaper morgues and other repositories that include images that may have been rapidly processed), most photographic print materials in poor condition have been damaged by exposure to poor environmental conditions and inappropriate handling and storage practices.

In platinum printing, a process prized by fine art photographers at the turn of the century for the pristine, near-neutral matte surface of the prints produced, the final image material is metallic platinum. Platinum is a noble metal; it will not tarnish, discolor, or fade. Platinum is a catalyst for cellulose degradation. For this reason, platinum prints may exhibit an embrittled and highly discolored primary support. Their pristine matte print surfaces are fragile and easily marred and abraded.

Pigments, including lamp black, burnt sienna, Prussian blue, and raw umber, have been used as the final image material in cyanotypes and gum bichromate and carbon prints. These pigments are typically dispersed in a binder and therefore tend to provide excellent image stability.

The synthetic dyes used in most color prints process—cyan, magenta, and yellow—are considerably less stable than metallic silver, platinum metal, or most pigments. These dyes will fade significantly in the dark as well as the light. The decoloration of organic dyestuffs is caused by irreversible changes in their organic structure. Image deterioration in color prints results in an overall loss of density, a shift in color balance as dye layers fade at different rates, and the formation of a yellow stain. Storage temperature will determine the rate of dye fading or staining.3 The extent and rate of this deterioration are also dependent on the type of color print materials. The image stability of instant color processes, for example, is very poor. In comparison, silver dye bleach (or Ilfochrome) processes composed of azo dyes have excellent dark stability.

The transparent layer that suspends and protects the final image is called the binder. Binders play an integral role in determining the optical properties and stability of print materials. The binders most commonly used in historic and contemporary print processes include albumen, a globular protein from the whites of hens' eggs, and gelatin, a highly purified, commercially prepared protein produced from animal hides and bones.

Introduced in 1851, the albumen process dominated photographic processes during the nineteenth century. Albumen binder layers yellow and discolor, often because of prolonged exposure to light and conditions of high relative humidity. Because the albumen binder layer expands and contracts at a different rate than its lightweight paper support, these prints typically exhibit cracked and crazed surfaces.

Photographic gelatin is a purified, homogenous material derived from collagen. Introduced to photography in the 1880s, this binder is used today for all silver and color photographic processes. Although gelatin is a relatively stable material chemically (unlike albumen), it is responsive to changes in temperature and relative humidity. Swollen gelatin allows for the rapid diffusion of oxidizing gases and other potentially corrosive contaminants, accelerating image degradation. Gelatin binder layers are an excellent nutrient for mold and can flake excessively when exposed to fluctuating environmental conditions.

The primary support used for photographic print materials is paper. Traditionally, these paper supports have been manufactured from high-quality rag or chemically purified wood pulp. By the mid-1880s, machinemade photographic papers were often coated in the factory with "baryta" a barrier layer that consisted of the white pigment barium sulfate dispersed in gelatin. This smooth, highly reflective white layer allowed for higher contrast and glossier images.

Plastic- or resin-coated photographic papers, introduced in the late 1960s, consist of a paper core laminated between two layers of polyethylene. The uppermost layer of polyethylene is pigmented with titanium dioxide, a white pigment that releases damaging peroxides when exposed to ultraviolet light. Early black-and-white and color resin-coated print materials may exhibit spotwise fading or embrittlement and cracking of their top polyethylene layer caused by interaction with these aggressive, light-induced oxidants. Contemporary papers

have increased stability (similar to that of fiber base if processed and housed properly) owing to the presence of antioxidant stabilizers.

The stability and appearance of photographic print materials may be influenced by the presence of secondary supports, hand-applied coloring, collage elements, adhesive layers, and final coatings, which may include waxes, natural resins, and gelatin.

PRESERVATION ISSUES

Photographic print materials can be damaged by exposure to inappropriate environmental conditions, careless handling practices, and the use of improper storage enclosures.

Environment Photographic print materials should be housed in a stable environment that protects them from excessive moisture, high temperatures, airborne particulates, and gaseous pollutants. The American National Standards Institute (ANSI) and other standards organizations have developed guidelines for the long-term storage of photographic materials.4 In general, print materials should be stored at a relative humidity level of 30 percent to 50 percent. Exposure to high relative humidity levels may accelerate image and binder layer degradation, causing image fading and highlight staining, as well as biological and physical damage such as increased curl. Excessively dry conditions may cause proteinaceous binder layers to crack and craze and primary supports to become brittle and prone to hairline cracking and handling-related creases. Humidity fluctuations of greater than 10 percent should be avoided.

Room-temperature storage conditions are recommended for non-color photographic print materials. Temperature cycling should not be greater than $+/-5^{\circ}$ C over a twenty-four-hour period. Low temperature storage at 4.5° C (40° F) or below is recommended for most color photography. The construction, selection, and maintenance of cold storage facilities require specialized knowledge and may not be practical for the preservation of privately owned collections. Issues relating to

proper packing and retrieval guidelines must be developed and implemented to ensure that collection materials are not damaged when moved from one environment to another.

Photographic collections should be protected from airborne pollutants through the use of carefully monitored air filtration systems and by proper filing enclosure and lidded boxes or closed cabinetry.

Handling Photographic prints may be seriously damaged when handled carelessly, as their surfaces are delicate and easily scratched or abraded and their lightweight paper supports may be creased and torn if lifted without adequate support. Prints should be handled by their edges and properly supported at all times. Unmounted or matted photographic prints (especially large-format materials) may require a temporary auxiliary support, such as a sheet of ragboard, during handling. The practice of wearing clean cotton or nylon gloves, especially when enclosures or mats do not protect prints, should be standard procedure. Inventories and box lists will minimize handling and enhance access and preservation.

Exhibition and Display Light damage is cumulative and irreversible. Following light exposure, primary and secondary paper supports may become brittle, and binder layers will yellow and stain. Hand-colored surfaces and ink inscriptions may fade, and the color balance of contemporary materials will shift as organic dyes rapidly decolorize at differing rates.

Exhibition standards do not exist, but conservation professionals typically recommend light levels of 50 lux (5 footcandles) for no more than four months per year for nineteenth-century print materials, including salted paper, albumen, and platinum. Pristine prints are often more adversely affected than those that are somewhat faded and deteriorated. Fifty lux is also recommended for all prints from processes that use applied color or binder-incorporated aniline dyes. Most silver gelatin prints may tolerate exposure to light levels of up to 100 lux (10 footcandles), but like nineteenth-century materials, annual exhibition times must be limited. The light-fading characteristics of modern color materials

vary considerably. For most color prints, the spectral distribution of the illumination source—incandescent versus fluorescent light, for example—has little effect on fading rates. Here, it is the intensity of the illumination that is important. Color photographic materials are highly vulnerable to light-induced damage; illumination levels should be kept as low as possible.

Photographic prints should not be exposed to direct sunlight or ultraviolet light. Tungsten or fiber optic illumination should be utilized. Filters and diffusers should be incorporated into all case lighting. Framed photographs should be properly hinged or photocornered into an acid-free mat glazed with ultraviolet-filtering acrylic sheeting. Only latex paints should be used to prepare exhibition spaces, as peroxides emitted during the curing of oil-base paints will accelerate silver image deterioration.

Photographic materials must be exhibited under carefully specified and controlled conditions. The risks of temperature extremes, cycling relative humidity levels, poor handling and transport practices, potential accidents, exposure to environmental pollutants, and vandalism must always be mitigated. All photographs are affected by exhibition. The question is not if changes are taking place, but rather at what rate and how much.

Storage Enclosures Photographic prints must be housed in protective enclosures to shield them from atmospheric pollutants, including dirt and dust, and rapid fluctuations in temperature and humidity. Both plastic- and paper-based enclosures provide photographic prints with increased physical support, protecting fragile surfaces from handling-related damages such as fingerprints, abrasions, and creasing. The current ANSI standard requires that all enclosures be chemically stable and free of acids and peroxides.5 Paper-based storage enclosures (including matboard, folder stock, and interleaving materials) should pass the Photographic Activity Test (PAT),6 an accelerated aging test that quantitatively evaluates potentially harmful physical (abrasion) or chemical (staining and fading) between a photographic print and its enclosure. Manufacturers of paper-based storage materials should stipulate PAT results. Independent testing is also possible.

Photographic enclosures made of paper should have a high alpha-cellulose content but not contain lignin, ground wood, or alum rosin sizing. Glassine papers or Kraft paper envelopes should not be used for photographic storage. According to the American National Standards Institute, papers in contact with silver gelatin prints (black-and-white images) should have a pH between 7.2 and 9.5. The alkaline reserve should be the equivalent of 2 percent calcium carbonate by weight. For color materials, the pH should not exceed 8.0; as the alkalinity increases, there is a greater potential for cyan dye fading or stain formation. At all times, physical properties such as smoothness and strength should be evaluated before a final selection is made.

For optimum handling protection, photographic prints may be matted with good-quality ragboard (that has passed the PAT). Slipsheets made of lightweight paper or polyester film may be inserted between the photograph and the window mat to guard against abrasion. When used properly, photocorners are the most reversible and safe form of attachment. In all cases, these corners must be large enough to properly support the photograph when hung vertically and situated in such a way that the print can expand slightly with changes in relative humidity. Tight corners may promote creasing or other forms of planar distortion. Corners should be fabricated from acid-free paper (plastic corners can emboss glossy surfaces) and held in place with a strip of archival-quality linen tape.

Photographic prints may also be safely housed in clear plastic enclosures. Suitable plastics include polypropylene, high-density polyethylene, and polyester. Chlorinated plastics, such as polyvinyl chloride, should never be used for the storage of photographic materials. Plastic enclosures are often not rigid enough to protect print materials from mechanical damage, including handling-related creases. A temporary auxiliary support (such as a piece of four-ply matboard) should be used wherever possible. Photographs with friable media or flaking emulsion should not be housed in plastic enclosures.

Collection size, condition, environmental parameters, projected access and use, and financial/time re-

sources must be carefully considered when deciding what type and style of enclosure to use. The Paul R. Jones Collection, for example, includes many unmounted silver gelatin prints. These prints are in stable condition. Many have been and will be used by scholars and students; a large percentage will be exhibited at various venues, including but not limited to the University of Delaware. To improve handling protection, these prints may be matted with paper photocorners. Space limitations may dictate that some of these prints be housed in high-quality plastic sleeves (to facilitate viewing) and boxed for further protection. All enclosures should be of standard size; flat storage is recommended, and boxes must not be overcrowded. It may be recommended that those photographic prints that are most heavily used or in particularly fragile condition be rehoused first.

Evaluation for Conservation Treatment Photographic prints should be carefully examined and evaluated to assess the need for conservation treatment. Custodians of photographic materials should learn to identify deterioration problems that may require immediate intervention.8 The presence of active mold growth, for example, is a critical and complex problem that must be addressed. Spore removal using special aspiration techniques combined with stringent environment controls should prevent further biodeterioration. Resultant mold staining is often permanent. Photographic print materials with active flaking binder layers, as well as those mounted with rubber cement or pressure-sensitive adhesives, should be identified for conservation treatment. These damages will worsen with time; adhesives will become intractable, and binder layers may be further damaged and lost entirely. Methods for the chemical restoration of faded photographs are currently unreliable. Further research is necessary. In some cases, however, severely faded and discolored images can be photographically or digitally copied for enhanced image resolution.

Practical, reversible, and predictable conservation treatment procedures for deteriorated photographic print materials continue to be developed and refined. In

all cases, conservation treatment should be undertaken by a trained photograph conservator and governed by informed respect for the photograph, its unique character and significance, and the photographer who created it. In the United States, conservation professionals are guided by the Code of Ethics9 of the American Institute for Conservation. Similar codes guide conservation professionals internationally. Adherence to this doctrine dictates that the conservator must use materials and methods that will have the least adverse effects and that can be removed most easily and completely. In doing so, conservation treatment must not modify or conceal the true nature of the object. It must be detectable, although it need not be conspicuous, and it must be fully documented. The conservator must adhere to the highest and most exacting standards and must practice within the limits of personal competence and education.

CASE STUDY

In the fall of 1998 Yana Van Dyke, a second-year fellow in the Winterthur/University of Delaware Program in Art Conservation, cexamined and treated a photograph of Booker T. Washington from the Paul R. Jones Collection as part of her photographic conservation graduate coursework under the author's supervision. This silver gelatin printed-out image, of central importance to the collection, was in fragile condition. It exhibited serious losses at all edges, numerous tears, creases, and other insecurities, and abundant surface dirt. The gelatin emulsion was actively flaking, and the photolytic silver

image was faded and discolored (pl. 40). Following extensive photographic and written documentation, this equestrian portrait was gently surface cleaned with a water/ethanol mixture, consolidated under the microscope with a dilute gelatin solution, mended with a long-fibered paper and reversible wheat starch paste, inserted with a toned contemporary paper of similar manufacture and weight, inpainted with watercolors, humidified, and flattened. Seventy-two hours later, the image had been stabilized from further damage and visually reintegrated (pl. 41).

PRIORITY FOR PRESERVATION

Preparation of a well-balanced preservation plan requires conscientious collaboration between the conservation professional and the collector and/or custodian responsible for the collection's long-term care. Shared decision making is essential. In all cases, photographic format and process, condition, housing, access, and value must be carefully evaluated. Fortunately, the Paul R. Jones Collection of Photography is in good condition, well protected from adverse environmental conditions, catalogued for access, and housed in good-quality enclosures.

The Paul R. Jones Collection of Photography offers art conservation undergraduate and graduate students a wonderful opportunity to examine, analyze, treat, and preserve a collection of contemporary photographic materials, to work closely with a visionary collector, and to collaborate with colleagues within the university community and beyond."

- J. Reilly, Care and Identification of 19th Century Photographic Prints (Rochester: Eastman Kodak Company, 1986).
- 2 K. Hendriks, "The Stability and Preservation of Recorded Images," in J. Storge, V. Walworth, and A. Shepp, eds., *Imaging Processes and Materials* (New York: Van Nostrand Reinhold, 1989), 637–686.
- 3 H. Wilhelm, The Permanence and Care of Color Photographs: Traditional and Digital Color Prints, Color Negatives, Slides, and Motion Pictures (Grinnell, IA: Preservation Publishing Company, 1993).
- 4 International Organization for Standardization (ISO), *Imaging Materials—Processed Photographic Reflection Prints—Storage Practices*, ISO 18920-2000 (Geneva, Switzerland: International Organization for Standardization, 2000).
- 5 D. Norris, "The Preservation of Photographic Collections in Natural History Collections," in Storage of Natural History Collections: A Preventive Conservation Λpproach (Iowa City, IA: Society for the Preservation of Natural History Collections, 1995), 355–365.
- 6 International Organization for Standardization (ISO), Photography—Processed Photographic Materials—Photographic Activity Test for Enclosure Materials, ISO 14523-1999 (Geneva, Switzerland: International Organization for Standardization, 1999).
- 7 International Organization for Standardization (ISO), Imaging Materials—Processed Photographic Films, Plates, and Papers—Filing Enclosures and Storage Containers, ISO 18902:2001 (Geneva, Switzerland: International Organization for Standardization, 2001).

- 8 D. Norris, *Photographs: The Winterthur Guide to Caring for Your Collection* (Winterthur, DE: The Henry Francis duPont Winterthur Museum, Inc., 2000), 79–91.
- Code of Ethics of the American Institute for Conservation of Historic and Artistic Works (Washington, DC: American Institute for Conservation of Historic and Artistic Works, 1994).
- The University of Delaware in collaboration with Winterthur Museum offers one of four master's-level programs in art conservation in the United States, one of only three programs nationally to offer a specialty in photograph conservation. Students in this program—the program accepts only ten annually—study with eighteen conservators and conservation scientists (full-time and part-time faculty) representing a broad range of conservation disciplines and educational backgrounds. The University of Delaware also offers the only formal undergraduate art conservation program in the United States.
- II In 2001–2002, the University of Delaware Art Conservation Department sponsored conservation lectures for Spelman students and the Atlanta community and worked with faculty at Spelman and Morehouse Colleges to identify required coursework in chemistry, art history, and studio art as well as Atlanta-based internship opportunities for students wishing to pursue careers in conservation. Martin Salazar, WUDPAC Class of 2002, spent one week at Spelman treating a collection of tightly rolled and damaged panoramic silver gelatin photographs from the Spelman Archives. This work, including surface cleaning, humidification, flattening, and tear repair, was conducted in the Spelman chemistry laboratories, where students were offered a rare opportunity to observe, assist, and learn about the field of art conservation. This was an exciting collaborative program that we intend to continue.

Jimmie Mosely, *Humanity #2*, 1968. Watercolor, 20 x 36 in.
The Paul R. Jones Collection, University of Delaware, Newark.

PLATE 2

John T. Riddle, *Professor from Zimbabwe #1*, 1979. Acrylics on board, 36×28 in. The Paul R. Jones Collection, University of Delaware, Newark.

The PAUL JONES COLLECTION

KING-TISDELL COTTAGE 514 E. HUNTINGDON STREET SAVANNAH, GEORGIA February 3 - March 15, 1985

PLATE 3

The Paul R. Jones Collection exhibition brochure,
King-Tisdell Cottage, Savannah, Georgia, February 3–March 15, 1985.
The Paul R. Jones Archives, Atlanta, Georgia.

FROM THE NEGRO CULTURE COLLECTION PAUL R. JONES

PLATE 4

"From The Negro Culture Collection: Paul R. Jones," exhibition sign, Savings and Loan in Charlotte, NC, 1969.

The Paul R. Jones Archives, Atlanta, Georgia.

PLATE 5
Bill Hutson, *Maiden Voyage*, 1987. Acrylic on raw canvas, 22 x 29 in.
The Paul R. Jones Collection, University of Delaware, Newark.

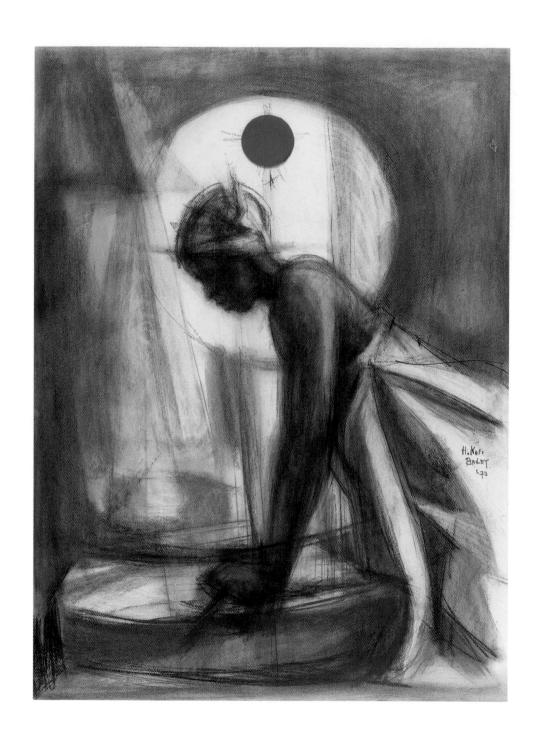

PLATE 6
Herman "Kofi" Bailey, Woman Grinding Peppers, 1973. Nu-pastel on paper, 40 x 30 in.
Collection of Paul R. Jones, Atlanta, Georgia.

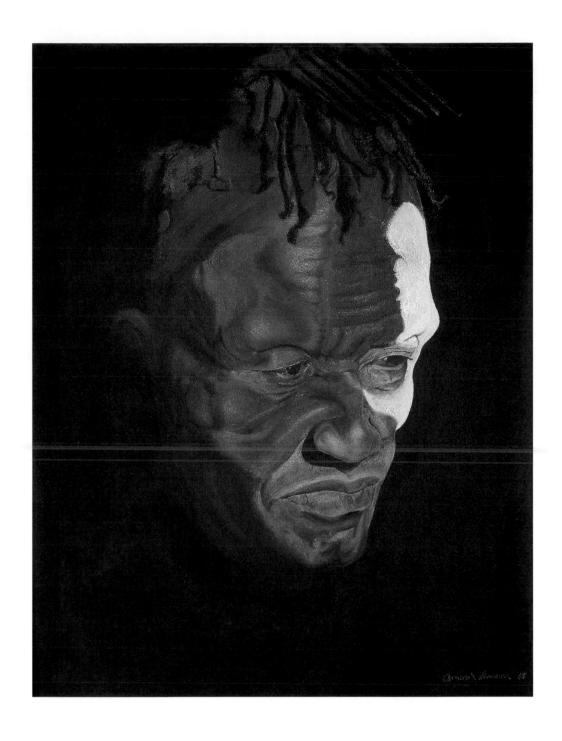

PLATE 7

Amos "Ashanti" Johnson, *Original Man,* 1968. Pastel, 35 x 29 in.

The Paul R. Jones Collection, University of Delaware, Newark.

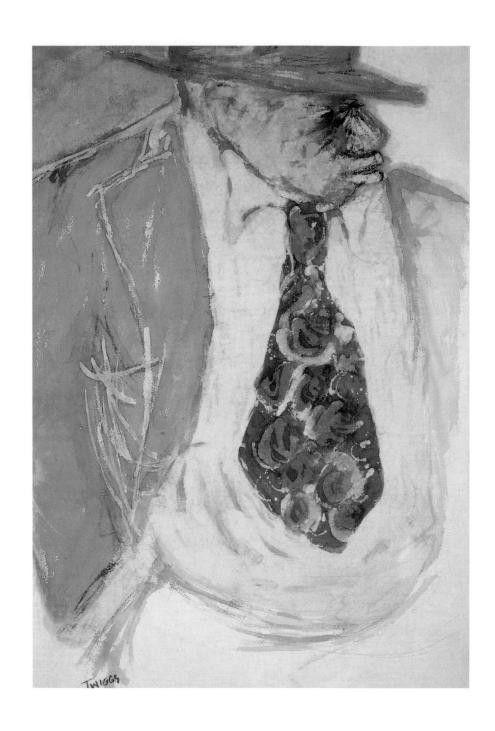

PLATE 8
Leo Twiggs, *Old Man with Wide Tie*, 1970. Batik, 38 x 28 in.
Collection of Paul R. Jones, Atlanta, Georgia.

PLATE 9

Henry Ossawa Tanner, *Return to the Tomb*, ca. 1910. Etching, 22 x 27 in.

The Paul R. Jones Collection, University of Delaware, Newark.

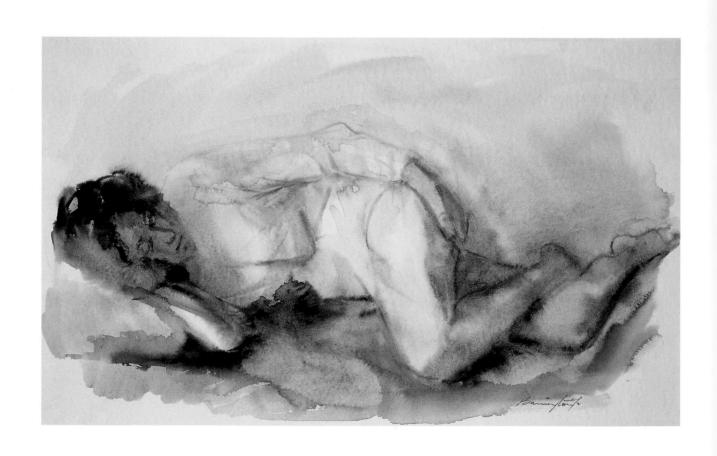

PLATE 10 Barrington Watson, *Reclining Nude*, 1972. Watercolor, $30^{1/2} \times 42^{1/4}$ in. Collection of Paul R. Jones, Atlanta, Georgia.

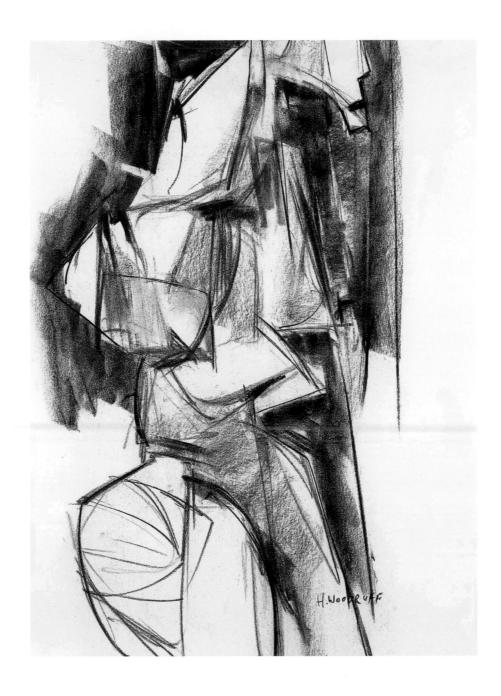

PLATE 11

Hale Woodruff, *Monkey Man #2,* 1974. Charcoal on paper, 30 x 22 in.

The Paul R. Jones Collection, University of Delaware, Newark.

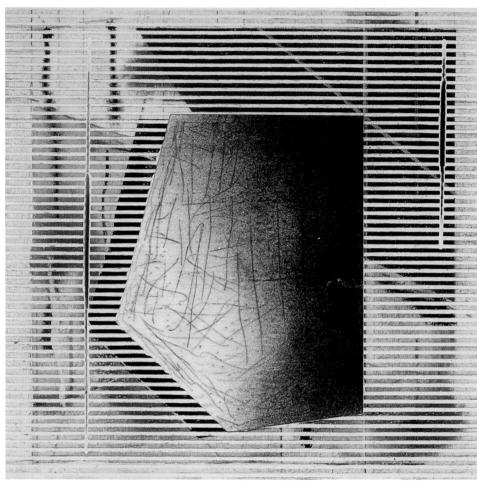

9. W. Han 99

PLATE 12

Jack Whitten, Untitled, 1977. Pencil and acrylic on paper, 7 x 7 in. Collection of Paul R. Jones, Atlanta, Georgia.

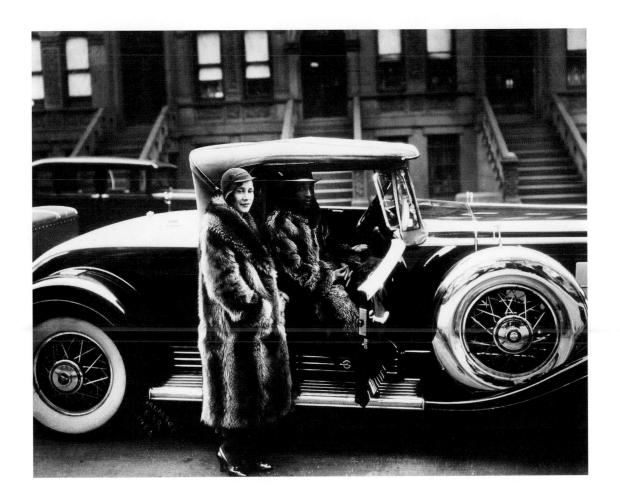

PLATE 13

James VanDerZee, Couple in Raccoon Coats, 1932. Gelatin silver print, $9^{1/2} \times 12$ in. Courtesy of Donna Mussenden VanDerZee, New York, New York © 1998 all rights reserved. Collection of Paul R. Jones, Atlanta, Georgia.

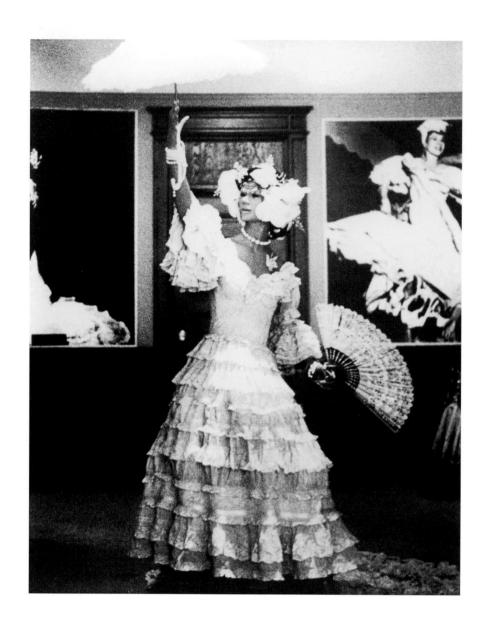

PLATE 14 Ming Smith Murray, *Katherine Dunham and Her Legacy*, 1984. Gelatin silver print, $40^{1/2} \times 30^{3/4}$ in. The Paul R. Jones Collection, University of Delaware, Newark.

 $\label{eq:PLATE 15} \mbox{William Anderson, $\textit{Man Shaving, 1988.}$ Gelatin silver print, 24 x 20 in.} \mbox{The Paul R. Jones Collection, University of Delaware, Newark.}$

PLATE 16

Romare Bearden, *School Bell Time*, ca. 1980. Lithograph, 40 x 60 in. © Romare Bearden Foundation / Licensed by VAGA, New York, NY. The Paul R. Jones Collection, University of Delaware, Newark.

PLATE 17
Nanette Carter, Light over Soweto #5, 1989. Oil pastel, 60×17 in. The Paul R. Jones Collection, University of Delaware, Newark.

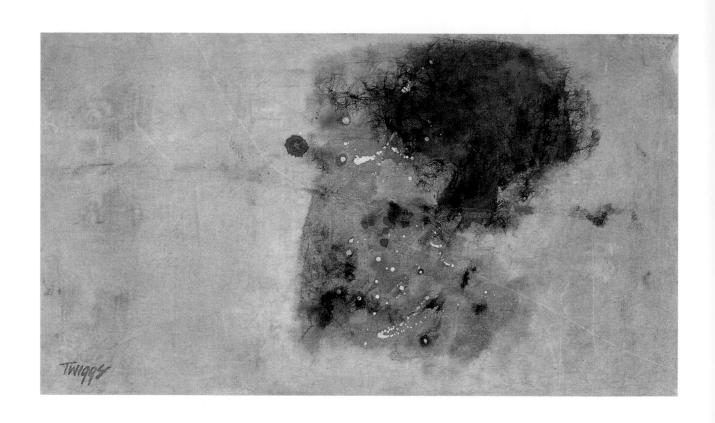

PLATE 18

Leo Twiggs, Low Country Landscape, 1974. Batik, 18 x 30 in.

The Paul R. Jones Collection, University of Delaware, Newark.

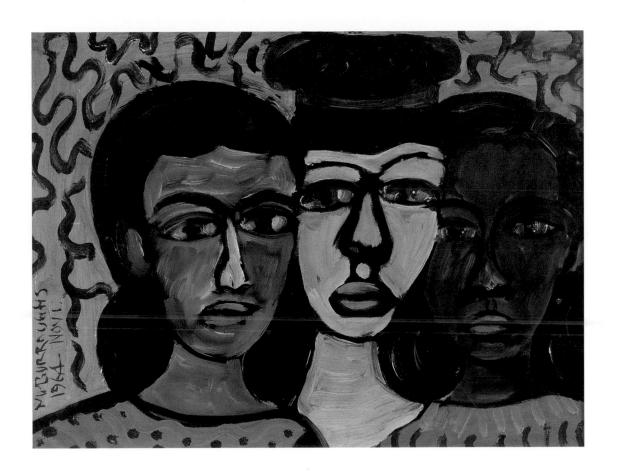

PLATE 19

Margaret T. Burroughs, *Three Souls*, 1968. Oil on canvas, $18 \times 21^{1}/8$ in. The Paul R. Jones Collection, University of Delaware, Newark.

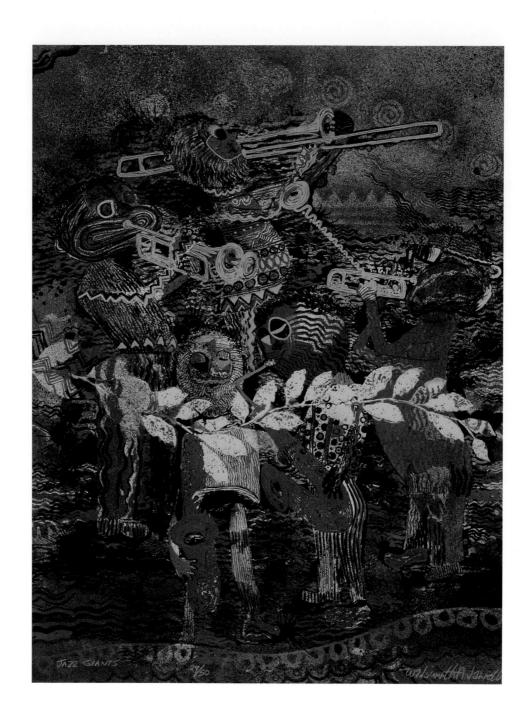

PLATE 20 Wadsworth Jarrell, Jazz Giants, 1987. Lithograph, $29^{1/2} \times 22^{1/4}$ in. Collection of Paul R. Jones, Atlanta, Georgia.

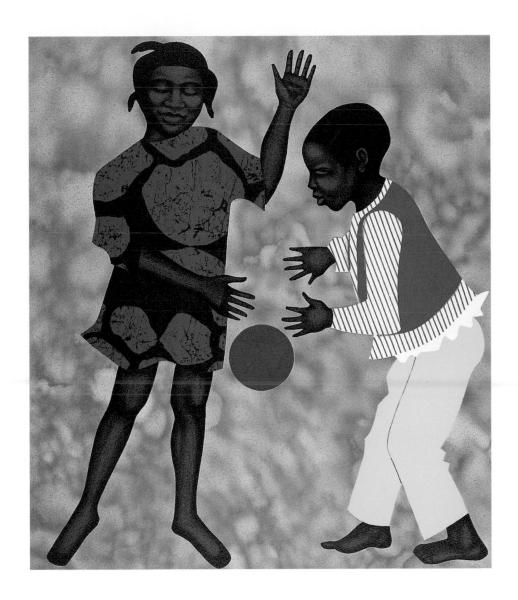

PLATE 21

Elizabeth Catlett, *Girl/Boy/Red Ball*, 1992. Color serigraph, 22³/₄ x 18⁵/8 in.

© Elizabeth Catlett / Licensed by VAGA, New York, NY.

The Paul R. Jones Collection, University of Delaware, Newark.

 $\label{eq:plate 22}$ Howardena Pindell, *Untitled #35*, 1974. Mixed media, 14 x 16 in. The Paul R. Jones Collection, University of Delaware, Newark.

PLATE 23

James Little, *Countdown*, 1981. Glazed oil washes on canvas, 58 x 91 in.

The Paul R. Jones Collection, University of Delaware, Newark.

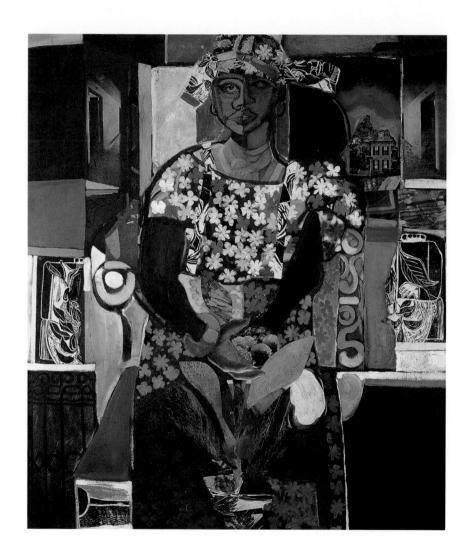

PLATE 24

David C. Driskell, *Woman in Interiors*, 1973. Mixed media painting, 47×40 in. The Paul R. Jones Collection, University of Delaware, Newark.

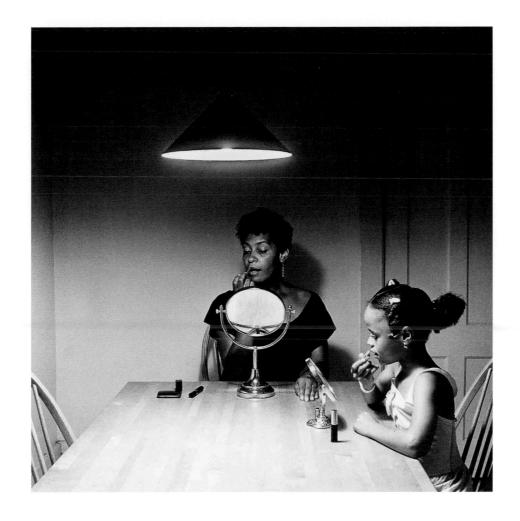

PLATE 25

Carrie Mae Weems, *Kitchen Table Series*, 1990. Gelatin silver print, 9 x 10 in.

The Paul R. Jones Collection, University of Delaware, Newark.

PLATE 26

Clarissa Sligh, *Portrait of Paul R. Jones*, 1996. Gelatin silver print, 8 x 10 in. The Paul R. Jones Collection, University of Delaware, Newark.

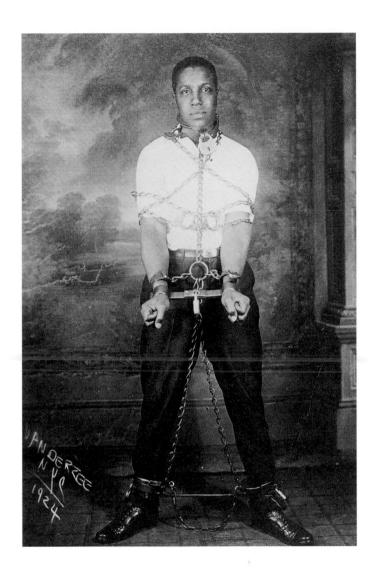

PLATE 27

James VanDerZee, *The Black Houdini*, 1924. Gelatin silver print (toned), 10 x 8 in.

The Paul R. Jones Collection, University of Delaware, Newark.

PLATE 28

Prentice H. Polk, *Margaret Blanche Polk*, 1946. Gelatin silver print, 8 x 10 in.

The Paul R. Jones Collection, University of Delaware, Newark.

Gift of Donald L. Polk (P. H. Polk Estate).

PLATE 29

Prentice H. Polk, *Alberta Osborn*, ca. 1929. Gelatin silver print, 10 x 8 in.

The Paul R. Jones Collection, University of Delaware, Newark.

Gift of Donald L. Polk (P. H. Polk Estate).

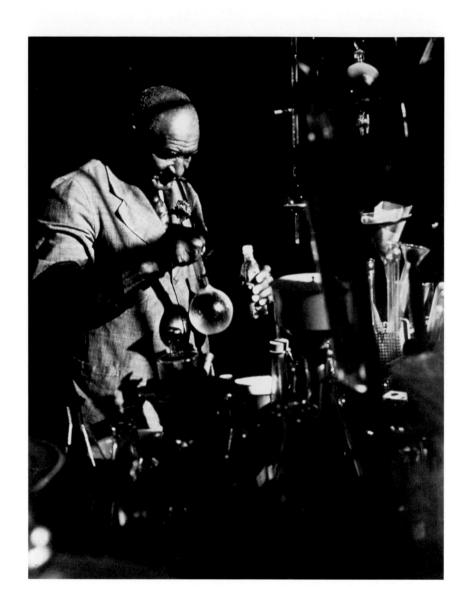

PLATE 30

Prentice H. Polk, *George Washington Carver*, ca. 1930. Gelatin silver print, 10 x 8 in.

The Paul R. Jones Collection, University of Delaware, Newark.

Gift of Donald L. Polk (P. H. Polk Estate).

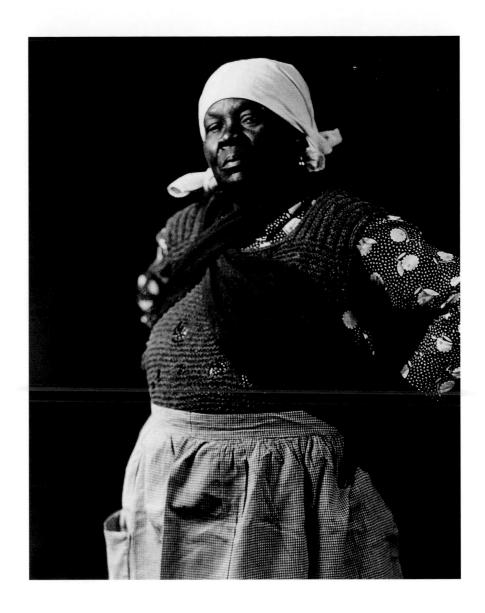

PLATE 31

Prentice H. Polk, *The Boss*, 1932. Gelatin silver print, 10 \times 8 in. The Paul R. Jones Collection, University of Delaware, Newark. Gift of Donald L. Polk (P. H. Polk Estate).

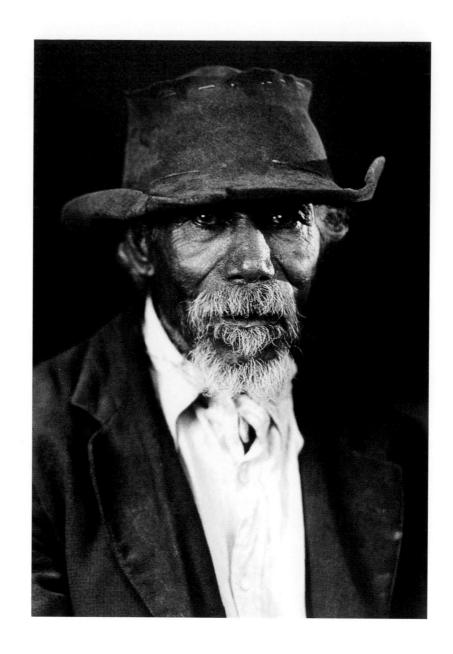

PLATE 32

Prentice H. Polk, *George Moore*, 1930. Gelatin silver print, 14 x 11 in.

The Paul R. Jones Collection, University of Delaware, Newark.

Gift of Donald L. Polk (P. H. Polk Estate).

PLATE 33

Michael Ellison, *The Bar,* 1984. Subtractive block print, 23 x 35 in.

The Paul R. Jones Collection, University of Delaware, Newark.

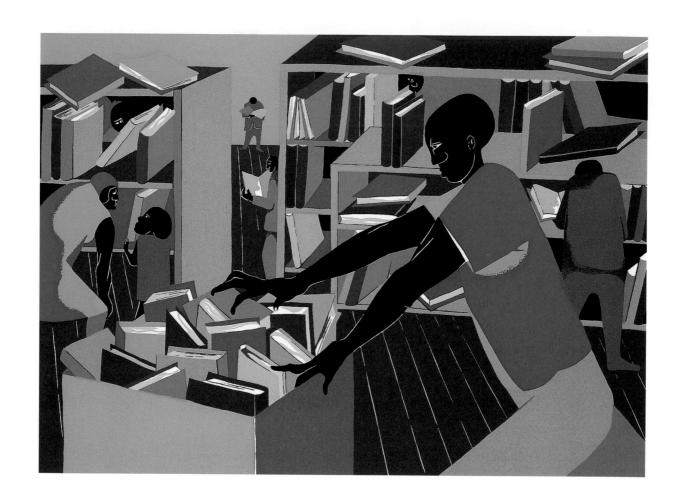

PLATE 34

Jacob Lawrence, *The Library*, 1978. Lithograph, 24 x 28 in.
© Gwendolyn Knight Lawrence, courtesy of the Jacob and Gwendolyn Lawrence Foundation.
The Paul R. Jones Collection, University of Delaware, Newark.

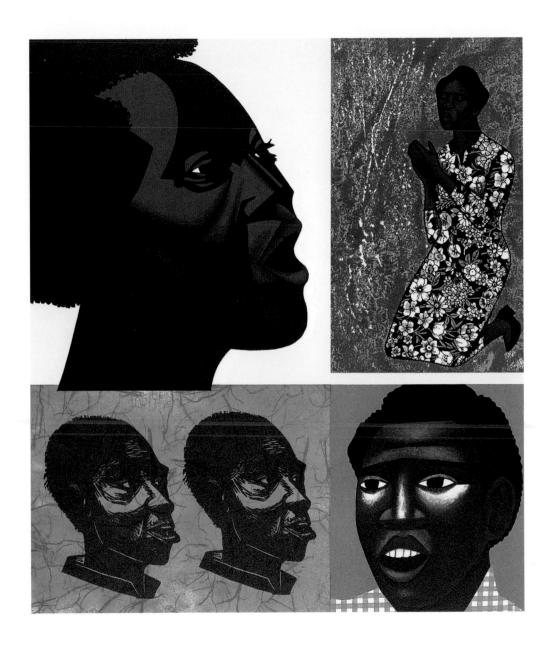

PLATE 35

Elizabeth Catlett, *Singing/Praying*, 1992. Serigraph, 23³/₄ x 18⁵/₈ in.

© Elizabeth Catlett / Licensed by VAGA, New York, NY.

The Paul R. Jones Collection, University of Delaware, Newark.

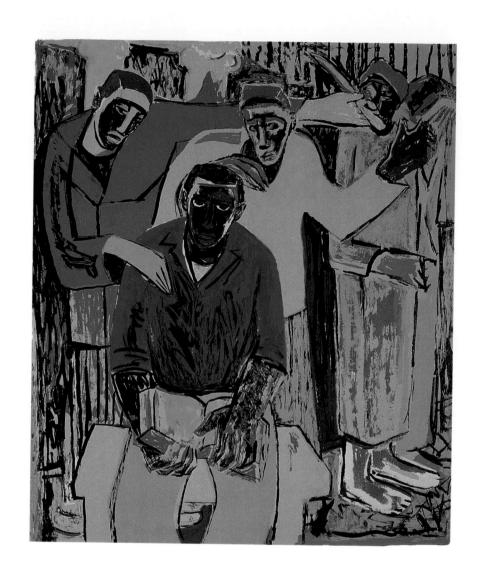

PLATE 36

Samella Lewis, *The Masquerade*, 1994. Lithograph, 37 x 33 in.
© Samella Lewis / Licensed by VAGA, New York, NY.
The Paul R. Jones Collection, University of Delaware, Newark.

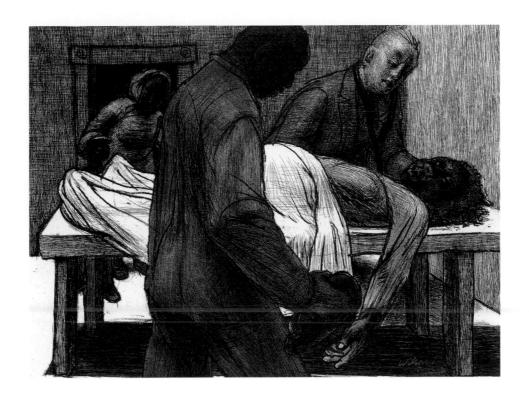

PLATE 37

John Wilson, Richard Wright Series: Death of Lulu, 2001. Etching, $11^3/4 \times 16$ in.

© John Wilson / Licensed by VAGA, New York, NY.

The Paul R. Jones Collection, University of Delaware, Newark.

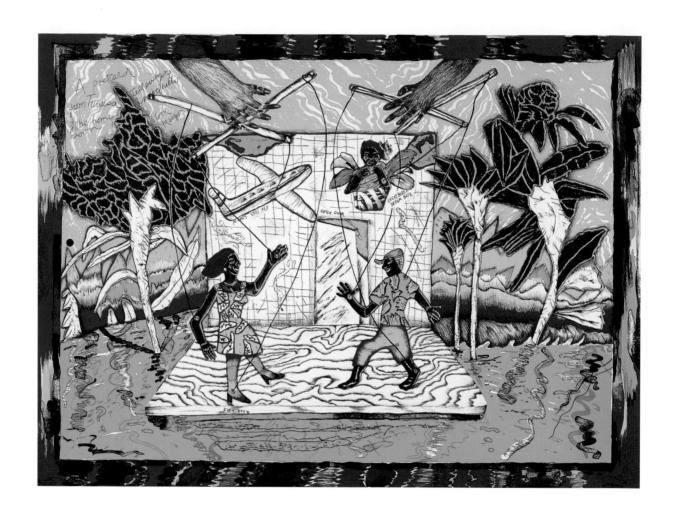

PLATE 38

Margo Humphrey, *Pulling Your Own Strings*, 1981. Lithograph, 22×30 in. The Paul R. Jones Collection, University of Delaware, Newark.

PLATE 39

Herman "Kofi" Bailey, *Portrait of Paul R. Jones*, 1973. Graphite on paper, 20 x 16 in.

Collection of Paul R. Jones, Atlanta, Georgia.

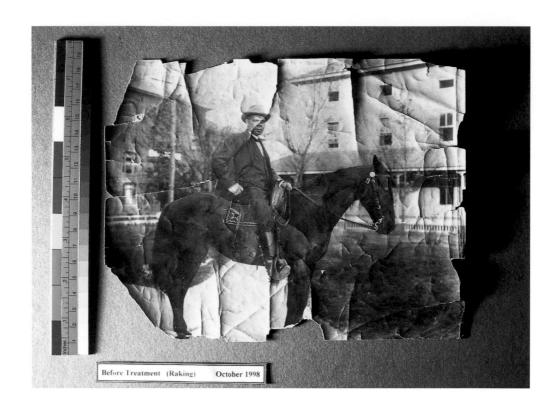

PLATE 40

Arthur P. Bedou, *Booker T. Washington*, ca. 1915, damaged silver gelatin photograph of Washington before conservation treatment at the Art Conservation Department at the University of Delaware.

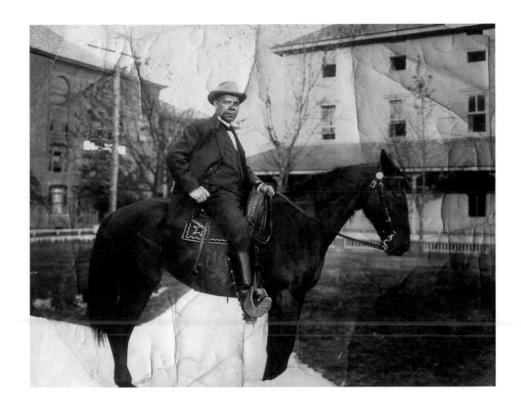

PLATE 41

Arthur P. Bedou, *Booker T. Washington*, ca. 1915, silver gelatin photograph of Washington after conservation treatment at the Art Conservation Department, University of Delaware. Treatment procedures included consolidation of the flaking gelatin binder layer, surface cleaning to remove embedded dirt and grime, and tear mending with lightweight Japanese tissue and wheat starch paste. Losses in the photograph's paper support were inserted with a toned contemporary paper and damages in the gelatin binder were inpainted with watercolors. The photograph was humidified and flattened and housed in a protective ragboard mat for safe handling.

PLATE 42

Benjamin Britt, *We Two*, 1968. Oil on canvas, 24 x 34 in.

The Paul R. Jones Collection, University of Delaware, Newark.

PLATE 43

Charles White, *John Henry*, 1975. Oil wash, 36 x 31 in.

© 1975 The Charles White Archives.

The Paul R. Jones Collection, University of Delaware, Newark.

PLATE 44

Edward Loper, Sr., *Portrait of Benoit Cote*, 2000. Oil on canvas, 28 x 20 in.

The Paul R. Jones Collection, University of Delaware, Newark.

PLATE 45
Ernest Chrichlow, *Untitled*, 1985. Acrylic on board, 28 x 22 in.
The Paul R. Jones Collection, University of Delaware, Newark.

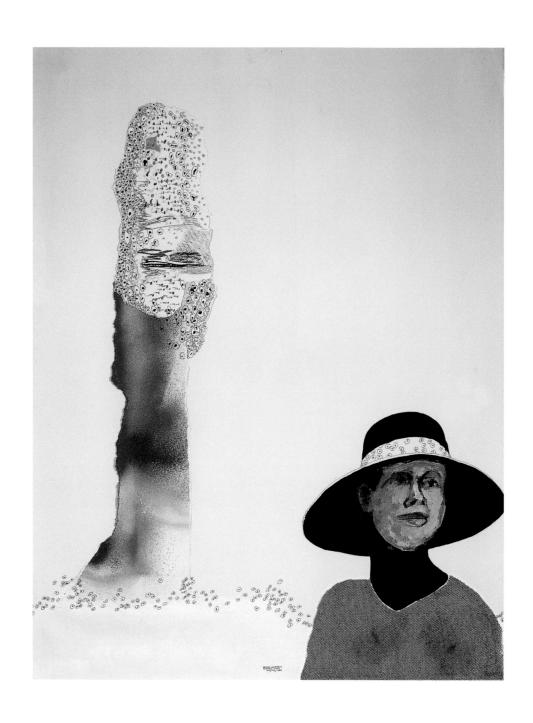

PLATE 46

Benny Andrews, *Dianne*, 1984. Mixed media, 34 x 27 in.

The Paul R. Jones Collection, University of Delaware, Newark.

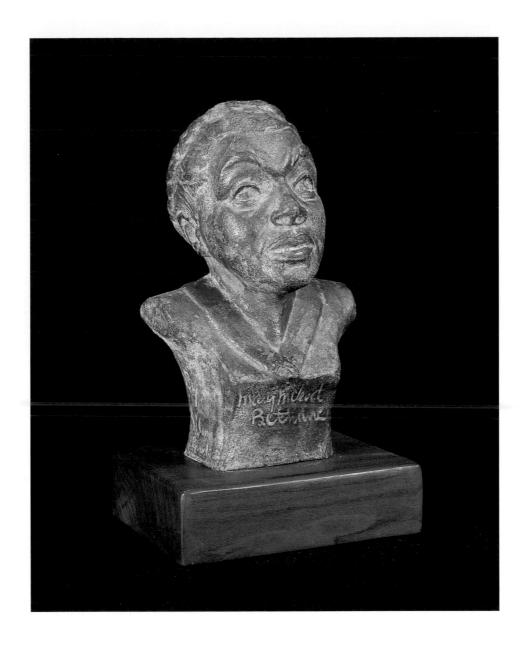

PLATE 47 Selma Burke, *Mary McLeod Bethune*, 1980. Brass, 10 \times 4 \times 5 in. The Paul R. Jones Collection, University of Delaware, Newark.

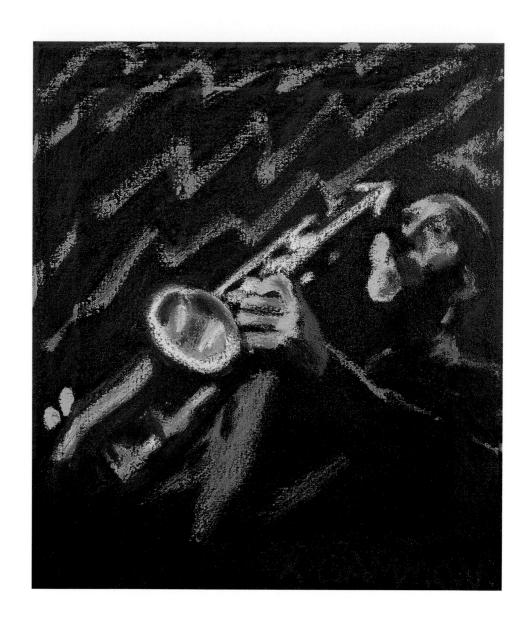

PLATE 48

Reginald Gammon, Sonny Rollins, 2002. Oil on canvas, 14 x 14 in.

The Paul R. Jones Collection, University of Delaware, Newark.

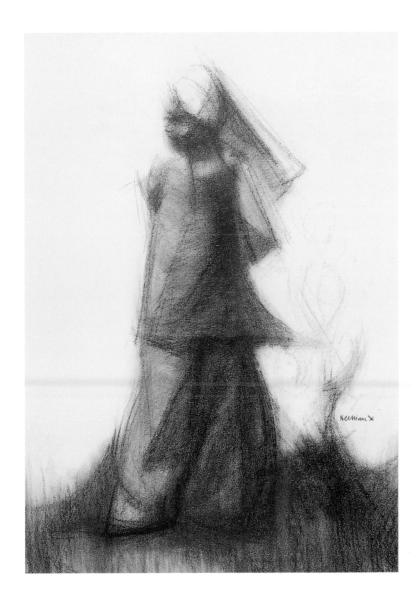

PLATE 49

Herman "Kofi" Bailey, *African Woman*, 1974. Graphite on paper, 24 x 18 in.

The Paul R. Jones Collection, University of Delaware, Newark.

PLATE 50

Alvin Smith, *Untitled*, 1985. Acrylic on canvas, 62 x 62 in.

The Paul R. Jones Collection, University of Delaware, Newark.

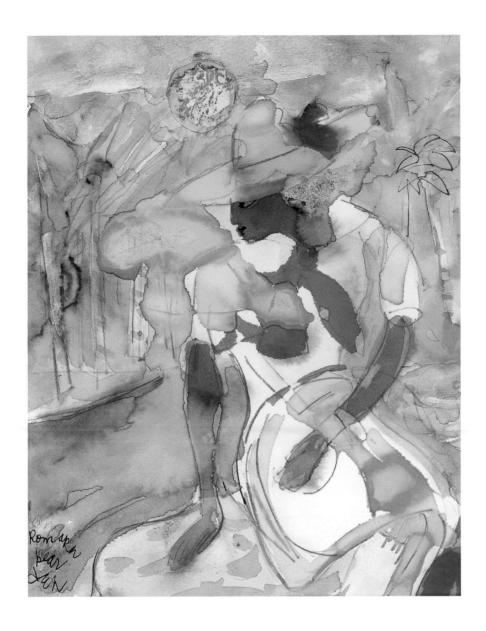

PLATE 51

Romare Bearden, *Island Scene*, 1984. Watercolor, 24 x 20 in.
© Romare Bearden Foundation / Licensed by VAGA, New York, NY.
The Paul R. Jones Collection, University of Delaware, Newark.

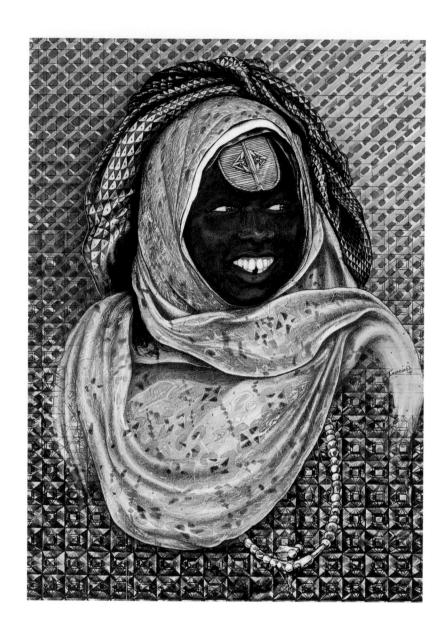

PLATE 52

Imaniah Shinar (James E. Coleman, Jr.), *Ebony Queen*, 2002. Mixed media on board, $25^{1/4} \times 17^{1/2}$ in. The Paul R. Jones Collection, University of Delaware, Newark.

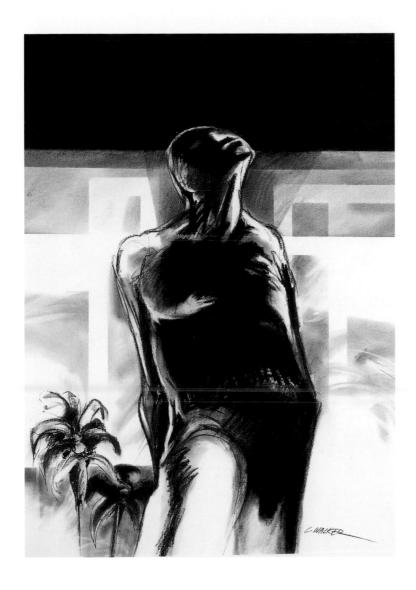

PLATE 53

Larry Walker, *Prelude,* 2000. Acrylic on paper, 38 x 26 in.

The Paul R. Jones Collection, University of Delaware, Newark.

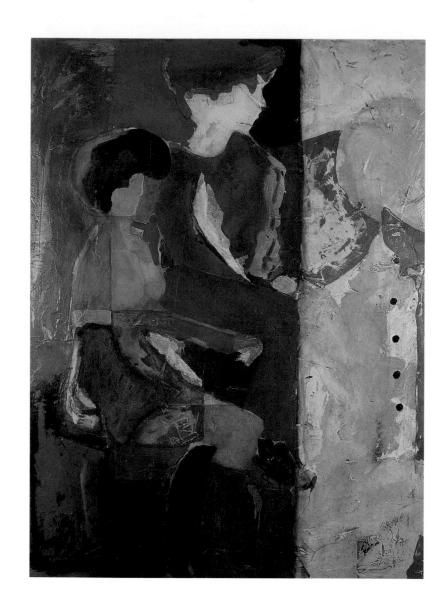

PLATE 54

John Feagin, *Reflections II*, 1973. Oil on board, $48 \times 35^{1/2}$ in. The Paul R. Jones Collection, University of Delaware, Newark.

PLATE 55
Frank Bowling, *Untitled*, 1980. Mixed media on canvas, 72 x 18 in.
The Paul R. Jones Collection, University of Delaware, Newark.

PLATE 56
Frank Bowling, *Untitled*, 1980. Mixed media on canvas, 72 x 18 in.
The Paul R. Jones Collection, University of Delaware, Newark.

PLATE 57

Harper T. Phillips, *Untitled*, 1974. Tissue collage, 26 x 30 in.

The Paul R. Jones Collection, University of Delaware, Newark.

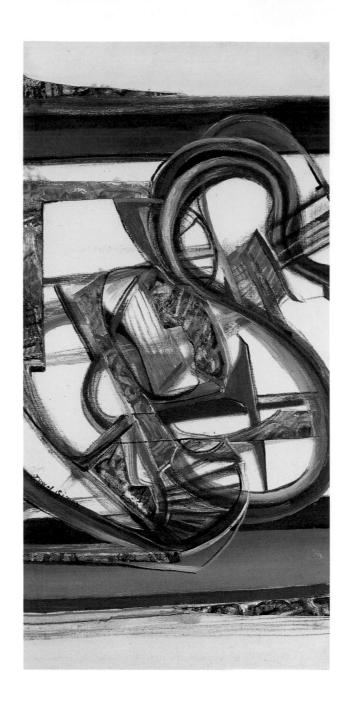

PLATE 58

Jewel Simon, *Lick*, 1944. Oil on canvas, 40 x 20 in.

The Paul R. Jones Collection, University of Delaware, Newark.

PLATE 59

Jack Whitten, *Annunciation XVIII*, 1989. Acrylic on canvas, 17 x 17 in.

The Paul R. Jones Collection, University of Delaware, Newark.

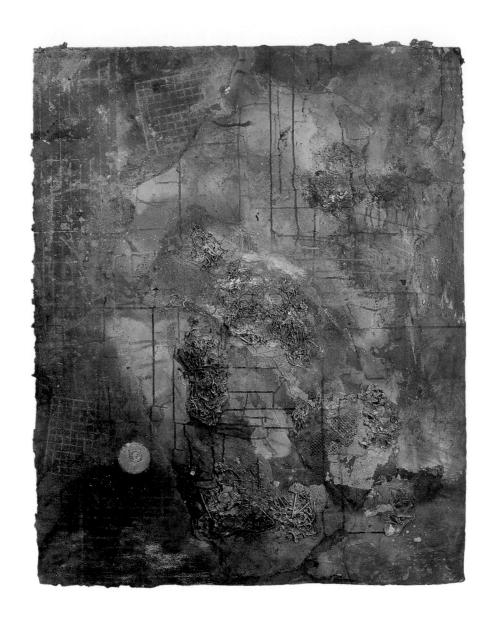

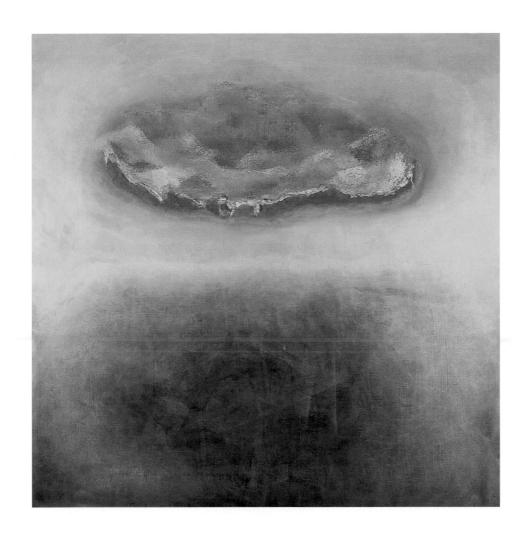

PLATE 61
Aimee Miller, *Untitled*, 2001. Mixed media on board, 49 x 48 in.
The Paul R. Jones Collection, University of Delaware, Newark.

PLATE 62

Ayokunle Odeleye, *Caring*, 1972. Mixed media on board, 47 x 45 in.

The Paul R. Jones Collection, University of Delaware, Newark.

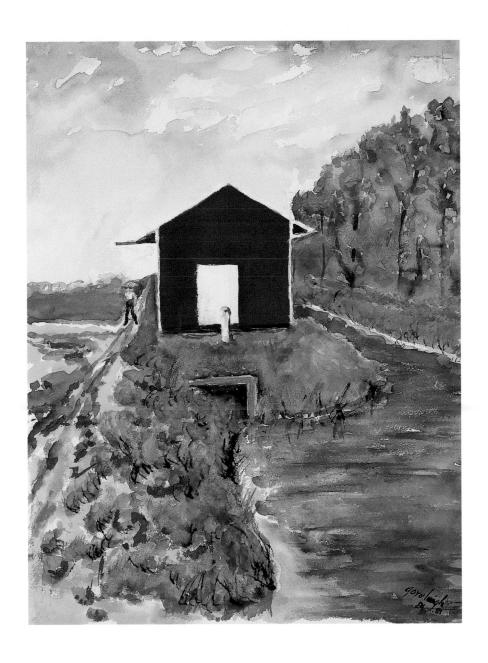

PLATE 63

Rex Gorleigh, *Red Barn*, 1981. Watercolor, 28 x 22 in.

The Paul R. Jones Collection, University of Delaware, Newark.

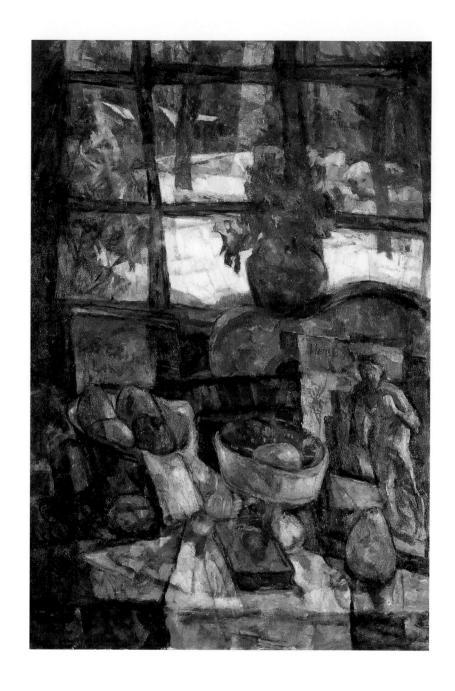

PLATE 64

Edward Loper, Sr., Winter Still Life, 2003. Oil on canvas, 48 x 35 in.

The Paul R. Jones Collection, University of Delaware, Newark.

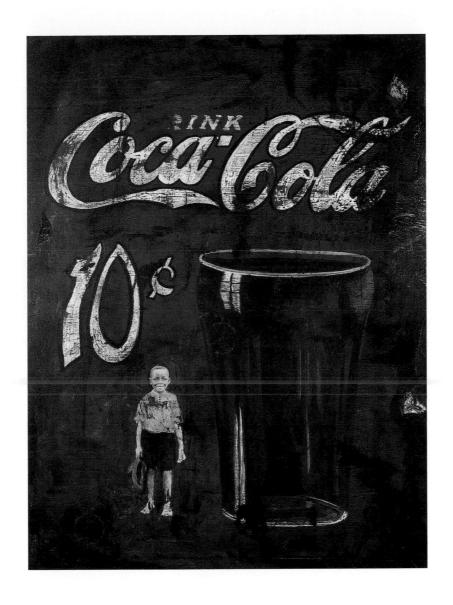

PLATE 65

Cedric Smith, *Coca-Cola*, 2002. Mixed media on canvas, 38 x 26 in.

The Paul R. Jones Collection, University of Delaware, Newark.

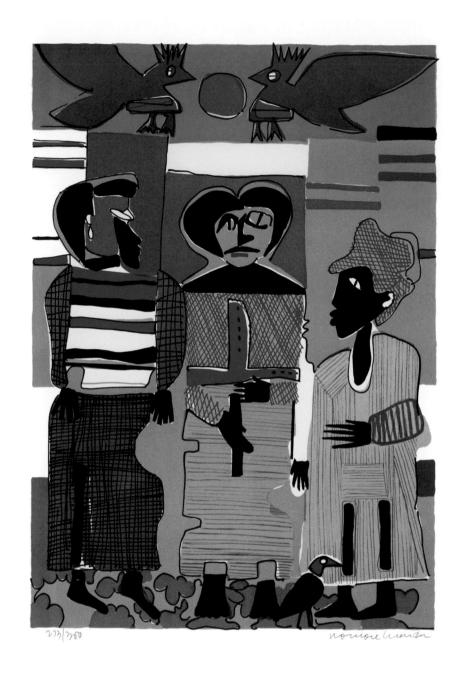

PLATE 66

Romare Bearden, *Firebirds*, 1979. Lithograph, 28 x 24 in.

© Romare Bearden Foundation / Licensed by VAGA, New York, NY.

The Paul R. Jones Collection, University of Delaware, Newark.

PLATE 67 Lionel Lofton, *Jungle Fever*, 2001. Mixed media on board, $18^{1/4} \times 22^{1/4}$ in. The Paul R. Jones Collection, University of Delaware, Newark.

PLATE 68

Camille Billops, *Fire Fighter*, 1990. Lithograph, 16 x 20 in. The Paul R. Jones Collection, University of Delaware, Newark.

PLATE 69 Earl J. Hooks, Man of Sorrows, 1950. Marble, $12^{1}/2 \times 7 \times 4$ in. The Paul R. Jones Collection, University of Delaware, Newark.

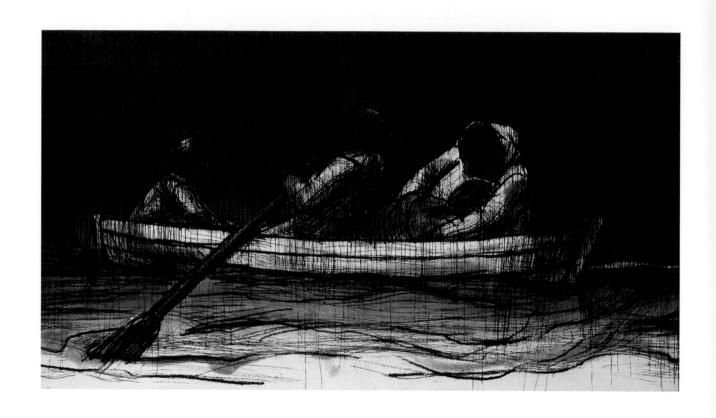

PLATE 70

John Wilson, *Richard Wright Series: Journey of the Mann Family,* 2001. Etching, $11^3/4 \times 16$ in. © John Wilson / Licensed by VAGA, New York, NY. The Paul R. Jones Collection, University of Delaware, Newark.

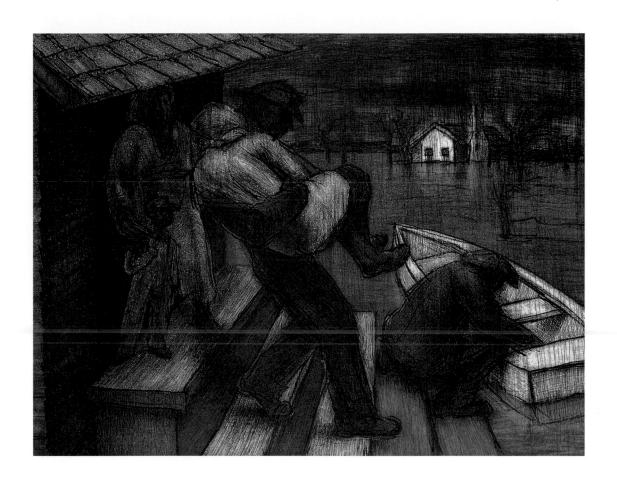

PLATE 71

John Wilson, *Richard Wright Series: Embarkation*, 2001. Etching, $11^3/4 \times 16$ in. © John Wilson / Licensed by VAGA, New York, NY. The Paul R. Jones Collection, University of Delaware, Newark.

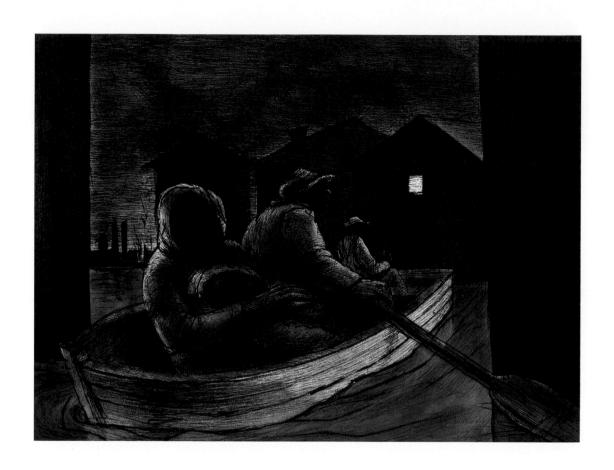

PLATE 72

John Wilson, *Richard Wright Series: Light in the Window,* 2001. Etching, $11^3/4 \times 16$ in. © John Wilson / Licensed by VAGA, New York, NY. The Paul R. Jones Collection, University of Delaware, Newark.

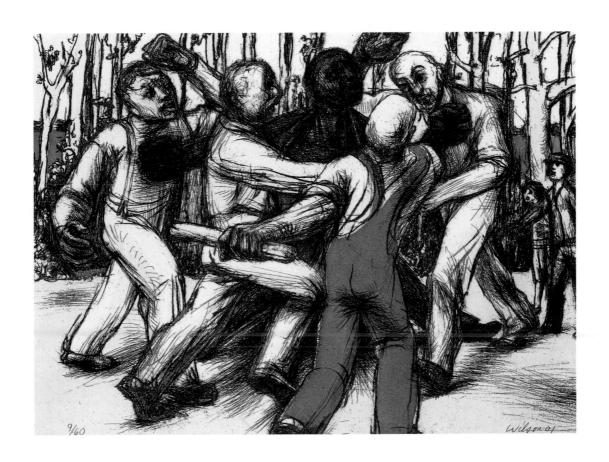

PLATE 73

John Wilson, *Richard Wright Series: Mann Attacked*, 2001. Etching, $11^3/4 \times 16$ in. © John Wilson / Licensed by VAGA, New York, NY. The Paul R. Jones Collection, University of Delaware, Newark.

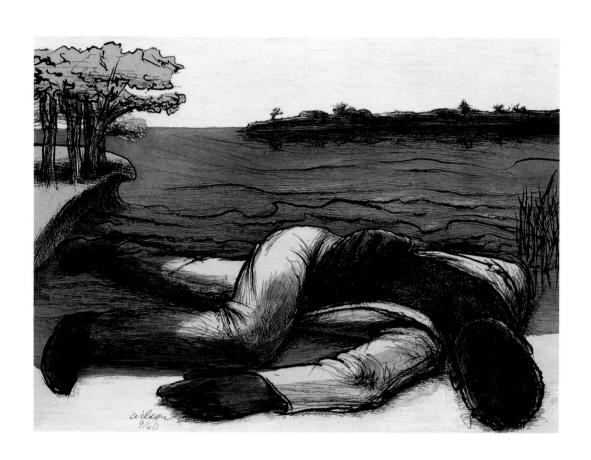

PLATE 74

John Wilson, *Richard Wright Series: The Death of Mann*, 2001. Etching, $11^3/4 \times 16$ in. © John Wilson / Licensed by VAGA, New York, NY. The Paul R. Jones Collection, University of Delaware, Newark.

PLATE 75

Charles White, Vision, 1973. Sterling etching, diameter 8 inches.

© 1973 The Charles White Archives.

The Paul R. Jones Collection, University of Delaware, Newark.

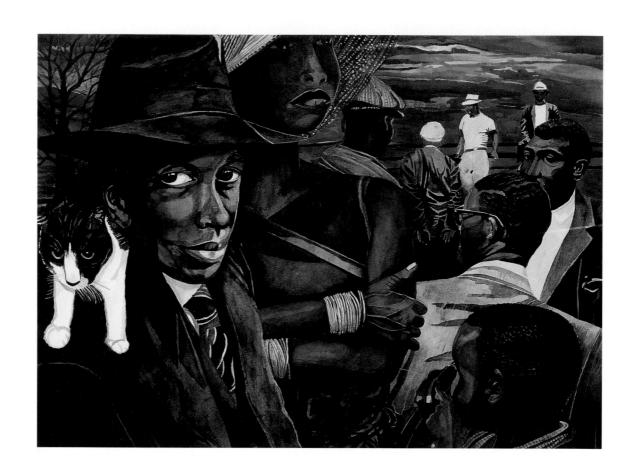

PLATE 76 Samuel Guilford, 9 Lives, 1999. Watercolor, $29^{1/4} \times 34^{1/4}$ in. The Paul R. Jones Collection, University of Delaware, Newark.

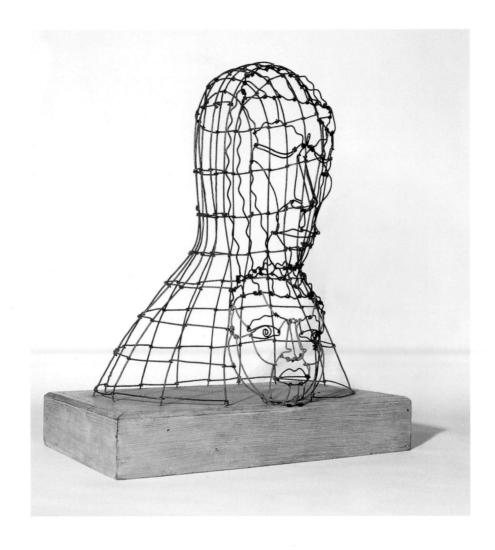

PLATE 77

Hayward L. Oubre, *Miscegenation*, 1963. Wire sculpture, 25 x 20 x 13 in.

The Paul R. Jones Collection, University of Delaware, Newark.

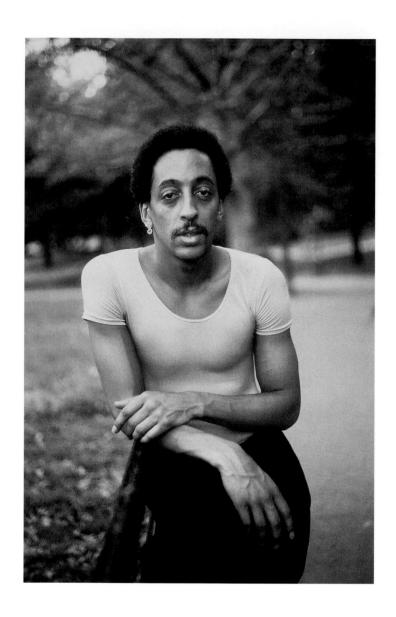

PLATE 78

Ming Smith Murray, *Gregory Hines*, 1985. Color photograph, 20 x 16 in.

The Paul R. Jones Collection, University of Delaware, Newark.

PLATE 79

Ming Smith Murray, *Arthur Blythe in Space*, 1989. Gelatin silver print, 8 x 10 in.

The Paul R. Jones Collection, University of Delaware, Newark.

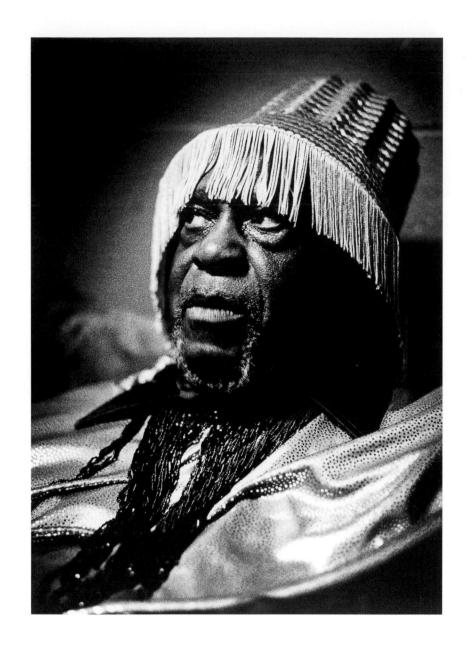

PLATE 80William Wallace, *Sun Ra*, 1988. Gelatin silver print, 14 x 11 in.
The Paul R. Jones Collection, University of Delaware, Newark.

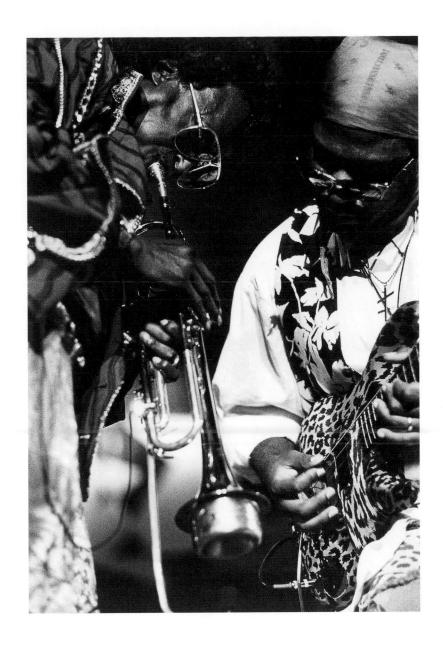

 $\label{eq:plate 81} \mbox{William Wallace, \it Miles Davis and Axel McQuerry, 1989. Gelatin silver print, 14 x 11 in.} \mbox{The Paul R. Jones Collection, University of Delaware, Newark.}$

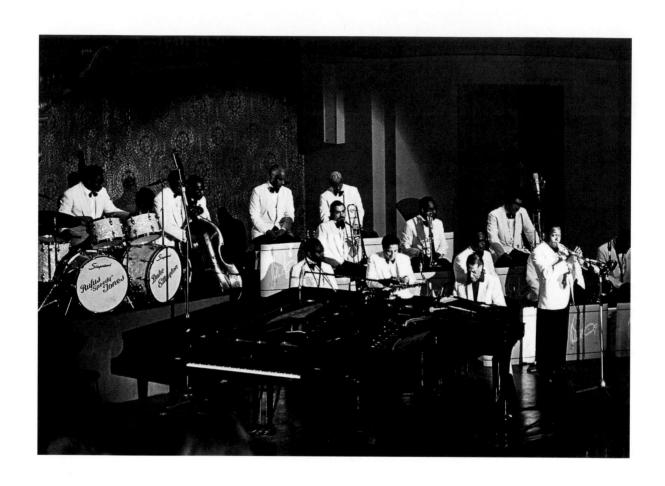

PLATE 82

Jim Alexander, Ellington Orchestra, 1972. Gelatin silver print, 9 x 117/8 in.

The Paul R. Jones Collection, University of Delaware, Newark.

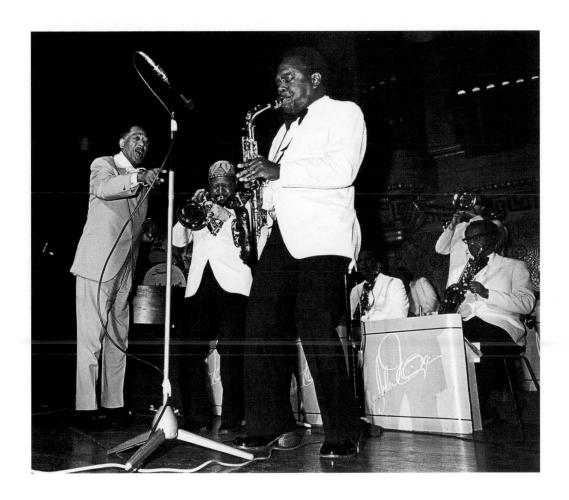

 $\label{eq:plate 83}$ Jim Alexander, Jamming, 1972. Gelatin silver print, 9 x 117/8 in. The Paul R. Jones Collection, University of Delaware, Newark.

PLATE 84

Bert Andrews, *Gloria Foster and Morgan Freeman,* 1979. Gelatin silver print, 16 x 20 in.

The Paul R. Jones Collection, University of Delaware, Newark.

PLATE 85
Bert Andrews, *Alfre Woodard and Others*, 1978. Gelatin silver print, 16 x 20 in.
The Paul R. Jones Collection, University of Delaware, Newark.

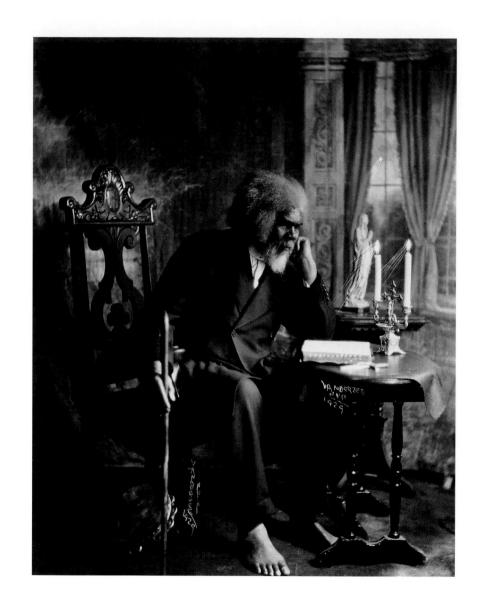

PLATE 86

James VanDerZee, *The Barefoot Prophet*, 1928. Gelatin silver print, 20 x 16 in.

The Paul R. Jones Collection, University of Delaware, Newark.

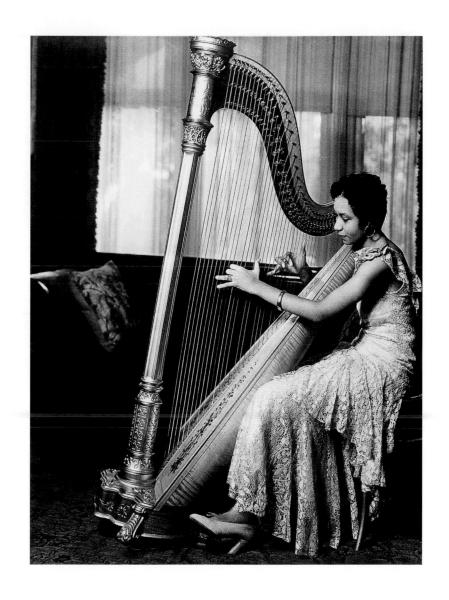

PLATE 87

Prentice H. Polk, *Catherine Moton Patterson*, 1936. Gelatin silver print, 10 x 8 in.

The Paul R. Jones Collection, University of Delaware, Newark.

Gift of Donald L. Polk (P. H. Polk Estate).

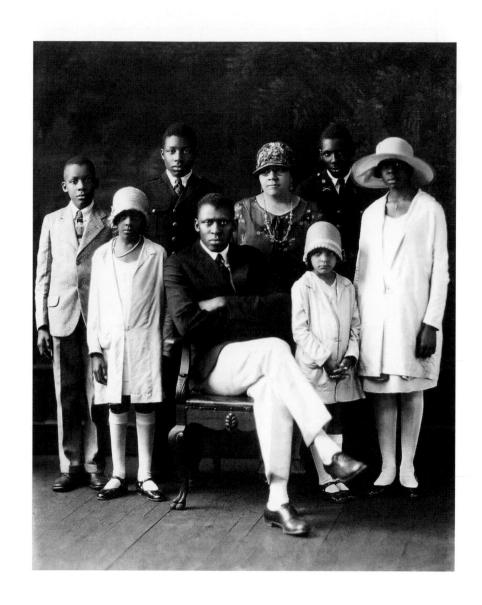

PLATE 88

Prentice H. Polk, *Mr. and Mrs. T. M. Campbell and Children*, ca. 1932. Gelatin silver print, 10 x 9 in.

The Paul R. Jones Collection, University of Delaware, Newark.

Gift of Donald L. Polk (P. H. Polk Estate).

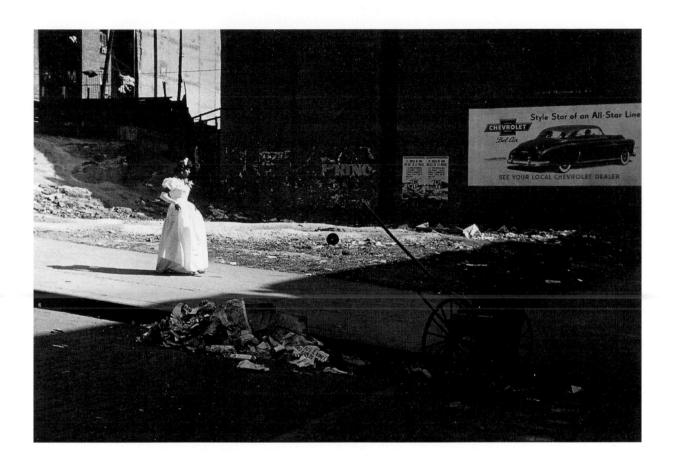

PLATE 89

Roy DeCarava, *Graduation Day*, 1949. Gelatin silver print, 16 \times 20 in. The Paul R. Jones Collection, University of Delaware, Newark.

PLATE 90 Doughba Hamilton Caranda-Martin, *Untitled*, 2003. Gelatin silver print, $34^3/_4 \times 29^7/8$ in. The Paul R. Jones Collection, University of Delaware, Newark.

PLATE 91

Doughba Hamilton Caranda-Martin, *Untitled*, 2003. Gelatin silver print, 28 x 20 in.

The Paul R. Jones Collection, University of Delaware, Newark.

PLATE 92

Doughba Hamilton Caranda-Martin, *Untitled*, 2003. Gelatin silver print, 28 x 20 in.

The Paul R. Jones Collection, University of Delaware, Newark.

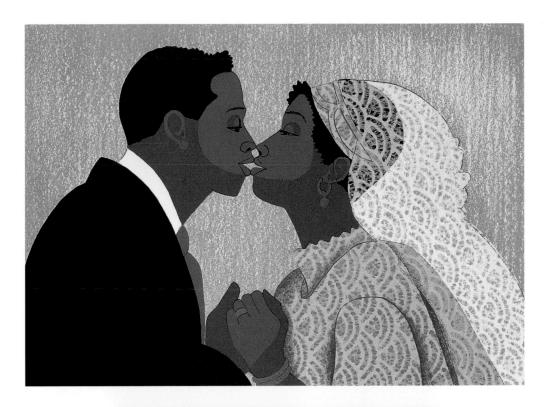

PLATE 93

Elizabeth Catlett, *Couple Kissing*, 1992. Serigraph, $23^{3}/_{4} \times 18^{5}/8$ in. © Elizabeth Catlett / Licensed by VAGA, New York, NY. The Paul R. Jones Collection, University of Delaware, Newark.

PLATE 94

Elizabeth Catlett, *Boy/Girl Profile*, 1992. Serigraph, $23^3/_4 \times 18^5/_8$ in. © Elizabeth Catlett / Licensed by VAGA, New York, NY. The Paul R. Jones Collection, University of Delaware, Newark.

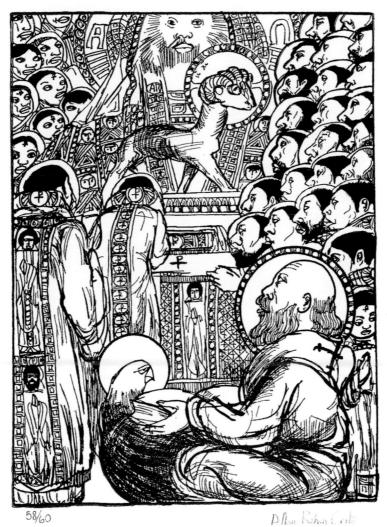

PHAR TORAL O

PLATE 95

Allan R. Crite, *The Revelation of St. John the Divine: Procession to Ram Altar,* 1994. Engraving, 20×17 in. The Paul R. Jones Collection, University of Delaware, Newark.

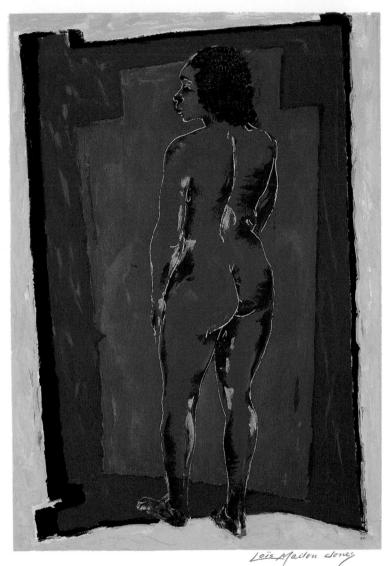

Lois Mailon dones

PLATE 96 Loïs Mailou Jones, *Nude*, 1996. Lithograph, $21^{3}/_{4} \times 17^{1}/_{2}$ in. The Paul R. Jones Collection, University of Delaware, Newark.

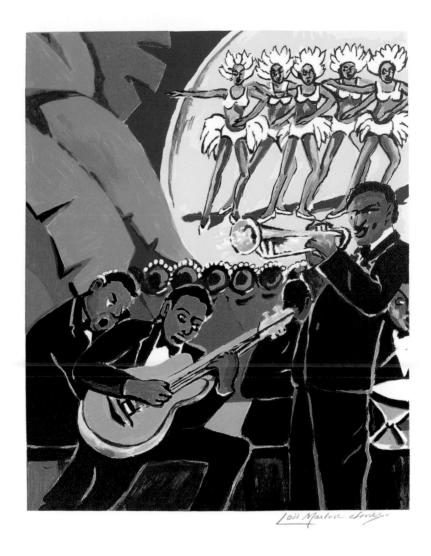

PLATE 97

Loïs Mailou Jones, *Jazz Combo*, 1996. Lithograph, $21^{3}/_{4} \times 17^{1}/_{2}$ in. The Paul R. Jones Collection, University of Delaware, Newark.

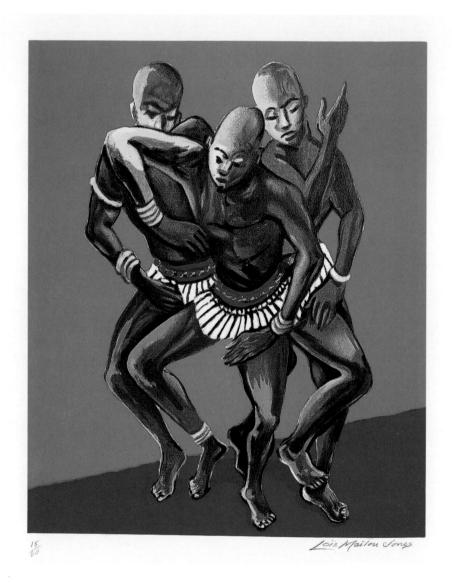

PLATE 98

Loïs Mailou Jones, 3 dancers, 1996. Lithograph, $21^3/4 \times 17^1/2$ in. The Paul R. Jones Collection, University of Delaware, Newark.

PLATE 99

Michael Ellison, *Brown Boy*, 1985. Subtractive block print, 19 \times 25 in. The Paul R. Jones Collection, University of Delaware, Newark.

PLATE 100

Michael Ellison, *The Mall*, 1985. Subtractive block print, 26 x 40 in. The Paul R. Jones Collection, University of Delaware, Newark.

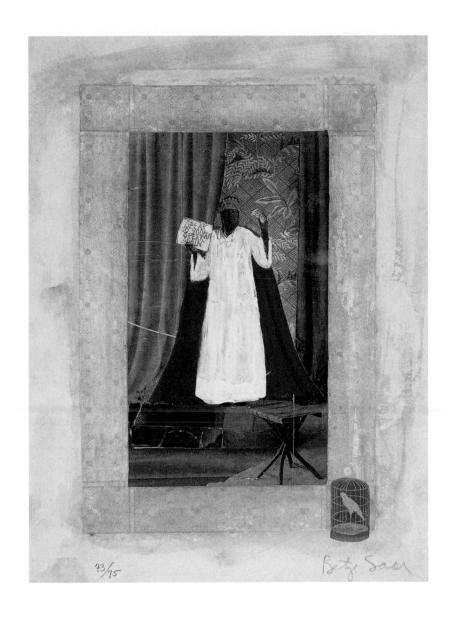

PLATE 101

Betye Saar, *Mother Catherine*, 2000. Serigraph, 20 \times 16 in. The Paul R. Jones Collection, University of Delaware, Newark.

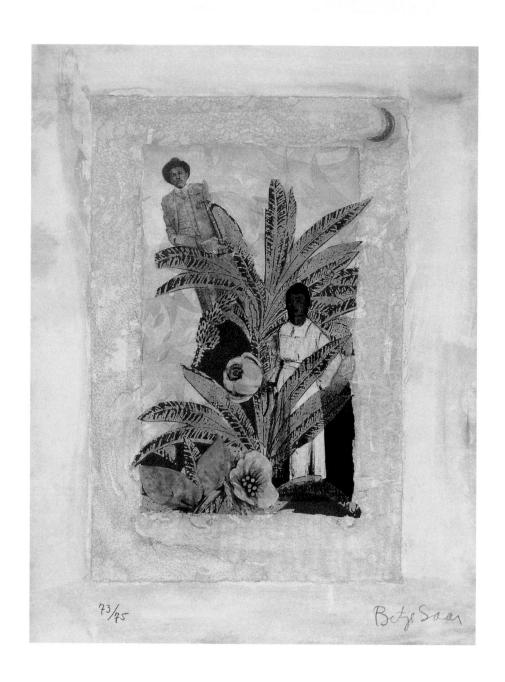

PLATE 102

Betye Saar, *Magnolia Flower*, 2000. Serigraph, 20 x 16 in. The Paul R. Jones Collection, University of Delaware, Newark.

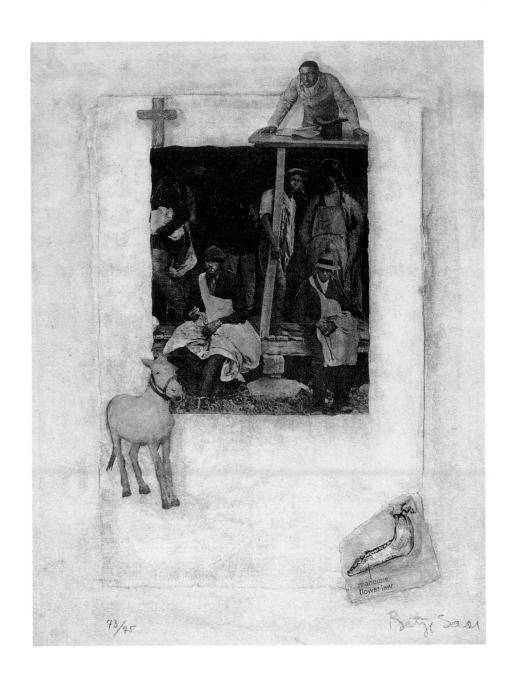

PLATE 103

Betye Saar, *The Conscience of the Court, 2000*. Serigraph, 20 x 16 in.

The Paul R. Jones Collection, University of Delaware, Newark.

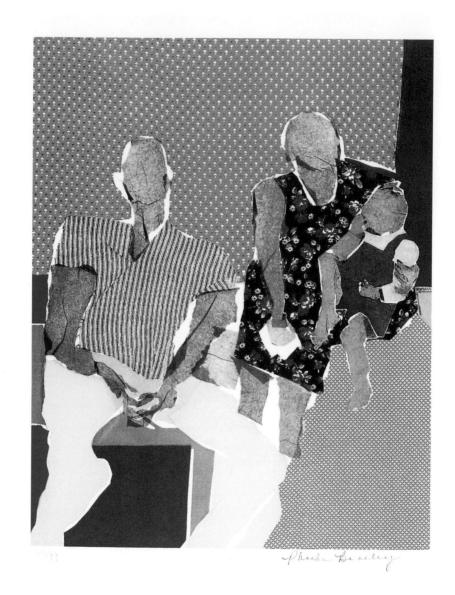

PLATE 104

Phoebe Beasley, *Man/Woman/Child*, 1998. Serigraph, 21¹/8 x 17 in. The Paul R. Jones Collection, University of Delaware, Newark.

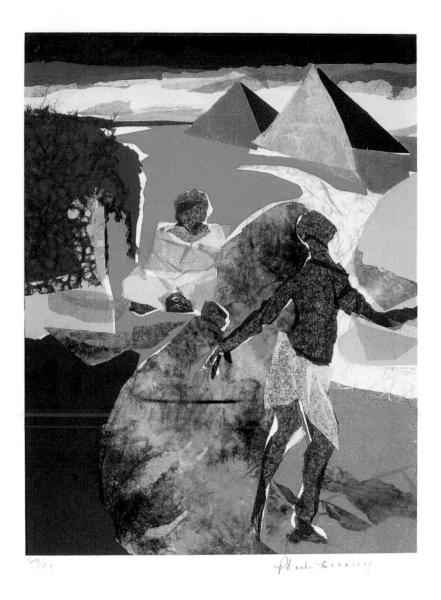

PLATE 105

Phoebe Beasley, *Yogi*, 1998. Serigraph, $21^{1/8} \times 17$ in. The Paul R. Jones Collection, University of Delaware, Newark.

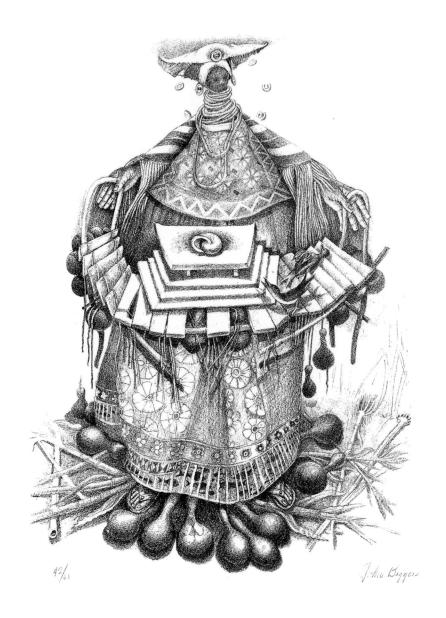

PLATE 106

John Biggers, *Untitled* (woman/planks/shell), 1996. Lithograph, 24×18 in. The Paul R. Jones Collection, University of Delaware, Newark.

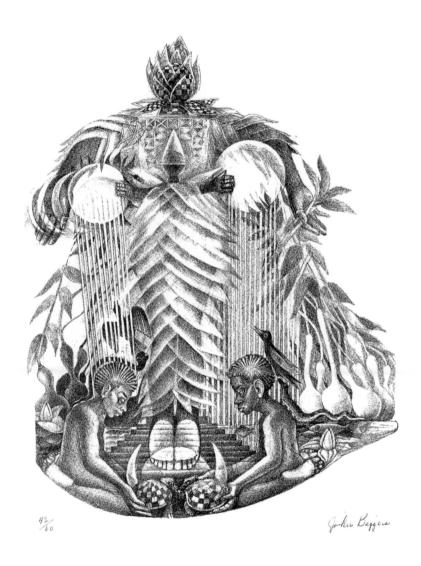

PLATE 107

John Biggers, *Untitled* (figures/two balls), 1996. Lithograph, 24×18 in. The Paul R. Jones Collection, University of Delaware, Newark.

PLATE 108

Paul Raymond (P. R.) Jones, Jr., *Untitled*, ca. 1971. Graphite on paper, $42 \times 29^{1/2}$ in. The Paul R. Jones Archives, Atlanta, Georgia.

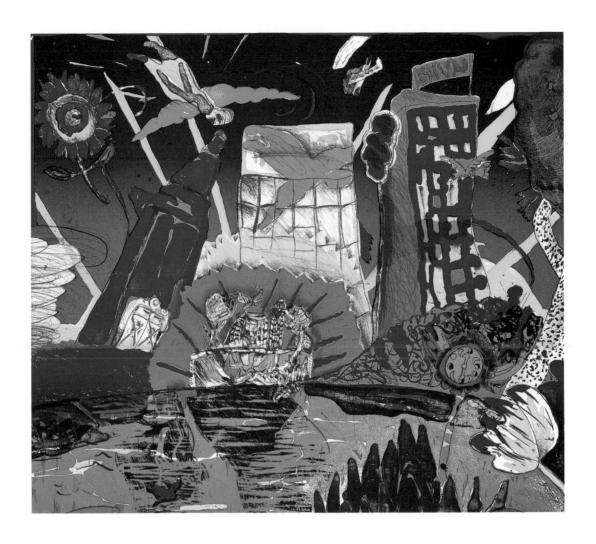

PLATE 109

Margo Humphrey, *Hometown Blues*, 1980. Color lithograph, $17^3/_4 \times 19^1/_4$ in. The Paul R. Jones Collection, University of Delaware, Newark.

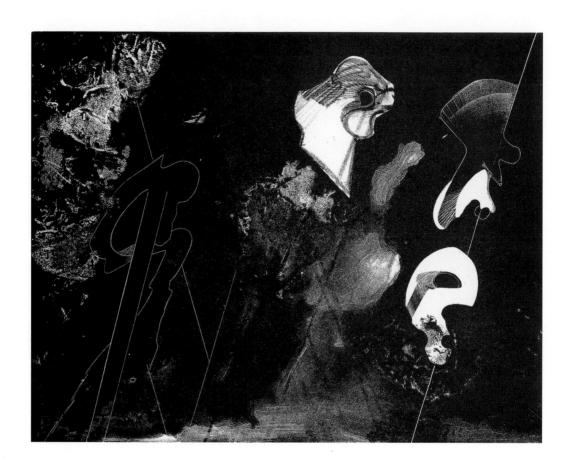

PLATE 110

Richard Hunt, *Untitled*, 1980. Lithograph, 14 x 11 in.

The Paul R. Jones Collection, University of Delaware, Newark.

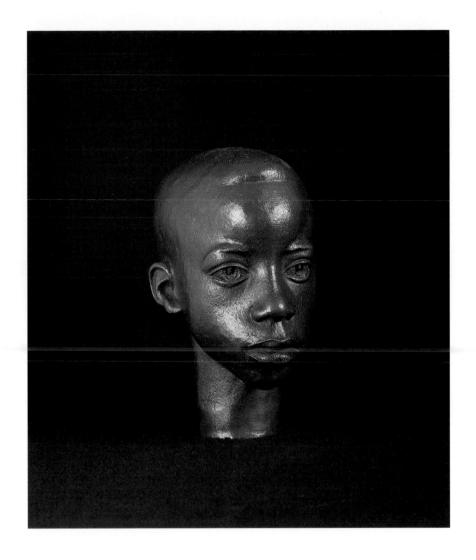

PLATE 111 William E. Artis, *Michael*, ca. 1950. Bronze, $9 \times 6^{1/2} \times 6^{3/4}$ in. The Paul R. Jones Collection, University of Delaware, Newark.

Artists' Biographies

JIM ALEXANDER

Born 1934 in Waldwick, New Jersey Resides in Atlanta, Georgia Photography

EDUCATION

New York Institute of Photography, 1968

MAJOR EXHIBITIONS

Auburn Avenue Resource Center Gallery, Atlanta, Georgia Emory University, Schatten Gallery, Atlanta, Georgia City Gallery East, City of Atlanta Bureau of Cultural Affairs, Atlanta, Georgia

Museum of African American Art, Los Angeles, California Afro-American Cultural Center, Charlotte, North Carolina University of Tennessee Center Gallery, Knoxville, Tennessee Nexus Contemporary Art Center (now The Contemporary), Atlanta, Georgia

The Studio Museum in Harlem, New York Yale University Art Center, New Haven, Connecticut Fort-de-France Festival, Martinique

J im Alexander distinguished himself as a documentary photographer of African American life. Beginning around 1963, after taking business courses at Rutgers University, he began making images of African Americans in the fields of art, entertainment, social activism, and other public arenas. Among his numerous

images of musicians, ranging from jazz to rock, is the extensive photoessay of legendary jazz great Duke Ellington (also highlighted in the publication *Duke and Other Legends*). He recorded scenes from the civil rights era, and interpreted the lives of African Americans after the assassination of Dr. Martin Luther King, Jr. in 1968 in 200 photographs from around the country. He was commissioned to photograph Black Hebrew Israelites in Israel and had a special exhibition for the governor of Connecticut in 1972. Alexander was photographer-inresidence at Clark Atlanta University for five years.

WILLIAM J. ANDERSON

Born August 30, 1932, in Selma, Alabama Resides in Atlanta, Georgia Photography, sculpture, printmaking

EDUCATION

B.S., Alabama State College (now University), 1959B.F.A., University of Wisconsin, 1962M.F.A., Instituto Allende (San Miguel, Mexico), 1968

MAJOR EXHIBITIONS

Atlanta University, Atlanta, Georgia Milwaukee Art Museum, Milwaukee, Wisconsin High Museum of Art, Atlanta, Georgia LeMoynes-Owens College, Memphis, Tennessee Contemporary Arts Center, New Orleans, Louisiana Corcoran Gallery of Art, Washington, D.C. Wadsworth Atheneum Museum of Art, Hartford, Connecticut

University Gallery, University of Delaware, Newark, Delaware

Iris & B. Gerald Cantor Center for Visual Arts, Stanford University, Stanford, California

TTTilliam Anderson's parents encouraged him to pursue his interests in music and art at an early age even though no formal instruction was available in the public schools he attended. After two years as a music major at Knoxville College, Anderson transferred to Alabama State College (now University) to study art under Hayward L. Oubre. Under Oubre's tutelage, Anderson explored many media although he became best known professionally for his photography, an interest that began with childhood experiences in his father's darkroom related to his father's work in the medical field. Anderson's photographs often depict rural southern life and urban street dwellers such as the homeless, the unemployed, and the underemployed. Anderson's work is represented in the collections of the High Museum of Art in Atlanta, Georgia, and the J. Paul Getty Museum in Los Angeles, California.

BENNY ANDREWS

Born November 13, 1930, in Madison, Georgia Resides in Brooklyn, New York Collage, printmaking, graphic art

EDUCATION

B.F.A., Art Institute of Chicago, 1958 Fort Valley State College, 1948–1950

MAJOR EXHIBITIONS

Metropolitan Museum of Art, New York

Museum of Modern Art, New York

Hirshhorn Museum and Sculpture Gardens, Smithsonian
Institution, Washington, DC

Bill Hodges Gallery, New York

Bomani Gallery, San Francisco, California
Dayton Art Institute, Dayton, Ohio
New Jersey State Museum, Trenton, New Jersey
Mississippi Museum of Art, Jackson, Mississippi
Wichita Art Museum, Wichita, Kansas
The Studio Museum in Harlem, New York
High Museum of Art, Atlanta, Georgia
Wichita State University Edwin A. Ulrich Museum
of Art, Wichita, Kansas
Wadsworth Atheneum Museum of Art,
Hartford, Connecticut
ACA Galleries, New York

turning from duties in Korea, he attended the Chicago Art Institute with assistance from the GI Bill. He moved to New York City after graduation, and became a strong activist on behalf of African American artists. In his work, he has responded to his social and cultural environment through paintings and collages since 1956 when he was a student in Chicago. Using found objects and incorporating other materials with cutouts from publications, Andrews is inspired by the people, events, and cultural milieu from his own experiences. Often relating back to his birth state, Georgia, he developed personal icons that have been contextualized in ways that make them easily readable and widely understandable. Much of his imagery is rooted in memories and fiction narratives related to the South. He protested the exclusion of African American artists by major art institutions in the 1970s and helped found the Black Emergency Cultural Coalition and was director of the Visual Arts Program for the National Endowment for the Arts between 1982 and 1984. Andrews has had more than seventy solo exhibitions throughout the country and abroad. His work is in the permanent collections of the Museum of Modern Art in New York, the Brooklyn Museum of Art in New York, the Detroit Institute of Art, the High Museum of Art in Atlanta, the Hirshhorn Museum in Washington, DC, the Chrysler Museum in Norfolk, Virginia, the Butler Institute of Art in Youngstown, Ohio, and the O'Hara Museum in Tokyo.

BERT ANDREWS

Born 1931 in Chicago, Illinois Died 1993? in New York, New York Photography

MAJOR EXHIBITIONS

University of Delaware University Gallery, Newark, Delaware Delaware State University Art Gallery, Dover, Delaware Georgia State University Art Gallery, Atlanta, Georgia

ert Andrews was the preeminent photographic **D** record-keeper of African American theater in New York, especially the Negro Ensemble Company between 1955 and 1985. Later, he became the exclusive documenter of Woodie King, Jr.'s New Federal Theater, and worked extensively for the Richard Allen Cultural Center and the Frank Silvera Writers' Workshop. Born in Chicago, he grew up in Harlem where he was a songwriter, dancer, and singer before studying photography and becoming an apprentice to renowned jazz photographer Chuck Stewart. Andrews was a freelancer selling work to the Amsterdam News, Our World, and Sepia when a casual encounter with actress and then model Cicely Tyson initiated his shift to theater. He made more than 40,000 negatives capturing the stage careers of such distinguished performers as Morgan Freeman, Denzel Washington, Gloria Foster, Alfre Woodard, Alvin Ailey, Samuel L. Jackson, and hundreds more, spanning a thirty-five-year history. His photographs appeared in numerous national and international publications, including Time, Newsweek, Life, and the New York Times; and in several books on American theater. An all-night fire in 1988 destroyed his studio and all of his negatives. Andrews teamed with theater historian, playwright, and director Paul Carter Harrison to produce In The Shadow of the Great White Way: Images from the Black Theater with Thunder's Mouth Press in 1989—negatives were made from photographs collected by various people in the theater industry.

WILLIAM ELLISWORTH ARTIS

Born 1914 in Washington, North Carolina Died 1977 Sculpture, pottery

EDUCATION

B.S., Nebraska State Teachers College, ChadronB.F.A (1950), M.F.A. (1951), Syracuse University,Syracuse, New YorkArt Students League, New York, 1933–1935

MAJOR EXHIBITIONS

Smithsonian Institution, Washington, DC
National Sculpture Society, New York
Howard University, Washington, DC
Indiana University Art Museum, Bloomington, Indiana
National Portrait Gallery, Smithsonian Institution,
Washington, DC

Walker Art Center and Minneapolis Sculpture Garden, Minneapolis, Minnesota

New Jersey State Museum of Art, Trenton, New Jersey
The City College of New York, New York
Atlanta University Art Gallery (now Clark Atlanta University
Art Galleries), Atlanta, Georgia

Xavier University Art Gallery, New Orleans, Louisiana Syracuse Museum of Fine Arts (now The Everson Museum of Art), Syracuse, New York

American Negro Exposition, Chicago, Illinois
Whitney Museum of American Art, New York
Salons of America, Inc., New York
Harmon Foundation, New York
Scripps College Ruth Chandler Willamson Gallery,
Claremont, California

William Artis studied with Augusta Savage in Harlem (1930s), sculptor Ivan Mestrovich, and at New York State University, New York State College of Ceramics, California State College at Long Beach, Pennsylvania State University at College Park, and Greenwich House Ceramics Center in New York. In 1946, he received a Harmon Foundation Fellowship to demonstrate his ceramics techniques at six Historically Black Colleges and Universities. He established a distinguished teaching career, briefly at Tuskegee Institute and in positions at

Nebraska State Teachers College in Chaldron from 1956 to 1966 and Mankato State College in Makato, Minnesota, in 1975. Artis worked predominately in terra cotta from 1930 to 1940, concentrating on abstraction and utility in ceramic objects thereafter. He was best known for his sensitive portrayals of unknown subjects, often male. His work is associated with the concept of "Negritude," which characterized the mythic aesthetic of the African personality as sensual and emotionally sensitive, embodying the Negro soul. He received nine Atlanta University Annual Awards (1942–1970) including two prestigious John Hope Prizes (1933, 1935), one Sculpture Purchase Prize, and six Purchase Awards. His work is in the collections of Fisk University, Hampton University, and the North Carolina Museum of Art.

HERMAN "KOFI" BAILEY

Born 1931 in Chicago, Illinois Died February 1981 in Atlanta, Georgia Graphic art, mixed media, illustration

EDUCATION

B.A., Alabama State University M.F.A., University of California

MAJOR EXHIBITIONS

High Museum of Art, Atlanta, Georgia
Marietta-Cobb Museum of Art, Marietta, Georgia
University of Delaware University Gallery, Newark, Delaware
Spelman College Museum of Fine Art, Atlanta, Georgia
Lewis-Waddell Gallery, Los Angeles, California

H erman Bailey was born in Chicago but grew up in Los Angeles, California. After graduating from Alabama State University, he entered Howard University, studying with Alain Locke, Sterling Brown, and James Porter before completing graduate work in California. His work has been exhibited throughout the United States, Mexico, Brazil, Canada, and West Africa. Strongly engaged in Pan Africanism, he became closely associated with W.E.B. Du Bois, and later, with Martin Luther King, Jr. and Kwame Nkrumah, the president of Ghana. Bailey's interest in African themes and in es-

tablishing associations between African and African American experience was evident in his work, as was his strong sense of social activism and political awareness. He was a prolific artist, creating numerous drawings and prints through which he also explored many materials. Best known for his charcoal and conte drawings, Bailey's work was widely acquired by private collectors in Africa, Mexico, and South America as well as in the United States. His work is also in the collections of the High Museum of Art in Atlanta and the Spelman College Museum of Fine Art.

ROMARE BEARDEN

Born September 2, 1914, in Charlotte, North Carolina Died March 12, 1988, in New York Collage, painting, printmaking

EDUCATION

B.S., New York University, New York, 1935 Art Students League, New York, 1942–1945

MAJOR EXHIBITIONS

Michael Warren Gallery, New York

Samuel Kootz Gallery, New York

National Gallery of Art, Washington, DC North Carolina Museum of Art, Raleigh, North Carolina ACA Galleries, New York Detroit Institute of Arts, Detroit, Michigan Memphis State University, Memphis, Tennessee The Mint Museums, Charlotte, North Carolina Everson Museum of Art, Syracuse, New York Pace Gallery, New York University of Iowa Museum of Art, Ames, Iowa Museum of Modern Art, New York Museum of Fine Arts, Boston, Massachusetts University of Southern California, Santa Barbara, California State University of New York, Albany, New York Dartmouth College Hopkins Center, Hanover, New Hampshire Spelman College Museum of Fine Art, Atlanta, Georgia Oakland Museum of California, Oakland, California Corcoran Gallery, Washington, DC Cordier and Ekstrom, New York

G Place Gallery, Washington, DC

Downtown Gallery, New York

Institute of Modern Art, Boston, Massachusetts

merica's preeminent collagist, Romare Bearden A was also a talented colorist and writer. Among the large number of African Americans moving north from the rural South in the early 1900s, his experiences from Charlotte, Harlem, Pittsburgh, Canada and, later Paris, are successfully blended into innovative imagery that was also influenced by African art and Chinese landscapes. While the dada style of mentor George Grosz (Art Students League) is traceable in Bearden's work, along with the cubist work of Picasso and Braque, the cutouts of Matisse, and the narrative paintings of Diego Rivera, the impact of jazz and blues, African American quilts, and trains are inseparable from a true understanding of his imagery. His oeuvre crosses many media of more than 2,000 known works ranging from social realism to cubism to abstract expressionism to his unique brand of modernist collage. Though he was proficient in various media, his signature style was the collage—an approach that exposed his tremendous ability to redefine collage inclusive of assemblage, papier-collé, photomontage, and color washes, and his complex narratives exploring numerous aspects of African American life. A founder of Spiral, a group of New York artists interested in participating in the civil rights struggle in America through their art, Bearden's move toward the use of purer color relationships, especially in watercolor, increased in the late 1970s inspired by his trips to the island of St. Martin. His work is in the permanent collections of the Metropolitan Museum in New York and National Museum of American Art.

PHOEBE BEASLEY

Born 1943 in Cleveland, Ohio Resides in Los Angeles, California Collage, printmaking

EDUCATION

B.F.A., Ohio University, Athens, Ohio M.A., Kent State University, Ohio

MAIOR EXHIBITIONS

Schomburg Center for Research in Black Culture, New York
Anheuser Busch Gallery at Coca, St. Louis, Missouri
Museum of Science and Industry, Chicago, Illinois
The Cinque Gallery, New York
Museum of African American Art, Los Angeles, California
Smithsonian Institution, Washington, DC

orking in collage for over thirty-five years, Phoebe Beasley combines oil paint, tissue paper, cloth, and other objects to create scenes of African American life, emphasizing people of ordinary means in acts of everyday experiences. She is the only artist to receive the Presidential Seal twice, from Presidents George Bush (1989) and Bill Clinton (1993). Her numerous public projects include a twenty-five-foot ABSOLUT Vodka billboard on Sunset Boulevard, a tobacco education project with the State of California, and an outdoor mural in North Hollywood commissioned by the City of Los Angeles. Her commissioned work also appeared on the TV mini-series Women of Brewster Place in 1989. Beasley has had numerous solo and group exhibitions in the United States and abroad, and was honored by the State Department for her participation in the Art in Embassies Program. Her work is in the collections of the University of Texas, University of Illinois, Syracuse University, Brigham Young University, Fisk University, Kansas State University, Southern University, Swathmore College, Cooper Union, the Schomburg Museum, Bowdoin College, Dillard University, and California African American Museum.

JOHN THOMAS BIGGERS

Born 1924 in Gastonia, North Carolina Died 2001 in Houston, Texas Painting, printmaking, mural, graphic art

EDUCATION

Hampton Institute, Hampton, Virginia B.S., M.S.E., Ph.D., Pennsylvania State University, College Park, Pennsylvania

MAJOR EXHIBITIONS

Penn State University, State College, Pennsylvania

Museum of Fine Arts, Houston, Texas
Virginia Museum of Fine Arts, Richmond, Virginia
The City College of New York, New York
Contemporary Arts Museum, Houston, Texas
Los Angeles County Museum, Los Angeles, California
Black Art Gallery, Houston, Texas
La Jolla Museum, La Jolla, California
Benin Sculpture Exhibition
Denver Art Museum, Denver, Colorado
Rockford College, Rockford, Illinois
Xavier University Art Gallery,
New Orleans, Louisiana
Dallas Museum of Fine Arts, Dallas, Texas
(Clark) Atlanta University, Atlanta, Georgia
Museum of Modern Art, New York

ohn Biggers taught at Michigan State University, East Lansing, briefly at Alabama State College, and established the art department at Texas Southern University (1949), where he was professor for over thirty years; he retired from teaching in 1983 and devoted himself exclusively to his art. His book containing eightyeight drawings and brief text, Ananse: The Web of Life in Africa, was published in 1962 based on his six-month stay in West Africa. Established as a muralist, he completed commissions for: Hampton University, (two), ca. 1944–1945; Burrows Education Building, Pennsylvania State University (1949); Eliza Johnson Home for Aged Negroes (1951); Y.W.C.A., Blue Triangle Branch, Houston (1953); Carver High School, Naples, Texas (1955); International Longshoremen's Association Local 872, Houston (1956); Dowling Veterinary Clinic, Houston (1960); W. L. Johnson Branch, Houston Public Library (1964); Hannah Hall, TSU (1967), Houston; Riverside Hospital, Houston (1976); TSU Student Union Building (1977); Florida A&M; and Houston Music Hall (1981). Biggers received Purchase Awards from Atlanta University (1950–1953), Museum of Fine Arts, Houston (1950), and the Dallas Museum of Fine Arts (1952); receiving the Harbison Award for teaching in 1968. His work is in the collections of the Pennsylvania State University, Texas Southern University in Houston, Lubbock Museum of Art in Texas, Dallas Museum of Fine Arts in

Texas, Museum of Fine Arts, Houston, and Howard University in Washington, DC.

CAMILLE BILLOPS

Born August 12, 1933, in Los Angeles, California Resides in New York Sculpture, printmaking, film

EDUCATION

B.A., California State College, Los Angeles, California, 1960 M.F.A., City College of New York, 1973 Studied, University at the Sorbonne, Paris, France

EXHIBITIONS

Gallerie Akhenaton, Cairo, Egypt Valley Cities Jewish Community Center, Los Angeles, California Atlanta College of Art, Atlanta, Georgia Spelman College Museum of Fine Art, Atlanta, Georgia Montclair State College Art Gallery, Montclair, New Jersey Bernice Steinbaum Gallery, New York Hampton University Art Gallery, Hampton, Virginia The Studio Museum in Harlem, New York Bucknell University Center Gallery, Lewisville, Pennsylvania Washington Project for the Arts, Washington, DC Gimpel and Weitzenhoffer Gallery, New York The New Museum of Contemporary Art, New York El Museo de Arte Moderno La Tertulia, Cali, Colombia Hamburg, Germany Kaohsiung, Taiwan

amille Billops first rose to the forefront in the visual arts field as a ceramic sculptor, but quickly became recognized for a range of additional talents including printmaking, drawing, book illustration, pottery, jewelry making, poetry, and filmmaking. She had her first one-person show in 1960 at the African American Art Exhibition in Los Angeles and was artist-in-residence at the Asilah First World Festival in Morocco in 1978. In 1975, Billops co-founded with her husband James Hatch the Hatch-Billops Collection, extensive archives of African American cultural history in the form of visual materials, oral histories, and thousands of books chronicling black

artists in the visual and performing arts. Billops began her career in filmmaking in the early 1980s with *Suzanne*, *Suzanne* (1982), followed by *Older Women and Love* (1987), *Finding Christa* (1991), which won the Grand Jury Prize for documentaries at the 1992 Sundance Film Festival, *The KKK Boutique Ain't Just Rednecks* (1994), *Take Your Bags* (1998), and *A String of Pearls* (2002). Billops's awards include: a Fellowship from the Huntington Hartford Foundation in 1963, a MacDowell Colony Fellowship in 1975, The International Women's Year Award for 1975–76, and the James VanDerZee Award, Brandywine Graphic Workshop in 1994. Her works are in the permanent collections of the Studio Museum of Harlem, Photographers Gallery, London, and the Museum of Drawers, Bern, Switzerland.

FRANK BOWLING

Born February 29, 1936, in Bartica, Essequibo, Guyana Resides in Brooklyn, New York Painting

EDUCATION

Chelsea School of Art Royal College of Art, London, England Slade School of Fine Arts, London, England, 1959–1962

MAJOR EXHIBITIONS

N'Nambdi Gallery, Chicago, Illinois UFA Gallery, Chelsea, New York Center for Art and Culture, Brooklyn, New York Midland Art Centre, Birmingham, England University Gallery, Bradford, Yorkshire, England Heimatmuseum, Eckernforde, Schleswig Holstein, Germany University of Delaware University Gallery, Newark, Delaware Royal West of England Academy, Bristol, England University Art Gallery, Reading, England Castlefield Gallery, Limerick, Ireland Tibor de Nagy Gallery, London, England Whitney Museum of American Art, New York Boston Museum of American Art, Boston, Massachusetts Rice University, Houston, Texas Princeton University, Princeton, New Jersey State University of New York, Stony Brook, New York

Tate Gallery, London, England Grabowski Gallery, London, England

F rank Bowling is a writer, critic, teacher, and artist. He was contributing editor and critic to Arts Magazine and Tutor, Camberwell School of Arts and Crafts in London, England. He has taught at Columbia University in New York, Rutgers University in New Jersey, Massachusetts College of Art, and School of Visual Arts in New York. He was artist-in-residence at the New York State Council of the Arts and the Skowhegan School of Painting and Sculpture in Maine. Bowling received the Pollock-Krasner Award in 1992 and 1998, a John Simon Guggenheim Fellowship in 1967, the 1967 Painting Prize in Edinburgh, Scotland, Grand Prize at the First World Festival of Negro Art at Dakar, Senegal, in 1966, and the Purchase Prize Award at Shakespeare Quatro-Cenetary, Stratford on Avon, England, in 1966. Bowling is best known for nonrepresentational paintings structured around color relationships, texture, and ambiguous spatial contexts. His imagery fuses compositional and surface readings linked to an African-derived and Western aesthetics. Often presented in large-scale and dramatic dimensional formats (such as extremely long and narrow), Bowling's paintings create the opportunity for varied readings and have tremendous power when considered as works structured around color and tonal relationships.

BENJAMIN BRITT

Born 1923 in Windfall, North Carolina

Death date unknown in Philadelphia, Pennsylvania

Painting

EDUCATION

Philadelphia's Museum College of Art Hussian School of Art Art Students League, New York

MAJOR EXHIBITIONS

Smith-Mason Gallery, Washington, DC State Armory, Wilmington, Delaware Xavier University Art Gallery, New Orleans, Louisiana Studio 5 Gallery, New York
University of Pennsylvania, Philadelphia, Pennsylvania
(Clark) Atlanta University, Atlanta, Georgia
October Gallery, Philadelphia, Pennsylvania
Schaffer Gallery, Chafont, Pennsylvania
Philadelphia Art Alliance, Philadelphia, Pennsylvania
Allens Lane Art Center, Philadelphia, Pennsylvania
Wharton Art Center, Philadelphia, Pennsylvania
Cheyney University, Cheyney, Pennsylvania

B enjamin Britt painted socially sensitive narratives using the African American model to address universal issues of humanity. Working nearly exclusively in oils, his subjects tended to be conditions or states or being rather than portrayals of individuals or types. Much of his work was in a surrealist or quasi-surrealist style that relied on representation in the depiction of forms, yet contained unusual, ambivalent, or fantasy-like environments. His figurative references were often of small children or adolescents. Britt's awards include the Laura Wheeler Waring Award in 1971, Painting Award in 1957 and Popular Purchase Awards in 1964 and 1958 at the Atlanta University Annual, and First Prize, Les Beaux Arts, Vineland, New Jersey, in the mid-1950s.

SELMA HORTENSE BURKE

Born 1900 in Mooresville, North Carolina Died 1995 in York, Pennsylvania Sculpture, printmaking

EDUCATION

B.F.A., Columbia University
Winston-Salem State University

MAJOR EXHIBITIONS

Marietta-Cobb Museum of Art, Marietta, Georgia
University of Delaware University Gallery, Newark, Delaware
Rainbow Sign Gallery, Berkeley, California
The City College of New York, New York
Howard University, Washington, DC
Avant Garde Gallery, New York
Carlen Galleries, Philadelphia, Pennsylvania
Julian Levy Galleries, New York

Modernage Gallery, New York (Clark) Atlanta University, Atlanta, Georgia American Negro Exposition, Chicago, Illinois

elma Burke became interested in forming objects in clay as a small child, pinpointing the beginning of her art-making efforts to 1907 when she dug clay out of the ground at her parent's farm in Mooresville, North Carolina, and squeezed it in her hands, attempting to shape animals with it. She later considered nursing as a career option, attending St. Agnes School of Nursing, Raleigh, and Women's Medical College in Philadelphia. She went on to study sculpture at Columbia and traveled to Europe where she studied ceramics with Povoleny in Vienna and sculpture with Maillol in Paris, returning to New York around 1940. The 1987 recipient of the Pearl S. Buck Foundation Woman's Award, Selma Burke taught at Howard University, Washington, DC, for forty-seven years (1930-1977) and at Harvard University, Livingstone College, and Swarthmore College. Her most famous work is the bust of President Franklin Delano Roosevelt that is on the United States dime. In 1944, President Roosevelt posed for the artist; her completed bronze plaque was unveiled by President Harry S. Truman in 1945 and stored at the Recorder of Deed Building in Washington, DC. Burke is best known for her plaster, clay, brass, and bronze heads of African Americans, most prominent among them being the portrait of Mary McCleod Bethune (1980). A Rosenwald Fellow in 1939, she received the Edward P. Alford, Jr. Award in the 1944 Atlanta University Annual.

MARGARET TAYLOR GOSS BURROUGHS

Born 1917 in St. Rose Parish, Louisiana Resides in Chicago, Illinois Painting, printmaking, illustration, graphic art

EDUCATION

B.A., Chicago Teacher's College, 1937 M.A.E., Art Institute of Chicago, 1948 Chicago Normal School Teacher's College, Columbia University, New York Northwestern University, Chicago

MAJOR EXHIBITIONS

Elmhurst College, Elmhurst, Illinois
Ball State University, Museum of Art, Muncie, Indiana
House of Friendship, Moscow
International Kook Art Exhibit, Leipzig, Germany
Xavier University Art Gallery, New Orleans, Louisiana
Howard University, Washington, DC
Kenosha Museum, Poland
Market Place Gallery, New York
San Francisco Civic Museum, San Francisco, California
(Clark) Atlanta University, Atlanta, Georgia
American Negro Exposition, Chicago, Illinois
Illinois State University, University Galleries,
Bloomington, Illinois
Winston-Salem State College Diggs Gallery,
Winston-Salem, North Carolina

argaret Burroughs was a founder of the South Side Community Art Center in Chicago, founder and director of the DuSable Museum of African American History in Chicago (1961), and a founder of the National Conference of Artists. She published her first children's book, *Jasper, the Drummin' Boy,* in 1947; in 1967, she and Dudley Randall edited an anthology called *For Malcolm: Poems on the Life and Death of Malcolm X,* and published several volumes of her own poetry.

Her paintings and prints are commentaries on the African American urban experience. She has work in the collections of Howard University in Washington, DC, (Clark) Atlanta University in Georgia, Oakland Museum in California, Alabama State (University), and DuSable Museum in Illinois.

DOUGHBA HAMILTON CARANDA-MARTIN III

Born in Liberia, West Africa Photography, painting, installation art

EDUCATION

B.F.A., School of Visual Art, New York

Konola Academy, Liberia University of Liberia

MAJOR EXHIBITIONS

Istanbul Biennial, Istanbul, Turkey
Venice Biennial, Venice, Italy
Philadelphia Museum of Art, Philadelphia, Pennsylvania
Wilma Jennings Gallery, New York
Gale-Martin Fine Arts, Chicago, Illinois
Rockland Center for the Arts, Rockland County, New York
French Cultural Center, New York
Porter Troupe Gallery, La Jolla, California
Delaware College of Art and Design, Wilmington, Delaware
The City College of New York, New York
Kenkeleba House, New York
Jamaica Center for Arts and Learning, New York
Adam Goldstein Fine Art, San Francisco, California

D. H. Caranda-Martin works in a variety of media, specializing in one-of-a kind photographs, mixed media installations, and abstract painting. His paintings explore color movement and abstract pigmentation achieved by layering oils, wax, and varnish to create a slick painted surface. Originally from Liberia, Caranda-Martin addresses such issues of multinationals, oil spills, human rights, and African history. His photographs are pensive, quiet, and introspective in a manner that renders them universally appealing.

NANETTE CARTER

Born 1954 in Columbus, Ohio Resides in New York, New York Painting, printmaking

EDUCATION

M.F.A., Pratt Institute of Art, Brooklyn, New York, 1978 B.A., Oberlin College, Oberlin, Ohio, 1976 L'Accademi di Belle Arti, Perugia, Italy, 1974–1975

MAJOR EXHIBITIONS

Sande Webster Gallery, Philadelphia, Pennsylvania G. R. N'Namdi Gallery, Birmingham, Michigan Rathbone Gallery, Albany, New York The Sage Colleges, Albany, New York June Kelly Gallery, New York
Franklin and Marshall College, Lancaster, Pennsylvania
Kebede Fine Arts, Los Angeles, California
Long Island University, Southampton, New York
Westminster Gallery, Bloomfield College,
Bloomfield, New Jersey
Bloomfield College, Bloomfield, New Jersey
Jersey City Museum, Jersey City, New Jersey
Montclair Art Museum, Montclair, New Jersey
Ericson Gallery, New York

Nanette Carter has taught at City College of New York since 1992, having previously been a teacher at the Dwight-Englewood School in New Jersey (1978-1987). Her abstract paintings and monoprints are abstract narratives of the African American experience emphasizing the political nuances and overt implications that unite all people of the African disapora. Her work brings to the forefront of consideration the sight, sound, and rhythms of place as a physical and psychological series of boundaries. Carter uses color as both a code and a structural element. She was a 1981 National Endowment for the Arts Fellow and received a Pollack Foundation grant in 1994. Her work is in the collections of the Jersey City Museum in New Jersey, the Newark Museum of Art in New Jersey, The Studio Museum in Harlem, Herbert F. Johnson Museum of Cornell University in New York, Jane Voorhees Zimmerli Art Museum of Rutgers University in New Jersey, and Yale Gallery of Art in Connecticut.

ALICE ELIZABETH CATLETT (MORA)

Born April 15, 1915, in Washington, DC Resides in Mexico Sculpture, printmaking

EDUCATION

B.S., Howard University, Washington, DC, 1937 M.F.A, University of Iowa, Iowa City, 1940

MAJOR EXHIBITIONS

June Kelly Gallery, New York

Hampton University, Virginia

Fisk University, Tennessee North Carolina Central University, Durham, North Carolina (Clark) Atlanta University, Atlanta, Georgia Art Institute of Chicago, Chicago, Illinois Corcoran Gallery of Art, Washington, DC Bomani Gallery, San Francisco, California Sragow Gallery, New York The Studio Museum in Harlem, New York California State University, Long Beach, California La Jolla Museum, La Jolla, California National Center of Afro-American Art. Roxbury, Maryland Museum of Modern Art, Mexico Cleveland Museum of Art, Cleveland, Ohio Albany Institute of History and Art, Albany, New York University of Chicago, Chicago, Illinois Baltimore Museum of Art, Baltimore, Maryland Newark Museum, Newark, New Jersey University of Iowa, Iowa City, Iowa

relizabeth Catlett is one of the most respected sculpf L tors and printmakers of America's living artists. She is the third child born to parents who were teachers, and grew up in an environment that emphasized learning and exploration and encouraged open expression. Following studies at Howard and Iowa, she continued at the Art Institute of Chicago, Illinois (1941), at the Art Students League, New York (1942-1943), with Ossip Zadkine in New York (1943), and under Jose L. Ruix and Francisco Zuniga at Escuela de Pintura y Escultura, Esmeralda, Mexico (1955, 1947-1948). The first African American recipient of an MFA in sculpture from Iowa State, she took a position at Prairie View College in Texas, and later at Dillard University in New Orleans where she pioneered the use of live models in the classroom while chair of the art department. Throughout her life and work, Catlett has been an advocate for improving the conditions and treatment of women, especially, but focusing on the struggles and triumphs of all oppressed people. She received a Rosenwald Fellowship in 1945 that allowed her to go to Mexico City and produce a body of

work on African American women. Catlett and Charles White, her husband at the time, met artists David Alfaro Siqueiros, Frida Kahlo, and Diego Rivera while renting a room from Siqueiros's mother-in-law. She and White soon returned to the states for a divorce, and Catlett went back alone. In 1947, she married Francisco Pancho Mora, a printmaker she met at the Popular Graphics Workshop. She began incorporating the historical placement and treatment of Mexican women and others into a more universalized approach in her work. Her primary subject matter, however, remained the African American woman. Catlett's work is in the permanent collections of the Baltimore Museum of Art in Maryland, High Museum of Art in Atlanta, National Museum of American Art in Washington, DC, New Orleans Museum of Art in Louisiana, Cleveland Museum of Art in Ohio, Metropolitan Museum of Art in New York, Museum of Modern Art in New York, Studio Museum in Harlem, Wadsworth Atheneum in Connecticut, Museo de Arte Moderno in Mexico City, and Narodniko Musea (National Museum) in Prague.

ERNEST CHRICHLOW

Born June 19, 1914, in Brooklyn, New York Resides in Brooklyn, New York Painting

EDUCATION

New York University, New York Art Students League, New York

MAJOR EXHIBITIONS

State Armory, Wilmington, Delaware
Museum of Fine Arts, Boston, Massachusetts
The City College of New York, New York
ACA Gallery, New York
Institute of Modern Art, Boston, Massachusetts
(Clark) Atlanta University, Atlanta, Georgia
American Negro Exposition, Chicago, Illinois
Harlem Community Center, New York
Newark Museum, Newark, New Jersey
The Cinque Gallery, New York
Downtown Gallery, New York

Federal Art Gallery, New York Smith College, Northampton, Massachusetts

E rnest Chrichlow was inspired to become an artist following an encounter with Augusta Savage and Norman Lewis in Savage's studio. He joined the Harlem Artist Guild in the 1930s and met Jacob Lawrence, Charles Alston, James Yeargans, and others. His work addresses social and political topics often using the single figure as a means to bringing focus and emphasis to his message. Chrichlow, whose parents had migrated from Barbados, returned frequently to island references as subjects, drawing particularly from Jamaica. His personal style has been referred to as interpretive realism due to the strong narrative nature of his imagery.

CARL CHRISTIAN

Born March 26, 1954, in Bessemer, Alabama Resides in Atlanta, Georgia Painting

EDUCATION

Art Institute of Atlanta, Atlanta, Georgia, 1984 M.M.Ed., Georgia State University, Atlanta, Georgia, 1983 B.S., Knoxville College, Knoxville, Tennessee, 1976

MAJOR EXHIBITIONS

Mary Holmes College, West Point, Mississippi
Cary-McPheeters Gallery, Atlanta, Georgia
D. Miles Gallery, Decatur, Georgia
Civil Rights Institute, Birmingham, Alabama
Morehouse College, Atlanta, Georgia
Gwinnett County Fine Arts Center, Duluth, Georgia
Atlanta Arts Festival, Atlanta, Georgia
City Gallery East, Atlanta, Georgia
Gallery 1024, Birmingham, Alabama
Municipal Gallery, Decatur, Georgia
(Clark) Atlanta University Center Library, Atlanta, Georgia
Birmingham Civil Rights Museum, Alabama

C arl Christian worked quietly and almost secretly, producing artwork while teaching in the public school system in the Atlanta area. After almost ten years,

he successfully entered his first art competition. Working primarily as an abstractionist, he applies bits of found objects and other materials to the surface of his paintings to create large-scale statements about spontaneity, intuitive patterning, and subconscious reading. Inspired by the improvisational properties of jazz and fundamental optimism about life, Christian finds the untold beauty in overlooked forms that are taken for granted. He considers his paintings explorations and experiments on texture, tactility, and form.

ALLAN ROHAN CRITE

Born 1918 in Plainfield, New Jersey Resides in Boston, Massachusetts Painting, printmaking, illustration

EDUCATION

School of Fine Arts, Boston, Massachusetts, 1929–1936 Painter's Workshop, Fogg Art Museum (ca. 1940) B.A., Harvard University Extension School, 1968

Boston Athenaeum, Boston, Massachusetts

MAJOR EXHIBITIONS

Museum of Fine Arts, Boston, Massachusetts Corcoran Gallery of Art, Washington, DC Museum of Modern Art, New York Art Institute of Chicago, Chicago, Illinois Columbus Museum, Columbus, Georgia Mount Holyoke College, Blanchard Art Gallery, South Hadley, Massachusetts Duncan Phillips Gallery, Washington, DC National Center of Afro-American Art, Roxbury, Maryland Newark Museum, Newark, New Jersey Smithsonian Institution, Washington, DC Howard University, Washington, DC Institute of Contemporary Art, Boston, Massachusetts Addison Gallery of American Art, Andover, Massachusetts Grace Horne Galleries, Boston, Massachusetts (Clark) Atlanta University, Atlanta, Georgia American Negro Exposition, Chicago, Illinois Harmon Foundation Exhibitions Boston Society of Independent Artists, Boston, Massachusetts

llan Crite has had a long and illustrious career as A an artist and mentor to numerous younger artists. He was one of the relatively few African American artists to work for the Federal Arts Project (FAP) during the 1930s and has continued to depict the conditions of African Americans over the changing decades since that time. His presentations of African Americans in community scenes were joined by an increasing interest in interpretations of religious themes, using black figures as the basis for his characterizations. He has written and illustrated several books, including Three Spirituals from Heaven in 1948, one of two volumes published by Harvard University Press. In portraying his religious works, Crite adopted a style that alluded to the formal religious imagery of Catholicism or the Episcopalian practices he later assumed. Crite established the Artists' Collective, a forum to support younger and emerging artists. His work is represented in the Museum of Fine Arts, Boston; the Museum of Modern Art, Phillips Collection, Corcoran Gallery, Washington, DC, Smithsonian Institution, and the Art Institute in Chicago.

ROY DECARAVA

Born 1919 in New York, New York Resides in Brooklyn, New York Photography

EDUCATION

Cooper Union, New York, 1938–1940 Harlem Art Center, New York, 1940–1942 George Washington Carver Art School, 1944

MAJOR EXHIBITIONS

Los Angeles County Museum,
Los Angeles, California
Fotografiska Museet, Stockholm, Sweden
The Studio Museum in Harlem, New York
The Witkin Gallery, New York
Museum of Fine Arts, Houston, Texas
Museum of Modern Art, New York
Forty-fourth Street Gallery, New York
Serigraph Gallery, New York

(Clark) Atlanta University, Atlanta, Georgia Minneapolis Institute of Arts, Minneapolis, Minnesota

oy DeCarava is a Distinguished Professor at Hunter $oldsymbol{K}$ College. He was initially a painter and printmaker who began photographing to document that work. He switched to photography as a primary medium in 1947, having his first solo exhibition in 1950. He has become one of the foremost photographic artists of the twentieth century. The first African American artist to receive the Guggenheim Fellowship (1952), his images have immortalized the jazz world through his photographs of contemporaries Billie Holiday, John Coltrane, Roy Haynes, and others. He photographed for Sports Illustrated, Look, and numerous other journals. In 1955, DeCarava teamed with writer Langston Hughes to produce The Sweet Flypaper of Life, which depicts the positive side of Harlem through text illustrated with photographs. DeCarava captures moments of intimacy and beauty in his images of family, friendship, faith, and other areas of strength. His work inspired younger artists such as Beuford Smith (b. 1941) to pursue the medium. He operated one of the first fine art photography galleries between 1954 and 1956, A Photographer's Gallery in New York. He cofounded the Kamoinge Workshop, a coalition of African American photographers in New York in 1963, which he ran through 1966. In 1971, DeCarava received the Benin Award for his contributions to the African American community. He was the Blue Ribbon Winner at the American Film Festival in 1984.

DAVID CLYDE DRISKELL

Born 1931 in Eatonton, Georgia Resides in Hyattsville, Maryland Painting, graphic art

EDUCATION

Rijksbureau voor Kunsthistorische Documentatie, The Hague, Holland, 1964 M.F.A., Catholic University of America, Washington, DC, 1962 B.F.A., Howard University, Washington, DC, 1955 Skowhegan School of Painting and Sculpture, Skowhegan, Maine, 1953

MAJOR EXHIBITIONS

Corcoran Art Gallery, Washington, DC National Museum of African American Art, Washington, DC Smithsonian Museum, Washington, DC Baltimore Museum of Art, Baltimore, Maryland Portland Museum of Art, Portland, Oregon Sherry Washington Gallery, Detroit, Michigan Diggs Gallery, Winston-Salem State University, Winston-Salem, North Carolina Bomani Gallery, San Francisco, California Pellon Gallery, Washington, DC University of Iowa Museum of Art, Iowa City, Iowa Whitney Museum of American Art, New York Norfolk Museum of Art, Norfolk, Virginia James David Brooks Memorial Gallery, Fairmont State College, Fairmont, West Virginia Cheekwood Botanical Garden and Museum of Art San Diego Fine Arts Gallery, San Diego, California Fisk University, Nashville, Tennessee Xavier University Art Gallery, New Orleans, Louisiana National Gallery of Art, Washington, DC

avid Driskell has excelled as an artist, writer, teacher, and consultant in the field of African American art. He taught at Talladega College in Alabama, Fisk University in Tennessee, and at the University of Maryland in College Park. In 1969–1970, he was visiting professor at the University of Ife in Ile Ife, Nigeria. His years of service to Maryland were rewarded with the establishment of a center bearing his name that will focus on African Diaspora studies. His collage-based paintings and purely abstract works are stylistically linked to the collage work of Romare Bearden and any number of African influences. The subjects and themes of many of his works refer specifically to the social and political climate in America with a tendency toward interweaving in his urban settings rural references. Driskell's work is in the collections of the Corcoran Gallery of Art, Barnett Aden, Le Moyne College, Howard University, and the Smithsonian Institution.

MICHAEL ELLISON

Born 1952 in Atlanta, Georgia Died July 22, 2001, in Atlanta, Georgia Printmaking

EDUCATION

M.A., Georgia State University, 1983 B.A., Atlanta College of Art

MAJOR EXHIBITIONS

High Museum of Art, Atlanta, Georgia Georgia Institute of Technology, Atlanta, Georgia South Carolina State, Orangeburg, South Carolina Georgia State University, Atlanta, Georgia Atlanta College of Art, Atlanta, Georgia McIntosh Gallery, Atlanta, Georgia

Michael Ellison mastered the subtractive linocut printmaking technique, creating colorful, abstract references to people and places in the urban centers where he lived and frequented in very low editions, usually of ten. He taught at Claflin College, South Carolina State College, and the Atlanta College of Art. He won the Georgia Business in the Arts Award in 1986 and was a first prize winner in printmaking in the Atlanta Life Insurance Company Annual Art Competition and Exhibition. Ellison's work was heavily acquired by private collectors throughout the Southeast, especially Paul R. Jones, and James Jackson and Gedney Vinings of Atlanta. His work is also represented in the permanent collection of the High Museum of Art in Atlanta.

JOHN W. FEAGIN

Born August 17, 1929, in Birmingham, Alabama Resides in Montgomery, Alabama Painting

EDUCATION

B.S., Alabama State University, 1957 M.A., Alabama State University, 1971

MAJOR EXHIBITIONS

University of Delaware Perkins Gallery, Newark, Delaware Alabama State University, Montgomery, Alabama Montgomery Museum of Fine Art, Montgomery, Alabama Birmingham Art Festival, Birmingham, Alabama (Clark) Atlanta University, Atlanta, Georgia

John Feagin was a dedicated teacher in the Alabama system for thirty-four years. He also taught drawing, painting, and ceramics for the city of Montgomery's recreation program for an additional ten years. As an artist, he evolved over the years from a representational to abstract and nonobjective painter. He actively experimented with ways in which to apply paint to his surfaces using different utensils and using glazes and mixtures for a variety of effects. Luminosity has remained important to him as he also worked to incorporate landscape elements. Working often in large formats, Feagin maintained a fierce interest in color as a structural and visceral point of concern as he continued to pursue surface manipulation.

REGINALD GAMMON

Born March 31, 1921, in Philadelphia, Pennsylvania Resides in Albuquerque, New Mexico Painting, photography

EDUCATION

Philadelphia Museum College of Art Stella Elkins School of Fine Art Tyler School of Art

MAJOR EXHIBITIONS

Saginaw Art Museum, Saginaw, Michigan
Smith-Mason Gallery, New York
Museum of Fine Arts, Boston, Massachusetts
Brooklyn College, New York
Minneapolis Institute of Art, Minneapolis, Minnesota
Everson Museum of Art, Syracuse, New York
Rhode Island School of Design, Providence, Rhode Island
The Studio Museum in Harlem, New York
Flint Institute of the Arts, Flint, Michigan

 $R^{\rm eginald}$ Gammon was at the center of the 1960s and 1970s activism in America. As a founding member of Spiral in New York, he advised Romare Bearden to use the photostat process and enlarge his photomontages to

achieve greater impact among young African American artists. He received critical acclaim for the 1965 painting, Freedom Now, his entry that year in the group's exhibition entitled "Black and White." The painting typified his strong, graphic, and punchy style that frequently revealed his knowledge of effective uses of photographic framing and cropping. Gammon was also noted for the formal quality in his compositions based upon his infusion of geometric properties. Based on current events, his figurebased paintings rely more on emotional impact than exact rendering. When Spiral disbanded, he joined Benny Andrews and others in the Black Emergency Cultural Coalition (BECC), adding to their protest of exclusion and ill treatment of African American artists in mainstream institutions. Gammon had a diverse work history, having worked for an advertising firm, Lifton, Gold, and Asher, for ten years (1954–1964), and having been artist-in-residence for the New York City Board of Education from 1967 to 1969. He relocated to Kalamazoo, Michigan, in 1983 when he became professor of humanities at Western Michigan University, a teaching position he held for twenty years.

REX GORLEIGH

Born 1902 in Penllyn, Pennsylvania Died 1987 in East Windsor, New Jersey Painting, printmaking

EDUCATION

University of Chicago, Chicago, Illinois, 1940–1941 Art Institute of Chicago, Chicago, Illinois, 1942 B.A., Livingston College, Rutgers University, New Brunswick, New Jersey, 1976

MAJOR EXHIBITIONS

Montclair State College, Montclair, New Jersey
The Art Museum, Princeton, New Jersey
The Studio Museum in Harlem, New York
Museum of Fine Arts, Boston, Massachusetts
National Center of Afro-American Art, Roxbury, Maryland
Trenton Museum, Trenton, New Jersey
Renaissance Gallery, Washington, DC
Newark Museum, Newark, New Jersey

Little Gallery, Princeton, New Jersey
New Jersey State Museum, Trenton, New Jersey
Montclair Museum of Art, Montclair, New Jersey
(Clark) Atlanta University, Atlanta, Georgia
American Artist Gallery, Chicago, Illinois
American Negro Exposition, Chicago, Illinois
Augusta Savage Studio, New York
Baltimore Museum of Art, Baltimore, Maryland
Harmon Foundation Exhibition, New York
Society of Independent Artists
Anderson Gallery
Shaw University, Raleigh, North Carolina
Gallery Strindberg, Helsinki, Finland

n ex Gorleigh began drawing at age five. Later, while I living in New York, he met a number of talented figures such as Claude McKay, Aaron Douglas, and Eubie Blake who inspired him even more to pursue the arts. He studied at Howard University, the University of Chicago, with Andre L'hote in Paris, and Xavier J. Barile in New York. Gorleigh taught art at several schools, among them Studio-on-the-Canal, in Princeton, New Jersey, Palmer Memorial Institute in Sedalia, North Carolina, and Chicago's Southside Community Art Center. Rex Gorleigh first exhibited his work in the non-juried shows organized by the Society of Independent Artists in the 1920s and 1930s. Much of his work reflects a sensitivity to the socially political climate of blacks in the rural South and the economic status of the African American in general. Works from the 1980s such as his Red Barn reveal his longstanding interest in issues specific to the agrarian community.

SAMUEL GUILFORD

Born February 1, 1956, in Barbour County, Alabama Resides in Atlanta, Georgia Painting

EDUCATION

Studied, Atlanta College of Art, Atlanta, Georgia

EXHIBITIONS

Morehouse College, Atlanta, Georgia Wire Grass Museum of Art, Dothan, Alabama Isabel Anderson Comer Museum, Sylacauga, Alabama Richard B. Russell Building, Atlanta, Georgia

S amuel Guilford is often inspired by family stories and biblical sources, with his work usually taking on a narrative theme by title as well as content. Although he refuses to be limited to a single style, his free-flowing style can be seen in his nonobjective, colorbased works as well as his figure-based painting and watercolors. He has been influenced most by his experiences with his family while growing up in Eufaula, Alabama, and the formal instruction he received at the Atlanta College of Art.

ways whether using natural basic materials in his pottery or carving forms in marble. Primarily a ceramist, he creates monochromatic forms that reveal his personal sense of design, balance, rhythm, harmony, and color. Although he follows a highly technical approach, Hooks maintains a commitment to the African American experience and expression. Hooks taught at Fisk University for more than twenty years, remaining a prolific sculptor throughout that time. Hooks was a prizewinner at Indiana University and the John Herron Art School in Indianapolis in 1959, DePauw University, and the South Bend Art Center.

arl Hooks transforms biological shapes in unique

EARL J. HOOKS

Born August 2, 1927, in Baltimore, Maryland Resides in Nashville, Tennessee Ceramics, sculpture, painting

EDUCATION

School of American Craftsman, New York, 1954–1955 (certificate) Rochester Institute of Technology, Rochester, New York, 1954 (certificate) Catholic University, Washington, DC, 1949–1951 B.A., Howard University, Washington, DC, 1945–1949

MAJOR EXHIBITIONS Fisk University, Nashville, Tennessee Lagos, Nigeria Art Institute of Chicago, Chicago, Illinois Everson Museum of Art, Syracuse, New York Fort Wayne Museum of Art, Fort Wayne, Indiana Smithsonian Institution, Washington, DC Howard University, Washington, DC Miami National, Miami, Florida John Herron School of Art, Indianapolis, Indiana Washington Street and Art Center, Somerville, Massachusetts Memorial Art Gallery of the University of Rochester, Rochester, New York American House, New York

MARGO HUMPHREY

Born 1940 in Oakland, California Resides in Hyattsville, Maryland Printmaking

EDUCATION

B.F.A., California College of Arts and Crafts,Oakland, CaliforniaM.F.A., Stanford UniversityWhitney Museum of American Art, Summer 1972

MAJOR EXHIBITIONS

Print Biennale in Ljubjiana, Slovenia

Museum of Modern Art, New York

National Gallery of Art, Washington, DC

Smithsonian Institution, Washington, DC.

Bradford Galleries, London, England

Museum of Modern Art, Rio de Janeiro, Brazil

San Francisco Legion of Honor, San Francisco, California

M argo Humphrey is an accomplished printmaker and teacher. Currently on the faculty of the University of Maryland, College Park, since 1989, she began teaching at the University of California in 1973. In her third year there, she was invited to teach at the University of the South Pacific at Suva, Fiji. She has also taught at the University of Texas, San Antonio, and as a visiting professor at the Art Institute of Chicago. Through the United State Information Agency Arts Program, she

has taught at Yaba Technological Institute of Fine Art, Ekoi Island, Nigeria; the University of Benin, Benin, Nigeria; the Margaret Trowell School of Fine Art, Kampala, Uganda; and the National Gallery of Art, Harare, Zaire. Humphrey creates brightly colored narrative prints that relate to various social and interfamilial interactions. Using color patterns and relationships that allude to African flags, textiles, and icons, she presents an immediate association to that culture by relating to casual or playful events.

RICHARD HOWARD HUNT

Born September 12, 1935, in Chicago, Illinois Resides in Chicago, Illinois Sculpture, printmaking

EDUCATION

B.A.E., Art Institute of Chicago, 1957 University of Chicago University of Illinois, Chicago

MAIOR EXHIBITIONS Laumeier Sculpture Park, St. Louis, Missouri Indiana State University Art Gallery, Terre Haute, Indiana Museum of African-American History, Detroit, Michigan Illinois State Museum, Chicago and Springfield, Illinois Lakeside Gallery, Lakeside, Michigan Holland Area Arts Council, Holland Michigan George N'Namdi Gallery, Detroit, Michigan The Studio Museum in Harlem, New York Andre Zarre Gallery, New York Worthington Gallery, Chicago, Illinois University of Notre Dame, The Snite Museum of Art, Notre Dame, Indiana Addison / Ripley Fine Art, Washington, DC Woodlot Gallery, Sheboygan, Wisconsin Whitney Museum of American Art, New York Metropolitan Museum of Art, New York Museum of Modern Art, New York Museum of Contemporary Art, Chicago, Illinois Minneapolis Institute of Art, Minneapolis, Minnesota

Milwaukee Art Center, Milwaukee, Wisconsin Cleveland Institute of Art, Cleveland, Ohio University of California, Los Angeles, California Art Institute of Chicago, Chicago, Illinois Arkansas Art Center, Little Rock, Arkansas Yale University School of Art and Architecture, New Haven, Connecticut Wesleyan College, Macon, Georgia Solomon R. Guggenheim Museum, New York University of Illinois, Urbana, Illinois Newark Museum, Newark, New Jersey Carnegie Museum of Art, Pittsburgh, Pennsylvania Cincinnati Art Museum, Ohio American Federation of the Arts. New York Israel Museum, Jerusalem Alan Gallery, New York Contemporary Arts Museum, Houston, Texas

▼ n 1963, critic Hilton Kramer wrote, "Richard Hunt is f L one of the most gifted and assured artists working in the direct-metal, open-form medium—and I mean not only in his own country and generation, but anywhere in the world. What may not be so immediately apparent is the speed and aesthetic ease with which he has achieved so remarkable a position." Some of the linear dominance prevalent in Hunt's sculptural work was carried over into his prints, particularly a series of dark-toned pieces that continued to explore balance, motion, and light. Hunt has received numerous honors and awards including two Guggenheim Fellowships, a Ford Foundation Fellowship, the James Nelson Raymond Foreign Travel Fellowship to study in England, France, Spain, and Italy (in 1957-1958), and several prizes from the Art Institute of Chicago. He has also received twelve honorary degrees from such institutions as the University of Michigan and Northwestern University, and been affiliated with more than twenty institutions in guest professorships or residencies. He taught as Michigan State University, East Lansing (1997); State University of New York, Binghamton (1990); Kalamazoo College, Kalamazoo, Michigan (1990); Harvard University, Cambridge, Massachusetts (1989–90); Eastern Michigan University, Yipsilanti, Michigan (1988); and Cornell University, Ithaca, New York (1985).

Hunt has served on more than twenty boards, committees, and commissions since 1960 with agencies and organizations in the art field. His work is represented in numerous collections, such as the Metropolitan Museum of Art, Whitney Museum of American Art, the Art Institute of Chicago, Israel Museum, Albright-Knox Art Gallery, Loyola University, Guggenheim Museum, and the Oakland Museum, among others.

BILL HUTSON

Born 1936 in San Marcus, Texas Resides in Pennsylvania

EDUCATION

University of New Mexico, Albuquerque, New Mexico, 1956–1957

Los Angeles City College, Los Angeles, California, 1958 San Francisco Academy of Art, San Francisco,

Philadelphia's Museum College of Art, Philadelphia, Pennsylvania Hussian School of Art Art Students League, New York

MAJOR EXHIBITIONS

Franklin and Marshall Phillips Museum, Lancaster, Pennsylvania Newark Museum, Newark, New Jersey National Center of Afro-American Art, Roxbury, Maryland University of Texas Art Museum, Texas Baltimore Museum of Art, Baltimore, Maryland Salon de Juvisy, France Galerie Re Cazenare, Paris, France Mickery Gallery, Amsterdam, The Netherlands Gallery de Haas, Rotterdam, The Netherlands Stedlijk Museum, Amsterdam, The Netherlands Gallery Krikhaar, Amsterdam, The Netherlands Prism Gallery, San Francisco, California San Francisco Museum of Modern Art. San Francisco, California The Studio Museum in Harlem, New York Columbus Museum of Art, Columbus, Ohio

T utson, largely a self-taught artist, began drawing at $oldsymbol{\Pi}$ a fairly young age as a positive distraction during periods of idleness. He began considering art as a possible profession in the 1960s after experiencing programs in New Mexico and California. Between 1963 and 1970, he traveled extensively in Europe with stays in Paris, London, Amsterdam, and Rome, exhibiting widely during that time and his work being acquired by several institutions. Greatly influenced by his movement and travel, Hutson's art assumed properties related to the phenomenon. At the same time, he sought the infusion of cultural intent. His abstract objects, some of which are extremely large scale, are architectonic in style and combine a variety of materials, often two or three dimensional in format. His work is in the collections at the National Gallery of Southern Australia, Midtown Galleries, New York, and Morgan State College, among others. Having been on the faculty from 1989 to 2001, he was named the Jennie Brown Cook and Betsy Hess Cook Distinguished artistin-residence at Franklin & Marshall College.

AMOS "ASHANTI" JOHNSON

Born 1950 in Berkley County, South Carolina Resides in Charleston, South Carolina Graphic art, printmaking

EDUCATION

Syracuse University, Syracuse, New York

MAJOR EXHIBITIONS

Marietta-Cobb Museum of Art, Marietta, Georgia
University of Delaware University Gallery, Newark, Delaware
High Museum of Art, Atlanta, Georgia
Parthenon Museum, Nashville, Tennessee
Alabama State University Art Gallery, Montgomery, Alabama
Emory University, Schatten Gallery, Atlanta, Georgia
National Black Arts Festival, Atlanta, Georgia
King-Tisdell Cottage, Savannah, Georgia

A mos "Ashanti" Johnson assumed the "Ashanti" name because he held a close, personal affinity for the Asante people in Ghana, and it was also a way of connecting to Africa and signifying that the association car-

ries over to his aesthetics as an artist. Johnson stylistically follows the tradition established by Charles White. A prolific draftsman, like the artist he so admired (White), Johnson put a premium on his drawings with the intent that they portray the dignity and spirituality of African American people. He is also interested in expressing the relationship between diaspora people and the continent of Africa. Johnson became extremely interested in White's work while he was an art student at Syracuse University. He considered White his mentor (though they never met) through his work, setting up reproductions of the elder artist's imagery in his studio and literally copying them, sometimes breaking the image down into a line-by-line/mark-by-mark scenario. Johnson was convinced that representational imagery was the best means to conveying cultural identity. His work is in the collection of the High Museum of Art.

LOÏS MAILOU JONES

Born 1905 in Boston, Massachusetts Died 1998 in Washington, DC Painting, illustration, printmaking

EDUCATION

B.A.E., Howard University, Washington, DC
Art Students League, New York
Boston Normal Art School, 1926–1927 (certificate)
School of the Museum of Fine Arts, Boston, 1923–1927
Academie Julian, Paris, France, 1937–1938
Ecole des Beaux Arts, Paris, France, 1937–1938

MAJOR EXHIBITIONS

Corcoran Museum of Art, Washington, DC
Art Institute of Chicago, Chicago, Illinois
High Museum of Art, Atlanta, Georgia
Fisk University, Nashville, Tennessee
The Studio Museum in Harlem, New York
Howard University, Washington, DC
Museum of Fine Arts, Boston, Massachusetts
State Armory, Wilmington, Delaware
Gallerie International, New York
Washington Watercolor Society
Society of Washington Artists

American Watercolor Society

Xavier University Art Gallery, New Orleans, Louisiana
Rhodesia Museum, Salisbury, Maryland

Washington Art Guild, Washington, DC

Phillips Collection, Washington, DC

Seattle Art Museum, Seattle, Washington

National Gallery of Art, Washington, DC

Baltimore Museum of Art, Baltimore, Maryland

Institute of Modern Art, Boston, Massachusetts

oïs Mailou Jones successfully blended European early I modernist styles with pure African-derived elements in much of her work. Although her oeuvre was diverse, her figurative work, landscapes/rooftops, and design images hold traces of an African sensibility and knowledge of European approaches. Best known for her paintings, she was also highly regarded as a teacher. Jones was a professor at Howard University for forty-seven years (1930–1977). Elizabeth Catlett and David Driskell are two of her most prominent former students. Among the first African American graduates of the Boston Museum School of Fine Arts, she established the art department at Palmer Memorial Institute in Sedalia, North Carolina, and was one of the strongest advocates for African American artists. Her work is in the collections of the Brooklyn Museum, the Phillips Collection, the Corcoran Gallery of Art, the Palais National in Haiti, and the Walker Art Center.

PAUL RAYMOND (P.R.) JONES, JR.

Born September 20, 1956, in Birmingham, Alabama Resides in Los Angeles, California Graphic art

EDUCATION

Studied, West Los Angeles Community College, California

MAJOR EXHIBITIONS

Marietta-Cobb Museum of Art, Marietta, Georgia

 ${f P}$. R. Jones worked for eleven years as a member of the computing staff of Hughes Aircraft in Los Angeles, California. His association with artist Amos Johnson in the 1970s sparked an interest in sketching and

drawing. The works he produced were primarily portraits and narrative scenes.

JACOB LAWRENCE

Born September 7, 1917, in Atlantic City, New Jersey Died June 13, 2000, in Seattle, Washington Painting

EDUCATION

Harlem Art Workshop, New York, 1932–1939 Harlem Community Art Center, New York, 1936 American Artists School, New York, 1937–1939

MAJOR EXHIBITIONS

American Artists School, New York Seattle Art Museum, Seattle, Washington The Phillips Collection, Washington, DC High Museum of Art, Atlanta, Georgia Whitney Museum of American Art, New York Herbert F. Johnson Museum of Art, Ithaca, New York National Institute of Arts and Letters Newark Museum, Newark, New Jersey Museum of Modern Art, New York Metropolitan Museum of Art, New York Art Institute of Chicago, Chicago, Illinois Brandeis University, Waltham, Massachusetts Museum of Fine Arts, Boston, Massachusetts Portland Museum of Art, Portland, Oregon National Institute of Arts and Letters Boston Institute of Modern Art, Boston, Massachusetts Baltimore Museum of Art, Baltimore, Maryland Brooklyn Museum of Art, Brooklyn, New York Hirshhorn Collection, Washington, DC Rhode Island School of Design, Providence, Rhode Island New Jersey State Museum, Trenton, New Jersey Museum of Modern Art, São Paulo, Brazil

J acob Lawrence has been a prominent figure on the American art scene for more than sixty years. His most revered body of work is his *Migration Series*, sixty panels completed in 1941 when Lawrence was twenty-three years old. Capturing the story of the African American exodus from the South to the North after World War I, Lawrence

included extensive text, affirming the reality of the historical event and assuring its connection to the present day is realized. Inspired by his first mentors, painter Charles Alston and sculptor Augusta Savage, Lawrence made the transition from Atlantic City and Philadelphia to Harlem's burgeoning culture community with relative ease. Early on, his preference for strong design, carefully formed color relationships, and a cubist-expressionist style was evident. By 1937, he was already working in a small panel format. Throughout his career, Lawrence created images of American life and heritage through the voice and experience of the African American. His work is in most major collections in the country, including the Metropolitan Museum of Art, the Museum of Modern Art, and the Whitney Museum of American Art.

SAMELLA SANDERS LEWIS

Born 1924 in New Orleans, Louisiana Resides in California Painting, printmaking

EDUCATION

M.A., Ph.D., Ohio State University B.S., Hampton University, 1945

MAJOR EXHIBITIONS

Hampton University Museum, Hampton, Virginia Fisk University, Nashville, Tennessee Newark Museum, Newark, New Jersey North Carolina Central University Art Museum, Durham, North Carolina Clark Atlanta University Art Galleries, Atlanta, Georgia Art Institute of Chicago, Chicago, Illinois The Fine Arts Museum of San Francisco, California High Museum of Art, Atlanta, Georgia Corcoran Gallery, Washington, DC The Studio Museum in Harlem, New York Colby College Museum of Art, Waterville, Massachusetts University of Maryland, College Park, Maryland Whitney Museum of American Art, New York State Armory, Wilmington, Delaware La Jolla Museum of Art, La Jolla, California Howard University, Washington, DC

amella Lewis was the first dual-doctorate major in ine arts and art history. Her stay at Hampton Institute (now Hampton University) in the 1940s was a pivotal stage in that career. She transferred to Hampton from Dillard University in New Orleans with her mentor, well-known African American artist Elizabeth Catlett, and was encouraged to continue doing the M.A. and Ph.D. work in art history, with a concentration on Asian and African arts and culture. Under the tutelage of Viktor Lowenfeld at Iowa, she created Waterboy, her first canvas painting and a work she did for personal satisfaction rather than a class assignment. Lowenfeld had heightened her sensitivity to pure colors from a symbolic standpoint and as a means to avoid muddying them in mixing. In the painting, she also began to move away from an imitative approach to making a portrait. Lewis also excelled as a teacher, having served as professor of art history at Scripps College for many years. She also is founder and publisher of the Hampton University-based International Review of African American Art, and has written important books on African American art as well as children's books. Lewis's work is included in many private collections, important galleries, and museum collections including Atlanta University and the High Museum of Art, Atlanta, Georgia; the Baltimore Museum of Art, Baltimore, Maryland; Hampton University Museum, Hampton, Virginia, and the Oakland Museum, Oakland, California.

JAMES LITTLE

Born 1952

Resides in New York

Painting

EDUCATION

M.F.A., Syracuse University, New York, 1976
B.F.A., Memphis Academy of Art, Tennessee, 1974

MAJOR EXHIBITIONS

Walker Art Center, Minneapolis, Minnesota Nexus Contemporary Art Center (now The Contemporary), Atlanta, Georgia

Marietta-Cobb Museum of Art, Marietta, Georgia

University of Delaware University Gallery, Newark, Delaware Pennsylvania State University, University Park, Pennsylvania Chrysler Museum of Art, Norfolk, Virginia University of Maryland Art Gallery, College Park, Maryland State University of New York, Westbury, New York Bucknell University Art Gallery, Lewisburg, Pennsylvania

he first generation of African American artists pursuing pure abstraction in their work emerged around 1960. Al Loving and William T. Williams were prominent in the development of geometric abstraction. Alma Thomas and Sam Gilliam were veterans in the color field school. Jack Whitten and Howardena Pindell captured, in distinct and individual ways, a sense of emphasis on process. James Little's abstract works burst on the art scene in the 1980s, and seemed to adhere to the tenets of pure abstraction on the one hand—containing an obvious reliance on color, surface texture, the interaction of elements in such a way that the topic, theme, and message are the painting itself—yet on the other hand, his manipulation of these points was done in such a way as to evoke associations with African aestheticism—tones, shine, patterning, and the nature of use of compartmentalization.

LIONEL LOFTON

Born 1954 in Houston, Texas Resides in Houston, Texas Painting, printmaking, mixed media

EDUCATION

Texas Southern University, Houston, Texas M.A., University of Houston, Clear Lake, Texas B.A., Prairie View A&M University, Texas

EXHIBITIONS

El Paso Museum of Art, Texas
San Antonio Museum of Art, Texas
Hunter Museum of Art, Chattanooga, Tennessee
Museum of African Life and Culture, Dallas, Texas
Artistic Expressions, Atlanta, Georgia
McAnthony's Gallery, Fort Worth, Texas
Thelma Harris Gallery, Berkeley, California
Museum of Science and Industry, Chicago, Illinois

Philadelphia, Pennsylvania Albuquerque, New Mexico

Lipaintings though he also frequently works in print-making and mixed media, combining acrylics, watercolor, and color pencil. His imagery often refers to concepts of inner strength, beauty, and spirituality. He was greatly influenced by John Biggers under whom he studied early in his development as an artist. His work has been seen extensively throughout the United States, especially in traveling exhibitions.

EDWARD L. LOPER, SR.

Born 1916 in Wilmington, Delaware Resides in Wilmington, Delaware Painting

MAJOR EXHIBITIONS

Michael Rosenfeld Gallery, New York Delaware Art Museum, Wilmington, Delaware

dward Loper is a state treasure to most Delawareans in the art community. Born on the east side of Wilmington, Loper has spent the majority of his life in the state perfecting his painting style, continuing to do so via a personal exploration of color and abstraction. Loper became interested in art when he was twenty years old and began working for the Index of American Design of the Works Progress Administration. By 1953, Loper was working full-time as an artist and art teacher, instructing hundreds of students over the decades. Having attended art classes at the Barnes Collection in Pennsylvania, Loper began fracturing the picture plane in the 1950s. Creating a kaleidoscope effect, he emphasized color increasingly more by the next decade. Loper is the subject of the thirty-minute video, *Edward L. Loper*: Prophet of Color. His work is in the permanent collections of the Philadelphia Museum of Art, the Corcoran Gallery of Art, the Museum of African American Art in Tampa, the Museum of American Art/Pennsylvania Academy of Fine Arts, Howard University in Washington, DC, Clark Atlanta University Art Galleries, and the Delaware Art Museum.

AIMEE MILLER

Born 1978 in Atlanta, Georgia Resides in Atlanta, Georgia Painting

EDUCATION

M.F.A., University of Delaware, Newark, Delaware, 2004 B.A., Spelman College, Atlanta, Georgia, 2001

MAJOR EXHIBITIONS

Newark Arts Alliance, Newark, Delaware University of Delaware University Gallery, Newark, Delaware Actors Theatre of Louisville, Louisville, Kentucky Spelman College Museum of Fine Art, Atlanta, Georgia

A frican American artists pursuing abstraction as a means to expressing personal interests. Relating her color fields to the nonphysical "landscapes" of faith and buoyancy in flight, Miller seeks to evoke viewer experiences that parallel actual physical realities but are brought into play because of memory triggered by the visual/physical reality of the painted surface.

JIMMIE LEE MOSELY

Born 1927 in Lakeland, Florida
Died 1974 in Maryland
Painting, printmaking, sculpture, mixed media

EDUCATION

M.A., Pennsylvania State University, 1955 B.A., Texas Southern University, 1952

MAJOR EXHIBITIONS

Marietta Cobb Museum, Marietta, Georgia
University of Delaware University Gallery, Newark, Delaware
Philadelphia Civic Center Museum,
Philadelphia, Pennsylvania
Smith Mason Gallery
Jonade Gallery, Baltimore, Maryland

Xavier University Art Gallery, New Orleans, Louisiana (Clark) Atlanta University Art Gallery, Atlanta, Georgia Illinois State University, Illinois Nelson Gallery, Kansas City, Missouri Atkins Museum, Kansas City, Missouri

Torking in watercolor in a manner that loosely referred to the style of Maurice Prendergast, Mosely consistently addressed street scenes and other community settings often with the African American portrayed in nonracial contexts. In other cases, as with *Protest* (1965), his watercolors respond to the social climate of the era. Mosely was director of art education at Maryland State College and president of the National Conference of Artists.

MING SMITH MURRAY

Born June 14 (undisclosed year) in Detroit, Michigan Resides in New York Photography

EDUCATION

B.S., Howard University, Washington, DC

EXHIBITIONS

Museum of Modern Art, New York The Studio Museum in Harlem, New York Smithsonian Institution, Washington, DC Atlanta History Center, Atlanta, Georgia Metro's Center for Visual Arts, University of Colorado at Denver

Rush Art Gallery, New York Watts Tower, Los Angeles, California African American Museum, Philadelphia, Pennsylvania California African American Art Museum, Los Angeles Art in the Atrium, Morristown, New Jersey Georgia State University Gallery, Atlanta, Georgia University of Delaware University Gallery, Newark, Delaware Delaware State University, Dover, Delaware

ing Smith Murray spent much of her youth in Left Columbus, Ohio, in a neighborhood that inspired some of her earliest approaches to image making. She creates allegorical, often atmospheric photographs that are frequently drawn from personal experiences and dreams. Avoiding literalness in much of her work, which is primarily black and white, she presents personalized depictions of people, places, objects, and events with theatrical drama and highly manipulated senses of atmosphere. Loaded with secret messages and allusions to coded data, her photographs read as visual diary entries that are sometimes evocative and other times blurred to the point of being disturbing.

AYOKUNLE ODELEYE

Born in 1951(?) in Newark, New Jersey Resides in Stone Mountain, Georgia Sculpture, painting

EDUCATION

M.F.A., Howard University, Washington, DC, 1975 B.F.A., Howard University, Washington, DC, 1973 Virginia Commonwealth University, Richmond, Virginia, 1969

MAJOR EXHIBITIONS

Thelma Harris Art Gallery, Oakland, California Kennesaw State University, Kennesaw, Georgia Savannah State University, Savannah, Georgia Marietta-Cobb Museum of Art, Marietta, Georgia Tubman Museum, Macon, Georgia Camille Love Gallery, Atlanta, Georgia Valdosta State University Fine Arts Gallery, Valdosta, Georgia Nexus Contemporary Art Center (now The Contemporary), Atlanta, Georgia Spelman College Museum of Fine Art, Atlanta, Georgia

Howard University, Washington, DC

yokunle Odeleye was born in Newark, New Jersey, A and raised in Fredericksburg, Virginia, where he attended high school. He began college at Virginia Commonwealth University in Richmond, Virginia, and later moved to Washington, D.C. Currently on the faculty at Kennesaw State University in Kennesaw, Georgia, he has taught at Howard University in Washington, D.C., and Spelman College and Georgia State College in Atlanta, Georgia. Known for his large and small-scale sculpture in a variety of media, Odeleye specializes in

large-scale environmental sculpture for public spaces. Having been awarded thirteen public art commissions, his work may be seen in Dallas, Texas, Pensacola and St. Petersburg, Florida, Wilmington, North Carolina, Richmond, Virginia, Mt. Rainer and Baltimore, Maryland, and at six sites in Atlanta, Georgia. Odeleye's work in the permanent collections of numerous institutions including Howard University Gallery of Art in Washington, D.C., Spelman College Museum of Fine Art in Atlanta, and Morehouse College in Atlanta.

HAYWARD LOUIS OUBRE, JR.

Born 1916 in New Orleans, Louisiana Resides in Winston-Salem, North Carolina Sculpture, painting, printmaking

EDUCATION

M.F.A., University of Iowa, 1948 Studied, Atlanta University, 1940 B.A., Dillard University, New Orleans, 1939

O ubre taught at Florida A&M University (1948), Alabama State College (currently University, 1949–1965), and Winston-Salem State University (1965–1981), chairing the department from 1965 to 1981. He also instituted the art studio major at Winston-Salem State. As an artist, Oubre worked in a social realist style in the 1940s and 1950s, and later explored the implications of color and texture in his paintings. Oubre is best known for his wire sculpture, some of his figurative pieces being life size and formed exclusively with wire cutters and pliers.

HARPER TRENHOLM PHILLIPS

Born August 28, 1928, in Courtland, Alabama Died July 27, 1988, in New York Painting, collage, mixed media

EDUCATION

M.A., New York University, New York, 1957 B.S., Alabama State University, Montgomery, Alabama, 1951

EXHIBITIONS

Whitney Museum of American Art, New York
The Louvre, Paris, France
Howard University, Washington, DC
National Academy Galleries, Washington, DC
Virginia Museum, Richmond, Virginia
University of Delaware, Perkins Center Gallery,
Newark, Delaware
Madison Gallery, New York
Delaware State University, Dover, Delaware

raper T. Phillips distinguished himself as an artist lacksquare and a teacher. After attaining a master's degree in New York, he taught at Columbia University Teachers College, Manhattan Community College, Bergen Community College, and the Creative Arts Academy of New York. He also taught at Grambling State University, Alabama State University, Hampton University, and The Horace Mann Lincoln Institute. His paintings and murals were shown across the United States and abroad. He completed commissions for Morehouse College in Atlanta, the Martin Luther King Dexter Avenue Memorial Church in Montgomery, and the state of New York. His use of bold abstraction and brilliant colors characterizes his paintings and collages, which vary from figural to fantastical abstraction. Phillips's artwork is in the collections of (Clark) Atlanta University in Atlanta, Georgia, Hampton University in Hampton, Virginia, Alabama State University in Montgomery, Alabama, Howard University in Washington, DC, and Jackson State University in Mississippi.

HOWARDENA PINDELL

Born 1943 in Philadelphia, Pennsylvania Resides in New York Painting, collage, graphic art, printmaking

EDUCATION

M.F.A., Yale University, New Haven, Connecticut, 1967 B.F.A., Boston University School of Fine and Applied Art, 1965

MAJOR EXHIBITIONS

Spelman College Museum of Fine Art, Atlanta, Georgia Louisiana Museum, Copenhagen, Denmark G. R. N'Namdi Gallery, Birmingham, Michigan Whitney Museum of American Art, New York

H owardena Pindell currently works in an autobiographical style as a means to discussing and focusing on issues of race, class, gender, and abuse. In the late 1970s, Pindell pasted punch-paper holes onto paper and canvas in ways that related her work to process art. She worked with the Museum of Modern Art in New York for twelve years as exhibition assistant, curatorial assistant, and associate curator. Since 1979 she has been professor of art, State University of New York at Stony Brook. Pindell has also been visiting professor at Yale University, and visiting faculty member at Skowhegan School of Painting.

PRENTICE HERMAN POLK

Born 1898 in Bessemer, Alabama Died 1984 in Tuskegee, Alabama Photography

EDUCATION

Tuskegee Institute, Tuskegee, Alabama, 1916–1920 Apprenticed with Fred Jensen, Chicago, Illinois, 1922–1926

MAJOR EXHIBITIONS

Spelman College Museum of Fine Art, Atlanta, Georgia Art Institute of Pittsburgh, Pittsburgh, Pennsylvania Iowa State University Museums, Ames, Iowa University of Delaware University Gallery, Newark, Delaware Atlanta University Center, Atlanta, Georgia Emory University, Schatten Gallery Birmingham Museum of Art, Birmingham, Alabama California Museum of African American History, Los Angeles, California Ledel Gallery, New York Corcoran Gallery, Washington, DC Douglas Elliot Gallery, San Francisco, California Pyramid Gallery of Art, Detroit, Michigan Nexus Contemporary Art Center (now The Contemporary), Atlanta, Georgia House of Friendship, Soviet Union Washington Gallery of Photography

The Studio Museum in Harlem, New York
Tuskegee Institute, Tuskegee, Alabama
New York Museum of National History, New York

Prentice Herman Polk was the preeminent recorder of Tuskegee University (then Institute) from the late 1920s through the civil rights era, and through his photographs of the noted scientist George Washington Carver. Polk created more than 500 negatives of Carver, capturing him in every conceivable situation on the campus. He also documented the string of illustrious visitors to the campus, including the nation's top political, social, education, and entertainment leaders from all racial backgrounds. At the same time, he enjoyed a lucrative studio business, making photographs of students, citizens, and models through which he established his technique of "working from the dark side"—revealing form by working from the deeper tones to the lighter ones.

JOHN T. RIDDLE

Born March 18, 1933, in Los Angeles, California Died March 2002 in Atlanta, Georgia Sculpture, painting, printmaking

EDUCATION

M.F.A., California State University, Los Angeles, 1973 B.A.E., California State University, Los Angeles, 1966

MAJOR EXHIBITIONS

High Museum of Art, Atlanta, Georgia
Atlanta University Center Inc., Atlanta, Georgia
San Jose State College, San Jose, California
University of Iowa Museum of Art, Iowa City, Iowa
California State College, Los Angeles, California
Ankrum Gallery, Los Angeles, California
Brockman Gallery, Los Angeles, California
Oakland Museum of California, Oakland, California

John Riddle returned from a tour in the U.S. Air Force and taught at Los Angeles High School and Beverly Hills High School before moving to Atlanta, Georgia, in 1984 to teach at Spelman College. His work chronicles the history of the African American experience through

the biographies of historical figures, significant events, and important literature. Riddle responded to the turbulent civil rights era of the 1960s, especially the 1965 Watts riots, by developing work rooted in African American consciousness. His early figurative paintings were in a flat painted style reminiscent of the works of Jacob Lawrence and Romare Bearden. But, finding painting too passive, he began exploring the streets in South Central Los Angeles collecting rusted metal, discarded machines, and other debris to use in his assemblages. He returned to Los Angeles in 1999 to work at the California African American Museum. Riddle received three first prizes in the Watts Festival in California and won a California Emmy Award for "Renaissance in Black," which aired on KNBC-TV in 1971. His work is in the collections of the High Museum of Art in Atlanta, Georgia, and the Oakland Museum in Oakland, California.

BETYE IRENE (BROWN) SAAR

Born July 30, 1926, in Los Angeles, California Resides in Los Angeles, California Assemblage, collage, printmaking, installation

EDUCATION

B.A., University of California, Los Angeles, 1949 Studied, Pasadena City College, Pasadena, California Studied, California State University, Long Beach

MAJOR EXHIBITIONS

Whitney Museum of American Art, New York
The New Museum of Contemporary Art, New York
San Francisco Museum of Modern Art, California
Fresno Art Museum, Fresno, California
The Studio Museum in Harlem, New York
Museum of Contemporary Art, Los Angeles, California
Parson-Otis Institute, Los Angeles, California
Philadelphia Museum of Art, Pennsylvania
Spelman College Museum of Fine Art, Atlanta, Georgia
Minnesota Museum of American Art,
St. Paul, Minnesota
University of Maryland Art Gallery,
College Park, Maryland
Museum of Fine Arts, Houston, Texas

netye Saar's career spans more than fifty years of f D work in assemblage, collage, printmaking, installations, and design, which has not only established her as one of America's most innovative practitioners but has also inspired her two daughters (Allison and Lezsley) to follow and succeed down a similar path. She, too, was creatively stimulated by the experiences of family and environment. Growing up in the midst of her mother's interest in knitting, jewelry making, and sewing had an impact, as did growing up in Watts where she witnessed Simon Rodi building the famous Watts Tower using such items as discarded bottlecaps, glass, and shells. Betye Saar was further influenced by the box art of Joseph Cornell after seeing an exhibition of his work at the Pasadena Art Museum (currently the Norton Simon Museum) in 1968. She began working with boxes and windows to encase images that spoke to her personal history, including her mixed heritage. Objects such as gloves, jewelry, fur, old family photographs, and other diverse (sometimes found) items were combined to create allegorical, mystical, and socially challenging works of art. This included image references to African American memorabilia and stereotypes such as Aunt Jemima. Her work is in the collections of the Metropolitan Museum of Art in New York, the Hirshhorn Museum and Sculpture Garden in Washington, DC, the High Museum of Art in Atlanta, Georgia, the National Museum of American Art in Washington, DC, and the Whitney Museum of American Art in New York.

IMANIAH SHINAR (JAMES COLEMAN, JR.)

Birthplace and date unknown Resides in Washington, DC Painting, graphic art

I maniah Shinar is a multitalented artist, skilled not only in the visuals arts as a painter and draftsman but also as a talented vocalist and musician who plays several instruments that he usually crafts himself. In his artwork, Imaniah focuses on subjects ranging from

traditional still-lifes to portraiture. The subjects in his portraits are generally derived from his own imagination and speak to a fundamental idea of African American presence and type that conveys a strong sense of high regard and deep affection.

JEWEL WOODARD SIMON

Born July 28, 1911, in Houston, Texas Died December 1996 in Atlanta, Georgia Painting, graphic art

EDUCATION

B.F.A., Atlanta College of Art, Atlanta, Georgia, 1967 B.A., Atlanta University, Atlanta, Georgia, 1931

MAJOR EXHIBITIONS

High Museum of Art, Atlanta, Georgia (Clark) Atlanta University, Atlanta, Georgia Winston-Salem State University, Winston-Salem, North Carolina Spelman College Museum of Fine Art, Atlanta, Georgia Huntsville Museum of Art, Huntsville, Alabama International Society of Artists, New York Japan Metropolitan Museum, Tokyo, Japan Florida A&M University, Tallahassee, Florida Emory University Schatten Gallery, Atlanta, Georgia Illinois State University, Normal, Illinois Mount Holyoke College, South Hadley, Massachusetts Georgia Institute of Technology, Atlanta, Georgia Southern Illinois University, Edwardville, Illinois Carnegie Museum of Art, Pittsburgh, Pennsylvania Jackson State College, Jackson, Mississippi Stillman College, Tuscaloosa, Alabama West Virginia State College, West Virginia Oakland Museum of California, Oakland, California University of California, Los Angeles, California Howard University, Washington, DC Museum of Fine Arts, Houston, Texas

J ewel Simon considered art a pastime until her drawings quickly sold at a fundraiser for the high school where she taught. Holding a degree in mathematics,

she developed an interest in art while studying at Atlanta University. Settling in Atlanta with her husband in 1941, Simon studied charcoal drawing under Bertha L. Hellman for two years. In 1946, she studied painting under Hale Woodruff, and, in 1947, sculpture under Alice Dunba. Simon persisted until she was allowed to enter the Atlanta College of Art, having been repeatedly denied because of a policy not to admit African Americans, and became the school's first black graduate. She won eight Purchase Awards and six honorable mentions at the (Clark) Atlanta University Annual. Her work appeared on the cover of the January 1973 issue of *Crisis* (NAACP) magazine.

CLARISSA T. SLIGH

Born 1939 in Washington, DC Resides in New York Photography, mixed media

EDUCATION

M.F.A., Howard University,
Washington, DC, 1999
M.B.A, University of Pennsylvania, 1973
B.F.A., Howard University,
Washington, DC, 1972

MAJOR EXHIBITIONS

Smithsonian Institution

C larissa Sligh is a widely exhibited independent artist whose work centers on personal memories and events as acts or reclamation. In constructing alternative versions she redefines and re-presents her story, taking ownership over her past and future. Through photography, writing, drawing, and computer manipulations she examines family, society, ethnicity, and gender from her perspective as an African American woman. She became known for her subtle reworkings of such books as the Dick and Jane series of the 1940s–1960s, which involved use of her own family snapshots. She employs various computer, photo, and graphic media to produce prints and books that involve a re-visioning of the semiotics of cultural icons and histories.

ALVIN SMITH

Born November 27, 1933, in Boston, Massachusetts Died 2001 Painting, illustration

EDUCATION

B.A., University of Iowa
University of Illinois
Kansas City Art Institute
Columbia University Teachers College, New York
New York University, New York

MAJOR EXHIBITIONS

Fisk University, Nashville, Tennessee Art Institute of Chicago, Chicago, Illinois Corcoran Gallery of Art, Washington, DC The Studio Museum in Harlem, New York University of Delaware University Gallery, Newark, Delaware Brandeis University, Waltham, Massachusetts Museé Rath, Geneva, Switzerland Brooklyn Museum of Art, Brooklyn, New York Mount Holyoke College, South Hadley, Massachusetts Columbia University Teachers College, New York National Academy Galleries, New York Purdue University, West Lafayette, Indiana (Clark) Atlanta University, Atlanta, Georgia Toledo Museum of Art, Toledo, Ohio Dayton Art Institute, Dayton, Ohio

A l Smith taught in high schools and taught art education at Queens College in Flushing, New York. He also illustrated children's books, winning the Newberry Award for Maia Wojciechowska's *Shadow of the Bull* (1965). He received the Pollock-Krasner Award for lifetime achievements in art. Smith won the painting award given by the *Chicago Tribune* in 1954, four purchase awards from the Atlanta University Annual between 1962 and 1967, and four purchase awards at Dayton Art Institute between 1961 and 1966. His work is in the collections of the Dayton Art Museum, National Museum of American Art, Smithsonian Institution, Columbia University, Clark Atlanta University, and Tougaloo University in Mississippi.

CEDRIC SMITH

Born 1970 in Philadelphia, Pennsylvania Resides in Atlanta, Georgia Painting, mixed media

MAJOR EXHIBITIONS

Eclectic Connection Fine Art Gallery, Summit, New Jersey
Thelma Harris Gallery, Oakland, California
In The Gallery, Nashville, Tennessee
Robert Matre Gallery, Atlanta, Georgia
Atmosphere Gallery, New York
Barbara Archer Gallery, Atlanta, Georgia
Noel Gallery, Charlotte, North Carolina
Beverly Libby Gallery, Atlanta, Georgia
Morris Brown College, Atlanta, Georgia
Tubman Museum, Macon, Georgia
Black Fine Art Show, New York
Courtland Jessup Gallery, New York
Fine Art Images, Richmond, Virginia
Hannibal International Fine Art, Brooklyn, New York
Gallery B Ltd, Atlanta, Georgia

edric Smith and his family moved from Philadelphia to Thomaston, Georgia, when he was very young. Influenced by the rural southern environment he experienced growing up, traditional landscapes, and popular media, Smith creates collage paintings that superimpose period photographs with contemporary commercial logos and labels. His work is in Georgia collections including the Francis Walker Museum in Thomaston, Tubman Museum in Macon, and Morris Brown College in Atlanta.

HENRY OSSAWA TANNER

Born June 21, 1859, in Pittsburgh, Pennsylvania Died May 25, 1937, in Etaples, Normandy, France Painting, printmaking

EDUCATION

Philadelphia Academy of Fine Art

MAJOR EXHIBITIONS

Philadelphia Museum of Art, Philadelphia, Pennsylvania Smithsonian Institution, Washington, DC University of Texas Art Museum, Texas Howard University, Washington, DC Spelman College Museum of Fine Art, Atlanta, Georgia Morgan State College, Baltimore, Maryland University of California, Los Angeles, California Xavier University Art Gallery, New Orleans, Louisiana Philadelphia Arts Alliance, Philadelphia, Pennsylvania National Artist Club Galleries, New York Salon des Artistes Français, Paris, France American Art Galleries, New York Vose Galleries, Boston, Massachusetts Knoedler Gallery, New York Carnegie Museum of Art, Pittsburgh, Pennsylvania Pennsylvania Academy of Fine Arts, Philadelphia, Pennsylvania Exhibition of the Society of American Artists Philadelphia Art Club, Philadelphia, Pennsylvania Universal Exposition, Paris, France

enry Ossawa Tanner was the first African Ameri-**T** can artist to become internationally well known. Convinced that artists should be free to pursue their craft without adhering to culturally determined guidelines, he painted only a few genre scenes, although they remain among the most recognizable. He routinely used people that he knew well, including his father who wanted him to become a minister. He was named an honorary Chevalier of the Order of the Legion of Honor in 1927, France's highest honor; and he became a full academician of the National Academy of Design. His work is represented in the collections of the Louvre in Paris, Pennsylvania Academy of Fine Arts, the Art Institute of Chicago, the Metropolitan Museum of Art, Los Angeles County Museum of Art, and the High Museum of Art.

LEO F. TWIGGS

Born 1934 in St. Stephens, South Carolina Resides in Orangeburg, South Carolina Batik painting

EDUCATION

Ph.D., University of Georgia, Athens, Georgia M.F.A., New York University, New York B.A., Claftin College

MAJOR EXHIBITIONS

Georgia Museum of Art, Athens, Georgia
Marietta-Cobb Museum, Marietta, Georgia
University of Delaware University Gallery, Newark, Delaware
Smith-Mason Gallery, Washington, DC
Columbia Museurn of Art, Columbia, South Carolina
The Mint Museum, Charlotte, North Carolina
University of Cincinnati, Cincinnati, Ohio
University of Georgia, Athens, Georgia
Indiana University, Bloomington, Indiana

eo Twiggs is nationally regarded for his unique L batik painting style that incorporates the ancient wax resin and dye process (associated with both Africa and Indonesia) with modern expressionistic painting techniques and innovative materials. The South Carolina native was the first African American to receive his doctorate in art education from the University of Georgia. Having been at South Carolina State University (initially South Carolina State College) since 1964, he founded the art department in 1973, serving as chair until his retirement in 1998. During much of that time he was also director of the I. P. Stanback Museum and Planetarium. While his imagery addressed a number of specific themes over the years, he consistently drew from the southern landscape environmentally and metaphorically. In 1981, he was the first visual artist to receive the South Carolina Governor's Trophy known as the Elizabeth O'Neil Verner Individual Award. Twiggs has presented more than fifty one-man shows and his work hangs in American embassies in Rome, Togoland, and Dacca.

JAMES VANDERZEE

Born June 29, 1886, in Lenox, Massachusetts Died May 15, 1983, in New York Photography

MAJOR EXHIBITIONS

Metropolitan Museum of Art, New York

Museum of Modern Art, New York

Smithsonian Museum of Art, Washington, DC

Smithsonian National Portrait Gallery, Washington, DC

Memphis Brooks Museum of Art, Memphis, Tennessee

High Museum of Art, Atlanta, Georgia

Nexus Contemporary Art Center (now The Contemporary),

Atlanta, Georgia

c ettling in New York in 1905, James VanDerZee of found the "city within the city" to be a place where he could work a traditional job, photograph his family and friends, and play the piano and violin in his free time. Within a few years he initiated his self-taught career as a photographer from a studio on 125th Street. With his most prolific period being 1920–1945, he became one of the busiest photographers in the city, and soon was regarded as the foremost recorder of the Harlem Renaissance era (ca. 1917–1933). His portrayals of people and events on the city's streets distinguished him from many other studio photographers. His images of weddings, funerals, family gatherings, and formal, posed portraits sometime included hand-drawn marks used to heighten the desired effect. Prolific until the end, VanDerZee's later subjects also reflected the successful and the famous, including portraits of Lou Rawls (1980), Romare Bearden (1981), Jean Michel Basquiat (1982), and his final sitting, Regenia Perry (February 5, 1983). VanDerZee photographs are in the collections of the Metropolitan Museum of Art in New York, the Museum of Modern Art in New York, the Studio Museum of Art in New York, and the Amon Carter Museum in Fort Worth, Texas.

LAWRENCE (LARRY) WALKER

Born October 22, 1935, in Franklin, Georgia Resides in Stone Mountain, Georgia Painting, mixed medium

EDUCATION

B.S., M.A., Wayne State University

MAJOR EXHIBITIONS

Huntsville Museum of Art, Huntsville, Alabama City Gallery East, Atlanta, Georgia Georgia State University, Atlanta, Georgia Mississippi State University, Mississippi State, Mississippi

Nexus Contemporary Art Center (now The Contemporary), Atlanta, Georgia

Sacramento State College, Sacramento, California
New Jersey State Museum, Trenton, New Jersey
Oakland Museum of California, Oakland, California
Smith-Mason Gallery, Washington, DC
Fresno Art Center, Fresno, California
Stanford University, Stanford, California
Wayne State University, Detroit, Michigan
Stanislaus State College, Turlock, California
University of Michigan, Dearborn, Michigan
Anna Werbe Gallery, Detroit, Michigan
Saginaw Art Museum, Saginaw, Michigan

arry Walker grew up in New York's Harlem, the locaition that formed the basis of his interest in urban environments. He taught at the University of the Pacific in Stockton, California, for nineteen years—seven as department chair—and at Georgia State University in Atlanta, Georgia, for seventeen years, serving as chair for six years. Beginning in the late 1970s he emphasized largeformat presentations of urban scenes and established the red wall as a repeated object in his work. His figurative works are generally of male silhouettes in black and white or deep reddish-browns and white blends with a few streaks of color. The forms are portrayed as anonymous, loosely defined beings in cosmic surroundings. His work is in the collections of the University of the Pacific, Stockton, the Oakland Museum, Pioneer Museum, and Haggin Art Galleries.

WILLIAM ("ONIKWA BILL") WALLACE

Born November 15, 1938, in Chicago, Illinois Resides in Chicago, Illinois Photography

EDUCATION

Studied Kennedy-King College, Chicago, Illinois

MAJOR EXHIBITIONS

Museum of Science and Industry, Chicago, Illinois Kenkeleba Gallery, New York DuSable Museum, Chicago, Illinois University of Delaware University Gallery, Newark, Delaware Delaware State University, Dover, Delaware Georgia State University, Atlanta, Georgia

"O nikwa Bill" Wallace was a staff photographer for the Chicago Daily Defender for several years before establishing himself as one of the nation's most prolific and intense fine art photographers. Although he has produced hundreds of works on a variety of subjects, his portrayals of entertainers and other performers across the spectrum of disciplines have brought him his greatest recognition in recent years. From the highly successful jazz and other musicians to those who take to the streets of New Orleans and other cities as festival or parade participants, Wallace captures the nature of their experiences in crisp, well-defined blackand-white photographs, which have caused him to be considered among the nation's best in his field. While maintaining his own successful film production studio in Chicago, Wallace continues to document with fine accuracy the essence of his subjects' talent, energy, and spirit at the height of their performances—often from very close range—without intrusiveness. His work is included in numerous major collections throughout the United States.

CARRIE MAE WEEMS

Born 1953 in Portland, Oregon Resides in upstate New York Photography

EDUCATION

Studied, University of California, Berkeley
M.F.A. University of California, San Diego, 1984
B.F.A. from California Institute of the Arts, Valencia, in 1981

MAJOR EXHIBITIONS

Massachusetts

Dartmouth College, Hanover, New Hampshire Nelson Atkins Museum of Art, Kansas City, Missouri High Museum of Art, Atlanta, Georgia International Center of Photography, New York Williams College Museum of Art, Williamstown, Massachusetts Museum of Fine Arts, Houston, Texas Minnesota Museum of American Art, St. Paul. Minnesota Spelman College Museum of Fine Art, Atlanta, Georgia National Museum of Women in the Arts, Washington, DC Contemporary Arts Museum, Houston, Texas Whitney Museum of American Art at Phillip Morris, New York Boston University Art Gallery, Boston,

arrie Weems calls attention to racially motivated habits and systems in contemporary life through her manipulation of images or concepts associated with a previous era. Her use of unexpected surfaces and poignant messages reverberate through the multiple components of her series. Weems is particularly well known for work that critically investigates the representation of African Americans. At times, her work provides an alternative view, if not one that begins the process of wiping the undesired image from memory. This treatment of time-distanced materials is, interestingly enough, the implied intent in her controversial multilayered work The Hampton Project, where she reinterprets the turn-of-the-century photographs taken by Frances Benjamin Johnston (1864-1952) at the Hampton Normal and Agricultural Institute (now Hampton University). Carrie Mae Weems: The Kitchen Table Series is another. Her series Ritual and Revolution has been shown in Chicago, Berkeley, Dakar, and Berlin. In 1999, Weems received an honorary degree from the California College of Arts and Crafts, Oakland. She has taught at Harvard University, Williams College, and Hunter College.

CHARLES WHITE

Born April 2, 1918, in Chicago, Illinois Died October 3, 1979, in southern California Painting, graphic art, education

EDUCATION

Taller de Grafica, Mexico
Escuela de Pintura y Escultura de la Secretaria de Educacion
Publica, 1946
Art Students League, New York, 1942
Art Institute of Chicago, 1936

MAJOR EXHIBITIONS

Hunter Museum of American Art, Chattanooga, Tennessee Brooklyn Museum of Art, Brooklyn, New York High Museum of Art, Atlanta, Georgia San Francisco Museum of Modern Art, San Francisco, California Internationale Buchkunst-Asstellungin, Leipzig, Germany University of California, Riverside, California Los Angeles County Museum of Art, Los Angeles, California Smithsonian Institution, Washington, DC Metropolitan Museum of Art, New York Museum of Fine Arts, Boston, Massachusetts Whitney Museum of American Art, New York Howard University, Washington, DC New York University, New York Hunter, The City University of New York, New York Brooklyn Museum of Art, Brooklyn, New York University of Chicago, Chicago, Illinois Baltimore Museum of Art, Baltimore, Maryland Newark Museum, Newark, New Jersey Institute of Modern Art, Boston, Massachusetts ACA Galleries. New York Art Institute of Chicago, Chicago, Illinois

harles White was seven years old when a birthday gift of a set of paints caused him to think about art as a profession. Like Jacob Lawrence, Bill Hutson, and numerous other artists, White frequented the library, thoroughly researching and getting to know the individuals and events that greatly shaped American society. Admired in the states and abroad, his expressionistic style

brought a unique social consciousness to visual art expression. In his work, collectively, we are given a graphic portrait of American life and history. His achievement in the field brought him awards such as a National Scholarship Award in 1937, the Childe Hassam Award from the American Academy of Art, and the Adolph and Clara Obrig award from the National Academy of Design, among numerous others.

JACK WHITTEN

Born December 5, 1939, in Bessemer, Alabama Resides in New York Painting

EDUCATION

Cooper Union for the Advancement of Science and Art, New York, 1960–1964 Southern University, Baton Rouge, Louisiana, 1959–1960 Tuskegee Institute, Tuskegee, Alabama, 1957–1959

MAJOR EXHIBITIONS

Newark Museum, Newark, New Jersey Cure Gallery, Los Angeles, California G. R. N'Namdi Gallery, Birmingham, Michigan California Afro-American Museum, Los Angeles, California Horodner Romley Gallery, New York Jamaica Arts Center, Jamaica, New York Hampton University, Hampton, Virginia Onyz Art Gallery, New York Bucknell University, Lewisburg, Pennsylvania Museum of Modern Art, New York The Studio Museum in Harlem, New York Hofstra University, Hempstead, New York Trenton State College, Trenton, New Jersey P.S.1, Long Island, New York Phoenix Art Museum, Phoenix, Arizona New Museum of Contemporary Art, New York Robert Miller Gallery, New York Metropolitan Museum of Art, New York Montclair State College, Montclair, New Jersey New York State University College at Brockport, New York Whitney Museum of American Art, New York Pratt Institute, Brooklyn, New York

Center for Visual Arts, New York

Aldrich Museum of Contemporary Art, Ridgefield,
Connecticut

Vassar College, Poughkeepsie, New York

Vassar College, Poughkeepsie, New York New York University, Stony Brook, New York Allan Stone Gallery, New York

F or many years, Jack Whitten as a painter explored modernist concepts of space. His paintings are often optical challenges, abstractly designed to the point of fluctuation between references to mystical fields derived from a landscape tradition, geometrically based studies of color and light and associated implications, and any number of surface/process considerations. Ranging from large scale to small formats, his works interact via bits and bites of color, texture, light, and space—both real and illusionary—to read as icons in addition to functioning as individual works.

JOHN WOODROW WILSON

Born 1922 in Boston, Massachusetts Resides in Boston, Massachusetts Printmaking, sculpture, graphic art

EDUCATION

Escuela de las Artes del Libro, Mexico, 1954–1955 Esmeralda School of Art, Mexico City, 1952 Instituto Politecnico, Mexico City, 1952 Fernand Leger's School, Paris, 1949 Tufts University, 1947 School of the Museum of Fine Arts, Boston, 1944

MAJOR EXHIBITIONS

Museum of Modern Art, New York
Metropolitan Museum of Art, New York
National Academy of Design, New York
(Clark) Atlanta University, Atlanta, Georgia
Art Institute of Chicago, Chicago, Illinois
Smith College, Northampton, Massachusetts
Detroit Institute of the Arts, Detroit, Michigan
Bezalel Museum, Jerusalem
Boris Mirski Gallery
Newark Museum, Newark, New Jersey

American International College, Springfield, Massachusetts
Cincinnati Art Museum, Cincinnati, Ohio
Museum of Fine Arts, Boston, Massachusetts
The City College of New York, New York
Musée des Beaux-Arts, Rouen, France
Bibliotheque Nationale, Paris, France
(Clark) Atlanta University, Atlanta, Georgia
Albany Institute of History and Art, Albany, New York
Downtown Gallery, New York

Action of the Wilson presents a gripping interpretation of the Richard Wright series: *The Story of the Mann Family*. True to his dramatic approach, he emphasized the figure being challenged in the image, building other elements around characters. He was the recipient of the John Hay Whitney Fellowship in 1950 and five Atlanta University Purchase prizes. His work is in the collections of the Museum of Modern Art, Schomburg Center, Smith College, Brandeis University, Tufts University, (Clark) Atlanta University, and many more.

HALE ASPACIO WOODRUFF

Born 1900 in Cairo, Illinois Died 1980 in New York Painting, mural, printmaking, education

EDUCATION

Harvard University, New Haven, Connecticut Academie Moderne, Paris, France John Herron Art Institute, Indianapolis, Indiana

MAJOR EXHIBITIONS

The Studio Museum in Harlem, New York
Whitney Museum of American Art, New York
Museum of Fine Arts, Boston, Massachusetts
Los Angeles County Museum of Art,
Los Angeles, California
San Diego Museum of Art, San Diego, California
High Museum of Art, Atlanta, Georgia
La Jolla Museum, La Jolla, California
New York University, New York
Albany Institute of History and Art, Albany, New York
Baltimore Museum of Art, Baltimore, Maryland

Museum of Fine Arts, Dallas, Texas
Harmon Foundation, New York
Valentine Gallery, New York
Pacquereau Gallery, Paris, France
Art Institute of Chicago, Chicago, Illinois
Kansas City Art Institute, Kansas City, Kansas
University of North Carolina, Chapel Hill, North Carolina
State Museum of North Carolina, Raleigh, North Carolina
University of Southern Illinois, Carbondale, Illinois
University of Michigan, Dearborn, Michigan
Tuskegee Institute, Tuskegee, Alabama
Hampton Institute, Hampton, Virginia

Hale Woodruff is among the most important African American artists of the twentieth century. As a young painter, he developed a serious interest in African art as a part of personal exploration of aesthetics and actively collected it. He vigorously pursued and engaged Henry Ossawa Tanner when he traveled to France eager to garner knowledge from the highly respected artist, and, understanding the relationship between African art and

the cubism of Picasso, Braque, and others, took every opportunity to view examples of their work firsthand. A model teacher, Woodruff established the art department at Spelman College in Atlanta (assisted by Nancy Elizabeth Prophet) and initiated the Atlanta University Annual Exhibition and Competition (1942-1971). He was a founder and central member of Spiral, a group of New York artists who sought an activist platform through art that corresponded to that demonstrated in America's streets during the civil rights era. Best known for painting the Amistad Murals (1938–1939) at Talladega College in Alabama, Woodruff was highly regarded among his peers for his modernist paintings as well. Drawing from the stimuli around him, he mastered each of the stylistic approaches he attempted from social realism to cubist-based abstraction. Woodruff's work is in collections at Spelman College, (Clark) Atlanta University, the Newark Museum, New York State University, and New York University.

Compiled by Amalia K. Amaki with the assistance of Aimee Miller and Monique Neal.

Notes on Contributors

AMALIA K. AMAKI is curator of the Paul R. Jones Collection and an assistant professor of art and Black American studies at the University of Delaware. She has written several articles, catalog essays, and art reviews along with two books-in-progress, Freedom Lights the Way: A History of All-Black Shows in America and Posed Pictures: Critical Readings in the Photographs of Prentice Herman Polk.

MARGARET ANDERSEN is a professor of sociology at the University of Delaware and the author of four books including *Race, Class, and Gender* (2000) and *Thinking about Women: Sociological Perspectives on Race and Gender*. She is currently working on a biography of Paul R. Jones with Carole Marks.

MARCIA R. COHEN is a professor of art at the Atlanta College of Art and a nationally known artist and color theorist who has lectured extensively on the theoretical topics related to color throughout the United States and Europe.

ANN EDEN GIBSON is a professor of art history at the University of Delaware. She writes extensively on abstract expressionism and has authored two books on the subject, Issues in Abstract Expressionism: The Artist-Run Periodicals and Abstract Expressionism: Other Politics.

WINSTON KENNEDY is a professor emeritus in art history at Howard University and a scholar-in-residence at the Schomburg Center for the Research in Black Culture. He specializes in the history of African American prints and African American printmaking workshops.

DIANA MCCLINTOCK is a professor of art history at the Atlanta College of Art. She is nationally known for her work on issues related to American art and modern art.

DEBRA HESS NORRIS is director of the Winter-thur/University of Delaware Art Conservation Program and project director of the Andrew W. Mellon Collaborative Workshops in Photograph Conservation. She is a world-renowned authority on photography conservation and author of numerous articles, brochures, and book chapters in the field, with her forthcoming book focusing on the treatment of historic and contemporary print materials.

IKEM STANLEY OKOYE is an associate professor of art history at the University of Delaware. He has written extensively on African architecture, African art, and African American art. His two books in progress are Hideous Architecture: Feint, Modernity, and Occultation in African Building Practice and A Critique of the Idea of the Vernacular in African Architecture.

SHARON PRUITT is an associate professor of art history at East Carolina University and has written articles and essays on contemporary African art and African American art subjects. She is currently completing a book on North Carolina African American artists.

CARLA WILLIAMS was the 2002–2003 Rockefeller Fellow in the Humanities at Stanford University. A writer and editor, her latest publication is *The Black Female Body: A Photographic History* (with Deborah Willis).

Index

NOTE: Italicized numbers indicate pages with plates.

Abernathy, Ralph David, 2

abstract works: African symbolism and, 48, 53n. 17; collecting, 11–12; figuration blurred with, 35; of Little, 235; of Lofton, 236; of Spiralists, 20

acrylics: Chrichlow, 147; Hutson, 7–8, 107; Riddle, 104; Smith, 55, 152; Walker, 155; Whitten, 11, 161

Aden, Alonzo J., 14n. 2

Adorno, Theodor, 40

Africa and Africanicity: Burroughs's work and, 46, 53n. 23; as influence, 233; primitivism linked with, 47–48; ritual performance in, 25; Woodruff's work linked to, 49, 53n. 17. *See also* African art; South Africa

African American art: aesthetic and philosophical issues in, 19–21, 45–46, 49; in American construct, 4; "closing the knowledge gaps" about, 7; color as political metaphor in, 47–48; de-race-ing of, xv; Locke's vision for, 80–81; promotion of, 39; recognizing value of, 1

African American identity: Bearden's collages as reflecting, 27–28; color as means of constructing, 48; complexity of defining, 17–18; discourse on, 19; skin color and, 46, 56–58. *See also* civil rights movement

African art: collecting and awareness of, 14n. 16; color and, 48; as influence, 24–25, 219; sculpture of, 24, 27; studies of, 19 African Methodist Episcopal (AME) Church, 80

African National Congress (ANC), 38, 40

Affican National Congress (ANC), 30,

AfriCobra, 47, 48, 52n. II after-images, 56

agency, 79

Ailey, Alvin, 217

Albers, Joseph, 55, 57

albumen process, 97

Alexander, Jim: biography of, 215; Ellington photographs by, 13, 215; works: Ellington Orchestra, 184; Jamming, 185

Allen, Samuel, 28n. 15

Alston, Charles "Spinky": acquaintances of, 225; as influence, 81–82, 234; loft space of, 28n. 8; racial identity of, 49; Spiral Group and, 19

American Federation of Arts, 82

American Institute for Conservation, 100

American National Standards Institute (ANSI), 97, 98, 99

Amos, Emma, 19

Ananse (Biggers), 220

ANC (African National Congress), 38, 40

Anderson, Charles Alfred, 73

Anderson, Ed, 11

Anderson, William J.: biography of, 215–216; reputation of, 13; works: *Man Shaving*, 117

Andrews, Benny: associates of, 229; biography of, 216; works: *Dianne*, 148

Andrews, Bert: biography of, 217; collecting work of, 12; works: Alfre Woodard and Others, 187; Gloria Foster and Morgan Freeman, 186

ANSI (American National Standards Institute), 97, 98, 99

apartheid, 36, 38-41

Apollinaire, Guillaume, 34

Appel, Karel, 52n. 11

Archimedes, 21

Aristotle, 56

art: finding solace in, 25; mathematics vs., 29n. 26; transformative power of, 91. *See also* African American art; African art

art collections: culture-based contextualization in, 4; ethnically defined, 3; gallery/museum/critic structure and, 14n. 17. See also Paul R. Jones Collection; preservation techniques art history tradition, 3, 5

Art in Embassies Program (U.S. State Dept.), 219

Art Institute of Chicago, 45, 50

Artis, William Ellisworth: biography of, 217–218; works: *Michael*, 11, 213

artists: critical questions for, 19–20; establishing track record for, 7; fascination with, 2–3; hopes of, 13; Jones's relationships with, 4, 6, 8–10, 11, 12, 15n. 31; racial discrimination against, 89; social responsibility of, 26; status of, 52n. 9; teaching of/as teachers, 46

Artists' Collective, 226

Arts Magazine, 221

Art Students League (N.Y.C.), 18

Asante people, 232-233

Asia, 14n. 16

Asilah First World Festival (Morocco), 220

assemblages: collecting material for, 240. See also collage

Atlanta College of Art, 84

Atlanta University: Annual Exhibition and Competition of, 9–10, 248; print collection of, 79

Atlanta University Center, 8

audience: Bearden on, 26; films for black, 71; frame's function for, 35–37

avant-garde, 34

Bailey, Herman "Kofi": biography of, 218; Jones's relationship with, 4, 8; works: African Woman, 151; Portrait of Paul R. Jones, 88 (detail), 141; Woman Grinding Peppers, 8, 108

Baker, Henry, 75

Baker, Mildred Hanson, 74

Baldwin, James, 25, 28n. 15, 69

Ball, James Presley, 63

Ball, Phillip, 58

Bannarn, Henry "Mike," 28n. 8

Bannister, Edward Mitchell, 81

Barile, Xavier J., 229

Barnett-Aden Gallery (Washington, DC), 2, 14n. 2

Basquiat, John Michel, 244

batik: description of, 243; by Twiggs, 9, 44 (detail), 51, 110, 120

Battey, Cornelius Marion, 64, 72

Baumgardner, George, 41n. 14

Bearden, Bessye, 18

Bearden, Howard, 18

Bearden, Romare: biography of, 18, 28n. 15, 218–219; collages of, 21–25, 28; color as used by, 47; dadaism of, 22–23; Gammon's relationship with, 228–229; racial identity of, 49; reputation of, 12; southern landscapes and, 25–28; Spiral Group and, 18–21; style of, 240; technique of, 22; VanDerZee's portrait of, 244; on Western culture, 17; works: Cotton, 25–26; Firebirds, 168; Island Scene, 153; Mysteries, 24; The Prevalence of Ritual, 24; Projections (exhibition), 21, 24; School Bell Time, 16 (detail), 118; Watching the Good Trains Go By, 27

Beasley, Phoebe: biography of, 219; works: Man/Woman/Child, 206; Yogi. 207

beauty: Greek ideal of, 29n. 25

BECC (Black Emergency Cultural Coalition), 216, 229

Bedou, Arthur P., 63; as Tuskegee photographer, 72; works: *Booker T. Washington*, 94 (detail), 100, 142–143

Benhabib, Seyla, 37-38, 40-41

Berlin, Brent, 58

Bertaux, Daniel, 92

Bethune, Mary McLeod, 11, 149, 222

Bhalla, Hans, 9, 10-11

biblical stories. See religious themes

Biggers, John Thomas: biography of, 219–220; as influence, 236; works: *Ananse* (book), 220; *Untitled* (figures/two balls), 209; *Untitled* (woman/planks/shell), 208

Biko, Steven, 36

Billops, Camille: biography of, 220–221; works: Fire Fighter, 170

biography: insights from, 91-93

Birth of a Nation, The (film), 71

Black Arts Movement, 21

black (color), 56, 58

Black Emergency Cultural Coalition (BECC), 216, 229

blackface minstrelsy, 71, 76n. 5

Black Hebrew Israelites, 215

Blake, Eubie, 229

block printing, subtractive: Ellison, 84, 135, 201, 202, 228

Blockton, Lula Mae, 39

blue (color), 55, 56

Blythe, Arthur, 181

Bois, Yves-Alain, 34

Bowling, Frank: biography of, 221; works: *Untitled* (1980), 157, 158

Brancusi, Constantin, 28n. 15

Brandywine Workshop, 79

Braque, Georges, 22, 28n. 15, 29n. 43, 219, 248

Brazil, 40

Britt, Arthur L., 10

Britt, Benjamin: biography of, 221–222; Jones's relationship with, 10; works: *We Two*, 144

Brockelton, Thomas, 34, 35

Brooke, James, 42n. 39

Brooklyn Museum, 82

Brotherhood of Sleeping Car Porters, 18, 27

Brown, Sterling, 218

Bueher, George, 45

Bunche, Ralph J., 2

Burke, Selma Hortense: biography of, 222; works: *Mary McLeod Bethune*, 11, 149, 222

Burroughs, Margaret Taylor Goss: Africanicity and, 46, 53n. 23; biography of, 45, 222–223; color as used by, 46; locale of, 49; works: *Jasper*, 223; *For Malcolm*, 223; *Three Souls*, 46, 121 Bush, Anita, 71

Campbell, T. M., family, 190

Caranda-Martin, Doughba Hamilton: biography of, 223; works: *Untitled* (2003), 192–194

Carmichael, Stokely M., 8

Carter, Nanette: biography of, 38–39, 223–224; mark-making of, 33, 34; on titles, 35, 36; works: Burning All Hatred, 40; Burning Apartheid, 40; Illumination series, 40; Light over Soweto #5, 32 (detail), 33–41, 119; Point-Counter-Point series, 36; Savannah Winds series, 40

Carter, William, 10

Carter, Yvonne Pickering, 39

Carver, George Washington, 12, 72, 73, 132, 239

Carver Industrial School, 73

Catlett, Alice Elizabeth (Mora): biography of, 82, 224–225; as influence, 235; teacher of, 233; works: *Boy/Girl Profile*, 196; *Couple Kissing*, 195; *Girl/Boy/Red Ball*, 54 (detail), 58, 83, 123; *The Negro Women Series*, 82; *Singing/Praying*, 82–83, 137

Central America, 14n. 16

ceramics: Hooks, 230

Cézanne, Paul, 22, 29n. 41

Chagall, Marc, 5, 14n. 18

Chanel, Coco, 57

Charles White Archives, 145, 177

Charlotte (N.C.), 6–7, 106

Chicago Defender, 245

Chicago Jazz Festival, 13

Child, Lydia Maria, 52n. 12

Chinese landscapes, 219

Chrichlow, Ernest: biography of, 225; works: *Untitled* (1985), 147 Christian, Carl: biography of, 225–226; works: *Evening in Summer*, 162

churches: works loaned to, 6, 7. *See also* religious themes civil rights movement: Bearden's images of, 17–18; creativity fostered in, 3–4; firsthand experience of violence in, 50;

identity and, 49–51; involvement in, 2; march depicted in, 20; role of singing in, 82–83; as social-historical context, 90–93. *See also* Spiral Group

Civil War, 70

Clark, Ed, 38-39

CoBra, 47, 48, 50, 52n. 11

COBRA (Committee of Bad Relevant Artists), 47

Cochran, John H., 13

Coleman, Floyd, 21

Coleman, James E., Jr. See Shinar, Imaniah (James E. Coleman, Jr.)

Colescott, Robert, 47, 53n. 28

collage: aesthetic of, 34–35; Beasley's work in, 219; description of, 21; Phillips's work in, 159. *See also* Bearden, Romare; Carter, Nanette

color: in biology, 56–58; centrality of, 52n. 5; emotionality linked to, 52n. 8; history of, 47–48; primitivism linked to, 46–47; racial identity and, 49–51; systematic use of, 45; theories of, 55–56

color coding practice, 56-57

Coltrane, John, 227

Committee of Bad Relevant Artists (COBRA), 47

communicative ethics (concept), 38

community/communities: collecting as means of constructing, I; of needs/solidarity vs. of rights/entitlements, 38; train tracks as racial divides in, 27; works loaned to, 6

Confederate iconography, 49–51

contextures (theory), 7

Conwill, Houston, 47

Corcoran Gallery (Washington, DC), 21

Cordier, Daniel, 20n. 31

Cordier & Ekstrom Gallery, 21, 29n. 31

Cornell, Joseph, 240

Cornish, John, 7

Cote, Benoit, 146

Courbet, Gustave, 26

Cowans, Adger W., 12

Cravola cravons, 58

Crite, Allan Rohan: biography of, 226; works: The Revelation of St. John the Divine, 197

Crite, William, 13

cross-cultural engagement, 2, 7

cubism, 23, 234. See also Braque, Georges; collage; Picasso, Pablo

cultural icons, 49-51, 56-57, 241

dadaism, 22–23

Darwin, Charles, 58

Daumier, Honoré, 29n. 51

David, Jacques Louis, 84

Davis, Miles, 183

DeCarava, Roy: biography of, 226–227; collecting work of, 12; works: *Graduation Day*, 191

deconstruction, 21-23. See also collage

Degas, Edgar, 5, 14n. 18

Diop, Alioune, 19

discourse theory, 37–38, 40–41, 42n. 37

Donaldson, Jeff, 48

Douglas, Aaron, 53n. 28, 229

Douglass, Calvin, 19

Douglass, Robert, Jr., 80

drawings: Bailey, 88 (detail), 141, 151; Jones, 210; Woodruff, 10,

Driskell, David Clyde: biography of, 227; exhibitions of, 6; influences on, 233; Jones's relationship with, 11; works: *Ghetto Girl*, 11; *Masked Man*, 11; *Woman in Interiors*, 11, 58, 126; *The Worker*, 11

Du Bois, W.E.B. (William Edward Burghardt), 8, 49, 85n. 1, 218

Duchamp, Marcel, 29n. 40, 34

Dunba, Alice, 241

Duncanson, Robert, 81

Dunham, Katherine, 12-13, 116

DuSable Museum of African American Art, 45-46, 223

Eakins, Thomas, 80

Ealey, Adolphus, 14n. 2

Eckstine, Billy, 18, 23

Edward L. Loper (documentary), 236

Eisenstein, Sergei, 34

Ekstrom, Arne, 21, 29n. 31

Ellington, Duke, 13, 215; Orchestra, 184

Ellison, Michael: biography of, 228; works: *The Bar, 135; Brown Boy,* 84, 201; *The Mall, 202*

Ellison, Ralph, 23

engravings: Crite, 197

etchings: Tanner, 9, 80–81, 111; White, 11, 177; Wilson, 84, 139,

European art: art history tradition and, 3, 5; color and emotionality in, 52n. 8; color and primitivism in, 46–47, 52n. 5. See also CoBra

Evers, Charles, 2

expressionism, 47, 246

family themes: Guilford, 230; Humphrey, 231; Saar, 240; Weems, 65

Feagin, John W.: biography of, 228; works: *Reflections II*, 156 Federal Arts Project (FAP), 226

Ferguson, Perry, 19

film: artists' work in, 219, 221; as influence, 69; stereotypes in, 71–72, 75

Finding Christa (film), 221

fires: transformation of, 40-41

Fisk University, 79

Fleming, Lee, 73

Ford, Henry, 73

For Malcolm (Burroughs), 223

Foster, Gloria, 186, 217

fragmentation: Bearden's collage and, 21-23

frames: function of, 35-37

Franklin, John Hope, 2

Frank Silvera Writers' Workshop, 217

Frazier, E. Franklin, 2

Frederick Douglass High School (Atlanta), 7 Freeman, Morgan, 186, 217 Free South Africa Movement, 38 Fried, Michael, 34

Gage, John, 55, 57 gallery/museum/critic structure, 14n. 17 Gammon, Reginald: biography of, 228-229; photomontages and, 21; Spiral Group and, 19; works: Freedom Now, 20, 229; Sonny Rollins, 150 Gardner, Alexander, 70 Garvey, Marcus, 12 Gates, Henry Louis, Jr., 7, 81 gelatin. See silver gelatin prints Georgia Museum of Art, 52n. 16 Germany, 22, 24, 55, 57 Geter, Tyrone, 53n. 27 Gilliam, Sam, 235 Gilroy, Paul, 37, 38 Goethe, Johann Wolfgang von, 56 Gone With the Wind (film), 71-72 Goode-Bryant, Linda, 7 "good eye" (concept), 5 Goodridge, Glenalvin J., 63 Goodridge, Wallace L., 63 Goodridge, William O., 63 Gorleigh, Rex: biography of, 229; works: Red Barn, 165, 229 Goya, Francisco de, 29n. 51 Greenberg, Clement, 34 Greenfield Village (Dearborn, MI), 73 Griffith, D. W., 71 Grosz, George, 18, 22, 24, 29n. 51, 219 Guarantee Photo Studio, 63-64 Guilford, Samuel: biography of, 229-230; works: 9 Lives, 178

Haitian Revolution, 82 Hampton Project, The (Weems), 245 Hampton University, 79 Hansen, Karen, 91 Harding, Vincent, 89 Harlem (N.Y.): photography studio in, 63-64 Harlem After Midnight (film), 71 Harlem Artist Guild, 19, 225 Harlem Renaissance. See New Negro Movement Harleston, Elise Forrest, 63 Harmon Foundation Fellowship, 217 Harris, Michael D., 48 Harrison, Paul Carter, 217 Hatch, James, 220-221 Hatch-Billops Collection, 220-221 Hausmann, Raoul, 22 Hawthorne, Nathaniel, 57 Haynes, Roy, 227 Heartfield, John (born Helmeut Herzfelde), 22 Hegel, G.W.F., 40 Henry, John, 145

Herring, James V., 14n. 2, 82 High Museum of Art (Atlanta), 7, 10 Hilbert, David, 57-58 Hines, Felrath, 19 Hines, Gregory, 180 Historically Black Colleges and Universities (HBCUs), 6. See also specific institutions Höch, Hannah, 22 Holiday, Billie, 23, 51, 227 Hollingsworth, Alvin, 19 Holloway, Jenelsie Walden, 6, 14n. 20 Holty, Carl, 26 Homer, William Innis, 12 hooks, bell, 61, 63 Hooks, Earl J.: biography of, 230; exhibitions of, 6; Jones's relationship with, II; works: B. B. King, II; Bust of Woman, II; Man of Sorrows, 11, 171; Torso, 11; Untitled (Faces), 11 Hoopes, James, 92 Howard University, 2, 79 Huff, Lawrence, 13 Hughes, Langston, 85n. 1, 227 Humphrey, Margo: biography of, 230-231; "self" as subject of, 84-85; works: Hometown Blues, 84-85, 211; Pulling Your Own Strings, 85, 140 Hunt, Richard Howard: biography of, 231-232; works: Untitled (1980), 212 Hutson, Bill: associates of, 39; biography of, 232; works: Maiden Voyage, 7-8, 107 Hyman, Leonard G., 72

improvisation, 21-23 industrialization, 23, 26 interactive universalism, 42n. 37 International Review of African American Art, 235 *In the Shadow of the Great White Way* (Andrews and Harrison). irony, 51

Jackson, Samuel L., 217 Jacob and Gwendolyn Lawrence Foundation, 136 Jarrell, Wadsworth: AfriCobra and, 48; works: Jazz Giants, 122 jazz music: art movement linked to, 48, 52n. II; Bearden's compositions of, 18, 23; finding solace in, 25; improvisational style of, 226; trains linked to, 27 Jenson, Fred A., 64, 72 Jews, 55, 57 Johnson, Amos "Ashanti": associates of, 233–234; biography of, 232–233; influences on, 8–9; works: The Original Man, 9, 109 Johnson, Charles, 85n. 1 Johnson, Deborah J., 74, 75 Johnson, James Weldon, 85n. 1 Johnson, William H., 52n. 8 Johnston, Frances Benjamin, 245 Jolson, Al, 71 Jones, Ella Reed Phillips, 1, 90

Jones, Jason E., 13

Jones, Loïs Mailou: biography of, 233; as influence, 2, 82; works:

Jazz Combo, 199; Nude, 198; 3 dancers, 200

Jones, Paul R.: acquisition methodology of, 3–6, 81; activities of, 6; background of, 1–3; Bailey's *Portrait* of, 88 (detail), 141; collection shared by, 5, 6–7; educational mission and, 90; open-mindedness of, 13; scrapbook of, xv; Sligh's *Portrait* of, 62–63, 65–66, 128; social-historical context of, 89–93. *See also* Paul R. Jones Collection

Jones, Paul Raymond (P.R.), Jr.: biography of, 233; works: Un-

titled (ca. 1971), 210

Jones, Steven Loring, 71

Jones, Ted, 6

Jones, William "Will" Norfleet, 1, 2, 6, 14n. 19, 90

Jordan, Eddie Jack, 10

Kahlo, Frida, 225 Kamoinge Workshop, 227

Kant, Immanuel, 35

Kay, Paul, 58

Keene, Paul, 28n. 15

Kennedy, Robert, 50

Kent State University, 50

King, Martin Luther, Jr.: assassination of, 50, 215; associates of, 2, 3, 8, 218; attitudes toward, 20; biblical stories and, 85n. 4

King, Woodie, Jr., 217

King-Tisdell Cottage (Savannah), 6, 105

Kirchner, Ernst, 47

KKK Boutique Ain't Just for Rednecks, The (documentary), 221

Kollowitz, Kathë, 29n. 51

Koons, Jeff, 34

Korean War, 216

Kramer, Hilton, 231

Krauss, Rosalind, 37, 41n. 7

Ku Klux Klan, 71

Lacan, Jacques, 70

landscapes: Bearden's collage and southern, 25–28; blues aesthetic in context of, 51; Chinese, 219; as metaphors, 35–41; Twiggs's use of, 44 (detail), 51, 120

language: signs in, 70; terms for color in, 58; visual, 5, 65–66

Law, W. W., 6

Lawrence, Gwendolyn Knight, 136

Lawrence, Jacob: acquaintances of, 28n. 13, 225; artistic development of, 81–82; biography of, 234; masked imagery of, 24; reputation of, 12; style of, 240; works: *The Library*, 78 (detail), 82, 136; *Migration* series, 82, 234; *Toussaint L'Ouverture* series, 82

Lawrence, Rosa Lee, 81

Lawrence, William, 81

Lewis, Norman: abstract expressionism of, 20; color as used by, 47; as influence, 225; racial identity of, 49; Spiral Group and, 18, 19

Lewis, Samella Sanders: biography of, 83, 234–235; works: *The Masquerade*, 83, 138; *Waterboy*, 235

L'hote, Andre, 229

Lifton, Gold, and Asher (advertising firm), 229

line: intellect/reason linked to, 5211. 8

Lion, Jules, 63

lithographs: Bearden, *16* (detail), *118*, *168*; Biggers, *208*–209; Billops, *170*; Humphrey, 84–85, *140*, *211*; Hunt, *212*; Jarrell, *122*; Jones, *198*–200; Lawrence, *78* (detail), 82, *136*; Lewis, *138* Little, James: biography of, *235*; works: *Countdown*, *7*, *57*, *125*

Little, James: biography of, 235; works: *Countdown*, 7, 57, 125 Locke, Alain Leroy: on African American art, 80–81; ancestral legacy in art views of, 49; as influence, 2, 85n. 1, 218

Lofton, Lionel: biography of, 235–236; works: *Jungle Fever*, 169 Long, Walter, 71

Loper, Edward L., Sr.: biography of, 236; works: Portrait of Benoit Cote, 146; Winter Still Life, 166

Loving, Al, 38-39, 235

Lowenfeld, Viktor, 83, 235

Lumumba, Patrice, 38

lynching, 51

Maillol, Aristide, 222

Mainor, Leonard, 13

Majors, William, 19

Malcolm X, 20, 50

Mandela, Nelson, 38, 39

"man's inhumanity to man" theme, 29n. 51

March on Washington (1963), 3-4, 18

Marietta-Cobb Museum of Art, 6

Martin, Clayhorn, 12, 63-64, 188

Marx, Karl, 40

Masekela, Barbara, 38-39

Masekela, Hugh, 38-39

masks, 11, 24, 25

mathematics vs. arts, 29n. 26

Matisse, Henri, 219

mats, photographic, 99

Mayhew, Richard, 19-20, 21

McBeth, Sally, 92

McDaniel, Hattie, 71–72

McKay, Claude, 19, 229

McNiven, Norah, 9–10

McQuerry, Axel, 183

media: exhibition covered by, 6, 14n. 23. See also film; stereotypes

memory: Bearden's use of, 23–28; in life history, 92; photography as, 64–65; Sligh's use of, 241

Mestrovich, Ivan, 217

metaphor: color as political, 47–48; landscapes as, 35–41; local color as, 57; mirror as, 70; in modernity, 34

metonymy, 34, 39

Metropolitan Museum of Art, 79

Micheaux, Oscar, 71

Migration series (Lawrence), 234

militancy, 19-20, 36. See also civil rights movement

Miller, Aimee: biography of, 236; works: Untitled (2001), 163

Miller, E. Ethelbert, 61

Miller, Earl, 19

Mills, C. Wright, 90

mimesis, 35, 39-40

minimalism: Pindell, 11, 56, 124

Mirzoeff, Nicholas, 4

mixed media: Andrews, 148; Bowling, 157–158; Christian, 162; Driskell, II, 58, 126; Lofton, 169; Miller, 163; Odeleye, 164; Pindell, II, 56, 124; Shinar, 154; Smith, 167; Whitten, 114

Model Cities program, 6-7

modernism and modernity: broken frame in, 35–37; Burroughs's work in context of, 46; historical logic of, 37; revising concept of, 34; space in, 247; as worldwide phenomenon, 5

mold damage, 99

Mondrian, Piet, 11

Moore, George, 75, 134

Moorhead, Scipio, 81, 85n. 6

Mora, Francisco Pancho, 82, 225

Mosely, Jimmie Lee: biography of, 236–237; Jones's relationship with, 10; works: *Humanity #2, 103*; *Protest, 237*

Moton, Robert Russa, 74

muralists: Beasley, 219; Biggers, 220; as influence, 83; Woodruff, 248

Murray, Albert, 24, 28n. 15

Murray, Ming Smith: biography of, 237; collecting work of, 12–13; works: Arthur Blythe in Space, 181; Gregory Hines, 180; Katherine Dunham and Her Legacy, 12–13, 116

Museum of Modern Art (N.Y.C.), 21, 24, 28n. 13, 79, 82

music: Catlett's references to, 82–83; consciousness organized via, 37. *See also* jazz music

NAACP (National Association for the Advancement of Colored People), 38, 71

narrative: in photography, 65-66; in prints, 79-85

Natanson, Nicholas, 74

National Conference of Artists (NCA), 46, 53n. 23, 223

National Endowment for the Arts, Visual Arts Program, 216

National Museum of Women in the Arts, 65

nature, 27, 39. See also landscapes

Nazi Germany, 55, 57

NCA. See National Conference of Artists

Negritude (concept), 19, 218

Negro Ensemble Company, 217

Nelson, George Preston, 34

New Federal Theater, 217

New Negro Movement: African art and, 48; influences on, 2, 85n. 1; Locke's hopes for art in, 80–81; photographs of, 244; Tanner as model for, 80; women's photographs in, 64

Newton, Isaac, 55, 56

New York City: photography gallery in, 76n. 3

New York City Board of Education, 229

Nexus Contemporary Art Center (now The Contemporary), 12

Nixon, Richard M., 90, 91, 92

Nkrumah, Kwame, 8, 218

Nolde, Emile, 47

North Carolina, 25-26

Odeleye, Ayokunle: biography of, 237–238; works: *Caring, 164* Odenthal, Andre, 42n. 39 Ohio State University, 83

oil pastels: Carter, 32 (detail), 33-41, 119

oils: Britt, 144; Burroughs, 46, 121; Feagin, 156; Gammon, 150; Little, 7, 125; Loper, 146, 166; Simon, 160; White, 11, 145

Older Women and Love (film), 221

Orangeburg (S.C.) Massacre, 50

Osborn, Alberta, 68 (detail), 74, 131

Oubre, Hayward Louis, Jr.: biography of, 238; as influence, 216; works: *Miscegenation*, 179

palette as color system, 57

Palmer Memorial Institute, 229, 233

Pan Africanism, 8, 218. See also Africa and Africanicity; New Negro Movement

papers, photographic, 97

Parthenon (Nashville, Tenn.), 6

pastels: Bailey, 8, 108; Johnson, 109. See also oil pastels

pattern: color coding and, 57-58

Patterson, Catherine "Kitty" Moton, 64, 65, 74, 189

Patterson, Frederick, 74

Paul R. Jones Collection: appreciation of, 89–93; description of, 7–13; eclecticism of, 5; exhibitions of, 6–7, 15n. 31, 105, 106; web site on, 93n. 2. *See also* Jones, Paul R.

Payne, Daniel A., 7

Pennsylvania Academy of Fine Arts, 80

performing arts: Bearden's references to, 23; photographic documentation of, 12–13, 116, 183–187, 217; possibilities in, 25

Perlman, William, 69

Perry, Regenia, 244

Philips, Mary S., 7

Phillips, Harper Trenholm: biography of, 238; works: *Untitled* (1980), 159

Phillips, Louella "Pip," 1

Photographers' Gallery (N.Y.), 227

Photographic Activity Test (PAT), 98

photography: black and white, 237; collecting of, 12–13; color, 96, 98, 99, 180; as documentation, 63–64; formal portraits in, 62–63; importance of, 61–62; as memory, 64–65; montages of, 17, 18, 21–23; as narrative, 65–66; preservation of, 95–100; professional studios for, 69–75. *See also* silver gelatin prints

Photo-Secession, 70, 76n. 3

Picasso, Pablo: artistic legacy of, 34; as influence, 20, 22, 219, 248; modernism and, 37; style of, 29n. 43; works: *Guernica*, 19

Picturing Us (anthology), 61-62

Pindell, Howardena: biography of, 238–239; style of, 235; works: *Untitled #35*, 11, 56, 124

Piper, Adrian, 47

plastics, photographic storage, 99

platinum prints, 96

Plato, 56

Poggi, Christine, 34

politics: color as metaphor in, 47–48; of fulfillment and of transformation, 37–38. *See also* civil rights movement

Polk, Margaret Blanche, 64, 72, 74, 130

Polk, Prentice Herman: biography of, 64, 72, 74, 239; Jones's relationship with, 12; studio of, 65, 72–73; style of, 73–75;

works: Alberta Osborn, 68 (detail), 74, 131; The Boss, 70, 75, 133; Catherine Moton Patterson, 64, 65, 74, 189; George Moore, 75, 134; George Washington Carver, 12, 72–73, 132, 239; Margaret Blanche Polk, 64, 74, 130; Mr. and Mrs. T. M. Campbell and Children, 190; The Pipe Smoker, 70

Pollock, Jackson, 34 Pope, Conrad, 76n. 9

Popular Graphics Workshop, 225

Porter, James A., 2, 82, 85n. 1, 218

Porter, Margaret, 39

portraiture: as documentation, 63–64; formal, 62–63; importance of, 61–62; as memory, 64–65; as narrative, 65–66. *See also* Polk. Prentice Herman

postcards, 85

postmodernism, 34–35

Povoleny (ceramicist), 222

Powell, Richard J., 3, 52n. 14, 79

Prendergast, Maurice, 237

preservation techniques: case study of, 94 (detail), 100, 142–143; challenges in, 95–97; issues in, 97–100

primitivism, 46-47, 48

prints and printmaking: exploring agency in, 79; Humphrey's work in, 230–231; narratives of, 79–85. *See also* block printing, subtractive; etchings; lithographs; serigraphs

Pritchard, William, 19 Projections (exhibition), 21 Prophet, Nancy Elizabeth, 248 Pullman Company, 18, 27, 72

Raab, Madeline, 39

race films, 71

railroads and trains, 26-27, 50

Randall, Dudley, 223

Randolph, A. Phillip, 3, 18, 19, 27

Rawls, Lou, 244

Ray, Maggie "Moch" Phillips, 1

Reason, Patrick, 81

red (color), 55, 58

religious themes: of Catlett, 82–83; of Crite, 226; as general influence, 85n. 4; of Guilford, 230; of Lewis, 83; of Tanner, 80

"Renaissance in Black" (television program), 240

representational imagery, 233. See also photography

Rice, Thomas Dartmouth "Daddy," 71

Richard Allen Cultural Center, 217

Riddle, John T.: biography of, 239–240; Jones's relationship with, 4; works: *Professor from Zimbabwe #1*, 104

Riley, Charles A., 57

Rivera, Diego, 219, 225

Rivers, William, 28n. 15

Roberts, Richard Samuel, 63

Robinson, Randall, 38

Rogoff, Irit, 5

Rollins, Sonny, 150

Romanticism, 52n. 8

Romare Bearden Foundation, 118, 153, 168

Roosevelt, Eleanor, 73

Roosevelt, Franklin Delano, 73, 222

Ruix, Jose L., 224

Rustin, Bayard, 3

Saar, Betye Irene (Brown): biography of, 240; works: The Conscience of the Court, 205; Magnolia Flower, 204; Mother Catherine, 203

Salazar, Martin, 101n. 11

Samuel Kootz Gallery, 18

Savage, Augusta, 217, 225, 234

Savings and Loan (Charlotte, N.C.), 6-7, 106

Scarborough, W. S., 81

Scarlet Letter, The (Hawthorne), 57

Schomburg, Arthur Alfonso, 7

Schomburg Center for Research in Black Culture, 79

SCLC (Southern Christian Leadership Conference), 8

sculpture, 230, 231, 238; brass: Burke, 11, 149, 222; bronze: Artis, 11, 213; clay, 222; marble: Hooks, 11, 171; wire: Oubre, 179

Scurlock, Addison N., 63

Scurlock, George, 63

Scurlock, Robert, 63

Sellers, Cleveland, 50

Selma (Ala.), 2, 91

Senghor, Léopold, 19

serigraphs: Beasley, 206–207; Catlett, 54 (detail), 58, 82–83, 123, 137, 105–106; Lawrence, 78 (detail), 82, 136; Saar, 203–205

Seyfert, Wylie, 24, 28n. 13

Shadow of the Bull (Wojciechowska, illus. Smith), 242

Shepherd, Harry, 63

Shinar, Imaniah (James E. Coleman, Jr.): biography of, 240–241; works: *Ebony Queen*, 154

Shuttlesworth, Fred L., 2

silver gelatin prints: conservation of, 100; process of, 95–97; storage of, 99; Alexander, 184–185; Anderson, 117; Andrews, 186–187; Bedou, 94 (detail), 100, 142–143; Caranda-Martin, 192–194; DeCarava, 191; Murray, 12–13, 116, 181; Polk, 12, 64, 65, 68 (detail), 70, 72–73, 74, 75, 130–134, 189, 190, 239; Sligh, 62–63, 65–66, 128; VanDerZee, 12, 63–64, 115, 129, 188; Wallace, 182–183; Weems, 60 (detail), 65, 127, 245

Simon, Jewel Woodard: biography of, 241; works: Lick, 160

Simpson, Merton, 19, 24

Sims, Sophronia "Sal" Phillips, 1

Siqueiros, David Alfaro, 225

skin color, 46, 56-58

Sligh, Clarissa: biography of, 241; collecting work of, 12; on meeting Jones, 62–63; works: *Portrait of Paul R. Jones*, 62–63, 65–66, 128

Smith, Alvin: biography of, 242; works: Untitled (1985), 55, 152

Smith, Bessie, 25

Smith, Beuford, 227

Smith, Cedric: biography of, 242; works: Coca-Cola, 167

SNCC (Student Nonviolent Coordinating Committee), 8

social protest art: attitudes toward, 19–20; Bearden on, 26; of

dadaists, 22–23; Woodruff's, 49

Society of Independent Artists, 229

Soles, Meredith K., 64

South: Confederate iconography in, 49–51; as cultural reservoir, 25–28; rural people of, 73, 74–75

South Africa, 36, 38–41 South America, 14n. 16

South Carolina State College, 46

Southeast Asia, 14n. 16

Southern Arts Federation, 12

Southern Christian Leadership Conference (SCLC), 8

South Side Community Center (Chicago), 45, 223, 229

Spelman College: artist in residence of, 8; exhibitions of, 10, 11, 15n. 31; photograph collection of, 101n. 11; works loaned to, 7 Spiral Group: abstract expressionism in, 48–49; Bearden's

role in, 17, 18–21; founders of, 219, 228–229, 248

Spriggs, Edward, 53n. 25

Steichen, Edward, 76n. 3

stereotypes: evolution of, 70; in films, 71; photographic contradictions to, 72–74; Polk's "old characters" as or not, 74–75

Stewart, Chuck, 217

Stewart, Frank, 12

Stieglitz, Alfred, 70, 76n. 3

Straw, Gerald, 13

String of Pearls, A (documentary), 221

Student Nonviolent Coordinating Committee (SNCC), 8

Styles, Freddie, 10

Sun Ra, 182

surrealism, 22-23, 222

Suzanne, Suzanne (film), 221

Take Your Bags (documentary), 221

Tanner, Benjamin Tucker, 80

Tanner, Henry Ossawa: biblical themes of, 80–81; biography of, 242–243; as influence, 248; mentioned, 52n. 8; works: *Annunciation XVIII*, 80; *Daniel in the Lion's Den*, 80; *Return to the Tomb*, 9, 80–81, 111

Tanner, Jessie MacCauley Olssen, 80

terra cotta, 218

Thomas, Alma Woodsey, 2, 14n. 2, 46, 47, 235

Thomas, Stefan, 73

Thompson, Margaret Blanche. See Polk, Margaret Blanche

Thompson, Mildred, 39

306 Group, 19, 28n. 8

Three Spirituals from Heaven (Crite), 226

Thunder's Mouth Press, 217

titles of works, 35, 36, 37, 39

Toulouse-Lautrec, Henri de, 5, 14n. 18

trains and railroads, 26-27, 50

Transafrica, 38

Troupe, Quincy, 39

Tucker, Lorenzo, 71

Turner, Nat, 85n. 4

Tuskegee (city): social elite of, 74, 76n. 13

Tuskegee Airmen, 73

Tuskegee University: photographic record of, 12, 64, 65, 73, 239; photography program of, 72; as place/model, 69

Twiggs, Leo F.: batik medium of, 49; biography of, 46, 243; color as used by, 48–49, 50–51; on color as used by African American artists, 53n. 26; Confederate iconography ex-

plored by, 49–51; Jones's relationship with, 9; one-person show of, 52n. 16; works: Confederate Flag series, 50; Low Country Landscape, 44 (detail), 51, 120; Old Man with Wide Tie, 9, 110; Silent Crossings series, 46

Tynes, Teri, 51 Tyson, Cicely, 217

United States Information Agency Arts Program, 230–231 universalism: of black people's suffering, 19; Carter's use of, 40–41; impossibility of, 35; interactive, discourse model of, 42n. 37

University of Delaware: art conservation program of, 100, 101nn. 10-11. See also Paul R. Jones Collection

University of Georgia, 46 University of Iowa, 82

VanDerZee, Donna Mussenden, 115

VanDerZee, Gaynella, 63

VanDerZee, James: biography of, 243–244; clientele of, 63–64; works: The Barefoot Prophet, 12, 63–64, 188; The Black Houdini, 64, 129; Couple in Raccoon Coats, 12, 115

Van Dyke, Yana, 100

"vision as critique" (concept), 5

Visual Arts Program (NEA), 216 visualization, 4–5, 25, 65–66

Wages of Sin (film), 71

Walker, Kara, 47, 53n. 28

Walker, Lawrence (Larry): biography of, 244; works: Prelude, 155

Wallace, William ("Onikwa Bill"): biography of, 244-245; reputation of, 13; works: Miles Davis and Axel McQuerry, 183; Sun Ra, 182

Warren, Michael, 29n. 31

Washington, Augustus, 63

Washington, Booker T.: educational goals of, 72; photographs of, 94 (detail), 100, 142–143

Washington, Denzel, 217

watercolors: Bearden, 153; Gorleigh, 165, 229; Guilford, 178; Mosely, 103; Watson, 112

Watson, Barrington: Jones's relationship with, 10; works: Reclining Nude, 112

Watts, Leah Kate Phillips, 1

Weeks, Edward F., 73

Weems, Carrie Mae: biography of, 65, 245; collecting work of, 12; narrated fictional photographs of, 65–66; photograph of, 65; works: *The Hampton Project*, 245; *Kitchen Table Series*, 60 (detail), 65, 127, 245; *Ritual and Revolution*, 245

Wells, James Lesesne, 2, 81

West, Cornel, 3, 69

Wheatley, Phillis, 81, 85n. 6

White, Charles: biography of, 45, 225, 246; as influence, 8–9, 233; Jones's relationship with, 9, 10–11, 15n. 31; works: *John Henry*, 11, 145; *Nude*, 11; *Prophet*, 11; *Vision*, 11, 177; *Wanted Poster Series # L-*5, 11

White, Dorothy, 39 white (color), 56, 58

Whitney Museum of American Art, 18, 28

Whitten, Jack: biography of, 246–247; style of, 11–12, 235; works: Annunciation XVIII, 11, 161; Untitled (1977), 114

Wilkin, Karen, 35

Williams, William T., 235

Wilson, August, 25

Wilson, John Woodrow: biography of, 83, 247; works (Richard Wright Series): Death of Lulu, 84, 139; The Death of Mann, 176; Embarkation, 84, 173; Journey of the Mann Family, 172; Light in the Window, 174; Mann Attacked, 175

Winterthur Museum, 100, 101nn. 10–11 Wolf, Jerome Miles, 13 Wollen, Peter, 34, 35 Women of Brewster Place, The (film), 219 women's rights, 224

Wood, Grant, 82

Woodard, Alfre, 187, 217

Woodruff, Hale Aspacio: associates of, 18, 19; biography of, 247–248; color as used by, 53n. 17; as influence, 46, 48–49, 241; Jones's relationship with, 9; racial identity of, 49; style of, 20; works: *Amistad* Murals, 248; *Celestial Gate*, 53n. 17; *Monkey Man #2*, 10, 113; *Torso*, 53n. 17

Works Progress Administration (WPA), 45, 236 Wright, Richard, 83–84

X: as symbol, 50

Yeargans, James, 19, 225 yellow (color), 55, 56, 57 Yolisa House (gallery), 39

Zadkine, Ossip, 224 Zuniga, Francisco, 224

ABOUT THE TYPE

This book was set in Scala, a family of typefaces by the Dutch type designer Martin Majoor. Designed in the 1980s as a proprietary typeface for use by the Vredenburg concert hall in Utrecht, the Netherlands, Scala was first issued in digital form by FontShop International, Berlin, in 1991, followed by a companion sans serif in 1993. Both Scala and Scala Sans are neohumanist typefaces, based on historical humanist letterforms, yet thoroughly modern and individual designs.

Designed and composed by Kevin Hanek

Printed and bound in China by Everbest Printing Company Limited

Brief Conte

Thematic Table of Contents xiii

Preface xv

Real Support for Instructors and Students xxx

A Note to Students from Susan Anker xxxiii

Part 1 How to Write Paragraphs and Essays 1

- 1. Critical Thinking, Reading, and Writing 3
- 2. Writing Basics 27
- Finding, Narrowing, and Exploring Your Topic 42
- **4.** Writing Your Topic Sentence or Thesis Statement 52
- 5. Supporting Your Point 68
- 6. Drafting 77
- 7. Revising 96

Part 2 Writing Different Kinds of Paragraphs and Essays 111

Narration 113

Illustration 132

- 10 Description 152
 - Process Analysis 170
- 12. Classification 188
- 13 Definition 207
- (14/ Comparison and Contrast 225
- 15. Cause and Effect 246
- **16.**) Argument 265

Part 3 Special College Writing Projects 289

- Writing Summaries, Reports, and Essay
 Exams 291
- **18.** Writing the Research Essay 302

Part 4 The Four Most Serious Errors 327

- 19. The Basic Sentence 329
- **20.** Fragments **3**41
- 21. Run-Ons 359
- 22. Problems with Subject-Verb Agreement

 377
- 23. Verb Tense 4 397

Part 5 Other Grammar Concerns 423

- **24.** Pronouns 425
- 25. Adjectives and Adverbs 448
- 26. Misplaced and Dangling Modifiers 458
- 27. Coordination and Subordination 465
- 28. Parallelism 478
- Sentence Variety 486
- 30. Formal English and ESL Concerns 499

Part 6 Word Use 533

- 31. Word Choice 535
- 32. Commonly Confused Words 545
- 33. Spelling 557

Part 7 Punctuation and Capitalization 565

- **34.** Commas **5**67
- 35. Apostrophes 582
- 36. Quotation Marks 590
- 37. Other Punctuation 598
- 38. Capitalization 4 604

EDITING REVIEW TESTS 1-10 609

Part 8 Readings for Writers 619

- 3. Narration 621
- An Illustration 629
- 41. Description 638
- 42. Process Analysis 648
- 43. Classification 657
- 44. Definition 667
- Comparison and Contrast 675
- 46. Cause and Effect 687
- 47) Argument 696

Index I-1

Real Take-Away Points

Editing and Proofreading Marks

For Easy Reference: Selected Lists and Charts

COMPANY AND THE BUT PROPERTY AND THE STATE OF THE STATE O

ternolities and resident termination and resident

Acquestion of the American Services of Ser

Real Writing with Readings

Paragraphs and Essays for College, Work, and Everyday Life

Susan Anker

Bedford / St. Martin's
Boston ◆ New York

For Bedford/St. Martin's

Senior Executive Editor, College Success and Developmental Studies: Edwin Hill

Executive Editor, Developmental Studies: Alexis Walker

Senior Developmental Editor: Martha Bustin Senior Production Editor: Deborah Baker Senior Production Supervisor: Jennifer Peterson Senior Marketing Manager: Christina Shea

Editorial Assistants: Amanda Legee, Regina Tavani

Copy Editor: Kathleen Lafferty

Indexer: Mary White

Photo Researcher: Naomi Kornhauser Permissions Manager: Kalina K. Ingham Senior Art Director: Anna Palchik Cover Design: Billy Boardman

Cover Photos: Front: © Sam Bloomberg-Rissman/Getty Images. Back: Joel Beaman

Composition: Graphic World Inc.

Printing and Binding: RR Donnelley and Sons

President, Bedford / St. Martin's: Denise B. Wydra

Presidents, Macmillan Higher Education: Joan E. Feinberg and Tom Scotty

Editor in Chief: Karen S. Henry Director of Marketing: Karen R. Soeltz Production Director: Susan W. Brown Associate Production Director: Elise S. Kaiser Managing Editor: Elizabeth M. Schaaf

Library of Congress Control Number: 2012935726

Copyright © 2013, 2010, 2007, 2004 by Bedford/St. Martin's

All rights reserved. No part of this book may be reproduced, stored in a retrieval system, or transmitted in any form or by any means, electronic, mechanical, photocopying, recording, or otherwise, except as may be expressly permitted by the applicable copyright statutes or in writing by the Publisher.

Manufactured in the United States of America.

7 6 5 4 3 2 f e d c b a

For information, write: Bedford/St. Martin's, 75 Arlington Street, Boston, MA 02116 (617-399-4000)

ISBN 978-1-4576-0199-6 (Student Edition) ISBN 978-1-4576-2425-4 (Loose-leaf Edition) ISBN 978-1-4576-2396-7 (Instructor's Annotated Edition)

Acknowledgments

Acknowledgments and copyrights are continued at the back of the book on pages 717–18, which constitute an extension of the copyright page. It is a violation of the law to reproduce these selections by any means whatsoever without the written permission of the copyright holder.

Contents

Thematic Table of Contents xiii

Preface xv

Real Support for Instructors and Students xxx

A Note to Students from Susan Anker xxxiii

Part 1 How to Write Paragraphs and Essays 1

1. Critical Thinking, Reading, and Writing: Making Connections 3

What Is Critical Thinking? 6

- FOUR BASICS OF CRITICAL THINKING 7
 What Is Critical Reading? 9
- 2PR: The Critical Reading Process 9

Amanda Jacobowitz, A Ban on Water Bottles: A Way to Bolster the University's Image 12

What Is Writing Critically about Readings? 16

■ Reading and Writing Critically 16

What Is Writing Critically about Visuals? 21

What Is Problem Solving? 24 Chapter Review 26

2. Writing Basics: Audience, Purpose, and Process 27

FOUR BASICS OF GOOD WRITING 27

Understand Audience and Purpose 27

DIAGRAM: Relationship between Paragraphs and Essays 32

Understand the Writing Process 34 Understand Grading Criteria 35 Chapter Review 41 3. Finding, Narrowing, and Exploring Your Topic: Choosing Something to Write About 42

Understand What a Topic Is 42
Practice Narrowing a Topic 43
Practice Exploring Your Topic 46
Write Your Own Topic and Ideas 50
Chapter Review 50

4. Writing Your Topic Sentence or Thesis Statement: Making Your Point 52

Understand What a Topic Sentence and a Thesis Statement Are 52

Practice Developing a Good Topic Sentence or Thesis Statement 55

> DIAGRAM: Relationship between Paragraphs and Essays 56

Write Your Own Topic Sentence or Thesis Statement 64

Chapter Review 66

5. Supporting Your Point: Finding Details, Examples, and Facts 68

Understand What Support Is 68
Practice Supporting a Main Point 71
Write Your Own Support 73
Chapter Review 75

6. Drafting: Putting Your Ideas Together 77

> Understand What a Draft Is 77 Arrange Your Ideas 78 Make a Plan 80

Practice Writing a Draft Paragraph 82
Practice Writing a Draft Essay 84
Write Your Own Draft Paragraph or
Essay 91
Chapter Review 94

7. Revising: Improving Your Paragraph or Essay 96

Understand What Revision Is 96
Understand What Peer Review Is 97
Practice Revising for Unity, Detail, and Coherence 98
Revise Your Own Paragraph 105
Revise Your Own Essay 107
Chapter Review 109

Part 2 Writing Different Kinds of Paragraphs and Essays 111

8. Narration: Writing That Tells Important Stories 113

Understand What Narration Is 113

FOUR BASICS OF GOOD NARRATION 113

Main Point in Narration 115

Support in Narration 116

DIAGRAM: Paragraphs vs. Essays in Narration 118

Organization in Narration 121

Read and Analyze Narration 123

PROFILE OF SUCCESS: Kelly Layland, Registered Nurse 123

Student Paragraph: Jelani Lynch: My Turnaround 124

Professional Essay: Amy Tan, Fish Cheeks 126

Write Your Own Narration (Assignments) 128

Writing about College, Work, and Everyday Life 128

Reading and Writing Critically 128

Writing Critically about Readings 129

Writing about Images 129

Writing to Solve a Problem 130

Checklist and Chapter Review 130

9. Illustration: Writing That Gives Examples 132

Understand What Illustration Is 132

FOUR BASICS OF GOOD ILLUSTRATION 132

Main Point in Illustration 134

Support in Illustration 135

DIAGRAM: Paragraphs vs. Essays in Illustration 136

Organization in Illustration 139

Read and Analyze Illustration 140

PROFILE OF SUCCESS: Karen Upright, Systems Manager 140

Student Paragraph: Casandra Palmer, Gifts from the Heart 142

Professional Essay: Susan Adams, The Weirdest Job Interview Questions and How to Handle Them 144

Write Your Own Illustration (Assignments) 147

Writing about College, Work, and Everyday Life 147

Reading and Writing Critically 148

Writing Critically about Readings 148

Writing about Images 149

Writing to Solve a Problem 150

Checklist and Chapter Review 150

10. Description: Writing That Creates Pictures in Words 152

Understand What Description Is 152

FOUR BASICS OF GOOD DESCRIPTION 152

Main Point in Description 154

Support in Description 156

DIAGRAM: Paragraphs vs. Essays in Description 158

Organization in Description 160

Read and Analyze Description 161

PROFILE OF SUCCESS: Celia Hyde, Chief of Police 161

Student Paragraph: Alessandra Cepeda, *Bird Rescue* 163

Professional Essay: Oscar Hijuelos, *Memories of New York City Snow* 164

Write Your Own Description (Assignments) 166

Writing about College, Work, and Everyday Life 166

Reading and Writing Critically 167
Writing Critically about Readings 167
Writing about Images 167
Writing to Solve a Problem 168
Checklist and Chapter Review 169
The second of the second of the second

11. Process Analysis: Writing That Explains How Things Happen 170

Understand What Process Analysis Is 170

FOUR BASICS OF GOOD PROCESS ANALYSIS 170

Main Point in Process Analysis 172

Support in Process Analysis 172

DIAGRAM: Paragraphs vs. Essays in Process Analysis 174

Organization in Process Analysis 176

Read and Analyze Process Analysis 176

PROFILE OF SUCCESS: Jeremy Graham, Youth Pastor and Motivational Speaker 177

Student Paragraph: Charlton Brown, *Buying a Car at an Auction* 178

Professional Essay: Ian Frazier, How to Operate the Shower Curtain 179

Write Your Own Process Analysis (Assignments) 183

Writing about College, Work, and Everyday

Life 183
Reading and Writing Critically 184

Writing Critically about Readings 184

Writing about Images 184

Writing to Solve a Problem 185

Checklist and Chapter Review 186

12. Classification: Writing That Sorts Things into Groups 188

Understand What Classification Is 188

FOUR BASICS OF GOOD CLASSIFICATION 188

Main Point in Classification 190

Support in Classification 193

DIAGRAM: Paragraphs vs. Essays in Classification 194

Organization in Classification 196

Read and Analyze Classification 197

PROFILE OF SUCCESS: Leigh King, Fashion Writer / Blogger 197

Student Paragraph: Lorenza Mattazi, All My Music 198

Professional Essay: Frances Cole Jones, L. Work in a Goat's Stomach 199

Write Your Own Classification (Assignments) 202

Writing about College, Work, and Everyday Life 202

Reading and Writing Critically 203

Writing Critically about Readings 203

Writing about Images 204

Writing to Solve a Problem 204

Checklist and Chapter Review 205

13. Definition: Writing That Tells What Something Means 207

Understand What Definition Is 207

FOUR BASICS OF GOOD DEFINITION 207

Main Point in Definition 209

Support in Definition 210

DIAGRAM: Paragraphs vs. Essays in Definition 212

Organization in Definition 214

Read and Analyze Definition 214

PROFILE OF SUCCESS: Walter Scanlon, Program and Workplace Consultant 215

Student Paragraph: Corin Costas, What Community Involvement Means to Me 216

Professional Essay: Janice E. Castro with Dan Cook and Cristina Garcia, *Spanglish* 218

Write Your Own Definition (Assignments) 220

Writing about College, Work, and Everyday Life 221

Reading and Writing Critically 221

Writing Critically about Readings 222

Writing about Images 222

Writing to Solve a Problem 223

Checklist and Chapter Review 223

14. Comparison and Contrast: Writing That Shows Similarities and Differences 225

Understand What Comparison and Contrast Are 225

FOUR BASICS OF GOOD COMPARISON AND CONTRAST 225

Main Point in Comparison and Contrast 228 Support in Comparison and Contrast 229 DIAGRAM: Paragraphs vs. Essays in Comparison and Contrast 230

Organization in Comparison and Contrast 232

Read and Analyze Comparison and Contrast 235

PROFILE OF SUCCESS: Brad Leibov, President, New Chicago Fund, Inc. 236

Student Paragraph: Said Ibrahim, Eyeglasses vs. Laser Surgery: Benefits and Drawbacks 237

Professional Essay: Mark Twain, Two Ways of Seeing a River 238

Write Your Own Comparison and Contrast (Assignments) 240

Writing about College, Work, and Everyday Life 240

Reading and Writing Critically 241

Writing Critically about Readings 241

Writing about Images 242

Writing to Solve a Problem 243

Checklist and Chapter Review 244

15. Cause and Effect: Writing That Explains Reasons or Results 246

Understand What Cause and Effect Are 246

FOUR BASICS OF GOOD CAUSE AND EFFECT 246

Main Point in Cause and Effect 250

Support in Cause and Effect 251

DIAGRAM: Paragraphs vs. Essays in Cause and Effect 252

Organization in Cause and Effect 254

Read and Analyze Cause and Effect 255

PROFILE OF SUCCESS: Mary LaCue Booker, Singer, Actor 256

Student Paragraph: Caitlin Prokop, A Difficult Decision with a Positive Outcome 257

Professional Essay: Kristen Ziman, Bad Attitudes and Glowworms 259

Write Your Own Cause and Effect (Assignments) 261

Writing about College, Work, and Everyday Life 261

Reading and Writing Critically 262

Writing Critically about Readings 262

Writing about Images 263

Writing to Solve a Problem 263

Checklist and Chapter Review 264

16. Argument: Writing That Persuades 265

Understand What Argument Is 265

FOUR BASICS OF GOOD ARGUMENT 265

Main Point in Argument 267

Support in Argument 268

DIAGRAM: Paragraphs vs. Essays in Argument 270

Organization in Argument 276

Read and Analyze Argument 278

PROFILE OF SUCCESS: Diane Melancon, Oncologist 279

Student Essay 1: "Yes" to Social Media in Education: Jason Yilmaz, *A Learning Tool Whose Time Has Come* 281

Student Essay 2: "No" to Social Media in Education: Shari Beck, *A Classroom Distraction—and Worse* 282

Write Your Own Argument (Assignments) 284

Writing about College, Work, and Everyday Life 284

Reading and Writing Critically 285

Writing Critically about Readings 285

Writing about Images 286

Writing to Solve a Problem 287

Checklist and Chapter Review 287

Part 3 Special College Writing Projects 289

17. Writing Summaries, Reports, and Essay Exams: Showing What You Have Learned 291

Write a Summary 291

FOUR BASICS OF A GOOD SUMMARY 291

Write a Report 295

FOUR BASICS OF A GOOD REPORT 295

Write a Response to an Essay Exam Question 298

FOUR BASICS OF A GOOD RESPONSE TO AN ESSAY QUESTION 299

Chapter Review 301

18. Writing the Research Essay: Using Sources in Your Writing 302

Make a Schedule 302 Choose a Topic 303 Find Sources 304 Evaluate Sources 307 Avoid Plagiarism 310 Cite and Document Your Sources 313 DIRECTORY OF MLA IN-TEXT CITATIONS 314 DIRECTORY OF MLA WORKS CITED 316

Student Research Essay: Dara Riesler. Service Dogs Help Heal the Mental Wounds of War 319

Part 4 The Four Most Serious Errors

19. The Basic Sentence: An Overview 329

The Four Most Serious Errors 329 The Parts of Speech 329 The Basic Sentence 331 Ohaptor Roview and Test 339

20. Fragments: Incomplete Sentences 341

Understand What Fragments Are 341 Find and Correct Fragments 342 Edit for Fragments 353 Chapter Review and Test 356

21. Run-Ons: Two Sentences Joined Incorrectly 359

Understand What Run-Ons Are 359 Find and Correct Run-Ons 361 Edit for Run-Ons 371 Chapter Review and Test 373

22. Problems with Subject-Verb **Agreement: When Subjects and** Verbs Don't Match 377

Understand What Subject-Verb Agreement Is 377 Find and Correct Errors in Subject-Verb Agreement 379

Edit for Subject-Verb Agreement Chapter Review and Test 393

23. Verb Tense: Using Verbs to Express Different Times 397

Understand What Verb Tense Is 397 Practice Using Correct Verbs 398 Edit for Verb Problems 416 Chapter Review and Test 418

Part 5 Other Grammar Concerns

24. Pronouns: Using Substitutes for Nouns 425

Understand What Pronouns Are 425 Practice Using Pronouns Correctly 425 Edit for Pronoun Problems 442 Chapter Review and Test 444

25. Adjectives and Adverbs: Using **Descriptive Words** 448

Understand What Adjectives and Adverbs Are 448 Practice Using Adjectives and Adverbs Correctly 449 Edit for Adjective and Adverb Problems 454 Chapter Review and Test 455

26. Misplaced and Dangling **Modifiers: Avoiding Confusing Descriptions** 458

Understand What Misplaced Modifiers Are 458 **Practice Correcting Misplaced** Modifiers 459 **Understand What Dangling Modifiers** Are 460 Practice Correcting Dangling Modifiers 460 Edit for Misplaced and Dangling Modifiers 461 Chapter Review and Test 462

27. Coordination and Subordination: Joining Sentences with Related Ideas 465

Understand What Coordination Is 465
Practice Using Coordination 465
Understand What Subordination Is 471
Practice Using Subordination 471
Edit for Coordination and Subordination 474
Chapter Review and Test 475

28. Parallelism: Balancing Ideas 478

Understand What Parallelism Is 478
Practice Writing Parallel Sentences 479
Edit for Parallelism Problems 483
Chapter Review and Test 484

29. Sentence Variety: Putting Rhythm in Your Writing 486

Understand What Sentence Variety Is 486
Practice Creating Sentence Variety 487
Edit for Sentence Variety 496
Chapter Review and Test 497

30. Formal English and ESL Concerns: Grammar Trouble Spots for Multilingual Students 499

Basic Sentence Patterns 499
Pronouns 505
Verbs 507
Articles 524
Prepositions 527
Chapter Review and Test 530

Part 6 Word Use 533

31. Word Choice: Using the Right Words 535

 Understand the Importance of Choosing Words Carefully 535
 Practice Avoiding Four Common Word-Choice Problems 536
 Edit for Word Choice 542
 Chapter Review and Test 542

32. Commonly Confused Words: Avoiding Mistakes with Soundalike Words 545

Understand Why Certain Words Are
Commonly Confused 545

Practice Using Commonly Confused Words
Correctly 545

Edit for Commonly Confused Words 555

Chapter Review and Test 556

33. Spelling: Using the Right Letters 557

Finding and Correcting Spelling
Mistakes 557
Strategies for Becoming a Better
Speller 558
Chapter Review and Test 563

Part 7 Punctuation and Capitalization 565

34. Commas (,) 567

Understand What Commas Do 567
Practice Using Commas Correctly 567
Edit for Commas 578
Chapter Review and Test 579

35. Apostrophes (¹) 582

Understand What Apostrophes Do 582
Practice Using Apostrophes Correctly 582
Edit for Apostrophes 587
Chapter Review and Test 588

36. Quotation Marks ("") 590

Understand What Quotation Marks Do 590
Practice Using Quotation Marks
Correctly 590
Edit for Quotation Marks 595
Chapter Review and Test 596

37. Other Punctuation (;:() ---) 598

Understand What Punctuation Does 598
Practice Using Punctuation Correctly 598
Edit for Other Punctuation Marks 601
Chapter Review and Test 602

38. Capitalization: Using Capital Letters 604

Understand Three Rules of Capitalization 604 Practice Capitalization 604 Chapter Review and Test 607

EDITING REVIEW TESTS 1-10 609

Part 8 Readings for Writers 619

39. Narration 621

Lauren Mack. Gel Pens 622 Pat Conroy, Chili Cheese Dogs, My Father, and Me 625

40. Illustration 629

True Shields, To Stand in Giants' Shadows 629 Dianne Hales, Why Are We So Angry? 634

41. Description 638

Brian Healy, First Day in Fallulah 638 Eric Liu, Po-Po in Chinatown 642

42. Process Analysis 648

Jasen Beverly, My Pilgrimage 648 Sherman Alexie, The Joy of Reading and Writing: Superman and Me 652

43. Classification 657

Kelly Hultgren, Pick Up the Phone to Call, Not Text 657 Stephanie Ericsson, The Ways We Lie 661

44. Definition 667

John Around Him, Free Money 667 Michael Thompson, Passage into Manhood 671

45. Comparison and Contrast 675

Courtney Stoker, The Great Debate: Essentialism vs. Dominance 675 Judith Ortiz Cofer, Don't Misread My Signals 682

46. Cause and Effect 687

Holly Moeller, Say, Don't Spray 687 John Tierney, Yes, Money Can Buy Happiness 692

47. Argument 696

SNITCHING 696

Robert Phansalkar, Stop Snitchin' Won't Stop Crime 697

Bill Maxwell, Start Snitching 700

Alexandra Natapoff, Bait and Snitch: The High Cost of Snitching for Law Enforcement 703

RIGHTS FOR ILLEGAL IMMIGRANTS 708

Heather Rushall, Dream Act Is Finance Fantasy 708

Dominic Deiro, I Have a DREAM 712

Index I-1 Real Take-Away Points **Editing and Proofreading Marks** For Easy Reference: Selected Lists and Charts ix ____

TO BE SEED OF MORE THAN I SHARE

Teal Toethaland Resident Pa

TO SERVICE THE SERVICE OF THE SERVIC

246,000,000

A STATE OF THE PROPERTY OF THE

To each Albert News, plant?

100 Supplies pate 2

100 Applies provide 3

the college for AVERGO and

Appga uz erkere artir arien en eller. Heren

The second of the control of the con

Thematic Table of Contents

Education

- Jason Yilmaz, A Learning Tool Whose Time Has
 Come (argument) 281
- Shari Beck, A Classroom Distraction—and Worse (argument) 282
- Jasen Beverly, My Pilgrimage (process analysis) 648
- Sherman Alexie, The Joy of Reading and Writing: Superman and Me (process analysis) 652
- John Around Him, Free Money (definition) 667
- Heather Rushall, *Dream Act Is Finance Fantasy* (argument) 708
- Dominic Deiro, *I Have a DREAM* (argument) 712

Humor

- Amy Tan, Fish Cheeks (narration) 126
- Susan Adams, The Weirdest Job Interview Questions and How to Handle Them (illustration) 144
- Ian Frazier, How to Operate the Shower Curtain (process analysis) 179
- Frances Cole Jones, *Don't Work in a Goat's Stomach* (classification) 199

Language and Communication

- Susan Adams, The Weirdest Job Interview Questions and How to Handle Them (illustration) 144
- Janice E. Castro with Dan Cook and Cristina Garcia, Spanglish (definition) 218
- Kelly Hultgren, *Pick Up the Phone to Call*, *Not Text* (classification) 657
- Stephanie Ericsson, *The Ways We Lie* (classification) 661

Courtney Stoker, *The Great Debate:*Essentialism vs. Dominance (comparison/contrast) 675

Personal Stories

- Amy Tan, Fish Cheeks (narration) 126
- Oscar Hijuelos, Memories of New York City Snow (description) 164
- Mark Twain, Two Ways of Seeing a River (comparison/contrast) 238
- Lauren Mack, Gel Pens (narration) 622
- Pat Conroy, Chili Cheese Dogs, My Father, and Me (narration) 625
- True Shields, To Stand in Giants' Shadows (illustration) 629
- Brian Healy, First Day in Fallujah (description) 638
- Eric Liu, *Po-Po in Chinatown* (description) 642
- Jasen Beverly, My Pilgrimage (process analysis) 648
- Sherman Alexie, *The Joy of Reading and Writing: Superman and Me* (process analysis) 657
- Judith Ortiz Cofer, *Don't Misread My Signals* (comparison/contrast) 682

Psychology: Behavior and the Mind

- Kristen Ziman, Bad Attitudes and Glowworms (cause/effect) 259
- Dara Riesler, Service Dogs Help Heal the Mental Wounds of War (argument) 320
- Dianne Hales, Why Are We So Angry? (illustration) 634
- Brian Healy, First Day in Fallujah (description) 638

- Stephanie Ericsson, *The Ways We Lie* (classification) 661
- Michael Thompson, Passage into Manhood (definition) 671
- Courtney Stoker, The Great Debate: Essentialism vs. Dominance (comparison/contrast) 675
- John Tierney, Yes, Money Can Buy Happiness (cause/effect) 692

Social Issues and Challenges

- Amanda Jacobowitz, A Ban on Water Bottles: A Way to Bolster the University's Image (argument) 12
- Jason Yilmaz, A Learning Tool Whose Time Has Come (argument) 281
- Shari Beck, A Classroom Distraction—and Worse (argument) 282
- Dara Riesler, Service Dogs Help Heal the Mental Wounds of War (argument) 320
- Brian Healy, First Day in Fallujah (description) 638
- Stephanie Ericsson, *The Ways We Lie* (classification) 661
- Michael Thompson, Passage into Manhood (definition) 671
- Holly Moeller, Say, Don't Spray (cause/effect) 687
- Courtney Stoker, *The Great Debate: Essentialism* vs. Dominance (comparison/contrast) 675
- Robert Phansalkar, Stop Snitchin' Won't Stop Crime (argument) 697
- Bill Maxwell, Start Snitching (argument) 700
- Alexandra Natapoff, Bait and Snitch: The High Cost of Snitching for Law Enforcement (argument) 703

- Heather Rushall, *Dream Act Is Finance Fantasy* (argument) 708
- Dominic Deiro, *I Have a DREAM* (argument) 712

Trends

- Amanda Jacobowitz, A Ban on Water Bottles: A Way to Bolster the University's Image (argument) 12
- Janice E. Castro with Dan Cook and Cristina Garcia, *Spanglish* (definition) 218
- Jason Yilmaz, A Learning Tool Whose Time Has
 Come (argument) 281
- Shari Beck, A Classroom Distraction—and Worse (argument) 282
- Dianne Hales, Why Are We So Angry? (illustration) 634
- Kelly Hultgren, *Pick Up the Phone to Call, Not Text* (classification) 657
- Holly Moeller, Say, Don't Spray (cause/effect) 687
- John Tierney, Yes, Money Can Buy Happiness (cause/effect) 692

Work

- Susan Adams, The Weirdest Job Interview
 Questions and How to Handle Them
 (illustration) 144
- Frances Cole Jones, *Don't Work in a Goat's Stomach* (classification) 199
- Mark Twain, Two Ways of Seeing a River (comparison/contrast) 238
- Kristen Ziman, Bad Attitudes and Glowworms (cause/effect) 259
- Brian Healy, First Day in Fallujah (description) 638

Preface

From its first edition to the present, *Real Writing*'s central message to students has been that good writing is not only *essential* but also *achievable*. In support of this message, the book provides both an engaging real-world context for writing and an abundance of engaging exercises and activities that will help students write strong sentences, paragraphs, and essays.

Real Writing reframes writing for students who view it as irrelevant, impossible, as an activity that only other people do, or as an arbitrary requirement, externally imposed. Instead, the text presents writing and the work of the writing class as potentially life-altering: eminently learnable and worthy of students' own best efforts. In small and large ways, Real Writing is designed to help students connect the writing course to their other courses, to their real lives, and to the expectations of the larger world.

Core Features

The core features that have worked so well for so many instructors and students in previous editions of *Real Writing* continue to anchor this edition.

MOTIVATES STUDENTS WITH A REAL-WORLD EMPHASIS

 Profiles of Success showcase former students who have overcome challenges to succeed in college and in life. Now employed in a range of professions, these inspiring individuals give examples of their

workplace writing, explaining why writing skills are important in their jobs, and helping students connect those skills with their own long-term goals. New profiles in this edition showcase a youth pastor and motivational speaker, a fashion writer and blogger, and a doctor.

PROFILE OF SUCCESS

Narration in the Real World

Background In high school, I was not a good student. I had a lot of other things to do, like having fun. I am a very social person; I loved my friends, and we had a great time. But when I decided I wanted to go to college, I had to pay the price. I had to take lots of noncredit courses to get my skills up to college level because I had fooled around during high school. The noncredit English course I took was very beneficial to me. After I passed it, I took English 101 and felt prepared for it.

Degrees/Colleges A.S., Monroe Community College; LPN, Isabella Graham Hart School of Nursing; RN, Monroe Community College

Employer Rochester General Hospital

Writing at work I write nursing notes that are narratives of patients' changing conditions and the level of care required. When I describe physical conditions, I have to support my descriptions with detailed examples. When I recommend medication for treatment, I have to justify it by explaining the patient's condition and the reasons I am making the recommendation. I also

Kelly Layland

- **Community Connections" sidebars offer mini-profiles of students whose engagement in college and community activities has helped them forge connections, stay in school, and build a path to future success.
- Numerous models of student and professional writing address such real-world issues and concerns as answering challenging job-interview questions, buying a car at an auction, and staying organized at work.

PRESENTS WRITING SKILLS IN MANAGEABLE INCREMENTS

Four Basics boxes guide students to focus first on the most important elements of writing. For example, the "Four Basics of Good Writing" stresses audience; purpose; a clear, definite main point; and support. In addition, each chapter in Part 2, "Writing Different Kinds of Paragraphs and

Essays," begins with the four key points to remember about the particular type of writing being discussed, followed by models that are color-coded to show the four basics at work.

■ End-of-chapter writing guides give students step-by-step advice as they write and revise their papers.

MAKES GRAMMAR LESS OVERWHELMING

A focus, initially, on the four most serious errors—fragments, run-ons, subject-verb agreement problems, and verb-tense problems—helps students avoid or fix the grammar mistakes that count against them most in college and the real world. Once

xvii

students master these four topics and start building their editing skills, they are better prepared to tackle the grammar errors treated in later chapters.

■ "Find and Fix" boxes and end-of-chapter review charts visually summarize key information and make excellent review and reference tools. ▼

New Features

Helpful input from many instructors and students guided us in making the following changes in this edition.

NEW INTEGRATED MEDIA: LEARNINGCURVE ACTIVITIES

Learning Curve, innovative online quizzing, lets students learn at their own pace. Each new copy of *Real Writing* now comes with access to Learning Curve, featuring a game-like interface that encourages them to keep at it. Quizzes are keyed to grammar instruction in the book, so what is taught in class gets reinforced at home. Instructors can also check in on each student's activity in a grade book.

A student access code is printed in every new student copy of *Real Writing* and *Real Writing with Readings*. Students who do not purchase a new print book can purchase access by going to bedfordstmartins.com/realwriting/LC. Instructors can also get access at this site.

NOTE: LearningCurve is also available in *WritingClass* and *SkillsClass* (see p. xxii), so if you are using either of these, encourage your students to access it there.

MORE HELP WITH CRITICAL THINKING, READING, AND WRITING

As we sought feedback from instructors, a major point of consensus emerged: Educators want to do more to build students' critical thinking skills, and with good reason. These skills are crucial not only for academic success but also for success in the workplace. According to the 2010 Critical Skills Survey of the American Management Association, the ability to think critically is one of the most in-demand competencies in the workplace.

Accordingly, a new Chapter 1, "Critical Thinking, Reading, and Writing," covers key academic skills, such as questioning assumptions; considering and connecting various points of view; and summarizing, analyzing, synthesizing, and evaluating source material. Examples and activities begin with what students already know; encourage them to examine preconceptions and draw thoughtful conclusions about readings, visuals, and real-life problems; and support transfer of these critical thinking, reading, and writing skills to other college courses and to the workplace.

Jess: I've been thinking about it a lot, Mar, and I really need to quit school.

Maryn: Really? You were so excited about it last summer.

The conversation between Jess and Maryn illustrates some important processes behind critical thinking.

Four Basics of Critical Thinking

- Be alert to assumptions made by you and others.
- 2 Question those assumptions.
 - Consider and connect various points of view, even those different from your own.
- Do not rush to conclusions, but instead remain patient with yourself and others and keep an open mind.

- New Reading and Writing Critically assignments in later chapters ask students to apply what they learned in Chapter 1. Additionally, the popular "College, Work, and Everyday Life" assignments have been revised to support transfer of critical thinking skills to multiple contexts.
- An expanded argument chapter (Chapter 16) also builds on the critical thinking skills students learned in Chapter 1, encouraging them to question assumptions as they search for evidence, a strategy that will help them create sound, well-supported arguments.

MORE EFFICIENT, VISUAL PRESENTATION OF INSTRUCTION

■ New color-coded charts give students a quick, at-a-glance understanding of the similarities and differences between writing paragraphs and writing essays. ▼

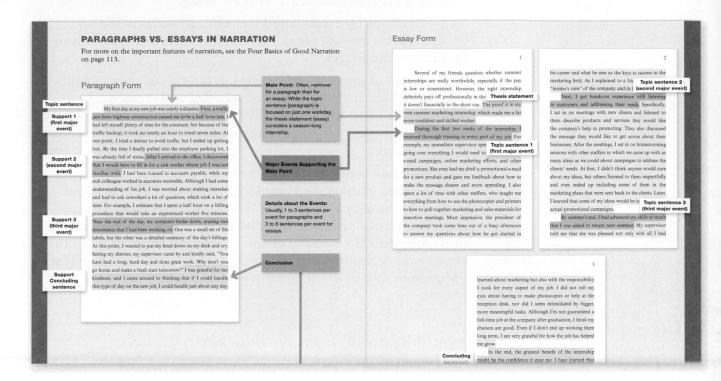

New, carefully selected images, many drawn from photojournalism and the world of contemporary photography, form the basis of two activity threads: writing prompts that help students visualize and understand the various rhetorical modes ("Seeing Narration," "Seeing Illustration," and so on) and "Writing about an Image" assignments, which ask students to apply the critical thinking skills introduced in Chapter 1.

Writing about Images

Study the photograph below, and complete the following steps.

1. Read the image You could explain to a friend what a sinkhole is, or you could show your friend the picture below. What makes this photograph such a striking visual definition? (For more on reading images, see Chapter 1.)

MANY NEW READINGS, WITH A BROADER RANGE OF AUTHORS AND TOPICS

- **Forty-six new readings** comprise more than half of the book's seventy-eight readings and provide an abundance of fresh, thought-provoking material for discussion and writing.
- New selections by established writers such as Amy Tan and Oscar Hijuelos now appear in Part 2, "Writing Different Kinds of Paragraphs and Essays."
- A larger set of argument readings in the expanded argument chapter includes paired readings on whether undocumented immigrants should be granted rights to financial aid and citizenship. The chapter retains the popular arguments on "snitching" from the previous edition.
- Engaging new student writing includes essays debating the pros and cons of using social media in education; "Service Dogs Help Heal the Mental Wounds of War," a research paper about how companion dogs assist veterans suffering from post-traumatic stress disorder; "To Stand in Giants' Shadows," an essay about the importance of mentors; and "Pick Up the Phone to Call, Not Text," a humorous look at the different types of texters.

You Get More with Real Writing, Sixth Edition

Real Writing does not stop with a book. Online and in print, you will find both free and affordable premium resources to help students get even more out of the book and your course. You will also find free, convenient instructor resources, such as a downloadable instructor's manual, additional exercises, and PowerPoint slides.

For information on ordering and to get ISBNs for packaging these resources with your students' books, see pages xxiv–xxv. You can also contact your Bedford/St. Martin's sales representative, e-mail sales support (sales_support@bfwpub.com), or visit bedfordstmartins.com/realwriting/catalog.

In the descriptions of resources below, the icon showing a book indicates a print ancillary. The icon showing a computer screen or disk indicates a media option.

STUDENT RESOURCES

Free and Open

Real Writing's free companion Web site, The Student Site for Real Writing, at bedfordstmartins.com/realwriting, provides students with supplemental exercises from Exercise Central, helpful guidelines on avoiding plagiarism and doing research, annotated model essays, advice on writing for the workplace, graphic

- organizers and peer review forms for all modes of writing covered in the book, and links to other useful resources from Bedford/St. Martin's.
- Exercise Central at bedfordstmartins.com/exercisecentral is the largest database of editing exercises on the Internet—and it is completely **free**. This comprehensive resource contains over 9,000 exercises that offer immediate feedback; the program also recommends personalized study plans and provides tutorials for common problems. Best of all, students' work reports to a grade book, allowing instructors to track students' progress quickly and easily.

Free with the Print Text

- Supplemental Exercises for *Real Writing with Readings*, Sixth Edition, offers more than one hundred additional practices to accompany the editing and research chapters of *Real Writing*. ISBN: 978-1-4576-2431-5
- Quick Reference Card. Students can prop this handy three-panel card up next to their computers for easy reference while they are writing and researching. It gives students, in concise form, the Four Basics of Good Writing, the structure of paragraphs and essays; a checklist for effective writing; the Four Most Serious Errors; tips for writing on the computer; and advice on evaluating sources, avoiding plagiarism, and documenting sources using MLA style. ISBN: 978-1-4576-2422-3
- Exercise Central to Go: Writing and Grammar Practices for Basic Writers CD-ROM provides hundreds of practice items to help students build their writing and editing skills. No Internet connection is necessary. ISBN: 978-0-312-44652-9
- The Bedford | St. Martin's ESL Workbook includes a broad range of exercises covering grammatical issues for multilingual students of varying language skills and backgrounds. Answers are at the back. ISBN: 978-0-312-54034-0
- The Make-a-Paragraph Kit is a fun, interactive CD-ROM that teaches students about paragraph development. It also contains exercises to help students build their own paragraphs, audio-visual tutorials on four of the most common errors for basic writers, and the content from Exercise Central to Go: Writing and Grammar Practices for Basic Writers. ISBN: 978-0-312-45332-9
- The Bedford I St. Martin's Planner includes everything that students need to plan and use their time effectively, with advice on preparing schedules and to-do lists plus blank schedules and calendars (monthly and weekly). The planner fits easily into a backpack or purse, so students can take it anywhere.

 ISBN: 978-0-312-57447-5

- Journal Writing: A Beginning is designed to give students an opportunity to use writing as a way to explore their thoughts and feelings. This writing journal includes a generous supply of inspirational quotations placed throughout the pages, tips for journaling, and suggested journal topics. ISBN: 978-0-312-59027-7
- From Practice to Mastery (study guide for the Florida Basic Skills Exit Tests) gives students all the resources they need to practice for—and pass—the Florida tests in reading and writing. It includes pre- and post-tests, abundant practices, many examples, and clear instruction in all the skills covered on the exams. ISBN: 978-0-312-41908-0

Premium

- Writing Class provides students with a dynamic, interactive online course space preloaded with exercises, diagnostics, video tutorials, writing and commenting tools, and more. Writing Class helps students stay focused and lets instructors see how they are progressing. It is available at a significant discount when packaged with the print text. To learn more about Writing Class, visit yourwriting class.com. For access card: ISBN: 978-1-4576-2426-1
- Skills Class offers all that Writing Class offers, plus guidance and practice in reading and study skills. This interactive online course space comes preloaded with exercises, diagnostics, video tutorials, writing and commenting tools, and more. It is available at a significant discount when packaged with the print text. To learn more about Skills Class, visit yourskillsclass.com. ISBN: 978-1-4576-2346-2
- Re:Writing Plus, now with VideoCentral, gathers all of our premium digital content for the writing class into one online collection. This impressive resource includes innovative and interactive help with writing a paragraph; tutorials and practices that show how writing works in students' real-world experience; VideoCentral, with over 140 brief videos for the writing classroom; the first-ever peer review game, Peer Factor; i-cite: visualizing sources; plus hundreds of models of writing and hundreds of readings.

 Re: Writing Plus can be purchased separately or packaged with Real Writing with Readings at a significant discount.

 ISBN: 978-0-312-48849-9

E-BOOK OPTIONS

• Real Writing with Readings e-book. Available for the first time as a value-priced e-book, available either as a CourseSmart e-book or in formats for use with computers, tablets, and e-readers—visit bedfordstmartins/realwriting/formats for more information.

FREE INSTRUCTOR RESOURCES

- The Instructor's Annotated Edition of Real Writing with Readings gives practical page-by-page advice on teaching with Real Writing with Readings, Sixth Edition, and answers to exercises. It includes discussion prompts, strategies for teaching ESL students, ideas for additional classroom activities, suggestions for using other print and media resources, and cross-references useful to teachers at all levels of experience. ISBN: 978-1-4576-2396-7
- Practical Suggestions for Teaching Real Writing with Readings, Sixth Edition, provides helpful information and advice on teaching developmental writing. It includes sample syllabi, reading levels scores, tips on building students' critical thinking skills, resources for teaching non-native speakers and speakers of nonstandard dialects, ideas for assessing students' writing and progress, and up-to-date suggestions for using technology in the writing classroom and lab. Chapter 7, "Facilitating Cooperative Learning," suggests specific activities for using the cooperative, group-oriented approach to foster students' positive interdependence and personal accountability as well as improved writing skills. Available for download; see bedfordstmartins.com/realwriting //catalog.
- Additional Resources for Teaching Real Writing with Readings, Sixth Edition. This collection of resources supplements the instructional materials in the text with a variety of extra exercises and tests, transparency masters, essay planning forms, and other reproducibles for classroom use. Available for download; see bedfordstmartins.com/realwriting/catalog.
- **Bedford Coursepacks** allow you to plug *Real Writing with Readings* content into your own course management system. For details, visit **bedfordstmartins.com/coursepacks**.
- Testing Tool Kit: Writing and Grammar Test Bank CD-ROM allows instructors to create secure, customized tests and quizzes from a pool of nearly 2,000 questions covering 47 topics. It also includes 10 prebuilt diagnostic tests. ISBN: 978-0-312-43032-0
- Teaching Developmental Writing: Background Readings, Fourth Edition, is a professional resource edited by Susan Naomi Bernstein, former co-chair of the Conference on Basic Writing. It offers essays on topics of interest to basic writing instructors, along with editorial apparatus pointing out practical applications for the classroom. ISBN: 978-0-312-60251-2
- The Bedford Bibliography for Teachers of Basic Writing, Third Edition (also available online at bedfordstmartins.com /basicbib) has been compiled by members of the Conference on Basic Writing under the general editorship of Gregory R. Glau and Chitralekha Duttagupta. This annotated list of books, articles, and

- periodicals was created specifically to help teachers of basic writing find valuable resources. ISBN: 978-0-312-58154-1
- Teaching Central at bedfordstmartins.com/teachingcentral offers the entire list of Bedford/St. Martin's print and online professional resources in one place. You will find landmark reference works, sourcebooks on pedagogical issues, award-winning collections, and practical advice for the classroom.
- Answers to all grammar exercises in *Real Writing*, Sixth Edition, are now available for download to instructors at bedfordstmartins.com/realwriting/catalog.

ORDERING INFORMATION

To order any of these ancillaries for *Real Writing with Readings*, Sixth Edition, contact your local Bedford/St. Martin's sales representative; send an e-mail to **sales_support@bfwpub.com**; or visit our Web site at **bedfordstmartins.com**.

Use these package ISBNs to order the following supplements packaged with your students' books:

REAL WRITING WITH READINGS, SIXT	H EDITION, PACKAGEL	WIIH:
WritingClass (access card)	978-1-4576-4353-8	Premium
SkillsClass (access card)	978-1-4576-4358-3	Premium
Re:Writing Plus (access card)	978-1-4576-4351-4	Premium
Quick Reference Card for Real Writing	978-1-4576-5402-4	Free with print text
Journal Writing: A Beginning	978-1-4576-4354-5	Free with print text
Merriam-Webster's Dictionary	978-1-4576-4350-7	Free with print text
Bedford/St. Martin's ESL Workbook	978-1-4576-4356-9	Free with print text
Exercise Central to Go CD-ROM	978-1-4576-4355-2	Free with print text
Make-a-Paragraph Kit CD-ROM	978-1-4576-4349-1	Free with print text
Bedford / St. Martin's Planner	978-1-4576-4357-6	Free with print text
From Practice to Mastery	978-1-4576-4348-4	Free with print text
REAL WRITING, SIXTH EDITION, PACK	AGED WITH:	
WritingClass (access card)	978-1-4576-4443-6	Premium
SkillsClass (access card)	978-1-4576-4442-9	Premium

Re:Writing Plus (access card)	978-1-4576-4441-2	Premium
Quick Reference Card for Real Writing	978-1-4576-5401-6	Free with print text
Journal Writing: A Beginning	978-1-4576-4445-0	Free with print text
Merriam-Webster's Dictionary	978-1-4576-4449-8	Free with print text
Bedford / St. Martin's ESL Workbook	978-1-4576-4450-4	Free with print text
Make-a-Paragraph Kit CD-ROM	978-1-4576-4436-8	Free with print text
Exercise Central to Go CD-ROM	978-1-4576-4434-4	Free with print text
Bedford/St. Martin's Planner	978-1-4576-4448-1	Free with print text
From Practice to Mastery	978-1-4576-4435-1	Free with print text

Acknowledgments

Like every edition that preceded it, this revision of *Real Writing* grew out of a collaboration with teachers and students across the country and with the talented staff of Bedford/St. Martin's. I am grateful for everyone's thoughtful contributions.

REVIEWERS

I would like to thank the following instructors for their many good ideas and suggestions for this edition. Their insights were invaluable.

Nikki Aitken, Illinois Central College Debbie Benson, Northwest-Shoals Community College Jan Bishop, Greenville Technical College Candace Boeck, San Diego State University Delmar Brewington, Piedmont Technical College Judy D. Covington, Trident Technical College Deborah DeVries, Oxnard College Karen Eisenhauer, Brevard Community College Lindsay Estes, Howard College Toni Fellela, Community College of Rhode Island Wendy Galgan, St. Francis College Lynn Gold, Bergen Community College Anissa Graham, University of North Alabama Judy Haberman, Phoenix College Donna Hogarty, Edinboro University of Pennsylvania Laura Jeffries, Florida State College at Jacksonville Eric Johnson, Grossmont College Theresa Johnson, Troy University Billy P. Jones, Miami Dade College

Raven L. Jones, Lansing Community College Timothy Jones, Oklahoma City Community College Kristyl Kepley, Georgia Military College Jan Lauten, College of The Albemarle Ginger Long, Northwest-Shoals Community College Paulette Longmore, Essex County College Rosalind Manning, Atlanta Technical College Applewhite Minyard, College of the Desert Virginia Nugent, Miami Dade College Robin Ozz, Phoenix College Charles Porter, Wor-Wic Community College Anne Marie Prendergast, Bergen Community College Marion Ruminski, Belmont Technical College Tamara Shue, Georgia Perimeter College Julia Simpson-Urrutia, Fresno City College Marvin Spiegelman, Miami Dade College Karen Taylor, Belmont Technical College Elizabeth L. Teagarden, Central Piedmont Community College Terri Wells, University of Arkansas-Fort Smith Patrick Williams, Chandler-Gilbert Community College Elizabeth Wurz, College of Coastal Georgia

I also want to acknowledge the invaluable help provided by reviewers of the previous edition. Space does not permit listing all reviewers who have provided advice for previous editions. I would just like to say that the book and the series would not be what they are without their help and advice.

Désiré Baloubi, Shaw University; Elizabeth Barnes, Daytona State College; Renee Bell, DeVry University; Randy L. Boone, Northampton Community College; Cynthia Bowden, Las Positas College; Michael Boyd, Illinois Central College; Cathy Brostrand, Mt. San Jacinto Community College; Dawn Copeland, Motlow State Community College; Claudia Edwards, Piedmont Technical College; Deb Fuller, Bunker Hill Community College; Tatiana Gorbunova, Owens Community College; Frank Gunshanan, Daytona State College; Vivian Hoskins, Phillips Community College of the University of Arkansas; Blaine Hunt, Tacoma Community College; Brenda J. Hunt, Western Piedmont Community College; Peggy Karsten, Ridgewater College; Merle K. Koury, College of Southern Maryland; Cathy Lally, Brevard Community College; Tricia Lord, Sierra College; Monique N. Matthews, Santa Monica College; Aubrey Moncrieffe, Housatonic Community College; Matthew Petti, PsyD, MFA, Instructor of English, University of the District of Columbia; Sandra Provence, Arkansas State University; Rick P. Rivera, Columbia College; Neal Roche, Adjunct Professor, Essex County College; Bill Shute, San Antonio College; Ann Smith, Modesto Junior College; Catherine Whitley, Edinboro University of Pennsylvania; Lisa Yanover, Napa Valley College; Rose Yesu, Massasoit Community College; and Guixia Yin, Bunker Hill Community College.

STUDENTS

Many current and former students have helped shape each edition of *Real Writing*, and I am grateful for all their contributions.

Among the students who provided paragraphs and essays for the book are Jess Murphy, John Around Him, Shari Beck, Jasen Beverly, Charlton Brown, Dominic Deiro, Brian Healy, Kelly Hultgren, Said Ibrahim, Amanda Jacobowitz, Jelani Lynch, Lauren Mack, Lorenza Mattazi, Holly Moeller, Casandra Palmer, Robert Phansalkar, Caitlin Prokop, Dara Riesler, Heather Rushall, True Shields, Courtney Stoker, and Jason Yilmaz.

The eight students featured in the new part opener portraits contributed their candid and thought-provoking answers to the question What do you write? and in so doing, helped us all to be aware of the deep usefulness of writing. My sincere thanks go to Daniel Brown, Tate Brown-Smith, Chris Eatmon, Jade Ellison, Katie Figueroa, John Fuqua, Ali Kellett, and Sam Malone.

Additionally, I would like to thank the students we profiled for the "Community Connections" sidebars. Some of them also contributed writings for exercises and examples. The students featured are Alessandra Cepeda, Corin Costas, Shawn Elswick, Jenny Haun, Caroline Powers, Evelka Rankins, Jorge Roque, Lynze Schiller, and Robin Wyant.

Last, but certainly not least, I would like to thank the nine former students who are included as "Profiles of Success." They are an inspiration to other students, and their words of advice and examples of workplace writing are central to the book. The Profiles of Success are Mary LaCue Booker, Jeremy Graham, Celia Hyde, Leigh King, Kelly Layland, Brad Leibov, Diane Melancon, Walter Scanlon, and Karen Upright.

CONTRIBUTORS

I gratefully acknowledge the invaluable help of Beth Castrodale, who was a tremendous font of energy, ideas, art, and words of wisdom. In addition to contributing to the reading and photo programs, critical thinking initiatives, and the new "Paragraph vs. Essay" charts, Beth was a brilliant adviser and sounding board from beginning to end. As I have noted in the past, I am truly blessed to work with Beth and to have had this chance to get to know her—as a creative and tireless contributor, an ever-delightful and insightful team member, and treasured friend.

In addition to the reviewers and students already mentioned, I would like to thank several others whose efforts were essential to producing this new edition of *Real Writing*. Michelle McSweeney and Valerie Duff helped to locate a variety of interesting new readings, and Michelle was extremely helpful in weighing in as we decided which of the many possible selections to include.

Art researcher Naomi Kornhauser, working with Martha Friedman, assisted with finding and obtaining permission for the many new, thought-provoking images included in the book.

Kathleen Karcher, working with Kalina Ingham, successfully completed the large and essential task of clearing text permissions.

I am also deeply grateful to designer Claire Seng-Niemoeller, who not only freshened the look of the book's interior but also helped us translate our ideas for the paragraph-essay charts into a vivid reality.

Photographer Joel Beaman contributed the eight striking new student portraits that appear in the "I Write" series of part openers. Working with students at Florida State College at Jacksonville and the University of North Florida, he made this series come to life. I thank him for his dedication, talent, skill, and infectious cheerfulness.

Finally, I would like to thank copyeditor Kathleen Lafferty for her careful attention to detail, good questions, and varied contributions to this book. She is a truly valuable team member.

BEDFORD/ST. MARTIN'S

Since undertaking the first edition of *Real Writing*, I have been extremely fortunate to work with the incredibly talented staff of Bedford/St. Martin's, whose perceptiveness, hard work, and dedication to everything they do are without parallel.

Alexis Walker, executive editor for Developmental Studies, has provided valuable insights from the start of the revision, helping to keep us on top of teaching trends and classroom needs. Thanks also to Edwin Hill, senior executive editor for College Success and Developmental Studies. Editorial assistants Amanda Legee, Mallory Moore, Karen Sikola, and Regina Tavani have helped with innumerable tasks, from running review programs to assisting with manuscript preparation to revising the book's companion Web site. Once again, we were very fortunate to have Deborah Baker, senior production editor, shepherding Real Writing through production. With her creativity, careful eye, project-management skills, and sense of humor, she made the path to publication seem as smooth as fresh blacktop despite the inevitable bumps in the road. Overseeing and thoughtfully contributing to all aspects of the design was Anna Palchik, senior art director. Like Claire, she was instrumental in making the new paragraph-essay charts a reality. Thanks to Billy Boardman for his work on the cover design. Pelle Cass consulted on the development of the photo program and brought his expert design sense to the book's brochure, both significant contributions that I gratefully acknowledge.

I must also extend tremendous gratitude to the sales and marketing team. Christina Shea, senior marketing manager, has been a great advocate for all my books and has helped me to forge greater connections with the developmental market and to stay up to date on its needs. I am also grateful to Jim Camp, senior specialist, Developmental Studies and College Skills, and to Dennis Adams and his team of humanities specialists, all of whom share so much valuable information from the field. And I continue to be deeply thankful for the hard work and smarts of all the sales managers and representatives.

The New Media group continues to develop great new teaching tools that respond to the needs of students and instructors. Many thanks especially to Harriet Wald, director of Digital Product Development, and to Marissa Zanetti, New Media editor. Many thanks also to

Barbara Flanagan for all her work on the LearningCurve activities for Real Writing.

Like all the previous editions of *Real Writing*, this edition would not have reached its fullest potential without the input and attention it received, from the earliest stages of development, from executives and long-time friends in the Boston office: Joan Feinberg, former president of Bedford/St. Martin's and now co-president of Macmillan Higher Education; Denise Wydra, president, Bedford/St. Martin's; Karen Henry, editor in chief; Karen Soeltz, director of marketing; and Jane Helms, associate director of marketing. I value all of them more than I can say.

Finally, the greatest share of the thanks for this edition of *Real Writing* must go to my editor and valued friend, Martha Bustin, whose countless good ideas for the revision, keen visual sense, attention to design, and endless well of patience and good humor both inspired and sustained me. Thank you so much, Martha.

As he has in the past, to my great good fortune, my husband Jim Anker provides assurance, confidence, steadiness, and the best companionship throughout the projects and the years. His surname is supremely fitting.

—Susan Anker

Real Support for Instructors and Students

GOALS AND LEARNING OUTCOMES	SUPPORT IN REAL WRITING	SUPPORT IN STUDENT ANCILLARIES	SUPPORT IN INSTRUCTOR ANCILLARIES
Students will connect the writing class with their goals in other courses and the larger world.	 Part 1: Chapter 1, "Critical Thinking, Reading, and Writing: Making Connections" Part 2: "Profiles of Success" and "Community Connections" sidebars Part 4: "Why Is It Important?" feature Part 8: Student writing with biographical notes and photos 	 Quick Reference Card: Portable guide to the basics of writing, editing, using sources, and more Student Site for Real Writing: Advice on finding a job (bedfordstmartins.com /realwriting) The Bedford / St. Martin's Planner: Helps students to plan and use their time effectively WritingClass, SkillsClass: Online course spaces with activities that help students apply what they have learned 	 Instructor's Annotated Edition: Marginal notes and tips suggest activities and discussion topics to help students see the context and relevance of what they are learning Practical Suggestions: Chapters 4, "Bringing the Real World into the Classroom," and 5, "Building Community in the English Class"
Students will write well- developed, organized paragraphs and essays.	 Part 1: Thorough coverage of critical thinking, reading, and writing process for paragraphs and essays Part 2: Coverage of rhetorical strategies, with detailed writing checklists; a focus on the "Four Basics" of each type of writing; and a special emphasis on main point, support, and organization Part 3: Focus on writing summaries, reports, essay exams, and research essays Parts 2 and 8: Models of different kinds of essays by students and professional writers 	 Quick Reference Card: Portable advice on understanding the structure of paragraphs and essays and a checklist for effective writing Student Site for Real Writing: Additional model readings and writing advice (bedfordstmartins.com/realwriting) Make-a-Paragraph Kit CD-ROM: Paragraph development advice and exercises Exercise Central to Go CD-ROM: Writing exercises (with more available at bedfordstmartins.com/exercisecentral) Re:Writing Plus: Additional writing support at bedfordstmartins.com /rewriting WritingClass, SkillsClass: Online course spaces with activities that help students apply what they have learned 	 Instructor's Annotated Edition: Marginal notes suggest activities and questions for use in teaching development, organization, and support Practical Suggestions: Advice on helping students develop critical thinking skills (Chapter 6), implementing a group approach to improve students' paragraphs and essays (Chapter 7), and using writing portfolios (Chapter 12) Additional Resources: Reproducible planning forms for writing Testing Tool Kit CD-ROM: Tests on topic sentences, thesis statements, support, organization, and more
Students will build grammar and editing skills.	 Parts 4 through 7: Thorough grammar coverage and many opportunities for practice, with a focus on the "Four Most Serious Errors" (Part 4) Editing Review Tests: Ten realistic cumulative tests follow the last grammar and punctuation part (Part 7, "Punctuation and Capitalization") 	■ LearningCurve Activities: Bedford/St. Martin's innovative online grammar quizzing system with adaptive technology and a game-like interface ■ Quick Reference Card: Portable advice on avoiding the "Four Most Serious Errors" ■ Supplemental Exercises for Real Writing: Offers more practices to accompany the editing chapters	 Instructor's Annotated Edition: Marginal suggestions to help students learn and review grammar Additional Resources: Reproducible exercises and transparencies for modeling correction of the "Four Most Serious Errors" Student Site for Real Writing: For instructors, downloadable answer key for all exercises in the text

GOALS AND LEARNING OUTCOMES	SUPPORT IN REAL WRITING	SUPPORT IN STUDENT ANCILLARIES	SUPPORT IN INSTRUCTOR ANCILLARIES
Students will build grammar and editing skills. (continued)		 Student Site for Real Writing: More grammar exercises through Exercise Central, with instant scoring and feedback (bedfordstmartins.com /realwriting) Make-a-Paragraph Kit CD-ROM: Tutorials on finding and fixing the "Four Most Serious Errors" Exercise Central to Go CD-ROM: Editing exercises (with more available at bedfordstmartins .com/exercisecentral) WritingClass, SkillsClass: Online course spaces with activities that help students apply what they have learned 	■ Testing Tool Kit CD-ROM: Test items on every grammar topic ■ Re:Writing Plus: Additional instructional support at bedfordstmartins.com/rewriting
Students will build research skills.	■ Chapter 18, "Writing a Research Essay," helps students choose a topic, find and evaluate sources, use summary and paraphrase, avoid plagiarism, and cite sources. Includes a pample student paper	 Quick Reference Card: Portable research and documentation advice Supplemental Exercises for Real Writing: Offers many additional practices to accompany the research chapter in Real Writing Student Site for Real Writing: Additional resources for students Un evaluating and integrating sources, avoiding plagiarism, and more (bedfordstmartins.com/realwriting) Re:Writing Plus: Research and documentation advice at bedfordstmartins.com/rewriting WritingClass, SkillsClass: Online course spaces with activities that help students apply what they have learned 	 Instructor's Annotated Edition: Marginal notes on helping students explore and become comfortable with the research process Additional Resources: Reproducible research exercises and other handouts
Students will read closely and critically.	 Chapter 1, "Critical Thinking, Reading, and Writing," helps students to preview, read, pause to reflect, and review and respond. The critical reading process is then covered throughout the book. Parts 1, 2, and 8: Integrated coverage of the critical reading process, with reinforcement on the need, when reading critically, to preview, read, pause, and review 	 Student Site for Real Writing: Provides annotated model essays and vocabulary help (bedfordstmartins.com /realwriting) WritingClass, SkillsClass: Online course spaces with reading skills instruction and activities 	 Instructor's Annotated Edition: Marginal tips for improving students' critical reading abilities Practical Suggestions: Advice on helping students bring in content from the real world and see connections in what they read (Chapter 4) and develop critical thinking and reading skills (Chapter 6)

GOALS AND LEARNING OUTCOMES	SUPPORT IN REAL WRITING	SUPPORT IN STUDENT ANCILLARIES	SUPPORT IN INSTRUCTOR ANCILLARIES
Students will think critically.	 Chapter 1: Step-by-step critical thinking and reading advice Parts 1, 2, and 8: Critical thinking components—summary, analysis, synthesis, and evaluation—are reinforced with questions 	 Student Site for Real Writing: Provides peer review forms, helpful checklists, and annotated model essays (bedfordstmartins.com /realwriting) WritingClass, SkillsClass: Online course spaces with activities that help students apply what they have learned 	 Instructor's Annotated Edition: Marginal critical thinking prompts Practical Suggestions: Advice on helping students bring in content from the real world and see connections in what they read (Chapter 4) and develop critical thinking and reading skills (Chapter 6)
Students will prepare for and pass tests.	 Chapter 17: Advice on writing essay exams Parts 4–7: Tests at the ends of grammar chapters Editing Review Tests: Ten realistic cumulative tests follow the last grammar and punctuation part (Part 7, "Punctuation and Capitalization") 	 Student Site for Real Writing: Includes section on test-taking and, in Exercise Central, grammar exercises, with instant scoring and feedback (bedfordstmartins.com /realwriting) From Practice to Mastery: Study guide for the Florida Basic Skills Exit Test WritingClass, SkillsClass: Online course spaces with activities that help students apply what they have learned 	 Additional Resources: General diagnostic tests as well as tests on specific grammar topics Practical Suggestions: Advice on assessing student writing, with model rubrics, advice on marking difficult papers, and more (Chapter 11) Testing Tool Kit CD-ROM: Tests on all writing and grammar issues covered in Real Writing
ESL and multilingual students will improve their proficiency in English grammar and usage.	 "Language Notes" throughout the grammar instruction ESL chapter (Chapter 30) with special attention to sentence patterns, pronouns, verbs, articles, and prepositions 	 Student Site for Real Writing: ESL exercises in Exercise Central, with instant scoring and feedback (bedfordstmartins.com /realwriting) The Bedford/St. Martin's ESL Workbook: Special instruction and exercises for ESL students Exercise Central to Go CD-ROM: Includes ESL exercises (even more exercises available at bedfordstmartins.com /exercisecentral) WritingClass, SkillsClass: Online course spaces with activities that help students apply what they have learned 	 Instructor's Annotated Edition: Tips for teaching ESL students Practical Suggestions: Advice on teaching ESL students and speakers of nonstandard English (Chapter 10) Testing Tool Kit CD-ROM: Test items on ESL issues

To order any of these ancillaries for *Real Writing with Readings* or *Real Writing*, Sixth Edition, please contact your Bedford/St. Martin's sales representative, e-mail sales support at sales_support@bfwpub.com, or visit our Web site at bedfordstmartins.com.

A note to students from Susan Anker

For the last twenty years or so, I have traveled the country talking to students about their goals and, more important, about the challenges they face on the way to achieving those goals. Students always tell me that they want good jobs and that they need a college degree to get those jobs. I designed *Real Writing* with those goals in mind—strengthening the writing, reading, and editing skills needed for success in college, at work, and in everyday life.

Here is something else: Good jobs require not only a college degree but also a college education: knowing not only how to read and write but how to think critically and learn effectively. So that is what I stress here, too. It is worth facing the challenges. All my best wishes to

you, in this course and in all your future endeavors.

YOU KNOW THIS

You have experience thinking critically.

- You figure out what is going on in a situation.
- You analyze how people act.
- You ask yourself if you believe what you hear or see.

think What do you think critical thinking is?

Critical Thinking, Reading, and Writing

Making Connections

"To be successful, be a critical thinker." This statement is becoming more and more common, and it is true. College courses require critical thinking. Workplaces require it. Life requires it. The good news is, you already practice critical thinking, and it is a skill you can strengthen, as you will learn in this chapter.

Take a closer look at a type of critical thinking you are already familiar with: making judgments about what to buy, or not to buy, based on product labels and advertising. First, **study** the picture to the right. **Ask yourself:**

- Why do you think the designers of this label chose to make it appear as it does?
- What textual and visual elements of the label suggest health and purity?
- Make a connection to your daily life: Does this label make it any more likely that you will purchase Pure Health Water or any other type of bottled water? Why or why not?

Now, **study** this advertisement from Tappening, an environmental group. **Ask yourself:**

- What is this ad's main message?
- What is the message behind the **boldface** note in the lower left corner of the ad?
- Make a connection to the previous label: How would the creator of the Tappening ad respond to the way the bottled-water company presents its product?
- **Make a connection** to your daily life: Does the Tappening ad make bottled water any less appealing to you? Why or why not?

Finally, study these labels. Ask yourself:

- What do these bottled-water labels say about the companies that produced them?
- Make a connection to the previous advertisement: How do these labels respond to the main message of the Tappening advertisement?
- **Make a connection** to your daily life: Reflect on all the previous images—the labels and the Tappening ad. Do they make you think differently about what kind of bottled water to purchase or about whether to buy bottled water at all? In what ways have product labels, your own experiences, and other information contributed to your decision?

The previous activities took you beneath the surface of the product labeling and beyond quick reactions to it. In other words, they encouraged **critical thinking**, actively questioning what you see, hear, and read to come to thoughtful conclusions about it. Building your critical thinking skills is one of the most important things you can do to succeed in college, at work, and in everyday situations.

As the previous activities show, critical thinking also involves **making** connections

- between existing impressions and new ones
- among various beliefs, claims, and bits of information

In the following sections, we will take a closer look at critical thinking strategies. Also, we will explore the connections among critical thinking, reading, and writing.

What Is Critical Thinking?

Jess: I've been thinking about it a lot, Mar, and I really need to quit school.

Maryn: Really? You were so excited about it last summer.

Jess: I know, I know. But I'm working, like, thirty hours a week now. And I'm just too burned out to study.

Maryn: Could you cut back your hours? *Jess:* I can't afford to. Not now, anyway.

Maryn: What about cutting your course load some?

Jess: Yeah, I guess that's a possibility, but . . .

Maryn: But what?

Jess: I know it sounds weird, Mar, but I feel like I'm defying the odds to stay in school. I mean, nobody in my family has ever finished college, so what makes me think I can?

Maryn: You're not them. You're you.

Jess (laughing): For better or worse.

Maryn: Seriously. Where's the Jess who told me a few weeks ago that she was loving her design class? The Jess who has some really amazing stuff in her portfolio?

Jess: She's still here. Just tired.

Maryn: OK. How can we keep her going?

The conversation between Jess and Maryn illustrates some important processes behind critical thinking.

Four Basics of Critical Thinking of school. How would persuade the friend to

Be alert to assumptions made by you and others.

Question those assumptions.

Consider and connect various points of view, even those different from your own.

Do not rush to conclusions, but instead remain patient with yourself and others and keep an open mind.

Assumptions—ideas or opinions that we do not question and that we automatically accept as true—can get in the way of clear, critical thinking. Here are some of Jess's assumptions:

She has no alternative but to quit school.

Because nobody in her family has ever finished college, she should not expect to either.

Because she has gotten fatigued and overwhelmed from all she is doing, it is a sign to give up on her dreams.

In college, work, and everyday life, we often hold assumptions that we are not even aware of. By identifying these assumptions, stating them, and questioning them, we stand a better chance of seeing reality and acting more effectively. Also, as in Jess's case, we can open up new possibilities for ourselves.

When questioning assumptions, try to get a bit of distance from them. Imagine what people with entirely different points of view might say. You might even try disagreeing with your own assumptions. Take a look at the following examples.

DISCUSSION Ask students what questions they would have for a friend who is thinking of dropping out of school. How would they persuade the friend to stay in school?

Questioning Assumptions

SITUATION	ASSUMPTION	QUESTIONS
COLLEGE: I saw from the syllabus that I need to write five essays for this course.	I am never going to pass this course.	Other students have passed this course; what makes me think I cannot? What obstacles might be getting in my way?
		What might be some ways around those obstacles?
		What have others done in this situation?
work: Two of my	My own raise is just	Did my coworkers accomplish anything I did not?
coworkers just got raises.	around the corner.	When was their last raise, and when was mine?
EVERYDAY LIFE: My	I must have done	Is it possible it has nothing to do with me?
neighbor has been cool to me lately.	something wrong.	Maybe he is going through something really difficult in his life?

TIP In every situation, try to be open to different points of view. Listen and think before responding or coming to any conclusions. Although you may not agree with other points of view, you can learn from them. You need to be aware not only of your own assumptions, but also of those in what you read, see, and hear. For example, bottled-water labels and advertising might suggest directly or indirectly that bottled water is better than tap water. What evidence do they provide for this assumption? What other sources of information could be consulted to either support, disprove, or call into question this assumption? However confidently a claim is made, never assume it cannot be questioned.

TEAMWORK Students might do Practice 1 in small groups, first discussing assumptions behind the images and then coming up with questions about the assumptions. One group member should write down key points of the discussion.

PRACTICE 1 Thinking Critically

What assumptions are behind each of the images on pages 3–5? Write down as many as you can identify. Then, write down questions about these assumptions, considering different points of view.

In addition to assumptions, be aware of **biases**, one-sided and sometimes prejudiced views that may blind you to the truth of a situation. Here is just one example:

No one older than fifty can pick up new skills quickly.

Others could contradict this extreme statement with their own experiences, exceptions, and insights or with additional information that could show reality is more nuanced or complicated than this statement allows.

Be on the lookout for bias in your own views and in whatever you read, see, and hear. When a statement seems one-sided or extreme, ask yourself what facts or points of view might have been omitted.

What Is Critical Reading?

Critical reading is paying close attention as you read and asking yourself questions about the author's purpose, his or her main point, the support he or she gives, and how good that support is. It is important to think critically as you read, looking out for assumptions and biases (both the writer's and your own). You should also consider whether you agree or disagree with the points being made.

Here are the four steps of the critical reading process:

2PR The Critical Reading Process

- Preview the reading.
- Read the piece, double-underlining the thesis statement and underlining the major support. Consider the quality of the support.
- **Pause** to think during reading. Take notes and ask questions about what you are reading. Talk to the author.
- **Review** the reading, your guiding question, your marginal notes, and your questions.

2PR Preview the Reading

Before reading any piece of writing, skim the whole thing, using the following steps.

READ THE TITLE, HEADNOTE, AND INTRODUCTORY PARAGRAPHS

The title of a chapter, an article, or any other document usually gives you some idea of what the topic is. Some documents are introduced by headnotes, which summarize or provide background about the selection. If there is a headnote, read it. Whether or not there is a headnote, writers often introduce their topic and main point in the first paragraphs, so read those and make a note stating what you think is the main point.

READ HEADINGS, KEY WORDS, AND DEFINITIONS

Textbooks and magazine articles often include headings to help readers follow the author's ideas. These headings (such as "Preview the Reading" above) tell you what the important subjects are within the larger piece of writing.

Any terms in **boldface** type are especially important. In textbooks, writers often use boldface for key words that are important to the topic.

LOOK FOR SUMMARIES, CHECKLISTS, AND CHAPTER REVIEWS

Many textbooks (such as this one) include features that summarize or list main points. Review summaries, checklists, or chapter reviews to make sure you have understood the main points.

READ THE CONCLUSION

Writers usually review their main point in their concluding paragraphs. Read the conclusion, and compare it with the note you made after you read the introduction and thought about what the main idea might be.

ASK A GUIDING QUESTION

As the final step in your preview of a reading, ask yourself a **guiding question**—a question you think the reading might answer. This question will give you a purpose for reading and help keep you focused. Sometimes, you can turn the title into a guiding question. For example, read the title of this chapter, and write a possible guiding question.

CRITICAL READING Preview Read Pause Review

2PR Read the Piece: Find the Main Point and the Support

After previewing, begin reading carefully for meaning, trying especially to identify a writer's main point and the support for that point.

MAIN POINT AND PURPOSE

For more on main points, see Chapter 4.

The **main point** of a reading is the central idea the author wants to communicate. The main point is related to the writer's **purpose**, which can be to explain, to demonstrate, to persuade, or to entertain. Writers often introduce their main point early, so read the first few paragraphs with special care. After reading the first paragraph (or more, depending on the length of the reading selection), stop and write down—in your own words—what you think the main idea is. If the writer has stated the main point in a single sentence, double-underline it.

TEAMWORK Practice 2 works well as a group activity.

PRACTICE 2 Finding the Main Point

Read each of the following paragraphs. Then, write the main point in your own words in the spaces provided.

1. Making a plan for your college studies is a good way to reach your academic goals. The first step to planning is answering this question: "What do I want to be?" If you have only a general idea—for example, "I would like to work in the health-care field"—break this large area into smaller, more specific subfields. These subfields might include

working as a registered nurse, a nurse practitioner, or a physical therapist. The second step to planning is to meet with an academic adviser to talk about the classes you will need to take to get a degree or certificate in your chosen field. Then, map out the courses you will be taking over the next couple of semesters. Throughout the whole process, bear in mind the words of student mentor Ed Powell: "Those who fail to plan, plan to fail." A good plan boosts your chances of success in college and beyond.

MAIN POINT: Answers will vary but should refer to the benefits of planning a course of study in college.

2. Networking is a way businesspeople build connections with others to get ahead. Building connections in college also is well worth the effort. One way to build connections is to get to know some of your classmates and to exchange names, phone numbers, and e-mail addresses with them. That way, if you cannot make it to a class, you will know someone who can tell you what you missed. You can also form study groups with these other students. Another way to build connections is to get to know your instructor. Make an appointment to visit your instructor during his or her office hours. When you go, ask questions about material you are not sure you understood in class or problems you have with other course material. You and your instructor will get the most out of these sessions if you bring examples of specific assignments that you are having trouble with.

MAIN POINT. Answers will vary but should refer to the henefits of networking in college.

SUPPORT

Support is the details that show, explain, or prove the main point. The author might use statistics, facts, definitions, and scientific results for support. Or he or she might use memories, stories, comparisons, quotations from experts, and personal observations.

For more on support, see Chapter 5.

PRACTICE 3 Identifying Support

Go back to Practice 2 (p. 10), and underline the support for the main ideas of each passage in the practice.

TEACHING TIP Ask students if they can identify the main idea and support in any of the essays in Part 8, Readings for Writers.

Not all support that an author offers in a piece of writing is good support. When you are reading, ask yourself: What information is the author including to help me understand or agree with the main point? Is the support (evidence) valid and convincing? If not, why not?

For online exercises on support, visit Exercise Central at bedfordstmartins.com/ realwriting.

CRITICAL READING Preview Read Pause Review

RESOURCES To gauge students' understanding of main point, support, and other writing and grammar issues, use the Testing Tool Kit CD available with this book.

2PR Pause to Think

Taking notes and asking questions as you read will help you understand the author's points and develop a thoughtful response. As you read:

- Double-underline or write the main idea in the margin.
- Note the major support points by underlining them.
- Note ideas that you agree with by placing a check mark next to them
- Note ideas that you do not agree with or that surprise you with an **X** or !, and ideas you do not understand with a question mark ?.
- Note any examples of an author's or expert's bias.
- Jot any additional notes or questions in the margin.
- Consider how parts of the reading relate to the main point.

Review and Respond

After reading, it is important to take a few minutes to look back and review. Go over your guiding question, your marginal notes, and your questions—and connect yourself to what you have read. Consider, "What interested me? What did I learn? How does it fit with what I know from other sources?" When you have reviewed your reading in this way and fixed it well in your mind and memory, it is much easier to respond in class discussion and writing assignments. To write about a reading, you need to generate and organize your ideas, draft and revise your response, and above all, use your critical thinking skills (see p. 7).

A Critical Reader at Work

Read the following piece. The notes in the margins show how one student applied the process of critical reading to an essay on bottled water.

Amanda Jacobowitz

A Ban on Water Bottles: A Way to **Bolster the University's Image**

Amanda Jacobowitz is a student at Washington University and a columnist for the university's publication Student Life, in which the following essay appeared.

Lately, I am always thirsty. Always! I could not figure out why until I 1 realized that the bottled water I had purchased continuously throughout my day had disappeared. At first I was just confused. Where did all the

Guiding Question: What does the author think about the ban on bottled water?

water bottles go? Then I learned the simple explanation: The University banned water bottles in an effort to be environmentally friendly.

Ideally, given the ban on selling water bottles, every student on campus should now take the initiative to carry a water bottle, filling it up throughout the day at the water fountains on campus. Realistically, we know this has not and will not happen. I have tried to bring a water bottle with me to classes—I do consider myself somewhat environmentally conscious—but have rarely succeeded in this effort. Instead, although I have never been too much of a soda drinker, I find myself reaching for a bottle of Coke out of pure convenience. We can't buy bottled water, but we can buy soda, juice, and other drinks, many of which come in plastic bottles. I am sure that for most people—particularly those who give very little thought to being environmentally conscientious—convenience prevails and they purchase a drink other than water. Wonderful result. The University can pride itself on being more environmentally friendly, with the fallback that its students will be less healthy!

Even if students are not buying unhealthy drinks, any benefit from the reduction of plastic water bottles could easily be offset by its alternatives.

Students are not using their hands to drink water during meals. They are using plastic cups—cups provided by the University at every eatery on campus. Presumably no person picks up a cup, drinks their glass of water, and then saves that same cup for later in the day. That being said, how many plastic cups are used by a single student, in a single day? How many cups are used by the total campus-wide population daily, yearly? This plastic cup use must equate to an exorbitant amount of waste as well.

My intent is not to have the University completely roll back the water bottle ban, nor is my intent for the University to level the playing field by banning all plastic drink bottles. I'm simply questioning the reasons for specifically banning bottled water of all things? Why not start with soda bottles—decreasing the environmental impact, as well as the health risks. There are also many other ways to help the environment that seem to be so easily overlooked.

Have you ever noticed a patch of grass on campus that's not perfectly green? I can't say that I have. The reason: the sprinklers. Now, I admit that I harbor some animosity when it comes to the campus sprinklers; I somehow always manage to mistakenly and inadvertently walk right in their path, the spray of water generously dousing my feet. However, my real problem with the sprinklers is the waste of water they represent. Do we really need our grass to be green at all times?

The landscaping around our beloved Danforth University Center 6 (Gold LEED Certified) is irrigated with the use of rainwater. There is a

 Larger main point (not stated directly): (1) the ban is ineffective, and (2) there are better ways to protect the environment.

 Why not just drink from a water fountain? You don't have to have a bottle.

Examples of other common forms of waste

 Examples of other ways to protect the environment Town/city water, I — assume.

50,000-gallon rainwater tank below the building to collect rain! I admit, this is pretty impressive, but what about the rest of the campus? What water is used to irrigate and keep green the rest of our 169 acres on the Danforth campus?

I understand that being environmentally conscious is difficult to do, 7 particularly at an institutional level. I applaud the Danforth University Center and other environmental efforts the University has initiated. However, I can't help but wonder if the University's ban on the sale of water bottles is more about appearance and less about decreasing the environmental impact of our student body. The water bottle ban has become a way to build the school's public image: we banned water bottles, we are working hard to be environmentally friendly! In reality, given the switch to plastic cups and the switch to other drinks sold in plastic bottles, is the environmental impact of the ban that significant? Now that the ban has been implemented, I certainly don't see the University retracting it. However, I hope that in the future the University focuses less on its public image and more on the environment itself when instituting such dramatic changes.

Is it really about public image? What would a university administrator say?

PRACTICE 4 Making Connections

Look back at the images on pages 3–5. Then, review the reading by Amanda Jacobowitz. What assumptions does she make about bottled water? What evidence, if any, is provided to support these assumptions? Based on your observations, would you like to see bottled water not banned or banned at your college? Why or why not?

Read Real-World Documents Critically

Careless reading in your everyday life can cause minor problems such as a ruined recipe, but it can also have more serious consequences. For example, if you overlook the fine print in a loan offer, you might end up agreeing to a high interest rate and, therefore, more debt.

To read real-world documents closely and carefully, try the **2PR** strategy, especially for longer documents. Also, when you see a document or sign that makes a claim, ask yourself: Does this claim look too good to be true? If so, why?

PRACTICE 5 Reading Real-World Documents

Working by yourself or with other students, read the following documents from college, work, and everyday life, and answer the critical reading questions.

Answers may vary. Possible answers are shown.

1. What is the writer's purpose? Excepting the drug label, the documents' purpose is to make money for the people who created them.

TEACHING TIP You might also have students apply the **2PR** strategy to essays or articles that you bring in (or ones from this book) or to textbooks for this or other classes.

- 2. Is the writer biased? Yes; the purpose is to sell something.
- 3. What are the key words or major claims? Answers could include any words in headlines or boldface type.
- 4. What is in the fine print? See "for those who qualify" in the e-mailed advertisement, "Some supply purchases may be required" in the telephone pole posting, and "faux" in the advertisement.
- odd, unrealistic, or unreliable? Give specific examples. None of the information is reliable: The college and work documents' claims can't possibly be true; the everyday life documents contain errors or misleading information. (Note excessively high dosage on drug label.)

COLLEGE: AN E-MAILED ADVERTISEMENT

GET A COLLEGE DEGREE IN TWO WEEKS!

Are a few letters after your name the only thing that's keeping you from your dream job? Degree Services International will grant you a B.A., M.A., M.S., M.B.A., or Ph.D. from a prestigious nonaccredited institution based on what you already know!

NO CLASSES, EXAMS, OR TEXTBOOKS ARE REQUIRED

for those who qualify

If you order now, you'll receive your degree within two weeks.

CALL 1-800-555-0021

HURRY! Qualified institutions can grant these diplomas only because of a legal loophole that may be closed within weeks.

WORK: A POSTING ON A TELEPHONE POLE

Earn Thousands of Dollars a Week Working at Home!

Flexible Hours + No Experience Needed

The health-care system is in crisis because of the millions of medical claims that have to be processed each day. You can benefit from this situation now by becoming an at-home medical claims processor. Work as much or as little as you like for great pay!

CALL 1-800-555-5831

for your starter kit

Some supply purchases may be required.

EVERYDAY LIFE: ADVERTISEMENT

TIP Pay attention to the dosage for adults.

EVERYDAY LIFE: PART OF A DRUG LABEL

Drug Facts	
Directions	
■ Do not take more than direct	eted.
Adults and children 12 years and over	■ Take 4 to 6 caplets every 2 hours as needed. ■ Do not take more than 8 caplets in 24 hours.
Children under 12 years	Do not use this product in children under 12 years of age. This could cause serious health problems.

What Is Writing Critically about Readings?

Being able to write critically about what you read is a key college skill because it shows your deep understanding of course content. When you write critically about readings you summarize, analyze, synthesize, and evaluate, and in doing so, you answer the following questions.

Reading and Writing Critically

Summarize

- What is important about the text?
- What is the purpose, the big picture?
- What are the main points and key support?

Analyze

- What elements have been used to convey the main point?
- Do any elements raise questions? Do any key points seem missing or undeveloped?

Synthesize

- What do other sources say about the topic of the text?
- How does your own (or others') experience affect how you see the topic?
- What new point(s) might you make by bringing together all the different sources and experiences?

Evaluate

- Based on your application of summary, analysis, and synthesis, what do you think about the material you have read?
- Is the work successful? Does it achieve its purpose?
- Does the author show any biases? If so, do they make the piece more effective or less effective?

Summary

A **summary** is a condensed, or shortened, version of something—often, a longer piece of writing, a movie or television show, a situation, or an event. In writing a summary, you give the main points and key support in your own words.

The following is an excerpt from the *Textbook of Basic Nursing* by Caroline Bunker Rosdahl and Mary T. Kowalski. It comes from a chapter that discusses some of the stresses that families can face, including divorce.

Adults who are facing separation from their partners—and a return to single life—may feel overwhelmed. They may become preoccupied with their own feelings, thereby limiting their ability to handle the situation effectively or to be strong for their children. The breakdown of the family system may require a restructuring of responsibilities, employment, childcare, and housing arrangements. Animosity between adults may expose children to uncontrolled emotions, arguments, anger, and depression.

Children may feel guilt and anxiety over their parents' divorce, believing the situation to be their fault. They may be unable to channel their conflicting emotions effectively. Their school performance may suffer, or they may engage in misbehavior. Even when a divorce is handled amicably, children may experience conflicts about their loyalties and may have difficulties making the transition from one household to another during visitation periods. . . .

Experts estimate that approximately 50% of all children whose parents divorce will experience another major life change within 3 years: remarriage. The arrival of a stepparent in the home presents additional stressors for children. Adapting to new rules of behavior, adjusting to a new person's habits, and sharing parents with new family members can cause resentment and anger. When families blend children, rivalries and competition for parental attention can lead to repeated conflicts.

TIP For more information on summarizing, see Chapter 17.

Now, here is a summary of the textbook excerpt. The main point is double-underlined, and the support points are underlined.

Although divorce seriously affects the people who are splitting up, Rosdahl and Kowalski point out that the couple's children face equally difficult consequences, both immediately and in the longer term. In the short term, according to the authors, children may blame themselves for the split or feel that their loyalty to both parents is divided. These negative emotions can affect their behavior at school and elsewhere. Later on, if one or both of the parents remarry, the children may have trouble adjusting to the new family structure.

Analysis

An **analysis** breaks down the points or parts of something and considers how they work together to make an impression or convey a main point. When writing an analysis, you might also consider points or parts that seem to be missing or that raise questions in your mind.

Here is an analysis of the excerpt from the *Textbook of Basic Nursing*. The main point is double-underlined, and the support points are underlined.

TEACHING TIP Ask students to read and write down questions about a reading from this book or from some other source. Then, have them write a brief analysis that poses these questions.

We all know that divorce is difficult for the people who are splitting up, but Rosdahl and Kowalski pay special attention to the problems faced by children of divorce, both right after the split and later on.

The authors mention several possible outcomes of divorce on children, including emotional and behavioral difficulties and trouble in school.

They also discuss the stresses that remarriage can create for children.

The authors rightly emphasize the negative effects that divorce can have on children. However, I found myself wondering what a divorcing couple could do to help their children through the process. Also, how might parents and stepparents help children adjust to a remarriage? I would like to examine these questions in a future paper. [Note how the writer raises questions about the textbook excerpt.]

Synthesis

A **synthesis** pulls together information from additional sources or experiences to make a new point. Here is a synthesis of the textbook material on divorce. Because the writer wanted to address some of the questions she raised in her analysis, she incorporated additional details from published sources and from people she interviewed. Her synthesis of this information helped her arrive at a fresh conclusion.

In the *Textbook of Basic Nursing*, Rosdahl and Kowalski focus on the problems faced by children of divorce, both right after the split and later on. According to the authors, immediate problems can include emotional and behavioral difficulties and trouble in school. Later on, parents' remarriage can create additional stresses for children. Although the authors discuss the impact of divorce on all parties, they do not suggest ways in which parents or stepparents might help children through the process of divorce or remarriage. However, other sources, as well as original research on friends who have experienced divorce as children or adults, provide some additional insights into these questions.

A Web site produced by the staff at the Mayo Clinic recommends that parents come together to break the news about their divorce to their children. The Web site also suggests that parents keep the discussion brief and free of "ugly details." In addition, parents should emphasize that the children are in no way to blame for the divorce and that they are deeply loved. As the divorce proceeds, neither parent should speak negatively about the other parent in the child's presence or otherwise try to turn the child against the ex-spouse. Finally, parents should consider counseling for themselves or their children if any problems around the divorce persist.

The Web site of the University of Missouri Extension addresses the blems that can arise for children after their parents remarry. Specific by, the Web site describes several things that stepparents can do to make eir stepchildren feel more comfortable with them and the new family so the One strategy is to try to establish a friendship with the children beautiful and the parents have assumed a more parental role, they should have

spouse stand by the same household rules and means of discipline. With time, the same household rules and means of nonagys and other

family gatherings to neip ounce.

To these sources, I added interviews with three friends—two who are children of divorce and one who is both a divorced parent and a stepparent. The children of divorce said that they experienced many of the same difficulties and stresses that Rosdahl and Kowalski described. Interestingly, though, they also reported that they felt quilty, even though their parents told them not to, just as the Mayo Clinic experts recommend. As my friend Kris said, "For a long time after the divorce, every time me and my dad were together, he seemed distracted, like he wished I wasn't there. I felt bad that I couldn't just vanish." Dale, the stepparent I interviewed,

First source

Second source

Third source

Fourth source

Fresh conclusion

TIP For more on finding reliable sources of information for your writing, see Chapter 18.

liked the strategies suggested by the University of Missouri Extension, and he had actually tried some of these approaches with his own stepchildren. However, as Dale told me, "When you're as busy as most parents and kids are these days, you can let important things fall by the wayside—even time together. That's not good for anyone."

Thinking back on Kris's and Dale's words and everything I've learned from the other sources, I have come to conclude that divorced parents and stepparents need to make sure they build "together time" with their own children and/or stepchildren into every day. Even if this time is just a discussion over a meal or a quick bedtime story, children will remember it and appreciate it. This approach

would help with some of the relationship building that the University of Missouri Extension recommends. It would also improve communication, help children understand that they are truly loved by *all* their parents, and assist with the process of postdivorce healing.

Works Cited

Leigh, Sharon, Maridith Jackson, and Janet A. Clark. "Foundations for a Successful Stepfamily." U of Missouri Extension, Apr. 2007. Web. 13 Oct. 2011.
Mayo Clinic Staff. "Children and Divorce: Helping Kids after a Breakup." Mayo Clinic. Mayo Clinic, 14 May 2011. Web. 12 Oct. 2011.

Rosdahl, Caroline Bunker, and Mary T. Kowalski. *Textbook of Basic Nursing*. 9th ed. Philadelphia: Lippincott Williams & Wilkins, 2008. 92. Print.

Evaluation

An **evaluation** is your *thoughtful* judgment about something based on what you have discovered through your summary, analysis, and synthesis. To evaluate something effectively, apply the questions from the Reading and Writing Critically box on pages 16–17. You will want to refer to these questions as you work through later chapters of this book and through readings from other college courses.

Here is an evaluation of the excerpt from the Textbook of Basic Nursing:

In just a few paragraphs, Rosdahl and Kowalski give a good description of the effects of diverse, not only on the former spouses but also on their children. The details that the authors provide help to clearly communicate the difficulties that such children face. In the short term, these difficulties can include emotional and behavioral problems and trouble in school. In the longer term, if one or both of a child's parents remarry,

the child faces the stress of dealing with a new and different family. Although the authors do not specifically address ways that parents and stepparents can ease children into divorce and/or new families, other sources—such as the Web sites of the University of Missouri Extension and the Mayo Clinic, as well as people I interviewed—do get into these issues. In the end, I think that Rosdahl and Kowalski present a good overview of their subject in a short piece of writing that was part of a larger discussion on family stresses.

PRACTICE 6 Making Connections

As you work through this exercise, refer to the Reading and Writing Critically box on pages 16–17 and to your responses to Practice 4 (if you completed it).

- 1. Summary: Summarize Amanda Jacobowitz's essay on pages 12–14.
- **2. Analysis:** Whether you agree or disagree with Jacobowitz, write a paragraph analyzing the points she presents.
- **3. Synthesis:** Read additional opinion pieces or blog postings about bottled water. In one paragraph, state your position on the subject according to your reading of these materials. Also, explain the range of opinions on the subject.
- **4. Evaluation:** Write a paragraph that evaluates Jacobowitz's essay.

What Is Writing Critically about Visuals?

Images play a huge role in our lives today, and it is important to think critically about them just as you would about what you read or hear. Whether the image is a Web site, a photograph or illustration, a graphic, or an advertisement, you need to be able to "read" it. You can apply the same critical reading skills of summary, analysis, synthesis, and evaluation to read a visual.

Look carefully at the advertisement from Tappening on page 4. Then, consider how to read a visual using the critical thinking skills you have learned.

TEACHING TIP Bring in additional advertisements or other visuals and ask students to summarize, analyze, synthesize, and evaluate them.

Summary

To summarize a visual, ask yourself what the big picture is: What is going on? What is the main impression or message (the main point)? What is the purpose? How is this purpose achieved (the support)? To answer these questions, consider some strategies used in visuals.

DOMINANT ELEMENTS

Artists, illustrators, and advertisers may place the most important object in the center of an image. Or, they may design visuals using a **Z pattern**, with the most important object in the top left and the second most important object in the bottom right. In English and many other languages, people read printed material from left to right and from top to bottom, and the Z pattern takes advantage of that pattern. Because of these design strategies, the main point of a visual can often be determined by looking at the center of the image or at the top left or bottom right.

FIGURES AND OBJECTS

The person who creates an image has a purpose (main point) and uses visual details to achieve (or support) that purpose. In a photograph, illustration, or painting, details about the figures and objects help create the impression the artist wants to convey. (Here, the term *figures* refers to people, animals, or other forms that can show action or emotion.) When studying any image, ask yourself:

- Are the figures from a certain period in history?
- What kind of clothes are they wearing?
- What are the expressions on their faces? How would I describe their attitudes?
- Are the figures shown realistically, or are they shown as sketches or cartoons?
- What important details about the figures does the creator of the image want me to focus on?

PRACTICE 7 Summarizing a Visual

Focus on the Tappening advertisement on page 4, and answer the following questions. Answers will vary. Possible answers are shown.

- 1. What is the big picture? What is going on? Polar bears and ice caps are suffering the effects of bottled-water consumption.
- 2. What is at the center of the ad? an unhappy polar bear
- 3. What is the ad's purpose? to get people to stop drinking bottled water
- 4. What details do you notice about the figure in the ad? Include as many as you can. The polar bear is crying, and the tears look like the water that is dripping from the melting ice cap. The circle around the bear's nose and mouth looks like a teardrop or water droplet.

Analysis

To analyze a visual, focus on the parts of it (figures, objects, type), and ask yourself how they contribute to the message or main impression. Consider the background, the use of light and dark, and the various elements' colors, contrasts, textures, and sizes.

PRACTICE 8 Analyzing a Visual

Focus on the Tappening advertisement on page 4, and answer the following questions. Answers will vary. Possible answers are shown.

- What color is the background? What colors are used in other elements? What impressions do the different colors suggest? The background is blue, the bear is white (except for its nose), and the large type is also white. Black is used for the smaller type and for the illustrations of the bear, the ice cap, and the water bottle. The blue reminds viewers of water: bottled water and the water melting from ice caps. It also conveys sadness.
- 2. What elements are placed in large type? Why? "98% melted ice caps" and "2% polar bear tears" are placed in large type to emphasize the negative effects of bottled-water consumption.
- 3. How do all these features contribute to the main impression? The colors and the use of type get across the threats of bottled water to polar bears and ice caps.

Synthesis

To synthesize your impressions of a visual, ask yourself what the message seems to be, using your summary and analysis skills. Consider how this message relates to what else you know from experience and observation.

PRACTICE 9 Synthesizing Your Impressions of a Visual

Focus on the Tappening advertisement on page 4, and answer the following questions. Answers will vary. Possible answers are shown.

1. What is the ad's central message? Bottled-water consumption is a threat to polar bears and the environment; therefore, we should stop drinking it.

How does this message relate to what you already know or have heard or experienced? Answers will vary. **Evaluation** To evaluate an image, ask yourself how effective it is in achieving its purpose and conveying its main point or message. What do you think of the image, using your summary, analysis, and synthesis skills? Consider any biases or assumptions that may be working in the image. PRACTICE 10 Evaluating a Visual Focus on the Tappening advertisement on page 4, and answer the following questions. What do you think about the ad, especially its visual elements? 1. Answers will vary. Does the creator of the ad seem to have any biases? Why or why not? 2. Is the ad effective, given its purpose and the main point it is trying to make? Why or why not? ____

What Is Problem Solving?

In college, at work, and in everyday life, we often need to "read" situations to make important decisions about them. This process, known as problem solving, can also involve summarizing, analyzing, synthesizing, and evaluating. Let's look at key steps in the process.

1. Summarize the problem.

Try to describe it in a brief statement or question.

EXAMPLE: My ten-year-old car needs a new transmission, which will cost at least \$750. Should I keep the car or buy a new one?

2. Analyze the problem.

Consider possible ways to solve it, examining any questions or assumptions you might have.

EXAMPLES:

Assumption: I need to have a reliable car.

Question: Is this assumption truly justified?

Answer: Yes. I can't get to school or work without a reliable car. I live more than fifteen miles from each location, and there is no regular public transportation to either place from my home.

POSSIBLE SOLUTIONS:

- Pay for the transmission repair.
- Buy a new car.

3. Synthesize information about the problem.

Consult various information sources to get opinions about the possible solutions.

EXAMPLES:

- My mechanic
- Friends who have had similar car problems
- Car advice from print or Web sources
- My past experience with car repairs and expenses

4. Evaluate the possible solutions, and make a decision.

You might consider the advantages and disadvantages of each possible solution. Also, when you make your decision, you should be able to give reasons for your choice.

EXAMPLES (CONSIDERING ONLY ADVANTAGES AND DISADVANTAGES):

Pay for the transmission repair.
Advantage: This option would be cheaper than buying a new car.
Disadvantage: The car might not last much longer, even with the new transmission.

Buy a new car.

Advantage: I will have a reliable car.

Disadvantage: This option is much more expensive than paying for the repair.

FINAL DECISION: Pay for the transmission repair.

REASONS: I do not have money for a new car, and I do not want to take on more debt. Also, two mechanics told me that my car should run for three to five more years with the new transmission. At that point, I will be in a better position to buy a new car.

TEACHING TIP Have students take a test on their problem-solving skills, available at www .queendom.com. Then, open up a discussion of the results. What did students learn by taking the test?

PRACTICE 11 Solving a Problem

Think of a problem you are facing now — in college, at work, or in your every-day life. On a separate sheet of paper, summarize the problem. Next, referring to the previous steps, write down and analyze possible solutions, considering different sources of information. Then, write down your final decision or preferred solution, giving reasons for your choice.

Chapter Review

- 1. What are the four basics of critical thinking? Be alert to assumptions made by you and others. Question those assumptions. Consider and connect various points of view. Do not rush to conclusions.
- 2. What are the four major steps of the critical reading process? preview, read, pause, review
- 3. Why is it important to read real-world documents critically? because not doing so can cause problems in everyday life
- 4. What are the four major steps of writing critically about readings and visuals? summarize, analyze, synthesize, evaluate
- 5. Without looking back in the chapter, define the task of synthesizing in your own words. Answers should mention pulling together various bits of information to come to a fresh conclusion.

reflect Using what you have learned in this chapter, revise your response to the "think" question on page 3.

YOU KNOW THIS

You write almost every day, for many reasons.

- You write a note to explain your child's absence from school.
- You e-mail a friend or coworker to ask a favor.

think How does the way you communicate change with different people (for example, a friend and a teacher)?

2

Writing Basics

Audience, Purpose, and Process

Four elements are key to good writing. Keep them in mind whenever you write.

Four Basics of Good Writing

- It considers what the audience knows and needs.
- 2 It fulfills the writer's purpose.
 - It includes a clear, definite point.
 - It provides support that shows, explains, or proves the main point.

TEACHING TIP Add your own examples to the You Know This boxes to help students think about how the chapter builds on something they already know.

This chapter discusses the four basics in more detail. It also outlines the writing process, previewing steps that will be covered more thoroughly in the next five chapters. Finally, it gives you some typical grading criteria and shows how they are applied to assess unsatisfactory, satisfactory, and excellent paragraphs.

Understand Audience and Purpose

Your **audience** is the person or people who will read what you write. In college, your audience is usually your instructors. Whenever you write, always have at least one real person in mind as a reader. Think about what that person already knows and what he or she will need to know to understand your main point.

Your **purpose** is your reason for writing. Let's take a look at some different audiences and purposes.

Audience and Purpose

TYPE OF WRITING	AUDIENCE	PURPOSE	TIPS
college: A research essay about the environmental effects of "fracking": fracturing rock layers to extract oil or natural gas	The professor of your environmental science class	To complete an assignment according to your professor's instructions and any research methods discussed in class To show what you have learned about the topic	When writing to fulfill a course assignment, never make assumptions like, "My instructor already knows this fact, so what's the point of mentioning it?" By providing plenty of relevant examples and details, you demonstrate your knowledge of a subject and make your writing more effective.
work: An e-mail to coworkers about your company's new insurance provider	Fellow workers	To make sure that coworkers understand all the important details about the new provider	Define or explain any terminology or concepts that will not be familiar to your audience.
EVERYDAY LIFE: An electronic comment about an online newspaper editorial that you disagree with	The editorial writer Other readers of the editorial	To make the editorial writer and other readers aware of your views	Keep all correspondence with others as polite as possible, even if you disagree with their views.

The tone and content of your writing will vary depending on your audiences and purposes. Read the following two notes, which describe the same situation but are written for different audiences and purposes.

SITUATION: Marta woke up one morning feeling strange, and her face was swollen and red. Marta immediately called her doctor's office and got an appointment. Marta's mother was coming to stay with Marta's children in a few minutes, so Marta asked a neighbor to watch her children until her mother got there. Marta then left a note for her mother telling her why she had already left. When she got to the doctor's office, she was feeling better, and since the doctor was running late, she decided not to wait. The nurse asked her to write a brief description of her symptoms for the doctor to read later.

MARTA'S NOTE TO HER MOTHER

Ma,

Not feeling well this morning. Stopping by doctor's office before work. Don't worry, I'm okay, just checking it out. Can't miss any more work. See you after. Thanks for watching the kids.

MARTA'S NOTE TO THE DOCTOR

When I woke up this morning, my face was swollen, especially around the eyes, which were almost shut. My lips and skin were red and dry, and my face was itchy. However, the swelling seemed to go down quickly.

PRACTICE 1 Comparing Marta's Notes

Read Marta's two notes, and answer the following questions. Answers will vary. Possible answers are shown.

- 1. How does Marta's note to her mother differ from the one to the doctor? The note to the doctor is more specific and more formal.
- 2. How do the different audiences and purposes affect what the notes say (the content) and how they say it (the tone)? Marta does not want to worry her mother, so she is general, and she is also informal. Marta wants the doctor to know exactly what happened, so she provides more specifics. She also writes more formally.
- 3. Which note has more detail, and why? the one to the doctor because

 Marta wants the doctor to know the symptoms she had

As these examples show, we communicate with family members and friends differently than we communicate with people in authority (like employers, instructors, or other professionals)—or we should. Marta's note to her mother uses informal English and incomplete sentences because the two women know each other well and are used to speaking casually to each other. Because Marta's purpose is to get quick information to her mother and to reassure her, she does not need to provide a lot of details. On the other hand, Marta's note to her doctor is more formal, with complete sentences, because the relationship is more formal. Also, the note to the doctor is more detailed because the doctor will be making treatment decisions based on it.

In college, at work, and in your everyday life, when you are speaking or writing to someone in authority for a serious purpose, use formal English; people will take you seriously.

TIP For more practice with writing for a formal audience, see the Using Formal English practices in Chapters 20–23. Or, visit Exercise Central at bedfordstmartins.com/realwriting.

PRACTICE 2 Writing for a Formal Audience

A student, Terri Travers, sent the following e-mail to a friend to complain about not getting into a criminal justice course. Rewrite the e-mail as if you were Terri and you were writing to Professor Widener. The purpose is to ask whether the professor would consider allowing you into the class given that you signed up early and have the necessary grades.

To: Miles Rona
Fr: Terri Travers
Subject: Bummin

Seriously bummin that I didn't get into Prof Widener's CJ class. U and Luis said it's the best ever, lol. Wonder why I didn't . . . I signed up early and I have the grades. Sup w/that?

C ya, TT

Understand Paragraph and Essay Form

In this course (and in the rest of college), you will write paragraphs and essays. Each kind of writing has a basic structure.

PARAGRAPH FORM

A **paragraph** has three necessary parts: the topic sentence, the body, and the concluding sentence.

	PARAGRAPH PART	PURPOSE OF THE PARAGRAPH PART
1.	The topic sentence	states the main point . The topic sentence is often the first sentence of the paragraph.
2.	The body	supports (shows, explains, or proves) the main point with support sentences that contain facts and details.
3.	The concluding sentence	reminds readers of the main point and often makes an observation.

Read the paragraph that follows with the paragraph parts labeled.

expenses over a specific financial period. Often, P-and-L's are used to

Topic sentence ————	Following a few basic strategies can help you take better notes, an
	important skill for succeeding in any course. First, start the notes for
	each class session on a fresh page of your course notebook, and record
	the date at the top of the page. Next, to improve the speed of your
	note taking, abbreviate certain words, especially ones your instructor
	uses regularly. For example, abbreviations for a business course might
Body —	include fncl for financial, svc for service, and mgt for management. How-
(with support sentences)	ever, don't try to write down every word your instructor says. Instead,
	look for ways to boil extended explanations down into short phrases.
	For instance, imagine that a business instructor says the following: "A
	profit-and-loss statement is a report of an organization's revenue and

determine ways to boost revenue or cut costs, with the goal of increasing profitability." The note taker might write down something like, "P&L: rpt of revenue + expenses over a specific period. Used to boost rev or cut costs." Although you do not need to record every word of a lecture, listen for clues that indicate that your instructor is making a point important enough to write down. At such times, the instructor might raise his or her voice. Or, he or she might introduce key information with such phrases as "It's important to remember" or "Bear in mind." In addition, if the instructor has made a certain point more than once, it is a good indication that this point is important. By carefully listening to and recording information from your instructor, you are not just getting good notes to study later; you are already beginning to seal this information into your memory.

Concluding sentence

ESSAY FORM

An **essay** is a piece of writing that examines a topic in more depth than a paragraph. A short essay may have four or five paragraphs, totaling three hundred to six hundred words. A long essay may be many pages long, depending on what the essay needs to accomplish, such as persuading someone to do something, using research to make a point, or explaining a complex concept.

An essay has three necessary parts: the introduction, the body, and the conclusion.

TEACHING TIP Have students interview a secondor third-year student in their major to find out what kind of writing that person does for his or her classes.

	ESSAY PART	PURPOSE OF THE ESSAY PART
1.	The introduction	states the main point , or thesis , generally in a single, strong statement. The introduction may be a single paragraph or multiple paragraphs.
2.	The body	supports (shows, explains, or proves) the main point. It generally has at least three support paragraphs, each containing facts and details that develop the main point. Each support paragraph has a topic sentence that supports the thesis statement.
3.	The conclusion	reminds readers of the main point and makes an observation. Often, it also summarizes and reinforces the support.

TEACHING TIP For some students, it helps to present visual analogies. Explain that just as a skyscraper needs more substantial support than a three-story apartment building, an essay needs more detailed support than a paragraph.

PARAGRAPH		ESSAY	
Topic sentence	\rightarrow	Thesis statement	
Support sentences	\rightarrow	Support paragraphs	
Concluding sentence	\rightarrow	Conclusion	

RESOURCES Additional Resources contains reproducible forms that students can use to plan their paragraphs and essays. These forms are also available online at bedfordstmartins.com/realwriting.

The diagram on pages 32–33 shows how the parts of an essay correspond to the parts of a paragraph.

RELATIONSHIP BETWEEN PARAGRAPHS AND ESSAYS

For more on the important features of writing, see the Four Basics of Good Writing on page 27.

Paragraph Form

als seek flexibility in the workplace; meaning, for one thing, that they want the independence to find the most effective way to work. Additionally, younger people generally prefer to work collaboratively and to motivate others on their team; therefore, they hold the

promise of being inspiring leaders. Second, Millennials are smart

about using technology to make connections and succeed on the

job. Most are accustomed to being in nearly constant contact with

others via phones, laptops, or other devices. Millennials who use

their electronic communication skills wisely will be comfortable

keeping managers and colleagues up to date about projects. Also, Millennials' social media skills can be put to good use by employers looking for new ways to market products. Finally, the economy is

creating more jobs that demand the flexibility, independence, and

technological skills that Millennials are acquiring. For example, many jobs are being created in the health care field, where workers must not only exercise independence in decision making but must also be able to collaborate effectively. Additionally, many more companies need employees who know how to use social media and other electronic tools. As long as they remain determined, Millen-

nials have every reason to believe that they will achieve success.

Topic sentence

Support 1

Support 2

Support 3

Concluding sentence

Although they are entering the job market in tough economic times, Millennials (those born between 1981 and 2000) have some important advantages in the workplace. First, having grown up in a fast-changing world, they value flexibility, independence, and collaboration. According to a report from the Boston College Center for Work and Family's Executive Briefing Series, Millenni-

Facts, Details, or Examples to Back Up the Support Points: Usually, 1 to 3 sentences per support point for paragraphs and 3 to

Main Point: May be the same

point for paragraphs and 3 to 8 sentences per support point for essays.

Conclusion

32

1

Introductory paragraph

Fairly often, I hear older people saying that
Millennials (those born between 1981 and 2000) are
spoiled, self-centered individuals who have much less to
contribute to the workplace than previous generations
did. Based on my own experiences and r Thesis statement
disagree. Although they are entering the job market in
tough economic times, Millennials have some important
advantages in the workplace.

Topic sentence 1

First, having grown up in a fast-changing world, they value flexibility, independence, and collaboration. Unlike their parents and grandparents, Millennials never knew a world without personal computers, and the youngest of them never knew a world without the Internet or ever-changing models of smart phones. They are used to rapid change, and most of them have learned to adapt to it. Consequently, Millennials, for the most part, expect workplaces to adapt to them. According to a report from the Boston College Center for Work and Family's Executive Briefing Series (EBS), Millennials seek flexibility in the workplace—for example, in when and where they work. This attitude does not mean that

they are looking out for themselves alone. Instead, they want the independence to find the most effective and productive way to work. Additionally, according to the EBS report, Millennials are more likely than older workers to reject old-fashioned business hierarchies in which managers tell lower-ranking employees what to do, and there is no give-and-take. In general, younger people prefer to work collaboratively and to do what they can to motivate others on their team; therefore, they hold the

promise of being inspiring leaders.

Topic sentence 2

Second, Millennials are smart about using technology to make connections and succeed on the job. Most of them are accustomed to being in nearly constant contact with others via phones, laptops, or other devices. Although some people fear that such connectedness can be a distraction in the workplace, these technologies can be used productively and allow effective multitast For instance, over the course of a day, Millennials have learned to use their electronic communication skills wisely will be comfortable keeping managers and colleagues up to date about projects and responding

3

to questions and requests as they arise. Furthermore, most Millennials are open to continuing such electronic exchanges during evenings and weekends if they feel they are collaborating with colleagues to meet an important goal. Also, many Millennials are skilled in using social media to reach out to and remain connected with others; in fact, some people refer to them as "the Facebook generation." Employers can put these skills to good use as they look for new ways to market their products and find new customers.

Topic sentence 3

Finally, the economy is creating more jobs that demand the flexibility, independence, and technological skills that Millennials are acquiring. For example, many jobs are being created in the health care field, where workers, such as nurses and physician assistants, must not only exercise independence in decision making but must also be able to collaborate effectively. Additionally, many more companies need employees who know how to use social media and other electronic tools for marketing purposes. Similarly, Millennials with social media skills may have an advantage in finding work in the marketing

4

and advertising industries specifically. There is also always a need for independent-minded people to create new businesses and innovations. Thus, Millennials Concluding play a valuable role in helping the economy grow.

As long as they remain determined and confident, Millennials have every reason to believe that they will achieve career success. According to the EBS report and other sources, meaningful, challenging work is more important to this generation than having a high salary. In the long term, workers with those types of values will always be in demand.

Understand the Writing Process

TEACHING TIP Ask students to describe a process related to their college experience, such as registering for classes, buying books, or applying for financial aid. The chart that follows shows the four stages of the **writing process**, all steps you will follow to write well. The rest of the chapters in Part 1 cover every stage except editing (presented later in the book). You will practice each stage, see how another student completed the process, and write your own paragraph or essay. Keep in mind that you may not always go in a straight line through the four stages; instead, you might circle back to earlier steps to further improve your writing.

THE WRITING PROCESS

Generate ideas

CONSIDER: What is my purpose in writing? Given this purpose, what interests me? Who will read this paper? What do they need to know?

- Find and explore your topic (Chapter 3).
- · Make your point (Chapter 4).
- Support your point (Chapter 5).

Draft

CONSIDER: How can I organize my ideas effectively and show my readers what I mean?

- Arrange your ideas, and make an outline (Chapter 6).
- Write a draft, including an introduction that will interest your readers, a strong conclusion, and a title (Chapter 6).

Revise

CONSIDER: How can I make my draft clearer or more convincing to my readers?

- Look for ideas that do not fit (Chapter 7).
- Look for ideas that could use more detailed support (Chapter 7).
- Connect ideas with transitional words and sentences (Chapter 7).

Edit

CONSIDER: What errors could confuse my readers and weaken my point?

- Find and correct errors in grammar (Chapters 19–30).
- Look for errors in word use (Chapters 31 and 32), spelling (Chapter 33), and punctuation and capitalization (Chapters 34–38).

Some writing strategies—such as finding and exploring a topic, coming up with a main point, and revising—are similar for both paragraphs and essays. In these cases, this book discusses the strategies for paragraphs and essays together. (See Chapters 3, 4, and 7.) However, other activities, such as supporting main points or drafting individual parts of paragraphs or essays, are somewhat different for the two types of writing. (See Chapters 5 and 6.) In those cases, this book makes greater distinctions between paragraphs and essays.

NOTE: AVOIDING PLAGIARISM

In all the writing you do, it is important to avoid plagiarism—using other people's words as your own or handing in information you gather from another source as your own. Your instructors are aware of plagiarism and know how to look for it. Writers who plagiarize, either on purpose or by accident, risk failing a course or losing their jobs and damaging their reputations.

To avoid plagiarism, take careful notes on every source (books, interviews, television shows, Web sites, and so on) you might use in your writing. When recording information from sources, take notes in your own words, unless you plan to use direct quotations. In that case, make sure to record the quotation word for word. Also, include quotation marks around it, both in your notes and in your paper. When you use material from other sources—whether you directly quote or put information in your own words (paraphrase)—you must name and give citation information about these sources.

TIP For more on avoiding plagiarism, and citing and documenting outside sources, see Chapter 18. Visit the Bedford/St. Martin's Workshop on Plagiarism at http://bcs.bedfordstmartins.com/plagiarism for online resources on avoiding plagiarism.

Understand Grading Criteria

Your instructor may use a **rubric**—a list of the elements that your papers will be graded on. If your instructor uses a rubric, it may be included in the course syllabus, and you should refer to it each time you write. Also, use the rubric to revise your writing.

The following sample rubric shows you some of the elements you may be graded on. Many rubrics include how each element is weighted; because that practice differs among instructors and courses, the example does not specify percentages of importance or points.

Samp	le l	Ru	bri	C

ELEMENT	GRADING CRITERIA	POINT RANGE
Appropriateness	Did the student follow the assignment directions?	0–5
Main idea	Does the paper clearly state a strong main point in a complete sentence?	0–10

(continued)

ELEMENT	GRADING CRITERIA	POINT RANGE
Support	 Is the main idea developed with specific support, including specific details and examples? 	0–10
	 Is enough support presented to make the main point evident to the reader? 	
	Is all the support directly related to the main point?	
Organization	Is the writing logically organized?	0–10
	 Does the student use transitions (also, for example, sometimes, and so on) to move the reader from one point to another? 	
Conclusion	Does the conclusion remind the reader of the main point?	0-5
	Does it make an observation based on the support?	
Grammar	• Is the writing free of the four most serious errors? (See Chapters 20–23.)	0–10
	Is the sentence structure clear?	
	 Does the student choose words that clearly express his or her meaning? 	
	 Are the words spelled correctly? 	
	• Is the punctuation correct?	

The paragraphs that follow show how rubrics are applied to a piece of writing. For a key to the correction symbols used, see the Useful Editing and Proofreading Marks chart at the back of this book.

ASSIGNMENT: Write a paragraph about something you enjoy doing. Make sure you give enough details about the activity so that a reader who knows little about it will have an idea of why you enjoy it.

PARAGRAPH 1

ANALYSIS OF PARAGRAPH 1: This paragraph would receive a low grade, for these reasons.

Sample Rubric

ELEMENT	GRADING CRITERIA	POINT: COMMENT
Appropriateness	Did the student follow the assignment directions?	2/5: Generally, yes, although without providing the details the assignment required.
Main idea	Does the paper clearly state a strong main point in a complete sentence?	0/10: No. The topic sentence is not a complete sentence (it is missing a subject).
Support	 Is the main idea developed with specific support, including specific details and examples? 	0/10: No. The major problem with the paragraph is that it includes few details.
	 Is enough support presented to make the main point evident to the reader? 	
	Is all the support directly related to the main point?	
Organization	Is the writing logically organized?	2/10: The writing is not logically
	 Does the student use transitions (also, for example, sometimes, and so on) to move the reader from one point to another? 	organized, although there are transitions
Conclusion	Does the conclusion remind the reader of the main point?	3/5: No reminder of the main point, but the last sentence has the start of an
	 Does it make an observation based on the support? 	observation.
Grammar	• Is the writing free of the four most serious errors? (See Chapters 20–23.)	2/10: No. The writing has many errors o all kinds.
	• Is the sentence structure clear?	
	 Does the student choose words that clearly express his or her meaning? 	
	Are the words spelled correctly?	
	Is the punctuation correct?	TOTAL POINTS: 9/50

PRACTICE 3 Adding Detail

Rewrite Paragraph 1, adding detail about the second and fourth sentences. If you know how to correct the grammar (including spelling and punctuation), make the corrections.

TEACHING TIP Have students work in pairs to do Practice 3.

Now, look at Paragraph 2.

PARAGRAPH 2

In my spare time, I enjoy talking with my friend Karen. I know tense

Karen since we ten, so we have growed up together and been

through many things. Like a sister. We can talk about anything.

Sometimes we talk about problems. Money problems, problems frag with men. When I was in a difficult relationship, for example. Now we both have children and we talk about how to raise them. Things are diffrent then when we kids. Talking with a good friend helps me make good decisions and patience. Especially now that my son is a teenager. We also talk about fun things, like what were going to do on the weekend, what clothes we buy. We tell each other good jokes and make each other laugh. These conversations are as important as talking about problems.

ANALYSIS OF PARAGRAPH 2: This paragraph would receive a higher grade (but still not an A or B), for the following reasons.

Sample Rubric

ELEMENT	GRADING CRITERIA	POINT: COMMENT
Appropriateness	Did the student follow the assignment directions?	5/5: Yes.
Main idea	Does the paper clearly state a strong main point in a complete sentence?	10/10: Yes.
Support	 Is the main idea developed with specific support, including specific details and examples? Is there enough support to make the main point evident to the reader? Is all the support directly related to the main point? 	5/10: The paragraph has more support and detail than Paragraph 1 does, but it could use more.
Organization	 Is the writing logically organized? Does the student use transitions (also, for example, sometimes, and so on) to move the reader from one point to another? 	6/10: The student uses a few transitions (sometimes, when, for example, now).
Conclusion	 Does the conclusion remind the reader of the main point? Does it make an observation based on the support? 	3/5: The conclusion is better than the one in Paragraph 1. It relates back to the main point, but the observation is weak.

ELEMENT	GRADING CRITERIA	POINT: COMMENT
Grammar	 Is the writing free of the four most serious errors? (See Chapters 20–23.) Is the sentence structure clear? 	6/10: Compared with Paragraph 1, the writing has fewer grammar errors, but it still has some major ones.
	 Does the student choose words that clearly express his or her meaning? 	
	 Are the words spelled correctly? 	
	Is the punctuation correct?	TOTAL POINTS: 37/50

PRACTICE 4 Making Corrections

Correct any of the errors in Paragraph 2 that you can.

RESOURCES If you are interested in having your students keep writing portfolios, see *Practical Suggestions*.

PRACTICE 5 Writing a Concluding Sentence

Try writing a concluding sentence to Paragraph 2. (Several answers are possible.)

Now, look at Paragraph 3.

PARAGRAPH 3

In my spare time, I enjoy talking with my friend Karen. We have been friends since we were ten, so we have grown up together. We have been through many things, both good and bad, in our lives, and we understand each other without having to explain the background of any situation. We have talked about our various problems throughout the years. Long ago, most of our problems were with our parents, who tried to control us too much. We would plan how to get around the rules we didn't like. Over the years, we have often talked about our relationships with men, which we call "the good, the bad, and the ugly." When I discovered that a man I was dating was cheating on me, Karen helped me see that the relationship wasn't good for me. She helped me get out of and over it. She helped me move on and value myself when I felt low. Now we talk often about our children and how to raise them right. For example, my son is now a teenager, and sometimes I can't control him, just as my parents couldn't control me. Karen helps me think of ways to get through to him without losing my temper. Also, we have always been able to make each other see the humor in whatever is going on. We tell each other good jokes, we make fun of people who are unfair to us, and we have a whole language of fun. These conversations are as important as the ones that help solve problems. Throughout my life, talking with Karen has helped keep me on a good path, and I truly enjoy talking with her.

ANALYSIS OF PARAGRAPH 3: This is an excellent paragraph, for the following reasons.

Sample Rubric

ELEMENT	GRADING CRITERIA	POINT: COMMENT				
Appropriateness	Did the student follow the assignment directions?	5/5: Yes.				
Main idea	Does the paper clearly state a strong main point in a complete sentence?	10/10: Yes.				
Support	 Is the main idea developed with specific support, including specific details and examples? 	10/10: Good support with lots of details.				
	 Is there enough support to make the main point evident to the reader? 					
	Is all the support directly related to the main point?	projective terror to appear to the growth for				
Organization	 Is the writing logically organized? Does the student use transitions (also, for 	10/10: Good use of transitions (long ago over the years, when, now, for example,				
	example, sometimes, and so on) to move the reader from one point to another?	also, throughout).				
Conclusion	Does the conclusion remind the reader of the main point?	5/5: Strong concluding sentence with a good observation.				
	Does it make an observation based on the support?					
Grammar	Is the writing free of the four most serious errors? (See Chapters 20–23.)	10/10: No errors.				
	Is the sentence structure clear?					
	 Does the student choose words that clearly express his or her meaning? 					
	Are the words spelled correctly?	Control to a state of an ex-				
	Is the punctuation correct?	TOTAL POINTS: 50/50				

TEACHING TIP Tell students that they will be learning about topic sentences, support, transitions, and conclusions. The practice is to show them that they already know some of what makes for good writing.

PRACTICE 6 Analyzing the Paragraph

Referring to Paragraph 3, answer the following questions. Some answers will vary. Possible answers are shown.

- 1. Which sentence is the topic sentence? sentence 1
- **2.** Underline some of the added details that make Paragraph 3 stronger than the first two paragraphs, and note those details here. Answers will vary.

- 3. Circle the transitions, and write them here. long ago, over the years, when, now, for example, also, throughout
- 4. In what way is the last sentence a good concluding sentence? It refers back to the topic sentence with the phrase "talking with Karen." It also makes an observation: "has helped keep me on a good path."

RESOURCES For advice about using writing portfolios, including how to structure and evaluate them, see *Practical Suggestions*.

Chapter Review

- **1.** Highlight important terms in this chapter. Make a list of them, noting what page they appear on. Answers will vary.
- 2. In your own words, define audience. the person or people who will read what I write
- **3.** In college, who is your audience likely to be? my instructors
- 4. What are the stages of the writing process? generating ideas, drafting, revising, editing
- Think of other courses in which you have written papers or taken tests.
 What purposes has that writing had? showing knowledge of the material, arguing for my point of view
- 6. What are four of the elements often evaluated in rubrics?

 appropriateness, main idea, support, organization, conclusion,

 grammar

reflect Having read this chapter, would you change your response to the "think" question on p. 27?

3

YOU KNOW THIS

You already know what a topic is:

- What was the topic of a movie you saw recently?
- What topic is in the headlines this week?
- What was the topic of an interesting conversation you had recently?

Finding, Narrowing, and Exploring Your Topic

Choosing Something to Write About

STUDENT VOICES

Message-Chelsea to Nick (9:15 a.m.)

I have a writing assignment--we choose our own topic. I can't think of anything to write about.

Message-Nick to Chelsea (9:18 a.m.)

Try asking yourself a few questions.

Like, what are you interested in?

What's been going on in your life lately? How's your job going?

think of a topic you have written about in the past. Was it a good topic? Why or why not?

Chelsea Wilson exchanged messages with her friend Nick Brown about an assignment she had received. Nick had taken the same writing course a semester earlier.

Understand What a Topic Is

A **topic** is who or what you are writing about. It is the subject of your paragraph or essay.

QUESTIONS FOR FINDING A GOOD TOPIC

- Does this topic interest me? If so, why do I care about it?
- Do I know something about the topic? Do I want to know more?
- Can I get involved with some part of the topic? Is it relevant to my life in some way?
- Is the topic specific enough for the assignment (a paragraph or a short essay)?

Choose one of the following topics or one of your own and focus on one part of it that you are familiar with. (For example, focus on one personal goal or a specific problem of working students that interests you.)

Music/group I like Sports

Problems of working students An essential survival skill

An activity/group I am involved in A personal goal

Something I can do well A time when I took a big risk

An issue in the news My ideal job
Relationships A current trend

TIP For help finding topic ideas, visit www.plinky .com.

PRACTICE 1 Finding a Good Topic

Ask the Questions for Finding a Good Topic about the topic you have chosen. If you answer "no" to any of them, keep looking for another topic or modify the topic.

MY TOPIC:	Answers	will	vary.	20 , 11	 51.53		0.300

With the general topic you have chosen in mind, read this chapter and complete all the practices. When you finish the chapter, you will have found a good topic to write about and explored ideas related to it.

Practice Narrowing a Topic

If your instructor assigns a general topic, it may at first seem uninteresting, unfamiliar, or too general. It is up to you to find a good, specific topic based on the general one. Whether the topic is your own or assigned, you next need to narrow and explore it. To **narrow** a general topic, focus on the smaller parts of it until you find one that is interesting and specific.

TEACHING TIP To give students an example of what narrowing a topic is like, use a camera analogy. The general topic is similar to using a wide-angle lens. Narrowing it is like zooming in closer so that you can examine or focus on smaller elements of your subject.

Here are some ways to narrow a general topic.

DIVIDE IT INTO SMALLER CATEGORIES

THINK OF SPECIFIC EXAMPLES FROM YOUR LIFE

GENERAL TOPIC Crime

Stolen identities (how does it happen?)

When I had my wallet stolen by two kids (how? what happened?)

The e-mail scam that my grandmother lost money in (how did it work?)

GENERAL TOPIC Social media

Twitter (which feeds do I follow regularly? what do I get from them?)

Facebook (what features are fun or useful? what feels like a waste of time?)

Google+ (is it just another Facebook, or is it truly different?)

TEACHING TIP Instructor James Grenier offers this advice to students: "Begin with ideas." As students start working on a paper, you might share this quotation with them.

Alternatively, read this reflection by E. L. Doctorow: "Writing is an exploration. You start from nothing and learn as you go."

THINK OF SPECIFIC EXAMPLES FROM CURRENT EVENTS

GENERAL TOPIC Job-creation ideas

Tax breaks for businesses

Training of future entrepreneurs in growth areas, like solar or wind energy

A special fund for public projects that will employ many people

GENERAL TOPIC

Heroism

The guy who pulled a stranger from a burning car The people who stopped a robbery downtown

QUESTION YOUR ASSUMPTIONS

Questioning assumptions—an important part of critical thinking (see Chapter 1)—can be a good way to narrow a topic. First, identify any assumptions you have about your topic. Then, question them, playing "devil's advocate"; in other words, imagine what someone with a different point of view might say. For example, imagine that your general topic is the pros or cons of letting kids play video games.

POSSIBLE ASSUMPTIONS	QUESTIONS			
Video game pros:	y mississ couplishes aminone			
Kids get rewarded with good scores for staying focused. →	Does staying focused on a video game mean that a kid will stay focused on homework or in class?			
Video games can teach some useful skills. →	Like what? How am I defining "useful"?			
Video game cons:				
They make kids more violent. →	Is there really any proof for that? What do experts say?			
They have no real educational value. →	Didn't my niece say that some video game helped her learn to read?			

Next, ask yourself what assumptions and questions interest you the most. Then, focus on those interests.

When you have found a promising topic for a paragraph or cssay, be sure to test it by using the Questions for Finding a Good Topic at the beginning of this chapter. You may need to narrow and test your ideas several times before you find a topic that will work for the assignment.

A topic for an essay can be a little broader than one for a paragraph because essays are longer than paragraphs and allow you to develop more ideas. But be careful: Most of the extra length in an essay should come from developing ideas in more depth (giving more examples and details, explaining what you mean), not from covering a broader topic.

Read the following examples of how a general topic was narrowed to a more specific topic for an essay and an even more specific topic for a paragraph. TEACHING TIP Have students work in small groups to identify and question each other's assumptions.

GENERAL TOPIC		NARROWED ESSAY TOPIC		NARROWED PARAGRAPH TOPIC
Internships	\rightarrow	How internships can help you get a job	\rightarrow	One or two important things you can learn from an internship
Public service opportunities	\rightarrow	Volunteering at a homeless shelter	\rightarrow	My first impression of the homeless shelter
A personal goal	\rightarrow	Getting healthy	\rightarrow	Eating the right foods
A great vacation	\rightarrow	A family camping trip	\rightarrow	What I learned on our family camping trip to Michigan

TEACHING TIP Give students examples of questions they might be asked that are too "big" to answer in a paragraph or essay. Have them figure out how to narrow the question or assignment.

PRACTICE 2 Narrowing a General Topic

Use one of the four methods above to narrow your topic. Then, ask yourself the Questions for Finding a Good Topic. Write your narrowed topic below.

MY NARROWED TOPIC: Answers will vary.

TIP Scholar and writer Mina Shaughnessy said that a writer "gets below the surface of a topic." When it comes to exploring a topic, what do you think getting "below the surface" means?

Practice Exploring Your Topic

Prewriting techniques can give you ideas at any time during your writing: to find a topic, to get ideas for what you want to say about it, and to support your ideas. Ask yourself: What interests me about this topic? What do I know? What do I want to say? Then, use one or more of the prewriting techniques to find the answers. No one uses all those techniques; writers choose the ones that work best for them.

PREWRITING TECHNIQUES

Freewriting

- Clustering/mapping
- Listing/brainstorming
- Using the Internet

Discussing

Keeping a journal

When prewriting, your goal is to come up with as many ideas as possible. Do not say, "Oh, that's stupid" or "That won't work." Just get your brain working by writing down all the possibilities.

A student, Chelsea Wilson, was assigned to write a short essay. She chose to write on the general topic of a personal goal, which she narrowed to "Getting a college degree." The following pages show how she used the first five prewriting techniques to explore her topic.

Freewriting

Freewriting is like having a conversation with yourself, on paper. To freewrite, just start writing everything you can think of about your topic. Write nonstop for five minutes. Do not go back and cross anything out, and do not worry about using correct grammar or spelling; just write. Here is Chelsea's freewriting:

a computer, try a kind of freewriting called "invisible writing." Turn the monitor off, or adjust the screen so that you cannot see what you are typing. Then, write quickly for five minutes without stopping. After five minutes, read what you have written. You may be surprised by the ideas that you can generate this way.

TIP If you are writing on

So I know I want to get a college degree even though sometimes I wonder if I ever can make it because it's so hard with work and my two-year-old daughter and no money and a car that needs work. I can't take more than two courses at a time and even then I hardly get a chance to sleep if I want to do any of the assignments or study. But I have to think I'll get a better job because this one at the restaurant is driving me nuts and doesn't pay much so I have to work a lot with a boss I can't stand and still wonder how I'm gonna pay the bills. I know life can be better if I can just manage to become a nurse. I'll make more money and can live anywhere I want because everyplace needs nurses. I won't have to work at a job where I am not respected by anyone. I want respect, I know I'm hardworking and smart and good with people and deserve better than this. So does my daughter. No one in my family has ever graduated from college even though my sister took two courses, but then she stopped. I know I can do this, I just have to make a commitment to do it and not look away.

Listing/Brainstorming

List all the ideas about your topic that you can think of. Write as many as you can in five minutes without stopping.

GETTING A COLLEGE DEGREE

want a better life for myself and my daughter want to be a nurse and help care for people make more money not have to work so many hours could live where I want in a nicer place good future and benefits like health insurance get respect proud of myself, achieve, show everyone be a professional, work in a clean place

Discussing

Many people find it helpful to discuss ideas with another person before they write. As they talk, they get more ideas and immediate feedback.

If you and your discussion partner both have writing assignments, first explore one person's topic and then explore the other's. The person whose topic is being explored is the interviewee; the other person is the interviewer. The interviewer should ask questions about anything that seems unclear and should let the interviewee know what sounds interesting. In addition, the interviewer should identify and try to question any assumptions the interviewee seems to be making (see page 44). The interviewee should give thoughtful answers and keep an open mind. He or she should also take notes. Here is Chelsea's discussion with Nick, a friend who had taken this writing course a semester before:

Nick: How's work?

Chelsea: It's OK except for lots of hours, a sleazy, stingy boss, and dirty conditions. Actually, I can't stand it. I want better.

Nick: Like what?

Chelsea: Getting a degree and becoming a nurse. Nurses make good money and can live wherever they want because everyone needs nurses.

Nick: Isn't a personal goal one of the topics the instructor gave you to choose from? How about "getting a degree and becoming a nurse"?

Chelsea: Yeah, I could write about getting a nursing degree, but I'm not sure I know enough about it. And I didn't leave lots of time to find out. The draft is due in two days, and I have to work.

Nick: So, other than wanting to become a nurse, why else do you want a degree? Write about that.

TIP If you find that talking about your ideas with someone is a good way to get going, you might want to ask another student to be your regular partner and discuss ideas before beginning any paragraph or essay assignment.

RESOURCES Advice for students about giving and getting feedback is available (along with the Peer Factor skills-building game) at the Re:Writing Plus site, at bedfordstmartins.com/rewritingplus.

PRACTICE 3 Exploring Your Narrowed Topic

Use two or three prewriting techniques to explore your narrowed topic.

Clustering/Mapping

TIP For online mapping tools, visit http://bubbl.us.

RESOURCES A clustering form for students is provided in *Additional Resources*.

RESOURCES For an animation of clustering, see the *Make-a-Paragraph Kit* CD-ROM.

Clustering, also called mapping, is like listing except that you arrange your ideas visually. Start by writing your narrowed topic in the center. Then, write the questions Why? What interests me? and What do I want to say? around the narrowed topic. Using Chelsea's clustering below as a model, write three answers to these questions. Keep branching out from the ideas until you feel you have fully explored your topic. Note that when Chelsea filled in "Why?" "What interests me?" and "What do I want to say?" she had lots of reasons and ideas that she could use in her writing assignment.

Using the Internet

Go to www.google.com, and type in specific key words about your topic. The search will provide more results than you can use, but it will help you with ideas for your paper. For example, Chelsea typed in "reasons to get a college degree" and got lots of information about aspects of her topic

that she did not know much about, such as what a college degree is worth. Make notes about important or useful ideas you get from the Internet.

Keeping a Journal

Setting aside a few minutes on a regular schedule to write in a journal will give you a great source of ideas when you need them. What you write does not need to be long or formal. You can use a journal in several ways:

- To record and explore your personal thoughts and feelings
- To comment on things that happen, to you personally or in politics, in your neighborhood, at work, in college, and so on
- To explore situations you do not understand (as you write, you may figure them out)

One student, Jack, did all these things in the following journal entry.

Been feeling a little confused about school lately. Doing OK in my classes and still liking the construction tech program. But having some doubts. Elena, another student in my English class, is studying to be a solar tech in a new program at the school. She's going to learn how to install and repair solar energy systems at a facility near campus, and that's pretty cool. Solar seems kind of sci-fi, and I love sci-fi movies. But seriously I'm truly interested in the technology, and some of the skills I've been learning in construction tech would probably transfer. And maybe I'd have a better chance of getting a job in solar energy since it's a field that seems to be growing? Not sure, but something to investigate. Bottom line: I can't get this new idea out of my mind, even though I thought I was sure about construction tech. I guess I'll keep talking with Elena about the solar tech program. And maybe I should meet with one of the instructors in the program? Or visit the solar facility?

TIP Look for the Idea Journal and Learning Journal assignments throughout this book.

RESOURCES For tips on helping students keep journals, see *Practical Suggestions*.

TIP If you start keeping a journal, you might use some of the strategies described by writer Joan Didion. She says, "I write entirely to find out what I'm thinking, what I'm looking at, what I see and what it means. What I want and what I fear."

Write Your Own Topic and Ideas

If you have worked through this chapter, you should have both your narrowed topic (recorded in Practice 2) and ideas from your prewriting. Now is the time to make sure your topic and ideas about it are clear. Use the checklist that follows to make sure you have completed this step of the writing process.

CH	IECKLIST
Eva	aluating Your Narrowed Topic
	This topic interests me.
	My narrowed topic is specific.
	I can write about it in a paragraph or an essay (whichever you have been assigned).
	I have generated some things to say about this topic.
	I have generated some things to say about this topic.

Now that you know what you are going to write about, you are ready to move on. Chapter 4 shows you how to express what is important to you about your narrowed topic.

Chapter Review

- **1.** Highlight important terms from this chapter (for example, *topic*, *narrow*, and *prewriting techniques*), and list them with their page numbers.
- 2. What are four questions that can help you find a good topic? Does it interest me? Do I know something about it? Can I get involved with some part of it? Is it specific enough for the assignment?
- 3. How can you narrow a topic that is too broad or general? Divide the topic into smaller categories, think of specific examples, and question your assumptions.
- **4.** What are some prewriting techniques? <u>freewriting</u>, <u>listing/brainstorming</u>, <u>discussing</u>, <u>clustering/mapping</u>, using the Internet, keeping a journal
- **5.** Write for one minute on "Topics I would like to know more about."
- **6.** Write for one minute about "What questions I should ask my instructor."

STUDENT VOICES

Message-Chelsea to Nick (11:37 a.m.)

OK, I'm going to write about a personal goal: why I want to get a college degree.

That's something I've thought a lot about.

Message-Nick to Chelsea (12:15 p.m.)

Sounds good! What's your next move?

reflect What prewriting technique was best for you? Do you have something to write about? What?

4

Writing Your Topic Sentence or Thesis Statement

Making Your Point

YOU KNOW THIS

You already have experience in making your point:

- You explain the point of a movie to someone who has not seen it.
- When a friend asks you, "What's your point?" you explain it.
- When you persuade someone to do something you want, you make your point about why he or she should.

Chelsea Wilson exchanged messages with her friend Nick Brown about an assignment she had received. Nick had taken the same writing course a semester earlier.

RESOURCES For an animated demonstration of writing topic sentences, see the Extreme Paragraph Makeover on the Make-a-Paragraph Kit CD-ROM.

Understand What a Topic Sentence and a Thesis Statement Are

Every good piece of writing has a **main point**—what the writer wants to get across to the readers about the topic or the writer's position on that topic. A **topic sentence** (for a paragraph) and a **thesis statement** (for an essay) express the writer's main point. To see the relationship between the thesis statement of an essay and the topic sentences of paragraphs that support a thesis statement, see the diagram on pages 56–57.

In many paragraphs, the main point is expressed in either the first or last sentence. In essays, the thesis statement is usually one sentence (often the first or last) in an introductory paragraph that contains several other sentences related to the main point.

A good topic sentence or thesis statement has several basic features.

BASICS OF A GOOD TOPIC SENTENCE OR THESIS STATEMENT

- It fits the size of the assignment.
- It states a single main point or position about a topic.
- It is specific.
- It is something you can show, explain, or prove.
- It is forceful.

WEAK

Giving children chores teaches them responsibility, and I think doing chores as a kid made me a better adult.

[This statement has more than one point (how chores teach responsibility and how they made the writer a better adult); it is not specific (what is "responsibility"? what does it mean to be a "better adult"?); and it is not forceful (the writer says, "I

think").]

GOOD

Giving children chores teaches them the responsibilities of taking care of things and completing assigned tasks.

Being assigned chores as a child helped teach me the important adult skills of teamwork and attention to detail.

(particularly Asian ones) avoid making direct points in writing. You may need to explain that in English the rhetorical convention is that the writer make a clear, direct point. Ask students if writing conventions in their countries approach the main point differently.

ESL Some cultures

IDEA JOURNAL What are your strongest communication skills? What other skills or talents do you have?

One way to write a topic sentence for a paragraph or a thesis statement for an essay is to use this basic formula as a start:

The tutoring center has helped me improve my writing.

If you have trouble coming up with a main point or position, look back over the prewriting you did. For example, when the student Chelsea Wilson looked over her prewriting about getting a college degree (see p. 46), she realized that several times she had mentioned the idea of more options for employment, living places, and chances to go on and be a nurse. She could also have chosen to focus on the topic of respect or on issues relating to her young daughter, but she was most drawn to write about the idea of options. Here is how she stated her main point:

TEACHING TIP Ask students to bring in newspaper or magazine articles in which they have highlighted thesis statements or topic sentences. They should also label the topic and main point or position about that topic. Read and discuss some of these examples in class.

PRACTICE 1 Finding the Topic Sentence and Main Point

Read the paragraph that follows, and underline the topic sentence. In the spaces below the paragraph, identify the narrowed topic and the main point.

A recent survey reported that employers consider communication skills more critical to success than technical skills. Employees can learn technical skills on the job and practice them every day. But they need to bring well-developed communication skills to the job. They need to be able to make themselves understood to colleagues, both in speech and in writing. They need to be able to work cooperatively as part of a team. Employers cannot take time to teach communication skills, but without them an employee will have a hard time.

NARROWED TOPIC: communication skills

MAIN POINT: Employers consider communication skills more

critical to success than technical skills.

PRACTICE 2 Identifying Topics and Main Points

In each of the following sentences, underline the topic and double-underline the main point about the topic.

EXAMPLE: Rosie the Riveter was the symbol of working women during World War II.

- 1. Discrimination in the workplace is alive and well.
- 2. The oldest child in the family is often the most independent and ambitious child.
- 3. Gadgets created for left-handed people are sometimes poorly designed.
- **4.** Presidential campaigns bring out dirty politics.
- **5.** Walking away from a mortgage has become a financial survival strategy for some homeowners.
- 6. The magazine Consumer Reports can help you decide which brands or models are the best value.
- 7. According to one study, dogs might be trained to detect signs of cancer on people's breath.
- 8. Status symbols are for insecure people.
- **9.** Some song lyrics have serious messages about important social issues.

10. The Puritans came to America to escape religious intolerance, but they were intolerant themselves.

As you get further along in your writing, you may go back several times to revise the topic sentence or thesis statement based on what you learn as you develop your ideas. Look at how one student revised the example sentence on page 53 to make it more detailed:

Practice Developing a Good Topic Sentence or Thesis Statement

The explanations and practices in this section, organized according to the "basics" described previously, will help you write good topic sentences and thesis statements.

It Fits the Size of the Assignment

As you develop a topic sentence or thesis statement, think carefully about the length of the assignment.

Sometimes, a main-point statement can be the same for a paragraph or essay.

If the writer had been assigned a paragraph, she might follow the main point with support sentences and a concluding sentence like those in the "paragraph" diagram on pages 56–57.

If the writer had been assigned an essay, she might develop the same support, but instead of writing single sentences to support her main idea, she would develop each support point into a paragraph. The support sentences she wrote in a paragraph might be topic sentences for support paragraphs. (For more on providing support, see Chapter 5.)

Often, however, a topic sentence for a paragraph is much narrower than a thesis statement for an essay, simply because a paragraph is shorter and allows less development of ideas.

RELATIONSHIP BETWEEN PARAGRAPHS AND ESSAYS

For more on the important features of writing, see the Four Basics of Good Writing on page 27.

Paragraph Form

Topic sentence

Support 1

Support 2

Support 3

Concluding sentence

I can say with confidence that living alone is far more gratifying than sharing a household with a less-than-ideal partner. One advantage of living alone is that I can spend my free time as I choose. If I want to sleep in past noon on a Saturday and devote the rest of the day to listening to music or watching movies, no one is there to make me feel guilty or to try to convince me that my time could be better spent. If I decide to take a night class during the week, no one questions my choice or says that building new skills is a "waste of time," as my ex did. Another advantage of living alone is that I am free to make my own life decisions, big and small, without push-back. On the small side, there is no one to complain about the financial consequences if I decide that I would like to sign up for a gym membership or buy a nice pair of jeans. On the big side, I can now take the step of adopting a child - something my husband was opposed to. The final, and perhaps greatest, advantage of living alone is that it has strengthened my social connections. When I was married, I spent little time going out with existing friends, making new friends, or getting involved in community activities. Now, however, I am able to accommodate a busy social life and also volunteer work. As a result, my life is more fulfilling than ever. Although a strong romantic partnership can be rewarding, I strongly believe that the advantages of being single are underrated.

Main Point: May be the same for a paragraph and an essay (as in this case). Or, the main point of a paragraph may be narrower than one for an essay (see pp. 30–31).

Support for the Main Point

Facts, Details, or Examples to Back Up the Support Points: Usually, 1 to 3 sentences per support point for paragraphs and 3 to 8 sentences per support point for essays.

Conclusion

As a young woman, I saw being single as a temporary—and undesirable—condition. When, at twenty-four, I married, I considered myself extremely lucky. That was until I spent years in an increasingly unsatisfying relationship that ultimately ended in divorce. Since the divorce, however, my life has c Thesis statement better in many ways. I can now say with confidence that living alone is far more gratifying than sharing a household with a less-than-ideal partner. Topic sentence 1

One advantage of living alone is that I can spend my free time as I choose. If I want to sleep in past noon on a Saturday and devote the rest of the day to listening to music or watching movies, no one is there to make me feel guilty or to try to convince me that my time could be better spent. If I decide to take a night class during the week, no one questions my choice or says that building new skills is a "waste of time," as my ex did. Also, when I am able to take vacation days, I can spend them relaxing at home, visiting out-of-state family members, or doing something more adventurous. In other words, I can set my own agenda, all the time.

Topic sentence 2

Another advantage of living alone is that I am free to make my own life decisions, big and small, without push-back. On the small side, there is no one to complain about the financial consequences if I decide that I would like to sign up for a gym membership or buy a nice Support of jeans. On the big side, I can now take the ste paragraphs adopting a child—something my husband was opposed to. I realize that making all my own decisions requires personal responsibility and the ability to take some risks.

But, to me, the benefits of independence far outweigh the challenges.

Topic sentence 3

The final, and perhaps greatest, advantage of living alone is that it has strengthened my social connections. When I was married, I spent little time going out with existing friends, making new friends, or getting involved in community activities. If I did not spend nearly all of my free time with my husband, he would complain. Now, however, I am able to accommodate a busy social life and also volunteer work in my community. As a result, my life is more fulfilling than ever.

3

Although a strong romantic partnership can be rewarding, I strongly believe that the advantages of being single are underrated. Consequently, I would like to offer one piece of advice to partnered people: Do not feel sorry for your single friends. One day, you may join their ranks and find that you have never been happier.

Concluding paragraph

EXAMPLE:

Consider how one general topic could be narrowed into an essay topic and into an even more specific paragraph topic.

GENERAL TOPIC	NARRO	OWED TOPIC		NARROWED PARAGRAPH TOPIC
Internships →		internships telp you get	\rightarrow	One or two important things you can learn from an internship
POSSIBLE THESIS STATEM (ESSAY)	ENT	through a sun get a good job [The essay wou ternships, descr	nme afte ld dis ibing rofess	nnections you gain r internship can help you er graduation. scuss several benefits of in- the various skills they can sional connections they can
POSSIBLE TOPIC SENTENG (PARAGRAPH)	CE	whether a par [The paragraph internships: The The paragraph	wou ey are migh	ship is a good way to test lar career is right for you. Id focus on one benefit of e a way to test out a career. It go on to discuss signs that a is or is not passing the test.]

PRACTICE 3 Writing Sentences to Fit the Assignment

participation in school sports are too high.

Using the following example as a guide, write a thesis statement for the narrowed essay topic and a topic sentence for the narrowed paragraph topic.

RESOURCES To test students on choosing effective thesis statements and topic sentences, see the *Testing Tool Kit* CD-ROM available with this book.

TOPIC: Sports
NARROWED FOR AN ESSAY: Competition in school sports
NARROWED FOR A PARAGRAPH: User fees for school sports
POSSIBLE THESIS STATEMENT (essay): Competition in school sports has
reached dangerous levels.
POSSIBLE TOPIC SENTENCE (paragraph): This year's user fees for

NARROWED FOR AN ESSAY: Volunteering at a homeless shelter

NARROWED FOR A PARAGRAPH: My first impression of the homeless shelter

POSSIBLE THESIS STATEMENT (essay): Answers will vary.

POSSIBLE TOPIC SENTENCE (paragraph):

TOPIC: A personal goal
NARROWED FOR AN ESSAY: Getting healthy
NARROWED FOR A PARAGRAPH: Eating the right foods
POSSIBLE THESIS STATEMENT (essay):
POSSIBLE TOPIC SENTENCE (paragraph):
TOPIC: A great vacation
NARROWED FOR AN ESSAY: A family camping trip
NARROWED FOR A PARAGRAPH: A lesson I learned on our family camping trip
POSSIBLE THESIS STATEMENT (essay):
POSSIBLE TOPIC SENTENCE (paragraph):

TEACHING TIP When students write on the computer, have them use boldface type for their topic sentence or thesis statement. Boldface type helps you see what they consider their main point and helps them stay focused as they provide support.

Some topic sentences or thesis statements are too broad for either a short essay or a paragraph. A main idea that is too broad is impossible to show, explain, or prove within the space of a paragraph or short essay.

TOO BROAD Art is important.

[How could a writer possibly support such a broad concept in a

paragraph or essay?]

NARROWER Art instruction for young children has surprising

benefits.

A topic sentence or thesis statement that is too narrow leaves the writer with little to write about. There is little to show, explain, or prove.

TOO NARROW Buy rechargeable batteries.

[OK, so now what?]

BROADER Choosing rechargeable batteries over conventional bat-

teries is one action you can take to reduce your effect

on the environment.

PRACTICE 4 Writing Topic Sentences That Are Neither Too Broad Nor Too Narrow

In the following five practice items, three of the topic sentences are either too broad or too narrow, and two of them are OK. In the space to the left of each item, write "B" for too broad, "N" for too narrow, or "OK" for just right. Rewrite the three weak sentences to make them broader or narrower as needed.

We are not providing our returning soldiers with enough help in readjusting to civilian life. I take public transportation to work.
I take public transportation to work.
nswers will vary.
Because of state and national education budget cuts, schools are
aving to lay off teachers and cut important programs.
3 College is challenging.
3 I would like to be successful in life.
K Having a positive attitude improves people's ability to function, im-
roves their interactions with others, and reduces stress.
saya sa kasaga a salaa Sala Signer ahan kasa kasaa a sala - Lee da f

It Contains a Single Main Point

Your topic sentence or thesis statement should focus on only one main point. Two main points can split and weaken the focus of the writing.

MAIN IDEA WITH TWO MAIN POINTS

High schools should sell healthy food instead of junk food, and they should start later in the morning.

The two main points are underlined. Although both are good main points, together they split both the writer's and the readers' focus. The writer would need to give reasons to support each point, and the ideas are completely different.

MAIN IDEA WITH A SINGLE MAIN POINT

High schools should sell healthy food instead of junk food.

OR

High schools should start later in the morning.

PRACTICE 5 Writing Sentences with a Single Main Point

In each of the following sentences, underline the main point(s). Identify the sentences that have more than a single main point by marking an X in the space provided to the left of that item. Put a check mark (\checkmark) next to sentences that have a single main point.

Shopping at secondhand stores is a fun way to save money, and you can meet all kinds of interesting people as you shop.

- 1.

 ✓ My younger sister, the baby of the family, was the most adventurous of my four siblings.
- 2. X Servicing hybrid cars is a growing part of automotive technology education, and dealers cannot keep enough hybrids in stock.
- 3. My brother, Bobby, is incredibly creative, and he takes in stray animals.
- 4. Pets can actually bring families together, and they require lots of care.
- **5.** <u>Unless people conserve voluntarily, we will deplete our water supply.</u>

It Is Specific

A good topic sentence or thesis statement gives readers specific information so that they know exactly what the writer's main point is.

GENERAL Students are often overwhelmed.

[How are students overwhelmed?]

SPECIFIC Working college students have to learn how to juggle

many responsibilities.

One way to make sure your topic sentence or thesis statement is specific is to make it a preview of what you are planning to say in the rest

of the paragraph or essay. Just be certain that every point you preview is closely related to your main idea.

PREVIEW: Working college students have to learn how to juggle many responsibilities: doing a good job at work, getting to class regularly and on time, being alert in class, and doing the homework assignments.

PREVIEW: I have a set routine every Saturday morning that includes sleeping late, going to the gym, and shopping for food.

PRACTICE 6 Writing Sentences That Are Specific

In the space below each item, revise the sentence to make it more specific. There is no one correct answer. As you read the sentences, think about what would make them more understandable to you if you were about to read a paragraph or essay on the topic.

EXAMPLE: Marriage can be a wonderful thing.

Marriage to the right person can add love, companionship, and support to life.

1.	My job is horrible.	
	Answers will vary.	

2.	Working	with	others	18	reward	ling
----	---------	------	--------	----	--------	------

I am a good worker.

3.

					15 × 11 lo

4.	This	place	could	use a	lot o	f improvement

5.	Getting my	driver's	license	was	challenging.
----	------------	----------	---------	-----	--------------

It Is an Idea You Can Show, Explain, or Prove

If a main point is so obvious that it does not need support or if it states a simple fact, you will not have much to say about it.

OBVIOUS The Toyota Prius is a top-selling car.

Many people like to take vacations in the summer.

REVISED Because of rising gas costs and concerns about the

environmental impact of carbon emissions, the Toyota

Prius is a top-selling car.

The vast and incredible beauty of the Grand Canyon

draws crowds of visitors each summer.

FACT Employment of medical lab technicians is projected to

increase by 14 percent between 2008 and 2018.

Three hundred cities worldwide have bicycle-sharing

programs.

REVISED Population growth and the creation of new types of

medical tests mean the employment of lab technicians should increase by 14 percent between 2008 and

2018.

Bicycle-sharing programs are popular, but funding them long-term can be challenging for cities with tight

budgets.

PRACTICE 7 Writing Sentences with Ideas You Can Show, Explain, or Prove

Revise the following sentences so that they contain an idea you could show, explain, or prove.

EXAMPLE: Leasing a car is popular.

Leasing a car has many advantages over buying one.

1.	Texting while driving is dangerous.	
	Answers will vary.	

- **2.** My monthly rent is \$750.
- **3.** Health insurance rates rise every year.
- **4.** Many people in this country work for minimum wage.
- **5.** Technology is becoming increasingly important.

It Is Forceful

A good topic sentence or thesis statement is forceful. Do not say you will make a point; just make it. Do not say "I think." Just state your point.

WEAK In my opinion, everyone should exercise.

FORCEFUL Everyone should exercise to reduce stress, maintain a

healthy weight, and feel better overall.

WEAK I think student fees are much too high.

FORCEFUL Student fees need to be explained and justified.

PRACTICE 8 Writing Forceful Sentences

Rewrite each of the following sentences to make them more forceful. Also, add details to make the sentences more specific. Answers will vary. Possible answers given.

EXAMPLE: Jason's Market is the best. Jason's Market is clean, organized, and filled with quality products.

- I will prove that drug testing in the workplace is an invasion of privacy.
 Drug testing in the workplace is an invasion of privacy.
- 2. This school does not allow cell phones in class. Because cell phones are disruptive, this school does not allow them in class.
- 3. I strongly think I deserve a raise. I deserve a raise based on my strong performance over the past year.
- 4. Nancy should be the head of the Students' Association.

 Because she is hardworking and concerned about campus issues,

 Nancy should be the head of the Students' Association.
- 5. I think my neighborhood is nice. My neighborhood is safe, close to stores, and diverse.

Write Your Own Topic Sentence or Thesis Statement

If you have worked through this chapter, you should have a good sense of how to write a topic sentence or thesis statement that includes the five features of a good one (see p. 53).

Before writing your own topic sentence or thesis statement, consider the process that Chelsea Wilson used. First, she narrowed her topic.

GENERAL TOPIC: a personal goal

NARROWED TOPIC (FOR A PARAGRAPH): why I want to get a nursing degree

NARROWED TOPIC (FOR AN ESSAY): the many benefits of getting a college degree

Then, she did prewriting (see Chapter 3) to get ideas about her topic.

FOR A PARAGRAPH: why I want to get a nursing degree make more money get a better job become a respected professional live where I want

FOR AN ESSAY: the many benefits of getting a college degree get a job as a nurse make more money be a good role model for my daughter be proud of myself

Next, she was ready to write the statement of her main point.

TOPIC SENTENCE (PARAGRAPH): My goal is to get a nursing degree.

THESIS STATEMENT (ESSAY): My goal is to get a college degree.

Finally, Chelsea revised this statement to make it more forceful.

TOPIC SENTENCE: My goal is to become a registered nurse.

THESIS STATEMENT: I am committed to getting a college degree because it will give me many good job and life options.

TIP For tools to use in getting a job, visit the Student Site for Real Writing at bedfordstmartins.com/realwriting.

You may want to change the wording of your topic sentence or thesis statement later, but following a sequence like Chelsea's should start you off with a good basic statement of your main point.

TEACHING TIP Even if you aren't reading a student's entire first draft, it always helps to check the topic sentence or thesis statement because you can clear up numerous potential problems before you have to give a grade.

WRITING ASSIGNMENT

Write a topic sentence or thesis statement using the narrowed topic you developed in Chapter 3, your response to the idea journal prompt on page 53, or one of the following topics (which you will have to narrow).

Community service Holiday traditions
A controversial issue A strong belief
Dressing for success Snitching

Movies Exciting experiences

Saving money Juggling many responsibilities

Interviewing for jobs Friendship

Music Learning/teaching cooking skills

After writing your topic sentence or thesis statement, complete the checklist that follows.

Evaluating Your Main Point It is a complete sentence. It fits the assignment. It includes my topic and the main point I want to make about it. It states a single main point. It is specific. It is something I can show, explain, or prove. It is forceful.

LEARNING JOURNAL How would you help someone who asked, "I have some ideas about my topic, but how do I write a good topic sentence or thesis statement?" Coming up with a good working topic sentence or thesis statement is the foundation of the writing you will do. Now that you know what you want to say, you are ready to learn more about how to show, explain, and prove your main point to others. The next chapter, Supporting Your Point, helps you make a strong case, consider what your readers need to know, and provide sufficient details and examples in your paragraph or essay.

Chapter Review

- **1.** Highlight important terms from this chapter (for example, *topic sentence*, *thesis statement*, and *main point*), and list them with their page numbers.
- 2. The main point of a piece of writing is what the writer wants to get across to the readers about the topic.

- **3.** One way to write a **topic sentence** or a **thesis statement** is to include the narrowed topic and the main point/position about the topic.
- **4.** The basics of a good topic sentence or thesis statement are It fits the size of the assignment.

It states a single main point or position about a topic.

It is specific.

It is something you can show, explain, or prove.

It is forceful.

5. Write for one minute about "What questions I should ask my instructor."

STUDENT VOICES

Message-Chelsea to Nick (2:33 p.m.)

I feel good about my topic sentence! It's specific, I know about the topic, AND it could be interesting to readers.

Message-Nick to Chelsea (2:48 p.m.)

Hey, you've got me wanting to read it! That's something!

reflect What do you think of Chelsea's topic sentence? Does it fit the basics of a good topic sentence?

5

Supporting Your Point

Finding Details, Examples, and Facts

YOU KNOW THIS

You have lots of experience in supporting your point:

- You explain why you think a movie was boring.
- You explain to a child why locking the door is important.
- In a job interview, you list specific qualifications to persuade an employer to hire you.

STUDENT VOICES

Message-Chelsea to Nick (3:06 p.m.)

There's something more I don't get.

How do I support my main point?

You know, the one I've stated in my topic sentence?

Message-Nick to Chelsea (3:10 p.m.)

Think specifics. Your main point is that you want a degree, right?

So start with your first reason, and give hard facts to show it's a GOOD reason.

think

What is the purpose of support in writing?

Chelsea Wilson exchanged messages with her friend Nick Brown about an assignment she had received. Nick had taken the same writing course a semester earlier.

RESOURCES For more on support, see the Extreme Paragraph Makeover feature on the Make-a-Paragraph Kit CD-ROM.

Understand What Support Is

Support is the collection of examples, facts, or evidence that shows, explains, or proves your main point. **Primary support points** are the major ideas that back up your main point, and **secondary support** gives details to back up your primary support.

Key Features of Good Support

Without support, you *state* the main point, but you do not *make* the main point. Consider these unsupported statements:

The amount shown on my bill is incorrect.

I deserve a raise.

I am innocent of the crime.

The statements may be true, but without good support, they are not convincing. If you sometimes get papers back with the comment "You need to support/develop your ideas," the suggestions in this chapter will help you.

Also, keep in mind that the same point repeated several times is not support. It is just repetition.

REPETITION, NOT SUPPORT The amount shown on my bill is incorrect. You overcharged me. It didn't cost that much. The total is

wrong.

SUPPORT

The amount shown on my bill is incorrect. I ordered the bacon-cheeseburger plate, which is \$6.99 on the menu. On the bill, the order is correct, but the amount is \$16.99.

IDEA JOURNAL Write about a time you were overcharged for something. How did you handle it?

As you develop support for your main point, make sure it has these three features.

BASICS OF GOOD SUPPORT

- It relates directly to your main point. Remember that the purpose of support is to show, explain, or prove your main point.
- It considers your readers and what they will need to know.
- It gives readers enough specific details, particularly through examples, so that they can see what you mean.

Support in Paragraphs versus Essays

Again, primary support points are the major ideas that back up your main point. In paragraphs, your main point is expressed in a topic sentence. In both paragraphs and essays, it is important to add enough details (secondary support) about the primary support to make the main point clear to readers.

In the following paragraph, the topic sentence is underlined twice, the primary support is underlined once, and the details for each primary support point are in italics.

When I first enrolled in college, I thought that studying history was a waste of time. But after taking two world history classes, I have come to the conclusion that these courses count for far more than some credit

TIP Showing involves providing visual details or other supporting observations. Explaining involves offering specific examples or illustrating aspects of the main point. Proving involves providing specific evidence, sometimes from outside sources.

hours in my college record. First, learning about historical events has helped me put important current events in perspective. For instance, by studying the history of migration around the world, I have learned that immigration has been going on for hundreds of years. In addition, it is common in many countries, not just the United States. I have also learned about ways in which various societies have debated immigration, just as Americans are doing today. Second, history courses have taught me about the power that individual people can have, even under very challenging circumstances. I was especially inspired by the story of Toussaint L'Ouverture, a former slave who, in the 1790s, led uprisings in the French colony of Saint-Domingue, transforming it into the independent nation of Haiti. Although L'Ouverture faced difficult odds, he persisted and achieved great things. The biggest benefit of taking history courses is that they have encouraged me to dig more deeply into subjects than I ever have before. For a paper about the lasting influence of Anne Frank, I drew on quotations from her famous diary, on biographies about her, and on essays written by noted historians. The research was fascinating, and I loved piecing together the various facts and insights to come to my own conclusions. To sum up, I have become hooked on history, and I have a feeling that the lessons it teaches me will be relevant far beyond college.

In an essay, each primary support point, along with its supporting details, is developed into a separate paragraph. (See the diagram on pages 56–57.) Specifically, each underlined point in the previous paragraph could be turned into a topic sentence that would be supported by the italicized details. However, in preparing an essay on the preceding topic, the writer would want to add more details and examples for each primary support point. Here are some possible additions:

- For primary support point 1: more connections between history and current events (one idea: the rise and fall of dictators in past societies and in the modern Middle East)
- For primary support point 2: more examples of influential historical figures (one idea: the story of Joan of Arc, who in the fifteenth century led the French to victories over English armies)
- For primary support point 3: more examples of becoming deeply engaged in historical subjects (one idea: fascination with reprinted diaries or letters of World War II soldiers)

^{1.} Anne Frank (1929–1945): a German Jewish girl who fled to the Netherlands with her family after Adolf Hitler, leader of the Nazi Party, became chancellor of Germany. In 1944, Anne and her family were arrested by the Nazis, and she died in a concentration camp the following year.

Practice Supporting a Main Point

Generate Support

To generate support for the main point of a paragraph or essay, try one or more of the following strategies.

THREE QUICK STRATEGIES FOR GENERATING SUPPORT

- Circle an important word or phrase in your topic sentence (for a paragraph) or thesis statement (for an essay), and write about it for a few minutes. As you work, refer back to your main point to make sure you're on the right track.
- 2. Reread your topic sentence or thesis statement, and write down the first thought you have. Then, write down your next thought. Keep going.
- 3. *Use a prewriting technique* (freewriting, listing, discussing, clustering, and so on) while thinking about your main point and your audience. Write for three to five minutes without stopping.

TEACHING TIP Emphasize to students that prewriting can help them at every stage of the writing process, whenever they need to develop ideas further or provide more detail.

PRACTICE 1 Generating Supporting Ideas

Choose one of the following sentences, or your own topic sentence or thesis statement, and use one of the three strategies to generate support just mentioned. Because you will need a good supply of ideas to support your main poliit, try to find at least a dozon possible supporting ideas. Keep your answers because you will use them in later practices in this chapter. Answers will vary.

- 1. Some television shows stir my mind instead of numbing it.
- **2.** Today there is no such thing as a "typical" college student.
- **3.** Learning happens not only in school but throughout a person's life.
- **4.** Practical intelligence can't be measured by grades.
- **5.** I deserve a raise.

IDEA JOURNAL Write about any of the sentences you don't choose for Practice 1.

Select the Best Primary Support

After you have generated possible support, review your ideas; then, select the best ones to use as primary support. Here you take control of your topic, shaping the way readers will see it and the main point you are making about it. These ideas are *yours*, and you need to sell them to your audience.

The following steps can help.

- 1. Carefully read the ideas you have generated.
- 2. Select three to five primary support points that will be clearest and most convincing to your readers, providing the best examples, facts,

TIP For a diagram showing the relationship between topic sentences and support in paragraphs, and thesis statements and support in essays, see pages 56–57 of Chapter 4. **TEACHING TIP** Remind students that just because they find a point interesting does not necessarily mean they should include it in their writing. It must support their main point.

and observations to support your main point. If you are writing a paragraph, these points will become the primary support for your topic sentence. If you are writing an essay, they will become topic sentences of the individual paragraphs that support your thesis statement.

- 3. Cross out ideas that are not closely related to your main point.
- 4. If you find that you have crossed out most of your ideas and do not have enough left to support your main point, use one of the three strategies from page 71 to find more.

PRACTICE 2 Selecting the Best Support

Refer to your response to Practice 1 (p. 71). Of your possible primary support points, choose three to five that you think will best show, explain, or prove your main point to your readers. Write your three to five points in the space provided.

Answers will vary				
	72 7255272	The state of the s		
LANGERT TO SECTION	168 10 10 1 1 1 1 1 1 1 1 1 1 1 1 1 1 1 1	27 70 perio (ris		
	eren i in del kato de		e Feeder Hillian	

Add Secondary Support

Once you have selected your best primary support points, you need to flesh them out for your readers. Do this by adding **secondary support**, specific examples, facts, and observations to back up your primary support points.

PRACTICE 3 Adding Secondary Support

Using your answers to Practice 2, choose three primary support points, and write them in the spaces indicated below. Then, read each of them carefully, and write down at least three supporting details (secondary support) for each one. For examples of secondary support, see the example paragraph on pages 69–70. Answers will vary.

PRIMARY SUPPORT POINT 1:

NURRORTING RETAIL O	
SUPPORTING DETAILS:	

TEACHING TIP Tell students to ask themselves the kinds of questions their readers will ask: Such as? In what way? For example? If their support points answer those questions, readers should understand their main point.

PRIMARY SUPPORT POINT 2:					
SU	PPORTING DETAILS:				i con i
PRIMARY	SUPPORT POINT 3:			er e	
su	PPORTING DETAILS:				
_					

Write Your Own Support

Before developing your own support for a main point, look at how Chelsea developed support for her paragraph.

TOPIC SENTENCE: My goal is to get a nursing degree.

First, she did some prewriting (using the listing technique) and selected the best primary support points, while eliminating ones she didn't think she would use.

PRIMARY SUPPORT POINTS

GETTING AN L.P.N. DEGREE

nurses help people and I want to do that jobs all over the country good jobs with decent pay good setting, clean a profession, not just a job opportunity, like R.N. bigger place, more money treated with respect role model pride in myself and my work, what I've done good benefits nice people to work with may get paid to take more classes—chance for further professional development uniform so not lots of money for clothes I'll be something

COMPUTER: Have students first type in possible support and then cut and paste to group it. They can easily move the points around to try new groupings.

Chelsea noticed that some of her notes were related to the same subject, so she arranged them into related clusters, with the smaller points indented under the larger ones.

ORGANIZED LIST OF SUPPORT POINTS

```
good job
decent pay
jobs all over the country
a profession, not just a job
treated with respect
opportunity for the future (like R.N.)
maybe get paid to take more classes?
pride/achievement
a job that helps people
I would take pride in my hard work
I'd be a role model
```

Then, she took the notes she made and organized them into primary support and supporting details. Notice how she changed and reorganized some of her smaller points.

PRIMARY SUPPORT: Being an L.P.N. is an excellent job.

SUPPORTING DETAILS: The pay is regular and averages about \$40,000 a year.

I could afford to move to a bigger and better place with more room for my daughter and work fewer hours.

PRIMARY SUPPORT: Nursing is a profession, not just a job.

SUPPORTING DETAILS: Nurses help care for people, an important job, giving to the world.

future opportunities, like becoming an R.N. with more money and responsibility.

People respect nurses.

PRIMARY SUPPORT: Being a nurse will be a great achievement for me.

SUPPORTING DETAILS: I will have worked hard and met my goal.

I will respect myself and be proud of what I do.

I will be a good role model for my daughter.

WRITING ASSIGNMENT

Develop primary support points and supporting details using your topic sentence or thesis statement from Chapter 4, your response to the idea journal prompt on page 71, or one of the following topic sentences/thesis statements.

LEARNING JOURNAL In your own words, explain what good support points are and why they are important.

	Same-sex marriages should/should not be legal in all fifty states.				
	he drinking age should/should not be lowered.				
	All families have some unique family traditions.				
	People who do not speak "proper" English are discriminated against.				
	Many movies have important messages for viewers.				
	ivially movies have important messages for viewers.				
Afte	er developing your support, complete the following checklist.				
CI	IECKLIST				
Ev	aluating Your Support				
	It is directly related to my main point.				
	It uses examples, facts, and observations that will make sense to my readers.				
	It includes enough specific details to show my readers exactly what I				
	mean.				
graj	Once you have pulled together your primary support points and secary supporting details, you are ready for the next step: drafting a parabh or essay based on a plan. For more information, go on to the next oter				
graj cha	ary supporting details, you are ready for the next step: drafting a parabh or essay based on a plan. For more information, go on to the next oter.				
graj cha	ary supporting details, you are ready for the next step: drafting a parabh or essay based on a plan. For more information, go on to the next				
graj cha	ary supporting details, you are ready for the next step: drafting a parabh or essay based on a plan. For more information, go on to the next oter.				
graj cha	ary supporting details, you are ready for the next step: drafting a parabh or essay based on a plan. For more information, go on to the next oter. Appear Review Highlight important terms from this chapter (such as support, primary)				
graj cha	ary supporting details, you are ready for the next step: drafting a parabh or essay based on a plan. For more information, go on to the next oter. Appear Review Highlight important terms from this chapter (such as support, primary support, and secondary support), and list them with their page numbers.				
Chancha	Apter Review Highlight important terms from this chapter (such as support, primary support, and secondary support), and list them with their page numbers. Support points are examples, facts, or evidence thatshow, explain, orprove your main point.				
graj cha	ary supporting details, you are ready for the next step: drafting a parabh or essay based on a plan. For more information, go on to the next oter. **Parabh of the next step: drafting a parabh or essay based on a plan. For more information, go on to the next oter. **Parabh of the next step: drafting a parabh or essay based on a plan. For more information, go on to the next oter. **Parabh of the next step: drafting a parabh or essay based on a plan. For more information, go on to the next oter. **Parabh of the next step: drafting a parabh or essay based on a plan. For more information, go on to the next oter. **Parabh of the next step: drafting a parabh or essay based on a plan. For more information, go on to the next oter. **Parabh of the next step: drafting a parabh or essay based on a plan. For more information, go on to the next oter. **Parabh of the next step: drafting a parabh or essay based on a plan. For more information, go on to the next oter. **Parabh of the next step: drafting a parabh or essay based on a plan. For more information, go on to the next oter. **Parabh of the next step: drafting a parabh or essay based on a plan. For more information, go on to the next oter. **Parabh of the next step: drafting a parabh or essay based on a plan. For more information, go on to the next oter. **Parabh of the next step: drafting a parabh or essay based on a plan. For more information, go on to the next oter. **Parabh of the next step: drafting a parabh or essay based on a plan. For more information, go on to the next oter. **Parabh of the next step: drafting a parabh or essay based on a plan. For more information, go on to the next oter. **Parabh of the next step: drafting a parabh or essay based on a plan. For more information, go on to the next oter. **Parabh of the next step: drafting a parabh or essay based on a plan. For more information, go on to the next oter. **Parabh of the next step: drafting a parabh or essay based on a plan. For more information, go on to the next oter. **Parabh o				
Chancha	Apter Review Highlight important terms from this chapter (such as support, primary support, and secondary support), and list them with their page numbers. Support points are examples, facts, or evidence thatshow, explain, or your main point. Three basics of good support are: It relates directly to your main				
Chancha	Apter Review Highlight important terms from this chapter (such as support, primary support, and secondary support), and list them with their page numbers. Support points are examples, facts, or evidence thatshow, explain, or prove your main point. Three basics of good support are: It relates directly to your main point.				
Ch 1. 2.	Any supporting details, you are ready for the next step: drafting a parash or essay based on a plan. For more information, go on to the next opter. **Parash of the next step: drafting a parash or essay based on a plan. For more information, go on to the next opter. **Parash of the next step: drafting a parash of th				
Chancha	Any supporting details, you are ready for the next step: drafting a parash or essay based on a plan. For more information, go on to the next oter. Highlight important terms from this chapter (such as support, primary support, and secondary support), and list them with their page numbers. Support points are examples, facts, or evidence thatshow,explain, or your main point. Three basics of good support are: It relates directly to your main point. It considers your readers.				
Ch 1. 2.	Arry supporting details, you are ready for the next step: drafting a parash or essay based on a plan. For more information, go on to the next opter. **Parash of the rest of the next step: drafting a parash or essay based on a plan. For more information, go on to the next opter. **Parash of the next step: drafting a parash of the next step: drafting a				
Ch 1. 2.	Any supporting details, you are ready for the next step: drafting a paraph or essay based on a plan. For more information, go on to the next oter. **Paper Review** Highlight important terms from this chapter (such as support, primary support, and secondary support), and list them with their page numbers. Support points are examples, facts, or evidence thatshow,explain, orprove your main point. Three basics of good support are: It relates directly to your mainpoint. It considers your readers. It gives specific details. To generate support, try these three strategies: Circle an important word or phrase in your topic sentence or thesis				

Use a prewriting technique.

- When you have selected your primary support points, what should you then add? secondary support (or supporting details)
- **6.** Write for one minute about "What questions I should ask my instructor."

YOU KNOW THIS

You often "give something a try," knowing you might not get it just right the first time:

- You rehearse in your head something you want to say to someone.
- You rehearse for a big event or play.
- You put out clothes you want to wear to an important event.

6

Drafting

Putting Your Ideas Together

Chelsea Wilson exchanged messages with her friend Nick Brown about an assignment she had received. Nick had taken the same writing course a semester earlier.

Understand What a Draft Is

A **draft** is the first whole version of all your ideas put together in a piece of writing. Do the best job you can in drafting, but know that you can make changes later.

BASICS OF A GOOD DRAFT

- It has a topic sentence (for a paragraph) and a thesis statement (for an essay) that makes a clear main point.
- It has a logical organization of ideas.
- It has primary and secondary support that shows, explains, or proves the main point.

IDEA JOURNAL Write about a time when you had a trial run before doing something.

- It has a conclusion that makes an observation about the main point.
- It follows standard paragraph form (see pages 91–92) or standard essay form (see page 93).

Two good first steps to drafting a paragraph or essay are (1) to arrange the ideas that you have generated in an order that makes sense and (2) to write out a plan for your draft. We will look at these steps next.

Arrange Your Ideas

In writing, **order** means the sequence in which you present your ideas: What comes first, what comes next, and so on. There are three common ways of ordering—arranging—your ideas: **time order** (also called chronological order), **space order**, and **order of importance**.

Read the paragraph examples that follow. In each paragraph, the topic sentences are underlined twice, the primary support points are underlined once, and the secondary support is in italics.

Use **time order** (chronological order) to arrange points according to when they happened. Time order works best when you are writing about events. You can go from

- First to last/last to first
- Most recent to least recent/least recent to most recent

Use Time Order to Write about Events

EXAMPLE USING TIME ORDER

Officer Meredith Pavlovic's traffic stop of August 23, 2011, was fairly typical of an investigation and arrest for drunk driving. First, at around 12:15 a.m. that day, she noticed that the driver of a blue Honda Civic was acting suspiciously. The car was weaving between the fast and center lanes of Interstate 93 North near exit 12. In addition, it was proceeding at approximately 45 mph in a 55 mph zone. Therefore, Officer Pavlovic took the second step of pulling the driver over for a closer investigation. The driver's license told Officer Pavlovic that the driver was twenty-six-year-old Paul Brownwell. Brownwell's red eyes, slurred speech, and alcohol-tainted breath told Officer Pavlovic that Brownwell was very drunk. But she had to be absolutely sure. Thus, as a next step, she tested his balance and blood alcohol level. The results were that Brownwell could barely get out of the car, let alone stand on one foot. Also, a breathalyzer test showed that his blood alcohol level was 0.13, well over the legal limit of 0.08. These results meant an arrest for Brownwell, an unfortunate outcome for him, but a lucky one for other people on the road at that time.

What kind of time order does the author use? first to last

IDEA JOURNAL Write about a plan you came up with recently. How well did it work?

DISCUSSION Call out different subjects to students (e.g., a wedding, a rescue, a vacation spot, a gathering place, a community controversy) and ask which type of order they would use to write about it.

Use Space Order to Describe Objects, Places, or People

Use **space order** to arrange ideas so that your readers picture your topic the way you see it. Space order usually works best when you are writing about a physical object or place, or a person's appearance. You can move from

- Top to bottom/bottom to top
- Near to far/far to near
- Left to right/right to left
- Back to front/front to back

EXAMPLE USING SPACE ORDER

Donna looked professional for her interview. Her long, dark, curly hair was held back with a gold clip. No stray wisps escaped. Normally wild and unruly, her hair was smooth, shiny, and neat. She wore a white silk blouse with just the top button open at her throat. Donna had made sure to leave time to iron it so that it wouldn't be wrinkled. The blouse was neatly tucked into her black A-line skirt, which came just to the top of her knee. She wore black stockings that she had checked for runs and black low-heeled shoes. Altogether, her appearance marked her as serious and professional, and she was sure to make a good first impression.

What type of space order does the example use? top to bottom

IDEA JOURNAL What would you wear to look professional?

Use Order of Importance to Emphasize a Particular Point

Use **order of importance** to arrange points according to their significance, interest, or surprise value. Usually, save the most important point for last.

EXAMPLE USING ORDER OF IMPORTANCE

People who keep guns in their homes risk endangering both themselves and others. Many accidental injuries occur when a weapon is improperly stored or handled. For example, someone cleaning a closet where a loaded gun is stored may handle the gun in a way that causes it to go off and injure him or her. Guns also feature in many reports of "crimes of passion." A couple with a violent history has a fight, and, in a fit of rage, one gets the gun and shoots the other, wounding or killing the other person. Most common and most tragic are incidents in which children find loaded guns and play with them, accidentally killing themselves or their playmates. Considering these factors, the risks of keeping guns in the home outweigh the advantages, for many people.

What is the writer's most important point? that children sometimes find loaded guns and accidentally kill themselves or their playmates

IDEA JOURNAL What do you think about keeping guns in your home? Does it guard against robberies? Is there risk involved?

RESOURCES To test students on ordering support effectively, see the *Testing Tool Kit* CD-ROM available with this book.

Make a Plan

TIP Try using the cut-andpaste function on your computer to experiment with different ways to order support for your main point. Doing so will give you a good sense of how your final paragraph or final essay will look. When you have decided how to order your primary support points, it is time to make a more detailed plan for your paragraph or essay. A good, visual way to plan a draft is to arrange your ideas in an outline. An **outline** lists the topic sentence (for a paragraph) or thesis statement (for an essay), the primary support points for the topic sentence or thesis statement, and secondary supporting details for each of the support points. It provides a map of your ideas that you can follow as you write.

Outlining Paragraphs

Look at the outline Chelsea Wilson created with the support she wrote. She had already grouped together similar points and put the more specific details under the primary support (see p. 74). When she thought about how to order her ideas, the only way that made sense to her was by importance. If she had been telling the steps she would take to become a nurse, time order would have worked well. If she had been describing a setting where nurses work, space order would have been a good choice. But because she was writing about why she wanted to get a college degree and become a nurse, she decided to arrange her reasons in order of importance. Notice that Chelsea also strengthened her topic sentence and made changes in her primary support and secondary support. At each stage, her ideas and the way she expressed them changed as she got closer to what she wanted to say.

RESOURCES A reproducible blank outline for essays is in *Additional Resources*.

SAMPLE OUTLINE FOR A PARAGRAPH

TOPIC SENTENCE: Becoming a nurse is a goal of mine because it offers so much that I value.

PRIMARY SUPPORT 1: It is a good and practical job.

supporting DETAILS: Licensed practical nurses make an average of \$40,000 per year. That amount is much more than I make now. With that salary, I could move to a better place with my daughter and give her more, including more time.

PRIMARY SUPPORT 2: Nursing is a profession, not just a job.

supporting DETAILS: It helps people who are sick and in need. Being an L.P.N. offers great opportunities, like the chance to go on to become a registered nurse, with more money and responsibility. People respect nurses.

PRIMARY SUPPORT 3: I will respect and be proud of myself for achieving my goal through hard work.

SUPPORTING DETAILS: I will be a good role model for my daughter. I will help her and others, but I will also be helping myself by knowing that I can accomplish good things.

CONCLUSION: Reaching my goal is important to me and worth the work.

TEACHING TIP You might point out to students that Chelsea has added a concluding sentence. It might change, but she is beginning to think about possible endings.

Outlining Essays

The outline below is for a typical five-paragraph essay, in which three body paragraphs (built around three topic sentences) support a thesis statement. The thesis statement is included in an introductory paragraph; the fifth paragraph is the conclusion. However, essays may include more or fewer than five paragraphs, depending on the size and complexity of the topic.

The example below is a "formal" outline form, with letters and numbers to distinguish between primary supporting and secondary supporting details. Some instructors require this format. If you are making an outline just for yourself, you might choose to write a less formal outline, simply indenting the secondary supporting details under the primary support rather than using numbers and letters.

TIP For an example of a five-paragraph essay, see Chapter 7.

SAMPLE OUTLINE FOR A FIVE-PARAGRAPH ESSAY

Thesis statement (part of introductory paragraph 1)

- A. Topic sentence for support point 1 (paragraph 2)
 - 1. Supporting detail 1 for support point 1
 - 2. Supporting detail 2 for support point 1 (and so on)
- B. Topic sentence for support point 2 (paragraph 3)
 - 1. Supporting detail 1 for support point 2
 - 2. Supporting detail 2 for support point 2 (and so on)
- C. Topic sentence for support point 3 (paragraph 4)
 - 1. Supporting detail 1 for support point 3
 - 2. Supporting detail 2 for support point 3 (and so on)

Concluding paragraph (paragraph 5)

PRACTICE 1 Making an Outline

Reread the paragraph on page 78 that illustrates time order of organization. Then, make an outline for it in the space provided.

TOPIC SENTENCE: Officer Meredith Pavlovic's traffic stop of August 23, 2011, was fairly typical of an investigation and arrest for drunk driving.

PRIMARY SUPPORT 1: First, at around 12:15 a.m. that day, she noticed that the driver of a blue Honda Civic was acting suspiciously.

- 1. SUPPORTING DETAIL: The car was weaving between the fast and center lanes of Interstate 93 North near exit 12.
- 2. SUPPORTING DETAIL: In addition, it was proceeding at approximately 45 mph in a 55 mph zone.

PRIMARY SUPPORT 2: Therefore, Officer Pavlovic took the second step of pulling the driver over for a closer investigation.

- 1. SUPPORTING DETAIL: The driver's license told Officer Pavlovic that the driver was twenty-six-year-old Paul Brownwell.
- 2. SUPPORTING DETAIL: Brownwell's red eyes, slurred speech, and alcohol-tainted breath told Officer Pavlovic that Brownwell was very drunk.

PRIMARY SUPPORT 3: Thus, as a next step, she tested his balance and blood alcohol level.

- 1. SUPPORTING DETAIL: The results were that Brownwell could barely get out of the car, let alone stand on one foot.
- 2. SUPPORTING DETAIL: Also, a breathalyzer test showed that his blood alcohol level was 0.13, well over the legal limit of 0.08.

TEACHING TIP If you are working with paragraphs only, ask students to read pages 82-84 and then move on to the sample draft paragraph and writing assignment on pages 91-92, followed by the Chapter Review. If you are working with essays only, ask students to skip ahead to pages 84-91, then to the sample essay draft and writing assignment on page 93, and finally to the Chapter Review.

Title -

Practice Writing a Draft Paragraph

As you write your paragraph, you will need to go through the steps in the following sections. Also, refer to the Basics of a Good Draft on pages 77–78.

Write a Draft Using Complete Sentences

Write your draft with your outline in front of you. Be sure to include your topic sentence, and express each point in a complete sentence. As you write, you may want to add support or change the order. It is OK to make changes from your outline as you write.

Read the following paragraph, annotated to show the various parts of the paragraph.

that parabens actually cause cancer. Nevertheless, some consumers

Parabens: Widely Used Chemicals Spark New Cautions

	- Files
Topic sentence ———	Parabens, preservatives used in many cosmetics and personal-care
Support ————————————————————————————————————	products, are raising concerns with more and more consumers. In
	some people, parabens cause allergic reactions, but the effects of these
	chemicals may be more than skin deep. After being applied to the face
	or body, parabens can enter the bloodstream, where they have been
	found to mimic the hormone estrogen. Because long-term exposure to
	estrogen can increase the risk of breast cancer, researchers have tried
	to determine whether there is any link between parabens and breast
	cancer. So far, the findings have been inconclusive. One study found
	parabens in the breast cancer tissue of some research subjects. How-
	ever, the study was small, and based on its results, it cannot be said

wish to reduce their use of paraben-containing products or to avoid them altogether. To do so, they carefully read the labels of personal-care products, looking out for ingredients like butylparaben, ethylparaben, methylparaben, isopropyl, and propylparaben. All these chemicals are parabens. Consumers who do not wish to give up parabens entirely might consider avoiding only those paraben-containing products, like lotions and makeup, that stay on the skin for an extended period. Products that are rinsed away quickly, like shampoos and soaps, do not have as much time to be absorbed through the skin.

Support

Although paragraphs typically begin with topic sentences, they may also begin with a quote, an example, or a surprising fact or idea. The topic sentence is then presented later in the paragraph. For examples of various introductory techniques, see pages 86–88.

TIP For more on topic sentences, see Chapter 4.

Write a Concluding Sentence

A **concluding sentence** refers back to the main point and makes an observation based on what you have written. The concluding sentence does not just repeat the topic sentence.

In the paragraph above, the main point, expressed in the topic sentence, is "Parabens, preservatives used in many cosmetics and personal-care products, are raising concerns with more and more consumers."

A good conclusion might be, "Given the growing concerns about parabens and uncertainties about their potential dangers, more research is clearly needed." This sentence **refers back to the main point** by repeating the words *parabens* and *concerns*. It **makes an observation** by stating, "more research is clearly needed."

Concluding paragraphs for essays are discussed on pages 89–90.

TEACHING TIP Tell students that the concluding sentence gives them an opportunity to express a personal opinion based on the support they have provided, but they should not use it to introduce new, unrelated ideas.

students about two common problems in endings of paragraphs: (1) stopping abruptly so that it seems as if the paragraph is unfinished or that the writer ran out of time and (2) changing focus so that readers are left wondering what the point is.

PRACTICE 2 Writing Concluding Sentences

Read the following paragraphs, and write a concluding sentence for each one.

1. One of the most valuable ways parents can help children is to read to them. Reading together is a good way for parents and children to relax, and it is sometimes the only "quality" time they spend together during a busy day. Reading develops children's vocabulary. They understand more words and are likely to learn new words more easily than children who are not read to. Also, hearing the words aloud helps children's pronunciation and makes them more confident with oral language. In addition, reading at home increases children's chances of success in school because reading is required in every course in every grade.

Possible Concluding Sentence: Answers will vary but should include the idea that reading helps children in many ways or that it is an important activity for parents and children to share.

2. Almost everyone uses certain memory devices, called *mnemonics*. One of them is the alphabet song. If you want to remember what letter comes after *j*, you will probably sing the alphabet song in your head. Another is the "Thirty days hath September" rhyme that people use when they want to know how many days are in a certain month. Another mnemonic device is the rhyme "In 1492, Columbus sailed the ocean blue."

Possible Concluding Sentence: Answers will vary but should refer to the memory devices and how commonly they are used.

Title Your Paragraph

The title is the first thing readers see, so it should give them a good idea of what your paragraph is about. Decide on a title by rereading your draft, especially your topic sentence. A paragraph title should not repeat your topic sentence.

Look at the title of the paragraph on pages 82–83. It includes the topic (parabens) and the main point (that these chemicals are sparking concerns). It lets readers know what the paragraph is about, but it does not repeat the topic sentence.

Titles for essays are discussed on page 91.

PRACTICE 3 Writing Titles

Write possible titles for the paragraphs in Practice 2.

1 Answers will vary.

2

DISCUSSION Ask students to name favorite television shows, movies, or songs, and write them on the board. Then, invite students to discuss what makes these titles interesting or dull, topic-appropriate or irrelevant. Can they think of better alternatives?

Practice Writing a Draft Essay

The basics of a good essay draft are all listed on pages 77–78. In addition,

- The essay should include an introductory paragraph that draws readers in and includes the thesis statement.
- The topic sentences for the paragraphs that follow the introduction should directly support the thesis statement. In turn, each topic sentence should be backed by enough support.
- The conclusion should be a full paragraph rather than a single sentence.

Let's start by looking at topic sentences and support for them.

Write Topic Sentences, and Draft the Body of the Essay

When you start to draft your essay, use your outline to write complete sentences for your primary support points. These sentences will serve as the topic sentences for the body paragraphs of your essay.

PRACTICE 4 Writing Topic Sentences

Each thesis statement that follows has support points that could be topic sentences for the body paragraphs of an essay. For each support point, write a topic sentence.

EXAMPLE

THESIS STATEMENT: My daughter is showing definite signs of becoming a teenager.

SUPPORT POINT: constantly texting friends

TOPIC SENTENCE: She texts friends constantly, even when they are sitting with her while I'm driving them.

SUPPORT POINT: a new style of clothes

TOPIC SENTENCE: She used to like really cute clothing, but now she wants to wear more grown-up-looking outfits.

SUPPORT POINT: doesn't want me to know what's going on

TOPIC SENTENCE: She used to tell me everything, but now she is secretive and private.

SUPPORT POINT: developing an "attitude"

TOPIC SENTENCE: The surest and most annoying sign that she is becoming a teenager is that she has developed a definite "attitude."

1. THESIS STATEMENT: Rhonda is doing everything she can to pass this course.

SUPPORT POINT: attends most classes

TOPIC SENTENCE: Answers will vary.

SUPPORT POINT: always has her book and does her homework

TOPIC SENTENCE:

SUPPORT POINT: is part of a study group to prepare for tests

TOPIC SENTENCE:

2. THESIS STATEMENT: The Latin American influence is evident in many areas of U.S. culture.

SUPPORT POINT: Spanish language used in lots of places

TOPIC SENTENCE:

SUPPORT POINT: lots of different kinds of foods
TOPIC SENTENCE:
SUPPORT POINT: new kinds of music and popular musicians
TOPIC SENTENCE:

Drafting topic sentences for your essay is a good way to start drafting the body of the essay (the paragraphs that support each of these topic sentences). As you write support for your topic sentences, refer back to your outline, where you listed supporting details. (For an example, see Chelsea Wilson's outline on page 80.) Turn these supporting details into complete sentences, and add additional support if necessary. (Prewriting techniques can help here; see Chapter 3.) Don't let yourself get stalled if you are having trouble with one word or sentence. Just keep writing. Remember that a draft is a first try; you will have time later to improve it.

Write an Introduction

The introduction to your essay captures your readers' interest and presents the main point. Ask yourself: How can I sell my essay to readers? You need to market your main point.

BASICS OF A GOOD INTRODUCTION

- It should catch readers' attention.
- It should present the thesis statement of the essay, usually in the first or the last sentence of an introductory paragraph.
- It should give readers a clear idea of what the essay will cover.

Here are some common kinds of introductions that spark readers' interest. In each one, the introductory technique is in boldface. These introductions are not the only ways to start essays, but they should give you some useful models.

OPEN WITH A QUOTATION

A good, short quotation definitely gets people interested. It must lead naturally into your main point, however, and not be there just for effect. If you start with a quotation, make sure you tell the reader who the speaker is.

George Farquhar once said that necessity was the mother of invention, but we know that to be nonsense, really: Who needs an iPod that holds 10,000 songs? There is, however, one area of life in which technology keeps step with nature—the size of things. As we Americans are getting bigger (the Centers for Disease Control and Prevention in

IDEA JOURNAL Write about the ways that advertising attracts people's attention.

ESL Remind nonnative speakers that it is a convention of English to present the main point in the first paragraph, stated explicitly.

Atlanta estimate that roughly a third of Americans are overweight, with 20 percent of us qualifying as obese), so, too, is our stuff.

- James Verini, "Supersize It"

GIVE AN EXAMPLE, OR TELL A STORY

People like stories, so opening an essay with a brief story or example often draws readers in.

Something snapped inside Jerry Sola during his evening commute through the Chicago suburbs two years ago. When the driver in front of the fifty-one-year-old salesman suddenly slammed on his brakes, Sola got so incensed that he gunned his engine to cut in front of the man. Still steaming when both cars stopped at a red light, Sola grabbed a golf club from the backseat and got out.

—Dianne Hales, "Why Are We So Angry?"

RESOURCES Hales's complete essay is in Chapter 40.

START WITH A SURPRISING FACT OR IDEA

Surprises capture people's interest. The more unexpected and surprising something is, the more likely people are to notice it.

I learned to read with a Superman comic book. Simple enough, I suppose. I cannot recall which particular Superman comic book I read, nor can I remember which villain he fought in that issue. I cannot remember the plot, nor the means by which I obtained the comic book. What I can remember is this: I was 3 years old, a Spokane Indian boy living with his family on the Spokane Indian Reservation in eastern Washington state. We were poor by most standards, but one of my parents usually managed to find some minimum-wage job or another, which made us middle-class by reservation standards. I had a brother and three sisters. We lived on a combination of irregular paychecks, hope, fear, and government surplus food.

- Sherman Alexie, "The Joy of Reading and Writing: Superman and Me"

RESOURCES Alexie's complete essay is in Chapter 42.

OFFER A STRONG OPINION OR POSITION

The stronger the opinion, the more likely it is that your readers will pay attention. Don't write wimpy introductions. Make your point and shout it!

Cedric "C. J." Mills. Isaiah Brooks. Tedric Maynor. Felicia Hines. Vinson Phillips. Kurt Anthony Bryant. Amuel Murph. Alfonso Williams. These names are forever inscribed on my private "Wall of Black Death." My wall contains the names of black people killed by other black people, along with those believed to have been killed by fellow blacks, in the Tampa Bay area since May. I will update the roster as new deaths are reported. More are sure to follow. I do not have

RESOURCES Maxwell's complete essay is in Chapter 47.

TEACHING TIP In the inverted-pyramid strategy, the introductory paragraph starts with a general statement and narrows to a thesis statement.

answers as to how to stop blacks from killing their brethren. But I do have an answer for catching some, if not all, of these murderers. Snitch.

-Bill Maxwell, "Start Snitching"

ASK A QUESTION

A question needs an answer, so if you start your introduction with a question, your readers will need to read on to get the answer.

TIP If you get stuck while writing your introductory statement, try one or more of the prewriting techniques described in Chapter 3 on pages 46–49.

Have you ever noticed how many gym membership advertisements appear on television right after the New Year? Many people overindulge through the holiday season, beginning with Halloween candy and ending with the last sip of eggnog on Christmas evening. On average, Americans gain seven pounds in that six-week period. That weight gain does not include the other forty-six weeks of the year when people typically overeat and quit going to the gym. Do not despair; there is hope! Instead of dreading the inevitable holiday weight gain and spending money on expensive exercise clubs, you can instead resign yourself to starting a new exercise routine at home. Exercise is the best way to combat the "battle of the bulge." One of the most effective ways to lose weight and get into shape is aerobic exercise. I am living proof that beginning a home workout regimen will become a positive, life-altering experience that quickly balances your physical and emotional health, has a maximum gain for minimum pain, and can lead you to improve other aspects of your life as well.

-Michele Wood, "My Home Exercise Program"

PRACTICE 5 Marketing Your Main Point

As you know from advertisements, a good writer can make just about anything sound interesting. For each of the following topics, write an introductory statement using the technique indicated. Some of these topics are purposely dull to show you that you can make an interesting statement about almost any subject, if you put your mind to it.

EXAMPLE

TOPIC: Reality TV

TECHNIQUE: Question

Exactly how many recent top-selling songs have been recorded by

former contestants of reality TV singing contests?

1. TOPIC: Credit cards

TECHNIQUE: Surprising fact or idea

Answers will vary.

TEACHING TIP Remind students that because the introduction should catch readers' attention, they should consider who their readers are and what those readers would find interesting.

2. TOPIC: Role of the elderly in society

TECHNIQUE: Question

3. TOPIC: Stress

TECHNIQUE: Quote (You can make up a good one.)

PRACTICE 6 Identifying Strong Introductions

In a newspaper or magazine, an online news site, an advertising flier—or anything written—find a strong introduction. Bring it to class to explain why you chose it as an example.

Write a Conclusion

When they have finished the body of their essay, some writers believe their work is done—but it isn't *quite* finished. Remember that people usually remember best what they see, hear, or read last. Use your concluding paragraph to drive your main point home one final time. Make sure your conclusion has the same energy as the rest of the essay, if not more.

BASICS OF A GOOD ESSAY CONCLUSION

- It refers back to the main point.
- It sums up what has been covered in the essay.
- It makes a further observation or point.

In general, a good conclusion creates a sense of completion. It brings readers back to where they started, but it also shows them how far they have come.

One of the best ways to end an essay is to refer directly to something in the introduction. If you asked a question, re-ask and answer it. If you started a story, finish it. If you used a quote, use another one—maybe a quote by the same person or maybe one by another person on the same topic. Or, use some of the same words you used in your introduction. Look again at two of the introductions you read earlier, and notice how the writers conclude their essays. Pay special attention to the text in boldface.

HALES'S INTRODUCTION

Something snapped inside Jerry Sola during his evening commute through the Chicago suburbs two years ago. When the driver in front of the fifty-one-year-old salesman suddenly slammed on his brakes, Sola got so incensed that he gunned his engine to cut in front of the man. Still steaming when both cars stopped at a red light, Sola grabbed a golf club from the backseat and got out.

HALES'S CONCLUSION

Since his roadside epiphany, Jerry Sola has conscientiously worked to rein in his rage. "I am a changed person," he says, "especially behind the wheel. I don't have to listen to the news on the car radio. Instead, I put on nice, soothing music. I force myself to smile at rude drivers. And if I feel myself getting angry, I ask a simple question: 'Why should I let a person I'm never going to see again control my mood and ruin my whole day?'"

—Dianne Hales, "Why Are We So Angry?"

MAXWELL'S INTRODUCTION

Cedric "C. J." Mills. Isaiah Brooks. Tedric Maynor. Felicia Hines. Vinson Phillips. Kurt Anthony Bryant. Amuel Murph. Alfonso Williams. These names are forever inscribed on my private "Wall of Black Death." My wall contains the names of black people killed by other black people, along with those believed to have been killed by fellow blacks, in the Tampa Bay area since May. I will update the roster as new deaths are reported. More are sure to follow. I do not have answers as to how to stop blacks from killing their brethren. But I do have an answer for catching some, if not all, of these murderers. Snitch.

-Bill Maxwell, "Start Snitching"

MAXWELL'S CONCLUSION

Because I regularly write about this issue, I receive a lot of hate mail from both blacks and whites. White letter-writers remind me that blacks are "animals" and "cause all of America's social problems." Black letter-writers see me as the "enemy of people" and a "sell-out" because I condemn blacks for killing one another without taking into account the nation's history of racism. To whites, I have nothing to say. To blacks, I have one message: We need to start snitching. Only we can stop black-on-black murders. Until then, I will be adding names to the Wall of Black Death.

-Bill Maxwell, "Start Snitching"

PRACTICE 7 Finding Good Introductions and Conclusions

In a newspaper or magazine or anything written, find a piece of writing that has a strong introduction and conclusion. (You may want to use what you found for Practice 6.) Answer the questions that follow.

- 1. What method of introduction is used? Answers will vary.
- **2.** What does the conclusion do? Restate the main idea? Sum up the support? Make a further observation?
- **3.** How are the introduction and the conclusion linked? _____

TEAMWORK Cut out the introductions and conclusions that students bring in, scramble them, and have the students work in small groups to match introductions and conclusions.

RESOURCES To test students on choosing effective introductions and conclusions, see the *Testing Tool Kit* CD-ROM available with this book.

Title Your Essay

Even if your title is the *last* part of the essay you write, it is the *first* thing readers read. Use your title to get your readers' attention and to tell them, in a brief way, what your paper is about. Use vivid, strong, specific words.

BASICS OF A GOOD ESSAY TITLE

- It makes people want to read the essay.
- It hints at the main point (thesis statement), but it does not repeat it.

One way to find a good title is to consider the type of essay you are writing. If you are writing an argument (as you will in Chapter 16), state your position in your title. If you are telling your readers how to do something (as you will in Chapter 11), try using the term *steps* or *how to* in the title. This way, your readers will know immediately not only what you are writing about but how you will discuss it.

TIP Center your title at the top of the page before the first paragraph. Do not put quotation marks around it or underline it.

PRACTICE 8 Titling an Essay

Reread the paired paragraphs on pages 89–90, and write alternate titles for the essays that they belong to.

Hales's introduction/conclusion: Answers will vary.	- G - X -
Maxwell's introduction/conclusion:	

Write Your Own Draft Paragraph or Essay

Before you draft your own paragraph, read Chelsea Wilson's annotated draft below. It is based on her outline from page 80.

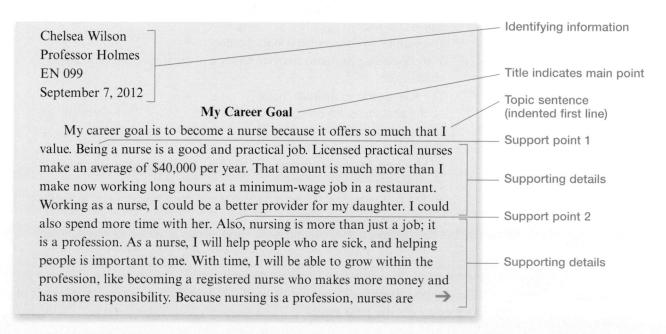

Support point 3

respected. When I become a nurse, I will respect myself and be proud
of myself for reaching my goal, even though I know it will take a lot of
hard work. The most important thing about becoming a nurse is that it
will be good for my young daughter. I will be a good role model for her.

For all of these reasons, my goal is to become a nurse. Reaching this goal
is important to me and worth the work.

computer Suggest to students that they highlight (using boldface or underlining) the support points in their drafts. This highlighting keeps them on track and also helps peer editors focus on the support points.

WRITING ASSIGNMENT Paragraph

Write a draft paragraph, using what you have developed in previous chapters, your response to the idea journal prompt on page 77, or one of the following topic sentences. If you use one of the topic sentences below, you may want to revise it to fit what you want to say.

Being a good ______ requires _____.

I can find any number of ways to waste my time.

People tell me I am ______, and I guess I have to agree.

So many decisions are involved in going to college.

The most important thing to me in life is ______.

After writing your draft paragraph, complete the following checklist.

CH	ECKLIST
Eva	luating Your Draft Paragraph
	It has a clear, confident topic sentence that states my main point.
	Each primary support point is backed up with supporting details, ex-
	amples, or facts.
	The support is arranged in a logical order.
	The concluding sentence reminds readers of my main point and makes an
	observation.
	The title reinforces the main point.
	All the sentences are complete, consisting of a subject and verb, and ex-
	pressing a complete thought.
	The draft is properly formatted:
	• My name, my instructor's name, the course, and the date appear in the
	upper left corner.
	 The first sentence of the paragraph is indented, and the text is double-
	spaced (for easier revision).
	I have followed any other formatting guidelines provided by my instructor.

Before you draft your own essay, read Chelsea Wilson's annotated draft of her essay on the next page.

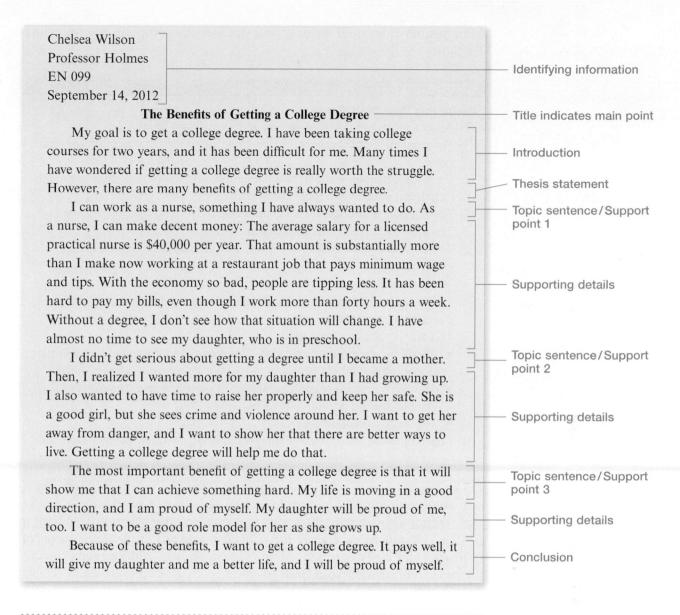

WRITING ASSIGNMENT Essay

Write a draft essay using what you have developed in previous chapters, your response to the idea journal prompt on page 77, or one of the following thesis statements. If you choose one of the thesis statements below, you may want to modify it to fit what you want to say.

most patient person.	d/parent/spouse/friend) can test even the
Being a good	requires
Doing	gave me a great deal of pride in myself.
A good long-term relation	aship involves flexibility and compromise.
Some of the differences be misunderstandings.	etween men and women create

After you have finished writing your draft essay, complete the following checklist.

CH	ECKLIST
Eva	luating Your Draft Essay
	A clear, confident thesis statement states my main point.
	The primary support points are now topic sentences that support the main point.
	Each topic sentence is part of a paragraph, and the other sentences in the paragraph support the topic sentence.
	The support is arranged in a logical order.
	The introduction will interest readers.
	The conclusion reinforces my main point and makes an additional
	observation.
	The title reinforces the main point.
	All the sentences are complete, consisting of a subject and verb, and expressing a complete thought.
	The draft is properly formatted:
	 My name, my instructor's name, the course, and the date appear in the upper left corner.
	 The first sentence of each paragraph is indented, and the text is double-spaced (for easier revision).
	The pages are numbered.
	I have followed any other formatting guidelines provided by my instructor.

LEARNING JOURNAL In your own words, explain how you write a draft.

Do not think about your draft anymore—for the moment. Give your-self some time away from it, at least a few hours and preferably a day or two. Taking a break will allow you to return to your writing later with a fresher eye and more energy for revision, resulting in a better piece of writing—and a better grade. After your break, you will be ready to take the next step: revising your draft.

Chapter Review

- **1.** Highlight important terms from this chapter (such as *draft*, *concluding sentence*, and *title*), and list them with their page numbers.
- 2. A draft is the first whole version of all your ideas put together in a piece of writing.

List the basic features of a good draft paragraph or essay: (Lists include features on pages 77–78.)	

4.	Three ways to order ideas are,					
	andimportance					
5.	Making an outline is a useful way to plan your draft.					
6.	Five ways to start an essay are					
	Open with a quotation.					
	Give an example or tell a story.					
	Start with a surprising fact or idea.					
	Offer a strong opinion or position.					
	Ask a question.					
7.	Three features of a good essay conclusion are					
	It refers back to the main point.					
	It sums up what has been covered in the essay.					
	It makes a further observation or point.					
3.	Two basic features of a good essay title are					
	It makes people want to read the essay.					
	It hints at the main point (thesis statement), but it does not repeat it.					

instructor."

9.

Message-Chelsea to Nick (5:38 p.m.)

Write for one minute about "What questions I should ask my

OK, I think I'm done!

Message-Nick to Chelsea (5:50 p.m.)

Are you totally sure?

I used to think I was done with a paper, but then I would set it down for a while and come back to it.

And I always found things I wanted to fix!

reflect What two changes could Chelsea make to improve her paragraph or her essay?

Revising

Improving Your Paragraph or Essay

YOU KNOW THIS

You often make changes to improve things:

- You dress for an important occasion and then try other clothes you think will be better.
- You go to buy one kind of television set, and then, based on information the salesperson gives you, you rethink your decision.
- You arrange furniture one way and then rearrange it a couple of times until it seems right.

Chelsea Wilson
exchanged
messages with her
friend Nick Brown
about an assignment
she had received.
Nick had taken the
same writing course
a semester earlier.

Understand What Revision Is

When you finish a draft, you probably wish that you were at the end: You don't want to have to look at it again. But a draft is just the first whole version, a rough cut; it is not the best you can do to represent yourself and your ideas. After taking a break, you need to look at the draft with fresh eyes to revise and edit it.

Revising is making your ideas clearer, stronger, and more convincing. When revising, you are evaluating how well you have made your point.

Editing is finding and correcting problems with grammar, word usage, punctuation, and capitalization. When editing, you are evaluating the words, phrases, and sentences you have used.

Most writers find it difficult to revise and edit well if they try to do both at once. It is easier to solve idea-level problems first (by revising) and then to correct smaller, word-level ones (by editing). This chapter focuses on revising. For editing help, use Chapters 19 through 38.

TIPS FOR REVISING YOUR WRITING

- Wait a few hours or, if possible, a couple of days before starting to revise.
- Read your draft aloud, and listen for places where the writing seems weak or unclear.
- Read critically and ask yourself questions, as if you were reading through someone else's eyes.
- Write notes about changes to make. For small things, like adding a transition (p. 103), you can make the change on the draft. For other things, like adding or getting rid of an idea or reordering your support points, make a note in the margin.
- Get help from a tutor at the writing center, or get feedback from a friend (see the following section for information on peer review).

Even the best writers do not get everything right the first time. So, if you finish reading your draft and have not found anything that could be better, you are not reading carefully enough or are not asking the right questions. Use the following checklist to help you make your writing better.

CHECKLIST

Revising Your Writing

If someone else just read my topic sentence or thesis statement, what

- would he or she think the paper is about? Would the main point make a lasting impression? What would I need to do to make it more interesting?

 Does each support point really relate to my main point? What more could be a support to the temperature of the paper.
- I say about the topic so that someone else will see it my way? Is any of what I have written weak? If so, should I delete it?
- ☐ What about the way the ideas are arranged? Should I change the order so that the writing makes more sense or has more effect on a reader?
- ☐ What about the ending? Does it just droop and fade away? How could I make it better?
- ☐ If, before reading my paragraph or essay, someone knew nothing about the topic or disagreed with my position, would what I have written be enough for him or her to understand the material or be convinced by my argument?

TIP For more on reading critically, see Chapter 1.

TEACHING TIP As students begin revising their work, consider sharing this observation by writer Sophy Burnham: "[T]he only element I find common to all successful writers is persistence—an overwhelming determination to succeed." Explain that revising and editing, done thoughtfully and regularly, can be especially productive forms of persistence.

TIP Add transitions as you read to help move from one idea to the next.

Understand What Peer Review Is

Peer review—when students exchange drafts and comment on one another's work—is one of the best ways to get help with revising. Other students can often see things that you might not—parts that are good and parts that need to be strengthened or clarified.

If you are working with one other student, read each other's papers and write down a few comments. If you are working in a small group, you may want to have writers take turns reading their papers aloud. Group members can make notes while listening and then offer comments to the writer that will help improve the paper.

BASICS OF USEFUL FEEDBACK

- It is given in a positive way.
- It offers specific suggestions.
- It may be given in writing or orally.

Often, it is useful for the writer to give the person or people providing feedback a few questions to focus on as they read or listen.

TEAMWORK Try modeling peer review. Bring in a short paragraph or essay, and have students answer the Questions for Peer Reviewers in small groups, with one person acting as a recorder. You can join each group for a few minutes to make sure students understand the process. Then, discuss the comments as a class.

RESOURCES Practical Suggestions contains a discussion of peer feedback. The Peer Factor skills-building online game is also available, at bedfordstmartins.com/ rewritingplus.

CHECKLIST **Questions for Peer Reviewers** ☐ What is the main point? ☐ Can I do anything to make my opening more interesting? ☐ Do I have enough support for my main point? Where could I use more? ☐ Where could I use more details? ☐ Are there places where you have to stop and reread something to understand it? If so, where? ☐ Do I give my reader clues as to where a new point starts? Does one point "flow" smoothly to the next? ☐ What about my conclusion? Does it just fade out? How could I make my point more forcefully? ☐ Where else could the paper be better? What would you do if it were your paper? ☐ If you were going to be graded on this paper, would you turn it in as is? If not, why not? ☐ What other comments or suggestions do you have?

Whenever you are reviewing another student's work, remember **2PR**, the critical reading process you learned about in Chapter 1. This process provides another way to question the work and make thoughtful comments about it. In addition, you might refer to the questions in the Reading and Writing Critically chart from that chapter (see pp. 16–17).

Practice Revising for Unity, Detail, and Coherence

You may need to read what you have written several times before deciding what changes would improve it. Remember to consider your audience and your purpose and to focus on three areas: unity, detail, and coherence.

Revise for Unity

Unity in writing means that all the points you make are related to your main point; they are *unified* in support of it. As you draft a paragraph or an essay, you may detour from your main point without even being aware of it, as the writer of the following paragraph did with the underlined sentences. The diagram after the paragraph shows what happens when readers read the paragraph.

First, double-underline the main point in the paragraph that follows to help you see where the writer got off-track.

If you want to drive like an elderly person, use a cell phone while driving. A group of researchers from the University of Utah tested the reaction times of two groups of people—those between the ages of sixty-five to seventy-four and those who were eighteen to twenty-five—in a variety of driving tasks. All tasks were done with hands-free cell phones. That part of the study surprised me because I thought the main problem was using only one hand to drive. I hardly ever drive with two hands, even when I'm not talking to anyone. Among other results, braking time for both groups slowed by 18 percent. A related result is that the number of rearend collisions doubled. The study determined that the younger drivers were paying as much—or more—attention to their phone conversations as they were to what was going on around them on the road. The elderly drivers also experienced longer reaction times and more accidents, pushing most of them into the category of dangerous driver. This study makes a good case for turning off the phone when you buckle up.

TEACHING TIP Read the paragraph aloud to the class, and ask students to stop you as soon as they hear it detouring from the main point.

IDEA JOURNAL Write about your reactions to this study, including your own experiences with cell phones and driving.

Elderly drivers also got worse

CONCLUDING SENTENCE: This study makes a good case for turning off the phone when you buckle up.

Detours weaken your writing because readers' focus is shifted from your main point. As you revise, check to make sure your paragraph or essay has unity.

PRACTICE 1 Revising for Unity

Each of the following paragraphs contains a sentence that detours from the main point. First, double-underline the main point. Then, underline the detour in each paragraph.

EXAMPLE:

<u>for and not get.</u>" When we buy something expensive, we make sure we take it home and use it. For example, we wouldn't think of spending a couple of hundred dollars on a new coat and shoes only to hide them away in a closet never to be worn. And we certainly wouldn't pay for those items and then decide to leave them at the store. <u>I once left a bag with three new shirts in it at the cash register, and I never got it back.</u> People pay a lot for education, but sometimes they look for ways to leave the "purchase" behind. They cheat themselves by not attending class, not paying attention, not studying, or not doing assignments. At the end of the term, they have a grade but didn't get what they paid for: education and knowledge. They have wasted money, just as if they had bought an expensive sound system and had never taken it out of the box.

1. One way to manage time is to keep a print or electronic calendar or schedule. It should have an hour-by-hour breakdown of the day and evening, with space for you to write next to the time. As appointments or responsibilities come up, add them on the right day and time. Before the

IDEA JOURNAL Write about the statement "Education is one of the few things people are willing to pay for and not get." Do you agree? How does this statement apply to you? end of the day, consult your calendar to see what's going on the next day. For example, tomorrow I have to meet Kara at noon, and if I forget, she will be furious with me. Once you are in the habit of using a calendar, you will see that it frees your mind because you are not always trying to think about what you're supposed to do, where you're supposed to be, or what you might have forgotten.

- 2. As you use a calendar to manage your time, think about how long certain activities will take. A common mistake is to underestimate the time needed to do something, even something simple. For example, when you are planning the time needed to get money from the cash machine, remember that a line of people may be ahead of you. Last week in the line I met a woman I went to high school with. When you are estimating time for a more complex activity, such as reading a chapter in a textbook, block out more time than you think you will need. If you finish in less time than you have allotted, so much the better.
- 3. Effective time management means allowing time for various "life" activities. For example, it is important to budget time for paying bills, buying food, picking up a child, or going to the doctor. My doctor is always an hour behind schedule. A daily schedule should also account for communication with other people, such as family members and friends. Also, allow yourself a little unscheduled relaxation time when possible. Finally, leave time for unexpected events that are a huge part of life, like last-minute phone calls, a car that won't start, or a bus that is late.

Revise for Detail and Support

When you revise a paper, look carefully at the support you have developed. Will readers have enough information to understand and be convinced by the main point?

In the margin or between the lines of your draft (which should be double-spaced), note ideas that seem weak or unclear. As you revise, build up your support by adding more details.

PRACTICE 2 Revising for Detail and Support

Read the following paragraphs, double-underline the main point, and add at least three additional support points or supporting details. Write them in the spaces provided under each paragraph, and indicate where they should go in the paragraph by writing in a caret $(\)$ and the number.

EXAMPLE:

about the evils of slavery. She was a slave herself in New York. 1

2After she had a religious vision, she traveled from place to place a giving speeches about how terrible it was to be a slave. 3But even after the Emancipation Proclamation was signed in 1863, slave owners did not follow the laws. Sojourner Truth was active in the Civil War, nursing soldiers and continuing to give speeches. She was active in the fight for racial equality until her death in 1883.

- 1. and was not allowed to learn to read or write.
- 2. Sojourner Truth ran away from her owner because of his cruelty.
- 3. Although she was beaten for her beliefs, she continued her work and was part of the force that caused Abraham Lincoln to sign the Emancipation Proclamation freeing the slaves.
- 1. Sports fans can turn from normal people into destructive maniacs.

 After big wins, a team's fans sometimes riot. Police have to be brought in.

 Even in school sports, parents of the players can become violent. People get so involved watching the game that they lose control of themselves and are dangerous.

Answers	will vary.			
172	1 18	<u> </u>	or the same	
			<u> </u>	<u> </u>

2. If a friend is going through a hard time, try to be as supportive as you can. For one thing, ask if you can help out with any errands or chores. Also, find a time when you can get together in a quiet, nonstressful place. Here, the two of you can talk about the friend's difficulties or just spend time visiting. Let the friend decide how the time is spent. Just knowing that you are there for him or her will mean a lot.

The state of the s	T. T	Aug - decoration	Small Service

Revise for Coherence

Coherence in writing means that all your support connects to form a whole. In other words, you have provided enough "glue" for readers to see how one point leads to another.

A good way to improve coherence is to use **transitions**—words, phrases, and sentences that connect your ideas so that your writing moves smoothly from one point to the next. The table that starts at the bottom of this page shows some common transitions and what they are used for.

Here are two paragraphs, one that does not use transitions and one that does. Read them and notice how much easier the second paragraph is to follow because of the underlined transitions.

NO TRANSITIONS

It is not difficult to get organized—it takes discipline to stay organized. All you need to do is follow a few simple ideas. You must decide what your priorities are and do these tasks first. You should ask yourself every day: What is the most important task I have to accomplish? Make the time to do it. To be organized, you need a personal system for keeping track of things. Making lists, keeping records, and using a schedule help you remember what tasks you need to do. It is a good idea not to let belongings and obligations stack up. Get rid of possessions you do not need, put items away every time you are done using them, and do not take on more responsibilities than you can handle. Getting organized is not a mystery; it is just good sense.

DISCUSSION Ask students who they think revises more — new writers or experienced writers.
Students will often say that new writers do. Point out that experienced writers typically revise a great deal.

TRANSITIONS ADDED

It is not difficult to get organized—even though it takes discipline to stay organized. All you need to do is follow a few simple ideas. You must decide what your priorities are and do these tasks first. For example, you should ask yourself every day: What is the most important task I have to accomplish? Then, make the time to do it. To be organized, you also need a personal system for keeping track of things. Making lists, keeping records, and using a schedule help you remember what tasks you need to do. Finally, it is a good idea not to let belongings and obligations stack up. Get rid of possessions you do not need, put items away every time you are done using them, and do not take on more responsibilities than you can handle. Getting organized is not a mystery; it is just good sense.

TEACHING TIP Ask students to bring in a newspaper or magazine article with all transitions underlined.

Common Transitional Words and Phrases INDICATING SPACE to the right above below near beside to the side across next to at the bottom beyond opposite under at the top farther/further over where

to the left

inside

behind

RESOURCES Charts showing transitions specific to the various rhetorical modes appear throughout Part 2.

INDICATING TIM	IE .		
after	eventually	meanwhile	soon
as	finally	next	then
at last	first	now	when
before	last	second	while
during	later	since	
INDICATING IMP	PORTANCE		
above all	in fact	more important	most important
best	in particular	most	worst
especially			
SIGNALING EXA	MPLES		
for example	for instance	for one thing	one reason
SIGNALING ADD	ITIONS		
additionally	and	as well as	in addition
also	another	furthermore	moreover
SIGNALING CON	ITRAST		
although	however	nevertheless	still
but	in contrast	on the other hand	yet
even though	instead		
SIGNALING CAU	ISES OR RESULTS		
as a result	finally	so	therefore
because			

PRACTICE 3 Adding Transitions

Read the following paragraphs. In each blank, add a transition that would smoothly connect the ideas. In each case, there is more than one correct answer.

EXAMPLE:

LifeGem, a C	Chicago company, has announced that it ca	an turn
cremated hu	man ashes into high-quality diamonds	After
cremation, th	ne ashes are heated to convert their carbo	n to graphite.
Then	, a lab wraps the graphite around a tiny	diamond

piece and aga	in heats it and pressurizes it	After	_ about a
week of crysta	allizing, the result is a diamond.	Because	of the
time and labo	or involved, this process can cost	as much a	as \$20,000.
Although	_ the idea is very creative, many	people wi	ll think it is
also very weir	d. Answers will vary.		

1. Frida Kahlo (1907–1954) is one of Mexico's most famous artists. From an early age, she had an eye for color and detail. was not until she was seriously injured in a traffic accident that she devoted During her recovery, she went to work on herself to painting. _ what would become the first of many self-portraits. _ Eventually Because married the famous muralist Diego Rivera. Rivera was unfaithful to Kahlo, their marriage was difficult. Nevertheless, Kahlo continued to develop as an artist and produce great work. Rivera may have summed up Kahlo's paintings the best, describing them as "acid and tender, hard as steel and delicate and fine as a butterfly's wing, lovable as a beautiful smile, and profound and cruel as the bitterness of life."

LEARNING JOURNAL How would you explain the terms unity, support, and coherence to someone who had never heard them?

Another way to give your writing coherence is to repeat a **key word**—a word that is directly related to your main point. For example, in the paragraphs on page 103, the writer repeats the word *organized* several times. Repetition of a key word is a good way to keep your readers focused on your main point, but make sure you don't overdo it.

Revise Your Own Paragraph

In Chapter 6, you read Chelsea's draft paragraph (pp. 91–92). Reread that now as if it were your own, asking yourself the questions in the Checklist for Revising Your Writing on page 97. Work either by yourself or with a partner or a small group to answer the questions about Chelsea's draft. Then, read Chelsea's revised paragraph that follows, and compare the

TEACHING TIP If you are working with paragraphs only, ask students to read this section and then move on to the Chapter Review, page 109. If you are working with essays only, skip this section and go to Revise Your Own Essay, page 107.

TEACHING TIP You might challenge teams of students to find the most revisions to the paragraph.

changes you suggested with those she made. Make notes on the similarities and differences to discuss with the rest of the class.

PRACTICE 4 Revising a Paragraph

Answers	will vary.
A TELLEGIS	
Did Chel	sea make any of the suggested changes? Which ones?
Did Chel	sea make any of the suggested changes? Which ones?

WRITING ASSIGNMENT Paragraph

Revise the draft paragraph you wrote in Chapter 6. After revising your draft, complete the following checklist.

CH	IECKLIST
Eva	aluating Your Revised Paragraph
	My topic sentence is confident, and my main point is clear.
	My ideas are detailed, specific, and organized logically.
	My ideas flow smoothly from one to the next.
	This paragraph fulfills the original assignment.
	I am ready to turn in this paragraph for a grade.
	This paragraph is the best I can do.

After you have finished revising your paragraph, you are ready to edit it. See the Important Note about editing on page 109.

Revise Your Own Essay

In Chapter 6, you read Chelsea's draft essay (p. 93). Reread that now as if it were your own, asking yourself the questions in the Checklist for Revising Your Writing on page 97. Work either by yourself or with a partner or a small group to answer the questions about Chelsea's draft. Then, read Chelsea's revised essay that follows, and compare the changes you suggested with those that she made. Make notes on the similarities and differences to discuss with the rest of the class.

TEACHING TIP You might challenge teams of students to find the most revisions to the essay.

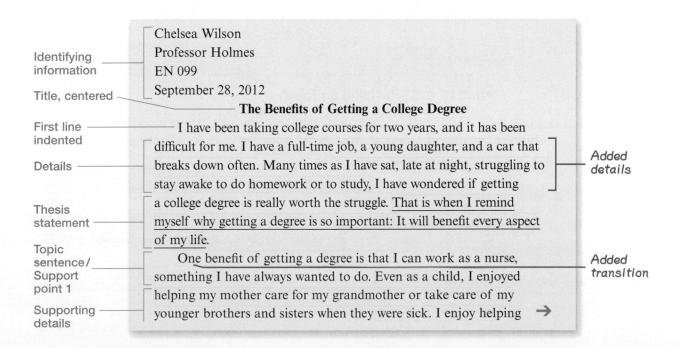

	others, and nursing will allow me to do so while making good money.	
Supporting	The average salary for a licensed practical nurse is \$40,000 per year,	
details	substantially more than I make now working at a restaurant. Without	
	a degree, I don't see how that situation will change. Meanwhile, I have	
Topic	almost no time to spend with my daughter.	Added
sentence/	Another benefit of getting a college degree is that it will allow	transitions
Support	me to be a better mother. In fact, I didn't get serious about getting a	
point 2	degree until I became a mother. Then, I realized I wanted more for my	
	daughter than I had had: a safer place to live, a bigger apartment, some	
	nice clothes, and birthday presents. I also wanted to have time to raise	
Supportingdetails	her properly and keep her safe. She is a good girl, but she sees crime and	
	violence around her. I want to get her away from danger, and I want to	
	show her that there are better ways to live. The job opportunities I will	
Topic	have with a college degree will enable me to do those things.	
sentence/	The most important benefit of getting a college degree is that it	
Support	will show me that I can achieve something hard. In the past, I have	Added
point 3	often given up and taken the easy way, which has led to nothing good.	details
	The easy way has led to a hard life. Now, however, working toward	
	a goal has moved my life in a good direction. I have confidence and	
Supporting details	self-respect. I can honestly say that I am proud of myself, and my	
details	daughter will be proud of me, too. I will be a good role model as	
	she grows up, not only for her but also for her friends. She will go to	
	college, just like her mother.	Conclusion
	So why am I working so hard to get a degree? I am doing it	strengthened
Conclusion	because I see in that degree the kind of life I want to live on this earth	with an observation
Conclusion ——	and the kind of human being I want to be. Achieving that vision is worth all the struggles.	

PRACTICE 5 Revising an Essay

What major changes did you suggest for Chelsea's draft in response to the questions in the Checklist for Revising Your Writing?
Answers will vary.
Did Chelsea make any of the suggested changes? Which ones?

RESOURCES For suggestions on having students keep writing portfolios, see *Practical*

TEACHING TIP Ask students to write you an informal letter and attach it to their papers. In the letter, they should comment on the assignment: whether it was easy or hard, interesting or not. They should also indicate what they might change about their own writing process if they were to do the assignment again.

LEARNING JOURNAL In your own words, summarize what you have learned about the

writing process.

Suggestions.

/RI	TING ASSIGNMENT Essay
	se the draft essay you wrote in Chapter 6. After revising your draft, comthe following checklist.
CH	ECKLIST
Eva	luating Your Revised Essay
	My thesis statement is confident, and my main point is clear.
	My ideas are detailed, specific, and organized logically.
	My ideas flow smoothly from one to the next.
	This essay fulfills the original assignment.
	I am ready to turn in this essay for a grade. This essay is the best I can do.
ng ou	errors in grammar, word use, punctuation, and capitalization. When
ng ou diti	errors in grammar, word use, punctuation, and capitalization. When are ready to edit your writing, turn to Part 4, the beginning of the
ou diti	errors in grammar, word use, punctuation, and capitalization. When are ready to edit your writing, turn to Part 4, the beginning of the ng chapters.
ou diti	errors in grammar, word use, punctuation, and capitalization. When are ready to edit your writing, turn to Part 4, the beginning of the ng chapters. apter Review Highlight the important terms from this chapter (for example, revising)
ou diti	errors in grammar, word use, punctuation, and capitalization. When are ready to edit your writing, turn to Part 4, the beginning of the ng chapters. apter Review Highlight the important terms from this chapter (for example, revising and editing), and list them with their page numbers. Revising is making your ideas clearer, stronger, and more convincing. Three basic features of useful feedback are
ou diti	errors in grammar, word use, punctuation, and capitalization. When are ready to edit your writing, turn to Part 4, the beginning of the ng chapters. apter Review Highlight the important terms from this chapter (for example, revising and editing), and list them with their page numbers. Revising is making your ideas clearer, stronger, and more convincing. Three basic features of useful feedback are
ou diti	errors in grammar, word use, punctuation, and capitalization. When are ready to edit your writing, turn to Part 4, the beginning of the ng chapters. apter Review Highlight the important terms from this chapter (for example, revising and editing), and list them with their page numbers. Revising is making your ideas clearer, stronger, and more convincing. Three basic features of useful feedback are
ou ditt	errors in grammar, word use, punctuation, and capitalization. When are ready to edit your writing, turn to Part 4, the beginning of the ng chapters. **The page numbers of useful feedback are It is given in a positive way. It offers specific suggestions. It may be given in writing or orally. As you revise, make sure your paragraph or essay has these three
ou ditt	Highlight the important terms from this chapter (for example, revising and editing), and list them with their page numbers. Revising is making your ideas clearer, stronger, and more convincing. Three basic features of useful feedback are It is given in a positive way. It offers specific suggestions. It may be given in writing or orally. As you revise, make sure your paragraph or essay has these three things: unity , detail/support , and coherence .
ou ditt	errors in grammar, word use, punctuation, and capitalization. When are ready to edit your writing, turn to Part 4, the beginning of the ng chapters. **The page numbers of useful feedback are It is given in a positive way. It offers specific suggestions. It may be given in writing or orally. As you revise, make sure your paragraph or essay has these three things:
ou dit:	errors in grammar, word use, punctuation, and capitalization. When are ready to edit your writing, turn to Part 4, the beginning of the ing chapters. **Part Review** Highlight the important terms from this chapter (for example, revising and editing), and list them with their page numbers. Revising is **making your ideas clearer, stronger, and more convincing.** Three basic features of useful feedback are It is given in a positive way. It offers specific suggestions. It may be given in writing or orally. As you revise, make sure your paragraph or essay has these three things: **unity**, **detail/support**, and **coherence**.

- 7. An important way to ensure coherence in your writing is to use transitions.
- 8. Transitions are words, phrases, and sentences that connect your ideas so that your writing moves smoothly from one point to the next.
- **9.** Write for one minute about "What questions I should ask my instructor."

STUDENT VOICES

Message-Chelsea to Nick (1:56 p.m.)

Do you think there are more changes that would make my paper better, before I turn it in?

Message-Nick to Chelsea (3:15 p.m.)

Well, double-check your grammar and spelling, and make sure all your thoughts are organized.

And then let's all go out to celebrate!

reflect Can you think of other changes that would make Chelsea's paper better?

YOU KNOW THIS

You often use narration:

- You explain a TV episode to a friend who missed it.
- You say, "You won't believe what happened." Then, you tell the story.

write for 2 minutes about what makes a good story or a good telling of events.

8

Narration

Writing That Tells Important Stories

Understand What Narration Is

Narration is writing that tells the story of an event or an experience.

Four Basics of Good Narration

It reveals something of importance to the writer (the main point).

- 2 It includes all the major events of the story (primary support).
- It brings the story to life with details about the major events (secondary support).
- It presents the events in a clear order, usually according to when they happened.

In the following paragraph, the numbers and colors correspond to the Four Basics of Good Narration.

Last year, a writing assignment that I hated produced the best writing I have done. When my English teacher told us that our assignment would be to do a few hours of community service and write about it, I was furious. I am a single mother, I work full-time, and I am going to school: Isn't that enough? The next day, I spoke to my teacher during her office hours and told her that I was already so busy that I could hardly make time for homework, never mind housework. My own life was too full to help with anyone else's life. She said that she understood perfectly and that the majority of her students had lives as full as mine. Then, she explained that the service assignment was just for four hours and that other students had enjoyed both doing the assignment

4 Events in time order

4 Events in time order

TEACHING TIP Finnish photographer Markku Lahdesmaki created a series portraying robots' experiences in the human world. (To see others, go to weburbanist.com and enter the photographer's name as a search term.) Show these photographs to your class and ask students what thoughts, feelings, and stories the images express (for example, immigration, tourism, technology, or the artist as outsider).

and writing about their experiences. She said they were all surprised and that I would be, too. 2 After talking with her, I decided to accept my fate. The next week, I went to the Community Service Club, and was set up to spend a few hours at an adult day-care center near where I live. A few weeks later, I went to the Creative Care Center in Cocoa Beach, not knowing what to expect. 3 I found friendly, approachable people who had so many stories to tell about their long, full lives. 2 The next thing I knew, I was taking notes because I was interested in these people: 3 their marriages, life during the Depression, the wars they fought in, their children, their joys and sorrows. I felt as if I was experiencing everything they lived while they shared their history with me. 2 When it came time to write about my experience, I had more than enough to write about: 3 I wrote the stories of the many wonderful elderly people I had talked with. 2 I got an A on the paper, and beyond that accomplishment, I made friends whom I will visit on my own, not because of an assignment, but because I value them.

You can use narration in many practical situations.

COLLEGE	In a lab course, you are asked to tell what happened in an experiment.
WORK	Something goes wrong at work, and you are asked to explain to your boss—in writing—what happened.
EVERYDAY LIFE	In a letter of complaint about service you received, you need to tell what happened that upset you.

In college, the word *narration* probably will not appear in writing assignments. Instead, an assignment might ask you to *describe* the events, *report* what happened, or *retell* what happened. Words or phrases that call for an *account of events* are situations that require narration.

TEACHING TIP Here and in the remaining chapters of Part 2, students are given examples of typical key words in assignments-key words that signal a need for narration, illustration, description, and so on. Show students sample assignments from your course and ask them to identify key words and the type of writing these words call for. To broaden the discussion, students might also bring in assignments from other courses.

Main Point in Narration

In narration, the **main point** is what is important about the story—to you and to your readers. To help you discover the main point for your own narration, complete the following sentence:

MAIN POINT
IN NARRATION

What is important to me about the experience is ...

The topic sentence (paragraph) or thesis statement (essay) usually includes the topic and the main point the writer wants to make about the topic. Let's look at a topic sentence first.

My first day at my new job was nearly a disaster.

Remember that a topic for an essay can be a little broader than one for a paragraph.

Whereas the topic sentence is focused on just one work day, the thesis statement considers a season-long internship.

IDEA JOURNAL Write about something that happened to you this week.

WRITER AT WORK

KELLY LAYLAND: I write nursing notes that are narratives about my patients' changing conditions.

(See Kelly Layland's PROFILE OF SUCCESS on p. 123)

TIP Sometimes, the same main point can be used for a paragraph and an essay, but the essay must develop this point in more detail. (See pp. 69–70.)

EXAMPLE:

PRACTICE 1 Writing a Main Point

Look at the example narration paragraph on pages 113–14. Fill in the diagram with the paragraph's topic sentence.

PRACTICE 2 Deciding on a Main Point

For each of the following topics, write a main point for a narration. Then, write a sentence that includes your topic and your main point. This sentence would be your topic sentence (paragraph) or thesis statement (essay).

	Topic: A fight I had with my sister
	Important because: it taught me something
	Main point: learned it is better to stay cool
	Topic sentence/Thesis: After a horrible fight with my sister, I
	learned the value of staying calm.
1.	Topic: A powerful, funny, or embarrassing experience
	Important because: Answers will vary.
	Main point: Answers will vary.
	Topic sentence/Thesis: Answers will vary.
2.	Topic: A strange or interesting incident that you witnessed
	Important because:
	Main point:
	Topic sentence/Thesis:

Support in Narration

In narration, **support** demonstrates the main point—what's important about the story.

The paragraph and essay models on pages 118–19 use the topic sentence (paragraph) and thesis statement (essay) from the Main Point section of this chapter. (The thesis statement has been revised slightly.)

TIP In an essay, the major events may form the topic sentences of paragraphs. The details supporting the major events then make up the body of these paragraphs.

Both models include the support used in all narration writing—major events backed up by details about the events. In the essay model, however, the major support points (events) are topic sentences for individual paragraphs.

CHOOSING MAJOR EVENTS

EXAMPLE:

When you tell a story to a friend, you can include events that are not essential to the story. When you are writing a narration, however, you need to give more careful thought to which events to include, selecting only those that most clearly demonstrate your main point.

TEACHING TIP Ask students to write a narrative joke they have heard. Then, examine the structure of one or two of these jokes.

PRACTICE 3 Choosing Major Events

Choose two items from Practice 2, and write down the topic sentence or thesis statement you came up with for each. Then, for each topic sentence/thesis statement, write three events that would help you make your main point.

Topic	sentence/Thesis: After a horrible fight with my sister, I
learnec	I the value of staying calm.
Events	: We disagreed about who was going to have the family party
She m	ade me so mad that I started yelling at her, and I got nasty.
I hung	up on her, and now we're not talking.
	A powerful, funny, or embarrassing experience sentence/Thesis: Answers will vary.
Г.	Answers will vary.
Events	
Topic:	A strange or interesting incident that you witnessed sentence/Thesis:

PARAGRAPHS VS. ESSAYS IN NARRATION

For more on the important features of narration, see the Four Basics of Good Narration on page 113.

Paragraph Form Main Point: Often, narrower for a paragraph than for an essay: While the topic **Topic sentence** sentence (paragraph) is My first day at my new job was nearly a disaster. First, a traffic focused on just one workday, Support 1 jam from highway construction caused me to be a half hour late. I the thesis statement (essay) (first major had left myself plenty of time for the commute, but because of the considers a season-long event) traffic backup, it took me nearly an hour to travel seven miles. At internship. one point, I tried a detour to avoid traffic, but I ended up getting lost. By the time I finally pulled into the employee parking lot, I was already full of stress. After I arrived in the office, I discovered Support 2 **Major Events Supporting the** (second major that I would have to fill in for a sick worker whose job I was not event) **Main Point** familiar with. I had been trained in accounts payable, while my sick colleague worked in accounts receivable. Although I had some understanding of his job, I was worried about making mistakes and had to ask coworkers a lot of questions, which took a lot of **Details about the Events:** time. For example, I estimate that I spent a half hour on a billing Usually, 1 to 3 sentences per procedure that would take an experienced worker five minutes. event for paragraphs and Support 3 Near the end of the day, my computer broke down, erasing two 3 to 8 sentences per event for (third major documents that I had been working on. One was a small set of file event) labels, but the other was a detailed summary of the day's billings. At this point, I wanted to put my head down on my desk and cry. Seeing my distress, my supervisor came by and kindly said, "You have had a long, hard day and done great work. Why don't you Conclusion go home and make a fresh start tomorrow?" I was grateful for her Support kindness, and I came around to thinking that if I could handle Concluding this type of day on the new job, I could handle just about any day. sentence

Think Critically As You Write Narration

ASK YOURSELF

- Would someone who is unfamiliar with this story be able to follow it and relate to it?
- Have I provided enough detail to bring each event to life?

1

Several of my friends question whether summer internships are really worthwhile, especially if the pay is low or nonexistent. However, the right internship definitely pays off professionally in the **Thesis statement** it doesn't financially in the short run. The proof is in my own summer marketing internship, which made me a far more confident and skilled worker.

During the first two weeks of the internship, I received thorough training in every part of my job. For example, my immediate supervisor sper going over everything I would need to e-mail campaigns, online marketing efforts, and other promotions. She even had me draft a promotional e-mail for a new product and gave me feedback about how to make the message clearer and more appealing. I also spent a lot of time with other staffers, who taught me everything from how to use the photocopier and printers to how to pull together marketing and sales materials for executive meetings. Most impressive, the president of the company took some time out of a busy afternoon to answer my questions about how he got started in

his career and what he sees as the keys to success in the marketing field. As I explained to a fric

Topic sentence 2

"insider's view" of the company and its I (second major event)

2

Next, I got hands-on experience with listening to customers and addressing their needs. Specifically, I sat in on meetings with new clients and listened to them describe products and services they would like the company's help in promoting. They also discussed the message they would like to get across about their businesses. After the meetings, I sat in on brainstorming sessions with other staffers in which we came up with as many ideas as we could about campaigns to address the clients' needs. At first, I didn't think anyone would care about my ideas, but others listened to them respectfully and even ended up including some of them in the marketing plans that were sent back to the clients. Later,

I learned that some of my ideas would be in actual promotional campaigns.

Topic sentence 3 (third major event)

By summer's end, I had advanced my skills so much that I was asked to return next summer. My supervisor told me that she was pleased not only with all I had

3

learned about marketing but also with the responsibility I took for every aspect of my job. I did not roll my eyes about having to make photocopies or help at the reception desk, nor did I seem intimidated by bigger, more meaningful tasks. Although I'm not guaranteed a full-time job at the company after graduation, I think my chances are good. Even if I don't end up working there long term, I am very grateful for how the job has helped me grow.

Concluding paragraph

In the end, the greatest benefit of the internship might be the confidence it gave me. I have learned that no matter how challenging the task before me—at work or in real life—I can succeed at it by getting the right information and input on anything unfamiliar, working effectively with others, and truly dedicating myself to doing my best. My time this past summer was definitely well spent.

GIVING DETAILS ABOUT THE EVENTS

When you write a narration, include examples and details that will make each event easier to visualize and understand. You want your readers to share your point of view and see the same message in the story that you do.

PRACTICE 4 Giving Details about the Events

Write down the topic sentence or thesis statement for each item from Practice 3. Then, write the major events in the spaces provided. Give a detail about each event.

TEACHING TIP A fun way to encourage critical thinking in the context of narration is to ask students for examples of urban legends, ghost stories, or other "amazing stories" they have heard. Then, ask them what type of support would be needed to prove or disprove such stories. If you have Internet access, you might type students' examples into the search box at www.snopes.com, which provides evidence to prove or debunk popular stories and rumors.

1.

EXAMPLE:
Topic sentence/Thesis: After a horrible fight with my sister, I
learned the value of staying calm.
Event: We disagreed about who was going to have the family party.
Detail: Even though we both work, she said she was too busy
and I would have to do it.
Event: She made me so mad I started yelling at her, and I got nasty.
Detail: I brought up times in the past when she had tried to
pass responsibilities off on me, and I told her I was sick of being
the one who did everything.
Event: I hung up on her, and now we are not talking.
Detail: I feel bad, and I know I will have to call her sooner or
later because she is my sister. I do love her, even though she is
a pain sometimes.
Topic sentence/Thesis: Answers will vary.
Event: Answers will vary.
Detail:
Event:
Detail:
Event:
Detail:

Event:	State of the same	eenige od too oog	
Detail:		anterent.	
-	talescaeper a bate	este en l'aux en de	
Event:			
Detail:			
Event:			
Detail:			

Organization in Narration

Narration usually presents events in the order in which they happened, known as **time (chronological) order**. As shown in the paragraph and essay models on pages 117–18, a narration starts at the beginning of the story and describes events as they unfolded.

Transitions move readers from one event to the next.

TIP For more on time order, see page 78.

after	eventually	meanwhile	since
as	finally	next	soon
at last	first	now	then
before	last	once	when
during	later	second	while

PRACTICE 5 Using Transitions in Narration

Read the paragraph that follows, and fill in the blanks with time transitions. Answers may vary. Possible answers are shown.

Some historians believe that as many as four hundred women disguised themselves as men so that they could serve in the U.S. Civil War (1861–1865). One of the best known of these women was Sarah Emma Edmonds.

Once the war began, Edmonds, an opponent

of slavery, felt driven to join the Union Army, which fought for the free When President Abraham Lincoln asked for army volunteers, she disguised herself as a man, took the name Frank Thompson, During ___ her military service, and enlisted in the infantry. Edmonds worked as a male nurse and a messenger. serving as a nurse, she learned that the Union general needed someone to After spy on the Confederates. __ _ extensive training, Edmonds took on this duty and, disguised as a slave, went behind enemy lines. Here, she learned about the Confederates' military strengths and weaknesses. <u>Eventually</u>, she returned to the Union side and went back to work as a nurse. In 1863, Edmonds left the army after developing malaria. She was worried that hospital workers would discover that she was a woman. As a result of her departure, "Frank Thompson" was listed as a deserter. In later years, Edmonds, under her real name, worked to get a veteran's pension and to get the desertion charge removed from her record. __, in 1884, a special act of Congress granted her both of these wishes.

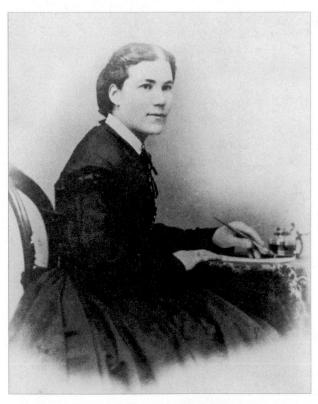

Left: Sarah Emma Edmonds; right: Edmonds disguised as Frank Thompson

Read and Analyze Narration

Reading examples of narration will help you write your own. The first example in this section is a Profile of Success from the real world of nursing. In this profile, Kelly Layland shows how she uses narration at work.

The second example is a narration paragraph by a student, and the third example is a narration essay by a professional writer. As you read these selections, pay attention to the vocabulary, and answer the questions in the margin. They will help you read critically.

READING SELECTIONS
For more examples of and activities for narration, see Chapter 39.

PROFILE OF SUCCESS

Narration in the Real World

Background In high school, I was not a good student. I had a lot of other things to do, like having fun. I am a very social person; I loved my friends, and we had a great time. But when I decided I wanted to go to college, I had to pay the price. I had to take lots of noncredit courses to get my skills up to college level because I had fooled around during high school. The noncredit English course I took was very beneficial to me. After I passed it, I took English 101 and felt prepared for it.

Degrees/Colleges A.S Monroe Community College; LPN, Isabella Graham Hart School of Nursing; RN, Monroe Community College

Writing at work I write nursing notes that are narratives of patients' changing conditions and the level of care required. When I describe physical conditions, I have to support my descriptions with detailed examples. When I recommend medication for treatment, I have to justify it by explaining the patient's condition and the reasons I am making the recommendation. I also have to write notes that integrate care with Medicare documentation. Basically, I have to write about everything I recommend and all that I do.

How Kelly uses narration Every day I write brief narratives that recount all that went on with the patient during the day: things that went wrong and things about his or her treatment that need to be changed.

Kelly's Narration

The following paragraph is an example of the daily reports that Kelly writes on each patient.

Kelly Layland Registered Nurse

RESOURCES For a discussion of how to use the profiles in Part 2 see *Practical Suggestions*.

Karella Lehmanoff, a two-month-old female infant, is improving steadily. When she was born, her birth weight was 1.3 pounds, but it has increased to 3.1 pounds. Her jaundice has completely disappeared, and her skin has begun to look rosy. Karella's pulse rate is normal for her development, and her resting heart rate has stabilized at about 150 beats per minute. Lung development was a big concern because of Karella's premature birth, but her lungs are now fully developed and largely functional. Dr. Lansing saw Karella at 1 P.M. and pronounced her in good condition. The parents were encouraged, and so am I. The prognosis for little Karella gets better with each day.

- 1. Double-underline the main point of the narration.
- 2. Underline the major events.
- 3. What order of organization does Kelly use? _____time_order

Vocabulary development

Underline these words as you read Jelani's paragraph.

integrity: honesty; having a sound moral codementor: a counselor, a teacher, an adviser

PREDICT What will Jelani's paragraph explain?

Student Narration Paragraph

Jelani Lynch

My Turnaround

Jelani Lynch graduated from Cambridge College/Year Up in 2009 with a degree in information technology. Now, he runs the video production company J/L visual media. As a writer, he says he is interested in exploring "issues that affect the community and the disparities that continue to affect the world." Reflecting on what motivated him to begin this essay, Jelani comments that he viewed his writing as a means of helping those around him: "I wrote this essay after I had just begun to get my life on track. I felt that the struggles that I have encountered needed to be publicized so my mistakes are not repeated by the people who read this essay."

Before my big turnaround, my life was headed in the wrong direction! I grew up in the city and had a typical sad story: broken home, not much money, gangs, and drugs. In this world, few positive male role models are available? I played the game "Street Life": running the streets, stealing bikes, robbing people, carrying a gun, and selling drugs. The men in

my neighborhood did not have regular jobs; they got their money outside the system. No one except my mother thought school was worth much.³ I had a history of poor school performance, a combination of not showing up and not doing any work when I did. My pattern of failure in that area was pretty strong. When I was seventeen, though, things got really bad. I was arrested for possession of crack cocaine. I was kicked out of school for good. During this time, I realized that my life was not going the way I wanted it to be. I was headed nowhere, except a life of crime, violence, and possibly early death. I knew that way of life, because I was surrounded by people who had chosen that direction. I did not want to go there anymore. (When) I made that decision, my life started to change? (First) I met Shawn Brown, a man who had had the same kind of life I did. He got out of that life, though, by graduating from high school and college and getting a good job. He has a house, a wife, and children, along with great clothes. Shawn became my role model, showing me that with honesty, integrity, and hard work I could live a much better life. (Since) meeting Shawn, I have turned my life around. I started taking school seriously and graduated from high school, something I thought I would never do. Working with Shawn, I have read books and learned I enjoy writing. I have met the mayor of Boston and got a summer job at the State House. I have been part of an educational video and had many opportunities to meet and work with people who are successful. (Now, I am a mentor with Diamond Educators, and I work with other young, urban males to give them a role model and help them make good choices. (Now, I have a bright future with goals and plans. I have turned my life around and know I will be a success.

REFLECT Have you ever made a decision that changed your life?

SUMMARIZE How did meeting Shawn change Jelani's life?

- 1. Underline the topic sentence.
- 2. What is important about the story? Answers will vary. Possible answer: People can take control of their lives with the help of a mentor.
- 3. Number the major events.
- **4.** Circle the **transitions**.
- 5. Does Jelani's paragraph follow the Four Basics of Good Narration (p. 113)? Be ready to give specific reasons for your answer. <u>Answers will vary. Possible answer: Yes. The story is important. It describes events and details in a clear time order.</u>

Vocabulary development

Underline these words as you read the narration essay.

prawns: shrimp or shrimplike creatures appalling: horrifying

clamor: noise murmured: spoke in low

tones
belched: burped

PREDICT Based on the second paragraph, what do you think will happen?

REFLECT Name an event during which you tried to make a good impression on someone.

Professional Narration Essay

Amy Tan

Fish Cheeks

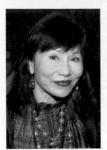

Amy Tan was born in Oakland, California, in 1952, several years after her mother and father emigrated from China. She studied at San Jose City College and later San Jose State University, receiving a B.A. with a double major in English and linguistics. In 1973, she earned an M.A. in linguistics from San Jose State University. In 1989, Tan published her first novel, *The Joy Luck Club*, which was nominated for the National Book Award and the National Book Critics Circle Award. Tan's other books include *The Kitchen God's Wife* (1991), *The Hundred Secret Senses* (1995), and *Saving Fish from Drowning* (2005). Her short stories and essays have

been published in the Atlantic, Grand Street, Harper's, the New Yorker, and other publications.

In the following essay, Tan uses narration to describe an experience that taught her an important lesson.

I fell in love with the minister's son the winter I turned fourteen. He was not Chinese, but as white as Mary in the manger. For Christmas I prayed for this blond-haired boy, Robert, and a slim new American nose.

When I found out that my parents had invited the minister's family over for Christmas dinner, I cried. What would Robert think of our shabby Chinese Christmas? What would he think of our noisy Chinese relatives who lacked proper American manners? What terrible disappointment would he feel upon seeing not a roasted turkey and sweet potatoes but Chinese food?

On Christmas Eve I saw that my mother had outdone herself in creating a strange menu. She was pulling black veins out of the backs of fleshy prawns. The kitchen was littered with appalling mounds of raw food: A slimy rock cod with bulging eyes that pleaded not to be thrown into a pan of hot oil. Tofu, which looked like stacked wedges of rubbery white sponges. A bowl soaking dried fungus back to life. A plate of squid, their backs crisscrossed with knife markings so they resembled bicycle tires.

And then they arrived—the minister's family and all my relatives in a clamor of doorbells and rumpled Christmas packages. Robert grunted hello, and I pretended he was not worthy of existence.

Dinner threw me into despair. My relatives licked the ends of their 5 chopsticks and reached across the table, dipping them into the dozen or so plates of food. Robert and his family waited patiently for platters to be passed to them. My relatives murmured with pleasure when my

mother brought out the whole steamed fish. Robert grimaced. Then my father poked his chopsticks just below the fish eye and plucked out the soft meat. "Amy, your favorite," he said, offering me the tender fish cheek. I wanted to disappear.

(At the end of the meal) my father leaned back and belched loudly, 6 thanking my mother for her fine cooking. "It's a polite Chinese custom to show you are satisfied," explained my father to our astonished guests. Robert was looking down at his plate with a reddened face. The minister managed to muster up a quiet burp. I was stunned into silence for the rest of the night.

(After)everyone had gone, my mother said to me, "You want to be the 7 REFLECT Have you ever felt same as American girls on the outside." She handed me an early gift. It was a miniskirt in beige tweed. "But inside you must always be Chinese. You must be proud you are different. Your only shame is to have shame."

And even though I didn't agree with her then, I knew that she under- 8 stood how much I had suffered during the evening's dinner. It wasn't until many years later—long after I had gotten over my crush on Robert that I was able to fully appreciate her lesson and the true purpose behind our particular menu. For Christmas Eve that year, she had chosen all my favorite foods.

- different on the outside than you did on the inside?
- What is Tan's purpose for writing? Answers will vary. Possible answers: to amuse readers; to describe an important event in her life; to help readers learn from her experience.
- 2. Does she achieve it? Answers will vary.
- In your own words, state her main point. Answers will vary. Possible 3. answer: It is important to take pride in your background, even if it is different from others' backgrounds.
- time order Circle the tran-How has Tan organized her essay? _ sitional words and phrases that indicate this order.

Respond to one of the following assignments in a paragraph or essay.

- 1. Have you ever been embarrassed by your family or by others close to you? Write about the experience, and describe what you learned
- 2. Write about a time when you felt different from other people. How did you react at the time? Have your feelings about the situation changed since then? If so, how?
- Write about an experience that was uncomfortable at the time but funny later. Explain how you came to see humor in the situation.

TIP For reading advice, see Chapter 1.

TIP For tools to build your vocabulary, visit the Student Site for Real Writing at bedfordstmartins .com/realwriting.

RESOURCES Reproducible peer-review guides for different kinds of papers are available in Additional Resources and online at bedfordstmartins.com/ realwriting.

COMMUNITY CONNECTIONS

JENNY HAUN wrote the Four Basics of Good Narration paragraph on page 113. Getting more involved in college and community activities, as Jenny did, can help you feel more connected to others and can even improve the chances that you will stay in school.

For more on this story, ways to make community connections, and writing assignments, visit bedfordstmartins.com/ realwriting.

Write Your Own Narration

In this section, you will write your own narration based on one of the following assignments. For help, refer to the "How to Write Narration" checklist on page 130.

ASSIGNMENT OPTIONS Writing about College, Work, and Everyday Life

Write a narration paragraph or essay on one of the following topics or on one of your own choice. If you responded to the idea journal prompt on page 115, you might develop that writing further.

COLLEGE

- Tell the story of how a teacher made a difference in your life.
- Write about a time when you achieved success or experienced a difficulty in school.
- Interview a college graduate about his or her educational experience. Questions might include "Why did you go to college?" "What were your biggest challenges?" and "What were your greatest accomplishments?" Then, write that person's story.

WORK

- Write about a situation or incident that made you decide to leave a job.
- Imagine a successful day at your current or previous job. Then, tell the story of that day, including examples of successes.
- Write your own work history, guided by a statement that you would like to make about this history or your work style. Here is one example: "Being a people person has helped me in every job I have ever had." You might imagine that you are interviewing with a potential employer.

EVERYDAY LIFE

- Write about an experience that triggered a strong emotion: happiness, sadness, fear, anger, regret.
- Find a campus community service club that offers short-term assignments. Take an assignment and write about your experience.
- Tell the story of a community issue that interests you. One example is plans to create a bike lane on a major road. Discuss how the issue arose, and describe key developments. Research details by visiting a local newspaper's Web site.

ASSIGNMENT OPTIONS Reading and Writing Critically

Complete one of the following assignments, which ask you to apply the critical thinking, reading, and writing skills discussed in Chapter 1.

Writing Critically about Readings

Both Jelani Lynch's "My Turnaround" (p. 124) and Caitlin Prokop's "A Difficult Decision with a Positive Outcome" (p. 257) tell the story of a major life decision with positive results. Review both of these pieces. Then, follow these steps:

- 1. Summarize Briefly summarize the works, listing major events.
- **2. Analyze** List any types of examples or details you wish had been included in Lynch's or Prokop's story. Also, write down any questions that the pieces raise for you.
- **3. Synthesize** Using examples from both Lynch's and Prokop's stories and from your own experience, write about how a big life decision can have a major effect on one's future.
- **4.** Evaluate Which piece do you think is more effective? Why? To write your evaluation, look back on your responses to step 2.

Writing about Images

Study the photograph below, and complete the following steps.

1. Read the image Ask yourself: What details does the photographer focus on? What seems to be the photo's message? (For more information on reading images, see Chapter 1.)

TIP For a reminder of how to summarize, analyze, synthesize, and evaluate, see the Reading and Writing Critically box on pages 16–17.

TEACHING TIP This photograph by Steve Davis appears in his book As American Falls (see stevedavisphotography.com). It tells a visual story of an Idaho town in decline after local businesses and small farms were replaced by corporate franchises and factory farms. Show these images in class, and ask students how the photos build on the story shown in this photo.

2. Write a narration Write a narration paragraph or essay about what has happened (or is happening) in the photograph. Be as creative as you like, but be sure to include details and reactions from step 1.

Writing to Solve a Problem

Read or review the discussion of problem solving in Chapter 1 (pp. 24–26). Then, consider the following problem:

You have learned that a generous scholarship is available for low-income, first-generation college students. You really need the money to cover day-care expenses while you are taking classes (in fact, you had thought you would have to stop going to college for a while). Many people have been applying. Part of the application is to write about yourself and why you deserve the scholarship.

TIP Such scholarships really do exist. Go online or to the college financial aid office to find out about them. If you are pleased with what you have written for this assignment, you could use it as part of your application.

ASSIGNMENT: Write a paragraph or essay that tells your story and why you should be considered for the scholarship. Think about how you can make your story stand out. You might start with the following sentence:

Even though you will be reading applications from many firstgeneration college students, my story is a little different because

STEPS		DETAILS	
	Narrow and explore your topic. See Chapter 3.	Make the topic more specific.Prewrite to get ideas about the narrowed topic.	
	Write a topic sentence (paragraph) or thesis statement (essay). See Chapter 4.	State what is most important to you about the topic and what you want your readers to understand.	
	Support your point. See Chapter 5.	Come up with examples and details to explain your main point to readers.	
	Write a draft. See Chapter 6.	 Make a plan that puts events or examples in a logical order. Include a topic sentence (paragraph) or thesis statement (essay) and all the supporting events, examples, and details. 	
	Revise your draft.	Make sure it has all the Four Basics of Good Narration.	
	See Chapter 7.	 Make sure you include transitions to move readers smoothly from one event or example to the next. 	
	Edit your revised draft. See Parts 4 through 7.	 Correct errors in grammar, spelling, word use, and punctuation. 	

Chapter Review

- 1. Narration is writing that tells the story of an event or experience.
- 2. List the Four Basics of Good Narration. It reveals something of importance to you. It includes all the major events of the story. It brings the story to life with details about the major events. It presents the events in a clear order, usually according to when they happened.
- 3. The topic sentence in a narration paragraph or the thesis statement in a narration essay usually includes what two things?

 your narrowed topic; your main point
- **4.** What type of organization do writers of narration usually use? time order, also known as chronological order
- **5.** List five common transitions for this type of organization. Answers will vary.
- Write sentences using the following vocabulary words: integrity, mentor, appalling, clamor. Answers will vary.

LEARNING JOURNAL

Reread your idea journal entry about an event that happened to you this week (p. 115). Then, rewrite it using what you now know about narration.

reflect Write for 2 minutes about how to tell a good story. Then, compare what you have written with what you wrote in response to the "write" prompt on page 113.

Writing That Gives Examples

YOU KNOW THIS

You use examples to illustrate your point in daily communication:

- You answer the question "Like what?"
- You give a friend some examples of fun things to do this weekend.

write for 2 minutes about what you know about writing illustration.

Understand What Illustration Is

Illustration is writing that uses examples to support a point.

Four Basics of Good Illustration

It has a point.

2 It gives specific examples that show, explain, or prove the point.

It gives details to support the examples.

It uses enough examples to get the point across to the reader.

In the following paragraph, the numbers and colors correspond to the Four Basics of Good Illustration.

1 Many people would like to serve their communities or help with causes that they believe in, but they do not have much time and do not know what to do. Now, the Internet provides people with ways to help that do not take much time or money. 2 Web sites now make it convenient to donate online. With a few clicks, an organization of your choice can receive your donation or money from a sponsoring advertiser. For example, if you are interested in helping rescue unwanted and abandoned animals, you can go to www.theanimalres cuesite.com. 3 When you click as instructed, a sponsoring advertiser will make a donation to help provide food and care for the 27 million animals in shelters. Also, a portion of any money you spend in

4 Enough examples to get the point across to the reader

the site's online store will go to providing animal care. 2 If you want to help fight world hunger, go to www.thehungersite.com 3 and click daily to have sponsor fees directed to hungry people in more than seventy countries via the Mercy Corps, Feeding America, and Millennium Promise. Each year, hundreds of millions of cups of food are distributed to one billion hungry people around the world. 2 Other examples of click-to-give sites are www.thechildhealthsite.com, www .theliteracysite.com, and www.breastcancersite.com. 3 Like the animal-rescue and hunger sites, these other sites have click-to-give links, online stores that direct a percentage of sales income to charity, and links to help you learn about causes you are interested in. One hundred percent of the sponsors' donations go to the charities, and you can give with a click every single day. Since I have found out about these sites, I go to at least one of them every day. 1 I have learned a lot about various problems, and every day, I feel as if I have helped a little.

TEACHING TIP This photograph shows part of artist Honey Lazar's "Keeping Track," which in her words is "a series of objects about remembering." As Lazar notes, "Looking at mementoes of our history tells a part of our story." Ask students about objects they have held onto for a long time. Why did they decide to keep these things?

Chapter 9 • Illustration

WRITER AT WORK

KAREN UPRIGHT: I am a computer scientist, but my writing has to be good.

(See Karen Upright's **PROFILE OF SUCCESS** on p. 140.)

IDEA JOURNAL Give some examples of things that annoy you.

TEACHING TIP Tell students that with illustration, examples often come to mind before the main point does. For example, they might have several bad meals at the cafeteria before realizing that the cafeteria has a qualitycontrol problem; then, write an e-mail or a memo listing examples and summing up the problem.

TIP Sometimes, the same main point can be used for a paragraph and an essay, essay must develop nore detail.

It is hard to explain anything without using examples, so you use illustration in almost every communication situation.

An exam question asks you to explain and give COLLEGE

examples of a concept.

Your boss asks you to tell her what office equipment WORK

needs to be replaced and why.

You complain to your landlord that the building **EVERYDAY** LIFE

superintendent is not doing his job. The landlord asks

for examples.

In college, the words illustration and illustrate may not appear in writing assignments. Instead, you might be asked to give examples of _____ or to be specific about _____. Regardless of an assignment's wording, to be clear and effective, most types of writing require specific examples. Include them whenever they help you make your point.

Main Point in Illustration

In illustration, the **main point** is the message you want your readers to receive and understand. To help you discover your main point, complete the following sentence:

What I want readers to know about this topic is ... MAIN POINT IN **ILLUSTRATION**

The topic sentence (in a paragraph) or thesis statement (in an essay) usually includes the topic and the main point the writer wants to make about the topic. Let's look at a topic sentence first.

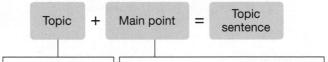

Home health aides provide vital services to the elderly.

Remember that a thesis statement for an essay can be a little broader than a paragraph topic.

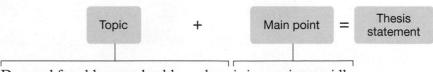

Demand for elder-care health workers is increasing rapidly.

Whereas the topic sentence is focused on just home health aides, the thesis statement considers elder-care careers in general.

PRACTICE 1 Making a Main Point

Each of the items in this practice is a narrowed topic. Think about each of them, and in the space provided, write a main point about each topic.

Support in Illustration

The paragraph and essay models on pages 136–37 use the topic sentence (paragraph) and thesis statement (essay) from the Main Point section of this chapter. Both models include the **support** used in all illustration writing: examples backed up by details about the examples. In the essay model, however, the major support points (examples) are topic sentences for individual paragraphs.

To generate good detailed examples, use one or more of the prewriting techniques discussed in Chapter 3. First, write down all the examples that come into your mind. Then, review your examples, and choose the ones that will best communicate your point to your readers.

PRACTICE 2 Supporting Your Main Point with Examples

Read the following main points, and give three examples you might use to support each one.

EXAMPLE:	My boss's cheapness is unprofessional.	
	makes us bring in our own calculators	
	makes us use old, rusted paper clips	
	will not replace burned-out lightbulbs	3 23

1.	My (friend, sister, brother, husband, wife—choose one) has some
	admirable traits.
	Answers will vary.

PARAGRAPHS VS. ESSAYS IN ILLUSTRATION

For more on the important features of narration, see the Four Basics of Good Illustration on page 132.

Paragraph Form

Topic sentence

Support 1 (first example)

Support 2 (second example)

Support 3 (third example)

Concluding sentence

Home health aides provide vital services to the elderly. First, they see to their clients' nutritional and personal-care needs. For instance, they often shop for and prepare meals, following any dietary restrictions clients may have. In addition, they may help clients get in and out of bed, bathe, dress, and accomplish other grooming tasks. Second, home health aides may assist with medical care. For example, they may check clients' vital signs and report any problems to the hospital or to a case manager. Specially trained aides may oversee the operation of medical equipment, such as ventilators; provide therapeutic massage; or assist with physical therapy. Most important, they provide companionship and emotional support. The simple presence of a home health aide is a comfort to clients, but aides who take the time to read to or have conversations with clients are especially valued. Additionally, health aides provide an important link between patients and their families, keeping relatives up to date about the patients' status and about any special needs that may arise. Aside from supplying key information, these updates let family members know that their loved one is in good hands. The bottom line is that for those who are interested in both the personal and the technical sides of health care, a job as a home health aide can be a good start.

Main Point: Often, narrower for a paragraph than for an essay: While the topic sentence (paragraph) is focused on just home health aides, the thesis statement (essay) considers elder-care careers in general.

Examples Supporting the Main Point

Details about the Examples: Usually, 1 to 3 sentences per example for paragraphs and 3 to 8 sentences per example for essays.

Conclusion

Think Critically As You Write Illustration

ASK YOURSELF

- Is each of my current examples clearly related to the main point?
- If my paragraph or essay feels "thin," might I find relevant new examples to enrich it? (For more on generating ideas, see pp. 46–49.)

1

During these difficult economic times, many students are looking to pursue careers in expanding fields with good long-term prospects. On **Thesis statement** should seriously consider is elder care. Because the U.S. population is aging, demand for workers who specialize in the health of the elderly is increasing rapidly.

One set of workers in great demand consists of physical therapists, who help elderly patients improve their mobility and retain their independence. Some of these therapists are based at hospi Topic sentence 1 (first example) facilities, others at clinics or private offi of where they work, they provide a variety of services to elderly patients, from helping stroke sufferers relearn how to walk and perform other daily activities to showing others how to live a more active life. Physical therapists can also help patients injured in falls reduce their reliance on painkillers, which can become less effective over time and in certain cases even addictive. According to the U.S. Department of Labor, employment of physical therapists will grow by 30 percent over the next ten years, largely because of the increasing number of elderly Americans.

2

Also in demand are nutritionists who specialize in older people's dietary needs. These p may plan meals and provide nutrition hospitals, nursing homes, and other institutions, or they may counsel individual patients on how to eat more healthfully or on how to prepare meals that meet certain dietary restrictions. For instance, elderly patients suffering from heart disease may need to cat foods that are low in salt and saturated fat. Other patients might have to avoid foods that interfere with the absorption of certain medications. Although the market for nutritionists is not expected to grow as quickly as that for physical therapists, it is projected to increase the population continues to age.

The highest-demand workers are those who provide at-home health care to the elderly. One subset of these workers consists of home nurses, who often provide follow-up care after patients are released from a hospital or other medical facility. These nurses help patients transition from an institutional setting while making sure they continue to receive high-quality care. For instance,

3

they track patients' vital signs, administer and monitor medications, and carry out specific tasks required to manage particular diseases. Another subset of home health workers is made up of home health aides, who assist nurses and other professionals with medical care, see to clients' nutritional and personal-care needs, and provide companionship and emotional support. Both home health aides and nurses provide an important link between patients and their families, keeping relatives up to date about the patients' status and about any special needs that may arise. In addition to supplying key information, these updates let family members know that their loved one is in good hands. Because of home health care workers' vital role in serving the expanding elderly population, their employment is expected to grow significantly: on average, 30 to 40 percent over Concluding paragraph ten years.

Given the growing demand for elder-care workers, people pursuing these professions stand an excellent chance of getting jobs with good long-term outlooks. Based on what I have learned about these professions, the

4

best candidates are those who have a strong interest in health or medicine, a willingness to work hard to get the necessary qualifications, and, perhaps most important, an ability to connect with and truly care for others.

ESL Tell students that if they are writing about something from their native country's culture, they have to think about what their readers may not be familiar with. They may need to give more details than they would need to provide for readers from their native culture.

developing?

PRA	ACTICE 3 Giving Details about the Examples
The	ne spaces provided, copy your main points and examples from Practice 2. n, for each example, write a detail that further shows, explains, or proves t you mean.
	EXAMPLE:
	Main point: My boss's cheapness is unprofessional.
	Example: makes us bring in our own calculators
	Detail: Some people do not have a calculator.
	Example: makes us use old, rusted paper clips
	Detail: They leave rust marks on important documents.
	Example: will not replace burned-out lightbulbs
	Detail: The dim light leads to more errors.
1.	Main point: Answers will vary.
	Example: Answers will vary.
	Detail: Answers will vary.
	Example:
	Detail:
	Example:
	Detail:
2.	Main point:
	Example:
	Detail:
	Example:
	Detail:
	Example:
	Detail:

Organization in Illustration

Illustration often uses **order of importance**, saving the most powerful example for last. This strategy is used in the paragraph and essay models on pages 135–37. Or, if the examples are given according to when they happened, it might be organized by **time order**.

Transitions in illustration let readers know that you are introducing an example or moving from one example to another.

TIP For more on order of importance and time order, see pages 78 and 79.

Common Transitions in Illustration

also

finally

first, second, and so on

for instance

in addition

another

for example

for one thing/ for another the most/the least

one example/ another example

PRACTICE 4 Using Transitions in Illustration

Read the paragraph that follows, and fill in the blanks with transitions. Answers may vary. Possible answers are shown.

Greek myths include many heroes, such as the great warriors Achilles In addition _, the myths describe several monsters that One example of these frightening creatures tested the heroes' strength. was the Hydra, a water serpent with many heads. When a warrior cut off one of these heads, two or more would sprout up in its place. Another example of these mythical monsters was the Gorgons, three sisters who had snakes for hair. Any person who looked into the Gorgons' eyes would turn to The most _ terrifying monster was Cerberus, a three-headed dog with snapping jaws. He guarded the gates to the underworld, keeping the living from entering and the dead from leaving. Fortunately, some heroes' cleverness equaled the monsters' hideousness. Herakles discovered that by applying a torch to the wounds of the Hydra, he could prevent the creature from growing more heads. __ Orpheus, a famous mythical musician, soothed Cerberus by plucking the strings of a lyre. In this way, Orpheus got past the beast and entered the underworld, from which he hoped to rescue his wife.

Painting of Cerberus, by William Blake (1757-1827)

CRITICAL READING

- Preview
- Read
- Review

See pages 9-12.

READING SELECTIONS For further examples of and activities for illustration, see Chapter 40.

Read and Analyze Illustration

Reading examples of illustration will help you write your own. The first example in this section is a Profile of Success from the real world of business. In this profile, Karen Upright shows how she uses illustration to communicate with her colleagues at Procter & Gamble.

The second example is an illustration paragraph by a student, and the third example is an illustration essay by a professional writer. As you read these pieces, pay attention to the vocabulary, and answer the questions in the margin. They will help you read critically.

PROFILE OF SUCCESS

Karen Upright Systems Manager

Illustration in the Real World

Background I started college a couple of times but failed most of my courses, mainly because I did not go to class and was not motivated. I was not involved and did not have a particular reason to go to college. I enrolled at FCCJ and took classes irregularly—sometimes full-time, sometimes parttime. I did well in some of the classes and poorly in others.

During this time, I got a job at CityStreet, a global benefits provider, and I realized that I really liked business. I also realized that I would not go far without a college degree. So I decided to try college one more time. My first course then was English, and my teacher, Marian Beaman, was great. I did well in that course and from then on. From FCCJ, I went to Florida State

and Purdue University, where I have recently completed an M.B.A. Later, I wrote Professor Beaman to thank her for setting me on a good course; it changed my life.

I now have a great job with lots of potential for advancement.

Degrees/Colleges A.A., Florida Community College, Jacksonville; B.S., Florida State University; M.B.A., Purdue University

Employer Procter & Gamble

Writing at work I write many kinds of documents, like memos, work and development plans, and speeches for presentations. We have structured meetings at P&G, so before meetings we prepare and distribute talk sheets, which provide the necessary background for what will be discussed at the meeting. I write technical design documents with precision analyses of systems. I also write e-mail that is read by senior management. I always make sure that those e-mails are correct because I do not want the executives to be distracted by errors. If I make careless mistakes in writing, I will not get far in the company. I also write about human resources issues. Whenever you manage people, you have to be aware of issues and situations that might offend employees.

I was surprised by how much writing I do as an essential part of the job. I am a computer scientist, but my writing has to be good.

Karen's Illustration

The following memo is an example of the illustration that Karen writes as part of her job. It details the objectives of a workplace initiative to help women already employed by Procter & Gamble plan careers within the company.

From: Upright, Karen

Subject: Women's Network: Assignment Planning Matrix

As you know, we have an enrollment goal for 30 percent of our employees to be women, but we are currently at 20 percent. We need to grow our enrollment, but we also need to retain the women currently in the organization. Greg and I met a few weeks ago to determine how to improve assignment planning for the women in our organization. We agreed to use the Assignment Planning Matrix as a starting point. The matrix is a good career-planning tool, with a section on career interests, rated from "highly desirable" to "undesirable." It also contains a section on specific P&G career interests, with sections to describe aspects that make a particular choice desirable or undesirable and a place to give weight to the various career choices. Completing the matrix requires thought as to what course an individual wants to pursue and why. I have reviewed a sample with and provided training to the women in our organization. Each of them has been asked to complete the matrix, meet with her manager to align on content, and submit a final version to her manager. This information can be shared at the next Leadership Team meeting.

Vocabulary development

Underline the following words as you read Karen's memo.

retain: to keep matrix: a grid or table aspects: parts of align: to be in line or parallel

(in this case, to agree)

objectives: goals

This initiative has several objectives:

- Have each member of the network start a long-term plan for her career.
- Use the long-term plan to develop a short-term plan for assignments and competency development.
- Share this information in written form with the immediate manager and section manager of each member of the network, enabling the manager to speak for each woman's career interests and providing a reference point for each member's career goals.
- Enable the Leadership Team to plan assignments within the organization for each member of the network, matching individual goals and interests to organizational goals and needs.

I encourage you to support the women on your teams as they work through the Assignment Planning Matrix over the next few weeks. Please let me know if you have any questions.

- 1. Double-underline the main point of the memo.
- 2. Karen gives examples about two topics. What are the two topics? the Assignment Planning Matrix and the objectives
- 3. What is the purpose of the memo? Answers will vary but should say to describe what action is being taken to meet a goal and what Karen thinks the action will achieve.

Student Illustration Paragraph

Casandra Palmer

Gifts from the Heart

PREDICT After reading the title, what do you think the paragraph will be about?

Casandra Palmer graduated from the University of Akron/Wayne College in 2009. After completing her essay "Gifts from the Heart," Casandra went on to seek publication in her campus paper at the encouragement of her instructor. She spent a few days revising the essay and looked to feedback from others to help strengthen the clarity of her points. With plans to continue writing for publication when time allows, Casandra enjoys reading inspirational novels and offers this advice to other student writers: "Learn all you can and never give up. Follow your dreams!"

In our home, gift exchanges have always been meaningful items to us. We do not just give things so that everyone has lots of presents. Each item has a purpose, such as a need or something that someone has desired for a long time. Some things have been given that may have made the other person laugh or cry. I remember one Christmas, our daughter Hannah had her boyfriend, who looked a lot like Harry Potter, join us. We wanted to include him, but we did not know him well, so it was hard to know what to give him. We decided to get Hannah a Harry Potter poster and crossed out the name Harry Potter. In place of Harry Potter, we put her boyfriend's name. Everyone thought it was funny, and we were all laughing, including Hannah's boyfriend. It was a personal gift that he knew we had thought about. For some reason, Hannah did not think it was so funny, but she will still remember it. [Another] meaningful gift came from watching the movie Titanic with my other daughter, Tabitha. We both cried hard and hugged each other. She surprised me by getting a necklace that resembled the gem known as "Heart of the Ocean." I was so touched that she gave me something to remind me of the experience we shared. These special moments have left lasting impressions on my heart.

REFLECT Have you ever received a gift that made you laugh or cry?

- 1. Double-underline the topic sentence.
- 2. Underline the examples that support the main point.
- 3. Circle the transitions.
- 4. Does the paragraph have the Four Basics of Good Illustration (p. 132)? Why or why not? Answers will vary but might say that the writer could have said more about Hannah's reaction or about what the necklace looked like.
- 5. Does the paragraph use a particular kind of organization, like time, space, or importance? Does that choice help the paragraph's effectiveness or not? No. The paragraph might have been more effective if the examples had been presented in order of increasing importance.

Vocabulary development

Underline these words as you read the illustration essay.

dovetailed: matched swimmingly: smoothly; well perfunctory: quick studiously: thoroughly; carefully

woefully: seriously; regrettably

tracheotomy: a cut made into the throat to open a blocked airway

grueling: difficult; tiring Maserati: a fast Italian sports car

Bentley: a British luxury car known more for elegance than speed

Professional Illustration Essay

Susan Adams

The Weirdest Job Interview Questions and How to Handle Them

Susan Adams is a senior editor at Forbes, a major publisher of business news. Since joining Forbes in 1995, Adams has written about a wide variety of subjects, including the art and auction market. Previously, she was a reporter for the *MacNeil/Lehrer NewsHour*. Adams holds a B.A. from Brown University and a J.D. from Yale University Law School.

Every week, Adams writes an advice column for Forbes .com, and the following is one of those columns. In it, she gives examples of some of the stranger questions that come up in job interviews.

PREDICT Think of one weird question that might be asked in a job interview.

I once interviewed for a job with a documentary producer who made boring if well-meaning films for public TV. By way of preparation, I studied up on the producer's projects and gave a lot of thought to how my interests and experience dovetailed with his. Our chat went swimmingly until he asked me a question that caught me completely off guard: "Who is your favorite comedian?"

Wait a second, I thought. Comedy is the opposite of what this guy 2 does. My mind did back flips while I desperately searched for a comedian who might be a favorite of a tweedy, bearded liberal Democrat. After maybe 30 seconds too long, I blurted out my personal favorite: David Alan Grier, an African-American funnyman on the weekly Fox TV show *In Living Color*. My potential boss looked at me blankly as I babbled about how much I liked Grier's characters, especially Antoine Merriweather, one of the two gay reviewers in the brilliantly hilarious sketch "Men on Film."

Wrong answer. I had derailed the interview. My potential employer 3 asked me a few more perfunctory questions and then saw me to the door.

We all prepare studiously for job interviews, doing our homework 4 about our potential employers and compiling short but detailed stories to illustrate our accomplishments, but how in the world do we prep for an off-the-wall interview question?

Glassdoor.com, a three-year-old Sausalito, California, Web site that 5 bills itself as "the TripAdvisor for careers," has compiled a list of "top oddball interview questions" for two years running. Glassdoor gets its information directly from employees who work at 120,000 companies.

Crazy as it sounds, an interviewer at Schlumberger, the giant Houston 6 REFLECT Pick one of the oilfield services provider, once asked some poor job applicant, "What was your best MacGyver moment?," referring to a 1980s action-adventure TV show. At Goldman Sachs, the question was, "If you were shrunk to the size of a pencil and put in a blender, how would you get out?" At Deloitte, "How many ridges [are there] around a quarter?" At AT&T, "If you were a superhero, which superhero would you be?" And at Boston Consulting: "How many hair salons are there in Japan?"

questions in this paragraph. How would you answer it?

No matter where you apply for work, there is a chance you could 7 get a question from left field. According to Rusty Rueff-a consultant at Glassdoor who is the author of Talent Force: A New Manifesto for the Human Side of Business and former head of human resources at PepsiCo and Electronic Arts-most job applicants are woefully unprepared for off-the-wall questions. "Ninety percent of people don't know how to deal with them," he says. Like me, they freeze and their minds go blank.

To deal with that, Rueff advises, first you have to realize that the interviewer isn't trying to make you look stupid, as stupid as the question may seem. For instance, the MacGyver question is meant as an invitation to talk about how you got out of a tough jam. "They're not looking for you to tell about the time you took out your ballpoint and did a tracheotomy," Rueff notes. Rather, you can probably extract an answer from one of the achievement stories you prepared in advance.

With a question like "How many hair salons are there in Japan," the interviewer is giving you an opportunity to demonstrate your thought processes. Rueff says you should think out loud, like the contestants on Who Wants to Be a Millionaire? You might start by saying, We'd have to know the population of Japan, and then we'd have to figure out what percentage of them get their hair done and how often. Rueff says it's fine to pull out a pen and paper and start doing some calculations right there in the interview.

Connie Thanasoulis-Cerrachio, a career services consultant at Vault 10 .com, agrees with Rueff. "These are called case interview questions," she says. Another example, which may seem equally impossible to answer: Why are manhole covers round?

In fact the manhole cover question, and "How would you move 11 Mt. Fuji?," were brought to light in a 2003 book, How Would You Move Mount Fuji? Microsoft's Cult of the Puzzle: How the World's Smartest Company Selects the Most Creative Thinkers. Microsoft's grueling interview process often includes such problem-solving and logic questions. Just start thinking through the question, out loud, Thanasoulis-Cerrachio advises. "I would say, a round manhole cover could keep the framework of the

tunnel stronger, because a round frame is much stronger than a square frame," she suggests. In fact, there are several reasons, including the fact that a round lid can't fall into the hole the way a square one can and the fact that it can be rolled.

Business schools teach students how to deal with case interview questions, and Vault has even put out a book on the subject, *Vault Guide to the Case Interview*.

Other weird-seeming questions, like "If you were a brick in a wall, which brick would you be and why," or "If you could be any animal, what would you be and why," are really just invitations to show a side of your personality. Thanasoulis-Cerrachio says a friend who is chief executive of a market research company used to ask applicants what kind of car they would be. "She wanted someone fast, who thought quickly," Thanasoulis-Cerrachio says. "She wanted someone who wanted to be a Maserati, not a Bentley." For the brick question, Thanasoulis-Cerrachio advises saying something like, "I would want to be a foundational brick because I'm a solid person. You can build on my experience and I will never let you down."

According to Rueff and Thanasoulis-Cerrachio, my comedian question was also a behavioral question, a test of my personality. "You gave a fine answer," says Rueff. Maybe. But I didn't get the job.

- 1. In your own words, state Adams's main point. Answers will vary.

 Possible answers: Weird interview questions have a purpose. You

 can give good answers to weird interview questions if you think and
 respond carefully.
- **2.** Underline the examples of weird interview questions.
- **3.** Circle the **transitional words** in paragraph 8. Can you find more places to add transitions? Answers will vary.
- **4.** What do you think of this essay? Do you have a better understanding of how to answer strange questions in job interviews? Answers will vary.

Respond to one of the following assignments in a paragraph or essay.

1. Write about your own experiences with job interviews, giving examples of anything you found challenging—the stress of preparing for the interview, questions or awkward moments during the interview, and so on. If you were able to address these challenges in any way, explain how. (If you have not had many job interviews, write about the experiences of a friend or relative.)

EVALUATE Based on Adams's observations, do you think weird interview questions are a good idea or a bad idea?

TIP For reading advice, see Chapter 1.

- 2. Adams discusses how unusual interview questions can provide useful information. Come up with at least three odd interview questions, and explain how each one would provide an employer with helpful information.
- 3. In your opinion, what professions would have the strangest interview questions? Write about the questions that employers in these professions might ask, and give examples of answers that would help interviewees get the job. (To get some ideas, you might investigate different professions on the Internet.)

Write Your Own Illustration

In this section, you will write your own illustration based on one of the following assignments. For help, refer to the How to Write Illustration checklist on page 150.

ASSIGNMENT OPTIONS Writing about College, Work, and Everyday Life

Write an illustration paragraph, essay, or other document (as described below) on one of the following topics or on one of your own choice. If you responded to the idea journal prompt on page 134, you might develop that writing further.

COLLEGE

- Describe your goals for this course, making sure to explain the benefits of achieving each goal.
- If you are still deciding on a degree program or major, identify at least two areas of study that interest you. To get some ideas, you might refer to a course catalog. Also, consider visiting a counselor at your college's guidance office or career center. The counselor might be able to recommend some study programs to you based on your goals and interests. Next, write about the areas of study that appeal to you the most, giving examples of what you would learn and explaining how each of your choices matches your goals and interests.
- Produce a one- or two-page newsletter for other students in your class on one of the following topics. Make sure to describe each club, opportunity, and event in enough detail for readers. Also, include contact information, as well as hours and locations for events and club meetings.
 - Student clubs
 - Volunteer opportunities
 - Upcoming campus events (such as lectures, movies, and sports events)
 - Upcoming events in the larger community

COMMUNITY

evelka rankins edits a weekly newsletter that lists events of interest to fellow students at her college. Getting more involved in college and community activities, as Evelka did, can help you feel more connected to others and can even improve the chances that you will stay in school.

For more on this story, ways to make community connections, and writing assignments, visit bedfordstmartins.com/realwriting.

WORK

- What is the best or worst job you have ever had? Give examples of what made it the best or worst job.
- Thinking like a television producer, find a category of jobs—such as "dirty jobs," the name of a popular cable show—that a TV audience would find strange and interesting. Then, give examples of jobs in the category. (Examples of professions covered in the show *Dirty Jobs* include maggot farming, camel ranching, and bologna making.) Give enough details about each job to make it clear why that job is unusual. To get some ideas, you might type "strange jobs" into a search engine.
- Think of the job you would most like to have after graduation. Then, write a list of your skills—both current ones and ones you will be building in college—that are relevant to the job. To identify skills you will be building through your degree program, you might refer to a course catalog. To identify relevant work skills, consider your past or present jobs as well as internships or other work experiences you would like to have before graduation. Finally, write a cover letter explaining why you are the best candidate for your ideal job. Be sure to provide several examples of your skills, referring to the list that you prepared.

TIP For sample cover letters and advice on writing these letters, visit bedfordstmartins.com/realwriting.

TEAMWORK Have students pair up and exchange drafts of their cover letters. Next, ask them to read each other's letters, paying special attention to the examples. They should mark any examples that are not clear or that could be developed in more detail.

EVERYDAY LIFE

- Write about stresses in your life or things that you like about your life. Give plenty of details for each example.
- Give examples of memories that have stayed with you for a long time. For each memory, provide enough details so that readers will be able to share your experience.
- Identify at least three public improvements you think would benefit a significant number of people in your community, such as the addition of sidewalks in residential areas to encourage exercise. These improvements should not include changes, such as the creation of a boat dock on a local lake, that would benefit only a small portion of the community. Then, in a letter to the editor of your local paper, describe each suggested improvement in detail, and explain why it would be an asset to the community.

ASSIGNMENT OPTIONS Reading and Writing Critically

Complete one of the following assignments, which ask you to apply the critical thinking, reading, and writing skills discussed in Chapter 1.

Writing Critically about Readings

Both Susan Adams's "The Weirdest Job Interview Questions and How to Handle Them" (p. 144) and Frances Cole Jones's "Don't Work in a Goat's Stomach" (p. 199) give advice in a humorous way. Read or review both of these pieces, and then follow these steps:

- 1. Summarize Briefly summarize the works, listing major examples.
- **2. Analyze** What questions do the essays raise for you? Are there any other issues you wish they had covered?
- **3. Synthesize** Using examples from both Adams's and Jones's essays and from your own experience, discuss how the right kind of advice can help people achieve success.
- **4. Evaluate** Which essay, Adams's or Jones's, do you think is more effective? Why? Does the writers' humor help get their points across? Why or why not? In writing your evaluation, you might look back on your responses to step 2.

Writing about Images

Study the photograph below, and complete the following steps.

- **1. Read the image** Ask yourself: What details does the photographer focus on? How do the colors and lights affect you as a viewer? What main impression does the picture make? (For more information on reading images, see Chapter 1.)
- **2. Write an illustration** The photograph shows a luxury liner whose bright, colorful lights attract onlookers and potential customers. Write an illustration paragraph or essay about businesses that draw customers with colorful displays, loud music, or some other appeal to the senses. Include the types of details you examined in step 1.

TIP For a reminder of how to summarize, analyze, synthesize, and evaluate, see the Reading and Writing Critically box on pages 16–17.

TEACHING TIP If time is short, students might complete just one or two steps of this assignment.

TEACHING TIP Students will notice that this photograph illustrates two different vacation options: a port-to-port voyage on a cruise ship and a camping trip in a recreational vehicle (RV). Ask students about the types of vacations they like the best. If any of them have ever traveled by cruise ship or RV, ask them to share some of their experiences, good or bad.

Writing to Solve a Problem

Read or review the discussion of problem solving in Chapter 1 (pp. 24–26). Then, consider the following problem.

Your college is increasing its tuition by \$500 next year, and you do not think that you can continue. You have done well so far, and you really want to get a college degree.

ASSIGNMENT: Rather than just giving up and dropping out next year, as many students do, working in a small group or on your own, make a list of resources you could consult to help you, and explain how they might help. You might want to start with the following sentence:

E	Before dropping out of	school for financial reasons,	students
si	hould consult	because	
	oaragraph: Name your be or office might help you	pest resource, and give example i.	s of how this
	essay: Name your three nelp you.	e best resources, and give exam	ples of how they
	•••••		

STEPS		DETAILS	
	Narrow and explore your topic. See Chapter 3.	Make the topic more specific.Prewrite to get ideas about the narrowed topic.	
	Write a topic sentence (paragraph) or thesis statement (essay). See Chapter 4.	State what you want your readers to understand about your topic.	
	Support your point. See Chapter 5.	 Come up with examples and details to show, explain, or prove your main point to readers. 	
	Write a draft. See Chapter 6.	 Make a plan that puts examples in a logical order. Include a topic sentence (paragraph) or thesis statement (essay) and all the supporting examples and details. 	
	Revise your draft. See Chapter 7.	 Make sure it has all the Four Basics of Good Illustration. Make sure you include transitions to move readers smoothly from one example to the next. 	
	Edit your revised draft. See Parts 4 through 7.	 Correct errors in grammar, spelling, word use, and punctuation. 	

Chapter Review

- 1. Illustration is writing that uses examples to show, explain, or prove a point.
- 2. What are the Four Basics of Good Illustration? It has a point. It gives specific examples that show, explain, or prove the point. It gives details to support the examples. It uses enough examples to get the point across to the reader.
- **3.** Write sentences using the following vocabulary words: retain, align, objectives, studiously, woefully, grueling. Answers will vary.

reflect Write for 2 minutes about what you have learned about writing illustration.

LEARNING JOURNAL

Reread your idea journal entry from page 134. Write another entry about the same topic, using what you have learned about illustration.

10

YOU KNOW THIS

You use description every day:

- You describe what someone looks like.
- You describe an item you want to buy.

write for 2 minutes about what you know about writing description.

Description

Writing That Creates Pictures in Words

Understand What Description Is

Description is writing that creates a clear and vivid impression of a person, place, or thing, often by appealing to the physical senses.

Four Basics of Good Description

- It creates a main impression—an overall effect, feeling, or image—about the topic.
- 2 It uses specific examples to support the main impression.
- It supports those examples with details that appeal to the five senses: sight, hearing, smell, taste, and touch.
- 4 It brings a person, place, or physical object to life for the reader.

In the following student paragraph, the numbers and colors correspond to the Four Basics of Good Description.

TEACHING TIP If you have done narration, point out to students that this description also uses narration.

Scars are stories written on a person's skin and sometimes on his heart. 1 My scar is not very big or very visible. 2 It is only about three inches long and an inch wide. It is on my knee, so it is usually covered, unseen. 3 It puckers the skin around it, and the texture of the scar itself is smoother than my real skin. It is flesh-colored, almost like a raggedy bandage. The story on my skin is a small one. 1 The story on my heart, though, is much deeper. 2 It was night, very cold, 3 my breath pluming into the frigid air. I took deep breaths that smelled like winter, piercing through my nasal passages and into my lungs as I walked to my

car. I saw a couple making out against the wall of a building I was nearing. 2 I smiled and thought about them making their own heat. 3 I thought I saw steam coming from them, but maybe I imagined that. As I got near, I heard a familiar giggle: my girlfriend's. Then I saw her scarlet scarf, one I had given her, along with soft red leather gloves. I turned and ran, before they could see me. There was loud pounding in my ears, from the inside, sounding and feeling as if my brain had just become the loudest bass I had ever heard. My head throbbed, and slipping on some ice, I crashed to the ground, landing on my hands and knees, ripping my pants. I knew my knee was bleeding, even in the dark. I didn't care: 4 That scar would heal. The other one would take a lot longer.

This photograph shows Pripyat, a town deserted after the 1986 explosion and fire at the nuclear power plant in Chernobyl, Ukraine. Since the disaster, vegetation and wildlife have taken over many sites once occupied by people.

Seeing Description

write Describe this photograph in detail. First, look at the image carefully. Then write ten words you want to use in your description.

Being able to describe something or someone accurately and in detail is important in many situations.

COLLEGE

On a physical therapy test, you describe the symptoms you observed in a patient.

WRITER AT WORK

CELIA HYDE: Writing descriptions helps solve crimes.

(See Celia Hyde's PROFILE OF SUCCESS on p. 161.)

WORK You write a memo to your boss describing how the

office could be arranged for increased efficiency.

EVERYDAY You describe something you lost to the lost-and-found

LIFE clerk at a store.

In college assignments, the word *describe* may mean *tell about* or *report*. When an assignment asks you to actually describe a person, place, or thing, however, you will need to use the kinds of specific descriptive details discussed later in this chapter.

Main Point in Description

In description, the **main point** is the main impression you want to create for your readers. To help you discover your main point, complete the following sentence:

What is most interesting, vivid, and important to me about this topic is . . .

If you do not have a main impression about your topic, think about how it smells, sounds, looks, tastes, or feels.

PRACTICE 1 Finding a Main Impression

For the following general topics, jot down four impressions that appeal to you, and circle the one you would use as a main impression. Base your choice on what is most interesting, vivid, and important to you.

EXAMPLE:

2.

3.

Topic: A vandalized car

Impressions: wrecked, smashed, damaged, battered

1. Topic: A movie-theater lobby

Impressions: Answers will vary.

Topic: A fireworks display

Impressions:

Topic: An elderly person

Impressions:

4. Topic: The room you are in

Impressions:

IDEA JOURNAL Describe what you are wearing.

The topic sentence (paragraph) or thesis statement (essay) in description usually contains both your narrowed topic and your main impression. Here is a topic sentence for a description paragraph:

Remember that a topic for an essay can be a little broader than one for a paragraph.

Whereas the topic sentence is focused on just one location and view, the thesis statement sets up descriptions of different views from different sites.

seen through an office window.

To be effective, your topic sentence or thesis statement should be specific. You can make it specific by adding details that appeal to the senses.

TIP Sometimes, the same main point can be used for a paragraph and an essay, but the essay must develop this point in more detail. (See pp. 69–70.)

PRACTICE 2 Writing a Statement of Your Main Impression

For three of the items from Practice 1, write the topic and your main impression. Then, write a statement of your main impression. Finally, revise the statement to make the main impression sharper and more specific.

EXAMPLE:

Statement:	The vandalized car on the side of the highway was
battered.	
	fic: The shell of a car on the side of the road was dented arently from a bat or club, and surrounded by broken

Topic/Main impression: Answers will vary.
Statement:
More specific:
Topic/Main impression:
Statement:
More specific:
Topic/Main impression:
Statement:
More specific:

TEAMWORK Put students in small groups, and give each group an object to describe using the questions in the text.

TIP For tools to build your vocabulary, visit the Student Site for Real Writing at bedfordstmartins.com/realwriting.

TIP When writing descriptions, consider this advice from writer Rhys Alexander: "Detail makes the difference between boring and terrific writing. It's the difference between a pencil sketch and a lush oil painting. As a writer, words are your paint. Use all the colors."

Support in Description

In description, **support** consists of the specific examples and details that help readers experience the sights, sounds, smells, tastes, and textures of your topic. Your description should get your main impression across to readers. Here are some qualities to consider.

SIGHT		SOUND	SMELL
Colors?		Loud/soft?	Sweet/sour?
Shapes?		Piercing/soothing?	Sharp/mild?
Sizes?		Continuous/off and	Good? (Like what?)
Patterns?		on?	Bad? (Rotten?)
Shiny/dull	•	Pleasant/unpleasant? (How?)	New? (New what?
Does it loo	k like		Leather? Plastic?)
anything	else?	Does it sound like	Old?
		anything else?	Does it smell like anything else?

TASTE	тоисн
Good? (What does "good"	Hard/soft?
taste like?)	Liquid/solid?
Bad? (What does "bad" taste	Rough/smooth?
like?)	Hot/cold?
Bitter/sugary? Metallic?	Dry/oily?
Burning? Spicy?	Textures?
Does it taste like anything else?	Does it feel like anything else?

The paragraph and essay models on pages 158-59 use the topic sentence (paragraph) and thesis statement (essay) from the Main Point section of this chapter. Both models include the support used in all descriptive writing—examples that communicate the writer's main impression, backed up by specific sensory details. In the essay model, however, the major support points (examples) are topic sentences for individual paragraphs.

PRACTICE 3 Finding Details to Support a Main Impression

Read the statements below, and write four sensory details you might use to support the main impression.

EXAMPLE:

The physical sensations of a day at the beach are as vivid as the visual ones.

- a. softness of the sand
- b. push and splash of waves
- c. chill of the water
- d. smoothness of worn stones and beach glass
- My favorite meal smells as good as it tastes.
 - Possible answers: sweetness of baked yams
 - b. sage in stuffing
 - buttery roasting turkey
 - d. apple pie with cinnamon
- The new office building has a contemporary look.
 - Possible answers: lots of glass
 - b. concrete
 - c. steel
 - d. tall
- A classroom during an exam echoes with the "sounds of silence."
 - Possible answers: people coughing
 - b. rustle of papers
 - c. radiator hissing
 - d. sounds of pens scratching paper

to think of a place that is important or memorable to them. Then, share with them this quotation from description usually consists of a few well-chosen details else." Finally, ask students which few well-chosen details would re-create their of those who have never been there.

TEACHING TIP Ask students Stephen King: "For me, good that will stand for everything important place in the minds

PARAGRAPHS VS. ESSAYS IN DESCRIPTION

For more on the important features of description, see the Four Basics of Good Description on page 152.

Paragraph Form

Topic sentence

Support 1 (first example)

Support 2 (second example)

Support 3 (third example)

Concluding

The view from the shore of Fisher Lake calms me every time I see it. Closest to the shore is the lake's smooth surface, blue by day and sparkling black at night. My favorite time to stand on the shore is midsummer at twilight, when I watch the water's blue darken and become more general, blotting out the day and all its troubles. I listen to waves lapping the dock and think my thoughts, or just let my mind clear. On nights with a bright moon, I stare out at the path of light across the water, losing track of time and sometimes even of myself. Farther out, on the opposite shore, a forest of pine trees reminds me of the cool shade I have enjoyed while hiking there. The pine smell is the first thing to trigger the memories. Evenings when there is still enough light, I look for the break in the trees where the main trail starts, thinking of the many times I have walked it. During the hottest, most trying summer of my life, the cool beauty of the trailside trees, ferns, and moss soothed my nerves and brought me back down to earth. Beyond the forest are rolling hills, soft gray in the morning and near dusk. The expression "old as the hills" comes to mind, and it feels like a just description, not an insult. The soft gray hulk of them makes me think of an ancient, huge, and eternally sleeping creaturesomething that predated me by millions of years and will outlive me for millions more. For some reason, I always find these thoughts comforting. And they are just one reason that standing

on the shore of Fisher Lake is better for me than any medicine.

Main Point: Often, narrower for a paragraph than for an essay: While the topic sentence (paragraph) is focused on just one location and view, the thesis statement (essay) sets up descriptions of different views from different sites.

Examples Supporting the Main Point (the Writer's Main Impression)

Details about the Examples: Usually, 1 to 3 sentences per example for paragraphs and 3 to 8 sentences per example for essays.

Conclusion

Think Critically As You Write Description

ASK YOURSELF

- Have I included enough examples and details to get across my main impression and to bring my subject to life?
- Do the examples and details appeal to more than one of the senses (sight, hearing, smell, taste, and touch)?

I have worked in many places, from a basement-level machine shop to a cubicle in a tenth-floor insurance office. Now that I am in the construction industry, I want to sing the praises of one employment b **Thesis statement** not get enough attention: The views from my sky-high welding jobs have been more stunning than any seen through an office window.

From a platform at my latest job, on a high-rise, the streets below look like scenes from a miniature village.

The cars and trucks—even the rushing p Topic sentence 1 (first example)

me of my nephews' motorized toys. { (first example)}

breeze carries up to me one of the few reminders that what I see is real: the smell of sausage or roasting chestnuts from street vendors, the honking of taxis or the scream of sirens, the dizzying clouds of diesel smoke.

Once, the streets below me were taken over for a fair, and during my lunch break, I sat on a beam and watched the scene below. I spotted the usual things—packs of people strolling by concession stands or game tents, and bands playing to crowds at different ends of the fair. As I finished my lunch, I saw two small flames near the edge

of one band stage, nothing burning, nothing to fear. It was, I soon realized, an acrobat carrying two torches.

I watched her climb high and walk a rope, juggling the torches as the crowd looked up and I looked torches as the crowd looked up

Even more impressive are the sights from an oil rig.

Two years ago, I worked on a rig in Prudhoe Bay, Alaska, right at the water's edge. In the long days of summer, I loved to watch the changing light in the sky and on the water: bright to darker blue as the hours passed, and at day's end, a dying gold. At the greatest heights I could see white dots of ships far out at sea, and looking inland, I might spot musk ox or bears roaming in the distance. In the long winter dark, we worked by spotlights, which blotted the views below. But I still remember one time near nightfall when the spotlights suddenly flashed off.

As my eyes adjusted, a crowd of caribou emerged below like ghosts. They snuffled the snow for foot to us.

Topic sentence 3 (third example)

To me, the most amazing views are those from bridges high over rivers. In 2006, I had the privilege of

3

briefly working on one of the tallest bridge-observatories in the world, over the Penobscot River in Maine. As many tourists now do, I reached the height of the observatory's top deck, 437 feet. Unlike them, however, my visits were routine and labor-intensive, giving me little time to appreciate the beauty all around me. But on clear days, during breaks and at the end of our shift, my coworkers and I would admire the wide, sapphire-colored river as it flowed to Penobscot Bay. Looking south, we would track the Maine coast's winding to the Camden Hills. Looking east, we would spot Acadia National Park, the famous Mount Desert Island offshore in the mist. Each sight made up a panoramic view that I will never forget.

Concluding paragraph

My line of work roots me in no one place, and it has a generous share of discomforts and dangers. But there are many reasons I would never trade it for another, and one of the biggest is the height from which it lets me see the world. For stretches of time, I feel nearly super human.

Organization in Description

TIP For more on these orders of organization, see pages 78–79.

Description can use any of the orders of organization—time, space, or importance—depending on your purpose. If you are writing to create a main impression of an event (for example, a description of fireworks), you might use time order. If you are describing what someone or something looks like, you might use space order, the strategy used in the paragraph model on page 158. If one detail about your topic is stronger than the others, you could use order of importance and leave that detail for last. This approach is taken in the essay model on page 159.

ORDER	SEQUENCE
Time	first to last/last to first, most recent to least recent/least recent to most recent
Space	top to bottom/bottom to top, right to left/left to right, near to far/far to near
Importance	end with detail that will make the strongest impression

Use **transitions** to move your readers from one sensory detail to the next. Usually, transitions should match your order of organization.

	sitions in Descr		
TIME			
as	finally	next	then
at last	first	now	when
before/after	last	second	while
during	later	since	
eventually	meanwhile	soon	
SPACE			
above	beneath	inside	over
across	beside	near	to the left/right
at the bottom/top	beyond	next to	to the side
behind	farther/further	on top of	under/underneath
below	in front of	opposite	where
IMPORTANCE			
especially	more/even r	nore	most vivid
in particular	most		strongest

PRACTICE 4 Using Transitions in Description

Read the paragraph that follows, and fill in the blanks with transitions.
Answers may vary. Possible answers are shown. I saw the kitchen at Morley's Place on my first day assisting the town
restaurant inspector, Morley's was empty of customers,
which made sense for 3 p.m. on a Tuesday. When my
boss and I saw the kitchen, we hoped the restaurant would stay empty.
Across from the kitchen entrance was the food-prep
counter, which was covered with a faint layer of grime. On top of
the counter were three food bins. As I aimed my
flashlight into one bin, numerous roaches scuttled away from the light.
Next to, Beside, To the left of, To the right of the counter, a
fan whirred loudly in an open window. Behind the stove,
we discovered a mouse trap holding a shriveled, long-dead mouse. Because
of the violations, the Health Department closed Morley's Place.

Read and Analyze Description

Reading examples of description will help you write your own. In the first example below, police chief Celia Hyde shows how she uses description in a crime scene report. The second example is a description paragraph by a student, and the third is a description essay by a professional writer. As you read, pay attention to the vocabulary, and answer the questions in the margin. They will help you read critically.

CRITICAL READING Preview Read Pause

See pages 9–12.

PROFILE OF SUCCESS

Description in the Real World

Background When I graduated from high school, I was not interested in academics. I took some courses at a community college but then dropped out to travel. After traveling and trying several different colleges, I returned home. The police chief in town was a family friend and encouraged me to think about law enforcement. I entered that field and have been there since.

Colleges Greenfield Community College, Mt. Wachusett Community College, Fort Lauderdale Community College

Employer Town of Bolton, Massachusetts

Celia Hyde Chief of Police

RESOURCES For a discussion of how to use the profiles in Part 2, see *Practical Suggestions*.

Writing at work As chief of police, I do many kinds of writing: policies and procedures for the officers to follow; responses to attorneys' requests for information; letters, reports, and budgets; interviews with witnesses; statements from victims and criminals; accident reports. In all of the writing I do, detail, clarity, and precision are essential. I have to choose my words carefully to avoid any confusion or misunderstanding.

How Celia uses description When I am called to a crime scene, I have to write a report that describes the scene precisely and in detail.

Celia's Description

The following report is one example of the descriptive reports Celia writes.

Report, breaking and entering scene Response to burglar alarm, 17:00 hours

The house at 123 Main Street is situated off the road with a <u>long</u>, narrow driveway and no visible neighbors. The dense fir trees along the drive block natural light, though it was almost dusk and getting dark. There was snow on the driveway from a recent storm. I observed one set of fresh tire marks entering the driveway and a set of footprints exiting it.

The homeowner, Mr. Smith, had been awakened by the <u>sounds of smashing glass</u> and the squeaking of the door as it opened. He felt a cold draft from the stairway and heard a soft shuffle of feet crossing the dining <u>room</u>. Smith descended the stairs to investigate and was met at the bottom by the intruder, who shoved him against the wall and ran out the front door.

While awaiting backup, I obtained a description of the intruder from Mr. Smith. The subject was a white male, approximately 25–30 years of age and 5'9"–5'11" in height. He had jet-black hair of medium length, and it was worn slicked back from his forehead. He wore a salt-and-pepper, closely shaved beard and had a birthmark on his neck the size of a dime. The subject was wearing a black nylon jacket with some logo on it in large white letters, a blue plaid shirt, and blue jeans.

READING SELECTIONS For further examples of and activities for description, see Chapter 41.

- 1. What is your main impression of the scene and of the intruder? <u>a dark</u>, isolated crime scene/an ordinary-looking man
- 2. Underline the details that support the main impression.
- 3. What senses do the details appeal to? sight, hearing, touch
- 4. How is the description organized? time order

Student Description Paragraph

Alessandra Cepeda

Bird Rescue

Alessandra Cepeda became deeply involved in animal welfare during her time at Bunker Hill Community College (BHCC), from which she received associate's degrees in education and early childhood education. While at BHCC, Cepeda assisted the Humane Society with animal-rescue efforts, and she also helped the Phi Beta Kappa organization become more involved in animal welfare.

In the following paragraph, Cepeda describes the scene at a storage unit containing abandoned birds. One of those birds was Samantha, shown in the photo with Cepeda.

When the owner opened the empty storage unit, we could not believe that any living creature could have survived under such horrible conditions. The inside was complete darkness, with no windows and no ventilation. The air hit us with the smell of rot and decay. A flashlight revealed three birds, quiet and huddled in the back corner. They were quivering and looked sickly. Two of the birds had injured wings, hanging from them uselessly at odd angles, obviously broken. They were exotic birds who should have had bright and colorful feathers, but the floor of the unit was covered in the feathers they had molted. We entered slowly and retrieved the abused birds. I cried at how such beautiful and helpless creatures had been mistreated. We adopted two of them, and our Samantha is now eight years old, with beautiful green feathers topped off with a brilliant blue and red head. She talks, flies, and is a wonderful pet who is dearly loved and, I admit, very spoiled. She deserves it after such a rough start to her life.

- **1.** Double-underline the **topic sentence**.
- 2. What main impression does the writer create? Answers will vary.

 Possible answer: that the storage unit was a cruel and messy place
 unfit for the birds
- **3.** Underline the **sensory details** (sight, sound, smell, taste, texture) that create the main impression.
- 4. Does the paragraph have the Four Basics of Good Description (p. 152)? Why or why not? Yes. Specific answers will vary, but students should be able to give examples of the four Basics.

Good phrsses?

What else could be added?

Storage unit (spilus ?)

Polted technology

Sing + poul-

Vocabulary development

Underline these words as you read the description essay.

circa: [taken] around

aloft: high

trestles: support structures tenement houses: apartment buildings, often crowded and in poor shape

girded: reinforced burlesque houses: theaters

that offer live, often humorous performances and/or striptease acts palatial: palace-like

paratial: parace-like perilous: dangerous nary: not even stint: brief job toque: hat

to the hilt: [dressed] in the fanciest clothing nostalgia: a longing for something from the past connotation: meaning or

association

inaccessible divinity: unreachable god

PREDICT Why might snow be significant to the author's father and godfather?

Professional Description Essay

Oscar Hijuelos

Memories of New York City Snow

Oscar Hijuelos, the son of Cuban immigrants, was born in New York City in 1951. After receiving undergraduate and master's degrees from the City University of New York, he took a job at an advertising firm and wrote fiction at night. Since then, he has published numerous novels. His first, *The Mambo Kings Play Songs of Love* (1989), was awarded the Pulitzer Prize for fiction, making Hijuelos the first Hispanic writer to receive this honor. His most recent novels include *A Simple Habana Melody* (2002), *Dark Dude* (2008), and *Beautiful Maria of My Soul* (2010). Hijuelos has also published a memoir, *Thoughts Without Cigarettes* (2011).

The following essay was taken from the anthology *Metropolis Found* (2003). In it, Hijuelos describes a New York City winter from the perspective of new immigrants, noting the emotions that the season inspired in them.

York City from the much warmer climate of Cuba in the mid-1940s, the very existence of snow was a source of fascination. A black-and-white photograph that I have always loved, circa 1948, its surface cracked like that of a thawing ice-covered pond, features my father, Pascual, and my godfather, Horacio, fresh up from **Oriente Province**, posing in a snow-covered meadow in Central Park. Decked out in long coats, scarves, and black-rimmed hats, they are holding, in their be-gloved hands, a huge chunk of hardened snow. Trees and their straggly witch's hair branches, glimmering with ice and frost, recede into the distance behind them. They stand on a field of whiteness, the two men seemingly afloat in midair, as if they were being held aloft by the magical substance itself.

That they bothered to have this photograph taken—I suppose to send back to family in Cuba—has always been a source of enchantment for me. That something so common to winters in New York would strike them as an object of exotic admiration has always spoken volumes about the newness—and innocence—of their immigrants' experience. How thrilling it all must have seemed to them, for their New York was so very different from the small town surrounded by farms in eastern Cuba that they hailed from. Their New York was a fanciful and bustling city of endless sidewalks and unimaginably high buildings; of great bridges and twisting outdoor elevated train trestles; of walkup tenement houses

1. Oriente Province: a former province of Cuba, in the eastern part of the country

with mysteriously dark basements, and subways that burrowed through an underworld of girded tunnels; of dancehalls, burlesque houses, and palatial department stores with their complement of Christmas Salvation Army Santa Clauses on every street corner. Delightful and perilous, their New York was a city of incredibly loud noises, of police and air raid sirens and factory whistles and subway rumble; a city where people sometimes shushed you for speaking Spanish in a public place, or could be unforgiving if you did not speak English well or seemed to be of a different ethnic background. (My father was once nearly hit by a garbage can that had been thrown off the rooftop of a building as he was walking along La Salle Street in upper Manhattan.)

Even so, New York represented the future. The city meant jobs and 3 money. Newly arrived, an aunt of mine went to work for Pan Am; another aunt, as a Macy's saleslady. My own mother, speaking nary a word of English, did a stint in the garment district as a seamstress. During the war some family friends, like my godfather, were eventually drafted, while others ended up as factory laborers. Landing a job at the Biltmore Men's Bar, my father joined the hotel and restaurant workers' union, paid his first weekly dues, and came home one day with a brand new white chef's toque in hand. Just about everybody found work, often for low pay and ridiculously long hours. And while the men of that generation worked a lot of overtime, or a second job, they always had their day or two off. Dressed to the hilt, they'd leave their uptown neighborhoods and make an excursion to another part of the city—perhaps to one of the grand movie palaces of Times Square or to beautiful Central Park, as my father and godfather, and their ladies, had once done, in the aftermath of a snowfall.

Snow, such as it can only fall in New York City, was not just about 4 REFLECT What types of the cold and wintry differences that mark the weather of the north. It was about a purity that would descend upon the grayness of its streets like a heaven of silence, the city's complexity and bustle abruptly subdued. But as beautiful as it could be, it was also something that provoked nostalgia; I am certain that my father would miss Cuba on some bitterly cold days. I remember that whenever we were out on a walk and it began to snow, my father would stop and look up at the sky, with wonderment—what he was seeing I don't know. Perhaps that's why to this day my own associations with a New York City snowfall have a mystical connotation, as if the presence of snow really meant that some kind of inaccessible divinity had settled his breath upon us.

- Double-underline the thesis statement. 1.
- 2. Underline the sensory details (sight, sound, smell, taste, texture).

REFLECT What main impression do these descriptions of the city create?

weather do you associate with particular feelings or moods?

> TIP For reading advice, see Chapter 1.

- 3. Circle the transitions.
- **4.** Does the essay create a clear picture of New York City in the winter? Why or why not? Answers will vary.

Respond to one of the following assignments in a paragraph or essay.

- **1.** Describe a place that is important to you or associated with significant memories. It might be a city, a favorite park, a friend's or relative's home, or a vacation spot.
- **2.** Describe an outdoor scene from your favorite season. You might work from a personal photograph taken during that season.
- **3.** Describe a person who has played a major role in your life. Try to include sensory details that go beyond the person's appearance. For instance, you might describe the sight of his or her usual surroundings, the sound of his or her voice, or the texture of a favorite piece of clothing.

Write Your Own Description

In this section, you will write your own description based on one of the following assignments. For help, refer to the How to Write Description checklist on page 169.

ESL Have students describe a famous place or popular meal in their native

countries.

ASSIGNMENT OPTIONS Writing about College, Work, and Everyday Life

Write a description paragraph or essay on one of the following topics or on one of your own choice. If you responded to the idea journal prompt on page 154, you might develop that writing further.

COLLEGE

- Describe the sights, sounds, smells, and tastes in the cafeteria or another dining spot on campus.
- Find a place where you can get a good view of your campus (for instance, a window on an upper floor of one of the buildings). Then, describe the scene using space order (p. 160).
- Think back on a place or scene on campus that has made a strong sensory impression on you. Then, describe the place or scene with specific examples and details, and explain why it made such an impression on you.

WORK

- Describe your workplace, including as many sensory details as you can.
- Describe your boss or a colleague you work with closely. First, think of the main impression you get from this person. Then, choose details that would make your impression clear to readers.

■ Take a quick look at Frances Cole Jones's "Don't Work in a Goat's Stomach" (p. 199). Have you ever worked with anyone who creates the kind of messes she discusses? If so, describe the person's work space and/or messes in detail.

EVERYDAY LIFE

- Describe a favorite photograph, using as many details as possible. For a good example of a photograph description, see the first paragraph of Oscar Hijuelos's essay (p. 164).
- Describe a holiday celebration from your past, including as many sensory details as possible. Think back on the people who attended, the food served, the decorations, and so on.
- Visit an organization that serves your community, such as an animal shelter or a food pantry. During your visit, take notes about what you see. Later, write a detailed description of the scene.

ASSIGNMENT OPTIONS Reading and Writing Critically

Complete one of the following assignments, which ask you to apply the critical thinking, reading, and writing skills discussed in Chapter 1.

Writing Critically about Readings

Both Oscar Hijuelos's "Memories of New York City Snow" (p. 164) and Amy Tan's "Fish Cheeks" (p. 126) describe scenes from the past. Read or review both of these pieces, and then follow these steps:

- **1. Summarize** Briefly summarize the works, listing major examples and details.
- **2. Analyze** Tan uses humor to make her point, whereas Hijuelos's essay is more serious. Why do you think the authors might have chosen these different approaches?
- **3. Synthesize** Using examples from both Tan's and Hijuelos's essays and from your own experience, discuss the types of details that make certain things in our lives (such as an event or a photograph) so memorable.
- **4. Evaluate** Which essay, Tan's or Hijuelos's, do you think is more effective? Why? In writing your evaluation, you might look back on your responses to step 2.

Writing about Images

Study the photograph on page 168, and complete the following steps.

1. Read the image Ask yourself: What part of the photograph draws your attention the most, and why? What main impression does the picture create, and what details contribute to this impression? (For more information on reading images, see Chapter 1.)

COMMUNITY CONNECTIONS

ALESSANDRA CEPEDA

(see the paragraph on p. 163) assisted with animal-rescue efforts while she was in college. Getting more involved in college and community activities, as Alessandra did, can help you feel more connected to others and can even improve the chances that you will stay in school.

For more on this story, ways to make community connections, and writing assignments, visit bedfordstmartins.com/realwriting.

TIP For a reminder of how to summarize, analyze, synthesize, and evaluate, see the Reading and Writing Critically box on pages 16–17. **2. Write a description** Write a paragraph or essay that describes the photograph and explains the main impression it gives. Include the details and reactions from step 1.

TEACHING TIP News photographs can make good subjects for descriptions. Ask students to choose and describe a photograph from a print or online news source.

Writing to Solve a Problem

Read or review the discussion of problem solving in Chapter 1 (pp. 24–26). Then, consider the following problem.

An abandoned house on your street is a safety hazard for the children in the neighborhood. Although you and some of your neighbors have called the local Board of Health, nothing has been done. Finally, you and your neighbors decide to write to the mayor.

ASSIGNMENT: Working in a small group or on your own, write to the mayor describing why this house is a safety hazard. Thoroughly describe the house (outside and inside). Imagine a place that is not just ugly; it must also pose safety problems to children. You might start with the following sentence:

Not only is	the abandoned	house at 4:	5 Main S	treet an	eyesore,	but
it is also _						

For a paragraph: Describe in detail one room on the first floor of the house or just the exterior you can see from the street.

For an essay: Describe in detail at least three rooms in the house or the exterior you can see if you walk entirely around the house.

STEPS	DETAILS
Narrow and explore your topic. See Chapter 3.	Make the topic more specific.Prewrite to get ideas about the narrowed topic.
 Write a topic sentence (paragrap or thesis statement (essay). See Chapter 4. 	State what is most interesting, vivid, and important about your topic.
Support your point. See Chapter 5.	 Come up with examples and details that create a main impression about your topic.
Write a draft. See Chapter 6.	 Make a plan that puts examples in a logical order. Include a topic sentence (paragraph) or thesis statement (essay) and all the supporting examples and details.
Revise your draft. See Chapter 7.	 Make sure it has all the Four Basics of Good Description. Make sure you include transitions to move readers smoothly from one detail to the next.
Edit your revised draft. See Parts 4 through 7.	 Correct errors in grammar, spelling, word use, and punctuation.

Chapter Review

1.	Description is writing that	creates	a clear	and	vivid	impression	of the
	topic.						

2. What are the Four Basics of Good Description? It creates a main impression about the topic.

It uses specific examples to support the main impression.

It supports those examples with details that appeal to the five senses. It brings a person, place, or physical object to life for the reader.

The taria centered in a description paragraph or the thesis statement

3. The topic sentence in a description paragraph or the thesis statement in a description essay includes what two elements? a narrowed topic and main impression about that topic

4. Write sentences using the following vocabulary words: aloft, palatial, perilous, stint, nostalgia. Answers will vary.

reflect Write for 2 minutes about what you have learned about writing description.

LEARNING JOURNAL

Reread your idea journal entry from page 154. Write another entry about the same topic, using what you have learned about good description.

YOU KNOW THIS

You often use process analysis:

- You teach a friend or a family member how to do something.
- You learn how to make or do something.

write for 2 minutes about how to do something you know about.

Process Analysis

Writing That Explains How Things Happen

Understand What Process Analysis Is

Process analysis either explains how to do something (so that your readers can do it) or explains how something works (so that your readers can understand it).

Four Basics of Good Process Analysis

- It tells readers what process the writer wants them to know about and makes a point about it.
- 2 It presents the essential steps in the process.
- 3 It explains the steps in detail.
- 4 It presents the steps in a logical order (usually time order).

In the following paragraph, the numbers and colors correspond to the Four Basics of Good Process Analysis.

4 Time order is used

The poet Dana Gioia once said, "Art delights, instructs, consoles. It educates our emotions."

1 Closely observing paintings, sculpture, and other forms of visual art is a great way to have the type of experience that Gioia describes, and following a few basic steps will help you get the most from the experience.

2 First, choose an art exhibit that interests you.

3 You can find listings for exhibits on local museums' Web sites or in the arts section of a newspaper. Links on the Web sites or articles in a newspaper may give you more information about the exhibits, the artists featured in them, and the types of work to be displayed.

2 Second, go to the museum with an open mind and, ideally, with a friend.

3 While

moving through the exhibit, take time to examine each work carefully. As you do so, ask yourself questions: What is my eye most drawn to, and why? What questions does this work raise for me, and how does it make me feel? How would I describe it to someone over the phone? Ask your friend the same questions, and consider the responses. You might also consult an exhibit brochure for information about the featured artists and their works. 2 Finally, keep your exploration going after you have left the museum. 3 Go out for coffee or a meal with your friend. Trade more of your thoughts and ideas about the artwork, and discuss your overall impressions. If you are especially interested in any of the artists or their works, you might look for additional information or images on the Internet, or you might consult books at the library. Throughout the whole experience, put aside the common belief that only artists or cultural experts "get" art. The artist Eugène Delacroix described paintings as "a bridge between the soul of the artist and that of the spectator." Trust your ability to cross that bridge and come to new understandings.

TEACHING TIP Diagrams like the one shown here are the best way to describe certain processes. Ask students about other processes that might be diagrammed.

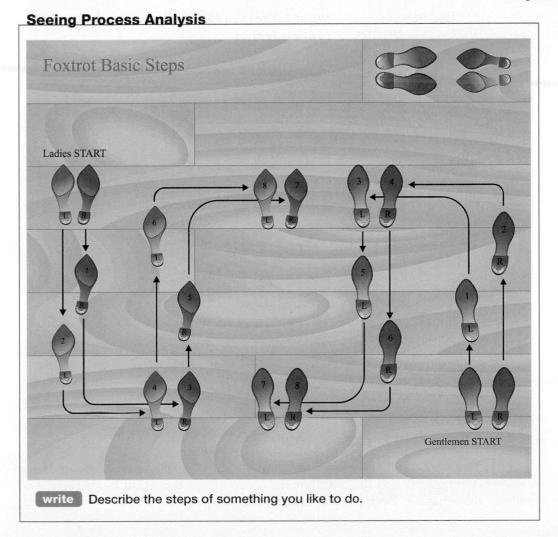

WRITER AT WORK

JEREMY GRAHAM: As a youth pastor, I give youth-group members step-by-step guidance in how to be leaders.

(See Jeremy Graham's PROFILE OF SUCCESS on p. 177.)

IDEA JOURNAL Write about something you recently learned how to do—and how you do it.

You use process analysis in many situations:

COLLEGE In a science course, you explain photosynthesis.

WORK You write instructions to explain how to operate some-

thing (the copier, the fax machine).

EVERYDAY LIFE You write out a recipe for an aunt.

In college, a writing assignment may ask you to describe the process of, but you might be asked to describe the stages of _____ or explain how ____ works. Whenever you need to identify and explain the steps or stages of anything, you will use process analysis.

Main Point in Process Analysis

In process analysis, your **purpose** is to explain how to do something or how something works. Your **main point** should tell readers what process you are describing and what you want readers to know about it.

To help you discover the main point for your process analysis, complete the following sentence:

MAIN POINT IN What I want readers to know about this process analysis process is that . . .

Here is an example of a topic sentence for a paragraph:

Remember that the topic for an essay can be a little broader than one for a paragraph.

Whereas the topic sentence focuses on just one method to improve energy efficiency, the thesis statement sets up a discussion of multiple methods.

Support in Process Analysis

The paragraph and essay models on pages 173–74 use the topic sentence (paragraph) and thesis statement (essay) from the Main Point section of this chapter. Both models include the **support** used in all writing about

TIP Sometimes, the same main point can be used for a paragraph and an essay, but the essay must develop this point in more detail. (See pp. 69–70.)

pro	cesses: the steps in the process backed up by details about these steps.	
In	the essay model, however, the major support points (steps) are topic tences for individual paragraphs.	
	ACTICE 1 Finding and Choosing the Essential Steps	
For	each of the following topics, write the essential steps in the order you ald perform them.	TEACHING TIP Students might be comforted to learn
1.	Making (your favorite food) is simple. Answers will vary.	that the most productive and rewarding writing process is rarely neat or linear. You might share with them some insights from composition
2.	I think I could teach anyone how to	scholar and writer Mina Shaughnessy. According to Shaughnessy, the best writers avoid a "tight, well- ordered, but empty paper";
3.	Operating a is	make a path through "a wilderness of possibilities"; and explore "alternate routes and unexpected places when that seems wise or
Cho dov to e	ACTICE 2 Adding Details to Essential Steps oose one of the topics from Practice 1. In the spaces that follow, first copy with the topic and the steps you wrote for it in Practice 1. Then, add a detail each of the steps. If the process has more than three steps, you might want use a separate sheet of paper.	TIP If you have written a narration paragraph already, you will notice that narration and process analysis are alike in that they both usually present events or steps
	Topic: Answers will vary. Step 1:	in time order—the order in which they occur. The difference is that narration
	Detail:	reports what happened, whereas process analysis
	Step 2:	describes how to do something or how something works.
	Detail:	WOIKS.
	Step 3:	
	Detail:	
	Step 4:	
	Detail:	

PARAGRAPHS VS. ESSAYS IN PROCESS ANALYSIS

For more on the important features of process analysis, see the Four Basics of Good Process Analysis on page 170.

Paragraph Form

Topic sentence

Support 1 (first step)

Support 2 (second step)

Support 3 (third step)

Concluding sentence

Sealing windows against the cold is an easy way to reduce heating bills. First, make sure the inside window frames are clean and clear of dust. Often, it is enough to wipe the frames with a soft, dry cloth. However, if the frames are especially dirty, clean them thoroughly with a damp cloth, and then dry them with paper towels or a blow dryer. Next, apply two-sided adhesive tape on all four sides of the window frame. Begin by peeling the cover from one side of the adhesive. Then, affix this side of the tape to the frame. After you have taped all four sides of the frame, remove the front side of the adhesive cover. Finally, attach the plastic sheeting to the tape. Start by measuring your window and cutting the plastic so that it fits. Next, apply the plastic to the tape, starting at the top of the window and working your way down. When the plastic is fully attached, seal it over the window by running a blow dryer over the plastic from top to bottom. By spending one morning or afternoon covering your windows, you can save \$300 on your heating bills and enjoy a much more comfortable home.

Main Point: Often, narrower for a paragraph than for an essay: While the topic sentence (paragraph) focuses on just one method to improve energy efficiency, the thesis statement (essay) sets up a discussion of multiple methods.

Support for the Main Point (the Steps of a Process)

Details about the Steps: Usually, 1 to 3 sentences per step for paragraphs and 3 to 8 sentences per step for essays.

Conclusion

Think Critically As You Write Process Analysis

ASK YOURSELF

- Have I included all the steps necessary for others to complete or understand the process?
- Would any information from experts make my description of the process clearer? (For more on finding and evaluating outside sources, see pp. 304–09.)

Many people are intimidated by the work necessary to make their homes more energy efficience. Thesis statement not see it as a do-it-yourself job. However, improving a home's energy efficiency can actually be done fairly easily, significantly lowering utility bills.

First, seal air leaks around windows and doors.

To seal air leaks around windows, apply window frames and walls. Also, if you hav windows that are not weather-proof, cover them with plastic before the cold temperatures set in. This process involves affixing two-sided adhesive tape to the window frames and then attaching plastic sheeting, which is sealed with the use of a blow dryer. Next, look for drafty spots around doors. Many air leaks at the top or sides of doors can be sealed with adhesive-backed foam strips. Leaks under doors can be stopped with foam draft guards. Alternatively, a rolled-up blanket, rug, or towel can keep the cold from coming in. All of

Second, install water-saving shower heads and faucet aerators. These fixtures are inexpensive and are

can save up to \$600 per season on heating (second step)

available in most hardware stores. Also, they are easy to install. First, unscrew the old shower or faucet head. Then, follow the package instructions for affixing the new shower head or aerator. In some cases, you might have to use pipe tape or a rubber washer to ensure a good seal. After this step, run the water to make sure there are no leaks. If you find any leaks, use pliers to tighten the seal. In time, you will discover that the new shower heads and aerators will cut your water usage and the start was a source of the start of

water heating by up to 50 percent. (third step)

Finally, look for other places where energy efficiency could be increased. One simple improvement is to replace traditional light bulbs with compact fluorescent

bulbs, which use up to 80 percent less energy. Also, make sure your insulation is as good as it can be. Many utilities now offer free assessments of home insulation, identifying places where it is missing or inadequate. In some cases, any necessary insulation improvements may be subsidized by the utilities or by government agencies. It is well worth considering such improvements, which, in

the case of poorly insulated homes, can save thousands

3

of dollars a year, quickly covering any costs. Although some people prefer to have professionals blow insulating foam into their walls, it is not difficult to add insulation to attics, where a large amount of heat can be lost during cold months.

Concluding paragraph Taking even one of these steps can make a significant financial difference in your life and also reduce your impact on the environment. My advice, though, is to improve your home's energy efficiency as much as possible, even if it means doing just a little at a time. The long-term payoff is too big to pass up.

Organization in Process Analysis

TIP For more on time order. see page 78.

Process analysis is usually organized by time order because it explains the steps of the process in the order in which they occur. This is the strategy used in the paragraph and essay models on pages 173-74.

Transitions move readers smoothly from one step to the next.

Common	Transitions in Pr	ocess Analysis	
after	eventually	meanwhile	since
as	finally	next	soon
at last	first	now	then
before	last	once	when
during	later	second	while

PRACTICE 3 Using Transitions in Process Analysis

Read the paragraph that follows, and fill in the blanks with transitions. Answers may vary. Possible answers are shown.

Scientists have discovered that, like something from a zombie movie, a mind-controlling fungus attacks certain carpenter ants. , as if following the fungus's orders, the ants help their invader reproduce. The process begins when an ant is infected. _, the ant begins to act strangely. For instance, instead of staying in its home high in the trees, it drops to the forest While floor. _ wandering, it searches for a cool, moist place. Once the zombie-ant finds the right place, it clamps its jaws to Eventually , the fungus within the ant grows until it a leaf and dies. bursts from the insect's head, and more ants are infected. By studying this process, researchers may find better ways to control the spread of carpenter ants.

READING SELECTIONS For further examples of and activities for other process analysis paragraphs and essays, see Chapter 42.

CRITICAL READING Preview Read Pause Review See pages 9-12. Reading examples of process analysis will help you write your own. In the

Read and Analyze Process Analysis

first example, Jeremy Graham shows how he uses process analysis in his job as a youth pastor. The second example is a paragraph by a student, and the third example is an essay by a professional writer. As you read, pay attention to the vocabulary, and answer the questions in the margin. They will help you read critically.

PROFILE OF SUCCESS

Process Analysis in the Real World

Background When I was growing up in New Orleans, my family was well off, and we lived in a nice home. But when I was thirteen, my dad moved out, leaving my mother with the mortgage and the responsibility of raising me and my younger brother. Eventually, we lost our home and were forced to move into a trailer. These changes put a lot of stress on all of us. I ended up dropping out of school and started selling drugs.

In August of 2005, when I was seventeen, Hurricane Katrina hit, and we fled the city for Mississippi, returning to New Orleans later that year. In December, my younger brother got into an altercation with a man in Lacombe, Louisiana, and ended up shooting and killing him, a crime for which he's now serving a life sentence. After his arrest, I moved back to Mississippi and started working menial jobs to get by. Because I had my GED by that time, my mom encouraged me to enroll in college. I entered Hinds Community College but was eventually suspended due to poor academic performance. Fortunately, a pastor in the community, Lionel Joseph Traylor, saw potential in me. He put me to work at his church, where I helped with things like cleaning and raking leaves. Pastor Traylor also gave me suits and other nice clothes to replace the T-shirts and jeans I usually wore, and he pushed me to go back to school.

With his encouragement, I got back into Hinds, and this time I was determined to succeed. I ended up graduating with a 3.0 GPA and a degree in business administration and accounting. Now, I am working on a bachelor's degree in business administration at Mississippi College, where I'm on scholarship. I expect to graduate in December of 2012.

I have also become an ordained minister, and I'm doing full-time ministry work with Pastor Traylor's church, where I am the youth pastor. I have also started sharing my story through public-speaking engagements. Although many people fear public speaking, I find that I get energy and motivation from the crowd.

Degree/College A.A., Hinds Community College

Employer Epicenter Church

Writing at work It is important for young people to learn leadership skills. At Epicenter Church, I write instructional materials for members of youth groups to help teach them these skills.

How Jeremy uses process analysis My instructional materials give members of youth groups step-by-step guidance for leadership within the youth group and beyond it. Having the materials in writing helps ensure that the guidance is followed consistently.

Jeremy's Process Analysis

The following paragraph is an example of the instructional materials that Jeremy writes.

Jeremy Graham Youth Pastor and Motivational Speaker

PREDICT What do you think one of the steps will be?

RESOURCES For a discussion of how to use the profiles in Part 2, see *Practical Suggestions*.

As a member of a youth group, you can become an active leader in the group and in your larger community. Following a few key steps can help you along the way. The first step is to lead by example. Older group members must set the path for younger members by showing them how to conduct themselves, work hard, and keep a positive attitude in any situation. By doing so, the younger members will build healthy relationships, and the skills they learn from older mentors will help them in school and future jobs. Second, youth leaders must encourage their peers to get involved with the community to make positive changes. Gathering together young people to visit homeless shelters, feed the homeless, and clean up the community are just a few things that can be done. These activities teach youth to be grateful for their living conditions and to extend a helping hand to others. The third step is to build good character and moral integrity. This happens naturally as youth leaders become more involved in their communities and serve as role models for other youth. Having good character and integrity improves young leaders' lives and helps them continue to have a positive impact on others. To sum up, all these steps greatly benefit youth leaders and the communities they serve.

- 1. What process is being analyzed? how to become an effective leader
- 2. How many steps does Jeremy give? three
- 3. In your own words, what are the steps to becoming an effective leader?

 Answers will vary.

Student Process Analysis Paragraph

Charlton Brown

Buying a Car at an Auction

PREDICT What do you think Charlton will say buyers need to be prepared about?

Buying a car at an auction is a good way to get a cheap car, but buyers need to be prepared. First, decide what kind of vehicle you want to buy. Then, find a local auction. Scams are common, though, so be careful. Three top sites that are legitimate are www.gov-auctions.org, www.carauctioninc.com, and www.seizecars.com. When you have found an auction and a vehicle you are interested in, become a savvy buyer. Make sure you know the car's actual market value. You can find this out

from Edmunds.com, Kellybluebook.com, or NADA (the National Automobile Dealers Association). Because bidding can become like a competition, decide on the highest bid you will make, and stick to that. Do not get drawn into the competition. On the day of the auction, get to the auction early so that you can look at the actual cars. If you do not know about cars yourself, bring someone who does with you to the auction so that he or she can examine the car. Next, begin your thorough examination. Check the exterior; especially look for any signs that the car has been in an accident. Also, check the windshield because many states will not give an inspection sticker to cars with any damage to the windshield. Check the interior and try the brakes. Start the engine and listen to how it sounds. Check the heat and air conditioning, the CD player, and all other functions. As a final check before the bidding, look at the car's engine and transmission. Finally, get ready to place your bid, and remember, do not go beyond the amount you settled on earlier. Good luck!

- 1. Double-underline the topic sentence.
- 2. What is Charlton's main point? Buyers should be prepared before buying a car at an auction.
- 3. Underline the major steps.
- **4.** Circle the words that signal when Charlton moves from one step to the next.
- 5. Does Charlton's paragraph follow the Four Basics of Good Process Analysis (p. 170)? Why or why not? Yes. Answers will vary.

Professional Process Analysis Essay

Ian Frazier

How to Operate the Shower Curtain

Born in 1951 in Cleveland, Ohio, writer lan Frazier is known both for his humorous essays and for his more serious explorations of subjects ranging from American history to fishing. A staff writer for the *New Yorker*, Frazier has contributed pieces to the magazine since 1974, shortly after his graduation from Harvard University. He has also published several books, most recently *Gone to New York: Adventures in the City* (2005), *Lamentations of the Father* (2008), and *Travels in Siberia* (2010).

In the following process analysis essay, Frazier finds humor in one source of annoyance for many people.

Vocabulary development

Underline the following words as you read the process analysis paragraph.

legitimate: lawful; genuine; real

savvy: knowledgeable; well informed

bid: an offer, in this case, of a price

thorough: complete; detailed

SUMMARIZE What steps are necessary to buy a car at auction?

Vocabulary development

Underline these words as you read the process analysis essay.

reputable: having a good reputation

owing to: as a result of disengaged: removed convection: a form of air circulation

microclimate: a small climate (set of weather conditions) within a larger

riser: vertical pipe
intervals: regular distances
tamper: to disturb
detaching: removing
inadvertent: unintentional;
accidental
scenario: situation
subsequently: afterward
receptacle: container
john: slang for toilet
inconsolably: so dramati-

cally it appears that one is beyond comforting

Dear Guest: The shower curtain in this bathroom has been purchased with care at a reputable "big box" store in order to provide maximum convenience in showering. After you have read these instructions, you will find with a little practice that our shower curtain is as easy to use as the one you have at home.

You'll note that the shower curtain consists of several parts. The top hem, closest to the ceiling, contains a series of regularly spaced holes designed for the insertion of shower-curtain rings. As this part receives much of the everyday strain of usage, it must be handled correctly. Grasp the shower curtain by its leading edge and gently pull until it is flush with the wall. Step into the tub, if you have not already done so. Then take the other edge of shower curtain and cautiously pull it in opposite direction until it, too, adjoins the wall. A little moisture between shower curtain and wall tiles will help curtain to stick.

Keep in mind that normal bathing will cause you unavoidably to 3 bump against shower curtain, which may cling to you for a moment owing to the natural adhesiveness of water. Some guests find the sensation of wet plastic on their naked flesh upsetting, and overreact to it. Instead, pinch the shower curtain between your thumb and forefinger near where it is adhering to you and simply move away from it until it is disengaged. Then, with the ends of your fingers, push it back to where it is supposed to be.

If shower curtain reattaches itself to you, repeat process above. Under 4 certain atmospheric conditions, a convection effect creates air currents outside shower curtain which will press it against you on all sides no matter what you do. If this happens, stand directly under showerhead until bathroom microclimate stabilizes.

Many guests are surprised to learn that all water pipes in our system 5 run off a single riser. This means that the opening of any hot or cold tap, or the flushing of a toilet, interrupts flow to shower. If you find water becoming extremely hot (or cold), exit tub promptly while using a sweeping motion with one arm to push shower curtain aside.

REMEMBER TO KEEP SHOWER CURTAIN *INSIDE* TUB AT ALL TIMES! 6 Failure to do this may result in baseboard rot, wallpaper mildew, destruction of living-room ceiling below, and possible dripping onto catered refreshments at social event in your honor that you are about to attend. So be careful!

This shower curtain comes equipped with small magnets in shape of 7 disks which have been sewn into the bottom hem at intervals. These serve no purpose whatsoever and may be ignored. Please do not tamper with

IDENTIFY Underline the steps described in this paragraph.

them. The vertical lines, or pleats, which you may have wondered about, are there for a simple reason: user safety. If you have to move from the tub fast, as outlined above, the easy accordion-type folding motion of the pleats makes that possible. The gray substance in some of the inner pleat folds is a kind of insignificant mildew, less toxic than what is found on some foreign cheeses.

When detaching shower curtain from clinging to you or when exiting tub during a change in water temperature, bear in mind that there are seventeen mostly empty plastic bottles of shampoo on tub edge next to wall. These bottles have accumulated in this area over time. Many have been set upside down in order to concentrate the last amounts of fluid in their cap mechanisms, and are balanced lightly. Inadvertent contact with a thigh or knee can cause all the bottles to be knocked over and to tumble into the tub or behind it. If this should somehow happen, we ask that you kindly pick the bottles up and put them back in the same order in which you found them. Thank you.

While picking up the bottles, a guest occasionally will lose his or her balance temporarily, and, in even rarer cases, fall. If you find this occurring, remember that panic is the enemy here. Let your body go limp, while reminding yourself that the shower curtain is not designed to bear your weight. Grabbing onto it will only complicate the situation.

If, in a "worst case" scenario, you do take hold of the shower curtain, and the curtain rings tear through the holes in the upper hem as you were warned they might, remain motionless and relaxed in the position in which you come to rest. If subsequently you hear a knock on the bathroom door, respond to any questions by saying either "Fine" or "No, I'm fine." When the questioner goes away, stand up, turn off shower, and lay shower curtain flat on floor and up against tub so you can see the extent of the damage. With a sharp object—a nail file, a pen, or your teeth—make new holes in top hem next to the ones that tore through.

Now lift shower curtain with both hands and reattach it to shower-curtain rings by unclipping, inserting, and reclipping them. If during this process the shower curtain slides down and again goes onto you, reach behind you to shelf under medicine cabinet, take nail file or curved fingernail scissors, and perform short, brisk slashing jabs on shower curtain to cut it back. It can always be repaired later with safety pins or adhesive tape from your toiletries kit.

At this point, you may prefer to get the shower curtain out of your way entirely by gathering it up with both arms and ripping it down with a

10 SUMMARIZE What process should a person follow after a fall? sharp yank. Now place it in the waste receptacle next to the john. In order that anyone who might be overhearing you will know that you are still all right, sing "Fat Bottomed Girls," by Queen,¹ as loudly as necessary. While waiting for tub to fill, wedge shower curtain into waste receptacle more firmly by treading it underfoot with a regular high-knee action as if marching in place.

We are happy to have you as our guest. There are many choices you could have made, but you are here, and we appreciate that. Operating the shower curtain is kind of tricky. Nobody is denying that. If you do not wish to deal with it, or if you would rather skip the whole subject for reasons you do not care to reveal, we accept your decision. You did not ask to be born. There is no need ever to touch the shower curtain again. If you would like to receive assistance, pound on the door, weep inconsolably, and someone will be along.

REFLECT Have you ever followed any of the steps described in this essay?

1. The first paragraph contains what seems to be the **thesis statement**. Double-underline it.

TIP For reading advice, see Chapter 1.

- 2. Now, look at this sentence from the last paragraph: "Operating the shower curtain is kind of tricky." Notice how this sentence opposes the thesis statement. What does this opposition say about the process?

 Answers will vary. Possible answers: Operating the shower curtain isn't as easy as the thesis statement makes it out to be. The process described isn't meant to be taken seriously.
- **3.** Circle the **transitions** that introduce steps in the process.
- 4. Does this essay follow the Four Basics of Good Process Analysis (p. 170)? Why or why not? Yes. Answers will vary.

Respond to one of the following assignments in a paragraph or essay.

- **1.** Identify another process that could be analyzed humorously. Then, write a comical description of this process.
- **2.** Frazier describes, in detail, a process for addressing a frustrating situation. Identify another process that you find frustrating, and write a detailed but serious description of it.
- **3.** Describe to a beginner how to do something that you do well.

1. Queen: British rock band popular in the 1970s and 1980s

Write Your Own Process Analysis

In this section, you will write your own process analysis based on one of the following assignments. For help, refer to the How to Write Process Analysis checklist on page 186.

ASSIGNMENT OPTIONS Writing about College, Work, and Everyday Life

Write a process analysis paragraph or essay on one of the following topics or on one of your own choice. If you responded to the idea journal prompt on page 172, you might develop that writing further.

COLLEGE

- Describe the process of preparing for an exam.
- Attend a tutoring session at your college's writing center. Afterward, describe the process: What specific things did the tutor do to help you? Also, explain what you learned from the process.
- Interview a college graduate about how he or she achieved success in school. During the interview, ask about the steps of specific processes. For example, one question might be, "What steps did you follow to take good notes?" After the interview, describe the processes in writing.

WORK

- Describe how to make a positive impression at a job interview.
- Think of a challenging task you had to accomplish at work. What steps did you go through to complete it?
- Identify a job that you would like to have after graduation. Then, investigate the process of getting this job, from the search stage to the interview. To gather information, visit the Web site of your college's career center. Better yet, make an appointment to speak with a career counselor. After you have completed your research, describe the process in writing.

EVERYDAY LIFE

- Describe the process of making something, such as a favorite meal, a set of shelves, or a sweater.
- Think of a challenging process that you have completed successfully, such as fixing a leak under the sink, applying for a loan, or finding a good deal on a car or an apartment. Describe the steps specifically enough so that someone else could complete the process just as successfully.
- Take part in a community activity, such as a fund-raising event for a charity, a neighborhood cleanup, or food preparation at a homeless shelter. Then, describe the process you went through.

CONNECTIONS

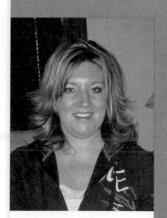

While attending college, ROBIN WYANT volunteered at a community crisis center in her city. Getting more involved in college and community activities, as Robin did, can help you feel more connected to others and can even improve the chances that you'll stay in school.

For more on this story, ways to make community connections, and writing assignments, visit bedfordstmartins.com/ realwriting.

Chapter 11 • Process Analysis

ESL Suggest that students write about a process they used in their native country or culture but don't use where they live now.

TIP For a reminder of how to summarize, analyze, synthesize, and evaluate, see the Reading and Writing Critically box on pages 16–17.

TEACHING TIP If time is short, students might complete just one or two steps of this assignment.

TEACHING TIP If you assign this Writing about Images activity, consider showing your class a brief documentary, Reformed Skinhead Removes Tattoos, that tells the story of Bryon Widner's transformation. To access this documentary, visit www.theblaze.com, and enter the search term erasing hate.

ASSIGNMENT OPTIONS Reading and Writing Critically

Complete one of the following assignments, which ask you to apply the critical thinking, reading, and writing skills discussed in Chapter 1.

Writing Critically about Readings

Although both Charlton Brown's "Buying a Car at Auction" (p. 178) and Ian Frazier's "How to Operate the Shower Curtain" (p. 179) describe processes, Frazier's process analysis is intended to be entertaining instead of truly useful. Read or review both of these pieces, and then follow these steps:

- **1. Summarize** Briefly summarize the works, listing steps in the processes described.
- **2. Analyze** Are there any other steps or details that the authors might have included?
- **3. Synthesize** Using examples from both Brown's and Frazier's writings and from your own experience, discuss (1) processes that would be fun to describe humorously and (2) processes that need to be described seriously.
- **4.** Evaluate Which piece, Brown's or Frazier's, do you think is more effective? Why? In writing your evaluation, you might look back on your responses to step 2.

Writing about Images

The following series of photographs, taken by Bill Brummel, accompanied an article about Bryon Widner, a former leader of the white power movement who sought to put his racist past behind him. One part of this effort was the removal of the many tattoos on his face and neck, which featured symbols of racial intolerance and violence. With the help of the Southern Poverty Law Center, Widner received funding for the expensive removal of his tattoos. After undergoing sixteen months of laser surgeries, Widner no longer has any tattoos on his face or neck.

Study the photographs of Widner's transformation, and complete the following steps.

- **1. Read the images** Ask yourself: What changes do you notice from photo to photo? What is the purpose of showing this process? (For more information on reading images, see Chapter 1.)
- **2. Write a process analysis** Write a paragraph or essay that describes the process shown in these photographs. (For more information about Widner's transformation, search for articles about it on the Internet.) In your description, include the changes you observed in step 1.

Writing to Solve a Problem

Read or review the discussion of problem solving in Chapter 1 (pp. 24–26). Then, consider the following problem.

Midway through a course you are taking, your instructor asks the class to tell her how she could improve the course. You have not been happy with the class because the instructor is always late and comes in seeming rushed and tense. She then lectures for most of the class before giving you an assignment that you start on while she sits at her desk, busily grading papers. You are afraid to ask questions about the lecture or assignment. You want to tell the instructor how the course could be better, but you do not want to offend her.

ASSIGNMENT: Working in a small group or on your own, write to your instructor about how she could improve the course. Think of how the class could be structured differently so that you could learn more. Begin with how the class could start. Then, describe how the rest of the class period could go, suggesting specific activities if you can. State your suggestions in positive terms. For

TEAMWORK For more detailed guidance on group work, see *Practical Suggestions*.

example, instead of telling the instructor what *not* to do, make suggestions using phrases like *you could, we could,* or *the class could*. Be sure to use formal English.

You might start in this way:

Several simple changes might improve our learning. At the	start
of each class,	
At the end, remember to thank your instructor for asking for studen suggestions.	ts'

STEPS		DETAILS	
	Narrow and explore your topic. See Chapter 3.	 Make the topic more specific. Prewrite to get ideas about the narrowed topic, and how you will explain the steps to your audience. Make sure your topic can be covered in the space given. 	
	Write a topic sentence (paragraph) or thesis statement (essay). See Chapter 4.	 Decide what you want readers to know about the process you are describing. 	
	Support your point. See Chapter 5.	 Include the steps in the process, and explain the steps in detail. 	
	Write a draft. See Chapter 6.	 Make a plan that puts the steps in a logical order (often chronological). Include a topic sentence (paragraph) or thesis statement (essay) and all the supporting details about each step. 	
	Revise your draft. See Chapter 7.	 Make sure it has all the Four Basics of Good Process Analysis. Read to make sure all the steps are present. Make sure you include transitions to move readers smoothly from one step to the next. 	
	Edit your revised draft. See Parts 4 through 7.	 Correct errors in grammar, spelling, word use, and punctuation. 	

Chapter Review

- 1. Process analysis is writing that either explains how to do something or explains how something works.
- 2. What are the Four Basics of Good Process Analysis?

 It tells readers what process you want them to know about and makes
 a point about it.

It presents the essential steps in the process.

It explains the steps in detail.

It presents the steps in a logical order (usually time order).

3. Write sentences using the following vocabulary words: legitimate, savvy, reputable, owing to, intervals. Answers will vary.

reflect Write for 2 minutes about what you have learned about writing process analysis.

LEARNING JOURNAL

Reread your idea journal entry about how to do something you recently learned (p. 172). Make another entry about the same process, using what you have learned about process analysis. Assume you are teaching someone else this process.

12

YOU KNOW THIS

You have had experience classifying various items:

- You see how movies in a video store are arranged.
- · You sort items for recycling.

write for 2 minutes about the kinds of responsibilities you have.

Classification

Writing That Sorts Things into Groups

Understand What Classification Is

Classification is writing that organizes, or sorts, people or items into categories. It uses an **organizing principle**: *how* the people or items are sorted. The organizing principle is directly related to the purpose for classifying. For example, you might sort clean laundry (your purpose) using one of the following organizing principles: by ownership (yours, your roommate's) or by where it goes (the bedroom, the bathroom).

Four Basics of Good Classification

It makes sense of a group of people or items by organizing them into categories.

2 It has a purpose for sorting the people or items.

It categorizes using a single organizing principle.

4 It gives detailed explanations or examples of what fits into each category.

In the following paragraph, the numbers and colors correspond to the Four Basics of Good Classification.

TIP For tools to use in getting a job, visit the Student Site for Real Writing at bedfordstmartins..com/realwriting.

In researching careers I might pursue, I have learned that there are three major types of workers, 2 each having different strengths and preferences. 3 The first type of worker is a big-picture person, who likes to look toward the future and think of new businesses, products, and services. 4 Big-picture people might also identify ways to make their workplaces more successful and productive. Often, they hold leadership positions, achieving their goals by assigning specific projects and tasks

to others. Big-picture people may be drawn to starting their own businesses. Or they might manage or become a consultant for an existing business. 3 The second type of worker is a detail person, who focuses on the smaller picture, whether it be a floor plan in a construction project. a spreadsheet showing a business's revenue and expenses, or data from a scientific experiment. 4 Detail people take pride in understanding all the ins and outs of a task and doing everything carefully and well. Some detail people prefer to work with their hands, doing such things as carpentry or electrical wiring. Others prefer office jobs, such as accounting or clerical work. Detail people may also be drawn to technical careers, such as scientific research or engineering. 3 The third type of worker is a people person, who gets a lot of satisfaction from reaching out to others and helping meet their needs. 4 A people person has good social skills and likes to get out in the world to use them. Therefore, this type of worker is unlikely to be happy sitting behind a desk. A successful people person often shares qualities of the other types of workers; for example, he or she may show leadership potential. In addition, his or her job may require careful attention to detail. Good jobs for a people person include teaching, sales, nursing, and other health-care positions. Having evaluated my own strengths and preferences, I believe that I am equal parts big-picture person and people person. I am happy to see that I have many career options.

Seeing Classification

write What do shoes tell you about their wearer? What types of shoes do you own?

TEACHING TIP Classification is of central importance to shoe and clothing stores. Ask students to give examples of other types of businesses that classify goods or services.

WRITER AT WORK

LEIGH KING: In my fashion blog, I write about many types of clothing, styles, and accessories.

(See Leigh King's PROFILE OF SUCCESS on p. 197.)

IDEA JOURNAL Write about the different kinds of students in this class or the different kinds of friends you have.

You use classification anytime you want to organize people or items.

COLLEGE

In a criminal justice course, you are asked to discuss the most common types of chronic offenders.

WORK

For a sales presentation, you classify the kinds of products your company produces.

EVERYDAY

LIFE

You classify your typical monthly expenses to make a budget.

In college, writing assignments probably will not use the word classification. Instead, you might be asked to describe the types of ______ or explain the types or kinds of ______. You might also be asked, How is _____ organized? or What are the parts of ______? These are the words and phrases that signal that you need to sort things into categories require classification.

Main Point in Classification

The **main point** in classification uses a single **organizing principle** to sort items in a way that serves your purpose. The categories should help you achieve your purpose.

To help you discover the organizing principle for your classification, complete the following sentences:

My purpose for classifying my topic is to explain to readers.

It would make most sense to my readers if I sorted this topic by . . .

PRACTICE 1 Using a Single Organizing Principle

For each topic that follows, one of the categories does not fit the same organizing principle as the rest. Circle the letter of the category that does not fit, and, in the space provided, write the organizing principle that the rest follow. Answers may vary. Possible answers are shown.

EXAMPLE:

Topic: Shoes

Categories:

a. Running

c. Golf

(b.) Leather

d. Bowling

Organizing principle: by type of activity

1. Topic: Relatives Categories: a. Aunts c. Sisters (b.) Uncles d. Nieces Organizing principle: female relatives 2. Topic: Jobs Categories: a. Weekly c. Monthly (d.) Summer b. Hourly Organizing principle: pay period 3. Topic: Animals Categories: a. Dogs c. Rabbits b. Cats (d.) Whales Organizing principle: pets; four legs

TEAMWORK Turn this practice around by presenting a few different organizing principles to the class, such as *special celebrations, motor vehicles,* and *awkward moments*. Then, have students break into small groups, and ask each group to come up with at least four categories of things that would fit each organizing principle. Finally ask the groups to share their categories.

Sometimes, it helps to think of classification in diagram form. Here is a diagram of the paragraph on pages 188–89.

In classification, the main point may or may not state the organizing principle directly. Look at the following examples:

In both main points, the organizing principle is *types* of things—columns in the case of the paragraph and buildings in the case of the essay. The thesis statement does not state this principle directly, however. Instead, the categories—stadiums, theaters, and temples—make the principle clear.

Also, notice that the topic for the essay is broader than the one for the paragraph. Whereas the topic sentence focuses on just one part of ancient Greek buildings—the columns—the thesis statement considers entire groups of structures.

Make sure that the categories in your classification serve your purpose. In the previous thesis statement, the categories serve the purpose of presenting impressive structures in ancient Greece.

TIP Sometimes, the same main point can be used for a paragraph and an essay, but the essay must develop this point in more detail. (See pp. 69–70.)

TEACHING TIP Walk

students through this step. Use a simple topic (stores in town or at a local mall, clothing students are wearing, courses offered at the college), and demonstrate how you would classify it. Or break the class into small groups, and give each group a topic. Then, call on students from each group to tell what they did.

PRACTICE 2 Choosing Categories

In the items that follow, you are given a topic and a purpose for sorting. For each item, list three categories that serve your purpose. (There are more than three correct categories for each item.)

EXAMPLE:

Topic: Pieces of paper in my wallet

Purpose for sorting: To get rid of what I do not need

Categories:

a. Things I need to keep in my wallet

b. Things I can throw away

c. Things I need to keep, but not in my wallet

1.	Topic: College courses
	Purpose for sorting: To decide what I will register for
	Categories: Answers will vary. Possible answers:
	a. English
	b. Accounting
	c. Math
2.	Topic: Stuff in my notebook
	Purpose for sorting: To organize my schoolwork
	Categories: Answers will vary. Possible answers:
	a. Homework
	b. Notes
	c. Class handouts
3.	Topic: Wedding guests
	Purpose for sorting: To arrange seating at tables
	Categories: Answers will vary. Possible answers:
	a. family members
	b. Neighbors
	c. friends
4.	Topic: Tools for home repair
	Purpose for sorting: To make them easy to find when needed
	Categories: Answers will vary. Possible answers:
	a. Plumbing tools
	b. Carpentry tools
	c. Painting tools

Support in Classification

The paragraph and essay models on pages 194–95 use the topic sentence (paragraph) and thesis statement (essay) from the Main Point section of this chapter. Both models include the **support** used in all classification writing: categories backed up by explanations or examples of each category. In the essay model, however, the major support points (categories) are topic sentences for individual paragraphs.

PARAGRAPHS VS. ESSAYS IN CLASSIFICATION

For more on the important features of classification, see the Four Basics of Good Classification on page 188.

Think Critically As You Write Classification

ASK YOURSELF

- Will readers be clear about my organizing principle even if my main point doesn't state it directly?
- Do the categories that make up the support for my main point go with my organizing principle? If not, does it make sense to rethink the categories, the organizing principle, or both?
- Are all the explanations or examples for each category relevant?

2

Ancient Greek civilization produced a wealth of architectural wonders that were both **Thesis statement** lasting. The most impressive structures were stadiums, theaters, and temples.

The stadiums were designed to hold thousands of spectators. These open-air spaces were s so that the seating, often stone benches from the central space, giving all spectators a decent view. One of the most famous stadiums, built in Delphi in the fifth century B.C., seated audiences of about 7,000 people. Many stadiums featured ornamental details such as dramatic arches, and some of the more sophisticated examples included heated bathhouses with heated floors. Most often, the stadiums hosted sporting events, such as foot races. A common racing distance v equaling one length of the stadium.

Another type of structure, the theater, was also a popular public gathering place. Like stadiums, the theaters were open-air sites that were set into hillsides. But instead of sports, they featured plays, musical performances, poetry readings, and other cultural events.

In the typical Greek theater, a central performance area was surrounded by semicircular seating, which was often broken into different sections. Wooden, and later stone, stages were set up in the central area, and in front of the stage was a space used for singing and dancing. This space was known as the "orchestra." Among the most famous ancient Greek theaters is the one at Epidaurus, built in the fourth century B.C. and seating to people. Performances still take place there.

The most beautiful structures were the temples, with their grand entrances and large open spaces. Temples were rectangular in shape, and their outer walls as well as some interior spaces were supported by columns. Their main structures were typically made of limestone or marble, while their roofs might be constructed of terra-cotta or marble tiles. Temples were created to serve as "homes" for particular gods or goddesses, who were represented by statues. People left food or other offerings to these gods or goddesses to stay in their good graces, and communities often held festivals and other celebrations in their honor. Temples tended to be built in either the

3

Doric or Ionic style, with Doric temples featuring simple, heavy columns and Ionic temples featuring slightly more ornate columns. The most famous temple, in the Doric style, is the Parthenon in Athens.

Concluding paragraph

Turning to the present day, many modern stadiums, theaters, and columned civic buildings show the influence of ancient Greek buildings. Recognizing the lasting strength and beauty of these old structures, architects and designers continue to return to them for inspiration. I predict that this inspiration will last at least a thousand more years.

Organization in Classification

Classification can be organized in different ways (time order, space order, or order of importance) depending on its purpose.

TIP For more on the orders of organization, see pages 78–79.

PURPOSE	LIKELY ORGANIZATION
to explain changes or events over time	time
to describe the arrangement of people/items in physical space	space
to discuss parts of an issue or problem, or types of people or things	importance

Order of importance is used in the essay model on page 195.

As you write your classification, use **transitions** to move your readers smoothly from one category to another.

Common Transition	s in Classification
another	for example
another kind	for instance
first, second, third,	last
and so on	one example/another example

PRACTICE 3 Using Transitions in Classification

Read the paragraph that follows, and fill in the blanks with transitions. You are not limited to the ones listed in the preceding box.

Answers may vary. Possible answers are shown.

Every day, I get three kinds of e-mail: work, personal, and junk. The first kind of e-mail, work, I have to read carefully and promptly.

Sometimes, the messages are important ones directed to me, but mostly they are group messages about meetings, policies, or procedures. For example, for instance, it seems as if the procedure for leaving the building during a fire alarm is always changing. The second kind,

Another kind of e-mail, personal, is from friends or my mother. These I read when I get a chance, but I read them quickly and delete any that are jokes or messages that have to be sent to ten friends for good luck.

The third kind, The last kind of e-mail is the most common and most annoying: junk. I get at least thirty junk e-mails a day, advertising all kinds

of things that I do not want, such as life insurance or baby products. Even when I reply asking that the company stop sending me these messages, they keep coming. Sometimes, I wish e-mail did not exist.

Read and Analyze Classification

Reading examples of classification will help you write your own. In the first example, Leigh King shows how she uses classification in her job as a fashion writer.

The second example is a classification paragraph by a student, and the third example is a classification essay by a professional writer. As you read these pieces, pay attention to the vocabulary, and answer the questions in the margin. They will help you read critically.

READING SELECTIONS For further examples of and activities for classification, see Chapter 43.

PROFILE OF SUCCESS

Classification in the Real World

Background I always knew that I wanted to work in the fashion industry, so I entered the Fashion Institute of Design & Merchandising (FIDM), where I studied merchandise marketing. I had to take a noncredit introduction-to-writing course, but it made a big difference for me, and the teacher inspired me to improve my writing.

Later on, while I was still at FIDM, I started a fashion blog, where I write about stylish pieces from up-and-coming designers. Through the blog, I overcame one of the biggest challenges facing people new to the fashion industry: making yourself stand out from the crowd, especially in a place like New York City. People in the industry took note of my blog, and it helped me get an internship in the Web Department at *Teen Vogue*. In that job, I wrote articles for the magazine and blogged about fashion news, celebrities, and many other topics.

My advice to other students is to put yourself out there with your writing, whether through blogging or some other online presence. If you make a good impression with your writing, you can get great results.

Degrees/Colleges A.A., Fashion Institute of Design & Merchandising; pursuing a bachelor of professional studies degree in fashion merchandising at LIM College

Employer Self. Previously interned at *Teen Vogue* and Tory Burch.

Writing at work Blogs, articles, e-mails, and more.

Leigh King Fashion Writer/Blogger

Leigh's Classification

The following piece is part of an e-mail that Leigh sent to colleagues about upcoming blog posts.

Now that we're on the eve of prom season, I am going to be writing about some of the most eye-catching prom fashions:

- Dresses: The newest looks range from classic and romantic, to glittery and modern, to vintage. And the new styles come in a variety of colors, from understated cream, to striking black and white, to candy colors or pastels.
- Clutch purses: There are plenty of new looks to choose from, including purses made of bold-patterned fabrics or accented with stylish beading.
- Shoes: No matter what style of dress a prom-goer chooses, there are beautiful shoes to go with it: ballet flats, chunky wooden heels, heels with jewels or bows, and more.
- 1. Double-underline the main point of the e-mail.
- 2. What categories does Leigh break the fashions into? <u>dresses</u>, <u>clutch</u> purses, shoes
- 3. Does the e-mail have the Four Basics of Good Classification (p. 188)?
 Yes. Specific answers may vary.

Student Classification Paragraph

Lorenza Mattazi

All My Music

TIP For advice on building your vocabulary, visit the Student Site for Real Writing at bedfordstmartins.com/realwriting.

From the time I was young, I have always loved music, all kinds of music. My first experience of music) was the opera that both of my parents always had playing in our house. I learned to understand the drama and emotion of operas. My parents both spoke Italian, and they told me the stories of the operas and translated the words sung in Italian to English so that I could understand. Because hearing opera made my parents happy, and they taught me about it, I loved it, too. Many of my friends think I am weird when I say I love opera, but to me it is very emotional and beautiful. When I was in my early teens, I found rock music and listened to it no

matter what I was doing. I like the music with words that tell a story that I can relate to. In that way, rock can be like opera, with stories that everyone can relate to, about love, heartbreak, happiness, and pain. The best rock has powerful guitars and bass, and a good, strong drumbeat. I love it when I can feel the bass in my chest. Rock has good energy and power. Now, I love rap music, too, not the rap with words that are violent or disrespectful of women, but the rest. The words are poetry, and the energy is so high that I feel as if I just have to move my body to the beat. That rhythm is so steady. I have even written some good rap, which my friends say is really good. Maybe I will try to get it published, even on something like Helium, or I could start a blog. I will always love music because it is a good way to communicate feelings and stories, and it makes people feel good.

- 1. Double-underline the topic sentence.
- 2. What categories of music does Lorenza write about? opera, rock music, rap
- 3. Circle the transitions.
- 4. Does the paragraph have the Four Basics of Good Classification (p. 188)? Why or why not? Answers will vary, but the paragraph could use some more detailed examples.
- **5.** What kind of organization does Lorenza use? time

Professional Classification Essay

Frances Cole Jones

Don't Work in a Goat's Stomach

Frances Cole Jones, who holds a B.A. in English/creative writing from Connecticut College and an M.A. in liberal studies from New York University, is founder and president of Cole Media Management. This firm focuses on improving clients' communication skills, helping them prepare for media interviews and presentations, among other things. Previously, Jones worked as a book editor, specializing in commercial nonfiction. More recently, she has published her own books: How to Wow: Proven Strategies for Presenting Your Ideas, Persuading Your Audience, and Perfecting Your Image (2008) and The Wow Factor: The 33 Things You Must

(and Must Not) Do to Guarantee Your Edge in Today's Business World (2010). Jones has said of these books, "My goal is to have every person who picks these up . . . feel more confident in their ability to present their best self—in any situation."

In the following excerpt from *The Wow Factor*, Jones discusses the types of work-place clutter that can get in the way of success on the job.

Vocabulary development

Underline these words as you read the classification essay.

inevitably: always; regularly **hazmat:** short for *hazardous materials*

hither and yon: from here to there

petri dish: a container used to grow bacteria

disproportionate: unusually large

cull: to reduce (in this case, cluttering items)

self-evident: clear; not needing an explanation

prone to: likely to do; inclined toward

communal: shared ficus: fig

whimsical: cute

aforementioned: previously mentioned

undermine: weaken paraphernalia: personal belongings

stowed: stored pristine: clean intermittent: regular When I was working in the nine-to-five world, there was a gentleman 1 down the hall whose office inevitably looked like it had been stirred up with a stick: a desk loaded with piles of paper, dirty cups, takeout containers, a Magic 8 Ball, and a keyboard that looked like you'd be better off wearing a hazmat suit when you touched it, more piles of papers on the desk, on the floor, on the chairs; shelving that was loaded with books, photos, and (bizarrely) pieces of sporting equipment, various items of clothing tossed hither and yon: jackets, sweaters, socks, shoes, hats.... One day, our boss walked by and said, "That office looks like the inside of a goat's stomach."

Not surprisingly, the occupant of the messy office wasn't with the 2 company much longer.

What I've learned since then is that my colleague had created a petri 3 dish of the three kinds of recognized office clutter. As identified by psychologist Sam Gosling, they are "identity clutter": photos of family, friends, pets, etc. that are designed to remind us we have a life outside the office; "thought and feeling regulators," which are chosen to change our mood: squeezable stress balls, miniature Zen gardens,² daily affirmation calendars;³ and "behavior residues"—old coffee cups, food wrappers, Post-its stuck to the keyboard, etc.

The trouble with having a disproportionate number of these items in and around your office is that it sends a message to those around you that you are out of control. As one of my CEO clients said to me after we'd walked past his junior report's disastrously messy office on the way to his company's conference room, "Doesn't she realize I notice—and care?"

Now I'm not saying you can't have a few personal items. And I am 5 certainly not going to mandate, as one of my clients has done, what kinds of flowers you are allowed to receive. In that office, your loved ones can send you a white orchid. That's it. But I am saying it's important to choose carefully, cull frequently, and clean daily.

In an effort to help you decide what stays and what goes, I have put 6 together two lists: Remove Immediately and Keep Selectively. Given its urgency, let's first look at those items I'd prefer you remove immediately.

Remove Immediately:

- <u>Leftover food</u>: food wrappers; dirty cups, plates, or silverware. While this may seem self-evident, I imagine that more than a few of you have found yourself at five o'clock speaking to your coworkers from
- 1. Magic 8 Ball: a fortune-telling toy that when shaken provides answers to questions
- 2. Zen gardens: miniature (in this case) gardens meant to create a peaceful setting
- 3. affirmation calendars: calendars that include encouraging sayings

IDENTIFY Underline the categories presented in this paragraph.

amid a small forest of half-empty coffee cups. (And I am hoping there are at least one or two of you who—like me—are still drinking absentmindedly from your 8 a.m. coffee at 5 p.m., a practice I'm prone to if not carefully supervised, which always makes my assistant exclaim with disgust.) All of these must go—again, if you're like me, for your own sake if no one else's. When you do remove them, please don't simply dump them in the sink of the shared kitchen down the hall. I know of one office that based its recent decision as to which of two equally qualified and experienced people was laid off on who was more prone to leaving their dirty dishes in the communal kitchen; deciding factors these days are, indeed, this small.

- Dead flowers/plants. The roses your ex gave you last Valentine's Day shouldn't become a dried flower arrangement on the shelf. That shedding ficus tree will be much happier if given to a friend with a green thumb.
- Stuffed animals/"whimsical" toys (such as the aforementioned Magic 8 Ball). While these can be helpful should your—or your boss's—kids come to the office, day to day they have the potential to undermine others' perceptions of the professionalism you bring to your work.

Keep Selectively:

- Grooming products. Hairbrushes, toothbrushes/paste, shaving and nail paraphernalia can all be handy to have on hand. Please don't, however, leave them in plain sight—or perform any personal maintenance in front of others.
- Extra pairs of shoes/a shirt. Again, both are useful on days when you have an unexpectedly important meeting, or uncooperative weather. They should, however, be stowed out of others' sight lines.
- Photos of family/friends. While these are lovely reminders of your life outside the office and can be great conversation starters, please do make sure everyone in each photo is fully clothed and behaving appropriately....

All this said, I do know that an office has to be worked in—and that 7 REFLECT Would you be worrying about keeping it pristine can, ultimately, detract from focusing on what you need to accomplish. For this reason, it can help to set aside fifteen minutes at the middle and end of each day to clear your desk/ chairs/floor of any accumulated clutter. A principle applied by airlines and luxury bus lines, these intermittent sweeps help keep things from piling up.

REFLECT Are there any other items you would put in the "Remove Immediately" or "Keep Selectively" categories?

willing to devote this much time each day to clearing your work space?

TIP For reading advice, see Chapter 1.

- 1. Double-underline the thesis statement.
- **2.** Within the categories "Remove Immediately" and "Keep Selectively," Jones presents six subcategories of things. Underline them.
- **3.** Do you agree with Jones's categorizations? For instance, do you see value in keeping any of the things Jones thinks should be removed immediately? Why or why not? Answers will vary.
- 4. Circle the transitions.

Respond to one of the following assignments in a paragraph or essay.

- **1.** Write about whether you are more of a keeper or a thrower-outer of things. Make sure to include examples of items you tend to keep or discard, and explain how you make your decisions.
- **2.** Write about classes of things you think should be kept or thrown out at home (as opposed to work). Explain the reasons for your decisions.
- **3.** Jones recommends avoiding a particular type of behavior: filling work spaces with needless clutter. Can you think of other behaviors that might keep people from reaching their potential at work or school? Give examples of these behaviors, and explain why they are problematic.

Write Your Own Classification

In this section, you will write your own classification based on one of the following assignments. For help, refer to the How to Write Classification checklist on page 205.

ESL Suggest to students that they write about something unique to their native cultures: foods, holidays, stores, vacation spots, housing, and so on.

ASSIGNMENT OPTIONS Writing about College, Work, and Everyday Life

Write a classification paragraph or essay on one of the following topics or on one of your own choice. If you responded to the idea journal prompt on page 190, you might develop that writing further.

COLLEGE

- Classify the types of resources available in your college's library, giving examples of things in each category. If you don't have time to visit the library, spend time looking at its Web site. (Some library Web sites include virtual tours.)
- Classify the course requirements for your program into different categories, such as easy, challenging, and very challenging. Your purpose could be to help a future student in the program understand what to expect.

Classify the types of students at your college, giving explanations and examples for each category. You might classify students by such things as their interests, their level of dedication to school, and their backgrounds (for example, older students returning to college and young students).

WORK

- Classify the different types of bosses, giving explanations and examples for each category.
- Classify the types of skills you need in your current job or a job you held in the past. Give explanations and examples for each category of skill.
- Look back at the paragraph on page 188 that illustrates the Four Basics of Good Classification. Based on your own experiences, think of at least two other ways in which workers might be classified. In writing about your classification, give examples of the types of jobs these workers would like and dislike.

EVERYDAY LIFE

- Using Lorenza Mattazi's paragraph as a guide (see p. 198), classify the types of music you enjoy.
- Write about the types of challenges you face in your everyday life, giving explanations and examples for each category.
- Find out about social-service volunteer opportunities in your community. Write about the types of opportunities that are available. Or research an organization that interests you, and write about the kinds of things it does.

ASSIGNMENT OPTIONS Reading and Writing Critically

Complete one of the following assignments, which ask you to apply the critical thinking, reading, and writing skills discussed in Chapter 1.

Writing Critically about Readings

Both Frances Cole Jones's "Don't Work in a Goat's Stomach" (p. 199) and Shari Beck's "A Classroom Distraction—and Worse" (p. 282) describe annoying behaviors (cluttering one's office in Jones's essay and texting instead of paying attention to others in Beck's). Read or review both of these essays, and then follow these steps:

- **1. Summarize** Briefly summarize the works, listing examples they include.
- **2. Analyze** Are there any other examples or details that the authors might have provided?
- **3. Synthesize** Using examples from both Jones's and Beck's essays and from your own experience, discuss various types of annoying behaviors, and explain why they are bothersome.

COMMUNITY

While attending college, CAROLINE **POWERS** volunteered for Girls, Inc., an organization that inspires girls to be "strong, smart, and bold." Getting more involved in college and community activities, as Caroline did, can help you feel more connected to others and can ever limprovo the chances that you'll stav in school.

For more on this story, ways to make community connections, and writing assignments, visit bedfordstmartins.com/realwriting.

TIP For a reminder of how to summarize, analyze, synthesize, and evaluate, see the Reading and Writing Critically box on pages 16–17.

TEACHING TIP If time is short, students might complete just one or two steps of this assignment.

4. Evaluate Which piece, Jones's or Beck's, do you think is more effective? Why? In writing your evaluation, you might look back on your responses to step 2.

Writing about Images

Study the visual below, and complete the following steps.

- **1. Read the image** Ask yourself: What purpose does the visual serve? How do the drawings in it help viewers understand the different types of barking? (For more information on reading images, see Chapter 1.)
- **2. Write a classification** Write a paragraph or essay classifying the types of behaviors that send signals to others. The signals can be from a pet or from a person. You might include or expand on the types of behaviors described in the visual.

TEACHING TIP

Dailyinfographic.com, from which this image was taken, presents in-depth visual explanations for a variety of interesting topics. Have your students explore the site's many categories and choose a topic they want to write about.

Writing to Solve a Problem

Read or review the discussion of problem solving in Chapter 1 (pp. 24–26). Then, consider the following problem.

You need a car loan. The loan officer gives you an application that asks for your monthly income and expenses. Because you find yourself short on money every month, you realize that you need to see how you spend your money. You decide to make a monthly budget that categorizes the kinds of expenses you have.

ASSIGNMENT: Working with a group or on your own, break your monthly expenses into categories, thinking of everything that you spend money on. Then,

TEAMWORK For more detailed guidance on group work, see *Practical Suggestions*.

review the expenses carefully to see which ones might be reduced. Next, write a classification paragraph or essay for the loan officer that classifies your monthly expenses, with examples, and ends with one or two suggestions about how you might reduce your monthly spending. You might start with this sentence:

My monthly expenses fall into	(number)	basic categories:
	, and	•

STEPS		DETAILS	
	Narrow and explore your topic. See Chapter 3.	Make the topic more specific.Prewrite to get ideas about the narrowed topic.	
	Write a topic sentence (paragraph) or thesis statement (essay). See Chapter 4.	 State your topic and your organizing principle or categories. 	
	Support your point. See Chapter 5.	 Come up with explanations/examples to support each category. 	
	Write a draft. See Chapter 6.	 Make a plan that puts the categories in a logical order. Include a topic sentence (paragraph) or thesis statement (essay) and all the supporting categories with explanations and examples. 	
	Revise your draft. See Chapter 7.	 Make sure it has all the Four Basics of Good Classification. Make sure you include transitions to move readers smoothly from one category to the next. 	
	Edit your revised draft. See Parts 4 through 7.	Correct errors in grammar, spelling, word use, and punctuation.	

Chapter Review

- 1. Classification is writing that <u>organizes</u>/sorts people or items into categories.
- 2. The organizing principle is how you sort the people or items.

A	What are the Four Basics of Good Classification?
I	t makes sense of a group of people or items by organizing them into
C	ategories.
I	t has a purpose for sorting the people or items.
I	t categorizes using a single organizing principle.
I	t gives detailed examples or explanations of what fits into each

LEARNING JOURNAL

Reread your idea journal entry (p. 190) about the kinds of students in this class or the kinds of friends you have. Make another entry about the same topic, using what you have learned about classification.

4.	Write sentences using the following vocabular	,
	disproportionate, prone to, whimsical, undermine.	Answers will vary.

reflect Write for 2 minutes about the kinds of responsibilities you have. Then, compare what you have written with what you wrote in response to the "write" prompt on page 188.

YOU KNOW THIS

You often ask, or are asked, for the meaning of something:

- When a friend tells you a relationship is serious, you ask what he means by serious.
- Another student calls a class you are considering terrible, and you ask what she means.

write for 2 minutes about how you would define a term to someone who had never heard it before.

13

Definition

Writing That Tells What Something Means

Understand What Definition Is

Definition is writing that explains what a term or concept means.

Four Basics of Good Definition

It tells readers what is being defined.

2 It presents a clear definition.

It uses examples to show what the writer means.

It gives details to support the examples.

In the following paragraph, the numbers and colors correspond to the Four Basics of Good Definition.

A 1 stereotype 2 is a conventional idea or image that is simplistic—and often wrong, particularly when it is applied to people or groups of people. Stereotypes can prevent us from seeing people as they really are because stereotypes blind us with preconceived notions about what a certain type of person is like. 3 For example, I had a stereotyped notion of Native Americans until I met my friend Daniel, a Chippewa Indian. 4 I thought all Indians wore feathers and beads, had long black hair, and avoided all contact with non–Native Americans because they resented their land being taken away. Daniel, however, wears jeans and T-shirts, and we talk about everything—even our different ancestries. After meeting him, I understood that my stereotype of Native Americans was completely wrong. 3 Not only was it wrong, but it set

reaching TIP This chapter is a good place to emphasize the benefits of vocabulary building and keeping a list of new words. Reinforce this practice by giving students a new word at the end of each class and challenging them to use the word during the next class.

up an us-them concept in my mind that made me feel that I, as a non-Native American, would never have anything in common with Native Americans. My stereotype would not have allowed me to see any Native American as an individual: I would have seen him or her as part of a group that I thought was all alike, and all different from me. From now on, I won't assume that any individual fits my stereotype; I will try to see that person as I would like them to see me: as myself, not a stereotyped image.

TEACHING TIP Ask students how they would define themselves through a sign. Do they consider themselves part of the 99 percent? Why or why not?

You can use definition in many practical situations.

On a math exam, you are asked to define *exponential* notation.

WORK On a job application, you are asked to choose one

word that describes you and explain why.

In a relationship, you define for your partner what

EVERYDAY In a relationship, you define for your partner what you mean by *commitment* or *communication*.

In college, writing assignments may include the word *define*, but they might also use phrases such as *explain the meaning of* _____ and *discuss the meaning of* _____. In these cases, use the strategies discussed in this chapter to complete the assignment.

TIP Once you have a basic statement of your definition, try revising it to make it stronger, clearer, or more interesting.

Main Point in Definition

In definition, the **main point** usually defines a term or concept. The main point is related to your purpose: to help your readers understand the term or concept as you are using it.

When you write your definition, do not just copy the dictionary definition; write it in your own words as you want your readers to understand it. To help you, you might first complete the following sentence:

MAIN POINT
IN DEFINITION

I want readers to understand that this term means . . .

Then, based on your response, write a topic sentence (paragraph) or thesis statement (essay). These main-point statements can take the following forms.

exposure to sunlight.

In this example, "Class" is the larger group the term belongs to. Mainpoint statements do not have to include a class, however. For example:

Now, look at this thesis statement about a related topic.

The thesis statement is broader in scope than the topic sentences, because it sets up a discussion of the larger subject of seasonal affective

WRITER AT WORK

walter scanlon: I take my writing seriously because I know that is how people will judge me.

(See Walter Scanlon's PROFILE OF SUCCESS on p. 215.)

TIP Sometimes, the same main point can be used for a paragraph and an essay, but the essay must develop this point in more detail. (See pp. 69–70.)

disorder. In contrast, the topic sentences consider one particular treatment for this disorder (phototherapy).

IDEA JOURNAL Write about what success means.

PRACTICE 1 Writing a Statement of Your Definition

For each of the following terms, write a definition statement using the pattern indicated in brackets. You may need to use a dictionary.

EXAMPLE:

Cirrhosis [term + class + detail]:

Cirrhosis is a liver disease often caused by alcohol abuse.

Answers will vary. Possible answers are shown.

- 1. Stress [term + class + detail]: Stress is an emotionally upsetting condition that can have physical effects.
- 2. Vacation [term + means/is + definition]: Vacation means taking time off to relax.
- 3. Confidence [term + class + detail]: Confidence is a feeling of trust or faith.
- **4.** Conservation [term + means/is + definition]: Conservation means preserving something from damage, loss, or neglect.
- 5. Marriage [term + means/is + definition]: Marriage is a union that requires respect, communication, and the ability to compromise.

Support in Definition

The paragraph and essay models on pages 211–12 use one topic sentence (paragraph) and the thesis statement (essay) from the Main Point section in this chapter. Both models include the **support** used in all definition writing: examples that explain what a term or concept means backed up by details about these examples. In the essay model, however, the major support points (examples) are topic sentences for individual paragraphs.

COMPUTER In computer classrooms, have students type one example into their computers and then move to the next computer, add an example for the topic there, and move to the next computer until there are three examples for each definition.

PRACTICE 2 Selecting Examples and Details to Explain the Definition

List three examples or pieces of information you could use to explain each of the following definitions.

EXAMPLE:

Insomnia means sleeplessness.

- a. hard to fall asleep
- b. wake up in the middle of the night
- c. wake up without feeling rested in the morning

Answers will vary. Possible answers are shown.

- 1. Confidence is feeling that you can conquer any obstacle.
 - a. You focus on chances of success.
 - b. You know you have the needed skills.
 - c. You let others know you are optimistic.
- 2. A real friend is not just someone for the fun times.
 - a. sticks up for you
 - b. helps when you need it
 - c. likes you for who you are
- **3.** A family is a group you always belong to, no matter what.
 - a. You can always count on family.
 - b. Distance, divorce, even death will not change it.
 - Sometimes, you might want to escape, but you cannot.
- **4.** Beauty is an important element in life that a viewer needs to be always looking for, even in unlikely places.
 - a. It is not perfect, but always contains a flaw or a potential to fade.
 - b. It is always changing across peoples' ages, locations, or lives.
 - c. It depends on each person being attentive.

DISCUSSION Ask students, "How has the definition of family changed in the last decade?"

PARAGRAPHS VS. ESSAYS IN DEFINITION

For more on the important features of definition, see the Four Basics of Good Definition on page 207.

Paragraph

Topic sentence

Support 1 (first example)

Support 2 (second example)

Support 3 (third example)

Concluding sentence

Phototherapy means treating seasonal depression through exposure to light. One form of phototherapy is spending time outdoors during the brightest time of day. Noon until 2 p.m. is ideal, but going outside earlier or later is better than not getting out at all. Because the sun sets earlier in the winter, it might be necessary to step outdoors before the end of a workday, perhaps during a lunch break. Alternatively, face a bright window for twenty to thirty minutes and absorb the rays. Another form of phototherapy is the use of a lamp that mimics outdoor light. Typically, people sit by these lamps as they read, work, or watch television. It is best to use them for at least twenty minutes a day. Apart from sunlight, the most effective form of phototherapy is the use of a light-therapy box. Some experts believe that light boxes allow users to absorb more light than is possible with the lamps, which tend to be smaller. However, both phototherapy lamps and light boxes are good ways to counter winter darkness and cloudy days in any season. Whether the solution is a lamp, a light box, or good old-fashioned sunlight, there is no reason to suffer from seasonal depression.

Main Point: Often, narrower for a paragraph than for an essay: While the topic sentence (paragraph) focuses on just one treatment for seasonal affective disorder, the thesis statement (essay) considers the disorder as a whole.

Examples Supporting the Main Point

Details about the Examples: Usually, 1 to 3 sentences per example for paragraphs and 3 to 8 sentences per example for essays.

Conclusion

Think Critically As You Write Definition

ASK YOURSELF

- Have I examined different definitions of this term or concept? (If not, research them and consider broadening or narrowing your definition based on what you learn. For more on finding and evaluating outside sources, see pp. 304–09.)
- Would someone who is unfamiliar with this term or concept understand it based on my definition and my supporting details and examples?

Thesis statement

Seasonal affective disorder (SAD) is a form of depression caused by inadequate exposure to sunlight in fall or winter. It can seriously affect the day the suffer from it.

Topic sentence 1 (first example)

One consequence of SAD is sleepiness and a lack of energy. SAD sufferers may find that they are sleeping longer yet are still drowsy during the day, especially during the afternoon. Connected to the drowsiness may be moodiness and an inability to concentrate. The latter effect can result in poorer performance at work and at other tasks. Those affected by SAD may also find that they move more slowly than usual and that all types of physical activity are more challenging than they used to be. All these difficulties can be a source sometimes worsening the depression.

Topic sentence 2 (second example)

Another consequence of SAD is loss of interest in work, hobbies, and other activities. To some extent, these symptoms may be connected to a lack of energy. Often, however, the feelings run deeper than that. Activities that once lifted one's spirits may have the opposite effect. For instance, a mother who at one time never missed her

child's soccer games might now see attending them as a burden. Someone who was once a top performer at work may find that it is all he or she can do to show up in the morning. Such changes in one's outlook can to a feeling of hopelessness.

Topic sentence 3 (third example)

The most serious consequence of SAD is withdrawal from interactions with others. SAD sufferers may find that they are no longer interested in going out with friends, and they may turn down requests to get together for movies, meals, or social events. They may even withdraw from family members, engaging less frequently in conversation or even spending time alone in their room. Furthermore, they may postpone or cancel activities, such as vacation trips, that might require them to interact with family for hours at a time. Withdrawal symptoms may also extend to the workplace, with SAD sufferers becoming less vocal at meetings or avoiding lunches or conversations with colleagues. Concern that family members or coworkers may be noticing such personality changes can cause or worsen anxiety in those with SAD.

Concluding paragraph

Because the effects of SAD can be so significant, it is important to address them as soon as possible. Fortunately, there are many good therapies for the condition, from drug treatment to greater exposure to sunlight, whether real or simulated through special lamps or light boxes. Often, such treatments have SAD sufferers feeling better quickly.

Organization in Definition

TIP For more on order of importance, see page 79.

The examples in definition are often organized by **order of importance**, meaning that the example that will have the most effect on readers is saved for last. This strategy is used in the paragraph and essay models on pages 211–12.

Transitions in definition move readers from one example to the next. Here are some transitions you might use in definition, although many others are possible, too.

Common Transitions in Definition

alternately first, second, third, and so on

another; one/another for example another kind for instance

PRACTICE 3 Using Transitions in Definition

Read the paragraph that follows, and fill in the blanks with transitions. You are not limited to the ones listed in the preceding box on page 211.

Answers may vary. Possible answers are shown.

Each year, Business Week publishes a list of the most family-friendly companies to work for. The magazine uses several factors to define the organizations as family-friendly.

One factor is whether the company has flextime, allowing employees to schedule work hours that better fit family needs.

For example, a parent might choose to work from 6:30 a.m. to 2:30 p.m. to be able to spend time with children.

Alternately, a parent might split his or her job with a colleague, so each person thus has more time for child care. Another, A second factor is whether family leave programs are encouraged. In addition to maternity leaves, for example, does the company encourage paternity leaves and leaves for care of elderly parents? Increasingly, companies are trying to become more family-friendly to attract and keep good employees.

READING SELECTIONS For further examples of and activities for definition, see Chapter 44.

Read and Analyze Definition

Reading examples of definition will help you write your own. In the first example, Walter Scanlon shows how he uses definition in his work as a program and workplace consultant.

The second example is a definition paragraph by a student, and the third example is a definition essay by a professional writer. As you read these pieces, pay attention to the vocabulary, and answer the questions in the margin. They will help you read critically.

PROFILE OF SUCCESS

Definition in the Real World

Background I grew up in a working-class neighborhood in New York City, in a family with a long history of alcohol problems. From my earliest days in grammar school, I assumed the role of class clown, somehow managing to just get by academically. By the time I reached high school, I was using drugs and alcohol, and I soon dropped out of school. For the next ten years, I was in and out of hospitals and prisons. When I was not in an institution, I lived on the streets—in abandoned buildings and deserted cars.

At one point after being released from yet another prison, I knew I had to do something different if I were to survive. Instead of looking for a drink or a drug this time out of jail, I joined Alcoholics Anonymous. That was the beginning of a new life for me.

I earned a GED, and took a pre-college reading course to improve my reading skills. Then, I took one college-level course, never intending to earn a degree but just to say I went to college. I did not do all that well in the first course, but I kept taking courses and got a bachelor's degree. I then went on for a master's and, finally, a Ph.D. Now, I run my own successful consulting business in which I work with companies' employee assistance programs, private individual clients, and families with a wide range of complex problems. I have also published two books and professional articles.

Degrees/Colleges B.A., Pace University; M.B.A., New York Institute of Technology; Ph.D., Columbus University

Employer Self

Writing at work I do all kinds of writing in my job: letters, proposals, presentations, articles, books, training programs, e-mails, memos, and more. I take my writing seriously because I know that is how people will judge me. Often, I have only a few minutes to present myself, so I work hard to make my point early on and very clearly. I believe that if you write clearly, you think clearly. In most situations, there are many factors that I cannot control, but I can always control my writing and the message it gives people.

I sometimes get e-mails that have all kinds of grammar mistakes in them, and believe me, I notice them and form opinions about the sender. (For an example of an e-mail that Walter received and his reaction to it, see Chapter 22, p. 378.)

How Walter uses definition As I work with clients, I often have to define a term so that they can understand it before I explain its relevance to the situation within which we are working.

Walter's Definition

In the following paragraph, Walter defines employee assistance program for a client.

Walter Scanlon
Program and Workplace
Consultant

RESOURCES For a discussion of how to use the profiles in Part 2, see *Practical Suggestions*.

Employee Assistance Program

The "employee assistance program" (EAP) is a confidential, early-intervention workplace counseling service designed to help employees who are experiencing personal problems. It is a social service within a work environment that can be found in most major corporations, associations, and government organizations. EAP services are always free to the employee and benefit the organization as much as the employee. Employees who are free of emotional problems are far more productive than those who are not. An employee whose productivity is negatively affected by a drinking problem, for example, might seek help through the EAP. He/she would be assessed by a counselor and then referred to an appropriate community resource for additional services. The *employee* is helped through the EAP while the *employer* is rewarded with improved productivity. An EAP is a win-win program for all involved.

- 1. Double-underline the topic sentence.
- 2. Fill in the blanks with the term defined in the paragraph and the definition.

Term: employee assistance program

Definition: a confidential, early-intervention workplace counseling service designed to help employees experiencing personal problems

- 3. Underline an example of what an EAP might do.
- **4.** Double-underline the sentence that makes a final observation about the topic.

Student Definition Paragraph

Corin Costas

What Community Involvement Means to Me

While at Bunker Hill Community College (BHCC), Corin Costas helped start a business club on campus. Later, he took on the leadership of SHOCWAVES (Students Helping Our Community with Activities), an organization focused on community-service projects. Costas initiated several projects, including Light One Little Candle, which asked BHCC students to give \$1 to have their names put on a paper candle. The money raised was donated to the Dana-Farber Cancer Institute to buy books for

children with cancer. After graduating from BHCC, Costas transferred to the University of Massachusetts Boston with a \$14,000 scholarship.

In the following paragraph, Costas defines SHOCWAVES and what it does.

SHOCWAVES is a student organization at Bunker Hill Community College. SHOCWAVES stands for Students Helping Our Community with Activities, and its mission is to get students involved with the community to become part of it by actively working in it in positive ways. Each year, SHOCWAVES is assigned a budget by the Student Activities Office, and it spends that budget in activities that help the community in a variety of ways. Some of the money is spent, for example, in fund-raising events for community causes. We have money to plan and launch a fund-raiser, which raises far more than we spend. In the process, other students and members of the community also become involved in the helping effort. We get to know lots of people, and we usually have a lot of fun—all while helping others. Recently, we have worked as part of the Charles River Cleanup, the Walk for Hunger, collecting toys for sick and needy children, and Light One Little Candle. While SHOCWAVES's mission is to help the community, it also benefits its members. Working in the community, I have learned so many valuable skills, and I always have something I care about to write about for my classes. I have learned about budgeting, advertising, organizing, and managing. I have also developed my creativity by coming up with new ways to do things. I have networked with many people, including people who are important in the business world. SHOCWAVES has greatly improved my life, and my chances for future success.

- 1. Double-underline the topic sentence.
- **2.** Underline the **examples** of what SHOCWAVES does for the community.
- **3.** Double-underline the sentence that makes a final observation about the topic.
- 4. Does this paragraph follow the Four Basics of Good Definition (p. 207)? Why or why not? Yes. Answers will vary.

Vocabulary development

Underline these words as you read the definition essay.

bemused: surprised and a bit confused

linguistic currency: typical speech

fractured syntax: language that breaks grammatical rules

patter: quick speech melting pot: a blending of people from different cultures

Anglo: a white, Englishspeaking person

contemporaries: peers phenomena: strange experiences or things

implicit: understood but not expressed directly

languorous: long and relaxing

hybrid: a combination of two things

wielded: held gaffes: mistakes

blunders: mistakes

inadvertently: by mistake; not intentionally

IDEA JOURNAL How important do you think it is for non-Hispanics in the United States to understand at least some Spanish?

SUMMARIZE In your own words, describe how Spanglish differs from the broken English of earlier immigrants to the United States.

PREDICT Based on the first part of the first sentence of paragraph 4, how do you suppose the authors will develop this paragraph?

Professional Definition Essay

Janice E. Castro with Dan Cook and Cristina Garcia Spanglish

Janice E. Castro is an assistant professor in the Medill New Media Program at Northwestern University. She worked as a reporter for *Time* for more than twenty years and started the magazine's health policy beat. After the publication of her book, *The American Way of Health: How Medicine Is Changing, and What It Means to You* (1994), she became the managing editor of *Time*'s online division.

Castro wrote "Spanglish" while at *Time* with the help of Dan Cook and Cristina Garcia. In the essay, she defines the language created when Spanish and English speakers come together in our blended culture.

In Manhattan a first-grader greets her visiting grandparents, happily exclaiming, "Come here, *siéntate*!" Her bemused grandfather, who does not speak Spanish, nevertheless knows she is asking him to sit down. A Miami personnel officer understands what a job applicant means when he says, "Quiero un part time." Nor do drivers miss a beat reading a billboard alongside a Los Angeles street advertising CERVEZA—SIX-PACK!

This free-form blend of Spanish and English, known as Spanglish, is common linguistic currency wherever concentrations of Hispanic Americans are found in the U.S. In Los Angeles, where 55 percent of the city's million inhabitants speak Spanish, Spanglish is as much a part of daily life as sunglasses. Unlike the broken-English efforts of earlier immigrants from Europe, Asia, and other regions, Spanglish has become a widely accepted conversational mode used casually—even playfully—by Spanish-speaking immigrants and native-born Americans alike.

Consisting of one part Hispanicized English, one part Americanized 3 Spanish, and more than a little fractured syntax, Spanglish is a bit like a Robin Williams comedy routine: a crackling line of cross-cultural patter straight from the melting pot. Often it enters Anglo homes and families through the children, who pick it up at school or at play with their young Hispanic contemporaries. In other cases, it comes from watching TV; many an Anglo child watching Sesame Street has learned uno dos tres almost as quickly as one two three.

Spanglish takes a variety of forms, from the Southern California 4 Anglos who bid farewell with the utterly silly "hasta la bye-bye" to the Cuban American drivers in Miami who parquean their carros. Some

Spanglish sentences are mostly Spanish, with a quick detour for an English word or two. A Latino friend may cut short a conversation by glancing at his watch and excusing himself with the explanation that he must "ir al supermarket."

Many of the English words transplanted in this way are simply har- 5 dier than their Spanish counterparts. No matter how distasteful the subject, for example, it is still easier to say "income tax" than impuesto sobre la renta. At the same time, many Spanish-speaking immigrants have adopted [such terms as] VCR, microwave, and dishwasher for what they view as largely American phenomena. Still other English words convey a cultural context that is not implicit in the Spanish. A friend who invites you to lonche most likely has in mind the brisk American custom of "doing lunch" rather than the languorous afternoon break traditionally implied by almuerzo.

Mainstream Americans exposed to similar hybrids of German, Chi- 6 nese, or Hindi might be mystified. But even Anglos who speak little or no Spanish are somewhat familiar with Spanglish. Living among them, for one thing, are 19 million Hispanics. In addition, more American high school and university students sign up for Spanish than for any other foreign language.

Only in the past ten years [in 1978-1988], though, has Spanglish 7 REFLECT Have you begun to turn into a national slang. Its popularity has grown with the explosive increases in U.S. immigration from Latin American countries. English has increasingly collided with Spanish in retail stores, offices and classrooms, in pop music, and on street corners. Anglos whose ancestors picked up such Spanish words as rancho, bronco, tornado, and incommunicado, [for instance] now freely use such Spanish words as gracias, bueno, amigo, and por favor.

Among Latinos, Spanglish conversations often flow easily from Span- 8 ESL If your class includes ish into several sentences of English and back.

Spanglish is a sort of code for Latinos: the speakers know Spanish, 9 but their hybrid language reflects the American culture in which they live. Many lean to shorter, clipped phrases in place of the longer, more graceful expressions their parents used. Says Leonel de la Cuesta, an assistant professor of modern languages at Florida International University in Miami: "In the U.S., time is money, and that is showing up in Spanglish as an economy of language." Conversational examples, taipiar (type) and winshiwiper (windshield wiper) replace escribir a màquina and limpiaparabrisas.

Major advertisers, eager to tap the estimated \$134 billion in spending power wielded by Spanish-speaking Americans, have ventured into Spanglish to promote their products. In some cases, attempts to sprinkle

encountered Spanglish? If so, what Spanglish slang are you familiar with?

- a number of Hispanic students, you might ask
- them to discuss whether Spanglish is as common in their conversation as the authors suggest. If they are willing, you might also have them give some examples of Spanglish in conversation. If you have ESL students whose native language is something other than Spanish, you might have them discuss the extent to which they use English terms
- 10 when speaking in their native language.

TIP For tools to build your vocabulary, visit the Student Site for Real Writing at bedfordstmartins.com/realwriting.

Spanish through commercials have produced embarrassing gaffes. A Braniff Airlines ad that sought to tell Spanish-speaking audiences they could settle back *en* (in) luxuriant *cuero* (leather) seats, for example inadvertently said they could fly without clothes (*encuero*). A fractured translation of the Miller Lite slogan told readers the beer was "Filling, and less delicious." Similar blunders are often made by Anglos trying to impress Spanish-speaking pals. But if Latinos are amused by mangled Spanglish, they also recognize these goofs as a sort of friendly acceptance. As they might put it, *no problema*.

- 1. Double-underline the thesis statement.
- 2. Circle the transitions used to introduce examples.
- 3. Do the writers provide enough examples of what they mean by *Spanglish*? If not, where could more examples be added? Answers will vary.
- 4. Look back at the final paragraph. Why do you suppose the authors chose to conclude in that way? Answers will vary. Possible answers: to show that Spanglish has become so popular that it is used even in advertising; to end on a humorous note

Respond to one of the following assignments in a paragraph or essay.

- 1. Do you have any personal experiences with the use of Spanglish? If so, give examples of the types of words you are familiar with and how they have been used. Also, discuss what using Spanglish means to you. For instance, if you are a native speaker of Spanish, does using Spanglish make you feel more connected to people from different cultures? Or is it just a fun way to communicate?
- **2.** Define an expression common to your group of friends, your workplace, your region, or some other group to which you belong. Make sure to give several examples of how the expression is used.
- **3.** Define a concept that is important to a culture to which you belong. You might, for example, choose to define *success*, *diversity*, or some other concept in terms of U.S. culture. Explain why the concept is important, and give examples.

Write Your Own Definition

In this section, you will write your own definition based on one of the following assignments. For help, refer to the How to Write Definition checklist on page 223.

TIP For reading advice, see Chapter 1.

ASSIGNMENT OPTIONS Writing about College, Work, and Everyday Life

Write a definition paragraph or essay on one of the following topics or on one of your own choice. If you responded to the idea journal prompt on page 210, you might develop that writing further.

ESL Suggest that students define a common term in their language that has no direct counterpart in English.

COLLEGE

- How would you define a good student or a bad student? Give examples to explain your definition.
- Identify a difficult or technical term from a class you are taking. Then, define the term, and give examples of different ways in which it might be used.
- Define *learning*, not only in terms of school, but in terms of all the ways in which it can occur. You might start by writing down the different types of learning that go on both in school and in other settings. Then,
 - (1) write a main point that defines learning in a broader way, and
 - (2) support your definition with the examples you came up with.

WORK

- Define a satisfying job, giving explanations and examples.
- If you have ever held a job that used unusual or interesting terminology, write about some of the terms used, what they meant, and their function on the job.
- In many businesses, it's common for workers to use jargon, which can be defined either as insider language or as vague, empty, or overused expressions. Some examples are "going the extra mile," "being on the same page," and "thinking outside the box." Give examples of work jargon that you've heard of, provide definitions, and explain why the jargon is vague or ineffective. Then, for each expression, suggest more specific words.

EVERYDAY LIFE

- What does it mean to be a good friend? Provide a definition, giving explanations and examples.
- What does it mean to be a good parent? Provide a definition, giving explanations and examples.
- Ask three (or more) people to tell you what they think *community service* means. Take notes on their responses, and then write a paragraph or an essay combining their definitions with your own.

ASSIGNMENT OPTIONS Reading and Writing Critically

Complete one of the following assignments, which ask you to apply the critical thinking, reading, and writing skills discussed in Chapter 1.

corin costas (see the paragraph on p. 217) led a community-service organization while attending college. Getting more involved in college and community activities, as Corin did, can help you feel more connected to others and can even improve the chances that you will stay in school.

For more on this story, ways to make community connections, and writing assignments, visit bedfordstmartins.com/realwriting.

TEACHING TIP Critical thinking is a term that encompasses many different definitions and instructional approaches. For insightful articles and other resources on these topics, visit www.criticalthinking.org.

TIP For a reminder of how to summarize, analyze, synthesize, and evaluate, see the Reading and Writing Critically box on pages 16–17.

TEACHING TIP This sinkhole opened up in Guatemala City in 2010 and swallowed several buildings. Experts believe that rainfall from a tropical storm may have been part of the cause. Consider sharing this information with students. Also, ask them what other types of phenomena might be defined visually.

Writing Critically about Readings

Both Janice E. Castro's "Spanglish" (p. 218) and Amy Tan's "Fish Cheeks" (p. 126) describe the effects of bringing two different cultures together. Read or review both of these essays, and then follow these steps:

- **1. Summarize** Briefly summarize the works, listing examples they include.
- 2. Analyze What questions do the essays raise for you?
- **3. Synthesize** Using examples from both essays and from your own experience, describe ways in which different cultures blend (as in "Spanglish") or maintain distance from each other (as in "Fish Cheeks"). What factors seem to be behind this blending or distancing?
- **4.** Evaluate Which essay do you think is more effective? Why? In writing your evaluation, look back on your responses to step 2.

Writing about Images

Study the photograph below, and complete the following steps.

1. Read the image You could explain to a friend what a sinkhole is, or you could show your friend the picture below. What makes this photograph such a striking visual definition? (For more on reading images, see Chapter 1.)

2. Write a definition Write a paragraph or essay that explains what a visual definition is. To support your definition, use examples of any types of images you are familiar with—signs, advertisements, photographs, and so on.

Writing to Solve a Problem

Read or review the discussion of problem solving in Chapter 1 (pp. 24–26). Then, consider the following problem.

A recent survey asked business managers what skills or traits they value most in employees. The top five responses were (1) motivation, (2) interpersonal skills, (3) initiative, (4) communication skills, and (5) maturity.

You have a job interview next week, and you want to be able to present yourself well. Before you can do that, though, you need to have a better understanding of the five skills and traits noted above and what examples you might be able to give to demonstrate that you have them. TIP For tools to use in getting a job, visit the Student Site for Real Writing at bedfordstmartins.com/realwriting.

ASSIGNMENT: Working in a group or on your own, come up with definitions of three of the five terms, and think of some examples of how the skills or traits could be used at work. Then, do one of the following assignments. You might begin with the following sentence:

TEAMWORK For more detailed guidance on group work, see *Practical Suggestions*.

I am a	person who is	(or has)	

For a paragraph: Choose one of the terms, and give examples of how you have demonstrated the trait.

For an essay: Write about how you have demonstrated the three traits.

CHECKLIST: HOW TO WRITE DEFINITION		
STEPS	DETAILS	
Narrow and explore your topic.See Chapter 3.	Make the topic more specific.Prewrite to get ideas about the narrowed topic.	
 Write a topic sentence (paragraph) or thesis statement (essay). See Chapter 4. 	State the term that you are focusing on, and provide a definition for it.	
Support your point. See Chapter 5.	Come up with examples and details to explain your definition.	
☐ Write a draft. See Chapter 6.	 Make a plan that puts the examples in a logical order. Include a topic sentence (paragraph) or thesis statement (essay) and all the supporting examples and details. 	

STEPS	DETAILS	
Revise your draft. See Chapter 7.	 Make sure it has all the Four Basics of Good Definition Make sure you include transitions to move readers smoothly from one example to the next. 	
Edit your revised draft. See Parts 4 through 7.	 Correct errors in grammar, spelling, word use, and punctuation. 	

Chapter Review

- 1. Definition is writing that explains what a term or concept means.
- 2. What are the Four Basics of Good Definition?

 It tells readers what is being defined.

 It presents a clear definition.

 It uses examples to show what the writer means.

 It gives details to support the examples.
- **3.** Write sentences using the following vocabulary words: bemused, contem-

poraries, phenomena, hybrid, blunders. Answers will vary.

LEARNING JOURNAL

Reread your idea journal entry from page 210. Write another entry on the same topic, using what you have learned about definition.

reflect Think of a term whose meaning you know. Write for 2 minutes about how you would define the term for someone who isn't familiar with it. Compare your response to what you wrote for the "write" prompt on page 207.

YOU KNOW THIS

You frequently compare and contrast different items or places:

- You compare different pairs of jeans before deciding which pair to buy.
- You compare two Web sites for the best price before buying a new computer.

write for 2 minutes about what you know about making comparisons and when you make them.

14

Comparison and Contrast

Writing That Shows Similarities and Differences

Understand What Comparison and Contrast Are

Comparison is writing that shows the similarities among subjects—people, ideas, situations, or items; **contrast** shows the differences. In conversation, people often use the word *compare* to mean either compare or contrast, but as you work through this chapter, the terms will be separated.

Compare = Similarities

Contrast = Differences

TEACHING TIP Point out to students that some professors in other disciplines ask for comparison when they really mean both comparison and contrast. Suggest that they ask professors to clarify questions that ask for comparisons.

Four Basics of Good Comparison and Contrast

It uses subjects that have enough in common to be compared/contrasted in a useful way.

It serves a purpose—to help readers make a decision, to help them understand the subjects, or to show your understanding of the subjects.

It presents several important, parallel points of comparison/contrast.

It arranges points in a logical order.

In the following paragraph, written for a biology course, the numbers and colors correspond to the Four Basics of Good Comparison and Contrast.

4 Points arranged in a logical order

TIP This paragraph uses point-by-point organization. For more information, see page 232.

1 Although frogs and toads are closely related, 2 they differ in appearance, in habitat, and in behavior. 3 The first major difference is in the creatures' physical characteristics. Whereas most frogs have smooth, slimy skin that helps them move through water, toads tend to have rough, bumpy skin suited to drier surroundings. Also, whereas frogs have long, muscular hind legs that help them leap away from predators or toward food, most toads have shorter legs and, therefore, less ability to move quickly. Another physical characteristic of frogs and toads is their bulging eyes, which help them see in different directions. This ability is important, because neither creature can turn its head to look for food or spot a predator. However, frogs' eyes may protrude more than toads'. The second major difference between frogs and toads is their choice of habitat. Frogs tend to live in or near ponds, lakes, or other sources of water. In contrast, toads live mostly in drier areas, such as gardens, forests, and fields. But, like frogs, they lay their eggs in water. The third major difference between frogs and toads concerns their behavior. Whereas frogs may be active during the day or at night, most toads keep a low profile until nighttime. Some biologists believe that it is nature's way of making up for toads' inability to escape from danger as quickly as frogs can. At night, toads are less likely to be spotted by predators. Finally, although both frogs and toads tend to live by themselves, toads, unlike frogs, may form groups while they are hibernating. Both creatures can teach us a lot about how animals adapt to their environments, and studying them is a lot of fun.

A froq

A toad

Seeing Comparison and Contrast

write

- What similarities and differences do you see among these three photographs by Asia Kepka?
- Looking at each photo individually, what comparisons and contrasts do you see being set up within each one?
- Choose two photos of the series, and compare and contrast the mood or atmosphere in each photo.
- What do you see as the differences between a real friend and an imaginary one?

TEACHING TIP These images are from a series of self-portraits by photographer Asia Kepka entitled *Bridget* and *I* (Bridget being the mannequin). Kepka has said of the series, "This project became my visual diary—[a] place where I record my dreams, my past, my everyday life." Ask students to create and write about their own visual diaries.

WRITER AT WORK

BRAD LEIBOV: Without good written proposals, I don't get jobs.

(See Brad Leibov's PROFILE OF SUCCESS on p. 236.)

IDEA JOURNAL Write about some of the differences between dogs and cats as pets.

Many situations require you to understand similarities and differences.

COLLEGE	In a pharmacy course, you compare and contrast the side effects of two drugs prescribed for the same illness.
WORK	You are asked to contrast this year's sales with last year's.
EVERYDAY LIFE	At the supermarket, you contrast brands of the same food to decide which to buy.

In college, writing assignments may include the words *compare and contrast*, but they might also use phrases such as *discuss similarities and differences*, *how is X like* (or *unlike*) Y?, or *what do X and Y have in common?* Also, assignments may use only the word *compare*.

Main Point in Comparison and Contrast

The **main point** should state the subjects you want to compare or contrast and help you achieve your purpose. (See the second of the Four Basics of Good Comparison and Contrast, p. 225.)

To help you discover your main point, complete the following sentence:

AND CONTRAST

I want my readers to ______

after reading my comparison or contrast.

Then, write a topic sentence (paragraph) or thesis statement (essay) that identifies the subjects and states the main point you want to make about them. Here is an example of a topic sentence for a paragraph:

Compared with conventional cars, hybrid cars show less mechanical wear over time.

[Purpose: to help readers understand mechanical differences between conventional cars and hybrids.]

Remember that the topic for an essay can be a little broader than one for a paragraph.

A hybrid car is a better choice than a conventional car, even one with low gas mileage.

[Purpose: to help readers decide which type of car to buy.]

Whereas the topic sentence focuses on the mechanical advantages of hybrid cars, the thesis statement sets up a broader discussion of these cars' benefits.

TIP Sometimes, the same main point can be used for a paragraph and an essay, but the essay must develop this point in more detail. (See p. 69–70.)

Support in Comparison and Contrast

The paragraph and essay models on pages 230–31 use the topic sentence (paragraph) and thesis statement (essay) from the Main Point section in this chapter. Both models include the **support** used in all comparison and contrast writing: points of comparison/contrast backed up by details. In the essay model, however, the points of comparison/contrast are topic sentences for individual paragraphs.

The support in comparison/contrast should show how your subjects are the same or different. To find support, many people make a list with two columns, one for each subject, with parallel points of comparison or contrast.

TOPIC SENTENCE/THESIS STATEMENT: The two credit cards I am considering offer different financial terms.

BIG CARD	MEGA CARD
no annual fee	\$35 annual fee
\$1 fee per cash advance	\$1.50 fee per cash advance
30 days before interest charges begin	25 days before interest charges begin
15.5% finance charge	17.9% finance charge

Choose points that will be convincing and understandable to your readers. Explain your points with facts, details, or examples.

TEACHING TIP You might mention that credit card offers provide a good opportunity for students to practice their critical-thinking skills. Card Hub (www.cardhub.com) has tools for comparing credit cards, as well as advice for college students about identifying the cards that best suit their budgets and needs.

PRACTICE 1 Finding Points of Contrast

Each of the following items lists some points of contrast. Fill in the blanks with more points.

EXAMPLE:

Contrast hair lengths

Long hair	Short hair
takes a long time to dry	dries quickly
can be worn a lot of ways	only one way to wear it
does not need to be cut often	needs to be cut every five weeks
gets tangled, needs brushing	low maintenance

PARAGRAPHS VS. ESSAYS IN COMPARISON AND CONTRAST

For more on the important features of comparison and contrast, see the Four Basics of Good Comparison and Contrast on page 225.

Paragraph Form Main Point: Often, narrower for a paragraph than for an essay: While the topic sentence (paragraph) focuses **Topic sentence** Compared with conventional cars, hybrid cars show less on the mechanical advantages mechanical wear over time. In conventional vehicles, braking of hybrid cars, the thesis Support 1 and idling place continual stress on the engine and brakes. When statement (essay) sets up a (first point of braking, drivers of such vehicles rely completely on the friction of broader discussion of these comparison/ contrast) cars' benefits. the brake pads to come to a stop. As a result, brakes wear down over time, sometimes rather quickly. Additionally, these vehicles burn gas even while idling, making the engine use unnecessary Support 2 energy and fuel. In contrast, hybrid cars are designed to reduce (second point Support for the Main Point brake and engine wear. Say that a hybrid driver is moving from a of comparison/ (Points of Comparison/ sixty-mile-per-hour stretch of highway to a twenty-five-mile-percontrast) Contrast) hour off-ramp. When he or she brakes, the hybrid's motor goes into reverse, slowing the car and allowing the driver to place less strain on the brakes. Then, as the driver enters stop-and-start traffic in town, the electric motor takes over from the gas engine, improving **Details about Each Point** energy efficiency during idling and reducing engine wear. These Concluding of Comparison / Contrast: mechanical benefits of hybrids can lead to lower maintenance sentence Usually, 1 to 3 sentences per costs, a significant improvement over conventional cars. point for paragraphs and 3 to 8 sentences per point for essays. Conclusion

Think Critically As You Write Comparison and Contrast

ASK YOURSELF

- Have I provided all the information needed to fulfill my purpose: to help readers make a decision or to understand the subjects being compared or contrasted? (This information includes all the important similarities or differences between the subjects, as well as details about these similarities or differences.)
- If my information about similarities or differences feels "thin," might consulting outside sources help me find new details? (For more on finding and evaluating sources, see pp. 304–09.)

1

They are too expensive. For the last two years, while trying to keep my dying 1999 Chevy on the road, these words have popped into my head every time I have thought about purchasing a hybrid car. **Thesis statement** I have done some research, I am finally convinced: A hybrid car is a better choice than a conventional car, even one with low gas mileage.

The first advantage of hybrid cars over conventional cars is that buyers can get tax breaks and other hybrid-specific benefits. Although federal tax crepurchasers expired in 2010, several st Colorado, Louisiana, Maryland, and continue to offer such credits. Also, in Arizona, Florida, and several other states, hybrid drivers are allowed to use the less congested high-occupancy vehicle (HOV) lanes

and several other states, hybrid drivers are allowed to use the less congested high-occupancy vehicle (HOV) lanes even if the driver is the only person on board. Additional benefits for hybrid drivers include longer warranties than those offered for conventional cars and, in some states and cities, rebates, reduced licensing fees, and free parking. None of these benefits are offered to drivers of conventional cars.

The second advantage of hybrid cars over conventional cars is that they save money over the long term. In addition to using less fuel, hy less mechanical wear over time, reducing n costs. When braking, drivers of convention

contrast) completely on the friction of the brake pads to come to a stop. As a result, brakes wear down over time, sometimes rather quickly. Additionally, these vehicles burn gas even while idling, making the engine use unnecessary energy and fuel. In contrast, when hybrid drivers hit the brakes, the car's motor goes into reverse, slowing the car and allowing the driver to place less strain on the brakes. Then, as the driver enters stop-and-start traffic in

town, the electric motor takes over from the improving energy efficiency during idling ar engine wear.

Topic sentence 3 (third point of comparison/ contrast)

The most important benefit of hybrid cars over conventional cars is that they have a lower impact on the environment. Experts estimate that each gallon of gas burned by conventional motor vehicles produces 28 pounds of carbon dioxide (CO₂), a greenhouse gas

3

that is a major contributor to global warming. Because hybrid cars use about half as much gas as conventional vehicles, they reduce pollution and greenhouse gases by at least 50 percent. Some experts estimate that they reduce such emissions by as much as 80 percent. The National Resources Defense Council says that if hybrid vehicles are widely adopted, annual reductions in emissions could reach 450 million metric tons by the year 2050. This reduction would be equal to taking 82.5 million cars off the road.

Concluding paragraph

Although hybrid cars are more expensive than conventional cars, they are well worth it. From an economic standpoint, they save on fuel and maintenance costs. But, to me, the best reasons for buying a hybrid are ethical: By switching to such a vehicle, I will help reduce my toll on the environment. So goodbye, 1999 Chevy, and hello, Toyota Prius!

1.	Contrast sports	
	Basketball	Soccer
	baskets = points	goals = points
	Answers will vary but should	ball is kicked
	focus on differences.	
2.	Contrast pets	
	Dogs	Cats
	bark	
		independent
Eac	ACTICE 2 Finding Points of Co	omparison points of comparison. Fill in the blanks
1.	Compare sports	
	Basketball	Soccer
	team sport	team sport
	Answers will vary but should	
	focus on similarities.	
2.	Compare pets	
	. (1) 이 경영에 가는 것이 되었다. 그런	
	Dogs	Cats
	shed fur	Cats
		Cats

Organization in Comparison and Contrast

TEACHING TIP Point out that in a whole-to-whole essay, there usually needs to be a strong transition when the essay moves from subject 1 to subject 2.

Comparison/contrast can be organized in one of two ways: A **point-by-point** organization presents one point of comparison or contrast between the subjects and then moves to the next point. (See the essay model on page 231.) A **whole-to-whole** organization presents all the points of comparison or contrast for one subject and then all the points for the next subject. (See the paragraph model on page 230.) Consider which organization will best explain the similarities or differences to your readers. Whichever organization you choose, stay with it throughout your writing.

PRACTICE 3 Organizing a Comparison/Contrast

The first outline that follows is for a comparison paper using a whole-to-whole organization. Reorganize the ideas and create a new outline (outline 2) using a point-by-point organization. The first blank has been filled in for you.

The third outline is for a contrast paper using a point-by-point organization. Reorganize the ideas, and create a new outline (outline 4) using a whole-to-whole organization. The first blank in outline 4 has been filled in for you.

1. Comparison paper using whole-to-whole organization

Main point: My daughter is a lot like I was at her age.

a. Me

Not interested in school

Good at sports

Hard on myself

b. My daughter

Does well in school but doesn't study much or do more than the minimum

Plays in a different sport each season

When she thinks she has made a mistake, she gets upset with herself

Comparison paper using point-by-point organization

Main point: My daughter is a lot like I was at her age.

Me: Not interested in school	
My daughter:	
Me:	
My daughter:	
Me:	
My daughter:	

Main point: My new computer is a great improvement over my old one.

a. Weight and portability

New computer: small and light

Old computer: heavy, not portable

b. Speed

New computer: fast
Old computer: slow

C.	Cost
	New computer: inexpensive
	Old computer: expensive
Co	ontrast paper using whole-to-whole organization
Ma	ain point: My new computer is a great improvement over my old one
a.	New computer small and light
b.	Old computer

TIP For more on order of importance, see page 79.

Comparison/contrast is often organized by **order of importance**, meaning that the most important point is saved for last. This strategy is used in the essay model on page 231.

Transitions in comparison/contrast move readers from one subject to another and from one point of comparison or contrast to the next.

COMPARISON CONTRAST both like/unlike most important similarity one similarity/another similarity similarly CONTRAST in contrast most important difference now/then one difference/another difference unlike while

PRACTICE 4 Using Transitions in Comparison and Contrast

Read the paragraph that follows, and fill in the blanks with transitions. You are not limited to the ones listed in the preceding box.

Answers may vary. Possible answers are shown.

Modern coffee shops share many similarities with the coffeehouses that opened hundreds of years ago in the Middle East and Europe.

One similarity is that the coffeehouses of history, like modern cafés, were popular places to socialize. In sixteenth-century Constantinople (now Istanbul, Turkey) and in seventeenth- and eighteenth-century London, customers shared stories, information, and opinions about current events, politics, and personal matters. The knowledge shared at London coffeehouses led customers to call these places "Penny Universities," a penny being the price of admission. Another similarity is that the old coffeehouses, like today's coffee shops, were often places of business. However, although most of today's coffee-shop customers work quietly on their laptops, customers of the old shops openly, and sometimes loudly, discussed business and sealed deals. In fact, for more than seventy years, traders for the London Stock Exchange operated out of coffeehouses. The most important similarity between the old coffeehouses and modern coffee shops is that they both increased the demand for coffee and places to drink it. In 1652, a former servant from western Turkey opened the first coffeehouse in London. As a result of its popularity, many more coffeehouses soon sprouted up all over the city, and within a hundred years there were more than 500 coffeehouses in London. Similarly, in recent years the popularity of Starbucks, and its shops, spread rapidly throughout the United States.

Read and Analyze Comparison and Contrast

Reading examples of comparison and contrast will help you write your own. In the first example, Brad Leibov, president of an urban planning and development firm, shows how he uses comparison and contrast on the job.

The second example is a comparison/contrast paragraph by a student, and the third example is a comparison/contrast essay by a professional writer.

As you read these pieces, pay attention to the vocabulary, and answer the questions in the margin. They will help you read critically.

READING SELECTIONS For further examples of and activities for comparison and contrast, see Chapter 45.

PROFILE OF SUCCESS

Brad Leibov President, New Chicago Fund, Inc.

RESOURCES For a discussion of how to use the profiles in Part 2, see *Practical Suggestions*.

Vocabulary development

Underline these words as you read.

liaison: someone who acts as a communication link hazardous: dangerous amenities: attractive features receptacles: containers poised: in this sense, ready; also means natural and balanced, relaxed

Comparison and Contrast in the Real World

Background In high school, I put very little effort into completing my coursework. When I first enrolled at Oakton Community College, I was not motivated and soon dropped all my courses. An instructor from Project Succeed contacted me after my first year, and this program helped me recognize that I really wanted to put in the effort necessary to succeed.

A few years later, I earned a B.A. degree from a four-year university. After working for a few years in community development, I was accepted into a top-tier graduate program in urban planning and policy, from which I graduated with a perfect grade-point average. Later, I started my own urban planning and development company to help revitalize inner-city commercial areas.

Degrees/Colleges B.A., DePaul University; M.A., University of Illinois, Chicago

Writing at work I write contracts, proposals, marketing materials, etc.

How Brad uses comparison and contrast I often give examples of how my company can improve a community—kind of before-and-after contrasts.

Brad's Comparison and Contrast

The following paragraph describes how Brad's company restored a special service area (SSA), a declining community targeted for improvements.

New Chicago Fund, Inc., is an expert at advising and leading organizations through all the steps necessary to establish an SSA with strong local support. Our experience acting as liaison among various neighborhood groups and individuals affected by an SSA helps us plan for and address the concerns of residents and property owners. In 2005, New Chicago Fund assisted the Uptown Community Development Corporation with establishing an SSA in Uptown, Chicago. Uptown's commercial area was estimated to lose approximately \$506 million annually in consumer expenditures to neighboring commercial districts and suburban shopping centers. Community leaders recognized that Uptown's sidewalks were uninviting with litter, hazardous with unshoveled snow, and unappealing in the lack of pedestrian-friendly amenities found in neighboring commercial districts. The Uptown SSA programs funded the transformation of the commercial area. The sidewalks are regularly cleaned and are litter-free. People no longer have to walk around uncleared snow mounds and risk slipping on the ice because maintenance programs provide fullservice clearing. Additionally, SSA funds provided new pedestrian-friendly amenities such as benches, trash receptacles, flower planters, and streetpole banners. The Uptown area is now poised for commercial success.

- 1. Double-underline the topic sentence.
- 2. What subjects are being contrasted? an area before and after SSA improvements; sidewalk features
- 3. What is the purpose of the paragraph? to sell services of New Chicago fund
- 4. What are the points of contrast? buildings, street activities, feelings of residents

Student Comparison/Contrast Paragraph

Said Ibrahim

Eyeglasses vs. Laser Surgery: Benefits and Drawbacks

Although both eyeglasses and laser surgery can address vision problems successfully, each approach has particular benefits and drawbacks. Whereas one pair of eyeglasses is reasonably priced in comparison with laser surgery, 1 eyeglass prescriptions often change over time, requiring regular lens replacements. As a result, 2 over the wearer's lifetime, costs of eyeglasses can exceed \$15,000. On the positive side, 3an accurate lens prescription results in clear vision with few or no side effects. Furthermore, ⁴glasses of just the right shape or color can be a great fashion accent.[In contrast to eveglasses, laser vision correction often has to be done only once. Consequently, 2 although the costs average \$2,500 per eye, the patient can save thousands of dollars over the following years. On the downside,3 some recipients of laser surgery report difficulties seeing at night, dry eyes, or infections. Fortunately, these problems are fairly rare. The final advantage of laser surgery applies to those who are happy to forgo the fashion benefits of eyeglasses. Most laser-surgery patients no longer have to wear any glasses other than sunglasses until later in life. At that point, they may need reading glasses. All in all, we are fortunate to live in a time when there are many good options for vision correction. Choosing the right one is a matter of carefully weighing the pros and cons of each approach.

Vocabulary development

Underline these words as you read.

laser: a concentrated beam of light; in this case it is used to reshape part of the eye

reasonably: not excessively forgo: go without

TIP For tools to build your vocabulary, visit the Student Site for Real Writing at bedfordstmartins.com/realwriting.

- 1. Double-underline the topic sentence.
- **2.** Is the **purpose** of the paragraph to help readers make a decision, to help them understand the subjects better, or both? both
- **3.** Underline **each point of contrast** in the sample paragraph. Give each parallel, or matched, point the same number.
- **4.** Which organization (point by point or whole to whole) does Ibrahim use? whole to whole
- **5.** Circle the **transitions** in the paragraph.

Professional Comparison/Contrast Essay

Mark Twain

Two Ways of Seeing a River

Born Samuel Langhorne Clemens, Mark Twain (1835–1910) is one of America's most admired writers, praised as much for his story-telling as for his humor and wit. He was also a sharp observer of society and politics, and he was known to criticize racial inequality, political corruption, and other injustices.

Twain, a native of Missouri, discovered his love for writing while working as a typesetter and editorial assistant at a local newspaper. Later, he took a job as a river pilot's apprentice. Among the many books Twain was to publish in the following years were *Tom Sawyer* (1876), *Huckleberry Finn* (1884), and *Life*

on the Mississippi (1883), from which the following excerpt was taken.

In this essay, Twain paints a vivid picture of the Mississippi River. He also describes an upsetting change to this picture, which occurred during his time as a pilot's apprentice.

Now when I had mastered the language of this water and had come to know every trifling feature that bordered the great river as familiarly as I knew the letters of the alphabet, I had made a valuable acquisition. But I had lost something, too. I had lost something which could never be restored to me while I lived. All the grace, the beauty, the poetry, had gone out of the majestic river! I still kept in mind a certain wonderful sunset which I witnessed when steamboating was new to me. A broad expanse of the river was turned to blood; in the middle distance the red hue brightened into gold, through which a solitary log came floating, black and conspicuous; in one place a long, slanting mark lay sparkling upon the water; in another the surface was broken by boiling, tumbling rings that were as many-tinted as an opal; where the ruddy flush was faintest was a smooth spot that was covered with graceful circles and radiating

Vocabulary development

Underline these words as you read the comparison/contrast essay.

mastered: had become skilled in

trifling: small; of little importance

majestic: great; dignified

hue: color; tint solitary: single

conspicuous: clearly visible opal: a gemstone that, typically, is made up of many colors

ruddy: rosv

radiating: extending outward

somber: sad bough: limb

unobstructed splendor: unblocked (view of) beauty marvels: wonderful things bewitched: under a spell;

fascinated

rapture: joy; ecstasy
wrought: caused to appear
bluff reef: a type of sandbar
that is difficult to see and,
therefore, dangerous to
boats

yonder: in the distance shoaling up: becoming shallow

snag: a tree or tree part in the water; it can damage boats

compassing: enabling; providing direction for break: a wave (in this case)

break: a wave (in this case) **unwholesome:** unhealthy

lines, ever so delicately traced; the shore on our left was densely wooded, and the somber shadow that fell from this forest was broken in one place by a long, ruffled trail that shone like silver; and high above the forest wall a clean-stemmed dead tree waved a single leafy bough that glowed like a flame in the unobstructed splendor that was flowing from the sun. There were graceful curves, reflected images, woody heights, soft distances, and over the whole scene, far and near, the dissolving lights drifted steadily, enriching it every passing moment with new marvels of coloring.

REFLECT What do these descriptions say about Twain's early feelings in relation to the river?

I stood like one bewitched. I drank it in, in a speechless rapture. The world was new to me and I had never seen anything like this at home. But as I have said, a day came when I began to cease from noting the glories and the charms which the moon and the sun and the twilight wrought upon the river's face; another day came when I ceased altogether to note them. Then, if that sunset scene had been repeated, I should have looked upon it without rapture and should have commented upon it inwardly after this fashion: "This sun means that we are going to have wind tomorrow; that floating log means that the river is rising, small thanks to it; that slanting mark on the water refers to a bluff reef which is going to kill somebody's steamboat one of these nights, if it keeps on stretching out like that; those tumbling 'boils' show a dissolving bar and a changing channel there; the lines and circles in the slick water over yonder are a warning that that troublesome place is shoaling up dangerously; that silver streak in the shadow of the forest is the 'break' from a new snag and he has located himself in the very best place he could have found to fish for steamboats; that tall dead tree, with a single living branch, is not going to last long, and then how is a body ever going to get through this blind place at night without the friendly old landmark?"

 IDENTIFY Underline the sentence in this paragraph that marks the change in Twain.

No, the romance and beauty were all gone from the river. All the value any feature of it had for me now was the amount of usefulness it could furnish toward compassing the safe piloting of a steamboat. Since those days, I have pitied doctors from my heart. What does the lovely flush in a beauty's cheek mean to a doctor but a "break" that ripples above some deadly disease? Are not all her visible charms sown thick with what are to him the signs and symbols of hidden decay? Does he ever see her beauty at all, or doesn't he simply view her professionally and comment upon her unwholesome condition all to himself? And doesn't he sometimes wonder whether he has gained most or lost most by learning his trade?

REFLECT What have you gained or lost by becoming very knowledgeable about something?

- 1. Double-underline the thesis statement.
- 2. What type of organization does this essay use (point by point or whole to whole)? whole to whole

TIP For reading advice, see Chapter 1.

- 3. Why do you suppose Twain's perceptions of the river changed?

 Answers will vary. Possible answers: He came to see the river as
 just part of his job, not as something to be valued for its beauty. His
 knowledge of the river from a pilot's perspective ruined his ability to
 see its beauty.
- 4. How is the writing in the "before" and "after" sections of the essay similar? How is it different? Answers will vary. Possible answer: In both sections, the writing is detailed. In the "before" section, however, the descriptions are focused on the river's beauty, whereas in the "after" section, they are more concerned with the threats the river poses to a steamboat.

Respond to one of the following assignments in a paragraph or essay.

- 1. In the final paragraph of the essay, Twain describes how doctors have lost the ability to see beauty in their patients; instead, they look only for signs of illness. Write about something beautiful (a person, place, or thing) from two different perspectives—one of an expert (such as a doctor, scientist, or architect) and one of an untrained but observant person.
- **2.** Twain argues that knowing too much about something can destroy its appeal. Write a paper that opposes this position, bringing in examples from college, work, or your everyday life.
- 3. Are there any people, places, or objects that we will always see beauty in, no matter how much knowledge we gain or how much time passes? If you believe that there are, describe these things, and explain why they have a more lasting appeal than some other things. If not, explain your reasons.

Write Your Own Comparison and Contrast

In this section, you will write your own comparison and contrast based on one of the following assignments. For help, refer to the How to Write Comparison and Contrast checklist on page 244.

ASSIGNMENT OPTIONS Writing about College, Work, and Everyday Life

Write a comparison/contrast paragraph or essay on one of the following topics or on one of your own choice. If you responded to the idea journal prompt on page 228, you might develop that writing further.

COLLEGE

- Describe similarities and differences between high school and college, and give examples.
- Compare two different approaches you have used to study, such as studying in a group and studying on your own using notes or other aids. Explain whether you prefer one approach over the other or like to use both methods.
- If you are still deciding on a major area of study, see if you can sit in on a class or two from programs that interest you. Then, compare and contrast the classes. If this process helped you decide on a program, explain the reasons for your choice.

WORK

- Compare a job you liked with one you did not like, and give reasons for your views.
- Have you had experience working for both a bad supervisor and a good one? If so, compare and contrast their behaviors, and explain why you preferred one supervisor to another.
- Work styles tend to differ from employee to employee. For instance, some like to work in teams, whereas others prefer to complete tasks on their own. Some like specific directions on how to do things, while others want more freedom. Contrast your own work style with someone else's, someone whose approach and preferences are quite different from yours.

EVERYDAY LIFE

- Compare your life now with the way you would like it to be in five years.
- Mark Twain writes about how his experience working on the river has changed how he sees the river (see p. 238). Have your experiences changed how you see your surroundings? If so, discuss your experiences, and give examples.
- Participate in a cleanup effort in your community, and then compare and contrast how the area looked before the cleanup with how it looked afterward.

ASSIGNMENT OPTIONS Reading and Writing Critically

Complete one of the following assignments, which ask you to apply the critical thinking, reading, and writing skills discussed in Chapter 1.

Writing Critically about Readings

Both Mark Twain's "Two Ways of Seeing a River" (p. 238) and Jelani Lynch's "My Turnaround" (p. 124) describe changes in the writers' lives. Read or review both of these pieces, and then follow these steps:

- **1. Summarize** Briefly summarize the works, listing major events.
- 2. Analyze What questions do the pieces raise for you?

COMMUNITY

LYNZE SCHILLER helped clean up and paint a storage room in a church, converting it into an Empowerment Room for community members who needed help and support. Getting more involved in college and community activities, as Lynze did, can help you feel more connected to others and can even improve the chances that you will stay in school.

For more on this story, ways to make community connections, and writing assignments, visit bedfordstmartins.com/realwriting.

TIP For a reminder of how to summarize, analyze, synthesize, and evaluate, see the Reading and Writing Critically box on pages 16–17. **TEACHING TIP** If time is short, students might complete just one or two steps of this assignment.

- **3. Synthesize** Sometimes we are thankful for changes in our lives, as in Lynch's paragraph, but other times we regret them, as in Twain's essay. Using examples from these writings and from your own experience, discuss which types of changes are positive, which types are negative, and why.
- **4. Evaluate** Which piece did you connect with more, and why? In writing your evaluation, you might look back on your responses to step 2.

Writing about Images

Study the photographs below, and complete the following steps.

- **1. Read the images** Ask yourself: What details are you drawn to in each photograph? What differences do you notice as you move from the 1973 model to the 1985 model and from these cell-phone ancestors to the 1991–2011 phones? (For more on reading images, see Chapter 1.)
- **2. Write a comparison and contrast** Choose two or more of the photographs to compare and contrast, and write a paragraph or essay about the changing looks of mobile phones. You might want to address

ANCESTORS OF MODERN CELL PHONES, 1973 AND 1985

Above left: Martin Cooper, chairman and CEO of ArrayComm, holds a Motorola DynaTAC, a 1973 prototype of the first handheld cellular telephone. Thirty years before this photograph was taken, on April 2, 2003, the first call was made from a cellular phone.

Above right: The Vodafone mobile phone, introduced in 1985. Marketed by Racal-Vodac Limited, this phone was aimed at busy professionals and regular travelers, for portable use or for use in their cars. This phone came with a battery charger and an antenna, for use in areas with poor reception.

CELL PHONES FROM 1991 TO 2011

Brands from left to right: Motorola (1991), Nokia (1999), LG (2005/2006), and Motorola Droid 2 Global (2011).

The Apple iPhone 4 (2011).

experts predict that mobile phones will continue to evolve rapidly. For example, some expect that phones of the near future will be physically flexible and waterproof and that people will use their phones—not cash or credit cards—to pay for things. Ask students what improvements or changes they would most like to see in mobile phones. Will we laugh someday at how antiquated the iPhone looks?

TEACHING TIP Industry

how changes in mobile phones represent larger changes in society and culture. Also, answer this question: What do you think phones will look like in another ten years? In writing your comparison/contrast, include the details and differences you identified in step 1.

Writing to Solve a Problem

Read or review the discussion of problem solving in Chapter 1 (pp. 24–26). Then, consider the following problem:

You need a new smartphone, and you want the best one for your money. Before ordering, you do some research.

ASSIGNMENT: Consult a Web site that rates smartphones, such as www .pcworld.com. Identify three features covered by the ratings, and make notes about why each feature is important to you. Then, choose a model based on these features. Finally, write a contrast paragraph or essay that explains your decision and contrasts your choice versus another model. Make sure to support your choice based on the three features you considered.

STEPS	DETAILS
 Narrow and explore your topic. See Chapter 3. 	Make the topic more specific.Prewrite to get ideas about the narrowed topic.
 Write a topic sentence (paragra or thesis statement (essay). See Chapter 4. 	State the main point you want to make in your comparison/contrast.
Support your point. See Chapter 5.	 Come up with points of comparison/contrast and with details about each one.
Write a draft. See Chapter 6.	 Make a plan that sets up a point-by-point or whole-to-whole comparison/contrast. Include a topic sentence (paragraph) or thesis statement (essay) and all the support points.
Revise your draft. See Chapter 7.	 Make sure it has all the Four Basics of Good Comparison and Contrast. Make sure you include transitions to move readers smoothly from one subject or comparison/contrast point to the next.
Edit your revised draft. See Parts 4 through 7.	 Correct errors in grammar, spelling, word use, and punctuation.

Chapter Review

1. What are the Four Basics of Good Comparison and Contrast?

It uses subjects that have enough in common to be compared/

contrasted in a useful way. It serves a purpose—to help readers

make a decision, to help them understand the subjects, or to show

your understanding of the subjects. It presents several important,

parallel points of comparison/contrast. It arranges points in a logical
order.

2.	The topic sentence (paragraph) or thesis statement (essay) in	
	comparison/contrast should include what two parts? the subjects	
	being compared or contrasted and the main point of the comparison/	
	contrast	
3.	What are the two ways to organize comparison/contrast? point by point and whole to whole	
	In your own words, explain the two ways of organizing comparison/contrast. Answers will vary.	
.	Write sentences using the following vocabulary words: liaison, amenities,	LEARNING JOURNAL
	poised, majestic, somber. Answers will vary.	Reread your idea journal entry (p. 228) about the differences between dogs and cats as pets. Make
		another entry about the same topic, using what you have learned about comparison and contrast.
		companion and contract

15

YOU KNOW THIS

You consider causes and effects every day:

- You explain to your boss what caused you to be late.
- You consider the possible effects of calling in sick.

write for 2 minutes about what a cause is and what an effect is.

Cause and Effect

Writing That Explains Reasons or Results

Understand What Cause and Effect Are

A **cause** is what made an event happen. An **effect** is what happens as a result of the event.

Four Basics of Good Cause and Effect

The main point reflects the writer's purpose: to explain causes, effects, or both.

2 If the purpose is to explain causes, the writing presents real causes.

If the purpose is to explain effects, it presents real effects.

It gives readers detailed examples or explanations of the causes or effects.

TEACHING TIP Explain to students the differences between effect (noun) and affect (verb).

In the following paragraph, the numbers and colors correspond to the Four Basics of Good Cause and Effect.

Although the thought of writing may be a source of stress for college students, researchers have recently found that it can also be a potent stress reliever. In the winter of 2008, during a time when many people catch colds or the flu or experience other symptoms of ill health, two psychologists conducted an experiment with college students to find out if writing could have positive effects on their minds and/or their bodies. After gathering a large group of college students, a mix of ages, genders, and backgrounds, the psychologists explained the task. The students were asked to write for only 2 minutes, on two consecutive days,

about their choice of three different kinds of experiences: a traumatic experience, a positive experience, or a neutral experience (something routine that happened). The psychologists did not give more detailed directions about the kinds of experiences, rather just a bad one, a good one, or one neither good nor bad. A month after collecting the students' writing, the psychologists interviewed each of the students and asked them to report any symptoms of ill health, such as colds, flu, headaches, or lack of sleep. 3 What the psychologists found was quite surprising. 4 Those students who had written about emotionally charged topics, either traumatic or positive, all reported that they had been in excellent health, avoiding the various illnesses that had been circulating in the college and the larger community. The students who had chosen to write about routine, day-to-day things that didn't matter to them reported the ill health effects that were typical of the season, such as colds, flu, poor sleep, and coughing. From these findings, the two psychologists reported that writing about things that are important to people actually has a positive effect on their health. Their experiment suggests the value to people of regularly recording their reactions to experiences, in a journal of some sort. If writing can keep you well, it is worth a good try. The mind-body connection continues to be studied because clearly each affects the other.

When you are writing about causes and effects, make sure that you do not confuse something that happened before an event with a real cause or something that happened after an event with a real effect. For example, if you have pizza on Monday and get the flu on Tuesday, eating the pizza is not the cause of the flu just because it happened before you got the flu, nor is the flu the effect of eating pizza. You just happened to get the flu the next day.

You use cause and effect in many situations.

In a nutrition course, you are asked to identify the consequences (effects) of poor nutrition.

WORK Sales are down in your group, and you have to explain

the cause.

You explain to your child why a certain behavior is not acceptable by warning him or her about the negative

effects of that behavior.

In college, writing assignments might include the words discuss the causes (or effects) of, but they might also use phrases such as explain the results of, discuss the impact of, and how did X affect Y? In all these cases, use the strategies discussed in this chapter.

TEACHING TIP Have students try the experiment, or just have them write about either negative or positive experiences.

TEACHING TIP You might point out that mistaken causes or effects are just one type of logical fallacy and that avoiding such errors in reasoning is an important part of critical thinking. One Web site that offers excellent explanations and examples of logical fallacies is Fallacy Files, at www.fallacyfiles.org.

WRITER AT WORK

MARY LACUE BOOKER: I started writing rap to teach my students.

(See Mary LaCue Booker's **PROFILE OF SUCCESS** on p. 256.)

Seeing Cause and Effect

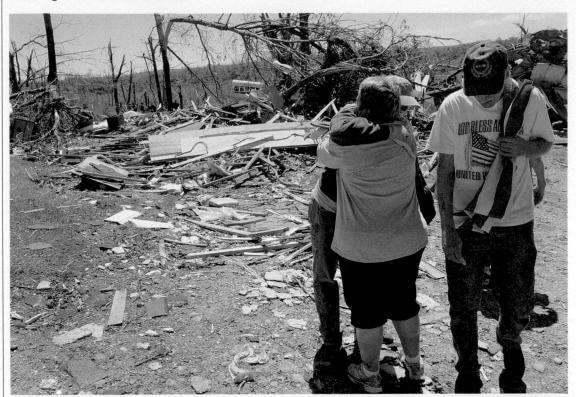

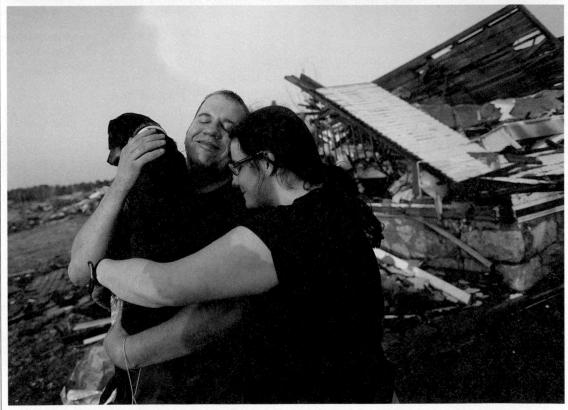

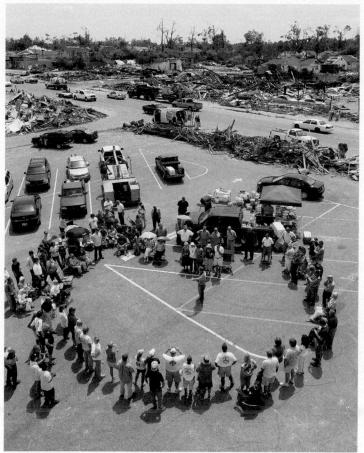

write

- Using these photos as starting points, what are some effects of natural disasters?
- What reactions and responses does a natural disaster cause?

TEACHING TIP Ask students to bring in additional images that show causes, effects, or both. Photograph details: Top photo, page 248: Campground residents hug amid the ruins of their homes in Brimfield, Massachusetts, the day after a tornado on June 2, 2011. Bottom photo, page 248: Residents hug their dog after the May 22, 2011, tornado that hit Joplin, Missouri. The two are Hurricane Katrina evacuees. Top photo, this page: Alberta Baptist Church members gather for a brief service before going out to help their neighbors after a tornado hit Tuscaloosa, Alabama, in May 2011. Bottom photo, this page: In June 2011, volunteers help clear rubble left from the Joplin tornado.

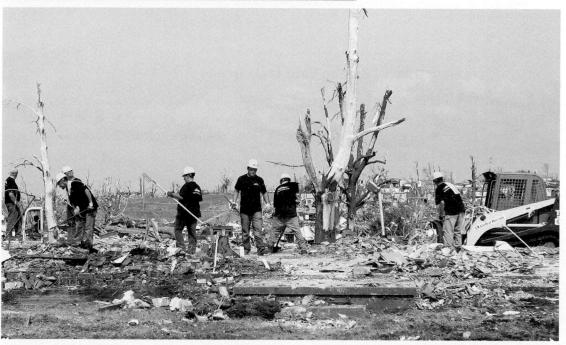

IDEA JOURNAL Write about a time when something you did caused someone to be happy or unhappy.

TIP If the writer wanted to explore causes, he or she might look into the factors that motivate people to exercise.

TIP Sometimes, the same main point can be used for a paragraph and an essay, but the essay must develop this point in more detail. (See pp. 69–70.)

Main Point in Cause and Effect

The **main point** introduces causes, effects, or both. To help you discover your main point, complete the following sentence:

MAIN POINT IN CAUSE AND EFFECT

(Your topic) causes (or caused) . . . (Your topic) resulted in (or results in) . . .

Here is an example of a topic sentence for a paragraph:

Regular exercise improves cardiovascular health.

Remember that the main point for an essay can be a little broader than one for a paragraph.

Regular exercise provides more physical and mental benefits than any medication could offer.

Whereas the topic sentence focuses on just one major benefit of regular exercise, the thesis statement considers multiple benefits.

PRACTICE 1 Stating Your Main Point

For each of the following topics, make notes about possible causes and effects on a separate sheet of paper. Then, in each of the spaces below, write a sentence that states a main point. First, look at the following example.

EXAMPLE:

Topic: Bankruptcy

Main point: Although many different kinds of people declare bankruptcy each year, the causes of bankruptcy are often the same.

1. Topic: A fire in someone's home

Main point: Answers will vary.

2. Topic: An "A" in this course

Main point:

3.	Topic: A car accident
	Main point:
••••	-
Su	pport in Cause and Effect
(pa this wri	e paragraph and essay models on pages 252–53 use the topic sentence ragraph) and thesis statement (essay) from the Main Point section of chapter. Both models include the support used in all cause-effect ting: statements of cause or effect backed up by detailed explanations examples. In the essay plan, however, the major support points (statents of cause/effect) are topic sentences for individual paragraphs.
PR/	ACTICE 2 Giving Examples and Details
Writ	e down two causes or two effects for two of the three topics from Practice hen, give an example or detail that explains each cause or effect.
	EXAMPLE:
	Topic: Bankruptcy
	Cause 1: Overspending
	Example/Detail: bought a leather jacket I liked and charged it
	Cause 2: Poor budgeting
	Example/Detail: not tracking monthly expenses versus income
1.	Topic: A fire in someone's home
	Cause/Effect 1: Answers will vary.
	Example/Detail:
	Cause/Effect 2:
	Example/Detail:
2.	Topic: An "A" in this course
	Cause/Effect 1:
	Example/Detail:
	Cause/Effect 2:
	Example/Detail:
3.	Topic: A car accident
	Cause/Effect 1:
	Example/Detail:

PARAGRAPHS VS. ESSAYS IN CAUSE AND EFFECT

For more on the important features of cause and effect, see the Four Basics of Good Cause and Effect on page 246.

Main Point: Often, narrower Paragraph Form for a paragraph than for an essay: While the topic sentence (paragraph) focuses Regular exercise improves cardiovascular health. One benefit **Topic sentence** on just one major benefit of of exercise is that it strengthens the heart. Like any other muscle, exercise, the thesis statement Support 1 the heart becomes stronger with use, and is able to pump blood (essay) considers multiple (cause 1 or benefits. through the body more efficiently. The result can be lower blood effect 1) pressure, reducing the risk of heart disease. Another benefit of Support 2 exercise is that it lessens the toll that excessive weight can take on (cause 2 or the heart. In seriously overweight individuals, the strain of carrying effect 2) Support for the Main Point extra pounds can cause the heart to enlarge, interfering with its (Statements of Cause ability to pump blood. By losing weight through exercise and or Effect) dietary changes, people can reduce the burden on their hearts and also their cardiovascular risk. The most important cardiovascular Support 3 benefit of exercise is that it lowers the risk of heart disease. As (cause 3 or previously noted, exercise can reduce blood pressure and strain effect 3) **Detailed Explanations or** on the heart, both risk factors for heart attack, stroke, and heart **Examples of Cause/Effect** failure. In addition, it can lower levels of "bad" cholesterol while Statements: Usually, 1 to raising levels of "good" cholesterol. Controlling bad cholesterol is 3 sentences per statement for paragraphs and 3 to important because when there is too much of this substance in the 8 sentences per statement for blood, it can build up on artery walls, causing reduced blood flow. essays. Regular and vigorous aerobic exercise is the best way to reap these Concluding sentence cardiovascular benefits, but even a brisk walk a few times a week is better than no activity at all. Conclusion

Think Critically As You Write Cause and Effect

ASK YOURSELF

- Have I examined a variety of possible causes and/or effects related to my topic? (If not, research them, and consider revising your main point and support based on what you learn. For more on finding and evaluating outside sources, see Chapter 18.)
- Am I certain that my causes are real causes and my effects real effects? (For help with answering this question, see p. 247.)

Most people know how hard it is to start and stick with an exercise program. However, there is a good reason to build a significant amount of t Thesis statement into every week: Regular exercise provides more physical and mental benefits than any medication could offer.

First, exercise helps people achieve and maintain a healthy weight. A nutritious diet that is Topic sentence 1 (cause 1 or calories has a greater effect on weight lo effect 1) does. However, regular exercise—ideally, throughout the day-can make an important contribution. For instance, people trying to lose weight might walk to work or to other destinations instead of driving. Or, they might take the stairs to their office instead of the elevator. If they go the gy the day, so much the better. Added up, (cause 2 or can make a difference. effect 2)

Second, exercise boosts mood and energy levels. For example, exercise causes the body to release endorphins, chemicals that give us a sense of well-being, even happiness. Accordingly, exercise can help reduce stress and combat depression. In addition, because exercise can make people look and feel more fit, it can improve their self-esteem. Finally, by improving st endurance, exercise gives individuals more e about their lives.

Topic sentence 3 (cause 3 or effect 3)

The most important benefit of exercise is that it can help prevent disease. For example, exercise can improve the body's use of insulin and, as noted earlier, help people maintain a healthy weight. Therefore, it can help prevent or control diabetes. Additionally, exercise can lower the risk of heart attacks, strokes, and heart failure. For instance, exercise strengthens the heart muscle, helping it pump blood more efficiently and reducing high blood pressure, a heart disease risk factor. Also, exercise can lower levels of "bad" cholesterol while raising levels of "good" cholesterol. Controlling levels of bad cholesterol is important because when there is too much of this substance in the blood, it can build up in the walls of arteries, possibly blocking blood flow. Finally, some research suggests that regular exercise can reduce the risk of certain cancers, including breast, colon, and lung cancer.

3

Concluding paragraph

In my own life, exercise has made a huge difference. Before starting a regular exercise program, I was close to needing prescription medications to lower my blood pressure and cholesterol. Thanks to regular physical activity, however, both my blood pressure and cholesterol levels are now in the normal range, and I have never felt better. Every bit of time spent at the gym or exchanging a ride in an elevator for a walk up the stairs has been well worth it.

Organization in Cause and Effect

TIP For more on the different orders of organization, see pages 78–79.

Cause and effect can be organized in a variety of ways, depending on your purpose.

MAIN POINT	PURPOSE	ORGANIZATION
The "Occupy" protests of 2011 brought attention to the economic difficulties faced by low- and middle-income citizens.	to explain the effects of the protests	order of importance, saving the most important effect for last
A desire to remain at a protest site for an extended period led "Occupy" protesters to create miniature towns, with food service, libraries, and more.	to describe the places where protesters camped out	space order
The "Occupy" protests in New York City inspired other protests throughout the country.	to describe the spread of the protest movement over time	time order

NOTE: If you are explaining both causes and effects, you would present the causes first and the effects later.

Use **transitions** to move readers smoothly from one cause to another, or from one effect to another, or from causes to effects. Because cause and effect can use any method of organization depending on your purpose, the following list shows just a few of the transitions you might use.

Common Transitions	in Cause and Effect
also	more important/serious cause or effect
as a result	most important/serious cause or effect
because	one cause/effect; another cause or effect
the final cause or effect	a primary cause; a secondary cause
the first, second, third cause or effect	a short-term effect; a long-term effect

PRACTICE 3 Using Transitions in Cause and Effect

Read the paragraph that follows, and fill in the blanks with transitions. Answers may vary. Possible answers are shown.

Recently, neuroscientists, who have long been skeptical about meditation, confirm that it has numerous positive outcomes. One, The first is that people who meditate can maintain their focus and attention longer than people who do not. This ability to stay "on task" was demonstrated among students who had been practicing meditation for several weeks. They reported more effective studying and learning because they were able to pay attention. Another, A second positive outcome was the ability to relax on command. Many people lead busy, stressful lives with multiple pressures on them—family responsibilities, work duties, financial worries, and uncertainties about the future. While meditating, people learned how to reduce their heart rates and blood pressure so that they could relax more easily in all kinds of situations. A third, The most important outcome was a thickening of the brain's cortex. Meditators' cortexes were uniformly thicker than nonmeditators'. Because the cortex enables memorization and the production of new ideas, this last outcome is especially exciting, particularly in fighting Alzheimer's disease and other dementias.

Read and Analyze Cause and Effect

Reading examples of cause and effect will help you write your own. In the first example, a singer shows how she uses cause and effect to write rap lyrics that do more than entertain.

The second example is a cause/effect paragraph by a student, and the third example is a cause/effect essay by a professional writer. As you read these pieces, pay attention to the vocabulary, and answer the questions in the margin. They will help you read critically.

READING SELECTIONS For further examples of and activities for cause and effect, see Chapter 46.

PROFILE OF SUCCESS

Mary LaCue Booker Singer, Actor (stage name: La Q)

RESOURCES For a discussion of how to use the profiles in Part 2, see *Practical Suggestions*.

Cause and Effect in the Real World

Background I grew up in a small town in Georgia but always had big dreams that I followed. Those dreams included becoming a nurse, a teacher, and then a singer and an actor. Before becoming a nurse and teacher, I went to college, studying both nursing and psychology. Later, I followed my dream of performing and left Georgia to attend the competitive American Academy of Dramatic Arts in Los Angeles.

I returned to Georgia and combined teaching and performance as chair of the Fine Arts Department at Columbia Middle School. I wrote rap songs for my students, and my first one, "School Rules," was an immediate hit in Atlanta. I now have three CDs and acted in the movie *We Must Go Forward*, about African American history. In addition to performing, I also am busy giving motivational speeches.

Degrees/Colleges A.A., DeKalb College; B.S., Brenau Women's College; M.Ed., Cambridge College

Writing at work When I taught, I wrote lesson plans, reports for students, and communications with parents. Now, I write song lyrics, speeches, and screenplays. I believe that writing is critical. I write from the heart, and it is a good outlet for my emotions. Sometimes, I freewrite around one word, like *mischievous*, which is the name of one of my CDs.

How La Q uses cause and effect Many of my songs and speeches are about causes and effects, like the effects of how we act or love or what causes pain or happiness. I wrote "School Rules" for my students, who did not listen to regular rules but would listen to a rap song about them.

La Q's Cause and Effect

Following are some lyrics from "School Rules."

Now get this, now get this, now get this.

If ya wanna be cool, obey the rules

Cause if ya don't, it's your future you lose.

I'm a school teacher from a rough school.

I see students every day breakin' the rules.

Here comes a new boy with a platinum grill

Makin' trouble, ringin' the fire drill.

There goes anotha' fool wanna run the school,
Breakin' all the damn school rules.
Runnin' in the halls, writin' graffiti on the walls,
Tellin' a lie without blinkin' an eye,
Usin' profanity, pleadin' insanity,
Callin' names, causin' pain,

Joinin' gangs like it's fame,

Dissin' the teacha and each otha.

Regardless of color, they're all sistas and brothas.

Now get this, now get this, now get this, now get this.

Boys and girls are skippin' class,

Cause they late with no hall pass.

They wanna have their say, and that's okay,

But they're outta their minds if they wanna have their way.

Now get this, now get this, now get this.

If ya wanna be free, school's not the place ta be.

But if ya wanna degree, you gotta feel me.

So if you wanna be cool, obey the rules

Cause if ya don't, it's your future you lose.

- 1. What is La Q's purpose? to tell students that breaking the rules will prevent them from getting a degree
- 2. What are the **effects** of breaking the rules? not getting a degree, losing your future
- 3. Underline the causes that lead to these effects.
- **4.** With a partner, or as a class, translate this rap into formal English.

TIP For more on using formal English, see Chapter 2.

Student Cause/Effect Paragraph

Caitlin Prokop

A Difficult Decision with a Positive Outcome

Caitlin Prokop wrote the following essay as she was preparing to begin her studies at Brevard Community College in Florida. Later, she went on to pursue a degree in elementary education at the University of Hawaii. She was inspired to write this essay by her parents and their life choices. Caitlin often produces several drafts of her work and understands the balance between inspiration and revision in writing. Of writing, she says, "Follow what the brain is telling the hand. Let it flow. If you cannot write about the topic that is given, put yourself in someone else's shoes and then write. Let your thoughts flow; then, revise and edit to get the finished copy."

Vocabulary development

Underline these words as you read Caitlin's paragraph. accompany: to be with; to go with cherish: to value highly

TIP For advice on building your vocabulary, visit the Student Site for Real Writing at bedfordstmartins.com/realwriting.

When my mother made the decision to move back to New York, I made the choice to move in with my dad so that I could finish high school. This decision affected me in a positive way because I graduated with my friends, built a better relationship with my father, and had the chance to go to college without leaving home. Graduating with my friends was very important to me because I have known most of them since we were in kindergarten. It was a journey through childhood that we had shared, and I wanted to finish it with them. Accomplishing the goal of graduating from high school with my close friends, those who accompanied me through school, made me a stronger and more confident person. Another good outcome of my difficult decision was the relationship I built with my dad. We never saw eye to eye when I lived with both of my parents. For example, we stopped talking for five months because I always sided against him with my mom. Living together for the past five years has made us closer, and I cherish that closeness we have developed. Every Thursday is our day, a day when we talk to each other about what is going on in our lives, so that we will never again have a distant relationship. A third good outcome of my decision is that I can go to Brevard Community College, which is right down the street. In high school, I had thought that I would want to go away to college, but then I realized that I would miss my home. By staying here, I have the opportunity to attend a wonderful college that is preparing me for transferring to a four-year college and finding a good career. I have done some research and believe I would like to become a police officer, a nurse, or a teacher. Through the school, I can do volunteer work in each of these areas. Right now, I am leaning toward becoming a teacher, based on my volunteer work in a kindergarten class. There, I can explore what grades I want to teach. In every way, I believe that my difficult decision was the right one, giving me many opportunities that I would not have had if I had moved to a new and unfamiliar place.

- **1.** Double-underline the **topic sentence**.
- 2. Does Caitlin write about causes or effects? effects
- **3.** Circle the **transitions** Caitlin uses to move readers from one point to the next.
- **4.** Does Caitlin's paragraph include the Four Basics of Good Cause and Effect? Why or why not? Yes. Answers will vary.
- **5.** Have you made a difficult decision that turned out to be a good one? Why and how? Answers will vary.

Professional Cause/Effect Essay

Kristen Ziman

Bad Attitudes and Glowworms

Kristen Ziman is a commander with the Aurora Police Department in Aurora, Illinois, and a columnist for the *Beacon News*, a *Chicago Sun-Times* publication. She holds a B.A. in criminal justice management from Aurora University and an M.A. in criminal justice / organizational leadership from Boston University. She is also a graduate of the Senior Executives in State and Local Government Program at Harvard University's Kennedy School of Government. In addition to writing for the *Beacon News*, Ziman regularly posts to her blog, *Think Different*.

In the following essay, Ziman discusses how keeping a positive attitude helps people maintain control over their lives, even under the most challenging circumstances.

In my third-grade classroom there was a poster on the wall that read: 1

I wish I were a glowworm,
A glowworm's never glum.
'Cuz how can you be grumpy
When the sun shines out your bum!

I didn't understand what that poem meant until I was in my twenties, 2 and I had an epiphany about attitude. I was partnered with a veteran officer, and two hours into our eight-hour shift, I began to realize that there was not a single thing he enjoyed about his job or his life. Being assigned to ride with me was also a source of contention for him, and he wasn't bashful about telling me so.

I found his disdain for life odd—especially given the fact that it was a beautiful summer day and the few calls we answered were relatively uneventful. As we patrolled the streets, I visualized a dark cloud exclusively over his head in contrast to the sunshine surrounding the rest of us, and I laughed out loud as the glowworm poem popped into my head. It was at that moment that I started to understand the effect our attitude has on our entire existence.

Throughout my life, I have been bombarded with lessons about attitude. It's not what happens to us in life, but the way we respond that makes a difference. If you can't change a situation, you must change the way you see the situation. I understand these lessons on an intellectual

Vocabulary development

Underline these words as you read the cause/effect essay.

epiphany: a sudden understanding or insight contention: conflict; displeasure

bashful: shy

disdain: contempt; hatred relatively: in comparison with (in this case) other times

exclusively: only

conceptually: in abstract or emotional terms, as opposed to factual terms

overwhelming: bordering on unbearable

metamorphosis:

transformation

motives: reasons for people's actions

hover: to float in the air above something

analytical: given to studying things carefully

gravitated towards: were drawn to

validated: confirmed; supported

proverbial: related to a proverb or common saying. ("Look at yourself in the mirror" is a common saying.)

endure: to survive; to make it through a difficult situation

thrive: to be successful attitudinally: in terms of attitude

self-imposed: put upon oneself

TEACHING TIP Point out to students how this essay also contains elements of comparison and contrast.

IDENTIFY Underline the causes of negative attitudes in this paragraph.

level, but conceptually, there are times I find it difficult to find the light when darkness seems to be so overwhelming.

As I gained more experience as a police officer, I began to understand how the metamorphosis from an optimist to a pessimist occurs. I became distrusting of other human beings, though not without reason. I had been lied to, spit on, and physically attacked while doing my job. I saw the evil human beings did to one another and started to become suspicious of motives all around me. There was a moment when I quietly challenged my decision to make this my career, and I felt my own dark cloud begin to hover.

Because I've always been very analytical and self-aware [by my own estimation], I started to pay attention to the negativity of my coworkers, and it suddenly became clear that the miserable ones seemed to feed off each other like vultures. They gravitated towards one another because they validated each other's thoughts and beliefs. They were always victims, and they effortlessly found someone else to blame for all that was wrong. Never did they stop to look in the proverbial mirror and ask themselves if they might be part of the problem.

My favorite book is *Man's Search for Meaning* by Viktor Frankl. In 7 his book, Frankl writes about his experiences in the concentration camps of Nazi Germany. He took particular interest in how some of his fellow prisoners seemed to endure and even thrive, while others gave up and laid down to die. From this, he concluded that "everything can be taken from a man but one thing: the last of human freedom is to choose one's attitude in any given set of circumstances—to choose one's own way."

We all struggle in some way with things that are completely out of 8 our control. But the way we gain control over these things—even if only attitudinally—is where our freedom lies. We don't have to experience torture in a concentration camp to apply Frankl's teachings to our own lives. We each have the freedom to make choices that liberate us from our self-imposed prisons.

If Frankl's story doesn't motivate you to choose the way you look at 9 things, maybe you need to surround yourselves with more glowworms.

1. Double-underline the thesis statement.

2. Does this essay present causes, effects, or both? Explain how you came to your conclusion. Answers will vary. Possible answer: The essay presents both causes and effects. A bad attitude causes a negative view of life's circumstances, resulting in an even more negative outlook on things. In other words, negativity feeds negativity.

SUMMARIZE What is the author's main point in this paragraph?

TIP For reading advice, see Chapter 1.

3. Does this essay follow the Four Basics of Good Cause and Effect (p. 246)? Why or why not? Answers will vary.

Respond to one of the following assignments in a paragraph or essay.

- 1. At the beginning of her essay, Ziman writes about a time when the words of an old poem popped into her head, helping her see a situation in a new light. Write about a time when something from your past (such as advice from a friend, song lyrics, or a scene from a favorite movie) came into your mind during a challenging time and helped you get through it.
- We have all met people who, like the police officer in paragraph 3 of Ziman's essay, constantly have a "dark cloud" over their heads. Is it ever a good idea to confront others about their negative attitudes? Or is it better to focus just on our own attitude toward the situation? Explain your position, supporting it with examples.
- 3. Look back on the Viktor Frankl quotation in paragraph 7 of the essay. Then, write about a time when you had to decide what kind of attitude you were going to take in a difficult situation. How did your attitude affect your view of the situation and of yourself?

Write Your Own Cause and Effect

In this section, you will write your own cause and effect based on one of the following assignments. For help, refer to the How to Write Cause and Effect checklist on page 264.

ESL Suggest that students write about the cause or effect of a cultural misunderstanding.

ASSIGNMENT OPTIONS Writing about College, Work, and Everyday Life

Write a cause/effect paragraph or essay on one of the following topics or on one of your own choice. If you responded to the idea journal prompt on page 250, you might develop that writing further.

COLLEGE

- Write about the causes, effects, or both of not studying for an exam.
- If you have chosen a major or program of study, explain the factors behind your decision. How do you think this choice will shape your future?
- Why do some people stay in college while others drop out? Interview one or two college graduates about the factors behind their decision to stay in school. Also, ask them how staying in school and graduating has affected their lives. Then, write about the causes and effects they describe.

COMMUNITY

While she was in college, SHAWN ELSWICK helped found an organization that provides support for victims of domestic abuse. Getting more involved in college and community activities, as Shawn did, can help you feel more connected to others and can even improve the chances that you will stay in school.

For more on this story, ways to make community connections, and writing assignments, visit bedfordstmartins.com/realwriting.

TIP For a reminder of how to summarize, analyze, synthesize, and evaluate, see the Reading and Writing Critically box on pages 16–17.

TEACHING TIP If time is short, students might complete just one or two steps of this assignment.

WORK

- Write about the causes, effects, or both of stress at work.
- Identify a friend or acquaintance who has been successful at work. Write about the factors behind this person's success.
- Write about the causes, effects, or both of having a good or bad attitude at work. For a description of how our attitudes can affect our lives, see Kristen Ziman's essay on page 259.

EVERYDAY LIFE

- Think of a possession that has great personal meaning for you. Then, write about why you value the possession, and give examples of its importance in your life.
- Try to fill in this blank: "_____ changed my life." Your response can be an event, an interaction with a particular person, or anything significant to you. It can be something positive or negative. After you fill in the blank, explain how and why this event, interaction, or time had so much significance.
- Arrange to spend a few hours at a local soup kitchen or food pantry, or on another volunteer opportunity that interests you. (You can use a search engine to find volunteer opportunities in your area.) Write about how the experience affected you.

ASSIGNMENT OPTIONS Reading and Writing Critically

Complete one of the following assignments, which ask you to apply the critical thinking, reading, and writing skills discussed in Chapter 1.

Writing Critically about Readings

Kristen Ziman's "Bad Attitudes and Glowworms" (p. 259), Caitlin Prokop's "A Difficult Decision with a Positive Outcome" (p. 257), and Jelani Lynch's "My Turnaround" (p. 124) talk about taking control of one's life. Read or review these pieces, and then follow these steps:

- 1. Summarize Briefly summarize the works, listing major examples.
- **2. Analyze** What questions do these pieces raise for you? Are there any other issues you wish they had covered?
- **3. Synthesize** Using examples from Ziman's, Prokop's, and Lynch's writings and from your own experience, discuss different ways—big and small—in which people can take control of their lives.
- **4. Evaluate** Which of the pieces had the deepest effect on you? Why? In writing your evaluation, you might look back on your responses to step 2.

Writing about Images

Researchers have discovered that laughter really is contagious. When we hear someone else laughing, our brain picks up the signal and puts our facial muscles into laughter mode. With that in mind, study the photographs on this page, and complete the following steps.

- **1. Read the images** Ask yourself: Why is it a good idea to use a series of photos, instead of a single photo, to show the effects of laughter? (For more information on reading images, see Chapter 1.)
- Write a cause leffect paragraph or essay Write about a time when someone else's laughter caused you to join in—even in a serious situation. What caused you to laugh, and what were the effects on you and everyone else?

Writing to Solve a Problem

Read or review the discussion of problem solving in Chapter 1 (pp. 24–26). Then, consider the following problem.

You have learned of a cheating ring at school that uses cell phones to give test answers to students taking the test. A few students in your math class, who are also friends of yours, think that this scheme is a great idea and are planning to cheat on a test you will be taking next week. You decide not to participate, partly because you fear getting caught, but also because you think that cheating is wrong. Now you want to convince your friends not to cheat, because you don't want them to get caught and possibly kicked out of school. How do you make your case?

ASSIGNMENT: Working in a group or on your own, list the various effects of cheating—both immediate and long term—you could use to convince your friends. Then, write a cause/effect paragraph or essay that identifies and explains some possible effects of cheating. You might start with this sentence:

Cheating on tests or papers is not worth the risks.

TEACHING TIP Ask students what other causes or effects might be well illustrated through a series of photos.

TEAMWORK For more detailed guidance on group work, see *Practical Suggestions*.

STE	EPS	DETAILS		
	Narrow and explore your topic. See Chapter 3.	Make the topic more specific.Prewrite to get ideas about the narrowed topic.		
	Write a topic sentence (paragraph) or thesis statement (essay). See Chapter 4.	State your subject and the causes, effects, or both that your paper will explore.		
	Support your point. See Chapter 5.	Come up with explanations/examples of the causes, effects, or both.		
	Write a draft. See Chapter 6.	 Make a plan that puts the support points in a logical order. Include a topic sentence (paragraph) or thesis statement (essay) and all the supporting explanations/examples. 		
	Revise your draft. See Chapter 7.	 Make sure it has all the Four Basics of Good Cause and Effect. Make sure you include transitions to move readers smoothly from one cause/effect to the next. 		
	Edit your revised draft. See Parts 4 through 7.	 Correct errors in grammar, spelling, word use, and punctuation. 		

Chapter Review

- 1. A cause is what made an event happen.
- 2. An effect is what happens as a result of the event.
- The main point reflects the writer's purpose: to explain causes, effects, or both. If the purpose is to explain causes, it presents real causes.

 If the purpose is to explain effects, it presents real effects. It gives readers detailed examples or explanations of the causes or effects.
- **4.** Write sentences using the following vocabulary words: *cherish*, *motives*, *endure*, *thrive*. Answers will vary.

LEARNING JOURNAL

Reread your idea journal entry (p. 250) about a time you caused someone to be happy or unhappy. Make another entry about this topic, using what you have learned about cause and effect.

reflect Write for 2 minutes about what you have learned about writing cause and effect.

YOU KNOW THIS

You often try to persuade others or make your opinion known:

- You convince your partner that it's better to save some money than to buy a new television set.
- You persuade someone to loan you money or let you borrow a car.

write for 2 minutes about how you convince others to see something your way.

16

Argument

Writing That Persuades

Understand What Argument Is

Argument is writing that takes a position on an issue and gives supporting evidence to persuade someone else to accept, or at least consider, the position. Argument is also used to convince someone to take (or not take) an action.

Four Basics of Good Argument

It takes a strong and definite position.

It gives good reasons and supporting evidence to defend the position.

It considers opposing views.

It has enthusiasm and energy from start to finish.

In the following paragraph, the numbers and colors correspond to the Four Basics of Good Argument.

Even though I write this blog post on an 88-degree day, I am truly glad that I stopped using my air conditioner, and I urge you to follow my lead. 2 For one thing, going without air conditioning can save a significant amount of money. Last summer, this strategy cut my electricity costs by nearly \$2,000, and I am on my way to achieving even higher savings this summer. For another thing, living without air conditioning reduces humans' effect on the environment. Agricultural researcher Stan Cox estimates that air conditioning creates 300 million tons of carbon dioxide (CO₂) emissions each year. This amount, he says, is the equivalent of every U.S. household buying an additional car and driving

TEACHING TIP Explain to students that argument is not like bickering or fighting. It is a reasonable defense of a position.

4 Argument is enthusiastic and energetic.

4 Argument is enthusiastic and energetic.

it 7,000 miles annually. Because CO₂ is one of the greenhouse gases responsible for trapping heat in our atmosphere, reducing CO₂ emissions is essential to curbing climate change. The final reason for going without air conditioning is that it is actually pretty comfortable. The key to staying cool is keeping the blinds down on south-facing windows during the day. It is also a good idea to open windows throughout the home for cross ventilation while turning on ceiling fans to improve air circulation. Although some people argue that using fans is just as bad as switching on the air conditioner, fans use far less electricity. In closing, let me make you a promise: The sooner you give up air conditioning, the sooner you will get comfortable with the change—and the sooner you and the planet will reap the rewards.

TEACHING TIP The source for this visual is Adbusters .org, which, according to the organization's Web site, is "working to change the way information flows, the way corporations wield power, and the way meaning is produced in our society." Ask students how spokespersons for the corporations represented on the left side of the visual might respond to the argument being made. Are there any ways in which some of these businesses help people connect more with the natural world?

Knowing how to make a good argument is one of the most useful skills you can develop.

COLLEGE	You argue for or against makeup exams for students who do not do well the first time.
WORK	You need to leave work an hour early one day a week for twelve weeks to take a course. You persuade your boss to allow you to do so.
EVERYDAY LIFE	You try to negotiate a better price on an item you want to buy.

In college, writing assignments might include questions or statements such as the following: Do you agree or disagree with _____? Defend or refute _____. Is _____ fair and just? In all these cases, use the strategies discussed in this chapter.

Main Point in Argument

Your **main point** in argument is the position you take on the issue (or topic) about which you are writing. When you are free to choose an issue, choose something that matters to you. When you are assigned an issue, try to find some part of it that matters to you. You might try starting with a "should" or "should not" sentence:

MAIN POINT
IN ARGUMENT

College football players should/should not be paid.

If you have trouble seeing how an issue matters, talk about it with a partner or write down ideas about it using the following tips.

TIPS FOR BUILDING ENTHUSIASM AND ENERGY

- Imagine yourself arguing your position with someone who disagrees.
- Imagine that your whole grade rests on persuading your instructor to agree with your position.
- Imagine how this issue could affect you or your family personally.
- Imagine that you are representing a large group of people who care about the issue very much and whose lives will be forever changed by it. It is up to you to win their case.

In argument, the topic sentence (in a paragraph) or thesis statement (in an essay) usually includes the issue/topic and your position about it. Here is an example of a topic sentence for a paragraph:

Our company should make regular contributions to local food banks.

Remember that the main point for an essay can be a little broader than one for a paragraph.

WRITER AT WORK

DIANE MELANCON: As a doctor, I make cases for diagnoses and treatments.

(See Diane Melancon's **PROFILE OF SUCCESS** on p. 279.)

IDEA JOURNAL Persuade a friend who has lost his job to take a course at your college.

TIP Sometimes, the same main point can be used for a paragraph and an essay, but the essay must develop this point in more detail. (See pp. 69–70.)

TEACHING TIP Have students type some keywords about their topic into a search engine (e.g., www.google.com)—for instance, animal testing and pros and cons. Seeing the points others have raised about an issue can help them consider the various sides.

Whereas the topic sentence focuses on just one type of charitable organization, the thesis statement sets up a discussion of different ways to help different charities.

PRACTICE 1 Writing a Statement of Your Position

Write a statement of your position for each item. Answers will vary. Possible answers are shown.

EXAMPLE:

Issue: Prisoners' rights

Position statement: Prisoners should not have more rights and privileges than law-abiding citizens.

1. Issue: Lab testing on animals

Position statement: Animals should continue to be used for lab testing.

2. Issue: Use of cell phones while driving

Position statement: Using a cell phone while driving is an individual's decision.

Issue: Athletes' salaries

Position statement: Limits should be placed on major league baseball players' salaries.

4. Issue: Treadmill desks

3.

Position statement: All desk workers should be provided with treadmill desks to encourage standing and healthy exercise.

5. Issue: Organic farming

Position statement: Organic farming is better for the environment than conventional farming.

Support in Argument

TIP For more on evidence, see page 271.

The paragraph and essay models on pages 270–71 use the topic sentence (paragraph) and thesis statement (essay) from the Main Point section of this chapter. Both models include the **support** used in all argument writing: the **reasons** for the writer's position backed up by **evidence**. In the essay model, however, the major support points (reasons) are topic sentences for individual paragraphs.

A good way to find strong support for an argument is to return to some of the critical-thinking strategies you learned about in Chapter 1. Let's take another look at the basics.

Four Basics of Critical Thinking Be alert to assumptions made by you and others. Question those assumptions. Consider and connect various points of view, even those different from your own. Do not rush to conclusions; instead, remain patient with yourself and others, and keep an open mind.

Jess, a student you might remember from Chapter 1, applied some of these basics while working on an argument paper for her English class. She got an idea for the paper while waiting to start her shift at a local restaurant. On the TV over the restaurant's bar, a political commentator and a doctor were debating whether a tax on soda would help reduce obesity.

Jess was in favor of just about any reasonable approach to fighting obesity, although she wasn't sure that a tax on soda (and other sugary beverages) would work. Even the doctor seemed a little unsure.

After finishing her shift, Jess thought about the issue some more, and she began to see how the pros of such a tax might outweigh the cons, but she decided to sleep on the issue before coming to any final conclusions. Here is the working main point she wrote down in her notebook before going to bed.

MAIN POINT Taxing sugary drinks might be a good way to reduce obesity.

QUESTIONING ASSUMPTIONS TO BUILD EVIDENCE

The next morning, Jess used a key critical-thinking strategy to explore her main point in more depth. Specifically, she tried to identify some of the **assumptions** (unquestioned ideas or opinions) behind her main point. She wrote them down on one half of a sheet of notebook paper. Next, she questioned each of her assumptions, trying to put herself in the shoes of someone opposed to beverage taxes. She wrote these questions on the other half of the notebook paper.

TIP Consider this advice from actor Alan Alda: "Begin challenging your own assumptions. Your assumptions are your windows on the world. Scrub them off every once in a while, or the light won't come in."

ASSUMPTIONS BEHIND MAIN POINT	QUESTIONS ABOUT ASSUMPTIONS		
Sugary drinks, like soda, energy drinks, and sweetened tea, can make people fat.	But why target sugary drinks instead of other junk food? Aren't french fries just as bad for the waistline as soda is?		

PARAGRAPHS VS. ESSAYS IN ARGUMENT

For more on the important features of argument, see the Four Basics of Good Argument on page 265.

Paragraph Form

Topic sentence

Support 1 (reason 1)

Support 2 (reason 2)

Support 3 (reason 3)

Concluding sentence

Our company should make regular contributions to local food banks. The first reason for making these contributions is that, as a food wholesaler, we have the resources to do so. Often, we find that we have a surplus of certain items, such as canned goods and pasta, and it would be a waste not to donate this food to organizations that need it so desperately. We could also donate food that is safe

that need it so desperately. We could also donate food that is safe to consume but that we cannot sell to stores or institutions. These items include market-testing products from manufacturers and goods with torn labels. Second, these contributions will improve our image among clients. All other things being equal, grocers, schools, hospitals, and other institutions will be more likely to purchase food from a wholesaler that gives something back to the community than one focused on its financial interests alone. The most important reason for making these contributions is to help our company become a better corporate citizen. Especially in challenging economic times, many people see corporations as

not only clients but also the wider community that we are one of the "good guys." That is, we are willing to do what is right, not only within our organization but also in society. Although some question the need for a donation program, arguing that it would take too much time to organize, the good that will come from the program will far exceed the effort devoted to it.

heartless, and motivated by profits alone. It is important to show

Main Point: Often, narrower for a paragraph than for an essay: While the topic sentence (paragraph) focuses on just one type of charitable organization, the thesis statement (essay) sets up a discussion of different ways to help different charities.

Support for the Main Point (Reasons for the Writer's Position)

Evidence to Back Up
Each Reason: Usually, 1 to
3 sentences per reason
for paragraphs and 3 to
8 sentences per reason for
essays.

Conclusion

Think Critically As You Write Argument

ASK YOURSELF

- · Have I questioned the assumptions behind my main point?
- Have I looked for evidence to respond to these questions and to develop support for my argument? (For more on finding and evaluating outside sources, see pp. 304–09.)
- Have I tested this evidence before including it in my paper?
 (For more on testing evidence, see p. 274.)

At the last executive meeting, we discussed several possible ways to improve our company's marketing and advertising and to increase employee morale. Since attending the meeting, I have become con **Thesis statement** effort would help in those areas and more: Our company should become more active in supporting charities.

This approach has worked well for : Topic sentence 1

First, giving time and money to community organizations is a good way to promote our organization.

competitors. For example, Lanse Industric (reason of for sponsoring Little League teams throughout the city. Its name is on the back of each uniform, and banners promoting Lanse's new products appear on the ball fields. Lanse gets free promotion of these efforts through articles in the local papers, and according to one company source quoted in the *Hillsburg Gazette*, Lanse's good works in the community have boosted its sales by 5 to 10 percent. Another competitor, Great Deals, has employees serve meals at soup kitchens over the holidays and at least once during the spring or summer. It, too, has gotten great

publicity from these efforts, including a spot on a local

TV news show. It is time for our company to s these kinds of benefits.

Topic sentence 2 (reason 2)

Second, activities like group volunteering will help employees feel more connected to one another and to their community. Kay Rodriguez, a manager at Great Deals and a good friend of mine, organized the company's group volunteering efforts at the soup kitchens, and she cannot say enough good things about the results. Aside from providing meals to the needy, the volunteering has boosted the morale of Great Deals employees because they understand that they are supporting an important cause in their community. Kay has also noticed that as employees work together at the soup kitchens, they form closer bonds. She says, "Some of these people work on different floors and rarely get to see each other during the work week. Or they just do not have time to talk. But while they work together on the volunteering, I see real connections forming." I know that some members of our executive committee might think it would be too time-consuming to organize companywide volunteering efforts. Kay assures me, however, that this is not the case

3

and that the rewards of such efforts far exceed the costs in time.

Topic sentence 3 (reason 3)

The most important reason for supporting charities is that it is the right thing to do. As a successful business that depends on the local community for a large share of revenue and employees, I believe we owe that community something in return. If our home city does not thrive, how can we? By giving time and money to local organizations, we provide a real service to people, and we present our company as a good and caring neighbor instead of a faceless corporation that could not care less if local citizens went hungry, had trash and graffiti in their parks, or couldn't afford sports teams for their kids. We could make our community proud to have us around.

Concluding paragraph

I realize that our main goal is to run a profitable and growing business. I do not believe, however, that this aim must exclude doing good in the community. In fact, I see these two goals moving side-by-side, and hand-in-hand. When companies give back to local citizens, their businesses benefit, the community benefits, and everyone is pleased by the results.

ASSUMPTIONS BEHIND MAIN POINT	QUESTIONS ABOUT ASSUMPTIONS
Taxes on sugary drinks would make people less likely to buy these beverages.	Really? It's easy for me to say that this tax would work because I'm not a big fan of these drinks. But if they taxed coffee, the taxes would have to be pretty big to break my four-cups-a-day habit.
The tax revenues would benefit the public.	How much difference would they really make?

TEACHING TIP Go over the concept of evidence carefully. Students' arguments are often weak because of poor evidence or lack of evidence.

To answer these questions, Jess turned to some sources recommended by a college librarian later that day. She also drew on information she found through a Google search, and on a few of her own experiences and observations. In doing so, she gathered the following four types of evidence used most often in support of arguments.

- **FACTS:** Statements or observations that can be proved. Statistics—real numbers from actual studies—can be persuasive factual evidence.
- **EXAMPLES:** Specific information or experiences that support your position.
- **EXPERT OPINIONS:** The opinions of people considered knowledgeable about your topic because of their educational or work background, their research into the topic, or other qualifications. It is important to choose these sources carefully. For example, an economics professor might be very knowledgeable about the possible benefits and drawbacks of beverage taxes. He or she probably wouldn't be the best source of information on the health effects of soda, however.
- **PREDICTIONS:** Forecasts of the possible outcomes of events or actions. These forecasts are the informed views of experts, not the best guesses of nonexperts.

TIP When looking for evidence about assumptions, always seek the most reliable sources of information. For more details on finding reliable sources, see Chapter 18.

The following chart shows the evidence Jess pulled together to address her assumptions and her questions about them. (She revised and expanded her original questions as she explored her topic further.)

ASSUMPTIONS/QUESTIONS TO INVESTIGATE	EVIDENCE IN RESPONSE
To what degree do sugary drinks contribute to obesity?	Fact: According to the Centers for Disease Control and Prevention, about half of all Americans get a major portion of their daily calories from sweetened beverages.
	Fact: In the <i>Journal of Pediatrics</i> , Robert Murray reported that one-fourth of U.S. teenagers drink as many as four cans of soda or fruit drinks a day, each one containing about 150 calories. That translates to a total of 600 calories a day, the equivalent of an additional meal.
	Expert opinion: Dr. Richard Adamson, senior scientific consultant for the American Beverage Association, says, "Blaming one specific product or ingredient as the root cause of obesity defies common sense. Instead, there are many contributing factors, including regular physical activity."

ASSUMPTIONS/QUESTIONS TO INVESTIGATE	EVIDENCE IN RESPONSE		
Do sugary drinks deserve to be targeted more than other dietary factors that can contribute to obesity?	Example (from Jess's personal experience): My brother, his wife, and their three kids are all big soda drinkers, and they are all overweight. They also eat lots of junk food, however, so it is hard to tell how much the soda is to blame for their weight.		
	Fact: The Center for Science in the Public Interest says that sugary beverages are more likely to cause weight gain than solid foods are. After eating solid food, people tend to reduce their consumption of other calorie sources. Unlike solid foods, however, sugary beverages do not make people feel full. Therefore, they may add on calories to satisfy their hunger.		
To what degree would taxes on sugary drinks discourage people from buying these beverages and also reduce	Expert opinion/fact: Several researchers say that the taxes would have to be pretty significant to affect consumer behavior. The average national tax on a 12-ounce bottle of soda is 5 cents, and that has not provided enough discouragement.		
obesity?	Prediction: In the <i>New England Journal of Medicine</i> , Kelly D. Brownell says that a penny-per-ounce tax on sugary beverages could reduce consumption of these beverages by more than 10 percent.		
Would the taxes have any other benefits?	Prediction: Kelly D. Brownell says that by reducing the consumption of sugary beverages, the taxes could help cut public expenditures on obesity. Each year, about \$79 billion goes toward the health-care costs of overweight and obese individuals. Approximately half of these costs are paid by taxpayers.		
	Expert opinion: Brownell also believes that the tax revenues could/should be used for programs to prevent childhood obesity.		

PRACTICE 2 Deepening the Search for Evidence

Come up with at least one other question that could be raised about Jess's topic. Then, list the type(s) of evidence (such as personal examples, an expert opinion from a scientific study, or a prediction from a business leader) that could help answer the question.

QUESTION(S):	Answers will vary.			
TYPE(S) OF EVIDENCE:				

In the process of investigating her assumptions, Jess not only gathered good support; she also encountered some opposing views (one of the Four Basics of Good Argument). One of the opposing views, from Dr. Richard Adamson of the American Beverage Association, gave her a little pause. Because he represents the interests of the beverage industry, he might not offer a completely balanced opinion on the health effects of sweetened drinks, but Jess decided that as long as she mentioned his affiliation with the beverage industry, his point might be worth including in her paper.

In reviewing her evidence, Jess also referred to the following tips from her instructor.

TEACHING TIP To aid students' critical thinking, consider sharing this quotation from Ralph Waldo Emerson: "Stay at home in your mind. Don't recite other people's opinions.... Tell me what you know." Even though students may be drawing on outside sources in their arguments, encourage them to be confident in the conclusions they draw from these sources and from their own observations.

TESTING EVIDENCE

- Consider your audience's view of the issue. Are audience members likely to agree with you, to be uncommitted, or to be hostile? Then, make sure your evidence would be convincing to a typical member of your audience.
- Reread your evidence from an opponent's perspective, looking for ways to knock it down. Anticipate your opponent's objections, and include evidence to answer them.
- Do not overgeneralize. Statements about what everyone else does or what always happens are easy to disprove. It is better to use facts (including statistics), specific examples, expert opinions, and informed predictions.
- Make sure you have considered every important angle of the issue.
- Reread the evidence to make sure it provides good support for your position. Also, the evidence must be relevant to your argument.

DISCUSSION Model the opponent's perspective in class. Put a topic and some evidence on the board.
Ask for ideas about how the opposition would try to knock down the evidence.

PRACTICE 3 Reviewing the Evidence

For each of the following positions, one piece of evidence is weak: It does not support the position. Circle the letter of the weak evidence, and, in the space provided, state why it is weak.

EXAMPLE:

Position: Advertisements should not use skinny models.

Reason: Skinny should not be promoted as ideal.

- a. Three friends of mine became anorexic trying to get skinny.
- **b.**) Everyone knows that most people are not that thin.
- **c.** A survey of girls shows that they think that they should be as thin as models.
- **d.** People can endanger their health trying to fit the skinny "ideal" promoted in advertisements.

Not strong evidence because "everyone knows" is not strong evidence; everyone obviously doesn't know that.

1. Position: People who own guns should not be allowed to keep them at home.

Reason: It is dangerous to keep a gun in the house.

- a. Guns can go off by accident.
- **b.** Keeping guns at home has been found to increase the risk of home suicides and adolescent suicides.
- **c.** Just last week, a story in the newspaper told about a man who, in a fit of rage, took his gun out of the drawer and shot his wife.
- **(d.)** Guns can be purchased easily.

computer If you are working in a lab setting, have each student list the evidence for his or her topic on the computer. Then, have each student move to another student's computer and write down opposition to the evidence that is listed. Students should then return to their own computers and try to answer the objections.

Not strong evidence because it is irrelevant; it doesn't support the position.

2. Position: Schoolchildren in the United States should go to school all year.

Reason: Year-round schooling promotes better learning.

- **a.** All my friends have agreed that we would like to end the long summer break.
- **b.** A survey of teachers across the country showed that children's learning improved when they had multiple shorter vacations rather than entire summers off.
- **c.** Many children are bored and restless after three weeks of vacation and would be better off returning to school.
- **d.** Test scores improved when a school system in Colorado went to year-round school sessions.

Not strong evidence because wanting it doesn't mean it should happen; also this statement is a personal preference, not evidence.

3. Position: The "three strikes and you're out" law that forces judges to send people to jail after three convictions should be revised.

Reason: Basing decisions about sentencing on numbers alone is neither reasonable nor fair.

- **a.** A week ago, a man who stole a slice of pizza was sentenced to eight to ten years in prison because it was his third conviction.
- **b.** The law makes prison overcrowding even worse.
- **c.**) Judges always give the longest sentence possible anyway.
- **d.** The law too often results in people getting major prison sentences for minor crimes.

Not strong evidence because		is	а	generality;	not	all	judges	act	this
way.					71.02	i e	Les Ediff		

After Jess reviewed her evidence, she decided to refine her initial position.

REVISED MAINTo help address the obesity crisis, states should place significant taxes on sugary beverages.

Notice that Jess got rid of the "might" wording that had been part of her original main point. Having done some research, she now believes strongly that the taxes are a good idea—as long as they are high enough to make a significant dent in consumption.

Before writing her paper, Jess created a rough outline stating her main point and her major support points—the reasons for the position expressed in her main point. The reasons are based on the evidence Jess gathered.

ROUGH OUTLINE

Main point: To help address the obesity crisis, states should place significant taxes on sugary beverages.

Support/reasons:

Sugary drinks are a major contributor to obesity.

As long as they are significant, taxes on these drinks could reduce consumption.

The taxes could fund programs targeting childhood obesity.

WRITING THE CONCLUSION

Your conclusion is your last opportunity to convince readers of your position. Make it memorable and forceful. Remind readers of the stand you are taking and the rightness of this stand, even in the face of opposing views.

Before writing your conclusion, imagine that you are an attorney making a final, impassioned appeal to the judge in an important case. Then, put this energy into words with a conclusion that drives your point home. (See Jess's conclusion on p. 277.)

Organization in Argument

Most arguments are organized by **order of importance**, starting with the least important evidence and saving the most convincing reason and evidence for last.

Use **transitions** to move your readers smoothly from one supporting reason to another. Here are some of the transitions you might use in your argument.

TIP For more on order of importance, see page 79.

Common Transitions in Argument

above all more important

best of all one fact/another fact

especially one reason/another reason

most important

for example one thing/another thing

in addition remember

in fact the first (second, third) point

in particular worst of all

in the first (second, third) place

also

Jess used order of importance to organize her argument in favor of taxes on sugary drinks, which follows. The transitions have been highlighted in bold.

You will notice that Jess didn't incorporate all the evidence from the chart on pages 272–73; instead, she chose the evidence she believed offered the strongest support for her main point. She also included an opposing view.

To help address the obesity crisis, states should place significant taxes on sugary beverages, such as soda, sweetened tea and fruit juices, and energy drinks. These drinks are a good target for taxation because they are a major contributor to obesity. According to the Centers for Disease Control and Prevention, about half of all Americans get a major portion of their daily calories from sweetened beverages. In addition, the Journal of Pediatrics reports that one-fourth of U.S. teenagers get as many as 600 calories a day from soda or fruit drinks. This consumption is the equivalent of an additional meal. Another reason to tax sugary drinks is that such taxation could reduce consumption. However, it is important that these taxes be significant, because taxes of just a few additional pennies per can or bottle probably wouldn't deter consumers. According to Kelly D. Brownell, director of the Rudd Center for Food Policy and Obesity, a penny-per-ounce tax on sugary beverages could cut consumption of these beverages by more than 10 percent. It could also reduce the estimated \$79 billion of taxpayer money spent each year on health care for overweight and obese individuals. The most important reason to tax sugary drinks is that the money from such taxes could be used to prevent future cases of obesity. As Brownell notes, the taxes could fund antiobesity programs aimed at educating children about healthy diets and encouraging them to exercise. Some people who are opposed to taxing sugary beverages, such as Dr. Richard Adamson of the American Beverage Association, argue that it is unfair to blame one product for our expanding waistlines. It is true that overconsumption of soda and other sweetened beverages is just one cause of obesity. Nevertheless, targeting this one cause could play a vital, lasting role in a larger campaign to bring this major health crisis under control.

PRACTICE 4 Using Transitions in Argument

The following argument essay encourages students to get involved in service work during college. It was written by Jorge Roque, an Iraq War veteran and Miami-Dade College student who is vice president of a service fraternity.

After reading Jorge's essay, fill in the blanks with transitions. You are not limited to the ones listed in the box on page 276. Answers may vary. Possible answers are shown.

Even for the busiest student, getting involved in service organizations is worth the time and effort it takes. At one point, after I had returned from Iraq, was homeless, and was experiencing post-traumatic stress disorder, I was referred to Veteran Love, a nonprofit organization that helps disabled ex-soldiers, and they helped when I needed it most. When I was back on track, I knew

that I wanted to help others. I was working and going to school with very little extra time, but getting involved has been important in ways I had not expected.

One reason for getting involved is that; In the first place, getting involved helps you meet many new people and form a new and larger network of friends and colleagues. You also learn new skills, like organization, project management, communication, teamwork, and public speaking. The practical experience I have now is more than I could have gotten from a class, and I have met people who want to help me in my career.

Another reason for doing service work is that; In the second place,

service work lets you help other people and learn about them. You feel as if
you have something valuable to give. You also feel part of something larger
than yourself. So often, students are not connected to meaningful communities and work, and service helps you while you help others.

The most important reason to get involved is that; Best of all, service work makes you feel better about yourself and your abilities. What I am doing is important and real, and I feel better than I ever have because of my service involvement. If you get involved with community service of any kind, you will become addicted to it. You get more than you could ever give.

READING SELECTIONS For further examples of and activities for argument, see Chapter 47.

CRITICAL READING Preview Read

Pause Review

See pages 9-12.

Read and Analyze Argument

Reading examples of argument will help you write your own. In the first example, Diane Melancon, an oncologist (cancer doctor), shows how she uses persuasive writing at work. The second examples are opposing argument essays by two students.

As you read these pieces, pay attention to the vocabulary, and answer the questions in the margin. They will help you read critically.

PROFILE OF SUCCESS

Argument in the Real World

Background Although I graduated second in my high school class in Fall River, Massachusetts, my family did not encourage me to go to college. Instead, it was expected that I would marry and get some kind of job that did not require a college degree. Nevertheless, after finishing high school I entered Southeastern Massachusetts University (now part of the University of Massachusetts) as a biology major. I had no idea what I really wanted to do, however, and I ended up leaving college after the first year and going to a vocational school to be a medical assistant. When I finished that training, I got a job as an EKG technician. After doing that for a year and a half, I applied to X-ray school at Northeastern University, where I eventually received my associate's degree. For two years after graduation, I worked at Boston University Medical Center. During this time I started to have doubts about whether I wanted to be an X-ray tech for the rest of my life. Some of my friends started saying, "You really should try to go to medical school." But to go to med school, I first needed to get a bachelor's degree, so I applied to and was accepted at Wellesley College. Wellesley was tough for me at the beginning because I started there when I was twenty-five, and to seventeenand eighteen-year-olds, I was kind of an old lady. But I got through, and after graduating with a biology degree, I was accepted into Dartmouth Medical School.

After graduating from medical school I practiced internal medicine in Massachusetts, New Hampshire, and Texas. In 2005, I happened to see an advertisement for a job in the hematology/oncology group of St. Mary's Hospital in Grand Junction, Colorado. I got the job, and after a year of training, I became a member of the hematology/oncology group, where I focus mostly on breast and gynecological cancers.

Although I followed kind of a curvy path to get to where I am now, I think I found what I was meant to do, and I love my work. As my experience shows, people can do much more than they ever think they can if they believe in themselves and persevere.

Degrees/Colleges Medical assistant certificate, Diman Regional Vocational Technical High School; A.S., Northeastern University; B.A., Wellesley College; M.D., Dartmouth Medical School

Employer St. Mary's Hospital

Writing at work The major types of writing that I do are (1) patient assessments, in which I pull together information about a patient's condition to specify a diagnosis, and (2) treatment plans.

Diane's Argument

In the following piece of writing, Diane argues for advance directives. In these legal documents, individuals spell out how they wish their medical treatment to be handled in a life-threatening situation. If you have studied definition, notice as you read that Diane uses elements of definition to make her argument.

Diane Melancon Oncologist

Vocabulary development

Underline these words as you read.

chemotherapy: drug therapy aimed at killing cancer cells

strains: difficulties sustaining: preserving ventilators: machines that help with or perform the breathing process

aggressive: powerful cardiopulmonary resuscitation: a method of restoring someone's heart and lung function in an emergency

incapable: unable contradicted: opposed scenario: situation

situation

Consider these difficult situations: (1) A car accident seriously damages a young man's brain, leaving his family to decide whether or not he should be kept on life support. (2) A patient's cancer is not responding well to chemotherapy. She must decide whether to continue with the therapy, despite its physical and emotional strains, or to receive only care that reduces pain and provides comfort. Nothing will make such decisions any easier for these patients or their families. However, people who are able to provide guidance for their treatment in advance of a medical crisis can help ensure that their wishes are followed, even under the most difficult circumstances. Therefore, everyone should seriously consider preparing advance directives for medical care.

[One major reason] for preparing advance directives is that they make it clear to care providers, family, and other loved ones which medical measures patients do or do not want to be taken during a health crisis. Directives specify these wishes even after patients are no longer able to do so themselves - because, for example, they have lost consciousness. Advance directives include living wills, legal documents that indicate which life-sustaining measures are acceptable to patients and under what circumstances. These measures include the use of breathing aids, such as ventilators, and of feeding aids, such as tube-delivered nutrition. Living wills may also indicate a point at which a patient wishes to receive only comfort care, as opposed to aggressive treatment. Furthermore, living wills may specify whether patients wish to receive cardiopulmonary resuscitation if their heart and breathing stop. Finally, through a legal document known as a medical power of attorney, patients may select another person to make medical decisions on their behalf if they become incapable of doing so themselves. All of these parts of advance directives help reduce the risk that patients' wishes will be overlooked or contradicted during any point of the treatment process.

Another important reason for preparing advanced directives is that they can reduce stress and confusion in the delivery of care. Ideally, patients should complete these directives while they are still relatively healthy in mind and body and capable of giving thoughtful and informed instructions for their own medical care. In contrast, waiting until a health problem is far advanced can increase the difficulty and stress of making medical decisions; at this point, patients and their loved ones may be feeling too overwhelmed to think carefully through the various options. In the worst-case scenario, patients may have moved beyond the ability to contribute to medical decisions at all. In such cases, family members and others close to patients may be forced to make their own judgments about which treatments should or should not be given, possibly resulting in disagreements and confusion. However, when patients have made their preferences clear in advance, care delivery moves more smoothly for them and everyone else.

Some people may believe that advance directives are too depressing to think about or that they are even unnecessary. They may take the attitude "Let's cross that bridge when we come to it." However, as has been noted, by the time the bridge is in sight it might already be too late. Although making advance plans for life-threatening medical situations can be difficult and emotional, avoiding such planning can create more stress for patients and their loved ones. Worse, it may mean that the patients' true wishes are never known or acted upon.

- 1. Double-underline the thesis statement.
- 2. Circle the transitions that introduce the different reasons supporting the argument.
- 3. Underline the part of the essay that presents an opposing view.
- Does this essay follow the Four Basics of Good Argument (p. 265)? Why 4. or why not? Yes. Answers will vary.

The next two student essays argue about the wisdom of using social media, like Facebook and Twitter, as educational aids in college. Read both essays, and answer the questions after the second one.

Student Argument Essay 1: "Yes" to Social Media in Education

Jason Yilmaz

A Learning Tool Whose Time **Has Come**

Efforts to incorporate social media into courses at our college have 1 drawn several complaints. A major objection is that Facebook and Twitter are distractions that have no place in the classroom. Based on my own experiences, I must completely disagree. Social media, when used intelligently, will get students more involved with their courses and help them be more successful in college.

In the first place, social media can help students engage deeply with 2 REFLECT Do you think using academic subjects. For example, in a sociology class that I took in high school, the instructor encouraged students to use Twitter in a research

Vocabulary development

Underline the following words as you read.

incorporate: to add; to bring

objection: an argument against something

distractions: things that draw attention away from something else

engage: to become involved in

social media in your classes would help you get more out of your education?

assignment. This assignment called for us to record, over one week, the number of times we observed students of different races and ethnic groups interacting outside of the classroom. Each of us made observations in the lunch room, in the courtyard where students liked to hang out between classes, and in other public areas. We tweeted our findings as we did our research, and in the end, we brought them together to write a group report. The Twitter exchanges gave each of us new ideas and insights. Also, the whole process helped us understand what a research team does in the real world.

In the second place, social media are a good way for students to get help and support outside of class. As a commuter student with a job, it is hard for me to get to my instructors' office hours, let alone meet with other students. Therefore, I would value Facebook groups that would let me post questions about assignments and other homework and get responses from instructors and other students. Also, I would be able to form online study groups with classmates.

Finally, social networking can make students feel more confident and connected. In the sociology course where I used Twitter, I found that other students valued and respected the information that I shared, just as I valued their contributions. Also, all of us felt like we were "in this together"—an uncommon experience in most classrooms. I have heard that feeling connected to other students and to the larger college community can make people less likely to drop out, and I believe it.

New things often scare people, and the use of social media in education is no exception. However, I would hate to see fears about social media get in the way of efforts to make students more engaged with and successful in college. We owe it to students to overcome such fears.

PREDICT What points do you think will be raised in the opposing argument?

Vocabulary development

Underline these words as you read.

spell: a state of being enchanted or fascinated by something

initiative: a program or process

compromise: to interfere with

savvy: knowledgeable or sophisticated

plagiarism: using other people's words as your own

Student Argument Essay 2: "No" to Social Media in Education

Shari Beck

A Classroom Distraction—and Worse

Last week, I saw the campus newspaper's story about new efforts to incorporate Twitter, Facebook, and other social media into courses. What did I think about these efforts? To get my answer, I only had to lower the newspaper. Across the table from me was my fourteen-year-old son, whom I'd just told, for the third time, to go upstairs and do his homework.

Instead, he was still under the spell of his phone, thumbs flying as he continued to text a friend about who knows what.

As you might have guessed already, my answer to my own question is 2 at bedfordstmartins.com/ this: Making social media part of a college education is a terrible idea, for a whole lot of reasons.

One reason is the distraction factor, illustrated by my phone-addicted 3 son. I am confident that he is not the only person incapable of turning his full attention to any subject when the competition is an incoming or outgoing text message, or anything happening on a computer screen. Supporters of the college's social-media initiative say that students will benefit from discussing course material on Facebook or Twitter. I am concerned, however, that such discussions—when and if they ever take place—would quickly go off-topic, turning into social exchanges. Also, participants' attention could easily wander to other links and news flashes.

Another reason I am opposed to social media in education is that stu- 4 dents' postings on Facebook or Twitter might compromise their privacy. I am not confident that all teachers will educate students about the importance of limiting the personal information that they make available in public forums. Tech-savvy students probably know how to maximize their privacy settings, but I doubt that all students do.

My biggest concern is that students will use social media to cheat. 5 SUMMARIZE Sum up According to proponents of the social-media initiative, one of the biggest educational advantages of Facebook and Twitter is that students can exchange information and form study groups. But it is also possible that they will share answers to homework or test questions or take credit for information posted or tweeted by others. They may not realize that such information theft is plagiarism—something that could cause them to fail a course, or worse. In responding to a 2011 survey by the Pew Research Center, 55 percent of college presidents said that student plagiarism had increased over the previous ten years. Of those who reported this increase, 89 percent said computers and the Internet played "a major role." It would be a shame to make this growing problem even worse through programs like the college's social-media initiative.

From where I sit—once again, across the table from my phone- 6 distracted son—the disadvantages of this initiative far outweigh the benefits. I plan to send an e-mail opposing it to the Student Affairs Office. First, though, I'm taking my son's phone away for the night.

- Double-underline the thesis statement in both essays.
- Underline the **reasons** for the position taken in each essay.

TIP For advice on building your vocabulary, visit the Student Site for Real Writing realwriting.

REFLECT Do you think people are too addicted to their cell phones? Why or why not?

TIP For reading advice, see Chapter 1.

the points made in this paragraph.

- **3.** Does each essay follow the Four Basics of Good Argument (p. 265)? Give examples to support your answer. Answers will vary.
- **4.** Write down at least one additional support point/reason that one of the authors might have included. Then, describe the types of evidence that could be used to back up this support point. Answers will vary.

Respond to one of the following assignments in a paragraph or essay.

- 1. Write a letter to Jason or Shari, either in support of or against his or her argument. Make sure to back up the reasons for your position with evidence.
- 2. The previous essays focus on the educational applications of social media. Now, think about the possible uses of social media in the workplace. Do you see any benefits to this usage, or do you think that social media would be just another distraction at work? Support your argument with evidence.
- **3.** Think of (1) a new policy or program you would like to see adopted at your school or (2) an existing or proposed policy or program you would like to see discontinued or dropped from consideration. Provide at least two reasons for your position, and make sure to back up your argument with evidence.

Write Your Own Argument

In this section, you will write your own argument based on one of the following assignments. For help, refer to the How to Write Argument checklist on page 287.

ASSIGNMENT OPTIONS Writing about College, Work, and Everyday Life

Write an argument paragraph or essay on one of the following topics or on one of your own choice. If you responded to the idea journal prompt on page 267, you might develop that writing further.

COLLEGE

- Take a position on a controversial issue on your campus. If you need help coming up with topics, you might consult the campus newspaper.
- Argue for or against the use of standardized tests or placement tests. Make sure to research different positions on the tests to support your argument and address opposing views. One Web site you might consult is standardizedtests.procon.org.

TEAMWORK Before students write a paper for Assignment 3, ask them to jot down their positions and reasons and exchange them with another student. Each student should suggest opposing views for the other student's argument and provide advice about evidence or other angles to consider.

debates on some of these topics. Poll the class on the issues, divide students into groups to develop arguments, and suggest using the library to gather evidence. Devote a class period to the debates and a discussion of the effectiveness of the arguments.

■ In 2011, "Occupy" protests swept college campuses. In them, students argued for a fairer economic system nationally, lower tuition, and other measures to reduce financial burdens on them and other citizens. If you support their arguments, explain why, providing specific reasons and examples. If you oppose their arguments, give reasons and examples for your position.

WORK

- Argue for a change in a company policy.
- Argue for something that you would like to get at work, such as a promotion, a raise, or a flexible schedule. Explain why you deserve what you are asking for, and give specific examples.
- Argue for an improvement in your workplace, such as the addition of a bike rack, new chairs in the break room, or a place to swap books or magazines. Make sure your request is reasonable in cost and will be beneficial to a significant number of employees.

EVERYDAY LIFE

- Take a position on a controversial issue in your community.
- Choose a community organization that you belong to, and write about why it is important. Try to persuade your readers to join.
- Oscar Wilde (1854–1900), a famous Irish writer, once commented, "Most people are other people. Their thoughts are someone else's opinions, their lives a mimicry, their passions a quotation." Write an argument that supports or opposes Wilde's views, giving reasons and examples for your position.

ASSIGNMENT OPTIONS Reading and Writing Critically

Complete one of the following assignments, which ask you to apply the critical thinking, reading, and writing skills discussed in Chapter 1.

Writing Critically about Readings

The pro/con essays by Jason Yilmaz and Shari Beck (see pp. 281–83) are strongly focused on arguing a position. Sometimes, however, arguments can take a more subtle form. See, for instance, Frances Cole Jones's "Don't Work in a Goat's Stomach" (p. 199) and Kristen Ziman's "Bad Attitudes and Glowworms" (p. 259). Read or review these pieces, and then follow these steps:

- **1. Summarize** Briefly summarize at least two of the works, listing major examples and details.
- **2. Analyze** What features of argument do you see in the essays by Jones and Ziman?

CONNECTIONS

JORGE ROQUE (see the essay on p. 278) is vice president of a service fraternity at his college. Getting more involved in college and community activities, as Jorge did, can help you feel more connected to others and can even improve the chances that you will stay in school.

For more on this story, ways to make community connections, and writing assignments, visit bedfordstmartins.com/realwriting.

TIP For a reminder of how to summarize, analyze, synthesize, and evaluate, see the Reading and Writing Critically box on pages 16–17.

TEACHING TIP If time is short, students might complete just one or two steps of this assignment.

TEACHING TIP Nele Azevedo says that the original purpose of her ice sculptures was to provide "a critical reading of the monument in contemporary cities." In contrast to largescale traditional monuments, made of stone or metal, her ice sculptures are small and perishable, like human bodies. Share Azevedo's quotation with students, and ask what they see as the purpose of public monuments.

- **3. Synthesize** Using examples from at least two of the previously mentioned essays and from your own experience, describe the features that make an argument successful and convincing. Think of features beyond those in the Four Basics of Good Argument.
- **4. Evaluate** In your opinion, are strongly focused arguments or subtler arguments more effective? Or do both types of writing have a place? Explain your answer.

Writing about Images

The following photograph is of an installation by Brazilian sculptor Nele Azevedo, who travels around the world and sets up ice sculptures of people on the steps of government buildings. Throughout the day, the sculptures melt, helping to illustrate the effect of climate change.

Study the photograph, and complete the following steps.

- **1. Read the image** Ask yourself: What details are you drawn to, and why? What emotions or reactions do the melting sculptures bring about in you? (For more information on reading images, see Chapter 1.)
- 2. Write an argument Write a paragraph or essay in which you respond to Azevedo's work and discuss the argument you think that she's making with it. How effective do you find her visual argument? Is it a good way to convey the effects of climate change? Why or why not? Include the details and reactions from step 1.

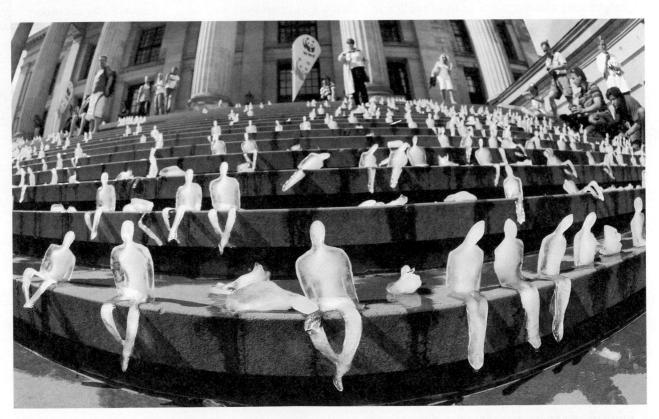

Writing to Solve a Problem

Read or review the discussion of problem solving in Chapter 1 (pp. 24–26). Then, consider the following problem.

Your friend/child/relative has just turned sixteen and is planning to drop out of high school. He has always done poorly, and if he drops out, he can increase his hours at the restaurant where he works. You think that this idea is terrible for many reasons.

ASSIGNMENT: In a group or on your own, come up with various reasons in support of your decision. Consider, too, your friend's/child's/relative's possible objections to your argument, and account for them. Then, write an argument paragraph or essay to persuade him to complete high school. Give at least three solid reasons, and support your reasons with good evidence or examples. You might start with the following sentence:

TEAMWORK For more detailed guidance on group work, see *Practical Suggestions*.

There are so many important reasons to stay in school and get	
your high school diploma.	

STI	EPS	DETAILS
311	=F-0	DETAILS
	Narrow and explore your topic. See Chapter 3.	Make the topic more specific.Prewrite to get ideas about the narrowed topic.
	Write a topic sentence (paragraph) or thesis statement (essay). See Chapter 4.	State your position on your topic.
	Support your point. See Chapter 5.	Come up with reasons and evidence to back up your position.
	Write a draft. See Chapter 6.	 Make a plan that puts the reasons in a logical order. Include a topic sentence (paragraph) or thesis statement (essay) and all the reasons and supporting evidence.
	Revise your draft. See Chapter 7.	 Make sure it has all the Four Basics of Good Argument. Make sure you include transitions to move readers smoothly from one reason to the next.
	Edit your revised draft. See Parts 4 through 7.	 Correct errors in grammar, spelling, word use, and punctuation.

Chapter Review

- 1. Argument is writing that takes a position on an issue and gives evidence to support it.
- 2. What are the Four Basics of Good Argument?

 It takes a strong and definite position.

It gives good reasons and supporting evidence to defend the position.

It considers opposing views.

It has enthusiasm and energy from start to finish.

- 3. The topic sentence (paragraph) or thesis statement (essay) in an argument should include what two elements? an issue and the writer's position on that issue
- **4.** What three types of information make good evidence? facts, examples, expert opinions
- 5. Why do you need to be aware of opposing views? to anticipate attacks that may damage the strength of your argument
- 6. Write sentences using the following vocabulary words: aggressive, contradicted, distractions, compromise, plagiarism. Answers will vary.

reflect Write for 2 minutes about what you have learned about writing a good argument.

LEARNING JOURNAL

Reread your idea journal entry (p. 267) about why your friend should take a college course. Make another entry about this topic, using what you have learned about argument.

apello? Tolowick

YOU KNOW THIS

You often share what you have learned with others:

- You summarize events or TV shows for friends.
- You tell a classmate who missed class what happened.
- You report on a meeting at work for your boss.

17

Writing Summaries, Reports, and Essay Exams

Showing What You Have Learned

Write a Summary

A **summary** is a condensed, or shortened, version of something—often, a longer piece of writing, a movie or TV show, a situation, or an event. It presents the main ideas and major support, stripping the information to its essential elements.

Four Basics of a Good Summary

- It has a topic sentence (in a paragraph) or a thesis statement (in an essay) that states what is being summarized and its main idea.
- 2 It identifies the major support points.
 - It includes any final observations or recommendations made in the original piece.
- It is written in your own words and presents information without your opinions.

1 The essay "A Classroom Distraction—and Worse" argues against using social media as an educational tool in college. 2 The first reason the author gives for her position is that social media might draw students' attention away from course content instead of encouraging them to focus on it. For example, online discussions of course material might turn into chit-chat sessions. 2 Second, the author argues that students

TIP Shari Beck's essay, "A Classroom Distraction—and Worse," appears on pages 282–83. 4 Summary is in the writer's own words.

might post too much information about themselves, harming their privacy. Finally, she says that students might use social media to give one another answers to test questions or homework assignments or to plagiarize—a growing problem, according to college presidents. 3 The author concludes by saying that any benefits provided by using social media in education are small in comparison to the drawbacks.

There are many uses for summarizing.

COLLEGE	To answer a test question for a history course, you summarize the causes of the Great Depression.		
WORK	You write a summary of a telephone conversation to send to a client and your boss.		
EVERYDAY LIFE	You summarize a car accident for your insurance company.		

The Reading Process for Summaries

To write a summary, you must first understand what you are reading. To note what is important as you read, you might follow this process:

READING TO SUMMARIZE

- 1. Double-underline the main point, and write "main point" in the margin next to it.
- 2. Underline the major support points, and write "major support" in the margin.
- 3. Underline the final observations, recommendations, or conclusions, and write "conclusion" in the margin.
- 4. After you finish reading, write a sentence or two, in your own words, about what is important about the piece.

Here is the paragraph from the Four Basics of a Good Summary, underlined and annotated using the steps of the reading process.

Main point ———	The essay "A Classroom Distraction—and Worse" argues against		
	using social media as an educational tool in college. The first reason th		
	author gives for her position is that social media might draw students'		
Major support ————	attention away from course content instead of encouraging them to		
	focus on it. For example, online discussions of course material might		
	turn into chit-chat sessions. Second, the author argues that students		
Major support ————	might post too much information about themselves, harming their		
	privacy. Finally, she says that students might use social media to give		
Major support ————	one another answers to test questions or homework assignments or		
	to plagiarize—a growing problem, according to college presidents.		

TIP Instead of underlining, you could use two different-colored highlighters for steps 1 and 2.

The author concludes by saying that any benefits provided by using social media in education are small in comparison to the drawbacks.

Conclusion

WHAT'S IMPORTANT: The writer argues that using social media in college does more harm than good.

PRACTICE 1 Reading to Summarize

Read the following essay, and mark it according to the four steps of Reading to Summarize.

In 2010, Congress passed a law to bring tighter regulations to Wall Street and prevent another major economic crisis. Despite this law's passage, the threat of another financial meltdown remains.

One reason the threat remains is that financial institutions have little incentive to change the practices that got them into trouble in the first place. In 2009, billions of dollars of taxpayer money went to rescuing banks and other financial interests perceived as "too big to fail." Even though the Wall Street Reform and Consumer Protection Act, also known as the Dodd-Frank law, seeks to reduce the need for future bailouts of this kind, it may have little effect in the long run. As business reporter Shahien Nasiripour writes, large financial institutions have come to believe that if they get into more trouble, the government will always come to their rescue; therefore, it is likely that they will continue to take risks, such as making careless loans.

Furthermore, continuing resistance to the Dodd-Frank law is reducing its effectiveness. Nasiripour reports that one year after passage of the legislation, only 38 of its 400 new rules had been finalized. One reason for this slow progress is financial institutions' reservations about various parts of the law, expressed in ongoing meetings with federal regulators. According to an article by *New York Times* reporter Edward Wyatt, financial lobbyists spent more than \$50 million in 2011 to try to change Dodd-Frank. They are getting help from Senate and House members who are taking steps to repeal the law, to further reduce its power, or to cut the budgets of regulatory bodies, such as the Securities and Exchange Commission, charged with enforcing the new rules (Nasiripour). Although the Dodd-Frank law is far from ideal, any successes in weakening or overturning it will place the U.S. economic system at greater risk.

Main point

Major support

Major support

TIP Summaries and reports often use specific passages or quotations from a piece. For more information on citing and documenting source material, see Chapter 18.

Major support

Major support

	Most b
Conclusion —	the econor
	ness as usu

Most big banks and other large financial institutions have come out of the economic crisis thriving and relieved that, for the most part, it is business as usual for them. But business as usual in financial regulation could have devastating consequences for the economy as a whole.

Works Cited

Nasiripour, Shahien. "A Year after Dodd-Frank, Too Big to Fail Remains Bigger Problem Than Ever." *Huffingtonpost.com*. Huffington Post, 20 July 2011. Web. 5 Dec. 2011.

Wyatt, Edward. "Dodd-Frank Under Fire a Year Later." *Nytimes.com*. New York Times, 18 July 2011. Web. 5 Dec. 2011.

WHAT'S IMPORTANT: Answers will vary but should get at the ongoing economic threat resulting from weaknesses in, and resistance to, the Dodd-Frank law.

PRACTICE 2 Reading to Summarize

Read Janice E. Castro's essay on pages 218–220, and mark it according to the four steps of Reading to Summarize.

The Writing Process for Summaries

Use the following checklist to help you write summaries.

STEPS		DETAILS
	Focus.	Think about why you are writing the summary and for whom. How much information will your audience need?
	Read the selection carefully.	Underline the main idea, the major support, and the conclusion(s), noting each in the margin.
	Write a short statement about what you have read.	 In your own words, write what is important about the piece.
	Reread the sections you underlined and annotated, along with your written statement.	Make additional notes or annotations.
	Draft the summary.	 For an essay-length summary, make an outline. While drafting your summary, refer to the original piece, but use your own words. Work in the points you have annotated, using your outline if you wrote one.

STEPS	DETAILS
☐ Revise the summary.	 Make sure it has all the Four Basics of a Good Summary (p. 291).
	 Add transitions to move readers smoothly from one point to another.
	 Have you clearly told your reader what article, essay, or other source you are summarizing?
☐ Edit your work. (See Parts 4 through 7.)	Check for errors in grammar, spelling, and punctuation.

Summary Assignments

Choose one of the following assignments, and complete it using the previous checklist.

- Using your notes from Practice 1, write a summary of the piece in Practice 1.
- Summarize a section of a textbook from one of your other courses.
- Summarize an editorial from a print or online magazine or newspaper.
- Summarize an entry from a blog that you have read.
- Summarize the plot of a movie or television program.
- Summarize one of the essays in Chapters 8 through 16.

Write a Report

A **report** usually begins with a short summary of a piece of writing, a conversation, or a situation. Then, it analyzes the information, providing reactions, opinions, or recommendations. Unlike a summary, a report often includes the writer's opinions.

The following apply to reports on pieces of writing.

In the first sentence or paragraph, it states the title and author of the piece and gives a brief overview. It summarizes the piece, including the main idea and major support points. It then moves to the writer's reactions and reasons for those reactions. It concludes with an opinion (such as whether the piece is good or bad) or a general observation from the writer.

TIP Notice that the present tense is used to describe the action in essays and literary works.

"A Brother's Murder": A Painful Story That Is as True as Ever

1 In the essay "A Brother's Murder," Brent Staples writes about his Title, author, and brief overview younger brother, Blake, who took a different path in life than Staples did. 2 The essay starts with a phone call in which Staples learns that Blake has been murdered, shot six times by a former friend (554). The essay goes on to tell about the conditions in which Blake grew up. The neighborhood in which the brothers lived was violent, and young men grew into dangerous adults. Staples recalls a conversation he overheard there between two Vietnam veterans, in which one of them said how much he Direct reference preferred to fight with young men from the inner city, who wear "their manhood on their sleeves." They weren't afraid to fight, believing that violence proved they were real men (554-55). Summary with major events/support The author leaves the neighborhood to go to college, and he never returns. Blake, however, stays, and the author recalls a visit home when he sees that his brother has been transformed and now hangs out with drug dealers and gangs (555). When Staples notices a wound on his brother's hand, Blake shrugs it off as "kickback from a shotgun" (555). The author Direct reference wants to help his brother and makes a date to see him the next night (556). Blake does not show up, and the author returns to Chicago, where he lives. Sometime later, he gets the phone call that announces Blake's death, and he regrets that he had not done something to help his brother. 3 "A Brother's Murder" is a moving and sad story about how men growing up in the inner city are destroyed. Although the essay was written in 1986, its message is at least as true today as it was then. Staples Writer's reactions shows how his brother is sucked into the routine violence of the streets, shooting and being shot because that is what he knows and that is how a man shows that he is a man. 4 Today, thousands of young men live this life and die before they are thirty. This essay makes me wonder why this situation continues, but it also makes me wonder how two brothers could go such differ-Conclusion with writer's ent ways. What happened to save Brent Staples? Could he have saved observations and opinion

societal problem.

Work Cited

Blake? What can we do to stop the violence? "A Brother's Murder" is an excellent and thought-provoking essay about a dangerous and growing

Staples, Brent. "A Brother's Murder." Real Skills with Readings: Sentences and Paragraphs for College, Work, and Everyday Life. Ed. Susan Anker. 2nd ed. Bedford/St. Martin's: 2010. 554–56. Print.

You may need to write a report in a number of situations.

COLLEGE	You are assigned to write a book report.
WORK	You are asked to report on a product or service your company is considering.
EVERYDAY LIFE	You write an e-mail to a friend reporting on how your first months of college are going.
	mot months of comege are going.

The Reading Process for Reports

Reading to write a report is like reading to write a summary except that, in the last step, you write your response to the piece instead of just noting what is important about it.

READING TO REPORT

- 1. Double-underline the main point, and write "main point" in the margin next to it.
- 2. Underline the major support points, and write "major support" in the margin.
- 3. Underline the final observations, recommendations, or conclusions, and write "conclusion" in the margin.
- 4. After you finish reading, write a sentence or two, in your own words, about how you responded to the piece and why.

PRACTICE 3 Reading to Report

Read Frances Cole Jones's essay on pages 199–201. Then, mark it according to the four steps of Reading to Report.

The Writing Process for Reports

Use the following checklist to help you write reports.

CHECKLIST: HOW TO WRITE A REPORT		
STEPS	DETAILS	
☐ Focus.	 Think about why you are writing the report and for whom. What do you think of the piece, and how can you get that view across to readers? 	
☐ Read the selection carefully.	 Underline the main idea, the major support, and the conclusion(s), noting each in the margin. 	

CHECKLIST: HOW TO WRITE A REPORT		
STEPS	DETAILS	
Write a short statement about what you have read.	 In your own words, write your reactions to the piece and reasons for those reactions. 	
Reread your underlinings, marginal notes, and reactions.	Make additional notes, and look for specific statements from the piece you might use in your report.	
☐ Draft the report.	 For an essay-length report, make an outline. While drafting your report, refer to the original piece, but use your own words. Start with a summary, including the major support points. Work from your outline if you wrote one, including your reactions. 	
Revise the report.	 Make sure it has all the Four Basics of a Good Report (p. 295). Add transitions to move readers smoothly from one point to another. Make sure the report (aside from quotations) is all in your own words. 	
Edit your work. (See Parts 4 through 7.)	Check for errors in grammar, spelling, and punctuation.	

Report Assignments

Complete one of the following assignments, using the checklist above.

- Using your notes from Practice 3, write a report on Frances Cole Jones's essay (pp. 199–201).
- Report on a movie or a concert you have seen recently.
- Report on an event in your community.
- Report on an article in a print or online magazine or news source.
- Report on one of the essays in Chapters 8 through 16.

Write a Response to an Essay Exam Question

In this course and others, you may be asked to complete an **essay exam**. In these exams, you must write an essay in response to questions like the following one from a sociology course:

Define *groupthink* and identify three of its major characteristics, giving explanations and examples.

Four Basics of a Good Response to an Essay Question It includes a thesis statement that directly responds to the essay question. It supports the thesis statement—again, by directly responding to the essay question. It provides enough explanations, examples, and details for each support point. It ends with a conclusion that refers back to the thesis statement and makes an observation.

The following essay responds to the exam question from the sociology course.

In *groupthink*, the members of a group value complete agreement among themselves over individuals' thoughts and ideas. 1 It has the following major characteristics.

One characteristic of groupthink is that group members are pressured to conform with the beliefs and practices of the group. If they have any doubts or concerns about these beliefs or practices, they usually do not express them and continue to go along with the group. According to psychologist Irving Janis, group members known as *mindguards* contribute to conformity by trying to block or counter any outside information that goes against the group's beliefs. Also, if a mindguard notices that any members of the group are starting to disagree with the group's ideas, he or she will put pressure on them to end their opposition.

2 Another characteristic of groupthink is that anyone who does not belong to the group is portrayed in a negative way. 3 This viewpoint helps group members feel superior to outsiders. It also helps dehumanize outsiders, making it easier for group members to mistreat them or, in the worst cases, kill them. One of the most horrifying examples of dehumanization under groupthink was Nazi Germany's oppression and murder of millions of Jews during World War II.

A third characteristic of groupthink is that group members believe that they are morally just, even if they have committed crimes against humanity. Group conformity contributes to this perception. For example, group members tend to think, "How can this action be wrong if all of us think it is the right thing to do?" Terrorist organizations, such as al-Qaeda, provide just one example of this type of groupthink.

In any group, even those with the best intentions, it is a good idea for members to look for these signs of groupthink and work against them—or, if this approach fails, to leave the group. The best groups welcome the ideas and views of members and respect non-members. In the long run, such openness can help them achieve better outcomes.

The Process of Succeeding on Essay Exams

Taking the following steps will help you do your best on an essay exam.

BEFORE THE TEST

- 1. Make sure you understand what will be covered on the exam. If you are unsure about anything, ask your instructor.
- 2. Review the relevant content from lecture notes, textbooks, or other materials. Begin this review as early as possible.
- 3. Come up with a sample essay question, and write a response to it. Give yourself only as much time as you will have for the actual test.

DURING THE TEST

- 1. Underline key words in the essay question—the words that tell you what you need to do or provide. (In the essay exam question on p. 298, the key words are *define*, *identify*, *three* ... *major characteristics*, and *explanations and examples*.)
- 2. Divide your time carefully. For example, for a 50-minute exam, you might devote 10 minutes to planning, 30 minutes to drafting, and 10 minutes to revising and editing.
- 3. Try to write a scratch outline for your essay. Your outline should include your thesis statement and at least three support points.
- 4. Stay focused on your topic by keeping the key words in mind as you write.
- 5. Make sure you have followed all the steps in the checklist on page 301.

PRACTICE 4 Identifying Key Words

Underline the key words in the following essay exam questions.

EXAMPLE: Discuss the effects of radiation on humans.

- 1. Describe the process of cell division in prokaryotes and eukaryotes.
- **2.** Summarize the controversy surrounding the use of graphic antismoking images on cigarette packages.
- 3. Discuss the causes and effects of delayed adoption of children.
- **4.** <u>Identify</u> and <u>explain</u> the <u>major differences</u> between the brains of teenagers and adults.
- **5.** Evaluate Joe Klein's argument in favor of legalizing marijuana, giving reasons for your responses.

The Writing Process for Essay Exams

Use the following checklist to help you write an effective response to an essay exam question.

CHECKLIST: HOW TO WRITE A RESPONSE TO AN ESSAY EXAM QUESTION STEPS DETAILS		
31273		
☐ Focus.	 Underline the key words in the essay question, and think about what they are asking you to do. 	
☐ Draft the essay.	 Make an outline, and refer to it as you write. 	
	Conclude with an observation about your topic.	
☐ Revise the essay.	 Make sure it has all the Four Basics of a Good Response to an Essay Question (p. 299). 	
	 Add transitions to move readers smoothly from one point to another. 	
☐ Edit your work. (See Parts 4 through 7.)	 Check for errors in grammar, spelling, word use, and punctuation. 	

Chapter Review

- It has a topic sentence (paragraph) or a thesis statement (essay)
 that states what is being summarized and its main idea. It identifies
 the major support points. It includes any final observations or
 recommendations made in the original piece. It is written in your own
 words and presents information without your opinions.
- 2. How is a summary different from a report? A summary is objective, whereas a report includes the writer's responses.
- **3.** What is the first thing you should do when you get an essay exam question? Underline the key words.

YOU KNOW THIS

You have done research and reported on it:

- You go online to find information about something you want to do or buy.
- You ask a coworker about how to do a certain job, and you take notes.

Writing the Research Essay

Using Sources in Your Writing

In all areas of your life, doing research makes you better informed and strengthens any point you want to make. Here are some situations in which you might use research skills.

COLLEGE In a criminal justice course, you are asked to write

about whether the death penalty deters crime.

WORK You are asked to do some research about a major office

product (such as a phone or computer system) that

your company wants to purchase.

EVERYDAY Your child's doctor has prescribed a certain

medication, and you want information about it.

This chapter explains the major steps of writing a college research essay: how to make a schedule; how to choose a topic and guiding research question; and how to find, evaluate, and document sources. A checklist guides you through the process of writing a research essay.

Make a Schedule

LIFE

Writing a college research essay takes time: It cannot be started and finished in a day or two. To make sure you allow enough time, make a schedule, and stick to it.

You can use the following schedule as a model for making your own.

SAMPLE RESEARCH ESSAY SCHEDULE

Assignment: (Write out what your instructor has assigned.)			
Number	of outside sources required: _	e element an element	
Length (if specified):	PRINCIPLE TO A CONTRACTOR OF THE STATE OF TH	
Draft du	e date:		
Final due	e date:	The Property of the Paris of th	
My gene	ral topic:	Caronska parbonoga Venera kojesti in dosani	
DO BY	STEP		
	Choose a topic.		

TIP F	or detailed
inforr	nation about
writin	g a research
essay	, visit
bedf	ordstmartins
.com	/researchroom.

DO DI	315
	Choose a topic.
	Find and evaluate sources; decide which ones to use.
	Take notes, keeping publication information for each source.
	Write a working thesis statement by answering a research question.
h <u>5-13/4/22</u>	Review all notes; choose the best support for your working thesis.
	Make an outline that includes your thesis statement and support.
	Write a draft, including a title.
	Revise the draft.
The state of the state of	Prepare a list of Works Cited using the correct form of documentation.
	Edit the revised draft.
· <u></u>	Submit the final copy.

Choose a Topic

Your instructor may assign a research paper topic or may want you to think of your own topic. If you are free to choose your own topic, find a subject that interests you and that you would like to explore. Ask yourself some questions such as the following:

- 1. What is going on in my own life that I want to know more about?
- 2. What do I daydream about? What frightens me? What inspires or encourages me?
- 3. What am I interested in doing in the future, either personally or professionally?
- 4. What famous person or people interest me?
- 5. What current issue do I care about?

TEACHING TIP Have students write an "I-search" paper—a proposal in which they report on what they are interested in learning and explain why they are interested in it. In the I-search papers, have students tell you what they know about their topics already and the specific questions they want answers to.

Here are some current topics you might want to research:

TEACHING TIP Have students choose three of these topics to write about in their journals.

Alternative energy sources	Jobs of the future
Behavior disorders	Music/musical groups
A career you are interested in	Obesity in the United States
Education issues	Online dating services
Environmental issues	Privacy and the Internet
Gay/lesbian marriage	Travel
Health/medical issues	Violence in the media
Immigration trends/policies	Volunteer opportunities

Before writing a working thesis statement, you need to learn more about your topic. It helps to come up with a **guiding research question**, which is often a variation of "What do I want to find out about my topic?" This question will help direct and focus your research.

The following is a guiding research question used by Dara Riesler, who chose the topic of dogs trained to help war veterans suffering from post-traumatic stress disorder (PTSD). (To learn how Dara answered this question, see her research paper on p. 319.)

GUIDING RESEARCH
QUESTION

What benefits do service dogs provide to veterans suffering from PTSD?

Find Sources

With both libraries and the Internet available to you, finding information is not a problem. Knowing how to find good, reliable sources of information, however, can be a challenge. The following strategies will help you.

TEACHING TIP If the library offers group training on library resources, schedule such a session for the class because many students will have the same questions.

RESOURCES For reproducible research handouts, see *Additional Resources*.

TIP A catalog is a searchable register of all a library's holdings.

Consult a Reference Librarian

Reference librarians are essential resources in helping you find appropriate information in both print and electronic forms. They will save you time and possible frustration in your search for relevant material.

If your library allows, schedule an appointment with a librarian. Before your appointment, write down some questions to ask, such as the following. Begin your conversation by telling the librarian your research topic.

QUESTIONS FOR THE LIBRARIAN

- How do I use an online catalog? What information will the library's catalog give me?
- Can I access the library catalog and article databases from home or other locations?

- What other reference tools would you recommend as a good starting place for research on my topic?
- Once I identify a source that might be useful, how do I find it?
- Can you recommend an Internet search engine that will help me find information on my topic? Can you also recommend some useful keywords?
- Does the college have access to a research database, such as *EBSCO*, *InfoTrac*, or *LexisNexis*?
- How can I tell whether a Web site is reliable?
- I have already found some articles related to my topic. Can you suggest some other places to look for sources?
- I have found good online sources, but how can I find some good print sources on my topic?

Use the Online Catalog

Most libraries now list their holdings online rather than in a card catalog. You can search by keyword, title, author, subject, publication data, and call number. Online catalog help is usually easy to find (generally on the screen or in a Help menu) and easy to follow. If you are just beginning your research, use the keyword search.

Dara Riesler, who wrote the research essay that appears later in this chapter, searched the library's online catalog using the keywords "service dogs and veterans." Here is one source she found:

TIP For more on conducting keyword searches, see page 306.

Author: Montalván, Luis Carlos

Additional contributors: Witter, Bret

Title: Until Tuesday: A Wounded Warrior and

the Golden Retriever Who Saved Him

Published: New York - Hyperion

Location: Main Library

Call #: HV1569.6.M56 2011

Status: Available

Physical description: xi, 252 p.: ill.; 22 cm.

Contents: The story of how a trained service

dog has helped a traumatized Iraq War

veteran live a better life.

A call number is an identification number that helps you locate a book in the library. Once you find the book you are looking for, browse the nearby shelves, where you may find other sources related to your topic.

If the book is available only at another library, ask a librarian to have the book sent to your library, or request it at your library's Web site.

Look at Your Library's Web Site

Most libraries have a Web site that can help researchers find useful information. The home page may have links to electronic research sources that the library subscribes to and that are free to library users. These databases are usually reliable and legitimate sources of information. The library home page may also list the library's hours, provide search tools, and offer research tips and other valuable information.

Use Your Library's Online Databases and Other Reference Materials

Magazines, journals, and newspapers are called *periodicals*. Periodical indexes help you locate information published in these sources. Online periodical indexes are called *periodical databases* and often include the full text of magazine, journal, or newspaper articles. Libraries often subscribe to these online services. Here are some of the most popular periodical indexes and databases:

EBSCO LexisNexis InfoTrac NewsBank JSTOR ProQuest

TIP Visit www.census.gov, the official Web site of the U.S. Census Bureau, for current state and national

statistical data related to

population, economics, and

TEAMWORK Send groups of students on a collaborative

research trip to the library,

asking each group to find

and report to the rest of the class on one of the

reference sources listed

here. (First, make sure the library has these sources.)

Students should be able

to explain how the source

they reported on could be relevant to their classmates'

research projects.

geography.

Use the Internet

This section will offer some basics on finding what you need on the Internet. To start, visit sites that categorize information on the Web, such as the Internet Public Library at www.ipl.org.

Some Internet sites charge fees for information (such as archived newspaper or magazine articles). Before using any of these sources, check to see whether they are available free through your library's databases.

SEARCH ENGINES AND KEYWORD SEARCHES

Google (www.google.com) is the most commonly used search engine. Others include Yahoo! at www.yahoo.com, www.duckduckgo.com, and www.bing.com.

To use a search engine, type in keywords related to your subject. Adding more specific keywords or phrases and using an Advanced Search option may narrow the number of entries (called *hits*) you have to sift through to find relevant information. Adding additional search terms can narrow a search even more. (With many search engines, you get the best results by enclosing phrases in quotation marks.)

When you discover a Web site to which you might want to return, save the Web address so that you do not have to remember it each time you want to go to the site. Different browsers have different ways of saving Web addresses; use the Bookmarks menu in Netscape or Firefox, or the Favorites menu in Microsoft Internet Explorer.

TEACHING TIP Ask students to test three different search engines by typing in keywords related to their research paper. Which search engine seemed most effective for their research needs? Why?

OTHER HELPFUL ONLINE RESEARCH SITES

Go to the following sites for tutorials on research processes and for other research advice. To access these sites, type their names and sponsors into a search engine.

- The Bedford Research Room (from Bedford/St. Martin's). This site provides advice on finding and evaluating sources and on writing research papers.
- Citing Electronic Information (from the Internet Public Library). This site contains links to various sources that explain how to document information found online.
- Evaluating Web Sites (from Cornell University). This site lists ways to evaluate Internet sources. Your own college library may have a similar Web site.

TIP Many instructors do not consider Wikipedia a good reference source. You might ask your instructor whether you may use Wikipedia for your research paper.

Interview People

Personal interviews can be excellent sources of information. Before interviewing anyone, however, plan carefully. First, consider what kind of person to interview. Do you want information from an expert on the subject or from someone directly affected by the issue? The person should be knowledgeable about the subject and have firsthand experience. When you have decided whom to interview, schedule an appointment.

Next, prepare a list of five to ten open-ended questions, such as What do you think of the proposal to build a new library? Closed questions, such as Are you in favor of building a new library?, will only lead to simple yes-or-no responses.

At the time of the interview, record the person's full name and qualifications and the date. Listen carefully to the responses to your questions and ask follow-up questions. Write down important ideas. If you plan to use any of the person's exact words, put them in quotation marks in your notes so that you can identify direct quotations later. For more on using direct quotations, see page 313 and Chapter 36.

Using a small recorder during the interview can be helpful. If you want to do so, make sure you ask the person for permission.

TEAMWORK Have students interview each other on their research topics. They can write a short summary of the interview using both direct quotations and paraphrases.

Evaluate Sources

Whether you are doing research for a college course, a work assignment, or personal reasons, make sure the sources you use are reliable. Reliable sources present accurate, up-to-date information written by authors with appropriate credentials for the subject matter. Research materials found in a college library (books, journals, and newspapers, for example) are generally considered reliable sources.

Materials found on the Internet must be approached with more caution. When you are doing research on the Internet, try to determine each source's purpose. A Web site set up solely to provide information might be

more reliable than an online product advertisement. A keyword search on "how to lose weight," for example, would point a researcher to thousands of sites; the two shown above and on the facing page are just samples. Which site do you think contains more reliable information?

Here are some questions you can ask to evaluate a source. If you answer "no" to any of these questions, do not use the source.

QUESTIONS FOR EVALUATING A PRINT OR ELECTRONIC SOURCE

- Is the source reliable? It should be a well-known magazine or publisher or from a reputable Web site. (For Web sites, also consider the Internet address extension; see the box on page 309 for guidance.)
- Is the author qualified to write reliably about the subject? If there is no biographical information, do an online search using the author's name, to learn more about the author's qualifications.
- Do you know who sponsored the publication or Web site? Be aware of the sponsor's motives (for example, to market a product).
- Does the author provide adequate support for key points, and does he or she cite the sources of this support?

TEACHING TIP Evaluating Internet sources is often difficult for students. Have them apply these questions to an article or Web site printout that you (or they) bring to class. Decide as a class whether the source is reliable.

Guide to Internet Address Extensions SPONSOR OF SITE **HOW RELIABLE? EXTENSION** Varies. Consider whether you have heard of the organization, A commercial or business .com organization and be sure to read its home page or "About us" link carefully. An educational institution Reliable, but may include materials of varying quality. .edu .gov A government agency Reliable. Varies. See the advice for ".com" extensions. A commercial organization .net Generally reliable, although each volunteer or professional A nonprofit organization .org group promotes its own interests.

Avoid Plagiarism

TIP For more information on evaluating sources and avoiding plagiarism, visit bedfordstmartins.com/researchroom.

ESL In some cultures, copying someone else's work is a gesture of respect. Be very clear with students about what constitutes plagiarism.

Plagiarism is passing off someone else's ideas and information as your own. Turning in a paper written by someone else, whether it is from the Internet or from a friend or family member who gives you permission, is deliberate plagiarism. Sometimes, however, students plagiarize by mistake because the notes they have taken do not indicate which ideas are theirs and which were taken from outside sources. As you find information for your research essay, do not rely on your memory to recall details about your sources. Take good notes from the start, using the guidance on the following pages.

NOTE: This section's advice on recording source information, and on citing and documenting sources, reflects Modern Language Association (MLA) style, the preferred style for English classes and other humanities courses.

Keep a Running Bibliography

In a **bibliography**, record complete publication information for each source at the time you consult it, even if you are not sure you will use it. This step will save you from having to look up this information again when you are preparing your list of **Works Cited**, which includes all the sources that you actually use in your essay. Most instructors require a list of Works Cited at the end of a research essay. Some may require a bibliography as well.

In both bibliographies and Works Cited lists, make sure to alphabetize sources by the authors' last names. In most cases, if no author is named, a source should be alphabetized by its title. (For Dara Riesler's Works Cited list, see p. 323.)

Here is a list of information to record for each source while you are taking notes.

TEACHING TIP Have students practice citing and documenting sources throughout the semester. For example, if they write summaries of readings from this textbook, articles, or Web sites, ask them to use in-text citations and to include a list of Works Cited at the end of each summary.

TIP Go to bedfordstmartins.com/researchroom, and click on "The Bedford Bibliographer" for help with your bibliography.

BOOKS	ARTICLES	WEB SITES
Author name(s) Title and subtitle Publisher and location of publisher	Author name(s) Title of article Page number(s) (for print sources)	Author name(s) (if any) Title of page or site Date of publication
Year of publication	Title of magazine, journal, or newspaper	or latest update (if available) Name of sponsoring organization
	Year, month, day of publication (2012 Jan. 4)	Date on which you accessed the source
	Main address for Web-based articles (for example, Nytimes.com)	Optional: Web address in angle brackets ()

When keeping a bibliography, think ahead to how you will use the good sources you find. You will probably integrate source material into your paper by summary, paraphrase, and direct quotation. In both summaries and paraphrases, you will put information from sources in your own words. Often, summaries condense whole works, and they include the source's main idea and support. Usually, they are significantly shorter than the original work. In contrast, paraphrases may condense only part of a larger work. Usually, they are slightly shorter than the source material. In all cases, give credit where credit is due. Let your readers know the source of words and ideas not your own.

As you take notes, record which method you are using so that you do not accidentally plagiarize. Tips for summarizing, paraphrasing, and using direct quotations follow.

Indirect Quotation: Summary

Be careful if you choose to summarize (or paraphrase). It is easy to think that you are using your own words when you are actually using only some of your own and some of the author's or speaker's words. When you summarize, follow these guidelines:

- Check your summary against the source to make sure you have not used the author's words or copied the author's sentence structure.
- Make sure to introduce the outside source when it is first mentioned—for example,

In an article from the military publication *Stars and Stripes* ("PTSD Treatment Goes to the Dogs: DOD Research Pairs Soldiers with K-9s"), Alan Bayley describes a study. . . .

■ Include in parentheses the page number(s), if available, of the entire section you have summarized. (You will need to provide full publication information later, in the Works Cited list.)

SUMMARY OF AN ARTICLE

In an article from the military publication Stars and Stripes ("PTSD Treatment Goes to the Dogs: DOD Research Pairs Soldiers with K-9s"), Alan Bayley describes a study aimed at determining whether specially trained dogs can help soldiers who are suffering from post-traumatic stress disorder (PTSD) (5). The study, funded by \$300,000 from the Department of Defense, will examine the benefits that the dogs may provide to soldiers returning from Iraq and Afghanistan. These benefits might include calming a soldier who is about to have a panic attack or helping a hallucinating owner distinguish between real and imagined events. Craig Love and Joan Esnayra will be conducting the study. In previous research, Love and Esnayra found that among 39 PTSD sufferers paired with service dogs, 82% reported fewer PTSD symptoms. In addition, 40% reported that they were able to reduce their use of medications. The DOD was not put off by some scientists' view that Love and Esnayra's investigations are too "touchy-feely" (Esnayra's words). If a new approach shows real potential, the department is willing to sponsor research into it.

Identifying information

Page reference

TIP For more on writing summaries, see Chapter 17.

Indirect Quotation: Paraphrase

To paraphrase responsibly, use the following guidelines:

RESOURCES Additional Resources contains exercises on integrating and citing sources within a research essay.

- Check your paraphrase against the original source to make sure you have not used too many of the author's words or copied the author's sentence structure.
- Make sure to introduce the outside source—for example, "According to Alicia Miller, an Army veteran who..."
- Include in parentheses the page number(s), if available, of the section you have paraphrased.

The following are examples of unacceptable and acceptable paraphrases.

TEACHING TIP Remind students that they must cite sources even when they summarize and paraphrase. Students often think that they need to cite only when quoting directly.

ORIGINAL SOURCE

The first documented use of animal-assisted therapy in the United States occurred from 1944 through 1945. The Pawling Army Air Force Convalescent Hospital (located in Dutchess County, approximately 60 miles north of New York City) treated soldiers suffering from either battle injuries or psychological trauma. In this rural setting, the patients interacted with farm animals including horses, chickens and cows. But there was no scientific data collected to assess the impact these animals had on the recuperating veterans when the program ceased at the end of World War II.

—From page 4 of Animal-Assisted Therapy by Donald Altschiller

UNACCEPTABLE PARAPHRASE: TOO CLOSE TO ORIGINAL

The first recorded use of animal therapy in the United States was in 1944–1945. This occurred at the Pawling Army Air Force Convalescent Hospital in Dutchess County, north of New York City. The soldiers there were being treated either for combat injuries or mental trauma. At the hospital, the patients interacted with such animals as horses, chickens, and cows. However, because no scientific information was gathered, it was not possible to assess the effectiveness of the animal therapy on the veterans.

This paraphrase is unacceptable for several reasons:

- The paraphrase too closely follows the original source in wording and sentence structure.
- The writer has not included identifying information or page numbers for the source.
- The writer has not expressed the ideas in his or her own words.

Identifying phrase

ACCEPTABLE PARAPHRASE

Donald Altschiller reports that as far back as the final years of World War II (1944–1945), animal companionship was attempted as a

treatment for both the mental and physical consequences of combat (4).

This approach was used by the Pawling Army Air Force Convalescent

Hospital in Dutchess County, New York. However, the effectiveness of the animal therapy was never determined because no one kept information on this treatment program.

The acceptable paraphrase presents the basic ideas, but in the writer's own words and structures. It also includes a parenthetical reference.

Direct Quotation

Use these guidelines when you write direct quotations:

- Record the exact words of the source.
- Include the name of the writer or speaker. If there is more than one author or speaker, record all names.
- Enclose the writer's or speaker's words in quotation marks.
- For print sources, include the page number on which the quotation appeared in the original source. The page number should go in parentheses after the end quotation mark but before the period. If the person quoted is not the author of the book or the article, include "qtd. in," the author's name, and the page number in parentheses. If there are two or three authors, give all names.
- If a direct quotation is more than five typed lines, indent the whole quotation, and do not use quotation marks.

DIRECT QUOTATION

According to Alicia Miller, an Army veteran who cofounded an organization that donates and trains service dogs for PTSD sufferers, "Medication works 50 percent of the time. Talk therapy, alone, works 30 percent of the time, and dogs work 84.5 percent of the time" (qtd. in Caprioli).

RESOURCES To gauge students' skills in summarizing, paraphrasing, and using direct quotations, and with citing and documenting sources, use the Testing Tool Kit CD-ROM available with this book.

Identifying phrase

Quotation in quotation marks

Cite and Document Your Sources

You need to not only document your sources at the end of your research essay in a Works Cited list, but also to include in-text citations of sources as you use them in the essay. No one can remember the specifics of correct citation and documentation, so be sure to refer to this section or a reference that your instructor directs you to. Include all the correct information, and pay attention to where punctuation marks such as commas, periods, and quotation marks should go.

There are several different systems of documentation. Most English instructors prefer the Modern Language Association (MLA) system, which is used in this chapter. When you are writing a research paper in another course, you may be required to use another system.

TIP For more information on documenting sources, visit bedfordstmartins.com/researchroom.

Use In-Text Citations within Your Essay

In-text citations such as the ones shown below are used for books and periodicals. For Web sites and other electronic sources, you typically will not be able to include page numbers, although you can note any paragraph, section, chapter, or part numbers used in place of page numbers.

When you refer to the author (or authors) in an introductory phrase, write just the relevant page number(s), if available, in parentheses at the end of the quotation.

DIRECT QUOTATION: In an article by Alan Bavley, veteran and PTSD sufferer Chris Kornkven was quoted as saying the following about service dogs he had observed: "They seemed like they would be really helpful, particularly for individuals living alone" (5).

INDIRECT QUOTATION: In an article by Alan Bavley, veteran and PTSD sufferer Chris Kornkven expressed the belief that service dogs would be especially beneficial to vets who live by themselves (5).

When you do not refer to the author(s) in an introductory phrase, write the author's name followed by the page number(s), if available, at the end of the quotation. If an author is not named, use the title of the source.

DIRECT QUOTATION: "Today's all-volunteer military is far smaller than past draftee-fed forces, requiring troops to be repeatedly recycled through combat zones" (*Issues in Peace and Conflict Studies* 395).

INDIRECT QUOTATION: Because the current wars are not supported by a draft, military forces are smaller than in past wars, and troops are being deployed multiple times (*Issues in Peace and Conflict Studies* 395).

The following section shows you how to include an in-text citation for various kinds of sources, inserting the citation after the material you have used. For a direct quotation, insert the citation after the end quote and before the period ending the sentence.

DIRECTORY OF MLA IN-TEXT CITATIONS

One author 315
Two or three authors 315
Four or more authors 315
Group, corporation, or government agency 315

Author not named 315
Encyclopedia or other reference work 315
Work in an anthology 316
Interview, e-mail, speech 316

NOTE: The formats given below are for print sources. To cite a Web source, use page numbers if available; if not, use a paragraph number instead. If there are no paragraphs, cite the author, title of the part of the Web site, or the site sponsor.

The series of dots (called ellipses) in the following examples indicate that words have been left out. Two examples are provided for each citation: (1) The author is named in an introductory phrase, with the page or paragraph number in parentheses. (2) The author's name and page or paragraph number appear in parentheses.

One author

As David Shipler states, "..." (16).

The number of people who work and fall below the poverty line has increased dramatically (Shipler 16).

Two or three authors Use all authors' last names.

Quigley and Morrison found that . . . (243).

Banks and credit card companies are charging many more fees . . . (Quigley and Morrison 243).

Four or more authors Use the first author's last name and the words et al. (et al. means "and others").

According to Sen et al., . . . (659).

The overuse of antibiotics can result in . . . (Sen et al. 659).

Group, corporation, or government agency Use the name of the group, corporation, or government agency. The source can be abbreviated in the parentheses, as shown in the second example.

The Texas Parks and Wildlife Department offers guidelines for landscaping . . . (26).

Texas has more native plants than any other . . . (Texas Parks and Wildlife Dept. 26).

Author not named Use article title in quotations, shortened if it is a long title.

In the article "Texas Wildscapes," . . . (7).

Many areas of Texas are filled with drought-tolerant native . . . ("Texas Wildscapes" 7).

Encyclopedia or other reference work Use the name of the entry you are using as a source.

In its entry on xeriscaping, the *Landscape Encyclopedia* claims that . . . ("Xeriscaping").

Xeriscaping is often used in . . . ("Xeriscaping").

Work in an anthology Use the name of the author(s) of the piece you are using as a source.

As Rich Chiappone believes, ... (200).

Fly-fishing is as much a spiritual . . . (Chiappone 200).

Interview, e-mail, speech Use the name of the person interviewed or speaker, or the author of an e-mail.

As University of Texas Vice President of Student Affairs Juan Gonzalez said in an interview. . . .

Students have many resources available to . . . (Gonzalez).

TIP If you have additional questions about MLA style, visit Research and Documentation Online by entering the title of this site and "Bedford/St. Martin's" into a search engine. Then, click on the "Humanities" link.

Use a Works Cited List at the End of Your Essay

Following are model Works Cited entries for major types of sources. At the end of your paper, you will need to include such entries for each source you cite in the body of the paper.

Books	Article from a database 318
One author 316 Two or three authors 317 Four or more authors 317 Editor 317 Work in an anthology 317 Encyclopedia article 317 Periodicals Magazine article 317 Newspaper article 317 Editorial in a magazine or newspaper 317 Electronic Sources An entire Web site 318 Part of a larger Web site 318	Article in an online magazine or newspaper 318 Government publication 318 Weblog (blog) 318 Digital file 319 E-mail 319 Multimedia Film 319 Film on DVD 319 Television and radio 319 Podcast online 319 Recording 319 Personal interview 319

Books

Book with one author

Author, last name first

Anker, Susan. Real Writing: Paragraphs and Essays for College, Work, and

Everyday Life. 6th ed. Boston: Bedford/St. Martin's, 2013. Print.

Edition Place of Publisher Publication date

number publication

All lines after first line of entry are indented.

Book with two or three authors

Baumeister, Roy F., and John Tierney. Willpower: Rediscovering the Greatest Human Strength. New York: Penguin, 2011. Print.

Hudson, Valerie M., Bonnie Ballif-Spanvill, Mary Caprioli, and Chad F. Emmett. *Sex and World Peace*. New York: Columbia UP, 2012. Print.

Book with four or more authors Et al. means "and others."

McKay, John P., et al. *A History of World Societies*. 9th ed. Boston: Bedford/St. Martin's, 2012. Print.

Book with an editor

Price, Steven D., ed. *The Best Advice Ever Given: Life Lessons for Success in the Real World.* Guilford: Lyons Press, 2006. Print.

Work in an anthology

Vowell, Sarah. "Shooting Dad." 50 Essays: A Portable Anthology. 3rd ed. Ed. Samuel Cohen. Boston: Bedford/St. Martin's, 2011. 412–19. Print.

Encyclopedia article

"Metaphor." The Columbia Encyclopedia. 6th ed. 2000. Print.

Periodicals

Magazine article

Author Title periodical date page numbers

Kapur, Akash. "The Shandy." New Yorker 10 Oct. 2011: 72–79. Print.

Newspaper article

Oliveira, Rebeca. "The Art of Storytelling Is Alive and Well." *Jamaica Plain Gazette* 7 Oct. 2011: 10–11. Print.

Editorial in a magazine or newspaper

Escobar, Veronica. "All Quiet on the Southern Front." Opinion. New York Times 6 Oct. 2011: A27. Print.

Electronic Sources

Electronic sources include Web sites; databases or subscription services such as *ERIC*, *InfoTrac*, *LexisNexis*, and *ProQuest*; and electronic communications such as e-mail. Because electronic sources change often, always note the date you accessed or read the source as well as the date on which the source was posted or updated online, if this information is available. If no date is available, write "n.d."

TIP For help creating source citations, try using the "Autocite" tool at www.easybib.com.

Document title

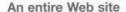

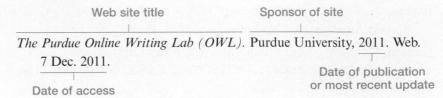

Part of a larger Web site

"How to Evaluate Sources: Introduction." The Bedford Research Room. Bedford/St. Martin's, n.d. Web. 7 Jan. 2012.

Article from a database

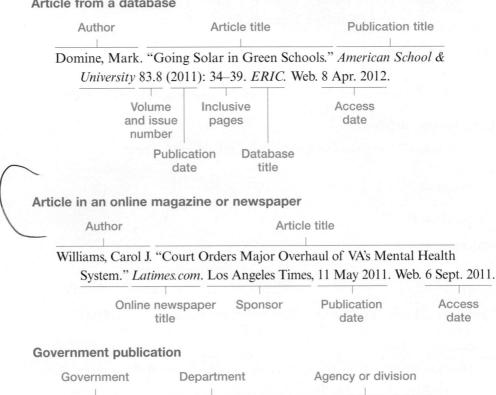

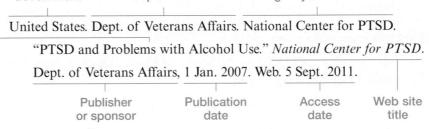

Weblog (blog)

Digital file

E-mail

Multimedia

Film

Film on DVD

Campion, Jane, dir. *Bright Star.* Perf. Abbie Cornish, Ben Whishaw, and Paul Schneider. Apparition, 2009. DVD.

Television and radio

"Dogs Decoded." Nova. PBS. 12 Oct. 2011. Television.

Podcast online

"Hidden Costs of Energy." Narr. Ann Merchant. *Sounds of Science*. National Academies, 29 Jan. 2010. Web. 13 Dec. 2011.

Recording

Jay-Z and Kanye West. "Made in America." *Watch the Throne*. Roc-A-Fella, 2011. CD.

Personal interview

Hain, Carla. Personal interview. 5 Sept. 2011.

Student Research Essay

Here is Dara Riesler's research essay, with annotations pointing out standard characteristics of content, documentation, and formatting.

1/2" margin between top of page and header Student's last name and page number on top of each page 4 October 2011 Identification of student, professor, course, and date Title centered Introduction Indirect and direct quotations with in-text citations Thesis statement Topic sentence

Dara Riesler **Professor Gomes** English 99

Service Dogs Help Heal the Mental Wounds of War

Riesler 1

Whenever Ken Costich, a former army colonel, is on the edge of a panic attack, his dog, Bandit, senses it immediately, nuzzling Costich until he feels calm again (Caprioli). Across the country, another dog, Maya, is also looking out for her owner, veteran Jacob Hyde. When Hyde, feeling nervous in a crowd, gives the command "block," Maya stands between him and other people, easing Hyde's fears (Lorber). Elsewhere, Mush, a Siberian husky, is helping her owner, Margaux Vair, get out and meet people—something Vair had avoided since returning from her service in Iraq (Albrecht). "Because [Mush] is a Husky and very pretty, everybody wants to pet her," Vair says. "What's happening is that people are coming up and talking to me, and it's helping with my confidence."

Bandit, Maya, and Mush—specially trained service dogs—are making a significant difference in the lives of their owners, all of whom suffer from post-traumatic stress disorder (PTSD) as a result of military service. As the benefits of service dogs become clearer, and as more PTSD sufferers return from the wars in Iraq and Afghanistan, demand for these helpful and caring pets is growing; in fact, at the present time, demand far exceeds supply.

- PTSD, as defined by the United States Department of Veterans Affairs (VA), is an anxiety disorder that can result from a traumatic experience, such as personal injury in combat or witnessing the deaths or injuries of others. According to the VA, symptoms of the condition include flashbacks of the trauma or nightmares about it. PTSD sufferers may also have difficulty forming or maintaining relationships with others. Additionally, some of them are constantly "keyed up" and "on the lookout for danger," as if they are still in a war zone ("What Are the Symptoms of PTSD?"). According to the RAND Corporation, a nonprofit research group, an estimated 300,000 of veterans from the wars in Afghanistan and Iraq suffer from PTSD or major depression. In attempts to escape or to numb the effects of PTSD, sufferers may turn to alcohol or drugs, possibly leading to addiction ("PTSD and Problems with Alcohol Use").

Titles used for in-text citations of sources without authors

Riesler 2

Worse, they may decide to end their lives, as an estimated 6,500 veterans do each year (Williams).

A variety of treatments are available to veterans with PTSD. — They include one-on-one discussions with a therapist, group therapy, and medicines—usually antidepressants—that address the symptoms of the condition ("Treatment of PTSD"). The use of service dogs as an additional therapy for PTSD is a relatively new practice. According to researchers Joan Esnayra and Craig Love, a key benefit of these dogs is that they are constant companions to PTSD sufferers, helping them go about their daily lives and directly addressing their symptoms. For example, service dogs may be trained to alert easily startled veterans that someone is approaching, to scan surroundings for possible threats, or to turn on the lights and wake up veterans suffering from nightmares (Esnayra and Love). These pets can also soothe veterans experiencing panic attacks and remind their owners when it is time to take medications (Caprioli).

Some veterans, however, find that their dog companions—outshine medication as a PTSD treatment. "This dog [did] more for me in three weeks than any medication," says Ken Costich (qtd. in Caprioli; see fig. 1). Alicia Miller, an Army veteran who cofounded an organization that donates and trains service dogs for vets, agrees.

"Medication works 50 percent of the time," says Miller, who also experiences symptoms of PTSD. "Talk therapy, alone, works 30 percent of the time, and dogs work 84.5 percent of the time" (qtd. in Caprioli).

In a recent study, Esnayra and Love found that among 39 PTSD sufferers paired with service dogs, 82% reported fewer PTSD symptoms (Bavley 5). In addition, 40% reported that they were able to reduce their use of medications. Recognizing that more research into the effectiveness of service-dog therapy is needed, the United States Department of Defense is funding a \$300,000 study on this topic (Bavley 5). Esnayra and Love are conducting the research.

Fig. 1. Ken Costich and his service dog, Bandit (Caprioli).

Topic sentence

Indirect quotations with in-text citations

Topic sentence

Source quoted within another source

Riesler 3

Topic sentence

Although service-dog therapy has many benefits, organizations that train these dogs have trouble keeping up with the demand created by the thousands of veterans who have returned from Iraq or Afghanistan with PTSD (Dreazen). Training is time-consuming and demanding; the dogs are taught to respond to as many as 150 commands and to notice subtle changes in vets—such as a quickening pulse—that signal emotional distress (Montalván and Witter 4). During a two-year period that ended in the spring of 2010, Puppies Behind Bars, a program in which prisoners train service dogs, placed 23 dogs with veterans suffering from PTSD (Lorber). Other nonprofit training organizations report similar, or lower, numbers of vet-ready dogs (Caprioli). Given the labor-intensive training, these numbers are understandable; however, the need remains.

Topic sentence

— Another challenge is the expense of the training, which in the case of many nonprofit organizations, like Puppies Behind Bars, is paid for by donations, not by the veterans (Caprioli; Dreazen). At Puppies Behind Bars, \$26,000 is needed to train each dog. Other training organizations report similar expenses.

Topic sentence

— Some lawmakers are taking steps to meet vets' growing need for helper dogs. In 2009, President Obama signed into law the Service Dogs for Veterans Act, which was sponsored by Senator Al Franken and Senator Johnny Isakson. According to Franken's office, this legislation matches at least 200 veterans with VA–funded service dogs, and it requires that at least 50% of these vets suffer mainly from mental-health problems, as opposed to physical disabilities. It also calls for a study of the participating veterans to learn more about the therapeutic and economic benefits of service dogs. Additionally, in January 2011, the Veterans Dog Training Therapy Act was introduced in the U.S. House of Representatives. Under this legislation, vets with PTSD would be taught how to train service dogs which, in turn, would be used by other vets (Peters).

With luck, and with the continuing efforts of legislators and concerned citizens, more helper dogs will find homes with veterans, providing not only valued service but also lasting friendship. As Army veteran Luis Carlos Montalván says of his service dog, Tuesday: "We are bonded, dog and man, in a way able-bodied people can never understand, because they will never experience anything like it. As long as Tuesday is alive, he will be with me. Neither of us will ever be alone. We will never be without companionship" (Montalván and Witter 6).

Conclusion

Riesler 4	
Works Cited	
Albrecht, Brian. "Psychiatric Service Dogs Aid Northeast Ohio ————————————————————————————————————	Article from online news site
Bavley, Alan. "PTSD Treatment Goes to the Dogs: DOD Research Pairs Soldiers with K-9s." Stars and Stripes 10 Sept. 2009, Mideast ed.: 5. Print.	Article from print newspaper
Caprioli, Jennifer M. "Dogs Go the Distance: Program Provides ————————————————————————————————————	——— Part of larger Web site
Dreazen, Yochi J. "'Sit! Stay! Snuggle!': An Iraq Vet Finds His Dog————————————————————————————————————	Article from online newspaper
Esnayra, Joan, and Craig Love. "A Survey of Mental Health Patients Utilizing Psychiatric Service Dogs." <i>PSD Lifestyle</i> . Psychiatric Service Dog Society, 2008. Web. 8 Sept. 2011. "Franken Leekson Service Dogs for Veterons Act Passes Senete." 41	
"Franken-Isakson Service Dogs for Veterans Act Passes Senate." <i>Al Franken: U.S. Senator for Minnesota.</i> Al Franken: U.S. Senator for Minnesota, 24 July 2009. Web. 7 Sept. 2011.	Parts of larger Web sites
"Invisible Wounds: Mental Health and Cognitive Care Needs of America's Returning Veterans." <i>RAND Corporation</i> . RAND Corporation, 2008. Web. 7 Sept. 2011.	
Lorber, Janie. "For the Battle-Scarred, Comfort at Leash's End." Nytimes.com. New York Times, 3 Apr. 2010. Web. 8 Sept. 2011.	Article from online newspaper
Montalván, Luis Carlos, and Bret Witter. <i>Until Tuesday: A Wounded — Warrior and the Golden Retriever Who Saved Him.</i> New York: Hyperion, 2011. Print.	Book with two authors
Peters, Sharon L. "Man's Best Friend Could Soon Be Veteran's Best — Medicine." <i>Usatoday.com.</i> USA Today, 19 Jan. 2011. Web. 7 Sept. 2011.	Article from online newspaper
United States. Dept. of Veterans Affairs. National Center for PTSD. "PTSD and Problems with Alcohol Use." <i>National Center for PTSD</i> . Dept. of Veterans Affairs, 1 Jan. 2007. Web. 5 Sept. 2011 National Center for PTSD. "Treatment of PTSD." <i>National</i>	Online government publications. Note: Three hyphens used in place of government
Center for PTSD. Dept. of Veterans Affairs, 1 Jan. 2007. Web. 5 Sept. 2011.	and department names in each entry after the first

newspaper

---. National Center for PTSD. "What Are the Symptoms of PTSD?" *National Center for PTSD*. Dept. of Veterans Affairs, 1 Jan. 2007. Web. 5 Sept. 2011.

Riesler 5

---. National Center for PTSD. "What Is PTSD?" National Center for PTSD. Dept. of Veterans Affairs, 1 Jan. 2007. Web. 5 Sept. 2011.

Williams, Carol J. "Court Orders Major Overhaul of VA's Mental Health System." *Latimes.com*. Los Angeles Times, 11 May 2011. Web. 6 Sept. 2011.

To write a research essay, use the checklist below.

STEPS	DETAILS
Make a schedule. (See the model on p. 303.)	 Include the due date and dates for doing the research, finishing a draft, and revising.
Choose a topic. (See pp. 303–04.)	Ask yourself the five questions on page 303.Choose a topic that interests you.
Ask a guiding research question. (See p. 304.)	 Ask a question about your topic that you will begin to answer as you do your initial research.
Find sources. (See pp. 304–07.)	 Go to the library and find out what resources are available to you, both in print and online.
Evaluate your sources. (See pp. 307–09.)	 Particularly for Web sites, look for the sponsor, and judge whether the site is reliable and accurate.
Avoid plagiarism. (See pp. 310–13.)	 As you make notes from your sources, write down the publication information you will need. Think ahead to how you will integrate your sources into your paper, giving source information as you summarize, paraphrase, and use direct quotation.
 Write a thesis statement. (For more on writing a thesis statement, see Chapter 4.) 	Try turning your guiding research question (see p. 304) into a statement.
Support your thesis statement. (For more on supporting your point, see Chapter 5.)	 Review all your notes, and choose the points that best support your thesis statement. If you do not have enough support to make your point, do a little more reading.
 □ Write a draft essay. (For more on writing a draft, see Chapter 6.) 	 Make an outline that includes your thesis statement and major support, arranged logically. Write an introduction that includes your thesis statement. Write topic sentences for each major support, and include supporting evidence. Cite sources in the body of your essay, and provide full publication information at the end, in the list of Works Cited. Write a conclusion that reminds readers of your thesis statement and makes a final observation.

CHECKLIST: HOW TO WRITE A RESEARCH ESSAY		
STEPS	DETAILS	
☐ Revise your draft. (For more on revising, see Chapter 7.) Consider getting comments from a peer first. For more information, see pages 97–98.	 Ask yourself: Do I have enough support that my readers are likely to understand my position on my topic? Have I included transitions that will help readers move smoothly from one point to the next? Have I integrated source material smoothly into the essay? Are all sources cited and documented correctly? 	
☐ Edit your essay. (See Parts 4 through 7.)	 Reread your essay, looking for errors in grammar, spelling, and punctuation. 	

EVER THOUGHT THIS?

"Grammar. I never get it. There's too much to remember."

-Tony Mancuso, Student

This chapter

- tells you which four errors are the most important to find and fix.
- gives you practice working with the basic elements of a sentence
- keeps grammar terms to a minimum.
- simplifies grammar so that you can get it.

write for 2 minutes on what you know about a sentence.

19

The Basic Sentence

An Overview

The Four Most Serious Errors

This part of the book focuses first on four grammar errors that people most often notice.

THE FOUR MOST SERIOUS ERRORS

- 1. Fragments (Chapter 20)
- 2. Run-ons (Chapter 21)
- 3. Problems with subject-verb agreement (Chapter 22)
- 4. Problems with verb form and tense (Chapter 23)

If you can edit your writing to correct these four errors, your grades will improve.

This chapter reviews the basic sentence elements that you will need to understand to find and fix the four most serious errors.

The Parts of Speech

There are seven basic parts of speech:

1. **Noun:** names a person, place, thing, or idea (for information on making nouns plural, see p. 561). A **noun phrase** is a group of words that includes a noun, or a word that functions as a noun, and any surrounding article and modifiers.

Jaime dances.

LearningCurve
Parts of Speech:
Nouns and Pronouns;
Verbs, Adjectives, and
Adverbs; Prepositions
and Conjunctions
bedfordstmartins
.com/realwriting/LC

RESOURCES This chapter offers associated LearningCurve activities for students. A student access code is printed in every new student copy of this text. Students who do not purchase a new print book can purchase access by going to bedfordstmartins.com/realwriting/LC.

TIP In the examples in this chapter, subjects are underlined once, and verbs are underlined twice.

TIP For a definition of subject, see page 331.

TIP Some grammar experts consider interjections to be a part of speech. Interjections are words or phrases that are often used to convey emotion-for example, "Ouch!", "Oh no!", and "Good grief!"

TIP For more on coordinating conjunctions, see pages 465-66. For more on subordinating conjunctions (dependent words), see pages 344-46.

TIP For more practice with the parts of speech. visit Exercise Central at bedfordstmartins.com/ realwriting.

2. Pronoun: replaces a noun in a sentence. He, she, it, we, and they are pronouns.

She dances.

3. Verb: tells what action the subject does or links a subject to another word that describes it.

Jaime dances. [The verb dances is what the subject, Jaime, does.]

She is a dancer. [The verb is links the subject, Jaime, to a word that describes her, dancer.]

4. Adjective: describes a noun or a pronoun (can also be a participle, a verb that functions as a noun).

Jaime is **thin**. [The adjective *thin* describes the noun *Jaime*.]

She is **graceful**. [The adjective *graceful* describes the pronoun *She*.]

5. Adverb: describes an adjective, a verb, or another adverb. Adverbs often end in -ly.

Jaime is extremely graceful. [The adverb extremely describes the adjective graceful.]

She practices **often**. [The adverb *often* describes the verb *practices*.]

Jaime dances quite beautifully. [The adverb quite describes another adverb, beautifully.]

6. **Preposition:** connects a noun, pronoun, or verb with information about it. Across, around, at, in, of, on, and out are prepositions (there are many others).

Jaime practices at the studio. [The preposition at connects the verb practices with the noun studio.]

7. Conjunction: connects words to each other. An easy way to remember the seven common conjunctions is to connect them in your mind to FANBOYS: for, and, nor, but, or, yet, so.

The <u>studio</u> is expensive **but** good.

PRACTICE 1 Using the Parts of Speech

Fill in the blanks with the part of speech indicated.

EXAMPLE: More and more wild animals are coming into towns and cities, making life challenging (adjective) for them and humans.

Answers will vary. Possible answers are shown.

1.	Two rare (adjective) hawks built a nest
	(noun) on the roof of (preposition) a city apartment
	building.
2.	The female laid eggs (noun) there, and they
	(pronoun) hatched a few days later, releasing fourextremely
	(adverb) noisy chicks.
3.	Some of the building's residentscomplained (verb) about
	the hawks, but (conjunction) others loved to stand
	(preposition) the street from the birds and watch
	them (pronoun).
4.	Because of the complaints, the (noun) was re-
	moved, but (conjunction) the people who liked the
	hawks got <u>very</u> (adverb) upset.
5.	The supporters of (preposition) the birds eventually
	won, and the hawks were allowed to (verb) to re-
	build their nest (noun).

The Basic Sentence

A **sentence** is the basic unit of written communication. A complete sentence in written standard English must have these three elements:

TEACHING TIP Make a list of your top ten grammar pet peeves and give it to your students to use.

- A subject
- A verb
- A complete thought

Subjects

The **subject** of a sentence is the person, place, thing, or idea that a sentence is about. The subject of a sentence can be a noun or a pronoun. For a list of common pronouns, see page 426.

To find the subject, ask yourself, Whom or what is the sentence about?

PERSON AS SUBJECT Isaac arrived last night.

[Whom is the sentence about? Isaac]

THING AS SUBJECT The restaurant has closed.

[What is the sentence about? The restaurant]

TEACHING TIP Have students look back at a recent paper and underline the subjects of sentences in a few paragraphs. If they are working on a computer, they can use the underline function.

A **compound subject** consists of two or more subjects joined by *and*, *or*, or *nor*.

TWO SUBJECTS Kelli and Kate love animals of all kinds.

SEVERAL SUBJECTS The baby, the cats, and the dog play well together.

The subject of a sentence is *never* in a **prepositional phrase**, a word group that begins with a preposition and ends with a noun or pronoun, called the **object of a preposition**.

Your dinner is in the oven.

Preposition

Prepositional phrase

PREPOSITION	OBJECT	PREPOSITIONAL PHRASE
from	the bakery	from the bakery
to	the next corner	to the next corner
under	the table	under the table

LANGUAGE NOTE: In and on can be tricky prepositions for people whose native language is not English. Keep these definitions and examples in mind:

in = inside of (in the box, in the office) or at a certain time (in January, in the fall, in three weeks)

on = on top of (on the table, on my foot), located in a certain place (on the page, on Main Street), or at a certain time (on January 31)

If you have trouble deciding what prepositions to use, see Chapter 30.

Common F	Prepositions	3		
about	before	for	on	until
above	behind	from	out	up
across	below	in	outside	upon
after	beneath	inside	over	with
against	beside	into	past	within
along	between	like	since	without
among	by	near	through	
around	down	next to	to	
at	during	of	toward	
because of	except	off	under	

TIP For common prepositional phrases, see Chapter 30.

See if you can identify the subject of the following sentence.

One of my best friends races cars.

Although you might think that the word *friends* is the subject, it isn't. *One* is the subject. The word *friends* cannot be the subject because it is in the prepositional phrase *of my best friends*. When you are looking for the subject of a sentence, cross out the prepositional phrase.

PREPOSITIONAL PHRASE CROSSED OUT

One of the students won the science prize.

The rules about the dress code are very specific.

LANGUAGE NOTE: The example sentences use the word *the* before the noun (*the rules*, *the dress code*). The, a, and an are called *articles*. If you have trouble deciding which article to use with which nouns, see Chapter 30.

PRACTICE 2 Identifying Subjects and Prepositional Phrases

In each of the following sentences, cross out any prepositional phrases, and underline the subject of the sentence.

EXAMPLE: Coupons from newspapers and Web sites are just one way to save money.

- 1. A friend from my neighborhood packs her lunch every day.
- 2. Sandwiches in her workplace cafeteria cost five dollars.
- **3.** Restaurants near her job charge even more.
- **4.** Therefore, <u>sandwiches</u> from her own kitchen are saving my friend twenty-five dollars or more each week.
- **5.** Savings in gasoline expenses are also possible.
- **6.** Everything in the trunk of a car increases the car's weight and gasoline usage.
- 7. Recently, a hiker down the street cleaned out his trunk.
- 8. The amount of old hiking gear in the trunk was surprisingly large.
- 9. The result of his cleanup was greatly reduced gasoline expenses.
- 10. Savings during just one week reached thirty dollars.

TIP For more practices on sentence basics, visit Exercise Central at bedfordstmartins.com/ realwriting.

RESOURCES Additional Resources contains supplemental exercises for this chapter.

TIP Verbs do not always immediately follow the subject: Other words may come between the subject and the verb. Example: The boy who came in first won a prize.

TEACHING TIP Have a verb contest. Call out a subject, and ask students to write as many action verbs as possible to go with it. Suggest that they work through the alphabet.

Verbs

Every sentence has a **main verb**, the word or words that tell what the subject does or that link the subject to another word that describes it. There are three kinds of verbs: action verbs, linking verbs, and helping verbs.

ACTION VERBS

An action verb tells what action the subject performs.

To find the main action verb in a sentence, ask yourself: What action does the subject perform?

ACTION VERBS

The band played all night.

The alarm rings loudly.

LINKING VERBS

A **linking verb** connects (links) the subject to another word or group of words that describes the subject. Linking verbs show no action. The most common linking verb is *be* (*am*, *is*, *are*, and so on). Other linking verbs, such as *seem* and *become*, can usually be replaced by a form of the verb *be*, and the sentence will still make sense.

To find linking verbs, ask yourself: What word joins the subject and the words that describe the subject?

LINKING VERBS

The bus is late.

My new shoes look shiny. (My new shoes are shiny.)

The <u>milk</u> <u>tastes</u> sour. (The <u>milk</u> <u>is</u> sour.)

Some words can be used as either action verbs or linking verbs, depending on how the verb is used in a particular sentence.

ACTION VERB <u>Justine</u> $\underline{\underline{\text{smelled}}}$ the flowers.

The flowers smelled wonderful.

Common Linking Verbs

FORMS OF BE	FORMS OF SEEM AND BECOME	FORMS OF SENSE VERBS
am	seem, seems, seemed	look, looks, looked
are	Seemed	appear, appears,
is	become, becomes,	appeared
15	became	amall amalla amalla
was		smell, smells, smelled
were		taste, tastes, tasted
Wele		fool fools folk
vvoic		feel, feels, felt

LANGUAGE NOTE: The verb be cannot be left out of sentences in English.

INCORRECT Tonya well now.

CORRECT Tonya is well now.

HELPING VERBS

A **helping verb** joins the main verb in a sentence to form the **complete verb** (also known as a verb phrase—the main verb and all of its helping verbs). The helping verb is often a form of the verb *be*, *have*, or *do*. A sentence may have more than one helping verb along with the main verb.

Helping verb + Main verb = Complete verb

Sharon was listening to the radio as she was studying for the test.

[The helping verb is was; the complete verbs are was listening and was studying.]

I am saving my money for a car.

Colleen might have borrowed my sweater.

You must pass this course before taking the next one.

You should stop smoking.

FORMS OF BE	FORMS OF HAVE	FORMS OF DO	OTHER
am	have	do	can
are	has	does	could
been	had	did	may
being			might
is			must
was			should
were			will
			would

Before you begin Practice 3, look at these examples to see how action, linking, and helping verbs are different.

ACTION VERB Kara graduated last year.

[The verb graduated is an action that Kara performed.]

LINKING VERB Kara is a graduate.

[The verb is links Kara to the word that describes her: graduate.

No action is performed.]

HELPING VERB

Kara is graduating next spring.

[The helping verb *is* joins the main verb *graduating* to make the complete verb *is graduating*, which tells what action the subject is taking.]

PRACTICE 3 Identifying the Verb (Action, Linking, or Helping Verb + Main Verb)

In the following sentences, underline each subject and double-underline each verb. Then, identify each verb as an action verb, a linking verb, or a helping verb + a main verb.

Helping verb + main verb

EXAMPLE: Bowling was created a long time ago.

1. The ancient Egyptians invented bowling.

- 2. Dutch settlers were responsible for bowling's introduction to North America.
- 3. They bowled outdoors on fields of grass.
- 4. One area in New York City is called Bowling Green because the Dutch Action verb bowled there in the 1600s.
- **5.** The first indoor bowling <u>alley</u> in the United States <u>opened</u> in 1840 in New York.
- **6.** Indoor bowling soon became popular across the country.
- 7. The largest bowling alley in the United States offers more than a hundred lanes.
- 8. Visitors to Las Vegas can bowl there.
- 9. Most people would not think of bowling as more popular than basketball.
- 10. However, more Americans participate in bowling than in any other sport.

Complete Thoughts

A **complete thought** is an idea, expressed in a sentence, that makes sense by itself, without additional words. An incomplete thought leaves readers wondering what's going on.

INCOMPLETE THOUGHT because my alarm did not go off

COMPLETE THOUGHT I was late because my alarm did not go off.

the people who won the lottery **INCOMPLETE THOUGHT** The people who won the lottery were old. **COMPLETE THOUGHT** To determine whether a thought is complete, ask yourself: Do I have to ask a question to understand? in my wallet **INCOMPLETE THOUGHT** [You would have to ask a question to understand, so it is not a complete thought.] My ticket is in my wallet. COMPLETE THOUGHT **PRACTICE 4** Identifying Complete Thoughts Some of the following items contain complete thoughts, and others do not. In the space to the left of each item, write either "C" for complete thought or "I" for incomplete thought. If you write "I," add words to make a sentence. Answers will vary. Possible edits are shown. is well known. **EXAMPLE:** ____ My love of the outdoors <u>C</u> 1. Therefore, I decided to study golf management.

TEAMWORK Have students read the items in this practice aloud to each other and decide if the items are sentences or incomplete thoughts.

<u>C</u> **10.** In one class, I am learning how to run a profitable pro shop.

is also interesting.

Six Basic English Sentence Patterns

_____ **9.** However, the classroom work/

C 8. Being outside is my favorite part of my studies.

In English, there are six basic sentence patterns, some of which you have just worked through in this chapter. Although there are other patterns, they build on these six.

1.	Subject-Verb (S-V). This pattern is the most basic one, as you have already seen.
	S V
	Babies <u>cry</u> .
2.	Subject-Linking Verb-Noun (S-LV-N)
	S LV N
	They are children.
3.	Subject-Linking Verb-Adjective (S-LV-ADJ)
	S LV ADJ
	Parents are tired.
4.	Subject-Verb-Adverb (S-V-ADV)
	S V ADV
	They sleep poorly.
5.	Subject-Verb-Direct Object (S-V-DO). A direct object directly receives the action of the verb.
	S V DO
	Teachers give tests. [The tests are given.]
6.	Subject-Verb-Direct Object-Indirect Object. An indirect object does not directly receive the action of the verb.
	S V DO IO
	Teachers give tests to students. [The tests are given; the students are not.]
	This pattern can also have the indirect object before the direct object.
	S V IO DO
	Teachers give students tests.
PR	ACTICE 5 Identifying Basic Sentence Patterns
Usi	ng the sentence pattern indicated, write a sentence for each of the followitems. Answers will vary.
1.	(Subject-verb-direct object)
2.	(Subject-linking verb-noun)
3.	(Subject-verb-adverb)

		P Property
(Subject-	verb-indirect object-direct object)	

PRACTICE 6 Identifying Complete Sentences

In this essay, underline the subject of each sentence, and double-underline the verb. Correct five incomplete thoughts. Answers may vary. Possible edits are shown.

- (1) Space <u>travel fascinates</u> my grandpa Bill. (2) <u>He watches</u> every space movie at least a dozen times. (3) Before 1996, <u>he never even thought</u> about the moon, Mars, or beyond. (4) <u>He was</u> too old to be an astronaut. (5) Now, however, <u>he is on board a satellite.</u> (6) <u>It analyzes particles in the and atmosphere.</u> (7) <u>He has the company of millions of other people</u> (8) And me, too. (9) Truthfully, only our <u>names travel</u> to Mars or beyond. (10) We are happy with that.
- (11) In 1996, the Planetary Society flew the names of members into using space/(12) Using the Mars Pathfinder. (13) At first, individuals signed a paper. (14) Then, Planetary Society members put the signatures into electronic form. (15) Now, people submit names on the Internet/(16) by filling out a form. (17) The names go on a microchip. (18) One spacecraft to the moon had more than a million names on board. (19) Some people have placed their names on a spacecraft going past Pluto and out of our solar system. (20) Their names are on a CD/(21) Which could survive for billions of years.
- (22) Grandpa and I feel good about our journey into space. (23) In a way, we will travel to places only dreamed about. (24) After signing up, we received colorful certificates to print out/(25) To tell about our mission.

 (26) My certificate hangs on my wall. (27) My grandpa and I travel proudly into space.

Chapter Review

1. List the seven parts of speech. nouns, pronouns, verbs, adjectives, adverbs, prepositions, and conjunctions

LEARNING JOURNAL What is the main thing you learned from this chapter? What is one thing that is unclear to you?

TEACHING TIP You can collect students' learning journals to find out what the class or individuals need more work on.

2.	A sentence must have three things: a subject, a verb, and a complete
	thought.
3.	A <u>subject</u> is the person, place, or thing that a sentence is about
4.	A prepositional phrase is a word group that begins with a preposition
	and ends with a noun or a pronoun.
5.	Write an example of a prepositional phrase (not from one of the examples presented earlier): Answers will vary.
6.	An action verb tells what action the subject performs.
7.	A linking verb connects the subject to another word or group of words that describes the subject.
8.	A helping verb joins the main verb in a sentence to form the complete verb.

Chapter Test

Circle the correct choice for each of the following items.

1. Identify the underlined part of speech in this sentence.

Devon walks so fast that I can never keep up with him.

a. Noun

(b.) Verb

c. Preposition

d. Adjective

2. Identify the underlined part of speech in this sentence.

In spring, the trees around our house are a beautiful shade of green.

(a.) Adjective

b. Adverb

c. Preposition

d. Verb

3. Identify the underlined part of speech in this sentence.

Shopping is Jerimiah's favorite hobby.

(a.) Noun

b. Verb

c. Adjective

d. Adverb

4. Identify the type of verb in this sentence.

The baby always seems tired after lunch.

a. Action verb

(b.) Linking verb

c. Helping verb

5. Choose the item that is a complete sentence.

a. Driving to the store.

b. Driving to the store, I saw Rick jogging.

c. Driving to the grocery store last Wednesday.

RESOURCES Testing Tool Kit, a CD-ROM available with this book, has even more grammar tests. Also, for cumulative Editing Review Tests, see pages 609–18.

EVER THOUGHT THIS?

"When my sentence gets too long, I think it probably needs a period, so I put one in, even though I'm not sure it goes there."

-Naomi Roman, Student

This chapter

- · explains what fragments are.
- gives you practice finding and correcting five common kinds of fragments.

20

Fragments

Incomplete Sentences

Understand What Fragments Are

A **fragment** is a group of words that is missing one or more parts of a complete sentence: a subject, a verb, or a complete thought.

SENTENCE

I was hungry, so I ate some cold pizza and drank a soda.

FRAGMENT

<u>I</u> was hungry, so <u>I</u> ate some cold pizza. *And drank a soda*. [*And drank a soda* contains a verb (*drank*) but no subject.]

LANGUAGE NOTE: Remember that any idea that ends with a period needs a subject and verb to be complete. As a quick review, a subject is the person, place, or thing that a sentence is about. A verb tells what the subject does, links the subject to another word that describes it, or "helps" another verb form a complete verb.

In the Real World, Why Is It Important to Correct Fragments?

People outside the English classroom notice fragments and consider them major mistakes.

SITUATION: Justina is interested in starting a blog to establish an online presence and attract potential employers, just as Leigh King did (see p. 197). Here is part of an e-mail that Justina sent to Leigh:

I am getting in touch with you about starting a blog on dress design/because I have heard about your success with your fashion blog. For a long time, I have designed and sewn many dresses for myself and my

LearningCurve
Fragments
bedfordstmartins
.com/realwriting/LC

RESOURCES This chapter offers associated LearningCurve activities for students. A student access code is printed in every new student copy of this text. Students who do not purchase a new print book can purchase access by going to bedfordstmartins .com/realwriting/LC.

TEACHING TIP

Students should underline the fragments for Practice 1 (on p. 342) and correct them for Practice 10 (on p. 355).

friends, and I have a good sense of style. On my blog, I would like to share sewing tips and patterns based on my dress designs/ Which should appeal to many readers. I would like to ask your opinion about many things/ Especially about how to write clear, interesting blog posts. I have to admit that my dream would be for my blog to catch the eye of a major fashion house looking for talent/ To come up with new looks for its dress line. Could we set up a time to talk in person?

WRITER AT WORK

Here are Leigh's thoughts about Justina's e-mail.

LEIGH KING'S RESPONSE: Justina seems to be a talented designer who has a lot of good information to share with others. However, her e-mail has a lot of mistakes in it, and if the writing in her blog will be as careless as the writing in the e-mail, I am concerned that readers—including potential employers—will not take her seriously. When I meet with Justina, I will recommend that she brush up on her writing skills and carefully edit her blog entries before posting them. If she can do all that, I think she could produce an appealing blog.

(See Leigh's PROFILE OF SUCCESS on p. 197.)

Find and Correct Fragments

To find fragments in your own writing, look for the five trouble spots in this chapter. They often signal fragments.

When you find a fragment in your own writing, you can usually correct it in one of two ways.

BASIC WAYS TO CORRECT A FRAGMENT

- Add what is missing (a subject, a verb, or both).
- Attach the fragment to the sentence before or after it.

PRACTICE 1 Finding Fragments

Find and underline the four fragments in Justina's e-mail above.

RESOURCES Additional Resources contains tests and supplemental exercises for this chapter as well as a transparency master for the summary chart at the end of the chapter.

TEACHING TIP Consider having students use different-colored highlighters to indicate subjects and verbs.

Seeing Fragments

write What elements are missing from this sentence? Rewrite it to make it complete.

1. Fragments That Start with Prepositions

Whenever a preposition starts what you think is a sentence, check for a subject, a verb, and a complete thought. If the group of words is missing any of these three elements, it is a fragment.

FRAGMENT

<u>I pounded</u> as hard as I could. *Against the door*. [*Against the door* lacks both a subject and a verb.]

Correct a fragment that starts with a preposition by connecting it to the sentence either before or after it. If you connect such a fragment to the sentence after it, put a comma after the fragment to join it to the next sentence. **TIP** Remember that the subject of a sentence is *never* in a prepositional phrase (see p. 332).

TIP In the examples in this chapter, subjects are underlined once, and verbs are underlined twice.

FINDING AND FIXING FRAGMENTS: Fragments That Start with a Preposition

Find

I pounded as hard as I could. (Against) the door.

- 1. Circle any preposition that starts a word group.
- 2. **Ask:** Does the word group have a subject? *No.* A verb? *No.* **Underline** any subject, and **double-underline** any verb.
- 3. Ask: Does the word group express a complete thought? No.
- 4. If the word group is missing a subject or verb or does not express a complete thought, it is a fragment. This word group is a fragment.

Fix

I pounded as hard as I could/Against the door.

5. Correct the fragment by joining it to the sentence before or after it.

TIP For more practice correcting fragments, visit Exercise Central at bedfordstmartins.com/realwriting.

2. Fragments That Start with Dependent Words

A dependent word (also called a subordinating conjunction) is the first word in a dependent clause (a clause is a group of words that has a subject and a verb).

SENTENCE WITH A
DEPENDENT WORD

We arrived early because we left early.

[Because is a dependent word introducing the dependent clause because we left early.]

A dependent clause cannot be a sentence because it does not express a complete thought, even though it has a subject and a verb. Whenever a dependent word starts what you think is a sentence, stop to check for a subject, a verb, and a complete thought.

FRAGMENT Since I moved. I have eaten out every day.

[Since I moved has a subject (I) and a verb (moved), but it does

not express a complete thought.]

CORRECTED Since I moved, I have eaten out every day.

DISCUSSION Ask students to jot down what they think the word dependent means in the real world and to give an example. After getting some responses, ask how dependent in dependent clause is similar to dependent in the real world.

Common Dependent Words after if/if only until although now that what (whatever) as/as if/as though once when (whenever) as long as/as soon as since where (wherever) because so that whether before that which

though

unless

while

who/whose

computer Suggest that students become aware of the dependent words they use most by doing a computer search for them as they edit their own writing. They can then make sure that dependent clauses are attached to sentences.

When a word group starts with who, whose, or which, it is not a complete sentence unless it is a question.

last week.

QUESTION Who gave you a ticket last week?

FRAGMENT He is the goalie. Whose team is so bad.

QUESTION Whose team are you on?

FRAGMENT Sherlene went to the HiHo Club. Which does not serve

alcohol.

That woman is the police officer. Who gave me a ticket

QUESTION Which club serves alcohol?

even if/even though

how

FRAGMENT

Correct a fragment that starts with a dependent word by connecting it to the sentence before or after it. If the dependent clause is joined to the sentence after it, put a comma after the dependent clause.

FINDING AND FIXING FRAGMENTS: Fragments That Start with a Dependent Word

Find

Because a job search is important. People should take the time to do it correctly.

- 1. Circle any dependent word that starts either word group.
- 2. **Ask:** Does the word group beginning with a dependent word have a subject? Yes. A verb? Yes. **Underline** any subject, and **double-underline** any verb.
- 3. Ask: Does this word group express a complete thought? No.
- 4. If the word group is missing a subject or verb or does not express a complete thought, it is a fragment. This word group is a fragment.

Fix

Because a job search is important/People should take the time to do it correctly.

5. **Correct the fragment** by joining it to the sentence before or after it. Add a comma if the dependent word group comes first.

TIP For more on commas with dependent clauses, see Chapters 27 and 34.

OFix In

PRACTICE 2 Correcting Fragments That Start with Prepositions or Dependent Words

In the following items, circle any prepositions or dependent words that start a word group. Then, correct each fragment by connecting it to the sentence before or after it. Answers may vary. Possible edits are shown.

EXAMPLE: The fire at the Triangle Waist Company in New York City marked a turning point U.S. labor history.

- 1. Before the fire occurred, on March 25, 1911 Labor activists had raised complaints against the company, a maker of women's blouses.
- 2. The activists demanded shorter hours and better wages For the company's overworked and underpaid sewing-machine operators.
- 3. The owners refused these requests, however Because they placed profits over their employees' welfare.

- **4.** When activists demanded better safety measures, such as sprinkler systems. The owners again refused to do anything.
- 5. On the day of the fire scrap bin on the eighth floor of the blouse factory ignited by accident.
- 6. Although workers threw buckets of water on the flames Their efforts could not keep the fire from spreading to other floors.
- 7. Without access to safe or unlocked exits Many workers died in the smoke and flames or jumped to their deaths.
- 8. One hundred and forty-six workers had lost their lives by the end of this tragic day.
- **9.** After news of the tragedy spread/The public reacted with outrage and greater demands for better working conditions.
- 10. Within a few years of the fire Legislatures in New York and in other states passed laws to improve workplace safety and worker rights.

PRACTICE 3 Correcting Fragments That Start with Prepositions or Dependent Words

Read the following paragraph, and circle the ten fragments that start with prepositions or dependent words. Then, correct the fragments. Answers may vary. Possible edits are shown.

Staying focused at an office job can be difficult Because of these jobs' many distractions. After making just a few changes. Workers will find that they are less distracted and more productive. A good first step is to clear away clutter, such as old paperwork from the desk. Once the workspace is cleared it is helpful to make a list of the most important tasks for the day. It is best for workers to do brain-demanding tasks when they are at their best. Which is often the start of the day. Workers can take on simpler tasks, like filing. When they are feeling less energetic. While they are doing something especially challenging. Workers might want to disconnect themselves from e-mail and turn off their cell phones. Although it is tempting to answer e-mails and phone calls immediately. They are among the worst workplace distractions. Some people set up a special electronic folder for personal e-mails. They check this folder only while they are on break or between tasks. Finally, it is important for workers to remember the importance of breaks. Which recharge the mind and improve its focus.

3. Fragments That Start with -ing Verb Forms

An -ing verb form (also called a gerund) is the form of a verb that ends in -ing: walking, writing, running. Sometimes, an -ing verb form is used at the beginning of a complete sentence.

SENTENCE

Walking is good exercise.

[The -ing verb form walking is the subject; is is the verb. The sentence expresses a complete thought.]

Sometimes, an -ing verb form introduces a fragment. When an -ing verb form starts what you think is a sentence, stop and check for a subject, a verb, and a complete thought.

FRAGMENT

I ran as fast as I could. Hoping to get there on time. [Hoping to get there on time lacks a subject, and it does not express a complete thought.]

Correct a fragment that starts with an -ing verb form either by adding whatever sentence elements are missing (usually a subject and a helping verb) or by connecting the fragment to the sentence before or after it. Usually, you will need to put a comma before or after the fragment to join it to the complete sentence.

FINDING AND FIXING FRAGMENTS:

Fragments That Start with -ing Verb Forms

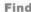

I was running as fast as I could. (Hoping) to get there on time.

- 1. Circle any -ing verb that starts a word group.
- 2. Ask: Does the word group have a subject? No. A verb? Yes. Underline any subject, and double-underline any verb.
- 3. Ask: Does the word group express a complete thought? No.
- 4. If the word group is missing a subject or a verb or does not express a complete thought, it is a fragment. This word group is a fragment.

I was running as fast as I could/Hoping to get there on time. I was hoping I was running as fast as I could. Hoping to get there on time.

5. Correct the fragment by joining it to the sentence before or after it. Alternative: Add the missing sentence elements.

PRACTICE 4 Correcting Fragments That Start with -ing Verb Forms

Circle any -ing verb that appears at the beginning of a word group in the paragraph. Then, read the word group to see if it has a subject and a verb and expresses a complete thought. Not all the word groups that start with an -ing verb are fragments, so read carefully. In the space provided, record the numbers of the word groups that are fragments. Then, correct each fragment either by adding the missing sentence elements or by connecting it to the sentence before or after it. Answers will vary. Possible edits are shown.

Which word groups are fragments? 4, 7, 9, 11

(1) People sometimes travel long distances in unusual ways trying to set new world records. (2) Walking is one unusual way to set records.

(3) In 1931, Plennie Wingo set out on an ambitious journey (4) Walking backward around the world. (5) Wearing sunglasses with rearview mirrors, he started his trip early one morning. (6) After eight thousand miles, Wingo's journey was interrupted by a war in Pakistan (7) Ending his ambitious journey. (8) Hans Mullikan spent more than two years in the late 1970s traveling to the White House by crawling from Texas to Washington, D.C. (9) Taking time out to earn money as a logger and a Baptist minister. (10) Alvin Straight, suffering from poor eyesight, traveled across the Midwest on a lawn mower (11) Looking for his long-lost brother.

4. Fragments That Start with to and a Verb

When what you think is a sentence begins with *to* and a verb (called the *infinitive* form of the verb), you need to make sure it is not a fragment.

FRAGMENT Each day, I check freecycle.org. To see if it has anything

I need.

CORRECTED Each day, \underline{I} check freecycle.org to see if it has anything

I need.

If a word group begins with *to* and a verb, it must have another verb; if not, it is not a complete sentence. When you see a word group that begins with *to* and a verb, first check to see if there is another verb. If there is no other verb, the word group is a fragment.

SENTENCE $\underline{To \ run}$ a complete marathon $\underline{\underline{was}}$ my goal. $\underline{[To \ run]}$ is the subject; was is the verb.

FRAGMENT Cheri got underneath the car. To change the oil.

[No other verb appears in the word group that begins with

to change.]

LANGUAGE NOTE: Do not confuse the infinitive (to before the verb) with that.

INCORRECT My brother wants *that* his girlfriend cook.

CORRECT My brother wants his girlfriend to cook.

To correct a fragment that starts with *to* and a verb, join it to the sentence before or after it, or add the missing sentence elements.

FINDING AND FIXING FRAGMENTS:

Fragments That Start with to and a Verb

Find

Cheri got underneath the car. To change the oil.

- 1. Circle any to-plus-verb combination that starts a word group.
- 2. **Ask:** Does the word group have a subject? *No.* A verb? Yes. **Underline** any subject, and **double-underline** any verb.
- 3. Ask: Does the word group express a complete thought? No.
- 4. If the word group is missing a subject or a verb or does not express a complete thought, it is a fragment. This word group is a fragment.

Fix

Cheri got underneath the car/ to change the oil.

To change the oil,

Cheri got underneath the car. To change the oil.

She needed to

Cheri got underneath the car. To change the oil.

 Correct the fragment by joining it to the sentence before or after it. If you put the to-plus-verb word group first, put a comma after it. Alternative: Add the missing sentence elements.

PRACTICE 5 Correcting Fragments That Start with to and a Verb

Circle any *to*-plus-verb combination that appears at the beginning of a sentence in the paragraph. Then, read the word group to see if it has a subject and a verb and expresses a complete thought. Not *all* the word groups that start with *to* and a verb are fragments, so read carefully. In the space provided, record the numbers of the word groups that are fragments. Then, correct each

fragment either by adding the missing sentence elements or by connecting it to the sentence before or after it. Answers may vary. Possible edits are shown.

Which word groups are fragments? _____3, 7, 9, 10

(1) For people older than twenty-five, each hour spent watching TV lowers life expectancy by nearly twenty-two minutes. (2) This finding is the result of Australian researchers' efforts/(3) To investigate the health effects of TV viewing. (4) To put it another way, watching an hour of television is about the same as smoking two cigarettes. (5) The problem is that most people are inactive while watching TV. (6) They are not doing anything, like walking or playing sports/(7) To strengthen their heart and maintain a healthy weight. (8) Fortunately, it is possible/(9) To counteract some of TV's negative health effects. (10) To increase their life expectancy by three years/(11) People need to exercise just fifteen minutes a day. (12) To accomplish this goal, they might exchange a ride in an elevator for a climb up the stairs. (13) Or they might walk around the block during a lunch break at work.

5. Fragments That Are Examples or Explanations

As you edit your writing, pay special attention to groups of words that are examples or explanations of information you presented in the previous sentence. They may be fragments.

More and more people are reporting food allergies. For

example, allergies to nuts or milk.

FRAGMENT My body reacts to wheat-containing foods. Such as

bread or pasta.

[For example, allergies to nuts or milk and Such as bread or pasta

are not complete thoughts.]

This last type of fragment is harder to recognize because there is no single word or kind of word to look for. The following words may signal a fragment, but fragments that are examples or explanations do not always start with these words.

especially for example like such as

When a group of words gives an example or explanation connected to the previous sentence, stop to check it for a subject, a verb, and a complete thought. **TIP** Such as and like do not often begin complete sentences.

FRAGMENT I have found great things at freecycle.org. Like a nearly

new computer.

FRAGMENT Freecycle.org is a good site. *Especially for household items*.

FRAGMENT It lists many gently used appliances. Such as DVD

players.

[Like a nearly new computer, Especially for household items, and

Such as DVD players are not complete thoughts.]

Correct a fragment that starts with an example or explanation by connecting it to the sentence before or after it. Sometimes, you can add whatever sentence elements are missing (a subject, a verb, or both) instead. When you connect the fragment to a sentence, you may need to change some punctuation. For example, fragments that are examples are often set off by a comma.

FINDING AND FIXING FRAGMENTS:

Fragments That Are Examples or Explanations

Freecycle.org recycles usable items. Such as clothing,

- 1. Circle the word group that is an example or explanation.
- 2. **Ask:** Does the word group have a subject, a verb, and a complete thought? *No.*
- 3. If the word group is missing a subject or a verb or does not express a complete thought, it is a fragment. This word group is a fragment.

ger z ...

Freecycle.org recycles usable items such as clothing.

You may need to add some words to correct fragments:

I should list some things on freecycle.org. The sweaters I never could keep others warm wear.

 Correct the fragment by joining it to the sentence before or after it or by adding the missing sentence elements.

PRACTICE 6 Correcting Fragments That Are Examples or Explanations

Circle word groups that are examples or explanations. Then, read the word group to see if it has a subject and verb and expresses a complete thought. In the space provided, record the numbers of the word groups that are fragments.

Then, correct each fragment either by adding the missing sentence elements or by connecting it to the sentence before or after it. Answers may vary. Possible edits are shown.

Which word groups are fragments? 2, 4, 6, 8, 10

(1) Being a smart consumer can be difficult (2) Especially when making a major purchase (3) At car dealerships, for example, important information is often in small type (4) Like finance charges or preparation charges (5) Advertisements also put negative information in small type (6) Such as a drug's side effects. (7) Credit-card offers often use tiny, hard-to-read print for the terms of the card (8) Like interest charges and late fees, which can really add up (9) Phone service charges can also be hidden in small print (10) Like limits on text messaging and other functions. (11) Especially now, as businesses try to make it seem as if you are getting a good deal, it is important to read any offer carefully.

Edit for Fragments

Use the chart on page 358, Finding and Fixing Fragments, to help you complete the practices in this section and edit your own writing.

PRACTICE 7 Correcting Various Fragments

In the following items, circle each word group that is a fragment. Then, correct fragments by connecting them to the previous or next sentence or by adding the missing sentence elements. Answers will vary. Possible edits are shown.

publishers are turning to a new source of revenue.

- publishers
 To add to their income/Publishers are placing advertisements in their games.
- a character might be shown Sometimes, the ads show a character using a product. For example, drinking a specific brand of soda to earn health points.
- One character, a race-car driver, drove his ad-covered car Across the finish line.
- When a warrior character picked up a sword decorated with an athletic-shoe logo/Some players complained.

TEAMWORK Divide the class into small groups, and have each group present a corrected paragraph. Compare the different ways the groups correct the fragments.

- 5. Worrying that ads are distracting. Some publishers are trying to limit the number of ads per game.
- 6. But most players do not seem to mind seeing ads in video games there are not too many of them.
- 7. These players are used to seeing ads in all kinds of places Like grocery carts and restroom walls.
- 8. For video game publishers. The goal is making a profit, but most publishers also care about the product.
- 9. To strike a balance between profitable advertising and high game quality. That is what publishers want.
- 10. Doing market research Will help publishers find that balance.

PRACTICE 8 Editing Paragraphs for Fragments

Find and correct ten fragments in the following paragraphs.

- 1. Ida Lewis was born on February 25, 1842, in Newport, Rhode Island. Her father, Hosea, had been a coast pilot but was transferred to the Lighthouse Service. Although he was in failing health/in 1853, he was appointed lighthouse keeper at Lime Rock in Newport. Many lighthouse keepers were forced to leave family behind when they assumed their duties/because the lighthouses were in remote locations and the living situations were poor. At first, Lime Rock had only a shed/for the keeper and a temporary lantern for light. Appropriate housing was constructed in 1857, and Hosea moved his family to Lime Rock.
- 2. Hosea was completely disabled by a stroke/In only a few months. Ida, who was already caring for an ill sister, took care of her father and the lighthouse as well/Keeping the lighthouse lamp lit. At sunset, the lamp had to be filled with oil and refilled at midnight. The reflectors needed constant polishing, and the light had to be extinguished in the morning. Since schools were on the mainland, Ida rowed her brothers and sisters to school every day/Strengthening her rowing ability, which ultimately saved many lives. In 1872, Hosea died, and Ida's mother was appointed keeper/Even though Ida did all the work. Finally, in 1879, Ida became the keeper and received a salary of \$500 a year.
- 3. She was the best-known lighthouse keeper because of her many for saving rescues. Some called her "The Bravest Woman in America," Saving eighteen

lives during her time of service. In 1867, during a storm, sheepherders had gone into the water after a lost sheep. Ida saved both the sheep and the sheepherders. She became famous, and many important people came to see her/for example, President Ulysses S. Grant. All the ships anchored in the harbor tolled their bells/fo honor her after her death. Later, the Rhode Island legislature changed the name of Lime Rock to Ida Lewis Rock, the first and only time this honor was awarded.

PRACTICE 9 Editing Fragments and Using Formal English

Your friend wants to send this thank-you note to an employer who interviewed her for a job. She knows that the note has problems and has asked for your help. Correct the fragments in the note. Then, edit the informal English in it. Answers will vary. Possible edits are shown.

Dear Ms. Hernandez,

(1) Thank you so much for taking the time (2) To meet with me this past excited

Wednesday. (3) I am more psyched than ever about the administrative assistant position at Fields Corporation. (4) Learning more about the challenges and requirements of the job was valuable to me. stuff I would need to do. Was very cool. (5) Also, I enjoyed meeting you and the other managers. (6) With my strong organizational skills, professional an asset to the company. experience, and friendly personality (7) I'm sure that I would be awesome of my strong interest in the position. (9) I hope you information, like will keep me in mind. (10) Please let me know if you need any other info.

(11) Like references or a writing sample. Thanks again for your time.

(12) Thank U much,

Sincerely.

Terri Hammons

PRACTICE 10 Editing Justina's E-mail

Look back at Justina's e-mail on page 341. You may have already underlined the fragments in her e-mail; if not, do so now. Next, using what you have learned in this chapter, correct each fragment in the e-mail.

PRACTICE 11 Editing Your Own Writing for Fragments

Edit fragments in a piece of your own writing—a paper for this course or another one, or something you have written for work or your everyday life. Use the chart on page 358 to help you.

TIP For more advice on using formal English, see Chapter 2. For advice on choosing appropriate words, see Chapter 31.

Chapter Review

LEARNING JOURNAL What kind of fragments do you find in your writing? What is the main thing you have learned about fragments that will help you? What is unclear to you?

TEACHING TIP You can collect students' learning journals to find out what the class or individual students need more work on.

A	fragment seems to be a complete sentence but is only a
piec	e of one. It lacks a <u>subject</u> , a <u>verb</u> , or a
com	plete thought
X 1771	
Wha	t are the five trouble spots that signal possible fragments?
A wo	ord group that starts with a preposition
	9 1 1
A w	ord group that starts with a dependent word
A w	ord group that starts with a dependent word
A wo	ord group that starts with a dependent word ord group that starts with an "-ing" verb form
A wo	ord group that starts with a dependent word ord group that starts with an "-ing" verb form ord group that starts with "to" and a verb

Chapter Test

Circle the correct choice for each of the following items. For help, refer to the chart on page 358, Finding and Fixing Fragments.

Attach the fragment to the sentence before or after it.

1. If an underlined portion of this sentence is incorrect, select the revision that fixes it. If the sentence is correct as written, choose d.

Natalie did not $\underline{go \text{ on }}$ our bike $\underline{trip. \text{ Because}}$ she could not $\underline{ride a}$ bike.

a. go. On

- c. ride; a
- (b.) trip because
- **d.** No change is necessary.
- **2.** Choose the item that has no errors.
 - **a.** Since Gary is the most experienced hiker here, he should lead the way.
 - **b.** Since Gary is the most experienced hiker here. He should lead the way.
 - **c.** Since Gary is the most experienced hiker here; he should lead the way.

RESOURCES The Testing Tool Kit CD-ROM available with this book has even more tests on fragments. Also, for cumulative Editing Review Tests, see pages 609–18.

- 4. Choose the item that has no errors.
 - **a.** To get to the concert hall; take exit 5 and drive for 3 miles.
 - **b.** To get to the concert hall. Take exit 5 and drive for 3 miles.
 - **(c.)** To get to the concert hall, take exit 5 and drive for 3 miles.
- **5.** If an underlined portion of this sentence is incorrect, select the revision that fixes it. If the sentence is correct as written, choose d.

Buying many unnecessary groceries. Can result in wasted food

and wasted money.

C

c.: wasted money

b.: in wasted

d. No change is necessary.

6. If an underlined portion of this sentence is incorrect, select the revision that fixes it. If the sentence is correct as written, choose d.

Some scientists predict that people will soon take vacation

Cruises. Into space.

C

a. predict, that

b. soon; take

d. No change is necessary.

- 7. Choose the item that has no errors.
 - **a.** Walking for 10 miles after her car broke down. Pearl became tired and frustrated.
 - **b.** Walking for 10 miles after her car broke down; Pearl became tired and frustrated.
 - **c.** Walking for 10 miles after her car broke down, Pearl became tired and frustrated.
- **8.** Choose the item that has no errors.
 - **a.** Many people find it hard. To concentrate during stressful times.
 - **b.** Many people find it hard to concentrate during stressful times.
 - c. Many people find it hard, to concentrate during stressful times.

9. If an underlined portion of this sentence is incorrect, select the revision that fixes it. If the sentence is correct as written, choose d.

Growing suspicious, the secret agent discovered a tiny recording A device inside a flower vase.

- a. Growing, suspicious
- c. inside, a flower vase
- b. agent. Discovered
- **d.**) No change is necessary.
- **10.** If an underlined portion of this sentence is incorrect, select the revision that fixes it. If the sentence is correct as written, choose d.

 $\frac{\text{Early in }}{\textbf{A}} \text{ their training, } \underbrace{\text{doctors learn}}_{\textbf{B}} \text{ that there is a fine } \\ \underline{\text{line. Between}} \text{ life and death.}$

a. Early, in

- (c.) line between
- b. doctors. Learn
- d. No change is necessary.

EVER THOUGHT THIS?

"I tried putting in commas instead of periods so that I wouldn't have fragments. But now my papers get marked for 'comma splices.'"

-Jimmy Lester, Student

This chapter

- · explains what run-ons are.
- gives you practice finding run-ons and shows five ways to correct them.

2

Run-Ons

Two Sentences Joined Incorrectly

Understand What Run-Ons Are

A sentence is also called an **independent clause**, a group of words with a subject and a verb that expresses a complete thought. Sometimes, two independent clauses can be joined to form one larger sentence.

SENTENCE WITH TWO INDEPENDENT CLAUSES

The college offers financial aid, and it encourages students to apply.

A **run-on** is two complete sentences (independent clauses) joined incorrectly as one sentence. There are two kinds of run-ons: **fused sentences** and **comma splices**.

A **fused sentence** is two complete sentences joined without a coordinating conjunction (*for*, *and*, *nor*, *but*, *or*, *yet*, *so*) or any punctuation.

FUSED SENTENCE Exercise is important it has many benefits.

No punctuation

A **comma splice** is two complete sentences joined by only a comma.

COMMA SPLICE My mother jogs every morning, she runs three miles.

LearningCurve
Run-On Sentences
bedfordstmartins
.com/realwriting/LC

RESOURCES This chapter offers associated LearningCurve activities for students. A student access code is printed in every new student copy of this text. Students who do not purchase a new print book can purchase access by going to bedfordstmartins.com/realwriting/LC.

TIP To find and correct run-ons, you need to be able to identify a complete sentence. For a review, see Chapter 19. TIP In the examples throughout this chapter, subjects are underlined once, and verbs are underlined twice.

RESOURCES Additional Resources contains tests and supplemental practice exercises for this chapter as well as a transparency master for the summary chart at the end of the chapter.

TEACHING TIP Students should underline the run-ons for Practice 1, page 361, and correct them for Practice 8, page 373.

When you join two sentences, use the proper punctuation.

CORRECTIONS Exercise is important; it has many benefits.

My mother jogs every morning; she runs 3 miles.

In the Real World, Why Is It Important to Correct Run-Ons?

People outside the English classroom notice run-ons and consider them major mistakes.

SITUATION: Naomi is applying to a special program for returning students at Cambridge College. Here is one of the essay questions on the application, followed by a paragraph from Naomi's answer.

STATEMENT OF PURPOSE: In two hundred words or less, describe your intellectual and professional goals and how a Cambridge College education will assist you in achieving them.

For many years, I did not take control of my life/I just drifted without any goals. I realized one day as I met with my daughter's guidance counselor that I hoped my daughter would not turn out like me. From that moment, I decided to do something to help myself and others. I set a goal of becoming and a teacher. To begin on that path, I took a math course at night school, then I took another in science. I passed both courses with hard work, I know I can do well in the Cambridge College program. I am committed to the professional goal I finally found it has given new purpose to my whole life.

WRITER AT WORK

Mary LaCue Booker, a master's degree recipient from Cambridge College, read Naomi's answer and commented.

MARY LACUE BOOKER'S RESPONSE:

Cambridge College wants students who are thoughtful, hardworking, and mature. Although Naomi's essay indicates that she has some of these qualities, her writing gives another impression. She makes several noticeable errors; I wonder if she took the time to really think about this essay. If she is careless on a document that represents her for college admission, will she be careless in other areas as well? It is too bad, because her qualifications are quite good otherwise.

Find and Correct Run-Ons

To find run-ons, focus on each sentence in your writing, one at a time, looking for fused sentences and comma splices. Pay special attention to sentences longer than two lines. By spending this extra time, your writing will improve.

PRACTICE 1 Finding Run-Ons

Find and underline the four run-ons in Naomi's writing on page 360.

Once you have found a run-on, there are five ways to correct it.

FIVE WAYS TO CORRECT RUN-ONS

1. Add a period.

2. Add a semicolon.

I saw the man; he did not see me.

3. Add a semicolon, a conjunctive adverb, and a comma.

however, I saw the man; he did not see me.

4. Add a comma and a coordinating conjunction.

 $\underline{\underline{I}} \underline{\underline{saw}}$ the man, $\underline{\underline{he}} \underline{\underline{did}}$ not $\underline{\underline{see}}$ me.

5. Add a dependent word.

When I saw the man, he did not see me.

Add a Period

You can correct run-ons by adding a period to make two separate sentences. After adding the period, capitalize the letter that begins the new sentence. Reread your two sentences to make sure they each contain a subject, a verb, and a complete thought.

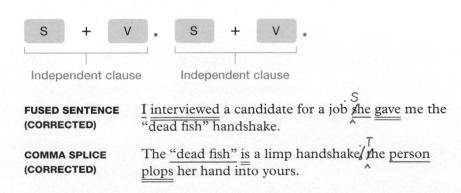

TEACHING TIP Remind students that a semicolon balances two independent clauses. What is on either side of it must be able to

stand alone as a complete

sentence.

Add a Semicolon

A second way to correct run-ons is to use a semicolon (3) to join the two sentences. Use a semicolon only when the two sentences express closely related ideas and the words on each side of the semicolon can stand alone as a complete sentence. Do not capitalize the word that follows a semicolon unless it is the name of a specific person, place, or thing that is usually capitalized—for example, Mary, New York, or the Eiffel Tower.

FUSED SENTENCE (CORRECTED)	Slouching creates a terrible impression it makes a person seem uninterested, bored, or lacking in self-confidence.	
COMMA SPLICE (CORRECTED)	It is important in an interview to hold your head up $\frac{1}{1}$ is just as important to sit up straight.	

Add a Semicolon, a Conjunctive Adverb, and a Comma

A third way to correct run-ons is to add a semicolon followed by a **conjunctive adverb** and a comma.

Common Con	junctive Advert	os	
consequently	indeed	moreover	still
finally	instead	nevertheless	then
furthermore	likewise	otherwise	therefore
however	meanwhile	similarly	

Conjunctive Semicolon adverb Comma

 $\underline{\underline{I}}$ <u>stopped</u> by the market; however, $\underline{\underline{it}}$ <u>was closed</u>.

Conjunctive Semicolon adverb Comma

Sharon is a neighbor; moreover, she is my friend.

FINDING AND FIXING RUN-ONS:

Adding a Period, a Semicolon, or a Semicolon, a Conjunctive Adverb, and a Comma

Find

Few people know the history of many popular holidays Valentine's Day is one of these holidays.

- To see if there are two independent clauses in a sentence, underline the subjects, and double-underline the verbs.
- 2. **Ask:** If the sentence has two independent clauses, are they separated by either a period or a semicolon? *No. It is a run-on.*

Fix

Few people know the history of many popular holidays. Valentine's Day is one of these holidays.

Few people know the history of many popular holidays; Valentine's Day is one of these holidays.

indeed,

Few people know the history of many popular holidays; Valentine's Day is one of these holidays.

Correct the error by adding a period, a semicolon, or a semicolon, a conjunctive adverb, and a comma.

PRACTICE 2 Correcting Run-Ons by Adding a Period or a Semicolon

For each of the following items, indicate in the space to the left whether it is a fused sentence ("FS") or a comma splice ("CS"). Then, correct the error by adding a period or a semicolon. Capitalize the letters as necessary to make two sentences. Answers will vary. Possible answers are shown.

EXAMPLE: <u>FS</u> Being a farmer can mean dealing with all types of challenges one of the biggest ones comes from the sky.

- CS 1. Farmers have been trying to keep hungry birds out of their crops for centuries/the first scarecrow was invented for this reason.
- CS 2. Some farmers have used a variety of chemicals other farmers have tried noise, such as small cannons.
- FS 3. Recently, a group of berry farmers tried something new they brought in bigger birds called falcons.

TIP For more practices on run-ons, visit Exercise Central at bedfordstmartins.com/ realwriting.

- **4.** Small birds such as starlings love munching on berries each year they destroy thousands of dollars' worth of farmers' berry crops.
- **5.** Because these starlings are frightened of falcons, they fly away when they see these birds of prey in the fields they need to get to where they feel safe.
- CS 6. Using falcons to protect their crops saves farmers money/it does not damage the environment either.
- 7. A falconer, or a person who raises and trains falcons, keeps an eye on the birds during the day he makes sure they only chase away the starlings instead of killing them.
- They

 Salign Services as well they are used in vineyards to keep pests from eating the grapes.
- 9. In recent years, the falcons have also been used in landfills to Some scatter birds and other wildlife some have even been used at large airports to keep flocks of birds out of the flight path of landing airplanes.

write How would you fix the run-on in this sign? What other errors do you notice? Write two more closely related sentences, and then connect them using a semicolon or a semicolon, a conjunctive adverb, and a comma. Make sure that all your punctuation is correct.

fS 10. Although a falconer's services are not cheap, they cost less than for some other methods that farmers have tried for example, putting nets over a berry field can often cost more than \$200,000.

a and a Coordinating Conjunction

to correct run-ons is to add a comma and a **coordinating** a link that joins independent clauses to form one sentence. bordinating conjunctions are *and*, *but*, *for*, *nor*, *or*, *so*, *yet*. Some nember these words by thinking of **FANBOYS**: *for*, *and*, *nor*, *st*, *so*.

brrect a fused sentence this way, add a comma and a coordinating tion. A comma splice already has a comma, so just add a coordiconjunction that makes sense in the sentence.

TIP Notice that the comma does not follow the conjunction. The comma follows the word before the conjunction.

FUSED SENTENCE (CORRECTED)

Nakeisha was qualified for the job she hurt her chances by mumbling.

The candidate smiled, she waved to the crowd.

Coordinating conjunctions need to connect two independent clauses. They are not used to join a dependent and an independent clause.

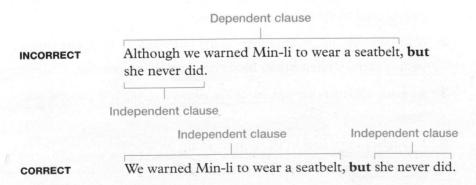

FINDING AND FIXING RUN-ONS:

Using a Comma and/or a Coordinating Conjunction

Find

Foods differ from place to place your favorite treat might someone from another culture.

- To see if there are two independent clauses in a sentence, subjects, and double-underline the verbs.
- 2. **Ask:** If the sentence has two independent clauses, are they seither a period or a semicolon? *No. It is a run-on.*

Fix

, and

Foods differ from place to place your favorite treat might disgus someone from another culture.

 Correct a fused sentence by adding a comma and a coordinating conjunction between the two independent clauses. Correct a comma splice adding just a coordinating conjunction.

PRACTICE 3 Correcting Run-Ons by Adding a Comma and/or a Coordinating Conjunction

Correct each of the following run-ons by adding a comma, if necessary, and an appropriate coordinating conjunction. First, underline the subjects, and double-underline the verbs. Answers will vary. Possible edits are shown.

EXAMPLE: Most Americans do not like the idea of eating certain kinds of food, most of us would probably reject horse meat.

- 1. In most cultures, popular <u>foods depend</u> on availability and tradition <u>people tend</u> to eat old familiar favorites.
- 2. Sushi shocked many Americans thirty years ago, today some young people in the United States have grown up eating raw fish.
- 3. In many societies, certain foods are allowed to age this process adds flavor.
- 4. <u>Icelanders bury eggs</u> in the ground to rot for months, these aged <u>eggs</u> are considered a special treat.

- 5. As an American, you might not like such eggs the thought of eating them might even revolt you.
- 6. In general, aged foods have a strong taste, the flavor is unpleasant to someone unaccustomed to those foods.
- 7. Many Koreans love to eat kimchee, a spicy aged cabbage, Americans often find the taste odd and the smell overpowering.
- 8. Herders in Kyrgyzstan drink kumiss this beverage is made of aged horse's milk.
- 9. Americans on a visit to Kyrgyzstan consider themselves brave for but tasting kumiss, local children drink it regularly.
- 10. We think of familiar foods as normal, favorite American foods might horrify people in other parts of the world.

Add a Dependent Word

A fifth way to correct run-ons is to make one of the complete sentences a dependent clause by adding a dependent word (a subordinating conjunction or a relative pronoun), such as after, because, before, even though, if, that, though, unless, when, who, and which. (For a more complete list of these words, see the graphic on p. 368.) Choose the dependent word that best expresses the relationship between the two clauses.

Turn an independent clause into a dependent one when it is less important than the other clause or explains it, as in the following sentence.

When I get to the train station, I will call Josh.

The italicized clause is dependent (subordinate) because it just explains when the most important part of the sentence—calling Josh—will happen. It begins with the dependent word *when*.

Because a dependent clause is not a complete sentence (it has a subject and verb but does not express a complete thought), it can be joined to a sentence without creating a run-on. When the dependent clause is the second clause in a sentence, you usually do not need to put a comma before it unless it is showing contrast.

TWO SENTENCES

<u>Halloween</u> <u>was</u> originally a religious holiday. <u>People</u> <u>worshipped</u> the saints.

DEPENDENT CLAUSE: NO COMMA NEEDED

<u>Halloween</u> $\underline{\underline{\text{was}}}$ originally a religious holiday when $\underline{\underline{\text{people}}}$ $\underline{\underline{\text{worshipped}}}$ the saints.

DEPENDENT CLAUSE SHOWING CONTRAST: COMMA NEEDED

Many holidays have religious origins, though some <u>celebrations</u> have moved away from their religious roots.

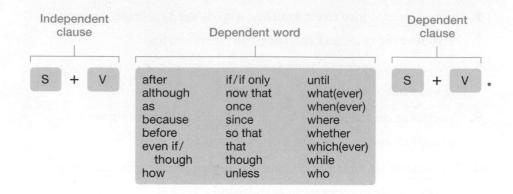

FUSED SENTENCE (CORRECTED)	Your final statement should express your interest in although the position you do not want to sound desperate. [The dependent clause although you do not want to sound desperate shows contrast, so a comma comes before it.]
COMMA SPLICE (CORRECTED)	It is important to end an interview on a positive note/ because that final impression is what the interviewer will remember.

You can also put the dependent clause first. When the dependent clause comes first, be sure to put a comma after it.

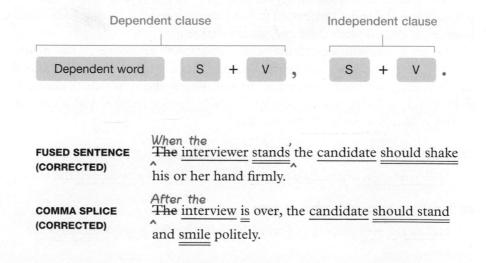

FINDING AND FIXING RUN-ONS:

Making a Dependent Clause

Find

Alzheimer's disease is a heartbreaking illness, it <u>causes</u> a steady decrease in brain capacity.

- 1. To see if there are two independent clauses in a sentence, **underline** the subjects, and **double-underline** the verbs.
- 2. **Ask:** If the sentence has two independent clauses, are they separated by a period, a semicolon, or a comma and a coordinating conjunction? *No.* It is a run-on.

Fix

because

Alzheimer's disease is a heartbreaking illness/it causes a steady decrease in brain capacity.

3. If one part of the sentence is less important than the other, or if you want to make it so, add a dependent word to the less important part.

PRACTICE 4 Correcting Run-Ons by Adding a Dependent Word

Correct run-ons by adding a dependent word to make a dependent clause. First, underline the subjects, and double-underline the verbs. Although these run-ons can be corrected in different ways, in this exercise correct by adding dependent words. You may want to refer to the graphic on page 368.

When many Answers will vary. Possible edits are shown.

Many soldiers returned from Iraq and Afghanistan missing arms or legs, demand for better artificial limbs increased.

- Before computer

 Computer chips were widely used artificial limbs remained largely unchanged for decades.
- Because computer Computer Computer chips now Control many artificial limbs, these limbs have more capabilities than the ones of the past.
- 3. The i-LIMB artificial hand picks up electrical signals from nearby arm so that muscles the amputee can move individual fingers of the hand.

- **4.** Before lighter-weight insterials were introduced artificial limbs were not as easy to move as they are today.
- 5. Now, the C-Leg artificial <u>leg</u> is popular it is lightweight, flexible, and technically advanced.
- 6. A C-Leg <u>user wants</u> to jog, bike, or drive instead of walk he or she can program the leg for the necessary speed and motion.
- 7. Major advances have been made in artificial limbs, researchers believe the technology has not reached its full potential.
- 8. Many will not be satisfied the human brain directly controls the motion of artificial limbs.
- Now that a A thought-controlled artificial arm is being tested on patients, that time may not be far off.
- 10. The artificial arm passes those tests it may be introduced to the market within the next few years.

A Word That Can Cause Run-Ons: Then

Many run-ons are caused by the word *then*. You can use *then* to join two sentences, but if you add it without the correct punctuation or added words, your sentence will be a run-on. Often, writers use just a comma before *then*, but that makes a comma splice.

COMMA SPLICE I picked up my laundry, then I went home.

Some of the methods you have just practiced can be used to correct errors caused by *then*. These methods are shown in the following examples.

 $\underline{\underline{I}} \ \underline{\underline{picked}} \ up \ my \ laundry / \underline{\underline{fhen}} \ \underline{\underline{I}} \ \underline{\underline{went}} \ home.$

 $\underline{\underline{I}}$ <u>picked</u> up my laundry, then $\underline{\underline{I}}$ <u>went</u> home.

<u>I</u> <u>picked</u> up my laundry, then <u>I</u> <u>went</u> home.

<u>I picked</u> up my laundry/then <u>I went</u> home. [dependent word before added to make a dependent clause]

Edit for Run-Ons

Use the chart on page 376, Finding and Fixing Run-Ons, to help you complete the practices in this section and edit your own writing.

PRACTICE 5 Correcting Various Run-Ons

In the following items, correct any run-ons. Use each method of correcting such errors—adding a period, adding a semicolon, adding a semicolon, a conjunctive adverb, and a comma, adding a comma and a coordinating conjunction, or adding a dependent word—at least once. Answers will vary. Possible edits are shown.

Although some
Some people doubt the existence of climate change, few can deny that the weather has become more extreme and dangerous.

- When more
 More than sixteen hundred tornadoes tore through the United States
 in 2011, hundreds of people lost their lives.
- 2. That same year, parts of the Midwest experienced severe flooding droughts in Texas cost farmers more than \$7 billion.
- 3. Some cities are taking steps to adapt to environmental changes, they are focusing on the biggest threats.
- Because global

 4. Global temperatures are rising, sea levels are also rising—a threat to coastal regions.
- **5.** As a result, some coastal cities are planning to build protective walls, while others are raising road beds.
- f. Extreme heat is another major problem urban planners are studying different ways to address it.
- 7. New York City is painting some rooftops white/light and heat will be reflected away from the city.
- 8. In Chicago, landscapers are planting heat-tolerant trees, these trees should help cool the environment and reduce flooding during heavy rains.
- 9. All these efforts are encouraging most parts of the United States are doing little or nothing to plan for ongoing environmental changes.
- 10. One study reports that only fourteen states are undertaking such ; meanwhile, planning the threats of severe weather remain.

TEACHING TIP Have students read the paragraphs aloud to listen for errors.

PRACTICE 6 Editing Paragraphs for Run-Ons

Find and correct the six run-ons in the following paragraphs. More than one correct response is possible.

- (1) For the first time, monster-size squids were filmed while still in the wild. (2) The images were caught on camera in the North Pacific Ocean the site is located just off the coast of southeastern Japan. (3) A team of Japanese scientists followed a group of sperm whales to locate the rare . The squids the whales like to eat the eight-legged creatures. (4) Wherever the whales went, the squids were likely to be found as well.
- (5) From aboard their research ship, the team located the squids thousands of feet under the water, the scientists lowered bait over the side to attract them. (6) Next, they sent down cameras alongside the bait to catch images of these bizarre animals as soon as they appeared.
- (7) The Dana octopus squid, also known as *Taningia danae*, often grows to the size of a human being or even larger. (8) Its eight arms are covered; however, in suckers, as most squid species are these particular types of arms end in catlike claws. (9) Two of the arms contain special organs on the ends called hotophores. (10) These photophores produce flashing bursts of light they are designed to lure and capture prey. (11) The burst of light stuns other creatures, giving a squid a chance to capture and eat its victim. (12) When the squid isn't hunting, it still glows. (13) Experts believe that squids remain lighted as a way of communicating with other squids about potential but dangers or as a way of attracting mates. (14) These lights appear eerie, the scientists were glad for them, as the lights made the giant squids slightly easier to find and finally film.

PRACTICE 7 Editing Run-Ons and Using Formal English

Your brother has been overcharged for an MP3 player he ordered online, and he is about to send this e-mail to the seller's customer-service department. Help him by correcting the run-ons. Then, edit the informal English. Answers will vary. Possible edits are shown.

To you because overcharged

(1) I'm writing 2U cuz I was seriously ripped off for the Star 3 MP3

player I ordered from your Web site last week. (2) U listed the price as

but

If you check

\$50 \$150 was charged to my credit card. (3) Check out any competitors'

TIP For more advice on using formal English, see Chapter 2. For advice on choosing appropriate words, see Chapter 31.

sites,	you to pay that much money for the Star model. The Will see that no one expects people 2 cough up that much eash Because
a lar	ne Star model, the prices are never higher than \$65. (4) I overpaid ge amount for this product, ucks on this, I want my money back as soon as possible. Sincerely, eriously bummin',
Chris	s Langley
PRA	CTICE 8 Editing Naomi's Application Answer
	back at Naomi's writing on page 360. You may have already underlined un-ons; if not, underline them now. Then, correct each error.
PRA	CTICE 9 Editing Your Own Writing for Run-Ons
one,	run-ons in a piece of your own writing—a paper for this course or another or something you have written for work or your everyday life. Use the on page 376 to help you.
Ch	apter Review
1.	A sentence can also be called an <u>independent clause</u> .
2.	A <u>fused sentence</u> is two complete sentences joined without any
	punctuation.
3.	Acomma splice is two complete sentences joined by only a
	comma.
4.	What are the five ways to correct run-ons?
••	Add a period.
	Add a semicolon.
	Add a semicolon, a conjunctive adverb, and a comma.
	Add a comma and a coordinating conjunction.
	Add a dependent word.
5.	What word in the middle of a sentence may signal a run-on? then
6.	What are the seven coordinating conjunctions? for, and, nor, but, or, yet, so

LEARNING JOURNAL If you found run-ons in your writing, how did you correct them? What is the main thing you have learned about run-ons that you will use? What is one thing that remains unclear?

TEACHING TIP You can collect students' learning journals to find out what the class or individual students need more work on.

Chapter Test

RESOURCES The Testing Tool Kit CD-ROM available with this book has even more tests on run-ons. Also, for cumulative Editing Review Tests, see pages 609-18.

Circle the correct choice for each of the following items. For help, refer to the
Finding and Fixing Run-Ons chart on page 376.

		and Fixing Run-Ons		376.
1.	a.		scription for n	ne, it is for my allergies.
	_			ne. It is for my allergies.
	C.	Flease III this pres	scription for i	ne it is for my allergies.
2.				ence is incorrect, select the revision et as written, choose d.
	На	rlan is busy now a	isk him if he	can do his report next week.
		A	В	C
	(a.)	now, so	c.	report; next
	b.	him, if	d.	No change is necessary.
3.	Ch	oose the item that l	has no errors.	
	a.	You cut all the oni cooking at the sam		ne same thickness, they will finish
	b.	You cut all the oni		ne same thickness they will finish
	c.	If you cut all the o		the same thickness, they will finish
4.	Ch	oose the correct an	swer to fill in	the blank.
	I h	ave told Jervis sev	eral times no	ot to tease the baby
		he	never listens	
	a (L.)	, but	c.	No word or nunctuation is necessary

- **5.** Choose the item that has no errors.
 - **a.** I am in no hurry to get a book I order it online.
 - **b.** I am in no hurry to get a book, I order it online.
 - **(c.)** When I am in no hurry to get a book, I order it online.
- **6.** If an underlined portion of this sentence is incorrect, select the revision that fixes it. If the sentence is correct as written, choose d.

Many pe	ople	think a	tomato	is a	vegetable	it is	really a	fruit
Λ					B		C	

	(a.) Although air conditioning makes hot days more comfortable, it will increase your energy bills.
	b. Air conditioning makes hot days more comfortable it will increase your energy bills.
	c. Air conditioning makes hot days more comfortable, it will increase your energy bills.
8.	If an underlined portion of this sentence is incorrect, select the revision that fixes it. If the sentence is correct as written, choose d.
	In northern Europe, bodies that are thousands of years old have
	been found in swamps, some bodies are so well preserved that they
	look like sleeping people.
	C Stephing people:
	a. old, have c. look, like
	(b.) swamps. Some d. No change is necessary.
	swamps. Some
9.	Choose the item that has no errors.
	a. Do not be shy about opening doors for strangers, courtesy is always appreciated.
	(b.) Do not be shy about opening doors for strangers; courtesy is always appreciated.
	c. Do not be shy about opening doors for strangers courtesy is always appreciated.
10.	Choose the correct answer to fill in the blank.
	You can ride with me to work you can take the train.
	(a.), or c. No word or punctuation is
	b. if necessary.

c. really; a

d. No change is necessary.

a. Many, people

7. Choose the item that has no errors.

b. vegetable; it

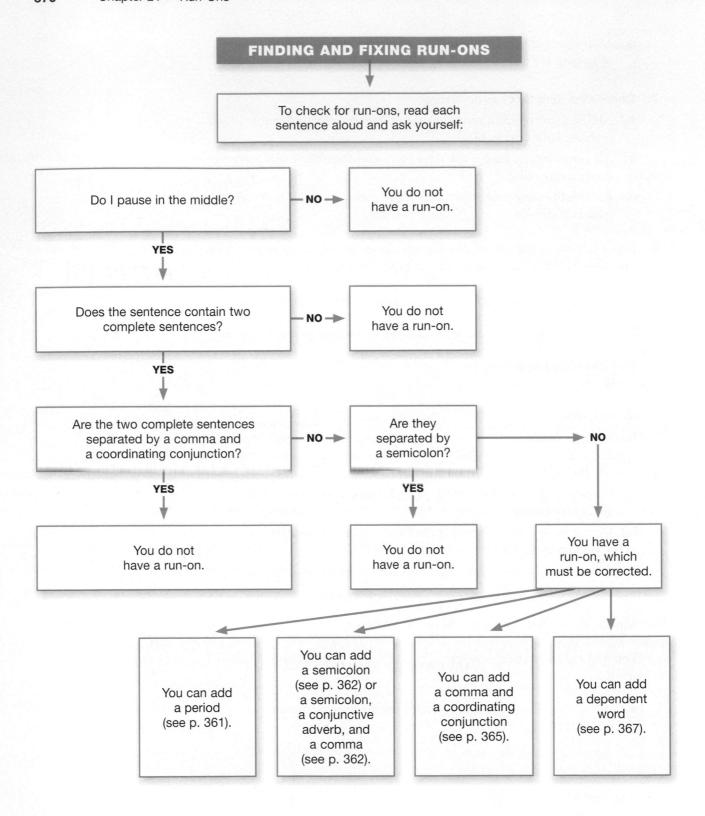

EVER THOUGHT THIS?

"I know sometimes the verb is supposed to end with -s and sometimes it isn't, but I always get confused."

-Mayerlin Fana, Student

This chapter

- explains what agreement between subjects and verbs is.
- explains the simple rules for regular verbs.
- identifies five trouble spots that can cause confusion.
- gives you practice finding and fixing errors in subjectverb agreement.

Problems with Subject-Verb Agreement

When Subjects and Verbs Don't Match

Understand What Subject-Verb Agreement Is

In any sentence, the **subject and the verb must match—or agree—**in number. If the subject is singular (one person, place, or thing), the verb must also be singular. If the subject is plural (more than one), the verb must also be plural.

The <u>skydiver jumps</u> out of the airplane.

PLURAL

The skydivers jump out of the airplane.

Regular Verbs, Present Tense SINGULAR PLURAL First person I walk. We walk. no -s Second person You walk. You walk. Third person He (she, it) walks. They walk. Joe walks. all end in -s Joe and Alice walk. The student walks. The students walk.

LearningCurve
Subject-Verb Agreement
bedfordstmartins
.com/realwriting/LC

RESOURCES This chapter offers associated LearningCurve activities for students. A student access code is printed in every new student copy of this text. Students who do not purchase a new print book can purchase access by going to bedfordstmartins..com/realwriting/LC.

TIP In the examples throughout this chapter, subjects are underlined, and verbs are double-underlined. **Regular verbs** (with forms that follow standard English patterns) have two forms in the present tense: one that ends in -s and one that has no ending. The third-person subjects—he, she, it—and singular nouns always use the form that ends in -s. First-person subjects (I), second-person subjects (you), and plural subjects use the form with no ending.

In the Real World, Why Is It Important to Correct Errors in Subject-Verb Agreement?

People outside the English classroom notice subject-verb agreement errors and consider them major mistakes.

SITUATION: Regina Toms (name changed) wrote the following brief report about a company employee whom she was sending to the employee assistance program. These programs help workers with various problems, such as alcoholism or mental illness, that may affect their job performance.

TEACHING TIP Students should underline the errors for Practice 1 (on p. 381), and correct them for Practice 11 (on p. 393).

Mr. XXX, who has been a model employee of the company for five has years, have recently behaved in ways that is inappropriate. For example, last week he was rude when a colleague asked him a question. He has been late to work several times and has missed work more often than usual. has When I spoke to him about his behavior and asked if he have problems, he admitted that he had been drinking more than usual. I would like him to understands speak to someone who understand more about this than I do.

WRITER AT WORK

When Walter Scanlon, program and workplace consultant, received Regina's report, he responded in this way:

walter scanlon's response: I immediately formed an opinion of her based on this short piece of correspondence: that she was either not well educated or not considerate of the addressee. Ms. Toms may indeed be intelligent and considerate, but those qualities are not reflected in this report. In this fast-paced world we live in, rapid-fire e-mails and brief telephone conversations are likely to be our first mode of contact. Since one never gets a second chance to make a first impression, make the first one count!

(See Walter's PROFILE OF SUCCESS on p. 215.)

Find and Correct Errors in Subject-Verb Agreement

To find problems with subject-verb agreement in your own writing, look for five trouble spots that often signal these problems.

1. The Verb Is a Form of Be, Have, or Do

The verbs be, have, and do do not follow the rules for forming singular and plural forms; they are **irregular verbs**.

Forms of the Verb Be PRESENT TENSE SINGULAR PLURAL First person I am we are Second person you are you are Third person she, he, it is they are the student is the students are PAST TENSE First person I was we were Second person you were you were Third person she, he, it was they were the student was the students were RESOURCES Additional Resources contains tests and supplemental practice exercises for this chapter as well as a transparency master for the summary chart at the end of the chapter.

TEACHING TIP Misuse of the verb be is a common error. If your students often use be for all forms and tenses of the verb be, you may want to have them flag this chart for ease of reference.

	SINGULAR	PLURAL
First person	<u>I</u> have	we have
Second person	you have	you have
Third person	she, he, it has	they have
	the student has	the students have

Third person

she, he, it does

the student does

they do

the students do

These verbs cause problems for writers who in conversation use the same form in all cases: *He do the cleaning; they do the cleaning.* People also sometimes use the word *be* instead of the correct form of *be: She be on vacation*.

In college and at work, use the correct forms of the verbs *be*, *have*, and *do* as shown in the charts above.

They is sick today.

has

Joan have the best jewelry.

does

Carlos do the laundry every Wednesday.

FINDING AND FIXING PROBLEMS WITH SUBJECT-VERB AGREEMENT:

Making Subjects and Verbs Agree When the Verb Is Be, Have, or Do

Find

I (am / is / are) a true believer in naps.

- 1. Underline the subject.
- 2. **Ask:** Is the subject in the first (I), second (you), or third person (he/she)? *first person*.
- 3. Ask: Is the subject singular or plural? Singular.

Fix

I (am)/ is / are) a true believer in naps.

4. **Choose** the verb by matching it to the form of the subject (first person, singular).

TIP For more practices on

subject-verb agreement, visit Exercise Central at bedfordstmartins.com/

realwriting.

PRACTICE 1 Identifying Problems with Subject-Verb Agreement

Find and underline the four problems with subject-verb agreement in Regina Toms's report on page 378.

PRACTICE 2 Using the Correct Form of Be, Have, or Do

In each sentence, underline the subject of the verb *be, have,* or *do,* and fill in the correct form of the verb indicated in parentheses.

EXAMPLE: She $\frac{has}{clear}$ (have) often looked at the stars on clear, dark nights.

- 1. Stars _____ (be) clustered together in constellations.
- **2.** Every constellation ______ has _____ (have) a name.
- **3.** I _______ do _____ (do) not know how they got their names.
- **4.** Most <u>constellations</u> <u>do</u> (*do*) not look much like the people or creatures they represent.
- **5.** You have (have) to use your imagination to see the pictures in the stars.
- **6.** Twelve constellations ______ (be) signs of the zodiac.
- 7. One _____ is ____ (be) supposed to look like a crab.
- **8.** Other star <u>clusters</u> <u>have</u> (have) the names of characters from ancient myths.
- **9.** Orion, the hunter, _____ is ____ (be) the only one I can recognize.

10. He ______ (do) not look like a hunter to me.

2. Words Come between the Subject and the Verb

When the subject and verb are not directly next to each other, it is more difficult to find them to make sure they agree. Most often, either a prepositional phrase or a dependent clause comes between the subject and the verb.

COMPUTER Have students highlight prepositional phrases in their writing and read only the nonhighlighted parts of their sentences.

PREPOSITIONAL PHRASE BETWEEN THE SUBJECT AND THE VERB

A **prepositional phrase** starts with a preposition and ends with a noun or pronoun: I took my bag *of books* and threw it *across the room*.

The subject of a sentence is never in a prepositional phrase. When you are looking for the subject of a sentence, you can cross out any prepositional phrases.

TIP For a list of common prepositions, see page 344.

A volunteer in the Peace Corps (serve / serves) two years.

FINDING AND FIXING PROBLEMS WITH SUBJECT-VERB AGREEMENT:

Making Subjects and Verbs Agree When They Are Separated by a Prepositional Phrase

Find

Learners with dyslexia (face / faces) many challenges.

- 1. Underline the subject.
- 2. Cross out any prepositional phrase that follows the subject.
- 3. Ask: Is the subject singular or plural? Plural.

Fix

Learners with dyslexia (face) / faces) many challenges.

4. Choose the form of the verb that matches the subject.

PRACTICE 3 Making Subjects and Verbs Agree When They Are Separated by a Prepositional Phrase

In each of the following sentences, cross out the prepositional phrase between the subject and the verb, and circle the correct form of the verb. Remember that the subject of a sentence is never in a prepositional phrase.

EXAMPLE: Tomatoes from the supermarket (is /(are)) often tasteless.

- **1.** Experts in agriculture and plant science (identifies /(identify)) several reasons for flavorless tomatoes.
- **2.** First, many commercial growers in the United States (chooses /choose) crop yield over taste.
- **3.** Specially engineered breeds of tomatoes (produces / produce) many more bushels per planting than traditional breeds do.
- **4.** Unfortunately, the tomatoes inside each bushel (tastes / taste) nothing like their sweet, juicy homegrown relatives.
- **5.** Growing conditions at commercial farms also (contributes / contribute) to the problem.

- **6.** The soil within the major southern growing regions (tends) / tend) to be sandy.
- **7.** Sandy soil because of its low nutrient levels (results) / result) in less-flavorful tomatoes.
- **8.** One way around the tasteless supermarket tomato (is)/ are) to purchase local farm-stand tomatoes.
- **9.** Also, many gardeners across the country (grows / grow) delicious tomatoes on their own land.
- **10.** Tomatoes from farm stands or home gardens (lasts /last) through the winter when they are canned.

DEPENDENT CLAUSE BETWEEN THE SUBJECT AND THE VERB

A **dependent clause** has a subject and a verb, but it does not express a complete thought. When a dependent clause comes between the subject and the verb, it usually starts with the word *who*, *whose*, *whom*, *that*, or *which*.

The subject of a sentence is never in a dependent clause. When you are looking for the subject of a sentence, you can cross out any dependent clauses.

The coins that I found last week (seem / seems) valuable.

FINDING AND FIXING PROBLEMS WITH SUBJECT-VERB AGREEMENT:

Making Subjects and Verbs Agree When They Are Separated by a Dependent Clause

Find

The security systems that shopping sites on the Internet provide (is / are) surprisingly effective.

- 1. **Underline** the subject.
- 2. **Cross out** any dependent clause that follows the subject. (Look for the words *who, whose, whom, that,* and *which* because they can signal such a clause.)
- 3. Ask: Is the subject singular or plural? Plural.

Fix

The security systems that shopping sites on the Internet provide (is /are) surprisingly effective.

4. **Choose** the form of the verb that matches the subject.

PRACTICE 4 Making Subjects and Verbs Agree When They Are Separated by a Dependent Clause

In each of the following sentences, cross out any dependent clauses. Then, correct any problems with subject-verb agreement. If the subject and the verb agree, write "OK" next to the sentence.

EXAMPLE: My cousins who immigrated to this country from have Ecuador has jobs in a fast-food restaurant.

- 1. The restaurant that hired my cousins are not treating them fairly.

 have ^
- 2. People who work in the kitchen has to report to work at 7:00 a.m.
- **3.** The boss who supervises the morning shift tells the workers not to punch in until 9:00 a.m. *OK*
- **4.** The benefits that full-time workers earn have not been offered to my cousins. *OK*
- **5.** Ramón, whose hand was injured slicing potatoes, need to have physical therapy.
- **6.** No one who works with him has helped him file for worker's compensation. *O*K
- 7. The doctors who cleaned his wound and put in his stitches at the hospital expects him to pay for the medical treatment.
- **8.** The managers who run the restaurant insist that he is not eligible for medical coverage.
- **9.** My cousins, whose English is not yet perfect, feel unable to leave their jobs.
- **10.** The restaurant that treats them so badly offers the only opportunity for them to earn a living. *OK*

3. The Sentence Has a Compound Subject

A compound subject is two (or more) subjects joined by and, or, or nor.

And/Or Rule: If two subjects are joined by *and*, use a plural verb. If two subjects are joined by *or* (or *nor*), they are considered separate, and the verb should agree with whatever subject it is closer to.

Plural subject = Plural verb

The <u>teacher</u> and her <u>aide</u> grade all the exams.

TIP Whenever you see a compound subject joined by and, try replacing it in your mind with they.

Subject or Plural subject = Plural verb

The teacher or her aides grade all the exams.

Subject nor Plural subject = Plural verb

Neither the teacher nor her aides grade all the exams.

FINDING AND FIXING PROBLEMS WITH SUBJECT-VERB AGREEMENT:

Making Subjects and Verbs Agree in a Sentence with a Compound Subject

Find

Watermelon or cantaloupe (makes / make) a delicious and healthy snack.

- 1. Underline the subjects.
- 2. Circle the word between the subjects.
- 3. **Ask:** Does that word join the subjects to make them plural or keep them separate? Keeps them separate.
- 4. Ask: Is the subject that is closer to the verb singular or plural? Singular.

Fix

Watermelon or cantaloupe (makes) / make) a delicious and healthy snack.

5. **Choose** the verb form that agrees with the subject that is closer to the verb.

PRACTICE 5 Choosing the Correct Verb in a Sentence with a Compound Subject

In each of the following sentences, underline the word (and or or) that joins the parts of the compound subject. Then, circle the correct form of the verb.

EXAMPLE: My mother and my sister (has / have) asked a nutritionist for advice on a healthy diet.

Seeing Subject-Verb Agreement Errors

write What is wrong with the verb here? Write two sentences—one with a compound subject joined by *and* and one with a compound subject joined by *or*. Make sure the verbs agree with the subjects.

- **1.** A tomato <u>and</u> a watermelon (shares /share) more than just red-colored flesh.
- **2.** A cooked tomato <u>or</u> a slice of watermelon <u>(contains)</u>/ contain) a nutrient called lycopene that seems to protect the human body from some diseases.
- **3.** Fruits and vegetables (is /are) an important part of a healthy diet, most experts agree.
- **4.** Nutrition experts <u>and</u> dietitians (believes / believe) that eating a variety of colors of fruits and vegetables is best for human health.
- **5.** Collard greens or spinach (provides)/ provide) vitamins, iron, and protection from blindness to those who eat them.
- **6.** Carrots <u>and</u> yellow squash (protects / protect) against cancer and some kinds of skin damage.
- **7.** Too often, a busy college student or worker (finds)/ find) it hard to eat the recommended five to nine servings of fruits and vegetables a day.

- **8.** A fast-food restaurant <u>or</u> vending machine (is)/ are) unlikely to have many fresh vegetable and fruit selections.
- **9.** A salad <u>or fresh fruit (costs)</u> / cost) more than a hamburger in many places where hurried people eat.
- **10.** Nevertheless, a brightly colored vegetable and fruit (adds /add) vitamins and healthy fiber to any meal.

4. The Subject Is an Indefinite Pronoun

An **indefinite pronoun** replaces a general person, place, or thing or a general group of people, places, or things. Indefinite pronouns are often singular, although there are some exceptions, as shown in the chart below.

SINGULAR	$\underline{\underline{\text{Everyone}}} \ \underline{\underline{\text{wants}}}$ the semester to end.
PLURAL	Many want the semester to end.
SINGULAR	Either of the meals is good.

Often, an indefinite pronoun is followed by a prepositional phrase or dependent clause. Remember that the verb of a sentence must agree with the subject of the sentence, and the subject of a sentence is *never in a prepositional phrase or dependent clause*. To choose the correct verb, cross out the prepositional phrase or dependent clause.

Everyone in all the classes (want / wants) the term to end.

Several who have to take the math exam (is / are) studying together.

Indefinite Pronouns MAY BE SINGULAR **ALWAYS SINGULAR** OR PLURAL another everybody no one all anybody everyone nothing any anyone everything one (of) none anything much somebody some each (of)* neither (of)* someone either (of)* nobody something *When one of these words is the subject, mentally replace it with one. One

*When one of these words is the subject, mentally replace it with one. One is singular and takes a singular verb.

FINDING AND FIXING PROBLEMS WITH SUBJECT-VERB AGREEMENT:

Making Subjects and Verbs Agree When the Subject Is an Indefinite Pronoun

Find

One of my best friends (lives / live) in California.

- 1. Underline the subject.
- Cross out any prepositional phrase or dependent clause that follows the subject.
- 3. Ask: Is the subject singular or plural? Singular.

Fix

One of my best friends (lives)/ live) in California.

4. Choose the verb form that agrees with the subject.

PRACTICE 6 Choosing the Correct Verb When the Subject Is an Indefinite Pronoun

In each of the following sentences, cross out any prepositional phrase or dependent clause that comes between the subject and the verb. Then, underline the subject, and circle the correct verb.

EXAMPLE: One of the strangest human experiences (results) / result) from the "small-world" phenomenon.

- **1.** Everyone (remembers)/ remember) an example of a "small-world" phenomenon.
- 2. Someone whom you have just met (tells) / tell) you a story.
- **3.** During the story, <u>one</u> of you (realizes)/ realize) that you are connected somehow.
- **4.** One of your friends (lives)/ live) next door to the person.
- **5.** Someone in your family (knows) / know) someone in the person's family.
- **6.** Each of your families (owns) own) a home in the same place.
- 7. One of your relatives (plans)/ plan) to marry his cousin.

- **8.** Some (believes / believe) that if you know one hundred people and talk to someone who knows one hundred people, together you are linked to one million people through friends and acquaintances.
- **9.** Someone in this class probably connects / connect) to you in one way or another.
- **10.** Each of you probably knows/ know) a good "small-world" story of your own.

5. The Verb Comes before the Subject

In most sentences, the subject comes before the verb. Two kinds of sentences often reverse the usual subject-verb order: questions and sentences that begin with *here* or *there*. In these two types of sentences, check carefully for errors in subject-verb agreement.

QUESTIONS

In questions, the verb or part of the verb comes before the subject. To find the subject and verb, you can turn the question around as if you were going to answer it.

Where is the bookstore? / The bookstore is . . .

Are you excited? / You are excited.

LANGUAGE NOTE: For reference charts showing how to form questions, see pages 512–14 and pages 515–18, in Chapter 30.

NOTE: Sometimes the verb in a sentence appears before the subject even in sentences that are not questions:

Most inspiring of all were her speeches on freedom.

SENTENCES THAT BEGIN WITH HERE OR THERE

When a sentence begins with *here* or *there*, the subject often follows the verb. Turn the sentence around to find the subject and verb.

Here is your key to the apartment. / Your key to the apartment is here.

There are four keys on the table. / Four keys are on the table.

TEAMWORK Divide the class down the middle. One side should ask questions (have students go in turns according to where they are sitting). The other side should turn the questions around (anyone can answer by raising his or her hand or calling out the answer). Keep a fairly fast pace.

FINDING AND FIXING PROBLEMS WITH SUBJECT-VERB AGREEMENT:

Making Subjects and Verbs Agree When the Verb Comes before the Subject

Find

What classes (is / are) the professor teaching?

There (is / are) two good classes in the music department.

- 1. If the sentence is a question, **turn the question into a statement**: *The professor (is/are) teaching the classes.*
- 2. If the sentence begins with here or there, **turn it around**: Two good classes (is/are) in the music department.
- 3. **Identify** the subject in each of the two new sentences. It is "professor" in the first sentence and "classes" in the second.
- Ask: Is the subject singular or plural? "Professor" is singular; "classes" is plural.

Fix

What classes (is) / are) the professor teaching?

There (is /are) two good classes in the music department.

5. Choose the form of the verb in each sentence that matches the subject.

PRACTICE 7 Correcting a Sentence When the Verb Comes before the Subject

Correct any problem with subject-verb agreement in the following sentences. If a sentence is already correct, write "OK" next to it.

does **EXAMPLE:** What electives do the school offer?

- 1. What are the best reason to study music?
- 2. There is several good reasons.
- **3.** There is evidence that music helps students with math. OK
- **4.** What is your favorite musical instrument? *OK*
- 5. Here is a guitar, a saxophone, and a piano.
- 6. There is very few people with natural musical ability.
- 7. What time of day does you usually practice?

- 8. There is no particular time. OK
- **9.** What musician does you admire most?
- 10. Here are some information about the importance of regular practice.

Edit for Subject-Verb Agreement

Use the chart on page 396, Finding and Fixing Problems with Subject-Verb Agreement, to help you complete the practices in this section and edit your own writing.

PRACTICE 8 Correcting Various Subject-Verb Agreement Problems

In the following sentences, identify any verb that does not agree with its subject. Then, correct the sentence using the correct form of the verb.

EXAMPLE: Some twenty-somethings in Washington, D.C., wakes before dawn to read the news.

- **1.** They does so not out of interest in current events.
- 2. Instead, their jobs in government and business requires them to read and summarize the latest information related to these jobs.
- needs

 Each of their bosses need this information early in the morning to be prepared for the day.
- **4.** For example, a politician who introduces new legislation want to know the public's reaction as soon as possible.
- 5. Learning of new complaints about such legislation by 8 a.m. gives the politician time to shape a thoughtful response for a 10 a.m. news conference.
- 6. What is the benefits of the reading-and-summarizing job?
- 7. There is several, according to the young people who do such work.
- 8. Information and power goes together, some of them say.
- **9.** A reputation for being in-the-know help them rise through the ranks at their workplaces.
- have
 10. Also, they has a chance to build skills and connections that can lead to other jobs.

PRACTICE 9 Editing Paragraphs for Subject-Verb Agreement

Find and correct six problems with subject-verb agreement in the following paragraphs.

- (1) You probably does not have a mirror at your computer desk, but if you did, you might notice something about yourself you had not been aware of before. (2) As you sit there, hour after hour, your shoulders are rounded, your back is slumped, and your posture are awful.
- (3) Do not worry; you are not alone. (4) Most students spend hours in front of a computer monitor with terrible posture. (5) Then, they make things worse by getting up and heading off to school with painfully heavy are backpacks on their backs. (6) Young people who carry a heavy burden is forced to hunch forward even more to balance the weight, adding strain to already seriously fatigued muscles. (7) Everyone who studies these trends is are concerned.
 - (8) The study of people and their surroundings is known as ergonomics.
- (9) Improperly slouching at the computer and toting around a heavy backare pack are both examples of poor ergonomics. (10) These bad habits is two causes of chronic back pain that can interfere with school, work, and sports. needs
 (11) Everyone, according to experts, need to sit up straight while at the computer, take frequent breaks to get up and walk around, and carry less in

PRACTICE 10 Editing Subject-Verb Agreement Errors and Using Formal English

A friend of yours has been turned down for a course because of high enrollment, even though she registered early. She knows that her e-mail to the instructor teaching the course has a few problems in it. Help her by correcting any subject-verb agreement errors. Then, edit the informal English in the e-mail. Answers will vary. Possible answers are shown.

Dear Professor

(1) Hey Prof Connors,

his or her backpack.

(2) I am e-mailing you to make sure you gets the e-mail I sent before about In my humble opinion, registering for your Business Writing course this semester. (3) IMHO, did it is one of the best classes this college offers. (4) I does not miss the deadline; I signed up on the first day, in fact. (5) I plans to graduate with a degree in business and economics, so your class is important to me.

TIP For more advice on using formal English, see Chapter 2. For advice on choosing appropriate words, see Chapter 31.

(6) Could you please check yur class roster to see if I was somehow skipped	
or missed? (7) I would sure appreciate it a ton, LOL. (8) Plz let me know	
what you finds out. (9) If I cannot get into your class this semester, I will	
have to rearrange my schedule so that I can takes it next semester instead.	
(10) I look forward to taking your class and learning all about business You are great, professor. writing. (11) You rocks, prof.	
(12) Sincerely,	
Cameron Taylor	
PRACTICE 11 Editing Regina's Report	
Look back at Regina Toms's report on page 378. You may have already underlined the subject-verb agreement errors; if not, do so now. Next, using what you have learned in this chapter, correct each error.	
PRACTICE 12 Editing Your Own Writing for Subject-Verb Agreement	
Edit for subject-verb agreement problems in a piece of your own writing—a paper for this course or another one, or something you have written for work or your everyday life. Use the chart on page 396 to help you.	
Chapter Review	
 The <u>subject</u> and the <u>verb</u> in a sentence must agree (match) in terms of number. They must both be <u>singular</u>, or they must both be plural. Five trouble spots can cause errors in subject-verb agreement: When the verb is a form of <u>be</u>, <u>have</u>, or <u>do</u> When a <u>prepositional phrase</u> or a <u>dependent clause</u> comes between the subject and the verb. 	LEARNING JOURNAL If you found errors in subject-verb agreement in your writing, were they one of the trouble spots (pp. 379–90)? What is the main thing you have learned about subject-verb agreement that you will use? What is one thing that remains unclear? TEACHING TIP You can collect students' learning journals to find out what the class or individual students
When the sentence has a <u>compound</u> subject joined by and, or, or nor. When the subject is an <u>indefinite</u> pronoun. When the <u>verb</u> comes <u>before</u> the subject.	need more work on.

Chapter Test

Circle the correct choice for each of the following items. For help, refer to the Finding and Fixing Problems with Subject-Verb Agreement chart on page 396.

that fixes it. If the sentence is correct as written, choose d.

1. If an underlined portion of this sentence is incorrect, select the revision

There is only certain times when you can call to get technical **RESOURCES** The Testing Tool Kit CD-ROM available with this book has even support for this computer. more tests on subjectverb agreement. Also, for (a.) There are c. getting cumulative Editing Review Tests, see pages 609-18. **b.** you could **d.** No change is necessary. **2.** Choose the correct word to fill in the blank. Dana's dog Bernard ____ _ just a puppy, but he moves so slowly that he seems old. a. be c. being b. am **3.** If an underlined portion of this sentence is incorrect, select the revision that fixes it. If the sentence is correct as written, choose d. The umpire was not happy to see that everyone were watching him argue with the baseball player. a. umpire were c. argues with everyone was **d.** No change is necessary.

5. Choose the item that has no errors.

a. are

4. Choose the correct word to fill in the blank.

The woman who rented us our kayaks _ dling her own kayak down the river.

a. Alex and Dane likes to travel now that they have retired from their jobs.

(**c.**) is

b. Alex and Dane liking to travel now that they have retired from their jobs.

b. be

c. Alex and Dane like to travel now that they have retired from their jobs.

6.	Choose the correct	word to fill in the blank	c.
	The builders of this als they could find		used the best materi-
	a. have	b. having	c. has
7.	Choose the correct	word to fill in the blank	ζ.
	The calm before h anxiety.	urricanes	most people with
	a. fill	b. filling	c. fills
8.	Choose the item tha	at has no errors.	
	Sheryl and her time.	sons go to the beach wh	nenever they can find the
	b. Sheryl and her time.	sons goes to the beach	whenever they can find the
	c. Sheryl and her the time.	sons is going to the bea	ch whenever they can find
9.	Choose the correct	word to fill in the blank	C
	Where	the children's v	vet swimsuits?
	a. are	b. is	c. be
10.	_	rtion of this sentence is entence is correct as wr	incorrect, select the revision itten, choose d.
	Anybody who $\frac{\operatorname{can}}{A}$	speak several languag	ges are in great demand to
	work for the gover	nment, especially in fo	oreign embassies.
	a. could	c. worki	ng
	b. is	d. No ch	nange is necessary.

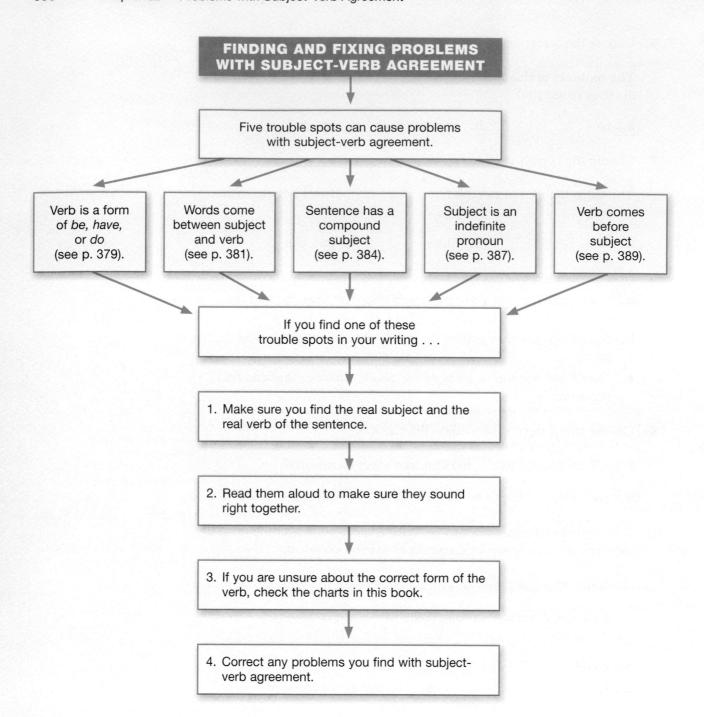

EVER THOUGHT THIS?

"I hear the word *tense* and I get all tense. I don't understand all the terms."

-Ken Hargreaves, Student

This chapter

- · explains what verb tense is.
- explains the present and past tenses of verbs.
- gives you a list of irregular verbs.
- gives you practice finding and correcting verb errors.

Verb Tense

Using Verbs to Express Different Times

Understand What Verb Tense Is

Verb tense tells *when* an action happened: in the past, in the present, or in the future. Verbs change their **base form** or use the helping verbs *have*, *be*, or *will* to indicate different tenses.

PRESENT TENSE Rick hikes every weekend.

PAST TENSE He hiked 10 miles last weekend.

FUTURE TENSE He will hike again on Saturday.

LANGUAGE NOTE: Remember to include needed endings on present-tense and past-tense verbs, even if they are not noticed in speech.

PRESENT TENSE Nate listens to his new iPod wherever he goes.

PAST TENSE Nate listened to his iPod while he walked the dog.

LearningCurve
Verbs; Active and
Passive Voice
bedfordstmartins
.com/realwriting/LC

RESOURCES This chapter offers associated LearningCurve activities for students. A student access code is printed in every new student copy of this text. Students who do not purchase a new print book can purchase access by going to bedfordstmartins..com/realwriting/LC.

In the Real World, Why Is It Important to Use the Correct Verb Tense?

People outside the English classroom notice errors in verb tense and consider them major mistakes.

SITUATION: Cal is a summer intern in the systems division of a large company. He would like to get a part-time job there during the school year because he is studying computer science and knows that the experience would help him get a job after graduation. He sends this e-mail to his supervisor.

TEACHING TIP Students should underline the verb errors for Practice 1, below, and correct them for Practice 16, on page 418.

I have work hard since coming to Technotron and learn many new things. Mr. Joseph tell me that he like my work and that I shown good motivation and teamwork. As he know, I spended many hours working on a special project for him. I would like to continue my work here beyond the summer. Therefore, I hope that you will consider me for future employment. Sincerely,

Cal Troppo

WRITER AT WORK

Karen Upright, systems manager, read Cal's e-mail and made the following comments:

KAREN UPRIGHT'S RESPONSE: I would probably not hire him because of the many errors in his writing. While he is in school, he should take a writing course and learn more about using correct verbs and verb tenses. Otherwise, his writing will be a barrier to his employment, not just at Procter & Gamble, but anywhere.

(See Karen's PROFILE OF SUCCESS on p. 140.)

Practice Using Correct Verbs

PRACTICE 1 Identifying Verb Errors

This section will teach you about verb tenses and give you practice with using them. The best way to learn how to use the various verb tenses correctly, however, is to read, write, and speak them as often as possible.

TIP To find and correct problems with verbs, you need to be able to identify subjects and verbs. For a review, see Chapter 19.

RESOURCES Additional Resources contains tests and supplemental practice exercises for this chapter as well as a transparency master for the summary chart at the end of the chapter.

sparency Immary of the Regular Verbs

Most verbs in English are **regular verbs** that follow standard rules about what endings to use to express time.

PRESENT-TENSE ENDINGS: -S AND NO ENDING

Find and underline the seven verb errors in Cal's e-mail above.

The **present tense** is used for actions that are happening at the same time that they are being written about (the present) and for things that happen all the time. Present-tense, regular verbs either end in -s or have no ending added.

TIP A complete verb, also known as a verb phrase, is made up of the main verb and all of its helping verbs.

-S ENDING	NO ENDING	
jumps	jump	
walks	walk	
lives	live	

Use the -s ending when the subject is he, she, it, or the name of one person or thing. Use no ending for all other subjects.

	SINGULAR	PLURAL
First person	<u>l jump</u> .	We jump.
Second person	You jump.	You jump.
Third person	She (he, it) jumps.	They jump.
	The child jumps.	The children jump

TIP For more about making verbs match subjects, see Chapter 22. For more about using present-tense and past-tense verbs, see Chapter 30.

Do not confuse the simple present tense with the **present progressive**, which is used with a form of the helping verb *be* to describe actions that are in progress right now.

SIMPLE PRESENT $\underline{\underline{I}}$ eat a banana every day.

PRESENT PROGRESSIVE I am eating a banana.

TIP In the examples throughout this chapter, subjects are underlined, and verbs are double-underlined.

LANGUAGE NOTE: Some languages do not use progressive tenses. If you have trouble using progressive tenses, see Chapter 30.

PRACTICE 2 Using Present-Tense Regular Verbs Correctly

In each of the following sentences, first underline the subject, and then circle the correct verb form.

EXAMPLE: I (tries / (try)) to keep to my budget.

- 1. My classes (requires / require) much of my time these days.
- **2.** In addition to attending school, \underline{I} (works /work) 20 hours a week in the college library.
- **3.** The other employees (agrees / agree) that the work atmosphere is pleasant.
- 4. Sometimes, we even (manages / manage) to do homework at the library.

TIP For more practices on verb problems, visit Exercise Central at bedfordstmartins.com/ realwriting. piscussion A common error is using only the present tense in writing. If your students do so, ask why. A common answer is that they know the present form and are less certain about others. Point out that using the present-tense form of a verb where the past tense is correct is as serious an error as using an incorrect past form.

TIP If a verb already ends in -e, just add -d: dance/danced. If a verb ends in -y, usually the -y changes to -i when -ed is added: spy/spied; try/tried.

- **5.** The job (pays)/ pay) a fairly low wage, however.
- **6.** My roommate (helps)/ help) with the rent on the apartment.
- 7. Because he is not in school, he often (wonders) / wonder) how I get by.
- **8.** I (uses /use) my bicycle to get everywhere I need to go.
- **9.** The <u>bicycle</u> (allows) / allow) me to stay in shape both physically and financially.
- **10.** I know that I will not be in school forever, so for now, <u>life</u> on a budget (satisfies) satisfy) me.

ONE REGULAR PAST-TENSE ENDING: -ED

The **past tense** is used for actions that have already happened. An *-ed* ending is needed on all regular verbs in the past tense.

	PRESENT TENSE	PAST TENSE
First person	<u>I</u> avoid her.	I avoided her.
Second person	You help me.	You helped me.
Third person	He walks quickly.	He walked quickly.

PRACTICE 3 Using the Past Tense of Regular Verbs Correctly

In each of the following sentences, fill in the correct past-tense forms of the verbs in parentheses.

(1) Last winter, I <u>displayed</u> (display) the clear signs of a cold.
(2) I sneezed (sneeze) often, and I developed (develop) a
sore throat. (3) The congestion in my nose and throatannoyed
(annoy) me, and it seemed (seem) that blowing my nose was
useless. (4) However, I visited (visit) with my friends and
attended (attend) classes at college. (5) I assumed
(assume) that I could not give anyone else my cold once I showed the
symptoms. (6) Unfortunately, many peoplejoined (join) me in
my misery because of my ignorance. (7) Later, I learned (learn)
that Iremained (remain) contagious for several days after I first
showed symptoms. (8) My doctorexplained (explain) to me that
I started (start) spreading my cold about one day after I became
infected with it. (9) However, after my symptomsdisappeared
(disappear), Ipassed (pass) on my cold to others for up to three
days more. (10) I wanted (want) to apologize to everyone I had

TIP The modal auxiliary verbs are can, could, may, might, must, shall, should,

will, and would.

	ted, but I also <u>realized</u> colds as well.	(realize) that others had given me
	colds as well.	
	REGULAR PAST-PARTICIPLE	
a mo parti	odal auxiliary), such as have of	used with a helping verb (also called r be. For all regular verbs, the past-ast-tense form: It uses an -ed ending. es are used, see pp. 410–14.)
P	PAST TENSE	PAST PARTICIPLE
	My kids <u>watched</u> cartoons. George <u>visited</u> his cousins.	They <u>have watched</u> cartoons before. He <u>has visited</u> them every year.
PRA	CTICE 4 Using the Past Part	iciple of Regular Verbs Correctly
In ea	ch of the following sentences, und	erline the helping verb (a form of have),
and f	ill in the correct form of the verb in	n parentheses.
	EXAMPLE: Because of pressure	o keen up with others, families
		to keep up with others, runnies
		_ (start) to give fancier and fancier
1.	have started birthday parties.	
1.	have started birthday parties. We have all received (a	_ (start) to give fancier and fancier
1.	have started birthday parties. We have all received (a	_ (start) to give fancier and fancier receive) invitations to simple birthday
1.	have started birthday parties. We have all received (aparties where children played ga	_ (start) to give fancier and fancier receive) invitations to simple birthday
	have started birthday parties. We have all received (a parties where children played gargone.	(start) to give fancier and fancier receive) invitations to simple birthday mes and had cake, but those days are turned (turn) into complicated
2.	have started birthday parties. We have all received (a parties where children played gargone. Kids' birthday parties have	(start) to give fancier and fancier receive) invitations to simple birthday mes and had cake, but those days are turned (turn) into complicated
2.	have started birthday parties. We have all received (a parties where children played gargone. Kids' birthday parties have and expensive events.	(start) to give fancier and fancier receive) invitations to simple birthday mes and had cake, but those days are turned (turn) into complicated
2.	havestarted	(start) to give fancier and fancier receive) invitations to simple birthday mes and had cake, but those days are turned (turn) into complicated ies have climbed (climb) to uning her daughter's birthday, one
2.	havestarted	(start) to give fancier and fancier receive) invitations to simple birthday mes and had cake, but those days are turned (turn) into complicated ies have climbed (climb) to uning her daughter's birthday, one devote) hundreds of dollars to the event.
2.	havestarted	(start) to give fancier and fancier receive) invitations to simple birthday mes and had cake, but those days are turned(turn) into complicated ies haveclimbed(climb) to uning her daughter's birthday, one devote) hundreds of dollars to the event. handed(hand) out \$50 for
2. 3. 4.	havestarted	(start) to give fancier and fancier receive) invitations to simple birthday mes and had cake, but those days are
2. 3. 4. 5.	havestarted	(start) to give fancier and fancier receive) invitations to simple birthday mes and had cake, but those days are turned(turn) into complicated ies haveclimbed(climb) to uning her daughter's birthday, one devote) hundreds of dollars to the event. handed(hand) out \$50 for otton-candy maker, and \$300 for an o Story.
2. 3. 4.	havestarted	(start) to give fancier and fancier receive) invitations to simple birthday mes and had cake, but those days are turned(turn) into complicated ies haveclimbed(climb) to uning her daughter's birthday, one devote) hundreds of dollars to the event. handed(hand) out \$50 for otton-candy maker, and \$300 for an story. increased(increase) as well.

\$20 each—\$400 total.

8.	However, some families have	decided	(decide) to go against
	the trend.		

- **9.** My best friend has ______ (save) money and effort by having small birthday parties for her son.
- **10.** The savings have reached (reach) \$500, and she is putting the money toward his college education.

Irregular Verbs

Irregular verbs do not follow the simple rules of regular verbs, which have just two present-tense endings (-s or -es) and two past-tense endings (-d or -ed). Irregular verbs show past tense with a change in spelling, although some irregular verbs, such as *cost*, *hit*, and *put*, do not change their spelling. The most common irregular verbs are *be* and *have* (see p. 405). As you write and edit, use the following chart to make sure you use the correct form of irregular verbs.

NOTE: What is called "Present Tense" in the chart below is sometimes called the "base form of the verb."

Irregular Verbs

PRESENT TENSE (BASE FORM OF VERB)	PAST TENSE	PAST PARTICIPLE (USED WITH HELPING VERB)	
be (am/are/is)	was/were	been	
become	became	become	
begin	began	begun	
bite	bit	bitten	
blow	blew	blown	
break	broke	broken	
bring	brought	brought	
build	built	built	
buy	bought	bought	
catch	caught	caught	
choose	chose	chosen	
come	came	come	
cost	cost	cost	

ESL It is helpful for students to hear the verb forms, particularly for irregular verbs. If you have access to a language lab, you might have them listen to verb tapes. If students can record, have them record personalized examples for one another.

See also the Extreme Paragraph Makeover in the Make-a-Paragraph Kit.

PRESENT TENSE (BASE FORM OF VERB)	PAST TENSE	PAST PARTICIPLE (USED WITH HELPING VERB
dive	dived, dove	dived
do	did	done
draw	drew	drawn
drink	drank	drunk
drive	drove	driven
eat	ate	eaten
fall	fell	fallen
feed	fed	fed
feel	felt	felt
fight	fought	fought
find	found	found
fly	flew	flown
forget	forgot	forgotten
get	got	gotten
give	gave	given
go	went	gone
grow	grew	grown
have/has	had	had
hear	heard	heard
hide	hid	hidden
hit	hit	hit
hold	held	held
hurt	hurt	hurt
keep	kept	kept
know	knew	known
lay	laid	laid
lead	led	led
leave	left	left
let	let	let
lie	lay	lain

TEACHING TIP Give students a few minutes in class, or ask them, as a homework assignment, to review the list of irregular verbs and underline the fifteen verbs they use most frequently.

PRESENT TENSE (BASE FORM OF VERB)	PAST TENSE	PAST PARTICIPLE (USED WITH HELPING VERB)
light	lit	lit
lose	lost	lost
make	made	made
mean	meant	meant
meet	met	met
pay	paid	paid
put	put	put
quit	quit	quit
read	read	read
ride	rode	ridden
ring	rang	rung
rise	rose	risen
run	ran	run
say	said	said
see	saw	seen
seek	sought	sought
sell	sold	sold
send	sent	sent
shake	shook	shaken
show	showed	shown
shrink	shrank	shrunk
shut	shut	shut
sing	sang	sung
sink	sank	sunk
sit	sat	sat
sleep	slept	slept
speak	spoke	spoken
spend	spent	spent
stand	stood	stood
steal	stole	stolen

PRESENT TENSE (BASE FORM OF VERB)	PAST TENSE	PAST PARTICIPLE (USED WITH HELPING VERB)
stick	stuck	stuck
sting	stung	stung
strike	struck	struck, stricken
swim	swam	swum
take	took	taken
teach	taught	taught
tear	tore	torn
tell	told	told
think	thought	thought
throw	threw	thrown
understand	understood	understood
wake	woke	woken
wear	wore	worn
win	won	won
write	wrote	written

PRESENT TENSE OF BE AND HAVE

The present tense of the verbs *be* and *have* is very irregular, as shown in the following chart.

BE		HAVE	
l am	we are	l have	we have
you are	you are	you have	you have
he, she, it is	they are	he, she, it has	they have
the editor is	the editors are		
Beth is	Beth and Christina are		

PRACTICE 5 Using Be and Have in the Present Tense

In each of the following sentences, fill in the correct form of the verb indicated in parentheses.

	(be) able to receive academic credit fo
	my summer job.
1.	I (have) a job lined up with a company that
	provides private security to many local businesses and residential developments.
2.	The company has (have) a good record of keeping its
	clients safe from crime.
3.	The company is (be) part of a fast-growing
	industry.
4.	Many people no longer have (have) faith in the ability of
	the police to protect them.
5.	People with lots of money (be) willing to pay for
	their own protection.
6.	Concern about crime is (be) especially noticeable in
	so-called gated communities.
7.	In these private residential areas, no one has (have) the
	right to enter without permission.
8.	If you (be) a visitor, you must obtain a special
	pass.
9.	Once you have (have) the pass, you show it to the secu-
	rity guard when you reach the gate.
10.	In a gated community, the residents are (be) likely to
	appreciate the security.

PAST TENSE OF BE

The past tense of the verb be is tricky because it has two different forms: was and were.

excited about

	SINGULAR	PLURAL
First person	<u>l</u> <u>was</u>	we were
Second person	you were	you were
Third person	she, he, it was	they were
	the student was	the students were

PRACTICE 6 Using Be in the Past Tense

EXAMPLE: During college, my sister _

In the paragraph that follows, fill in each blank with the correct past tense of the verb be.

a big decision she had made. (1) My sister _ always afraid of visits to the doctor. (2) Therefore, my parents and I _ were surprised when she announced that she wanted to become a doctor herself. (3) We thought that medicine _ a strange choice for her. (4) "Since you a little girl, you have disliked doctors," I reminded her. (5) I _ sure she would quickly change her mind. (6) She was admitted that she _ ___ still afraid, but she hoped that understanding medicine would help her overcome her fears. (7) Her premedical were courses in college _ _ difficult, but finally she was accepted were into medical school. (8) We ____ _ very proud of her that day, and we knew that she would be a great doctor.

PRACTICE 7 Using Irregular Verbs in the Past Tense

In the following paragraph, replace any incorrect present-tense verbs with the correct past tense of the verb. If you are unsure of the past-tense forms of irregular verbs, refer to the chart on pages 402–05.

(1) For years, Homer and Langley Collyer are known for their strange living conditions. (2) Neighbors who passed by the brothers' New York saw
City townhouse see huge piles of trash through the windows. (3) At night,

Langley roamed the streets in search of more junk. (4) In March 1947, an told anonymous caller tells the police that someone had died in the Collyers' broke home. (5) In response, officers break through a second-floor window and tunneled through mounds of newspapers, old umbrellas, and other junk. (6) Eventually, they find the body of Homer Collyer, who seemed to have died of starvation. (7) But where was Langley? (8) In efforts to locate him, workers spend days removing trash from the house—more than one hundred tons' worth in total. (9) They bring a strange variety of items to the curb, including medical equipment, bowling balls, fourteen pianos, and the frame of a Model T car. (10) In early April, a worker finally discovered Langley's body. (11) It lies just 10 feet from where Homer had been found. (12) Apparently, Langley died while bringing food to his disabled brother. (13) As he tunneled ahead, a pile of trash falls on him and crushed him. (14) This trash was part of a booby trap that Langley had created to stop intruders. (15) Not long after the brothers' deaths, the city demolished their former home. (16) In 1965, community leaders do something that might have surprised Homer and Langley: Where the trash-filled home once stood stands, workers created a neat and peaceful park. (17) In the 1990s, this became green space becomes the Collyer Brothers Park.

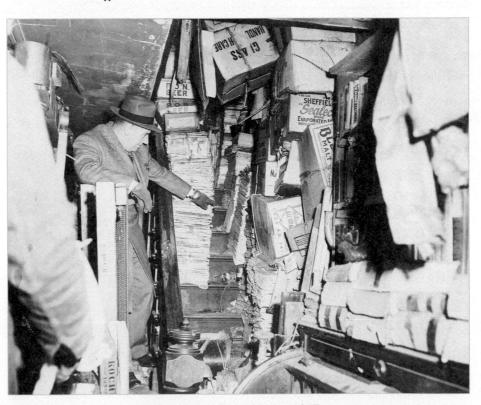

A police inspector in the Collyer brothers' home, 1947

The Collyer Brothers Park today

For irregular verbs, the past participle is often different from the past tense.

	PAST TENSE	PAST PARTICIPLE
REGULAR VERB	I walked home.	I have walked home before.
IRREGULAR VERB	$\underline{\underline{I}} \underline{\underline{drove}}$ home.	I have driven home before.

It is difficult to predict how irregular verbs form the past participle. Until you are familiar with them, find them in the chart on pages 402–05.

PRACTICE 8 Using the Past Participle of Irregular Verbs

In each of the following sentences, fill in the correct helping verb (a form of *have*) and the correct past-participle form of the verb in parentheses. If you do not know the correct form, find the word in the chart on pages 402–05.

EXAMPLE: Even though she has passed her seventy-fourth birthday, has become (become) a star in the fit-Ernestine Shepherd ness world. 1. In 2010, recognizing the work Shepherd had done (do) to build her muscles, the Guinness Book of World Records named her the oldest female bodybuilder. has told _ (tell) many fans the story of 2. Since then, Shepherd her success. 3. She and her sister started working out in their fifties because they had grown (grow) tired of carrying extra pounds. 4. Tragically, Shepherd's sister died soon afterward; nevertheless, by the had made end of a long mourning period, Shepherd __ (make) an even stronger commitment to staying in shape. has kept **5.** From that time on, she _ (keep) a busy workout schedule. has run (run) up to 80 miles a week. **6.** For years, she _ 7. In addition, she <u>has gotten</u> (get) a lot of attention for her ability to bench-press 150 pounds. **8.** Since becoming a personal trainer, Shepherd _ (teach) many other senior citizens how to stay in shape. has given _ (give) hope to many elderly people who 9. Also, she _ want to live more active lives. **10.** Throughout her busy days, Shepherd has stuck (stick) to her belief that growing older does not necessarily mean growing weaker; sometimes, it can mean the exact opposite.

Past Participles

A **past participle**, by itself, cannot be the main verb of a sentence. When a past participle is combined with another verb, called a **helping verb**, however, it can be used to make the present perfect tense and the past perfect tense.

TIP For more about using perfect-tense verbs, see Chapter 30.

TEACHING TIP As you introduce this section, remind students that the purpose of this chapter is not to memorize the terms but to use verbs correctly in writing.

The **present perfect** tense is used for an action that began in the past and either continues into the present or was completed at some unknown time in the past.

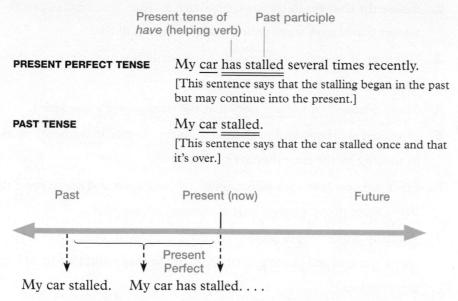

	SINGULAR	PLURAL
First person	<u>I</u> have laughed.	We have laughed.
Second person	You have laughed.	You have laughed.
Third person	She/he/it has laughed.	They have laughed.
	The baby has laughed.	The babies have laughed

LANGUAGE NOTE: Be careful not to leave out *have* when it is needed for the present perfect. Time-signal words like *since* and *for* may mean that the present perfect is required.

INCORRECT	$\underline{\underline{I}}$ drive since 1985.	$\underline{\underline{\text{We}}}$ wait for 2 hours.
CORRECT	$\underline{\underline{I}}$ have driven since 1985.	We have waited for 2 hours.

PRACTICE 9 Using the Present Perfect Tense

In each of the following sentences, circle the correct verb tense.

EXAMPLE: For many years now, the laws of most states (allowed / have allowed) only doctors to write prescriptions for patients.

- **1.** In the past few years, a number of states (began / have begun) to allow physician assistants and nurse practitioners to write prescriptions.
- **2.** Before the changes in the laws, physician assistants and nurse practitioners (saw)/ have seen) patients with common illnesses.
- **3.** However, if the patients (needed) / have needed) a prescription, a doctor had to write it.
- **4.** Many doctors (said / have said) that the changes are a good idea.
- **5.** Physician assistants and nurse practitioners (spent / have spent) years in training by the time they get their licenses.
- **6.** Since the new laws took effect, physician assistants and nurse practitioners (wrote /(have written)) many common prescriptions.
- **7.** Recently, some people (expressed / have expressed) concern that physician assistants and nurse practitioners might make mistakes in writing prescriptions.
- **8.** However, the possibility of a mistake in a prescription (always existed / has always existed).
- **9.** For the past several years, pharmacists (kept / have kept) track of prescription errors.
- **10.** Doctors made all but one of the mistakes that they (found / (have found)) so far.

Had + Past participle = Past perfect tense

Use *had* plus the past participle to make the **past perfect tense**. The past perfect tense is used for an action that began in the past and ended before some other past action.

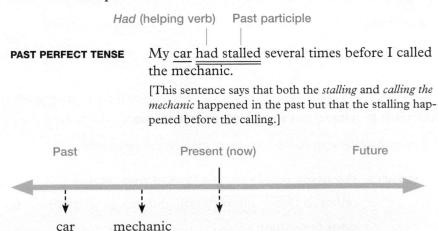

called

stalled

PRACTICE 10 Using the Past Perfect Tense

In each of the following sentences, circle the correct verb tense.

EXAMPLE: When musician Ray Charles was born in September 1930, the Great Depression already (caused / had caused) many Americans to lose hope.

- 1. His family (was / had been) poor even before the Great Depression started.
- 2. Until he was four years old, Ray (enjoyed)/ had enjoyed) normal vision.
- **3.** However, by the time he was seven, he (became / had become) totally blind.
- **4.** When he <u>(tripped)</u>/ had tripped) over furniture and asked for his mother's help, often she just watched him and remained silent.
- **5.** In this way, she (encouraged) had encouraged) him to learn how to help himself get back up.
- **6.** She (come / (had come) to recognize how important it was for Ray to find his way on his own.
- **7.** Ray later (spent)/ had spent) several years in Florida's state school for the deaf and blind.
- **8.** By the time he left the school, he (developed / had developed) his unusual gift for playing, composing, and arranging music.
- **9.** By the time he became a star, Ray Charles (refined / had refined) his unique musical style.
- **10.** By the time of his death in 2004, Charles understood that he (inspired / had inspired) many people.

A sentence that is written in the **passive voice** has a subject that does not perform an action. Instead, the subject is acted upon. To create the passive voice, combine a form of the verb *be* with a past participle.

Most sentences should be written in the **active voice**, which means that the subject performs the action.

The delivery person threw the newspaper onto the

porch.

[The subject, *delivery person*, performed the action: He or she threw the newspaper.]

Use the passive voice when no one person performed the action, when you do not know who performed the action, or when you want to emphasize the receiver of the action. When you know who performed the action, it is usually preferable to identify the actor.

ACTIVE The bandleader chose Kelly to do a solo.

PASSIVE Kelly was chosen to do a solo.

[If you wanted to emphasize Kelly's being chosen rather than the bandleader's choice, you might decide to use the passive voice.]

FINDING AND FIXING VERB-TENSE ERRORS:

Changing from Passive to Active Voice

The game was turned around by Jo Cortez's touchdown passl

- 1. **Underline** the subject, and **double-underline** the verb (in this case, a form of *be* with a past participle).
- Circle any word or words that describe who or what performed the action in the sentence.

Fix

Jo Cortez's touchdown pass
The game was turned around by Jo Cortez's touchdown pass.

3. Make the circled words the subject of the sentence, and delete the word by.

Jo Cortez's touchdown pass
The game was turned around by Jo Cortez's touchdown pass.

4. Change the verb from a past-participle form, using the correct tense.

Jo Cortez's touchdown pass turned the game

The game was turned around. by Jo Cortez's touchdown pass.

5. Move the former subject so that it receives the action.

NOTE: If you do not have specific information on who or what performed the action, you might use a general word like *someone* or *people*.

Someone left flowers Flowers were left on my desk.

PRACTICE 11 Changing the Passive Voice to the Active Voice

Rewrite the following sentences, changing them from the passive voice to the active voice. Answers will vary. Possible answers are shown.

The legislature cut funding **EXAMPLE:** Funding for animal shelters was cut by the legislature.

The owners were going to close some

Some shelters, were going to be closed by the owners. No one knew what

What would become of the animals was unknown. Animal lovers started a

3. A campaign was started by animal lovers.
The owners and volunteers at shelters gave interviews.

4. Interviews were given by the owners and volunteers at shelters. News teams filmed the

5. The animals, were filmed by news teams. All the local television stations aired the

6. The stories were aired on all the local television stations.

Animal lovers across the state staged a

7. A protest was staged by animal lovers across the state. People held fund-raisers

8. Fund-raisers of all sorts, were held. The legislature restored some

Some funds were restored by the legislature. People raised enough

10. Enough money was raised to keep the shelters open.

Consistency of Verb Tense

Consistency of verb tense means that all actions in a sentence that happen (or happened) at the same time are in the same tense. If all the actions happen in the present or happen all the time, use the present for all verbs in the sentence. If all the actions happened in the past, use the past tense for all verbs.

Past tense Present tense INCONSISTENT The movie started just as we take our seats. [The actions both happened at the same time, but started is in the past tense, and *take* is in the present tense.] Past tense Past tense The movie started just as we took our seats. CONSISTENT, **PAST TENSE**

[The actions started and took both happened in the past, and both are in the past tense.]

Use different tenses only when you are referring to different times.

My daughter hated math as a child, but now she loves it.

[The sentence uses two different tenses because the first verb (hated) refers to a past condition, whereas the second verb (loves) refers to a present one.]

PRACTICE 12 Using Consistent Verb Tense

In each of the following sentences, double-underline the verbs, and correct any unnecessary shifts in verb tense. Write the correct form of the verb in the blank space provided.

	EXAMPLE:	have	Although some people dream of having
	1	their picture t	aken by a famous photographer, not many
	1	the chanc	e.
1.	wan	ts Now,	special stores in malls take magazine-quality
	photograp	hs of anyone w	ho wanted one.
2.	hea	rd The f	ounder of one business got the idea when
	she hear fr	riends complair	ning about how bad they looked in family
	photograp	hs.	
3.	decid	ded She e	leeide to open a business to take studio-style
	photograp	hs that did not	cost a lot of money.
4.	offer	red Her f	irst store included special lighting and offers
	different s	ets, such as col	ored backgrounds and outdoor scenes.
5.	wa	nt Now,	her stores even have makeup studios for
	people wh	o wanted a spe	ecial look for their pictures.

Edit for Verb Problems

Use the chart on page 421, Finding and Fixing Verb-Tense Errors, to help you complete the practices in this section and edit your own writing.

PRACTICE 13 Correcting Various Verb Problems

In the following sentences, find and correct any verb problems.

EXAMPLE: Sheena be tired of the tattoo on her left shoulder.

- 1. Sheena had never consider a tattoo until several of her friends got them.
- went

 Sheena was twenty-two when she goes to the tattoo parlor.
- **3.** After looking at many designs, she ehoose a purple rose design, which she gave to the tattoo artist.
- 4. Her sister liked the tattoo, but her mother faints.

have

- 5. Like Sheena, many people who now reached their thirties want to get rid of their old tattoos.
- **6.** A few years ago, when a person decides to have a tattoo removed, doctors had to cut out the design.
- 7. That technique leaved scars.
- use use Today, doctors using laser light to break up the ink molecules in the skin.
- 9. Six months ago, Sheena start to have treatments to remove her tattoo.
- **10.** The procedure hurted every time she saw the doctor, but she hoped it would be worth the pain.

PRACTICE 14 Editing Paragraphs for Verb Problems

Find and correct seven problems with verb tense in the following paragraphs.

- (1) When you thought about a farm, you probably imagine acres of cornfields and stalls full of noisy animals. (2) Although that is an understandable vision, it may not be a particularly accurate one in the near future. believe
 (3) Some experts believes that farms of the future will be found inside the has top floors of a city's tallest skyscrapers. (4) This concept have been referred to as "vertical gardening."
- (5) Indoor city gardening not only would help make places become more self-sufficient but also could provide new uses for the variety of found abandoned buildings that are finded scattered throughout large cities.

 (6) Experts has suggested that the water used for these small farms and gardens could be recycled from indoor fishponds. (7) False sunlight could be created through the use of artificial lights. (8) Thermostats could control the indoor temperatures.
- (9) Although this technology is not currently available, architects has been toying with possible designs. (10) In the future, farms will most likely include everything from solar panels and windmills to generators that run will be on biofuels. (11) It is about five to ten years before all these ideas will be commonplace.

PRACTICE 15 Editing Verb Problems and Using Formal English

Your sister has a bad case of laryngitis and wants to bring a note about her condition to her doctor. Help her by correcting the verb problems in the note. Then, edit the informal English. Answers will vary. Possible edits are shown.

LEARNING JOURNAL If you found verb errors in your writing, what kind were they? What is the main thing you have learned about verb tense that you will use? What is one thing that remains

TEACHING TIP You can collect students' learning journals to find out what the class or individual students need more work on.

unclear?

(1)	Dear Dr. Kerrigan, What's up, Doc Kerrigan?
(2)	Your assistant ask me to tell you about my symptoms, so I will describe
	m as well as I can. (3) I becomed sick about a day ago. (4) Now, my
	hurts hurt every time I swallowed, and I cannot speak. (5) Also, I has a high
feve	am very have felt bad er, and I be wicked tired. (6) I do not think I has ever feeled so erappy
	ore. (7) I looked forward to seeing you during my appointment.
(8)	very^much, Thanks mucho,
	rrine Evans
PR	ACTICE 16 Editing Cal's E-mail
sev	ok back at Cal's e-mail on page 398. You may have already underlined the en verb errors; if not, do so now. Next, using what you have learned in this apter, correct each error.
PR	ACTICE 17 Editing Your Own Writing for Verb Problems
	t verb-tense problems in a piece of your own writing — a paper for this urse or another one, or something you have written for work or your every-
day	life. Use the chart on page 421 to help you.
0000	
C	hapter Review
	Verb tense indicates when the action in a sentence han-
1.	melicates when the action in a sentence hap-
	pens (past, present, or future).
2.	What are the two present-tense endings for regular verbs?
	-s and no ending
3.	How do regular verbs in the past tense end?
4.	The past participle is used with a <u>helping</u> verb.
_	
5.	Verbs that do not follow the regular pattern for verbs are called
5.	Verbs that do not follow the regular pattern for verbs are called irregular .
5. 6.	그들을 하는 사용을 하다가 사용적으로 살아왔다. 이 지역 하는 사용을 하는 경기에 가장하는 사람들이 되었다.

An action that happened in the past before something else that hap-

pened in the past uses the _past perfect tense

RESOURCES The Testing Tool Kit CD-ROM available with this book has even more tests on verbs. Also, for cumulative Editing Review Tests, see pages 609–18.

8.	You should usually avoid using thepassive voice, which has
	a subject that performs no action but is acted upon.
9.	Verb tenses are consistent when actions that happen at the same tense
CI	hapter Test
	cle the correct choice for each of the following items. For help, refer to the ding and Fixing Verb-Tense Errors chart on page 421.
1.	If an underlined portion of this sentence is incorrect, select the revision that fixes it. If the sentence is correct as written, choose d.
	It has became difficult to tell whether Trisha is tired of her work or
	tired of her boss.
	(a.) become c. tiring
	d. No change is necessary.
2	Choose the item that has no errors.
_	a. By the time we arrived, Michelle already gave her recital.
	b. By the time we arrived, Michelle had already given her recital.
	c. By the time we arrived, Michelle has already given her recital.
3.	If an underlined portion of this sentence is incorrect, select the revision that fixes it. If the sentence is correct as written, choose d.
	$I = \frac{\text{likes}}{A}$ Manuel's new car, but $I = \frac{\text{wish}}{B}$ he wouldn't park it in my
	space when he $\frac{\text{comes}}{C}$ home from work.
	a. like c. came
	d. No change is necessary.
4.	Choose the item that has no errors.
	Patrick has such a bad memory that he has to write down everything he is supposed to do.
	b. Patrick had such a bad memory that he has to write down every-

c. Patrick had such a bad memory that he having to write down

thing he is supposed to do.

everything he is supposed to do.

5.	Choo	se the correct wo	ord(s) t	to fill in	the blank.			
		nany years, Stev candfather had			th	e mai	nual type	writer
	a. ke	eeped	b.	kept		c.	was keep	ing
6.	a. II	se the item that have be cutting that has been cutting have been cuttin	back or	n the am	mount of c	offee l	drink.	
7.	Choo	se the correct wo	ord(s)	to fill in	the blank.			
		ad intended to w			T- 10 10 10 10 10 10 10 10 10 10 10 10 10	hile w	/e	
	a. w	as	b.	had we	re	c.	were	
8.	Choo	se the correct wo	ord(s)	to fill in	the blank.			
		familys annual dinner		a d	ish and bro	ought	it to our	knittin
	a. p	repares	b.	prepare	ed	c.	have pre	pared
9.		underlined porti						revision
	The b	ooy jumped out o	of the v	way just	before the	car is		hit him
	a. ju	imping		c.	hitted			
	(b.) w	ras		d.	No change	e is ne	ecessary.	
10.	Choo	se the correct wo	ord to	fill in th	e blank.			
	Who	has		the tra	in to New	York 1	pefore?	
	(a.) ta	aken	b.	take		C.	taked	

THIS CHAPTER

- explains what the different kinds of pronouns are.
- explains how to make your pronouns agree with your nouns.
- shows how to avoid pronoun problems.
- gives you practice using the different kinds of pronouns correctly.

24

Pronouns

Using Substitutes for Nouns

Understand What Pronouns Are

A **pronoun** is used in place of a noun or other pronoun mentioned earlier. Pronouns enable you to avoid repeating those nouns or other pronouns mentioned earlier.

her
Sheryl got into Sheryl's car.
He^
I like Mario. Mario is a good dancer.

The noun or pronoun that a pronoun replaces is called the **antecedent**. In most cases, a pronoun refers to a specific antecedent nearby.

I picked up my new glasses. They are cool.

Pronoun replacing antecedent

LearningCurve
Pronoun Agreement
and Reference
bedfordstmartins.com/
realwriting/LC

RESOURCES This chapter offers associated LearningCurve activities for students. A student access code is printed in every new student copy of this text. Students who do not purchase a new print book can purchase access by going to bedfordstmartins.com/realwriting/LC.

Practice Using Pronouns Correctly

Identify Pronouns

Before you practice finding and correcting common pronoun errors, it is helpful to practice identifying pronouns.

PERSONAL PRONOUNS	POSSESSIVE PRONOUNS	INDEFINITE PR	ONOUNS
1	my	all	much
me	mine	any	neither (of)
you	your/yours	anybody	nobody
she/he	hers/his	anyone	none (of)
her/him	hers/his	anything	no one
it	its	both	nothing
we	our/ours	each (of)	one (of)
us	our/ours	either (of)	some
they	their/theirs	everybody	somebody
them	their/theirs	everyone	someone
		everything	something
		few (of)	

TIP For more practice with pronoun usage, visit *Exercise Central* at **bedfordstmartins.com/** realwriting.

RESOURCES Additional Resources contains tests and supplemental exercises for this chapter as well as a transparency master for the chart at the end of the chapter.

PRACTICE 1 Identifying Pronouns

In each of the following sentences, circle the pronoun, underline the noun it refers to, and draw an arrow from the pronoun to the noun.

EXAMPLE: People can have a hard time seeing stars at night if they live in or near a big city.

- 1. Each night, the stars fill the skies, but in many large cities, they are impossible to see.
- 2. The huge amount of light coming from homes, businesses, and streets creates a type of pollution, and(it)makes seeing the stars difficult.
- 3. The average night sky has approximately 2,500 stars in (it) and (they can be seen with the human eye.
- 4. In many neighborhoods, however, only two hundred or three hundred stars can be spotted, whereas in a big city, only about a dozen of them can be seen.
- 5. The International Dark Sky Association focuses on reducing light pollution as its main goal and has several recommendations.

- **6.** Pointing <u>lights</u> down toward the ground instead of allowing them to shine up toward the sky is one suggestion.
- 7. To help battle light pollution, some <u>cities and towns</u> have passed laws limiting what lights (they) will allow.
- **8.** Experts have been studying light pollution, and they have reported that (it) can affect many things, including wildlife and even human health.
- **9.** Migrating birds sometimes fly over brightly lit cities and, confused by the unnatural light, fly in circles until they become exhausted.
- 10. Too much light has also been shown to be harmful to humans, and studies are being done to determine just how this overexposure affects (them).

ESL ESL students may have particular trouble with pronouns and benefit from extra practice exercises.

Check for Pronoun Agreement

A pronoun must agree with (match) the noun or pronoun it refers to in number. It must be either singular (one) or plural (more than one).

If a pronoun is singular, it must also match the noun or pronoun it refers to in gender (*he*, *she*, or *it*).

CONSISTENT Magda sold *her* old television set.

[Her agrees with Magda because both are singular and feminine.]

CONSISTENT The Wilsons sold *their* old television set.

[Their agrees with the Wilsons because both are plural.]

Watch out for singular, general nouns. If a noun is singular, the pronoun that refers to it must be singular as well.

INCONSISTENT Any student can tell you what *their* least favorite

course is.

[Student is singular, but the pronoun their is plural.]

CONSISTENT Any student can tell you what *his* or *her* least favorite

course is.

[Student is singular, and so are the pronouns his and her.]

To avoid using the awkward phrase *his or her*, make the subject plural when you can.

CONSISTENT Most students can tell you what *their* least favorite

course is.

Two types of words often cause errors in pronoun agreement: indefinite pronouns and collective nouns.

INDEFINITE PRONOUNS

An **indefinite pronoun** does not refer to a specific person, place, or thing: It is general. Indefinite pronouns often take singular verbs. Whenever a pronoun refers to an indefinite pronoun, check for agreement.

The monks got up at dawn. Everybody had their chores for the day.

TEACHING TIP Have
students focus on the
"significant seven" indefinite
pronouns: any, each, either,
and neither and words
ending in -one, -thing, or
-body.

ALWAYS SINGULAR	MAY BE PLURAL OR SINGULAR		
another	everyone	nothing	all
anybody/anyone	everything	one (of)	any
anything	much	somebody	none
each (of)	neither (of)	someone	some
either (of)	nobody	something	
everybody	no one		

NOTE: Many people object to the use of only the masculine pronoun *he* when referring to a singular indefinite pronoun, such as *everyone*. Although grammatically correct, using the masculine form alone to refer to an indefinite pronoun is considered sexist. Here are two ways to avoid this problem:

COMPUTER Students can use the find or search function on their computer to check each use of *their* in their own writing and make sure that this pronoun matches the noun that it refers to in number.

1. Use his or her.

Someone posted his or her e-mail address to the Web site.

2. Change the sentence so that the pronoun refers to a plural noun or pronoun.

Some students posted their e-mail addresses to the Web site.

TEACHING TIP Doing this practice orally will help students hear the correct choice. The same is true of Practices 4, 6, 7, 9, and 10.

PRACTICE 2 Using Indefinite Pronouns

Circle the correct pronoun or group of words in parentheses.

(1) Anyone who wants to start (their / his or her) own business had better be prepared to work hard. (2) One may find, for example, that his or her their) work is never done. (3) Something is always waiting, with

- own. (5) Anybody who expects to have more freedom now that he or she no longer works / they no longer work) for a boss may be disappointed.

 (6) After all, when you work as an employee for a company, someone above you makes decisions as (they see / he or she sees) fit. (7) When you are your own boss, no one else places (themselves / himself or herself) in the position of final responsibility.
- (8) Somebody starting a business may also be surprised by how much tax (they /he or she) must pay. (9) Each employee at a company pays only about half as much toward social security as what (they /he or she) would pay if self-employed. (10) Neither medical nor dental coverage can be obtained as inexpensively as (it)/ they) can when a person is an employee at a corporation.

COLLECTIVE NOUNS

A collective noun names a group that acts as a single unit.

Common Colle	ective Nouns	
audience	company	group
class	crowd	jury
college	family	society
committee	government	team

Collective nouns are usually singular, so when you use a pronoun to refer to a collective noun, it is also usually singular.

The team had their sixth consecutive win of the season.

If the people in a group are acting as individuals, however, the noun is plural and should be used with a plural pronoun.

The class brought their papers to read.

FINDING AND FIXING PRONOUN PROBLEMS:

Using Collective Nouns and Pronouns

The committee changed (its / their) meeting time.

- 1. Underline any collective nouns.
- 2. **Ask:** Is the collective noun singular (a group acting as a single unit) or plural (people in a group acting as individuals)? *Singular*.

Fix

The committee changed (its)/ their) meeting time.

3. **Choose** the pronoun that agrees with the subject.

PRACTICE 3 Using Collective Nouns and Pronouns

Fill in the correct pronoun (it, its, or their) in each of the following sentences.

unusual approach to investigating unsolved murders, or "cold cases."

- 1. The Philadelphia-based club got ______ its _____ name from Eugène François Vidocq, a French detective who also worked on unsolved crimes.
- **2.** A police department with a cold case may find that ______ it can benefit from the Vidocq Society's services.
- **3.** During the society's monthly meetings, a team of crime investigators, psychologists, scientists, and others bring ______ their varied skills to such cases.
- **4.** When guests with knowledge about a case speak to the society, the audience gives _____ full attention to the information.
- **5.** A group of police officers who worked a particular murder case might describe ______ their _____ original findings in detailed presentations.

6.	Next, as a group, the society considers the evidence before
	; with their combined skills and fresh eyes, members
	sometimes see things that earlier investigators missed.
7.	The 2000 murder of an Oregon teen was unsolved for years until the
	club used its expertise to help authorities find the vic-
	tim's killer: her former boyfriend.
8.	In 2011, the jury assigned to the case returned its
	verdict: The ex-boyfriend was found guilty of manslaughter.
9.	The slain teen's family could not hide their emotions,
	which ranged from joy over the conviction to tears of relief.
10.	The Vidocq Society has an excellent reputation because of successes
	like this case and because a committee carefully evaluates potential
	new members beforeit decides to admit them.

Make Pronoun Reference Clear

In an **ambiguous pronoun reference**, the pronoun could refer to more than one noun.

AMBIGUOUS Enrico told Jim that he needed a better résumé.

[Did Enrico tell Jim that Enrico himself needed a better résumé?

Or did Enrico tell Jim that Jim needed a better résumé?]

Enrico advised Jim to revise his résumé.

AMBIGUOUS I put the glass on the shelf, even though it was dirty.

[Was the glass dirty? Or was the shelf dirty?]

EDITED I put the dirty glass on the shelf.

In a **vague pronoun reference**, the pronoun does not refer clearly to any particular person, place, or thing. To correct a vague pronoun reference, use a more specific noun instead of the pronoun.

VAGUE When Tom got to the clinic, *they* told him it was closed.

[Who told Tom the clinic was closed?]

EDITED When Tom got to the clinic, the nurse told him it was

closed.

TEACHING TIP
Criticalthinking.org
provides excellent
suggestions for integrating
critical thinking into grammar
instruction. To access this
material, type "integrated
grammar" into the "search"
box on the Web site.

VAGUE Before I finished printing my report, *it* ran out of paper.

[What ran out of paper?]

EDITED Before I finished printing my report, the printer ran

out of paper.

FINDING AND FIXING PRONOUN PROBLEMS:

Avoiding Ambiguous or Vague Pronoun References

Find

The cashier said that they were out of milk.

- 1. Underline the subject.
- 2. Circle the pronoun.
- Ask: Who or what does the pronoun refer to? No one. "They" does not refer to "cashier."

Fix

the store was
The cashier said that they were out of milk.

4. **Correct the pronoun reference** by revising the sentence to make the pronoun more specific.

PRACTICE 4 Avoiding Ambiguous or Vague Pronoun References

Edit each sentence to eliminate ambiguous or vague pronoun references. Some sentences may be revised in more than one way. Answers may vary. Possible edits are shown.

EXAMPLE: I am always looking for good advice on controlling my experts weight, but they have provided little help.

- **1.** My doctor referred me to a physical therapist, and she said that I needed to exercise more.
- 2. I joined a workout group and did exercises with the members, but it did not solve my problem.
- this combination I tried a lower-fat diet along with the exercising, but # did not really work either.
- Some nutritionists

 4. They used to say that eliminating carbohydrates is the easiest way to lose weight.

- 5. Therefore, I started eating fats again and stopped consuming carbs, these methods were but this was not a permanent solution.
- this low-carb diet

 Although I lost weight and loved eating fatty foods, it did not keep me
 from eventually gaining the weight back.
- 7. Last week, I overheard my Uncle Kevin talking to my brother, and he explained how he stayed slender even while traveling a lot.
- 8. Uncle Kevin eats fruit and vegetables instead of junk food while travelthis diet ing, and it has kept off the pounds.
- **9.** He says that it is not hard to pack carrots or apples for a trip, so anyplan in advance one can do this.
- 10. I now try to plan better, eat less at each meal, and ignore all diet these three strategies work books, and I hope it works.

In a **repetitious pronoun reference**, the pronoun repeats a reference to a noun rather than replacing the noun.

The nurse at the clinic he told Tom that it was closed.

The newspaper/it says that the new diet therapy is promising.

ESL Repetitious pronoun reference is a very common error among ESL students. Read aloud some sentences with this problem (from their own writing, if possible), and ask students to raise their hands when they hear a repetitious pronoun reference.

FINDING AND FIXING PRONOUN PROBLEMS:

Avoiding Repetitious Pronoun References

Find

Television <u>advertising</u> it sometimes <u>has</u> a negative influence on young viewers.

- 1. Underline the subject, and double-underline the verb.
- 2. Circle any pronouns in the sentence.
- 3. Ask: What noun does the pronoun refer to? Advertising.
- 4. Ask: Do the noun and the pronoun that refers to it share the same verb? Yes. Does the pronoun just repeat the noun rather than replace it? Yes. If the answer to one or both questions is yes, the pronoun is repetitious.

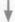

Fix

Television advertising it sometimes has a negative influence on young viewers.

5. Correct the sentence by crossing out the repetitious pronoun.

PRACTICE 5 Avoiding Repetitious Pronoun References

Correct any repetitious pronoun references in the following sentences.

EXAMPLE: Car commercials they want viewers to believe that buying a certain brand of car will bring happiness.

- **1.** Young people they sometimes take advertisements too literally.
- 2. In a beer advertisement/it might suggest that drinking alcohol makes people more attractive and popular.
- **3.** People who see or hear an advertisement they have to think about the message.
- **4.** Parents should help their children understand why advertisements they do not show the real world.
- 5. A recent study/it said that parents can help kids overcome the influence of advertising.

Use the Right Type of Pronoun

Three important types of pronouns are subject pronouns, object pronouns, and possessive pronouns. Notice their uses in the following sentences.

Object Subject pronoun pronoun

The dog barked at him, and he laughed.

Possessive pronoun

As Josh walked out, *his* phone started ringing.

Pronoun Types			
	SUBJECT	OBJECT	POSSESSIVE
First-person singular/plural	I/we	me/us	my, mine/ our, ours
Second-person singular/plural	you/you	you/you	your, yours/ your, yours
Third-person singular	he, she, it	him, her, it	his, her, hers, its
	who	whom	whose
Third-person plural	they	them	their, theirs
	who	whom	whose

TIP Never put an apostrophe in a possessive pronoun.

LANGUAGE NOTE: Notice that pronouns have gender (he/she, him/her, his/her/hers). The pronoun must agree with the gender of the noun it refers to.

INCORRECT Carolyn went to see *his* boyfriend.

Carolyn went to see *her* boyfriend.

Also, notice that English has different forms for subject and object pronouns, as shown in the previous chart.

Read the following sentence, and replace the underlined nouns with pronouns. Notice that the pronouns are all different.

When Andreas made an A on Andreas's final exam, Andreas was proud of himself, and the teacher congratulated Andreas.

SUBJECT PRONOUNS

Subject pronouns serve as the subject of a verb.

You live next door to a coffee shop.

I opened the door too quickly.

OBJECT PRONOUNS

Object pronouns either receive the action of a verb or are part of a prepositional phrase.

TIP For a list of common prepositions, see page 332.

OBJECT OF THE VERB

Jay gave me his watch.

OBJECT OF THE PREPOSITION

Jay gave his watch to me.

POSSESSIVE PRONOUNS

Possessive pronouns show ownership.

Dave is my uncle.

Three trouble spots make it difficult to know what type of pronoun to use; compound subjects and objects; comparisons; and sentences that need *who* or *whom*.

OTHER TYPES OF PRONOUNS

Intensive pronouns emphasize a noun or other pronoun. **Reflexive pronouns** are used when the performer of an action is also the receiver of the action. Both types of pronouns end in *-self* or *-selves*.

REFLEXIVE He taught *himself* how to play the guitar.

INTENSIVE The club members *themselves* have offered to support

the initiative.

Relative pronouns refer to a noun already mentioned, and introduce a group of words that describe this noun (who, whom, whose, which, that).

Tomatoes, which are popular worldwide, were first grown in South America.

Interrogative pronouns are used to begin questions (*who, whom, whose, which, what*).

What did the senator say at the meeting?

Demonstrative pronouns specify which noun is being referred to (*this*, *these*, *that*, *those*).

Use this simple budgeting app, not that complicated one.

Reciprocal pronouns refer to individuals when the antecedent is plural (each other, one another).

My friend and I could not see one another in the crowd.

PRONOUNS USED WITH COMPOUND SUBJECTS AND OBJECTS

A **compound subject** has more than one subject joined by *and* or *or*. A **compound object** has more than one object joined by *and* or *or*.

COMPOUND SUBJECT Chandler and I worked on the project.

COMPOUND OBJECT My boss gave the assignment to Chandler and me.

TIP When you are writing about yourself and someone else, always put yourself after everyone else. My friends and I went to a club, not I and my friends went to a club.

FINDING AND FIXING PRONOUN PROBLEMS:

Using Pronouns in Compound Constructions

Find

My friend and me talk at least once a week.

- Underline the subject, double-underline the verb, and circle any object or objects.
- 2. **Ask:** Does the sentence have a compound subject or object? Yes—"friend and me" is a compound subject.
- Ask: Do the nouns in the compound construction share a verb? Yes—"talk."
- 4. Cross out one of the subjects so that only the pronoun remains.
- 5. **Ask:** Does the sentence sound correct with just the pronoun as the subject? *No.*

Fix

My friend and me talk at least once a week.

Correct the sentence by replacing the incorrect pronoun with the correct one.

To decide what type of pronoun to use in a compound construction, try leaving out the other part of the compound and the *and* or *or*. Then, say the sentence aloud to yourself.

Compound subject

Joan and (me /1) went to the movies last night.

[Think: I went to the movies last night.]

Compound object

The car was headed right for Tom and (she / her).

[Think: The car was headed right for her.]

If a pronoun is part of a compound object in a prepositional phrase, use an object pronoun.

Compound object

I will keep that information just between you and (I/me).

[Between you and me is a prepositional phrase, so an object pronoun, me, is required.]

TIP Many people make the mistake of using *I* in the phrase *between you and I*. The correct pronoun with *between* is the object *me*.

PRACTICE 6 Editing Pronouns in Compound Constructions

Correct any pronoun errors in the following sentences. If a sentence is already correct, write a "C" next to it.

EXAMPLE: Marie Curie made several major contributions to she science, but in 1898, her and her husband, Pierre Curie, announced their greatest achievement: the discovery of radium.

- 1. Before this discovery, Marie and Pierre understood that certain subthey
 stances gave off rays of energy, but them and other scientists were just
 beginning to learn why and how.
- **2.** Eventually, the Curies made a discovery that intrigued they and, soon afterward, hundreds of other researchers.
- **3.** Two previously unknown elements, radium and polonium, were responsible for the extra radioactivity; fascinated by this finding, Marie began thinking about the consequences of the work that she and her husband had done. *C*
- 4. As them and other researchers were to discover, radium was especially valuable because it could be used in X-rays and for other medical purposes.
- **5.** Marie was deeply moved when, in 1903, the scientific community honher ored she and Pierre with the Nobel Prize in physics.

TEACHING TIP Have each student write a sentence that uses implied words in a comparison. Then, have the students read the sentences aloud and ask other class members to supply the missing words.

TIP To find comparisons, look for the word *than* or as.

PRONOUNS USED IN COMPARISONS

Using the right type of pronoun in comparisons is particularly important because using the wrong type changes the meaning of the sentence. Editing comparisons can be tricky because they often imply (suggest the presence of) words that are not actually included in the sentence.

Bob trusts Donna more than *I*.

[This sentence means that Bob trusts Donna more than I trust her. The implied words are *trust her*.]

Bob trusts Donna more than me.

[This sentence means that Bob trusts Donna more than he trusts me. The implied words are *he trusts*.]

To decide whether to use a subject or object pronoun in a comparison, try adding the implied words and saying the sentence aloud.

The registrar is much more efficient than (us / (we)). [Think: The registrar is much more efficient than we are.]

Susan rides her bicycle more than (he)/ him).

[Think: Susan rides her bicycle more than he does.]

TIP Add the additional words to the comparison when you speak and write. Then, others will not think you are incorrect.

FINDING AND FIXING PRONOUN PROBLEMS:

Using Pronouns in Comparisons

Find

The other band attracts a bigger audience (than) us on Friday nights.

- 1. Circle the word that indicates a comparison.
- 2. Ask: What word or words that would come after the comparison word are implied but missing from the sentence? "Do."
- 3. Ask: If you add the missing word or words, does the pronoun make sense? No.

Fix

we (do) The other band attracts a bigger audience than us on Friday nights.

4. Correct the sentence by replacing the incorrect pronoun with the correct one.

PRACTICE 7 Editing Pronouns in Comparisons

Correct any pronoun errors in the following sentences. If a sentence is correct, put a "C" next to it.

EXAMPLE: The camping trip we planned did not seem dangerous to Hannah, so she was not as nervous about it as me.

- 1. In addition, I was nowhere near as well equipped for camping as her.
- 2. In the store, Hannah rather than me did all the talking.
- **3.** At the campground, I could see that some of the other camping groups were not as prepared as we. C
- us **4.** The park ranger chatted with the other campers more than we. theu
- **5.** He seemed to believe that we were more experienced than them.

TEACHING TIP Have students read the sentences aloud, adding the implied words.

- 6. On the hiking trail, the other campers walked faster than we. C
- 7. They all hurried past us, but Hannah kept hiking just as slowly as me.
- **8.** Our boots had been crunching on the trail for hours when we suddenly we heard that a group ahead was being much louder than us.
- **9.** When Hannah and I saw the group running back toward us, I was she more alarmed than her.
- **10.** When we spotted the bear that was chasing the other hikers, Hannah ran to hide a lot faster than I. *C*

CHOOSING BETWEEN WHO AND WHOM

Who is always a subject; whom is always an object. If a pronoun performs an action, use the subject form who. If a pronoun does not perform an action, use the object form whom.

WHO = SUBJECT I would like to know who delivered this package.

WHOM = OBJECT He told me to whom \underline{I} should report.

In sentences other than questions, when the pronoun (who or whom) is followed by a verb, use who. When the pronoun (who or whom) is followed by a noun or pronoun, use whom.

The pianist who/ whom) <u>played</u> was excellent. [The pronoun is followed by the verb *played*. Use *who*.]

The pianist (who / whom) \underline{I} $\underline{\underline{saw}}$ was excellent. [The pronoun is followed by another pronoun: *I*. Use *whom*.]

PRACTICE 8 Choosing between Who and Whom

In each sentence, circle the correct word, who or whom.

EXAMPLE: Police officers who/ whom) want to solve a crime—or prevent one—are now relying more than ever on technology.

- **1.** Face-recognition software is supposed to identify possible criminals (who /whom) cameras have photographed in public places.
- 2. Use of such software, which compares security-camera images with photos from a criminal database, can help law enforcement officials determine (who / whom) they want to question about a crime.

TIP In the examples here, subjects are underlined, and verbs are double-underlined.

TIP Whoever is a subject pronoun; whomever is an object pronoun.

- 3. Police will try to detain any person (who)/ whom) is identified by the software as a criminal.
- Police know that the software will single out some innocent people (who)/ whom) resemble criminals.
- However, police and nervous Americans are hopeful that this method can help identify terrorists (who)/ whom) appear in airports or other locations.

Make Pronouns Consistent in Person

Person is the point of view a writer uses—the perspective from which he or she writes. Pronouns may be in first person (I or we), second person (you), or third person (he, she, or it). (See the chart on p. 435.)

INCONSISTENT As soon as a shopper walks into the store, you can tell it

is a weird place.

[The sentence starts with the third person (a shopper) but shifts

to the second person (you).]

CONSISTENT, As soon as a shopper walks into the store, he or she can SINGULAR

tell it is a weird place.

CONSISTENT, As soon as *shoppers* walk into the store, they can tell it is

PLURAL a weird place.

FINDING AND FIXING PRONOUN PROBLEMS:

Making Pronouns Consistent in Person

Find

I had the correct answer, but to win the tickets you had to be the ninth caller.

- 1. **Underline** all the subject nouns and pronouns in the sentence.
- 2. Circle any pronouns that refer to another subject noun or pronoun in the
- 3. Ask: Is the subject noun or pronoun that the circled pronoun refers to in the first (I or we), second (you), or third person (he, she, or it)? First
- 4. Ask: What person is the pronoun in? Second.

Fix

I had the correct answer, but to win the tickets you had to be the ninth caller.

Correct the sentence by changing the pronoun to be consistent with the noun or pronoun it refers to.

PRACTICE 9 Making Pronouns Consistent in Person

In the following sentences, correct the shifts in person. There may be more than one way to correct some sentences. Answers may vary. Possible edits are shown.

EXAMPLE: Many college students have access to a writing center they where you can get tutoring.

his or her

- 1. A writing tutor must know your way around college writing assignments.
- 2. I have gone to the writing center at my school because sometimes you need a second pair of eyes to look over a paper.
- **3.** Students signing up for tutoring at the writing center may not be in *their* your first semester of college.
- 4. Even a graduate student may need help with your writing at times.

 his or her
 his or her
- **5.** The writing-center tutor is careful not to correct their students' papers.
- **6.** My tutor told me that you had to learn to edit a paper.
- his or her

 7. Every student has to learn to catch your own mistakes.
- his or her

 8. A student's tutor is not like your English professor.

 his or her
- **9.** No student gets their grade on a paper from a writing tutor.
- **10.** Tutors do not judge but simply help students with your papers.

Edit for Pronoun Problems

PRACTICE 10 Correcting Various Pronoun Problems

In the following sentences, find and correct problems with pronoun use. You may be able to revise some sentences in more than one way, and you may need to rewrite some sentences to correct errors. Answers may vary. Possible edits are shown.

Students with busy schedules have

EXAMPLE: Everyone with a busy schedule has probably been tempted to take shortcuts on their coursework.

their

My class received its term paper grades yesterday.

- 2. My friend Gene and me were shocked to see that he had gotten an F on his paper.
- 3. I usually get better grades than him, but he does not usually fail.
- **4.** Mr. Padilla, the instructor, who most students consider strict but fair, scheduled an appointment with Gene.
- the office assistant
 When Gene went to the department office, they told him where to find
 Mr. Padilla.
- did not think Gene
 6. Mr. Padilla told Gene that he did not think he had written the paper.
- 7. The paper it contained language that was unusual for Gene.
- **8.** The instructor said that you could compare Gene's in-class writing with this paper and see differences.
- **9.** Mr. Padilla, who had typed some passages from Gene's paper into a search engine, found two online papers containing sentences that were also in Gene's paper.
- admitted

 10. Gene told Mr. Padilla that he had made a terrible mistake.
- 11. Gene told my girlfriend and I later that he did not realize that borrowing sentences from online sources was plagiarism.
- **12.** We looked at the paper, and we could tell that parts of it did not sound like Gene's writing.
- **13.** Anyone doing Internet research must be especially careful to docuhis or her
 ment their sources, as Gene now knows.
- **14.** The department decided that they would not suspend Gene from school.
- **15.** Mr. Padilla will let Gene take the class again and will help him avoid accidental plagiarism, and Gene said that no one had ever been more he relieved than him to hear that news.

TEACHING TIP Have students underline every pronoun in their paragraphs and draw an arrow to the word or words each pronoun refers to.

PRACTICE 11 Editing Paragraphs for Pronoun Problems

Find and correct seven errors in pronoun use in the following paragraphs. Answers may vary. Possible edits are shown. he or she

- (1) Ask anyone who has moved to a city, and they will tell you: At first, life can feel pretty lonely. (2) Fortunately, it is possible to make friends just about anywhere. (3) One good strategy is to get involved in a group that interests you, such as a sports team or arts club. (4) In many cases, its a local baseball team or theater group will open their arms to new talent.

 (5) Joining in on practices, games, or performances is a great way to build who friendships with others whom have interests like yours. (6) Also, most community organizations are always in need of volunteering munity organizations are always in need of volunteers. (7) He is a great way to form new friendships while doing something positive for society.
- (8) Getting a pet or gardening, it is another great way to meet new people. (9) In many cities, you can walk down the street for a long time and never be greeted by another person. (10) If you are walking a dog, though, it is likely that others will say hello. (11) Some may even stop to talk with you and pet your dog. (12) Also, gardeners tend to draw other gardeners. (13) If you are planting flowers and other flower growers stop by they to chat, them and you will have plenty to talk about.
- (14) To sum up, newcomers to any city do not have to spend all their They nights alone in front of the TV. (15) You have plenty of opportunities to get out and feel more connected.

PRACTICE 12 Editing Your Own Writing for Pronoun Problems

Edit pronoun errors in a piece of your own writing—a paper for this course or another one, or something you have written for work or your everyday life. Use the chart on page 447 to help you.

Chapter Review

- **1.** Pronouns replace <u>nouns</u> or other <u>pronouns</u> in a sentence.
- 2. A pronoun must agree with (match) the noun or pronoun it replaces in

 number and gender.

3.	In anambiguous pronoun reference, the pronoun could refer	
	to more than one noun.	
4.	Subject pronouns serve as the subject of a verb. Write a sentence using	
	a subject pronoun. Answers will vary. Possible answer: We went to	
	the movies last night.	
5.	What are two other types of pronouns? object pronouns and	LEARNING JOURNAL Did
	possessive pronouns	you find pronoun errors in
•		your writing? What is the main thing you have learned
6.	What are three trouble spots in pronoun use?	about pronouns that will hel you? What is unclear to you
	compound subjects and objects	
	comparisons	TEACHING TIP You can collect students' learning
	sentences that need who or whom	journals to find out what the class or individual students
		need more work on.
Ch	napter Test	
Circ	le the correct choice for each of the following items.	
1	Choose the item that has no errors.	
	a. When he skis, Jim never falls down as much as me.	
	(b.) When he skis, Jim never falls down as much as I.	
	c. When he skis, Jim never falls down as much as mine.	RESOURCES The Testing
		Tool Kit CD-ROM available
2.	Choose the correct word(s) to fill in the blank.	with this book has even more tests on pronoun usage.
	Everyone hopes that the jury will deliver verdict	Also, for cumulative Editing Review Tests, see pages
	by the end of this week.	609–18.
	a. his or her b. their c. its	
	a. his or her b. their (c.) its	
3.	If an underlined portion of this sentence is incorrect, select the revision	
	that fixes it. If the sentence is correct as written, choose d.	
	She is the one who Jake always calls whenever he wants a favor.	
	A B Green B Wiles a ray of the walls a ray of the B	
	a. Her c. him	
	(b.) whom d. No change is necessary.	
4.	If an underlined portion of this sentence is incorrect, select the revision	
	that fixes it. If the sentence is correct as written, choose d.	
	Somebody has left their camera here, and we do not know to whom	
	A R R R R R R R R R R R R R R R R R R R	

it belongs.

	a.	his or her	c.	who			
	b.	us	d.	No change is	necessary.		
5.	Ch	oose the item that l	nas no errors.				
	a. Becky told Lydia that she needed to help clean up after the part						
b. Becky told Lydia to help clean up after the party.							
	c.	Becky told Lydia t	that she neede	d to help clean	up after it.		
6. Choose the item that has no errors.							
	a.	When I applied fo needed a special c	일, 10명 경영 선생님, 2007 10 전 10 10 10 10 10 10 10 10 10 10 10 10 10	rator job, I was	told that you		
	b.	When I applied fo needed a special c		rator job, you v	vere told that you		
	c.	When I applied fo special certificate.		rator job, I was	told that I needed	d a	
7.	Ch	oose the correct wo	ord(s) to fill in	the blank.			
	Nic tin	cole's	must b	e lonely becau	se he barks all th	e	
	a.	dog he	b. dog hi	m (dog		
8.	Ch	oose the correct wo	ords to fill in t	he blank.			
	Th	e other players in	my soccer cl	ub like me bed	eause		
	-	ag	ree on the im	portance of te	amwork.		
	a.	they and I	b. them a	and me	c. them and I		
9.		an underlined porti at fixes it. If the sen				ion	
	I t	hink that my next	-door neighb	or has mice in	him house becau	ıse	
	he	keeps asking me	to lend him n	ny cat.			
	a.	me next-door	c.	lend he			
	b.	his house	d.	No change is	necessary.		
10.	Cł	noose the item that	has no errors.				
	a.	Any lifeguard can on the job.	tell you abou	t a scary experi	ence they have ha	d	
	b.	Any lifeguard can on the job.	tell you abou	t a scary experi	ence her have had		
	c.	Most lifeguards c	an tell you ab	out a scary exp	erience they have		

had on the job.

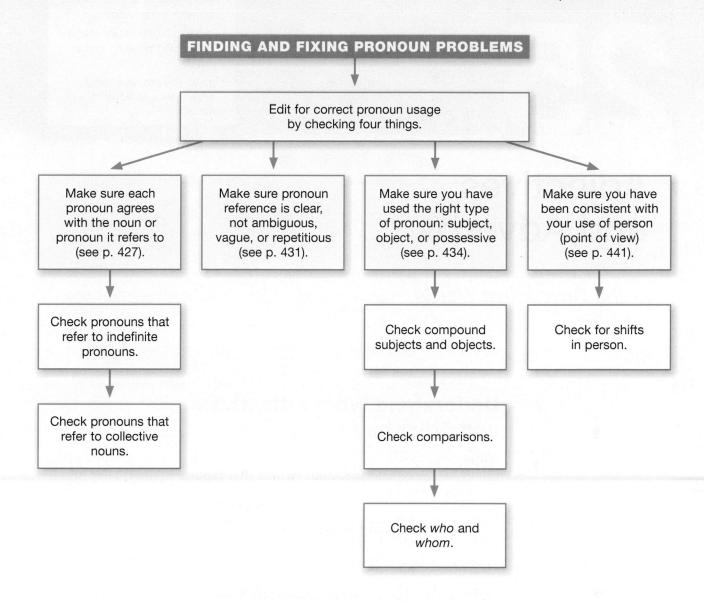

25

THIS CHAPTER

- explains what adjectives and adverbs are and do.
- explains when to use an adjective and when to use an adverb.
- gives you practice using adjectives and adverbs correctly.

Adjectives and Adverbs

Using Descriptive Words

Understand What Adjectives and Adverbs Are

Adjectives describe or modify nouns (words that name people, places, things, or ideas) and pronouns (words that replace nouns). They add information about *what kind*, *which one*, or *how many*.

The final exam was today.

It was long and difficult.

The three shiny new coins were on the dresser.

LANGUAGE NOTE: In English, adjectives do not indicate whether the words they describe are singular or plural.

INCORRECT The three babies are *adorables*.

[The adjective adorables should not end in -s.]

CORRECT The three babies are *adorable*.

Adverbs describe or modify verbs (words that tell what happens in a sentence), adjectives, or other adverbs. They add information about *how, how much, when, where, why,* or *to what extent.*

MODIFYING VERB Sharon *enthusiastically* accepted the job.

MODIFYING ADJECTIVE The *very* young lawyer handled the case.

MODIFYING ANOTHER The team played surprisingly well.

TIP To understand this chapter on adjectives and adverbs, you need to know what nouns and verbs are. For a review, see Chapter 19. Adjectives usually come before the words they modify; adverbs come before or after. You can use more than one adjective or adverb to modify a word.

LANGUAGE NOTE: The -ed and -ing forms of adjectives are sometimes confused. Common examples include bored/boring, confused/confusing, excited/exciting, and interested/interesting.

Often, the *-ed* form describes a person's reaction, whereas the *-ing* form describes the thing to which a person is reacting.

INCORRECT	Janelle is interesting in ghosts and ghost stories.
CORRECT	Janelle is interested in ghosts and ghost stories.
CORRECT	Janelle finds ghosts and ghost stories interesting.

Practice Using Adjectives and Adverbs Correctly

Choosing between Adjectives and Adverbs

Many adverbs are formed by adding -ly to the end of an adjective.

ADJECTIVE	ADVERB
She received a quick answer.	Her sister answered quickly.
Our <i>new</i> neighbors just got married.	The couple is <i>newly</i> married.
That is an honest answer.	Please answer honestly.

To decide whether to use an adjective or an adverb, find the word being described. If that word is a noun or pronoun, use an adjective. If it is a verb, adjective, or another adverb, use an adverb. **DISCUSSION** To get students focused on adjectives and adverbs, throw out a few sentences containing adjectives, with students in the class as the subjects (*Dan is wearing a black leather jacket*). Ask the student named in the sentence what the adjectives are.

PRACTICE 1 Choosing between Adjectives and Adverbs

In each sentence, underline the word in the sentence that is being described or modified. Then, circle the correct word in parentheses.

EXAMPLE: People are (common / commonly) <u>aware</u> that smoking causes health risks.

- 1. Many smokers are (stubborn)/ stubbornly) about refusing to quit.
- **2.** Others who are thinking about quitting may decide (sudden/suddenly) that the damage from smoking has already been done.

TIP For more practice with adjective and adverb usage, visit *Exercise Central* at **bedfordstmartins.com/** realwriting.

- **3.** In such cases, the (typical)/ typically) smoker sees no reason to stop.
- **4.** The news about secondhand smoke may have made some smokers stop (quick/quickly) to save the health of their families.
- **5.** Research now shows that pet lovers who smoke can have a (terrible)/ terribly) effect on their cats.
- **6.** Cats who live with smokers (frequent / frequently) develop cancer.
- **7.** Veterinarians point out that the cats of smokers may <u>smell</u> (strong / <u>strongly</u>) of smoke.
- **8.** Cats like to have their <u>fur</u> (clean)/ cleanly), and they lick the fur to groom themselves.
- **9.** When they are grooming, cats may inhale a (large)/ largely) dose of tobacco smoke.
- **10.** Perhaps some smokers who believe that it is too late for their own health will (serious / seriously) consider quitting for the sake of their pets.

Using Adjectives and Adverbs in Comparisons

To compare two people, places, or things, use the **comparative** form of adjectives or adverbs. Comparisons often use the word *than*.

Carol ran *faster* than I did. Johan is *more intelligent* than his sister.

To compare three or more people, places, or things, use the **superlative** form of adjectives or adverbs.

Carol ran the *fastest* of all the women runners. Johan is the *most intelligent* of the five children.

If an adjective or adverb is short (one syllable), add the endings -er to form the comparative and -est to form the superlative. Also use this pattern for adjectives that end in -y (but change the -y to -i before adding -er or -est).

For all other adjectives and adverbs, add the word *more* to make the comparative and the word *most* to make the superlative.

ADJECTIVE OR ADVERB	COMPARATIVE	SUPERLATIVE
ADJECTIVES AND ADVERBS O	F ONE SYLLABLE	
tall	taller	tallest
fast	faster	fastest
ADJECTIVES ENDING IN -Y		
happy	happier	happiest
silly	sillier	silliest
OTHER ADJECTIVES AND ADV	ERBS	
graceful	more graceful	most graceful
gracefully	more gracefully	most gracefully
intelligent	more intelligent	most intelligent
intelligently	more intelligently	most intelligently

TIP Some people refer to the correct use of comparatives and superlatives as appropriate degree forms.

Use either an ending (-er or -est) or an extra word (more or most) to form a comparative or superlative—not both at once.

Lance Armstrong is the most greatest cyclist in the world.

PRACTICE 2 Using Adjectives and Adverbs in Comparisons

In the space provided in each sentence, write the correct form of the adjective or adverb in parentheses. You may need to add *more* or *most* to some adjectives and adverbs.

EXAMPLE: It was one of the <u>scariest</u> (scary) experiences of my life.

- **1.** I was driving along Route 17 and was <u>more relaxed</u> (relaxed) than I ought to have been.
- **2.** Knowing it was a busy highway, I was <u>more careful</u> (careful) than usual to make sure my cell phone was ready in case of an accident.
- **3.** I had run the cord for the phone's earbud over my armrest, where it would be in the ______ (easy) place to reach if the phone rang.
- **4.** I was in the <u>heaviest</u> (heavy) traffic of my drive when the cell phone rang.

TEACHING TIP Have students do this practice aloud so that they can hear the correct choice.

5.	I saw that the earbud was (hard) to reach than be-
	fore because the cord had fallen between the front seats of the car.
6.	When I reached down to get the earbud, a pickup truck to my right
	suddenly started going faster (fast).
7.	The truck swerved toward my lane, coming closer (close)
	than I wanted it to be.
8.	I took thequickest (quick) action I could think of, shifting to
	the left lane and just barely avoiding the pickup.
9.	Calmer (Calm) now, I decided to give up trying to find the
	earbud.
10.	I wanted the cell phone ready for safety's sake, but I now think that
	concentrating on my driving is the <u>most intelligent</u> (intelligent)
	thing to do.
• • • •	

TIP Irregular means not

following a standard rule.

	COMPARATIVE	SUPERLATIVE
ADJECTIVE		
good	better	best
bad	worse	worst
ADVERB		
well	better	best
badly	worse	worst

Four common adjectives and adverbs have irregular forms: good, well, bad,

People often get confused about whether to use *good* or *well*. *Good* is an adjective, so use it to describe a noun or pronoun. *Well* is an adverb, so use it to describe a verb or an adjective.

ADJECTIVE	She has a good job.
ADVERB	He works well with his colleagues.

Using Good, Well, Bad, and Badly

and badly.

Well can also be an adjective to describe someone's health: I am not well today.

PRACTICE 3 Using Good and Well

Complete each sentence by circling the correct word in parentheses. Underline the word that *good* or *well* modifies.

EXAMPLE: A (good) / well) <u>pediatrician</u> spends as much time talking with parents as he or she does examining patients.

- **1.** The ability to <u>communicate</u> (good /well) is something that many parents look for in a pediatrician.
- **2.** With a firstborn child, parents see a doctor's visit as a good/ well) chance to ask questions.
- **3.** Parents can become worried when their infant does not <u>feel</u> (good / well) because the child cannot say what the problem is.
- **4.** Doctors today have (good)/ well) diagnostic tools, however.
- **5.** An otoscope helps a doctor see (good /well) when he or she looks into a patient's ear.
- **6.** A fever and an inflamed eardrum are **good**/well) <u>signs</u> of a middle-ear infection.
- **7.** Children who have many ear infections may not hear as (good /well) as children who have fewer infections.
- **8.** If the pediatrician presents clear options for treatment, parents can make a (good /well)-informed decision about treating their child's illness.
- **9.** Some parents decide that ear-tube surgery is a good/well) solution to the problem of frequent ear infections.
- **10.** Within an hour after ear-tube surgery, most <u>children</u> are (good / well) enough to go home.

PRACTICE 4 Using Comparative and Superlative Forms of *Good* and *Bad*

Complete each sentence by circling the correct comparative or superlative form of *good* or *bad* in parentheses.

EXAMPLE: One of the (worse / worst) outcomes of heavy drinking is severe impairment of mental and physical functioning.

1. Research has shown that if a man and a woman drink the same amount of alcohol, the woman may experience (worse) / worst) effects.

- **2.** The (better / best) explanation for this difference concerns the physical differences between women and men.
- **3.** Men are (better) best) at processing alcohol because they have a higher proportion of water in their bodies than women do, and this higher water content helps lower the concentration of alcohol in men's blood.
- **4.** Also, because of additional physical differences between women and men, the same amount of alcohol may have a worse/worst) effect on women's livers.
- **5.** The (worse /worst) effect of heavy drinking on the liver is cirrhosis, in which normal liver cells are replaced with scar tissue.
- **6.** Hearing about what alcohol can do to their bodies, some women may think that it is (better / best) not to drink at all.
- **7.** Not all women who drink have (worse) worst) health outcomes than women who do not, however.
- **8.** In fact, recent studies have shown that women who drink one alcoholic beverage a day have a (better)/ best) chance of aging healthfully than those who drink more heavily or not at all.
- **9.** Women who drink more heavily, though, may do worse/ worst) than nondrinkers and minimal drinkers because they can increase their risk of breast cancer.
- **10.** The (better / best) approach for those who enjoy wine, beer, or cocktails is to drink these beverages in moderation—advice that both women and men should follow.

Edit for Adjective and Adverb Problems

PRACTICE 5 Editing Paragraphs for Correct Adjectives and Adverbs

Find and correct seven adjective and adverb errors in the following paragraphs.

Answers may vary. Possible edits are shown.

most popular

(1) Every day, many people log on to play one of the popularest computer games of all time, World of Warcraft. (2) This multiplayer game was quickly first introduced by Blizzard Entertainment in 1994 and has grown quick

TEAMWORK Copy an article from the newspaper or some other source, and have students find all the adjectives and adverbs, drawing arrows from the modifiers to the words they modify. This activity can be done in small groups in class or assigned as homework and gone over the next day in class.

ever since. (3) More than 11 million players participate in the game every most recent month, according to the recentest figures.

- (4) Computer game experts call World of Warcraft a "massively multiplayer online role-playing game," or MMORPG for short. (5) Players of this game select a realm in which to play. (6) They choose from among four different differenty realms. (7) Each realm has its own set of rules and even its own language. (8) Players also choose if they want to be members of the Alliance or the Horde, which are groups that oppose each other. (9) Each side tends better to think that it is gooder than the other one.
 - (10) In World of Warcraft, questing is one of the funnest activities.
- (11) Questing players undertake special missions or tasks to earn experience and gold. (12) The goal is to trade these earnings for better skills and equip-carefully ment. (13) Players must proceed careful to stay in the game and increase their overall power and abilities.

PRACTICE 6 Editing Your Own Writing for Correct Adjectives and Adverbs

Edit a piece of your own writing for correct use of adjectives and adverbs. It can be a paper for this course or another one, or something you have written for work or your everyday life. Use the chart on page 457 to help you.

Chapter Review

- **1.** Adjectives modify <u>nouns</u> and <u>pronouns</u>
- 2. Adverbs modify <u>verbs</u>, <u>adjectives</u>, or other adverbs
- **3.** Many adverbs are formed by adding an ______ ending to an adjective.
- **4.** The comparative form of an adjective or adverb is used to compare how many people, places, things, or ideas? _______
- **5.** The superlative form of an adjective or adverb is used to compare how many people, places, things, or ideas? ______ three or more_____
- **6.** What four words have irregular comparative and superlative forms? *good, well, bad, badly*

LEARNING JOURNAL Did you find adjective or adverb errors in your writing? What is the main thing you have learned about adjectives and adverbs that will help you? What is unclear to you?

TEACHING TIP You can collect students' learning journals to find out what the class or individual students need more work on.

1.

Chapter Test

Circle the correct choice for each of the following items.

Choose the correct word to fill in the blank.

		We performed	i	n the debate, s	o we will have to	
		be better prepared		,		
RESOURCES The Testing Tool Kit CD-ROM available		a. bad	b. worse	(6	badly	
with this book has even more tests on adjectives and adverbs. Also, for cumulative Editing Review Tests, see	2.	If an underlined port that fixes it. If the ser				
pages 609–18.		After the beautiful of A church's stone steps		room danced	happy down the	
		a. beautifully	c.	stonily		
		b. happily		No change is a	necessary.	
	3.	Choose the item that a. Sarah's foot is he b. Sarah's foot is he c. Sarah's foot is he Choose the correct w	aling well, and aling good, and aling good, and	d she is making d she is making	a good recovery.	
		With Kenneth's wild than Conor for writ			choice	
		a. gooder	b. better	c	more good	
	5.	If an underlined port that fixes it. If the ser				
	When asked about the thoughtfulest person					
		gave the name of my best friend, who is kind to everyone.				
		a. most thoughtful	c.	kindest		
		b. bestest	d.	No change is r	necessary.	

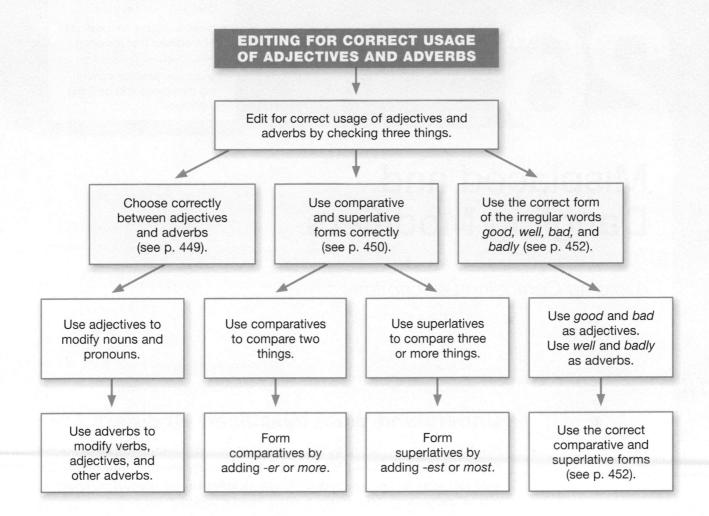

26

THIS CHAPTER

- explains what misplaced and dangling modifiers are.
- gives examples of the kinds of modifiers that are often misplaced.
- gives you practice correcting misplaced and dangling modifiers.

Misplaced and Dangling Modifiers

Avoiding Confusing Descriptions

TIP For a review of basic sentence elements, see Chapter 19.

Understand What Misplaced Modifiers Are

Modifiers are words or word groups that describe other words in a sentence. Modifiers should be near the words they modify; otherwise, the sentence can be unintentionally funny. A **misplaced modifier**, because it is in the wrong place, describes the wrong word or words.

MISPLACED

Linda saw the White House flying over Washington, D.C.

[Was the White House flying over Washington?]

CLEAR

Flying over Washington, D.C., Linda saw the White House.

To correct a misplaced modifier, place the modifier as close as possible to the word or words it modifies, often directly before it.

Wearing my bathrobe, I went outside to get the paper wearing my bathrobe.

Four constructions often lead to misplaced modifiers.

RESOURCES Additional Resources contains tests and supplemental practice exercises for this chapter as well as a transparency master for the chart at the end of the chapter.

1. Modifiers such as *only*, *almost*, *hardly*, *nearly*, and *just*. These words need to be immediately before—not just close to—the words or phrases they modify.

I only found two old photos in the drawer.

[The intended meaning is that just two photos were in the drawer.]

almost

Joanne almost ate the whole cake.

[Joanne actually ate; she did not "almost" eat.]

nearly Thomas nearly spent 2 hours waiting for the bus. [Thomas spent close to 2 hours waiting; he did not "nearly" spend them.]

2. Modifiers that are prepositional phrases.

from the cash register The cashier found money on the floor. from the cash register.

in plastic cups Jen served punch to the seniors.in plastic cups.

3. Modifiers that start with -ing verbs.

Using jumper cables, Darlene started the car using jumper cables. [The car was not using jumper cables; Darlene was.]

Wearing flip-flops, Javier climbed the mountain wearing flip flops. [The mountain was not wearing flip-flops; Javier was.]

4. Modifier clauses that start with who, whose, that, or which.

that was infecting my hard drive Joel found the computer virus attached to an e-mail message that was infecting my hard drive.

[The e-mail did not infect the hard drive; the virus did.]

who was crying The baby on the bus who was crying had curly hair. [The bus was not crying; the baby was.]

TEAMWORK As homework, have each student write a sentence that is funny because of a misplaced or dangling modifier. Collect the sentences, and read some aloud, asking the class for corrections.

Practice Correcting Misplaced Modifiers

PRACTICE 1 Correcting Misplaced Modifiers

Find and correct misplaced modifiers in the following sentences.

EXAMPLE: I write things in my blog that I used to only tell my best friends.

in a diary 1. I used to write about all kinds of personal things and private observations.in a diary.

nearly 2. Now, I nearly write the same things in my blog.

that is entertaining

3. Any story might show up in my blog that is entertaining.
of my cousin Tim's birthday
4. The video I was making was definitely something I wanted to write

about in my blog. of my cousin Tim's birthday.

Wanting the video to be funny, 5. I had invited to the birthday party my loudest, wildest friends. wanting the video to be funny.

TIP For more practice correcting misplaced and dangling modifiers, visit Exercise Central at bedfordstmartins.com/ realwriting.

almost **6.** We jumped off tables, had mock swordfights, and almost used ten cans of whipped cream in a food fight.

that I was using to make the video 7. Unfortunately, the battery in the smartphone died. that I was using to make the video.

Apologizing to my friends, I told them

8. I told my friends that I would write a blog post about the party anyway. apologizing to them.

in the blog post

9. I explained how I would include the funny story about the failed video session.in the blog post.

hardly **10.** My friends hardly said that they could wait until we tried again to make the video.

COMPUTER Have students highlight introductory phrases in their writing.

Then, ask them to look at the first word after the phrase to make sure it is the noun or pronoun the phrase describes.

TEACHING TIP Students sometimes try to correct a dangling modifier by adding a subordinating conjunction (such as while) without sufficiently reworking the sentence itself. Point out that adding while alone does not correct the problem with this sentence: While trying to eat a hot dog....

Understand What Dangling Modifiers Are

A dangling modifier "dangles" because the word or word group it modifies is not in the sentence. Dangling modifiers usually appear at the beginning of a sentence and seem to modify the noun or pronoun that immediately follows them, but they are really modifying another word or group of words.

DANGLING Rushing to class, the books fell out of my bag.

[The books were not rushing to class.]

CLEAR Rushing to class, I dropped my books.

There are two basic ways to correct dangling modifiers. Use the one that makes more sense. One way is to add the word being modified immediately after the opening modifier so that the connection between the two is clear.

on my bike Trying to eat a hot dog, my bike swerved.

Another way is to add the word being modified in the opening modifier itself.

While I was trying Trying to eat a hot dog, my bike swerved.

Practice Correcting Dangling Modifiers

PRACTICE 2 Correcting Dangling Modifiers

Find and correct any dangling modifiers in the following sentences. If a sentence is correct, write a "C" next to it. It may be necessary to add new words or ideas to some sentences. Answers may vary. Possible edits are shown.

Because I had invited **EXAMPLE:** Inviting my whole family to dinner, the kitchen was filled with all kinds of food.

While I was preparing
1. Preparing a big family dinner, the oven suddenly stopped working.

2. In a panic, we searched for Carmen, who can solve any problem. C With everyone trying

3. Trying to help, the kitchen was crowded.

- we could see that

 4. Looking into the oven, the turkey was not done.

 we almost canceled dinner.
- 5. Discouraged, the dinner was about to be canceled.
 As I was staring
- **6.** Staring out the window, a pizza truck went by.
- 7. Using a credit card, Carmen ordered six pizzas. Cone and
- 8. With one quick phone call/six large pizzas solved our problem.
 When I returned
- **9.** Returning to the crowd in the kitchen, family members still surrounded the oven.
- they cheered.

 10. Delighted with Carmen's decision, cheers filled the room.

Edit for Misplaced and Dangling Modifiers

PRACTICE 3 Editing Paragraphs for Misplaced and Dangling Modifiers

Find and correct any misplaced or dangling modifiers in the following paragraphs. Answers may vary. Possible edits are shown.

(1) Carrying overfilled backpacks is a common habit, but not necessarily a good one. (2) Bulging with books, water bottles, and sports backpacks can equipment and weighing an average of 14 to 18 pounds, students' backs can gradually damage students' backs. students gradually become damaged. (3) Because they have to plan ahead for the whole day and often need books, extra clothes, and on-the-go meals, backpacks get heavier and heavier. (4) An increasing number of doctors, primarily physical therapists, are seeing young people with chronic back problems. from the University of Pennsylvania and the Marine Biological Laboratory (5) Researchers have recently invented a new type of backpack.

the University of Pennsylvania and the Marine Biological Laboratory.

(6) Designed with springs, the backpack moves up and down as a person walks. (7) This new backpack creates energy, which is then collected and transferred to an electrical generator. (8) Experiencing relief from the wear wearers of the new packs find that and tear on muscles, the springs make the pack more comfortable.

(9) What is the purpose of the electricity generated by these new backsoldiers
packs? (10) Needing electricity for their night-vision goggles, the backpacks
use the backpacks to
could solve a problem. for soldiers. (11) Soldiers could benefit from such an
efficient energy source to power their global positioning systems and other
They
electronic gear. (12) Instead of being battery operated, the soldiers could
for their battery-operated gear
use the special backpacks and would not have to carry additional batteries.

(13) For the average student, these backpacks might one day provide convenient energy for video games, television, and music players, all at the same
Wearing backpacks designed
time. (14) Designed with this technology, kids would just have to look both
ways before crossing the street.

PRACTICE 4 Editing Your Own Writing for Misplaced and Dangling Modifiers

Edit a piece of your own writing for misplaced and dangling modifiers. It can be a paper for this course or another one, or something you have written for work or your everyday life. You may want to use the chart on page 464.

Chapter Review

- **1.** <u>Modifiers</u> are words or word groups that describe other words in a sentence.
- 2. A <u>misplaced modifier</u> describes the incorrect word or word group because it is in the wrong place in a sentence.
- **3.** When an opening modifier does not modify any word in the sentence, it is a <u>dangling modifier</u>
- 4. Which four constructions often lead to misplaced modifiers?

 modifiers such as "only," "almost," "hardly," "nearly," and "just";

 modifiers that are prepositional phrases; modifiers that start with

 "-ing" verbs; and modifier clauses that start with "who," "whose,"

 "that," or "which"

LEARNING JOURNAL Do you sometimes write sentences with misplaced or dangling modifiers? What is the main thing you have learned about correcting them? What remains unclear to you?

TEACHING TIP You can collect students' learning journals to find out what the class or individual students need more work on.

Chapter Test

Circle the correct choice for each of the following items.

1. If an underlined portion of this sentence is incorrect, select the revision that fixes it. If the sentence is correct as written, choose d.

Annoyed by the flashing cameras, the limousine drove the celebrity

A away from the crowd in front of the restaurant.

- a. Annoying
- **(b.)** the celebrity got into the limousine, which drove
- c. the restaurant in front of
- d. No change is necessary.
- **2.** Choose the item that has no errors.
 - **a.** The thief found the code in the bank clerk's desk for the alarm system.
 - **b.** The thief found the code for the alarm system in the bank clerk's desk
 - **c.** For the alarm system, the thief found the code in the bank clerk's desk.
- **3.** If an underlined portion of this sentence is incorrect, select the revision that fixes it. If the sentence is correct as written, choose d.

Talking on his cell phone, his shopping cart rolled over my foot.

- a. Talking and concentrating too much
- **b.** his cell phones
- (c.) he rolled his shopping cart
- d. No change is necessary.
- **4.** If an underlined portion of this sentence is incorrect, select the revision that fixes it. If the sentence is correct as written, choose d.

 $\frac{I \text{ only bought two tickets to the game, so one of the three of us}}{\textbf{A}} \quad \text{\textbf{B}} \quad \textbf{\textbf{C}}$ cannot go.

- **a.** bought only
- c. of the us three of
- **b.** to go to the game
- d. No change is necessary.

RESOURCES The Testing
Tool Kit CD-ROM available
with this book has even
more tests on misplaced and
dangling modifiers. Also, for
cumulative Editing Review
Tests, see pages 609–18.

THIS CHAPTER

- explains what coordination and subordination are.
- explains how to use coordination and subordination to combine sentences.
- gives you practice joining sentences with coordination and subordination.

27

Coordination and Subordination

Joining Sentences with Related Ideas

Understand What Coordination Is

Coordination is used to join two sentences with related ideas, and it can make your writing less choppy. The sentences remain complete and independent, but they are joined with a comma and a coordinating conjunction.

TIP To understand this chapter, you need to be familiar with basic sentence elements. For a review, see Chapter 19.

Practice Using Coordination

Using Coordinating Conjunctions

Conjunctions join words, phrases, or clauses. **Coordinating conjunctions** join ideas of equal importance. (You can remember them by thinking of **FANBOYS**—for, and, nor, but, or, yet, so.) To join two sentences through coordination, put a comma and one of these conjunctions

RESOURCES Additional Resources contains tests and supplemental practice exercises for this chapter as well as a transparency master for the chart at the end of the chapter. between the sentences. Choose the conjunction that makes the most sense for the meaning of the two sentences.

Complete sentence

, for
, and
, nor
, but
, or
, yet
, so

TIP For more on the use of commas, see Chapter 34.

TEACHING TIP Emphasize that conjunctions are not interchangeable (but can't fill in for so, for example). Write two independent clauses on the board (Tom was hungry/he had a sandwich). Ask students which conjunctions would work. Ask how the sentence would have to change to use others.

Wikipedia is a popular , for it is easily available encyclopedia online.

[For indicates a reason or cause.]

The encyclopedia is , and anyone can add open to all information to it.

[And simply joins two ideas.]

Often, inaccurate entries , nor is there any penalty cannot be stopped for them.

[Nor indicates a negative.]

People have complained , but the mistakes may or about errors may not be fixed.

[But indicates a contrast.]

Some people delete , or they add their own information interpretations.

[Or indicates alternatives.]

Many people know that , yet they continue to use it. Wikipedia is flawed

[Yet indicates a contrast or possibility.]

Wikipedia now has , so perhaps it will be trustees monitored more closely.

[So indicates a result.]

PRACTICE 1 Combining Sentences with Coordinating Conjunctions

Combine each pair of sentences into a single sentence by using a comma and a coordinating conjunction. In some cases, there may be more than one correct answer. Answers may vary. Possible edits are shown.

EXAMPLE: In business, e-mails can make a good or bad impression/so people People should mind their e-mail manners.

1. Many professionals use e-mail to keep in touch with clients and con, so they tacts/They must be especially careful not to offend anyone with their e-mail messages.

TIP For more practice with coordination and subordination, visit Exercise Central at bedfordstmartins.com/realwriting.

- 2. However, anyone who uses e-mail should be cautious. He is dangerously easy to send messages to the wrong person.
- 3. Employees may have time to send personal messages from work they should remember that employers often have the ability to read their workers' messages.
- 4. R-rated language and jokes may be deleted automatically by a company's server/ They may be read by managers and cause problems for the employee sending or receiving them.
- 5. No message should be forwarded to everyone in a sender's address , and senders book/Senders should ask permission before adding someone to a mass-mailing list.
- 6. People should check the authenticity of mailings about lost children, for most dreadful diseases, and terrorist threats before passing them on Most such messages are hoaxes.
- 7. Typographical errors and misspellings in e-mail make the message yet using appear less professional Using all capital letters—a practice known as shouting—is usually considered even worse.
- 8. People who use e-mail for business want to be taken seriously. They should make their e-mails as professional as possible.

Using Semicolons

A **semicolon** is a punctuation mark that can join two sentences through coordination. Use semicolons *only* when the ideas in the two sentences are closely related. Do not overuse semicolons.

Complete sentence	;	Complete sentence
Antarctica is a mystery	;	few people know much about it.
Its climate is extreme	;	few people want to endure it.
My cousin went there	;	he loves to explore the unknown.

A semicolon alone does not tell readers much about the relationship between the two ideas. To give more information about the relationship, use a **conjunctive adverb** after the semicolon. Put a comma after the conjunctive adverb.

TEACHING TIP Remind students that a semicolon balances two independent clauses; what's on either side must be able to stand alone as a complete sentence.

TIP When you connect two sentences with a conjunctive adverb, the statement following the semicolon remains a complete thought. If you use a subordinating word such as because, however, the second statement becomes a dependent clause, and a semicolon is not needed: The desert is cold at night because sand does not store heat well.

Complete sentence ; also, Complete sentence ; as a result, ; besides, ; furthermore, ; however, ; in addition, ; in fact, ; instead, ; moreover, ; still, ; then, ; therefore, Antarctica is ; as a result, it is unpopulated. largely unexplored It receives little rain ; also, it is incredibly cold. It is a huge area ; therefore, scientists are becoming

more interested in it.

EDITING FOR COORDINATION:

Joining Sentences with Related Ideas

Find

I go to bed late at night. I get up early in the morning.

- Ask: Should the sentences be joined by a coordinating conjunction (FANBOYS) or by a semicolon and a conjunctive adverb? These sentences could be joined in either way.
- Ask: What coordinating conjunction(s) or conjunctive adverb(s) best expresses the relationship between the two sentences? "And" could join the two ideas; "but," "yet," or "however" could show a contrast.

Edit

I go to bed late at night/I get up early in the morning.

I go to bed late at night/I get up early in the morning.

I go to bed late at night/I get up early in the morning.

I go to bed late at night/I get up early in the morning.

I go to bed late at night/I get up early in the morning.

3. **Join the two sentences** with a coordinating conjunction or a semicolon and a conjunctive adverb.

PRACTICE 2 Combining Sentences with Semicolons and Conjunctive Adverbs

Combine each pair of sentences by using a semicolon and a conjunctive adverb. In some cases, there may be more than one correct answer. Answers may vary. Possible edits are shown.

EXAMPLE: More and more people are researching their family ; in fact, this history, or genealogy/This type of research is now considered one of the fastest-growing hobbies in North America.

- 1. Before the Internet, genealogy researchers had to contact public offices to get records of ancestors' births, marriages, occupations, and ; in addition, some deaths/Some visited libraries to search for old newspaper articles mentioning the ancestors.
- 2. There was no quick and easy way to search records or article data; however, with
 bases/With the rise of the Internet and new digital tools, genealogy
 research became much simpler.
- 3. These tools allow people to search a wide range of records with key; therefore, researchers words/Researchers can gather details about their ancestors' lives much more quickly and efficiently.
- **4.** Recently, people have started using social-networking tools to find out ; as a result, some about living and dead relatives/Some of them are getting more information even more quickly.
- formation on the birth mother of her husband, who had been adopted then, using Using this information, she searched for his birth mother on Facebook.
- 6. The entire search, which ended successfully, took only 2 hours. In less than a week, Axelrod's husband was talking on the phone with his birth mother.
- 7. Not everyone thinks that genealogy research has to be a purely serious; instead, some hobby/Some people see it as a great way to have fun.
- 8. In the online Family Village Game, players create characters, or ; also, using avatars, representing their ancestors, Using genealogical records, they add background information on these ancestors.
- 9. Players have a lot of fun creating the characters and their worlds, They get additional genealogical information by following the research suggestions provided by the game.

10.	Some parents play Family Village Game with their children The children dren see their connection to the past.					
PRA	CTICE 3 Choosing the Right Coordinating					
	Conjunctions and Conjunctive Adverbs					
make	the blanks with a coordinating conjunction or conjunctive adverb that es sense in the sentence. Make sure to add the correct punctuation. vers may vary. Possible answers are shown. EXAMPLE: Rebates sound like a good deal, but they					
	rarely are.					
1.	Rebate offers are common, and you have probably seen many of them on packages for appliances and electronics.					
2.	These offers may promise to return hundreds of dollars to consumers					
	; as a result, many people apply for them.					
3.	Applicants hope to get a lot of money back soon; however,					
	they are often disappointed.					
4.	They might have to wait several months , or they might					
	not get their rebate at all.					
5.	Rebate applications are not short are they easy to					
	fill out.					
6.	One applicant compared completing a rebate form to filling out tax					
7	forms, for he spent more than an hour on the process.					
۲.	Manufacturers sometimes use rebates to move unpopular products off the shelves; then, they can replace these products with					
	newer goods.					
8.	Only about 10 to 30 percent of people who apply for a rebate eventu-					
	ally get it; therefore, consumer groups are warning people to					
	be careful.					
9.	Problems with rebates are getting more attention, so					
	companies that offer them might have to improve their processes for					
	giving refunds.					
10.	Manufacturers have received a lot of complaints about rebates					
	; however, they will probably never stop making these offers.					

Understand What Subordination Is

Like coordination, **subordination** is a way to join short, choppy sentences with related ideas into a longer sentence. With subordination, you put a dependent word (such as *after*, *although*, *because*, or *when*) in front of one of the sentences, which then becomes a dependent clause and is no longer a complete sentence.

Practice Using Subordination

To join two sentences through subordination, use a **subordinating conjunction**. Choose the conjunction that makes the most sense with the two sentences. Here are some of the most common subordinating conjunctions.

Complete after now that Dependent sentence although once clause since as as if so that because unless before until even if/ when though whenever if where if only while I love music because it makes me relax. It is hard to study when my children want at home my attention.

TEACHING TIP Write two sentences on the board, and have students suggest how the sentences would have to change to accommodate different subordinating conjunctions.

TEACHING TIP Point out that unlike the conjunctive adverbs on page 468, these subordinating conjunctions are never used with a semicolon in front of them and a comma after.

When a dependent clause ends a sentence, it usually does not need to be preceded by a comma unless it is showing a contrast.

When the dependent clause begins a sentence, use a comma to separate it from the rest of the sentence.

Subordinating conjunction	Dependent clause	,	Complete sentence
When	I eat out	,	I usually have steak.
Although	it is harmful	,	young people still smoke.

EDITING FOR SUBORDINATION:

Joining Ideas with Related Ideas

Find

It is hard to sleep in the city. It is always very noisy.

- 1. **Ask:** What is the relationship between the two complete sentences? The second sentence explains the first.
- 2. **Ask:** What subordinating conjunctions express that relationship? "Because," "as," or "since."

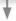

Edit

Join the two sentences with a subordinating conjunction that makes sense.

PRACTICE 4 Combining Sentences through Subordination

TEACHING TIP This practice is a good one to do orally.

Combine each pair of sentences into a single sentence by using an appropriate subordinating conjunction either at the beginning of or between the two sentences. Use a conjunction that makes sense with the two sentences, and add commas where necessary. Answers may vary. Possible edits are shown.

If someone
Someone told you that you share DNA with humans'
extinct relatives, the Neanderthals/You might be
surprised.

- 1. In fact, scientists have found that mating between humans and Neanafter groups
 derthals occurred Groups of humans migrated north and east from
 Africa.
- When scientists
 Scientists examined the DNA of modern humans, They made a startling discovery: 1 to 4 percent of all non-Africans' DNA is Neanderthal DNA.
- Because old

 Old illustrations present Neanderthals as bent over and primitive looking. It may be hard to believe that humans would want to mate with them.

- 4. However, a Neanderthal man got a good shave and a nice set of clothes. He might pass for a modern man.
- Although researchers

 Seesarchers are learning more about Neanderthals, Many mysteries remain.
- As researchers
 Researchers continue their investigations, They are trying to answer one key question: What are the specific genetic differences between humans and Neanderthals?
- 7. They have started sequencing the entire Neanderthal genome. They can answer this question.
- Because the
 The genome is the entire set of genetic material for an organism/
 comparing
 Comparing
 Comparing the Neanderthal genome to the human one might help
 researchers identify a number of differences between the two species.
 While these
- **9.** These differences have yet to be identified. Scientists are growing more and more certain about the answer to one question: Why did Neanderthals become extinct?
- Even though humans they Humans mated with Neanderthals, They also contributed to Neanderthals' extinction, either by killing them or by outcompeting them for food and other resources.

PRACTICE 5 Combining Sentences through Coordination and Subordination

Join each of the following sentence pairs in two ways, first by coordination and then by subordination. Answers may vary. Possible edits are shown.

EXAMPLE: Rick has many talents. He is still deciding what to do with his life.

JOINED BY COORDINATION: Rick has many talents, but he is still deciding what to do with his life.

JOINED BY SUBORDINATION: Although Rick has many talents, he is still deciding what to do with his life.

1. Rick rides a unicycle. He can juggle four oranges.

JOINED BY COORDINATION: Rick rides a unicycle, and he can juggle four oranges.

JOINED BY SUBORDINATION: While Rick rides a unicycle, he can juggle four oranges.

2. A trapeze school opened in our town. Rick signed up immediately.

JOINED BY COORDINATION: A trapeze school opened in our town, so Rick signed up immediately.

JOINED BY SUBORDINATION: When a trapeze school opened in our town, Rick signed up immediately.

3. Rick is now at the top of his class. He worked hard practicing trapeze routines.

JOINED BY COORDINATION: Rick is now at the top of his class, for he worked hard practicing trapeze routines.

JOINED BY SUBORDINATION: Rick is now at the top of his class because

he worked hard practicing trapeze routines.

4. Rick asks me for career advice. I try to be encouraging.

JOINED BY COORDINATION: Rick asks me for career advice, and I try to be encouraging.

JOINED BY SUBORDINATION: Whenever Rick asks me for career advice, I try to be encouraging.

5. He does not want to join the circus. He could study entertainment management.
JOINED BY COORDINATION: He does not want to join the circus, but he could study entertainment management.

JOINED BY SUBORDINATION: If he does not want to join the circus, he could study entertainment management.

Edit for Coordination and Subordination

PRACTICE 6 Editing Paragraphs for Coordination and Subordination

In the following paragraphs, combine the six pairs of underlined sentences. For three of the sentence pairs, use coordination. For the other three sentence pairs, use subordination. Do not forget to punctuate correctly, and keep in mind that there may be more than one way to combine each sentence pair. Answers may vary. Possible edits are shown.

(1) Washington, D.C., was the first city in the United States to offer a public bicycle-sharing program (2) The idea has been popular in Europe for years. (3) In fact, Paris has more than twenty thousand bikes available

for people to rent and ride around the city. (4) Called Capital Bikeshare, the Washington program costs citizens \$7 a day, \$25 a month, or \$75 a year to join. (5) For that fee, they have access to more than one thousand bikes available at 110 stations set up all over Washington and in Arlington, Virginia. (6) After using the bikes, people must return them to one of the stations/(7) Other riders might be waiting. (8) Regular users have come to depend on Capital Bikeshare for short trips and errands/(9) The popularity of the program is growing.

(10) Throughout the United States, cycling has become much more since gasoline popular in recent years/(11) Gasoline prices have increased. (12) A number of other cities are now considering bike-sharing programs/(13) Studies show that these programs can reduce city traffic by 4 to 5 percent. (14) Some companies are already creating similar programs to encourage their employees to exercise more and drive less. (15) Company leaders are aware that fit employees and a healthier environment are important goals to achieve/even if it

(16) It means that the company spends a little extra time, money, and effort to start and run a bike-sharing program.

PRACTICE 7 Editing Your Own Writing for Coordination and Subordination

Edit a piece of your own writing for coordination and subordination. It can be a paper for this course or another one, or something you have written for work or your everyday life. You may want to use the chart on page 477.

Chapter Review

- 1. What are the two ways to join sentences through coordination?

 Use a comma and a coordinating conjunction.
 - Use a semicolon alone, or use a semicolon and a conjunctive adverb followed by a comma.
- 2. Use a semicolon *only* when the sentences are <u>closely related</u>
- 3. Write two sentences using coordination.

 Answers will vary. One possibility: I worked until midnight, and I was paid overtime.

LEARNING JOURNAL Did you find coordination or subordination errors in your writing? What is the main thing you have learned about coordination and subordination that will help you? What is unclear to you?

TEACHING TIP You can collect students' learning journals to find out what the class or individual students need more work on.

4.	With subordination, you put a	dependent word	in front of one of
	two related sentences.		

5. Write two sentences using subordination.
Answers will vary. One possibility: Because I worked until midnight,
I am tired today.

Chapter Test

Circle the correct choice to fill in each blank.

	she does	not seem ple	eased with the	e change.
a. or	b.	and	c.	but
	the candi			odium, a group o
a. So that	b.	As if	c.	As
Daniel is ve is right.	ry clever	ł	ne can convin	ace anyone that h
a., but	b.	;	c.	,
you are sure that the lightning has stopped, don't let the kids get back into the pool.				
a. Until	b.	Before	c.	As if
	ve a smartphone; nen I am away fro			not access the
a. besides	, b.	however,	c.	therefore,
Matt speaks out against glorifying college sports he himself is the star of our football team.				
a. until	b.	even though	h c.	unless
I did not like the teacher's criticism of my paper; I must admit that everything she said was right.				
a. as a res	ult h	in addition,		still,

RESOURCES The Testing Tool Kit CD-ROM available with this book has even more tests on coordination and subordination. Also, for cumulative Editing Review Tests, see pages 609–18.

3. Jenna is the best speaker in the the graduation speech.	class, she will give
a. or b. so	c. yet
There were now neat rows of su had once been orange groves.	uburban homes ther
a. where b. as	if c. before
we bought a plained about having to shovel a	snowblower, my son has not com- after storms.
a. Since b. W	here c. Unless
	COORDINATION
AND SUBC	ORDINATION
	ordination are used to join with related ideas.
	—
Coordination is used to join ideas of equal importance (see p. 465).	Subordination is used to make one sentence subordinate to (dependent on) another (see p. 471).
+	
You can coordinate two ideas or sentences with a coordinating conjunction (for, and, nor, but, or, yet, so) and a comma.	Join two sentences by adding a dependent word (such as although, because, or when) in front of one of them. The sentence with a dependent word is now a dependent clause (see p. 471).
OR	
You can coordinate two ideas or entences with a semicolon or with a semicolon and a conjunctive adverb (such as also, however, or instead) followed by a comma.	If the complete sentence comes before the dependent clause, a comma is usually not needed. If the complete sentence comes after the dependent clause, add a comma after the dependent clause.

28

THIS CHAPTER

- · explains what parallelism is.
- explains how to use parallelism when writing lists and comparisons.
- explains how to write parallel sentences with paired words.
- gives you practice writing parallel sentences.

Parallelism

Balancing Ideas

Understand What Parallelism Is

Parallelism in writing means that similar parts in a sentence have the same structure: Their parts are balanced. Use nouns with nouns, verbs with verbs, and phrases with phrases.

LearningCurve
Parallelism
bedfordstmartins.com/
realwriting/LC

RESOURCES This chapter offers associated LearningCurve activities for students. A student access code is printed in every new student copy of this text. Students who do not purchase a new print book can purchase access by going to bedfordstmartins.com/realwriting/LC.

TIP To understand this chapter, you need to be familiar with basic sentence elements, such as nouns and verbs. For a review, see Chapter 19.

NOT PARALLEL I enjoy basketball more than playing video games.

[Basketball is a noun, but playing video games is a phrase.]

PARALLEL I enjoy basketball more than video games.

PARALLEL I enjoy playing basketball more than playing video games.

NOT PARALLEL Last night, I worked, studied, and was watching

television.

[Verbs must be in the same tense to be parallel. Was watching has a different structure from worked and studied.]

PARALLEL Last night, I worked, studied, and watched television.

PARALLEL Last night, I was working, studying, and watching

television.

NOT PARALLEL This weekend, we can go to the beach or walking in

the mountains.

[To the beach should be paired with another prepositional phrase:

to the mountains.]

PARALLEL This weekend, we can go to the beach or to the

mountains.

Practice Writing Parallel Sentences

Parallelism in Pairs and Lists

When two or more items in a series are joined by and or or, use a similar form for each item.

NOT PARALLEL The professor assigned <u>readings</u>, <u>practices to do</u>, and

a paper.

PARALLEL The professor assigned readings, practices, and a paper.

NOT PARALLEL The story was in the newspaper, on the radio, and the

television.

[In the newspaper and on the radio are prepositional phrases. The

television is not.]

PARALLEL The story was in the newspaper, on the radio, and on

the television.

PRACTICE 1 Using Parallelism in Pairs and Lists

In each sentence, underline the parts of the sentence that should be parallel. Then, edit the sentence to make it parallel. Answers may vary. Possible edits are shown.

EXAMPLE: Coyotes roam the western mountains, the central plains, and they are in the suburbs of the East Coast of the

United States.

TIP For more practice with making sentences parallel, visit Exercise Central at bedfordstmartins.com/realwriting.

- Wild predators, such as wolves, are vanishing because people hunt take them and are taking over their land.
- **2.** Coyotes are surviving and they do well in the modern United States.

 adaptability
- 3. The success of the coyote is due to its varied diet and adapting easily.
- **4.** Coyotes are sometimes <u>vegetarians</u>, sometimes <u>scavengers</u>, and somehunters times they hunt.
- **5.** Today, they are spreading and populate the East Coast for the first time.
- **6.** The coyotes' appearance surprises and is worrying many people.
- 7. The animals have chosen an area that is more populated and less wild than that is more populated and it's not as wild as their traditional home.
- 8 Goyotes can adapt to <u>rural</u>, <u>suburban</u>, and <u>even living in a city</u>.
- **9.** One coyote was <u>identified</u>, <u>tracked</u>, and <u>they captured</u> <u>him</u> in Central Park in New York City.
- and sound

 10. Suburbanites are getting used to the sight of coyotes. and hearing them.

RESOURCES Additional Resources contains tests and supplemental practice exercises for this chapter as well as a transparency master for the chart at the end of the chapter.

TEACHING TIP Doing this practice orally allows students to hear problems with parallelism. The same is true of Practices 2, 3, and 5.

Parallelism in Comparisons

Comparisons often use the word *than* or *as*. When you edit for parallelism, make sure the items on either side of those words have parallel structures.

	NOT PARALLEL	Taking the bus downtown is as fast as the drive there.		
	PARALLEL	Taking the bus downtown is as fast as driving there.		
	NOT PARALLEL	To admit a mistake is better than denying it.		
PARALLEL		To admit a mistake is better than to deny it.		
		Admitting a mistake is better than denying it.		

Sometimes you need to add or delete a word or two to make the parts of a sentence parallel.

NOT PARALLEL	A tour package is less expensive than arranging every
	travel detail yourself.
PARALLEL,	Buying a tour package is less expensive than arranging
WORD ADDED	every travel detail yourself.
NOT PARALLEL	The sale price of the shoes is as low as paying half of the regular price.
PARALLEL, WORDS DROPPED	The sale price of the shoes is as low as half of the regular price.

PRACTICE 2 Using Parallelism in Comparisons

In each sentence, underline the parts of the sentence that should be parallel. Then, edit the sentence to make it parallel. Answers may vary. Possible edits are shown.

EXAMPLE: Leasing a new car may be less expensive than to buy one.

- Car dealers often require less money down for leasing a car than for purchasing the purchase of one.
- 2. The monthly payments for a leased car may be as low as payments for a leased car may be as low as low as paying for a loan.
- 3. You should check the terms of leasing to make sure they are as favorable as to buy.
- You may find that to lease is a safer bet than buying.
- 5. You will be making less of a financial commitment by leasing a car by owning than to own it.

- 6. Buying a car may be better than leasing a lease on one if you plan to keep it for several years.
- 7. A used car can be more economical than getting a new one.
- 8. However, maintenance of a new car may be easier than taking care of a used car.
- **9.** A used car may not be as impressive as buying a brand-new vehicle.
- 10. To get a used car from a reputable source can be a better decision than to buy a new vehicle that loses value the moment you drive it home.

Parallelism with Certain Paired Words

Certain paired words, called **correlative conjunctions**, link two equal elements and show the relationship between them. Here are the paired words:

both . . . and neither . . . nor rather . . . than either . . . or not only . . . but also

Make sure the items joined by these paired words are parallel.

NOT PARALLEL Bruce wants *both* freedom *and* to be wealthy.

[Both is used with and, but the items joined by them are not

parallel.]

PARALLEL Bruce wants both freedom and wealth.

PARALLEL Bruce wants both to have freedom and to be wealthy.

NOT PARALLEL He can neither fail the course and quitting his job is

also impossible.

PARALLEL He can *neither* fail the course *nor* quit his job.

PRACTICE 3 Using Parallelism with Certain Paired Words

In each sentence, circle the paired words, and underline the parts of the sentence that should be parallel. Then, edit the sentence to make it parallel. You may need to change one of the paired elements to make the sentence parallel. Answers may vary. Possible edits are shown.

EXAMPLE: A cell phone can be either a lifesaver or it can be annoying.

1. Twenty years ago, most people neither had cell phones nor wanted want them.

computer Students can use the find or search function to locate the first word in correlative conjunctions. They should read the sentences with those constructions carefully to make sure the second word is present and parallel structure is used.

- **2.** Today, cell phones are not only used by people of all ages but also are carried everywhere.
- (rather) ban cell phones on buses and trains than being forced to listen to other people's conversations.
- 4. No one denies that a cell phone can be both useful and convenience is a factor.
- **5.** A motorist stranded on a deserted road would rather have a cell phone than to walk to the nearest gas station.
- **6.** When cell phones were first introduced, some people feared that they (either) caused brain tumors (or) they were a dangerous source of radiation.
- 7. Most Americans today neither worry about radiation from cell phones fear nor other injuries.
- The biggest risk of cell phones is either that drivers are distracted by that people get them or people getting angry at someone talking too loudly in public on a cell phone.
- **9.** Cell phones probably do not cause brain tumors, but some experiments on human cells have shown that energy from the phones may (both) affect people's reflexes (and) it might alter the brain's blood vessels.
- 10. Some scientists think that these experiments show that cell phone use also mental ones might have not only physical effects on human beings but it also could influence mental processes.

PRACTICE 4 Completing Sentences with Paired Words

For each sentence, complete the correlative conjunction, and add more information. Make sure the structures on both sides of the correlative conjunction are parallel. Answers may vary. Possible answers are shown.

EXAMPLE: I am both impressed by your company and enthusiastic to work for you

- 1. I could bring to this job not only youthful enthusiasm but also relevant experience
- I am willing to work either in your main office or in your San Francisco
 office

- 3. My current job neither encourages initiative nor allows flexibility
- 4. I would rather work in a challenging job than work in a boring one
- 5. In college, I learned a lot both from my classes and from other students

Edit for Parallelism Problems

PRACTICE 5 Editing Paragraphs for Parallelism Problems

Find and correct five parallelism errors in the following paragraphs.

- (1) On a mountainous island between Norway and the North Pole is a special underground vault. (2) It contains neither gold and other currency. (3) Instead, it is full of a different kind of treasure: seeds. (4) They are being saved for the future in case something happens to the plants that people need to grow for food.
 - (5) The vault has the capacity to hold 4.5 million types of seed samples.
- (6) Each sample contains an average of five hundred seeds, which means Storing that up to 2.25 billion seeds can be stored in the vault. (7) To store them is better than planting them. (8) Stored, they are preserved for future generations to plant. (9) On the first day that the vault's storage program began, 268,000 different seeds were deposited, put into sealed packages, and collected collecting into sealed boxes. (10) Some of the seeds were for maize (corn), while others were for rice, wheat, and barley.
- (11) Although some people call it the "Doomsday Vault," many others see it as a type of insurance policy against starvation in the case of a terrible natural disaster. (12) The vault's location keeps it safe from floods, earth-storms quakes, and storming. (13) Carefully storing these seeds not only will help but also will ensure people will have food to eat plus make sure important crops never go extinct.

PRACTICE 6 Editing Your Own Writing for Parallelism

Edit a piece of your own writing for parallelism. It can be a paper for this course or another one, or something you have written for work or your everyday life. You may want to use the chart on page 485.

TEAMWORK Have students form small groups. Then, have each group write five sentences that are not parallel. Each group should then exchange sentences with another group and correct the other group's sentences.

Chapter Review

you find parallelism errors in your writing? What is the main thing you have learned about parallelism that will help you? What is unclear to you?

TEACHING TIP You can collect students' learning journals to find out what the class or individual students need more work on.

1. Parallelism in writing means that similar parts in a sentence have the same structure

- 2. In what three situations do problems with parallelism most often occur? with pairs and lists, with comparisons, and with certain paired words
- **3.** What are two pairs of correlative conjunctions? Possible answers: both/and, neither/nor
- 4. Write two sentences using parallelism.

 Answers will vary. One possibility: He was walking to the store and whistled all the way.

Chapter Test

Circle the correct choice for each of the following items.

1. If an underlined portion of this sentence is incorrect, select the revision that fixes it. If the sentence is correct as written, choose d.

For our home renovation, we are planning to expand the kitchen,

A

retile the bathroom, and we also want to add a bedroom.

a. add space to the kitchen

(c.) add a bedroom

b. replace the tile in the bathroom

d. No change is necessary.

2. Choose the correct word(s) to fill in the blank.

In my personal ad, I said that I like taking long walks on the beach, dining over candlelight, and ______ sculptures with a chain saw.

a. to carve

b.) carving

c. carved

3. If an underlined portion of this sentence is incorrect, select the revision that fixes it. If the sentence is correct as written, choose d.

 $\frac{\text{To get her elbow back into shape, she wants } \underline{\frac{\text{exercising}}{B}} \text{ and not } \underline{\frac{\text{to take pills.}}{C}}$

RESOURCES The Testing Tool Kit CD-ROM available with this book has even more tests on parallelism. Also, for cumulative Editing Review Tests, see pages 609–18. a. To getting

- c. taking pills
- (b.) to do exercises
- d. No change is necessary.
- **4.** Choose the correct word(s) to fill in the blank.

I have learned that _____ a pet is better than buying one from a pet store.

- (a.) adopting
- **b.** have adopted
- c. to adopt
- **5.** Choose the correct words to fill in the blank.

You can travel by car, by plane, or _____

- a. boating is fine
- (b.) by boat
- c. on boat

- gives you five ways to vary your sentences as you write.
- gives you practice using those ways to achieve variety.

29

Sentence Variety

Putting Rhythm in Your Writing

Understand What Sentence Variety Is

Sentence variety means using different sentence patterns and lengths to give your writing good rhythm and flow. Notice how the first example below does not have any rhythm.

WITH SHORT, SIMPLE SENTENCES

Many people do not realize how important their speaking voice and style are. Speaking style can make a difference, particularly in a job interview. What you say is important. How you say it is nearly as important. Your speaking voice creates an impression. Mumbling is a bad way of speaking. It makes the speaker appear sloppy and lacking in confidence. Mumbling also makes it difficult for the interviewer to hear what is being said. Talking too fast is another bad speech behavior. The speaker runs his or her ideas together. The interviewer cannot follow them or distinguish what is important. A third common bad speech behavior concerns verbal "tics." Verbal tics are empty filler phrases like "um," "like," and "you know." Practice for an interview. Sit up straight. Look the person to whom you are speaking directly in the eye. Speak up. Slow down. One good way to find out how you sound is to leave yourself a voice-mail message. If you sound bad to yourself, you need practice speaking aloud. Do not let poor speech behavior interfere with creating a good impression.

WITH SENTENCE VARIETY

Many people do not realize how important their speaking voice and style are, particularly in a job interview. What you say is important, but how you say it is nearly as important in creating a good impression. Mumbling is a bad way of speaking. Not only does it make the speaker appear sloppy and lacking in confidence, but mumbling also makes it difficult for the interviewer to hear what is being said. Talking too fast is

computer Students can get a visual measure of the length of their sentences by inserting two returns after every period in a paragraph. (They can search for periods to find the ends of sentences.)

another bad speech behavior. The speaker runs his or her ideas together, and the interviewer cannot follow them or distinguish what is important. A third common bad speech behavior is called verbal "tics," empty filler expressions such as "um," "like," and "you know." When you practice for an interview, sit up straight, look the person to whom you are speaking directly in the eye, speak up, and slow down. One good way to find out how you sound is to leave yourself a voice-mail message. If you sound bad to yourself, you need practice speaking aloud. Do not let poor speech behavior interfere with creating a good impression.

Practice Creating Sentence Variety

Most writers tend to write short sentences that start with the subject, so this chapter will focus on techniques for starting with something other than the subject and for writing a variety of longer sentences. Two additional techniques for achieving sentence variety—coordination and subordination—are covered in Chapter 27.

RESOURCES Additional Resources contains tests and supplemental practice exercises for this chapter as well as a transparency master for the chart at the end of the chapter.

Start Some Sentences with Adverbs

Adverbs are words that describe verbs, adjectives, or other adverbs; they often end with -ly. As long as the meaning is clear, adverbs can be placed at the beginning of a sentence instead of in the middle. Adverbs at the beginning of a sentence are usually followed by a comma.

TIP For more about adverbs, see Chapter 25.

ADVERB IN MIDDLE	Stories about haunted houses <i>frequently</i> surface at Halloween.
ADVERB AT BEGINNING	Frequently, stories about haunted houses surface at Halloween.
ADVERB IN MIDDLE	These stories often focus on ship captains lost at sea.
ADVERB AT BEGINNING	Often, these stories focus on ship captains lost at sea.

PRACTICE 1 Starting Sentences with an Adverb

Edit each sentence so that it begins with an adverb. Answers may vary.

Infortunately rabies Possible answers are shown.

Unfortunately, rabies Possible answers are show EXAMPLE: Rabies unfortunately remains a problem in the United States.

TIP For more practice with sentence variety, visit Exercise Central at bedfordstmartins.com/ realwriting.

Once, rabies

1. Rabies once was a major threat to domestic pets in this country.

2. Now, the The disease is now most deadly to wildlife such as raccoons, skunks, and bats.

frequently, people 3. People frequently fail to have their pets vaccinated against rabies.

Mistakenly, they believe They believe mistakenly that their dogs and cats are no longer in danger.

Thankfully, an

5. An oral vaccine that prevents rabies in raccoons and skunks has been developed, thankfully.

PRACTICE 2 Writing Sentences That Start with an Adverb

Write three sentences that start with an adverb. Use commas as necessary. Choose among the following adverbs: often, sadly, amazingly, luckily, lovingly, aggressively, gently, frequently, stupidly.

Join Ideas Using an -ing Verb

One way to combine sentences is to add -ing to the verb in the less important of the two sentences and to delete the subject, creating a phrase.

TWO SENTENCES A pecan roll from our bakery is not a health food. It contains 800 calories.

JOINED WITH -ING Containing 800 calories, a pecan roll from our bakery **VERB FORM** is not a health food.

You can add the -ing phrase to the beginning or the end of the other sentence, depending on what makes more sense.

equaling The fat content is also high/It equals the fat in a huge country breakfast.

If you add the -ing phrase to the beginning of a sentence, you will usually need to put a comma after it. If you add the phrase to the end of a sentence, you will usually need to put a comma before it. A comma should *not* be used only when the *-ing* phrase is essential to the meaning of the sentence.

TWO SENTENCES

Experts examined the effects of exercise on arthritis patients. The experts found that walking, jogging, or swimming could reduce pain.

TEACHING TIP Explain to students that in their own writing they will need to consider the context when deciding which sentence contains the more important idea.

JOINED WITHOUT COMMAS

Experts examining the effects of exercise on arthritis patients found that walking, jogging, or swimming could reduce pain.

[The phrase examining the effects of exercise on arthritis patients is essential to the meaning of the sentence.]

If you put a phrase starting with an *-ing* verb at the beginning of a sentence, be sure the word that the phrase modifies follows immediately. Otherwise, you will create a dangling modifier.

TIP For more on finding and correcting dangling modifiers, see Chapter 26, and for more on joining ideas, see Chapter 27.

TWO SENTENCES I ran through the rain. My raincoat got all wet.

DANGLING MODIFIER Running through the rain, my raincoat got all wet.

EDITED Running through the rain, I got my raincoat all wet.

PRACTICE 3 Joining Ideas Using an -ing Verb

Combine each pair of sentences into a single sentence by using an -ing verb. Add or delete words as necessary. Answers may vary. Possible edits are shown.

EXAMPLE: Some people read faces amazingly well. They interpret nonverbal cues that other people miss.

TEACHING TIP Doing this practice orally will help students hear the correct formation. The same is true of Practices 5, 7, 8, and 10.

- 1. A recent study tested children's abilities to interpret facial expressions.

 The study made headlines.
- Participating in the study, physically

 Physically abused children participated in the study. They saw photographs of faces changing from one expression to another.
- 3. The children told researchers what emotion was most obvious in each , choosing face/ The children chose among fear, anger, sadness, happiness, and other emotions.
- 4. The study also included nonabused children, They served as a control group for comparison with the other children.
- 5. All the children in the study were equally good at identifying most , responding emotions/ They all responded similarly to happiness or fear.
- 6. Battered children were especially sensitive to one emotion on the identifying faces/These children identified anger much more quickly than the other children could.
- Having
 The abused children have learned to look for anger/They protect
 themselves with this early-warning system.
- 8. Their sensitivity to anger may not help the abused children later in life, perhaps hurting It perhaps hurts them socially.

9.	Tending The abused children tend to run from anger they observe have Abused children They have
	difficulty connecting with people who exhibit anger.
10.	The human brain works hard to acquire useful information/It often
	hangs on to the information after its usefulness has passed.
• • • • •	
PRA	CTICE 4 Joining Ideas Using an -ing Verb
Write	e two sets of sentences, and join them using an -ing verb form.
	EXAMPLE: a. Carol looked up.
	b. She saw three falling stars in the sky.
	Combined: Looking up, Carol saw three falling stars in the
	sky.
1.	a. Answers will vary.
	b
	Combined:
2.	a
	b
	Combined:

TIP For more on helping verbs, see Chapters 19 and 23. Chapter 23 also covers past participles.

Join Ideas Using a Past Participle

Another way to combine sentences is to use a past participle (often, a verb ending in -ed) to turn the less important of the two sentences into a phrase.

TWO SENTENCES

Henry VIII was a powerful English king. He is remembered for his many wives.

JOINED WITH A
PAST PARTICIPLE

Remembered for his many wives, Henry VIII was a powerful English king.

Past participles of irregular verbs do not end in -ed; they take different forms.

Tim Treadwell was *eaten* by a grizzly bear. He showed that wild animals are unpredictable.

JOINED WITH A PAST PARTICIPLE

Tim Treadwell was *eaten* by a grizzly bear, Tim Treadwell showed that wild animals are unpredictable.

Notice that sentences can be joined this way when one of them has a form of *be* along with a past participle (*is remembered* in the first Henry VIII example and *was eaten* in the first Tim Treadwell example).

To combine sentences this way, delete the subject and the *be* form from the sentence that has the *be* form and the past participle. You now have a phrase that can be added to the beginning or the end of the other sentence, depending on what makes more sense.

If you add a phrase that begins with a past participle to the beginning of a sentence, put a comma after it. If you add the phrase to the end of the sentence, put a comma before it.

TIP If you put a phrase starting with a past participle at the beginning of a sentence, be sure the word that the phrase modifies follows immediately.

Otherwise, you will create a dangling modifier.

PRACTICE 5 Joining Ideas Using a Past Participle

Combine each pair of sentences into a single sentence by using a past participle. Answers may vary. Possible edits are shown.

Forced
The oil company was forced to take the local women's objections seriously/The company had to close for ten days during their protest.

Angered by British colonial rule in 1929, the
The women of southern Nigeria were angered by British colonial rule
in 1929. They organized a protest.

Covered with pipelines and oil wells,

2. Nigeria is now one of the top ten oil-producing countries. The nation

is covered with pipelines and oil wells.

Pumped
The oil is pumped by American and other foreign oil companies/The oil often ends up in wealthy Western economies.

Stolen by corrupt rulers in many cases, the

4. The money from the oil seldom reaches Nigeria's local people. The

cash is stolen by corrupt rulers in many cases.

Polluted , the Nigerian countryside 5. The Nigerian countryside is polluted by the oil industry. The land

then becomes a wasteland.

Insulted

Many Nigerians are insulted by the way the oil industry treats

many Nigerians
them/They want the oil companies to pay attention to their
problems.

- Inspired
 Local Nigerian women were inspired by the 1929 women's protests/
 , local Nigerian women
 They launched a series of protests against the oil industry in the summer of 2002.
- **8.** The women prevented workers from entering or leaving two oil company offices/, The offices were located in the port of Warri. Concerned
- 9. Workers at the oil company were concerned about the women's threat nany workers at the oil company to take their clothes off/Many workers told company officials that such a protest would bring a curse on the company and shame to its employees.
- 10. The company eventually agreed to hire more local people and to invest in local projects/The projects are intended to supply electricity and provide the villagers with a market for fish and poultry.

Chair is taling intermediate accounting

PRACTICE 6 Joining Ideas Using a Past Participle

Write two sets of sentences, and join them with a past participle.

EXAMPLE:	a. Chris is taking intermediate accounting.
	b. It is believed to be the most difficult course in the major.
	Combined: Chris is taking intermediate accounting,
	believed to be the most difficult course in the major.
a. Answe	rs will vary.
b	ti de de la companya de la companya La companya de la co
Combine	d:
· Cartesia la la	
a	
b	
Combine	d:

Join Ideas Using an Appositive

An **appositive** is a noun or noun phrase that renames a noun or pronoun. Appositives can be used to combine two sentences into one.

TWO SENTENCES Brussels sprouts can be roasted for a delicious flavor. They are a commonly disliked food.

TEACHING TIP Say aloud a sentence that has as its subject something familiar to students in the class (for example, the president, a celebrity). Ask them to suggest a good appositive.

JOINED WITH AN **APPOSITIVE**

Brussels sprouts, a commonly disliked food, can be roasted for a delicious flavor.

[The phrase a commonly disliked food renames the noun brussels

TIP Usually, you will want to turn the less important of the two sentences into an appositive.

Notice that the sentence that renames the noun was turned into a noun phrase by dropping the subject and the verb (*They* and *are*). Also, commas set off the appositive.

PRACTICE 7 Joining Ideas Using an Appositive

Combine each pair of sentences into a single sentence by using an appositive. Be sure to use a comma or commas to set off the appositive. Answers may vary. Possible edits are shown.
, perhaps the most famous work clothes in the world,

EXAMPLE: Levi's jeans have looked the same for well over a century.

They are perhaps the most famous work clothes in the world.

- 1. Jacob Davis, was a Russian immigrant working in Reno, Nevada, He was the inventor of Levi's jeans.
- , the riveted seam,

 2. Davis came up with an invention that made work clothes last longer. The invention was the riveted seam.
- 3. Davis bought denim from a wholesaler, The wholesaler was Levi Strauss.
- **4.** In 1870, he offered to sell the rights to his invention to Levi Strauss for the price of the patent, Patents then cost about \$70.
- 5. Davis joined the firm in 1873 and supervised the final development of its product/, The product was the famous Levi's jeans.
- 6. Davis oversaw a crucial design element. The jeans all had orange stitching.
- Another The curved stitching on the back pockets was another choice Davis

 , the curved stitching on the back pockets,
 made/H also survives in today's Levi's.
- A , the stitching on the pockets has been a trademark since 1942/It is very recognizable.
- 9. During World War II, Levi Strauss temporarily stopped adding the pocket stitches because they wasted thread, It was a valuable resource.

10. Until the war ended, the pocket design was added with a less valuable material. The company used paint.

Join Ideas Using an Adjective Clause

TIP For more about adjectives, see Chapter 25.

An **adjective clause** is a group of words with a subject and a verb that describes a noun. An adjective clause often begins with the word *who*, *which*, or *that*, and it can be used to combine two sentences into one.

TWO SENTENCES Lauren has won many basketball awards. She is

captain of her college team.

JOINED WITH AN Lauren, who is captain of her college team, has won

ADJECTIVE CLAUSE many basketball awards.

To join sentences this way, use *who*, *which*, or *that* to replace the subject in a sentence that describes a noun in the other sentence. You now have an adjective clause that you can move so that it follows the noun it describes. The sentence with the more important idea (the one you want to emphasize) should become the main clause. The less important idea should be in the adjective clause.

Leigh got an internship because of her blog/# caught the eye of people in the fashion industry.

[The more important idea here is that Leigh got an internship because of her blog. The less important idea is that the blog caught the eye of people in the fashion industry.]

NOTE: If an adjective clause can be taken out of a sentence without completely changing the meaning of the sentence, put commas around it.

Lauren, who is captain of her college team, has won many basketball awards.

[The phrase who is captain of her college team adds information about Lauren, but it is not essential.]

If an adjective clause is an essential part of a sentence, do not put commas around it.

Lauren is an award-winning basketball player who overcame childhood cancer.

[Who overcame childhood cancer is an essential part of this sentence.]

TIP Use who to refer to a person, which to refer to places or things (but not to people), and that for places or things.

PRACTICE 8 Joining Ideas Using an Adjective Clause

Combine each pair of sentences into a single sentence by using an adjective clause beginning with who, which, or that. Answers will vary. Possible edits are shown.

example: My friend Erin had her first child last June. She has been going to college for the past three years.

- 1. While Erin goes to classes, her haby boy stays at a day-care center/ The day-care center costs Erin about \$100 a week.
- 2. Twice when her son was ill, Erin had to miss her geology lab/The lab is an important part of her grade for that course.
- , who live about 70 miles away,

 3. Occasionally, Erin's parents come up and watch the baby while Erin is studying. They live about 70 miles away.
- 4. Sometimes Erin feels discouraged by the extra costs/The costs have come from having a child.
- who have never been parents themselves

 5. She believes that some of her professors are not very sympathetic.

These professors are the ones who have never been parents themselves.

, who wants to be a good mother and a good student,

- 6. Erin understands that she must take responsibility for both her child and her education. She wants to be a good mother and a good student.
- , which were once straight A's,

 Her grades have suffered somewhat since she had her son. They were once straight A's.
- , who hopes to go to graduate school someday, Erin wants to graduate with honors. She hopes to go to graduate school someday.
- 9. Her son is more important than an A in geology. He is the most important thing to her.
- , who Erin still expects to have a high grade point average/She has simply given up expecting to be perfect.

PRACTICE 9 Joining Ideas Using an Adjective Clause

Fill in the blank in each of the following sentences with an appropriate adjective clause. Add commas, if necessary. Answers may vary. Possible edits are shown.

EXAMPLE: The firefighters <u>who responded to the alarm</u> entered the burning building.

- 1. A fire <u>that was probably caused by faulty wiring</u> began in our house in the middle of the night.
- 2. The members of my family who were home at the time of the fire were all asleep.
- 3. My father ___, who has always been a light sleeper, was the first to smell smoke.
- 4. He ran to our bedrooms ___, which were on the second floor, and woke us up with his shouting.
- 5. The house __, which was the only home I had ever lived in, was damaged, but everyone in my family reached safety.

Edit for Sentence Variety

PRACTICE 10 Editing Paragraphs for Sentence Variety

Create sentence variety in the following paragraphs by joining at least two sentences in each of the paragraphs. Use several of the techniques covered in this chapter. More than one correct answer is possible. Answers may vary. Possible edits are shown.

- (1) Few people would associate the famous English poet and playwright William Shakespeare with prison. (2) However, Shakespeare has taken on an important role in the lives of certain inmates/(3) They are serving time Brought at the Luther Luckett Correctional Complex in Kentucky. (4) These interest mates were brought together by the Shakespeare Behind Bars program/(5) They spend nine months preparing for a performance of one of the great writer's plays.
- (6) Recently, prisoners at Luckett performed *The Merchant of*Venice, (7) It is one of Shakespeare's most popular plays. (8) Many of the actors identified with Shylock, (9) He is a moneylender who is discriminated against because he is Jewish. (10) When a rival asks Shylock for a demanding loan to help a friend, Shylock drives a hard bargain, (11) He demands a pound of the rival's flesh if the loan is not repaid. (12) One inmate shared his views of this play with a newspaper reporter, (13) The inmate said, "It deals with race. It deals with discrimination. It deals with gambling, debt, cutting people. It deals with it all. And we were all living that someway, somehow."

(14) Through the Shakespeare performances, the inmates form bonds not only with the characters but also with one another. (15) Additionally, they are able to explore their own histories and their responsibility for the crimes they committed. (16) Many feel changed by their experience on the Affected stage. (17) One actor was affected deeply by his role in The Merchant of one actor Venice (18) He said, "You feel like you're in a theater outside of here. You don't feel the razor wire."

PRACTICE 11 Editing Your Own Writing for Sentence Variety

Add more sentence variety to a piece of your own writing—a paper for this course or another one, or something you have written for work or your everyday life. You may want to use the chart on page 498.

Chapter Review

- 1. Having sentence variety means using different sentence patterns and lengths to give your writing good rhythm and flow
- 2. If you tend to write short, similar-sounding sentences, what five techniques should you try? starting some sentences with adverbs, joining sentences using an "-ing" verb, joining sentences using a past participle, joining sentences using an appositive, and joining sentences using an adjective clause
- **3.** An <u>appositive</u> is a noun or noun phrase that renames a noun.
- 4. An <u>adjective</u> clause often starts with who, <u>which</u>, or <u>that</u>. It describes a noun or pronoun.
- **5.** Use commas around an adjective clause when the information in it is (essential / not essential) to the meaning of the sentence.

LEARNING JOURNAL Did you find short, choppy sentences in your writing? What is the main thing you have learned about sentence variety that will help you? How would you explain how to vary sentences to someone else? What is unclear to you?

TEACHING TIP You can collect students' learning journals to find out what the class or individual students need more work on.

Chapter Test

For each of the following sentence pairs, choose the answer that joins the sentences logically using one of the strategies in this chapter.

- 1. Luis straightened his tie. He waited to be called in for his job interview.
 - a. Straightened his tie, Luis waited to be called in for his job interview.
 - **b.** Straightening his tie, Luis waited to be called in for his job interview.

RESOURCES The Testing Tool Kit CD-ROM available with this book has even more tests. Also, for cumulative Editing Review Tests, see pages 609–18.

- 2. The auditorium was noisy and chaotic. It was filled with people in Superman outfits.
 - **a.** Filled with people in Superman outfits, the auditorium was noisy and chaotic.
 - **b.** Filled with people in Superman outfits; the auditorium was noisy and chaotic.
- 3. My niece is a star softball player. She loves to watch baseball on TV.
 - (a.) My niece, a star softball player, loves to watch baseball on TV.
 - **b.** Starring as a softball player, my niece loves to watch baseball on TV.
- **4.** Chocolate is a favorite sweet worldwide. It has compounds that might lower the risk of certain diseases.
 - **a.** Chocolate is a favorite sweet worldwide, for it has compounds that might lower the risk of certain diseases.
 - **b.** Chocolate, a favorite sweet worldwide, has compounds that might lower the risk of certain diseases.
- **5.** The lawyer believed passionately in his client's innocence. He convinced the jury to come to a verdict of not guilty.
 - **a.** The lawyer, who believed passionately in his client's innocence, convinced the jury to come to a verdict of not guilty.
 - **b.** The lawyer believed passionately in his client's innocence, yet he convinced the jury to come to a verdict of not guilty.

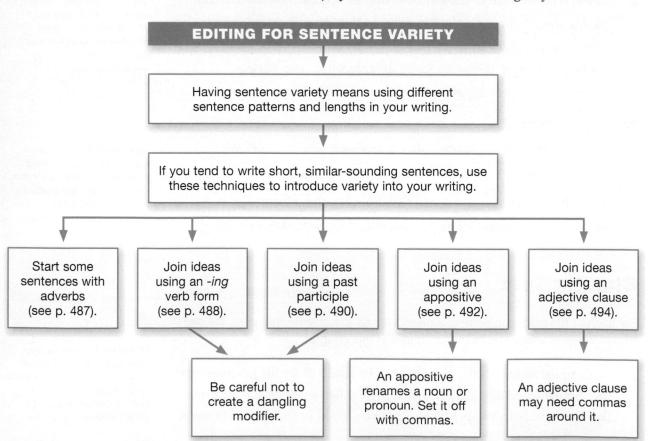

THIS CHAPTER

- explains four basic sentence patterns.
- shows how to form negatives and questions.
- explains the different kinds of pronouns and how to use them.
- shows some verb tenses that can be tricky and gives you summary charts to refer to.
- explains how to use articles and prepositions correctly.

30

Formal English and ESL Concerns

Grammar Trouble Spots for Multilingual Students

Academic, or formal, English is the English you will be expected to use in college and in most work situations, especially in writing. If you are not accustomed to using formal English or if English is not your native language, this chapter will help you avoid the most common problems with key sentence parts.

TIP In this chapter, we use the word English to refer to formal English. Throughout the chapter, subjects are underlined, and verbs are double-underlined.

Basic Sentence Patterns

Statements

Every sentence in English must have at least one subject and one verb (S-V) that together express a complete idea. The subject performs the action, and the verb names the action, as in the sentence that follows.

S V | | The pitcher throws.

Other English sentence patterns build on that structure. One of the most common patterns is subject-verb-object (S-V-O).

RESOURCES For additional support and exercises for ESL students, see *The Bedford/St. Martin's ESL Workbook, Second Edition, available with this text.*

TEACHING TIP You may wish to assign this chapter to your class as a whole, especially if you have native students who speak nonstandard English. Even if they know the parts of speech, many students need extra practice with how those parts function in writing.

There are two kinds of objects.

DIRECT OBJECTS receive the action of the verb.

The pitcher throws the ball.

[The ball directly receives the action of the verb throws.]

INDIRECT OBJECTS do not receive the action of the verb. Instead, the action is performed *for* or *to* the person.

PRACTICE 1 Sentence Patterns

Label the subject (S), verb (V), direct object (DO), and indirect object (IO), if any, in the following two sentences.

1. $\frac{S}{S} = \frac{V}{V} = \frac{DO}{I}$ S = $\frac{S}{V}$ IO DO

2. John sent Beth the letter.

Another common sentence pattern is subject-verb-prepositional phrase. In standard English, the prepositional phrase typically follows the subject and verb.

PRACTICE 2 Using Correct Word Order

Read each of the sentences that follow. If the sentence is correct, write "C" in the blank to the left of it. If it is incorrect, write "I"; then, rewrite the sentence using correct word order.

EXAMPLE: ___I My friend to me gave a present.

Revision: My friend gave me a present.

I ____I. Presents I like very much.

Revision: I like presents very much.

I ____I. To parties I go often.

Revision: I go to parties often.

TIP For more on prepositions, see pages 332–33. For more on the parts of sentences, see Chapter 19.

I	_ 3.	To parties, I always bring a present.
		Revision: I always bring a present to parties.
С	4.	At my parties, people bring me presents, too.
		Revision:
I	5.	Always write to them a thank-you note.
		Revision: I always write them a thank-you note.

Negatives

To form a negative statement, use one of the words listed here, often with a helping verb such as *can/could*, *does/did*, *has/have*, or *should/will/would*.

never	nobody	no one	nowhere
no	none	not	

Notice in these examples that the word not comes after the helping verb.

SENTENCE	Dina can sing.
NEGATIVE	Dina no can sing.
SENTENCE	The store sells cigarettes.
NEGATIVE	The store no sells cigarettes.
SENTENCE	$\frac{\text{Bruce } \underbrace{\text{will call.}}_{not}$
NEGATIVE	Bruce no will call.
SENTENCE	Caroline walked.
NEGATIVE	Caroline no did walk.

have	do	can
has	does	could
had	did	may
		might
		must
		should
		will
	has	has does

TIP For more on helping verbs and their forms, see Chapter 23.

The helping verb cannot be omitted in expressions using not.

INCORRECT The store not sell cigarettes.

CORRECT The store *does not sell* cigarettes.

[Does, a form of the helping verb do, must come before not.]

CORRECT The store is not selling cigarettes.

[Is, a form of be, must come before not.]

Double negatives are not standard in English.

Shane does not have no ride.

CORRECT Shane does not have a ride.

CORRECT Shane has no ride.

When forming a negative in the simple past tense, use the past tense of the helping verb do.

did + not + Base verb without an -ed = Negative past tense

SENTENCE I talked to Jairo last night.

[Talked is the past tense.]

NEGATIVE I did not talk to Jairo last night.

[Notice that talk in this sentence does not have an -ed ending

because the helping verb did conveys the past tense.]

PRACTICE 3 Forming Negatives

Rewrite the sentences to make them negative.

example: Hassan's son is talking now.

cannot

1. He ean say several words.

does not

2. Hassan remembers when his daughter started talking.

3. He thinks it was at the same age.

not

4. His daughter was an early speaker.

does not ^

5. Hassan expects his son to be a talkative adult.

Questions

To turn a statement into a question, move the helping verb so that it comes before the subject. Add a question mark (?) to the end of the question.

TIP Sometimes the verb appears before the subject in sentences that are not questions: Behind the supermarket is the sub shop.

STATEMENT Johan can go tonight.

QUESTION <u>Can Johan go</u> tonight?

If the only verb in the statement is a form of *be*, it should be moved before the subject.

STATEMENT $\underline{\underline{Jamie}} \ \underline{\underline{is}} \ at \ work.$

QUESTION Is Jamie at work?

If the statement does not contain a helping verb or a form of *be*, add a form of *do* and put it before the subject. Be sure to end the question with a question mark (?).

STATEMENT Norah sings in the choir. Tyrone goes to college.

QUESTION <u>Does Norah sing</u> in the <u>Does Tyrone go</u> to college?

choir?

STATEMENT The building burned. The plate broke.

QUESTION <u>Did</u> the <u>building burn?</u> <u>Did</u> the <u>plate</u> break?

Notice that the verb changed once the helping verb *did* was added. *Do* is used with *I*, *you*, *we*, and *they*. *Does* is used with *he*, *she*, and *it*.

EXAMPLES Do [I/you/we/they] practice every day?

Does [he/she/it] sound terrible?

PRACTICE 4 Forming Questions

Rewrite the sentences to make them into questions.

EXAMPLE: Brad knows how to cook/

- Does he ?? He makes dinner every night for his family?
- 2. Does he go
 He goes to the grocery store once a week
- 3. Does he He uses coupons to save money
- 4. Brad saves a lot of money using coupons

There Is and There Are

English sentences often include there is or there are to indicate the existence of something.

There is a man at the door.

[You could also say, A man is at the door.]

There are many men in the class.

[You could also say, Many men are in the class.]

When a sentence includes the words *there is* or *there are*, the verb (*is, are*) comes before the noun it goes with (which is actually the subject of the sentence). The verb must agree with the noun in number. For example, the first sentence above uses the singular verb *is* to agree with the singular noun *man*, and the second sentence uses the plural verb *are* to agree with the plural noun *men*.

In questions, is or are comes before there.

There is plenty to eat.

There are some things to do.

QUESTIONS

Is there plenty to eat?

Are there some things to do?

PRACTICE 5 Using There Is and There Are

In each of the following sentences, fill in the blank with *there is* or *there are*, using the correct word order for any questions.

	EXAMPLE: Although my parents are busy constantly, they say that there is always more that can be done.
1.	Every morning, there are flowers to water and weeds to pull.
2.	Later in the day, there are more chores, like mowing the lawn
	or cleaning out the garage.
3.	I always ask, " Is there anything I can do?"
4.	They are too polite to say that there is work that they need
	help with.
5.	If more productive parents in the world, I would be surprised.

Pronouns

Pronouns replace nouns or other pronouns in a sentence so that you do not have to repeat them. There are three types of pronouns: subject pronouns, object pronouns, and possessive pronouns.

SUBJECT PRONOUNS serve as the subject of the verb (and remember that every English sentence *must* have a subject).

 $\underline{\underline{Rob}}$ is my cousin. $\underline{\underline{\underline{Rob}}}$ lives next to me.

OBJECT PRONOUNS receive the action of the verb or are part of a prepositional phrase.

Rob asked me for a favor.

[The object pronoun me receives the action of the verb asked.]

Rob lives next door to me.

[To me is the prepositional phrase; me is the object pronoun.]

POSSESSIVE PRONOUNS show ownership.

Rob is my cousin.

Use the following chart to check which type of pronoun to use.

SUBJECT		OBJECT		POSSESSIVE	
SINGULAR	PLURAL	SINGULAR	PLURAL	SINGULAR	PLURAL
Ι	we	me	us	my/mine	our/ours
you	you	you	you	your/yours	your/yours
he/she/it	they	him/her/it	them	his/her/hers/its	theirs
RELATIVE P	RONOUNS				

The singular pronouns *he/she*, *him/her*, and *his/hers* show gender. *He*, *him*, and *his* are masculine pronouns; *she*, *her*, and *hers* are feminine.

Here are some examples of common pronoun errors, with corrections.

Confusing Subject and Object Pronouns

Use a subject pronoun for the word that *performs* the action of the verb, and use an object pronoun for the word that *receives* the action.

TIP For more on pronouns, see Chapter 24.

Tashia is a good student. Her gets all A's.

[The pronoun performs the action gets, so it should be the subject pronoun, she.]

her

Tomas gave the keys to she. Banh gave the coat to he.

[The pronoun receives the action of gave, so it should be the object pronoun, her or him.]

Confusing Gender

Use masculine pronouns to replace masculine nouns, and use feminine pronouns to replace feminine nouns.

Nick is sick. She has the flu.

[Nick is a masculine noun, so the pronoun must be masculine.]

The jacket belongs to Jane. Give it to him.

[Jane is feminine, so the pronoun must be feminine.]

Leaving Out a Pronoun

Some sentences use the pronoun it as the subject or object. Do not leave it out of the sentence.

It is

Is a holiday today.

Maria will bring the food. Will be delicious.

I tried calamari last night and liked very much.

Using a Pronoun to Repeat a Subject

A pronoun replaces a noun, so do not use both a subject noun and a pronoun.

My father he is very strict.

[Father is the subject noun, so the sentence should not also have the subject pronoun he.]

The $\underline{\text{bus}}$ if $\underline{\text{was}}$ late.

[Bus is the subject noun, so the sentence should not also have the subject pronoun it.]

Using Relative Pronouns

The words who, which, and that are **relative pronouns**. Use relative pronouns in a clause that gives more information about the subject.

Use who to refer to a person or people.

The man who lives next door plays piano.

Use which or that to refer to nonliving things. The plant, which was a gift, died. The phone that I bought last week is broken. **PRACTICE 6** Using Correct Pronouns Using the chart of pronouns on page 505, fill in the blanks with the correct pronoun. Answers may vary. Possible answers are shown. **EXAMPLE:** Tennis is popular, for ______ is an exciting sport. 1. Since the first time I played tennis, I have liked _____it much. My favorite player is John McEnroe. He ____ is famous for his bad temper. **4.** Even though he is now middle-aged, his _ serve is perfect. **5.** No matter how much I practice, _____ my serve will never be as good. **6.** McEnroe got a lot of publicity when _____ challenged Venus and Serena Williams to a match. They ____ declined. 7. **8.** Venus said that she did not know if she could fit him into her _ schedule. **9.** Both of the sisters were busy with _____ their _ tournament matches. **10.** Who is ______ favorite tennis player? **Verbs**

Verbs have different tenses to show when something happened: in the past, present, or future.

This section contains time lines, examples, and common errors for the simple and perfect tenses; coverage of progressive tenses; and more. See Chapter 23 for full coverage of the simple tenses and the perfect tenses, as well as practice exercises.

The Simple Tenses

SIMPLE PRESENT

Use the simple present to describe situations that exist now.

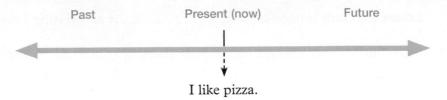

I/You/We/They like pizza.

She/He likes pizza.

The third-person singular (*she/he*) of regular verbs ends in -s or -es. For irregular verb endings, see pages 402–05.

SIMPLE PAST

Use the simple past to describe situations that began and ended in the past.

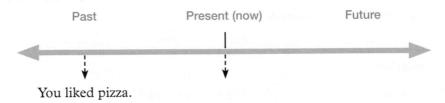

 $\underline{I}/\underline{You}/\underline{She}/\underline{He}/\underline{We}/\underline{They} = \underline{liked}$ pizza.

For regular verbs, the simple past is formed by adding either -d or -ed to the verb. For the past forms of irregular verbs, see the chart on pages 402–05.

SIMPLE FUTURE

Use the simple future to describe situations that will happen in the future. It is easier to form than the past tense. Use this formula for forming the future tense.

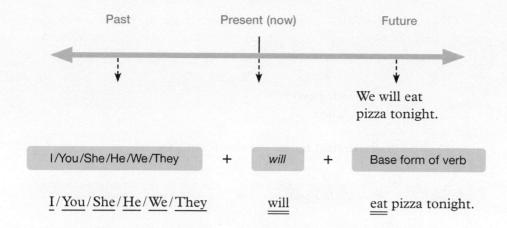

COMMON ERRORS IN USING SIMPLE TENSES

Following are some common errors in using simple tenses.

Simple present. Forgetting to add -s or -es to verbs that go with third-person singular subjects (she/he/it)

TIP The subject and the verb must agree in number. For more on subject-verb agreement, see Chapter 22.

INCORRECT She know the manager.

She knows the manager.

Simple past. Forgetting to add -d or -ed to regular verbs

INCORRECT Gina work late last night.

CORRECT Gina worked late last night.

Forgetting to use the correct past forms of irregular verbs (see the chart of irregular verb forms on pages 402–05)

INCORRECT Gerard speaked to her about the problem.

CORRECT Gerard **spoke** to her about the problem.

Forgetting to use the base verb without an ending for negative sentences

INCORRECT She $\underline{\underline{\text{does}}}$ not $\underline{\underline{\text{wants}}}$ money for helping.

CORRECT She does not want money for helping.

TIP Double negatives (Johnetta will not call no one) are not standard in English. One negative is enough (Johnetta will not call anybody).

The Perfect Tenses

PRESENT PERFECT

Use the present perfect to describe situations that started in the past and either continue into the present or were completed at some unknown time in the past.

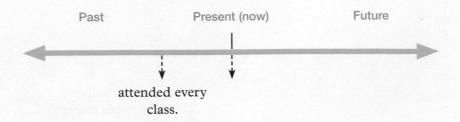

To form the present perfect tense, use this formula:

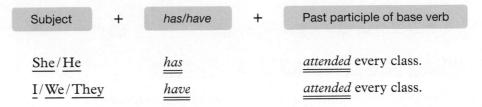

Notice that *I/We/They* use *have* and that *She/He* use *has*.

PAST PERFECT

Use the past perfect to describe situations that began and ended before some other situation happened.

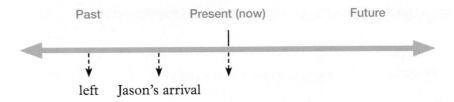

To form the past perfect tense, use this formula:

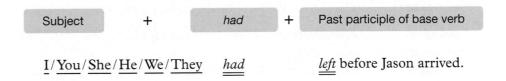

FUTURE PERFECT

Use the future perfect to describe situations that begin and end before another situation begins.

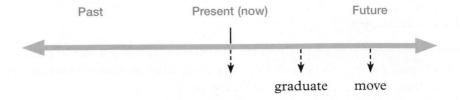

Use this formula to form the future perfect tense:

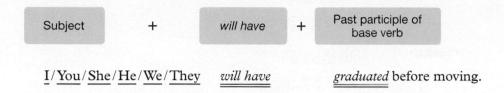

COMMON ERRORS IN FORMING THE PERFECT TENSE

Using had instead of has or have for the present perfect

we <u>had lived</u> here since 2003.

We <u>have lived</u> here since 2003.

Forgetting to use past participles (with -d or -ed endings for regular verbs)

CORRECT She has attend every class.

She has attended every class.

Using been between have or has and the past participle of a base verb

I have been attended every class.

CORRECT

I have attended every class.

INCORRECT

I will have been graduated before I move.

CORRECT

I will have graduated before I move.

The Present Progressive Tenses

The progressive tense is used to describe ongoing actions in the present, past, or future. Following are some common errors in using the present progressive tense.

Forgetting to add -ing to the verb

INCORRECT \underline{I} am type now.

She/he is not type now.

CORRECT \underline{I} am typing now.

She/he is not typing now.

Forgetting to include a form of be (am/is/are)

INCORRECT He typing now.

They typing now.

CORRECT He is typing now.

They are typing now.

Forgetting to use a form of be (am/is/are) to start questions

INCORRECT They typing now?

CORRECT Are they typing now?

The following charts show how to use the present, past, and future progressive tenses in regular statements, negative statements, and questions.

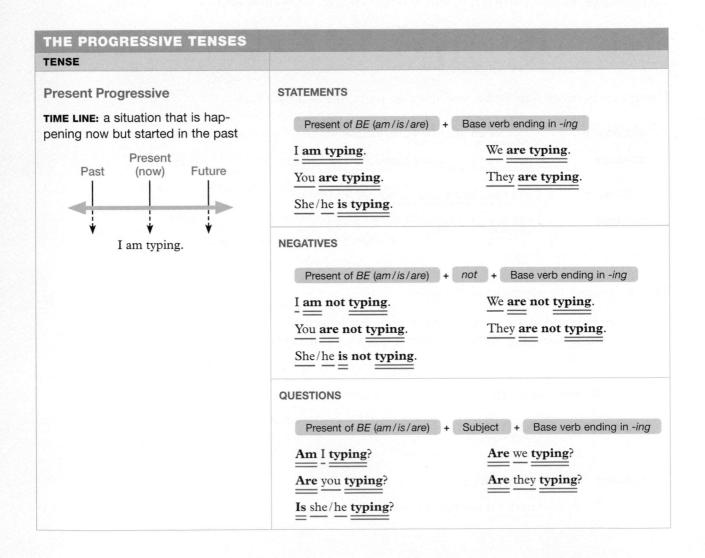

TENSE **Past Progressive STATEMENTS** TIME LINE: a situation that was going Past of BE (was/were) + Base verb ending in -ing on in the past It was raining when I got to the restaurant at 7:00. Present Past (now) **Future** The students were studying all night. **NEGATIVES** arrival at raining Past of BE (was/were) + not + Base verb ending in -ing restaurant It was not raining when I got to the restaurant at 7:00. The students were not studying all night. QUESTIONS Past of BE (was/were) + Subject + Base verb ending in -ing Was it raining when I got to the restaurant at 7:00? Were the students studying all night? **Future Progressive STATEMENTS** TIME LINE: a situation that will be onwill be + Base verb ending in -ing going at some point in the future I/you will be working when Jan gets home. Present Past (now) **Future** She/he will be working when Jan gets home. We will be working when Jan gets home. They will be working when Jan gets home. working Jan's arrival **NEGATIVES** will + not + be + Base verb ending in -ing I/you will not be working when Jan gets home. She/he will not be working when Jan gets home. We will not be working when Jan gets home. They will not be working when Jan gets home.

TENSE	
	QUESTIONS
	will + Subject + be + Base verb ending in -ing
	Will I/you be working when Jan gets home?
	Will she/he be working when Jan gets home?
	Will we be working when Jan gets home?
	Will they be working when Jan gets home?

PRACTICE 7 Using the Progressive Tense

Fill in the correct progressive form of the verb in parentheses after each blank.

trying **EXAMPLE:** My friend Maria and I are ____ healthier. **1.** First, we are _____starting ____ (start) to walk every day. **2.** Why are we _____ making ____ (make) this change? was visiting (visit) me, she said that I 3. Last week, when Maria ___ didn't seem like myself. **4.** I answered, "Yes, I am ______ (feel) kind of sad." **5.** "Are you _____ sleeping ____ (sleep) well?" she asked. 6. "Oh, yes," I said. "I ____ am getting___ (get) plenty of sleep." 7. "What about your diet? Are you ______eating____ (eat) right?" she asked. **8.** "I eat in the cafeteria," I explained. "The chefs there are always ___ (cook) healthy options." **9.** "What about activities? Are you <u>exercising</u> (exercise) at all?" **10.** "Not really, unless you count my brain while I am _____studying (study)!" I admitted.

PRACTICE 8 Forming Negative Statements and Questions

Rewrite the following sentences as indicated.

- **1.** Betsy is golfing today. Make the sentence a question: Is Betsy golfing today?
- 2. It was snowing when we got up. Make the sentence a negative statement: It was not snowing when we got up.
- 3. You are going to the mall. Make the sentence a question: Are you going to the mall?
- **4.** They are losing the game. Make the sentence a negative statement: They are not losing the game.
- **5.** Meriam was eating when you arrived. Make the sentence into a question: Was Meriam eating when you arrived?

Modal (Helping) Verbs

Modal verbs (or modal auxiliary verbs) are helping verbs that express the writer's attitude about an action. You do not have to learn too many modal verbs—just the eight in the chart that follows.

TIP For more on helping verbs, see Chapter 19.

MODAL (HELPING) VERE	s						
General Formulas	STATEMENTS						
For all modal verbs. (More	Present:	Subject	+	Modal verb	+ (Base verb	
modal verbs are shown below.)		Dumbo		can		fly.	
	Past: Forms	vary—see belo	w.				
	NEGATIVES		Of the state				
	Present:	Subject	+ (Modal verb + not	+ [Base verb	
	100	Dumbo		cannot		fly.	
	Past: Forms	vary—see belo	w.				
	QUESTIONS						
	Present:	Modal verb	+ (Subject	+ 🗐	Base verb	
		Can		Dumbo		fly?	
	Past: Forms	vary—see belo	w.				\rightarrow

MODAL (HELPING) VERB	S			
Can	STATEMENTS			
Means ability	Present: Beth can work fast.			
	Past: Beth could work fast.			
	NEGATIVES			
	Present: Beth cannot work fast.			
	Past: Beth could not work fast.			
	QUESTIONS			
	Present: <u>Can</u> Beth work fast?			
	Past: Could Beth work fast?			
Could	STATEMENTS			
Means possibility. It can also	Present: Beth could work quickly if she had more time.			
be the past tense of can.	Past: Beth could have worked quickly if she had had more time.			
	NEGATIVES			
	Can is used for present negatives. (See above.)			
	Past: Beth could not have worked quickly.			
	QUESTIONS			
	Present: Could Beth work quickly?			
	Past: Could Beth have worked quickly?			
May	STATEMENTS			
Means permission	Present: You may borrow my car.			
For past-tense forms, see <i>might</i> .	NEGATIVES			
	Present: You may not borrow my car.			
	QUESTIONS			
	Present: May I borrow your car?			

MODAL (HELPING) VERBS	
Might	STATEMENTS
Means possibility. It can also	Present (with be): Lou might be asleep.
be the past tense of may.	Past (with have + past participle of be): Lou might have been asleep.
	Future: Lou might sleep.
	NEGATIVES
	Present (with be): Lou might not be asleep.
	Past (with have + past participle of be): Lou might not have been asleep.
	Future: Lou might not sleep.
	QUESTIONS
	Might in questions is very formal and not often used.
Must	STATEMENTS
Means necessary	Present: We must try.
	Past (with have + past participle of base verb): We must have tried.
	Past (with $had + to + base verb$): We had to try.
	NEGATIVES
	Present: We must not try.
	Past (with have + past participle of base verb): We must not have tried.
	QUESTIONS
	Present: Must we try?
	Past-tense questions with <i>must</i> are unusual.
Should	STATEMENTS
Means duty or expectation	Present: They should call.
	Past (with have + past participle of base verb): They should have called.
	NEGATIVES
	Present: They should not call.
	Past (with have + past participle of base verb): They should not have called.
	QUESTIONS
	Present: Should they call?
	Past (with have + past participle of base verb): Should they have called?

MODAL (HELPING) VERBS	
Will	STATEMENTS
Means intend to (future)	Future: I will succeed.
For past-tense forms, see would.	NEGATIVES Future: I will not succeed.
	QUESTIONS
	Future: Will I succeed?
Would	STATEMENTS
Means <i>prefer</i> or used to start	Present: I would like to travel.
a future request. It can also be	Past (with have + past participle of base verb):
the past tense of will.	I would have traveled if I had had the money.
	NEGATIVES
	Present: I would not like to travel.
	Past (with have + past participle of base verb):
	I would not have traveled if it had not been for you.
	QUESTIONS
	Present: Would you like to travel?
	Or to start a request: Would you help me?
	Past (with have + past participle of base verb):
	Would you have traveled with me if I had asked you?

COMMON ERRORS WITH MODAL VERBS

Following are some common errors in using modal verbs.

Using more than one helping verb

They will can help.

They will help. (future intention)

They can help. (are able to)

Using to between the modal verb and the main (base) verb

Emilio might to come with us.

CORRECT Emilio **might** come with us.

Using must instead of had to to form the past tens	Jsing	must	instead	of	had	to	to	form	the	past	tens	e
--	-------	------	---------	----	-----	----	----	------	-----	------	------	---

INCORRECT She **must** work yesterday.

She had to work yesterday.

Forgetting to change can to could to form the past negative

INCORRECT Last night, <u>I</u> <u>cannot sleep</u>.

CORRECT Last night, I could not sleep.

Forgetting to use have with could/should/would to form the past tense

INCORRECT Tara should called last night.

Tara should have called last night.

Using will instead of would to express a preference in the present tense

INCORRECT I will like to travel.

CORRECT <u>I</u> would like to travel.

PRACTICE 9 Using Modal Verbs

Fill in the appropriate modal verbs in the sentences below. Answers may vary. Possible answers are shown.

EXAMPLE: Lilly _____ like to help the homeless.

- 1. What ____ should ___ she do?
- **2.** First, she _____ find out what programs exist in her community.
- **3.** For example, there ______might ____ be a chapter of Habitat for Humanity.
- **4.** Religious organizations ______ might _____ have started soup kitchens.
- **5.** If she <u>cannot</u> find anything in her community, she should contact a national organization, such as the National Coalition for the Homeless.
- **6.** The organization _____ definitely give her some ideas.
- **7.** Also, she <u>should not</u> feel as though she must volunteer alone.
- **8.** Surely, there are other people who _____ will want to help.
- 9. How _____ she get them involved?
- **10.** She _____ spread the word, perhaps through e-mail.

PRACTICE 10 Using the Correct Tense

Fill in the blanks with the correct form of the verbs in parentheses, adding nelping verbs as needed. Refer to the verb charts if you need help. Answers may vary. Possible answers are shown. EXAMPLE: Many critics have argued (argue) that Citizen Kane,
directed by Orson Welles, is the greatest movie ever made.
1. You might not want to watch a movie from 1941, but Citizen Kane
will convince (convince) you to give older films a chance.
2. The story (begin) with the death of Charles Foster
Kane, who was once a powerful man.
3. By the time of his death, Kane had lost (lose) much of his
power.
4. Charles's parents were poor, but he <u>inherited</u> (inherit) a lot of
money as a child.
5. He also inherited a failing newspaper, <i>The Inquirer</i> , and
turned (turn) it into a success.
6. In the beginning, his marriage was also a success, but his wife divorced
him when she discovered that hewas having (have) an affair.
7. At the time of the discovery, Kane <u>was running</u> (run) for
governor.
8. Because of the scandal, he (lose) the election.
9. Kane's last word was "Rosebud." What could (can) he
have meant (mean) by that?
10. You <u>must watch</u> (watch) the movie to find out.
PRACTICE 11 Using the Correct Tense
Fill in the blanks with the correct form of the verbs in parentheses, adding helping verbs as needed. Refer to the verb charts if you need help.
EXAMPLE: Have you heard (hear) of volcano
boarding?
(1) In a November 5, 2002, article in National Geographic Today,
Zoltan Istvan <u>reported</u> (report) on a new sport: volcano boarding.
(2) Istvan first got (get) the idea in 1995, when he

was sailing (sail) past Mt. Yasur, an active volcano on an island off				
the coast of Australia. (3) For centuries, Mt. Yasur has had (have)				
the reputation of being a dangerous volcano. (4) For example, it regularly				
spits (spit) out lava bombs. (5) These large molten rocks				
have often struck (strike) visitors on the head.				
(6) There is a village at the base of Mt. Yasur. (7) When Istvan arrived				
with his snowboard, the villagers did not know				
(know) what to think. (8) He (make) his way to the				
volcano, hiked (hike) up the highest peak, and rode his board				
all the way down. (9) After he reached (reach) the bottom,				
Istvan admitted that volcano boarding is more difficult than snowboarding.				
(10) Luckily, no lava bombs fell (fall) from the sky,				
although the volcano <u>had erupted</u> (erupt) seconds before his descent.				
(11) Istvan hopes that this new sportwill become (become) popular				
with snowboarders around the world.				

Gerunds and Infinitives

A **gerund** is a verb form that ends in *ing* and acts as a noun. An **infinitive** is a verb form that is preceded by the word *to*. Gerunds and infinitives cannot be the main verbs in sentences; each sentence must have another word that is the main verb.

GERUND	Mike loves swimming.
	[Loves is the main verb, and swimming is a gerund.]
INFINITIVE	Mike loves to run.
	[Loves is the main verb, and to run is an infinitive]

How do you decide whether to use a gerund or an infinitive? The decision often depends on the main verb in a sentence. Some verbs can be followed by either a gerund or an infinitive.

	Can Be Follow rund or an Inf	[4] [1] [1] [1] [1] [1] [1] [1] [1] [1] [1	
begin	hate	remember	try
continue	like	start	
forget	love	stop	

TIP To improve your ability to write and speak standard English, read print or online articles, and listen to television and radio news programs. Also, reading articles aloud will help your pronunciation. Sometimes, using a gerund or an infinitive after one of these verbs results in the same meaning.

GERUND Joan likes **playing** the piano.

INFINITIVE Joan likes to play the piano.

Other times, however, the meaning changes depending on whether you use a gerund or an infinitive.

INFINITIVE Carla stopped helping me.

[This wording means Carla no longer helps me.]

GERUND Carla stopped to help me.

[This wording means Carla stopped what she was doing and

refuse

want

helped me.]

Verbs That Are Followed by a Gerund

admit discuss keep risk
avoid enjoy miss suggest
consider finish practice
deny imagine quit

The politician risked **losing** her supporters.

Sophia considered quitting her job.

Verbs That Are Followed by an Infinitive

agree decide need
ask expect offer
beg fail plan
choose hope pretend
claim manage promise

Aunt Sally wants to help.

Cal hopes to become a millionaire.

Do not use the base form of the verb when you need a gerund or an infinitive.

INCORRECT, BASE VERB Swim is my favorite activity. [Swim is the base form of the verb, not a noun; it cannot be the subject of the sentence.] CORRECT, GERUND Swimming is my favorite activity. [Swimming is a gerund that can be the subject of the sentence.] **INCORRECT, BASE VERB** My goal is graduate from college. My goal is graduating from college. **CORRECT, GERUND** My goal is to graduate from college. **CORRECT, INFINITIVE** I need stop at the store. **INCORRECT, BASE VERB** [Need is the verb, so there cannot be another verb that shows the action of the subject, I.] I need to stop at the store. **CORRECT, INFINITIVE**

PRACTICE 12 Using Gerunds and Infinitives

Read the paragraphs, and fill in the blanks with either a gerund or an infinitive as appropriate. Answers may vary. Possible answers are shown.

EXAMPLE: If you want ______ to be _____ (be) an actor, be aware that the profession is not all fun and glamour.

(1) When you were a child, did you pretend (be)
famous people? (2) Did you imagineplaying (play) roles in mov-
ies or on television? (3) Do you like to take (take) part in plays?
(4) If so, you might want to make (make) a career out of acting.
(5) Be aware of some drawbacks, however. (6) If you hate working (work) with others, acting may not be the career for you.
(7) Also, if you do not enjoy <u>repeating</u> (repeat) the same lines over and over, you will find acting dull. (8) You must practice <u>speaking</u>
(speak) lines to memorize them. (9) Despite these drawbacks, you will
gain nothing if you refuse to try (try). (10) Anyone who hopes to become (become) an actor has a chance at succeeding through
hard work and determination.

TEACHING TIP Have students submit (anonymously, if they prefer) paragraphs from one of their rough drafts. Then, copy and distribute the paragraphs, and, as a whole class, edit the paragraphs with attention to verb forms.

Articles

Articles announce a noun. English uses only three articles—a, an, and the—and the same articles are used for both masculine and feminine nouns.

Definite and Indefinite Articles

The is a **definite article** and is used before a specific person, place, or thing. A and an are **indefinite articles** and are used with a person, place, or thing whose specific identity is not known.

DEFINITE ARTICLE		The car crashed into the building.
		[A specific car crashed into the building.]
	INDEFINITE ARTICLE	A car crashed into the building.
		[Some car, we don't know which one exactly, crashed into the building.]

When the word following the article begins with a vowel (a, e, i, o, u), use an instead of a.

An old car crashed into the building.

To use the correct article, you need to know what count and non-count nouns are.

Count and Noncount Nouns

Count nouns name things that can be counted, and they can be made plural, usually by adding -s or -es. **Noncount nouns** name things that cannot be counted, and they are usually singular. They cannot be made plural.

COUNT NOUN/SINGULAR	$\underline{\underline{I}} \underline{\underline{got}}$ a ticket for the concert.
COUNT NOUN/PLURAL	$\underline{\underline{I}} \ \underline{\underline{got}} \ two \ \textbf{tickets} \ for the concert.$
NONCOUNT NOUN	The Internet has all kinds of information.
	[You would not say, The Internet has all kinds of informations.]

Here is a brief list of several count and noncount nouns. In English, all nouns are either count or noncount.

0011117	NONCOUNT		
COUNT	NONCOUNT		
apple/apples	beauty	grass	
chair/chairs	flour	grief	
dollar/dollars	furniture	happiness	

COUNT	NONCOUNT	
letter/letters	health	poverty
smile/smiles	homework	rain
tree/trees	honey	rice
	information	salt
	jewelry	sand
	mail	spaghetti
	milk	sunlight
	money	thunder
	postage	wealth

Use the chart that follows to determine when to use *a*, *an*, *the*, or no article.

COUNT NOUNS		ARTICLE USED
SINGULAR		
Specific	\rightarrow	the
		I want to read the book on taxes that you recommended.
		[The sentence refers to one particular book: the one that was recommended.]
		I cannot stay in the sun very long.
		[There is only one sun.]
Not specific	\rightarrow	a or an
		I want to read a book on taxes.
		[It could be any book on taxes.]
PLURAL		
Specific	\rightarrow	the
		I enjoyed the books that we read.
		[The sentence refers to a particular group of books: the ones that we read.]
Not specific	\rightarrow	no article or some
		I usually enjoy books .
		[The sentence refers to books in general.]
		She found some books.
		[I do not know which books she found.]

NONCOUNT NO	DUNS	ARTICLE USED
SINGULAR		
Specific	\rightarrow	the
		I put away the food that we bought.
		[The sentence refers to particular food: the food that we bought.]
Not specific	\rightarrow	no article or some
		There is food all over the kitchen.
		[The reader does not know what food the sentence refers to.]
		Give some food to the neighbors.
		[The sentence refers to an indefinite quantity of food.]

TEACHING TIP Have students, in small groups, create two separate lists: one of count nouns and the other of noncount nouns. Then, ask students to write two brief stories, each using all the words from one of the lists.

PRACTICE 13 Using Articles Correctly

social skills.

Fill in the correct article (a, an, or the) in each of the following sentences. If no article is needed, write "no article."

EXAMPLE: Children who go to _____ no article ____ preschool have several advantages over those who do not.

- 1. First, _____ good preschool will help students learn about letters and numbers. 2. These skills can make _____ big difference when preschoolers move on to kindergarten. the **3.** Research shows that ____ ____ prereading and math skills of children who have attended preschool are stronger than those of kids who have not. **4.** Additionally, preschoolers learn everyday information, such as the names of the days of the week. **5.** But ___
- **6.** Children who have spent most of their time at _____ no article home might be uncomfortable with other kids.

___ biggest advantage of preschool is that it teaches

- 7. For example, they might cry when they are asked to share
- **8.** Preschool teaches children how to share, take turns, and enjoy ______ no article____ others' company.
- **9.** By the time preschooled children enter kindergarten, they are used to being part of _____ a ___ classroom.
- **10.** Also, they have learned how to be more independent from their parents or ______ no article _____ other caretakers.

Prepositions

A **preposition** is a word (such as *of, above, between*, or *about*) that connects a noun, pronoun, or verb with information about it. The correct preposition to use is often determined by common practice rather than by the preposition's actual meaning.

TIP For more on prepositions, see Chapter 19.

Prepositions after Adjectives

Adjectives are often followed by prepositions. Here are some common examples.

afraid of full of scared of
ashamed of happy about sorry about/sorry for
aware of interested in tired of
confused by proud of
excited about responsible for

Peri is afraid to walking alone.

About
We are happy of Dino's promotion.

Prepositions after Verbs

Many verbs consist of a verb plus a preposition. The meaning of these combinations is not usually the meaning that the verb and the preposition would each have on its own. Often, the meaning of the verb changes completely depending on which preposition is used with it.

You must **take out** the trash. [take out = bring to a different location]
You must **take in** the exciting sights of New York City. [take in = observe]

Here are a few common verb/preposition combinations.

call in (telephone) You can call in your order. call off (cancel) They called off the party. call on (ask for a response) The teacher always calls on me. drop in (visit) *Drop in* the next time you are around. drop off (leave behind) Juan will drop off the car for service. drop out (quit) Many students drop out of school. fight against (combat) He tried to fight against the proposal. fight for (defend) We will fight for our rights. fill out (complete) Please fill out the form. Do not fill up with junk food. fill up (make full) find out (discover) Did you find out the answer? give up (forfeit) Do not give up your chance to succeed. go by (visit, pass by) I may go by the store on my way home. go over (review) Please go over your notes before the

All children grow up.

Please hand in your homework.

Seeing Preposition Errors

grow up (mature)

hand in (submit)

No Eating on This Area

write As the editing of this sign shows, *in* is the correct preposition to use when referring to someone or something *within* a particular place or enclosure (the clerk in the store, the papers in the box). On is used to refer to something on a surface (the teapot on the table, the picture on the wall). Write two sentences that use *in* correctly and two sentences that use *on* correctly.

lock up (secure) Lock up the apartment before leaving.

look up (check) Look up the meaning in the

dictionary.

pick out (choose) Pick out a good apple.

pick up (take or collect) Please pick up some drinks.

put off (postpone) Do not put off starting your paper.

sign in (register) Sign in when you arrive.

sign out (borrow) You can sign out a book from the

library.

sign up (register for) I want to sign up for the contest.

think about (consider) Simon thinks about moving.

turn in (submit) Please turn in your homework.

PRACTICE 14 Editing Paragraphs for Preposition Problems

Edit the following paragraphs to make sure the correct prepositions are used.

EXAMPLE: At some point, many people think out having a more flexible work schedule.

- (1) If they are responsible in child care, they might want to get home from work earlier than usual. (2) Or they might be interested on having one workday a week free for studying or other activities. (3) Employees shouldn't be afraid to asking a supervisor about the possibility of a flexible schedule. (4) For instance, the supervisor might be very willing to allow the employee to do 40 hours of work in four days instead of five days. (5) Or a worker who wants to leave a little earlier than usual might give out half of a lunch hour to do so.
- (6) The wide use of computers also allows for flexibility. (7) For example, busy parents might use their laptops to work from home a day or two a week. (8) They can stay in touch with the office by e-mailing supervisors or coworkers, or they might call on.
- (9) Often, employers who allow more flexibility find in that they benefit, about too. (10) Workers are happy on having more control over their own time; therefore, they are less stressed out and more productive than they would have been on a fixed schedule.

Chapter Review

LEARNING JOURNAL Did you find errors in your writing? Record the types of errors in your learning journal, and review them before you edit your own writing.

- What is a pronoun? a word that replaces a noun or another pronoun
 What are the three types of pronouns in English? subject, object,
 possessive
- 2. Rewrite this sentence in the simple past and the simple future.
 Melinda picks flowers every morning.
 Past: Melinda picked flowers yesterday. (or another past time)
 Future: Melinda will pick flowers tomorrow. (or another future time)
- 3. Rewrite this sentence so that it uses the perfect tense correctly.

 They have call an ambulance.

 They have called an ambulance.
- 4. Using the progressive tenses, first rewrite this sentence as a question. Then, rewrite the question in the past tense and in the future tense. Chris is learning Spanish.

Question: Is Chris learning Spanish?

Past: Was Chris learning Spanish?

Future: Will Chris be learning Spanish?

- Fewrite these sentences so that they use the modal verb correctly. Jennifer should to help her mother. Jennifer should help her mother. Yesterday, I cannot work.
 Yesterday, I could not work.
- What is a gerund? a verb form that ends in "-ing" and acts as a noun

 Write a sentence with a gerund in it. Answers will vary.
- What is an infinitive? a verb form that is preceded by the word "to"

 Write a sentence with an infinitive in it. Answers will vary.
- **8.** Give an example of a count noun. Answers will vary. Give an example of a noncount noun. Answers will vary.
- **9.** What is a preposition? <u>a word that connects a noun, pronoun, or verb</u> with information about it

Write a sentence using a preposition. Answers will vary.

RESOURCES The Testing Tool Kit CD-ROM available with this book has even more tests on ESL trouble spots. Also, for cumulative Editing Review Tests, see pages

609-18.

Chapter Test

Circle the	correct	choice	for	each	of the	following	items
Oll Old Lillo	COLLECT	CHOICE	101	Cacil	OI LIIC	TOHOWING	ILCITIO.

ircl	e the correct choice for	or each of the following	items.
1.	Choose the correct v	word(s) to fill in the bla	ank.
	You need	me if you ha	ve a problem.
	a. telling	b. to tell	c. told
2.	Choose the sentence	that has no errors.	
	a. I have been written never heard back		three times, but I have
	b. I have been written never heard back		three times, but I have
	c. I have written to heard back from		e times, but I have never
3.	Choose the sentence	that has no errors.	
	(a.) I walked 5 miles	yesterday.	
	b. I walk 5 miles ye		
	c. I walking 5 miles	s yesterday.	
1	Channatha agus at	word to fill in the blank	
٠.	Choose the correct v	void to iii iii the blair	
	In January, they	to vac	cation in Florida.
	a. going	b. is going	c. are going
5.	_	tion of this sentence is ntence is correct as wr	incorrect, select the revision itten, choose d.
	Pasquale might to	get a job at his father $\overline{\mathbf{B}}$'s construction business.
	a. might	c. constr	ructing
	b. on	d. No ch	nange is necessary.
6.	Choose the correct v	word to fill in the blank	ς.
	Elena tells the funnlaugh.	iest jokes	always makes me
	a. Her	b. Him	C. She

7.	Ch	oose the sentence that is in	the c	correct order.
	a.	One pound of chocolate I	ate la	last week.
	b.)	I ate one pound of chocola	ite las	ast week.
	_	Chocolate one pound I ate		
8.		n underlined portion of this t fixes it. If the sentence is o		ntence is incorrect, select the revision ect as written, choose d.
	Th	$\frac{\text{e}}{\mathbf{B}}$ of our employee	s is v	very important.
	a.	A	c.	• were
	b.	health	d.	1. No change is necessary.
9.	Ch	oose the sentence that has r	no eri	errors.
	(a.)	Was it snowing when you g	got to	to the mountain?
	b.	Snowing it was when you g	got to	to the mountain?
	c.	When you got to the mour	ntain,	n, snowing it was?
10.	Ch	oose the correct word to fill	l in th	the blank.
	Be	cause it rained, we called		the picnic.
	a.	on b. ir	1	c.) off

THIS CHAPTER

- explains two resources for finding words and their meanings.
- explains four common wordchoice problems and gives you practice avoiding them.

3

Word Choice

Using the Right Words

Understand the Importance of Choosing Words Carefully

In conversation, you show much of your meaning through facial expression, tone of voice, and gestures. In writing, you have only the words on the page to make your point, so you must choose them carefully. If you use vague or inappropriate words, your readers may not understand you.

Two resources will help you find the best words for your meaning: a dictionary and a thesaurus.

RESOURCES Additional Resources contains tests and supplemental practice exercises for this chapter.

Dictionary

Dictionaries give you all kinds of useful information about words: spelling, division of words into syllables, pronunciation, parts of speech, other forms of words, definitions, and examples of use. Following is a sample dictionary entry.

TIP A number of good dictionaries are now available free online. An excellent resource is at www.dictionary.com.

Spelling and end-of-line division Pronunciation

Parts of Other speech forms

con • crete (kon'krēt, kong'-, kon-krēt'), adj., n., v. -cret • ed, -cret • ing, adj. 1. constituting an actual thing or instance; real; perceptible; substantial: concrete proof. 2. pertaining to or concerned with realities or actual instances rather than abstractions; particular as opposed to general: concrete proposals. 3. referring to an actual substance or thing, as opposed to an abstract quality: The words cat, water, and teacher are concrete, whereas the words truth, excellence, and adulthood are abstract.

— Random House Webster's College Dictionary

Definition Example

ESL ESL students may want to use a dictionary written especially for nonnative speakers (such as the Longman Dictionary of American English) in addition to a standard English dictionary.

Thesaurus

TIP To look up words online in both a dictionary and a thesaurus, go to the free online resource www .merriam-webster.com. A thesaurus gives **synonyms** (words that have the same meaning) for the word you look up. Use a thesaurus when you cannot find the right word for what you mean. Be careful, however, to choose a word that has the precise meaning you intend. Following is a sample thesaurus entry.

Concrete, *adj.* 1. Particular, specific, single, certain, special, unique, sole, peculiar, individual, separate, isolated, distinct, exact, precise, direct, strict, minute; definite, plain, evident, obvious; pointed, emphasized; restrictive, limiting, limited, well-defined, clear-cut, fixed, finite; determining, conclusive, decided.

—J. I. Rodale, The Synonym Finder

Practice Avoiding Four Common Word-Choice Problems

Four common problems with word choice may make it hard for readers to understand your point.

TIP For tools to build your vocabulary, visit the Student Site for Real Writing at bedfordstmartins.com/realwriting. Also, try the word games at www.dictionary.com.

Vague and Abstract Words

Vague and abstract words are too general. They do not give your readers a clear idea of what you mean. Here are some common vague and abstract words.

COMPUTER Tell students that they can use a computer's search or find function to locate these words in their own writing.

Vague and A	Abstract Words		
a lot	cute	nice	stuff
amazing	dumb	OK (okay)	terrible
awesome	good	old	thing
bad	great	pretty	very
beautiful	happy	sad	whatever
big	huge	small	young

TEACHING TIP Take students to a spot on campus, and have each student write a description of the same scene. Then, have them compare what they wrote, noting the use of concrete and specific language as well as of vague and abstract words.

When you see one of these words or another general word in your writing, replace it with a concrete or more specific word or description. A **concrete** word names something that can be seen, heard, felt, tasted, or smelled. A **specific** word names a particular person or quality. Compare these two sentences:

VAGUE AND ABSTRACT

An old man crossed the street.

CONCRETE AND SPECIFIC

An eighty-seven-year-old priest stumbled along Main Street.

The first version is too general to be interesting. The second version creates a clear, strong image. Some words are so vague that it is best to avoid them altogether.

VAGUE AND ABSTRACT

It is awesome.

[This sentence is neither concrete nor specific.]

PRACTICE 1 Avoiding Vague and Abstract Words

In the following sentences, underline any words that are vague or abstract. Then, edit each sentence by replacing the vague or abstract words with concrete, specific ones. You may invent details or base them on brief online research into physician assistant careers. Answers may vary. Possible edits are shown.

EXAMPLE: It would be <u>cool</u> to be a physician assistant (PA). <u>It would</u> be rewarding to be a physician assistant (PA).

- 1. I am drawn to this career because it would let me do neat things for others. I am drawn to this career because it would let me help others by providing them with medical care.
- 2. I know that becoming a PA would require tons of work. I know that becoming a PA would require years of study and practice with patients.
- 3. Also, each day in the classroom or clinic would be long. Also, each day in the classroom or clinic would last 10 to 12 hours.
- 4. Furthermore, I would have to be able to tolerate some rough sights.

 furthermore, I would have to be able to tolerate the sight of blood and injuries.
- 5. However, I would learn a lot. However, I would learn how to examine patients and how to diagnose and treat various conditions.
- 6. And in meetings with patients, I would be able to apply my great listening skills. And in meetings with patients, I would be able to apply my ability to listen to others carefully.
- All this stuff would be interesting. My time in the classroom or with patients would be interesting.
- 8. I am confident that my PA education would have a good outcome.

 I am confident that my PA education would help me get a job soon after graduation.
- 9. Also, my starting salary would be decent. Also, my starting salary would be at least \$60,000 a year.

TIP For more practice on choosing words effectively, visit *Exercise Central* at **bedfordstmartins.com/** realwriting.

10. Getting accepted into a PA program would be awesome. Getting accepted into a PA program would help me get started on a career that I would love.

Slang

TEAMWORK Students can collaborate to list slang words and then translate them into formal English.

Slang, informal and casual language, should be used only in informal situations. Avoid it when you write, especially for college classes or at work. Use language that is appropriate for your audience and purpose.

SLANG	EDITED
S'all good.	Everything is going well.
Dawg, I don't deserve this grade.	Professor, I don't deserve this grade.

PRACTICE 2 Avoiding Slang

In the following sentences, underline any slang words. Then, edit the sentences by replacing the slang with language appropriate for a formal audience and purpose. Imagine that you are writing to a boss where you work. Answers may

EXAMPLE: $\frac{\text{Hello}}{A}$, Randy, I need to talk $\frac{\text{to}}{A}$ you for a minute.

- helpful and much appreciated

 1. That reference letter you wrote for me was really awesome sweet.
- 2. I am grateful because the one my English instructor did for me sucked.
- **3.** She said that I thought I was all that, but that is not true.
- 4. I would be down with doing a favor for you in return if you need it.

 spend time together
- **5.** Maybe you and I could hang sometime one of these weekends?
- 6. I know that we cannot be best buds, but we could shoot some hoops or something.
- what you have planned
 7. You could let me know whazzup when I see you at work next week.
- **8.** If you are too stressed, do not go all emo on me.
- relax

 9. Just chill out, and forget about it.
- 10. Contact a chance Text me when you get a mo.

Wordy Language

People sometimes use too many words to express their ideas. They may think that using more words will make them sound smart, but too many words can weaken a writer's point. **WORDY** I am not interested at this point in time.

EDITED I am not interested now.

[The phrase at this point in time uses five words to express what

could be said in one word: now.]

WORDY	EDITED
As a result of	Because
Due to the fact that	Because
In spite of the fact that	Although
It is my opinion that	I think (or just make the point)
In the event that	If
The fact of the matter is that	(Just state the point.)
A great number of	Many
At that time	Then
In this day and age	Now
At this point in time	Now
In this paper I will show that	(Just make the point; do not announce it.
Utilize	Use

COMPUTER Students can use a computer's search or find function to locate these phrases (or others like them) in their writing.

PRACTICE 3 Avoiding Wordy Language

In the following sentences, underline the wordy or repetitive language. Then, edit each sentence to make it more concise. Some sentences may contain more than one wordy phrase. Answers may vary. Possible edits are shown.

EXAMPLE: Sugar substitutes are a popular diet choice for people reduce

of all ages when they are searching for ways to each day on all the calories they ingest on a daily basis.

- 1. It is a well-known fact that dieting is difficult for most people.

 Because
- 2. Due to the fact that people are trying to cut calories, sugar substitutes are used in sodas, snacks, and other products.
- These

 The fact of the matter is that these substitutes provide a sweet taste, but without the calories of sugar or honey.

 Many
- 4. A great number of researchers have stated at this time that such substitutes are not necessarily safe or healthy to use in large quantities.

- Some of the current experts on the matter are of the opinion that sugar substitutes can cause cancer, allergies, and other serious health problems.
- 6. At this point in time, other experts on the same subject believe that using these substitutes maintains a person's addiction to sugar and leads people to eat more junk food.
- 7. Despite these warnings/negative evaluations, and critical opinions from the experts, nearly 200 million people consume sugar-free or low-calorie products each year.
- People

 In this day and age, people are consuming an average of four of these items each day.
- 9. Although
 In spite of the fact that people know sugar is bad for them, their tastes soon will probably not change anytime in the near future.
- 10. It is my opinion that it would be better if people just learned to consume foods that do not contain sweeteners of any kind.

Clichés

Clichés are phrases used so often that people no longer pay attention to them. To get your point across and to get your readers' attention, replace clichés with fresh and specific language.

CLICHÉS	EDITED
I cannot make ends meet.	I do not have enough money to live on.
My uncle worked his way up the corporate ladder.	My uncle started as a shipping clerk but ended up as a regional vice president.
This roll is as hard as a rock.	This roll is so hard I could bounce it.

COMPUTER Students can use a computer's search or find function to locate these phrases (or others like them) in their writing.

Common Clichés		
as big as a house	few and far between	spoiled brat
as light as a feather	hell on earth	starting from scratch
better late than never	last but not least	sweating blood/bullets
break the ice	no way on earth	too little, too late
crystal clear	110 percent	24/7
a drop in the bucket	playing with fire	work like a dog
easier said than done		

TIP Hundreds of clichés

exist. To check if you have used one, go to

www.clichesite.com.

PRACTICE 4 Avoiding Clichés

In the following sentences, underline the clichés. Then, edit each sentence by replacing the clichés with fresh and specific language. Answers will vary. Possible edits are shown.

excruciating excruciating a bicycle 100 miles a day can be hell on earth work extremely hard unless you are willing to give 110 percent.

devote every bit of your strength to the challenge 1. You have to persuade yourself to sweat blood and work like a dog for

up to 10 hours.

It is impossible to

There's no way on earth you can do it without extensive training.

the very last mile, an enormously di

3. Staying on your bike until the bitter end, of course, is easier said than task done.

Maintain your determination
4. It is important to keep the fire in your belly and keep your goal of finalways present ishing the race erystal clear in your mind.

5. No matter how long it takes you to cross the finish line, remind your-finishing at all is a tremendous achievement self that it's better late than never.

6. Even if you are not a champion racer, training for a bike race will keep in top physical condition you fit as a fiddle.

7. It may take discipline to make yourself train, but you should keep your to work hard nose to the grindstone.

8. Bike racers should always protect themselves play it safe by wearing helmets.

* watch carefully

9. When you train for road racing, keep an eye peeled for cars.

You do not want to end up flat on your back in the hospital or killed in the hospital or winder!

A FINAL NOTE: Language that favors one gender over another or that assumes that only one gender performs a certain role is called *sexist*. Such language should be avoided.

TIP See Chapter 24 for more advice on using pronouns.

SEXIST

A doctor should politely answer his patients' questions.

[Not all doctors are male, as suggested by the pronoun his.]

REVISED

A doctor should politely answer *his or her* patients' questions.

Doctors should politely answer their patients' questions.

[The first revision changes his to his or her to avoid sexism. The second revision changes the subject to a plural noun (*Doctors*) so that a genderless pronoun (*their*) can be used. Usually, it is preferable to avoid his or her.]

Edit for Word Choice

PRACTICE 5 Editing Paragraphs for Word Choice

Find and edit six examples of vague or abstract language, slang, wordy language, or clichés in the following paragraphs. Answers may vary. Possible edits are shown.

most unusual

- (1) Imagine spending almost two weeks living in the coolest home in the world. (2) That is what scientist Lloyd Godson did when he lived at the bottom of a lake in Australia for thirteen days. (3) While there is no way on not earth I would want to do that, it sure sounds fascinating.
- (4) Godson's home was an 8-by-11-foot-long yellow steel box that he dubbed the BioSUB. (5) His air supply came from the algae plants grow-supplies ing inside the BioSUB. (6) Divers brought him food, water, and other junk through a manhole built in the bottom of his underwater home. (7) To keep busy, he rode on an exercise bicycle, which created electricity for him to recharge his laptop and run the lights for his plants. (8) He used his computer to talk to students all over the world and to watch movies.
- (9) Godson paid for this experiment with money he had won in the "Live Your Dream" contest. (10) At this point in time, I have to say that for for most people, the BioSUB home would be less appealing than a regular, aboveground room, apartment, or house. (11) Indeed, by the time his two weeks were over, Godson was ready to come up/feel the sunshine and wind on his face again/and "smell the roses."

PRACTICE 6 Editing Your Own Writing for Word Choice

Edit a piece of your own writing for word choice. It can be a paper for this course or another one, or something you have written for work or your every-day life. You may want to use the chart on page 544.

Chapter Review

- 1. What two resources will help you choose the best words to get your ideas across in writing? a dictionary and a thesaurus
- 2. What are four common word-choice problems? <u>vague and abstract</u> words, slang, wordy language, and clichés

you find problems with word choice in your writing? What is the main thing you have learned about word choice that will help you? What is unclear to you?

3.	Replace vague and abstract words with concrete and						
	specific words.						
4.	When is it appropriate to use slang in college writing or in writing at work?						
5.	Give two examples of wordy expressions. Answers will vary.						
	The state of the s						
Ch	napter Test						
	each of the following items, choose words or sentences that are specific						
anu	appropriate for a formal (academic or work) audience.						
1.	Choose the item that uses words most effectively.						
	a. My dorm is just an OK place to study.						
	b. My dorm is so noisy and full of activity that it is difficult to study						
	there.						
	c. My dorm is not where I go when I want to study.						
2.	Choose the best words to fill in the blank.						
	I am afraid that all your hand work did not						
	I am afraid that all your hard work did not						
	a. solve our problem b. do the trick c. do it for us						
2							
3.	Choose the best word(s) to fill in the blank.						
	Kevin was extremely about his new job.						
	a. juiced b. turned on (c.) enthusiastic						
	a. juiced b. turned on (c.) enthusiastic						
4.	Choose the item that uses words most effectively.						
	a. I like that thing Nikki does whenever she scores a goal.						
	b. I like the way Nikki goes nuts whenever she scores a goal.						
	c. I like the way Nikki does a backflip whenever she scores a goal.						
_	Change the item that were words most offertively						
5.	Choose the item that uses words most effectively.						
	a. In the event that you are ever in River City, stop by to see me. (b) If you are ever in Piver City, stop by to see me.						
	(b.) If you are ever in River City, stop by to see me.						
	c. If by chance you are ever in River City, stop by to see me.						

TEACHING TIP You can collect students' learning journals to find out what the class or individual students need more work on.

RESOURCES The Testing Tool Kit CD-ROM available with this book has even more tests on word choice. Also, for cumulative Editing Review Tests, see pages 609–18.

THIS CHAPTER

- gives you twenty-seven sets of commonly confused words.
- explains what the words mean and how they should be used.
- gives you practice using them correctly.

Commonly Confused Words

Avoiding Mistakes with Soundalike Words

Understand Why Certain Words Are Commonly Confused

People often confuse certain words in English because they sound alike and may have similar meanings. In speech, words that sound alike are not a problem. In writing, however, words that sound alike may be spelled differently, and readers rely on the spelling to understand what you mean. Edit your writing carefully to make sure you have used the correct words.

RESOURCES Additional Resources contains tests and supplemental exercises for this chapter.

- **Proofread carefully**, using the techniques discussed on page 558.
- Use a dictionary to look up any words you are unsure about.
- **Focus on finding and correcting mistakes** you make with the twenty-seven sets of commonly confused words covered in this chapter.
- Develop a personal list of soundalike words you confuse often. In your learning journal, record words that you confuse in your writing and their meanings. Before you turn in any piece of writing, consult your personal word list to make sure you have used words correctly.

Practice Using Commonly Confused Words Correctly

Study the different meanings and spellings of these twenty-seven sets of commonly confused words. Complete the sentence after each set of words, filling in each blank with the correct word.

TIP Some commonly confused words sound similar but not exactly alike, such as conscience and conscious, loose and lose, and of and have. To avoid confusing these words, practice pronouncing them correctly.

TIP For tools to build your vocabulary, visit the Student Site for Real Writing at bedfordstmartins.com/realwriting. Also, try the word games at www.dictionary.com.

A/AN/AND

a: used before a word that begins with a consonant sound A friend of mine just won the lottery.

an: used before a word that begins with a vowel sound An old friend of mine just won the lottery.

and: used to join two words

My friend and I went out to celebrate.

A friend and I ate at an Italian restaurant.

Other lottery winners were ______ an ____ algebra teacher _____ and a ____ bowling team.

ACCEPT / EXCEPT

accept: to agree to receive or admit (verb)

I will accept the job offer.

except: but, other than

All the stores are closed except the Quik-Stop.

I accept all the job conditions except the low pay.

Do not _____ gifts from clients _____ those who are also personal friends.

TIP For more practice using commonly confused words correctly, visit Exercise Central at bedfordstmartins.com/realwriting.

ADVICE/ADVISE

advice: opinion (noun)

I would like your advice before I make a decision.

advise: to give an opinion (verb)

Please advise me what to do.

Please advise me what to do; you always give me good advice.

If you do not like my ________, please _______ me how to proceed.

AFFECT/EFFEÇT

affeet: to make an impact on, to change something (verb)

The whole city was affected by the hurricane.

effect: a result (noun)

What *effect* will the hurricane have on the local economy?

Although the storm will have many negative *effects*, it will not *affect* the price of food.

The_	effect	of the disaster will	affect	many people.

TIP Thinking "the effect" will help you remember that effect is a noun.

are: a form of the verb be

The workers are about to go on strike.

our: a pronoun showing ownership

The children played on our porch.

My relatives are staying at our house.

Our new neighbors are moving in today.

TEACHING TIP It is helpful to complete these sentences as a class or to assign them as homework and then go over them in class. Have students read the sentences aloud so that they can focus on differences in pronunciation.

BY/BUY/BYE

by: next to, before, or past

Meet me by the entrance.

Make sure the bill is paid by the fifteenth of the month.

The motorcycle raced by me.

buy: to purchase (verb)

I would like to buy a new laptop.

bye: an informal way to say goodbye

"Bye, Grandma!"

Seeing Commonly Confused Words

write What error do you see in this sign? Write a sentence that uses by, buy, and bye correctly.

I said "	Bye	" from the window as we drove
by	our friends, who were standing next to the ho	
I wanted to	Ь	ıy

TIP Remember that one of the words is *con-science*; the other is not.

CONSCIENCE/CONSCIOUS

conscience: a personal sense of right and wrong (noun)

Jake's conscience would not allow him to cheat.

conscious: awake, aware (adjective)

The coma patient is now conscious.

I am conscious that it is getting late.

The judge was *conscious* that the accused had acted according to his *conscience* even though he had broken the law.

The man said that he was not <u>conscious</u> that what he had done was illegal, or his <u>conscience</u> would not have let him do it.

FINE/FIND

fine: of high quality (adjective); feeling well (adjective); a penalty for breaking a law (noun)

This jacket is made of fine leather.

After a day in bed, Jacob felt fine.

The fine for exceeding the speed limit is \$50.

find: to locate, to discover (verb)

Did Clara find her glasses?

I find gardening to be a fine pastime.

Were you able to ______ find _____ a place to store your _____ fine _____ jewelry?

TS/IT'S

its: a pronoun showing ownership

The dog chased its tail.

it's: a contraction of the words it is

It's about time you got here.

It's very hard for a dog to keep its teeth clean.

______ no surprise that the college raised _____ its tuition.

TIP If you are not sure whether to use *its* or *it's* in a sentence, try substituting *it is*. If the sentence does not make sense with *it is*, use *its*.

Seeing Commonly Confused Words

write What error do you see in this sign? What other types of errors have you noticed on signs, on television, in newspapers or magazines, or in online content?

KNEW/NEW/KNOW/NO

knew: understood; recognized (past tense of the verb *know*)

I knew the answer, but I could not think of it.

new: unused, recent, or just introduced (adjective)

The building has a new security code.

know: to understand; to have knowledge of (verb)

I know how to bake bread.

no: used to form a negative

I have no idea what the answer is.

I never knew how much a new car costs.

Thealready.	new	teacher	knew	many of he	er students
There is Celia is hid	no	way To	m could	know	_ where
I kno		that there is	no	cake left.	

LOOSE/LOSE

In hot weather, people tend to wear loose clothing.

lose: to misplace; to forfeit possession of (verb)

Every summer, I lose about three pairs of sunglasses.

If the ring is too loose on your finger, you might lose it.

I lose my patience with the loose rules on

MIND/MINE

Wall Street.

mind: to object to (verb); the thinking or feeling part of one's brain (noun)

Toby does not mind if I borrow his tool chest.

Estela has a good mind, but often she does not use it.

mine: belonging to me (pronoun); a source of ore and minerals (noun)

That coat is mine.

My uncle worked in a coal mine in West Virginia.

That writing problem of mine was on my mind.

If you do not ______, the gloves you just took are mine

OF/HAVE

of: coming from; caused by; part of a group; made from (preposition)

The leader of the band played bass guitar.

have: to possess (verb; also used as a helping verb)

I have one more course to take before I graduate.

I should have started studying earlier.

The president of the company should have resigned.

Sidney could <u>have</u> been one <u>of</u> the winners.

NOTE: Do not use of after would, should, could, and might. Use have after those words (would have, should have).

PASSED/PAST

passed: went by or went ahead (past tense of the verb *pass*)

We *passed* the hospital on the way to the airport.

	past: time that has gone by (noun); gone by, over, just beyond (preposition)
	In the past, I was able to stay up all night and not be tired.
	I drove past the burning warehouse.
	This past school year, I passed all my exams.
	Trishpassed me as we ranpast the 1-mile marker.
E	ACE/PIECE
	peace: no disagreement; calm
	Could you quiet down and give me a little peace?
	piece: a part of something larger
	May I have a piece of that pie?
	The feuding families found <i>peace</i> after they sold the <i>piece</i> of land.
	To keep the, give your sister a of
	candy.
PR	INCIPAL/PRINCIPLE
	principal: main (adjective); head of a school or leader of an organization (noun)
	Brush fires are the principal risk in the hills of California.
	Ms. Edwards is the principal of Memorial Elementary School.
	Corinne is a principal in the management consulting firm.
	principle: a standard of beliefs or behaviors (noun)
	Although tempted, she held on to her moral principles.
	The principal questioned the delinquent student's principles.
	Theprincipal problem is that you want me to act against myprinciples
วบ	IET/QUITE/QUIT
	quiet: soft in sound; not noisy (adjective)
	The library was quiet.
	quite: completely; very (adverb)
	After cleaning all the windows, Alex was quite tired.
	quit: to stop (verb)
	She quit her job.
	After the band quit playing, the hall was quite quiet.
	If you would quit shouting and he quiet

quite

_ pleasant.

you would find that the scenery is ___

COMPUTER Tell students that although a spell checker won't help them with the spelling of most of these words, they can use the search or find function to find every instance of the words they have trouble with.

RIGHT/WRITE

right: correct; in a direction opposite from left (adjective)

You definitely made the right choice.

When you get to the stoplight, make a right turn.

write: to put words on paper (verb)

Will you write your phone number for me?

Please write the right answer in the space provided.

You were <u>right</u> to <u>write</u> to the senator.

SET/SIT

set: a collection of something (noun); to place an object somewhere (verb)

Paul has a complete set of Johnny Cash records.

Please set the package on the table.

sit: to rest in a chair or other seatlike surface; to be located in a particular place

I need to sit on the sofa for a few minutes.

The shed sits between the house and the garden.

If I sit down now, I will not have time to set the plants outside.

Before you ______ on that chair, _____ the magazines on the floor.

SUPPOSE/SUPPOSED

suppose: to imagine or assume to be true

I suppose you would like something to eat.

Suppose you won a million dollars.

supposed: past tense of suppose; intended

Karen *supposed* Thomas was late because of traffic.

I suppose you know that Rita was supposed to be home by 6:30.

I <u>suppose</u> you want to leave soon because we are supposed to arrive before the guests.

THAN/THEN

than: a word used to compare two or more people, places, or things It is colder inside *than* outside.

then: at a certain time; next in time

I got out of the car and then realized the keys were still in it.

Clara ran more miles than she ever had before, and then she collapsed.

TIP If you are not sure whether to use *their* or *they're*, substitute *they are*. If the sentence does not make

sense, use their.

Back	then	, I smoked n	nore	than	three packs
a day.					
HEIR/THE	RE/THEY	RE			
their: a p	oronoun sh	nowing ownersh	ip		
I born	owed their	clippers to trin	n the hedge	es.	
there: a	word indic	cating location o	r existence		
Just p	ut the key	s there on the de	esk.		
There	are too m	any lawyers.			
they're:	a contract	ion of the words	s they are		
They'	re about to	leave.			
There is a	car in their	driveway, which	indicates t	hat they'	re home.
The	, ,	each house is en	npty except there	for the o	one week that
HOUGH/TH	IROUGH/	THREW			
though:	however; r	nevertheless; in	spite of (co	njunctio	on)
Thoug	gh he is she	ort, he plays gre	at basketba	all.	
through: (prepositi		with (adjective);	from one	side to th	ne other
I am	through arg	guing with you.			
The b	baseball we	ent right through	the windo	w.	
threw: h	urled; toss	ed (past tense o	f the verb	throw)	
She th	hrew the ba	asketball.			
Even thou		legal, she threw t	he empty c	up <i>throug</i>	gh the window
Thou thre	011	e did not really beenny through			g good luck, Jan he fountain.
~					
0/T00/TV	vo				
	d indicating	ng a direction or of a verb	· movemen	t (prepo	sition); part of
Please	e give the	message to Shar	on.		
It is e	asier to asl	x for forgiveness	than to ge	t permis	sion.
too: also;	more than	n enough; very	(adverb)		
I am	tired too.				
Dan a	ate too mu	ch and felt sick.			

That dream was too real.

two: the number between one and three (noun)

The lab had only two computers.

They went to a restaurant and ordered too much food for two people.

When Marty went ______ to ____ pay for his meal, the cashier charged him _____ two ____ times, which was _____ too ____ bad.

USE/USED

use: to employ or put into service (verb)

How do you plan to use that blueprint?

used: past tense of the verb *use. Used to* can indicate a past fact or state, or it can mean "familiar with."

He used his lunch hour to do errands.

He used to go for a walk during his lunch hour.

She *used* to be a chef, so she knows how to *use* all kinds of kitchen gadgets.

She is also used to improvising in the kitchen.

Tom ______ the prize money to buy a boat; his family hoped he would _____ the money for his education, but Tom was _____ to getting his way.

WHO'S / WHOSE

who's: a contraction of the words who is

Who's at the door?

whose: a pronoun showing ownership

Whose car is parked outside?

Who's the person whose car sank in the river?

The student _____ whose ____ name is first on the list is the one _____ who's ____ in charge.

YOUR/YOU'RE

your: a pronoun showing ownership

Did you bring your wallet?

you're: a contraction of the words you are

You're not telling me the whole story.

You're going to have your third exam tomorrow.

Your teacher says that you're good with numbers.

TIP Writing use to instead of used to is a common error. Train yourself not to make that mistake.

TIP If you are not sure whether to use whose or who's, substitute who is. If the sentence does not make sense, use whose.

TIP If you are not sure whether to use *your* or *you're*, substitute *you are*. If the sentence does not make sense, use *your*.

Edit for Commonly Confused Words

PRACTICE 1 Editing Paragraphs for Commonly Confused Words

Edit the following paragraphs to correct eighteen errors in word use.

selves for protection.

- (1) More and more women are purchasing handguns, against the advise of law enforcement officers. (2) Few of these women are criminals or plan accept to commit crimes. (3) They no the risks of guns, and they except those risks.

 (4) They buy weapons primarily because their tired of feeling like victims.

 (5) They do not want to contribute too the violence in are society, but they also realize that women are the victims of violent attacks far to often.

 lose their

 (6) Many women loose they're lives because they cannot fight off there conscious attackers. (7) Some women have made a conscience decision to arm them-
- (8) But does buying a gun make things worse rather then better?

 (9) Having a gun in you're house makes it three times more likely that someone will be killed there—and that someone is just as likely to be you or one of your children as a criminal. (10) Most young children cannot tell the find difference between a real gun and a toy gun when they fine one. (11) Every there year, their are tragic examples of children who accidentally shoot and even whose kill other youngsters while they are playing with guns. (12) A mother who's children are injured while playing with her gun will never again think that a peace gun provides piece of mind. (13) Reducing the violence in are society may be a better solution.

PRACTICE 2 Editing Your Own Writing for Commonly Confused Words

Edit a piece of your own writing for commonly confused words. It can be a paper for this course or another one, or something you have written for work or your everyday life.

TEACHING TIP Ask students for a few more commonly confused words. Start them off by putting one set on the board; then, list others they suggest.

Chapter Review

LEARNING JOURNAL

Record your personal list of commonly confused words, and look at it when you edit your own writing.

- 1. What are four strategies you can use to avoid confusing words that sound alike or have similar meanings? Proofread carefully, use a dictionary to look up any words you are unsure about, find and correct mistakes you make with the twenty-seven sets of commonly confused words, and develop a personal list of soundalike words you confuse often.
- **2.** What are the top five commonly confused words on your personal list? Answers will vary.

Chapter Test

Use the words in parentheses to correctly fill in the blanks in each of the following sentences.

- 1. The coin machine will <u>accept</u> any coins <u>except</u> foreign ones. (accept, except)
- 2. They're going to arrive there late, but they will be sure to bring all their tools. (their, there, they're)
- There is ______ much confusion in our department now that _____ supervisors have been asked _____ to perform the same job. (to, too, two)
- **4.** Everyone thinks that <u>you're</u> going to get a perfect score on <u>your</u> exam. (your, you're)
- 5. The veterinarian told me ______it's _____ not necessary to wash a cat because a cat keeps ______ its ____ own fur clean. (its, it's)

RESOURCES The Testing Tool Kit CD-ROM available with this book has even more tests on word usage. Also, for cumulative Editing Review Tests, see pages 609–18.

THIS CHAPTER

- gives you strategies for finding and correcting spelling errors.
- gives you methods to become a better speller.
- gives you a list of one hundred commonly misspelled words to use as a reference.

33

Spelling

Using the Right Letters

Finding and Correcting Spelling Mistakes

Some extremely smart people are poor spellers. Unfortunately, spelling errors are easy for readers to spot, and they make a bad impression. Learn to find and correct spelling mistakes in your writing by using the following strategies.

Use a Dictionary

When proofreading your papers, consult a dictionary whenever you are unsure about the spelling of a word. Checking a dictionary is the single most important thing you can do to improve your spelling.

Use a Spell Checker-with Caution

Use a spell checker after you have completed a piece of writing but before you print it out. This word-processing tool finds and highlights a word that may be misspelled, suggests other spellings, and gives you the opportunity to change the spelling of the word.

However, never rely on a spell checker to do your editing for you. It ignores anything it recognizes as a word, so it will not help you find words that are misused or misspellings that are also words. For example, a spell checker would not highlight any of the problems in these phrases:

Just to it. (Correct: Just do it.)

pain in the *nick* (Correct: pain in the *neck*)

my writing *coarse* (Correct: my writing *course*)

TEACHING TIP Keep at least two dictionaries in the classroom. Let students know where the dictionaries are, but also emphasize that students should buy their own.

TIP Online dictionaries, such as www .merriamwebster.com, can help you spell, as they often allow you to type in an incorrectly spelled word and get the correct spelling.

RESOURCES Additional Resources contains tests and supplemental exercises for this chapter.

Use Proofreading Techniques

TIP For more spelling practice, visit Exercise Central at bedfordstmartins.com/realwriting.

Use some of the following proofreading techniques to focus on the spelling of one word at a time. Try them all. Then, decide which ones work best for you.

- Print out your paper before proofreading. (Many writers find it easier to detect errors on paper than on a computer screen.)
- Put a piece of paper under the line that you are reading.
- Proofread your paper backward, one word at a time.
- Print out a version of your paper that looks noticeably different: Make the words larger, make the margins larger, triple-space the lines, or make all these changes.
- Read your paper aloud. This strategy will help you if you tend to leave words out.
- Exchange papers with a partner, and proofread each other's papers, identifying only possible misspellings.

Make a Personal Spelling List

Set aside a section of your course notebook or learning journal for your spelling list. Every time you edit a paper, write down the words that you misspelled. Every couple of weeks, go back to your spelling list to see if your problem words have changed. Are you misspelling fewer words in each paper?

For each word on your list, create a memory aid or silly phrase to help you remember the correct spelling. For example, if you often misspell *a lot*, you could remember that "*a lot* is a lot of words."

TEACHING TIP Telling students that they will have to turn in their spelling lists reinforces the importance of making a list. If you have time, you can make up individualized spelling quizzes. Premade quizzes are included in the Testing Tool Kit CD-ROM available with this book.

Strategies for Becoming a Better Speller

Here are three good strategies for becoming a better speller.

Master Commonly Confused Words

Chapter 32 covers twenty-seven sets of words that are commonly confused because they sound similar, such as *write* and *right*. If you can master these commonly confused words, you will avoid many spelling mistakes.

Learn Six Spelling Rules

If you can remember the following six rules, you can correct many of the spelling errors in your writing.

First, here is a quick review of vowels and consonants.

VOWELS:

a, e, i, o, and u

CONSONANTS:

b, c, d, f, g, h, j, k, l, m, n, p, q, r, s, t, v, w, x, and z

The letter y can be either a vowel or a consonant. It is a vowel when it sounds like the y in fly or hungry. It is a consonant when it sounds like the y in yellow.

Rule 1. "I before e, except after e. Or when sounded like e, as in neighbor or weigh."

Many people repeat this rhyme to themselves as they decide whether a word is spelled with an *ie* or an *ei*.

```
piece (i before e)
receive (except after c)
eight (sounds like a)
```

TEAMWORK For each rule, have students give three additional examples of words that follow the rule. This exercise can be done in small groups or pairs.

EXCEPTIONS: either, neither, foreign, height, seize, society, their, weird

Rule 2. Drop the final *e* when adding an ending that begins with a vowel.

```
hope + ing = hoping
imagine + ation = imagination
```

Keep the final e when adding an ending that begins with a consonant.

```
achieve + ment = achievement
definite + ly = definitely
```

EXCEPTIONS: argument, awful, judgment, simply, truly, and others

Rule 3. When adding an ending to a word that ends in y, change the y to i when a consonant comes before the y.

Do not change the y when a vowel comes before the y.

```
boy + ish = boyish
pay + ment = payment
survey + or = surveyor
buy + er = buyer
```

EXCEPTIONS:

- 1. When adding *-ing* to a word ending in y, always keep the y, even if a consonant comes before it: study + ing = studying.
- 2. Other exceptions include daily, dryer, said, and paid.

Rule 4. When adding an ending that starts with a vowel to a one-syllable word, follow these rules.

Double the final consonant only if the word ends with a consonant-vowel-consonant.

Do not double the final consonant if the word ends with some other combination.

VOWEL-VOWEL-CONSONANT	VOWEL-CONSONANT-CONSONANT
clean + est = cleanest	sl ick + er = slicker
p oor + er = poo r er	teach + er = teacher
clear + ed = cleared	last + ed = lasted

Rule 5. When adding an ending that starts with a vowel to a word with two or more syllables, follow these rules.

Double the final consonant only if the word ends with a consonant-vowel-consonant and the stress is on the last syllable.

```
submit + ing = submitting
prefer + ed = preferred
```

Do not double the final consonant in other cases.

Rule 6. Add -s to most nouns to form the plural, including words that end in o preceded by a vowel.

MOST WORDS	WORDS THAT END IN VOWEL PLUS O
book + s = books	video + s = videos
college + s = colleges	stereo + s = stereos

Add -es to words that end in o preceded by a consonant and words that end in s, sh, ch, or x.

WORDS THAT END IN CONSONANT PLUS O	WORDS THAT END IN S, SH, CH, OR X
potato + es = potatoes	class + es = classes
hero + es = heroes	push + es = pushes
	bench + es = benches
	fax + es = faxes

Exceptions When Forming Plurals

A **compound noun** is formed when two nouns are joined, with a hyphen (*in-law*), a space (*life vest*), or no space (*keyboard*, *stockpile*). Plurals of compound nouns are generally formed by adding an -s to the end of the last noun (*in-laws*, *life vests*) or to the end of the combined word (*keyboards*, *stockpiles*). Some hyphenated compound words such as *mother-in-law* or *hole-in-one* form plurals by adding an -s to the chief word (*mothers-in-law*, *holes-in-one*).

Some words form plurals in different ways, as in the list below.

SINGULAR	PLURAL	SINGULAR	PLURAL
analysis	analyses	louse	lice
bacteria	bacterium	loaf	loaves
bison	bison	medium	media
cactus	cacti	man	men
calf	calves	mouse	mice
child	children	phenomenon	phenomena
deer	deer	roof	roofs
die	dice	sheep	sheep
foot	feet	shelf	shelves
focus	foci	tooth	teeth
goose	geese	thief	thieves
half	halves	vertebra	vertebrae
hoof	hooves	wife	wives
knife	knives	wolf	wolves
leaf	leaves	woman	women

Consult a List of Commonly Misspelled Words

Use a list like the one below as an easy reference to check your spelling.

absence	cruelty	height	recognize
achieve	daughter	humorous	recommend
across	definite	illegal	restaurant
aisle	describe	immediately	rhythm
a lot	develop	independent	roommate
already	dictionary	interest	schedule
analyze	different	jewelry	scissors
answer	disappoint	judgment	secretary
appetite	dollar	knowledge	separate
argument	eighth	license	sincerely
athlete	embarrass	lightning	sophomore
awful	environment	Ioneliness	succeed
basically	especially	marriage	successful
beautiful	exaggerate	meant	surprise
beginning	excellent/	muscle	truly
believe	excellence	necessary	until
business	exercise	ninety	usually
calendar	fascinate	noticeable	vacuum
career	February	occasion	valuable
category	finally	perform	vegetable
chief	foreign	physically	weight
column	friend	prejudice	weird
coming	government	probably	writing
commitment	grief	psychology	written
conscious	guidance	receive	

write Which word is misspelled? Use the correct form of this word in a sentence.

Chapter Review

- 1. What are two important tools for finding and correcting spelling mistakes? Answers should include two of the following: a dictionary, a spell checker, a proofreading tool/technique, a spelling list
- 2. What three strategies can you use to become a better speller?

 Master commonly confused words, learn the six spelling rules, and consult a list of commonly misspelled words.

LEARNING JOURNAL What spelling errors do you make most often? How will you remember to spell them correctly?

Chapter Test

In each sentence, fill in the blank with the correctly spelled word.

- **1.** Your joining us for dinner is a pleasant ______.
 - a. suprise
- **b.** surprize
- **c.** surprise
- **2.** When can I expect to _____ the package?
 - a. recieve
- (b.) receive
- c. reeceive

RESOURCES The Testing Tool Kit CD-ROM available with this book has even more tests. Also, for cumulative Editing Review Tests, see pages 609–18. 564

3.		e solar technology pr dents.	rogra	m is	n	nany new
	a.	admiting	b.	admitting	c.	addmitting
4.	Co	lin's roommate is		we	eird.	
	a.	definately	b.	definitely	c.	definitly
5.		er my doctor diagno ysical therapist.	sed n	ny injury, she		me to a
	a.	refered	b.	reffered	c.	referred
6.	We	will have to go in		ca	irs.	
	-			seperate		sepurate
7.	Ih	ave not seen her sinc	e		_ grade.	
		eith		eigth	_	eighth
8.	Th	e date is circled on the	he			
		callender	_			calander
9.	Da	na got her		last week.		
		lisense			_	license
10.	Th	at ring is				
		valuble	0	valuable	c.	valueble

THIS CHAPTER

- shows you how and where to use commas (and tells you where not to use them).
- gives you practice using commas correctly.

34

Commas

Understand What Commas Do

Commas (,) are punctuation marks that help readers understand a sentence. Read aloud the following three sentences. How does the use of commas change the meaning?

LearningCurve
Commas
bedfordstmartins.com/
realwriting/LC

RESOURCES This

chapter offers

When you call Sarah I will start cooking.

When you call Sarah, I will start cooking.

When you call, Sarah, I will start cooking.

To get your intended meaning across to your readers, it is important that you understand when and how to use commas.

associated
LearningCurve activities
for students. A student
access code is printed
in every new student
copy of this text.
Students who do not
purchase a new print
book can purchase
access by going to

bedfordstmartins.com/

realwriting/LC.

Practice Using Commas Correctly

Commas between Items in a Series

Use commas to separate the items in a series (three or more items), including the last item in the series, which usually has *and* before it.

Item , Item , and Item

To get from South Dakota to Texas, we will drive through *Nebraska*, *Kansas*, and *Oklahoma*.

We can sleep in the car, stay in a motel, or camp outside.

As I drive, I see many beautiful sights, such as mountains, plains, and prairies.

TIP How does a comma change the way you read a sentence aloud? Many readers pause when they come to a comma.

RESOURCES For instructor resources, go to bedfordstmartins.com/rewritingbasics.

NOTE: Writers do not always use a comma before the final item in a series. In college writing, however, it is best to include it.

Commas between Coordinate Adjectives

Coordinate adjectives are two or more adjectives that independently modify the same noun and are separated by commas.

Conor ordered a big, fat, greasy burger.

The diner food was cheap, unhealthy, and delicious.

Do *not* use a comma between the final adjective and the noun it describes.

INCORRECT Joelle wore a long, clingy, red, dress.

CORRECT Joelle wore a long, clingy, red dress.

Cumulative adjectives describe the same noun but are not separated by commas because they form a unit that describes the noun. You can identify cumulative adjectives because separating them by *and* does not make any sense.

The store is having its last storewide clearance sale.

[Putting and between last and storewide and between storewide and clearance would make an odd sentence: The store is having its last and storewide and clearance sale. The adjectives in the sentence are cumulative adjectives and should not be separated by commas.]

In summary:

- **Do** use commas to separate two or more **coordinate adjectives**.
- Do not use commas to separate cumulative adjectives.

PRACTICE 1 Using Commas in Series and with Adjectives

Edit the following sentences by underlining the items in the series and adding commas where they are needed. If a sentence is already correct, put a "C" next to it.

EXAMPLE: In 1935, the U.S. government hired writers, teachers, historians, and others to work for the Federal Writers' Project (FWP).

1. The FWP was part of an effort to create jobs during the long, devastating economic crisis known as the Great Depression.

TEACHING TIP Write this incorrectly punctuated sentence on the board: My daughter is a fast aggressive, and competitive soccer player. Read it aloud (as if it were correctly punctuated), and ask students if they can hear where the missing comma should go.

TIP For more practice using commas correctly, visit Exercise Central at bedfordstmartins.com/realwriting.

- Many famous writers, such as John Cheever, Ralph Ellison, and Zora Neale Hurston, joined the FWP.
- Americans, writing down their stories, and bringing together this information so that it could be shared with the public.
- **4.** Folklore Unit workers were able to collect not only life stories but also songs, folktales, and superstitions.
- **5.** The director of the Folklore Unit hoped that by publishing this information, the FWP might make Americans more accepting of fellow citizens whose experiences, beliefs, and interests were different from their own. *C*
- **6.** Through all its efforts, the FWP helped to create a more <u>vivid</u>, <u>engaging</u>, and <u>personal</u> history of the country.
- **7.** Some of the most striking FWP records are interviews with former slaves who lived in Georgia, South Carolina, Virginia, and other parts of the South. *C*
- **8.** Interviewers asked the former slaves to tell their personal stories and also to describe their working conditions, diets, and experiences with racism.
- 9. Eventually, the government published a thorough, highly informative collection of these interviews: Slave Narratives: A Folk History of Slavery in the United States from Interviews with Former Slaves.
- **10.** This collection is a valued resource for historians, social scientists, and anyone interested in American history.

Commas in Compound Sentences

A **compound sentence** contains two complete sentences joined by a coordinating conjunction: *and*, *but*, *for*, *nor*, *or*, *so*, *yet*. Use a comma before the joining word to separate the two complete sentences.

TIP Remember the coordinating conjunctions with FANBOYS: for, and, nor, but, or, yet, and so. For more information, see Chapter 27.

Sentence

and, but, for, nor, or, so, yet

Sentence.

I called my best friend, and she agreed to drive me to work.

I asked my best friend to drive me to work, but she was busy.

I can take the bus to work, or I can call another friend.

LANGUAGE NOTE: A comma alone cannot separate two sentences in English. Doing so creates a run-on (see Chapter 21).

EDITING FOR CORRECT COMMA USAGE:

Using Commas in Compound Sentences

Find

Many college students are the first in their families to go to college (and) these students' relatives are proud of them.

- To determine if the sentence is compound, underline the subjects, and double-underline the verbs.
- 2. Ask: Is the sentence compound? Yes.
- 3. Circle the word that joins them.

Edit

Many college students are the first in their families to go to college, and these students' relatives are proud of them.

4. Put a comma before the word that joins the two sentences.

PRACTICE Q Uoing Commao in Compound Sontonoco

Edit the following compound sentences by adding commas where they are needed. If a sentence is already correct, put a "C" next to it.

EXAMPLE: Marika wanted to get a college education, but her husband did not like the idea.

- **1.** Marika's hospital volunteer work had convinced her to become a physical therapist, but she needed a college degree to qualify. *C*
- Deciding to apply to college was difficult for her, so she was excited when she was admitted.
- 3. She had chosen the college carefully, for it had an excellent program in physical therapy.
- Marika knew that the courses would be difficult, but she had not expected her husband to oppose her plan.
- **5.** They had been married for twelve years, and he was surprised that she wanted a career. *C*

ESL Because different languages have different intonation patterns, students should not rely on intonation alone to decide where to put commas.

- 6. She tried to tell him about the exciting things she was learning but he did not seem interested.
- **7.** It was hard for her to manage the house and keep up with her classes, but he would not help. *C*
- **8.** Maybe he was upset that she wanted more education than he had, or perhaps he was afraid that they would grow apart.
- **9.** She did not want to have to choose between her husband and an education, and she did not have to.
- **10.** They talked about their problems, and now he thinks that her career might even help their marriage.

Commas after Introductory Words

Use a comma after an introductory word, phrase, or clause. The comma lets your readers know when the main part of the sentence is starting.

Introductory word or word group

Main part of sentence.

INTRODUCTORY WORD:

Yesterday, I went to the game.

INTRODUCTORY PHRASE:

By the way, I do not have a babysitter for

tomorrow.

INTRODUCTORY CLAUSE:

While I waited outside, Susan went backstage.

PRACTICE 3 Using Commas after Introductory Word Groups

In each item, underline introductory words or word groups. Then, add commas after introductory word groups where they are needed. If a sentence is already correct, put a "C" next to it.

EXAMPLE: In the 1960s, John Mackey became famous for his speed and strength as a tight end for the Baltimore Colts football team.

1. In his later years, the National Football League Hall-of-Famer was in the news for another reason: He suffered from dementia possibly linked to the head blows he received on the football field.

According to medical experts, repeated concussions can severely damage the brain over time, and they are especially harmful to young people, whose brains are still developing. C

Based on these warnings and on stories like John Mackey's, athletic associations, coaches, and parents of young athletes are taking new precautions.

4. For example, more football coaches are teaching players to tackle and block with their heads up, reducing the chance that they will receive a blow to the top of the head.

5. Also, when players show signs of a concussion—such as dizziness, nausea, or confusion—more coaches are taking them out of the game.

6. <u>Ideally</u>, coaches then make sure injured players receive immediate medical attention.

7. Once concussion sufferers are back home, they should take a break from sports until the symptoms of their injury are gone. C

B. During their recovery, they should also avoid any activity that puts too much stress on the brain; these activities can include playing video games, studying, and driving.

9. When concussion sufferers feel ready to get back into the game, a doctor should confirm that it is safe for them to do so.

As a result of these new precautions, young athletes may avoid experiencing anything like the long, difficult decline of John Mackey, who died in 2011.

Commas around Appositives and Interrupters /

An **appositive** comes directly before or after a noun or pronoun and renames it.

Lily, a senior, will take her nursing exam this summer.

The prices are outrageous at Beans, the local coffee shop.

An **interrupter** is an aside or transition that interrupts the flow of a sentence and does not affect its meaning.

My sister, incidentally, has good reasons for being late.

Her child had a fever, for example.

TIP For more on appositives, see Chapter 29.

Putting commas around appositives and interrupters tells readers that these elements give extra information but are not essential to the meaning of a sentence. If an appositive or interrupter is in the middle of a sentence, set it off with a pair of commas, one before and one after. If an appositive or interrupter comes at the beginning or end of a sentence, separate it from the rest of the sentence with one comma.

By the way, your proposal has been accepted.

Your proposal, by the way, has been accepted.

Your proposal has been accepted, by the way.

NOTE: Sometimes, an appositive is essential to the meaning of a sentence. When a sentence would not have the same meaning without the appositive, the appositive should not be set off with commas.

The actor Leonardo DiCaprio has never won an Oscar.

[The sentence The actor has never won an Oscar does not have the same meaning.]

Local decorate the same meaning.]

Local decorate the same meaning.]

EDITING FOR CORRECT COMMA USAGE:

Using Commas to Set Off Appositives and Interrupters

Find

Tamara my sister-in-law moved in with us last week.

- 1. Underline the subject.
- 2. Underline any appositive (which renames the subject) or interrupter (which interrupts the flow of the sentence).
- 3. Ask: Is the appositive or interrupter essential to the meaning of the sentence? No.

Edit

Tamara, my sister-in-law, moved in with us last week.

4. If it is not essential, set it off with commas.

PRACTICE 4 Using Commas to Set Off Appositives and Interrupters

Underline all the appositives and interrupters in the following sentences. Then, use commas to set them off.

EXAMPLE: Harry, an attentive student, could not hear his teacher because the radiator in class made a constant rattling.

- 1. Some rooms, in fact, are full of echoes, dead zones, and mechanical noises that make it hard for students to hear.
- 2. The American Speech-Language-Hearing Association, experts on how noise levels affect learning abilities, has set guidelines for how much noise in a classroom is too much.
 - The association recommends that background noise, the constant whirring or whining sounds made by radiators, lights, and other machines, be no more than 35 decibels.
- 4. That level, 35 decibels, is about as loud as a whispering voice 15 feet away.
- 5. One study found a level of 65 decibels, the volume of a vacuum cleaner, in a number of classrooms around the country.
- 6. Other classroom noises came, for example, from ancient heating systems, whirring air-conditioning units, rattling windows, humming classroom computers, buzzing clocks, and the honking of traffic on nearby streets.
- **7.** An increasing number of school districts are beginning to pay more attention to acoustics, the study of sound, when they plan new schools.
- 8. Some changes, such as putting felt pads on the bottoms of chair and desk legs to keep them from scraping against the floor, are simple and inexpensive.
- **9.** Other changes, however, can be costly and controversial; these changes include buying thicker drapes, building thicker walls, or installing specially designed acoustic ceiling tiles.
- 10. School administrators, often parents themselves, hope that these improvements will result in a better learning environment for students.

Commas around Adjective Clauses

An **adjective clause** is a group of words that begins with *who, which,* or *that*; has a subject and a verb; and describes a noun right before it in a sentence.

If an adjective clause can be taken out of a sentence without completely changing the meaning of the sentence, put commas around the clause.

Lily, who is my cousin, will take her nursing exam this summer.

Beans, which is the local coffee shop, charges outrageous prices.

I complained to Mr. Kranz, who is the shop's manager.

If an adjective clause is essential to the meaning of a sentence, do not put commas around it. You can tell whether a clause is essential by taking it out and seeing if the meaning of the sentence changes significantly, as it would if you took the clauses out of the following examples.

The only grocery store that sold good bread went out of business.

Students who do internships often improve their hiring potential.

Salesclerks who sell liquor to minors are breaking the law.

TEACHING TIP Ask students to explain what is meant by "essential" in this context. Help them see that essential (restrictive) phrases and clauses generally answer the question "Which one?" If a phrase or clause is taken out, the meaning of the sentence can change completely.

EDITING FOR CORRECT COMMA USAGE:

Using Commas to Set Off Adjective Clauses

Find

The woman who had octuplets received much publicity.

- 1. **Underline** any adjective clause (a word group that begins with *who*, *which*, or *that*).
- 2. Read the sentence without this clause.
- 3. Ask: Does the meaning change significantly without the clause? Yes.

Edit

The woman who had octuplets received much publicity.

4. If the meaning *does* change, as in this case, **do not put in commas**. (Add commas only if the meaning *does not* change.)

PRACTICE 5 Using Commas to Set Off Adjective Clauses

In each item, underline the adjective clauses. Then, put commas around these clauses where they are needed. Remember that if an adjective clause is essential to the meaning of a sentence, commas are not necessary. If a sentence is already correct, put a "C" next to it.

EXAMPLE: Daniel Kish, who has been blind since the age of one, has changed many people's ideas about what blind people can and cannot do.

- 1. Kish, who runs the organization World Access for the Blind, regularly rides his bike down busy streets and goes on long hikes.
- 2. His system for "seeing" his surroundings, which is known as echolocation, uses sound waves to create mental pictures of buildings, cars, trees, and other objects.
- **3.** As Kish bikes around his neighborhood or hikes to sites that are deep in the wilderness, he clicks his tongue and listens to the echoes. *C*
- 4. The echoes, which differ depending on the distance and physical features of nearby objects, allow him to map his surroundings in his mind.
- 5. This mental map, which he constantly revises as he moves ahead, helps him avoid running into cars, trees, and other obstacles.
- **6.** Researchers who recently investigated Kish's echolocation made some interesting discoveries. *C*
- 7. They found that Kish's visual cortex, which is the part of the brain that processes visual information, was activated during his sessions of mapping with sound.
- 8. This finding, which received a lot of attention in the scientific community, suggests that Kish's way of seeing the world is indeed visual.
- **9.** Other blind people who have been trained in echolocation have learned to be as active and independent as Kish is. *C*
- **10.** The successes that they and Kish have achieved offer additional proof that blindness does not equal helplessness. *C*

Other Uses for Commas

COMMAS WITH QUOTATION MARKS

TIP For more on quotation marks, see Chapter 36.

Quotation marks are used to show that you are repeating exactly what someone said. Use commas to set off the words inside quotation marks from the rest of the sentence.

"Let me see your license," demanded the police officer.

"Did you realize," she asked, "that you were going 80 miles per hour?" I exclaimed, "No!"

Notice that a comma never comes directly after a quotation mark.

When quotations are not attributed to a particular person, commas may not be necessary.

"Pretty is as pretty does" never made sense to me.

COMMAS IN ADDRESSES

Use commas to separate the elements of an address included in a sentence. However, do not use a comma before a zip code.

My address is 2512 Windermere Street, Jackson, Mississippi 40720.

If a sentence continues after a city-state combination or after a street address, put a comma after the state or the address.

I moved here from Detroit, Michigan, when I was eighteen.

I've lived at 24 Heener Street, Madison, since 1989.

COMMAS IN DATES

Separate the day from the year with a comma. If you give just the month and year, do not separate them with a comma.

My daughter was born on November 8, 2004.

The next conference is in August 2014.

If a sentence continues after the date, put a comma after the date.

On April 21, 2013, the contract will expire.

COMMAS WITH NAMES

Put a comma after (and sometimes before) the name of someone being addressed directly.

Don, I want you to come look at this.

Unfortunately, Marie, you need to finish the report by next week.

COMMAS WITH YES OR NO

Put a comma after the word yes or no in response to a question.

Yes, I believe that you are right.

PRACTICE 6 Using Commas in Other Ways

Edit the following sentences by adding commas where they are needed. If a sentence is already correct, put a "C" next to it.

EXAMPLE: On August 12,2011, beach front property was badly damaged by a fast-moving storm.

- **1.** Some homeowners were still waiting to settle their claims with their insurance companies in January 2012. *C*
 - 2. Rob McGregor of 31 Hudson Street, Wesleyville, is one of those homeowners.
- 3. Asked if he was losing patience, McGregor replied, "Yes, I sure am."
- 4. "I've really had it up to here," McGregor said. C
- **5.** His wife said, "Rob, don't go mouthing off to any reporters."
 - **6.** "Betty, I'll say what I want to say," Rob replied.
 - 7. An official of Value-Safe Insurance of Wrightsville, Ohio, said that the company will process claims within the next few months.
 - 8. "No, there is no way we can do it any sooner," the official said.
 - **9.** Customers unhappy with their service may write to Value-Safe Insurance, P.O. Box 225, Wrightsville, Ohio 62812. *C*
 - **10.** The company's home office in Rye, New York, can be reached by a toll-free number.

Edit for Commas

PRACTICE 7 Editing Paragraphs for Commas

Edit the following paragraphs by adding commas where they are needed.

(1) By the end of 2011, communities in California, Texas, Washington, and several other states had banned the use of plastic bags. (2) One grocery store chain, Whole Foods Market, was an early leader in restricting the use of these bags. (3) As of April 22,2008, Whole Foods stopped asking customers if they wanted paper bags or plastic bags. (4) The store, which cares about environmental issues, now offers only paper bags made from recycled paper.

- (5) The president of Whole Foods stated, "We estimate we will keep 100 million new plastic grocery bags out of our environment between Earth Day and the end of this year." (6) The company also sells cloth bags, hoping to encourage shoppers to bring their own reusable bags with them when they go shopping.
- (7) Experts believe that plastic bags do a great deal of damage to the environment. (8) They clog drains, harm wildlife, and take up an enormous amount of space in the nation's landfills. (9) According to the experts, it takes more than a thousand years for a plastic bag to break down, and Americans use 100 billion of them every single year.

PRACTICE 8 Editing Your Own Writing for Commas

Edit a piece of your own writing for comma usage. It can be a paper for this course or another one, or something you have written for work or your every-day life.

Chapter Review

- **1.** A comma (,) is a <u>punctuation mark</u> that helps readers understand a sentence.
- In a series of items, use commas to separate three or more items

 In a compound sentence, use a comma and a coordinating conjunction to make two sentences into one

With introductory words, use a comma after the word, clause, or phrase

- **3.** An appositive comes before or after a noun or pronoun and <u>renames</u> the noun or pronoun
- **4.** An interrupter is an <u>aside or transition</u> that interrupts the flow of a sentence.
- 5. Put commas around an adjective clause when it is <u>not essential</u> to the meaning of a sentence.

LEARNING JOURNAL Did you find comma errors in your writing? What is the main thing you have learned about using commas that will help you? What is unclear to you?

TEACHING TIP Collect students' learning journals to find out what the class or individual students need more work on.

Chapter Test

Circle the correct choice for each of the following items.

1. If an underlined portion of this sentence is incorrect, select the revision that fixes it. If the sentence is correct as written, choose d.

The company owners, for your information are planning to inspect our department this afternoon. \blacksquare

RESOURCES The Testing Tool Kit CD-ROM available with this book has even more tests on comma usage. Also, for cumulative Editing Review Tests, see pages 609–18.

_		C
a.	owners	Ior

- c. department, this
- (b.) information, are

C

- **d.** No change is necessary.
- 2. Choose the item that has no errors.
 - **a.** I used to hate parties but now I like to socialize with others.
 - **(b.)** I used to hate parties, but now I like to socialize with others.
 - **c.** I used to hate parties, but, now I like to socialize with others.
- 3. Choose the item that has no errors.
 - **a.** If you do not file your income tax forms by April 15, 2013 you could face penalties.
 - **(b.)** If you do not file your income tax forms by April 15, 2013, you could face penalties.
 - **c.** If you do not file your income tax forms by April 15 2013 you could face penalties.
- **4.** If an underlined portion of this sentence is incorrect, select the revision that fixes it. If the sentence is correct as written, choose d.

Henry's favorite hobbies are watching birds, collecting stamps, and $\bf A$ $\bf B$ fixing up old cars.

- a. favorite, hobbies
- c. stamps and
- **b.** are watching, birds
- (d.) No change is necessary.
- **5.** Choose the item that has no errors.
 - (a.) Roger, who teaches dance at a local studio, will be my partner for the ballroom competition.
 - **b.** Roger who teaches dance at a local studio will be my partner for the ballroom competition.
 - **c.** Roger who teaches dance at a local studio, will be my partner for the ballroom competition.

d. No change is necessary.

b. swim paddle

35

explains how to use apostrophes. gives you practice using

apostrophes correctly.

Apostrophes (*)

LearningCurve Apostrophes bedfordstmartins.com/ realwriting/LC

RESOURCES This chapter offers associated LearningCurve activities for students. A student access code is printed in every new student copy of this text. Students who do not purchase a new print book can purchase access by going to bedfordstmartins.com/realwriting/LC.

TIP Use apostrophes to show ownership for abbreviations: *The NBA's playoff system has changed.*

Understand What Apostrophes Do

An **apostrophe** (') is a punctuation mark that either shows ownership (Susan's) or indicates that a letter has been intentionally left out to form a contraction (I'm, that's, they're).

Practice Using Apostrophes Correctly

Apostrophes to Show Ownership

Add -'s to a singular noun to show ownership even if the noun already ends in -s.

Karen's apartment is on the South Side.

James's roommate is looking for him.

If a noun is plural and ends in -s, just add an apostrophe. If it is plural but does not end in -s, add -'s.

My books covers are falling off.
[more than one book]

The *twins*⁹ father was building them a playhouse. [more than one twin]

The children's toys were broken.

The men's locker room is being painted.

The placement of an apostrophe makes a difference in meaning.

My sister's six children are at my house for the weekend. [one sister who has six children]

My sisters' six children are at my house for the weekend. [two or more sisters who together have six children]

Do not use an apostrophe to form the plural of a noun.

Gina went camping with her sisters and their children.

All the highways to the airport are under construction.

Do not use an apostrophe with a possessive pronoun. These pronouns already show ownership (possession).

Is that bag yours? No, it is ourls.

RESOURCES Additional Resources contains tests and supplemental exercises for this chapter. For additional instructor resources, go to bedfordstmartins.com/ rewritingbasics.

TEACHING TIP Using an apostrophe with a possessive pronoun is a common error; tell students to be especially careful of this problem when they edit. You may also want to have students discuss why this error is so common.

y	his	its	their
ine	her	our	theirs
our	hers	ours	whose

The single most common error with apostrophes and pronouns is confusing its (a possessive pronoun) with it's (a contraction meaning "it is"). Whenever you write it's, test correctness by replacing it with it is and reading the sentence aloud to hear if it makes sense.

PRACTICE 1 Using Apostrophes to Show Ownership

Edit the following sentences by adding -'s or an apostrophe alone to show ownership and by crossing out any incorrect use of an apostrophe or -'s.

EXAMPLE: Not long ago, my cousins résumé was looking thin because he was young and had not held many job/s.

1. Also, his previous jobs as a welder's assistant and a line cook did not relate to what he most wanted to do: landscaping.

COMPUTER If some students often misuse apostrophes in possessive pronouns, advise them to use the find or search function to find and check all uses of -'s in papers before turning them in. Tell them to write "checked for -'s" at the top of each paper.

Seeing Apostrophe Errors

TIP The "Restroom's" photo was taken by Jeff Deck, coauthor of *The Great Typo Hunt: Two Friends Changing the World, One Correction at a Time.* For more typos hunted down by Jeff and others, visit the book's Web site at **greattypohunt.com**.

write How would you correct the apostrophe errors in these signs? Also, in the sign on the left, what is the correct plural form of *hero*?

- 2. He had some contacts in the landscaping business: Two friends sisters were landscapers, and another friends father managed the grounds at a golf course.
- **3.** But my cousin couldn't get jobs through these contacts because he had no experience working on a landscaper's crew or with a professional gardener.
- **4.** To build up the right kind of skills, he spent six month/s of last year volunteering at a community garden.
- 5. Under the guidance of the community garden's most expert member, my cousin learned about soil drainage, composting, and chemical-free pest control.

- **6.** Last month, when my cousin applied for a job as a landscaping assistant, the interviewer told him that there had been many other applicants but that his skills were far more impressive than their/s.
- **7.** He was very excited about getting the job, and he is pleased with it/s benefits.
- **8.** As my cousins example shows, many people's résumés can be improved through volunteering.
- **9.** Volunteering provides a way not only to acquire new skills but also to test different career path/s.
- **10.** For instance, volunteers who comfort patients families at a local hospital will get a sense of whether working in a medical setting is a good choice for them.

TIP For more practice using apostrophes correctly, visit Exercise Central at bedfordstmartins.com/realwriting.

Apostrophes in Contractions

A **contraction** is formed by joining two words and leaving out one or more of the letters. When writing a contraction, put an apostrophe where the letter or letters have been left out.

TIP Ask your instructor if contractions are acceptable in papers.

She's on her way. = She is on her way.

 $I^{\mathfrak{I}}$ see you there. = I will see you there.

Be sure to put the apostrophe in the correct place.

It does n't really matter.

TIP To shorten the full year to only the final two numbers, replace the first two numbers: The year 2013 becomes '13.

Common Contractions

aren't = are not I'd = I would, I had

can't = cannot I'll = I will

couldn't = could not I'm = I am

didn't = did not I've = I have don't = do not isn't = is not

he'd = he would, he had it's = it is, it has

he'll = he will let's = let us

he's = he is, he has she'd = she would, she had

ESL Because contractions are often new to ESL students, you may want to advise them to avoid all contractions in college work that they are submitting for a grade. They should use apostrophes only to show ownership.

she'll = she will who'll = who will

she's = she is, she has who's = who is, who has

there's = there is won't = will not

they'd = they would, they had wouldn't = would not

they'll = they will you'd = you would, you had

they're = they are you'll = you will they've = they have you're = you are

who'd = who would, who had you've = you have

PRACTICE 2 Using Apostrophes in Contractions

Read each sentence carefully, looking for any words that have missing letters. Edit these words by adding apostrophes where needed and crossing out incorrectly used apostrophes.

example: Although we observe personal space boundaries in our daily lives, they're not something we spend much time thinking about.

- 1. You'll notice right away if a stranger leans over and talks to you so that his face is practically touching yours.
- 2. Perhaps you'd accept this kind of behavior from a family member.
- 3. There is not one single acceptable boundary we'd use in all situations.
- **4.** An elevator has its own rules: Don't stand right next to a person if there is open space.
- 5. With coworkers, we're likely to keep a personal space of 4 to 12 feet.
- **6.** Well accept a personal space of 4 feet down to 18 inches with friends.
- 7. The last 16 inches are reserved for people were most intimate with.
- **8.** When people hug or kiss, theyre willing to surrender their personal space to each other.
- **9.** A supervisor who's not aware of the personal space boundaries of his or her employees might make workers uncomfortable.
- 10. Even if the supervisor does/nt intend anything by the gestures, it's his or her responsibility to act appropriately.

Apostrophes with Letters, Numbers, and Time

Use -'s to make letters and numbers plural. The apostrophe prevents confusion or misreading.

In Scrabble games, there are more e^3s than any other letter.

In women's shoes, size 8's are more common than size 10's.

Use an apostrophe or -'s in certain expressions in which time nouns are treated as if they possess something.

She took four weeks maternity leave after the baby was born.

This year's graduating class is huge.

PRACTICE 3 Using Apostrophes with Letters, Numbers, and Time

Edit the following sentences by adding apostrophes where needed and crossing out incorrectly used apostrophes.

EXAMPLE: When I returned to work after two weeks vacation, I had what looked like a decades worth of work in my box.

- 1. I sorted letters alphabetically, starting with As.
- **2.** There were more letters by names starting with M_s than any other.
- **3.** When I checked my e-mail, the screen flashed 48s to show that I had forty-eight messages.
- 4. My voice mail wasn't much better, telling me that in two weeks time I had received twenty-five messages.
- **5.** I needed another weeks time just to return all the phone calls.

Edit for Apostrophes

PRACTICE 4 Editing Paragraphs for Apostrophes

Edit the following paragraphs by adding two apostrophes where needed and crossing out five incorrectly used apostrophes.

(1) Have you noticed many honeybee/s when you go outside? (2) If not, it is/nt surprising. (3) For reasons that scientists still don't quite understand, these bees have been disappearing all across the country. (4) This mass

disappearance is a problem because bees are an important part of growing a wide variety of flowers, fruits, vegetables, and nuts as they spread pollen from one place to another.

- (5) In the last year, more than one-third, or billions, of the honeybees in the United States have disappeared. (6) As a consequence, farmers have been forced either to buy or to rent beehives for their crops. (7) Typically, people who are in the bee business ship hives to farmers fields by truck. (8) The hives often have to travel hundreds of miles.
- (9) Scientist's have been trying to find out what happened to the oncethriving bee population. (10) They suspect that either a disease or chemicals harmed the honeybee/s.

PRACTICE 5 Editing Your Own Writing for Apostrophes

Edit a piece of your own writing for apostrophes. It can be a paper for this course or another one, or something you have written for work or your everyday life.

Chapter Review

LEARNING JOURNAL Did you find apostrophe errors in your writing? What is the main thing you have learned about apostrophes that will help you? What is unclear to you?

TEACHING TIP Collect students' learning journals to find out what the class or individual students need more work on.

1.	An apostrophe (') is a punctuation mark that either shows ownership or indicates that a letter or letters have been inten-
	tionally left out to form acontraction
2.	To show ownership, add to a singular noun,
	even if the noun already ends in -s. For a plural noun, add an
	apostrophe alone if the noun ends in -s; add 's
	if the noun does not end in -s.
3.	Do not use an apostrophe with a possessive pronoun.

- ownership 4. Do not confuse its and it's. Its shows _ ; it's is a contraction meaning "it is."
- contraction 5. __ is formed by joining two words and leaving out one or more of the letters.

Chapter Test

Circle the correct choice for each of the following items.

1. If an underlined portion of this sentence is incorrect, select the revision that fixes it. If the sentence is correct as written, choose d.

 $\frac{\text{I've}}{\textbf{A}}$ always believed that its a crime to use software that you haven't paid for.

C

a. Ive

c. havent

(b.) it's

- d. No change is necessary.
- 2. Choose the item that has no errors.
 - **a.** The thieves boldness made them a lot of money, but it eventually landed them in jail.
 - **b.** The thieves's boldness made them a lot of money, but it eventually landed them in jail.
 - **c.** The thieves' boldness made them a lot of money, but it eventually landed them in jail.
- **3.** Choose the item that has no errors.
 - a. By playing that slot machine, your throwing away money.
 - (b.) By playing that slot machine, you're throwing away money.
 - **c.** By playing that slot machine, youre' throwing away money.
- **4.** If an underlined portion of this sentence is incorrect, select the revision that fixes it. If the sentence is correct as written, choose d.

The house is now Renee's, but she'll regret having an address with

five 3s in it.

C

a. Renees

c. 3's

b. sh'ell

- d. No change is necessary.
- **5.** Choose the item that has no errors.
 - **a.** Her eighteen months' service overseas has somehow made her seem older.
 - **b.** Her eighteen month's service overseas has somehow made her seem older.
 - **c.** Her eighteen months service overseas has somehow made her seem older.

RESOURCES The Testing Tool Kit CD-ROM available with this book has even more punctuation tests. Also, for cumulative Editing Review Tests, see pages 609–18.

gives you practice using quotation marks correctly.

Quotation Marks (ff 33)

Understand What Quotation Marks Do

Quotation marks (" ") always appear in pairs. Quotation marks have two common uses in college writing:

- They are used with **direct quotations**, which exactly repeat, word for word, what someone said or wrote. (*Nick said*, ⁶⁶You should take the downtown bus. ⁵⁹)
- They are used to set off **titles**. (My favorite song is "Sophisticated Lady.")

Practice Using Quotation Marks Correctly

Quotation Marks for Direct Quotations

When you write a direct quotation, use quotation marks around the quoted words. Quotation marks tell readers that the words used are exactly what was said or written.

RESOURCES Additional Resources contains tests and supplemental exercises for this chapter.

- 1. "I do not know what she means," I said to my friend Lina.
- 2. Lina asked, "Do you think we should ask a question?"
- 3. "Excuse me, Professor Soames," I called out, "but could you explain that again?"
- 4. "Yes," said Professor Soames. "Let me make sure you all understand."
- 5. After further explanation, Professor Soames asked, "Are there any other questions?"

When you are writing a paper that uses outside sources, use quotation marks to indicate where you quote the exact words of a source.

We all need to become more conscientious recyclers. A recent editorial in the *Bolton Common* reported, "When recycling volunteers spot-checked bags that were supposed to contain only newspaper, they found a collection of nonrecyclable items such as plastic candy wrappers, aluminum foil, and birthday cards."

When quoting, writers usually use words that identify who is speaking, such as *I said to my friend Lina* in the first example on the previous page. The identifying words can come after the quoted words (example 1), before them (example 2), or in the middle of them (example 3). Here are some guidelines for capitalization and punctuation.

TIP For more on incorporating outside source material through quoting and other methods, see Chapter 18.

GUIDELINES FOR CAPITALIZATION AND PUNCTUATION

- Capitalize the first letter in a complete sentence that is being quoted, even if it comes after some identifying words (example 2 on the previous page).
- Do not capitalize the first letter in a quotation if it is not the first word in a complete sentence (*but* in example 3).
- If it is a complete sentence and it is clear who the speaker is, a quotation can stand on its own (second sentence in example 4).
- Identifying words must be attached to a quotation; they cannot be a sentence on their own.
- Use commas to separate any identifying words from quoted words in the same sentence.
- Always put quotation marks after commas and periods. Put quotation marks after question marks and exclamation points if they are part of the quoted sentence.

with quotation marks, see Chapter 34.

TIP For more on commas

If a question mark or exclamation point is part of your own sentence, put it after the quotation mark.

TEACHING TIP As you go over the first two rules on capitalization, put a sentence on the board without any quotation marks. Ask students where the quotation marks should go and which letters should be capitalized.

SETTING OFF A QUOTATION WITHIN ANOTHER QUOTATION

Sometimes, when you quote someone directly, part of what that person said quotes words that someone else said or wrote. Put single quotation marks (⁶) around the quotation within a quotation so that readers understand who said what.

The student handbook says, "Students must be given the opportunity to make up work missed for legitimate reasons."

Terry told his instructor, "I am sorry I missed the exam, but that is not a reason to fail me for the term. Our student handbook says, "Students must be given the opportunity to make up work missed for legitimate reasons," and I have a good reason."

PRACTICE 1 Punctuating Direct Quotations

Edit the following sentences by adding quotation marks and commas where needed.

TIP For more practice using quotation marks correctly, visit Exercise Central at bedfordstmartins.com/realwriting.

EXAMPLE: A radio journalist asked a nurse at a critical-care facility,

"Do you believe that the medical community needlessly

prolongs the life of the terminally ill?"

- 1. "If I could answer that question quickly, the nurse replied," I would deserve an honorary degree in ethics."
- 2. She added, But I see it as the greatest dilemma we face today."
- **3.** "How would you describe that dilemma?" the reporter asked the nurse.
- **4.** The nurse said, It is a choice of when to use our amazing medical technology and when not to.
- 5. The reporter asked, So there are times when you would favor letting patients die on their own?"
- 6. "Yes, the nurse replied,"I would."
- 7. The reporter asked, Under what circumstances should a patient be allowed to die?"
- **8.** "I cannot really answer that question because so many variables are involved," the nurse replied.
- **9.** "Is this a matter of deciding how to allocate scarce resources?" the reporter asked.

10. "In a sense, it is, the nurse replied." As a colleague of mine says, We should not try to keep everyone alive for as long as possible just because we can."

No Quotation Marks for Indirect Quotations

When you report what someone said or wrote but do not use the person's exact words, you are writing an **indirect quotation**. Do not use quotation marks for indirect quotations. Indirect quotations often begin with the word *that*.

INDIRECT QUOTATION	DIRECT QUOTATION
Sam said that there was a fire downtown.	Sam said, ⁶⁶ There was a fire downtown. ⁹⁹
The police told us to move along.	"Move along," directed the police.
Tara told me that she is graduating.	Tara said, "I am graduating."

TEAMWORK Have students interview each other on a controversial issue that you have chosen. The interviewer should write up the interview using direct and indirect quotations.

PRACTICE 2 Punctuating Direct and Indirect Quotations

Edit the following sentences by adding quotation marks where needed and crossing out quotation marks that are used incorrectly. If a sentence is already correct, put a "C" next to it.

EXAMPLE: Three days before her apartment was robbed, Jocelyn told a friend, "I worry about the safety of this building."

- 1. "Have you complained to the landlord yet?" her friend asked.
- 2. "Not yet," Jocelyn replied, "although I know I should."
- **3.** Jocelyn phoned the landlord and asked him to install a more secure lock on the front door. *C*
- 4. The landlord said that 'he believed that the lock was fine the way it was.'
- **5.** When Jocelyn phoned the landlord after the burglary, she said, "I know this burglary would not have happened if that lock had been installed."
- 6. "I am sorry," the landlord replied, but there is nothing I can do about it now."
- **7.** Jocelyn asked a tenants' rights group whether she had grounds for a lawsuit. *C*

- 8. The person she spoke to said that 4she probably did.
- 9. "If I were you," the person said," I would let your landlord know about your plans."
- **10.** When Jocelyn told her landlord of the possible lawsuit, he said that he would reimburse her for the stolen items. *C*

Quotation Marks for Certain Titles

When you refer to a short work such as a magazine or newspaper article, a chapter in a book, a short story, an essay, a song, or a poem, put quotation marks around the title of the work.

NEWSPAPER ARTICLE

⁶⁶Volunteers Honored for Service⁹⁹

SHORT STORY

⁶⁶The Awakening⁹⁹

ESSAY

"Why Are We So Angry?"

Usually, titles of longer works, such as novels, books, magazines, newspapers, movies, television programs, and CDs, are italicized. The titles of sacred books such as the Bible or the Koran are neither underlined nor surrounded by quotation marks.

воок

The Good Earth

NEWSPAPER

Washington Post

[Do not italicize or capitalize the word *the* before the name of a newspaper or magazine, even if it is part of the title: I saw that article in the *New York Times*. But do capitalize *The* when it is the first word in titles of books, movies, and other sources.]

If you are writing a paper with many outside sources, your instructor will probably refer you to a particular system of citing sources. Follow that system's guidelines when you use titles in your paper.

NOTE: Do not enclose the title of a paragraph or an essay that you have written in quotation marks when it appears at the beginning of your paper. Do not italicize it either.

PRACTICE 3 Using Quotation Marks for Titles

Edit the following sentences by adding quotation marks around titles as needed. Underline any book, magazine, or newspaper titles.

EXAMPLE: After the terrorist attacks of September 11, 2001, the twelve hundred radio stations belonging to Clear Channel Communications were asked not to play songs with a political message, such as "Imagine" by John Lennon.

TIP For more information on citing sources, see Chapter 18.

- 1. In 2002, Bruce Springsteen released his first new album in years, containing songs like "Worlds Apart" that dealt with the terrorist attacks on the United States.
- 2. "The Missing," a review of the Springsteen album in the New Yorker magazine, found Springsteen's new songs unusual because they did not include many specific details about people, as older Springsteen songs like Born in the U.S.A. had done.
- 3. In 2011, Lady Gaga's song Judas was met with controversy for religious, rather than political, reasons.
- 4. In an article titled Lady Gaga's 'Judas' Upsets Religious Groups," the

 Hollywood Reporter described a Catholic leader's criticism of the song
 and Lady Gaga's video of it.
- **5.** However, in an article in the British newspaper the <u>Sun</u>, Lady Gaga said how proud she was of the video.

Edit for Quotation Marks

PRACTICE 4 Editing Paragraphs for Quotation Marks

Edit the following paragraphs by adding twelve sets of quotation marks where needed and crossing out the two sets of incorrectly used quotation marks. Correct any errors in punctuation.

- (1) When Ruiz first came into my office, he told me that he was a poor student. (2) I asked, "What makes you think that?"
- (3) Ruiz answered, I have always gotten bad grades, and I do not know how to get any better. (4) He shook his head. (5) I have just about given up.
- (6) I told him that #there were some resources on campus he could use and that we could work together to help him.
- (7) "What kind of things are you talking about?" asked Ruiz. (8) What exactly will I learn?"
- (9) I said, "There are plenty of programs to help you. (10) You really have no excuse to fail."
 - (11) Can you be a little more specific? he asked.

- (12) "Certainly," I said. (13) I told him about the survival skills program. (14) I also pulled out folders on study skills, such as managing time, improving memory, taking notes, and having a positive attitude. (15) "Take a look at these," I said.
- (16) Ruiz said, No, I am not interested in that. (17) And I do not have time."
- (18) I replied, "That is your decision, Ruiz, but remember that education is one of the few things that people are willing to pay for and not get."
 (19) I paused and then added, It sounds to me like you are wasting the money you spent on tuition. (20) Why not try to get what you paid for?"
- (21) Ruiz thought for a moment, while he looked out the window, and finally told me that #he would try.#
 - (22) Good, I said. (23) I am glad to hear it."

PRACTICE 5 Editing Your Own Writing for Quotation Marks

Edit a piece of your own writing for quotation marks. It can be a paper for this course or another one, or something you have written for work or your every-day life.

Chapter Review

- 1. Quotation marks look like ______. They always appear in (pairs)/ threes).
- 2. A direct quotation exactly <u>repeats</u> what someone (or some outside source) said or wrote. (Use) Do not use) quotation marks around direct quotations.
- 3. An indirect quotation restates what someone said or wrote, but not word for word

 (Use /(Do not use)) quotation marks with indirect quotations.
- 4. To set off a quotation within a quotation, use single quotation marks
- Put quotation marks around the titles of short works such as (give four examples) Answers will vary. Possible answers: short stories, poems, songs, articles
- **6.** For longer works such as magazines, novels, books, newspapers, and so on, ____italicize____ the titles.

LEARNING JOURNAL Did you find quotation mark errors in your writing? How would you explain the use of quotation marks in direct and indirect quotes? What is unclear to you?

TEACHING TIP Collect students' learning journals to find out what the class or individual students need more work on.

Chapter Test

Circle the correct choice for each of the following items.

1. If an underlined portion of this sentence is incorrect, select the revision that fixes it. If the sentence is correct as written, choose d.

Do you think that she was serious when she said, "Leave the building immediately?"

C

a. "she"

(c.) immediately"?

b. said "Leave

d. No change is necessary.

- **2.** Choose the item that has no errors.
 - **a.** "You need to strengthen that knee," Dr. Wheeler warned, "so be sure to do all your exercises".
 - **b.** "You need to strengthen that knee," Dr. Wheeler warned, so be sure to do all your exercises.
 - **c.** "You need to strengthen that knee," Dr. Wheeler warned, "so be sure to do all your exercises."
- **3.** Choose the item that has no errors.
 - **a.** Eric pointed at an article titled 'New Alternative Fuel in Your Backyard.'
 - **b.** Eric pointed at an article titled New Alternative Fuel in Your Backyard.
 - **©.** Eric pointed at an article titled "New Alternative Fuel in Your Backyard."
- **4.** If an underlined portion of this sentence is incorrect, select the revision that fixes it. If the sentence is correct as written, choose d.

The man said, "I'm sorry, officer, but did I hear you correctly

when you said, "Drive into that ditch'?"

- a. officer, "but
- c. ditch?"
- (b.) said, 'Drive
- d. No change is necessary.
- **5.** Choose the item that has no errors.
 - (a.) Rachel told the security guard that she needed to enter the building for official business.
 - **b.** Rachel told the security guard that "she needed to enter the building for official business."
 - **c.** Rachel told the security guard that she "needed to enter the building for official business."

RESOURCES The Testing Tool Kit CD-ROM available with this book has even more punctuation tests. Also, for cumulative Editing Review Tests, see pages 609–18.

THIS CHAPTER

- explains what five other punctuation marks are and how they are used.
- gives you practice using punctuation correctly.

Other Punctuation

(; : () -- -)

Understand What Punctuation Does

Punctuation helps readers understand your writing. If you use punctuation incorrectly, you send readers a confusing—or, even worse, a wrong—message. This chapter covers five punctuation marks that people sometimes use incorrectly because they are not quite sure what these marks are supposed to do.

Practice Using Punctuation Correctly

Semicolon;

SEMICOLONS TO JOIN CLOSELY RELATED SENTENCES

Use a semicolon to join two closely related sentences into one sentence.

In an interview, hold your head up and do not slouch; it is important to look alert.

Make good eye contact; looking down is not appropriate in an interview.

LANGUAGE NOTE: Using a comma instead of a semicolon to join two sentences would create a run-on (see Chapter 21).

SEMICOLONS WHEN ITEMS IN A LIST CONTAIN COMMAS

Use semicolons to separate items in a list that itself contains commas. Otherwise, it is difficult for readers to tell where one item ends and another begins.

RESOURCES Additional Resources contains tests and supplemental exercises for this chapter.

TEACHING TIP Caution students not to use semicolons unless they feel certain about how they are used. Because many students use semicolons as a default solution when trying to increase sentence complexity, they end up overusing or misusing them.

For dinner, Bob ate an order of onion rings; a 16-ounce steak; a baked potato with sour cream, bacon bits, and cheese; a green salad; and a huge bowl of ice cream with fudge sauce.

Because one item, a baked potato with sour cream, bacon bits, and cheese, contains its own commas, all items need to be separated by semicolons.

Colon:

COLONS BEFORE LISTS

Use a colon after an independent clause to introduce a list. An independent clause contains a subject, a verb, and a complete thought. It can stand on its own as a sentence.

The software conference fair featured a vast array of products* financial-management applications, games, educational CDs, college-application programs, and so on.

COLONS BEFORE EXPLANATIONS OR EXAMPLES

Use a colon after an independent clause to let readers know that you are about to provide an explanation or example of what you just wrote.

The conference was overwhelming: too much hype about too many things.

One of the most common misuses of colons is to use them after a phrase instead of an independent clause. Watch out especially for colons following the phrases *such as* and *for example*.

INCORRECT	Tonya enjoys sports that are sometimes dangerous. For example: white-water rafting, wilderness skiing, rock climbing, and motorcycle racing.		
CORRECT	Tonya enjoys sports that are sometimes dangerous: white-water rafting, wilderness skiing, rock climbing, and motorcycle racing.		
INCORRECT	Jeff has many interests. They are: bicycle racing, sculpting, and building musical instruments.		
CORRLOT	Jeff has many interests: bicycle racing, sculpting, and building musical instruments.		

TIP See Chapter 34 (Commas), Chapter 35 (Apostrophes), and Chapter 36 (Quotation Marks) for coverage of these punctuation marks. For more information on using semicolons to join sentences, see Chapter 27.

COLONS IN BUSINE'S CORRESPONDENCE AND BEFORE SUBTITL'S

Use a colon after a greeting called a *salutation*) in a business letter and after the standard heading lines at the beginning of a memorandum.

Dear Mr. Hernandez:

To: Pat Toney
From: Susan Anker

Colons should also be used before subtitles—for example, "Running a Marathon: The Five Most Important Tips."

Parentheses ()

Use parentheses to set off information that is not essential to the meaning of a sentence. Parentheses are always used in pairs and should be used sparingly.

My grandfather's most successful invention (and also his first) was the electric blanket.

When he died (at the age of ninety-six), he had more than 150 patents registered.

Dash --

Dashes can be used like parentheses to set off additional information, particularly information that you want to emphasize. Make a dash by writing or typing two hyphens together. Do not put extra spaces around a dash.

The final exam==worth 25 percent of your total grade==will be next Thursday.

A dash can also indicate a pause, much like a comma does.

My uncle went on long fishing trips—without my aunt and cousins.

Hyphen -

HYPHENS TO JOIN WORDS THAT FORM A SINGLE DESCRIPTION

Writers often join two or more words that together form a single description of a person, place, or thing. To join the words, use a hyphen.

Being a stockbroker is a high-risk career.

Jill is a lovely three-year-old girl.

When writing out two-word numbers from twenty-one to ninety-nine, put a hyphen between the two words.

Seventy-five people participated in the demonstration.

TEACHING TIP Advise students that although an occasional set of parentheses is fine, too many are distracting.

HYPHENS TO DIVIDE A WORD AT THE END OF A LINE

Use a hyphen to divide a word when part of the word must continue on the next line.

Critics accused the tobacco industry of increasing the amounts of nicotine in cigarettes to encourage addiction and boost sales.

If you are not sure where to break a word, look it up in a dictionary. The word's main entry will show you where you can break the word: dic • tio • nary. If you still are not confident that you are putting the hyphen in the correct place, do not break the word; write it all on the next line.

TIP Most word-processing programs automatically put an entire word on the next line rather than hyphenating it. When you write by hand, however, you need to hyphenate correctly.

Edit for Other Punctuation Marks

PRACTICE 1 Editing Paragraphs for Other Punctuation Marks

Edit the following paragraphs by adding semicolons, colons, parentheses, dashes, and hyphens when needed. In some places, more than one type of punctuation may be acceptable. Answers may vary. Possible edits are shown.

- (1) When John Wood was on a backpacking trip to Nepal in 1998, he discovered something he had not expected; only a few books in the nation's schools. (2) He knew that if the students did not have the materials they needed, it would be much harder for them to learn. (3) They did not need high-tech old-fashioned books. (4) Wood high teeh supplies as much as they needed old fashioned books. (4) Wood decided that he would find a way to get those books.
- (5) Two years later, Wood founded Room to Read, an organization dedicated to shipping books to students who needed them. (6) Since then, the group has donated more than three million books. (7) One of Wood's first shipments was carried to students on the back of a yak. (8) Many others arrived in a Cathay Pacific Airlines plane.
- (9) Along with the books, Room to Read has also built almost three hundred schools and has opened five thousand libraries. (10) Different companies donate books to the organization; Scholastic, Inc., recently sent 400,000 books to Wood's group. (11) Money to fund all these efforts comes through various fund-raisers: read-a-thons, auctions, and coin drives.

TIP For more practice using the types of punctuation covered in this chapter, visit Exercise Central at bedfordstmartins.com/ realwriting.

PRACTICE 2 Editing Your Own Writing for Punctuation

Edit a piece of your own writing for semicolons, colons, parentheses, dashes, and hyphens. It can be a paper for this course or another one, or something you have written for work or your everyday life. You may want to try more than one way to use these punctuation marks in your writing.

Chapter Review

- 1. Semicolons (;) can be used to join closely related sentences into one sentence and to separate items in a list that itself contains commas
- 2. Colons (:) can be used in what three ways? after an independent clause to introduce a list; after an independent clause to provide an explanation or example of what you just wrote; after a greeting in a business letter, after heading lines in a memo, and before subtitles
- 3. A colon in a sentence must always be used after an independent clause.
- **4.** Parentheses () set off information that is <u>not essential</u> to a sentence.
- **5.** <u>Dashes (--)</u> also set off information in a sentence, usually information that you want to emphasize.
- 6. Hyphens (-) can be used to join two or more words that together

 form a single description and to break a word at the end
 of a line.

LEARNING JOURNAL What is the main thing you have learned about the punctuation marks in this chapter? What is unclear to you?

TEACHING TIP You can collect students' learning journals to find out what the class or individual students need more work on.

Chapter Test

Circle the correct choice for each of the following items.

- 1. Choose the item that has no errors.
 - **a.** Our car trip took us through Pittsburgh, Pennsylvania, Wheeling, West Virginia, and Bristol, Tennessee.
 - **(b.)** Our car trip took us through Pittsburgh, Pennsylvania; Wheeling, West Virginia; and Bristol, Tennessee.
 - **c.** Our car trip took us through Pittsburgh; Pennsylvania, Wheeling; West Virginia, and Bristol; Tennessee.

RESOURCES The Testing
Tool Kit CD-ROM available
with this book has even more
punctuation tests. Also, for
cumulative Editing Review
Tests, see pages 609–18.

2. If an underlined portion of this sentence is incorrect, select the revision that fixes it. If the sentence is correct as written, choose d.

Gary's dog (a seventeen-year-old easily won first prize in the

Elderly Dog Show; she had the shiniest coat and the most youthful step.

- (a seventeen-year-old)
- c. coat: and

b. Show-she

- d. No change is necessary.
- **3.** Choose the item that has no errors.
 - As our computer specialist, you have three tasks: fixing malfunctioning computers, teaching people to use their computers, and not making any problem worse.
 - **b.** As our computer specialist: you have three tasks, fixing malfunctioning computers, teaching people to use their computers, and not making any problem worse.
 - **c.** As our computer specialist, you have three tasks: fixing malfunctioning computers, teaching people to use their computers (and not making any problem worse).
- **4.** Choose the item that has no errors.
 - a. Is there such a thing as a low-stress-job?
 - **b.** Is there such a thing as a low-stress job?
 - **c.** Is there such a thing as a low stress-job?
- **5.** If an underlined portion of this sentence is incorrect, select the revision that fixes it. If the sentence is correct as written, choose d.

You will have $\frac{5 \text{ and only 5}}{A}$ minutes $\frac{\text{to leave}}{B}$ the office $\frac{\text{before the}}{C}$ alarm sounds.

- **(a.)** 5—and only 5—
- c. before; the

b. to: leave

d. No change is necessary.

- explains three important rules of capitalization.
- gives you practice capitalizing correctly.

Capitalization

Using Capital Letters

LearningCurve
Capitalization
bedfordstmartins.com/
realwriting/LC

RESOURCES This chapter offers associated LearningCurve activities for students. A student access code is printed in every new student copy of this text. Students who do not purchase a new print book can purchase access by going to bedfordstmartins.com/realwriting/LC.

Understand Three Rules of Capitalization

Capital letters (A, B, C) are generally bigger than lowercase letters (a, b, c), and they may have a different form. To avoid the most common errors of capitalization, follow these three rules:

Capitalize the first letter

- Of every new sentence.
- In names of specific people, places, dates, and things (also known as proper nouns).
- Of important words in titles.

Practice Capitalization

Capitalization of Sentences

Capitalize the first letter of each new sentence, including the first word of a direct quotation.

The superintendent was surprised.

He asked, "What is going on here?"

Capitalization of Names of Specific People, Places, Dates, and Things

The general rule is to capitalize the first letter in names of specific people, places, dates, and things. Do not capitalize a generic (common) name such as *college* as opposed to the specific name: *Carroll State College*. Look at the examples for each group.

PEOPLE

Capitalize the first letter in names of specific people and in titles used with names of specific people.

SPECIFIC	NOT SPECIFIC
lean Heaton	my neighbor
Professor Fitzgerald	your math professor
SPECIFIC	NOT SPECIFIC
Or. Cornog	the doctor
Aunt Pat, Mother	my aunt, your mother

TEACHING TIP Have students come up with their own "specific" and "not specific" examples.

The name of a family member is capitalized when the family member is being addressed directly: Happy Birthday, *Mother*. In other instances, do not capitalize: It is my *mother*'s birthday.

The word *president* is not capitalized unless it comes directly before a name as part of that person's title: *President* Barack Obama.

RESOURCES Additional Resources contains tests and supplemental exercises for this chapter.

TEACHING TIP Remind students that they should not write or type in all capital letters because it will be more difficult for them to recognize and edit their capitalization errors.

PLACES

Capitalize the first letter in names of specific buildings, streets, cities, states, regions, and countries.

SPECIFIC	NOT SPECIFIC
Bolton Town Hall	the town hall
Arlington Street	our street
Dearborn Heights	my hometown
Arizona	this state
the South	the southern region
Spain	that country

Do not capitalize directions in a sentence.

Drive south for five blocks.

DATES

Capitalize the first letter in the names of days, months, and holidays. Do not capitalize the names of the seasons (winter, spring, summer, fall).

SPECIFIC	NOT SPECIFIC
Of Earlie	NOT SPECIFIC
Wednesday	tomorrow
June 25	
Julie 25	summer
Thanksgiving	my birthday

ESL Ask ESL students to identify any English capitalization rules that differ from the rules in their first language.

LANGUAGE NOTE: Some languages, such as Spanish, French, and Italian, do not capitalize days, months, and languages. In English, such words must be capitalized.

INCORRECT I study russian every monday, wednesday, and friday

from january through may.

CORRECT I study Russian every Monday, Wednesday, and

Friday from January through May.

ORGANIZATIONS, COMPANIES, AND GROUPS

SPECIFIC	NOT SPECIFIC	
Taft Community College	my college	
Microsoft	that software company	
Alcoholics Anonymous	the self-help group	

LANGUAGES, NATIONALITIES, AND RELIGIONS

SPECIFIC	NOT SPECIFIC	
English, Greek, Spanish	my first language	
Christianity, Buddhism	your religion	

The names of languages should be capitalized even if you aren't referring to a specific course.

I am taking psychology and Spanish.

COURSES

SPECIFIC	NOT SPECIFIC	
Composition 101	a writing course	
Introduction to Psychology	my psychology course	

COMMERCIAL PRODUCTS

SPECIFIC	NOT SPECIFIC
Diet Pepsi	a diet cola
Skippy peanut butter	peanut butter

Capitalization of Titles

When you write the title of a book, movie, television program, magazine, newspaper, article, story, song, paper, poem, and so on, capitalize the first word and all important words. The only words that do not need to

TIP For more on punctuating titles, see Chapter 36. For a list of common prepositions, see page 332.

be capitalized (unless they are the first word) are the, a, an, coordinating conjunctions (and, but, for, nor, or, so, yet), and prepositions.

I Love Lucy was a long-running television program.

Both USA Today and the New York Times are popular newspapers.

"Once More to the Lake" is one of Chuck's favorite essays.

Chapter Revie	ew
----------------------	----

- 1. Capitalize the <u>first letter</u> of every new sentence.
- 3. Capitalize the first word and all _important words _in titles.

Chapter Test

Circle the correct choice for each of the following items.

- 1. Choose the item that has no errors.
 - **a.** My daughter's school, Spitzer High School, no longer sells pepsi and other sodas in its vending machines.
 - **b.** My daughter's school, Spitzer high school, no longer sells pepsi and other sodas in its vending machines.
 - **c.** My daughter's school, Spitzer High School, no longer sells Pepsi and other sodas in its vending machines.
- **2.** If an underlined portion of this sentence is incorrect, select the revision that fixes it. If the sentence is correct as written, choose d.

Will our company President speak at the annual meeting, or will

Dr. Anders?

C

(a.) president

- c. doctor Anders
- **b.** Annual Meeting
- **d.** No change is necessary.
- **3.** Choose the item that has no errors.
 - **a.** Which Library do you go to, Hill Library or Barry Township Library?
 - **(b.)** Which library do you go to, Hill Library or Barry Township Library?
 - **c.** Which library do you go to, Hill library or Barry Township library?

LEARNING JOURNAL Did you find capitalization errors in your writing? What is the main thing you have learned about capitalization that will help you? What is unclear to you?

TEACHING TIP Collect students' learning journals to find out what the class or individual students need more work on.

RESOURCES The Testing
Tool Kit CD-ROM available
with this book has even
more tests on capitalization.
Also, for cumulative Editing
Review Tests, see pages
609–18.

4. If an underlined portion of this sentence is incorrect, select the revision that fixes it. If the sentence is correct as written, choose d.

In my english 99 class last summer, we read some interesting B essays by famous authors.

a. English 99

- c. Famous Authors
- b. last Summer
- d. No change is necessary.
- **5.** If an underlined portion of this sentence is incorrect, select the revision that fixes it. If the sentence is correct as written, choose d.

Of the states in the $\underbrace{\frac{\text{East}}{A}}$, one can travel the farthest $\underbrace{\frac{\text{North}}{B}}$ in $\underbrace{\frac{\text{Maine}}{C}}$

a. east

c. maine

b. north

d. No change is necessary.

Editing Review Test 1

The Four Most Serious Errors (Chapters 19-23)

DIRECTIONS: Each of the underlined word groups contains one or more errors. As you locate and identify each error, write its item number on the appropriate line below. Then, edit the underlined word groups to correct the errors. If you need help, turn back to the chapters indicated. Answers may vary. Possible edits are shown.

Two fragments 2, 9 Two verb problems 10, 16

Two run-ons 8, 15 Four subject-verb agreement errors 4, 6, 11, 14

1 Every time you step outside, you are under attack. 2 Which you may not know what is hitting you, but the attack is truly happening. 3 Invisible storms of sky dust rain down on you all the time. 4 It does not matter if the sun is shining and the sky are bright blue. 5 The dust is still there.

6 Sky dust consists of bug parts, specks of hair, pollen, and even tiny chunks of comets. 7 According to experts, 6 million pounds of space dust settle on the earth's surface every year. 8 You will never notice it's scientists, however, are collecting it in order to learn more about weather patterns and pollution. 9 Scientists use Using sophisticated equipment like high-tech planes and sterile filters to collect dust samples.

Dan Murray, a geologist at the University of Rhode Island, has began a new project that invites students and teachers to help collect samples of cosmic dust.

11 Murray says that collecting the dust particles are quite simple. 12 It starts with a researcher setting up a small, inflatable swimming pool. 13 Next, this investigator leaves the pool out in the open for 48 hours. 14 Finally, the researcher uses a special type has of tape to pick up whatever have settled over time. 15 The tape is put into a beaker of water to dissolve a microscope is used to analyze what comes off the tape. 16 The information finded there will help scientists predict insect seasons, measure meteor showers, or even catch signs of global warming.

Editing Review Test 2

The Four Most Serious Errors (Chapters 19-23)

DIRECTIONS: Each of the underlined word groups contains one or more errors. As you locate and identify each error, write its item number on the appropriate line below. Then, edit the underlined word groups to correct the errors. If you need help, turn back to the chapters indicated. Answers may vary. Possible edits are shown.

Two fragments	5, 12	Two verb problems	4, 16	e Terr
Three run-ons	6, 9, 14	Three subject-verb		
		agreement errors	1, 8, 17	4 -

1 Most people spend many hours a day indoors, so windows and natural light are is important to their health. 2 Light helps people feel connected to the world around them. 3 However, traditional windows allow the loss of heat in winter and of cool air in summer; the result is high energy costs to maintain office buildings and homes at know comfortable temperatures. 4 Architects and designers knowed this fact, so they have developed energy-efficient "smart windows." 5 Smart windows shift developed energy-efficient "smart windows." 5 Shifting from clear to dark and back again. 6 Some smart windows change from clear to dark with a touch of a button others change automatically in response to the intensity of the outside light.

7 Their design and engineering make smart windows *chromogenic*, or able to shift change colors. 8 Smart windows shifts to darker colors when they are given a small electrical charge. 9 The darker the room, the more it remains cool the sun does not warm it. 10 Smart windows take only a minute or so to darken.

11 Although these smart windows save energy, they may not be ready for the market/12 for a few more years. 13 At present, designers face some resistance from potential customers who distrust the technology. 14 Another obstacle is the price tag/
This this new technology remains expensive. 15 To deal with both of these issues, developers are starting small. 16 They were creating motorcycle and ski helmets with face masks that switch between dark and clear. 17 They hopes that handy products like these helmets will help the new technology gain wide acceptance.

Editing Review Test 3

The Four Most Serious Errors (Chapters 19–23) Other Grammar Concerns (Chapters 24–30)

DIRECTIONS: Each of the underlined word groups contains one or more errors. As you locate and identify each error, write its item number on the appropriate line below. Then, edit the underlined word groups to correct the errors. If you need help, turn back to the chapters indicated. Answers may vary. Possible edits are shown.

Two fragments	3, 6	Two verb problems	1, 5	1.6%
One run-on	10	Two pronoun errors	2, 8	
One adjective error	11	One parallelism error	13	
Two subject-verb agreement errors	16, 17			

1 Flying an airplane across the Atlantic Ocean may have been a miracle almost a century ago, but today it be quite commonplace. 2 When a man named Maynard Hill decided to do it, however, most people told him that he simply could not be done.

He gave
Giving it a try despite everyone's doubts. 4 His persistence was rewarded when TAM-5, his 11-pound model airplane, flew from Canada to Ireland in approximately set and set and set are to set only for the longest distance but also for the longest time ever flown by this type of airplane. 6 Following the same path as the first nonstop flight across the ocean in 1919.

7 This successful trip was not Hill's first attempt, by any means. 8 He started his its project a decade ago, and he lost several planes trying to complete the journey.

9 Finally, in August 2003, he made a fifth attempt. 10 He tossed the TAM-5 into the air once airborne, it was guided by remote control on the ground. 11 It was the most best version he had made. 12 It soared to a cruising altitude of almost 1,000 feet, and at that point a computerized autopilot took over.

13 For days, the flight crew watched the clock, followed the TAM-5's progress, and hoped hopes for the best.

14 A crowd of fifty people waited on the shore in Ireland to watch the TAM-5's landing. 15 When the plane appeared on the horizon, a cheer went up.

16 Today, model plane enthusiasts remembers his feat. 17 Even though the plane was made out of nothing more than balsa wood, fiberglass, and plastic film, it flew right into history that August afternoon.

Editing Review Test 4

The Four Most Serious Errors (Chapters 19–23) Other Grammar Concerns (Chapters 24–30)

DIRECTIONS: Each of the underlined word groups contains one or more errors. As you locate and identify each error, write its item number on the appropriate line below. Then, edit the underlined word groups to correct the errors. If you need help, turn back to the chapters indicated. Answers may vary. Possible edits are shown.

Two fragments	11, 14	One run-on	13
One subject-verb agr	eement error15	One pronoun error	8
One misplaced/dang	ling modifier3	Two coordination/	1. 7
One use of inappropr	iately	subordination errors	4, /
informal or casual lar	40		

1 Early on May 1, 2011, Sohaib Athar, an IT consultant in Pakistan, was surprised to hear helicopters flying over his house. 2 Soon, he sent a Twitter message about it:

for the next half hour, he "Helicopter hovering above Abbottabad at 1 AM (is a rare event)." 3 He continued to tweet about what he was hearing for the next half hour, attracting many Twitter followers.

Although

4 Because he didn't know it at the time, Athar became the first person to publicize the raid in which Osama bin Laden was captured and assassinated. 5 For this reason, Athar also became one of the most famous of a growing number of so-called citizen journalists. 6 Unlike most traditional news gatherers, citizen journalists aren't trained in journalism. 7 They follow events and trends that interest them, but they send their observations to others through Facebook, Twitter, and other social media.

8 Certain media critics argue, however, that if someone tweets about something he or she doesn't newsworthy, they don't necessarily deserve to be called a journalist. 9 That is the view of Dan Miller, a reporter who had the following reaction to Athar's famous reports: "Wondering on Twitter why there are helicopters flying around your neighborhood isn't journalism." 10 According to Miller, traditional media, not Athar, got the 411 about bin Laden's capture out to the whole world 11 Not to just some Twitter followers.

12 Others say that Athar provided a more valuable service. 13 For example, he communicated with people who were following him and tried to answer their questions he he sought out other sources of information and shared them. 14 Also, tried to analyze what he observed himself and what he learned from other sources.

15 Whether or not Athar deserves to be called a journalist, one thing is clear: More are people is feeling driven to tweet, text, or blog from their particular corners of the world.

coming New Year.

Editing Review Test 5

The Four Most Serious Errors (Chapters 19–23)
Other Grammar Concerns (Chapters 24–30)
Word Use (Chapters 31–33)

DIRECTIONS: Each of the underlined word groups contains one or more errors. As you locate and identify each error, write its item number on the appropriate line below. Then, edit the underlined word groups to correct the errors. If you need help, turn back to the chapters indicated. Answers may vary. Possible edits are shown.

- 1 How do you celebrate the New Year? 2 Some people watch television on New they
 Year's Eve so that he can see the glittering ball drop in New York's Times Square.

 3 Others invite friends and family over to celebrate with special foods or fireworks.
- The New Year are celebrated all over the world in a variety of ways. 5 For spend example, in Australia, people spended the day in fun, outdoor activities, such as picnics, trips to the beach, and rodeos. 6 After all, it is summertime there in January.

 7 In Spain, people eat a dozen grapes at midnight. 8 They eat one each time the clock they chimes because she believe that it will bring good luck for the New Year. 9 The people of Denmark have the unusualest tradition. 10 On New Year's Eve, they throw old dishes at the doors of their friends' homes. 11 If you find a lot of broken junk in front of your house in the morning, you are well-liked. 12 Wearing all new clothes is the way many their Koreans celebrate the start of the New Year. 13 In Germany, people leave food on there plates this practice is meant to ensure that their kitchens will be full of food for the
- 14 Not all countries celebrate the New Year on January 1. 15 Setting off
 The
 , by setting off firecrackers.
 firecrackers, the holiday is celebrated later by the Chinese people/16 The date of the

 calendar
 Chinese New Year depends on the lunar calander and usually falls somewhere between

 January 21 and February 20.
 17 The Chinese often have a big parade with colorful symbols
 floats of dancing dragons. 18 The mythical creatures are supposed to be cymbols of wealth and long life.

Editing Review Test 6

The Four Most Serious Errors (Chapters 19–23) Other Grammar Concerns (Chapters 24–30) Word Use (Chapters 31–33)

DIRECTIONS: Each of the underlined word groups contains one or more errors. As you locate and identify each error, write its item number on the appropriate line below. Then, edit the underlined word groups to correct the errors. If you need help, turn back to the chapters indicated. Answers may vary. Possible edits are shown.

One run-on	4		One use of inappropriately	
One subject-verb agree	ement error	8	informal or casual language	6
			One verb problem	2
One parallelism error _				0
Two commonly			One pronoun error	7
confused word errors	3, 13	-	Two spelling errors	7, 14

- 1 The idea of being able to unlock your car, turn on a light, or starting your computer just by waving your hand sounds like something out of a science-fiction novel.
- Thanks to advancements in technology, the futuristic idea has became a reality.
- Some people are all ready able to accomplish routine actions in this unusual way.
- 4 They do not have special powers they have special computer chips embedded inside their bodies. 5 These high-tech chips help people do daily tasks with little or no effort.
- Known as RFIDs, which stands for "radio frequency identification devices," the extremely chips are way small. 7 They are as tiny as a peice of rice, have small antennas that send signals, and can be painlessly implanted and worn under the skin. 8 Health-care workers use uses the chips in a variety of life-saving ways. 9 For example, emergency medical their workers can scan the chips in accident victims to determine his blood type or allergies.
- 10 For security reasons, some parents have their children wear RFIDs on backpacks, bracelets, or ID tags. 11 Through a cell-phone signal, the chips automatically let the parents know when their children have reached and left school or other destinations. 12 Even some pets are now equipped with these computer chips. 13 If the then pet runs away or gets lost, than its owners can track down their pet more easily by using the chip. 14 Although many people think that these chips have great potential, others worry that the government will eventually use them to spy on people.

Editing Review Test 7

The Four Most Serious Errors (Chapters 19–23)
Other Grammar Concerns (Chapters 24–30)
Word Use (Chapters 31–33)
Punctuation and Capitalization (Chapters 34–38)

DIRECTIONS: Each of the underlined word groups contains one or more errors. As you locate and identify each error, write its item number on the appropriate line below. Then, edit the underlined word groups to correct the errors. If you need help, turn back to the chapters indicated. Answers may vary. Possible edits are shown.

One run-on	7	One verb problem	13	
One apostrophe error _	3	One pronoun error	10	
One adverb error	2	One quotation mark error _	9	ex el-
One subject-verb agreement error11		One capitalization error	4	b
One comma error	8	One semicolon error	5	

- 1 In response to the ongoing economic crisis, more high schools are teaching financial literacy: how to create a budget, save money, and stay out of debt. 2 Although most experts agree that teaching these skills is a good idea, some recommend that such education begin more earlier—even in preschool. 3 This way, young people have more time to learn good habit/s, save money, and plan for their financial future.
- 4 The Moonjar is one Tool for teaching children good money skills. 5 It consists of three tin boxes/each of which is labeled "spend," "save," or "share." 6 Children are encouraged to divide allowances or gifts of money equally among the boxes. 7 As the weeks pass by, they watch their savings grow, helping them see the benefits of saving money over time/they also learn discipline about spending. 8 For example a child who is shopping with a parent might ask for a pack of candy or a small toy. 9 The parent can reply, "Do you have enough money in your spend box" 10 Exchanges like that one help the child understand the consequences of financial decisions; if they spend money on one item now, less money will be available for other purchases in the future.
- 11 Mary Ryan Karges, who is in charge of sales for Moonjar LLC, recommend that financial skills be emphasized as much as other basic skills taught to young children.

 12 She says, "If we teach save, spend, share with the same vigor that we teach stop, look, listen, we won't run into so many financial problems." 13 Once children have seed the benefits of good financial choices, they are on their way to a better future.

Editing Review Test 8

The Four Most Serious Errors (Chapters 19–23)
Other Grammar Concerns (Chapters 24–30)
Word Use (Chapters 31–33)
Punctuation and Capitalization (Chapters 34–38)

DIRECTIONS: Each of the underlined word groups contains one or more errors. As you locate and identify each error, write its item number on the appropriate line below. Then, edit the underlined word groups to correct the errors. If you need help, turn back to the chapters indicated. Answers may vary. Possible edits are shown.

One run-on	5	One semicolon error	1
One pronoun error	13	One verb problem	4
One comma error		One adverb error	10
One apostrophe error		One spelling error	11
One use of inappropriately		One parallelism error	
informal or casual language	11	One hyphen error	
One capitalization error	6		

- 1 If it seems as though places in the United States are more crowded lately/it might be because the country's population recently hit 300 million. 2 The nation has the third-largest population in the world. 3 Only China and India have more people.

 Delieve

 4 Experts belief that by 2043 there will be 400 million people in the United States.
- The country is growing rapidly because people are having more babies more

 people are moving to the United States. 6 The northeast is the most populated area

 within the country. 7 It took fifty-two years for the country's population to go from

 100 million to 200 million. 8 It took only thirty-nine years to rise from 200 million to its

 current 300 million. 9 If experts statistics are correct, it will take even less time for the

 population of the United States to reach 400 million.
- 10 Some people worry that the United States is growing too quickly frightening possibilities predict some super scary possibilities.

 They state that if the population grows

 too large, it will stress available land, deplete water resources, and it can increase air pollution.

 13 Their their the population just keeps growing.

 Although this country is large future generations may be squeezed in more tightly than the present generation can imagine.

Editing Review Test 9

The Four Most Serious Errors (Chapters 19–23)
Other Grammar Concerns (Chapters 24–30)
Word Use (Chapters 31–33)
Punctuation and Capitalization (Chapters 34–38)

DIRECTIONS: Each of the underlined word groups contains one or more errors. As you locate and identify each error, write its item number on the appropriate line below. Then, edit the underlined word groups to correct the errors. If you need help, turn back to the chapters indicated. Answers may vary. Possible edits are shown.

One fragment	7	One spelling error	9
One run-on	10	One hyphen error	4
One pronoun error	13	One semicolon error	8
One parallelism error _	14	One parenthesis error	12
One commonly		One word-choice error	2
confused word error	3		

1 Whenever you have to write a paper, a letter, or any other document for work Today, or school, you probably head toward the computer. 2 In this day and age, most people reach for keyboards faster than they pick up pens. 3 At one elementary school in Scotland, however, the principal, Bryan Lewis, is taking a different approach. 4 He believes that neat handwriting is still an important skill, so he has his students write not only by hand but also with old fashioned fountain pens.

5 Fountain pens were used in schools long ago and lately have been regaining popularity because they are refillable. 6 A writer using a fountain pen dips the point into a little ink bottle/7 Drawing ink up into the barrel of the pen, as needed. 8 Today, a writer simply throws an empty pen away/and gets a new one.

9 So far, Principal Lewis is pleased with the results of his experiment. 10 He reports that students are taking more care with their work/their self-esteem has improved as well. 11 He stresses to teachers all over the world that the ability to produce legible handwriting remains a necessary skill. 12 Lewis is happy with the improvement he sees in his students' writing (and in his own writing, too. 13 He knows that computers are here to stay and that it will not disappear. 14 However, he believes that the practice with fountain pens helps students focus, write faster, and they can feel proud of themselves.

Editing Review Test 10

The Four Most Serious Errors (Chapters 19–23)
Other Grammar Concerns (Chapters 24–30)
Word Use (Chapters 31–33)
Punctuation and Capitalization (Chapters 34–38)

DIRECTIONS: Each of the underlined word groups contains one or more errors. As you locate and identify each error, write its item number on the appropriate line below. Then, edit the underlined word groups to correct the errors. If you need help, turn back to the chapters indicated. Answers may vary. Possible edits are shown.

One subject-verb agreement error11		One spelling error	7
One pronoun error	4	One comma error	14
One coordination/subordination error2_		One semicolon error	13
One colon error	9	One apostrophe error	12
One commonly confus	ed word error 15		

1 When Shaun Ellis decided that he wanted to learn more about wolves, he made and a radical life change. 2 He decided to live with the wolves yet imitate their wild lifestyle as closely as he possibly could. 3 For eighteen months, he lived with three wolf pups that had been abandoned. 4 He pretended to be the months in many ways. 5 He worked to teach them the skills they would need to survive in the wild. 6 It certainly was not an easy way to live. 7 Ellis shared an outdoor pen with the pups, and it had no heat or bedding. 8 To keep warm on the cold nights, he had to snuggle with the young wolves.

9 To communicate with them, Ellis learned how to/growl, snarl, and howl.

10 He also learned how to use body positions and facial expressions in order to get a tried message across to the animals. 11 While living with the wolves, he also try to eliminate any emotion because animals do not feel things as human beings do. 12 This mans transition back to regular life was quite difficult for him.

13 Ellis's unorthodox methods have earned him criticism from his colleagues/but
he firmly believes that his techniques led to valuable knowledge about wolves. 14 He
has founded/the Wolf Pack Management organization in England. 15 Its goal is to get
captive wolves released back into the wild and than use what was learned to help the
animals avoid future conflicts with humans.

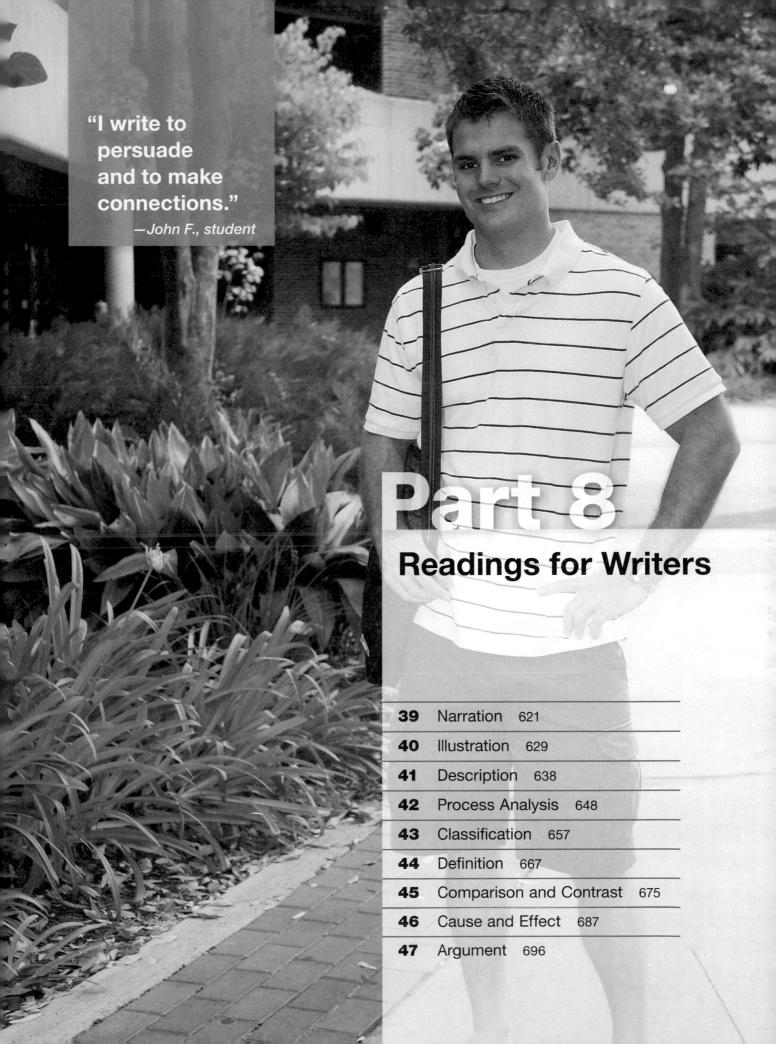

39

Narration

In this part of the book (this chapter through Chapter 47), you will find twenty-one essays that demonstrate the types of writing you studied in Part 2 of this book. In all cases but Chapter 47 (Argument), the first essay in each chapter is written by a student; the second one is by a professional writer. (Chapter 47 contains three student essays and two professional essays.)

In addition to serving as good models of writing, these essays can also provide you with ideas for your own writing, both in and out of school. Most important, they offer you a chance to become a better reader and to learn skills from other writers.

Each essay in this chapter uses narration to get its main point across to the reader. As you read these essays, consider how they achieve the Four Basics of Good Narration that are listed below and discussed in Chapter 8.

TIP As discussed in Chapter 3, it is a good idea to keep a journal to record and explore your thoughts and feelings and come up with ideas for writing. Throughout this part of the book, you will be asked to record information in an idea journal, which you may have started already. You might also want to keep a reading iournal to record information about the essays in this chapter and your thoughts about them.

Four Basics of Good Narration

- It reveals something of importance to the writer (the main point).
- 2 It includes all the major events of the story (primary support).
 - It brings the story to life with details about the major events (secondary support).
- It presents the events in a clear order, usually according to when they happened.

Lauren Mack

Gel Pens

Lauren Mack expects to graduate from the University of Massachusetts Amherst in 2013 with a major in communications and a minor in film studies. Mack wrote "Gel Pens" for an English class when she was a senior in high school preparing to go to college. She was inspired to write this essay because it was a true story that had a strong effect on her. The fifth-grade incident made her realize the importance of kindness over popularity, and it showed her the true meaning of friendship. Mack's advice to other writers is to read a lot and to write what you know. "When something means a lot to you, the writing will come naturally," she said.

In this essay, Mack tells the story of a grade school experience that changed how she sees herself.

GUIDING QUESTION

Why are gel pens important in this essay?

I was in fifth grade. Everything was new and interesting; our elementary school had just been redone, I had a new teacher, and a whole new class. And more than anything, I wanted to be cool. The way I saw it, once I was cool, I'd be popular; and once I was popular, I'd have lots of friends which, of course, was the key to juvenile happiness. So on the first day of school, I pulled the boldest move of my elementary career. Rather than sitting with my old friends who I knew were friendly and nice, I sat with the popular girls, Caitlin, Carly, and Maggie. It was my ticket to fame, I thought, because these girls could help me become the person I wanted to be. But I'd never been so wrong.

And so all year, I sat with Caitlin, Carly, and Maggie, and throughout that entire year, I was the odd girl out. What stands out more than anything from fifth grade were these gel pens. I remember the girls had this fantastic collection of gel pens in all different colors; sparkly greens and pinks and blues, and they were the greatest things that a fifth grader could fathom² and they were all right in front of me—except I couldn't use them. I wasn't cool enough to use these gel pens and, to me, this was absolutely heartbreaking.

Looking back, it's strange to think that, throughout an entire year of being shunned³ and neglected by these girls, it was a collection of pens that made me come to my senses about what I was doing wrong. What was the logical⁴ sense in being popular if, in the end, I was constantly feeling jealous, upset, and left out? To answer this, I turned to music and writing as my refuge.⁵ After I graduated fifth grade, I began playing guitar and writing my own songs. And with that, it didn't take me long to realize

CRITICAL READING Preview

Read

Pause Review

See pages 9-12.

VOCABULARY
DEVELOPMENT Certain
words in this essay are
defined at the bottom of the
page. Underline these words
as you read them.

IDEA JOURNAL Write about what made students popular in your grade school days.

REFLECT: Have you ever turned to the types of refuges that Mack describes?

1. juvenile: an adjective referring to young people 2. fathom: to understand or discover 3. shunned: avoided 4. logical: based on reasoning 5. refuge: a place of escape or relief

that there is so much more to happiness than Caitlin, Carly, and Maggie and their silly gel pens. In breaking free from the disciples⁶ of "cool," I felt that I not only set myself apart from others but also found something I hadn't found at all that year: happiness and satisfaction in myself.

These days, I refuse to adjust myself to meet the standards of others. Instead, I invest my time working on the things that have molded me into the person I am today. I am a musician: I write my songs about people, but not for them. I am an artist: I create my works from my own imagination, not from the person next to me. I am a writer: I express my ideas and opinions by crafting words to my own liking. But above all, I am my own person: People can influence me, but they cannot change me, regardless of how many gel pens they may have.

IDENTIFY: Underline the definitions Mack gives of "an artist," "a writer," and "my own person."

SUMMARIZE AND RESPOND

In your reading journal or elsewhere, summarize the main point of "Gel Pens." Then, go back over the essay, and check off the support for this idea. Next, write a brief summary of the essay. Finally, write a brief response to the reading. How does the author rethink or build upon traditional definitions of "happiness"?

CHECK YOUR COMPREHENSION

- 1. An alternate title for this essay could be
 - a. "Gel Pens Are Artists' Best Tools."
 - **b.** "A Musician Joins the Cool Kids and Thrives."
 - (c.) "Happiness Found in a Break with the Crowd."
 - d. "The Most Popular Students Are Shallow."
- 2. The main point of this essay is that
 - **a.** young people will find the most happiness if they take the time and effort to be accepted by the popular crowd.
 - **b.** a person who develops into a talented artist may be shunned by others who are jealous.
 - **c.** playing the guitar and writing songs is a better way to find happiness than drawing with gel pens.
 - d. happiness comes from becoming one's own person, not from being accepted by the popular crowd.
- **3.** How did the gel pens help the author "come to [her] senses about what [she] was doing wrong"?
 - **a.** The pens helped the author see that her artistic talents were greater than any talents the popular girls possessed.
 - **(b.)** The author realized that the pens, and the girls who used them, weren't as important as pursuing her own interests.

6. disciples: followers 7. crafting: to form skillfully

- **c.** The pens helped the author see that visual art wasn't for her; instead, making music was what she loved most.
- **d.** Because the "cool" girls didn't want to share their pens with the author, she saw that she was better off without the popular crowd.
- **4.** Does this essay include the Four Basics of Good Narration? Why or why not?
- **5.** Look back at the vocabulary you underlined, and write sentences using these words: *fathom* (para. 2); *refuge*, *disciples* (3); *crafting* (4).

TIP For tools to build your vocabulary, visit the Student Site for Real Writing at bedfordstmartins.com/realwriting.

READ CRITICALLY

- 1. The opening paragraph suggests different definitions of friendship. In your view, what are these different definitions, and what are the results of pursuing one type of friendship over another?
- **2.** How did the author's idea of who she wanted to be (para. 1) change as a result of the experiences described in the essay?
- **3.** Why do you suppose Mack chose to make the gel pens an important part of her essay? What appeal did they have for her apart from their "sparkly greens and pinks and blues" (2)?
- 4. Mack discusses how making music and writing helped her become a more satisfied and independent person. Would any further details about her music and writing have helped you better understand Mack and the changes she went through? If so, explain the types of details you would like her to have included.
- 5. In the final paragraph, Mack writes, "People can influence me, but they cannot change me." Based on this essay and your own experiences, what kind of things influence people (affect their beliefs or behaviors, often in subtle ways), and what kinds of things cause deep and lasting change? Give as many examples as you can.

WRITE

TIP For a sample narration paragraph, see page 124.

WRITE A PARAGRAPH: In a paragraph, tell the story of how finding a personal interest—in music, sports, or something else—has had a positive effect on your life. Make your story as specific and detailed as possible.

WRITE AN ESSAY: Write an essay about a time when an action you took to improve your life (such as Mack's joining in with the popular crowd) had unexpected results. What was the experience, and what did you learn from it?

Pat Conroy

Chili Cheese Dogs, My Father, and Me

The writing of Pat Conroy (b. 1945) draws heavily on his life experiences. *The Water Is Wide* (1972) recounts his days teaching at a one-room school in South Carolina. *The Great Santini* (1976) describes the difficulty of growing up with a strict military father. Several of Conroy's books have been made into movies. The most famous of these films is *The Prince of Tides* (1991), which was based on Conroy's 1986 novel of the same name. His most recent books include *The Pat Conroy Cookbook: Recipes of My Life* (2005), a mix of food writing and memoir; the novel *South of Broad* (2009); and *My Reading Life* (2010), in which Conroy explores the

role of books in his life.

In the following essay, Conroy uses narration to tell a story about two important relationships—with food and with his father—and how they came together.

TEACHING TIP Students should see that this essay has three parts: (1) the story of the author's sixth birthday, (2) the story of his first visit to Chicago, and (3) the story of his final days with his father.

GUIDING QUESTION

What is the significance of chili cheese dogs in the narrator's relationship with his father?

When I was growing up and lived at my grandmother's house in Atlanta, my mother would take us after church to The Varsity, an institution with more religious significance to me than any cathedral in the city. Its food was celebratory, fresh, and cleansing to the soul. It still remains one of my favorite restaurants in the world.

I had then what I order now—a habit that has not deviated¹ since my 2 sixth birthday in 1951, when my grandmother, Stanny, ordered for me what she considered the picture-perfect Varsity meal: a chili cheese hot dog, onion rings, and a soft drink called "The Big Orange."

On that occasion, when my family had finished the meal, my mother 3 lit six candles on a cupcake she had made, and Stanny, Papa Jack, my mother, and my sister Carol sang "Happy Birthday" as I blushed with pleasure and surprise. I put together for the first time that the consumption² of food and celebration was a natural and fitting combination. It was also the first time I realized that no one in my family could carry a tune.

When my father returned home from the Korean War, he refused to believe that The Varsity—or the American South, for that matter—could produce a hot dog worthy of consumption. My Chicago-born father was a fierce partisan³ of his hometown, and he promised me that he would take me to eat a real "red hot" after we attended my first White Sox game.

That summer, we stayed with my dad's parents on the South Side of 5 Chicago. There, I met the South Side Irish for the first time on their own turf. My uncles spent the summer teasing me about being a southern hick as they played endless games of pinochle⁴ with my father. Then, my father

IDEA JOURNAL Describe a relationship of yours that has changed over time.

CRITICAL
READING
Preview
Read
Pause
Review

See pages 9-12.

VOCABULARY DEVELOPMENT Certain

- words in this es say are defined at the jottom of the page. Underline these words as you read frem.
- 4 REFLEC f: Based on paragr .ph 4, how would you d scribe the father's personality?

- 1. deviated: changed 2. consumption: using; eating (in the case of food)
- **3. partisan:** one who takes sides **4. pinochle:** a card game popular in the mid-1900s

per knok

took me for the sacramental⁵ rite of passage: my first major league baseball game. We watched the White Sox beat the despised Yankees.

After the game, my father drove my Uncle Willie and me to a place called Superdawg to get a red hot. He insisted that the Superdawg sold the best red hots in the city. When my father handed me the first red hot I had ever eaten, he said, "This will make you forget The Varsity for all time." That summer, I learned that geography itself was one of the great formative⁶ shapers of identity. The red hot was delicious, but in my lifetime I will never forsake⁷ the pleasure of The Varsity chili cheese dog.

When my father was dying of colon cancer in 1998, he would spend 7 his days with me at home on Fripp Island, South Carolina, then go back to Beaufort at night to stay with my sister Kathy, who is a nurse and was in charge of his medications. Since I was responsible for his daily lunch, I told him I would cook him anything he wanted as long as I could find it in a South Carolina supermarket.

"Anything, pal?" my father asked.

"Anything," I said.

Thus, the last days between a hard-core Marine and his edgy son, who had spent his career writing about horrific father-son relationships, became our best days as we found ourselves united by the glorious subject of food.

8

12

13

My father was a simple man with simple tastes, but he was well-traveled, and he began telling me his life story as we spent our long hours together. The first meal he ordered was an egg sandwich, a meal I had never heard of but one that kept him alive during the Depression. He told me, "You put a fried egg on two slices of white bread which has been spread with ketchup."

"It sounds repulsive," I said.

"It's delicious," he replied.

When Dad spoke of his service in Korea, I fixed him kimchi (spicy pickled vegetables), and when he talked about his yearlong duty on an aircraft carrier on the Mediterranean, I made spaghetti carbonara¹⁰ or gazpacho.¹¹ But most of the time, I made him elaborate sandwiches: salami or baloney tiered high with lettuce, tomatoes, and red onions. The more elaborate I made them, the more my father loved them.

He surprised me one day by asking me to make him some red hots, done "the Chicago way, pal." That day, I called Superdawg and was surprised that it was still in business. A very pleasant woman told me to dress the red hots with relish, mustard, onion, and hot peppers with a pickle on the side. "If you put ketchup on it, just throw it in the trash," she added.

The following week, he surprised me again by ordering up some chili the cheese dogs, "just like they make at The Varsity in Atlanta." So I called The Varsity and learned step by step how to make one of their scrumptious chili cheese dogs.

PREDICT: What do you think will happen next?

TEACHING TIP Have students apply the basics of critical thinking (see Chapters 1 and 16) to some of the readings in Part 8. For example, individually or in small groups, they might identify and question assumptions that the authors seem to be making.

5. sacramental: sacred
6. formative: giving form to
7. forsake: to give up
8. Depression: a serious economic downturn lasting from 1929 until the late 1930s
9. repulsive: disgusting
10. spaghetti carbonara: pasta with a sauce of cream, eggs, and bacon
11. gazpacho: a cold vegetable soup from Spain

When my father began his quick, slippery descent¹² into death, my 17 REFLECT: Why does Carol brothers and sisters drove from all directions to sit six-hour shifts at his bedside. We learned that watching a fighter pilot die is not an easy thing. One morning, I arrived for my shift and heard screaming coming from the house. I raced inside and found Carol yelling at Dad: "Dad, you've got to tell me you're proud of me. You've got to do it before you die."

I walked Carol out of the bedroom and sat her down on the sofa. 18 "That's Don Conroy in there, Carol—not Bill Cosby," I said. "You've got to learn how to translate Dad. He says it, but in his own way."

Two weeks before my father died, he presented me with a gift of infinite price. I made him the last chili cheese dog from The Varsity's recipe that he would ever eat. When he finished, I took the plate back to the kitchen and was shocked to hear him say, "I think the chili cheese dog is the best red hot I've ever eaten."

There is a translation to all of this, and here is how it reads: In the last 20 SUMMARIZE: How do the days of his life, my father was telling me how much he loved me, his oldest son, and he was doing it with food.

act as she does here?

loves his son?

father's words show that he

SUMMARIZE AND RESPOND

In your reading journal or elsewhere, summarize the main point of "Chili Cheese Dogs, My Father, and Me." Then, go back over the essay, and check off the support for this idea. Next, write a brief summary of the essay. Finally, write a brief response to the reading. What impression does Conroy create of his changing relationship with his father?

CHECK YOUR COMPREHENSION

- An alternate title for this essay could be
 - a. "My Father, the Fighter Pilot."
 - (b.) "How My Father Told Me He Loved Me."
 - c. "How I Learned to Love Chili Cheese Dogs."
 - d. "The Varsity vs. Superdawg."
- 2. The main point of this essay is that
 - **a.** chili cheese dogs are better tasting than red hots.
 - **b.** men can learn to be excellent and creative cooks.
 - (c.) people can communicate their affection for others in indirect ways.
 - **d.** only when a parent is dying does a child learn what that parent is really like.

^{12.} descent: a way down; a passage down to a wise, kind father in a 1980s TV comedy

^{13.} Bill Cosby: the actor who played

- **3.** What is Conroy's point in telling the story of his sister Carol's angry outburst toward their father (para. 17)?
 - **a.** He wants readers to understand that he comes from a family in which yelling is common.
 - **b.** He wants to show the kind of relationship he has with his sister.
 - **c.** He wants readers to see that anger is not useful in dealing with parents.
 - **d.** He wants to show how difficult it is for his father to express feelings for his children.
- **4.** Look back at the vocabulary you underlined, and write sentences using the following words: *deviated* (2); *consumption* (3); *formative* (6); *repulsive* (12); *descent* (17).

READ CRITICALLY

- **1.** What details show the change in Conroy's father's attitude toward The Varsity's chili cheese dogs? What is the significance of this change?
- **2.** What three stories does Conroy narrate in this essay? When does he shift to telling about his father's last days? How do you know?
- **3.** Based on details from the essay, describe the ways in which father and son are "united by the glorious subject of food"?
- **4.** Beginning in paragraph 8, Conroy includes a number of direct quotations from himself and his father. What is the effect of Conroy's presenting this dialogue?
- **5.** Although this essay tells a sad story overall, it has some humorous moments. What are they, and how did they affect you?

WRITE

WRITE A PARAGRAPH: Write a paragraph that tells about a time when a particular food played a special role during a family celebration, such as a birthday or a holiday. Like Conroy, include details about family members and your own response to the occasion.

WRITE AN ESSAY: In an essay, trace the history of your relationship with an older family member or someone else who has played a significant role in your life. As Conroy does in writing about his relationship with his father, tell specific stories about your times with this person, and suggest ways in which your relationship changed over time.

40

Illustration

Each essay in this chapter uses illustration to get its main point across to the reader. As you read these essays, consider how they achieve the Four Basics of Good Illustration that are listed below and discussed in Chapter 9 of this book.

Four Basics of Good Illustration

2 It gives specific examples that show, explain, or prove the point.

3 It gives details to support the examples.

It uses enough examples to get the point across to the reader.

True Shields

To Stand in Giants' Shadows

True Shields wrote the following essay for the *Daily Californian*, an independent student newspaper at the University of California, Berkeley, where he majored in English and graduated in the spring of 2012. Shields also writes short fiction, and he hopes to enter an M.F.A. program in writing.

Of "To Stand in Giants' Shadows" Shields writes, "The piece is about the first time I really got interested in games as something with a competitive ladder—that is, I found out that competition is fun, even when you know you're a poor athlete/gamer, because

you can always learn from someone. I enjoyed writing this column because it gave me an opportunity to think about people to whom I really owe a lot of thanks."

Shields's advice to other aspiring writers is to "find a routine and stick with it. There's no greater enemy to writers than a lack of discipline. Also, make sure your computer isn't connected to the Internet, if you're using one to write."

GUIDING QUESTION

hand guides yours.

Who are the "giants" in this essay?

Imagine being guided by an old yet firm hand into a living room and then sat before a growling fire and a bowl of ice cream. The hand pats you on the back after sitting you down and leaves momentarily to retrieve something: a circular wooden board, with semi-spherical divots¹ bored out of it in a first-aid symbol pattern. The marbles—some quartz, some amethyst,² and others minerals you don't recognize—rest like clay soldiers awaiting a general's hand in the grooves. The hand removes one marble from the center and then leapfrogs another marble over an adjacent³ one, removing the hopped-over crystal sphere. It motions for you to do the same. Bewildered,⁴ you look down and reach, uncertain, while the

This was my first introduction to games.

I remember childhood visits to my grandparents' house in the Pacific 3 Palisades as opportunities for my brother and me to stuff our faces and fall asleep in front of the fire after going for a swim. This was all fine and good, but the real meat and potatoes of our visits, our *raisons d'être*, were the times spent hunched over the marble solitaire board like miniature Rodin sculptures.

I never knew much about my grandfather—he was tall, handsome in his youth and was stationed in Southeast Asia during World War II—but I did know he was a master of this particular game. He would ceaselessly⁸ eliminate the marbles, one by one, without mercy or hesitation. He seemed to just know how it worked. I recall picking more difficult starting points (normally the center marble is removed), and he still managed to decimate⁹ the poor things like they were disobedient legionnaires.¹⁰

Like most solitaire games, patience and planning are key to winning. 5 One can't expect to pick marbles out willy-nilly¹¹ like a heron¹² at a sardine farm and succeed—that is a recipe for disaster. The few times I have

CRITICAL READING

Preview
Read
Pause
Review
See pages 9-12.

VOCABULARY
DEVELOPMENT Certain
words in this essay are
defined at the bottom of the
page. Underline these words
as you read them.

IDEA JOURNAL Write about a game you like to play and why you enjoy it.

IDENTIFY: Underline the examples of the grandfather's skills in this paragraph.

1. divots: indentations 2. amethyst: a purple-colored quartz stone

3. adjacent: nearby **4. bewildered:** confused; puzzled **5. raisons d'être:** reasons for being (French) **6. solitaire:** in this case, a game somewhat similar to chess in that the player tries to eliminate marbles from the playing board by jumping them with another marble. The goal is to have just one marble left on the board at the end of the game. **7. Rodin:** Auguste Rodin, a French sculptor best known for *The Thinker*, a marble-and-bronze statue of a man shown in deep thought

8. ceaselessly: without pause **9. decimate:** to get rid of; destroy. The word is based on the Latin root *decimus*, meaning *tenth*, and is said to relate to Roman military leaders' practice of punishing disobedient troops by killing every tenth man.

10. legionnaires: soldiers 11. willy-nilly: carelessly 12. heron: a bird whose diet consists largely of fish

managed to get down to three or four marbles have been the result of carefully calculated moves and persistence. 13 A healthy dose of dumb luck never hurts, either.

I myself never managed to reach the one-marble end zone before my 6 REFLECT: What games have grandfather passed away, but the game remains with my grandmother, who often chides14 me playfully when I insist that this time, I've got it. I never do. But the importance of the game is that it is something passed on, something I am beholden15 to as a token of my grandfather's influence on my early life.

Older people seem to have an uncanny¹⁶ ability to dominate games 7 of skill. Whether it is the pith¹⁷-helmeted man playing chess and shouting nonsense or the crusty old veteran of the beach volleyball courts, often the most expert competitors are those who have seen all the moves.

My grandfather was surely one of these people. But these people do 8 not simply punish you for losing by kicking sand in your face or jamming bishops up your nose—many masters of games are more than willing to pass on their wisdom to young upstarts.18

These days the closest thing I have to a mentor is Cal's 19 club volleyball coach. At first glance Omar might not seem a font of wisdom—he is strong but chubby, smart but physically slow due to his age, and he speaks with a nearly indecipherable²⁰ Cuban accent.

"Jou godda flotate de serf, adawaise de atha team, dey can pass de boll 10 more eassier."

"When jou are blocking, turn de ousside han into de cour and ge ih 11 frrron ohf dem."

Yet he remains well loved because of his willingness to take the youngest players aside during practice and show them what he learned playing for the Cuban national team years ago. Even off the court, he has demonstrated knowledge that helps a bunch of lanky21 boys become men; to date, he has instructed us on how best to compliment women, taught us how to salsa dance, and given marriage advice to prospective²² husbands.

Mentors can teach us fundamental lessons about winning and losing 13 that we often take for granted. They teach us that life has certain rules and that to succeed in this world we must play by them yet use them to their fullest advantage. Especially in the realm²³ of gaming, the advice mentors give is often applicable²⁴ beyond the game.

When the gentleman across from you warns you not to bring your 14 queen out too early, he's really telling you not to be so impetuous.25 When the beach player tells you to float serve because the wind will make it difficult to pass, he's telling you to watch your surroundings. The lessons we glean from mentors transcend²⁶ games themselves, if we pay close enough attention.

13. persistence: continual/dedicated effort 14. chides: scolds 15. beholden: 16. uncanny: mysterious; supernatural 17. pith: plant tissue often used in protective helmets 18. upstarts: people who are rising up quickly in a certain skill area or social group 19. Cal's: belonging to the University of California, Berkeley 20: indecipherable: not understandable 21. lanky: skinny 22. prospective: potential; future 23. realm: world 24. applicable: relevant 25. impetuous: impulsive; careless 26. transcend: go beyond

you enjoyed in the past? What did you learn from

12 SUMMARIZE: In your own words, summarize the points made in paragraphs 12 and 13.

Without them, we would just pick marbles at random and hope to succeed. Instead, I will endeavor to choose my moves in life carefully and imagine a guiding hand helping me pick the best move.

It just gets a little weirder when I imagine a phantom Omar helping 16 me suavely²⁷ talk about babies while salsa dancing.

SUMMARIZE AND RESPOND

In your reading journal or elsewhere, summarize the main point of "To Stand in Giants' Shadows." Then, go back over the essay, and check off the support for this idea. Next, write a brief summary of the essay. Finally, write a brief response to the reading. What kind of life skills can we learn from others—skills that are not necessarily taught at school?

CHECK YOUR COMPREHENSION

- 1. An alternate title for this essay could be
 - a. "Games Are Essential to Forming Family Bonds."
 - b. "With the Right Skills, Game Players Achieve Regular Success."
 - (c.) "Mentors in Game Playing Can Teach Lasting Lessons."
 - d. "Older People Are the Best Teachers."
- 2. The main point of this essay is that
 - **a.** the importance of game playing to happiness and personal success should be recognized more widely.
 - **b.** under the guidance of a good mentor, a game player can learn skills that are relevant not only to the game but also to life.
 - **c.** patience and persistence are the most important requirements for succeeding in games—and in life in general.
 - **d.** no one can truly achieve success in life without game-playir experience.
- **3.** Why does the game that Shields used to play wir'. nis grandfather have lasting importance to him?
 - **a.** It taught Shields that he could beat anyone at this game if he tried hard enough.
 - **b.** It represents a major influence that the grandfather had during Shields's childhood.
 - **c.** It proved to him that cheating at a game is useless if the opponent is highly skilled.
 - **d.** It showed Shields that the best players do not show any emotion while they are winning or losing.

27. suavely: in a sophisticated way

- **4.** Does this essay include the Four Basics of Good Illustration? Why or why not?
- **5.** Look back at the vocabulary you underlined, and write sentences using these words: *bewildered* (para. 1); *persistence* (5); *uncanny* (7); *impetuous*, *transcend* (14).

TIP For tools to build your vocabulary, visit the Student Site for Real Writing at bedfordstmartins.com/realwriting.

READ CRITICALLY

- 1. Shields weaves personal stories into his essay to make his point about the importance of mentors. How would the essay have been different if he had left out such stories and used only information from psychologists or other experts about the benefits that mentors provide? Would the essay have been more interesting and informative or less so? Why?
- 2. Shields focuses on mentors who help others become better game players—and more. In what other situations might he have come in contact with and benefited from mentors? Are there any other points about mentors that could be made?
- 3. Shields appears to be an experienced game player, but instead of bragging about his expertise, he modestly describes what he has learned—and continues to learn—from others. How does this perspective affect you as a reader? Would a more prideful tone impress you, or would it put you off? Why?
- **4.** In a few places, Shields uses very short paragraphs. (See, for instance, paras. 2 and 16.) What might be the reason for including such short paragraphs? What effect(s) do they produce?
- **5.** Do the last two paragraphs provide a satisfying conclusion? Why or why not?

WRITE

WRITE A PARAGRAPH: In a paragraph, write about one of your own mentors, giving examples and details that will make it clear to readers why this person is important to you.

WRITE AN ESSAY: Write an essay about at least two mentors who have played an important role in your life. Give as many examples and details as you can so that readers will understand these mentors' significance to you. Also, provide clear transitions from one example to the next.

TIP For a sample illustration paragraph, see page 142.

Dianne Hales

Why Are We So Angry?

PREDICT: After reading the title, what do you expect this essay to do?

Dianne Hales specializes in writing about mental health, fitness, and other issues related to the body and mind. A former contributing editor for *Parade* magazine, she has also written several college-level health textbooks. In her critically acclaimed book *Just Like a Woman* (2000), she examined assumptions about the biological differences between women and men. Most recently, she authored *La Bella Lingua: My Love Affair with Italian, the World's Most Enchanting Language* (2009). Both the American Psychiatric Association and the American Psychological Association have pre-

sented Hales with awards for excellence in writing. In addition, she has earned an Exceptional Media Merit Award (EMMA) from the National Women's Political Caucus for health reporting. She lives in Marin County, California.

In the following article, Hales uses vivid examples to illustrate the "rage" phenomenon. She reports on the causes and results of the apparent increase in out-of-control anger—and explains what can be done to relieve the problem.

CRITICAL READING

- READING

 Preview
- Read
- Pause
- Review

See pages 9-12.

GUIDING QUESTION

Does the author present specific and plentiful examples to answer the question that she poses in her title?

IDEA JOURNAL List some examples of publicly displayed anger that you have experienced.

VOCABULARY
DEVELOPMENT Certain
words in this essay are
defined at the bottom of the
page. Underline these words
as you read them.

Something snapped inside Jerry Sola during his evening commute through the Chicago suburbs two years ago. When the driver in front of the fifty-one-year-old salesman suddenly slammed on his brakes, Sola got so incensed¹ that he gunned his engine to cut in front of the man. Still steaming when both cars stopped at a red light, Sola grabbed a golf club from the backseat and got out.

"I was just about to smash his windshield or do him some damage," 2 the brawny, 6-foot-1 former police officer recalls. "Then it hit me: 'What in God's name am I doing? I'm really a nice, helpful guy. What if I killed a man, went to jail, and destroyed two families over a crazy, trivial thing?' I got back into my car and drove away."

Like Sola, more and more Americans are feeling pushed to the breaking point. The American Automobile Association's Foundation for Traffic Safety says incidents of violently aggressive driving—which some dub² "mad driver disease"—rose 7 percent a year in the 1990s. Airlines are reporting more outbursts of sky rage. And sideline rage has become widespread: A Pennsylvania kids' football game ended in a brawl involving more than one hundred coaches, players, parents, and fans. In a particularly tragic incident that captured national attention, a Massachusetts father—angered over rough play during his son's hockey practice—beat another father to death as their children watched.

No one seems immune³ to the anger epidemic. Women fly off the 4 handle just as often as men, though they're less likely to get physical. The young and the infamous, such as musicians Sean "Puffy" Combs

IDENTIFY: Underline the main point in this paragraph.

1. incensed: angered 2. dub: to call 3. immune: protected against

and Courtney Love—both sentenced to anger-management classes for violent outbursts—may seem more volatile,⁴ but even senior citizens have erupted into "line rage" and pushed ahead of others simply because they felt they had "waited long enough" in their lives.

"People no longer hold themselves accountable⁵ for their bad behavior," says Doris Wilde Helmering, a therapist and author of *Sense Ability*. "They blame anyone and everything for their anger."

It's a mad, mad world. Violent outbursts are just as likely to occur in leafy suburbs as in crowded cities, and even idyllic⁶ vacation spots are not immune. "Everyone everywhere seems to be hotter under the collar these days," observes Sybil Evans, a conflict-resolution expert in New York City, who singles out three primary culprits⁷: time, technology, and tension. "Americans are working longer hours than anyone else in the world. The cell phones and pagers that were supposed to make our lives easier have put us on call 24/7/365. Since we're always running, we're tense and low on patience. And the less patience we have, the less we monitor what we say to people and how we treat them."

Ironically,⁸ the recent boom times may have brought out the worst 7 in some people. "Never have so many with so much been so unhappy," observes Leslie Charles, author of *Why Is Everyone So Cranky?* "There are more of us than ever, all wanting the same space, goods, services, or attention. Everyone thinks, 'Me first. I don't have time to be polite.' We've lost not only our civility but our tolerance for inconvenience."

The sheer complexity of our lives also has shortened our collective fuse. We rely on computers that crash, drive on roads that gridlock, place calls to machines that put us on endless hold. "It's not any one thing but lots of little things that make people feel like they don't have control of their lives," says Jane Middleton-Moz, a therapist and author. "A sense of helplessness is what triggers rage. It's why people end up kicking ATM machines."

Getting a grip. When his lawn mower wouldn't start, a St. Louis 9 man got so angry that he picked it up by the handle, smashed it against the patio, and tore off each of its wheels. Playing golf, he sometimes became so enraged that he threw his clubs 50 feet up the fairway and into the trees and had to get someone to retrieve them. In anger-therapy sessions with Doris Wilde Helmering, he learned that such outbursts accomplish nothing. "Venting" may make you feel better—but only for a moment.

"Catharsis is worse than useless," says Brad Bushman, a psychology professor at Iowa State University whose research has shown that letting anger out makes people more aggressive, not less. "Many people think of anger as the psychological equivalent of the steam in a pressure cooker: It has to be released, or it will explode. That's not true. The people who react by hitting, kicking, screaming, and swearing just feel more angry."

Over time, temper tantrums sabotage physical health as well as psychological equanimity. ¹⁰ By churning out stress hormones like adrenaline,

PREDICT: Pick one of the culprits; how do you think Hales in subsequent paragraphs will show it to be a cause of anger?

8 IDENTIFY: According to this paragraph, what triggers rage?

SUMMARIZE: In your own words, summarize how letting anger out creates problems.

^{4.} volatile: explosive 5. accountable: responsible 6. idyllic: peaceful

^{7.} culprits: guilty ones 8. ironically: opposite to what is or might be expected

^{9.} catharsis: release of emotional tension 10. equanimity: balance

chronic¹¹ anger revs the body into a state of combat readiness, multiplying the risk for stroke and heart attack—even in healthy individuals. In one study by Duke University researchers, young women with "Jerry Springer Show—type anger," who tended to slam doors, curse, and throw things in a fury, had higher cholesterol levels than those who reacted more calmly.

How do you tame a toxic temper? The first step is to figure out what's really making you angry. Usually the rude sales clerk is the final straw that unleashes bottled-up fury over a more difficult issue, such as a divorce or a domineering boss. Next, monitor yourself for early signs of exhaustion or overload. While stress alone doesn't cause a blow-up, it makes you more vulnerable¹² to overreacting.

When you feel yourself getting angry, control your tongue and your brain. "Like any feeling, anger lasts only about three seconds," says Doris Wilde Helmering. "What keeps it going is your negative thinking." As long as you focus on who or what irritated you—like the oaf who rammed that grocery cart into your heels—you'll stay angry. "Once you come to understand that you're driving your own anger with your thoughts," adds Helmering, "you can stop it."

Since his roadside epiphany,¹³ Jerry Sola has conscientiously worked to rein in his rage. "I am a changed person," he says, "especially behind the wheel. I don't listen to the news on the car radio. Instead, I put on nice, soothing music. I force myself to smile at rude drivers. And if I feel myself getting angry, I ask a simple question: 'Why should I let a person I'm never going to see again control my mood and ruin my whole day?'"

IDENTIFY: Underline the sentence that presents a solution to releasing anger.

TEACHING TIP In addition to providing vivid examples, this article traces the causes and effects of what appears to be an increase in angry outbursts. If you are also teaching the cause-and-effect chapters (15 and 46), you might want to point to this essay as an example of how these (and other) writing strategies can be mixed.

SUMMARIZE AND RESPOND

In your reading journal or elsewhere, summarize the main point of "Why Are We So Angry?" Then, go back over the essay, and check off the support for this idea. Next, write a brief summary of the essay. Finally, write a brief response to the reading. Can you identify with the angry people Hales writes about in this essay? Have you ever been one of them?

CHECK YOUR COMPREHENSION

- 1. An alternate title for this essay could be
 - a. "Anger Management."
 - b. "Road Rage."
 - **c.** "Investigating the Anger Epidemic."
 - d. "The Breaking Point."

11. chronic: habitual 12. vulnerable: open to damage or attack

13. epiphany: a sudden understanding of something

- 2. The main point of this essay is that
 - (a.) anger is a widespread occurrence in today's society.
 - **b.** anger is most common in sports.
 - c. people should enroll in anger-management courses.
 - d. road rage must stop.
- **3.** What do experts say about releasing anger?
 - a. Releasing anger reduces frustration.
 - **b.** Hitting a pillow is a simple way to release anger.
 - (c.) Releasing anger is not productive.
 - **d.** People in the suburbs are most likely to release anger.
- **4.** Look back at the vocabulary you underlined, and write sentences using the following words: *immune* (para. 4); *accountable* (5); *chronic* (11); *vulnerable* (12).

READ CRITICALLY

- **1.** Based on your personal experience and observations, do the examples presented in this essay seem realistic?
- **2.** Throughout the essay, Hales presents information gained from therapists and experts. Does this information strengthen Hales's main point? Would the essay be just as effective without it?
- **3.** What role does technology play in creating anger?
- **4.** Do the steps presented under "How do you tame a toxic temper?" (paras. 12 and 13) seem like a workable solution? Why or why not?
- **5.** Hales begins her essay with the example of Jerry Sola and ends with it. Why do you suppose she uses this technique?

WRITE

WRITE A PARAGRAPH: Write a paragraph about a location where you have seen people exhibit their anger. Identify the location, and provide concrete examples of the way people show their anger.

WRITE AN ESSAY: Write an essay about a time when either you or someone you knew lost control. What happened? Give concrete examples of the loss of control. What were the consequences? Did you learn anything from the experience about expressing anger? Feel free to include the ideas you wrote about in your reading journal for Summarize and Respond.

41

Description

Each essay in this chapter uses description to get its main point across to the reader. As you read these essays, consider how they achieve the Four Basics of Good Description that are listed below and discussed in Chapter 10 of this book.

Four Basics of Good Description

- It creates a main impression—an overall effect, feeling, or image—about the topic.
- 2 It uses specific examples to support the main impression.
- It supports those examples with details that appeal to the five senses: sight, hearing, smell, taste, and touch.
- 4 It brings a person, place, or physical object to life for the reader.

Brian Healy

First Day in Fallujah

Brian Healy served in Iraq and later pursued a degree in business management at Florida Community College. Although a typical writing process includes submitting a piece to several rounds of revision, Healy decided to "revise this essay as little as possible." He says, "I felt that given the topic, I should go with what I first wrote so that it would show more dirty truth than be polished to perfection." He values the role of emotion in writing and exhorts others not to "write for the sake of writing, [but to] write because you are passionate about it."

GUIDING QUESTION

What events affected Healy?

The year was 2004, and I was a young, 21-year-old Marine Corporal 1 on my second tour of Iraq. I had been in the country for five months and was not enjoying it any more than the first time. From the first time I had set foot in Iraq, I perceived it as a foul-smelling wasteland where my youth and, as I would soon find out, my innocence were being squandered.2 I had been in a number of firefights, roadside bomb attacks, and mortar and rocket attacks; therefore, I had thought I had seen it all. So when the word came down that my battalion3 was going to Fallujah to drive through the center of the city, I was as naïve4 as a child on the first day of school. The lesson of that first day would be taught with blood, sweat, and tears, learned through pain and suffering, and never forgotten.

At 2:00 in the morning on November 10, the voice of my commander 2 as you read them. pierced the night: "Mount up!" Upon hearing these words, I boarded the amtrack transport. I heard a loud "clank, clank," the sound of metal hitting metal as the ramp closed and sealed us in. Sitting shoulder to shoulder, we had no more room to move than sardines in a very dark can. The diesel fumes choked our lungs and burned our throats. There was a sudden jolt as the metal beast began to move, and with each bump and each turn, I was thrown from side to side inside the beast's belly with only the invisible bodies of my comrades to steady myself. I thought back to my childhood, to a time of carefree youth. I thought how my father would tell me how I was the cleanest of his sons. I chuckled as I thought, "If only he could see me now, covered in sweat and dirt and five days away from my last shower."

I was violently jerked back into the present with three thunderous 3 explosions on the right side of the amtrack vehicle. We continued to move faster and faster with more intensity and urgency than before. My heart was racing, pounding as if it were trying to escape from my chest when we came to a screeching halt.

With the same clank that sealed us in, the ramp dropped and released 4 IDENTIFY: Underline some us from our can. I ran out of the amtrack nearly tripping on the ramp. There was no moon, no street light, nothing to pierce the blanket of night. Therefore, seeing was almost completely out of the question. However, what was visible was a scene that I will never forget. The massive craters⁵ from our bombs made it seem as if we were running on the surface of the moon. More disturbing were the dead bodies of those enemies hit with the bombs. Their bodies were strewn about in a frenzied manner: a leg or arm here, torso⁶ there, a head severed⁷ from its body. Trying to avoid stepping on them was impossible. Amidst all this and the natural "fog of war,"8 we managed to get our bearings and move toward our objective.9

1. wasteland: an area that is uncultivated and barren, or devastated by natural disasters 2. squandered: wasted; not used to good advantage 3. battalion: an army unit 4. naïve: unsophisticated; lacking experience, judgment, or information 5. craters: shallow, bowl-shaped depressions on a surface, caused by an impact or **6. torso:** the trunk of a human body 7. severed: cut or divided 8. fog of war: a term describing the general uncertainty that soldiers experience during military operations 9. objective: a goal or target

CRITICAL READING Preview Read Pause Review See pages 9-12.

VOCABULARY **DEVELOPMENT** Certain words in this essay are defined at the bottom of the page. Underline these words

IDEA JOURNAL Write about a time when you were very frightened.

PREDICT: What do you think the next paragraph will be about?

of the vivid images.

We were able to take the entrance to a government complex located at the center of the city, and we did so in fine style. "Not so tough," we all thought. We would not have to wait long until we would find out how insanely foolish we were.

As the sun began to rise, there were no morning prayers, no loud-speakers, and no noise at all. This, of course, was odd since we had become accustomed to the sounds of Iraq in the morning. However, this silence did not last long and was shattered as the enemy released hell's wrath¹⁰ upon us. The enemy was relentless¹¹ in its initial assault but was unable to gain the advantage and was slowly pushed back.

As the day dragged on, the enemy fought us in an endless cycle of attack and retreat. There was no time to relax as rocket-propelled grenades¹² whistled by our heads time and time again. Snipers' bullets skipped off the surface of the roof we were on. While some bullets tore through packs, radios, and boots and clothing, a lucky few found their mark and ripped through flesh like a hot knife through butter.

Suddenly, there was a deafening crack as three 82-millimeter mortars rained upon us, throwing me to the ground. The dust blacked out the sun and choked my lungs. I began to rise only to be thrown back down by a rocket-propelled grenade whizzing just overhead, narrowly missing my face. At this point, it seemed clear to me that there was no end to this enemy. In the windows, out the doorways, through alleyways, and down streets, they would run. We would kill one, and another would pop up in his stead, as if some factory just out of sight was producing more and more men to fight us.

As the sun fell behind the horizon, the battle, which had so suddenly started, ended just as swiftly. The enemy, like moths to light, were nowhere to be seen. The rifles of the Marines, which were so active that day, were silent now. We were puzzled as to why it was so quiet. My ears were still ringing from that day's events when the order came down to hole up for the night. There was no sleep for me that night; the events of the day made sure of that. I sat there that cold November night not really thinking of anything. I just sat in a trance, listening to small firefights of the battle that were still raging: a blast of machine gun fire, tracer rounds, and air strikes. Artillery lying through the air gave the appearance of a laser light show. Explosions rattling the earth lit my comrades' faces. As I looked over at them, I did not see my friends from earlier in the day; instead, I was looking at old men who were wondering what the next day would bring. I wondered if I would survive the next day.

The battle for Fallujah would rage on for another three weeks. The Marines of the First Battalion Eighth Marine Regiment would continue to fight with courage and honor. As each day of the battle passed, I witnessed new horrors and acts of bravery, of which normal men are not

IDENTIFY: What senses has Healy used in his description?

10. wrath: strong, fierce anger; angry vengeance unyielding 12. grenades: handheld explosives 13. trance: a dazed or bewildered condition; a state seemingly between sleeping and waking 14. tracer rounds: ammunition containing a substance that causes bullets or rounds to trail smoke or fire so as to make their path visible and show a target for other shooters
 15. artillery: large, crew-operated weapons

capable. However, none of those days would have the impact16 on me that that first day did.

The battle is over, but for the men who were there, it will never end. 10 REFLECT: What effect does It is fought every day in their heads and in voices of friends long gone, all the while listening to the screams and taunts¹⁷ of people who know nothing of war but would call these men terrorists.

this essay have on you?

SUMMARIZE AND RESPOND

In your reading journal or elsewhere, summarize the main point of "First Day in Fallujah." Then, go back over the essay, and check off the support for this idea. Next, write a brief summary of the essay. Finally, write a brief response to the reading. Although Healy writes about the chaotic and violent aspects of war, does he also make his battle experience meaningful?

CHECK YOUR COMPREHENSION

- An alternate title for this essay could be
 - a. "The United States at War in the Middle East."
 - (b.) "Changed Forever in the Fog of War."
 - c. "Liberating Fallujah and Iraq."
 - **d.** "A News Update from Iraq."
- 2. The main point of this essay is that
 - **a.** the United States should make military service a requirement for all citizens.
 - b. the writer has maintained his innocence, despite having experi-
 - (c.) combat is intense, frightening, and confusing, and its effects change soldiers.
 - **d.** the war in Iraq was unwinnable because the number of enemies there is infinite.
- Why does Healy recall his father's remark that Healy was "the cleanest of his sons"?
 - a. Healy wants the reader to know how infrequently soldiers bathe.
 - (b.) This memory shows Healy's change from the child he once was.
 - **c.** Healy wants to show how well he adapted to conditions in Iraq.
 - **d.** Healy thinks his father would be disappointed at how dirty he has become.
- Does this essay include the Four Basics of Good Description? Why or why not?

16. impact: influence; an effect; a collision 17. taunts: scornful insults, jeering, or ridicule

TIP For tools to build your vocabulary, visit the Student Site for Real Writing at bedfordstmartins.com/realwriting.

5. Look back at the vocabulary you underlined, and write sentences using these words: *squandered*, *naïve* (para. 1); *severed* (4); *relentless* (5); *impact* (9).

READ CRITICALLY

- 1. In giving his description of combat, how does Healy appeal to his readers' different senses? Provide specific examples.
- 2. How would you characterize the tone of "First Day in Fallujah," and why?
- **3.** Healy opens his essay by describing himself as "a young, 21-year-old Marine Corporal." How does he change during the course of his account? What is the difference between "lost" innocence and "squandered" innocence?
- **4.** In paragraph 9, Healy says that his battalion fought with "courage and honor" and that he witnessed "new horrors and acts of bravery, of which normal men are not capable." What does he mean by "normal"?
- **5.** In the conclusion of his essay, Healy writes that the battle is still fought every day in the heads of these soldiers and "in voices of friends long gone." What experience is he writing about here?

WRITE

TIP For a sample description paragraph, see page 163.

WRITE A PARAGRAPH: Write a descriptive paragraph that recounts a personal experience that transformed you and made you less innocent or naïve.

WRITE AN ESSAY: At the very end of his narrative, Healy refers to people who "know nothing of war but would call these men terrorists." Write an essay that considers the value of reading accounts such as Healy's: Do they help us "know" war? Did his essay change the way you understand soldiers, combat, and war, generally?

Eric Liu

Po-Po in Chinatown

Eric Liu, a graduate of Yale University and Harvard Law School, is a former speechwriter for President Bill Clinton and also served as the president's Deputy Domestic Policy Advisor. Liu has written several books on a range of subjects and edited the Norton anthology Next: Young American Writers on the New Generation (1994). His book The Accidental Asian: Notes of a Native Speaker (1999) was selected as a New York Times Notable Book and was also featured in the PBS documentary Matters of Race. His most recent book is Imagination First: Unlocking the Power of Possibil-

ity, which he coauthored with Scott Noppe-Brandon.

GUIDING QUESTION

What picture do you form of Po-Po and the author's attitude toward her?

For more than two decades, my mother's mother, Po-Po, lived in a cinder-block¹ one-bedroom apartment on the edge of New York's Chinatown.² She was twenty floors up, so if you looked straight out of the main room, which faced north, one block appeared to melt into the next, all the way to the spire of the Empire State Building³ off in the distance. This was a saving grace, the view, since her own block down below was not much to look at. Her building, one of those interchangeable towers of 1970s public housing, was on the lower east side of the Lower East Side,⁴ at the corner of South and Clinton Streets. It was, as the Realtors say, only minutes from the Brooklyn Bridge and the South Street Seaport, although those landmarks,⁵ for all she cared, might as well have been in Nebraska. They weren't part of the world Po-Po inhabited, which was the world that I visited every few months during the last years of her life.

My visits followed a certain pattern. I'd get to her apartment around noon, and when I knocked on the door, I could hear her scurrying⁶ with excitement. When she opened the door, I'd be struck always as if for the first time, by how tiny she was: four feet nine and shrinking. She wore loose, baggy clothes, nylons, and ill-fitting old glasses that covered her soft, wrinkled face. It was a face I recognized from my own second-grade class photo. *Eh*, *Po-Po*, *ni hao maaa?* She offered a giggle as I bent to embrace her. With an impish smile, she proclaimed my American name in her Yoda-like⁷ voice: *Areek*. She got a kick out of that. As she shuffled to the kitchen where Li Tai Tai, her caregiver, was preparing lunch, I would head to the bathroom, trained to wash my hands upon entering Po-Po's home.

In the small bath were the accessories of her everyday life: a frayed8 toothbrush in a plastic Star Trek mug I'd given her in 1979, stiff washrags and aged pantyhose hanging from a clothesline, medicine bottles and hair dye cluttered on the sinktop. I often paused for a moment there, looking for my reflection in the filmy, clouded mirror, taking a deep breath or two. Then I would walk back into the main room. The place was neat but basically grimy. Some of the furniture—the lumpy couch, the coffee table with old magazines and congealed9 candies, the lawn chair where she read her Chinese newspaper through a magnifying glass—had been there as long as I could remember. The windowsill was crammed with plants and flowers. The only thing on the thickly painted white wall was a calendar. Your house looks so nice, I'd say in a tender tone of Mandarin¹0 that I used only with her. On a tray beside me, also surveying the scene, was a faded black-and-white portrait of Po-Po as a beautiful young woman, dressed in Chinese costume. Lai chi ba, Po-Po would say, inviting me to eat.

cinder-block: a concrete block

 chinatown: a section of New York City with a large population of Chinese immigrants
 Empire State Building: a famous skyscraper in New York City
 Lower East Side: a neighborhood in New York
 traditionally known for its immigrant population
 landmarks: buildings with historical importance
 scurrying: moving quickly
 Yoda: a small, elderly creature from the Star Wars movies
 frayed: worn out, with threads raveling

 Mandarin: the official language of China

VOCABULARY
DEVELOPMENT Certain
words in this essay are
defined at the bottom of the
page. Underline these words
as you read them.

IDEA JOURNAL Describe an older relative's apartment or house.

B IDENTIFY: What senses has the author used in his description so far? Invariably,¹¹ there was a banquet's worth of food awaiting me on the small kitchen table: *hongshao* stewed beef, a broiled fish with scallions and ginger, a leafy green called *jielan*, a soup with chicken and winter melon and radishes, tofu with ground pork, stir-fried shrimp still in their salty shells. Po-Po ate sparingly, and Li Tai Tai, in her mannerly Chinese way, adamantly¹² refused to dine with us, so it was up to me to attack this meal. I gorged¹³ myself, loosening my belt within the half hour and sitting back dazed and short of breath by the end. No matter how much I put down, Po-Po would express disappointment at my meager¹⁴ appetite.

As I ate, she chattered excitedly, pouring forth a torrent¹⁵ of opinions 5 about politics in China, Hong Kong pop singers, the latest developments in Taiwan. After a while, she'd move into stories about people I'd never met, distant relations, half-brothers killed by the Communists, my grandfather, who had died when I was a toddler. Then she'd talk about her friends who lived down the "F" train in Flushing16 or on the other side of Chinatown and who were dving one by one, and she'd tell me about seeing Jesus after she'd had a cancer operation in 1988, and how this blond Jesus had materialized and said to her in Chinese, You are a good person, too good to die now. Nobody knows how good you are. Nobody appreciates you as much as I do. I would sit quietly then, not sure whether to smile. But just as she approached the brink, 17 she would take a sip of 7-Up and swerve back to something in the news, perhaps something about her heroine, the Burmese dissident¹⁸ aunt Aung San Kyi. 19 She was an incredible talker, Po-Po, using her hands and her eyes like a performer. She built up a tidal momentum, relentless, imaginative, spiteful²⁰ like a child.

I generally didn't have much to say in response to Po-Po's commentary, save the occasional Chinese-inflected²¹ *Oh?* and *Wah!* I took in the lilt²² of her Sichuan²³ accent and relied on context to figure out what she was saying. In fact, it wasn't until I brought my girlfriend to meet Po-Po that I realized just how vague my comprehension was. *What did she say?* Carroll would ask. *Um, something about, something, I think, about the president of Taiwan.* Of course, I'm not sure Po-Po even cared whether I understood. If I interrupted, she'd cut me off with a hasty *bushide—no, it's not that—* a habit I found endearing in small doses but that my mother, over a lifetime, had found maddening.

If there was a lull, I might ask Po-Po about her health, which would prompt her to spring up from her chair and, bracing herself on the counter, kick her leg up in the air: I do this ten times every morning at five, she would proudly say in Chinese. Then this, she'd add, and she would stretch her arms out like little wings, making circles with her fingertips. And last week, I had a headache, so I rubbed each eye like this thirty-six times. Pretty soon, I was out of my chair, too, laughing, rubbing, kicking, as Po-Po

REFLECT: Why do you think that the author finds Po-Po endearing, whereas his mother found her maddening?

11. invariably: always; without exception 12. adamantly: in a stubborn or unvielding manner 13. gorged: ate a huge amount 14. meager: deficient; of a very small amount 15. torrent: a violently flowing stream, river, or downpour 16. Flushing: a neighborhood in New York City 17. brink: the 18. dissident: a protester; one who disagrees with a political edge, as of a cliff 19. Aung San [Suu] Kyi: a Nobel Peace Prize-winning human establishment rights activist from Burma 20. spiteful: mean-spirited 21. inflected: accented 22. lilt: a pleasant varation in the pitch of one's speech in a certain way 23. Sichuan: a province of south-central China

schooled me in her system of exercises and home remedies. We did this every visit, like a ritual.

Time moved so slowly when I was at Po-Po's. After lunch, we might sit on the couch next to each other or go to her room so she could tell me things that she didn't want Li Tai Tai to hear. We would rest there, digesting, our conversation turning more mellow. I might pull out of my bag a small keepsake²⁴ for her, a picture of Carroll and me, or a souvenir from a recent vacation. She would show me a bundle of poems she had written in classical Chinese, scribbled on the backs of small cardboard rectangles that come with travel packs of Kleenex. She would recount how she'd been inspired to write this poem or that one. Then she would open a spiral notebook that she kept, stuffed with news clippings and filled with idioms²⁵ and sentences she had copied out of the Chinese newspaper's daily English lesson: *Let's get a move on. I don't like the looks of this.* At my urging, she'd read the sentences aloud, tentatively.²⁶ I would praise her warmly, she would chuckle, and then she might show me something else, a photo album, a book about qigong.²⁷

One day, she revealed to me her own way of prayer, demonstrating how she sat on the side of her bed at night, and clasped her hands, bowing as if before Buddha, repeating in fragile English, God bless me? God bless me? Another time, she urgently recited to me a short story that had moved her to tears, but I understood hardly a word of it. On another visit, she fell asleep beside me, her glasses still on, her chin tucked into itself. And so the hours would pass, until it was time for me to go—until, that is, I decided it was time to go, for she would have wanted me to stay forever—and I would hold her close and stroke her knotted back and tell her that I loved her and that I would miss her, and Po-Po, too modest to declare her heart so openly, would nod and press a little red envelope of money into my hand and say to me quietly in Chinese, How I wish I had wings so I could come to see you where you live.

SUMMARIZE AND RESPOND

In your reading journal or elsewhere, summarize the main point of "Po-Po in Chinatown." Then, go back over the essay, and check off the support for the idea. Next, write a brief summary of the essay. Finally, write a brief response to the reading. Do you think Liu enjoyed these visits with his grandmother? Why or why not?

CHECK YOUR COMPREHENSION

- 1. An alternate title for this essay could be
 - **a.** "Memories of My Chinese Grandmother."
 - b. "My Grandmother's Dirty Apartment."

24. keepsake: a reminder of something past 25. idioms: words or sayings specific to a region 26. tentatively: uncertainly; hesitantly 27. qigong: a traditional Chinese practice of meditation and self-healing

- c. "Confessions of a Chinese American Grandmother."
- d. "An Immigrant Story."
- 2. The main point of this essay is that
 - **a.** the language barrier between Liu and his Chinese grandmother made their relationship nearly impossible.
 - **b.** New York is a city full of immigrant neighborhoods, such as Chinatown.
 - **c.** Liu's grandmother liked to talk, but her anger and inability to learn English made it impossible for her to feel at home in America.
 - **d.** Liu's grandmother was a complex, funny, and opinionated woman, and his memories of visiting her remain with him.
- **3.** Why does Liu mention the 1979 plastic Star Trek mug in his grandmother's bathroom?
 - **a.** It shows how his grandmother had abandoned her Chinese heritage.
 - **b.** His grandmother loved watching American television.
 - (c.) It shows how time stood still in her apartment.
 - d. It shows that his grandmother had good health habits.
- **4.** Look back at the vocabulary you underlined, and write sentences using these words: *adamantly*, *meager* (para. 4); *torrent*, *spiteful* (5); *tentatively* (8).

READ CRITICALLY

- 1. In paragraph 3, Liu writes that his grandmother's apartment was "neat but basically grimy." What do you think that distinction means? How do the details in the essay support this claim?
- **2.** Liu appeals to his reader's senses throughout the essay. Find specific examples in the text where he appeals to at least three of the five senses (sound, sight, taste, touch, and smell). How do they contribute to the overall impression of "Po-Po in Chinatown"?
- **3.** Liu writes in paragraph 5 that his grandmother "built up a tidal momentum" when she talked. In what specific ways does Liu's writing evoke her excited chatter for the reader?
- **4.** In paragraph 6, Liu writes that he's not sure if his grandmother even cared if he understood what she said to him. What does this sentence say about their relationship, and how is it related to the larger point of the essay?
- **5.** At the conclusion of the essay, Liu writes that he would tell his grandmother he loved her but that she was "too modest to declare her heart so openly." How does he give an impression of his grandmother's love, even though she never tells him explicitly?

WRITE

WRITE A PARAGRAPH: Write a paragraph that vividly describes the home, apartment, or living space of a close friend or relative. Like Liu, include details that show how the person's home reflects his or her personality, life, and relationships.

WRITE AN ESSAY: Liu writes that his visits to his grandmother "followed a certain pattern," which he then recounts in the essay. Write an essay in which you describe the pattern of your own regular visits or meetings with a friend, relative, or group of people. Try to show how this order of events reveals important aspects of your relationship with the person or people you visit.

42

Process Analysis

Each essay in this chapter uses process analysis to get its main point across to the reader. As you read these essays, consider how they achieve the Four Basics of Good Process Analysis that are listed below and discussed in Chapter 11 of this book.

Four Basics of Good Process Analysis

- It tells readers what process the writer wants them to know about and makes a point about it.
- 2 It presents the essential steps in the process.
- It explains the steps in detail.
- 4 It presents the steps in a logical order (usually time order).

Jasen Beverly

My Pilgrimage

Jasen Beverly is the author of the essay "My Pilgrimage," a piece he began for an introductory college English class. Although publication was not an original goal of his, he was later encouraged to seek a larger audience beyond his class. Before submitting the essay, Beverly spent two weeks editing his work, working through several drafts and aiming each time "to make it better with every draft." In addition to a series of revisions, he also looks to his friends for editorial support with his writing and "to make sure it is

never too wordy or sugar-coated."

GUIDING QUESTION

Why does Beverly title his essay "My Pilgrimage"?

I'm tired and scared as hell. I've been running from this thing for who knows how long, but now I'm trapped. I crouch into a fetal position as the monster approaches me. With a closer look, I realize it's my best friend trying to kill me. He lifts his arm and cocks the gun back. Without words, he pulls the trigger.

The sound of a newly received instant message wakes me up. It's only 6:30 in the morning, so I'm hesitant to check the instant message. Minutes later, I roll over and reach for my phone. I slowly wipe the crust from my eyes and begin to read, "Wakey, wakey, eggs and bakey . . . skoo time!" reads the IM from my Mexican friend. I slide my phone open and reply with a quick "aiight," before I proceed to pass out again. Just as I begin to reconnect with my dream, at about 6:45, I'm interrupted once more. This time, it is a loud repeated banging at my bedroom door.

Without thoughts or words, I roll out of bed, grab my cloth and towel, and head for the bathroom. Upon reaching the bathroom, I hop into the shower. When my shower ends, I am forced to rush through both the grooming and dressing processes because there is a massive cold front sweeping through my apartment. This cold front is caused by a lack of heat in the apartment. This, in turn, is caused by what I like to call "hard times."

By 7:20, all is well, and I am ready to begin my pilgrimage¹ to Bunker Hill Community College for my first day of college. I leave my apartment with my hoodie unzipped, backpack half on, while trying fast to detangle my headphones for use. As I walk down the street, the frigid air begins to take its toll. My whole face is stinging as if it was being poked, the air circulating inside my shirt. I immediately slip my headphones into my pocket and zip my hoodie. I tie my hood tightly around my eyes. My hood cuts off my peripheral² vision but keeps all unwanted air off my face. Now I finish untangling my headphones and plug them into my phone. I quickly browse my list of albums before choosing one to listen to. This morning, I choose John Legend's *Once Again*. The music is soothing; it puts me in the zone as I continue the short trek to the bus stop.

While waiting patiently at the bus stop, I begin to ponder.³ My first 5 thought is, "How much longer will I be here waiting for the bus?" Next, I ask myself, "Am I even going to be able to sit when I get on the bus?" As this thought leaves my head, I see a bus coming down Columbia Road.

I enter the bus, tap my Charlie Card⁴ on the target area, and begin to walk away. Shortly after, a stranger taps me on my leg as I walk by. When I look back, he is pointing to the fare box. I walk back and notice the driver saying something. I'm not able to make out what he is saying because I have my headphones on. My card must not have been processed

CRITICAL
READING
Preview
Read
Pause
Review
See pages 9–12.

VOCABULARY
DEVELOPMENT Certain
words in this essay are
defined at the bottom of the
page. Underline these words
as you read them.

IDEA JOURNAL Write about a trip you make so often that you do not usually think about the many steps involved.

TEACHING TIP If you have covered narration, point out to students that this essay is also a narration.

iDENTIFY: What detail gives you information about Beverly's financial situation?

pilgrimage: a long journey, often made to some sacred place as an act of religious devotion
 peripheral: to the sides of a person's main line of sight
 ponder: to think about
 Charlie Card: a plastic pass card used to pay fares on Boston's public transportation

REFLECT: Why does Beverly think about the businesspeople?

SUMMARIZE: What kind of student was Beverly in high school?

correctly. I re-tap my card on the target area. This time, I wait for it to register before walking away. I spot a seat in the back of the bus, so I fill it. Once I sit, I look around at the other people on the bus. I feel as if everyone is looking at me, so I close my eyes and let the music soothe my mind. When the bus pulls into Andrews Station, I stand and exit the bus. I walk down the stairs and wait for the train to arrive.

When it arrives, it is packed with an uncountable number of business-people taking a trip to the Financial District. In fact, it is so packed that I prefer to wait for the next train. While waiting, I begin to think about all of the businesspeople. I ask myself, "How long did they have to attend college to put themselves into the position they're in now?" As the next train pulls into the station, I notice it is much like the last, but this time I squeeze myself into the middle of the car. Luckily for me, Downtown Crossing, my stop, is only three stops away.

Upon reaching Downtown Crossing at 7:45, I exit the train and begin 8 to watch as people dart down the long corridor in hopes of catching the train. This becomes the highlight of the morning as I watch the doors slam in people's faces. There's no explaining the humor of watching people who have tried so hard, panting angrily as the train leaves without them. After this joyous moment, I proceed to transfer from the Red Line to the Orange Line.

Standing on the Orange Line platform, I recognize a few familiar faces. 9 They belong to students of Charlestown High School. I laugh, knowing that school for them began at 7:20. Then I begin to reminisce⁵ about my own CHS experiences. I think about all my suspension hearings, the work I refused to do, and how easy it was to get by doing the bare minimum. Only the cold draft of the approaching train brings me back to reality.

I step on the train and position myself against the door. I could sit, 10 but I figure it is too short a ride to get comfortable. One by one, the stops come and go: State, Haymarket, and then North Station. The train seems to be on an effortless glide as it starts to move toward Community College.

My stomach begins to churn⁶ as I start the last phase of my pilgrimage. The last phase consists of walking out of the train station, down the walkway, and into Bunker Hill Community College. I compare this walk to the walk death row inmates take before they are executed. As I take this walk, I begin to ask myself, "What the ---- are you doing here?" Within seconds, my sensible half answers, "You're here so that you don't have to live like the rest of your family. The rest of your friends are in school, and Lord knows half of them aren't half as smart as you. Lastly, we already paid for this, so get it done." With BHCC right in front of me, I take a deep breath and end this pilgrimage by entering the Mecca⁷ that will start me on the path of reaching my pinnacle.⁸

5. reminisce: to think back or recollect
6. churn: to stir powerfully
7. Mecca: a place that many people want to visit; a center of activity (Mecca is an Islamic holy city in Saudi Arabia)
8. pinnacle: the highest point or achievement

SUMMARIZE AND RESPOND

In your reading journal or elsewhere, summarize the main point of "My Pilgrimage." Then go back over the essay, and check off the support for this idea. Next, write a brief summary of the essay. Finally, write a brief response to the reading. How would you describe Beverly's attitude toward his education?

CHECK YOUR COMPREHENSION

- 1. An alternate title for this essay could be
 - (a.) "First Steps on My Path to Success."
 - **b.** "Why I Hate School-Day Mornings."
 - c. "How Music Gets Me through My Day."
 - d. "Public Transportation Is a Good Option for Students."
- 2. The main point of this essay is that
 - (a.) the first day of college can be exciting and a little scary.
 - **b.** the writer does not take his education seriously enough.
 - **c.** people must make the most of their educational opportunities.
 - **d.** college is not much different than high school.
- **3.** What memories of high school does Beverly recall?
 - a. He remembers his athletic success and popularity.
 - **b.** He recalls how he enjoyed traveling to high school in the mornings more than he enjoys his college commute.
 - (c.) He remembers how he got in trouble and did not work hard.
 - **d.** He recalls that his teachers encouraged him to go to college.
- **4.** Does this essay include the Four Basics of Good Process Analysis? Why or why not?
- **5.** Look back at the vocabulary you underlined, and write sentences using these words: *peripheral* (para. 4); *ponder* (5); *reminisce* (9); *pinnacle* (11).

TIP For tools to build your vocabulary, visit the *Student Site for Real Writing* at **bedfordstmartins.com/ realwriting**.

READ CRITICALLY

- **1.** What do you think is the author's main point or purpose in writing this essay?
- **2.** This essay opens with the author's having a nightmare. What effect does this introduction have? How do you think the bad dream is related to the rest of the essay?
- **3.** According to Beverly, his apartment does not have heat because of what he refers to as "hard times." What do you think those words mean, and why would he put them in quotation marks?

- **4.** Beverly gives almost a step-by-step account of his morning commute and "pilgrimage." What details stand out the most for you?
- **5.** What motivates Beverly to go on this pilgrimage? What do we learn about his fears, hopes, and goals from this essay?

WRITE

TIP For a sample process analysis paragraph, see page 178.

WRITE A PARAGRAPH: Write a paragraph about a short, everyday kind of trip you often take. As Beverly does in "My Pilgrimage," give a description of every step of the trip.

WRITE AN ESSAY: Write an essay analyzing the process of your own current commute to work or school, or any other trip you make regularly that seems meaningful or memorable. What do you see, think about, or feel during the journey?

Sherman Alexie

The Joy of Reading and Writing: Superman and Me

Acclaimed author Sherman Alexie was born in 1966 and raised on the Spokane Indian Reservation, northwest of Spokane, Washington. An avid reader from an early age, he graduated from Washington State University with a B.A. in American studies. Soon after, Alexie published two books of poetry, *The Business of Fancydancing* (1992), which inspired a later screenplay by Alexie, and *I Would Steal Horses* (also 1992). He is best known, however, for his works of fiction, which include *The Lone Ranger and Tonto Fistfight in Heaven* (1993), a winner of the PEN/Hemingway Award for the Best First Book of Fiction; *Reservation Blues* (1995); *Flight*

(2007); and, most recently, *War Dances* (2009), winner of the 2010 PEN Faulkner Award. Alexie also wrote the screenplay for the award-winning film *Smoke Signals* (1998).

In the following essay, Alexie explores the process of becoming a reader and of transforming his life through the power of words.

GUIDING QUESTION

What do you think "the joy of reading and writing" might be?

learned to read with a Superman comic book. Simple enough, I suppose. I cannot recall which particular Superman comic book I read, nor can I remember which villain he fought in that issue. I cannot remember the plot, nor the means by which I obtained the comic book. What I can remember is this: I was 3 years old, a Spokane Indian boy living with his family on the Spokane Indian Reservation in eastern Washington state. We were poor by most standards, but one of my parents usually managed to

CRITICAL
READING
Preview
Read
Pause
Review

See pages 9-12.

find some minimum-wage job or another, which made us middle-class by reservation standards. I had a brother and three sisters. We lived on a combination of irregular paychecks, hope, fear, and government surplus food.

My father, who is one of the few Indians who went to Catholic school 2 VOCABULARY on purpose, was an avid reader of westerns, spy thrillers, murder mysteries, gangster epics, basketball player biographies, and anything else he could find. He bought his books by the pound at Dutch's Pawn Shop, Goodwill, Salvation Army, and Value Village. When he had extra money, he bought new novels at supermarkets, covenience stores, and hospital gift shops. Our house was filled with books. They were stacked in crazy piles in the bathroom, bedrooms, and living room. In a fit of unemploymentinspired creative energy, my father built a set of bookshelves and soon filled them with a random assortment of books about the Kennedy assassination, Watergate, the Vietnam War, and the entire 23-book series of the Apache westerns. My father loved books, and since I loved my father with an aching devotion,3 I decided to love books as well.

I can remember picking up my father's books before I could read. 3 The words themselves were mostly foreign, but I still remember the exact moment when I first understood, with a sudden clarity,4 the purpose of a paragraph. I didn't have the vocabulary to say "paragraph," but I realized that a paragraph was a fence that held words. The words inside a paragraph worked together for a common purpose. They had some specific reason for being inside the same fence. This knowledge delighted me. I began to think of everything in terms of paragraphs. Our reservation was a small paragraph within the United States. My family's house was a paragraph, distinct from the other paragraphs of the LeBrets to the north, the Fords to our south, and the Tribal School to the west. Inside our house, each family member existed as a separate paragraph but still had genetics5 and common experiences to link us. Now, using this logic, I can see my changed family as an essay of seven paragraphs: mother, father, older brother, the deceased sister, my younger twin sisters, and our adopted little brother.

At the same time I was seeing the world in paragraphs, I also picked up that Superman comic book. Each panel, complete with picture, dialogue, and narrative was a three-dimensional⁶ paragraph. In one panel, Superman breaks through a door. His suit is red, blue, and yellow. The brown door shatters into many pieces. I look at the narrative above the picture. I cannot read the words, but I assume it tells me that "Superman is breaking down the door." Aloud, I pretend to read the words and say, "Superman is breaking down the door." Words, dialogue, also float out of Superman's mouth. Because he is breaking down the door, I assume he says, "I am breaking down the door." Once again, I prétend to read the words and say aloud, "I am breaking down the door." In this way, I learned to read.

1. Kennedy assassination: the assassination of President John F. Kennedy on 2. Watergate: a series of political scandals that led to the November 22, 1963 resignation of President Richard M. Nixon in August 1974 3. aching devotion: 4. clarity: clearness 5. genetics: inherited biological deep dedication or lovalty 6. three-dimensional: having the illusion of depth or variations in distance

PREDICT: How do you think the Superman comic book taught the author to read?

DEVELOPMENT Certain words in this essay are defined at the bottom of the page. Underline these words as you read them.

IDEA JOURNAL Write about how you learned to read.

4 IDENTIFY: Check off the steps in the process described in this paragraph. This might be an interesting story all by itself. A little Indian 5 boy teaches himself to read at an early age and advances quickly. He reads *Grapes of Wrath*⁷ in kindergarten when other children are struggling through "Dick and Jane." If he'd been anything but an Indian boy living on the reservation, he might have been called a prodigy. But he is an Indian boy living on the reservation and is simply an oddity. He grows into a man who often speaks of his childhood in the third person, as if it will somehow dull the pain and make him sound more modest about his talents.

SUMMARIZE: In your own words, summarize the main point of this paragraph.

A smart Indian is a dangerous person, widely feared and ridiculed by Indians and non-Indians alike. I fought with my classmates on a daily basis. They wanted me to stay quiet when the non-Indian teacher asked for answers, for volunteers, for help. We were Indian children who were expected to be stupid. Most lived up to those expectations inside the classroom but subverted¹⁰ them on the outside. They struggled with basic reading in school but could remember how to sing a few dozen powwow¹¹ songs. They were monosyllabic¹² in front of their non-Indian teachers but could tell complicated stories and jokes at the dinner table. They submissively¹³ ducked their heads when confronted by a non-Indian adult but would slug it out with the Indian bully who was 10 years older. As Indian children, we were expected to fail in the non-Indian world. Those who failed were ceremonially¹⁴ accepted by other Indians and appropriately pitied by non-Indians.

I refused to fail. I was smart. I was arrogant. Is I was lucky. I read books late into the night, until I could barely keep my eyes open. I read books at recess, then during lunch, and in the few minutes left after I had finished my classroom assignments. I read books in the car when my family traveled to powwows or basketball games. In shopping malls, I ran to the bookstores and read bits and pieces of as many books as I could. I read the books my father brought home from the pawnshops and secondhand. I read the books I borrowed from the library. I read the backs of cereal boxes. I read the newspaper. I read the bulletins posted on the walls of the school, the clinic, the tribal offices, the post office. I read junk mail. I read auto-repair manuals. I read magazines. I read anything that had words and paragraphs. I read with equal parts joy and desperation. I loved those books, but I also knew that love had only one purpose. I was trying to save my life.

Despite all the books I read, I am still surprised I became a writer. I 8 was going to be a pediatrician. These days, I write novels, short stories, and poems. I visit schools and teach creative writing to Indian kids. In all my years in the reservation school system, I was never taught how to write

TEACHING TIP You might show your class a portion of Alberto Rios's interview with Sherman Alexie, available through YouTube.

^{7.} Grapes of Wrath: an award-winning 1939 novel by John Steinbeck (1902–1968) about the difficulties faced by migrant workers in California 8. "Dick and Jane": a series of books, popular from the 1930s through the 1960s, that was used to teach children how to read 9. prodigy: an unusually talented young person 10. subverted: overthrew; defied 11. powwow: a Native American ceremony 12. monosyllabic: speaking few words; literally, "consisting of one syllable" 13. submissively: obediently 14. ceremonially: ritually 15. arrogant: proud; assuming a superior attitude toward others

poetry, short stories, or novels. I was certainly never taught that Indians wrote poetry, short stories, and novels. Writing was something beyond Indians. I cannot recall a single time that a guest teacher visited the reservation. There must have been visiting teachers. Who were they? Where are they now? Do they exist? I visit the schools as often as possible. The Indian kids crowd the classroom. Many are writing their own poems, short stories, and novels. They have read my books. They have read many other books. They look at me with bright eyes and arrogant wonder. They are trying to save their lives. Then there are the sullen¹⁶ and already defeated Indian kids who sit in the back rows and ignore me with theatrical precision. The pages of their notebooks are empty. They carry neither pencil nor pen. They stare out the window. They refuse and resist. "Books," I say to them. "Books," I say. I throw my weight against their locked doors. The door holds. I am smart. I am arrogant. I am lucky. I am trying to save our lives.

SUMMARIZE AND RESPOND

In your reading journal or elsewhere, summarize the main point of "The Joy of Reading and Writing: Superman and Me." Then, go back over the essay, and check off the support for this idea. Next, write a brief summary of the essay. Finally, write a brief response to the reading. Why has reading been so important to Alexie? What importance does it have in your own life?

CHECK YOUR COMPREHENSION

- 1. An alternate title for this essay could be
 - (a.) "Defying Others' Low Expectations through a Love of Books."
 - **b.** "The Importance of Reading in Children's Lives."
 - c. "Parents Who Read Make Their Children Lifelong Readers."
 - **d.** "Schools on Indian Reservations Must Place a Greater Emphasis on Reading."
- 2. The main point of this essay is that
 - a. some children read at an unusually early age.
 - **b.** comic books are a good tool for teaching kids to read.
 - (c.) reading has the power to change lives.
 - **d.** smart kids are often subject to bullying.
- **3.** After learning what the word *paragraph* meant, Alexie
 - a. couldn't stop repeating this definition.
 - **b.** started circling paragraphs in everything he read.
 - c. started writing paragraph-length stories.
 - (d.) started to think of everything in terms of paragraphs.

16. sullen: gloomy; quiet **17. theatrical precision:** an exaggerated or dramatic manner

4. Look back at the vocabulary you underlined, and write sentences using these words: *clarity* (para. 3); *prodigy* (5); *submissively* (6); *arrogant* (7); *sullen* (8).

READ CRITICALLY

- **1.** Why do you suppose that Alexie opens the essay with his memory of the Superman comic book? Why does that memory—and the comic book itself—have so much significance to him?
- **2.** In parts of the essay, Alexie suggests that his love of reading and learning didn't always have positive results. What were some of the drawbacks of this love?
- **3.** In paragraph 7, Alexie describes the wide variety of the things he read. What might be the purpose of mentioning even junk mail and the writing on cereal boxes?
- **4.** In paragraphs 7 and 8, Alexie makes repeated references to reading as a life saver. What do you think he means by this word choice? Are you convinced by the point he is making? Why or why not?
- **5.** Notice how, at the end of paragraph 8, Alexie mentions throwing his weight against the "locked doors" of students who are resistant to books. Now, look back at paragraph 4. How are these paragraphs connected in wording and meaning? What is Alexie trying to say about the power of reading?

WRITE

WRITE A PARAGRAPH: Identify something you like to do that you think others would also enjoy or benefit from. Then, write a paragraph describing the steps you would take to get friends interested in this activity.

WRITE AN ESSAY: Alexie writes about "trying to save [his] life" through reading. Think about an activity or hobby that changed your life or helped make you the person you are today. Then, write an essay that introduces readers to this activity or hobby and describes—step by step, if possible—how it changed you. Like Alexie, you might also discuss others' reactions to this change or to your interests.

Classification

Each essay in this chapter uses classification to get its main point across to the reader. As you read these essays, consider how they achieve the Four Basics of Good Classification that are listed below and discussed in Chapter 12 of this book.

Four Basics of Good Classification

- It makes sense of a group of people or items by organizing them into categories.
- 2 It has a purpose for sorting the people or items.
- It categorizes using a single organizing principle.
- 4 It gives detailed explanations or examples of what fits into each category.

Kelly Hultgren

Pick Up the Phone to Call, Not Text

Kelly Hultgren is studying journalism, communication, and anthropology at the University of Arizona and plans to graduate in the spring of 2013. In addition to contributing articles to the *Arizona Daily Wildcat*, the student newspaper in which the following essay first appeared, Hultgren also enjoys writing creative nonfiction.

In this essay, Hultgren writes about the different types of texters and the limitations of texting. She says, "Nowadays, people get to know one another through technology rather than

face to face. We're attempting to get personal through impersonal methods, and subsequently judging potential partners' characters through technology."

GUIDING QUESTION

What are the different types of texters?

CRITICAL READING Preview Read Pause Review

See pages 9-12.

VOCABULARY **DEVELOPMENT** Certain words in this essay are defined at the bottom of the page. Underline these words as you read them.

IDEA JOURNAL When do you think it is better to call rather than text someone?

REFLECT: Have you ever made an incorrect assumption about a texter based on his or her message or a lack of response to one of your own texts?

IDENTIFY: Underline the different types of texters Hultgren describes.

"So, I met this guy last week and I thought he really liked me, because 1 he was texting me all the time, and then suddenly he started taking longer to respond. I think he's not interested anymore. You better believe I am not texting him until he texts me first. I can't believe he led me on like that."

Does that sound familiar? That's because you've probably heard 2 someone say it or have said it yourself. Perhaps not word for word, but please raise your hand if you've ever made assumptions at the beginning of a relationship, based solely on texts. My hand just hit the ceiling.

Once upon a time, people pursuing potential mates evaluated each 3 other on personality, looks, lifestyle, and how the person felt he or she was being treated. People always will base their opinions on the categories listed above, but now, a more relevant and scrutinized trait is a person's texting habits. People, especially we college students, rely on texting to get to know someone. Both men and women are equally guilty of this. We are all busy, and texting is quick and convenient and facilitates² communication throughout the day. I've used those arguments too. But instead of spending three hours on Facebook or watching TV, pick up the damn phone, call, and meet in person.

For budding relationships, texting is used not only as a screening device but also as a deal-breaker. It sounds absolutely ridiculous because it is. From simply looking to get some action to embarking³ on a longlasting romantic journey, cellular discourse⁴ is now crucial in the process. Take my starting quote, for example. The hypothetical⁵ girl first assumed the hypothetical guy liked her and then assumed he didn't based only on his texting frequency. What if the poor guy was having phone issues or was working? You're just getting started; don't expect him to drop the whole world just to send back a response to your simple "hey" text message.

This example addresses some aspects of texting: You don't know what 5 the person is physically doing, and you cannot tell the person's mood (emoticons⁶ do not count). Therefore, one of every student's favorite forms of interaction is inherently deceiving. At the start of a relationship, why do we communicate and subsequently8 put so much emphasis on texting, when it's not a reliable way to get to know someone?

As I mentioned before, texting can be a deal-breaker. Let's classify 6 some different types of texters and how they can create problems.

First up, we have Lazy Texters. Lazy Texters often initiate the con- 7 versation and then leave the responsibility of carrying on the conversation with the other person, rarely asking questions and usually responding with one-word answers.

- 1. scrutinized: closely observed or studied 2. facilitates: makes something easier
- 3. embarking: starting out on 4. discourse: communication; discussion
- 5. hypothetical: theoretical; supposed or imagined 6. emoticons: tiny electronic images or punctuation groupings meant to imitate facial expressions and thus to convey emotions 7. inherently: by its very nature 8. subsequently: afterward

Then we have the Minimalists. Minimalists make their texts short and 8 concise, and they often take longer to respond. They are also notorious⁹ for ignoring people, but you would never know this, because you didn't call. This leads us to another bittersweet characteristic of texting: You really don't know if someone has seen your text or not (unless you have Blackberry Messenger; then, your cover is blown).

The next type is the Stage Five Clinger, who will constantly blow up 9 your phone wanting to know what you're doing, where you're going, and where you live. This texter sometimes sends text after text, even when you're not responding. Creepy.

A less creepy yet still consistent type of texter is the Text-a-holic. They 10 are constantly texting, and they experience separation anxiety10 when away from their phones.

The use of texting to get acquainted with someone is really just a small 11 REFLECT: Do you plan portion of humanity's increasing problem of becoming socially inept. 11 I said socially inept, not social-networking inept, as in not being able to communicate with someone face to face. The next time you meet someone and get that warm and fuzzy feeling in your tummy, break through the technological barricade¹² and get to know the person in person. And, please refrain¹³ from sending the emoticon with hearts for its eyes.

to take any of Hultgren's advice? Why or why not?

SUMMARIZE AND RESPOND

In your reading journal or elsewhere, summarize the main point of "Pick Up the Phone to Call, Not Text." Then, go back over the essay and check off the support for this idea. Next, write a brief summary of the essay. Finally, write a brief response to the reading. Did Hultgren's essay change your view of texting in any way? If so, how?

CHECK YOUR COMPREHENSION

- An alternate title for this essay could be
 - a. "Talking over the Phone Is a Better Way to Communicate Than Texting."
 - (b.) "To Really Get to Know Someone, Meet in Person Instead of Texting."
 - **c.** "People Who Call Instead of Text Are More Successful in Dating."
 - **d.** "The More Texts You Send Each Day, the More You Will Annoy Others."

9. notorious: well known 10. separation anxiety: emotional upset caused by being separated from someone or something 11. inept: clumsy or lacking in skill **12. barricade:** barrier **13. refrain:** to resist a temptation; to avoid doing something

- 2. The main point of the essay is that
 - **a.** before the days of texting, people had more successful personal relationships.
 - **b.** people are becoming more and more socially inept.
 - **c.** people are more likely to be dishonest in text messages than in person.
 - **d.** if you really want to get to know someone, meet him or her face to face.
- 3. What is one characteristic of Minimalists?
 - a. They respond quickly but with few words.
 - **b.** They text only once or twice a day.
 - **c.**) They may ignore texts sent to them.
 - d. They carry a phone but few other gadgets.
- **4.** Does this essay include the Four Basics of Good Classification? Why or why not?
- **5.** Look back at the vocabulary you underlined, and write sentences using these words: *scrutinized* (para. 3); *hypothetical* (4); *inherently* (5); *notorious* (8); *inept* (11).

TIP For tools to build your vocabulary, visit the *Student Site for Real Writing* at **bedfordstmartins.com/ realwriting**.

READ CRITICALLY

- 1. Hultgren begins her essay with a quotation from a hypothetical texter. What might be the reasons for starting the essay this way? What other approaches might have been used?
- 2. In paragraph 3, Hultgren writes, "People, especially we college students, rely on texting to get to know someone." Do you agree or disagree with this statement? Give examples from your own experiences to support your answer.
- **3.** Is there any way in which you would revise the categories of texters as presented by Hultgren? What other categories might you add?
- **4.** In paragraph 11, Hultgren says that an overreliance on texting in personal relationships "is really just a small portion of humanity's increasing problem of becoming socially inept." Do you agree with this statement? Why or why not?
- Hultgren refers to situations in which it is better to call someone and meet him or her in person rather than sending a text. Are there any situations in which you think it is better to text instead of call or meet face to face? Provide examples of these situations.

WRITE

WRITE A PARAGRAPH: Write a paragraph that describes one type of behavior that you find either annoying or admirable. Give specific examples of actions that fit into this category.

WRITE AN ESSAY: Think of a group of people (such as students, drivers, or shoppers) who might be categorized according to their varying behaviors, habits, or preferences. Then, using Hultgren's essay as a model, write an essay that breaks the group into categories, giving reasons and examples for your subgroupings.

TIP For a sample classification paragraph, see page 198.

Stephanie Ericsson

The Ways We Lie

Stephanie Ericsson was born in 1953 and raised in San Francisco. She has lived in a variety of places, including New York, Los Angeles, London, Mexico, the Spanish island of Ibiza, and Minnesota, where she currently resides. Ericsson's life took a major turn when her husband died suddenly, when she was two months pregnant. She began a journal to help her cope with the grief and loss, and she later used her writing to help others with similar struggles. An excerpt from her journal appeared in the *Utne Reader*, and her writings were later published in a book entitled *Companion*

through the Darkness: Inner Dialogues on Grief (1993). About her book, Ericsson writes, "It belongs to those who have had the blinders ripped from their eyes, who suddenly see the lies of our lives and the truths of existence for what they are."

In "The Ways We Lie," which also appeared in the *Utne Reader* and is taken from her follow-up work, *Companion into the Dawn: Inner Dialogues on Loving* (1994), Ericsson continues her search for truth by examining and classifying our daily lies.

GUIDING QUESTION

As you read this essay, pay attention to the examples Ericsson provides. What examples of lying can you think of from your own experience?

The bank called today, and I told them my deposit was in the mail,X1 even though I hadn't written a check yet. It'd been a rough day. The baby I'm pregnant with decided to do aerobics on my lungs for two hours, our three-year-old daughter painted the living-room couch with lipstick, the IRS put me on hold for an hour, and I was late to a business meeting because I was tired.

I told my client that the traffic had been bad. When my partner came X2 VOCABULARY home, his haggard face told me his day hadn't gone any better than mine, so when he asked, "How was your day?" I said, "Oh, fine," knowing that X

CRITICAL
READING
Preview
Read
Pause
Review

See pages 9-12.

VOCABULARY
DEVELOPMENT Certain
words in this essay are
defined at the bottom of the
page. Underline these words
as you read them.

1. haggard: drawn, worn out

IDEA JOURNAL Think of another common human behavior. Break it into categories, and give examples for each category.

IDENTIFY: In the first two paragraphs, the author provides four examples of lies she has told. Put an X by these examples.

REFLECT: Do you agree that there "must be some merit to lying"? Why or why not?

TEACHING TIP Have small groups diagram the essay. Discuss whether all the categories in the essay are really lies (for example, is stereotyping really a lie?). What other categories should the author have included? Have students record the ways they lie and share their responses at the next class meeting (anonymously, if necessary). Classify the responses according to category.

one more straw might break his back. A friend called and wanted to take me to lunch. I said I was busy. Four lies in the course of a day, none of X which I felt the least bit guilty about.

We lie. We all do. We exaggerate, we minimize,² we avoid confrontation,³ we spare people's feelings, we conveniently forget, we keep secrets, we justify lying to the big-guy institutions. Like most people, I indulge⁴ in small falsehoods and still think of myself as an honest person. Sure I lie, but it doesn't hurt anything. Or does it?

I once tried going a whole week without telling a lie, and it was paralyzing. I discovered that telling the truth all the time is nearly impossible. It means living with some serious consequences: The bank charges me \$60 in overdraft fees, my partner keels⁵ over when I tell him about my travails,⁶ my client fires me for telling her I didn't feel like being on time, and my friend takes it personally when I say I'm not hungry. There must be some merit to lying.

But if I justify lying, what makes me any different from slick politicians or the corporate robbers who raided the S&L industry? Saying it's OK to lie one way and not another is hedging. I cannot seem to escape the voice deep inside me that tells me: When someone lies, someone loses.

What far-reaching consequences will I, or others, pay as a result of 6 my lie? Will someone's trust be destroyed? Will someone else pay my penance8 because I ducked out? We must consider the meaning of our actions. Deception, lies, capital crimes, and misdemeanors9 all carry meanings. Webster's definition of lie is specific:

- 1. a false statement or action especially made with the intent to deceive;
- 2. anything that gives or is meant to give a false impression.

A definition like this implies that there are many, many ways to tell a 7 lie. Here are just a few.

The White Lie

The white lie assumes that the truth will cause more damage than a simple, harmless untruth. Telling a friend he looks great when he looks like hell can be based on a decision that the friend needs a compliment more than a frank¹⁰ opinion. But, in effect, it is the liar deciding what is best for the lied to. Ultimately, it is a vote of no confidence. It is an act of subtle arrogance¹¹ for anyone to decide what is best for someone else.

Yet not all circumstances are quite so cut and dried. Take, for instance, the sergeant in Vietnam who knew one of his men was killed in action but listed him as missing so that the man's family would receive

2. minimize: to reduce 3. confrontation: an argumentative meeting
4. indulge: to become involved in 5. keels: falls over 6. travails: painful efforts; tribulations 7. hedging: avoiding the question 8. penance: a penalty to make up for an action 9. misdemeanors: minor violations of rules 10. frank: honest; direct 11. arrogance: belief in one's superiority

indefinite compensation instead of the lump-sum pittance¹² the military gives widows and children. His intent was honorable. Yet for twenty years this family kept their hopes alive, unable to move on to a new life.

Facades

We all put up facades¹³ to one degree or another. When I put on a suit to 10 go to see a client, I feel as though I am putting on another face, obeying the expectation that serious businesspeople wear suits rather than sweatpants. But I'm a writer. Normally, I get up, get the kid off to school, and sit at my computer in my pajamas until four in the afternoon. When I answer the phone, the caller thinks I'm wearing a suit (although the UPS man knows better).

But facades can be destructive because they are used to seduce others into an illusion. For instance, I recently realized that a former friend was a liar. He presented himself with all the right looks and the right words and offered lots of new consciousness theories, fabulous books to read, and fascinating insights. Then I did some business with him, and the time came for him to pay me. He turned out to be all talk and no walk. I heard a plethora¹⁴ of reasonable excuses, including in-depth descriptions of the big break around the corner. In six months of work, I saw less than a hundred bucks. When I confronted him, he raised both eyebrows and tried to convince me that I'd heard him wrong, that he'd made no commitment to me. A simple investigation into his past revealed a crowded graveyard of disenchanted former friends.

11 IDENTIFY: Underline the main point of this paragraph. What example does Ericsson use to support it?

Ignoring the Plain Facts

In the sixties, the Catholic Church in Massachusetts began hearing com- 12 SUMMARIZE: In your own plaints that Father James Porter was sexually molesting children. Rather than relieving him of his duties, the ecclesiastical¹⁵ authorities simply moved him from one parish to another between 1960 and 1967, actually providing him with a fresh supply of unsuspecting families and innocent children to abuse. After treatment in 1967 for pedophilia, 16 he went back to work, this time in Minnesota. The new diocese¹⁷ was aware of Father Porter's obsession with children, but they needed priests and recklessly believed treatment had cured him. More children were abused until he was relieved of his duties a year later. By his own admission, Porter may have abused as many as a hundred children.

Ignoring the facts may not in and of itself be a form of lying, but consider the context¹⁸ of this situation. If a lie is a false action done with the intent to deceive, then the Catholic Church's conscious covering for Porter created irreparable consequences. The church became a coperpetrator¹⁹ with Porter.

words, summarize the example in this paragraph in one or two sentences.

12. pittance: a small amount 13. facades: masks 14. plethora: excess 15. ecclesiastical: relating to a church 16. pedophilia: sexual abuse of children 17. diocese: a district or churches under the guidance of a bishop

18. context: a 19. coperpetrator: the helper of a person who commits an surrounding situation action

Stereotypes and Clichés

Stereotype and cliché serve a purpose as a form of shorthand. Our need for vast amounts of information in nanoseconds²⁰ has made the stereotype vital to modern communication. Unfortunately, it often shuts down original thinking, giving those hungry for truth a candy bar of misinformation instead of a balanced meal. The stereotype explains a situation with just enough truth to seem unquestionable.

All the *isms*—racism, sexism, ageism, et al.—are founded on and fueled by the stereotype and the cliché, which are lies of exaggeration, omission, and ignorance. They are always dangerous. They take a single tree and make it a landscape. They destroy curiosity. They close minds and separate people. The single mother on welfare is assumed to be cheating. Any black male could tell you how much of his identity is obliterated²¹ daily by stereotypes. Fat people, ugly people, beautiful people, old people, large-breasted women, short men, the mentally ill, and the homeless all could tell you how much more they are like us than we want to think. I once admitted to a group of people that I had a mouth like a truck driver. Much to my surprise, a man stood up and said, "I'm a truck driver, and I never cuss." Needless to say, I was humbled.

Out-and-Out Lies

Of all the ways to lie, I like this one the best, probably because I get tired of trying to figure out the real meanings behind things. At least I can trust the bald-faced lie. I once asked my five-year-old nephew, "Who broke the fence?" (I had seen him do it.) He answered, "The murderers." Who could argue?

At least when this sort of lie is told it can be easily confronted. As the person who is lied to, I know where I stand. The bald-faced lie doesn't toy with my perceptions—it argues with them. It doesn't try to refashion reality; it tries to refute²² it. *Read my lips* . . . No sleight²³ of hand. No guessing. If this were the only form of lying, there would be no such thing as floating anxiety or the adult-children of alcoholics movement.

These are only a few of the ways we lie. Or are lied to. As I said earlier, it's not easy to entirely eliminate lies from our lives. No matter how pious²⁴ we may try to be, we will still embellish,²⁵ hedge, and omit to lubricate the daily machinery of living. But there is a world of difference between telling functional lies and living a lie. Martin Buber once said, "The lie is the spirit committing treason against itself." Our acceptance of lies becomes a cultural cancer that eventually shrouds²⁶ and reorders reality until moral garbage becomes as invisible to us as water is to a fish.

How much do we tolerate before we become sick and tired of being sick and tired? When will we stand up and declare our *right* to trust? When do we stop accepting that the real truth is in the fine print? Whose lips do we read this year when we vote for president? When will we stop being so

PREDICT: Pause just as you start the "Out-and-Out Lies" section. How do you think Ericsson might define such lies?

REFLECT: Think back on your answer to the question on page 662 about whether lying ever has any merit. Have your views on this issue changed? Why or why not?

20. nanoseconds: billionths of a second to deny 23. sleight: a skillful trick 24. pious: religious 25. embellish: to decorate 26. shrouds: covers, conceals

reticent²⁷ about making judgments? When do we stop turning over our personal power and responsibility to liars?

Maybe if I don't tell the bank the check's in the mail I'll be less tolerant of the lies told to me every day. A country song I once heard said it all for me: "You've got to stand for something or you'll fall for anything."

SUMMARIZE AND RESPOND

In your reading journal or elsewhere, summarize the main point of "The Ways We Lie." Then, go back over the essay, and check off the support for this idea. Next, write a brief summary of the essay. Finally, write a brief response to the reading. What did it make you think about or feel? Do you agree with Ericsson's claim that we all tell lies every day? Provide examples from your own experience that support your answer.

CHECK YOUR COMPREHENSION

- 1. An alternate title for this essay could be
 - a. "Lying Never Hurt Anyone."
 - **b.** "The Check's in the Mail: The Greatest Lie of All."
 - c. "Justification for Lying."
 - (d.) "Lies in Our Lives."
- 2. The main point of this essay is that
 - a. small lies are OK because everyone lies.
 - **(b.)** we should reevaluate the role that lies play in our lives.
 - **c.** lies told by someone you trust are the worst kind of lies.
 - **d.** to trust and be trusted, we must refuse to lie.
- **3.** What distinction does Ericsson make between telling a functional lie and living a lie?
 - **a.** Telling a functional lie makes someone feel bad, and living a lie cheats big institutions.
 - **(b.)** Telling a functional lie is relatively harmless, but living a lie can have serious consequences.
 - **c.** Telling a functional lie has no merit, and living a lie is a good idea.
 - **d.** Telling a functional lie is honest, and living a lie is dishonest.
- **4.** Look back at the vocabulary you underlined, and write sentences using these words: *confrontation* (para. 3); *penance* (6); *obliterated* (15); *embellish* (18); *reticent* (19).

READ CRITICALLY

- 1. Describe Ericsson's tone in this essay. For example, what is her tone in paragraph 1 when she tells us that "the baby I'm pregnant with decided to do aerobics on my lungs for two hours"?
- 2. How does Ericsson organize her essay? How does she classify the ways we tell lies?
- **3.** What images does Ericsson associate with telling lies? Select one that you like, and explain why.
- **4.** What is Ericsson's attitude toward lying? What examples in the essay support your answer?
- **5.** In paragraph 16, Ericsson writes, "At least I can trust the bald-faced lie." What do you think she means by trusting a lie?

WRITE

WRITE A PARAGRAPH: Write a paragraph that describes another category of lies. Be sure to provide examples for your readers.

WRITE AN ESSAY: Write an essay that continues Ericsson's classification of the ways we lie. Provide detailed examples from your experiences—or the experiences of people you know—for at least two of the categories she provides. Develop two new categories of your own. Feel free to include the ideas you wrote about in your reading journal for Summarize and Respond.

44

Definition

Each essay in this chapter uses definition to get its main point across to the reader. As you read these essays, consider how they achieve the Four Basics of Good Definition that are listed below and discussed in Chapter 13 of this book.

Four Basics of Good Definition

It uses examples to show what the writer means.

It gives details to support the examples.

John Around Him

Free Money

John Around Him grew up on a reservation in South Dakota. He wrote the following essay for a writing class he took when he was a student at Bunker Hill Community College (BHCC) in Boston. Before enrolling at BHCC, John had served as a Marine in Iraq, so he qualified for financial aid. In 2008, he transferred from BHCC to Dartmouth College, from which he graduated in 2012. As a writer, Around Him is interested in education and Native American issues, and he plans to pursue a career in education, which he knows will require a lot of writing. Before beginning an essay, he says that he

often looks to his friends as a sounding board for his ideas and potential topics because "they give a different window in which to see my ideas." When offering advice to fellow student writers, Around Him writes, "Through writing you may discover who you are, so have fun while doing it."

GUIDING QUESTION

How does a student get financial aid for college?

Free money: The words almost take your breath away. For the average college student, the idea is especially appealing. The weight of college tuition, in combination with the cost of food, rent, and other living expenses, makes the climb toward educational success appear almost impossible. However, assistance in the form of financial aid is available to help lighten the load.

Financial aid is money to help pay for college tuition or other expenses while going to college. Financial aid comes in an array¹ of programs, from federal and state funding to scholarships. Federal financial aid is the source most students use. It is available in the form of grants, student loans, and the Federal Work-Study Program. A grant really is free money, while a student loan has to be repaid when a student either completes college or stops going. The Federal Work-Study Program allows students to earn money while attending college. In 2008, the budget for Federal Pell Grants was about \$15 billion. In that same year, the student loan budget was \$72.8 billion, and the work-study program's budget was \$980 million.

To apply for federal financial aid, students must fill out the Free Application for Federal Student Aid (FAFSA), available at your college's financial aid office or online (Google FAFSA). In order to receive aid, a student must meet the following criteria: be a U.S. citizen or eligible non-citizen of the United States with a valid social security number; have a high school diploma or have passed the General Education Development (GED) test; and be enrolled in a degree program, taking a minimum of six credits. Men between the ages of eighteen and twenty-six must have registered in the selective service.³

Using the information provided in the FAFSA, the federal government calculates each applicant's Expected Family Contribution (EFC). The EFC is calculated with a formula based on the student's income or, if the student is a dependent, the family's income and assets. For students who are dependents but do not receive financial support from their parents, the EFC can be a problem because counting family income might

CRITICAL
READING
Preview
Read
Pause
Review
See pages 9-12.

VOCABULARY
DEVELOPMENT Certain
words in this essay are
defined at the bottom of the
page. Underline these words
as you read them.

IDEA JOURNAL Have you ever received something for free?

PREDICT: What do you think the essay will be about?

IDENTIFY: Underline the eligibility criteria.

array: a large range of a particular kind of thing
 criteria: standards by which something is judged or decided
 selective service: a system that requires all men between the ages of eighteen and twenty-six to register so that the federal government has information available about potential soldiers in case of war
 dependent: a person who relies on someone for money or other support
 assets: total financial resources, such as cash and property

make the student ineligible. However, that is the formula. Other factors⁶ include the number of family members in the household and number of family members in college. Last year, I applied for financial aid but did not qualify because, according to the financial aid office at my college, I made too much money. Nevertheless, I will continue to apply for financial aid.

Students should always apply for financial aid, but many do not. Much 5 REFLECT: Have you visited of the money available is not used because students do not know about it or fill out the proper forms. Looking around and going to your college's financial aid office is worth the time required because there really is free money. For example, there are scholarships for health-care programs, for business programs, for graduate programs, to name just a few. My goal is to finish my two-year degree and transfer to a four-year college. In order to do this, I need to have a plan and prepare myself by researching schools to find out which ones are suitable for me. Then, I can find out what courses I need to take to graduate and to transfer with as many credits as possible. I won't do this alone: I will take advantage of the various services available at my college, including meeting with my adviser. I will apply to many sources of financial aid, because getting my degree will be very expensive.

Clearly, the price tag for higher education is very high, and most students cannot afford it without assistance. I know that the money is available, and some of it is free. However, as the saying goes, "Nothing in life is free," and that means that getting what I need requires effort. It is my responsibility to work hard to find that money, along with working hard to get good grades.

your college's financial aid office?

6 REFLECT: What services does your college offer?

SUMMARIZE AND RESPOND

In your reading journal or elsewhere, summarize the main point of "Free Money." Then, go back over the essay, and check off the support for this idea. Next, write a brief summary of the essay. Finally, write a brief response to the reading. Do you think federal and state governments do enough to help college students financially?

CHECK YOUR COMPREHENSION

- An alternate title for this essay could be
 - a. "Nothing in Life Is Free."
 - b. "Wealthy Students Should Not Receive Financial Aid."
 - c. "Students Need to Learn to Save Money."
 - (d.) "Students Should Take Advantage of Financial Aid."
- 6. factors: elements that contribute to a process, a result, or an accomplishment

- 2. The main point of this essay is that
 - (a.) many financial resources are available to students.
 - **b.** the federal government should increase aid to college students.
 - c. the selective service is a requirement for financial aid.
 - **d.** students should be less financially dependent on their families.
- 3. In the past, the writer was denied financial aid for college because
 - a. he had not registered for selective service.
 - **b.** he was not a U.S. citizen.
 - (c.) he made too much money.
 - d. he missed the deadline for applying.
- **4.** Does this essay include the Four Basics of Good Definition? Why or why not?
- **5.** Look back at the vocabulary you underlined, and write sentences using these words: *array* (para. 2); *criteria* (3); *dependent, assets, factors* (4).

TIP For tools to build your vocabulary, visit the Student Site for Real Writing at bedfordstmartins..com/realwriting.

READ CRITICALLY

- **1.** What do you think Around Him wants his readers to do with the information in this essay?
- 2. In paragraph 1, the writer says that college tuition and expenses can make getting an education "appear almost impossible." Do you agree, and do you think higher education is too expensive?
- **3.** Around Him lists and explains the requirements students must meet to receive federal or state financial aid. Do these requirements seem reasonable? Why or why not?
- **4.** Do you think it is fair that some students are ineligible for financial aid because their parents have too much money?
- **5.** Although this essay encourages students to seek financial support, how does it also suggest that they take responsibility for their education?

WRITE

TIP For a sample definition paragraph, see page 216.

WRITE A PARAGRAPH: Around Him refers to the saying "Nothing in life is free." Write a paragraph that either supports this saying or argues against it. You may draw on a personal experience to make your point.

WRITE AN ESSAY: Around Him argues that students "should always apply for financial aid." Who do you think should receive "free money" to go to college? In an essay, define the kinds of students who should receive the most financial assistance for college expenses.

Michael Thompson

Passage into Manhood

Michael Thompson is a consultant, child psychologist, and author. His 1999 book *Raising Cain: Protecting the Emotional Life of Boys* (1999), cowritten with Dan Kindlon, was the inspiration for a PBS documentary of the same name. Both the book and the documentary, which was hosted by Thompson, explore boys' emotional development and the negative consequences of common misunderstandings about them. Thompson's other books include *Speaking of Boys: Answers to the Most-Asked Questions about Raising Sons* (2000), *Mom, They're Teasing Me: Helping Your Child*

Solve Social Problems (2002), The Pressured Child: Helping Your Child Achieve Success in School and in Life (with Teresa Barker, 2004), and It's a Boy! Your Son's Development from Birth to Age 18 (2008).

In "Passage into Manhood," which appeared in the *Boston Globe* in 2005, Thompson gets one young man's definition of manhood, raising questions about what our society does—and, more important, does not do—to prepare boys to become men.

GUIDING QUESTION

What is necessary for the passage into manhood, according to the author?

The boy sitting next to me on the plane from Toronto to North Bay 1 was seventeen years old, a rising high school senior with a slight beard. He had the misfortune¹ to sit next to a child psychologist, a so-called expert on boys, who would pester him with questions for the entire trip about how he was spending his summer, and why. "This is kind of like a final exam," he observed, trying to get me to relent,² but I wouldn't let go.

After he had gamely³ answered a number of my questions about the summer camp to which he was headed, I sprang the big one on him, the question I have asked many boys his age. "Do you consider yourself to be a man?"

"Yes," he replied immediately. Then he caught himself, hesitating momentarily before declaring with conviction: "Well, no. But I will be in August!"

What could a seventeen-year-old boy do between the last week of June and August that he could anticipate⁵ would make him a man? American culture doesn't have any universal ritual⁶ that sees a boy through that psychologically difficult passage from boyhood to manhood. Many boys, actually, almost every boy, struggles with what it means to become a man. Boys (or young men, if you prefer) of seventeen, nineteen, and into their early twenties wrestle with the riddle: What test do I have to pass to become a man, and who will be able to recognize that I have reached that point? My young companion thought he had found an answer.

See pages 9-12.

2 VOCABULARY DEVELOPMENT Certain words in this essay are defined at the bottom of the page. Underline these words a syou read them.

REFLECT: In paragraph 3, why do you suppose the boy answered "yes" and then changed his mind?

IDEA JOURNAL Write about a personal experience that you believe marked a passage from youth to adulthood. What happened, and how did the experience change you?

misfortune: bad luck
 relent: to give up; to stop enthusiastically
 conviction: a strong belief or feeling expect
 ritual: a ceremony or rite of passage

3. gamely:5. anticipate: to

IDENTIFY: Paragraph 5 provides several examples. Check off the experiences that the boy expects to have.

IDENTIFY: In paragraphs 6 and 7, underline the boy's definitions of manhood.

SUMMARIZE: In a sentence or two (in your own words), sum up the point that the author makes in paragraph 10.

TEACHING TIP Write "man" on one side of the board and "woman" on the other. Then, ask students to call out the names of people (famous or otherwise) that they consider to be ideal men and women, and write the names down. Students should give at least one reason for their choices; write the reasons down as well. Next, discuss the similarities and differences among the people and reasons listed. Did students give different reasons for the different genders? If so, what do the differences suggest about what society values in men versus women?

It turned out that he was going to embark⁷ the next morning on a 5 fifty-day canoeing trip that would take him and nine companions through lakes, rivers, rapids, mud, and ferocious8 mosquitoes, all the way up to Hudson's Bay, a distance of six hundred miles. He and his friends had been preparing for this by developing wilderness skills for the last four years at their camp. They would carry all of their own food, they would take risks, and they would suffer. Toward the end of their journey they would see the Northern lights9 and would visit an Inuit10 settlement. They might see moose and wolves, but, he told me, they were not going to be tourists. "This isn't about seeing wild animals," he asserted.

What was his definition of manhood? "It's taking responsibility," he said. "At the end of the day, it's taking responsibility and taking things you've learned from others and creating your own self."

"It's about finishing a grueling portage," 11 he said. "It's about doing 7 work and getting a result."

Didn't he get that from school and varsity athletics? No. Though he 8 did well in school and had bright college prospects, school didn't address his hunger to be a man, not even playing sports. "After sports you go home, take a shower, and watch TV." When he was canoe tripping, he felt as if he made a sustained12 effort that connected him to all the men who had canoed before him at that camp for more than one hundred years.

Could he find the experience he sought among his friends back home? 9 What were they doing this summer? "Hanging out. They're playing video games," he said. They didn't get it. "It's frustrating. You try to explain to them how great it is. You tell them about paddling all day, and cooking your own food, about the mosquitoes, and carrying a wood canoe, and they say, 'What, are you crazy?'"

This young about-to-be man described his father as a "good guy," his mother as a hardworking professional, and his step-father as financially successful, but none of them seemed to hold the key to helping him become a man. American culture has no universal ritual for helping boys move from boyhood to manhood. Jewish boys have their bar mitzvahs, 13 Mormon boys have their year of missionary service, other boys sign up for the military. Yet every boy yearns¹⁴ to be a man, and traditional societies always took boys away from their parents to pass an initiation rite. We no longer have such rituals, but boys still wonder: What is the test, where do I find it, how do I pass it, and who will recognize that moment when I pass from boyhood to manhood? We fail to provide a meaningful, challenging path that speaks to the souls of a majority of boys.

The key to his manhood lay with the counselors who accompany him 11 on the journey and with his companions whose lives he would protect and who would, in turn, look out for him. Past the rain, the bugs, the smelling

7. embark: to go on board; to make a start

9. Northern lights: a colorful display of lights in the sky, caused by solar winds

10. Inuit: a native people of North America journey that requires the carrying of supplies 11. grueling portage: a difficult 12. sustained: continuous; ongoing

8. ferocious: fierce; menacing

13. bar mitzvahs: ceremonies marking Jewish boys' thirteenth birthdays and the beginning of their religious responsibilities 14. yearns: wants, desires

bad, he would discover his manhood in community and in the kind of challenge that only nature offers up.

Our plane journey over, I wished him luck. And then I couldn't get our conversation out of my mind. While a demanding canoe trip is not for every boy, I'm certain that every boy is searching for a test. You can find the test by taking on anything that requires commitment and courage. However, there is something that happens out-of-doors that strips you down to the essentials: safety, companionship, a shared sense of mission. You set aside the busyness and crap of daily life, and then you can think about what it actually means to be a man.

SUMMARIZE AND RESPOND

In your reading journal or elsewhere, summarize the main point of "Passage into Manhood." Then, go back over the essay, and check off support for this idea. Next, write a brief summary of the essay. Finally, write a brief response to the reading. Do you agree with the author about what is needed for boys to make the passage into manhood?

CHECK YOUR COMPREHENSION

- 1. An alternate title for this essay could be
 - a. "American Boys Overwhelmed by Adult Responsibilities."
 - **b.** "One Teen's Story of His Passage into Manhood."
 - c. "The Path to Manhood: A Difficult Journey for Most Boys."
 - (d.) "American Boys Need a Meaningful Path to Manhood."
- **2.** The main point of this essay is that
 - **a.** undergoing a wilderness challenge is the only real way to become a man.
 - **b.** young men should be able to define for themselves what it means to be a man, even if most people would disagree.
 - going through a significant ritual or test makes boys feel like men, but American culture fails to provide such paths.
 - **d.** American boys should be given a bar mitzvah or be required to perform missionary service.
- **3.** What challenge was the boy Thompson spoke with about to take on?
 - a. A boating competition
 - **b.**) A fifty-day canoeing trip
 - c. A hiking and biking tour
 - d. A Canadian triathalon
- **4.** Look back at the vocabulary you underlined, and write sentences using the following words: *relent* (para. 1); *conviction* (3); *anticipate* (4); *sustained* (8); *yearns* (10).

READ CRITICALLY

- 1. In paragraph 2, the author asks the boy what he considers to be a "big" question: Does the boy consider himself to be a man? Why does the author consider it to be a big question, and do you agree? Why or why not?
- **2.** How do you define manhood or womanhood? How is your definition similar to or different from that provided by the boy Thompson speaks to?
- **3.** In paragraph 10, Thompson argues, "We fail to provide a meaningful, challenging path [to adulthood] that speaks to the souls of a majority of boys." Do you agree? Why or why not? What other possible paths to manhood are not mentioned by Thompson?
- **4.** Why, according to Thompson, are outdoor challenges especially useful for boys making the passage toward manhood? Do you share his view?
- **5.** Why do you suppose Thompson is interested in the opinions of one young person he meets on a plane? How do the quotations from the boy contribute to the point of Thompson's essay?

WRITE

WRITE A PARAGRAPH: Write a paragraph that gives at least two pieces of advice to a boy who is about to become a man or to a girl who is about to become a woman. The person could be a brother or sister, a son or daughter, or a friend. Or you could imagine a boy or girl to address the advice to. Be sure to explain why each piece of advice is important, and give examples to show what you mean

WRITE AN ESSAY: Write an essay that defines what it is to be a man or a woman. Use examples from your personal experience to help define the concept. If you answered question 2 under Read Critically, you might want to use some of the insights from that question to develop your essay. Explain why you think Thompson, or the boy he interviewed, might agree or disagree with your definition.

Comparison and Contrast

Each essay in this chapter uses comparison and contrast to get its main point across to the reader. As you read these essays, consider how they achieve the Four Basics of Good Comparison and Contrast that are listed below and discussed in Chapter 14 of this book.

Four Basics of Good Comparison and Contrast

- It serves a purpose—to help readers make a decision, to help them understand the subjects, or to show your understanding of the subjects.
- It presents several important, parallel points of comparison/contrast.
- 4 It arranges points in a logical order.

Courtney Stoker

The Great Debate: Essentialism vs. Dominance

Courtney Stoker wrote the following essay while pursuing an accounting degree at the University of North Carolina at Pembroke, where she was a member of the Sigma Alpha Pi and Alpha Chi honor societies and a university marshal. She also served as vice president of the Accounting Students Association and as secretary of the Honors Council, and she was a member of the student chapter of the Society of Human Resource Management.

This essay was published in ReVisions: Best Student Essays of the University of North Carolina at Pembroke. In it, Stoker

examines researchers' claims about the differing communication styles of men and women, and she comes to some thoughtful conclusions.

GUIDING QUESTION

What perceived differences between men and women are behind the "great debate"?

In an episode of the popular television show *Friends*, Rachel kisses Ross and then they each go home and tell their friends about their experience. Rachel's girlfriends, Phoebe and Monica, get very excited and have to get out the wine and unplug the phone before she tells the story so that they do not miss any details. They giggle and clap as they ask all sorts of questions like where his hands were and what kind of kiss it was. On the other hand, Ross simply tells his friends, Chandler and Joey, that he kissed her. The boys do not even stop eating to hear about the kiss, and the only question they have is whether or not tongue was involved ("Difference Between Men and Women"). Clearly, this episode demonstrates and exaggerates the existence of communication differences between men and women recognized by many linguists¹ today. While a pretty solid consensus² exists among scholars and the general public that differences in communication purposes and styles exist, the conflict lies in why these differences are present.

There are two prominent³ explanations available for the discrepancies⁴ in communication between the sexes—the essentialism theory and the dominance theory. Essentialism is the original theory and found strength in the 1950s and 1960s as feminists began to embrace and celebrate the qualities of a female. According to the essentialism school of thought, women and men are innately⁵ different, and women are more polite and nurturing⁶ from birth because they are women (Bucholtz 416). According to the essentialist school of thought, Rachel is giddy⁷ because she is a woman, and it is part of her natural instincts to react in that way. Furthermore, Dr. Louann Brizendine, a professor of neuropsychiatry,⁸ would attribute⁹ Rachel's and her girlfriends' chatty¹⁰ tendencies to a rush of oxytocin—a hormone related to emotions—which women presumably¹¹ get while gossiping (Solomon). In essence, the essentialism theory claims that by exhibiting differences in communication, men and women are simply conveying their natural selves.

As time progressed, many found the essentialism theory to be too 3 limited in defining gender; thus, the dominance theory was born. According to the dominance theory, the differences in communication between the sexes are a learned behavior that can be blamed on men's historical dominance in society over women. According to the dominance theory, a woman is polite and does not say much because she fears punishment

CRITICAL
READING
Preview
Read
Pause
Review

See pages 9-12.

VOCABULARY
DEVELOPMENT Certain
words in this essay are
defined at the bottom of the
page. Underline these words
as you read them.

IDEA JOURNAL What differences have you observed between women and men in terms of how they communicate?

IDENTIFY: What pattern of comparison and contrast does Stoker use to organize paragraph 2?

PREDICT: Look at the final sentence of paragraph 2. What specific problems do you think Stoker will find with the data?

linguists: those who study language or its use
 consensus: general agreement
 prominent: leading; well-known
 discrepancies: differences; inconsistencies

5. innately: by nature
6. nurturing: supportive; protective; motherly
7. giddy: dizzy with joy
8. neuropsychiatry: a field of psychiatry that considers neurological (nervous system) factors behind mental states and disorders
9. attribute: to assign

10. chatty: talkative 11. presumably: probably; likely

for overstepping her bounds in society. In Rachel's case, the dominance theory would suggest that she was simply living up to the giddy, gabby¹² girl that society would want a woman to be and that Ross was simply being the cool guy who is only concerned about the sexual aspect of their relationship because society has defined men as unemotional creatures. But dominance theory fails to explain why women continue to communicate differently than men among a group of all females; it would seem that in the absence of sexual diversity, there would be no subservient¹³ group that would feel the need to live up to stereotypes. While it is easy to simply take a side in the great debate, the fact is that neither side has enough empirical¹⁴ data or an effective way of measuring the data to be declared victorious.

Two major figures in the debate of essentialism and dominance are 4 essentialist theorist¹⁵ Deborah Tannen and dominance theorist Deborah Cameron. According to Tannen, men communicate to solve problems, whereas women communicate to establish emotional connections. Additionally, women find intimacy through conversation, and men find it through actions. Tannen claims a man's need to solve problems leads to disputes because a woman feels her heterosexual mate does not understand her problems or is belittling¹⁶ them by constantly offering solutions while the woman is actually seeking support (Kelly and Cotter). This theory gained popularity because it is relatable to everyday life. For example, when my mother complained to my father about being worn out and tired after a long day at work, he suggested she start taking a multivitamin in order to keep her energy up. My mother became annoyed because she felt that my father's suggestion of a multivitamin was belittling her stress and partly blaming her for not taking better care of her body; additionally, he had failed to give her the emotional recognition and understanding she craved. On the other hand, my father was upset that my mother did not appreciate his helpful advice. My parents' misunderstanding is a typical case of a communication problem between men and women. Essentialists would argue that we must learn about these innate differences so that men and women can better understand one another.

Both essentialists and dominance theorists recognize a woman's tendency to be suggestive¹⁷ and indirect with language. This claim may be finding some validity¹⁸ today with many studies claiming that women use language more indirectly by making suggestions rather than giving orders. On the other hand, these studies claim that men are more likely to bark out orders, clearly conveying their wants. This use of suggestions versus orders can often leave men confused as to what women actually mean or want, and women are left annoyed that men are not more perceptive.¹⁹ Many women feel that if their mate truly loves and cares about them, then they will be able to know what they want and understand exactly what

5 SUMMARIZE: In your own words, summarize the start of this paragraph (up to the story of Amanda and Christopher).

^{12.} gabby: talkative
13. subservient: submissive or subordinate to others; in a serving position rather than a leading one oclose observation
15. theorist: one who develops or applies theories
16. belittling: insulting; talking down to suggesting something instead of stating it directly
18. validity: acceptance based on reason
19. perceptive: insightful; understanding

biscussion Direct students' attention to the personal stories related in paragraphs 4 and 5. Then, ask them whether they have observed similar situations. Has Stoker's essay changed the way they see these situations and what they say about the differences in the ways women and men communicate? If so, in what ways?

IDENTIFY: Underline the main point of paragraph 6.

they are thinking without clear verbalization²⁰ (Cotter and Kelly). For example, my friend Amanda told her boyfriend of nine months, Christopher, that she did not want to celebrate Valentine's Day because it was a "greeting card company holiday." When February fourteenth rolled around, Amanda got exactly what she asked for—nothing, not even a card. Enraged, Amanda called me to vent²¹ about how unloving, unromantic, and emotionally handicapped Christopher was. In Christopher's eyes when Amanda said "no Valentine's Day," she meant no Valentine's Day. But what Amanda actually meant was "I want you to think that I do not want anything, but I really do care about Valentine's Day, and no matter what I say, you should get me something because you love me, and on top of that you should know me well enough to know that deep down I really do care about Valentine's Day." Clearly it is easy to understand why Christopher would be confused. According to essentialist thinkers, Amanda and Christopher need to learn about and accept their communication differences in order to communicate more effectively. To them, Amanda cannot help that she wants Christopher to be able to read between the lines and do exactly what she wants even if she does not verbalize it. However, according to dominance theorists, Amanda and Christopher need to stop living up to the stereotypes set for them by society and openly communicate. Amanda need not fear seeming clingy and needy by wanting a Valentine's Day gift. It is easy to see both sides of the debate and how they play a role in everyday relationship and communication problems.

The main problem with the essentialist school of thought is that it is 6 outdated and even insulting in today's world. Essentialism taken to the extreme would define both men and women as having the ability to hold only certain roles or occupations in our society. Clearly, this is not the case today with male nurses, Nancy Pelosi²² as the speaker of the House, Sarah Palin²³ running for vice president, men being stay-at-home dads, women working as CEOs, etc. Our society is redefining the gender roles and stereotypes that have been in place for hundreds of years. According to dominance theorists, women were put into their subservient and nurturing roles because of a lack of birth control; in the past, prior to effective contraceptives, a woman could have been pregnant as many as fifteen or twenty times in a lifetime. Thus, a woman was easily forced into the nurturing role, but, as birth control developed and women's rights emerged, women were able to begin to redefine themselves as more than the babymaking machines of society (Solomon). The possibilities for women and men are not defined merely by their gender, and for that reason their language cannot be either. Many of the opponents of essentialism feel that essentialism as a school of thought boxes the genders into stereotypical roles, actions, and ways of communicating that cannot be condoned²⁴ in today's "equal opportunity" society.

20. verbalization: the use of words
21. vent: to express feelings; to complain
22. Nancy Pelosi: minority leader of the U.S. House of Representatives; from 2007 to
2011, speaker of the House
23. Sarah Palin: former Alaska governor who was the Republican nominee for vice president during the 2008 U.S. presidential race
24. condoned: allowed; approved of

6

Cameron blatantly²⁵ condemns the work of Tannen and other "self 7 help" authors as being nothing more than a string of fallacies26 and stereotypes taken as scientific fact. While condemning the work of others, Cameron argues that the issue of gender and language is so complex that it cannot be correctly analyzed or studied without isolating all of the factors besides gender that may affect language, an obviously impossible task to accomplish (Cameron 578-80). While Cameron still maintains that language differences are created by society, she seems to admit that the research is still impossible. Furthermore, Cameron attacks scientists and intellectuals who blindly quote the trumped-up²⁷ data from self help books in their academic work (578)....

Regarding the differences in communication between men and 8 men, I acknowledge and accept some aspects of both the essentialist ASUMT women, I acknowledge and accept some aspects of both the essentialist school of thought (men and women are simply different in some ways) and the dominance theory (some behaviors and tendencies in men and women become magnified by stereotypes). But I also condemn some aspects of both. In reference to the essentialist school of thought, I do not feel that we are completely predestined²⁸ or predetermined²⁹ by gender. Nor do I feel that history and society can be fully blamed for the differences between men and women as presented by the dominance theory. Presently, there is not sufficient evidence to support either side of the debate. I believe the true answer may be some sort of a blend of the two, with some tendencies and habits being more prevalent in men or women at birth and yet others simply the product of the society that we live in and historical injustices. But once again, I do not feel as if there is enough evidence to consciously declare one theory correct. Before any accurate judgments can be made, the field of gender language studies is going to have to be revised to create uniform standards of experimentation. Furthermore, if scientists and linguists are going to apply the results of their studies to the population as a whole, a more accurate representation of society must be represented in the studies. Middle-class white suburbia³⁰ cannot be used to represent the population as a whole by any account. Studies must include samples from a diverse group of economic, educational, social, religious, cultural, and ethnic groups; by not acknowledging the role of all of these factors, the human experience is being oversimplified. It is irresponsible and impossible to expect accurate and reproducible results while measuring such subjective³¹ data in such haphazard³² and biased ways. While creating the standards for research will address the issue of whether or not differences exist and what exactly they are, it still will not answer the question of why these differences exist. Honestly, we may never be able to confidently and empirically show the root of differences between men and women; the human experience may simply be too complex and multidimensional to pinpoint the cause. However, it is important to continue to look for the answers in determining how and

TEACHING TIP Linguist Susan C. Herring has said that men "tend to feel a greater sense of entitlement to occupy public space." She adds that they "regularly post longer messages to online discussion forums than women do, and they rarely apologize for message length, even when they go on for 20 screens, whereas women apologize even for short messages." Share this quotation with students, and ask them if they notice any difference in online behaviors or texting between women and men. What, in their view, is behind this difference?

25. blatantly: strongly 26. fallacies: statements that are false, misleading, or logically unsound 27. trumped-up: heavily praised or promoted despite faults 28.-29. predestined, predetermined: following a preset, unchangeable course 30. suburbia: the suburbs, collectively 31. subjective: based on personal opinions or reactions 32. haphazard: disorganized; careless

why men and women are different so that future generations can communicate more effectively. But for now, in my book, the argument over dominance theory versus essentialism goes down as yet another stalemate³³ taking us back once again to one of the great questions of life: nature or nurture?³⁴

Works Cited

- Bucholtz, Mary. "Language, Gender, and Sexuality." *Language in the USA: Themes for the Twenty-First Century*. Ed. Edward Finegan and John R. Rickford. Cambridge: Cambridge UP, 2004. 410–29. Print.
- Cameron, Deborah. "A Language in Common." *Psychologist* 22.7 (2009): 578–80. *Academic Search Complete. EBSCO*. Web. 24 Feb. 2010.
- "Difference between Men and Women." YouTube. Web. 31 Mar. 2010.
- Kelly, K., and M. Cotter. "In the Name of Domestic Glasnost, Deborah Tannen Tries to Bridge the Linguistic Gap between the Sexes." *People* 34.10 (1990): 133. *Academic Search Complete. EBSCO*. Web. 24 Feb. 2010.
- Solomon, Deborah. "Questions for Dr. Louann Brizendine: He Thought, She Thought." *Nytimes.com*. New York Times, 10 Dec. 2006. Web. 30 Mar. 2010.

SUMMARIZE AND RESPOND

In your reading journal or elsewhere, summarize the main point of "Essentialism vs. Dominance." Then, go back over the essay, and check off the support for this idea. Next, write a brief summary of the essay. Finally, write a brief response to the reading. To what extent does your own experience match Stoker's observations? Do you agree with her conclusions about the "great debate"?

CHECK YOUR COMPREHENSION

- 1. An alternate title for this essay could be
 - **a.** "Better Research Would Prove that Men's and Women's Communication Styles Are More Alike than Different."
 - **b.** "Researchers Will Never Fully Understand Communication Differences between Men and Women."
 - **c.** "Dominance Theory Insults Women and Oversimplifies Their Behavior."
 - **d.** "Better Research Needed to Understand Communication Differences between Men and Women."

^{33.} stalemate: a situation in which two opposing sides have come to a standstill on an issue or argument 34. nature or nurture: the longstanding debate over whether nature (our genetic inheritance) or nurture (how we are raised and under what conditions) plays a greater part in shaping who we are

- 2. The main point of this essay is that
 - **a.** the dominance theory, although imperfect, is the best and most fair explanation of the communication differences between men and women.
 - **b.** the two main theories about why men and women communicate differently are flawed.
 - **c.** because most behavioral researchers are biased, they should base their findings on numerical data instead of personal observations.
 - **d.** essentialism does a better job than dominance of showing how social factors influence men's and women's communication styles.
- **3.** According to the author, both essentialist and dominance theorists agree that
 - (a.) women can be indirect in their use of language.
 - **b.** women express more understanding of others than men do.
 - c. women's use of language is becoming more like men's.
 - **d.** men need to be more understanding of how women communicate.
- **4.** Does this essay include the Four Basics of Good Comparison and Contrast? Why or why not?
- **5.** Look back at the vocabulary you underlined, and write sentences using these words: consensus (para. 1); discrepancies (2); subservient (3); blatantly (7); predestined (8).

TIP For tools to build your vocabulary, visit the Student Site for Real Writing at bedfordstmartins.com/realwriting.

READ CRITICALLY

- 1. What do you suppose Stoker wants general readers, as opposed to researchers, to take away from this essay? Specifically, how does she want us to think about the communication differences between women and men, and about what experts have previously said about these differences?
- 2. In paragraphs 4 and 5, Stoker provides personal examples illustrating communication differences between women and men. Why do you suppose she chose personal stories instead of examples from academic sources?
- **3.** Stoker has applied some of the basics of critical thinking (see p. 7) and of argument (see p. 696). Which basics do you notice, and where? In general, do you think she makes an effective argument? Why or why not?
- **4.** This essay also has elements of cause and effect (see Chapters 15 and 46). Where do you notice these elements, and why do you think the author included them?
- **5.** Stoker cites several sources to support her main point. Think of a question that you still have about her topic. Then, with this question

in mind, use a search engine or your college library's online catalog to identify at least two sources that could help answer it.

WRITE

TIP For a sample comparison-and-contrast paragraph, see page 237.

WRITE A PARAGRAPH: Write a paragraph describing another difference in behavior between women and men. Be sure to describe this differing behavior clearly and in detail.

write an essay: Stoker focuses mainly on differences between women and men. Write an essay on the behavior of men and women in a particular situation (or in various situations), but try not to limit yourself to contrasts; consider similarities as well. Develop a clear thesis that makes a general point about the behavior of women and men, and support this point using specific examples from your own observations and experiences.

Judith Ortiz Cofer

Don't Misread My Signals

Judith Ortiz Cofer is a Puerto Rican author and the Regents' and Franklin Professor of English and Creative Writing at the University of Georgia, where she has taught since 1984. She earned a B.A. in English from Augusta College and an M.A. in English from Florida Atlantic University. In 2007, she was awarded an honorary doctorate in human letters from Lehman University in New York City. Cofer's works span across literary genres, including books of poetry, novels, autobiographical writing, and collections of short stories and essays. Her work has appeared in numerous literary

journals, and it is often anthologized and included in textbooks.

GUIDING QUESTION

How do people's assumptions about Cofer, based on her appearance, differ from who she is?

On a bus to London from Oxford University, where I was earning 1 some graduate credits one summer, a young man, obviously fresh from a pub, approached my seat. With both hands over his heart, he went down on his knees in the aisle and broke into an Irish tenor's rendition of "Maria" from West Side Story. I was not amused. "Maria" had followed me to London, reminding me of a prime fact of my life: You can leave the island of Puerto Rico, master the English language, and travel as far as

- CRITICAL
 READING
 Preview
 Read
 Pause
 - See pages 9-12.

Review

- 1. tenor: the highest range of the adult male voice 2. rendition: a performance
- 3. "Maria": a song from West Side Story about one of the main Puerto Rican characters
- 4. West Side Story: a 1957 Broadway musical, made into a film in 1961

you can, but if you're a Latina,⁵ especially one who so clearly belongs to Rita Moreno's⁶ gene pool, the island travels with you.

Growing up in New Jersey and wanting most of all to belong, I lived 2 in two completely different worlds. My parents designed our life as a microcosm⁷ of their casas⁸ on the island—we spoke Spanish, ate Puerto Rican food bought at the bodega,⁹ and practiced strict Catholicism complete with Sunday mass in Spanish.

I was kept under tight surveillance¹⁰ by my parents, since my virtue and modesty were, by their cultural equation, the same as their honor. As teenagers, my friends and I were lectured constantly on how to behave as proper senoritas. But it was a conflicting message we received, since our Puerto Rican mothers also encouraged us to look and act like women by dressing us in clothes our Anglo schoolmates and their mothers found too "mature" and flashy.¹¹ I often felt humiliated when I appeared at an American friend's birthday party wearing a dress more suitable for a semiformal. At Puerto Rican festivities, neither the music nor the colors we wore could be too loud.

I remember Career Day in high school, when our teachers told us to come dressed as if for a job interview. That morning, I agonized¹² in front of my closet, trying to figure out what a "career girl" would wear, because the only model I had was Marlo Thomas¹³ on TV. To me and my Puerto Rican girlfriends, dressing up meant wearing our mothers' ornate¹⁴ jewelry and clothing.

At school that day, the teachers assailed¹⁵ us for wearing "everything 5 at once"—meaning too much jewelry and too many accessories. And it was painfully obvious that the other students in their tailored skirts and silk blouses thought we were hopeless and vulgar.¹⁶ The way they looked at us was a taste of the cultural clash that awaited us in the real world, where prospective¹⁷ employers and men on the street would often misinterpret our tight skirts and bright colors as a come-on.¹⁸

It is custom, not chromosomes,¹⁹ that leads us to choose scarlet over pale pink. Our mothers had grown up on a tropical island where the natural environment was a riot of primary colors, where showing your skin was one way to keep cool as well as to look sexy. On the island, women felt free to dress and move provocatively²⁰ since they were protected by the traditions and laws of a Spanish Catholic system of morality and machismo,²¹ the main rule of which was, "You may look at my sister, but if

VOCABULARY
DEVELOPMENT Certain
words in this essay are
defined at the bottom of the

defined at the bottom of the page. Underline these words as you read them.

IDEA JOURNAL Compare the way you dress now with how you dressed ten years ago and what each kind of style says about you.

IDENTIFY: As you read, check off customs and details that made the author different.

6 REFLECT: What are some customs your family has that others may find odd?

5. Latina: a female Latin American living in the United States 6. Rita Moreno: a Puerto Rican actress who played in West Side Story 7. microcosm: a world in 8. casas: Spanish for "houses" 9. bodega: Spanish for "small miniature grocery store" 10. surveillance: a watch kept over a person or group of people 11. flashy: showy 12. agonized/worried: to worry about **Thomas:** an American actress who played a modern single woman on the television show That Girl, which ran from 1966 to 1971 14. ornate: decorated with complex 15. assailed: attacked 16. vulgar: common; crude; lacking in good 17. prospective: likely to become; expected 18. come-on: flirting 19. chromosomes: material that carries genes or biological traits from parent to child 20. provocatively: in a way that causes a response or calls forth feelings, thoughts, or 21. machismo: a strong or exaggerated sense of manliness or power actions

you touch her, I will kill you." The extended family and church structure provided them with a circle of safety on the island; if a man "wronged" a girl, everyone would close in to save her family honor.

Off-island, signals often get mixed. When a Puerto Rican girl who is dressed in her idea of what is attractive meets a man from mainstream²² culture who has been trained to react to certain types of clothing as a sexual signal, a clash is likely to take place. She is seen as a Hot Tamale, a sexual firebrand.²³ I learned this lesson at my first formal dance when my date leaned over and painfully planted a sloppy, overeager kiss on my mouth. When I didn't respond with sufficient passion, he said in a resentful tone, "I thought you Latin girls were supposed to mature early." It was the first time I would feel like a fruit or vegetable—I was supposed to ripen, not just grow into womanhood like other girls.

These stereotypes,²⁴ though rarer, still surface in my life. I recently 8 stayed at a classy metropolitan hotel. After having dinner with a friend, I was returning to my room when a middle-aged man in a tuxedo stepped directly into my path. With his champagne glass extended toward me, he exclaimed, "Evita!"²⁵

Blocking my way, he bellowed the song "Don't Cry for Me, Argentina." Playing to the gathering crowd, he began to sing loudly, a ditty²⁶ to the tune of "La Bamba"—except the lyrics were about a girl named Maria whose exploits²⁷ all rhymed with her name and gonorrhea.²⁸

I knew that this same man—probably a corporate executive, even worldly by most standards—would never have regaled²⁹ a white woman with a dirty song in public. But to him, I was just a character in his universe of "others," all cartoons.

Still, I am one of the lucky ones. There are thousands of Latinas without the privilege of the education that my parents gave me. For them, every day is a struggle against the misconceptions³⁰ perpetuated³¹ by the myth of the Latina as a whore, domestic worker, or criminal.

Rather than fight these pervasive³² stereotypes, I try to replace them with a more interesting set of realities. I travel around the United States reading from my books of poetry and my novel. With the stories I tell, the dreams and fears I examine in my work, I try to get my audience past the particulars of my skin color, my accent, or my clothes.

I once wrote a poem in which I called Latinas "God's brown daughters." It is really a prayer of sorts, for communication and respect. In it, Latin women pray "in Spanish to an Anglo God with a Jewish heritage," and they are "fervently³³ hoping that if not omnipotent,³⁴ at least He be bilingual."

22. mainstream: ideas and behaviors considered to be normal 23. firebrand: a person who is passionate about a particular cause 24. stereotypes: conventional and oversimplified ideas, opinions, or images 25. Evita: a musical and film about Eva Perón, Argentina's first lady from 1946 to 1952 26. ditty: a short, 27. exploits: bold and daring actions 28. gonorrhea: a sexually transmitted disease 29. regaled: entertained 30. misconceptions: false opinions based on lack of understanding 31. perpetuated: preserved 32. pervasive: widespread 33. fervently: passionately 34. omnipotent: all-powerful

REFLECT: Have you ever been stereotyped? How?

SUMMARIZE AND RESPOND

In your reading journal or elsewhere, summarize the main point of "Don't Misread My Signals." Then, go back over the essay, and check off the support for this idea. Next, write a brief summary of the essay. Finally, write a brief response to the reading. Have you ever misread signals, stereotyped someone, or gotten the wrong impression of someone? How did it occur?

CHECK YOUR COMPREHENSION

- 1. An alternate title for this essay could be
 - (a.) "My Name Is Not 'Maria."
 - **b.** "Learning to Embrace Stereotypes."
 - c. "The Struggles of Immigrant Life."
 - d. "The Benefits of a Good Education."
- 2. The main point of this essay is that
 - a. young Puerto Rican women often dress in a flashy, provocative way.
 - **b.** Cofer dislikes musicals like West Side Story and Evita.
 - **(c.)** Cofer has faced common misunderstandings about Latinas.
 - **d.** Cofer's parents kept a strict watch over their daughters.
- 3. Cofer includes accounts of strangers singing to her because
 - a. she likes getting attention from men.
 - **b.** the stories are good examples of stereotyping.
 - c. these men show a strict morality and machismo.
 - **d.** in Puerto Rico, it is common for men to sing in public.
- **4.** Look back at the vocabulary you underlined, and write sentences using these words: *prospective* (para. 5); *misconceptions*, *perpetuated* (11); *pervasive* (12); *fervently* (13).

READ CRITICALLY

- 1. Who do you suppose is Cofer's intended audience for this essay? Why?
- **2.** The title of the essay is "Don't Misread My Signals." What specific examples does Cofer provide of people misreading her?
- **3.** In paragraph 3, Cofer refers to receiving a "conflicting message." What is it, and how does it cause difficulties?
- **4.** Cofer is writing about stereotypes of Latinas. Where do these images and ideas seem to come from? How do they distort reality?

5. According to Cofer, she has a "privilege" that many other Latinas do not have. What is her privilege, and what does this advantage allow her to do?

WRITE

WRITE A PARAGRAPH: Cofer is writing, in part, about being misunderstood. Write a paragraph in which you recall a time when people have misunderstood you or have gotten the wrong idea about your behavior, background, appearance, or words. Contrast the misunderstanding with the reality of the situation, and try to understand the source of the mistake.

WRITE AN ESSAY: Cofer focuses primarily on misunderstandings or myths about Latinas, but there are many other stereotypes in our culture as well. Choose and describe a common stereotype that you think is mistaken; then, compare and contrast those stereotypical images or ideas with a more accurate portrait of reality. For example, you might write about the way women are portrayed in some rap songs versus how they really are.

Cause and Effect

Each essay in this chapter uses cause and effect to get its main point across to the reader. As you read these essays, consider how they achieve the Four Basics of Good Cause and Effect that are listed below and discussed in Chapter 15 of this book.

Four Basics of Good Cause and Effect

The main point reflects the writer's purpose: to explain causes, effects, or

If the purpose is to explain causes, the writing presents real causes.

If the purpose is to explain effects, it presents real effects.

It gives readers detailed examples or explanations of the causes or effects.

Holly Moeller

Say, Don't Spray

Holly Moeller received a bachelor's degree in chemistry and biology from Rutgers University in 2008. In 2010, she received a master's degree in biological oceanography jointly from the Massachusetts Institute of Technology and the Woods Hole Oceanographic Institution. Currently, she is pursuing a doctorate at Stanford University, where she plans to finish her studies in 2014.

Her essay "Say, Don't Spray," about the effects of agricultural pesticides, is an entry from Moeller's Seeing Green column for

the Stanford Daily, Stanford's student newspaper. Moeller says of her column, "I write Seeing Green because I believe in the importance of scientific communication. If I can write one piece a week and teach just one person about an environmental issue that

had never before crossed his or her radar, then I feel like I'm doing part of my job as an environmental scientist."

Moeller offers this writing advice: "Be disciplined. Find a strategy for breaking writer's block that works for you, and use it. For me, that sometimes means shutting the door, turning off phones and computers (yes, I still write all my columns out by hand before revising!), and not leaving my desk until a column is written. And, it's just like exercise: if you consistently manage to drag yourself out the door for a morning run, it will get easier, and even become a habit."

GUIDING QUESTION

What are the effects of pesticides used in agriculture?

READING
Preview
Read
Pause
Review

CRITICAL

See pages 9-12.

VOCABULARY
DEVELOPMENT Certain
words in this essay are
defined at the bottom of the
page. Underline these words
as you read them.

IDEA JOURNAL Write about an event or situation that strongly affected you.

REFLECT: Why do you suppose the agriculture industry uses such a large share of pesticides in the United States?

PREDICT: Why do you think we became so chemically dependent?

The news finally broke last week, months after the first anxious reports of browning and dying trees near lawns and golf courses across America: unlike their wild cousins in the Rockies and British Columbia, these confers aren't dying of pest outbreaks—they're suffering from pesticides.²

It seems that Imprelis, a recently released DuPont herbicide mar-

It seems that Imprelis, a recently released DuPont herbicide³ marketed for environmental friendliness, is poisoning ornamentals⁴ like Norway spruce and eastern white pine. Now, DuPont is promising new labeling for Imprelis; the Environmental Protection Agency is reevaluating its approval, and New York and California are congratulating themselves for never approving it in the first place. Add Imprelis to the list of pesticides whose ultimate toxicity⁵ took us by surprise. At least this time we noticed the signs within six months, not 25 years, as was the case with DDT.⁶

The herbicides, fungicides,⁷ and insecticides⁸ applied to lawns each year may seem the most gratuitous⁹—at least to those of us who don't mind a dandelion or clover here and there. But it's actually agriculture that applies 80 percent of the 1.1 billion pounds of pesticides used in the U.S. each year, quelling¹⁰ insect outbreaks, smothering weeds, and ensuring¹¹ un-nibbled produce.

Of course, when we nibble that produce—or eat animals who've 4 nibbled it—any residues¹² and leftover toxins transfer to us.

How did we become so chemically dependent?

Most of the story should be familiar: it's the tale of the Green Revolution, which tripled our agricultural yields. ¹³ By growing hybrid ¹⁴ crops with shallow root systems and short stalks, farmers ensure that their plants dedicate the majority of their energy to producing big yields. But these varieties also need babying: lots of water to keep shallow roots moist, fertilizer to support increased fruiting, and pesticide applications to knock out wilder, tougher neighbors and natural enemies.

1. conifers: evergreen trees or shrubs 2. pesticides: chemicals used to kill pests, such as weeds, insects, or funguses 3. herbicide: a pesticide used to kill weeds 4. ornamentals: decorative trees or shrubs 5. toxicity: the quality of being toxic or poisonous **6. DDT:** a powerful insect-killing chemical that was found to harm humans and animals. In 1972, the U.S. government banned it for most 7. fungicides: pesticides used to kill funguses specifically 8. insecticides: pesticides used to kill insects specifically 9. gratuitous: without a good reason 10. quelling: stopping 11. ensuring: making possible 12. residues: remaining materials 13. yields: goods produced 14. hybrid: in this case, a genetic combination of different plants

Of course, pesticide application is not without consequences. In sufficiently high doses, some pesticides are acutely¹⁵ toxic to humans as well as their intended victims. Low-level, long-term exposures can cause cancer, reduce fertility, and disrupt endocrine signaling.¹⁶ And many of the compounds don't break down right away, so they're washed into waterways and may accumulate¹⁷ downstream—persistent¹⁸ pollutants acting in unintended ways on unintended targets.

Some new technologies have been developed to reduce this spillover 8 (and, of course, make immense profits for their patent¹⁹ holders).

In 1996, Monsanto began marketing its Roundup Ready line—crop varieties resistant to the herbicide glyphosate (Roundup). Glyphosate is believed to break down quickly on fields, theoretically²⁰ providing a localized, targeted attack on weeds. But beyond campaigns against genetically modified crops (nicknamed "Frankenfoods" by protestors), there are real fears that glyphosate resistance could "escape" (through genetic reshuffling by cross-pollination) and take off in the wild weeds. Repeated application of glyphosate on acre after rolling acre creates strong selection pressure in favor of any plant that evolves to tolerate the chemical. Like antibiotic resistance, pesticide resistance can spread rapidly through populations, devastating food supplies and livelihoods.

To minimize such risks, Roundup Ready's sister seed, Bt-corn, comes with a mandate²¹ that other corn strains be planted alongside it. Bt-corn has been genetically modified to produce a toxin normally manufactured by the soil bacterium *Bacillus thuringiensis* (Bt). This Bt toxin is noxious²² to insects that would normally attack the corn—in fact, farmers sometimes spray the bacterium itself on crops.

Of course, any bug that developed a tolerance for Bt toxin would have exclusive²³ rights to a field full of juicy, fat ears of corn. Its reproductive fitness would skyrocket, and that field, and its neighbors, would be demolished by the lucky arthropod's²⁴ offspring. In theory, though, any toxin-free corn nearby would harbor²⁵ an abundance²⁶ of the same species, but without resistant traits. Hopefully, that first resistant bug would choose a mate from among the susceptible²⁷ population, and the resistance trait would be lost in the genetic shuffle. (Note: this only works if resistance arises from a recessive mutation, i.e., one in which two copies of the gene are needed—one from each parent.)

But who wants to plant an offering for the enemy when Bt-corn is so profitable and successful? At least one in four farmers was willing to dodge²⁸ the law back in 2008, when the EPA surveyed U.S. corn plantings. With reports of resistance spreading in China and India, our time bomb could explode at any moment.

15. acutely: severely 16. endocrine signaling: the process by which hormones are released from endocrine glands to regulate functions in the body 17. accumulate: 18. persistent: lasting 19. patent: the right to make, use, or to build up sell an invented or discovered item for a limited period 20: theoretically: in theory; supposedly 21. mandate: requirement 22. noxious: poisonous 23. exclusive: sole; not extended to others 24. arthropod: a category of invertebrates that includes insects 25. harbor: to provide shelter for 26. abundance: a large amount 27. susceptible: at risk—in this case to death

28. dodge: to avoid

by toxins

11 IDENTIFY: Check the effects described in this paragraph.

TEACHING TIP: Ask your students if any of them have tried organic gardening or started purchasing more organic produce. If so, why have they made these choices? If not, why not?

And so we find ourselves locked into another arms race with evolution, pitting our chemical engineering against the random²⁹ luck of millions of mutating, adapting plants, insects, and fungi. To fail is to surrender a huge and critical segment of our food supply. But to prevail is to release more and more toxins deliberately into our environment, some of which will have side effects far deadlier than DuPont's Imprelis.

Some people are bowing gracefully out of the dance, turning to the traditional methods of "Integrated Pest Management." They rotate crops, use mechanical pest traps, breed pest predators, ³⁰ and plant a range of plant varieties. These are the tools organic farmers use—with the delicious success you can witness at weekend farmers' markets or in your own backyard garden.

Join me for a bite.

15

SUMMARIZE AND RESPOND

In your reading journal or elsewhere, summarize the main point of "Say, Don't Spray." Then, go back over the essay, and check off the support for this idea. Next, write a brief summary of the essay. Finally, write a brief response to the reading. Did it change your view or understanding of how pesticides affect the environment and human health? If so, how?

CHECK YOUR COMPREHENSION

- **1.** An alternate title for this essay could be
 - (a.) "Agricultural Pesticides Create More Problems than Solutions."
 - b. "Most People Remain Unaware of Pesticides' Dangers."
 - c. "Corn Crops Are Especially Susceptible to Weeds and Insects."
 - **d.** "Organic Farming Is the Best Alternative to Chemical-Based Agriculture."
- **2.** The main point of this essay is that
 - (a.) chemical- and gene-based efforts to fight pests are creating a more toxic environment in the long run.
 - **b.** because of a growing awareness of pesticides' dangers, more and more U.S. farmers are turning to organic-farming techniques.
 - **c.** gene-based approaches to pest control are safer than chemical-based methods and should be more widely adopted.
 - **d.** the growing use of pesticides is affecting the mating patterns of insects.
- **3.** What is one of the drawbacks of higher-yield hybrid crops?
 - **a.** They are too expensive for the average farmer and do not always produce the yields promised by the seed industry.

29. random: unpredictable; not following a pattern **30. predators:** killers

- **b.** They rely on the use of pesticides to combat natural enemies and tougher plants nearby.
- **c.** They are especially susceptible to damage by agricultural chemicals
- **d.** They have been bred to contain toxins that can harm humans as well as pests.
- **4.** Does this essay include the Four Basics of Good Cause and Effect? Why?
- **5.** Look back at the vocabulary you underlined, and write sentences using these words: toxicity (para. 2); gratuitous (3); yields (6); persistent (7); susceptible (11).

TIP For tools to build your vocabulary, visit the Student Site for Real Writing at bedfordstmartins.com/realwriting.

READ CRITICALLY

- **1.** According to Moeller, why did the agriculture industry become so dependent on chemicals? What have been the effects of this dependency?
- **2.** What is Moeller's opinion of one attempt to reduce the effect of herbicides—the Roundup Ready product line? What facts does she present to support this opinion?
- **3.** This essay describes some complicated biological processes (see para. 11, for example). In your opinion, are these processes clearly explained? What questions, if any, do you have about this material?
- **4.** What would be the benefits of using the "Integrated Pest Management" strategies Moeller describes in paragraph 14?
- **5.** What larger argument is Moeller making in the last sentence of her essay? Are you convinced that you should join her? Why or why not?

WRITE

WRITE A PARAGRAPH: Sometimes, actions we take to improve a situation have unexpected and undesired results. Write a paragraph in which you describe a situation in which your actions, or someone else's, had a different effect than what was planned or desired.

WRITE AN ESSAY: Humans' negative effect on the environment has been the subject of much discussion in the media and elsewhere. At the same time, efforts are being made to reduce this effect or in some cases to reverse it. Identify one type of negative environmental effect (such as air pollution, water pollution, or improper waste disposal). Then, in a brief research essay that draws on at least two sources, discuss the causes and effects of this effect, and describe efforts being made to reduce it.

TIP For a sample cause-and-effect paragraph, see page 257.

TIP The Web site for the Environmental Protection Agency, www.epa.gov, might be a good place to start your research. For more information on the research essay, see Chapter 18.

John Tierney

Yes, Money Can Buy Happiness

A well-known columnist for the *New York Times* since 1990, John Tierney has an extensive background in news writing. After graduating with a degree in American studies from Yale University, Tierney reported for a series of publications, including the *Bergen Record*, the *Washington Star*, and *Science* magazine. He then worked for several years as a freelance writer, reporting on six continents and publishing articles in more than fifteen national newspapers and magazines. His 2011 book, *Willpower: Rediscovering the Greatest Human Strength*, written with Roy Baumeister,

was named one of Amazon's Best Books of that year.

GUIDING QUESTION

In the essay, how does money buy happiness?

Yes, money can buy happiness, but probably not in the way you imagined. Spending it on yourself may not do much for your spirits, but spending it on others will make you happier, according to a report from a team of social psychologists in the new issue of *Science*.

The researchers confirmed¹ the joys of giving in three separate ways. 2 First, by surveying a national sample of more than 600 Americans, they found that spending more on gifts and charity correlated² with greater happiness, whereas spending more money on oneself did not. Second, by tracking sixteen workers before and after they received profit-sharing bonuses, the researchers found that the workers who gave more of the money to others ended up happier than the ones who spent more of it on themselves. In fact, how the bonus was spent was a better predictor of happiness than the size of the bonus.

The final bit of evidence came from an experiment in which forty-six 3 students were given either \$5 or \$20 to spend by the end of the day. The ones who were instructed to spend the money on others—they bought toys for siblings, treated friends to meals, and made donations to the homeless—were happier at the end of the day than the ones who were instructed to spend the money on themselves.

"These experimental results," the researchers conclude, "provide 4 direct support for our causal argument that spending money on others promotes happiness more than spending money on oneself." The social psychologists—Elizabeth Dunn and Lara Aknin of the University of British Columbia, Vancouver, and Michael Norton of Harvard Business School—also conclude that "how people choose to spend their money is at least as important as how much money they make."

I asked Dr. Dunn if she had any advice for readers on how much to spend on others. Her reply was, "I think even minor changes in spending habits can make a difference. In our experiment with college students,

CRITICAL READING

Preview
Read
Pause

Review

See pages 9-12.

VOCABULARY DEVELOPMENT Certain words in this essay are defined at the bottom of the

defined at the bottom of the page. Underline these words as you read them.

IDEA JOURNAL Write about a time when you did something good for someone and how you felt afterward.

TEACHING TIP If you have discussed illustration, point out that paragraphs 2 and 3 use illustration.

SUMMARIZE: Summarize the three causes of positive feelings.

1. confirmed: proved the truth 2. correlated: had a connection with

we found that spending just \$5 prosocially³ had a substantial⁴ effect on happiness at the end of the day. But I wouldn't say that there's some fixed amount that everyone should spend on others. Rather, the best bet might be for people to think about whether they can push themselves to devote just a little more of their money to helping others."

But why wouldn't people be doing that already? Because most people 6 don't realize the personal benefits of charity, according to Dr. Dunn and her colleagues. When the researchers surveyed another group of students, they found that most of the respondents predicted that personal spending would make them happier than spending the money on other people.

Perhaps that will change as word of these experiments circulates—although that prospect raises another question, which I put to Dr. Dunn: If people started giving away money chiefly in the hope of making themselves happier, as opposed to wanting to help others, would they still derive⁵ the same happiness from it?

"This is a fascinating question," she replied. "I certainly hope that 8 telling people about the emotional benefits of prosocial spending doesn't completely erase these benefits; I would hate to be responsible for the downfall of joyful prosocial behavior."

Do you have any theories on the joys of giving? Any reports of your own experiments? Or any questions you'd like to ask the researchers? Dr. Dunn, in keeping with the results of her experiments, has generously offered to provide some answers free of charge.

7 REFLECT: Do you agree that charity always makes people feel better?

9 REFLECT: Answer the questions in paragraph 9.

SUMMARIZE AND RESPOND

In your reading journal or elsewhere, summarize the main point of "Yes, Money Can Buy Happiness." Then, go back over the essay, and check off the support for this idea. Next, write a brief summary of the essay. Finally, write a brief response to the reading. How do you see the relationship between money and happiness in your own life, both now and as you look toward the future?

CHECK YOUR COMPREHENSION

- **1.** An alternate title for this essay could be
 - a. "Profit-Sharing Proves Profitable for Employees and Employers."
 - **(b.)** "Spending Money on Others Can Increase Your Happiness."
 - c. "Charity Should Begin and End at Home."
 - d. "Study Finds that Money Is the Key to Happiness."

^{3.} prosocially: in a manner that is intended to benefit another person, as in cases of helping or sharing
4. substantial: significant
5. derive: to get something from
6. downfall: a loss of power or status

- 2. The main point of this essay is that
 - **a.** people are often happier when they spend money on others than on themselves.
 - **b.** people are beginning to give more money to charity because they realize that such generosity is a source of happiness.
 - **c.** scientists are fascinated by the spending habits of the American people.
 - **d.** even in a bad economy, people should continue their charitable giving.
- **3.** According to the article, why don't people spend more money on others than they already do?
 - **a.** Human beings are selfish and therefore do not like giving.
 - **b.** People mostly like to be charitable during the holiday season.
 - **c.** College students do not make a good sample for a scientific study.
 - **d.**) Most people do not realize the personal benefits of charity.
- **4.** Look back at the vocabulary you underlined, and write sentences using these words: *confirmed* (para. 2); *substantial* (5); *derive* (7); *downfall* (8).

READ CRITICALLY

- 1. Tierney suggests in his opening paragraph that money can buy happiness, "but probably not in the way you imagined." Do you find the results of these studies surprising? Why or why not?
- **2.** Tierney writes that spending money "on yourself may not do much for your spirits." How do people generally spend money to change their mood or lift their "spirits"?
- 3. Social psychologists in the article conclude that "how people spend their money is at least as important as how much money they make" (para. 4). Does this statement seem true to you? What other factors might social psychologists take into account as far as discovering the relationship between money and happiness?
- **4.** How does Tierney structure this essay in terms of explaining the experiments, the conclusions, and their implications?
- **5.** What apparently common human flaw or flaws does this article highlight in paragraph 8?

WRITE

WRITE A PARAGRAPH: The scientist in the article says she hopes that people will "think about whether they can push themselves to devote just a little more of their money to helping others." Will this article change your attitude about

charity or cause you to alter your behavior in any way? Write a paragraph explaining your answer.

WRITE AN ESSAY: Tierney's article explores "the emotional benefits of prosocial spending." Have you ever experienced these "benefits"? Write an essay in which you examine an experience when you spent money on or helped others. Did the action cause the effects that scientists found in their studies?

47

Argument

The essays in this chapter use argument to make clear their positions on two different topics: (1) snitching and (2) the granting of certain rights to illegal immigrants. As you read these essays, consider how the writers achieve the Four Basics of Good Argument listed below and discussed in Chapter 16 of this book.

Four Basics of Good Argument It takes a strong and definite position. It gives good reasons and supporting evidence to defend the position. It considers opposing views. It has enthusiasm and energy from start to finish.

Also, keep in mind the basics of critical thinking discussed in Chapter 1 and reviewed in Chapter 16. In particular, pay attention to the assumptions being made by the writers, and be sure to question them. Such questioning will help you form your own position on the two topics, as you will be asked to do in the writing assignments on pages 708 and 716.

SNITCHING

Each of the following essays—the first one by a student and the next two by professional writers—offers a different viewpoint on the subject of snitching. As you read them, pay close attention to how each writer interprets what snitching is.

Robert Phansalkar

Stop Snitchin' Won't Stop Crime

Robert Phansalkar graduated from the University of Wisconsin (UW) in 2007 with degrees in languages and cultures of Asia and political science, and he later received a law degree from Fordham Law School. He wrote the essay "Stop Snitchin' Won't Stop Crime" when he was a student at UW, and it first appeared in the UW student newspaper, the Badger Herald Weekly. Of the piece, he says he explores "Issues facing minorities in law enforcement," a topic that connects to his overall concerns as a writer: "Law and social justice issues interest me the most because these play off of

fundamental issues of fairness. It is rare to find someone who does not have an opinion, developed or not, on these issues."

GUIDING QUESTION

How would Phansalkar define snitching, and what is his position on the Stop Snitchin' movement?

The "Stop Snitchin" movement is a reaction to racial profiling and 1 racism in police actions. Now widespread and promoted by many, it began with a homemade DVD called Stop Snitching, hosted by a rapper known as Skinny Suge. It featured a number of rappers and others who threatened violence against people who gave the police any information about crimes. Among the people in the DVD was Carmelo Anthony, an NBA star, whose participation helped the DVD gain media attention. Now there are Web sites, T-shirts, and lots of other items that promote the Stop Snitchin' campaign. The movement maintains1 that until the system reflects real justice, minorities should willfully avoid helping police with ongoing investigations, regardless of circumstance or crime. While many support the movement, maintaining that silence in the face of injustice is more honorable than cooperation, the cities suffer as witnesses fail to give any information they have about crimes. Stop Snitchin' does not stop crime.

While the movement has developed into rappers' sales and perceived 2 "street cred,"2 it has also blossomed into an unfortunate force that hinders3 crime prevention. For example, Cameron Giles, known as Cam'ron or Killa Cam, was shot multiple times during an attempted carjacking, but he refused to give police information about the suspects. Avoiding the police encourages the very kind of lawlessness that is all too common in cities riddled4 with gang violence. At the movement's Web site, stopsnitchin.com, rappers and others complain about their experiences in rough, violent neighborhoods, but they promote it with Stop Snitchin'.

It is difficult to connect how refusing to contribute to investigations 3 IDENTIFY: Where does the helps the problem. Even if the Stop Snitchin' movement isn't aiming to lower crime rates, not cooperating with police certainly does not help the

CRIT!CAL READING Preview Read Pause Review See pages 9-12.

VOCABULARY **DEVELOPMENT** Certain words in this essay are defined at the bottom of the page. Underline these words

IDEA JOURNAL Write about a time you "snitched" on someone.

as you read them.

author acknowledge the opposing view?

neighborhoods that these rappers grew up in, which makes their support

1. maintains: believes; states 2. street cred: trustworthiness and value as seen by young, urban people, especially in hip-hop culture 3. hinders: causes difficulties or delays 4. riddled: spread throughout

of the movement all the more confusing. If people actually want to reduce gang violence in the neighborhoods and have a shot at breaking boundaries and moving beyond poverty and violence, why allow criminals to run wild? Why not work to promote successful and peaceful neighborhoods? Most of the rappers and other supporters of Stop Snitchin' believe that the justice system is based on racism and that cooperating with the police actually threatens innocent people because snitchers lie to save themselves.

Certainly, racism in law enforcement practices is a legitimate⁵ issue 4 that needs to be addressed, but simply not cooperating with the institutions that exist to protect people is a ludicrous⁶ solution. Turning your back on the system ensures one thing: The system will continue to not work for you. Expecting change to happen when you look away is precisely the kind of mentality⁷ that rarely accomplishes anything and draws more heat than if you were working positively to effect change in your community.

Instead of rapping about not snitching on real criminals, why not rap about not committing crimes? Why not rap about improving the systems of inequality and injustice through positive action? Stop Snitchin' doesn't answer any of these questions, and even though the movement defies⁸ the logic of self-preservation, it continues because nobody has the courage to stand up and say what really happened.

SUMMARIZE: What is the author's basic argument? Do his reasons support his position?

SUMMARIZE AND RESPOND

In your writing journal or elsewhere, summarize the main point of "Stop Snitchin' Won't Stop Crime." Then, go back over the essay, and check off the support for this idea. Next, write a brief summary of the essay. Finally, write a brief response to the reading. Why would a campaign like "Stop Snitchin'" be popular or persuasive?

CHECK YOUR COMPREHENSION

- 1. An alternate title for this essay could be
 - (a.) "Turning Your Back on the System Ensures More Crime and Injustice."
 - **b.** "High-Crime Communities Need Jobs and Schools, Not Snitches."
 - **c.** "Hip-Hop Stars and Athletes Must Strive to Be Better Role Models."
 - **d.** "Silence in the Face of Injustice Is More Honorable than Cooperation."

- 2. The main point of this essay is that
 - **a.** too many people are using the Internet to promote illegal behavior.
 - **b.** racism is not a problem in the United States, although many people claim that it still exists.
 - **c.** refusing to cooperate with the police will not change the legal system or prevent crime.
 - **d.** snitches threaten innocent people because they often lie to save themselves.
- **3.** According to the writer, rappers might have a more positive effect if they would
 - (a.) rap about fixing inequalities and work to create peaceful neighborhoods.
 - **b.** discourage people from snitching, even though it will make cities less safe.
 - **c.** join with professional athletes to speak out against carjacking.
 - d. stop complaining about racism.
- **4.** Does this essay include the Four Basics of Good Argument? Why or why not?
- **5.** Look back at the vocabulary you underlined, and write sentences using these words: *maintains* (para. 1); *hinders* (2); *legitimate*, *mentality* (4); *defies* (5).

TIP For tools to build your vocabulary, visit the Student Site for Real Writing at bedfordstmartins.com/realwriting.

READ CRITICALLY

- 1. How would you state the thesis of Phansalkar's essay in your own words?
- **2.** Where and how does the writer acknowledge and address views other than his own?
- **3.** Who is the audience for this essay? What readers does the writer want to persuade? How do you know?
- **4.** Why does Phansalkar include the example of rapper Cameron Giles (para. 2), who was shot during a carjacking? What point does it make?
- **5.** Phansalkar ends his essay by questioning the "courage" of those who participate in or support the Stop Snitchin' campaign. Why does he do so? What effect does it have?

WRITE

As Phansalkar writes, NBA player Carmelo Anthony participated in the Stop Snitchin' campaign. Do you think star athletes and other celebrities have an obligation to be law-abiding role models? Should society hold them to a higher standard than private citizens? Write a paragraph or an essay that takes a position on this issue.

Bill Maxwell

Start Snitching

Bill Maxwell is an internationally syndicated columnist and editorial writer for the *Tampa Bay Times* (formerly the *St. Petersburg Times*) in Florida. After receiving a B.A. from Bethune-Cookman College, he went on to earn a master's and a doctoral degree from the University of Chicago before he began teaching in 1973. His diverse background as an educator and a writer is evident in the many publications for which he has written, including the *Fort Pierce Tribune*, the *Gainesville Sun*, and the *Tampa Bay Times*. He wrote the essay "Start Snitching" in September 2007 for the *Times* in re-

sponse to the deaths of several black men from the community.

GUIDING QUESTION

What does Maxwell's Wall of Black Death represent to him, and how does it relate to snitching?

Cedric "C. J." Mills. Isaiah Brooks. Tedric Maynor. Felicia Hines. 1 Vinson Phillips. Kurt Anthony Bryant. Amuel Murph. Alfonso Williams. These names are forever inscribed¹ on my private "Wall of Black Death." My wall contains the names of black people killed by other black people, along with those believed to have been killed by fellow blacks, in the Tampa Bay area since May. I will update the roster² as soon as new deaths are reported. More are sure to follow. I do not have answers as to how to stop blacks from killing their brethren.³ But I do have an answer for catching some, if not all, of these murderers. Snitch.

Nationwide, too many blacks refuse to help the police identify, find, and arrest killers in their communities. To enjoy a decent quality of life in their communities, blacks must begin to help the police. Studies show that homicides, 4 especially unsolved homicides, destabilize 1 low-income communities. Needless to say, many of the nation's black communities have individuals and families with low incomes. Businesses that can provide jobs for unemployed residents and provide the amenities 6 that other areas take for granted are wary 7 of locating in black communities where homicide rates are high.

A recent *St. Petersburg Times* article reported that a group of Tampa black residents have organized an effort to stop the "don't snitch" culture that permits killers to remain free. Many of the organizers are related in some way to a youngster killed by a fellow black. Consider this sobering portrait of blacks and homicide and other serious crimes from a recent U.S. Bureau of Justice Statistics report: Although blacks comprised only 13 percent of the population in 2005, they were victims of about 49 percent of all homicides. The bureau estimated that 16,400 murders

2. roster: a list of people

CRITICAL READING

Preview Read

Pause

Review

See pages 9-12.

VOCABULARY
DEVELOPMENT Certain
words in this essay are
defined at the bottom of the
page. Underline these words

as you read them.

REFLECT: What effect does the list of names that starts the essay have?

IDEA JOURNAL Are you surprised when you read about gang murders? Why or why not?

IDENTIFY: What kinds of evidence does the author use?

people **3. brethren:** brothers; **4. homicides:** murders

5. destabilize: to make unsteady or cause something to failcomforts, conveniences, or pleasures7. wary: cautious

1. inscribed: listed; written

men within the same race, nationality, or group

occurred in the United States in 2005. Of that number, 8,000 victims were black, 93 percent of those victims were killed by other blacks, and 77 percent of those murders involved firearms. Most black victims were between ages 17 and 29.

Many people, including police officials I have spoken with, say that 4 fear prevents most blacks from snitching. I agree that some residents remain silent out of fear, but I suspect that the fear factor receives too much weight. I have come to believe that an untold number of blacks have grown as insensitive to black-on-black murders as they have to other black-on-black crimes. For one thing, the high number of homicides in their communities has made many blacks inured8 to all but the most sensational killings that receive a lot of press.

"I expect somebody to shoot somebody every week around here," a St. Petersburg woman who lives in a predominantly black neighborhood said a few weeks ago when I asked if she had known a man who had been killed recently. "I don't go near my windows at night. They shoot guns around here all the time. I don't pay attention when they say somebody got shot. I just try to make sure it won't be me one of these days."

I am not a sociologist, 10 but I suspect that many blacks in high-crime 6 communities have all the symptoms of the abused person syndrome:11 We have been cruel toward one another for so long we have internalized12 the belief that such cruelty is normal. Those of us who have internalized the cruelty think nothing of treating other blacks likewise, thus perpetuating13 the cycle without apparent14 end. Each day I open the newspaper and switch on TV news, I brace15 myself for yet another murder. With each killing, I feel sadness, regret, helplessness, anger, and shame-shame of being associated with such people in any way.

Because I regularly write about this issue, I receive a lot of hate mail 7 REFLECT: Does the race of from both whites and blacks. White letter-writers remind me that blacks are "animals" and "cause all of America's social problems." Black letterwriters see me as the "enemy of the people" and a "sell-out" because I condemn blacks for killing one another without taking into account the nation's history of racism. To whites, I have nothing to say. To blacks, I have one message: We need to start snitching. Only we can stop blackon-black murders. Until then, I will be adding names to the Wall of Black Death.

SUMMARIZE AND RESPOND

In your reading journal or elsewhere, summarize the main point of "Start Snitching." Then, go back over the essay, and check off the support for this idea. Next, write a brief summary of the essay. Finally, write a brief response to the reading. Maxwell speculates that "an untold number of blacks" have

8. inured: accustomed to or used to 9. predominantly: mainly 10. sociologist: a person who studies the origin, development, and other aspects of human society 11. syndrome: a disorder or an illness 12. internalized: made something part of your core beliefs or attitudes 13. perpetuating: continuing 14. apparent: obvious 15. brace: to prepare for

REFLECT: Does the information in paragraphs 4 and 5 surprise you?

the author have an effect on the way you read this essay? Why or why not?

become "insensitive to black-on-black murders." As a result, they refuse to snitch. What other reasons would you suggest account for this reluctance to work with the police?

CHECK YOUR COMPREHENSION

- 1. An alternate title for this essay could be
 - (a.) "Snitching and the 'Wall of Black Death.'"
 - b. "Black Communities Must Provide More Jobs and Amenities."
 - c. "Stop Racist Hate Mail."
 - d. "Most Black Murder Victims Are between 17 and 29."
- 2. The main point of this essay is that
 - **a.** only the most sensational killings now capture the attention of African Americans.
 - **b.** Maxwell lives in fear of speaking out about snitching because he gets so much angry mail.
 - **c.** white people have become indifferent to the crime and violence in America's black communities.
 - **d.** African Americans must cooperate with police to help reduce black-on-black violence.
- **3.** According to Maxwell, what is one of the reasons African Americans do not snitch?
 - **a.** They have been persuaded by calls from black celebrities and athletes to avoid speaking to the police about black-on-black crime.
 - **b.** The police do not listen to the concerns of people living in predominantly black neighborhoods.
 - **c.** People in black communities prefer to enforce their own justice when they catch suspected criminals and do not wish to bother the police.
 - **d.** Many blacks are insensitive to black-on-black murders, having internalized the belief that such behavior is "normal."
- **4.** Look back at the vocabulary you underlined, and write sentences using these words: wary (para. 2); predominantly (5); syndrome, perpetuating, apparent (6).

READ CRITICALLY

- **1.** Why does Maxwell open his essay with this list of names? Do you find the introduction effective? Why or why not?
- **2.** What effects does black-on-black violence have on communities, according to Maxwell?

- How does the quotation in paragraph 5 help Maxwell's argument? Which of his claims does it support?
- 4. Does the writer acknowledge or address competing points of view in his essay?
- In the concluding paragraph, Maxwell refers to his hate mail and claims that he has "nothing to say" to the whites who write him hate mail. Why do you think he refuses to address these letter writers?

WRITE

In the conclusion of his essay, Maxwell refers to the "hate mail" he receives from two general categories of letter writers. Write a paragraph or essay that addresses and responds to the claims of either one of these groups. How would you engage them in a civil and meaningful discussion?

Alexandra Natapoff

Bait and Snitch: The High Cost of **Snitching for Law Enforcement**

Alexandra Natapoff is a law professor at Loyola Law School in Los Angeles, California, where she teaches criminal law and criminal procedure. She graduated cum laude with a B.A. from Yale University and earned her J.D. with distinction at Stanford Law School. Before becoming a professor, Natapoff worked as an assistant federal public defender in Baltimore, Maryland; while there, she founded the Urban Law & Advocacy Project. As a scholar and writer, Natapoff is interested in the criminal justice system, as well as race and the law and administrative law. Her book, Snitching:

GUIDING QUESTION

How does Natapoff define snitching?

From Baltimore to Boston to New York; in Pittsburgh, Denver, and 1 Milwaukee, kids are sporting the ominous1 fashion statement, "Stop Snitchin'," prompting local fear, outrage, and fierce arguments over crime. Several trials have been disrupted by the T-shirts; some witnesses refuse to testify. With cameo appearances in the growing controversy² by NBA star Carmelo Anthony of the Denver Nuggets and the rapper Lil Kim, snitching is making urban culture headlines.

VOCABULARY DEVELOPMENT Certain words in this essay are defined at the bottom of the page. Underline these words as you read them.

1. ominous: threatening

2. controversy: an argument; a conflict of opinion

IDEA JOURNAL Write about a law or practice that you think is unfair.

IDENTIFY: Check the reasons the author gives to show that snitching is a bad practice.

The "Stop Snitchin" T-shirt drama looks, at first, like a dust-up³ over a simple counterculture⁴ message launched by some urban criminal entrepreneurs;⁵ that friends don't snitch on friends. But it is, in fact, a symptom of a more insidious⁶ reality that has largely escaped public notice.

For the last 20 years, state and federal governments have been creating 3 criminal snitches and setting them loose in poor, high-crime communities. The backlash⁷ against snitches reflects a growing national recognition that snitching is dangerous public policy—producing bad information, endangering innocent people, letting dangerous criminals off the hook, compromising the integrity⁸ of police work, and inciting⁹ violence and distrust in socially vulnerable¹⁰ neighborhoods.

The heart of the snitching problem lies in the secret deals that police and prosecutors make with criminals. In investigating drug offenses, police and prosecutors rely heavily—and sometimes exclusively—on criminals willing to trade information about other criminals in exchange for leniency. Many snitches avoid arrest altogether, thus continuing to use and deal drugs and commit other crimes in their neighborhoods, while providing information to the police. As drug dockets swell and police and prosecutors become increasingly dependent on snitches, high-crime communities are filling up with these active criminals who will turn in friends, family, and neighbors in order to "work off" their own crimes.

Critics of the T-shirts tend to dismiss the "stop snitching" sentiment as pro-criminal and antisocial, a subcultural expression of misplaced loyalty. But the T-shirts should be heeded¹³ as evidence of a failed public policy. Snitching is an entrenched¹⁴ law-enforcement practice that has become pervasive¹⁵ due to its crucial role in the war on drugs. This practice is favored not only by police and prosecutors, but by legislatures: Mandatory¹⁶ minimum sentences and restrictions on judges make snitching one of the only means for defendants to negotiate in the face of rigid and drastic¹⁷ sentences. But the policy has turned out to be a double-edged sword.¹⁸ Nearly every drug offense involves a snitch, and snitching is increasingly displacing more traditional police work, such as undercover operations and independent investigation.

According to some agents and prosecutors, snitching is also slowly crippling law enforcement: "Informers are running today's drug investigations, not the agents," says veteran DEA [Drug Enforcement Administration] agent Celerino Castillo. "Agents have become so dependent on informers that the agents are at their mercy."

The government's traditional justification for creating criminal 7 snitches—"we-need-to-flip-little-fishes-to-get-to-the-Big-Fish"—is at best

3. dust-up: a fight 4. counterculture: opposed to established culture 5. entrepreneurs: people who start or manage businesses 6. insidious: dangerous 7. backlash: a strong or sudden violent reaction toward while appearing harmless 8. integrity: morality, honesty, and legality 9. inciting: urging on; something 10. vulnerable: easily harmed 11. leniency: mildness; softness; encouraging 12. dockets: lists of legal cases to be tried 13. heeded: paid attention tolerance 14. entrenched: deeply dug in; secure 15. pervasive: widespread 18. double-edged sword: 16. mandatory: required 17. drastic: extreme something that can have both good and bad consequences

an ideal and mostly the remnant¹⁹ of one. Today, the government lets all sorts of criminals, both big and little, trade information to escape punishment for nearly every kind of crime, and often the snitches are more dangerous than the targets.

Snitching thus puts us right through the looking glass:²⁰ Criminals direct police investigations while avoiding arrest and punishment. Nevertheless, snitching is ever more popular with law enforcement: It is easier to "flip" defendants and turn them into snitches than it is to fight over their cases. For a criminal system that has more cases than it can prosecute, and more defendants than it can incarcerate,²¹ snitching has become a convenient case-management tool for an institution that has bitten off more than it can chew.

And while the government's snitching policy has gone mostly unchallenged, it is both damaging to the justice system and socially expensive. Snitches are famously unreliable: A 2004 study by the Northwestern University Law School's Center on Wrongful Convictions reveals that 46 percent of wrongful death penalty convictions are due to snitch misinformation—making snitches the leading cause of wrongful conviction in capital cases. Jailhouse snitches routinely concoct²² information; the system gives them every incentive²³ to do so. Los Angeles snitch Leslie White infamously avoided punishment for his crimes for years by fabricating²⁴ confessions and attributing²⁵ them to his cellmates.

Snitches also undermine law-enforcement legitimacy—pólice who rely on and protect their informants are often perceived as favoring criminals. In a growing number of public fiascos, 26 snitches actually invent crimes and criminals in order to provide the government with the information it demands. In Dallas, for example, in the so-called "fake drug scandal," paid informants set up innocent Mexican immigrants with fake drugs (gypsum) while police falsified drug field tests in order to inflate their drug-bust statistics.

Finally, as the T-shirt controversy illustrates, snitching worsens crime, violence, and distrust in some of the nation's most socially vulnerable communities. In the poorest neighborhoods, vast numbers of young people are in contact with the criminal justice system. Nearly every family contains someone who is in prison, under supervision, or has a criminal record. In these communities, the law-enforcement policy of pressuring everyone to snitch can have the devastating²⁷ effect of tearing families and social networks apart. Ironically,²⁸ these are the communities most in need of positive role models, strong social institutions, and good police-community relations. Snitching undermines these important goals by setting criminals loose, creating distrust, and compromising police integrity.

10 REFLECT: Why is this paragraph's evidence persuasive?

19. remnant: a piece or part of 20. through the looking glass: a place or situation where things happen in a way that is the opposite of expectations 21. incarcerate: to put in jail 22. concoct: to make up or invent 23. incentive: a reason to do something 24. fabricating: making up or inventing 25. attributing: giving credit to someone 26. fiascos: complete failures 27. devastating: overwhelming; destructive 28. ironically: in a way that goes against expectations or a desired outcome

ANALYZE: How are the author's opinions different from Phansalkar's (pp. 697–98)?

REFLECT: Does the author present a good argument? Has she changed your mind?

The "Stop Snitchin'" T-shirts have drawn local fire for their perceived threat to law-abiding citizens who call the police. But in the outrage over that perceived threat, the larger message of the shirts has been missed: Government policies that favor criminal snitching harm the communities most in need of law-enforcement protection.

While snitching will never be abolished,²⁹ the practice could be substantially improved, mostly by lifting the veil of secrecy that shields lawenforcement practices from public scrutiny. As things stand, police and prosecutors can cut a deal with a criminal; turn him into a snitch or cut him loose; forgive his crimes or resurrect them later; release him into the community; or decide to pick him up. They do all this at their discretion, without legal rules, in complete secrecy, with no judicial or public accountability. As a result, we have no idea whether snitching even reduces crime or actually increases it, and we can only guess at the collateral harms it imposes on high-crime communities.

The government should reveal snitching's real costs, including data on how many snitches are released into high-crime neighborhoods and what sorts of snitch crimes are forgiven. The government should also be required to establish the concrete benefit of a policy that releases some criminals to catch others, by accounting for how much crime actually gets stopped or solved by snitch information. Only then can we rationally evaluate how much government-sponsored snitching makes sense. Until we can know the real value of snitching, the T-shirts remain an important reminder that this particular cure for crime may be as bad as the disease.

SUMMARIZE AND RESPOND

In your reading journal or elsewhere, summarize the main point of "Bait and Snitch: The High Cost of Snitching for Law Enforcement." Then, go back over the essay, and check off the support for this idea. Next, write a brief summary of the essay. Finally, write a brief response to the reading. The writer discusses the popularity of "Stop Snitchin'" T-shirts, which some say are procriminal and antisocial. Why do you think crime and criminals—whether organized crime, "urban criminal entrepreneurs," or even western outlaws—have had such a lasting appeal in American popular culture?

CHECK YOUR COMPREHENSION

- 1. An alternate title for this essay could be
 - a. "The United States Needs to Build More Prisons."
 - **(b.)** "Snitching Undermines Law Enforcement and Harms Communities."
 - **c.** "Law Enforcement Authorities Must Take Steps to Ban 'Stop Snitchin' 'T-Shirts."
 - **d.** "Too Many Snitches Cut Deals with the Police and Escape Justice."

- **2.** The main point of this essay is that
 - **a.** the U.S. justice system is weak, which means that too many criminals go unpunished.
 - **b.** the police and other legal authorities are overwhelmed by the number of drug offenders.
 - **c.** policies that favor criminal snitching harm the legal system and do damage to many communities.
 - **d.** snitching is an unfortunate but necessary part of our justice system.
- **3.** According to Natapoff, the heart of the snitching problem lies in
 - **a.** the communities that choose to protect criminals rather than bring them to justice.
 - **b.** American prisons, which are overcrowded.
 - **c.** police officers, judges, and politicians who incarcerate too many innocent people.
 - **d.** the secret deals that police and prosecutors make with criminals.
- **4.** Look back at the vocabulary you underlined, and write sentences using these words: *controversy* (para. 1); *integrity* (3); *mandatory* (5); *concoct* (9); *abolished* (13).

READ CRITICALLY

- 1. Natapoff argues that critics of the "Stop Snitchin" T-shirts misunderstand their meaning. What is the misunderstanding? What do the T-shirts actually represent, according to Natapoff?
- **2.** In paragraph 3, the writer claims that the practice of using "criminal snitches" hurts the "integrity of police work." What do you think that phrase means?
- **3.** The writer argues that the reliance on snitches has led to "public fiascos" (para. 10). How does she support this claim?
- **4.** How does Natapoff use statistics in this essay, and how do they support her argument?
- **5.** What practical steps does Natapoff propose at the conclusion of this essay? Does the essay convince you that they are necessary? Why or why not?

WRITE

The immediate focus of this essay is the role of snitching in law enforcement, but the figure of the "snitch," "rat," informant, or even "tattletale" has almost always been one that many people dislike. Why do you think that is the case, even if such informants and snitches can help bring criminals to justice or,

more generally, stop bad things from happening? Write a paragraph or essay that addresses these issues.

TIP For more on quoting and paraphrasing, see Chapter 18.

WRITE USING READINGS

Write an essay either in favor of or against snitching, drawing on the opinions and evidence given in the essays by Phansalkar, Maxwell, and Natapoff. You may want to quote directly from any of the three essays or paraphrase their arguments. Whichever position you take, you should take the opposing position into consideration by referring to one of the authors who disagrees with your opinion. In your concluding paragraph, review the reasons you have given to support your position.

RIGHTS FOR ILLEGAL IMMIGRANTS

The next two essays, both by students, take positions on legislation aimed at granting more rights, in limited cases, to illegal immigrants. The first essay describes a law, passed in California in 2011, that gives eligible members of this population access to state-funded financial aid. The second essay describes the federal DREAM Act, which would grant U.S. citizenship rights to illegal immigrants who meet certain requirements.

Heather Rushall

Dream Act Is Finance Fantasy

Heather Rushall wrote the following essay for the *Daily Aztec*, the student newspaper at San Diego State University, where she is studying journalism and political science and expects to graduate in June 2013. Rushall, also the author of the blog "Heather Writes," says that she has enjoyed writing as far back as she can remember, and in the past she's produced poetry, short stories, and many journal entries. Her advice to other student writers is, "Just write. Don't think about it, don't try to plan it. Just sit down and write. You will be amazed with what you can produce, and there is al-

ways room to improve upon it afterwards." This essay was published on October 17, 2011.

GUIDING QUESTION

What issues does the author take with California's Dream Act?

As of July 1 next year [July 1, 2012], just weeks before the start of a new school year, illegal immigrants will be eligible to receive state-funded financial aid in California. The new opportunity has been coined¹ the

1. coined: named

See pages 9-12.

California Dream Act—Development, Relief and Education of Alien Minors—also known as Assembly Bill 131. Acting with unmatched time management abilities, Gov. Jerry Brown waited until the last minute to sign the bill, which was proposed by Assemblyman Gil Cedillo of Los Angeles earlier this year.

Requirements to reap² the benefits of the act are simple: Applicants must have attended a California high school for at least three years, graduated from said high school or have received a GED diploma, and must show proof they are either actively seeking citizenship or will seek it once they are eligible to do so.

✓ Those seem like some ridiculously easy and unfair requirements compared to the standards needed to be filled by applicants who are already U.S. citizens living in California. Cal Grant—the program the new Dream Act would make undocumented immigrants eligible for—requires traditional applicants to first prove, through the Free Application for Student Aid system, that they are "independent."

Independent students can be 25 years of age or older, a parent of a child who receives at least half of his or her income, or married. If the student is not considered independent, they must file using their parents' tax information and come from a poverty-level home based on income. That requirement alone makes a very large portion of financial aid applicants ineligible right off the bat.

The Cal Grant issuance is split into two sections—Cal Grant A and 5 Cal Grant B. Most applicants will receive only one of the sections based on the difference in eligibility requirements. Part A is based entirely on grade point average and financial need, whereas part B considers GPA, the highest level of school completed by the applicant's parents, and marital³ status. Unmarried applicants will not receive part B, and students with average or less-than-average grades will not receive either portion.

A "Competitive Cal Grant" is money available to students with exceptional⁴ need or otherwise special circumstances. These grants will only be available to Dream Act applicants if there is additional funding available after the grants have been awarded.

The other program the Dream Act will make available to non-citizen 7 applicants living in California is the Board of Governors Fee Waiver. The fee waiver allows students of low-income backgrounds to pay little or no money for enrollment in community college, waives health and other service fees, and decreases the cost of parking permits. The waiver is based solely on financial necessity, and few other requirements need to be met.

In general, the act is unfair to citizens. Because of the lesser eligibility requirements imposed⁶ upon the undocumented applicants, they will be able to garner⁷ more funding in a quicker, easier manner with less paperwork to process than resident students. According to the California Department of Finance, about 2,500 students are projected⁸ to receive Cal Grants totaling \$14.5 million, averaging \$5,800 per student. While our state government is struggling to balance a budget, the governor adds

VOCABULARY
DEVELOPMENT Certain
words in this essay are
defined at the bottom of the
page. Underline these words
as you read them.

- 2 IDEA JOURNAL Did you face any challenges in your applications to college or for financial aid? What were they?
- 3 IDENTIFY: Put a check mark next to the topic sentence of paragraph 3. Then, underline the support for it in paragraphs 3 and 4.

8 SUMMARIZE: In your own words, summarize the main

point of this paragraph.

 ^{2.} reap: receive 3. marital: marriage 4. exceptional: unusual 5. waiver: a document that releases or relieves someone from something 6. imposed: placed
 7. garner: get 8. projected: predicted; expected

REFLECT: What do you think would be a fair approach to illegal immigrants who want to go to college in the United States?

TEACHING TIP: An opinion piece opposing the stance taken by Heather Rushall can be found on the Web site for the Daily Aztec (www.thedailyaztec.com; search under the words "Act is affordable and fair incentive"). You might have your class read this piece as well.

more debt to the list. We cannot afford to extend these comforts to people not paying into the funds they are receiving or hoping to receive.

Like simple parenting, rewarding a child for poor behavior is counterproductive. Similarly, rewarding illegal immigrants for successfully defying the system is hardly fair to anyone. I am by no means against immigration, but the "illegal" part of the immigration gives absolutely no means for compensation. Having eager and willing people wanting to come to our free and beautiful country is an honor, but issuing government money from taxpayer dollars to accommodate someone who chose not to immigrate legally is disgraceful. Perhaps allowing additional financial funding to successfully immigrated persons as a reward for coming here with legitimate papers and going through the necessary steps to become a U.S. citizen would be more fair.

Education is vital to anyone's future. Paying to educate people who cannot work because they do not have a Social Security number and therefore cannot pay taxes is a backward system with no real benefit. I personally would be more inclined¹³ to assist a person openly willing to come to America the "right way" than I would to assist someone who cheated the system long enough to have completed high school without documentation.

GOP Assemblyman Tim Donnelly has a similar view. Donnelly had previously vowed¹⁴ to file a referendum¹⁵ prior to the act being passed, and with a total of 505,000 signatures (5 percent of last year's gubernatorial¹⁶ votes), the bill could be frozen before being implemented.¹⁷ Donnelly has only 90 days to collect the signatures, but practically before the ink dried from Brown's signature hitting the bill, he already had 5,000 volunteers ready to collect the community's John Hancocks.¹⁸

"Brown chose to fund illegals' dreams over funding our schools, pub safety & veterans," Donnelly tweeted just days after the bill was signed.

Whether the Dream Act is implemented next year or not, in the end someone is going to be left unhappy. But who should be the priority:¹⁹ American citizens or illegal immigrants?

SUMMARIZE AND RESPOND

In your reading journal or elsewhere, summarize the main point of "Dream Act Is Finance Fantasy." Then, go back over the essay, and check off the support for this idea. Next, write a brief summary of the essay. Finally, write a brief response to the reading. Do you think the law it describes should be kept or repealed? Why?

9. counterproductive: working against advancement or improvement 10. defying: challenging; going against 11. compensation: benefits—usually, financial ones 12. accommodate: make way for 13. inclined: in favor of 14. vowed: promised 15. referendum: a means of setting up a vote on whether a proposed or existing law should be passed or rejected 16. gubernatorial: related to a governor—in this case, the election of a governor 17. implemented: carried out 18. John Hancocks: signatures; refers to the American statesman who was the first signer of the Declaration of Independence 19. priority: something placed ahead of other things

CHECK YOUR COMPREHENSION

- 1. An alternate title for this essay could be
 - a. "California Dream Act Likely to Be Repealed."
 - b. "California Dream Act Will Leave the State in Financial Ruin."
 - (c.) "California Dream Act Unfair to Legal Residents."
 - **d.** "New Dream Act Will Cause Illegal Immigrants to Flood to California."
- 2. The main point of this essay is that
 - **a.** the California Dream Act makes it easy for illegal immigrants to get financial aid and push legal residents out of college enrollment slots.
 - **(b.)** the California Dream Act rewards illegal immigrants for breaking the law while putting legal residents at a disadvantage.
 - **c.** States should impose tougher financial aid restrictions on illegal immigrants who want to attend college.
 - **d.** Some changes to the California Dream Act would make it more acceptable to all residents of the state.
- **3.** According to Rushall, when it comes to the Cal Grant program, what is one requirement imposed on legal residents that is not imposed on illegal immigrants?
 - **a.** Legal residents must file a much longer financial aid application with copies of past tax returns—their own or those of their parents.
 - **b.** Legal residents must file a much longer financial aid application and include a copy of their birth certificate.
 - **c.** Legal residents must prove that they are independent and provide tax information to show that they are receiving poverty-level wages.
 - **d.** Legal residents must prove that they are independent, or they must provide their parents' tax information and prove that they come from a poverty-level household.
- **4.** Does this essay include the Four Basics of Good Argument? Why or why not?
- **5.** Look back at the vocabulary you underlined, and write sentences using these words: *reap* (para. 2); *imposed*, *garner* (8); *defying* (9); *vowed* (11).

TIP For tools to build your vocabulary, visit the Student Site for Real Writing at bedfordstmartins.com/realwriting.

READ CRITICALLY

- 1. What seems to be the purpose of the essay? How do you know?
- 2. Does Rushall do enough to address opposing views? Why or why not?

- **3.** In paragraph 9, Rushall says, "Like simple parenting, rewarding a child for poor behavior is counterproductive. Similarly, rewarding illegal immigrants for successfully defying the system is hardly fair to anyone." Do you think this comparison is just and accurate? Why or why not?
- **4.** What evidence does Rushall provide to support her claim that the new law is unfair?
- 5. The quotation from Assemblyman Tim Donnelly in paragraph 12 makes a point that goes beyond the law's perceived unfairness to legal residents. What is this point, and why do you think Rushall included it?

WRITE

Rushall describes financial aid requirements for both legal citizens and illegal immigrants in California. If you applied for financial aid, think back on all the steps you had to take and all the information you had to provide to complete your application. Can you identify any ways in which the process could be simplified or otherwise improved for all types of applicants, regardless of their legal status? Write a paragraph or essay that outlines your proposed changes and explains their benefits.

Dominic Deiro

I Have a DREAM

Dominic Deiro (1990–2011) wrote the following essay for an English course at San Joaquin Delta College, where he had been expecting to graduate with an associate's degree in 2012. The piece was published in *Delta Winds*, a collection of writings by students at the college. Deiro said of his essay, "After completing some research on the DREAM Act, I saw how it encompassed the idea of 'freedom of opportunity' that America stands for, and how it would benefit the youth of our nation and the overall goodwill of our society if passed by Congress." Deiro recommended that stu-

dent writers who are assigned an argument paper research their topic thoroughly. Also, he suggested that they get other students to review their work "to eliminate any careless mistakes or to clear up any misunderstandings." (For more on peer review, see Chapter 7.)

GUIDING QUESTION

What is the "dream," as the author defines it?

Imagine being in high school all four years, making friends, joining 1 clubs, playing sports, and bettering your education. What if that were ripped away from you in one second because you were an illegal alien about to be deported? I, along with many other Americans, believe this

1. deported: forced to leave the country

CRITICAL
READING
Preview
Read
Pause
Review

See pages 9-12.

type of treatment to be inhumane.² In order to combat the issue of deporting young illegal aliens, Senator Dick Durbin and Senator Richard Lugar drew up the DREAM Act, which would allow illegal alien students who graduated from high school, who have good moral character, who arrived in the U.S. as minors, and who have been in the country for at least five years the opportunity to earn permanent residency if they complete two years in the military or two years in college. Even though proponents³ of the act drew many supporters in 2007, with 52 senators voting in favor of it, they still could not break the filibuster,⁴ and thus the DREAM Act was not considered. However, in December of 2010, the act may come up for vote again. If it were proposed in Congress today, I would vote for the DREAM Act because it would increase the number of active duty soldiers, it would raise the amount of money in circulation, and it would allow young individuals the opportunity to get an education and to further benefit the community.

After considering the pros and cons of the DREAM Act, I have de- 2 IDENTIFY: Underline the cided that I should support this bill because it would increase the number of active duty soldiers in our various military branches. The DREAM Act states that illegal aliens who want to gain citizenship must either attend college or join the military for two years. I believe many immigrants would sign up for the military since some of them are not good in school. They would rather take their chances in the military. Despite our active participation in the wars in Iraq and Afghanistan, our American military units are in need of people to serve. Essentially, if this act were to be passed, then our number of service personnel would increase, and our armed forces would be stronger and more unstoppable. My brother is in the National Guard, and when I asked him how he felt about having outsiders enlist in the Army, he smiled and said the following: "All of us in the Army feel like a big family, and we gladly accept anyone who is willing to join. If some people who want to be Americans want to join the Army, we would all accept them without doubts or hesitations." If the people who are risking their lives for this country are willing to accept immigrants into their family, I think we should too. I believe that we should support the DREAM Act due to its potential to increase the number of active duty soldiers.

Besides increasing the number of participants in the armed forces, 3 SUMMARIZE: In your own the DREAM Act would improve the economy. If the illegal immigrants were granted U.S. citizenships, they would also become law-abiding⁵ taxpayers. Currently, in many of our cities and states, we have illegal immigrants working under poor conditions: They are paid low wages "under the table." This money is not taxed. Even though the workers eventually do spend their money to buy products, there could potentially be more money in our economy from taxes on their wages. At my first job, I was paid under the table, and I was not taxed at all. Nowadays, however, with

VOCABULARY **DEVELOPMENT** Certain words in this essay are defined at the bottom of the page. Underline these words as you read them.

IDEA JOURNAL In your opinion, how can education create better citizens?

reasons it would be helpful to have immigrants join the military.

words, summarize the main point of this paragraph.

^{4.} filibuster: 2. inhumane: cruel; lacking humanity 3. proponents: supporters an effort to block passage of a piece of legislation 5. abiding: following *The version of the DREAM Act described in this essay did not pass into law. At the time of this writing, a revised version of the act, introduced in 2011, was still pending in Congress.

my current job, I am taxed every time I receive a paycheck, and I am often astonished⁶ at how much is taken out. America is in a depression, and there is no sign of us getting out. If the DREAM act were passed, wages would increase for those individuals who qualify. Essentially, not only would the DREAM Act open up more opportunities for individuals in continuing their education and finding jobs, but it could potentially provide the chance for us to boost the economy.

Lastly, the DREAM Act should be passed because it would allow 4 young individuals the opportunity to get an education and to further benefit the community. The act states that in order to become an American citizen, the individual must either join the military or enroll in a college. With those extra years of schooling, these individuals would increase their knowledge and would be in a position to benefit society. Throughout the history of America, there have been many immigrants who have made a strong and long-lasting impact. Albert Einstein, who emigrated from Germany, was critical in World War II when he advised President Roosevelt of a bomb the Nazis were developing. John Muir, 8 who emigrated from Scotland, helped to create Yosemite National Park to benefit our environment. More personally, my mother, who worked at St. Joseph's Hospital, learned about an immigrant doctor from Iraq. She told me that he was one of the most skilled doctors at the hospital: "He was very attentive,9 always focused in surgery. I've seen him save more lives than any other doctor I have worked with." In all of these examples, the immigrants who had an opportunity to become American citizens were able to benefit society—giving back to the nation that allowed them to work toward their goals. Under the DREAM Act, young immigrants would have the same chance.

REFLECT: In your opinion, what is the most important part of the American Dream?

I believe that America, its citizens, and those around the world would benefit from the DREAM Act. By increasing the number of active duty soldiers, improving the economy, and allowing young individuals the opportunity to get an education, the DREAM Act builds on our forefathers' idea of life, liberty, and the pursuit of happiness. Increasing the number of individuals in our military not only strengthens our stance as an international power but also builds on a sense of family and camaraderie. Taxes on paychecks would increase the amount of money in circulation and would aid the U.S. in its quest to get out of debt. Finally, more individuals would be granted the opportunity to get an education, which would allow them to further benefit the community. Overall, these three reasons promote strength and support for the DREAM Act. I believe that it should be passed so that everyone can be a part of the American Dream.

6. astonished: shocked or surprised
7. Albert Einstein (1879–1955): Nobel
Prize-winning physicist who formulated the theory of relativity
8. John Muir (1838–1914): a naturalist and conservationist who has been called the "Father of Our National Parks"
9. attentive: observant; focused
10. forefathers: ancestors; in this case, the signers of the U.S. Declaration of Independence
11. stance: position
12. camaraderie: companionship; alliance

SUMMARIZE AND RESPOND

In your reading journal or elsewhere, summarize the main point of "I Have a DREAM." Then, go back over the essay, and check off the support for this idea. Next, write a brief summary of the essay. Finally, write a brief response to the reading. Do you think passage of the federal DREAM Act would lead to all the benefits Deiro describes? Why or why not?

CHECK YOUR COMPREHENSION

- 1. An alternate title for this essay could be
 - (a.) "Passage of the DREAM Act Would Benefit Immigrants and Society as a Whole."
 - **b.** "Passage of the DREAM Act Is Essential to Maintaining U.S. Military Strength."
 - **c.** "Passage of the DREAM Act Would Double the Growth of the U.S. Economy."
 - **d.** "Passage of the DREAM Act Would Make the United States More Respected Internationally."
- 2. The main point of this essay is that
 - **a.** immigrants will be more of a burden to society than a benefit to it if they are not given a chance to become legal citizens.
 - **b.** passage of the DREAM Act, and the increased tax base it would provide, might be the only way to get the United States out of debt within a decade.
 - passage of the DREAM Act would benefit the military, strengthen the U.S. economy, and give immigrants more opportunity to get an education and improve their communities.
 - **d.** granting citizenship rights to educated illegal immigrants will produce more geniuses like Albert Einstein.
- **3.** According to the author's brother, what would soldiers think of illegal immigrants who want to join the Army?
 - **a.** They would accept the immigrants reluctantly because the Army is in need of recruits.
 - **(b.)** They would accept the immigrants without hesitation.
 - **c.** They would prefer that the immigrants join the Navy, Air Force, or Marines instead.
 - **d.** They would accept the immigrants slowly, after getting to know them.
- **4.** Does this essay include the Four Basics of Good Argument? Why or why not?

TIP For tools to build your vocabulary, visit the Student Site for Real Writing at bedfordstmartins.com/realwriting.

5. Look back at the vocabulary you underlined, and write sentences using these words: *inhumane* (para. 1); *astonished* (3); *attentive* (4); *camaraderie* (5).

READ CRITICALLY

- 1. In the first two sentences of his essay, Deiro asks readers to put themselves in the shoes of illegal immigrants. How did this opening affect you? Do you think it is a good way to begin the essay? Why or why not?
- **2.** Does Deiro acknowledge and address views other than his own? If so, where?
- **3.** Deiro includes quotations from two sources he interviewed. Which parts of his argument do these quotations support?
- **4.** Why, according to the author, is the current status of illegal immigrants problematic from an economic point of view? Are you convinced by the argument being made here?
- **5.** In paragraph 4, Deiro mentions the famous immigrants Albert Einstein and John Muir. How do these examples contribute to his argument?

WRITE

In the final paragraph of his essay, Deiro says that passage of the DREAM Act would help more U.S. residents achieve the "American Dream." How would you define the American Dream, and, in your opinion, what specific opportunities and achievements does it include? In a paragraph or essay, explain your views, using examples from Deiro's essay and including examples and observations of your own.

WRITE USING READINGS

Drawing on opinions and evidence from the essays by Rushall and Deiro, write an essay either in favor of or against extending more rights—including financial aid and citizenship—to illegal immigrants. You may quote directly from Rushall's and Deiro's writings or paraphrase their arguments. Whichever position you take, you should include opposing views by referring to the author who disagrees with your opinion. In your concluding paragraph, review the reasons you have given to support your position.

Acknowledgments

- Susan Adams. "The Weirdest Job Interview Questions and How to Handle Them." Forbes.com, June 16, 2011. Reprinted by permission of Forbes Media LLC © 2011.
- Sherman Alexie. "Superman and Me," from *The Most Wonderful Books: Writers on Discovering the Pleasures of Reading*, ed. Michael Dorris and Emilie Buchwald.
- Janice Castro with Dan Cook and Cristina Garcia, "Spanglish Spoken Here." From *Time*, July 11, 1988. Copyright TIME INC. Reprinted by permission. TIME is a registered trademark of Time Inc. All rights reserved.
- Judith Ortiz Cofer. "Don't Misread My Signals." From The Latin Deli: Prose and Poetry. Copyright © 1993 by Judith Ortiz Cofer. Reprinted by permission of the University of Georgia Press.
- Patrick Conroy. "Chili Cheese Dogs, My Father and Me."
 From *Parade Magazine*, November 4, 2004, pp. 4–5. © Pat
 Conroy. Initially published in *Parade Magazine*. All rights
 reserved. Used by permission of Parade Magazine and
 Marly Rusoff & Associates, Inc.
- Dominic Deiro. "I Have a Dream." *Delta Winds: A Magazine of Student Essays 2011*. San Joaquin Delta College. Reprinted by permission.
- Ericsson, Stephanie. "The Ways We Lie." Copyright © 1992 by Stephanie Ericsson. Originally published by The Utne Reader. Reprinted by permission of Dunham Literary as agents for the author.
- Ian Frazier. "How to Operate the Shower Curtain." The New Yorker, January 8, 2007. Reprinted by permission of the author.
- Dianne Hales. "Why Are We So Angry?" © 2001 by Dianne Hales. Originally published in *Parade Magazine*, September 2, 2001. All rights reserved.
- Oscar Hijuelos. "Memories of New York City Snow" from Metropolis Found: New York Is Book Country 25th Anniversary Collection (New York: New York Is Book Country, 2003). Copyright © 2003 by Oscar Hijuelos. Reprinted with the permission of The Jennifer Lyons Literary Agency, LLC for the author.
- Kelly Hultgren. "Pick Up the Phone to Call, Not Text." Dailywildcat.com, August 31, 2011. Reprinted by permission of the author.
- Amanda Jacobowitz. "A Ban on Water Bottles: A Way to Bolster the University's Image." *Student Life* newspaper. Posted by Amanda Jacobowitz on April 28, 2010. Forum Staff Columnists. Reprinted by permission of the author.
- Frances Cole Jones. "Don't Work in a Goat's Stomach," from *The Wow Factor: The 33 Things You Must (and Must Not) Do to Guarantee Your Edge in Today's Business World* by Frances Cole Jones, copyright © 2009, 2010 by Frances Cole Jones. Used by permission of Ballantine Books, a division of Random House, Inc.
- Eric Liu. Excerpt from "The Chinatown Idea," from *The Accidental Asian: Notes of a Native Speaker* by Eric Liu, copyright © 1998 by Eric Liu. Used by permission of Random House, Inc.
- Lauren Mack. "Gel Pens." Reprinted by permission of the author.
- Heather [Rushall] Mathis. "Dream Act Is Finance Fantasy." The Daily Aztec, October 17, 2011.
- Bill Maxwell. "Start Snitching." St. Petersburg Times, September 30, 2007. Reprinted by permission of the author.
- Holly Moeller. "Seeing Green: Say, Don't Spray." The Stanford Daily, July 21, 2011. Reprinted by permission of the author.

- Alexandra Natapoff. "Bait and Snitch." Used by permission of Alexandra Natapoff.
- Robert Phansalkar. "Stop Snitchin' Won't Stop Crime." From the *Badger Herald*, March 1, 2007. Used by permission of the Badger Herald.
- Caroline Bunker Rosdahl and Mary T. Kowalski. Excerpt from *Textbook of Basic Nursing* 9th. © 2008 Wolters Kluwer Health/Lippincott Williams & Wilkins.
- Shields, True. "The Daily Californian—To Stand in Giants' Shadows." Reprinted by permission of the author.
- Courtney Stoker. "The Great Debate." From ReVisions: Best Student Essays of the University of North Carolina at Pembroke, Vol. 11, Spring 2011, p. 22. Reprinted by permission of the author
- Amy Tan. "Fish Cheeks." First appeared in *Seventeen* magazine. Reprinted by permission of the author and the Sandra Dijkstra Literary Agency.
- Michael Thompson. "Passage into Manhood." Used by permission of Michael Thompson.
- John Tierney. "Yes, Money Can Buy Happiness." From The New York Times, March 20, 2008. © 2008 The New York Times. All rights reserved. Used by permission and protected by the laws of the United States. The printing, copying redistribution, or transmission of the material without express permission is prohibited.
- Commander Kristen Ziman. "Bad Attitudes and Glowworms." Originally appeared in the *Sun-Times Beacon News*, May 8, 2011. Reprinted by permission of the author.

Photo/Art Credits

Part photos by Joel Beaman.

Page 4: Courtesy of DIGO (DiMassimo Goldstein).

Page 6: ADB Photography.

Page 20: Ryan McVay/Getty Images.

Page 25: Tim Boyle/Getty Images.

Page 52: Chapters 3–7 Chelsea Wilson/Nick Brown photographs: Pelle Cass.

Page 114: Markku Lahdesmaki/Lightroom Inc.

Page 122: Getty Images.

Page 126: WireImage/Getty Images.

Page 129: Steve Davis Photography.

Page 133: Honey Lazar.

Page 140: The Art Archive/Tate Gallery London/ Eileen Tweedy/Art Resource, NY.

Page 144: Photo by Seth David Cohen.

Page 149: Martin Kirchner/laif/Redux.

Page 153: Timm Suess.

Page 164: Taylor Hill/Getty Images.

Page 168: AP Photo/Khalid Mohammed.

Page 171: Yamakov/Shutterstock.

Page 179: Lawrence Lucier/Getty Images.

Page 185: Photos from the film *ERASING HATE*, courtesy of Bill Brummel, erasinghatethemovie.com.

Page 189: Javier Larrea/Getty Images.

Page 194: mart/Shutterstock.

Page 199: ©2007 Cosimo Scianna.

Page 204: Razorlight Media/waltonportfolio.com.

Page 208: Stan Honda/Getty Images.

Page 218: Courtesy Janice E. Castro.

Page 222: Reuters/STR/Landov.

Page 226: (Frog) David Maitland/Getty Images.
(Toad) Joel Sartore/Getty Images.

Page 227: Asia Kepka.

Page 238: Library of Congress.

Pages 242–43: (1973 phone) AP Photo/Eric Risberg. (1985 phone) ©Science and Society/SuperStock. (4 phones) Martin Shields/Photo Researchers, Inc. (new phone) AP Photo/Steve Senne.

Pages 248–49: (Tornado survivors in Brimfield, MA, June 2011.) AP Photo/Worcester Telegram & Gazette. (Tornado survivors, who had previously survived Hurricane Katrina, in Joplin, MO, May 2011.) AP Photo/Tulsa World, Adam Wisneski. (Prayer circle outside destroyed church in Tuscaloosa, AL, May 2011.) AP Photo/Dave Martin. (Volunteers from another town help clear rubble in Joplin, MO, June 2011.) Reuters/STR/Landov.

Page 259: Daniel White/Daily Herald.

Page 263: Ken Fisher/Getty Images.

Page 266: Courtesy of adbusters.org.

Page 286: AP Photo/Maya Hitij.

Page 308: Jason Stitt/Shutterstock.

Page 309: Mayo Foundation for Medical Education and Research.

Page 321: Photo by Jennifer Caprioli/Courtesy of U.S. Army.

Page 343: iofoto/Shutterstock.

Page 364: Arun Joseph.

Page 408: The New York Times / Redux.

Page 409: Jon Gilbert Leavitt.

Page 547: Matt Devine/Alamy.

Page 549: AP Photo/The Daily Comet, Abb Tabor.

Page 563: Janet Fekete/Getty Images.

Page 584: (Heroes sign) Martin Sasse/laif/Redux. (Restroom sign) Jeff Deck.

Page 625: AP Photo/Lou Krasky.

Page 629: The Daily Californian.

Page 634: Robert E. Hales.

Page 642: © Barbara Kinney.

Page 652: Ulf Andersen/Getty Images.

Page 661: Copyright ©2009 by Stephanie Ericsson. Reprinted by the permission of Dunham Literary as agents for the author.

Page 671: Ming Louie.

Page 682: University of Georgia Photographic Services. All rights reserved.

Page 687: Photograph by Daniel Karp.

Page 692: Fred R. Conrad/The New York Times/Redux.

Page 700: Michelle Gray/StPetePhotos.com.

Page 703: Courtesy Alexandra Natapoff.

Index

A	Analysis	Audience, understanding, 27–33
a	in problem solving, 24-25	Audio recording, Works Cited
versus an/and, 546	of reading, 18	documentation of, 319
basics of, 524–27	of visual image, 23	
capitalization of, 607	and	
Abbreviations, possessive of, 582	versus a/an , 546	В
Abstract words, avoiding, 536–38	in compound sentences, 569	"Bad Attitudes and Glowworms"
accept/except, 546	for coordination, 465–66	(Ziman), 259–60
Action verbs, 334	correcting run-ons with, 365–66	bad/badly, 452-54
Active voice, 414–15	parallelism and, 479	"Bait and Snitch: The High Cost
Adams, Susan, "The Weirdest Job	subject-verb agreement and,	of Snitching for Law Enforce-
Interview Questions and How	384–87	ment" (Natapoff), 703-06
to Handle Them," 144–47	"Animal-Assisted Therapy"	"Ban on Water Bottles: A Way
Additions, transitional	(Altschiller), 312	to Bolster the University's
words/phrases for, 104	Antecedent, 425	Image, A" (Jacobowitz),
Addresses, commas in, 577	Anthology	12–14
Adjective clauses	in-text citations of, 316	Base form (of verb), 397
commas around, 574–76	Works Cited documentation of,	be, forms of
joining ideas with, 494–96	317 Anastrophes	as helping verbs, 335
Adjectives, 448–57	Apostrophes basics of, 582–89	as linking verbs, 334 passive voice and, 413–15
basics of, 330 coordinate, commas between,	possessive pronouns and, 435	past participles and, 401–02
568–69	Appositives	in past progressive tense, 513
cumulative, 568	commas around, 572–74	in past tense, 379, 406–07
prepositions after, 527	joining ideas with, 492–94	in present progressive tense, 512
sentence patterns and, 338	Appropriate degree forms, 568; see	in present tense, 379, 405–06
Adverbs, 448–57	also Cumulative adjectives	questions and, 503
basics of, 330	are; see also be, forms of	subject-verb agreement and,
conjunctive; see Conjunctive	versus our, 547	379–81
adverbs	present tense and, 405	Beck, Shari, "A Classroom
sentence patterns and, 338	Argument, 265–88	Distraction—and Worse,"
starting sentences with, 487-88	reading and analyzing, 278-84	282–83
advice / advise, 546	readings for, 696–716	become
affect / effect, 546	understanding, 265–78	forms of, 334
Alexie, Sherman, "The Joy of	writing, 284–87	as linking verb, 334
Reading and Writing: Super-	Around Him, John, "Free Money,"	Bedford Research Room, 307
man and Me," 652-55	667–69	been, after have or has, 511
introduction of, 87	Articles, running bibliography for,	"Benefits of Getting a College
"All My Music" (Mattazi), 198–99	310	Degree, The" (Wilson), 93,
almost, 458–59	Articles (a, an, the), basics of,	107–08
Altschiller, Donald, "Animal-	524–27; see also a; an; the	Beverly, Jasen, "My Pilgrimage," 648–50
Assisted Therapy," 312	in comparisons, 438	Biases, avoiding, 8–9
am, 405; see also be, forms of	parallelism and, 480	Bible, 594
Ambiguous pronoun reference, 431–33	Assumptions, questioning	Bibliography, running, 310–11
an	in argument, 271–76	"Bird Rescue" (Cepeda), 163
basics of, 524–27	critical thinking and, 7–8	Blogs, Works Cited documentation
capitalization of, 607	narrowing topic by, 44–45	of, 319

community involvement of, 167

Body of essay Chapter in book, quotation marks after introductory words, 571-72 compared to paragraph, 31-33, for title of, 594 around adjective clauses, 574-76 55-57 Chapter reviews, previewing, 10 around appositives and interruptdrafting, 85-86 Checklists ers, 572-74 purpose of, 31 for evaluating draft essay, 94 in compound sentences, 569-71 Body of paragraph for evaluating draft paragraph, 92 for conjunctive adverbs, 467-68 compared to essay, 32-33, 55-57 for evaluating main point, 66 between coordinate adjectives, purpose of, 30-31 for evaluating revised essay, 109 568-69 Boldface terms, previewing, 9 for evaluating revised paragraph, for coordination, 465-66 Booker, Mary LaCue, 247, 256-57, 107 correcting run-ons with, 361, 362, 360 for evaluating support, 75 365-66 Books for peer reviewing, 98 in dates, 577 in-text citation of, 314-15 for previewing, 10 for dependent clauses, 368 italicizing title of, 594 for responding to essay exam in direct quotations, 591 running bibliography for, 310 questions, 301 editing for, 578-79 Works Cited documentation of, for revising, 97 for fragments as examples or 316-17 for topic choice, 50 explanations, 352 both . . . and, 481 for writing argument, 287 for fragments starting with depen-Brainstorming, 47 for writing cause and effect, 264 dent words, 345, 346 "'A Brother's Murder': A Painful for writing classification, 205 for fragments starting with -ing Story That Is As True as Ever," for writing comparison and converb forms, 348 trast, 244 for fragments starting with prepo-Brown, Charlton, "Buying a Car at for writing definition, 223-24 sitions, 343 an Auction," 178-79 for writing description, 169 for fragments starting with to plus Brown, Nick, 42, 47, 51, 52, 67 for writing illustration, 150 verb, 350 Business correspondence, colons in, for writing narration, 130 between items in series, 567-68 599-600 for writing process analysis, 186 for joining ideas with adjective for writing report, 297-98 clauses, 494 in compound sentences, 569 for writing research essay, 325-26 for joining ideas with appositives, for coordination, 465-66 for writing summary, 294-95 correcting run-ons with, 365-66 "Chili Cheese Dogs, My Father, for joining ideas with -ing verbs, buy/by/bye, 547-48 and Me" (Conroy), 625-27 "Buying a Car at an Auction" Chronological order for joining ideas with past parti-(Brown), 178-79 in narration, 121 ciples, 491 transitional words/phrases for, with names, 577 104 with quotation marks, 576-77 C using, 78 with semicolons, 598-99 Call number, library, 305 Citing Electronic Information, 307 for subordination, 471-72 can, as helping verb, 516, 519 Citing sources, 313-18 then and, 370 Capitalization Classification, 188-206 with yes or no, 577 basics of, 604-08 reading and analyzing, 197-202 Comma splice of direct quotations, 591 readings for, 657-66 correcting with comma and coorof specific (proper) nouns, 604 understanding, 188-97 dinating conjunction, 365 Castro, Janice E., "Spanglish," writing, 202-05 correcting with dependent word, 218 - 20"Classroom Distraction-and 368 Cause and effect, 246-64 Worse, A" (Beck), 282-83 correcting with period, 361 reading and analyzing, 266-61 Clause, 344 correcting with semicolon, 362 readings for, 687-95 Clichés, avoiding, 540-41 as run-on, 359 understanding, 246-55 Clustering, 48 Commercial products, capitalization writing, 261-64 Cofer, Judith Ortiz, "Don't Misread of, 606 Causes, transitional words/phrases My Signals," 682-84 Common (generic) nouns, 604 for, 104 Coherence, revising for, 103-05 Commonly confused words, CDs Collective nouns, pronouns for, 545-56, 558 429-31 italicizing title of, 594 Commonly misspelled words, Colons, 599-600 Works Cited documentation of, 562 319 Commas, 567-81 Community Connections Cepeda, Alessandra in addresses, 577 Cepeda, Alessandra, 167 "Bird Rescue," 163 for adverbs at start of sentence,

Costas, Corin, 221

Elswick, Shawn, 262

do, forms of

D Haun, Jenny, 128 in illustration, 137 in narration, 119 Powers, Caroline, 203 previewing, 10 for past tense, 400 Rankins, Evelka, 147 for simple past tense, 508, 509 in process analysis, 175 Roque, Jorge, 285 Dangling modifiers, 460-64 Schiller, Lynze, 241 purpose of, 31 Dashes, 600 Wyant, Robin, 183 Concrete words, using, 536–37 Database articles, Works Cited Companies, capitalization of, 606 Confused words, commonly, documentation of, 318 545-56, 558 Comparatives, 450-54 Databases, library, 306 Conjunctions Comparison and contrast, 225-45 Dates basics of, 330 reading and analyzing, 235-40 capitalization of, 604, 605-06 coordinating; see Coordinating readings for, 675-86 commas in, 577 conjunctions understanding, 225-35 Deck, Jeff, The Great Typo Hunt: Two correlative, 481-83 writing, 240-44 Friends Changing the World, One subordinating; see Dependent Comparisons Correction at a Time, 584 adjectives and adverbs in, words Definite articles, 524; see also the 450-52 Conjunctive adverbs Definition, 207-24 parallelism in, 480-81 for coordination, 467-68 correcting run-ons with, 361, reading and analyzing, 214-20 pronouns used in, 438-40 readings for, 667-74 Complete sentences, drafting in, 362 list of common, 362 understanding, 207-14 82 - 83Conroy, Pat, "Chili Cheese Dogs, writing, 220-24 Complete thoughts, sentences as, Definition of terms, previewing, 9 My Father, and Me," 625-27 336 - 37Deiro, Dominic, "I Have a Complete verbs, helping verbs and, conscience / conscious, 548 DREAM," 712-14 Consonants doubling final, spelling rules for, Demonstrative pronouns, 436 Compound nouns, plurals of, 561 Dependent clauses 560 Compound objects, pronouns used subject-verb agreement and, list of, 559 with, 436-38 383-84 Contractions, apostrophes in, Compound sentences, commas in, for subordination, 471-72 569-71 585-86 Dependent words Compound subjects Contrast; see also Comparison and correcting run-ons with, 361, basics of, 332 contrast 367-69 pronouns used with, 436-38 definition of, 225 fragments starting with, 344-47 transitional words/phrases for, subject-verb agreement and, list of common, 345 104 384-87 for subordination, 471–72 Cook, Dan, "Spanglish," 218-20 Concluding sentence Description, 152-69 Coordinate adjectives, commas in argument, 270 reading and analyzing, 161-66 between, 568-69 in cause and effect, 253 readings for, 638-47 Coordinating conjunctions in classification, 194 understanding, 152-61 compared to essay conclusion, capitalization of, 607 writing, 166-69 for coordination, 465-67 31-33, 55-57 Detail; see Support correcting run-ons with, 361, in comparison and contrast, 229 365-66 Dictionaries in definition, 212 Coordination, 465-70, 473-77 for spelling, 557 in description, 158 for word choice, 535 Correlative conjunctions, 481-83 drafting, 83 Differences; see Comparison and Costas, Corin in illustration, 136 community involvement of, 221 contrast in narration, 118 "Difficult Decision with a Positive "What Community Involvement in outline, 80 Outcome, A" (Prokop), 257-58 Means to Me," 216-17 in process analysis, 174 Digital files, Works Cited documenpurpose of, 30 could tation of, 319 as helping verb, 516, 519 Conclusion of essay Direct objects, sentence patterns using of or have after, 550 in argument, 269, 271, 276 Count nouns, using a, an or the and, 338, 500 in cause and effect, 253 Direct quotations in classification, 195 with, 524-27 avoiding plagiarism and, 313 Courses, capitalization of, 606 compared to concluding sentence, in-text citation of, 314 Critical reading, 9-16 31-33, 55-57 quotation marks for, 590-93 Critical thinking in comparison and contrast, 231 Discussing, as prewriting technique, in argument, 271 in definition, 213 understanding, 3-9 47 in description, 159

Cumulative adjectives, 568

drafting, 89-90

as helping verbs, 335 negative statements and, 502 in present tense, 380 questions and, 503 subject-verb agreement and, 379 - 81Documenting sources, 313-18 "Don't Misread My Signals" (Cofer), 682-84 "Don't Work in a Goat's Stomach" (Jones), 199-201 Double negatives, 502, 509 Drafting, 77-95 arranging ideas in, 78-79 of essay, 84-91 making plan in, 80-82 of paragraph, 82-84 understanding, 77-78 writing process and, 34 "Dream Act Is Finance Fantasy" (Rushall), 708-10 DVD, Works Cited documentation of, 319

-e, dropping final, spelling rules for, 559

-ea adjectives ending in, 449 past participles and, 401-02 past tense and, 400-01 simple past tense and, 508, 509 Editing

versus revising, 96-97 writing process and, 34 Editing review tests, 609-18 Editorials, Works Cited documentation of, 317 .edu, 309

Effect, 246; see also Cause and effect

effect / affect, 546 either ... or, 481

ei versus ie, spelling rules for, 559 Electronic sources, Works Cited

documentation of, 317-19

Elswick, Shawn, 262 E-mail

in-text citation of, 316

Works Cited documentation of,

Emerson, Ralph Waldo, 273 Encyclopedia articles in-text citation of, 315 Works Cited documentation of, 317

Energy, in argument, 267

English, formal, audience and, 29-30

English as Second Language; see English basics

English basics, 499-532

articles (a, an, the) and, 524-27 making direct points and, 53

prepositions and, 527-29 pronouns and, 505-07

sentence patterns and, 499-504 verbs and, 507-23; see also Verbs

Enthusiasm, in argument, 267 -er, 450-51

Ericsson, Stephanie, "The Ways We Lie," 661-65

adding, spelling rules for, 560-61 count nouns and, 524 for simple present tense, 508, 509

ESL; see English basics

Essays; see also Essays versus paragraphs; Research essay

drafting, 84-91

exam questions and, 298-301

outlining, 81-82

quotation marks for title of, 594 revising, 107-09; see also Revising

topic for, 45

understanding form of, 30-33

Essays versus paragraphs in argument, 270-71

in cause and effect, 252-53 in classification, 194-95

in comparison and contrast,

230 - 31

comparison of forms in, 31-33, 55-57

in definition, 212-13 in description, 158-59

in illustration, 136-37

in narration, 118-19

in process analysis, 174-75 support in, 69-70

adjectives ending in, 449 superlatives and, 450-51

et al., 317

Evaluating Web sites, 307-09

Evaluation

in problem solving, 25-26 of reading, 20-21

of visual images, 24

Events, time order for, 78

Evidence, in argument, 268-76 Examples; see also Illustration

in argument, 272-73

colons before, 599 fragments as, 351-53 opening essay with, 87 transitional words/phrases for,

Exam questions, 298-301

except/accept, 546

Exclamation points, in direct quotations, 591

Expert opinion, in argument, 272 - 73

Explanations

colons before, 599

fragments as, 351-53

"Eyeglasses vs. Laser Surgery: Benefits and Drawbacks" (Ibrahim), 237

F

Facts, in argument, 272-73 Fana, Mayerlin, 377 FANBOYS, 330, 365, 465, 569

Feminine pronouns

basics of, 505, 506

pronoun agreement and, 427

Figures in visual images, 22

Film, Works Cited documentation

of, 319

fine/find, 548

"First Day in Fallujah" (Healy), 638 - 41

First person pronouns, 441-42 "Fish Cheeks" (Tan), 126-27

Flowcharts

for adjectives and adverbs, 457 for coordination, 469, 477

for dangling modifiers, 464

for fragments, 358

for misplaced modifiers, 464

for parallelism, 485

for pronouns, 447

for run-ons, 376

for sentence variety, 498

for subject-verb agreement errors, 396

for subordination, 477

for verb tense errors, 421

for word choice, 544

in compound sentences, 569 for coordination, 465-66

correcting run-ons with, 365-66 Forecasts, in argument, 272-73

Formal English

basics of; see English basics formal audience and, 29-30

Fragments, 341-58

editing for, 353-55

as examples or explanations,

351 - 53

H ie versus ei, spelling rules for, 559 flowchart for finding and fixing, had, for past perfect tense, 412-13, "I Have a DREAM" (Deiro), 712 - 14510, 511 starting with dependent words, had to, versus must, 519 Illustration, 132-51 344 - 47Hales, Dianne, "Why Are We So starting with -ing verb forms, reading and analyzing, 140-47 348-49 Angry?," 634-36 readings for, 629-37 starting with prepositions, 343-44 introduction of, 87 understanding, 132-40 starting with to plus verb, 349-51 reference of conclusion to introwriting, 147-50 Importance, order of; see Order of understanding, 341-42 duction in, 89-90 Frazier, Ian, "How to Operate the hardly, 458-59 importance Shower Curtain," 179-82 Hargreaves, Ken, 397 Incomplete sentences; see Fragments "Free Money" (Around Him), has, for present perfect tense, Incomplete thoughts, 336-37 Indefinite articles, 524; see also a; an 667-69 410-12, 510, 511 Freewriting, 46 Indefinite pronouns Haun, Jenny, 128 Fused sentences have, forms of basics of, 428-29 correcting with comma and coorwith could/should/would, 519 list of common, 367, 426 dinating conjunction, 365 as helping verb, 335 subject-verb agreement and, versus of, 550 387-89 correcting with dependent word, past participles and, 401-02 Independent clauses, 359; see also 368 correcting with period, 361 in present perfect tense, 410-12, Sentences 510, 511 Indirect objects, sentence patterns correcting with semicolon, 362 as run-on, 359 in present tense, 379, 405-06 and, 338, 500 Indirect quotations Future tenses subject-verb agreement and, perfect, 510-11 379-81 avoiding plagiarism and, 311-13 in-text citation of, 314 progressive, 513-14 he, sexist use of, 428 quotation marks and, 593-94 simple, 508-9 Headings, previewing, 9 Headnotes, previewing, 9 Infinitives Healy, Brian, "First Day in Falbasics of, 521-23 G lujah," 638-41 fragments starting with, 349-51 Garcia, Cristina, "Spanglish," Helping verbs, 335-36 -ing, adding to word ending in -y, 218 - 20list of common, 501 "Gel Pens" (Mack), 622-23 in negative statements, 501-02 -ing verb forms fragments starting with, 348-49 past participles and, 410-15 Gender questions and, 503 for future progressive tense, of pronouns, 427-31, 505, 506 sexist language and, 541 here, subject-verb agreement and, 513 - 14389-91 joining ideas with, 488-90 Generating ideas, writing process and, 34 Hijuelos, Oscar, "Memories of New as misplaced modifiers, 459 York City Snow," 164-65 for past progressive tense, 513 Generic (common) nouns, 604 his or her, 427, 428 for present progressive tense, Gerunds, 521-23; see also -ing verb "How to Operate the Shower Cur-511 - 12forms "Gifts from the Heart" (Palmer), tain" (Frazier), 179-82 Intensive pronouns, 436 Hultgren, Kelly, "Pick Up the Interjections, 331 142 - 43Internet good, versus well, 452-54 Phone to Call, Not Text," Government publications 657-59 address extensions on, 309 in-text citation of, 315 Hyde, Celia, 154 evaluating sources from, 307-09 Works Cited documentation of, Hyphenating words, 601 finding sources on, 306-07 prewriting and, 48-49 318 Hyphens, 600-01 Grading criteria, 35-40 Interrogative pronouns, 436 Interrupters, commas around, Graham, Jeremy, 172, 177-78 572-74 "Great Debate, The: Essentialism vs. Dominance" (Stoker), -i, changing -y to Interviews 675 - 80adding -ed to, 400 conducting, 307 Great Typo Hunt: Two Friends before adding -er or -est, 450-51 in-text citation of, 314, 316 Changing the World, One Correcspelling rules for, 559-60 Works Cited documentation of, tion at a Time, The (Deck), 584 319 I, versus me, 436 Ibrahim, Said, "Eyeglasses vs. Laser In-text citations, 313, 314-16 Groups, capitalization of, 606 Introduction of essay Surgery: Benefits and Draw-Guiding question backs," 237 conclusion referring to, 89-90 asking, before reading, 10

Ideas, arranging, 78-79

drafting, 86-89

for research, 304

Introduction of essay (cont.) previewing, 9 purpose of, 31 Introductory words, commas after, 571-72 Invisible writing, 46 Irregular plurals, 561 Irregular verbs subject-verb agreement and, 379-81 verb tense and, 402-10 is, 405; see also be, forms of Items in series, commas for, 567-68 its, versus it's, 548, 583 Listing Jacobowitz, Amanda, "A Ban on Water Bottles: A Way to Bolster the University's Image," 12 - 14

K

Key words previewing, 9 repeating for coherence, 105 searching with, 306 King, Leigh, 190, 197-98, 342 knew/new/know/no, 549 know/no/knew/new, 549 Koran, 594 Kowalski, Mary T., Textbook of Basic Nursing, 17

Jones, Frances Cole, "Don't Work in

Journal articles, running bibliogra-

"Joy of Reading and Writing: Super-

man and Me, The" (Alexie),

Journal, prewriting and, 49

phy for, 310

introduction of, 87

652-55

just, 458-59

a Goat's Stomach," 199-201

Language notes on adjectives as singular or plural, on articles (a/an/the), 333 on be, 335 on capitalization, 606 on complete sentences, 341 on -ed and -ing forms of adjectives, 449 on forming questions, 389 on in and on, 332 on present perfect tense, 411

on progressive tenses, 399 on pronoun gender, 435 on that, 350 on verb endings, 397 Languages, capitalization of, 606 Layland, Kelly, 115, 123-24 "Learning Tool Whose Time Has Come, A" (Yilmaz), 281-82 Leibov, Brad, 228, 236-37 Lester, Jimmy, 359 Letters, apostrophes with, 587 Librarian, consulting, 304–05 Library, finding sources at, 304-06 Linking verbs, 334-35, 338 for generating support, 73 as prewriting technique, 47 colons before, 599 parallelism in, 479 semicolons for, 598-99 Liu, Eric, "Po-Po in Chinatown," 642-45 lose/loose, 550 Lowercase, 604 -ly, forming adverbs with, 449 Lynch, Jelani, "My Turnaround," 124-25

M

Mack, Lauren, "Gel Pens," 622-23 Magazine articles quotation marks for title of, 594 running bibliography for, 310 Works Cited documentation of, 317, 318 Magazines, italicizing title of, 594 Main point; see also Thesis statement; Topic sentence in argument, 267-68, 269-71 in cause and effect, 250-53 in classification, 190-95 in comparison and contrast, 228 - 31in definition, 209–10, 212–13 in description, 154–56, 157–59 of essay, 31 finding while reading, 10-11 forceful, 64 as idea to show, explain, or prove, 62 - 63in illustration, 134-37 in narration, 115-16, 117-19 of paragraph, 30 of paragraph versus essay, 32-33 in process analysis, 172, 173-75 single versus multiple, 60-61 specific versus general, 61-62

Main verb, 334; see also Verbs Mancuso, Tony, 329 Mapping, 48 Masculine pronouns basics of, 505, 506 pronoun agreement and, 427, Mattazi, Lorenza, "All My Music," 198-99 Maxwell, Bill, "Start Snitching," 700-02 introduction of, 87-88 reference of conclusion to introduction in, 90 may, as helping verb, 516 me, versus I, 436 Melancon, Diane, 266, 279-81 "Memories of New York City Snow" (Hijuelos), 164-65 might as helping verb, 517 using of or have after, 550 mind/mine, 550 Misplaced modifiers, 458–60, 461-64 Misspelled words, commonly, 562 MLA documentation, 313-18 Modal verbs (modal auxiliaries), 401, 515-19; see also Helping verbs Modifiers dangling, 460-64 misplaced, 458-60, 461-64 Moeller, Holly, "Say, Don't Spray," 687-90 more, 450-51 most, 450-51 Movies italicizing title of, 594 Works Cited documentation of, must, as helping verb, 517, 519 "My Career Goal" (Wilson), 91-92, "My Home Exercise Program" (Wood), 88 "My Pilgrimage" (Beverly), 648-50 "My Turnaround" (Lynch), 124-25

Names capitalization of, 604-06 commas with, 577 Narration, 113-31 opening essay with, 87 reading and analyzing, 123-27 readings for, 621-28

in direct quotations, 591

	2~ : 1 : [1] [1] [1] [1] [1] [1] [1] [1] [1] [1]	경기 경기 경기를 받아 있다면 내가 되는 것이 없었다.
understanding, 113–22	Objects	revising, 105-07; see also Revising
writing, 128–30	sentence patterns and, 499–500	titling, 84
Natapoff, Alexandra, "Bait and	space order for, 79	topics for, 45
Snitch: The High Cost of	in visual images, 22	understanding form of, 30–33
Snitching for Law Enforce-	of/have, 550	Paragraphs versus essays
ment," 703–06	Online databases, library, 306	in argument, 270–71
Nationalities, capitalization of, 606	Online dictionaries, 535, 557	in cause and effect, 252–53
n.d., 317	Online library catalog, 305	in classification, 194–95
nearly, 458–59	Online thesaurus, 536	in comparison and contrast,
Negative statements	only, 458–59	230–31
basics of, 501–02	Opinion, opening essay with, 87–88	comparison of forms in, 31–33,
in future progressive tense, 513	or	55–57
helping verbs for, 515–18	in compound sentences, 569	in definition, 212–13
in past progressive tense, 513	for coordination, 465–66	in description, 158–59
in present progressive tense, 512	correcting run-ons with, 365–66	in illustration, 136–37
in simple tense, 509	parallelism and, 479	in narration, 118–19
neither nor, 481	subject-verb agreement and,	in process analysis, 174–75
.net, 309	384–87	support in, 69–70
new/knew/know/no, 549	Order of ideas, 78–79	Parallelism, 478–85
Newspaper articles	Order of importance	Paraphrases, avoiding plagiarism in,
quotation marks for title of, 594	in argument, 276–77	311, 312–13
running bibliography for, 310	in cause and effect, 254	Parentheses, 600
Works Cited documentation of,	in classification, 196	Participle, 330
317, 318	in comparison and contrast, 234	"Passage into Manhood"
Newspapers, italicizing title of,	in definition, 214	(Thompson), 671–73
594	in description, 160	passed/past, 550-51
no	in illustration, 139	Passive voice, 413–15
commas with, 577	transitional words/phrases for, 104	Past participles
versus know/knew/new, 549	using, 78, 79	for future perfect tense, 511
Noncount nouns, using a, an, the	.org, 309	irregular verbs as, 402-05,
with, 524–27	Organization	409–10
nor	in argument, 276–78	joining ideas with, 490–92
nor in compound sentences, 569	in cause and effect, 254-55	for past perfect tense, 510, 511
in compound sentences, 569 for coordination, 465–66	in cause and effect, 254–55 in classification, 196–97	for past perfect tense, 510, 511 for present perfect tense, 510,
in compound sentences, 569 for coordination, 465–66 correcting run-ons with, 365–66	in cause and effect, 254–55 in classification, 196–97 in comparison and contrast,	for past perfect tense, 510, 511 for present perfect tense, 510, 511
in compound sentences, 569 for coordination, 465–66	in cause and effect, 254–55 in classification, 196–97 in comparison and contrast, 232–35	for past perfect tense, 510, 511 for present perfect tense, 510, 511 regular verbs as, 401–02
in compound sentences, 569 for coordination, 465–66 correcting run-ons with, 365–66	in cause and effect, 254–55 in classification, 196–97 in comparison and contrast, 232–35 in definition, 214	for past perfect tense, 510, 511 for present perfect tense, 510, 511
in compound sentences, 569 for coordination, 465–66 correcting run-ons with, 365–66 subject-verb agreement and, 384–87 not, negative statements and,	in cause and effect, 254–55 in classification, 196–97 in comparison and contrast, 232–35 in definition, 214 in description, 160–61	for past perfect tense, 510, 511 for present perfect tense, 510, 511 regular verbs as, 401–02 verb tense and, 410–15 Past tenses
in compound sentences, 569 for coordination, 465–66 correcting run-ons with, 365–66 subject-verb agreement and, 384–87	in cause and effect, 254–55 in classification, 196–97 in comparison and contrast, 232–35 in definition, 214	for past perfect tense, 510, 511 for present perfect tense, 510, 511 regular verbs as, 401–02 verb tense and, 410–15 Past tenses forms of be in, 379, 406–07
in compound sentences, 569 for coordination, 465–66 correcting run-ons with, 365–66 subject-verb agreement and, 384–87 not, negative statements and, 501–02 not only but also, 481	in cause and effect, 254–55 in classification, 196–97 in comparison and contrast, 232–35 in definition, 214 in description, 160–61	for past perfect tense, 510, 511 for present perfect tense, 510, 511 regular verbs as, 401–02 verb tense and, 410–15 Past tenses forms of <i>be</i> in, 379, 406–07 irregular verbs in, 402–05
in compound sentences, 569 for coordination, 465–66 correcting run-ons with, 365–66 subject-verb agreement and, 384–87 not, negative statements and, 501–02	in cause and effect, 254–55 in classification, 196–97 in comparison and contrast, 232–35 in definition, 214 in description, 160–61 in illustration, 139	for past perfect tense, 510, 511 for present perfect tense, 510, 511 regular verbs as, 401–02 verb tense and, 410–15 Past tenses forms of <i>be</i> in, 379, 406–07 irregular verbs in, 402–05 perfect, 412–13, 510
in compound sentences, 569 for coordination, 465–66 correcting run-ons with, 365–66 subject-verb agreement and, 384–87 not, negative statements and, 501–02 not only but also, 481	in cause and effect, 254–55 in classification, 196–97 in comparison and contrast, 232–35 in definition, 214 in description, 160–61 in illustration, 139 in narration, 121–22 in process analysis, 176 Organizations, capitalization of, 606	for past perfect tense, 510, 511 for present perfect tense, 510, 511 regular verbs as, 401–02 verb tense and, 410–15 Past tenses forms of <i>be</i> in, 379, 406–07 irregular verbs in, 402–05
in compound sentences, 569 for coordination, 465–66 correcting run-ons with, 365–66 subject-verb agreement and, 384–87 not, negative statements and, 501–02 not only but also, 481 Noun phrase, 329, 493	in cause and effect, 254–55 in classification, 196–97 in comparison and contrast, 232–35 in definition, 214 in description, 160–61 in illustration, 139 in narration, 121–22 in process analysis, 176	for past perfect tense, 510, 511 for present perfect tense, 510, 511 regular verbs as, 401–02 verb tense and, 410–15 Past tenses forms of <i>be</i> in, 379, 406–07 irregular verbs in, 402–05 perfect, 412–13, 510
in compound sentences, 569 for coordination, 465–66 correcting run-ons with, 365–66 subject-verb agreement and, 384–87 not, negative statements and, 501–02 not only but also, 481 Noun phrase, 329, 493 Nouns; see also Pronouns	in cause and effect, 254–55 in classification, 196–97 in comparison and contrast, 232–35 in definition, 214 in description, 160–61 in illustration, 139 in narration, 121–22 in process analysis, 176 Organizations, capitalization of, 606	for past perfect tense, 510, 511 for present perfect tense, 510, 511 regular verbs as, 401–02 verb tense and, 410–15 Past tenses forms of <i>be</i> in, 379, 406–07 irregular verbs in, 402–05 perfect, 412–13, 510 progressive, 511–12, 513
in compound sentences, 569 for coordination, 465–66 correcting run-ons with, 365–66 subject-verb agreement and, 384–87 not, negative statements and, 501–02 not only but also, 481 Noun phrase, 329, 493 Nouns; see also Pronouns basics of, 329	in cause and effect, 254–55 in classification, 196–97 in comparison and contrast, 232–35 in definition, 214 in description, 160–61 in illustration, 139 in narration, 121–22 in process analysis, 176 Organizations, capitalization of, 606 Organizing principle, in classification, 188, 190–92 our/are, 547	for past perfect tense, 510, 511 for present perfect tense, 510, 511 regular verbs as, 401–02 verb tense and, 410–15 Past tenses forms of be in, 379, 406–07 irregular verbs in, 402–05 perfect, 412–13, 510 progressive, 511–12, 513 regular verbs in, 400–01
in compound sentences, 569 for coordination, 465–66 correcting run-ons with, 365–66 subject-verb agreement and, 384–87 not, negative statements and, 501–02 not onlybut also, 481 Noun phrase, 329, 493 Nouns; see also Pronouns basics of, 329 sentence patterns and, 338	in cause and effect, 254–55 in classification, 196–97 in comparison and contrast, 232–35 in definition, 214 in description, 160–61 in illustration, 139 in narration, 121–22 in process analysis, 176 Organizations, capitalization of, 606 Organizing principle, in classification, 188, 190–92	for past perfect tense, 510, 511 for present perfect tense, 510, 511 regular verbs as, 401–02 verb tense and, 410–15 Past tenses forms of be in, 379, 406–07 irregular verbs in, 402–05 perfect, 412–13, 510 progressive, 511–12, 513 regular verbs in, 400–01 simple, 502, 508, 509
in compound sentences, 569 for coordination, 465–66 correcting run-ons with, 365–66 subject-verb agreement and, 384–87 not, negative statements and, 501–02 not only but also, 481 Noun phrase, 329, 493 Nouns; see also Pronouns basics of, 329 sentence patterns and, 338 Novels, italicizing title of, 594 Numbers apostrophes with, 587	in cause and effect, 254–55 in classification, 196–97 in comparison and contrast, 232–35 in definition, 214 in description, 160–61 in illustration, 139 in narration, 121–22 in process analysis, 176 Organizations, capitalization of, 606 Organizing principle, in classification, 188, 190–92 our/are, 547	for past perfect tense, 510, 511 for present perfect tense, 510, 511 regular verbs as, 401–02 verb tense and, 410–15 Past tenses forms of be in, 379, 406–07 irregular verbs in, 402–05 perfect, 412–13, 510 progressive, 511–12, 513 regular verbs in, 400–01 simple, 502, 508, 509 peace/piece, 551 Peer review, 97–98 People
in compound sentences, 569 for coordination, 465–66 correcting run-ons with, 365–66 subject-verb agreement and, 384–87 not, negative statements and, 501–02 not only but also, 481 Noun phrase, 329, 493 Nouns; see also Pronouns basics of, 329 sentence patterns and, 338 Novels, italicizing title of, 594 Numbers	in cause and effect, 254–55 in classification, 196–97 in comparison and contrast, 232–35 in definition, 214 in description, 160–61 in illustration, 139 in narration, 121–22 in process analysis, 176 Organizations, capitalization of, 606 Organizing principle, in classification, 188, 190–92 our/are, 547 Outlining, 80–82	for past perfect tense, 510, 511 for present perfect tense, 510, 511 regular verbs as, 401–02 verb tense and, 410–15 Past tenses forms of be in, 379, 406–07 irregular verbs in, 402–05 perfect, 412–13, 510 progressive, 511–12, 513 regular verbs in, 400–01 simple, 502, 508, 509 peace/piece, 551 Peer review, 97–98
in compound sentences, 569 for coordination, 465–66 correcting run-ons with, 365–66 subject-verb agreement and, 384–87 not, negative statements and, 501–02 not only but also, 481 Noun phrase, 329, 493 Nouns; see also Pronouns basics of, 329 sentence patterns and, 338 Novels, italicizing title of, 594 Numbers apostrophes with, 587	in cause and effect, 254–55 in classification, 196–97 in comparison and contrast, 232–35 in definition, 214 in description, 160–61 in illustration, 139 in narration, 121–22 in process analysis, 176 Organizations, capitalization of, 606 Organizing principle, in classification, 188, 190–92 our/are, 547 Outlining, 80–82 Ownership, apostrophes for, 582–85	for past perfect tense, 510, 511 for present perfect tense, 510, 511 regular verbs as, 401–02 verb tense and, 410–15 Past tenses forms of be in, 379, 406–07 irregular verbs in, 402–05 perfect, 412–13, 510 progressive, 511–12, 513 regular verbs in, 400–01 simple, 502, 508, 509 peace/piece, 551 Peer review, 97–98 People capitalization of, 604–05 space order for, 79
in compound sentences, 569 for coordination, 465–66 correcting run-ons with, 365–66 subject-verb agreement and, 384–87 not, negative statements and, 501–02 not only but also, 481 Noun phrase, 329, 493 Nouns; see also Pronouns basics of, 329 sentence patterns and, 338 Novels, italicizing title of, 594 Numbers apostrophes with, 587 writing out with hyphens, 600	in cause and effect, 254–55 in classification, 196–97 in comparison and contrast, 232–35 in definition, 214 in description, 160–61 in illustration, 139 in narration, 121–22 in process analysis, 176 Organizations, capitalization of, 606 Organizing principle, in classification, 188, 190–92 our/are, 547 Outlining, 80–82	for past perfect tense, 510, 511 for present perfect tense, 510, 511 regular verbs as, 401–02 verb tense and, 410–15 Past tenses forms of be in, 379, 406–07 irregular verbs in, 402–05 perfect, 412–13, 510 progressive, 511–12, 513 regular verbs in, 400–01 simple, 502, 508, 509 peace/piece, 551 Peer review, 97–98 People capitalization of, 604–05 space order for, 79 Periodicals
in compound sentences, 569 for coordination, 465–66 correcting run-ons with, 365–66 subject-verb agreement and, 384–87 not, negative statements and, 501–02 not only but also, 481 Noun phrase, 329, 493 Nouns; see also Pronouns basics of, 329 sentence patterns and, 338 Novels, italicizing title of, 594 Numbers apostrophes with, 587 writing out with hyphens, 600	in cause and effect, 254–55 in classification, 196–97 in comparison and contrast, 232–35 in definition, 214 in description, 160–61 in illustration, 139 in narration, 121–22 in process analysis, 176 Organizations, capitalization of, 606 Organizing principle, in classification, 188, 190–92 our/are, 547 Outlining, 80–82 Ownership, apostrophes for, 582–85	for past perfect tense, 510, 511 for present perfect tense, 510, 511 regular verbs as, 401–02 verb tense and, 410–15 Past tenses forms of be in, 379, 406–07 irregular verbs in, 402–05 perfect, 412–13, 510 progressive, 511–12, 513 regular verbs in, 400–01 simple, 502, 508, 509 peace/piece, 551 Peer review, 97–98 People capitalization of, 604–05 space order for, 79 Periodicals indexes/databases for, 306
in compound sentences, 569 for coordination, 465–66 correcting run-ons with, 365–66 subject-verb agreement and, 384–87 not, negative statements and, 501–02 not only but also, 481 Noun phrase, 329, 493 Nouns; see also Pronouns basics of, 329 sentence patterns and, 338 Novels, italicizing title of, 594 Numbers apostrophes with, 587 writing out with hyphens, 600	in cause and effect, 254–55 in classification, 196–97 in comparison and contrast, 232–35 in definition, 214 in description, 160–61 in illustration, 139 in narration, 121–22 in process analysis, 176 Organizations, capitalization of, 606 Organizing principle, in classification, 188, 190–92 our/are, 547 Outlining, 80–82 Ownership, apostrophes for, 582–85	for past perfect tense, 510, 511 for present perfect tense, 510, 511 regular verbs as, 401–02 verb tense and, 410–15 Past tenses forms of be in, 379, 406–07 irregular verbs in, 402–05 perfect, 412–13, 510 progressive, 511–12, 513 regular verbs in, 400–01 simple, 502, 508, 509 peace/piece, 551 Peer review, 97–98 People capitalization of, 604–05 space order for, 79 Periodicals
in compound sentences, 569 for coordination, 465–66 correcting run-ons with, 365–66 subject-verb agreement and, 384–87 not, negative statements and, 501–02 not only but also, 481 Noun phrase, 329, 493 Nouns; see also Pronouns basics of, 329 sentence patterns and, 338 Novels, italicizing title of, 594 Numbers apostrophes with, 587 writing out with hyphens, 600	in cause and effect, 254–55 in classification, 196–97 in comparison and contrast, 232–35 in definition, 214 in description, 160–61 in illustration, 139 in narration, 121–22 in process analysis, 176 Organizations, capitalization of, 606 Organizing principle, in classification, 188, 190–92 our/are, 547 Outlining, 80–82 Ownership, apostrophes for, 582–85 P Pairs, parallelism in, 479 Palmer, Casandra, "Gifts from the Heart," 142–43	for past perfect tense, 510, 511 for present perfect tense, 510, 511 regular verbs as, 401–02 verb tense and, 410–15 Past tenses forms of be in, 379, 406–07 irregular verbs in, 402–05 perfect, 412–13, 510 progressive, 511–12, 513 regular verbs in, 400–01 simple, 502, 508, 509 peace/piece, 551 Peer review, 97–98 People capitalization of, 604–05 space order for, 79 Periodicals indexes/databases for, 306 in-text citation of, 314 running bibliography for, 310
in compound sentences, 569 for coordination, 465–66 correcting run-ons with, 365–66 subject-verb agreement and, 384–87 not, negative statements and, 501–02 not only but also, 481 Noun phrase, 329, 493 Nouns; see also Pronouns basics of, 329 sentence patterns and, 338 Novels, italicizing title of, 594 Numbers apostrophes with, 587 writing out with hyphens, 600 Object of preposition, subject of	in cause and effect, 254–55 in classification, 196–97 in comparison and contrast, 232–35 in definition, 214 in description, 160–61 in illustration, 139 in narration, 121–22 in process analysis, 176 Organizations, capitalization of, 606 Organizing principle, in classification, 188, 190–92 our/are, 547 Outlining, 80–82 Ownership, apostrophes for, 582–85 P Pairs, parallelism in, 479 Palmer, Casandra, "Gifts from the Heart," 142–43 "Parabens: Widely Used Chemicals	for past perfect tense, 510, 511 for present perfect tense, 510, 511 regular verbs as, 401–02 verb tense and, 410–15 Past tenses forms of be in, 379, 406–07 irregular verbs in, 402–05 perfect, 412–13, 510 progressive, 511–12, 513 regular verbs in, 400–01 simple, 502, 508, 509 peace/piece, 551 Peer review, 97–98 People capitalization of, 604–05 space order for, 79 Periodicals indexes/databases for, 306 in-text citation of, 314
in compound sentences, 569 for coordination, 465–66 correcting run-ons with, 365–66 subject-verb agreement and, 384–87 not, negative statements and, 501–02 not only but also, 481 Noun phrase, 329, 493 Nouns; see also Pronouns basics of, 329 sentence patterns and, 338 Novels, italicizing title of, 594 Numbers apostrophes with, 587 writing out with hyphens, 600 Object of preposition, subject of sentence and, 332 Object pronouns basics of, 505–06	in cause and effect, 254–55 in classification, 196–97 in comparison and contrast, 232–35 in definition, 214 in description, 160–61 in illustration, 139 in narration, 121–22 in process analysis, 176 Organizations, capitalization of, 606 Organizing principle, in classification, 188, 190–92 our/are, 547 Outlining, 80–82 Ownership, apostrophes for, 582–85 P Pairs, parallelism in, 479 Palmer, Casandra, "Gifts from the Heart," 142–43	for past perfect tense, 510, 511 for present perfect tense, 510, 511 regular verbs as, 401–02 verb tense and, 410–15 Past tenses forms of be in, 379, 406–07 irregular verbs in, 402–05 perfect, 412–13, 510 progressive, 511–12, 513 regular verbs in, 400–01 simple, 502, 508, 509 peace/piece, 551 Peer review, 97–98 People capitalization of, 604–05 space order for, 79 Periodicals indexes/databases for, 306 in-text citation of, 314 running bibliography for, 310 Works Cited documentation of, 317
in compound sentences, 569 for coordination, 465–66 correcting run-ons with, 365–66 subject-verb agreement and, 384–87 not, negative statements and, 501–02 not only but also, 481 Noun phrase, 329, 493 Nouns; see also Pronouns basics of, 329 sentence patterns and, 338 Novels, italicizing title of, 594 Numbers apostrophes with, 587 writing out with hyphens, 600 Object of preposition, subject of sentence and, 332 Object pronouns	in cause and effect, 254–55 in classification, 196–97 in comparison and contrast, 232–35 in definition, 214 in description, 160–61 in illustration, 139 in narration, 121–22 in process analysis, 176 Organizations, capitalization of, 606 Organizing principle, in classification, 188, 190–92 our/are, 547 Outlining, 80–82 Ownership, apostrophes for, 582–85 P Pairs, parallelism in, 479 Palmer, Casandra, "Gifts from the Heart," 142–43 "Parabens: Widely Used Chemicals	for past perfect tense, 510, 511 for present perfect tense, 510, 511 regular verbs as, 401–02 verb tense and, 410–15 Past tenses forms of be in, 379, 406–07 irregular verbs in, 402–05 perfect, 412–13, 510 progressive, 511–12, 513 regular verbs in, 400–01 simple, 502, 508, 509 peace/piece, 551 Peer review, 97–98 People capitalization of, 604–05 space order for, 79 Periodicals indexes/databases for, 306 in-text citation of, 314 running bibliography for, 310 Works Cited documentation of,
in compound sentences, 569 for coordination, 465–66 correcting run-ons with, 365–66 subject-verb agreement and, 384–87 not, negative statements and, 501–02 not only but also, 481 Noun phrase, 329, 493 Nouns; see also Pronouns basics of, 329 sentence patterns and, 338 Novels, italicizing title of, 594 Numbers apostrophes with, 587 writing out with hyphens, 600 Object of preposition, subject of sentence and, 332 Object pronouns basics of, 505–06	in cause and effect, 254–55 in classification, 196–97 in comparison and contrast, 232–35 in definition, 214 in description, 160–61 in illustration, 139 in narration, 121–22 in process analysis, 176 Organizations, capitalization of, 606 Organizing principle, in classification, 188, 190–92 our/are, 547 Outlining, 80–82 Ownership, apostrophes for, 582–85 P Pairs, parallelism in, 479 Palmer, Casandra, "Gifts from the Heart," 142–43 "Parabens: Widely Used Chemicals Spark New Cautions," 82–83	for past perfect tense, 510, 511 for present perfect tense, 510, 511 regular verbs as, 401–02 verb tense and, 410–15 Past tenses forms of be in, 379, 406–07 irregular verbs in, 402–05 perfect, 412–13, 510 progressive, 511–12, 513 regular verbs in, 400–01 simple, 502, 508, 509 peace/piece, 551 Peer review, 97–98 People capitalization of, 604–05 space order for, 79 Periodicals indexes/databases for, 306 in-text citation of, 314 running bibliography for, 310 Works Cited documentation of, 317

outlining, 80

whom as, 440-41

Personal interviews regular verbs in, 377-78, 398-400 understanding, 425 conducting, 307 simple, 399, 508, 509 using right type of, 434-41 in-text citation of, 314 Previewing, before reading, 9-10 Proofreading, for spelling, 558 Works Cited documentation of, Prewriting techniques Proper (specific) nouns, 604 319 for exploring topic, 46-49 Punctuation Personal pronouns, list of common, for generating support, 71 apostrophes, 435, 582-89 426 Primary support colons, 599-600 Personal spelling list, 558 in argument, 269-71 commas; see Commas Person of pronouns, 441-42 in cause and effect, 251-53 dashes, 600 Persuasion; see Argument in classification, 194-95 hyphens, 600-01 Phansalkar, Robert, "Stop Snitchin' in comparison and contrast, parentheses, 600 Won't Stop Crime," 697-98 229 - 31question marks, 503, 591 "Pick Up the Phone to Call, Not in definition, 212-13 quotation marks; see Quotation Text" (Hultgren), 657-59 in description, 158-59 marks piece / peace, 551 drafting, 85-86 semicolons; see Semicolons Places in essays, 70 Purpose for writing capitalization of, 604, 605 in illustration, 136-37 finding while reading, 10 space order for, 79 in narration, 116-19 understanding, 27-33 Plagiarism, avoiding, 35, 310-13 in outlines, 80, 81 Plural nouns/pronouns, 427-31, in paragraphs, 69-70 561 Q in process analysis, 174–75 Plural subject/verb, 377; see also selecting best, 71-72 qtd. in, 313 Subject-verb agreement student example of, 74 Question marks Plurals, irregular, 561 understanding, 68 basics of, 503 Podcast, Works Cited documentaprincipal/principle, 551 in direct quotations, 591 tion of, 319 Problem solving, 24-26 Questions Poems, quotation marks for title of, Process analysis, 170-87 asking, to narrow topic, 45 reading and analyzing, 176-82 basics of, 503 Point-by-point comparison, 232-34 readings for, 648-56 in future progressive tense, 514 "Po-Po in Chinatown" (Liu), understanding, 170-76 guiding, asking before reading, 10 642 - 45writing, 183-86 helping verbs for, 515-18 Position, opening essay with, 87-88 Profiles of Success opening essay with, 88 Possessive pronouns Booker, Mary LaCue, 256-57 in past progressive tense, 513 apostrophes and, 583 Graham, Jeremy, 177-78 in present progressive tense, 512 basics of, 505 Hyde, Celia, 161-62 subject-verb agreement and, 389, correct use of, 434-35, 436 King, Leigh, 197-98 390-91 list of common, 426 Layland, Kelly, 123-24 quiet/quite/quit, 551 Powers, Caroline, 203 Leibov, Brad, 236-37 Quotation marks Predictions, in argument, 272-73 Melancon, Diane, 279-81 basics of, 590-97 Prepositional phrases Scanlon, Walter, 215-16 commas with, 576-77 as misplaced modifiers, 459 Upright, Karen, 140-42 for direct quotations, 313 pronouns in, 436 Prokop, Caitlin, "A Difficult Decisingle, 592 sentence patterns and, 500 sion with a Positive Outcome," Quotations subject of sentence and, 332-33 257-58 avoiding plagiarism and, 35, subject-verb agreement and, Pronouns, 425-47 311-13 381 - 83basics of, 330, 505-07 direct, 590-93 Prepositions checking for agreement of, indirect, 593-94 basics of, 330, 527-29 427-31 in-text citation of, 314 capitalization of, 607 editing, 442-44 opening essay with, 86-87 flowchart for errors with, 447 fragments starting with, 343-44 with quotations, 592 list of common, 332, 344 identifying, 425-27 Present tenses indefinite; see Indefinite pronouns forms of be in, 379, 405-06 R list of common, 426 forms of do in, 380 making clear reference of, Radio program, Works Cited docuforms of have in, 379, 405-06 431 - 34mentation of, 319 Random House Webster's College irregular verbs in, 402-05 making consistent in person, perfect, 410-12, 509-10, 511 441-42 Dictionary, 535 progressive, 399

relative; see Relative pronouns

Rankins, Evelka, 147

critically, 9–17 to report, 297 editing to summarize, 292–94 finding writing critically about, 16–21 Real-world documents, reading critically, 14–16 Rushall,	ibliography, 310–11 complete thoughts and, 336–37 incomplete; see Fragments joining with semicolons, 598 parts of speech and, 329–31 run-ons and, 359 nding, 359–60 subjects of, 331–33 verbs in, 334–36 Sentence variety, 486–98 editing for, 496–97 joining ideas with adjective
tion of, 319	clauses for, 494-96
	joining ideas with appositives for, spelling rules for, 560–61 492–94
Regular verbs; see also Verbs preser in present tense, 377–78 398	joining ideas with <i>-ing</i> verbs for, 488–90 joining ideas with past participles resent tense and, 508, for, 490–92
Relative pronouns 509 basics of, 436, 505, 506–07 -'s	starting sentences with adverbs for, 487–88
	l letters and numbers, understanding, 486–87
Religions, capitalization of, 606 587	Series, items in, commas for,
Repetitious pronoun reference, to sho with t	ownership, 582–85 567–68 e, 587 "Service Dogs Help Heal the
그 그렇게 얼마면 뭐 그리다면 맛이 걸어 먹는 것이 없는 것이었다면 없어요.	t Spray" (Moeller), Mental Wounds of War"
*	alter, 208, 215–16, 378 set/sit, 552
choosing topic for, 303–04 Schedule	for research essay, 302–03 Sexist language
citing and documenting sources Schiller,	
	ines, 306 pronouns and, 428
evaluating sources for, 307–09 Seconda finding sources for, 304–07 adding	72–73 Shadows," 629–32
	ent, 268–71 Short stories, quotation marks for
	and effect, 251–53 title of, 594 should
	urison and contrast, as helping verb, 517, 519
Review tests for editing, 609–18 229	
	ion, 212–13 Sight, in description, 156
for coherence, 103–05 in desc	otion, 157-59 Similarities; see Comparison and
for detail and support, 101–02 in essa	
	ation, 135–37 Simple future tense, 508–09
	on, 116–18 Simple past tense
	es, 80, 81 basics of, 508, 509 aphs, 69–70 negatives in, 502
	s analysis, 174–75 Simple present tense
•	example of, 74 basics of, 508, 509
	nding, 68 versus present progressive, 399
research steps of, 304, 305 Second p "Service Dogs Help Heal the seem, 334	son pronouns, 441–42 Singular nouns/pronouns, 427–31
Mental Wounds of War," Semicolo 320–24 basics	Singular subject/verb, 377; see also Subject-verb agreement
	ination, 467–69 sit/set, 552
536 362	
	lescription, 156 so
Roque, Jorge, 277–78, 285 Rosdahl, Caroline Bunker, Textbook of Basic Nursing, 17 Sentence basic p 499-	terns of, 337–39, for coordination, 465–66

Songs, quotation marks for title of,	Subordinating conjunctions; see	as misplaced modifier, 459
594	Dependent words	subject-verb agreement and,
Sound, in description, 156	Subordination, 471–77	383
Soundalike words, 545–56	Subtitles, colons before, 599–600	the
Sources	Summary	basics of, 524–27
avoiding plagiarism and, 35	avoiding plagiarism in, 311	capitalization of, 607
citing and documenting, 313–18	previewing, 10	italicizing or capitalizing, 594
evaluating, for research essay,	in problem solving, 24	their
307-09	of readings, 17–18	versus his or her, 428
finding, for research essay,	of visual images, 21–22	versus there they're, 553
304–07	writing, 291–95	then
Space order	Superlatives, 450–54	run-ons caused by, 370
in cause and effect, 254	"Supersize It" (Verini), 86–87	versus than, 552-53
in classification, 196	Support, 68–76	there, subject-verb agreement and,
in description, 160	in argument, 268–76	389–91
transitional words/phrases for,	in cause and effect, 251–53	there is there are, 504
103	in classification, 193-95	Thesaurus, 536
using, 78, 79	in comparison and contrast,	Thesis statement, 52-67; see also
"Spanglish" (Castro et al), 218-20	229–31	Main point
Specific (proper) nouns, 604	in definition, 210–13	in argument, 267-68, 270-71
Specific words, using, 536–37	in description, 156-59	in cause and effect, 250, 251,
Speech, parts of, 329-31	finding while reading, 10, 11–12	252-53
Spell checker, 557	in illustration, 135–37	in classification, 192, 193-95
Spelling, 557–63	in narration, 116–20	compared to topic sentence,
"Start Snitching" (Maxwell),	in process analysis, 172–75	31–33, 55–57
700–02	revising for, 101–02	in comparison and contrast,
introduction of, 87–88	Support paragraphs, 31–33,	228–29, 230–31
reference of conclusion to intro-	55–57	in definition, 209–10, 212–13
duction in, 90	Support sentences, 30–33, 55–57	in description, 155, 157, 158–159
Statements, basics of, 499–501	suppose / supposed, 552	developing, 55–64
	Surprise, opening essay with, 87	drafting, 85
Stoker, Courtney, "The Great		
Debate: Essentialism vs. Domi-	Synonym Finder, The (Rodale), 536	in illustration, 134, 135, 136–37
nance," 675–80	Synonyms, thesaurus for, 536	in narration, 115, 116, 118–19
"Stop Snitchin' Won't Stop Crime"	Synthesis	in outline, 80, 81
(Phansalkar), 697–98	in problem solving, 25	in process analysis, 172, 174–75
Subject of sentence	of readings, 18–20	purpose of, 31
basics of, 331–33, 341	of visual images, 23–24	supporting, 68–76
sentence patterns and, 338,		understanding, 52–55
499–500	_	writing, 64–66
verbs before, 389–91	T	Thinking critically, 3–9
words between verb and, 381–84	Tan, Amy, "Fish Cheeks," 126–27	Third person pronouns, 441–42
Subject pronouns	Tappening advertisement, 4–5	Thompson, Michael, "Passage into
basics of, 505–06	Taste, in description, 156	Manhood," 671–73
in comparisons, 438–40	Television programs	though / through / threw, 553
compound subjects and, 436-38	italicizing title of, 594	through / threw / though, 553
correct use of, 434–35	Works Cited documentation of,	Tierney, John, "Yes, Money Can
who as, 440-41	319	Buy Happiness," 692-93
Subject-verb agreement, 377-96	Tests, editing review, 609–18	Time, apostrophes with, 587
compound subject and, 384-87	Textbook of Basic Nursing (Rosdahl	Time order
editing for, 391–93	and Kowalski), 17	in cause and effect, 254
flowchart for, 396	than	in classification, 196
forms of be, have, do and,	in comparisons, 438	in description, 160
379–81	parallelism and, 480	in illustration, 139
indefinite pronouns and, 387–89	versus then, 552–53	in narration, 121
understanding, 377–78	that	in process analysis, 176
verb before subject and, 389–91	adjective clauses and, 494	transitional words/phrases for,
words between subject and verb	basics of, 506–07	104
and, 381–84	commas and, 574–75	using, 78
and, Joi of	commission and, JIT 13	451115, 10

Titles capitalization of, 606–07	Twain, Mark, "Two Ways of Seeing a River," 238–39	of subject-verb agreement errors, 386
of paragraph, 84	two/too/to, 553-54	writing critically about, 21-24
previewing, 9	"Two Ways of Seeing a River"	Vowels, list of, 559
quotation marks for, 590, 594-95	(Twain), 238–39	
to		
helping verbs and, 518		W
versus too and two, 553-54	U	was, 406-07; see also be, forms of
Topic, 42–51	Unity, revising for, 99–101	"Ways We Lie, The" (Ericsson),
choosing for research essay,	Upright, Karen, 134, 140-42, 398	661–65
303-04	use/used, 554	Weblogs, Works Cited documenta-
exploring, 46–49		tion of, 318
finding, 43		Web sites
narrowing, 43-45	V	evaluating reliability of, 308-09
understanding, 42-43	Vague pronoun reference, 431–33	in-text citation of, 314
Topic sentence, 52-67; see also Main	Vague words, avoiding, 536-38	library, 306
point	Verb phrase, 335	running bibliography for, 310
in argument, 267-68, 269, 270	Verbs	Works Cited documentation of,
in cause and effect, 250, 251, 252	base form of, 397	318
in classification, 192, 193, 194	basics of, 330, 334-36	"Weirdest Job Interview Questions
compared to thesis statement,	followed by gerunds and infini-	and How to Handle Them,
31–33, 55–57	tives, 521-23	The" (Adams), 144-47
in comparison and contrast,	helping verbs and, 515-19	well, versus good, 452-54
228–29, 230	prepositions after, 527–29	were, 406-07; see also be, forms of
concluding sentence referring	sentence patterns and, 338,	"What Community Involvement
to, 83	499–500	Means to Me" (Costas), 216-17
in definition, 209, 210-11, 212	before subjects, 389–91	which
in description, 155, 157-58	words between subjects and,	adjective clauses and, 494
developing, 55-64	381-84	basics of, 506-07
drafting for essay, 85–86	Verh tense, 397-421; ooo also Futuic	commus and, 5/4-/5
in illustration, 134, 135-36	tenses; Past tenses; Present	fragments starting with, 345
in narration, 115, 116–19	tenses	as misplaced modifier, 459
in outline, 80, 81	basics of, 507–23	subject-verb agreement and, 383
in process analysis, 172, 173-74	consistency of, 415–16	who
purpose of, 30	editing for, 416–18	adjective clauses and, 494
revising for unity with, 99-100	flowchart for, 421	basics of, 506–07
supporting, 68–76	irregular verbs and, 402-10	commas and, 574-75
of support paragraphs in essay,	past participles and, 410–15	fragments starting with, 345
31–33	regular verbs and, 398-402	as misplaced modifier, 459
understanding, 52–55	understanding, 397–98	subject-verb agreement and, 383
writing, 64–66	Verini, James, "Supersize It," 86–87	versus whom, 440-41
to plus verb	Visual images	whoever, 440
basics of, 521–23	of apostrophe errors, 584	Whole-to-whole comparison, 232–34
fragments starting with, 349–51	of argument, 266, 286	whom
"To Stand in Giants' Shadows"	of cause and effect, 248–49, 263	subject-verb agreement and, 383
(Shields), 629–32	of classification, 189, 204	versus who, 440-41
Touch, in description, 156	of commonly confused words,	whomever, 440
Transitions	547, 549	whose
in argument, 276–77	of comparison and contrast, 227,	fragments starting with, 345
in cause and effect, 254	242–43	as misplaced modifier, 459
in classification, 196	of definition, 208, 222–23	subject-verb agreement and, 383
for coherence, 103–05	of description, 153, 167–68	versus who's, 554
in comparison and contrast, 234	of fragments, 343	who's/whose, 554
in definition, 214	of illustration, 133, 149	"Why Are We So Angry?" (Hales),
in description, 160	of narration, 114, 129–30	634–36
in illustration, 139	of process analysis, 171, 184–85	introduction of, 87
in narration, 121	of run-ons, 364	reference of conclusion to intro-
in process analysis, 176	of spelling errors, 563	duction in, 89–90

Wikipedia, 307 Wilde, Oscar, 285 will as helping verb, 518, 519 for simple future tense, 509 will be, 513-14 will have, 511 Wilson, Chelsea "The Benefits of Getting a College Degree," 93, 107-08 "My Career Goal," 91-92, 106 outlining by, 80 prewriting techniques by, 46-48 primary and secondary support by, 73-74 topic sentence by, 65 Wood, Michele, "My Home Exercise Program," 88 Words choice of, 535-44 commonly confused, 545-56, 558 commonly misspelled, 562 Wordy language, avoiding, 538-40 Works Cited guidelines for, 313, 314–18 running bibliography for, 310 student example of, 322-23

would as helping verb, 518, 519 using of or have after, 550 write/right, 552 Writers at Work Booker, Mary LaCue, 247, 360 Graham, Jeremy, 172 Hyde, Celia, 154 King, Leigh, 190, 342 Layland, Kelly, 115 Leibov, Brad, 228 Melancon, Diane, 266 Scanlon, Walter, 208, 378 Upright, Karen, 134, 398 Writing basics, 27–41 audience and, 27-33 grading criteria and, 35-40 purpose for writing and, 27-33 writing process and, 34-35 Writing critically about readings, 16-21 about visual images, 21-24 Writing process, understanding, 34 - 35Wyant, Robin, 183

-y adding -ing to, 560 changing to -i, adding -ed to, 400 changing to -i, before adding -er or -est, 450-51 changing to -i, spelling rules for, 559-60 as vowel or consonant, 559 yes, commas with, 577 "Yes, Money Can Buy Happiness" (Tierney), 692-93 yet in compound sentences, 569 for coordination, 465-66 correcting run-ons with, 365-66 Yilmaz, Jason, "A Learning Tool Whose Time Has Come," 281-82 your/you're, 554

Y

Z Ziman, Kristen, "Bad Attitudes and Glowworms," 259–60 Z pattern of visuals, 22

antible business saleur und

The first of the first out in the paper taken on a section by the section of the

en en station de la company de la compan La company de la company d La company de la company de

Real Take-Away Points

Four Basics of Good Writing

- It considers what the audience knows and needs.
- It fulfills the writer's purpose.
- It includes a clear, definite point.
- It provides support that shows, explains, or proves the main point.

For more on the elements of good writing, see Chapter 2.

5 hays to fix petinitions
FAN + Petinitions

2PR The Critical Reading Process

Preview the reading. Establish a guiding question.

Read the piece, locating the thesis, support, and transitions, and considering the quality of the support.

Pause to think during reading. Take notes and ask questions about what you are reading: Talk to the author.

Review the reading, your guiding question, your marginal notes, and questions.

For more on the critical reading process, see pages 9-12.

10 holds

Reading and Writing Critically

Summarize When you are reading, consider the author's purpose, main point, and the evidence given in support of the main point.

Analyze Consider whether the support is logical or if it leaves you with questions; what assumptions the author might be making about the subject or reader; and what assumptions you as the reader may be making.

Synthesize Consider how the reading relates and connects to your own experience and knowledge, and what new ideas it has given you.

Evaluate Consider whether the author seems biased, whether you are reading with a biased point of view, and whether or not the piece achieves the author's intended purpose.

For more on reading and writing critically, see pages 16-21.

Editing and Proofreading Marks

The marks and abbreviations below are those typically used by instructors when marking papers (add any alternate marks used by your instructor in the left-hand column), but you can also mark your own work or that of your peers with these helpful symbols.

ALTERNATE SYMBOL	STANDARD SYMBOL	HOW TO REVISE OR EDIT (numbers in boldface are chapters where you can find help)
	adj	Use correct adjective form Ch. 25
	adv	Use correct adverb form Ch. 25
	agr	Correct subject-verb agreement or pronoun agreement Chs. 22 and 24
	awk	Awkward expression: edit for clarity Ch. 22
	cap or triple underline [example]	Use capital letter correctly Ch. 38
	case	Use correct pronoun case Ch. 24
	cliché	Replace overused phrase with fresh words Ch. 31
	coh	Revise paragraph or essay for coherence Ch. 7
	coord	Use coordination correctly Ch. 27
	cs	Comma splice: join the sentences correctly Ch. 21
	dev	Develop your paragraph or essay more completely Chs. 3 and 5
4 - 4 - 12	dm	Revise to avoid a dangling modifier Ch. 26
	frag	Attach the fragment to a sentence or make it a sentence Ch. 20
	fs	Fused sentence: join the two sentences correctly Ch. 21
	ital	Use italics Ch. 36
	lc or diagonal slash [Example]	Use lowercase Ch. 38
	mm	Revise to avoid a misplaced modifier Ch. 26
	pl	Use the correct plural form of the verb Ch. 23
	ref	Make pronoun reference clear Ch. 24
	ro	Run-on sentence; join the two sentences correctly Ch. 21
	sp	Correct the spelling error Ch. 33
	sub	Use subordination correctly Ch. 27
	sup	Support your point with details, examples, or facts Ch. 5
	tense	Correct the problem with verb tense Ch. 23
	trans	Add a transition Ch. 7
	w	Delete unnecessary words Ch. 31
1 6,70	wc	Reconsider your word choice Ch. 31
130 673	· ?	Make your meaning clearer Ch. 7
	^	Use comma correctly Ch. 34
	; : ()	Use semicolon/colon/parentheses/hyphen/dash correctly Ch. 37
	" »	Use quotation marks correctly Ch. 36
	^	Insert something
	y [exaample]	Delete something
	○ [words example]	Change the order of letters or words
Secretary of	9	Start a new paragraph
	# [examplewords]	Add a space
	C [ex ample]	Close up a space

For Easy Reference: Selected Lists and Charts

Critical Reading and Thinking Help

Four Basics of Critical Thinking 7 Questioning Assumptions 8

2PR The Critical Reading Process 9

Reading and Writing Critically 16

Four Basics of Good

Writing 27

Narration 113

Illustration 132

Description 152

Process Analysis 170

Classification 188

Definition 207

Comparison and Contrast

Cause and Effect 246

Argument 265

Summaries 291

Reports 295

Responses to Essay Questions

Writing Help

Audience and Purpose 28

The Writing Process 34

Questions for Finding a Good Topic 43

Prewriting Techniques 46

Basics of a Good Topic Sentence or Thesis

Statement 53

Basics of Good Support 69

Three Quick Strategies for Generating

Support 71

Basics of a Good Draft 77

Basics of a Good Introduction 86

Basics of a Good Essay Conclusion

Basics of a Good Essay Title 91

Tips for Revising Your Writing

Basics of Useful Feedback 98

Questions for Peer Reviewers 98

Reading to Summarize 292

Sample Research Essay Schedule

Questions for the Librarian 304

Questions for Evaluating a Print or Electronic

Source 308

destrotion

Guide to Internet Address Extensions 309

Directory of MLA In-Text Citations 314

Directory of MLA Works Cited 316

Sample Student Research Paper 320

Grammar Help: How to . . .

Use Common Transitional Words and Phrases 103

Find and Fix Fragments 358

Find and Fix Run-Ons 376

Find and Fix Problems with Subject-Verb Agreement 396

Use Irregular Verb Forms 402

Find and Fix Verb-Tense Errors 421

Find and Fix Pronoun Problems 447

Edit for Correct Usage of Adjectives and

Adverbs 457

Edit for Misplaced and Dangling Modifiers 464

Edit for Coordination and Subordination 477

Edit for Parallelism 485

Edit for Sentence Variety 498

Use Articles with Count and Noncount Nouns 525

Avoid Vague and Abstract Words 536

Avoid Common Wordy Expressions 539

Avoid Common Clichés 540

Edit for Word Choice 544

Avoid Commonly Misspelled Words 562

Profiles of Success

Kelly Layland, Registered Nurse 123

Karen Upright, Systems Manager 140

Celia Hyde, Chief of Police 161

Jeremy Graham, Youth Pastor and

Motivational Speaker 177

Leigh King, Fashion Writer / Blogger 197

Walter Scanlon, Program and Workplace Consultant 215

Brad Leibov, President, New Chicago Fund,

Mary LaCue Booker, Singer, Actor 256 Diane Melancon, Oncologist 279